YALE UNIVERSITY PRESS
PELICAN HISTORY OF ART

FOUNDING EDITOR: NIKOLAUS PEVSNER

C.R. DODWELL

THE PICTORIAL ARTS OF THE WEST
800–1200

C.R. Dodwell

The Pictorial Arts of the West
800–1200

Yale University Press
New Haven and London

First published 1993
Copyright © C.R. Dodwell, 1993
All rights reserved

Typeset in Monophoto Ehrhardt
and printed in Singapore by
C. S. Graphics

Designed by Sally Salvesen

Library of Congress Cataloging-in-Publication Data

Dodwell, C. R. (Charles Reginald)
 Pictorial arts of the West 800–1200/C. R. Dodwell.
 p. cm .— (Yale University Press Pelican history of art)
 Includes bibliographical references and indexes.
 ISBN 0–300–05348–7
 1. Art, Medieval. I. Title. II. Series.
N5970.D84 1992
709'. 02' 1—dc20
 92–32502
 CIP

Title page illustration:
The Morgan Master, Winchester: *Scenes from the Life of David*,
detail of a detached leaf intended for the Winchester Bible.
New York, Pierpont Morgan Library

Contents

Preface and Acknowledgements

This book is not an update of my earlier *Painting in Europe: 800–1200* but – apart from some of the brief final chapter – is a new work incorporating wide areas of new research, relating the relevant arts to the documentary sources, and now covering embroidery, mosaics, and stained glass as well as painting. It also includes new chapters on Irish, Anglo-Saxon, and English Romanesque art as well as much new material on the actual embroiderers and painters of the period.

In writing this volume I have received invaluable help from Timothy Graham. George Zarnecki has made constructive comments on the typescript, Michael Kauffmann did the same for Chapter 12, David O'Connor read and commented on Chapter 13, Paul Crossley helped me with the section on Polish art. To all these friends I extend my warmest thanks. I am grateful also to the co-editor, Judy Nairn, though unhappily she will not read these words. She worked fastidiously and sympathetically on the chapter-by-chapter editing of this book and was so tireless in her activities that it came as a shock to me to learn that she had been seriously ill during the latter part of this time. Indeed, her stoicism was such that my own first inkling of her illness was when it had already run its course. She died when this book was still in the Press. It is therefore one of the final volumes in the many that she 'mothered' through their pre-publication stages, always in harmonious association with their authors. They will all be grieved by her untimely death though they will know that the fruits of her bookmaking talents will live on. This, one of the last books she edited, is concerned with Middle Ages and it was a medieval lover of books and admirer of book-makers who wrote: 'In books I find the dead as if they were alive'.

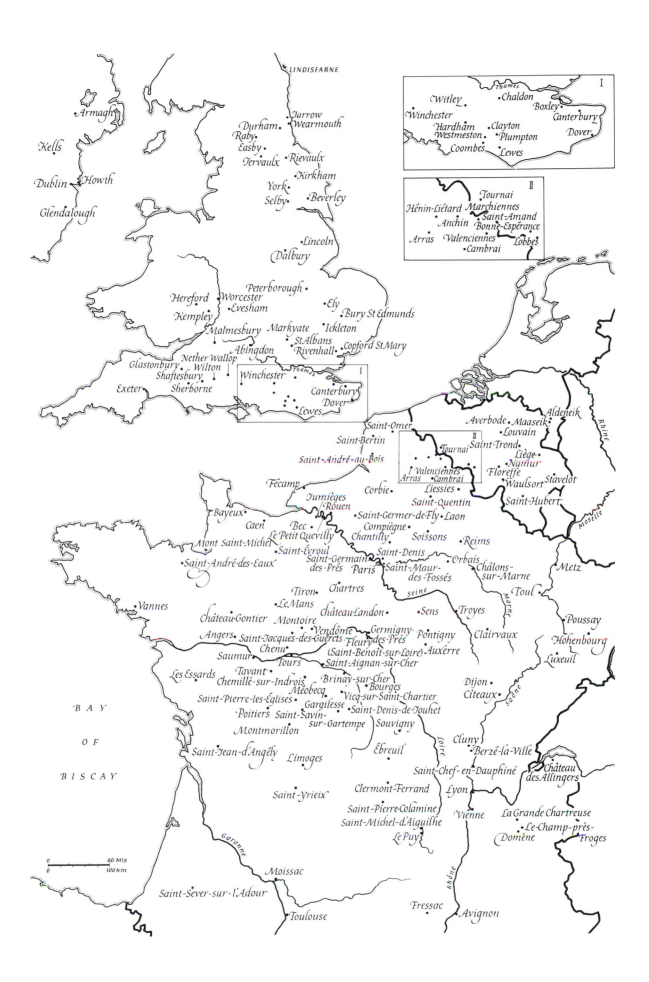

LINDISFARNE

I

Witley · Chaldon
Winchester · Boxley
Hardham · Clayton · Canterbury
Westmeston · Plumpton · Dover
Coombes · Lewes

II

Tournai
Hénin-Liétard · Marchiennes
Anchin · Saint-Amand
Bonne-Espérance
Arras · Valenciennes · Lobbes
Cambrai

Armagh
Kells
Dublin · Howth
Glendalough

Durham · Jarrow
Raby · Wearmouth
Easby
Jervaulx · Rievaulx
York · Kirkham
Selby · Beverley

Lincoln
Dalbury

Hereford · Peterborough
Worcester · Evesham · Ely
Kempley · Bury St Edmunds
Malmesbury · Markyate · Ickleton
St Albans · Copford St Mary
Abingdon · Rivenhall
Glastonbury · Nether Wallop
Wilton
Shaftesbury · Sherborne
Exeter

Winchester · Thames
Canterbury
Dover
Lewes

Saint-Omer
Saint-Bertin
Saint-André-au-Bois

Fécamp
Jumièges
Bayeux · Rouen
Caen · Bec
Mont Saint-Michel · Le Petit Quevilly
Saint-Évroul
Saint-André-des-Eaux · Saint-Germain-des-Prés · Paris

Averbode · Maaseik · Aldeneik
Louvain
Saint-Trond
Tournai · Liège · Namur
Valenciennes · Floreffe · Stavelot
Arras · Cambrai · Waulsort
Liessies · Saint-Hubert
Corbie · Saint-Quentin
Saint-Germer-de-Fly · Laon
Compiègne
Chantilly · Soissons · Reims
Saint-Denis · Orbais
Saint-Maur- · Châlons-
des-Fossés · sur-Marne · Metz

Rhine
Moselle

Vannes

Tiron · Chartres · seine
Le Mans · Sens · Troyes · Toul
Château-Gontier · Château-Landon · Poussay
Montoire · Clairvaux
Angers · Vendôme · Germigny- · Pontigny · Hohenbourg
Saint-Jacques-des-Guérets · des-Prés · Luxeuil
Chenu · Fleury · Auxerre
Saumur · Tours · (Saint-Benoît-sur-Loire)
Les Essards · Saint-Aignan-sur-Cher · Dijon
Tavant · Brinay-sur-Cher · Cîteaux
Chemillé-sur-Indrois · Bourges
Méobecq · Vicq-sur-Saint-Chartier
Saint-Pierre-les-Églises · Gargilesse · Saint-Denis-de-Jouhet
Poitiers · Saint-Savin- · Souvigny · Cluny
Montmorillon · sur-Gartempe · Berzé-la-Ville
Saint-Jean-d'Angély · Ébreuil · Château des Allingers
Limoges · Saint-Chef-en-Dauphiné
Saint-Yrieix · Clermont-Ferrand · Lyon
Saint-Pierre-Colamine · La Grande Chartreuse
Saint-Michel-d'Aiguilhe · Vienne · Le-Champ-près-
Le Puy · Domène · Froges

BAY
OF
BISCAY

Garonne
Saône
Loire
Marne
Rhône

Moissac
Saint-Sever-sur-l'Adour
Toulouse · Fressac · Avignon

0 — 60 Mls
0 — 100 Km

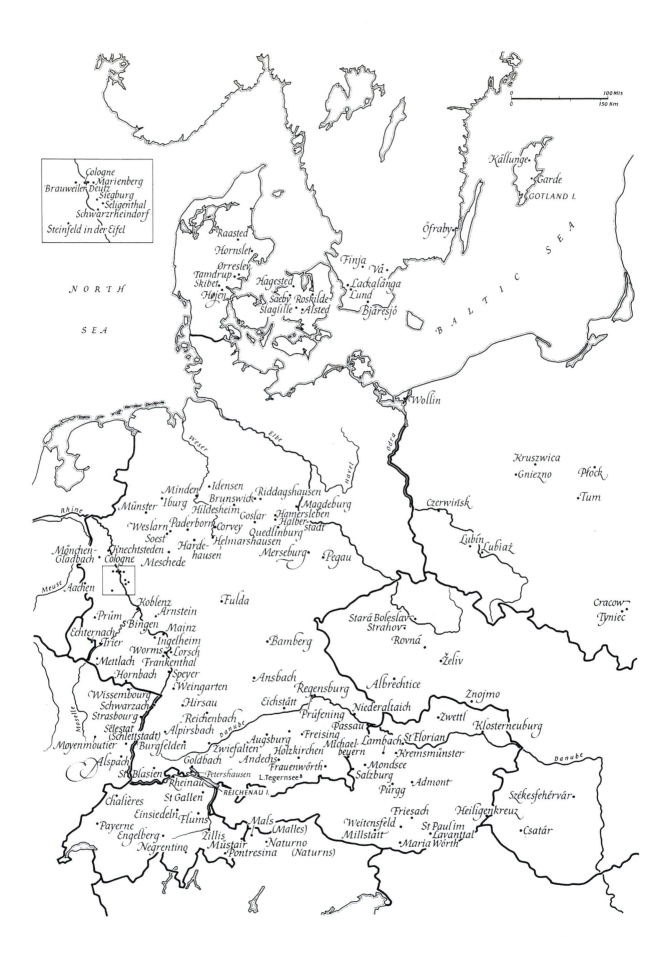

100 MIS
150 Km

Cologne
Brauweiler Deutz • Marienberg
• Siegburg
• Seligenthal
Schwarzrheindorf
Steinfeld in der Eifel

NORTH

SEA

BALTIC

SEA

Kållunge•
•Garde
GOTLAND I.

Ôfraby•

Raasted•
Hornslet•
Ørreslev• Finja• Vá•
Tamdrup• •Lackalänga
Skibet• Hagested• •Lund
Højen• Saeby Roskilde• Bjäresjö•
Slaglille• Alsted

Wollin•

Kruszwica•
•Gniezno Płock•
•Tum
Czerwińsk•

Weser
Elbe
Havel
Odra

Minden• •Idensen
Münster• Iburg• Brunswick Riddagshausen•
Hildesheim• •Magdeburg
Weslarn Paderborn Goslar• Hamersleben•
Rhine Soest• Corvey Halberstadt
Mønchen- Knechtsteden• Harde- Helmarshausen•
Gladbach •Cologne hausen Quedlinburg•
Meschede• Merseburg• Pegau•

Lubín• Lubiąż•

Stará Boleslav•
Strahov•
Rovná•

Cracow•
Tyniec•

Meuse
Aachen•
Koblenz•
Prüm• Arnstein•
•Bingen Mainz•
Echternach• Ingelheim•
Trier• Worms• •Lorsch
Mettlach• Frankenthal
Hornbach• Speyer•
Wissembourg •Weingarten
Schwarzach•
Strasbourg• Hirsau•
Sélestat Reichenbach•
(Schlettstadt) Alpirsbach•
Moyenmoutier •Burgfelden
Alspach Goldbach•
St Blasien•
Rheinau• Petershausen•
Chalières• St Gallen•
Einsiedeln• Fluins
Payerne• Mals•
Engelberg• Zillis (Malles)
Negrentino• Müstair• •Naturno
Pontresina (Naturns)

•Fulda

Bamberg•

•Želiv

Ansbach• Regensburg• Albrechtice•
Eichstätt• Niederaltaich•
Prüfening• Passau•
Freising•
Augsburg• Michael-
Holzkirchen• beuern
Zwiefalten• Andechs Lambach•
Frauenwörth• Kremsmünster•
L.Tegernsee Mondsee•
REICHENAU I. Salzburg•
Pürgg•

Znojmo•
Zwettl• Klosterneuburg•

St Florian•

Admont•

Székesfehérvár•
Friesach• Heiligenkreuz
Weitensfeld• St Paul im •Csatár
Millstätt• Lavanttal•
Maria Wörth•

Moselle
Danube
Danube

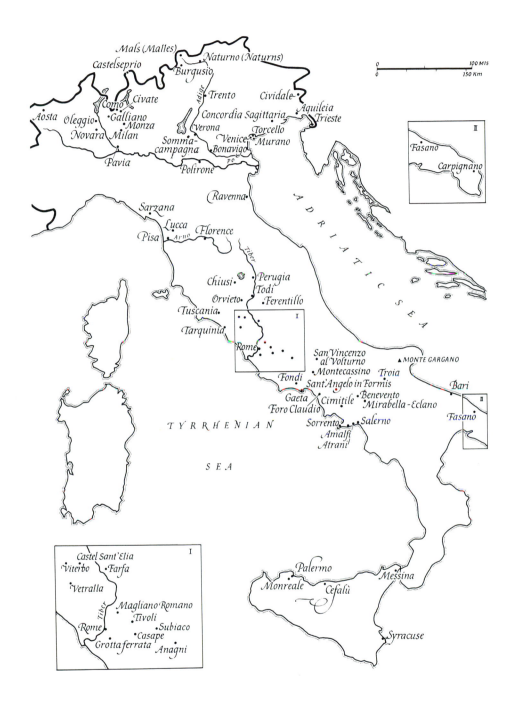

Mals (Malles)
Naturno (Naturns)
Castelseprio
Burgusio
Trento
Cividale
Como
Civate
Aquileia
Trieste
Aosta
Oleggio
Galliano
Concordia Sagittaria
Novara
Monza
Verona
Somma-
Torcello
Pavia
campagna
Venice
Murano
Bonavigo
Po
Polirone

Ravenna

Sarzana
Lucca
Florence
Pisa
Arno

A D R I A T I C

Chiusi
Perugia
Todi
Orvieto
Ferentillo
Tuscania

Tarquinia
Rome

San Vincenzo
al Volturno
MONTE GARGANO
Fondi
Montecassino
Troia
Sant'Angelo in Formis
Bari
Gaeta
Cimitile
Benevento
Foro Claudio
Mirabella-Eclano
Fasano
Sorrento
Salerno
T Y R R H E N I A N
Amalfi
Atrani

S E A

Palermo
Messina
Monreale
Cefalù

Syracuse

Fasano
Carpignano

Castel Sant'Elia
Viterbo
Farfa
Vetralla
Magliano Romano
Tivoli
Rome
Subiaco
Casape
Grottaferrata
Anagni

100 MIS
150 Km

II

I

II

S E A

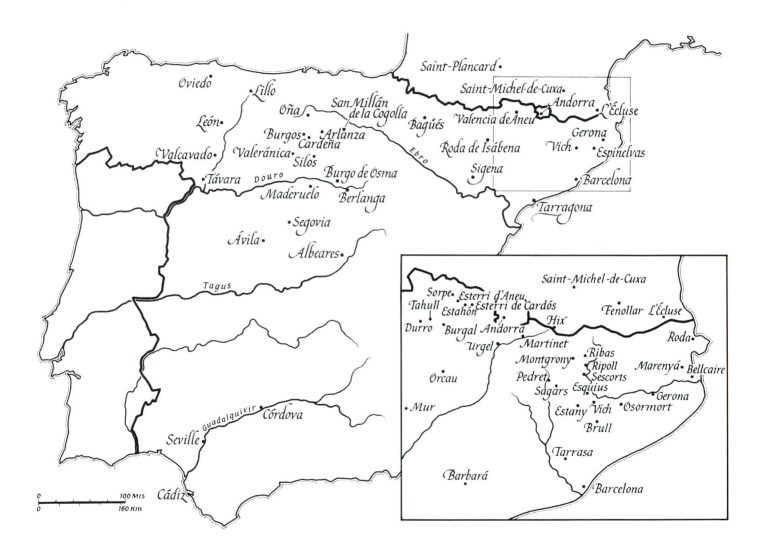

Oviedo

Lillo

León

Valcavado

Távara

Oña

San Millán
de la Cogolla

Burgos Arlanza
 Cardeña
Valeránica
 Silos
 Burgo de Osma
Maderuelo Berlanga

Segovia

Ávila

Albeares

DOURO

Tagus

Guadalquivir Córdova

Seville

Cádiz

0 100 MIS
0 160 Km

Saint-Plancard

Saint-Michel-de-Cuxa
 Andorra L'Écluse
Valencia de Áneu

Bagüés

Roda de Ísabena Gerona
 Vich Espinelvas
 Sigena

 Barcelona

Tarragona

Ebro

Saint-Michel-de-Cuxa

Sorpe Esterri d'Aneu
Tahull Estahón Esterri de Cardós Fenollar L'Écluse
Durro Hix
 Burgal Andorra Roda
 Urgel Martinet
Orcau Montgrony Ribas Marenyá
 Pedret Ripoll Bellcaire
 Sescorts
Mur Ságars Esquius Gerona
 Estany Vich Osormort
 Brull

 Tarrasa

 Barbará

 Barcelona

The Pictorial Arts of the West
800–1200

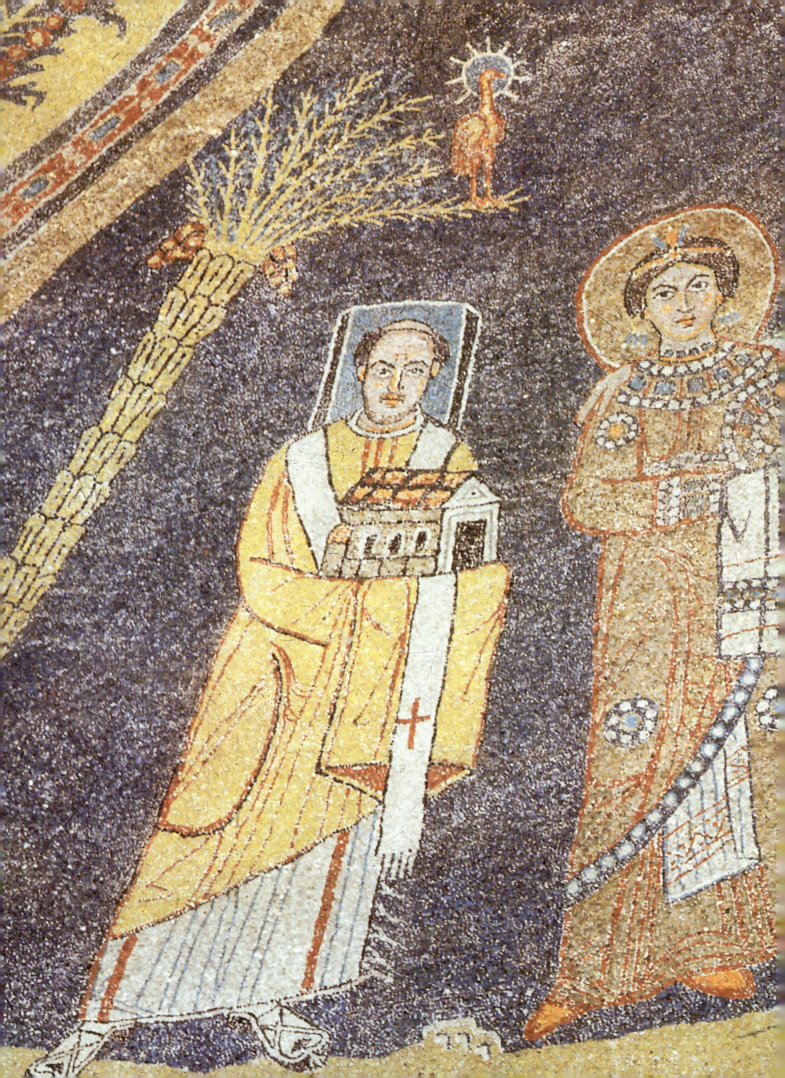

Eastern and Western Christendom

HISTORICAL BACKGROUND

The four hundred years covered by this book begin with the inauguration of one empire and end with the collapse of another. Both were Christian and both claimed to be the heirs of Rome.

In the fourth century, the emperor Constantine had given to the classical Roman empire a new religious direction and a new geographical focus: he had made it Christian, and he had moved its political centre to the Hellenic East. The new capital, which he called Constantinople, was also christened the New, or Second, Rome – a title that was taken seriously in the Middle Ages. Indeed, in the tenth century, papal envoys were thrown into prison for addressing the Byzantine emperor solely as Emperor of the Greeks and not also of the Romans, and even today the patriarch of Constantinople is entitled Archbishop of Constantinople, New Rome, and Oecumenical Patriarch. When the Roman empire came to be divided, however, its eastern half took its title from Constantinople's original pagan name of Byzantium.

The centre of gravity of the Roman empire was transferred to the East because it was there that danger seemed most threatening. In the event, it was the West that crumbled first, and in the fifth and sixth centuries the barbarians (as the Romans called all foreigners) poured into the Europe of the future, and settled in areas that were later to become their homelands – the Goths and Lombards in 'Italy', the Visigoths in 'Spain' and southern 'France', the Franks in northern 'France' and western 'Germany', the Saxons in 'Belgium', 'Holland', south 'Denmark' and 'England'.

The New Rome did not collapse like the Old, but it faced the constant threat of forces just as devastating. These were the Arab tribes. Their energies were unleashed by zeal for the new religion of Islam, and in the century after the death of Mohammed in 632 the Muslims swarmed over the wealthy southern areas of the Byzantine empire, conquering Syria and North Africa and absorbing Antioch, Alexandria, Carthage, and Jerusalem. Sweeping across the straits of Gibraltar (itself named after a Muslim leader), they occupied almost the whole of Spain, and then crossed the Pyrenees into the France of the future, where they captured the cities of Carcassonne and Nîmes and burned down the church of Saint-Hilaire at Poitiers where, in 732, one hundred years after the death of the Prophet, they were checked and defeated by Charles Martel, the leader of the very 'barbarians' who had taken possession of the western areas of the old Roman empire. Not long afterwards the Muslims withdrew to Spain, to be finally dislodged only at the end of the Middle Ages.

The view of one Islamic chronicler that the victory of the Franks left the rest of Europe to intellectual darkness is understandable when we consider the sophistication of the Muslim culture in Spain. But the Frankish victory most assuredly saved Europe from *artistic* darkness in the Western sense, for the Muslims were fiercely opposed to human representation in the visual arts as a blasphemy against God, the only creator of human kind. They left many monuments in Spain to their own refined civilization, including noble buildings, traces of exotic music, subtle scholarship, and cultivated forms of behaviour, but little in the way of painting or sculpture. When, in the sixteenth century, the Muslim Turks occupied Hungary on the other side of Europe, they destroyed everything figural they could find, and even in the nineteenth, a Western artist (it was Edward Lear) making innocent sketches of the scenery of a Muslim area of the Balkans was attacked as the devil and his drawings were forcibly removed.[1] Like the adherents of other religions over the centuries, Muslims maintained the tenets of their faith with varying degrees of intensity; later on, in areas distant from Mecca, such as India, we do find examples of Muslim representational art. But there is no doubt that, without the famous victory of the Franks at Poitiers, 'Europe' would never have been clothed with the great figural paintings and sculptures of the Middle Ages, and neither this book nor those dealing with the later painting and sculpture of the West could have been written.

Though shorn of its provinces in Syria, Palestine, Egypt, and North Africa, the Byzantine empire still remained a world power. Long considered the strongest and most civilized area of the former Roman empire, it also remained forceful enough under great emperors to recover (if only temporarily) some of its former territories. Indeed, Byzantium's continued occupation or control of key areas of Italy and Sicily, including Ravenna, Naples, Milan, and Venice, and its hold until the 1070s on southern Italy, were to have a significant effect on Western painting.

The Roman papacy accepted the authority of Byzantium. Indeed, the papacy for a time *was* Byzantine, for no less than thirteen popes between 606 and 741 were Greek or Syrian, and when, in 704, St Wilfrid presented a petition to the pope, the Anglo-Saxon party discovered to their surprise that it was discussed in Greek.[2] However, for a number of reasons, a breach developed between the papacy and Byzantium in the eighth century. One factor was the inability of Byzantium to protect Italy from the expansionist ambitions of the Lombards, who had captured Ravenna in 751 and then attempted to impose their authority on Rome itself. Another was directly concerned with questions of art, and therefore has special relevance to our present study.

BYZANTINE ICONOCLASM
AND ITS EFFECTS

The prohibition on figural art was accepted even within some areas of the Byzantine empire, but only in respect of religious pictures. At first submerged, this opposition to figural representation seems to have fed on battlefield defeats, which were perhaps silently ascribed to the breaking of the second Commandment, 'Thou shalt not make unto thee any graven image, or any likeness of anything that is in the heaven above, or that is in the earth beneath, or that is in the water under the earth' (Exodus xx, 4). In the Middle Ages, as in other epochs, military defeat was usually attributed to moral sin, and in 726 the emperor Leo III himself preached a sermon in Hagia Sophia equating religious figural art with idolatry. Many argued that such paintings should be destroyed, and their cause was fuelled when the first Byzantine victory in Muslim-held territory for a century was won by a particularly zealous supporter of their views. All this culminated in 754, when an Oecumenical Council anathematized the veneration of images, and the destruction of religious paintings was regularized. Owners of religious pictures were persecuted, and artists began to flee to Italy. There was a period of remission under the empress Irene (780–802), followed by another flare-up early in the ninth century, but after this the controversy subsided into a purely theological dispute, acrid indeed, but no longer envenomed by bouts of torture and murder.

The papacy in Rome set its face strongly against the iconoclasm ordained by Constantinople. It held the traditional Western view, enunciated by Gregory the Great, that art was a support for the Church, particularly in its evangelizing activities, and indeed this standpoint was not unknown to Byzantium, for one of its missionaries, St Methodius, is said to have converted the king of Bulgaria by painting the walls of his royal palace with pictures of the Divine Judgement. Whatever the reasons, the papacy took a firm stand, and its response to a Byzantine edict of 730 supporting iconoclasm was to excommunicate all iconoclasts. The expedition sent by the emperor to punish this temerity was aborted by a storm in the Adriatic, but the breach between the papacy in the Old Rome and the empire in the New was nevertheless becoming irreparable.

The Franks had proved effective allies against the Lombards, and the papacy began to hope that they might also afford protection against the local factions of Rome, and incidentally against the theological extremism of Constantinople. Accordingly the Franks were given the fullest support, culminating in the creation of a new Western empire when, on Christmas Day 800 in Rome, the Frankish king Charlemagne was crowned Holy Roman Emperor by a pope who, ironically, bore the same name and number as the iconoclast emperor Leo III. This resuscitation of the Western part of the old Roman empire in a Christianized form provides a dramatic opening for the period covered by this book. It was to have an equally dramatic but more melancholy end.

The title of 'Empire' was no more than a kind of papal sanction of the military conquest of the territories already won by the Franks. The area was far smaller than its resounding title might suggest, and it effectively comprised the France, Germany, and parts of Italy of today. It was by no means secure against the future, and though the appellation of Holy Roman Emperor was only finally suppressed by Napoleon in 1806, it survived primarily as a title of prestige for, after many vicissitudes, including dismemberment and disintegration, the Carolingian empire effectually existed only until the early tenth century. Given his Roman title, it was appropriate that Charlemagne should be buried at Aachen, a city of the old Roman empire; but less than seventy years later, Aachen was sacked by the Norsemen from Scandinavia, whose first depredations had been recorded during Charlemagne's own reign.

The Norsemen were the northern seaborne equivalent of the land forces of Islam to the south, sweeping all before them. They were not averse to trade, but they were chiefly known to the West as ruthless pirates and resolute invaders. They settled in Iceland and discovered Greenland and North America. They penetrated Finland and northern Russia, founding colonies at Novgorod and Kiev. They invaded Spain, attacked Morocco, ransacked the ports of southern France, and ravaged those of Italy. They conquered a large part of Ireland, establishing a kingdom centred in Dublin. They harried England, and then invaded and occupied a considerable part of that country too. They plundered France, and in the late ninth century established themselves in an area of its Channel coast which was confirmed to them as their own duchy of Normandy in 911. There, they assimilated themselves to the customs, culture, and religion of 'France'. But the duchy was too small to hold them. In 1066, the French Norsemen, who were now called Normans, invaded and conquered England, and in the same century they launched attacks on south Italy and Sicily, where they carved out new kingdoms for themselves. They even went on to threaten Constantinople and the Byzantine empire.

BYZANTIUM AND THE WEST

Norse dynamism was only one manifestation of the new energies that were building up all over western Christendom. The papacy tried to channel them in a Christian direction in the form of the Crusades, but found that it had not only unleashed forces of religious zeal – an anxiety to help the Byzantines against Islam and a desire to recover Jerusalem – but also fuelled more self-serving drives, particularly the land-hunger of the aristocratic classes, who took the Holy Land itself only to divide it into small Crusading states. But the same territory had earlier been wrested by the Muslims from the Byzantines, and the Byzantines understandably still saw it as their own. The ensuing division of interest soon drove a solid wedge between the two Christian empires which was hardened and broadened by conceptions, or misconceptions, relating to the Crusading movement. The Byzantines resented the fact that the Crusading forces crossing their terrain behaved more like an army of occupation than the forces of an ally. The Latins took offence at the superior and patronizing attitudes of the Byzantines. Alliances made by Constantinople with the Muslims from the point of view of expediency were interpreted by the Latins as a form of treachery, despite the fact that they were prepared to make similar arrangements for themselves –

indeed, in 1175, Western forces had successfully urged the Seljuq Turks to invade Byzantium in order to lessen pressure on the Latin Crusader states. Hostilities between the two former allies became more and more virulent and, in 1182, the Latins of Constantinople were massacred by some of the indigenous inhabitants, who had themselves faced a recent traumatic experience. In 1202 the Venetians were able to divert the Fourth Crusade to the seizure of the rebel but Christian city of Zara in Dalmatia. Then, in 1203, they further diverted the Crusaders to Constantinople in a move which began as a political intervention and ended, in 1204, in the sack of the famous city, which was plundered by Christian forces with a ruthlessness that led one later historian to compare it with the sack of Rome by the Vandals. The Crusaders' next move was to partition the Byzantine empire among themselves and to set up a Latin patriarch in Constantinople. The devitalized empire somehow continued to survive for two and a half centuries until it finally fell to Islam in 1452.

Against this changing historical background, it is understandable that dealings between the Latin and Greek empires should oscillate between friendliness and suspicion, between caution and malevolence, and it is only curious that – except in local areas such as Venice – artistic relationships did not follow the graph of political ones. Indeed, they reached their zenith when political animosities were reaching theirs, namely during the course of the twelfth century. One reason for the closer artistic connections was of course the Crusading movement – not because it brought back Byzantine works of art to the West, but because it took vast numbers of Westerners through parts of the Byzantine Empire or through areas of Italy where the work of Byzantine artists could be seen. The West was thereby made more generally aware of Byzantine art and more anxious to emulate it. Byzantium had always of course had an artistic effect on the West, but it was during the great period of the Crusades that it exerted its strongest influence, and the result was not without its ironies. The Crusading kingdom of Jerusalem, effectively an extension of France politically, became artistically a near-colony of Byzantium. Even the Norman kings of Sicily, who were so strongly opposed to Byzantine power, were not above using Byzantine mosaicists to enhance their own prestige.

THE PRESTIGE OF BYZANTINE ART

Throughout our period, Byzantine art remained a touchstone in the West for the opulent and the exotic. It was the chief standard of comparison for splendour. William of Poitiers spoke for the Norman conquerors of England in the eleventh century when he declared that the art treasures they had acquired would draw admiration even from those who had visited Byzantium.[3] In the twelfth century Suger, the art-loving abbot of the great foundation of Saint-Denis, expressed his pride in his artistic possessions by comparing his church vessels with those of Hagia Sophia, of which, he writes, 'we had heard wonderful and almost incredible reports'.[4] It was the same in vernacular Romances. In her lay of *The Ash Tree*, Marie de France indicates the noble birth of the abandoned babe by describing it as wrapped in a striped silken cloth

brought back from Constantinople,[5] and the hero of Chrétien de Troyes' *Erec et Enide* wore a 'coat of noble diaper that had been made in Constantinople'.[6] This association of Byzantine art with opulence is unconsciously taken up in a later account in the *Heimskringla* of the early-twelfth-century visit of King Sigurd to Constantinople:[7] precious textiles were said to have been spread out before the royal visitor as he rode from the Golden Port to the imperial palace, where he was showered with rare gifts of costly silks and gold ornaments. All this, no doubt, reflected something of the diplomatic ploys of the period, which aimed to impress by displays of wealth, but from our point of view the important thing is to see how art itself was perceived as an expression of that wealth. Indeed, one emperor in the mid tenth century actually arranged an exhibition of what we today would call art treasures in his own Great Palace simply to impress a group of diplomats.[8]

Constantinople was always aware of the association between apparent power and gorgeous display, and it was no accident that others should turn to the arts of Byzantium for tangible symbols of their own authority. These took the form of goldsmiths' work, of fine silks, of purple-paged manuscripts and, not least, of mosaics. Even the Muslims who had overrun parts of the Byzantine empire saw Byzantine mosaics as a means of enhancing their prestige. These, of course, contained no figural representation, but in 726 an Umayyad prince had fine mosaics laid in the floors of his palace near Jericho, for which Constantinople supplied some of the artists and materials, and in the early tenth century the caliph El-Hakim successfully petitioned the Byzantine emperor for mosaics and a mosaic-worker to embellish the sanctuary of his mosque at Cordova.

It is therefore understandable that the first Holy Roman Emperor of the West, Charlemagne, should wish to adorn his capital with prestigious mosaics such as those that decorated his palace chapel at Aachen.[9] The figure of God enthroned in the dome, more than life-size and surrounded by the twenty-four elders of the Apocalypse, is now unfortunately known to us only from a print by Ciampini and a seventeenth-century sketch by Peiresc, but the apse mosaic commissioned by one of his entourage, Theodulf, at Germigny-des-Prés still survives[10] [36], and we shall come back to it in Chapter 4. Both Charlemagne and Theodulf were no doubt chiefly inspired by the rich Early Christian and Byzantine mosaics that remained in many regions of Italy.

ROMAN MOSAICS

Rome in fact possessed some of the greatest sequences of mosaics outside Byzantium, dating in the case of the churches of Santa Costanza, Santa Pudenziana, the Lateran Baptistery, and Santa Maria Maggiore from the fourth and fifth centuries. The art was revived in Rome at the very outset of our period, and the pope who crowned Charlemagne emperor – Leo III (795–816) – was himself responsible for adorning many Roman churches with mosaics. Unfortunately they have not survived, but on the instructions of Benedict XIV (1740–59) a faithful copy was made of what the pope's own inscription describes as 'the ancient mosaic of the western apse of the refectory of the Lateran Palace, a room built by Pope Leo III

for meetings of the Holy Synod and for the performance of other ceremonies'.[11] This copy now adorns the eighteenth-century Tribune of Benedict XIV in the piazza before the church of San Giovanni in Laterano. It shows Christ sending out the eleven apostles on their task of evangelization with, on the left of the arch before the main composition, Christ giving the keys – the symbol of spiritual power – to St Peter (or possibly Pope Sylvester) and the banner – the symbol of temporal power – to the emperor Constantine and, on the right, St Peter confirming these powers to Leo III and Charlemagne. The mosaics are of particular historical interest for, since the originals were made in 799, before Charlemagne's imperial coronation, they must have been presenting him as patrician rather than emperor. Moreover they were making something of a revolutionary visual statement in propounding, in effect, the theory of the 'two swords', which held the spiritual and secular authorities each to be supreme within its own sphere, while excluding the Byzantine emperor from this division of power. Both pope and king wear the square nimbus, which often indicates that the figures concerned were alive at the time, and an inscription in a cartouche tells us that St Peter was conferring life on Pope Leo and victory on Charlemagne. To judge from two authentic heads of the original apostles of the main composition which survive in the Vatican Library,[12] the quality of the work was high, and the implication of all this is that the revival of mosaics in Rome was actually pioneered by Leo. Leo and Charlemagne were represented with Christ, the Virgin, and saints in another mosaic in the apse of Santa Susanna, which today is known to us only by copies.[13]

Pascal I (817–24) continued the work of Leo III, making a conscious effort to renew in his mosaics the compositions as well as the magnificence of the great period of Early Christian art. The very inscriptions sometimes recall those of an earlier period. The one on his earliest surviving mosaic, in the apse of Santa Maria in Domnica, announces that its glory 'shines like that of Phoebus in the universe when he frees himself from the dark veils of obscure night', just as that in the sixth-century mosaics of SS. Cosma e Damiano had proclaimed 'The house of God shines with the brilliancy of the purest metals and the light of the faith glows there the more preciously.'

Christ, the God of power, surrounded with mystic symbols of immortality and of the future life, was a significant theme of Roman apse mosaics of the fifth and sixth centuries. The finest surviving example, of the early sixth century, is at SS. Cosma e Damiano [1]. Here, the standing figure of Christ dominates the apse. He holds a scroll in one hand and raises the other aloft. From either side approach the Roman apostles, St Peter and St Paul, to present to him St Cosmas and St Damian, who bear, as tributes, their martyrs' crowns. On the right, another martyr proffers his crown, and the patron, Felix IV (526–30), holds out a model of the building. Palm trees on either side indicate Paradise, or perhaps the victory of martyrdom, and the phoenix symbolizes immortality. Below, the Paschal Lamb is approached on either side by sheep representing the apostles, six emerging from Jerusalem, six from Bethlehem, to signify Jewish and Gentile converts. The message of celestial power and promise was originally completed by Apocalyptic symbolism on the arch –

the twenty-four elders proffering their crowns to the Lamb of God on the throne, the book with the seven seals, the seven candlesticks, and the Apocalyptic symbols of the evangelists.

Pascal's apse composition of Santa Prassede[14] [2] follows the earlier one almost exactly, though the donor is now Pascal I holding the model of Santa Prassede, and the saints being presented to Christ are St Praxedis, to whom the church is dedicated, and St Pudenziana. The grouping of figures, dominated by Christ in the centre against a background of clouds, is the same as at SS. Cosma e Damiano, and so is the mystic symbolism of the palm trees, the sheep, and the allegorical cities. Even the Apocalyptic symbolism on the apsidal arch closely adheres to the composition of the earlier mosaics, and so too does the Agnus Dei lying on the throne on the inner arch. The whole scheme is repeated once more in Pascal's apse mosaic of Santa Cecilia,[15] even originally to the Apocalyptic symbolism, and yet again in the apse mosaic of San Marco, commissioned by Pascal's successor, Gregory IV (827–44).

The past is drawn on, too, in the chapel of San Zeno, erected by Pascal as a tomb for his mother in the monastery for Greeks he founded in Santa Prassede.[16] Here, the mosaic bust of Christ in a medallion supported by four diagonally placed angels [3] repeats a sixth-century composition in the archiepiscopal palace at Ravenna. On the exterior wall, the sequence of medallions set in two semicircular compositions and containing busts of Christ, the Virgin and Child, apostles, and martyrs, closely parallels fifth-century mosaics at Santa Sabina, now known only from copies. The apse mosaic of Santa Maria in Domnica[17] belongs to the time of Pascal's reconstruction of the ancient basilica. The triumphal arch before the apse elaborates a theme of the lost latefifth-century mosaics of Sant'Agata dei Goti:[18] from either side, shimmering files of apostles approach the figure of Christ seated upon the arc of the heavens, while in the apse itself the Virgin and Child are surrounded by a choir of angels.

It cannot be pretended that in these mosaics of the first half of the ninth century we find a renewal of early styles as well as of early compositions, though the draperies are clearly Early Christian in inspiration and related in some ways to those of the sixth-century mosaics of the archiepiscopal palace of Ravenna. Oakeshott also detects in some of the Santa Maria in Domnica heads reminiscences of the *pointilliste* tradition of late Antiquity, which had been transmitted by Early Christian mosaics like those of the triumphal arch of Santa Maria Maggiore.[19] However, there is not in these ninth-century mosaics the spaciousness or breadth of those at SS. Cosma e Damiano, for example. Indeed, their chief glory, as Matthiae rightly says,[20] is their exaltation of pure colour. Some of them, such as those of Santa Cecilia and San Marco, have a certain frigidity, and others, like those of Santa Maria in Domnica, have a looser, more linear quality which conforms to tendencies already appearing in the mosaics of Italy before the time of Leo III. These had shown a steady linearization of Early Christian styles, and a deflation of the structure of the body in the interests of the abstract, the ethereal, and even the purely decorative – traits which were already beginning to emerge in the sixth-century mosaics of the Roman oratory of St Venantius; the trend was continued, and even consummated, in the ninth-century mosaics of

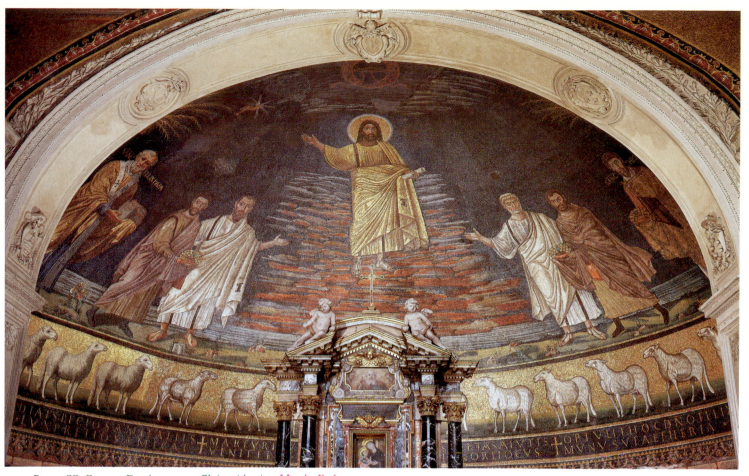

1. Rome, SS. Cosma e Damiano, apse, *Christ with saints*. Mosaic. Early
sixth century

2. Rome, Santa Prassede, apse, *Christ with saints*. Mosaic. 817/24

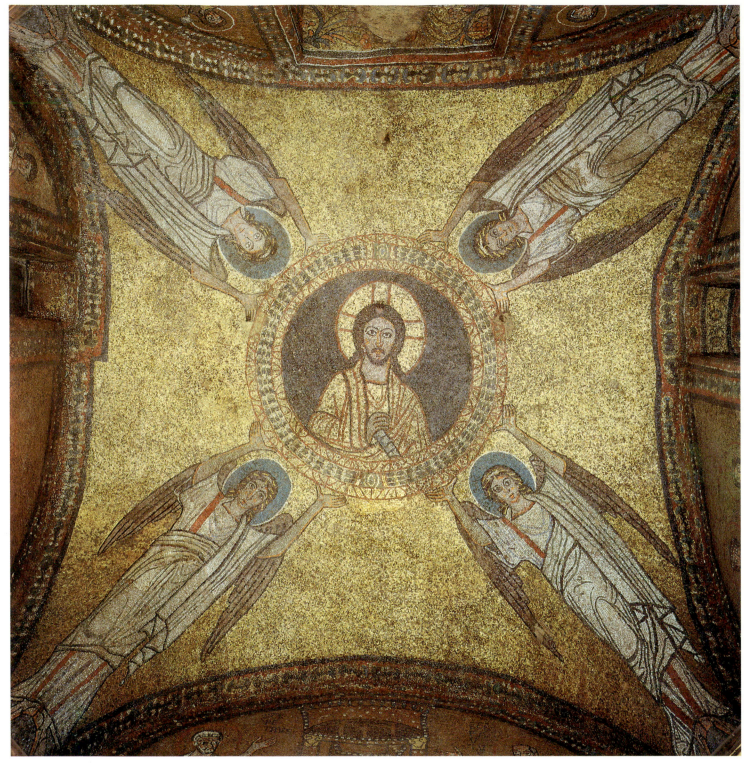

3. Rome, Santa Prassede, chapel of San Zeno, vault, *Christ with angels*. Mosaic. 817/24

Santa Prassede [2]. There, the physical bulk of the figures has been emptied away, and no attempt has been made to register the weight beneath the draperies. The scenes are sensitively drawn against their backgrounds of gold and deep colours; the mood is incorporeal, spiritual, tender, and almost elegiac.

The mosaics of the first half of the ninth century are not devoid of originality: the depiction of the New Jerusalem on the triumphal arch of Santa Prassede, for example, has elements that are genuinely fresh. Yet, when all reservations have been made, we can detect in them an absorption in the past which is as self-conscious in its way as Charlemagne's political restoration of empire.

After the ninth century, except during rare periods of political estrangement – as in Venice during the twelfth century – the mosaic art of Italy and Sicily was dominated by Byzantium. Indeed, the only general handbook of the arts to survive from our period takes it for granted that glass *tesserae* for mosaics will be made by Greeks.[21] However, its writer, Theophilus, was a German who could have had little personal experience of mosaics, for after the Carolingian period – from which at least Theodulf's mosaic survives

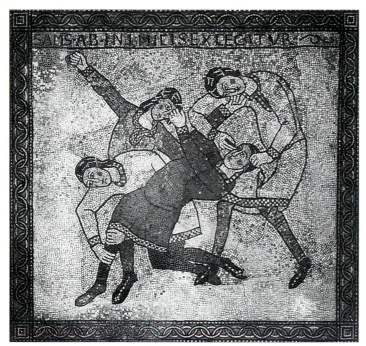

4. Cologne, St Gereon, *Samson being blinded by the Philistines*. Mosaic. Perhaps 1151/6

[36] – they hardly ever appeared north of the Alps. The rare references to them include the information that Gauzlin, abbot of Fleury-sur-Loire from 1005 to 1029, sent abroad for a mosaic-worker to embellish the vault of his newly built church, but died before the work could be done,[22] and that Abbot Wolfhelm, before his own death in 1091, adorned his church of Brauweiler with mosaics as well as paintings.[23] At Cologne – in the church of St Gereon – we have actual surviving mosaics of scenes from the lives of Samson and David,[24] from which we reproduce the blinding of Samson [4]. These Cologne mosaics probably belong to the years when Archbishop Arnold von Wied was building the choir (1151–6), and they may have been moved to their present place in the crypt during the seventeenth century when the choir was being reconstructed. It is significant that their style is influenced from Italy, for mosaics remained popular there throughout the centuries covered by this volume. In the north, as we have seen, it was different. When Abbot Suger commissioned a mosaic for Saint-Denis a few years before the Cologne ones were made, he significantly commented on the fact that their use was 'contrary to modern custom'.[25]

THE TRANSMISSION OF BYZANTINE ART TO THE WEST

Byzantine art was the most important single influence on Western painting between 800 and 1200. It was not, however, a static art, and its variations were reflected in the art of the West – a linear emphasis early on, an interest in the more painterly and the more dynamic at a later period, and a tranquil, almost classical phase at the end of the twelfth century. The paths by which these influences travelled were diverse. One was trodden by Byzantine artists at first driven to flee to the West by the furies of iconoclasm, but who later needed no such pressures. In the eleventh and twelfth

centuries whole teams of Greeks set up mosaics in Montecassino, Venice, Torcello, and Sicily; the activities of the Greek painters who went to Apulia and Calabria, and even to Ottonian Germany, will be noted in later chapters.

Another method of transmission was by means of sketches of Byzantine mosaics and paintings which were used as pictorial guides by the Byzantine artists; as Kitzinger points out,[26] there are references to such drawings in a life of St Pancras of Taormina. Others were made by Western artists abroad, and such a collection must have been one source for a particularly famous illustrated manuscript of our period – the *Hortus Deliciarum* produced in Alsace.[27] The use of such sketches, copied and recopied and disseminated over wide areas, will explain the relationship between the cycle of the life of the Virgin executed by local artists in St Mark's at Venice and that in the Mirozh cathedral of Pskov.[28] It will also account for the similarities between scenes of the Feeding of the Five Thousand in the Venetian mosaics and in wall paintings at Friesach and Pürgg in Austria.[29] Of course, such sketches were by their nature ephemeral, and almost all have

5. Alsace: *Christ and Zaccheus and* (below) *two mounted saints*. Sketches from a fragment of a model-book. Later twelfth century. Freiburg im Breisgau, Augustinermuseum

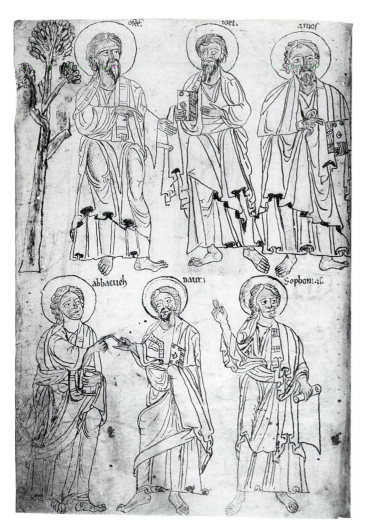

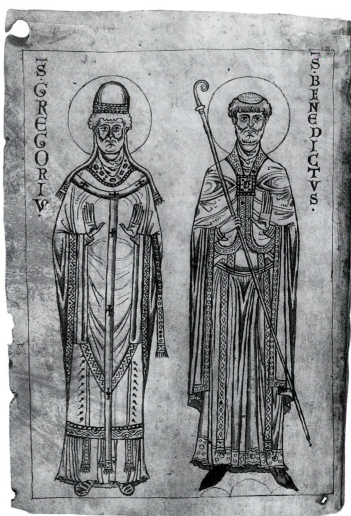

6. German: *Minor prophets*. Sketches from a pattern-sheet, MS. Vat. lat. 1976, folio 1 verso. End of the twelfth century. Rome, Vatican Library

7. Einsiedeln(?): *St Gregory and St Benedict*. Tinted drawings from a model-book, MS. 112, p. 2. First half of the twelfth century. Einsiedeln, Stiftsbibliothek

now disappeared. However, the remnants of one series – known from a list of contents to have originally comprised a sizeable number of scenes – is preserved in the Augustinermuseum of Freiburg im Breisgau.[30] It was made by a German in the later part of the twelfth century, and its Christ and Zaccheus [5] are particularly close to the same characters in the Greek mosaics of Monreale.[31] The Vatican Library has other such sketches of Byzantine figures, also made by a German artist towards the end of the twelfth century,[32] and from them we reproduce the drawings of six of the minor prophets [6]. Again, there is at Einsiedeln[33] what seems to be an artist's pattern-book with drawings in an Italo-Byzantine style, including fine tinted drawings of St Gregory and St Benedict [7]. Outside our period, the thirteenth-century notebook of the architect Villard de Honnecourt[34] contains a well-known example of a similar artistic aide-mémoire.

Actual Byzantine works of art also found their way to the West, some of them in the form of diplomatic gifts, as when the Byzantine emperor Michael sent to Pope Benedict III (855–8) 'by the hand of the monk Lazarus, who was highly skilled in the art of painting ... a Gospel Book [bound] in

purest gold and decorated with a variety of precious stones'.[35] Similarly, a German emperor of the eleventh century received a wonderful gold panel,[36] and another, of the twelfth, gifts from Constantinople including silks of many colours.[37] In the ninth century a bishop of Cambrai was presented with fine ivory book-covers,[38] and the biography of Archbishop Gebehard of Salzburg (1060–88) refers to a splendid vestment, adorned with gold and gems, given him by the emperor of Byzantium when he was serving as an imperial legate.[39] Ekkehard, in his chronicle, speaks of 'the many important gifts consisting of gold and silver vessels and silks' that the Greek ambassadors brought to St Gallen in 1083.[40] In 1097, Robert, duke of Normandy, received from the emperor Alexius Comnenus beautifully crafted vessels and precious garments,[41] and favoured dignitaries journeying to the Holy Land through Constantinople might also benefit from Byzantine largesse. In the twelfth century, a bishop of Prague received a rich vestment adorned with gold,[42] and Abbot Wibald, who visited Constantinople on two diplomatic missions, may have brought to Stavelot the two Byzantine reliquaries which are now part of a twelfth-century Stavelot triptych in the Pierpont Morgan Library.[43] The more

enterprising (and perhaps more impoverished) Italian ecclesiastics even solicited such presentations for their churches; in this way, one eleventh-century bishop of Anagni obtained gifts of church vessels from Constantinople.[44] A twelfth-century abbot who sought help from the 'New Rome' – as his chronicler tactfully described Constantinople – was yet more successful, receiving from the emperor, the empress, and the city prefect gifts for his newly built church in Calabria that included not only sacred vessels but also artistic portrayals (*imagines*: presumably pictures), costly vestments, and books.[45]

Other Byzantine works of art reached the West by purchase, as in the case of an eleventh-century monk named Aethelwine, who bought in Constantinople 'a very valuable and beautiful covering' for the tomb of St Dunstan at Canterbury.[46] Nor did one have to visit the East to make such purchases, for in the twelfth century the empress Matilda could give to the monastery of Bec 'many gifts, most precious alike for their material and workmanship' (note the allusion to Ovid that we shall refer to in Chapter 11) 'which she had obtained at great cost from Constantinople'.[47] Works of art might also actually be commissioned, as in the case of a manuscript ordered about 1077 in Constantinople for the church of St Gereon in Cologne.[48] Abbot Desiderius of Montecassino, too, sent one of his monks to Constantinople in the eleventh century with instructions and the necessary gold 'to have an antependium fashioned in gold with jewels and splendid enamel work' representing the miracles of St Benedict and stories from the Gospels.[49] The 'gold panel, marvellously fashioned in Constantinople and [embellished] with jewels and pearls' set above the altar of St Mark's by the doge of Venice in 1106[50] may also have been specially commissioned. More certainly, we know that magnates in southern Italy, particularly the powerful Pantaleoni family of Amalfi, obtained from Constantinople bronze doors with figurative or decorative work.[51] Thus, Pantaleon I ordered a pair of doors for the cathedral of Amalfi: his son Mauro paid for those of the abbey church of Montecassino: Pantaleon II gave another pair to the grotto church of St Michael at Monte Gargano in 1076: and, in 1087, Pantaleon III presented yet another to the church of San Salvatore at Atrani. In 1070, through the same family, the famous Cardinal Hildebrand (later Pope Gregory VII) ordered lavishly illustrated doors for the portal of San Paolo fuori le Mura at Rome, and at about the same time Salerno Cathedral also received bronze doors from Byzantium.

The Byzantine works that reached the West in the greatest profusion were, however, silks. They were sought by the wealthy of every land, and they must have played an active part in disseminating Byzantine forms of decoration and even Byzantine iconography, for some of them presented scriptural figures and scenes. These pictured silks are copiously documented in the accounts of papal gifts to Roman churches,[52] and their influence must have been appreciable, though it is usually overlooked by art historians. Here, I shall content myself with drawing attention to the gifts dispensed by only two popes – Leo III (795–816) and his almost immediate successor, Pascal I (817–24). Our source, the *Liber Pontificalis*,[53] does not tell us where their textiles came from, but its occasional transliteration of Greek words into a Latin

form, and its references to Byzantine purple (*de blatin byzantea*), and to a technique known by the Greek-derived name of *chrysoclavus* (it consisted of defining the figure, or scene, by means of gold studs), all suggest that the textiles derived from an area under significant Greek influence – perhaps Rome itself, which offered asylum to Greeks fleeing from the iconoclasm of Byzantium.

Of the large number of textiles given by Leo to Roman churches, six had representations of the Annunciation, more than twenty of the Resurrection, and ten of the Ascension. They also had scenes of the Nativity, the Massacre of the Innocents, the Presentation in the Temple, Christ calling the disciples, Christ's Entry into Jerusalem, Christ giving Peter the power to bind and loose, the Passion, Pentecost, Christ with St Peter and St Paul preaching, the martyrdoms of St Peter and St Paul, the death of the Virgin, and the martyrdom of St Anastasius. Yet others had representations of SS. Joachim and Anne, of Christ, the Virgin, and the apostles, of the Litany, and of various unspecified scenes. Besides all this, Leo gave to Sant'Apollinare in Ravenna a hanging showing episodes of the Annunciation, the Nativity, the Passion, the Resurrection, and Pentecost, and to San Pietro at Albano a tapestry picturing Christ reaching out to St Peter as he attempted to walk on the water. The scenes on the textiles presented by Pascal were of the Annunciation, the Nativity, the history of Christ (in a series of twenty-six that also included depictions of the Nativity of the Virgin and her Assumption), the Baptism of Christ, Palm Sunday, the parable of the wise and foolish virgins, the Resurrection, the Ascension, Christ resplendent in heaven with archangels and apostles, the Descent of the Holy Spirit, the miracles of the apostles (in forty-six textiles), the Virgin with SS. Peter and Paul, St Peter being freed from his chains by an angel, Christ and the martyrs SS. Cosmas, Damian, Anthimus, Leontius, and Euprepus, St Peter and the martyrs Processus and Martinianus, and an angel crowning SS. Cecilia, Valerianus, and Tiburtius.

Such pictured textiles – and those listed above, let me repeat, were the donations of two popes alone – must have been well known to the pilgrims who thronged to Rome from all over western Christendom, for one of their objectives was to visit the churches where these hangings were displayed. The same pilgrims could even purchase, both in Rome and in Pavia – the chief staging-post for pilgrims returning northwards – Byzantine silks to take back with them to their own churches at home. Indeed, an account of such a transaction – or would-be transaction – provides an endearing anecdote.[54] One pilgrim, Gerald of Aurillac (c. 855–909), broke his journey at Pavia, and was approached by Venetian merchants anxious to sell him their Byzantine silks. He explained that he had already bought silks in Rome, at a price clearly less than the Venetians were asking. Perturbed, presumably, at being undercut, they accused him of having underpaid the Romans – whereupon the innocent Gerald sent off to Rome a sum in compensation for the alleged shortfall. However, one did not have to visit Pavia, or Rome, or Constantinople itself to buy Byzantine silks, for traders imported them regularly to the West – a fact that is taken for granted in an English schoolbook of the tenth century.[55]

Whatever their route, enormous quantities of silks found

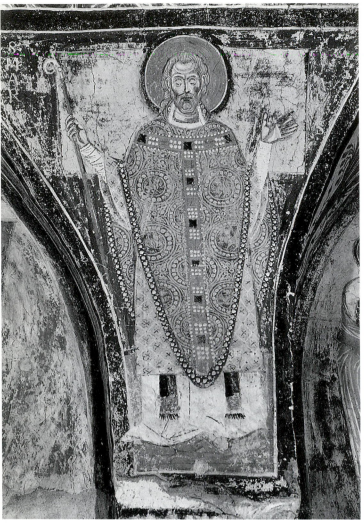

8. Aquileia Cathedral, crypt, *St Martial*. Wall painting. *c.* 1200

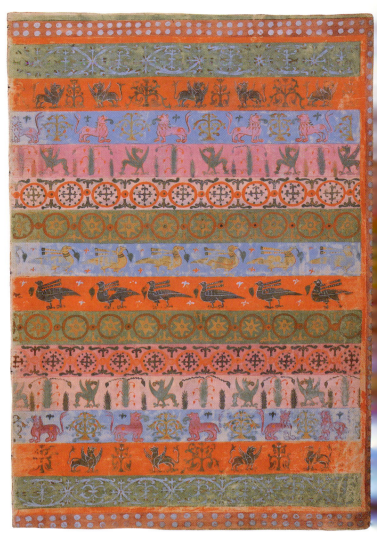

9. Echternach: Decorative page from the *Nuremberg Golden Gospels (Codex Aureus)*, folio 51 verso. *c.* 1025–40. Nuremberg, Germanisches National-Museum

their way into Europe between 800 and 1200, most of them from Byzantium, for Constantinople had the monopoly of manufacture within the Christian world during the greater part of our period.

Our written sources are primarily ecclesiastical, so that, in the West, it is primarily of silks that were put to church use that we hear. Some were made into vestments – perhaps resembling the chasuble worn by St Martial in a wall painting of *c.* 1200 in the cathedral of Aquileia [8]; others were used as altar dressings, wall hangings, or tomb covers. We can see their effects on Western art in the paintings of heraldically arranged beasts and birds in an Echternach manuscript [9] and in textiles such as the Bayeux Tapestry. There is some evidence that they also influenced the figures of a stole and maniple made in Winchester between 909 and 916 [24].[56]

These Winchester embroideries – like most of the surviving Byzantine silks in the West – remain to us because they were shut away from the air in a tomb. Most silks, however, were exposed to the atmosphere and have consequently perished: indeed, we can see today how regimental banners of silk, set up in churches less than a century ago, have already disintegrated into a gauze-like consistency. Thus, even before Byzantium itself crumbled in 1452, many of these Byzantine silks in the West must already have been reduced to dust. Nevertheless, they had served the important function of bringing to innumerable areas of 'Europe' some vision of the splendour of the Christian empire of the East – an empire whose art was to inspire Western artists for most of our period.

Embroidery: 800–1200

SECULAR HANGINGS

As well as importing Byzantine silks, the West embroidered its own textiles, and one of the oldest of medieval love songs describes the walls of the love-nest as decorated with hangings (*velis ornata*):

Come, sweetheart, come,
Dear as my heart to me,
Come to the room
I have made fine for thee.

Here there be couches spread,
Tapestry tented,
Flowers for thee to tread,
Green herbs sweet scented.[1]

Such textile enrichments of important houses have now almost all disappeared, but they are referred to in other secular poems. In a beast epic of about 940, written near Toul, it is in a tapestried[2] area that the lion is assumed to give a banquet for the other animals.[3] In Thomas's version of *Tristan*, the hero is taken to 'a beautiful chamber adorned with precious hangings' to recover from his wound,[4] and in the *chanson* of Girart de Roussillon[5] a room was so extensively tapestried that 'you could see neither wall nor wood nor lath behind'. In more factual historical accounts, Angilbert tells us that the hall of Charlemagne's palace shone 'brightly with pictured [or coloured] hangings' (*pictis ... vestibus*),[6] and Alexander says that the walls of the palace of Roger I of Sicily (d. 1154) were covered with gloriously shining tapestries.[7] In a less elevated context, an account of an eleventh-century miracle describes the home of 'a rich and honest man' as bright with pictured (or coloured) hangings,[8] and the contemporary biography of a holy woman of the twelfth century reports that the guest chamber of a family, comfortably placed but not aristocratic, 'was hung with beautiful tapestries'.[9] Secular hangings are itemized, too, in the wills of our period, and there are even schematized representations of them in manuscripts.[10]

Tapestries could be very large. In an aristocrat's home of the eleventh century they were extensive enough to conceal a whole group of soldiers,[11] and a comfortably placed woman of the twelfth century was enabled to escape the attentions of a would-be seducer by springing from her bed in order to cling 'with both hands to a nail which was fixed in the wall, and there hang trembling between the wall and the hangings'.[12] Some hangings were made of linen or of colourfully dyed wools, and some were enriched with embroidery. In the twelfth century, for example, we read of a certain lady, called Agnes, commissioning for the monastery of Liessies a (non-domestic) linen hanging embroidered with a representation of the death of the founder, Theodoric, count of Avesnes.[13] For secular embroidered hangings we must turn chiefly to England. There, a tradition of epics rendered in embroidery seems to have run parallel to a similar tradition in poetry. Already in *Beowulf*, the most famous of Anglo-Saxon epics, there is a description of a royal hall where 'tapestries decorated with gold shone along the walls, many wonderful sights for everyone who gazes at such things' (lines 994–6), and the *Liber Eliensis* tells us that, in the tenth century, the epic deeds of the East Anglian warrior Byrhtnoth – conspicuous in the thick of battle by his height and his swan-white hair – were the subject of an embroidery which found its way to the monastery of Ely.[14] Even at sea, the *Vita Aedwardi Regis* informs us, the sails of an Anglo-Saxon royal ship could be embroidered in gold with suitable pictures of English naval victories.[15] There must have been a number of epic hangings in England at the time of the Norman Conquest, and, in my view, it was the sight of these that inspired the Normans to make at least one of their own.

The one reservation to be made in this connection is that the Viking forbears of the Normans had a tradition of narrative tapestries, though not, as far as we know, of epic ones. Among the wealth of objects discovered when the ninth-century Oseberg ship burial came to light in 1904 were fragments of a long, narrow tapestry whose subject was perhaps from one of the Sagas.[16] We know from written sources too that it was the custom of the Vikings to adorn their ships, dwellings, and churches with hangings. A colourful fragment of a later Norwegian tapestry of the twelfth century, formerly in the church of Baldishol and now in the Kunstindustrimuseet in Oslo,[17] illustrates the months of April and May; assuming that originally all twelve months were portrayed, the complete work would have been about 12 metres long.

To return to the Bayeux Tapestry, it is ironic that it dealt with the defeat of the Anglo-Saxons and that it is the only surviving example of its genre. It is the most significant embroidery to come down to us from the centuries covered by this book, and for this reason we shall examine it in some detail.

THE BAYEUX TAPESTRY

A narrow 'frieze' of vast length (70 metres long and 50 centimetres high), the Bayeux Tapestry[18] was made in eight sections which were later joined together. Its technique was laid and couched work with some stem and outline stitching on linen, and the wools were of eight colours – terracotta red, buff, yellow, two shades of blue, and three of green.

The Tapestry was produced at a time when the reputation of Anglo-Saxon needlewomen was unrivalled in the West and when – as we shall see later – the Normans are known to have been using their services elsewhere. That the makers of the Tapestry were English is borne out by particular as well as by general considerations. The pictures exhibit a very English feeling for the contemporary scene, and also a talent for integrating a number of episodes which the Anglo-Saxons had learned from the Utrecht Psalter and exercised in

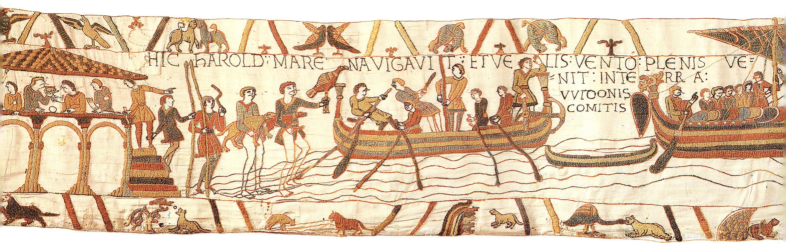

10. Canterbury: *Earl Harold crosses the Channel and is arrested by Count Guy of Ponthieu.* Bayeux Tapestry. 1066/82

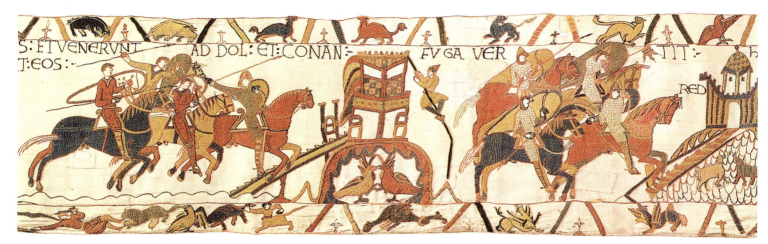

11. Canterbury: *Earl Harold assists Duke William in his campaign against Count Conan of Brittany.* Bayeux Tapestry. 1066/82

manuscripts such as the Bury Psalter.[19] The facts that some of the architectural features relate to those found in a pre-Conquest Canterbury manuscript,[20] and that two of the figures have actually been borrowed from another manuscript from Canterbury,[21] support the rest of the stylistic evidence in pointing to a designer from this primatial city.

The intention of the Tapestry, on its simplest level, was to place on record the Norman version of the Conquest of England and the events that allegedly led up to it. Apart from certain personal exaggerations and additions and some very occasional Anglo-Saxon ingredients, its narrative account is very much in line with the story of the Conquest provided by the Norman chroniclers, William of Poitiers and William of Jumièges.[22] The scenes rolling through its length therefore begin with a portrayal of Harold being despatched across the Channel by Edward the Confessor on what is clearly a diplomatic enterprise, and this accords with the claim of Duke William's biographer, William of Poitiers, that Edward had offered William the English throne. After crossing the Channel [10], Harold's party is seized by Count Guy of Ponthieu on the coast of France, and then taken to the duke. Next come the co-operation of Harold and William in the

Norman campaign against Brittany [11], the alleged oath made by Harold to William, and the return of Harold to England. After this we are shown the death of Edward, the coronation of Harold, the preparation of a fleet by the Normans, their subsequent invasion of England, and the so-called Battle of Hastings [12], leading up to the Norman victory and the flight of the English. The original conclusion is missing; possibly it showed William's coronation at Westminster. The upper and lower borders of this extensive sequence are peopled with animals, birds, and human beings, most of them decorative, though, as we shall see, a few do participate in, or comment on, the main stream of events.

If at one level the Tapestry is a simple narrative with a Norman bias, it also has a more subtle aspect, for it interprets the Conquest in accordance with the traditions of a specific literary genre – the French *chanson de geste*.[23] The *chansons*, like other literary forms, had their own conventions. Their main theme was warfare, and the Spanish authority, Menéndez Pidal, likened them to American Westerns in the sense that both genres focus so much attention on the thrills and excitements of combat. Certainly, a *chanson* without a battle is as inconceivable as an Italian opera without an aria,

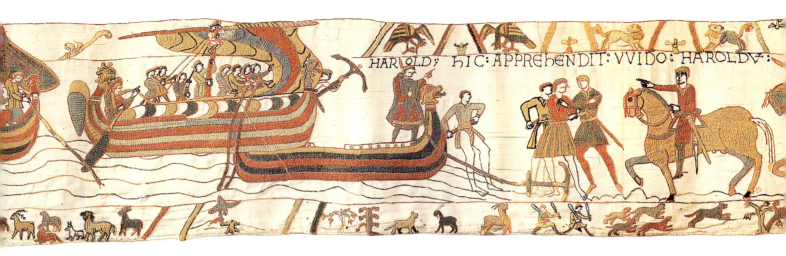

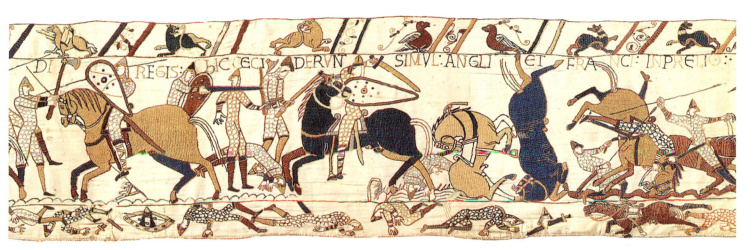

12. Canterbury: *Scenes from the Battle of Hastings*. Bayeux Tapestry.
1066/82

and in this context, the very considerable space that the Tapestry devotes to warfare – not only to the Battle of Hastings [12] but also to the earlier campaign in Brittany [11] – should not be lost on us. The plots of the *chansons* almost invariably hinge on treachery, and treachery is the very nub of the account offered by the Bayeux Tapestry, which presents Harold as an oath-breaking villain. He is not, however, the simple black-and-white villain of the contemporary Norman chronicler William of Poitiers, for whom Harold is the infamous son of an odious and dishonest father – cruel, perfidious, avaricious, consumed by pride, a felon, and even a murderer. Rather, like the more complex villains of the French epics, he is allowed some virtues. Like Ganelon, the classic villain of the *chansons*, Harold is presented as a Christian, and is, indeed, the only character to go into a church to pray. He is furthermore credited with great courage and strength, rescuing men of William's own army from the perilous quicksands of the river Couesnon during the Brittany campaign, and fighting valiantly at Hastings. But, like the villains of the *chansons*, he is marred by the fatal flaw of treachery: he is presented as a traitor to his king (if we allow that his mission at the beginning of the

Tapestry was to offer William the crown), as a traitor to his feudal seigneur (for he is represented as William's vassal after the campaign in Brittany), and as a traitor to the saints above (for it is on their relics that Harold is supposed to have made an oath).

Fable scenes in the lower border underline the theme of treachery, and although such commentaries occur also at later points,[24] it is significant that their largest cluster forebodingly accompanies Harold as he crosses the Channel on his way to Duke William [10]. Here we see depicted the fox who tricks the crow into letting go its piece of cheese: the bitch who, having given birth to her litter, evicts from her own home the bitch who had offered her shelter: the wolf who betrays his oath to the crane: another wolf who, having promised not to harm his subjects, breaks his word and devours them all: the frog who repays a mouse's hospitality by trying to drown her under the pretext of guiding her: the wolf who attempts to deceive a young kid while its mother is absent: and yet another wolf who is betrayed into the hands of shepherds by his supposed friend, the fox. These fables emphasizing perfidy closely link the Tapestry with the *chansons*, and amount to a pictorial 'editorial aside', commenting upon the

main action, that parallels the verbal asides of the *chansons*. Moreover the Tapestry, like the *chansons*, heightens the dramatic action by anticipating future events, not only on the theme of treachery, but also by illustrating in the borders such phenomena as the comet which appears immediately after Harold's coronation to presage his downfall, and, at the same point in the narrative, ghostly ships to foreshadow the Nemesis that will be visited on Harold through the Norman invasion fleet.

England, of course, had a much longer tradition of epic poems than France, but it was the *chansons* that inspired the patron of the Bayeux Tapestry, whose native language was French. The argument that the Tapestry is related to Anglo-Saxon poems such as the *Battle of Maldon*[25] seems quite untenable, even if we accept the odd assumption that the Norman who commissioned it could read – let alone take a literary interest in – Old English. The main theme of the *Battle of Maldon* is, after all, not treachery – which enters the poem only at a very subsidiary level in terms of the retainer who does not remain with his lord on the field of battle – but imprudence: an imprudence made glorious by deeds of courage: an imprudence which leads to defeat and death but yet has its own element of triumph. The Anglo-Saxon poem tells of how Byrhtnoth brings about his own downfall by granting the enemy Vikings safe conduct from their existing weak position to a stronger one. While his injudiciousness is not glossed over, the burden of the poem is the human dignity and heroic prowess of Byrhtnoth and his small army, who transcend their self-inflicted disaster and are invested with a higher form of victory:

> Courage shall grow keener, clearer the will,
> the heart fiercer, as our force faileth.[26]

The theme of the Bayeux Tapestry is treachery which brings its own punishment. The theme of the *Battle of Maldon* is imprudence redeemed by heroism. And this is not the only basic difference between the two works.[27] It is to French and not to Anglo-Saxon epics that we must look for the inspiration behind the Bayeux Tapestry, and it is hardly a coincidence that its patron, Odo, half-brother of William the Conqueror and bishop of Bayeux, is also thought to be the patron of an early version of the greatest of the *chansons de geste*, the *Song of Roland*.

Odo's influence can be seen in some points of emphasis, and even of distortion, in the Tapestry's 'story-line'. For instance the scene of the alleged oath is transferred from the Rouen, or Bonneville, of the Norman chroniclers to Bayeux, and Odo's part in the Conquest is exaggerated far beyond anything recorded by contemporary writers. Where William of Poitiers observes that, when news of Harold's coronation reached him, William deliberated with all the great men of state and church, the Tapestry shows Odo alone being consulted: the impressive role assigned to him in the Battle of Hastings is suggested by no other source: and the very few characters identified by name include three of Odo's tenants who held the bulk of their lands from him in Kent – Turold, Wadard, and Vital[28] (later known as Vital 'de Canterbires').[29]

Odo was, of course, made earl of Kent after the successful invasion of England, and this will explain the Tapestry's close links with Canterbury. All the evidence suggests that it was actually made there, despite one attempt to move its provenance to Winchester.[30] We might only add, in this Canterbury context, that Goscelin of Flanders was in that city when he wrote his eulogy of English needlewomen that will be quoted later.

As far as date is concerned, the Tapestry was obviously made after 1066 and before Odo's death in 1097. From 1082 to 1087, however, Odo was the prisoner of William the Conqueror, and though one could possibly argue that he commissioned the Tapestry as a *pièce justificative* on his release, we know that he spent many of his later years away from England. In our present state of knowledge, then, we must suppose that the Tapestry was made some time between 1066 and 1082.

It used to be said that the Tapestry was made for Bayeux Cathedral, but though Odo presumably bequeathed or gave it to the cathedral, there is no reason to suppose that that was its original destination. Indeed, as a permanent adornment for any large cathedral, particularly a Romanesque one of Odo's day, this enormously lengthy, thin strip of embroidery would have looked rather curious. Nor is its subject matter appropriate for a religious setting. Although the alleged oath on relics is shown, the event is given far more weight by contemporary Norman chroniclers such as William of Poitiers, who further invests the whole military adventure with a kind of Crusading aura, relating how William secured a consecrated papal banner, paraded the relics of St Valéry in procession in order to secure favourable winds, and took to the battlefield the relics on which Harold was supposed to have perjured himself. His account is pervaded with a sanctimonious religiosity which finds no trace in the Tapestry, where no one, other than Harold himself, is even seen entering a church – there are no prayers before the battle, no solicitations to the saints, and no banner being received from the pope. The Tapestry has, in fact, no religious drift and was, I believe, originally made for an extensive secular hall. This view receives some support from an account in a contemporary poem written by Baudri de Bourgueil for the daughter of William the Conqueror of a tapestry in her bed/reception-chamber that, like Odo's, commemorated the Norman Conquest of England.[31] In other words, the author envisaged that a tapestry with this kind of subject matter would be found in a private palace. We have already cited examples of tapestries hung in secular mansions, and I would suggest that, as Byrhtnoth's epic tapestry found its way from his home to Ely Cathedral in the tenth century, so in the eleventh century did Odo's tapestry travel from one of his palaces (which he had in England, Normandy, and Rome) to Bayeux Cathedral.

At least one other medieval tapestry featuring the Norman Conquest of England is known: it is catalogued in an inventory of tapestries belonging to King Charles VI of France as 'Ung grant tappiz de haulte lice, nommé le *Duc Guillaume, qui conquist l'Angleterre*'.[32] This however no longer exists, nor could it ever have had the interest of the Bayeux Tapestry, which is unique in supplying a detailed (if strongly biased) account of a near-contemporary event. It is also unique in being the only survivor of the Anglo-Saxon genre of epic hangings. As such, it will always have a special place in the history of art.

13. Aquileia Cathedral, crypt. Wall painting simulating a textile. *c.* 1200

RELIGIOUS EMBROIDERIES

The scarcity of references to secular embroideries in the writings of our period is accounted for by the fact that, apart from romances, books were mostly written by clerics and monks, who were largely indifferent to the arts of the secular world. They had little to say even about the textiles of their own churches, though we do have a number of inventories which itemize the holdings of some of them.

One thing, however, is quite clear, and this is that embroidered hangings were sought by the more affluent churches. It is no accident therefore that, when the Norman monarch William II saw an English church in a vision, he described it as being dressed in all its quarters 'with figured hangings', as well as with 'precious Greek textiles and cloths of pure silk and of purple'.[33] And it is significant that one of the complaints made by the Cistercians against the Cluniacs in the twelfth century was that their churches were embellished with beautiful pictured tapestries.[34] Indeed, the interest in expensive hangings went so far that when churches could not afford them, they sometimes chose to simulate them in the cheaper form of wall paintings, and we find such imitation hangings in churches such as San Quirce de Pedret

in Spain and Santa Maria della Libera at Foro Claudio in Italy. They even appear in the crypt of Aquileia Cathedral, where it was presumably thought that actual hangings might appear over-luxurious. Illustration 13, of an equestrian bowman and a knight in conflict, demonstrates how convincingly some of these murals could imitate textiles.

In a sermon preached in the abbey church of Saint-Martial at Limoges in 1029 or 1030, Adémar de Chabannes referred to the textiles hung in newly consecrated churches.[35] They were in particular use on festive occasions; others, more sombre, would be brought out as veils during Lent. A wealthy church such as Cluny – concerning which we have information from a source believed by Mortet to have been written between 1039 and 1049[36] – expected its monks to adorn their church on Easter Saturday

with linen hangings, woollen draperies and curtains over the walls throughout. Mats should cover the stools, and seat-covers the choir-stalls... Outside, above the doors of the main façade, they [the monks] should position a hanging embroidered in raised work [*eglyphinatum*] with various representations.

Other rare descriptions of hangings were evoked by the losses

occasioned by the fires which raged with alarming frequency in the Middle Ages. Before such a disaster at Mainz in the later twelfth century there were

such great stores of precious silk hangings that, on feast days, the whole minster, long and wide though it is, was completely covered with them and there were still some to spare. There were tapestries and curtains adorned with a wonderful variety of representation, which delighted the hearts of those who looked at them and wondered at the delicacy and beauty of their workmanship. Apart from these, there were others, which were spread on the floor of the church and the stalls and in front of the altar. There were precious altar cloths woven with gold...[37]

A fire at Laon occasioned Guibert of Nogent's reference to the great size of some of the textiles.[38] The church was, apparently, 'decked out with hangings and tapestries' to celebrate a religious festival when the fire broke out, whereupon thieves slipped in to steal some of them. Others perished because of their magnitude, for they could only be manipulated by pulleys which needed several people to work them – more personnel apparently than the thieves could muster. In a different part of the West, the great size of a hanging and tapestry intended by Salome, wife of the Polish prince Boleslav III, for the monastery of Zwiefalten in the early part of the twelfth century prevented their delivery, for, as the chronicler explains, not even two horses could draw them, along with the other gifts which were included in the presentation.[39]

Some ecclesiastical textiles were embroidered with figures or scenes. At the church of St Januarius in southern Italy were great hangings illustrated with the Gospel story.[40] In the second quarter of the eleventh century Abbot Lambert gave to his abbey church of Moyenmoutier two showing Christ's miracles and scenes from the life of St Hydulphus;[41] another, presented by Bishop Humbaud (1087–1114) to his cathedral of Auxerre, had representations of kings and emperors.[42] A further two, given for use in the choir of the abbey church of Saint-Florent near Saumur between 1128 and 1155, had scenes of the Apocalypse; on others, hung in the nave during festivals, were representations of lions and archers.[43] One that Zwiefalten received from Bohemia had a portrayal of Christ in Majesty with Charlemagne.[44] At Liège, a local abbot was responsible for a programme of allegorization and harmonization of Old and New Testament scenes,[45] and at Worms, on hangings acquired in the second quarter of the twelfth century, St Peter declaring that his office was to loose bonds was accompanied by apostles, prophets, and the earliest bishops of the church whose merits, according to the inscriptions, enabled them 'to thrive after the manner of olive-trees as companions of Peter'.[46] Also in the twelfth century, the church of Marienberg had a Lenten hanging with Old Testament figures and scenes, with an inscription inviting prayers for the church's founders, Lord Udalric and Lady Uta,[47] whose deeds and responsibilities were illustrated on another Lenten hanging.[48] At Minden Cathedral, tapestries on each side of the choir – the gift of the mother of Bishop Anno (1171–85) – depicted the calling, miracles, and Passion of St Peter, and the Passion of St Gorgonius.[49] Also at Minden – according to Herman de

Lerbeke, the chronicler of the bishops of Minden – was 'a great hanging surpassing in size all the hangings I have seen'.[50] Presented in 1158, it illustrated one of the epistles of St Paul with 'many axioms and proverbs of masters and poets magisterially worked into it' admonishing the spectator to 'follow in the steps of the philosophers', to 'act rightly and shun vices', to 'employ words sparingly', to 'drink but little wine since it distorts the truth', and so on. One of its particular interests for us is the two lines of verse that identify the two persons who had made it:[51]

> Rederich and Cunegund
> fashioned me...;
> In the hope of the kingdom of heaven,
> they gave me to the Lord.

An inscription on a hanging at Augsburg was ambiguous in this respect. It read: 'Udalscalc [the abbot] and Gerard provided the cloth whilst Brother Beretha provided the work of the embroidery.'[52] Taken at face value,[53] the inscriptions at Minden, at least, indicate that men embroidered wall coverings as well as women. Another hanging at Augsburg showed its four donors, identified as Scuiger, Cunrat, Christina, and Gerunc, offering their gift to Abbot Udalscalc.[54]

We owe our information about the Augsburg hangings to a Renaissance writer, Wilhelm Wittwer (1449–1512), who composed an account of the abbots of the monastery of SS. Udalrich and Afra,[55] and his treatise indicates the kind of Romanesque hangings that might be held by a wealthy foundation of the period. It was fortunate that he wrote when he did, for one or two of the textiles he described were already fading and incomplete when he saw them.

Like the Minden tapestry, the Augsburg hangings were replete with inscriptions, some so lengthy that the textiles must have been huge to have had room for the pictures as well. Wittwer tells us that Udalscalc, abbot from 1126 to 1149, commissioned and himself designed some of the hangings, and supplied them with Leonine hexameters.[56] Two of them compared the Old Dispensation with the New by figures and personifications,[57] and a third, behind the Crucifix in the choir, hailed the triumph of the Cross.[58] His Lenten hangings included one embroidered with the Passions of the abbey's patron saints and scenes from the life of St Udalrich, together with the four donors already mentioned.[59] Another bore 'various figures and images', together with 'texts from the New and the Old Testaments' which Wittwer omitted because of their 'great length and because they are impossible to read, being indistinct by reason of their great age'. His transcriptions of the other lengthy inscriptions make it clear however that the subject matter was the transition from the Old Covenant to the New. The scenes continued over eight panels, the last of which carried the information about those who had supplied the cloth and the workmanship together with a request to the patron saints of the house to 'help these three with your pious prayers'. The final Lenten hanging, with eight panels devoted to the Crucifixion and Resurrection, together with illustrations and moralizing comments, was already incomplete in Wittwer's time.

In 1172, it was the turn of the sacristan, Henry – a later abbot – to commission hangings for the same monastery.

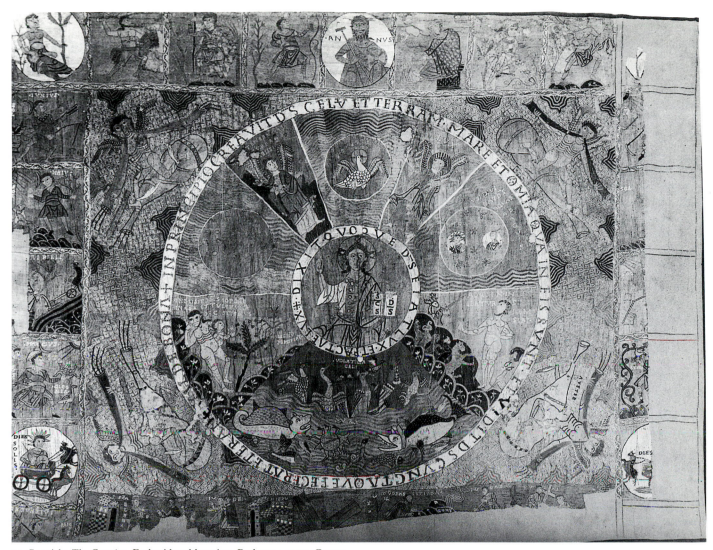

14. Spanish: *The Creation*. Embroidered hanging. Perhaps *c. 1100*. Gerona Cathedral

He also supplied the subjects and the inscriptions.[60] They included Christ with the seven gifts of the Holy Spirit in the Heavenly Jerusalem, parables, saints, personifications, and allegories.[61]

It is only because a writer of the Renaissance decided to give an account of these Romanesque hangings at Augsburg that we have such insights into the exhortatory nature and complex theological thought of some of the textiles in Germany. He has also enabled us to assess the richness of the holdings of one particular monastery. Others were presumably as richly endowed, but no single complete hanging of the hundreds, perhaps thousands, that were commissioned for the churches of the West between 800 and 1200 has come down to us: all we have is six incomplete ones, one in Spain, the other five in Germany.

In its original condition, the Spanish hanging,[62] which can be attributed to the period around 1100, probably measured about fifteen metres square. The lower part is missing, but the upper part – with its comparatively fresh greens and rusts and yellows and chestnut browns – is still in the cathedral of Gerona for which it was made [14]. It focuses on the events of the Creation. God is seated at the centre, the 'hub' of a wheel encircled by illustrated quotations from the Book of Genesis concerning his acts of creation. Between the two uppermost 'spokes' of the wheel, the Spirit of God, in the traditional form of a dove, moves upon the face of the waters. On either side, an angel of light and an angel of darkness represent the division of day from night. Between other 'spokes' are represented or symbolized the creation of the firmament and the division of the land from the sea (including the creation of the sun and moon), the creation of birds and fish, the creation of animals (incorporating their naming by Adam), and the creation of Adam and Eve. In the 'spandrels' between wheel and frame are personifications of the four winds. The frame itself is divided into square compartments, now incomplete. In the corner ones were personifications of the four rivers of Paradise, of which only the reclining semi-nude figure of Geon survives. The top centre compartment is dominated by a personification of the year, and on either side are the pursuits of the four seasons and figures of Hercules and Samson. The occupations of the months in the side borders are also now incomplete. The message of this part of the hanging would seem to be that God is the centre of the world and rules it and all its forces.

15. *The Sacrifice of Isaac*, from the Abraham tapestry. *c.* 1150. Halberstadt Cathedral, Museum

The fact that the lower part was devoted to the finding of the true Cross by Constantine's mother, St Helena, has led to the suggestion that the hanging was intended for display behind an altar dedicated to her. The lost part probably had scenes in three registers, of which only the subject matter of the top one can be reconstructed. At its centre can be seen the tip of a very large cross, and surviving inscriptions and details make it clear that on one side of the cross was St Helena consulting Judas and two other Jews concerning the whereabouts of the true Cross, and on the other Judas praying, digging for the Cross, and finally finding it.

Though lost in black and white reproduction, the hanging has a style whose delicacy is more akin to miniatures than to monumental paintings. Yet, though undoubtedly Spanish – de Palol points out that the inscriptions come from a Spanish version of the Bible, the *Vetus latina hispana*[63] – it is difficult to find convincing associations with Spanish miniatures. The embroideries are indeed reminiscent of Carolingian art in such classicizing elements as the personifications of the sun and moon, and the serpent representing the month of March, and there are French influences in the representations of the seasonal pursuits, and Byzantine ones – especially from Octateuchs – in one or two of the iconographic elements.[64]

Three of the six incomplete hangings we have mentioned are at Halberstadt in Saxony. When Betty Kurth described them in 1926,[65] they were still on display in the cathedral for which they had probably been made. They are now in its museum. Two more tapestries still, according to the records, in existence in the eighteenth century are now known only from painted copies. The three surviving tapestries belong to the twelfth century.

The oldest may be attributed to the mid century. In its present incomplete form, it looks rather like a frieze. Abraham first receives the three angels, then entertains them in accordance with the episode narrated in Genesis XVIII, 1 ff., and finally takes Isaac to his impending sacrifice, which is stayed by an admonition from above [15]. One of the inscriptions draws attention to the time-honoured association between the sacrifice of Isaac and that of Christ on the Cross. In a separate panel, to the right, St Michael and the dragon are represented in a bold style with strong, block-like figures of little subtlety, though the formalized trees that punctuate the scenes contribute a certain frozen elegance. Comparisons have been made between the figure style here and that of tomb carvings at Enger bei Herford and at Quedlinburg,[66] and, judging by a painted copy, the style of one of the lost hangings seems to have been similar. Its theme of an angel visiting Jacob as he dreamed of the ladder set on earth and reaching up to heaven (Genesis XXVIII, 12) suggests that it may have been part of, or at least 'twinned' with, the Abraham themes of entertainment and sacrifice on the surviving tapestry; we find such a linkage in another area of Romanesque art, the paintings of the Lambeth Bible.[67] The second lost tapestry was related to the Abraham embroidery in style and also in theme, for it showed Christ holding a banner to signify his victory over death, and Isaac of course was also a victim who cheated death.

The second surviving tapestry, though not very different

16. *Christ in Majesty*. Detail of a tapestry. *c.* 1150–70. Halberstadt Cathedral, Museum

in date – it belongs, perhaps, to the 50s or 60s – is much more polished in style. Its figures have been stylistically compared to those in two Missals from Hildesheim, and in manuscripts from Hardehausen and Riddagshausen.[68] They are of Christ, seated in Majesty in a circular frame held by the archangels Michael and Gabriel, with the twelve apostles on either side [16]. Christ's draperies are disposed in a Byzantine style now very much at home in Germany and similar, for example, to those he wears in the earlier so-called Lectionary of Archbishop Friedrich of Cologne[69] [276], which was made in the Cologne area. The apostles are ritualistic figures – remote, timeless, and essentially Romanesque – and hold stiff scrolls inscribed with their own identifications.

The third surviving tapestry is very different from the others. Charlemagne is represented with four philosophers [17], Cato and Seneca, and possibly (the identifications are lost) Socrates and Plato. This tapestry is not religious, but moralizing: Seneca holds a scroll bearing the famous Latin tag 'He gives twice who gives quickly', and the inscription surrounding Charlemagne declares that, though honour and power and beauty and youth may give pleasure, they do not last long. All this is reminiscent of the moralizing tapestries of Minden and Augsburg. Charlemagne was traditionally believed to have founded the cathedral of Halberstadt, so it is not difficult to understand why he should be commemorated there. What is startling is that the designer has made a conscious effort to place the emperor in his historical context by giving him a Carolingian setting as the central figure within a diamond frame – as Christ is framed in two related

manuscripts of the Carolingian period, the Vivian Bible [58] and the San Paolo Bible.[70] The four seated evangelists at the corners of the Carolingian model, or models, are now the four seated philosophers.

The Charlemagne is brighter in colour and more relaxed in style than the second of the Halberstadt tapestries, and also later. It belongs to the end of the twelfth century – a time when another German tapestry was being made in another part of Saxony – at Quedlinburg. In terms of colour and style, the relationship between the Charlemagne and Quedlinburg tapestries is such that Kurth believed they were made in the same Quedlinburg workshop.[71]

The nunnery of Quedlinburg was a house of considerable financial and political power which attracted the daughters of the Saxon nobility. Five pieces of its tapestry – thought to have measured in its entirety about eight by seven and a third metres – survive in the Schlosskirche there. One source says that Agnes, abbess between 1186 and 1203, commissioned the work as a gift for the pope.[72] Late though this information is, it is clearly correct, since it derives from an inscription on the tapestry itself, of which fragments survive. Lessing speculated that Agnes's intention may have been frustrated because she died before it could be carried out.[73]

The uppermost registers are in a different style from the rest.[74] The top one [19], especially, has a spaciousness and authority difficult to parallel elsewhere in Germany, though there are anticipations of it in the much earlier wall paintings of Prüfening. The other three registers are closer in style to the Charlemagne tapestry, and probably slightly earlier than

17. *Charlemagne tapestry.* Late twelfth century.
Halberstadt Cathedral, Museum

the upper ones. Around 1600, it was customary to bring the tapestry out on high feast days to decorate the floor of the choir. Because of this, and because, when discovered in 1835, the pieces were being used by the nuns as a carpet, it has been supposed that the tapestry was originally intended as a floor-covering. The distinguished scholar Lessing was quite convinced of it, claiming that, if the tapestry had been hung up high on a wall, its inscriptions could not have been read.[75] However, as we have seen, monumental hangings at Augsburg and elsewhere were replete with inscriptions. The report in an undated Quedlinburg source that Agnes made the tapestry herself 'with her nuns'[76] may represent a romantic post-medieval view, akin to the fabricated French legend that it was Queen Matilda who embroidered the Bayeux Tapestry.

The main theme of the tapestry is the Marriage of Philologia and Mercury – the title (*De Nuptiis Philologiae et Mercurii*) of a book in verse and prose by the fifth-century Carthaginian Martianus Capella. C.S. Lewis dubbed him 'the very type of the scholar',[77] though with no flattering intention, for he had in mind his own particular definition of the scholar as 'one who has a propensity to collect useless information'. Yet, rambling and digressive though Martianus's treatise is, it became a fundamental resource for the Middle Ages, for it was primarily a dissertation on the seven liberal arts, which – grouped into the *trivium* and *quadrivium* – were then considered the basis of all education. In the sixth century, Gregory of Tours relied on it for his knowledge of dialectic, rhetoric, astrology, and so on, and in the ninth, theologians like Martin of Laon, John Scotus Erigena, and Remigius of Auxerre annotated it carefully. In the eleventh century, its first two books were translated by Notker Labeo into Old High German, and in the twelfth it influenced scholars of

the calibre of Bernard Silvestris, Adelard of Bath, Thierry of Chartres, and John of Salisbury. It was also commented on by Alexander Neckam and William of Conches. The view of John Scotus Erigena, which was followed by Remigius of Auxerre and John of Salisbury, was that Philologia symbolized reason and Mercury eloquence, and that the person in whom these two qualities were united, as in a marriage alliance, could readily arrive at a knowledge and practice of the liberal arts.[78]

It is hardly remarkable, then, that the designer of the Quedlinburg tapestry should turn to the *De Nuptiis* for his, or her, subject matter though it is surprising to find so much attention focused on its romantic overture – the betrothal and marriage of Mercury and Philologia, intended by Martianus simply as an introduction to his main theme of the liberal arts. However, if we are to believe Ekkehard, the chronicler of St Gallen, the same subject – the nuptials of Philologia – had been chosen as the theme of an embroidery in gold for an alb given to his monastery by Duchess Hedwig of Swabia some time between 958 and 971.[79]

In Martianus's narrative, Mercury desires to take a bride, but is unable to find one among the immortals – Wisdom (Sophia) wishes to remain a virgin like her foster-sister Pallas; Divination (Mantice) is already betrothed to Mercury's brother Apollo; and Psyche has been captured by Cupid. So Mercury is advised to wed a mortal bride, Philologia, and he puts the plan to his father, Jupiter, who calls a conference of the gods and goddesses. There it is agreed that Philologia shall be raised to immortal status, and indeed that immortality shall be the reward of all humans who lead lives of heavenly aspiration. Philologia is then summoned through the celestial spheres to Jupiter's abode, where the marriage is celebrated in the presence of all the gods and goddesses. On Mercury's behalf, Apollo presents her with a wedding gift of seven women of Mercury's household who are none other than the personifications of the seven liberal arts – appropriate handmaidens for Philologia, whose name means Learning. Martianus goes on to dedicate a book to each of them.

The surviving part of the second register of the hanging illustrates Mercury's pursuit of a bride and his betrothal. On the far left is the seated, now incomplete, figure of Martianus himself addressing the youthful figure of Mercury, who looks towards Mantice, Psyche, and Sophia. In the centre is Hymen, the god of marriage, and to the right, Mercury and Philologia join hands as they plight their troth. Of the third register below only a small part survives. On it are an enthroned youth – no doubt Mercury himself – and Philologia's mother bringing her daughter clothing and adornments in accordance with the text [18]. Yet further to the right is a scribe identified by inscription as the *Iovis scriba* and *Genius* of the poem, ready with pen and ink to write out the marriage contract. The fourth register is completely lost. On the surviving part of the fifth register is Venus, her symbol – the wheel – held by a genuflecting youth. Other remaining figures, or part-figures, make allusion to, or actually represent, forces of nature: the seasons, the winds, and the elements.

The topmost register offers subject matter quite distinct from anything that follows. The theme is the Concord of Church and State [19], personified by an enthroned bishop and monarch looking towards Piety and Justice – the virtues they should respectively embody – who embrace between them. To the left of the king are Fortitude and Prudence, and to the right of the bishop is Temperance, probably once accompanied by another virtue. The representation of so Christian a theme in so overtly pagan a context is probably accounted for by the medieval anxiety to find a Christian meaning in universal history. Classical figures and gods were often interpreted as symbols or prefigurations of the Christian story: one example particularly pertinent to our theme is the association perceived by Alexander Neckam in the twelfth century between Martianus's Mercury and Christ on the one hand, and his Philologia and the Church on the other.[80] The explanation of the tapestry must be (as Lessing and Kurth remarked many years ago) that there was an edition of Martianus's *Marriage* which allegorized it in Christian terms – a view as yet unsupported by a known copy (there are many manuscripts of Capella's treatise still awaiting publication), but lent colour by one or two details of the surviving parts of the tapestry, for example the significant emphasis on the Christian virtue of chastity; the inscription on the scroll held by the personification of Chaste Love in the third register – 'Let her be immortal' – implying that chastity may provide a passport to heaven; and the sword held up by Mercury between himself and Philologia in the betrothal scene – a motif frequent in medieval literature,[81] and signifying a couple committed to sexual abstinence. Capella credits Philologia with having brought down sacred writings from the celestial sphere, and with having an understanding of all things in heaven, to which she is able to raise men and their prayers: the Middle Ages would therefore have had little difficulty in seeing an analogy between her and the Church. In similar fashion the French Saint-Vaast Bible of the eleventh century (see Chapter 9[82]) portrays the liberal arts as the seven daughters of divine wisdom through whom – as elucidated by the Church – salvation could be achieved.

Martianus begins with an invocation to Hymen, the god of marriage, who brings harmony and concord to the world and to nature, and, despite the loss of so many essential details, we may suppose that the guiding theme of the tapestry was love in its chaste and spiritual sense – the love that bound the religious to Christ, that, on the analogy of Philologia and Mercury, could unite Church and State, and that, in a cosmic sense, balanced and reconciled the contending elements and the different seasons, unifying all things into a harmonious whole. While all this may indeed reflect a lost allegorized text of Martianus, in my view it also owes much to the thought of another late Antique writer, a Christian of Rome whose treatise on *The Consolation of Philosophy* was a popular text throughout the whole of the Middle Ages. He was Boethius, who also sees pure love not only as the binding force of marriage but also as a cosmic force which welds together the world itself and the universe:

> Love ruling heaven, and earth, and seas,
> them in this course doth bind.
> And if it once let loose their reins,
> their friendship turns to war,
> Tearing the world whose ordered form
> their quiet motions bear.
> By it all holy laws are made and

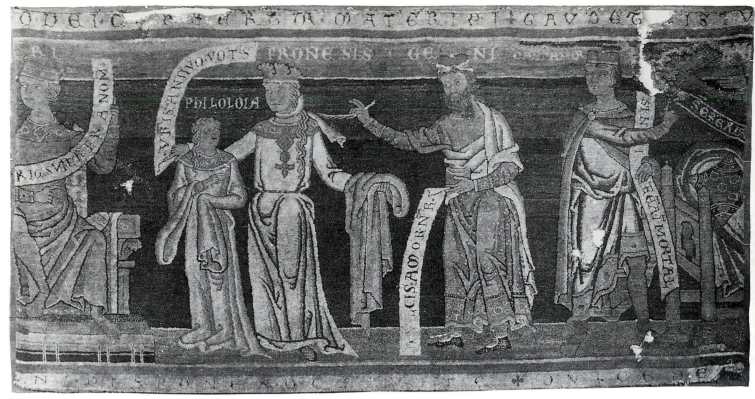

18. Quedlinburg: *Mercury(?) with Philologia's mother bringing clothing and adornment to her daughter.* Tapestry. Late twelfth century. Quedlinburg, Schlosskirche

> marriage rites are tied,
> By it is faithful friendship joined.
> How happy mortals were,
> If that pure love did guide their minds,
> which heavenly spheres doth guide![83]

It perhaps needed some ingenuity to read a vision of harmony between Church and State into Capella's text, but it would have required almost as much to conceive of such harmony in Agnes of Quedlinburg's day, for it was a time when relationships between Church and State were particularly sour. It is indeed difficult to find a date in the late twelfth century when a portrayal of amity between Church and State could have seemed even remotely plausible, and only two possibilities present themselves. The first was in 1196, when Henry VI took up the Cross. The second – which would have had special relevance to Saxony, where the tapestry was made – occurred during the brief period of rapprochement after Henry's death in 1198, when Otto IV, son of Henry the Lion, the famous duke of Saxony, obtained the support of Pope Innocent III in his bid for the imperial crown. In the event, Otto failed to attain his goal until 1208, but in Saxony in 1198 it might well have appeared that a new emperor from Saxony could herald a period of unaccustomed harmony between Church and State. Indeed, even after Agnes's death in 1203, Innocent continued to support Otto, despite the election of his rival, Philip of Swabia, in 1198. This tapestry, then, might well have been commissioned during the final five years of Agnes's life when, moreover, such features of female attire as the mantle fastened with cord and tassel and, more importantly, the hanging sleeves (see those of Philologia in the third register [18]) were still in fashion: they disappeared rapidly in the early years of the thirteenth century.[84]

The Quedlinburg tapestry stands alone among the religious hangings of our period in its artistic authority and philosophical content, and in this regard it is *sui generis*. Nevertheless, the surviving top half of another Saxon hanging, now in the Kunstgewerbemuseum in Berlin,[85] has some interest for us. Embroidered in silks of subdued colours on linen, it probably originally measured almost two by two and a third metres. It is thought to have had four registers of which the two upper registers survive. In the top one are Pentecost and part of a scene of St Peter healing the lame Aeneas, in the second, the Resurrection and the Holy Women at the sepulchre. At the lower righthand corner of each scene is a female worshipper. The hanging was probably made in the 1160s, perhaps – judging by the style and the inscriptions – for Hamersleben. Fragments of another from the same area, made perhaps in the 1150s, are now dispersed between Paris, London, and Vienna.[86]

Besides walls, the larger embroidered textiles of our period were used to adorn the tombs of saints. A textile in St Kunibert, Cologne,[87] three hundred and ten centimetres long by eighty-three centimetres wide, once covered the relics of two Anglo-Saxon saints, both named Hewald, and both martyred by the pagans about 695. In the centre is a zigzag pattern bordered by rosettes, and the silk used to work the ends is still fresh in colour. At one end the Sun and Moon, holding torches, appear within a circle of stars surrounded by the zodiac; at the other, the Year holds up the two heads of night and day. Encircling busts represent the elements and the seasons, and in an outer ring the signs of the zodiac indicate the months of the year. Between the 'spandrels' formed between this outer ring and the border are embroideries of Alpha and Omega and personifications of the Earth and the Sea, and the whole is framed by an elaborate inscription. The style is so naïve and akin to folk art that it makes dating difficult; however, the decoration of the

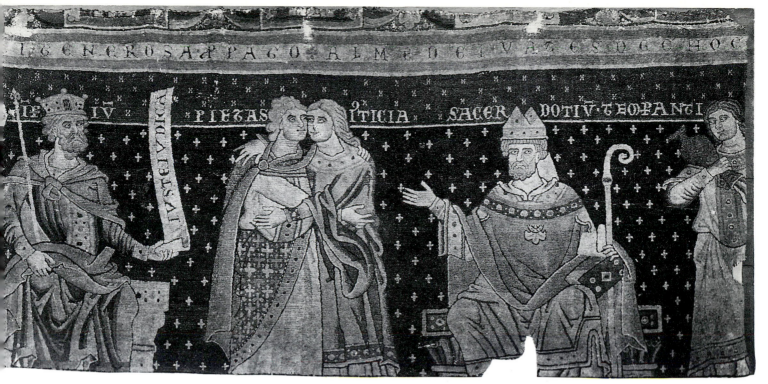

19. Quedlinburg: *The Concord of Church and State*. Tapestry. Late twelfth century. Quedlinburg, Schlosskirche

20. *The Ascension*. Detail of a lost altar cloth. Late twelfth century. Berlin, Schlossmuseum (formerly)

inscription contains debased elements of Carolingian styles and anticipations of Ottonian ones, and I would tend to join Joachim Plotzek[88] in placing this embroidered textile in the tenth century.

Embroideries in the form of cushions were used to honour minor relics. One of these, assigned to the first half of the twelfth century, was found beneath the skull of St Patroclus in his cathedral at Soest when his reliquary (of Renaissance date) was opened in 1899.[89] On one side was the Lamb of God, on the other Alexander the Great attempting to fly with the help of two eagles – a clear contrast between humility and arrogance.

Schnitzler believed that the St Kunibert textile had earlier been used as a lectern cover.[90] I have not myself come across allusions in the written sources to such a use for an embroidery – perhaps because inventorists and chroniclers considered it too unimportant to mention. However, there are references to embroidered manuscript covers, of which two survive from twelfth-century Swabia.[91] The first, bearing the Agnus Dei with half-figures of the evangelists on the display side, was made in the first half of the twelfth century for an Epistolary belonging to the Benedictine house of Zwiefalten. The second, made for a Gospel Book in the Benedictine abbey of Alspach in Alsace, has on the front the enthroned Christ in a mandorla, with the evangelist symbols at the corners, and on the back Christ delivering the Sermon on the Mount to a group of listeners. A book being offered to Christ from an adjacent border presumably represents the Gospel Book for which the cover was made, and whose mid-twelfth-century miniatures are related to the embroidery, though the embroidery is even closer to the illumination of

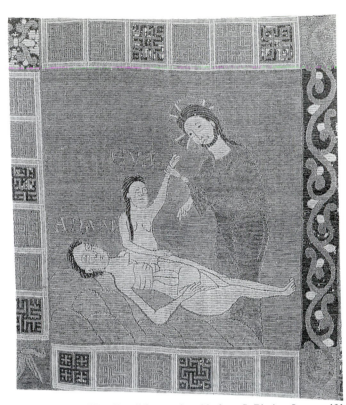

21. English: *The martyrdom of St Thomas Becket*. Embroidered mitre from Seligenthal. *c.* 1180–1200. Munich, Bayerisches Nationalmuseum

22. *The creation of Eve*. Detail from a chasuble from St Blasien. Late twelfth century. St Paul im Lavanttal

a Passionary[92] that we shall encounter in another chapter.[93] Boeckler's view that the Passionary originated at Hirsau is not universally accepted.

We have already seen that, in his sermon in the abbey of Saint-Martial at Limoges in 1029 or 1030, Adémar de Chabannes mentioned hangings on the walls of newly consecrated churches. He also alluded to their altar coverings,[94] and such coverings might be embroidered with figures or scenes. Medieval sources therefore refer to an altar cloth at Zwiefalten which glittered and shone with gold embroidery, and bore 'a representation of Christ in Majesty with the twelve apostles';[95] to one at Selby with Christ in Majesty, the four evangelists, the Crucifixion, and the twelve apostles;[96] to an altar frontal at Wollin representing the Crucifixion witnessed by St John and the Virgin;[97] and to a Lenten covering for an altar at Milan showing Abraham, Joseph, and David.[98] Unfortunately, very few of these figured altar covers have survived. A particularly fine one of late-twelfth-century German workmanship, with scenes from the life of the Virgin,[99] was destroyed in Berlin as late as the Second World War, but good photographs remain (cf. the detail of the Ascension [20]). A sumptuous altar cloth, worked in silver and gold, from Rupertsberg, near Bingen on the Rhine,[100] probably belongs to the early thirteenth century but is still Romanesque in style. It portrays a Majesty, with figures connected with the church and convent around.

Needlework pictures sometimes also adorned the vestments of the clergy. On a tenth-century English alb, all in gold, were figures of the apostles standing around the Lord,[101] and later English vestments had scenes of the Nativity,[102] of the expulsion of Adam and Eve from

Paradise,[103] and of the martyrdoms of saints. Among the few surviving examples of this kind of embroidery we may mention a pictured mitre[104] given, according to tradition, to Kloster Seligenthal by the duchess Ludmilla and bearing on one side the martyrdom of St Thomas Becket [21], on the other that of St Stephen. It would seem to be an English production of the 1180s or 1190s. The association between St Thomas and St Stephen was anticipated by Thomas himself when, at a critical juncture of his dispute with Henry II, he celebrated the Mass of St Stephen with its introit: 'Princes did sit and speak against me.' The mitre may have been connected with the chapel in joint honour of Becket and St Stephen that Baldwin, his next successor but one as archbishop of Canterbury, was licensed to build in 1186. Three other mitres – in Tarragona Cathedral, in Sens Cathedral, and in the convent of Notre-Dame at Namur – are associated with this one.

A minor vestment, a girdle, surviving in the Benedictine monastery of Andechs[105] carries appropriate inscriptions on one side, and on the other a decoration in squares of griffins, dogs, panthers, and birds. Long described as the girdle of John the Evangelist, and even claimed by one sixteenth-century inventorist as the work of the Mother of God herself, it belongs, in fact, to the middle of the twelfth century and is probably German. A late-twelfth-century chasuble from the Austrian house of St Blasien, now at St Paul im Lavanttal (Kärnten), whither the monks migrated in 1809,[106] is a colourful vestment embroidered in silks of mustard yellow and pale greys, greens and lilacs. It illustrates the life and Passion of Christ, together with their Old Testament prefigurations including the creation of Eve [22], and also

bears ten representations of saints and thirty-five busts of prophets, evangelists, and apostles in medallions. Another chasuble, later used as a royal robe at the coronation of the kings of Hungary, is preserved in the Hungarian National Museum. It is worked in silks (now faded) and some gold, and an embroidered inscription tells us that it was originally presented to the basilica of Székesfehérvár by King Stephen (997–1038) and his queen, Gisla.

In her closely analytical account, Kovács[107] argues that the numerous figures of the Székesfehérvár chasuble [23] illustrate the Te Deum. The angels, prophets, apostles, and martyrs, she says, represent the relevant celestial choirs; the standing Christ, the almost obliterated hand of God, and the dove of the Holy Spirit symbolize the Trinity; and the enthroned figure of Christ is the judge of men foretold by the Te Deum. Superimposed on the semicircular shape of the robe is a Y design, its yoke dominated by Christ holding the triumphant Cross-standard and trampling underfoot the lion and the dragon. On either side, higher up, angels support mandorlas containing the Virgin in Glory and St John. All three major figures are accompanied by inscriptions. The stem of the Y is occupied by a Christ enthroned, its branches by ten half-figures of angels in medallions. Next, identified prophets with scrolls stand in a sweeping semicircle above the apostles seated within architectural settings. Three-quarter-length figures of martyrs in medallions, with King Stephen and Queen Gisla as the two innermost figures, follow the semicircular hem, the king holding orb and lance, the queen a model of the church. The bust of a young man in a much

smaller disc between them is thought to represent their son Emeric, who died later in the same year, 1031, that (according to an inscription) the chasuble was presented. When – probably late in the twelfth century – the chasuble was converted into a coronation robe, an inscription referring to a cross in front was mutilated and – Kovács tells us[108] – the king and queen at the feet of Christ were almost completely lost.

Some Hungarian scholars, including Kovács, see the embroidery as Hungarian, but Kovács herself emphasizes its German associations, and it seems likely from its style that it was, in fact, made by German craftswomen. Queen Gisla herself, of course, was German, and might either have brought her countrywomen with her to do the work, or have had access to the women employed by her brother, the Emperor Henry II, who – as we shall see later – presented sumptuous embroidered robes to Bamberg Cathedral.

The sheer richness of the vestments of the wealthiest churches and cathedrals, and especially their lavish use of gold, is difficult for us to visualize today. When three of the many vestments presented to Canterbury Cathedral at the end of the eleventh century wore out in the fourteenth, they yielded an amount of gold that could have paid for the building of the cloisters of Boxley Abbey.[109] An alb bought for his establishment by Abbot Gauzlin of Fleury was so 'stiff with gold' that it weighed ten pounds,[110] and Cluny received a chasuble so solid with the precious metal that it could hardly be bent.[111] Among the very many gold-embroidered vestments owned by the church of Mainz, one chasuble was

23. German: The so-called *Coronation Robe of St Stephen* from Székesfehérvár. Presented in 1031. Budapest, Magyar Nemzeti Múzeum

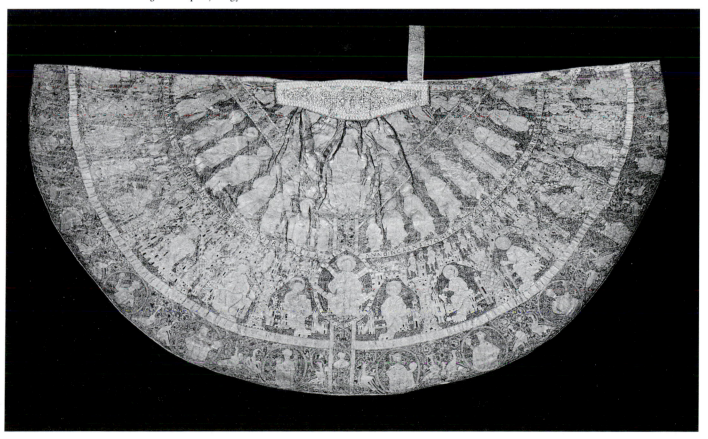

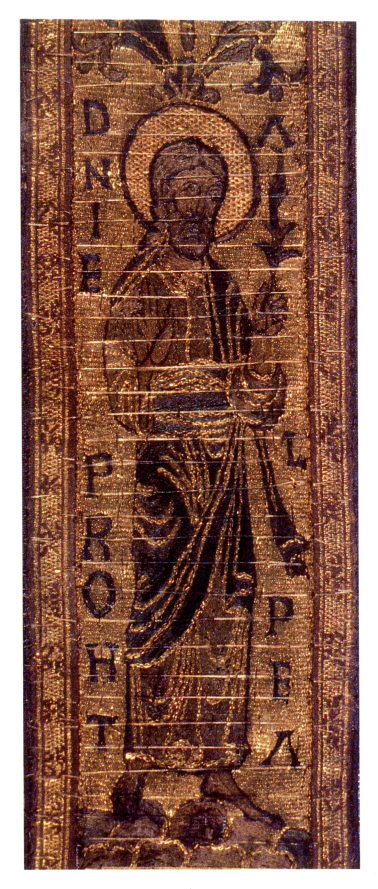

24. *The prophet Daniel*. Detail from the stole found in the tomb of St Cuthbert. 909/16. Durham Cathedral Treasury

particularly lavishly encrusted. 'Because of the gold,' says the chronicler, 'it was so heavy that . . . scarce anyone could wear it to celebrate the Divine Mysteries unless he were very strong,' and even then it had to be changed for something more pliant part-way through the service.[112] Some vestments, already rich with gold embroidery, were made even more splendid by the addition of gems and pearls. The alb said to have been made by a nun at Wilton in the late tenth century,[113] showing the apostles standing round Christ and the nun herself kissing his feet, was 'embroidered in gold, and with jewels, margarites and English pearls'.[114] A cope acquired by Cluny was virtually sheathed in gold, gems, pearls, and amber,[115] a dalmatic at Montecassino was sumptuous with gold embroidery and pearls,[116] a purple chasuble at Saint-Bertin was likewise 'wonderfully adorned',[117] a gold maniple at Passau was enhanced with gems,[118] and so we could go on. However, we will limit ourselves to a description of the vestments that clothed the body of Adalbert, archbishop of Mainz between 1138 and 1141, when he was laid in his tomb:[119]

The costliness of his garments . . . would scarcely be believed in the telling. The mitre which adorned his head sparkled, interwoven with jewels . . . the colour of gold gleamed from part of it and part was sprinkled with the radiant colour of silver. The quality of the chasuble and episcopal stole shone forth from their workmanship . . . The chasuble blazed with jewels and with the blush of gold . . . A glittering dalmatic with glowing threads . . . was heavy with jewels and decorated with different designs.

Very little survives of the abundance of gold embroidery referred to in our sources, so the three minor vestments – a stole, a girdle, and a maniple – preserved in the treasury of Durham Cathedral[120] take on a special significance. Inscribed in embroidery at the ends of the stole and maniple as having been commissioned by Queen Aelfflaed for Bishop Frithestan of Winchester (i.e. between 909 and 916), they were found in St Cuthbert's coffin, where it is thought that they were placed some time between 925 and 939. The girdle is decorated with ornamental foliage. Figures stand along the entire length of the stole and maniple, with half-figures at the ends, all identified by inscriptions. On the stole, of the original sixteen major and minor prophets thirteen remain in varying states of completeness [24]. At the centre is the Lamb of God between two of the prophets who foretold him, and on the end-pieces are busts of St Thomas and St James. On the maniple are Popes Sixtus II and Gregory the Great and their deacons, Laurence and Peter, with busts of John the Baptist and John the Evangelist on the end-pieces. The centre here is the hand of God, symbolizing his intervention in the sacrament, and it is, of course, appropriate that the standing figures should have a special association with the Roman Mass. Gold thread – or, more precisely, thread sheathed in gold – packs the backgrounds so closely that it appears to be a solid mass of the precious metal, and gold is also used as an overlay for the figures, which otherwise are in blues, browns, and brownish-reds. Freyhan has cogently argued that the style shows influences from Byzantium,[121] and has gone further to claim that the designer had some knowledge of pre-tenth-century Byzantine stoles.[122] We know that

Byzantine textiles were on sale in Pavia,[123] where Theodred, consecrated bishop of London some time between 909 and 916, bought his episcopal vestments,[124] and he is unlikely to have been the only Anglo-Saxon pontiff to take advantage of these trading facilities on his way back from Rome.

Since they combined costliness with attractiveness, gold-embroidered vestments made useful diplomatic gifts; in the eleventh century, the archbishop of Canterbury gave the archbishop of Benevento a cope richly embellished in this way,[125] and later William the Conqueror and his consort presented gold vestments to Cluny[126] and other houses. It is therefore hardly surprising that one or two other examples of Anglo-Saxon gold-embroidered vestments are to be found on the Continent, though not now in particularly good condition.

One small group of Anglo-Saxon textiles from Aldeneik owes its survival to the mistaken belief that it represented relics of the two sister-saints Harlindis and Relindis, who had founded the abbey there in the early part of the eighth century. Removed to the church of St Catherine at Maaseik in Limburg in the sixteenth century, the embroideries have now been closely analysed and discussed.[127] One is the so-called *velamen* of Harlindis. Probably made in the late eighth or early ninth century, it incorporates tablet-woven braids brocaded with gold threads. It retains two of the pearls that feature in early descriptions of Anglo-Saxon embroidery, and has, as well, blue and green glass beads and gilded sugar-loaf bosses, themselves originally encircled with pearls. Of the '*velamen*' of Relindis – which in any case may not belong to our period – we have only the stripped remnants. The most important survival by far is the so-called *casula* of the two saints – a patchwork of different textiles assembled into a large rectangle, probably in the late Middle Ages, and including a King David silk and eight pieces of Anglo-Saxon embroidery. The silk, woven in red and yellow, shows repeat designs of a very formalized King David (identified in Latin) within circles whose inside circumferences are decorated with interlace and arches. It is thought to belong to the late eighth or early ninth century, and may have been made in the West. If so, it offers a very rare example of early silk-weaving there. The embroidered pieces, which form a set, use six colours of silk: red, beige, green, yellow, and two shades of blue. There was also originally some pearling, as we can see from surviving threads for it. The embroidered decoration – which takes the form of roundels containing a stylized bird or animal, and arcadings densely patterned inside and out with animal, foliate, and interlace ornament, sometimes combined – has with justice been compared to the illumination of Anglo-Saxon manuscripts such as the Vespasian Psalter and the Leningrad and Barberini Gospels.[128] The pieces are attributed to southern England of the late eighth or early ninth century.

Fragments of Anglo-Saxon gold embroidery among the relics of St Ambrose in the Basilica Ambrosiana at Milan[129] are technically related to the Durham girdle but earlier – of the ninth century. Minor vestments of a much later date, the early twelfth century, though far cruder, are also related to the Durham embroideries.[130] They are fragments of a stole and maniple embroidered with full-length figures of identified apostles, saints, and kings, and with an Agnus Dei in a roundel which survive from the tomb of William of Blois, bishop of Worcester from 1218 to 1236.

The taste for gold in the embroidery of ecclesiastical robes indicated by our written sources extended also to richer secular dress, though it tends to come to our notice only when such lay garments were given to a monastic church for transformation into vestments. Thus we learn of one of his imperial robes of gold only because the Emperor Henry II (1002–24) presented it to Cluny.[131] And it is only because King Edgar of England (959–75) gave his cloak to the abbey of Ely to be made into a chasuble that we know that it was so laden with gold embroidery that it looked like chain mail,[132] while the cloak he gave to Glastonbury was splendid enough to be used as an altar cover.[133] William the Conqueror left one of his cloaks, 'wonderfully adorned with gold and precious stones', to Battle Abbey,[134] presumably to be made into a vestment, and his consort, Matilda, bequeathed one of hers, 'made of gold', to the Trinité at Caen to be made into a cope.[135] The monastery of Pegau about 1109 received from Lord Wibert of Groitsch, to be converted into a chasuble, a cloak embroidered with outstanding skill in gold,[136] and a little earlier, in 1096, from Countess Judith of Bohemia her own 'gold-embroidered' robe.[137] In the early twelfth century, Salome, duchess of Poland, sent to the house of Zwiefalten to be made into a cope 'her red cloak which had a gold border', and another to be converted into a chasuble which was completely embroidered with gold, and had 'a deep border of gold and a red hem ornamented with gold stars after the fashion of that people'.[138]

References to costly secular attire in non-ecclesiastical contexts are rare. Walafrid Strabo's account in a ninth-century poem[139] of a cloak designed and made by 'the artist, N...' which was 'embroidered ... with resplendent figures' may have been a literary fancy, but another Carolingian poet, Ermoldus Nigellus, tells us that the Emperor Louis the Pious and his consort, Judith, gave to the Danish king and queen and their son, respectively, a cloak bordered with gold and embroidered with jewels, 'a tunic made of gold and encrusted with gems', and 'garments worked in gold'.[140] A saint's life records that a princess of the tenth century was shown royal attire of jewelled robes and cloaks embroidered with gold to test her vocation as a nun.[141] An account of an eleventh-century king speaks of the number of his gold-embellished robes,[142] and a twelfth-century clerical correspondent refers fleetingly to a prince wearing resplendent 'garments of silk embroidered with gold'.[143] The owners of such robes must of course have been wealthy, but not necessarily of royal or noble birth, for Anglo-Saxon moralists of the eleventh century attacked the wearers of costly gold-embroidered attire in quite general terms,[144] and we know that resplendent gold garments were worn at an eleventh-century banquet given by a man no more than 'rich and honest'.[145]

Virtually all these costly secular garments have disappeared, but two surviving ceremonial robes at Bamberg of the Emperor Henry II (1002–24) will indicate the magnificence that royalty could achieve. The first is known to German art historians as the 'Sternenmantel',[146] for its blue background is studded with the heavenly constellations embroidered in gold [25]. Nimbed busts in medallions represent the planets, and the signs of the zodiac figure prominently, in diamond borders interlinked with square

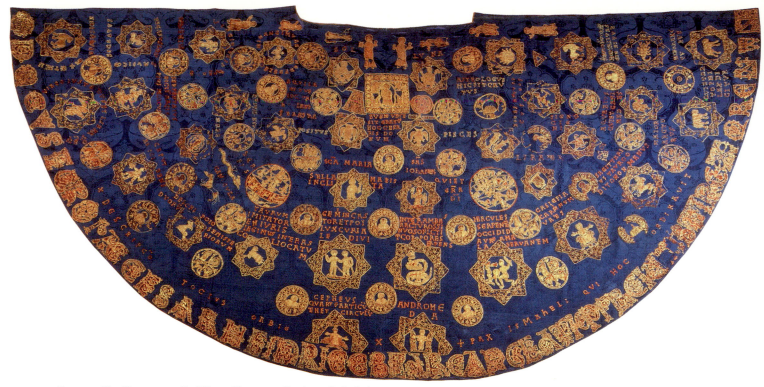

25. German: *The 'Sternenmantel' of Henry II. c.* 1014. Bamberg Cathedral Treasury

ones. Perseus is shown with the head of Medusa, Hercules attacks a snake coiled round a tree, and Pegasus, Andromeda, the Swan, the Eagle, and other constellations are also represented. The Sternenmantel is generally thought to have been made for Henry's coronation, and a significant light on contemporary conceptions of the authority of the Holy Roman Emperor is cast both by the cosmic associations of the robe and by the gold inscription round its edge, which entreats the Eternal King to increase the rule of Henry II, who is the glory of Europe. At a central point of the cloak – the pole around which the cosmos revolves – is Christ surrounded by the symbols of the evangelists. To either side are the Alpha and Omega, and above and below, in star-shaped compartments, are cherubim and seraphim and the luminaries of day and night – the Sun with his chariot, the Moon with crescent and torch. There are besides six elders of the Apocalypse, the Agnus Dei, and the Virgin Mary and St John. Medallions, each bearing a cross with the evangelist symbols between its arms, are scattered over the whole cloak, suggesting the diffusion of the truth of the Gospels throughout the cosmos.

A slightly later inscription informs us that the garment was given to Henry by Duke Ismahel of Apulia – perhaps in order to gain his support against the Byzantines, who were hungry for the duke's territory. Von Pölnitz's hypothesis that the themes show a familiarity with Greek mythology which indicates manufacture in an area under Greek influence – presumably southern Italy – is an unnecessary one. To begin with, the literary source of the imagery was not directly Greek but a Carolingian reworking of a seventh-century translation of a Greek astronomical poem.[147] Then again, as Henry II was related to the Greek consort of his imperial antecedent, Otto II, his textile designers could no doubt have gained any access they required to Greek iconography through the imperial household. In fact, the embroidery has all the appearance of being Ottonian, and the ornately decorated majuscules of the primary inscription have associations with the inscription round the border of the Cologne relic cover that we have discussed earlier. Ismahel may have paid for the garment, but it seems probable that he commissioned it in Germany.

Many of the vestments presented to Bamberg by Henry II were lost in the cathedral's secularization under the elector Max Joseph, but other robes of his do survive – no doubt preserved as relics after his canonization in 1146. One of them [26][148] is thought to have been made for Henry to wear at the dedication of Bamberg Cathedral in 1012, though it has long been known as the great mantle of Kunigunde, his consort, later also canonized. Its dark blue silk is illuminated by sixty-three gold historiated medallions, with delicate vegetal decoration filling the spaces between. In the medallions are 'miniatures' of religious subjects. The theme of the Incarnation dominates the central area, where Christ is shown in a mandorla with Divine Wisdom personified above, Bethlehem below, and all around, scenes associated with the coming of the Redeemer: the Nativity, the Virgin and Child, a series of events relating to the Annunciation to the Shepherds, and the episode of Moses and the Burning Bush, traditionally thought to prefigure the virginity of Mary. Related inscriptions proclaim that 'The Word was made flesh' (John I, 14), 'There shall come a star out of Jacob' (Numbers XXIV, 17), and so on. The inscriptions in the frames of the medallions recall those of Regensburg miniatures, though here they have a delicacy of their own. Around the shoulders of the mantle are illustrated the lives, miracles, and Passions of two of the saints to whom the cathedral of Bamberg was dedicated – Peter and Paul.

Another surviving ceremonial garment of Henry II in far less good condition is a tunic, its original silk largely replaced by white damask in the Baroque period.[149] However, in the

26. German: The so-called *Great Mantle of Kunigunde.*
c. 1012. Bamberg Cathedral Treasury

surviving original gold embroidery of the neck-line, cuffs, and hem, the griffins within circles show clear influences from Byzantine silks. In its pristine state, the tunic was embellished also with pearls. Another of Henry's gold-embroidered robes, later converted at Bamberg into an ecclesiastical vestment and surviving in only fair condition, follows a Byzantine prototype with its image of an enthroned emperor holding a globe and *labarum* (imperial standard).

THE EMBROIDERERS

It is difficult to discover what kinds of persons were responsible for the artistic productions of our period, for these were almost always unsigned and anonymous. The chroniclers, largely monks and clerics, were incurious about lay artists, and such interest as they showed was largely confined to the aristocratic benefactresses of churches, who were themselves said to be needlewomen. We shall come to them later. Some embroiderers were nuns, but we know extremely little about them or about the amount of work they produced. It is true that a charter from Vienne,[150] written some time between 1030 and 1070, speaks of a lay physician asking the archbishop for the use of accommodation earlier set aside for female weavers in gold, but it was not within a nunnery, it was within the precincts of Vienne Cathedral itself,[151] and there is no evidence that the weavers were nuns.

Although there is no firm evidence of conventual workshops, there are occasional reports of individual nuns who worked embroideries. Before our period begins, in England, the Council of Clovesho (747) tried to dissuade nuns from embroidering their habits,[152] and – if we are to believe their ninth-century biographer[153] – the two early-eighth-century saints, Harlindis and Relindis, whom we have met earlier in this chapter, were accomplished embroideresses

who had been instructed in the arts of weaving and sewing in the nunnery of Valencina (probably Valenciennes). Moreover in what is now Switzerland, in the first quarter of the tenth century, the recluse St Wiborad was apparently accustomed to make beautiful linen covers for the books of priests[154] – presumably those at St Gallen where she had her cell – and, as we have already seen, a later biographer said that the tenth-century Anglo-Saxon nun, Edith, was a skilled embroideress. But Edith, besides being a princess, was later considered by some to be a saint, so the statement should be treated with caution. There was always a tendency for objects to be wrongly associated with saints so that they could thereby be treated as relics, which all religious foundations were anxious to procure. St Aethelwold is a clear case in point, as we can see from later comments on his supposed artistic activities.[155]

A twelfth-century biographer informs us that Christina, when prioress of Markyate in Hertfordshire, embroidered three mitres of wonderful workmanship which were sent as gifts to the English pope, Adrian IV, in 1155.[156] We shall discuss Christina at length in Chapter 12, where we shall see that she was of gentle, but not of noble birth. However – as we have indicated earlier – some royal and aristocratic ladies apparently did make embroideries for churches. A late biography claims that Kunigunde, the saintly consort of the Emperor Henry II in the early eleventh century, was skilled in decorating vestments with gold and jewels,[157] and Paulina, a wealthy and pious lady of Thuringia popularly hailed as a saint after her death in 1107, had 'no superior and scarcely any equal in the province of Thuringia where she lived, in the making of gold borders and stoles' and in all kinds of work in gold, silver, and silk thread.[158] We are told by a chronicler of the aristocratic monastery of St Gallen that, in the ninth century, the sister of the abbot, Hartmut (872–83), made a hanging that was set before the Crucifix at the time

of Lent.[159] In England, moreover, a noblewoman called Ethelswith embroidered in gold for the monastery of Ely in the early eleventh century,[160] and another, Ethelwynn, was making ready to 'embellish and diversify a stole with gold and precious stones' a few decades earlier.[161] All these pious ladies were presumably hoping for a spiritual reward, as was Gundrada who, according to a tenth-century verse account, completed a garment begun for the Vatican by her mother, Peratsuind, in the hope that 'she and her lord and protector . . . may before long reach the kingdom of heaven and that the gifts of paradise may be revealed to them'.[162] According to such sources, skills in embroidery were almost inevitably accompanied by nobility and piety, but there was one exception: Adela, a daughter of the German count Balderic, was endowed both with noble birth and the necessary skills, but lacked the mandatory piety. Indeed, an account of 1021[163] describes her as strident of voice, coarse of conversation, and disorderly of mind, adding for good measure that she had a fickle disposition which was expressed by her beckoning eyes – yet she is said to have surpassed almost all her countrywomen in the fashioning of costly vestments.

There are also rare references to consorts embroidering garments for their lords which, given the prevalent viewpoint that kings and emperors were the Lord's anointed, could also no doubt be seen as a form of piety. In the ninth century, John Scotus Erigena referred ingratiatingly in one of his poems[164] to Irmintrude, the wife of the emperor Charles the Bald, practising the art of Pallas Athene and causing her husband's robes to shine with gold embroidery – adding the unexpected comment that she covered the very garments beneath his robes with a pattern of jewels. Other verses claim that Charles the Bald's mother, Judith, adorned the robe of her husband Louis the Pious so that 'he might shine like a hero in the eyes of the people'.[165] Her work was apparently completed by Irmintrude and put to religious use. In eleventh-century England, an early biographer of Edward the Confessor relates that his garments were 'interwoven with gold which his queen had most sumptuously embellished'.[166]

Given the fact – to be elaborated in the next chapter – that in our period credit for a work of art tended to be given rather to its patron than to its executant, a sense of caution, not to say scepticism, might well be thought advisable at the continual association of embroidery skills with blue blood. Yet Countess Adelheit of Gamertingen is recorded as having presented to the monastery of Zwiefalten 'two great linen hangings to be hung in the church during the days of Lent' which were made 'with her own hands',[167] as were the hanging presented to St Gallen by Abbot Hartmut's sister[168] and the chasuble made by Ethelswith in England.[169] They must however have needed help, as is confirmed by the *Liber Eliensis*, for when Ethelswith withdrew from male company and from the world in order to make vestments for the monastery at Ely, she was thereafter 'free to devote herself *with her maidservants* [my italics] to making orphrey and to weaving'.[170] There is a similarly significant reference in the account of the miracle which supplies our knowledge of the embroidering interests of Ethelwynn: when it occurred, 'all her women completely forgetting the work in their hands' looked 'at each other in awe'.[171] Adela of the beckoning eyes, too, 'had a great number of maids who were trained in various aspects of textile work',[172] and the life of Burchard, bishop

of Worms (d. 1025), records not only that his sister had considerable ability in making precious hangings but also that 'she had with her women who were skilled in a wide variety of textile work.'[173] The impression given by the written records is that these ladies of breeding on the whole supervised, designed, and put the finishing decorative touches to embroideries rather than undertaking the bulk of the work themselves, yet it remains important to know that they considered embroidery to be compatible with their rank. In this respect, a description of the sewing-room of a queen of Scotland, St Margaret (*c.* 1045–90), written by her spiritual adviser Turgot, is particularly telling. It was, he says,[174]

never empty of objects . . . for use in the divine service . . . There, cantors' copes, chasubles, stoles, altar cloths and other priestly vestments . . . were always to be seen. Some were being worked on by skilful hands, others were finished and were receiving their due admiration. To this task were allocated ladies of noble birth, commended by their virtuous ways, who were judged worthy to take part in the queen's service.

All this preoccupation of our clerical and monastic sources with the embroidery skills of noble benefactresses should however be counterbalanced by the evidence of an Anglo-Saxon dictum concerning the more depressed classes – that a woman's proper place was at her embroidery.[175] That some of those who earned their living by embroidery were servants in wealthy households is demonstrated by the four sources quoted above. No doubt there were many more such workers: one mid-tenth-century Anglo-Saxon will even indicates that slave-women might be put to the less skilled work of weaving and sewing.[176] However, there were certainly professional embroideresses outside domestic households. Goscelin of Flanders, writing in the later part of the eleventh century in praise of the skill of Anglo-Saxon women in gold embroidery and the embellishment of the garments of princes and prelates with gold-work and gems and pearls,[177] seems to have been writing generally, and not solely of household staff. Nor was the Norman, William of Poitiers, likely to have been speaking of needlewomen tied to great houses when he referred to the skill of Englishwomen in gold embroidery, commenting that their work was exported 'to distant lands'.[178]

The document from Vienne already cited indicates that there were already workshops in the eleventh century, if not for embroideresses, at least for weavers. The one at Vienne may have been set up *ad hoc* by Archbishop Léger to provide gold thread for hangings and vestments for the cathedral he was rebuilding – indeed, the existence of *ad hoc* workshops may explain how other prelates, such as Lanfranc, could quickly obtain large numbers of beautifully embroidered vestments for their newly built, or rebuilt, cathedrals. Unfortunately, however, there is no further information on workshops until we come to twelfth-century Sicily, where the mingling of Greek, Arab, and Latin cultures led to a precocity unparalleled in the rest of Europe. Hugh Falcandus, writing in 1189,[179] gives us an overblown but fascinating account of the cluster of highly organized workshops set up by King Roger (1130–54) in his anxiety to compete with the Byzantine court to produce silks of various kinds and qualities for himself, his court, and even for outside purchasers. Describing the sights of Palermo, Falcandus writes:

Nor is it fitting to pass over in silence those noble workshops that adjoin the palace, in which silken fleeces are thinned out into thread of various colours and combined with one another by various manners of weaving. For here you may see the single-thread, the double-thread and the triple-thread all being made ...; here the samite [literally 'the sextuple-thread'] also is seen being compacted together with an abundance of richer material; in one place an intense rose colour dazzles the eye with its fiery brilliance; in another a pale green soothes the spectator with its pleasing appearance; and in another there are Saracen cloths embellished with roundels of various descriptions, which while lacking in any greater degree of workmanship or of richness of material, will nonetheless be retailed at a higher price. And many other decorative accoutrements you may see here of various colours and types: silks in which gold is interwoven, and in which a variety of different depictions are lit up by an interspersion of glittering gems. Pearls also are either set whole in little golden compartments, or else are pierced and joined on with fine thread, and by careful and elegant arrangement are set in place to show up the form of the embroidered work ... And the area that stretches between the middle of the city and the harbour, where the two other parts of the city come together, contains the Amalfitan quarter, abundantly rich in foreign wares: here garments of various colours and prices are displayed to buyers, garments both silken and woven from Gallic fleece.

Actual survivals from these Sicilian workshops are few. If we exclude the coronation mantle of 1133/4, which is, in fact, entirely Arabic in workmanship, the significant ones in order of date are as follows.[180] First, a gold-embroidered fragment of the second third of the twelfth century, now at Lyon, with men and mythical animals within, and between, coiled ornamental bands, and also a female dancer. Second, a mitre at Salzburg of the mid century or a little later, with gold borders and the zodiacal signs of Capricorn and Scorpio. Third, the so-called Mantle of Charlemagne (in fact a pluvial and nothing to do with Charlemagne) at Metz. Embroidered in gold on red, it displays, in clear emulation of Byzantine silks of earlier centuries, four heraldic nimbed eagles, two of them standing on coiled snakes – a device reminiscent of a Spanish device to be described in a later chapter. The 'Mantle of Charlemagne' is usually given to the end of the twelfth or to the early thirteenth century, though some would place it much earlier. Finally, a fragment now in London of a brocade found in the Palermo tomb of Henry VI (the first Hohenstaufen king of Sicily) and thought to be of the same period. It has gazelles and birds confronted about a continuous 'frieze' of Trees of Life.

The scanty information we have about a third class of needlewomen – those who hired out their services on an individual basis – refers only to workers in gold thread, suggesting that they, at least, were well placed. So, we learn from the Domesday Book of 1086 that a Buckinghamshire sheriff was prepared to allow Elfgyth, a specialist in gold embroidery, to enjoy land from the king's demesne as long as she instructed his daughter in her skill.[181] The same source mentions Leofgyth, a professional worker in gold embroidery who made gold hems for the new Norman king and queen as she had for their predecessors before the Conquest.[182] She was quite well-to-do, for she controlled her husband's old

village of Knook, which had a rateable value of $3\frac{1}{2}$ hides (a hide was usually reckoned as 120 acres). The will of the Conqueror's consort, Queen Matilda, mentions Anglo-Saxon embroideresses in gold in her employ, among them Alderet's wife near Winchester,[183] who was also probably quite well placed. The Domesday survey of the areas around Winchester lists two women married to men named Aldred. The first had held, as a tenant of the bishop of Winchester, land now (in 1086) granted to her husband, with its own small church and meadow. It lay in Kilmeston in the Hundred of Fawley, and was rated at five hides.[184] The second had, before the Conquest, held in dowry land belonging to New Minster which was now in the tenancy of her husband. The land – within, or within the jurisdiction of, the vast hundredal manor of Micheldever – was rated at one and a half hides.[185] If this was Queen Matilda's needlewoman, she may have made embroidery for the abbey; if it was the other Aldred's wife, she may have supplied the bishop.

A professional gold-embroidery worker also clearly of good social standing is referred to in the context of a miracle which took place some time between 1134 and 1138, when she was involved in an urgent dress-making commission from the countess of Gloucester. One 'who used to adorn the garments of kings and rich people with gold, to make them glisten with jewels, and to decorate them with a variety of pictures and foliated and inlaid work',[186] she is introduced as 'a noble matron of London', and it soon becomes clear that she had at least one servant. The Pipe Rolls of King Henry II of England mention an embroideress, called Mabel, who was making orphrey-work for the king in 1183/4[187] and may have been 'the wife of Brihtmar' mentioned in the same connection in 1165/6.[188] Brihtmar's full title, Brihtmar de Haverhell, suggests that he was the lord of an estate, and his wife would hardly have been of lowly stock. Moreover, if the Rederich and Cunegund who, as we saw earlier, fashioned (composuerunt) the Minden hanging indeed themselves worked it, they too must have been quite affluent to be able to present it as a gift.

Although it was the embroideresses (and perhaps embroiderers, too) who played the vital role in creating the works of art described in this chapter, we must not overlook the importance of the designers. Some of them may have been manuscript painters, which would explain the stylistic relationship between Anglo-Saxon manuscript illumination and the Anglo-Saxon embroideries at Maaseik. Indeed, there is a tenth-century account, both contemporary and reliable, of Ethelwynn summoning the miniaturist Dunstan 'to her with a friendly request that he should design for her a stole for the divine service with various figured patterns, which she could afterwards embellish and diversify with gold and precious stones'.[189] This vestment has vanished, though luckily one of St Dunstan's own drawings has come down to us [80].

It is typical of the plight of the so much more perishable embroideries that the drawing by Dunstan should have remained while the stole embellished by Ethelwynn has vanished. Embroidery is given far less space in these pages than its very high reputation in the Middle Ages would warrant simply because, compared with painting, the numbers surviving the ravages of the centuries are so pitifully small.

Painting: 800–1200

ATTITUDES TO REPRESENTATIONAL ART

In the first chapter we saw that, in the eighth century, the Byzantine empire was overtaken by a wave of officially sponsored iconoclasm, and that it was not until 843 that the ban on religious figural art was finally lifted in the Eastern Church. There was, however, an interlude after 787 when the Second Council of Nicaea, summoned by the Empress Irene (780–802), repudiated the earlier decisions of the Oecumenical Council of 754 and concluded that religious images were in fact worthy of veneration. This verdict, adhered to by Irene's immediate successors, was to have significant repercussions in the West, for it was greeted with enthusiasm by Pope Hadrian I, whose own envoys had been present at Nicaea, and who immediately ordered a Latin translation of the proceedings to be made and despatched to the Frankish court, where he expected it to be warmly welcomed. However, largely because of deficiencies in the translation, Charlemagne and his theologians were persuaded that the Council had come down in favour of idolatry, and indeed that a heresy even more pernicious than iconoclasm had now arisen in the East. So serious did the situation seem to the emperor that he caused one of his entourage – almost certainly Theodulf of Orléans[1] – to undertake a point-by-point refutation of the Council's main utterances. The resulting treatise, completed in 791 or 792 and known as the *Libri Carolini* or *Books of Charlemagne*,[2] is much the fullest statement of the Western attitude to representational art that has been left to us by the Middle Ages.

Ironically, when the *Libri Carolini* were rediscovered in the sixteenth century, the vigour with which they opposed any tendency towards image-worship appealed to the leading Protestants of the Reformation, most notably Calvin, who drew on them in the various editions of his *Institutes*.[3] The Catholics reacted by placing them on the Index (where they remained until 1900)[4] and by casting doubt on their authenticity – indeed, a nineteenth-century author went so far as to claim that the only manuscript of the *Libri* then known was the work of a skilful sixteenthcentury Protestant forger who had meticulously schooled himself in the Carolingian script.[5] However, the *Libri* are not in any sense iconoclastic: they sprang after all from Charlemagne's court at Aachen, the milieu that gave rise to so many splendid works of art, and Theodulf himself is known to have had a keen appreciation of the visual arts. Rather, the *Libri*, while pursuing their chief aim – to oppose the view that religious images merit the adoration of the beholder – attempted to steer a middle course between the extremes of Byzantine theology, and to keep to a commonsense view of the place of art within the Christian religion. So it is that, castigating the Byzantine theologians of both 754 and 787, the author pointedly remarks that 'we neither destroy in common with the former nor adore in common with the latter'.[6]

Whereas the Nicene fathers had argued that there was an essential connection between an image and what it represented, so that the image participated to some degree in the qualities of its prototype, the *Libri* emphasize that images, be they paintings or sculptures, are no more than material objects devoid of any inherent mystique. If there is sanctity in images, they ironically ask, then where was the sanctity before the image came into being – was it in the wood, the colours, or the wax from which it was made?[7] Images are simply the products of a craftsman who has learned his skill through worldly experience,[8] and there is nothing supernatural in them to evoke our worship. However, it is repeatedly affirmed that they have two perfectly legitimate functions: to beautify and to instruct. 'We permit the use of images in the churches of the saints,' it is observed, 'not that they should be adored, but in order to recall past events and for the adornment of the walls.'[9] Similarly, pictorial art can 'bring to beholders the memory of events that had actually occurred and lead minds from falsehood to the cultivation of truth'.[10]

The concepts of the *Libri Carolini* were enlarged on by twelfth-century writers such as Theophilus, who will be quoted later in this chapter, and though they did not prevent artists, especially of the Romanesque period, from seeking to penetrate beneath the external appearance of a subject in order to register the inner reality, in their extended form they shaped attitudes to art throughout the Middle Ages and beyond; for in the face of another rash of iconoclasm proceeding from the extreme wing of the Protestant movement, the Council of Trent, in its session of December 1565, affirmed the Church's opposition in terms that captured the spirit of the *Libri Carolini* not long after the Calvinists had misconstrued its letter, and spoke in ways that Theophilus would have well understood. The Counter-Reformation Council recalled 'the usage of the Catholic and Christian Church as received from the primitive times of the Christian religion' and, referring to the Second Council of Nicaea, laid it down that images were placed in churches not because of any virtue or divinity inherent in them, but to instruct and confirm in the people the mysteries of religion that they represented, to move them to a love of God and a memory of the benefits procured for them by Christ, and, by their representations of saints, to induce in the beholders a desire to fashion their lives in imitation of these holy figures.

In fact, similar views to those of the *Libri* were held nearly a century earlier by Bede,[11] and indeed the pedagogic value of art had been fully recognized as early as 600 by Gregory the Great in a famous epistolary comment: 'what writing is to the reader, painting is to the uneducated for ... they can "read" a painting even if they do not understand letters'.[12] Even as far back as the early fifth century, one of St Paulinus's poems relates how he caused the basilica of St Felix at Cimitile outside Nola (Campania) to be painted with scenes from the Scriptures in the hope that they would so entrance the peasantry, recently converted from paganism, that they would no longer eat and drink in church and pollute the resting-places of the local saints with the fumes of alcohol.[13]

In spite of the emphasis placed by the Church on the purely instructive value of representational art, at the popular level there was a recurrent tendency to idolatry; in fact Gregory's letter was a reprimand to a bishop of Marseilles whose excessive zeal had prompted him to smash images of the saints in order to prevent them from being worshipped. For the same reason, Bishop Claudius of Turin (d. *c.* 840) not only removed every painting from the churches of his diocese, but even destroyed all crosses,[14] and a contemporary, Bishop Agobard of Lyon (d. 840/1), recommended in a treatise against image-worship that 'images of the saints ... should be altogether pulverised and reduced to dust'.[15] Apparently to forestall criticism, a lavishly illustrated Psalter of the first half of the twelfth century[16] included Gregory the Great's remarks, together with a French translation of them; and later in the same century an inscription on a mosaic picture of Christ at St Mark's in Venice admonished the beholder to honour what the image represents, i.e. not the image itself.[17] Moreover at the turn of the eleventh and twelfth centuries, an abbot of Westminster used the vehicle of a dispute between a Christian and a Jew to defend representational art against charges of idolatry.[18]

A much more celebrated abbot of the twelfth century, St Bernard, gave misgivings about certain forms of art very powerful expression in one of the most famous of medieval diatribes, whose sonorous intensity is completely lost in any excerpted sentences. His fears, however, concerned not the idolatrous but the seductive potentialities of art to divert the minds of the monks from the things of the spirit:

I say naught of ... the curious carvings and paintings which attract the worshipper's gaze and hinder his attention... They [i.e. those who enter a decorated church] are shown a most comely image of some saint whom they think all the more saintly that he is the more gaudily painted ... there is more admiration for his comeliness than veneration for his sanctity ... so many and so marvellous are the varieties of divers shapes on every hand, that we are more tempted to read in the marble than in our books, and to spend the whole day in wondering at these things rather than in meditating the law of God.[19]

In the fourth century, St Augustine had been frank about the sensual appeal that music had for him, and it may be that, in the twelfth, St Bernard was similarly susceptible to the visual arts. We are given an insight into the fascination that painting at that time exercised by a description of the chapel being built between 1145 and 1187 by Bishop William of Le Mans:[20]

the images painted there ... ravished the eyes and minds of the beholders and attracted their attention to such an extent that, in their simple pleasure, they forgot their own undertakings and some, who had work on hand, were to be seen there completely idle, enchanted by the paintings.

In the next century, Bartholomew the Englishman advised physicians not to make pictures accessible to a frenzied man lest they aggravate his illness[21] – an unusual medical *caveat* which was probably derived from a much earlier authority known as Constantinus.

In the twelfth century, interest in painting was such that it could provide ready terms of reference for the educated public; the moralist Geoffrey of Vigeois, for example, was able to compare the pretentious dress of his day to the dress of 'the devils that we see in paintings',[22] and a chronicler such as Peter the Deacon of Montecassino could expect to be readily understood when he suggested that a mind confused by worldly anxieties would achieve as little as a painter trying to represent human figures with inappropriately mixed colours.[23] Again, when the friends of Gerald of Wales felt that he was squandering his talents, they compared him to a painter who uses a wealth of colours to embellish an impoverished dwelling instead of a palace or a church.[24] Similarly, the twelfth-century Norman chronicler William Calculus used a reference to painters' techniques in singling out Henry I of England for praise: as the top coat of a painting glows more brightly than the darker undercoat, he said, so Henry was more glorious than his brothers.[25] Stained glass, too, was used as an analogy when the poet Hartmann von Aue compared the feelings of a woman seeing her beloved apparently dead to the darkness of grisaille, and her relief on finding him in fact alive to glass that was clear.[26]

The impact of pictures also led to their influence on visions. Two examples come from Montecassino. The first is supplied by Abbot Desiderius (1058–86), who tells us that when his community were awaiting the death of one of their number, Azo, who had been zealous in restoring a church dedicated to St Michael, one of the monks saw the saint, whom he identified from a portrayal 'in a certain instructive painting', passing through the abbey's dormitory.[27] After confirming his identity, the monk asked St Michael whither he was going, and received the reply that he was on his way to the infirmary to bear away Azo. Desiderius's work on the Miracles of St Benedict, in which this incident is related, seems to have been written in the 1070s, so that as the monk, then advanced in years, is said to have seen the vision in his youth, it may be supposed to have occurred during the 1030s or 40s. About a century later – some years before 1137, according to the chronicler – another monk of Montecassino, called Albert, was said to have been carried away in spirit, and to have seen in the chapter house of the abbey a vision of Christ and his mother seated together as in a picture.[28] The picture perhaps looked something like the mosaic at Santa Maria in Trastevere [148] which shows Christ and his mother enthroned together.

A vision of 1073 has a special interest in that it shows that peasants, too, could be deeply affected by paintings. When Cardinal Hildebrand was elected Pope Gregory VII, two peasants ran to the church of San Giovanni in Laterano to catch a glimpse of him. 'The following night,' Paulus Bernriedensis relates, there appeared to one of them in a vision 'three men who were all handsomely apparelled and of brilliant countenance', one of whom the man recognized as St Peter from paintings he had seen.[29]

A vision of the French-born St Anskar (801–65), best known as the evangelizer of Denmark, seems to have been inspired by a painting of the Apocalypse. He saw

various rows of saints, some standing near and others further from the East, but all looking towards the East. And they all praised God who appeared in the East and adored him, some with bent heads, some with uplifted faces and outstretched hands: and when we had reached the East, behold twenty-four elders who were seated on thrones, as it is written in the Apocalypse, but who left clear a very wide approach; they

too looked towards the East with reverence and expressed ineffable praises to God... The brilliance which came from God stretched over them as they sat round about, like an arch of clouds.[30]

My view that Anskar was inspired by a painting depends, in the last resort, on art-historical criteria. But the vision that came to the cleric and scholar Gerald of Wales on 10 May 1189 just before cock-crow, when he was at Chinon with King Henry II, is associated by Gerald himself with painted representations.[31] He saw the heavenly host being attacked in the skies, and in the midst 'the Prince of the heavenly force Himself, Who was sitting... in Majesty as He is customarily painted'. Gerald took the vision to refer to the assaults of the Saracens, who were trying to wrest away Christ's kingdom and his glory even after he had ascended into heaven.

Christ in Majesty must have been the best known of all artistic themes during our period, and it is therefore not surprising to read of another Majesty appearing in a vision, this time involving an actual painting in stained glass. According to Reginald of Durham,[32] at some time during the last three decades of the twelfth century an English carpenter at Finchale saw the deceased St Godric raptly gazing at a window bearing 'an image of the highest Majesty' – an image which, no doubt, the carpenter had actually seen. Another vision at Finchale incorporated a known work of art in a more unusual way. It concerned a patterned and multi-coloured altar cloth from the church of St John the Baptist which was worn in a visitation by the saint himself.[33] At Prüfening in Germany, some time around 1123, the monk Boto had a vision which will be discussed further in Chapter 11. This one involved murals. Boto tells us that he saw the Virgin (the abbey's patron) in the infirmary chapel, gazing at some recently completed wall paintings largely dedicated to her, and then expressing her gratitude to the convent for the devotion they embodied. Presumably the Virgin he saw resembled the portrayals of her on the walls.

Paintings influenced poems, too, particularly visionary ones. The most famous in our period, and also one of the most beautiful, is the Old English *Dream of the Rood*. It begins:

> It seemed I saw the Tree itself
> borne on the air, light wound about it,
> – a beam of brightest wood, a beacon clad
> in overlapping gold, gleaming gems
> fair at its foot, and five stones
> set in a crux flashed from the cross-tree.
> Around, angels of God
> all gazed on ...[34]

Peter Clemoes has observed that the picture it presents in lines 4–12 of a golden, begemmed, radiant cross, towering in the sky and adored by angels, holy spirits, men on earth, and all the glorious creation, may owe something to a mosaic that the poet had seen, perhaps in Rome.[35] A mosaic with some similarities existed in Anglo-Saxon times in the vault of the fifth-century oratory of the Holy Cross, originally a part of the Lateran Baptistery. The oratory was destroyed at the time of Sixtus V's restoration, but we have two seventeenth-century accounts of the mosaic. Cardinal Cesare Rasponi reported that 'The vaulted roof was decorated with most

elegant golden mosaic work, and in the corners there were seen four angels who supported a huge Cross... a little below the vault were... mosaic images of the holy Apostles... and holy martyrs...'[36] Some surviving Roman mosaics also show some affinities with the description given in the *Dream*: the late-fourth-century mosaic of Santa Pudenziana has a huge bejewelled cross 'borne on the air' as in the poem, and once also had the twelve apostles as well as Christ and symbols of the evangelists around; and in the apse of S. Giovanni in Laterano saints below adored the jewelled cross, with angels looking on above. The Lateran version was reworked by Jacopo Torriti in the thirteenth century and reconstructed in the nineteenth, but it is generally agreed that Torriti followed the principal lines of the earlier work, and that the nineteenth-century reconstruction was a faithful one.[37]

Clemoes points out that Cynewulf's poem on the Ascension is another Anglo-Saxon work owing much to the stimulus of the visual arts, and suggests that its source 'could have been a picture in a church in which he [Cynewulf] worshipped'.[38] He remarks, as well, that elements of the account of the Ascension in the Old English poem *Christ and Satan* (cf. lines 562–6: 'and the Lord of Hosts ascended up on high ... The hand of God appeared and He received the Prince ...') 'come straight out of a picture of the type represented in the Benedictional of St Aethelwold',[39] to which we might add that the earlier Drogo Sacramentary has a similar composition [46].

Thus paintings and mosaics had an impact on both poet and peasant. Paintings, in particular, were integral to the civilization of the medieval West. In catacombs they had accompanied the rise of Christianity in Italy, and St Gregory was one of those who considered them a valuable tool in the work of evangelization, as did St Augustine who, in his mission to the Anglo-Saxons, caused a painting of 'the image of our Lord and Saviour' to be borne with him as a kind of standard. In the centuries that followed, paintings were used in the West to confirm and reinforce the Christian message and later to elaborate on it and to propagate new views. As we shall see in a later chapter on Italy and Sicily, the authority of emperors, popes, and even the doges of Venice was affirmed by means both of paintings and of mosaics. In Italy they were used to give expression to partisan views concerning the conflict between empire and papacy that raged in the later eleventh century and part of the twelfth, and were especially favoured by the Church to promote the idea that it embraced within itself both *regnum* and *sacerdotium* (finding a precedent in Moses' delegation of authority to both Aaron and Hur: Exodus XXIV, 14); to allegorize the supposed oppression of the Church by the Empire; and to symbolize the recently developed view that the emperor's authority rested on papal approval. In more specific areas, we shall see them pressed into service to justify Venice's claims to primacy over Istria and Dalmatia, to express the hostility of popes to anti-popes, to oppose simony (the buying and selling of church offices), and to counter the idea that ordination was valid only if the officiating prelate – in this case the pope himself – was a worthy one. We shall also see visual messages used in Sicily now to support the Norman rule, now to oppose it; now to offer evidence in favour of papal claims to primacy, now to bear witness against them.

Because of their obvious power to impress, the visual arts

were treated with caution by members of the intelligentsia such as the (probably English) author of the late-twelfth-century tract *Pictor in Carmine*.[40] He shared St Bernard's views on their dangers, fulminating against artists who introduced into churches 'meaningless paintings' that were 'not only vain but even profane', and advocating the restriction of pictures in churches to religious themes. In this respect, however, he was more tolerant than St Bernard, who persuaded his Order to forgo paintings of every description; indeed, when English Cistercians took over a church in the twelfth century, they replaced its stained-glass windows with clear glass.[41] St Bernard's influence even extended to the two great Orders of the next century, the Dominicans and the Franciscans, who proscribed any kind of *curiositates* in the paintings of their establishments; ironically, even Abelard, who had been mercilessly hounded by St Bernard for his theological views, forbade Heloïse any artistic adornment other than a painted wooden Crucifix in her own church of the Paraclete.

However, traditional views about the desirability of art continued to hold the field, and they were well expressed by Theophilus, a German contemporary of St Bernard whom we shall meet again. He himself was aware of the sensual attractions of art, but believed – as he told aspiring artists – that all could be dedicated to the greater glory of God, 'who delighted in adornment of this kind':

you have embellished the ceilings or walls with varied work in different colours and have, in some measure, shown to beholders the paradise of God, glowing with varied flowers, verdant with herbs and foliage, and cherishing with crowns of varying merit the souls of the saints. You have given them cause to praise the Creator in the creature and proclaim Him wonderful in His works. For the human eye is not able to consider on what work first to fix its gaze; if it beholds the ceilings they glow like silks [*pallia*];[42] if it considers the walls they are a kind of paradise; if it regards the profusion of light from the windows, it marvels at the inestimable beauty of the glass and the infinitely rich and various workmanship. But if, perchance, the faithful soul observes the representation of the Lord's Passion expressed in art, it is stung with compassion. If it sees how many torments the saints endured in their bodies and what rewards of eternal life they have received, it eagerly embraces the observance of a better life. If it beholds how great are the joys of heaven and how great the torments in the infernal flames, it is animated by the hope of its good deeds and is shaken with fear by reflection on its sins.[43]

In stressing the moral and educative role of art, Theophilus does not overlook the admiration that may be evoked by sheer craftsmanship. Abbot Adam of Eynsham, too, appears to have been open to such feelings: in his life of St Hugh of Lincoln (d. 1200),[44] he reports that in 1199 the saint used the relief sculpture of the Last Judgement over the portal of the conventual church at Fontevrault to illustrate a pointed homily to John, shortly to be crowned king of England, on how kings should conduct themselves if they were to avoid the pains of eternal torment. In it he also observed that, through the skill of the sculptor, the Judgement theme was 'expressed decorously enough by the standards of human

craftsmanship'. Enthusiasm for craftsmanship is frequent in the sources, especially in the eleventh and twelfth centuries, and embraces every field of artistic expression. Appreciation ranges from a nod in passing at the 'most beautiful workmanship',[45] the 'subtle artifice',[46] and so on, to more specific comments. One chronicler, for example, while confessing himself unqualified to describe the workmanship of a precious vestment given to Ely Cathedral by Abbot Leofsige in the second quarter of the eleventh century, yet comments particularly on the highly skilled floral embroidery on the back, and the panelling on the front of gold interspersed with precious stones.[47] Similarly, the description 'wonderfully crafted'[48] applied to a portable altar in gold made at Verdun around the same time is enlarged upon when the writer tells us that he especially admired the subtlety with which the artist had managed to incorporate the motif of the Cross into the decoration.[49] The whole, we gather, was supported on cast metal figures of the evangelist symbols in *contrapposto*.

Many comments on painting are couched only in the most general terms: thus the picture of the donor in the Service Book that Bishop Sigebert of Minden (1022–36) presented to his cathedral is simply said to be 'beautifully and skilfully painted'.[50] Perhaps the most interesting feature of the account by a twelfth-century Jew of Cologne[51] of the pictures and carvings of a church at Münster, including paintings of the Crucifixion and of Christ in Majesty, is that they may have been among the influences that led to his conversion to Christianity: concerning the works of art themselves, he is tantalizingly inexplicit, referring only to their 'ingenious diversities'. William of Malmesbury on the other hand is more forthcoming on the subject of St Dunstan, singling out his ability to 'rival nature by art', and informing us that 'whatever of beauty he saw anywhere he would transform from living being into silent image'.[52]

Such descriptions, however, probably owe more to literary modes than to actual observation, and, in general, the art of our period does not seem to have set much store by realism. Descriptions of it do occur – for example, in Leo of Ostia's account of the Byzantine mosaics at Montecassino to be quoted in Chapter 8 – but in my view we should treat them with caution as relating rather to a literary tradition of word painting than to a genuine visual perception of the writer. The general trend, in fact, was away from the naturalistic towards the more formal and idealized, and it comes as something of a surprise to find Gerald of Wales, in a work written in the late 1180s, placing a premium on realism. He observes that 'a professional painter loses his authority to imitate nature by art if, carefully bringing to light the good features, he bashfully omits the less favourable'.[53] We may perhaps link this comment with the transition from Romanesque to Gothic, but it could itself be no more than a literary device to pave the way for Gerald's verbal portrait of Henry II.

As it happens, Gerald has left us the fullest appreciation we have by a medieval author of the illumination of a manuscript[54] (which will be quoted in a later chapter[55]). It concerns a Gospel Book shown him on a visit to Kildare in Ireland, which he believed to belong to the time of St Brigid (d. *c.* 525). From Gerald's description, its illumination must

have been every bit as spectacular as that of the Book of Kells. He overflows with praise for the artist's skill, and it is clear that what made the deepest impression upon him was the controlled complexity and the exceptional finesse revealed by prolonged contemplation of the decoration; indeed, our sources show that it was frequently the intricate and the minutely executed that awakened the admiration of observers.[56] Gerald also marvelled that the book was 'still so freshly irradiated by the colours' – an enthusiasm for the bright and lustrous that is a commonplace among medieval appraisals of the painter's craft. A pre-Carolingian inscription compares a Christ with saints in an apse to the splendour of the many-coloured rainbow as it shimmers through the haze when dark blue rain-clouds encircle the sky,[57] and Baudri de Bourgueil, describing a comparatively modestly illuminated copy of his own poems in the late eleventh century, hopes that those who are not charmed by its contents will be attracted by its appearance, emphasizing the wonderful brightness of the manuscript and the fact that the letters 'sparkle' and 'laugh' with their brilliant colour.[58] There seems to have been a special sensitivity – notably in England – to iridescences and to the effect wrought upon colour by variations in the intensity of light. A number of the colour words of the Anglo-Saxons were expressive not so much of hue as of nuances of brightness;[59] and in the later twelfth century we find Reginald of Durham rejoicing at the glinting effect produced – admittedly not in a painting, but in a precious dalmatic – through the delicate suffusion of its reddish material by a yellow tincture which makes the red 'shine out the more powerfully and the more brightly'.[60]

There was also a straightforward appreciation of richness of colour, and so it is that we find chroniclers at Cambrai[61] and St Gallen[62] drawing attention to the quality of pigments used in murals there. Certain pigments were noticeably costly, and this was especially true of the sumptuous and highly admired lapis lazuli, which had to be imported from afar. Indeed, so greatly was it prized that we learn from one reliable account that it could pass from one country to another as a much valued gift.[63]

LOST PAINTINGS

Of the multitude of paintings in churches with which the *Libri Carolini*, the *Pictor in Carmine*, St Bernard, and Theophilus were all in their different ways concerned, only a tiny fraction has survived, and these quite random: 'The iniquity of oblivion', wrote Sir Thomas Browne in the seventeenth century, 'blindly scattereth her poppy.' Many were already lost during the Middle Ages. If wall surfaces were damp, the paintings on them simply disintegrated. If pigments were unstable, a sequence could fade, as happened at Petershausen, where a tenth-century cycle was described in the twelfth as being thereby 'deprived of its great beauty'.[64] Shifts of architectural taste could lead to the sacrifice of whole walls with their pictures, and this was particularly true in the period of transition from Romanesque to Gothic. Changes in pictorial fashions, too, sometimes led to the replacement of old paintings by new: at Müstair in Switzerland Carolingian murals were overpainted in the twelfth century, and there are other instances of overpainting at Saint-Léger d'Ébreuil

(Bourbonnais), Saint-Jacques-des-Guérets (Loir-et-Cher), and elsewhere. Fires, endemic throughout the Middle Ages, destroyed many religious buildings, consuming also the paintings on their walls; and later, when iconoclasm at last erupted in the West, with particular virulence in areas of the new reform, Protestants carried out wholesale destruction of medieval paintings. Those that survived were at the mercy of a general indifference which persisted until the nineteenth century, when the renewal of interest often led to restoration that was well-meaning but misinformed. Thus the most important source for a study of religious wall paintings – the paintings themselves – is not only scanty but frequently falsified by restoration and by fading.

The fading makes it difficult for us today to visualize the brightness of a building adorned with medieval murals. 'We reckon that little has been accomplished', said the English chronicler William of Malmesbury in the twelfth century, when contrasting Benedictine buildings with the austere Cistercian ones, '... unless the walls glisten with various coloured paintings' that 'deflect the sun's rays to the ceiling'.[65] In Germany, we have seen how Theophilus, himself an artist, could compare the paintings of a ceiling to the glowing of silks.[66] In Italy, somewhat earlier, the paintings commissioned by Pope Sergius II (844–7) for the basilica of the Holy Archangel at Monte Sant'Angelo, near Rome, were described as shining with light,[67] and in France, even earlier still, the murals of the cathedral of Tours were said to be gleaming, or irradiated.[68] In the wealthier churches, gold added further resplendence. In the tenth century, the monastic church of Petershausen in Germany had a 'likeness of Mary, Holy Mother of God, depicted in gold and the finest colours' above the choir,[69] and the nunnery church of Wilton in England had a wall painting of its patron saint which incorporated gold.[70] In the eleventh century, the ceiling of the church of Beverley[71] and the apse of Montecassino[72] had paintings with an intermingling of gold, and in the twelfth, the nave of Saint-Denis was 'becomingly painted with gold and precious colours'[73] and the walls of the cathedral of Salzburg were adorned from end to end with paintings that glowed with gold.[74]

Wall paintings of our period remain in the smallest and most out-of-the-way parish churches such as those of Santa Coloma and Bagüés in Spain, Fenollar in France, Pürgg in Austria, and Nether Wallop and Clayton in England. Indeed, one is led to the conclusion that there could have been very few Western churches, even in the most remote country areas, without them. They were an essential part of the furbishing of any new or newly rebuilt church, and a feature of any overall scheme of internal decoration.

Their programmes followed the ground rules of the *Libri Carolini* and presented the Christian dogma and the Christian story. Usually, the east end was dominated by the Christ in Majesty of the Apocalypse, with scenes from the Bible and from the lives of saints on the lateral walls. Repetitiveness was not a problem because there were so many scenes in the Bible to choose from, and so many saints to celebrate. Important monasteries and the centres of powerful dioceses had wall paintings that attained much higher levels of sophistication and might reveal considerable erudition. The wall paintings of the chapter house of Brauweiler, near

Cologne, for example, offer a subtle commentary on the eleventh chapter of St Paul's Epistle to the Hebrews, and the murals of the Allerheiligenkapelle at Regensburg, based upon the singling out of the servants of God in the Book of Revelation (chapter VII), were unquestionably devised by a learned theologian. We have already seen how elaborate was the thought behind large wall hangings in churches such as those of the monastery of SS. Udalrich and Afra at Augsburg, and these, in a sense, were costly alternatives to wall paintings.

If the church paintings of our period have fared grievously, secular paintings have suffered to the extent that not a single one is known to have survived. Yet we learn from Paul the Deacon[75] that as early as the late sixth or early seventh century there were in Queen Theodelinda's palace at Monza, in the Lombard kingdom of northern Italy, secular paintings that 'portrayed some aspects of the history of the Lombards'. (Their sociological interest warrants an extended quotation in the notes.[76]) Moreover Gerald of Wales, a well placed cleric in the twelfth century, implied that the artist who painted a church might equally well be painting a palace 'with his wealth of precious colours',[77] and in the same century Samson, the most famous abbot of the great English abbey of Bury St Edmunds, spoke admiringly of the resplendence, the variety of colours, and the intricate beauty of the murals of palaces.[78] Wall paintings, like wall hangings, emerge in contemporary secular poetry as an accepted feature of the furnishings of the wealthy: the *Chanson de Roland* speaks of Marsile being carried to a vaulted and painted chamber;[79] in *Erec et Enide*, Chrétien de Troyes refers to a room embellished with paintings at Castle Bradigant;[80] Baudri de Bourgueil mentions paintings in the reception-chamber of a princess,[81] and Marie de France a lady's room 'painted all around' with pictures on the theme of Venus, the goddess of Love.[82] It may be that surviving twelfth-century secular mosaics in the palaces of Sicily[83] can give us an idea of what some of these lost murals looked like. The mosaics are brightly coloured and fastidiously ornamented, with decorative trees, handsome birds and animals, centaurs, and hunting scenes. Themes of hunting and animals also survive in the secular murals of the first half of the thirteenth century in the tower of the abbey of San Zeno in Verona,[84] together with grotesques and figures paying homage to an emperor.

The techniques of wall painting in our period are an extensive study in themselves, and the interested reader will find them described at some length by Theophilus in his treatise *De Diversis Artibus*.[85] It is a fundamental source for our period, of which we shall hear more again.

WALL PAINTERS

If we can agree that virtually all the churches of the West were decorated with wall paintings, then we must suppose that thousands of wall painters were active between 800 and 1200. Yet only about a score are known by name, and that for two reasons: their work was almost always unsigned; and they were seldom identified by the writers of the period who, by and large, were monks and clerics uninterested in the names of secular painters. When they are mentioned at all, it is usually in the context of miracles, or of lives of saints, or – rarely – in administrative or legal records. There was

besides a tendency to give the credit for artistic accomplishments to the patron rather than to the artist, in accordance with the observation in Boethius's popular *De Institutione Musica* (I, 33) that the person who conceived what was made – in our case the person commissioning it – was much more important than the actual maker. 'For the buildings', wrote Boethius, 'are inscribed and the triumphs held in the names of those by whose rule and reason they were begun, not of those by whose labour and servitude they were completed.' This was bluntly indicated by a chronicler of Bury St Edmunds, who tells us that although death prevented one of the abbey's sacristans, Walter de Banham, from completing a new building, 'yet whatever we see there of marble-work or of gilded statues or of masonry – whether complete or still to be completed – is entirely his work since he paid out all the expenses for them whilst he lived'.[86] The point is reinforced in another characteristic statement: 'If you wish to know who is responsible for such magnificence, which makes this house of God beautiful and radiant, the noble and good Abbot Gauto ... accomplished this whole work for the love of God.'[87] There follows a description of the paintings and a request for a prayer for Gauto, the patron. The painter is not even mentioned. Perhaps the most exaggerated illustration of this attitude is provided by the art-loving Abbot Suger of Saint-Denis in one of the most celebrated art-historical sources of the twelfth century, his *De Administratione*. Suger tells us that, as the patron of Saint-Denis, he had 'portraits' of himself and thirteen inscriptions referring to himself set up in his foundation, yet, although he speaks quite flatteringly in general terms of the artists of the many splendid works he commissioned – referring, for example, to the 'exquisite' work of the painters of glass[88] – he does not name a single one of them.

One fact that does emerge from the written sources is that some of the wall painters were monks. In the ninth century, for example, the monastery of Reichenau lent its wall painters to St Gallen,[89] and later Ekkehard claims that one St Gallen monk, Notker II, 'made many paintings ... on the doors and on the ceiling of the church' after a fire there in 937.[90] In the twelfth century, Walter Map refers to a painter monk (albeit in a scandalous context),[91] and Hugh of Saint-Victor speaks, again deprecatingly, of another who 'paints the deeds of Christ upon the wall, but would that he held them in his mind that he might know how to "paint" them ... by his example and habits!'[92] Theophilus's twelfth-century treatise on the techniques of all the arts was, of course, specifically written for monks, and we may perhaps note that he devoted a good part of the first of its three books to the art of wall painting.

When all this has been said, however, the number of cowled wall painters working at any one time must have been tiny in relation to the overall numbers of wall painters in the West. Indeed, such artist monks must have been few, *tout court*, since the communities to which they belonged were frequently of modest size. The ninth-century plan of St Gallen postulated only some seventy monks, and according to Riché, other great Carolingian monasteries numbered from seventy to a hundred and twenty.[93] The pre-Conquest monasteries of England were even smaller. Knowles points out that, before the Norman Conquest, the average

membership of two of the most important – the Old and New Minsters at Winchester – was about fifty and about forty, and that on the eve of the Conquest 'almost all the monasteries would seem to have been smaller than this ... and Evesham and Worcester ... were reduced to a dozen monks'.[94] When monastic houses increased in size in the twelfth century, so did their wealth, which led to the growing employment of paid professionals. The artists called in by Suger to paint the walls and windows of Saint-Denis in the 1140s seem to have been secular,[95] and the wall painter depicted in a manuscript of a Canterbury monastery a few years later[96] [353] certainly was. So was a contemporary glass-painter in the Premonstratensian house of Arnstein in Germany, as we can see from his self-portrait[97] [396]. The numbers of painter monks must therefore have been few, and even so – as Hugh of Saint-Victor sharply pointed out – it was not their business to wander abroad with paint-pot and brush but to follow their vocation in the cloisters.

Such painter monks as there were did not necessarily learn their craft in a monastery. Brother Bertold who, the chronicler tells us, painted the new monastery of Zwiefalten, together with the chapel of St Michael, for its dedication in 1109,[98] is described as *Magister pictor* in the community's Book of the Dead,[99] which seems to indicate that he had originally been a secular artist. Some skilled craftsmen certainly joined religious communities in their mature years, among them a trained, but unnamed, turner at St Blasien in the Black Forest,[100] an experienced metalworker called Godric at Evesham,[101] and a glass-worker, Daniel, who had a wife and son before entering the monastery of St Benet's in Norfolk[102] and eventually becoming its abbot.

Religious communities – especially new foundations – had a particular interest in attracting craftsmen. Thus when Bernard, the former abbot of Quincy, set up the house of Tiron, near Chartres, in 1141, he let it be known that craftsmen who became monks could continue to practise their skills. As a result, 'there readily came to him ... goldsmiths, painters, and masons ... and others skilled in all kinds of crafts'.[103] Again, the Italian abbot William of Volpiano had been joined in his rebuilding of the abbey church of Saint-Bénigne at Dijon just over a century earlier by Italians who 'were experienced masters of various crafts ... and whose skill and ingenuity were of great use to this place'.[104] One established community is even alleged to have recruited a craftsman in a more dubious manner, for at the turn of the eleventh and twelfth centuries, the secular canons of the cathedral of Avignon lodged a formal petition against the regular canons of Saint-Ruf on the grounds that a painter of theirs had been secretly seduced 'with enticements, a show of complaisance and great promises' and had been spirited away to join the Saint-Ruf community.[105]

The document concerning Saint-Ruf is particularly valuable in providing information about how an artist might be trained in the later eleventh century. The painter's father had apparently sent him as a boy to a relative who would bring him up to practise the craft. This he did, also hiring other masters to teach the boy their particular skills – in noteworthy contrast to the later apprenticeship system in western Europe whereby boys were placed in the household of a master to acquire their craft. It is also interesting to learn

of the effort that was made to give our painter a grounding in a broad variety of artistic techniques; it may indeed have been the many-sidedness of his talents that attracted the attention of Saint-Ruf. The relative who fostered the painter, we are told, later decided to take to a life of religion and became a canon of Avignon Cathedral. The young man, after going away on a pilgrimage, also directed his steps to the cathedral, and 'gave himself over to God, to the Blessed Mary, and to the provost of that place', becoming attached to the community but apparently not a full member. A room was granted him, and he was permitted to eat his meals with the chapter if he so wished. It was three years later that he became the target of the rival house's attentions.

Guibert, the learned abbot of Nogent-sous-Coucy (1053–1124), relates in his autobiography[106] another story concerning a painter who shifted his theatre of operations. He was a wall painter who, after leading a frivolous life as a cleric at Reims, became a regular canon of the church of All Saints at Châlons-sur-Marne, returned to Reims to marry and beget several children, and finally, after a long illness, became a monk at the abbey of St Nicasius, where he died. Guibert speaks highly of his prowess as an artist, but is not flattering about him as a scholar ('mediocriter literatus at pingendi gnarus'); and at Auxerre in the eleventh century, too, Bishop Geoffrey (1052–76) appointed some of his canons entirely on the strength of their craftsmanship, securing by this means an experienced painter, a clever glass-worker, and a marvellous goldsmith.[107] Other artist canons were, however, academically inclined. Indeed, his own scholarship embittered Peter the Painter, a canon of Saint-Omer in the early part of the twelfth century, for he had supposed that it would secure him a bishopric, realizing too late that it was lining the right pockets and not reading the right books that led to such preferments. Peter tells us that he dedicated his days to painting religious subjects and his nights to writing poetry,[108] yet 'their elegance brings no benefit to me'. An earlier presumably educated painter canon, once a canon of Trier, became the chaplain of the Anglo-Saxon nunnery at Wilton for ladies of the aristocracy. His name was Benna, and he was 'renowned as a splendid designer of pictures'; we are reliably informed that just before 984, when the church was dedicated, he made wall and ceiling paintings of Christ's Passion and of the patron saint of the nunnery church, in gold and azure 'and many other colours'.[109] We know of Benna because Edith, one of the nuns of Wilton at the time, was a king's daughter who was later thought to be a saint, and her life was written up by a pious and (fortunately for us) prolix Fleming who did not omit Benna's artistic talents from his account.

Thus, the information we have about religious wall painters is chiefly anecdotal, but at least we learn from it that some were monks and others canons, that a number worked in more than one centre, and that some were trained in the secular world.

It has already been noted that the writers of our period were drawn chiefly from the church and the monastery, so that it is about artists from those two spheres that we know the most. Yet common sense dictates that the wall painters of the West must have been largely secular. We have – as we shall see – only a few crumbs of information about them, including the facts first that a survey of Winchester of 1148

mentions four secular painters there[110] (in the thirteenth century there was a female painter at Winchester, Agnete la Peynteuresse[111]), and second that documents relating to Canterbury in the period 1153–1206 refer to five painters by name.[112] More obliquely, the sheriff's accounts for the reign of Henry II (1154–89) speak of payments made for painting the king's chambers at Clarendon and Winchester[113] (the theme of the Winchester painting is outlined in Chapter 12), and also of colours for painters being sent by order of the king to Woodstock,[114] though here we cannot tell exactly what the word 'painters' means.[115]

The name of one secular artist of France is known because a copy of his terms of service has chanced to survive.[116] It tells us that at some time between 1082 and 1106 'a certain man called Foulque, well versed in the art of painting', promised Girard, abbot of Saint-Aubin at Angers, and his community to 'paint their whole monastery and anything they instruct him to paint', and also to make glass windows (whether they were to be of stained glass is not clear, though a Zwiefalten contemporary[117] seems to have been a painter both of walls and of stained glass). In exchange, Foulque was to be granted a house and a small vineyard for life. Comparable arrangements were made with other craftsmen – particularly masons – as we learn from records pertaining to St Albans in England[118] and to Grenoble in France,[119] where a particular post was kept in one family, as it was intended that Foulque's should be. Foulque was to become a free man of the abbot's. This seems to imply that he had so far been a serf, a term which carried different connotations at different times and in different countries in the Middle Ages, but during our period applied to most of those working on manorial estates, and probably also to most of the skilled artisans on agricultural estates – smiths, wheelwrights, etc.

Foulque's contract shows that, as well as acquiring craftsmen by attracting them to their religious Rule, monasteries could employ them on normal feudal terms of service, and Suger's record of his administration tells us of another way in which they could be retained: he rewarded a specialist for the maintenance of the stained glass of Saint-Denis with a prebend, with 'coins from the altar, and with flour from the common storehouse of the brethren'.[120]

Foulque is frequently quoted, but there is no reason to suppose that he typified the secular wall painters of our period in terms of class. Some could even be landowners in a small way, as is proved by an English document of between 963 and 992 which refers to a painter called Wulfnoth who could dispose of fifty-five acres of land in Northamptonshire,[121] and by a German mention of a painter named Heribert who was able to sell seven acres of land to the abbey of Klosterrad in 1137.[122] Our four painters of Winchester, too, were free tenants of the city, and so were the five of Canterbury. Other twelfth-century English painters of good standing were Reinald, Hascuil, and Walter, mentioned in connection with the monasteries of Colchester and Kirkstall,[123] and at Chur in Switzerland a twelfth-century painter, Lopicinus, was well enough thought of to be commemorated in the church's *Liber Anniversorum*.[124] However it would be dangerous to generalize on the basis of the information we have, for across four centuries and all the countries of the West there must have been secular wall painters of all kinds and conditions.

THE COSMOPOLITANISM OF PAINTING

Though parochial at village level, higher up the social ladder the medieval West was international, and this is reflected in its art. In the seventh century, Benedict Biscop brought glass-workers from Gaul to England, and travelled five times from the northern edge of Christendom to Rome in search of paintings and vessels for his two Northumbrian churches of Wearmouth and Jarrow.[125] In the eighth and ninth centuries, illuminated manuscripts were making their way from Italy both to the British Isles and to the heartland of the Frankish empire, and in the tenth and eleventh they were passing between England, France, Germany, and Italy. The fact that, in the twelfth century, icons made by Westerners in Jerusalem were to be found on Mount Sinai[126] [240] typifies the cosmopolitanism of the period, which is engagingly described by Theophilus in his treatise:

you will find in it whatever kinds and blends of various colours Greece possesses: whatever Russia knows of workmanship in enamels or variety of niello: whatever Arabia adorns with repoussé or castwork, or engravings in relief: whatever gold embellishments Italy applies to various vessels or to the carving of gems and ivories: whatever France esteems in her precious variety of windows: whatever skill Germany praises in subtle work in gold, silver, copper, iron, wood and stone.[127]

Artists too travelled from place to place. In the cathedral of Tournai, for example, were twelfth-century wall paintings by an artist who also worked at the monastery of Knechtsteden, near Cologne,[128] and in the same century masters from England were painting at the nunnery of Sigena, in Aragon.[129] The artist responsible for the apse of San Clemente de Tahull in Catalonia went on to paint part of the cathedral of Roda de Isábena in Aragon,[130] and the master of the apse of Santa María de Tahull worked later on the murals of the chapel of the Ermita de la Vera Cruz at Maderuelo in Castile.[131] The lesser paintings of both San Clemente and Santa María were made by the same minor, no doubt local, artist: travel was for the more talented. Glass-painters too could be peripatetic. In the eleventh century, one named Roger went on from Reims to work at Saint-Hubert in the Ardennes,[132] and Grodecki draws attention to an artist of the early thirteenth century, just outside our period, who made stained glass for both Bourges and Poitiers.[133] We know too from the occasional written record that in the early ninth century an abbot of Saint-Wandrille at Fontenelle sent to the church of Cambrai for a wall painter named Madalulfus;[134] that in the tenth, Tuotilo, a painter monk of St Gallen, was (or was later thought to be) 'a much travelled man with extensive knowledge of places and cities';[135] and that in the eleventh an artist came to France from Italy in order to make murals for the monastery of Saint-Benoît-sur-Loire.[136] Another artist who crossed the Alps to execute wall paintings for Otto III at Aachen[137] was later to work in Flanders;[138] he was clearly a cleric, for he was rewarded by the emperor with an Italian bishopric. Finally, in the twelfth century, Suger summoned 'the best painters I could find from different regions' for wall paintings at Saint-Denis, and 'many masters from different regions' for its stained-glass windows.[139]

Personal recommendation must have played a part in all

this, and indeed a letter survives from Einhard, one of Charlemagne's 'ministers', asking Count G. 'to find occupation for the painter N ... and to intercede for him with our lord the Emperor'.[140] Another, dated 1081, from Conrad, bishop of Utrecht, recommends to Rupert, bishop of Bamberg, a craftsman of unknown specialization who 'has served me faithfully and well, and is a good Christian'.[141] Finally, in recommending Master G.'s son as a monk, Bishop Stephen of Tournai (1191-1203) writes to the abbot of St Bavo in Ghent that Master G. (perhaps a painter)[142] is distinguished by a talent that is demonstrated by his magnificent works in public and religious buildings.[143]

PORTABLE PAINTINGS

Paintings were also executed on portable objects. Secular romances and historical chronicles refer for example to painted saddles: one twelfth-century sermon complains of their use by clergymen,[144] and Theophilus's treatise advises on how to adorn them with 'figures or animals or birds in foliage'.[145] Chairs sometimes had paintings, too, and so did small chests. Rosamund, the beautiful mistress of England's King Henry II – remembered in her epitaph as 'not a pure rose but the Rose of the world' – owned a casket decorated with 'champions fighting, animals in action, birds flying, fish leaping...',[146] though painting is not specified. At Vannes, however, is a fortunate rare survival: a twelfth-century *coffret de mariage* painted with secular scenes of falconing and knighthood, and of a youth serenading a lady.[147]

But our main source for paintings is manuscripts which, tucked away as they were in libraries, usually escaped the excesses of Protestant zeal. Their paintings were sheltered from the light, and are therefore normally in pristine condition. There are very many of them, of every type and kind, differing in quality from the incompetent to the masterly, in purpose from the decorative to the illustrative, in size from the tiny to the immense, and in distinction from the humdrum to the luxurious. Another great advantage they have for us is that, unlike other types of painting, they can be approximately dated from the scripts of the volumes which they embellish.

To study the paintings of manuscripts in isolation would have appeared to their original owners extremely odd. For them, the illuminated manuscript, and especially the luxury manuscript, was an artistic whole, in which the binding and calligraphy were every bit as important as the paintings. Indeed, the chief interest of manuscripts for the vast majority of medieval writers was their costly bindings, and there is nothing untypical about the ninth-century chronicler of Regensburg who refers first to the gold and jewelled bindings of manuscripts, then to their calligraphy, and to their paintings last of all.[148] A chronicler of Tegernsee speaks only of the 'gold and silver binding and fine script' of the great Bible presented by his house to the Emperor Henry III in 1054,[149] and a chronicler of Merseburg concerns himself with the sumptuous binding alone of a Gospel Book given by the Emperor Henry II.[150] Almost all such precious bindings mentioned in the records of our period have disappeared. Of eight that survive we shall hear in later pages.

The interest of contemporary writers in the scripts of our period is well deserved. Carolingian calligraphy was of such elegance that it was copied by the humanists of the Italian Renaissance and became the basis for the earliest Italian printing, and the later Romanesque script, combining as it does a bold harmony with a decisive clarity, is one of the most handsome of all time. The work of the scribes was very highly valued by their contemporaries, who praised them in their chronicles and gave them a place in their dedication pictures rarely accorded to the illuminators; indeed, one of the most monumental 'portraits' of our period is that of a scribe [359]. The concentration in this book on the paintings of manuscripts would have been incomprehensible to a medieval observer, who would have considered it a form of visual dismemberment.

The forty-eighth chapter of the Rule of St Benedict, which guided most of the monks of the West, laid it down that idleness was the enemy of the soul, and that the brothers should therefore occupy themselves at certain times in working with their hands, and at others – even more important – in holy reading, for which ample opportunity was afforded. Books were therefore clearly of the greatest importance, yet monastic writers showed little interest in the artists who painted them. The reasons for this are basically two: if the artists were secular, they were no more than hired craftsmen; and if they were religious, they were expected to practise a diffidence which, in effect, meant anonymity – indeed, chapter 57 of the Rule speaks of the special need for humility in the monk-craftsman. Yet, luckily for us, there were some writers more anxious to record the accomplishments of their houses than to keep too literally to the injunctions of St Benedict, and others so concerned to extol a canonized monk or nun that – though, as we have earlier said, we should treat with special caution remarks associating works of art with venerated persons – they would reveal details of the saint's artistic pursuits that would not otherwise have come to light. Only very rarely are the illuminations themselves 'signed'.

Artists' signatures in medieval manuscripts were not, however, the statements of individuality they were later to become (and indeed few of the 'signed' works were by artists of any real talent): they were instead either requests to the beholder to say a prayer for the artist's soul, or supplications to God and his saints to look benevolently on his offering. This is illustrated with particular vividness in a picture with a pronounced element of wish-fulfilment in a German manuscript of the twelfth century[151] [27]. Here, the scribe-artist lies on his death-bed, and in front of him the illuminated manuscript he has made is being placed by an angel on the scales, where it helps his virtues to outweigh his vices – to the discomfiture of the lurking devil and the satisfaction of God above. A comparable sentiment occurs in an anecdote

27. Prüfening: *Judgement of a scribe-artist*, from Isidore of Seville's *Etymologiae*, Clm. 13031, folio 1. Probably 1160/5. Munich, Bayerische Staatsbibliothek

28. Echternach: *The Echternach scriptorium*, from the *Pericope Book of Henry III*, MS. b.21, folio 124 verso. 1039/40. Bremen, Stadtbibliothek

SCRIPTORIS·MISERI·DIGNARE·DS·MISERERI·NOLLCVLPARY· QVOND·PENSARE·MEARY·
PARVA·LICEL·BONA·SINLSVP·ERALTATAMALISИ· NAR·LVCI·CEDAL·VITE·MORS·

ISTE·RE GFD·XП·

recounted by the Anglo-Norman monk Orderic Vitalis,[152] who says that 'the venerable Thierry', abbot of Saint-Évroul in Normandy, urged his young monks 'repeatedly to avoid mental sloth which could harm body and soul alike [and] he used often to tell the following story':

In a certain monastery, there dwelt a brother who had committed almost every possible sin against the monastic Rule; but he was a scribe, devoted to his work, who had of his own free will completed a huge volume of the Divine law. After his death, his soul was brought for judgement before the throne of the just Judge. Whilst the evil spirits accused him vehemently, bringing forward all his many sins, the holy angels showed in his defence the book that he had written in the House of God; and the letters in the huge book were carefully weighed one by one against his sins. In the end, one letter alone remained in excess of all the sins; and the demons tried in vain to find any fault to weigh against it. So the Judge in his mercy spared this brother, and allowed his soul to return to his body for a little while, so that he might amend his life. Bear this in mind, my dearest brethren . . . and offer the works of your hands to the Lord God as a never-ceasing sacrifice.

Many manuscripts between 800 and 1200 were illuminated by secular artists – indeed, our period opens with lay illuminators at Charlemagne's court, and closes with secular practitioners very much in the ascendancy. However, the evidence that we have suggests that, between 800 and about 1150, most of the paintings and drawings in manuscripts were made by members of religious houses. Some were colleges of canons – we find bishops such as Godehard of Hildesheim (1022–38)[153] and Imad of Paderborn (1051–76)[154] encouraging both calligraphy and illumination among their cathedral clergy – but the majority were monasteries and, occasionally, nunneries: in tenth-century England, as we shall see, the nun Edith at Wilton was said to be an illuminator;[155] a roughly contemporary Spanish nun, called Ende, illuminated the Gerona Apocalypse;[156] and in the second half of the twelfth century a nun in the area of the Middle Rhine left a small picture of herself inside an initial with the inscription, 'Guda, the sinful woman, wrote and illuminated this book.'[157] Until about 1150, monasteries were the most important centres of illumination, supplying both their own needs and those of others, for emperors, kings, and potentates usually looked to them for their *manuscrits de luxe*. There are, of course, many exceptions, and caution should be exercised even in respect of monasteries, for laymen and monks sometimes worked alongside there; for example, an eleventh-century picture of the scriptorium of the monastery of Echternach shows a secular artist painting and a monk writing[158] [28]; a Bohemian manuscript of the twelfth century portrays the artist as a secular and the scribe as a monk;[159] and, again, in a series of German drawings of various crafts[160] the illustrator of a manuscript is represented as a lay person and the scribe as a religious [29].

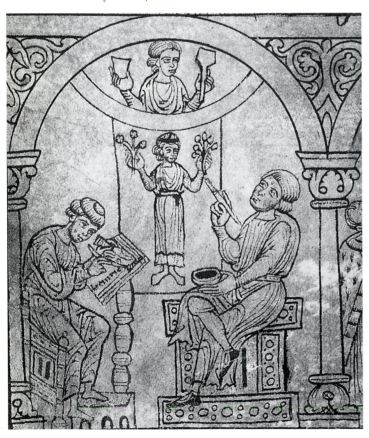

29. Rein: *A scribe and artist at work*, from MS. 507, folio 2 verso. Early thirteenth century. Vienna, Österreichische Nationalbibliothek

THE MOVEMENT AND VIRTUOSITY OF SOME MANUSCRIPT PAINTERS

The secular artist of the Bohemian manuscript was probably trained in Cologne,[161] and there is occasional evidence of the movement of other secular illuminators in the twelfth century. One – the Ávila Master – worked both in the Roman region and in Florence[162] (an Italian illuminator, perhaps a cleric, had earlier worked in Milan and France[163]), an English artist practised in Canterbury as well as Liessies,[164] and yet another illuminator left examples of his workmanship in England and France.[165] On rare occasions, even artist monks might travel to foreign monasteries, for in the eleventh century, Anglo-Saxon artist monks were working in France.[166]

There is some slight evidence of artists practising two crafts. The tenth-century Swiss chronicler Ekkehard, for example, though often more colourful than accurate, asserted that Notker of St Gallen 'illuminated various books'[167] besides, as we have seen, claiming him as a wall painter, and Foulque, the artist of Saint-Aubin at Angers also mentioned earlier, is believed by some to have painted both manuscripts and walls.[168] What is more certain is that miniaturists at Winchester in the later part of the twelfth century made wall paintings at Sigena in Spain,[169] too, and a later chapter will introduce a very rare miniaturist who was also a painter of glass.[170]

Over our four-hundred-year period we can assume a certain amount of versatility among the more talented artists. In the tenth century, for example, the monk Tuotilo of St Gallen was apparently both illuminator and carver[171] (as was Sawalo of Saint-Amand in the twelfth century[172]), and the

30. Roger of Helmarshausen: *St Philip the Apostle*. Detail of the portable altar. *c.* 1100. Paderborn Cathedral Treasury

Anglo-Saxon nun Edith of Wilton was said to have practised both illumination and embroidery.[173] Quite a few illuminators were also calligraphers;[174] in England alone, in the tenth century at the monastery of Glastonbury St Dunstan 'diligently cultivated the art of calligraphy ... and also of painting',[175] and in the eleventh, at the monastery of Peterborough, St Wulfstan's tutor, Ernwig, was 'greatly skilled in calligraphy and in making coloured paintings'.[176] In eleventh-century Germany, Bishop Godehard apparently ensured that the community at his newly established monastery of the Ascension at Hildesheim included some monks skilled in calligraphy and painting,[177] though not necessarily in both.

Besides the natural relationship between those who illuminated books and those who copied them out, there may well have been an affinity between the illuminator and the goldsmith. The illuminator, after all, used gold in his most precious paintings, and there was also a good chance that the more costly manuscripts on which he worked would be bound by goldsmiths in silver or gold. My own belief is that, very occasionally, the illuminator was himself a goldsmith. My evidence must concentrate on saints and prelates because they are the focus of attention of the written sources: but we can surely assume that there were others like them among the uncanonized and unbeneficed. In eleventh-century Germany, then, St Bernward, bishop of Hildesheim, practised both painting and metalwork;[178] in what is now Austria, Thiemo, archbishop of Salzburg, was skilled in both painting and engraving;[179] and in France, Abbot Adelard II of Saint-Trond,[180] in Bohemia, Abbot Reginhard of Sazawa,[181] and in England, Abbot Spearhavoc of Abingdon[182] and Abbot Mannig of Evesham,[183] were all painters as well as engravers. Exceptionally, at Tegernsee, the chronicler draws attention to a humbler practitioner of both crafts, a monk named Wernher, or Weczil, whose delicacy in fashioning gold and silver decorations for book-binding was singled out for praise.[184] Also exceptional are the secular Hugo of Bury St Edmunds in the twelfth century, mentioned as an engraver and illuminator,[185] and his predecessor Wohancus, who also apparently commanded both skills,[186] as did an unnamed commercial artist referred to in the context of a miracle at Durham of about 1170.[187] Again, the painter Albericus and the goldsmith Albericus mentioned in Canterbury documents of the second half of the twelfth century[188] may possibly have been one and the same person.

There is, of course, some affinity between the art of engraving, where one begins by scribing, and the art of illumination, where one begins with a preliminary drawing: this will become instantly apparent if we cast an eye over some of the engraved work of our period – the back of the eleventh-century imperial altar cross in Vienna, for example, or the engraved Christ in Majesty on Roger of Helmarshausen's portable altar of about 1100 [30]. Later pages will show how closely the illumination of one or two Western areas – particularly the Meuse Valley and Saxony – could approximate to goldsmith's work. Particularly interesting is the case of Eilbert of Cologne's portable altar of about 1160, for which he summoned up all his celebrated skills in engraving and *champlevé* work yet chose as the centrepiece of the top surface a vellum painting of Christ in Majesty with evangelists, set under rock crystal between metal-engravings of apostles and Christological scenes [31].

STYLISTIC TRENDS OF THE PERIOD

The Carolingian painters of the beginning of our period could still draw on an inheritance which included many of the realistic elements of late Antiquity: they could represent weight and mass, register recession in space and perspective in architecture [39], and convey a feeling of atmosphere [44]. Indeed, artists were always capable, when they chose, of realistic likenesses. Even among very formalized works we can find portraits – like that of Desiderius, the aristocratic abbot of Montecassino, at Sant'Angelo in Formis [154] – which register both physical appearance and character. Particularly interesting in this regard is the information that, in the early twelfth century, a picture of Anselm of Canterbury, then a fugitive, was sent across Europe so that he might be apprehended on his way across the Alps;[189] here we can assume that the circumstances dictated a very good likeness. Some illustrated books on plants have pictures which are astonishingly true to life,[190] and they would need to be if the herbs portrayed were to be used for medicinal purposes. They may have derived from antique models, but the chronicler Visselbeccius records that in Germany in 1131 a painting of a flower was specially commissioned because of its botanical interest as a hybrid.[191] On the whole, however, the artists of our period were not much motivated by the desire to capture likenesses.

31. Eilbert of Cologne: Top surface of the portable altar. *c.* 1160. Berlin, Staatliche Museen

In the twelfth century, Abbot Ailred of Rievaulx delivered a sermon based on the text from Genesis that man was made in the image of his maker.[192] The theme was by no means new, and Ailred, of course, was concerned with its spiritual aspects. What is striking for us is that he deliberately took an analogy from art, drawing a distinction between the painting of an image and the painting of a likeness. It was the image, not the likeness, that primarily concerned the painters of our period – man in his essence, not man in his outward and changeable features – and this reflected the traditional theological teaching that the external was only a husk masking the kernel of the true reality within. This was the basis of almost all interpretations of the Scriptures during our centuries, becoming an accepted part of the thinking of the educated classes. Although such an attitude may seem remote to us today, it yet has its parallels with an established form of modern medical practice, namely psychoanalysis. Like medieval theology, psychoanalysis assumes that what appears on the surface (in this case the statements of patients) is but a veil for deeper significances which a trained mind can discover. Like medieval theology, it supposes that the ostensible is of less value, and is less true, than the hidden meanings, and it is much concerned with initiating the novice into a new language. Of course, there are vast differences between the goals of the two: the medieval thinker was striving to discover the profundities of the Christian message; the modern psychoanalyst is concerned to improve the emotional and mental health of his patient. Nevertheless, they share the view that there are deeper meanings to be retrieved by the trained observer from below the surface of things.

Given these medieval attitudes, stemming from attempts to uncover the veiled meanings of the Bible, it is no accident that artists should conceive of outward appearances as being superficial, if not actually misleading. As a result, they were already in the Carolingian period discarding elements of realism, repudiating feelings of weight and space, and transforming to rhythms and patterns the subtleties of atmosphere. The early classicizing phase to be discussed in the next chapter, though important, was but an interruption of a basic process which led artists to become less and less concerned with accidental externals and which – as we shall see – was to continue to evolve towards an art that was abstract in a double sense: in its preoccupation with capturing the spiritual and emotional forces behind reality, and in its interest in interpreting figures as reflections of the rhythms and cadences of God's eternal universe.

Painting during our period seems to progress by fits and starts, but the abstract remains its goal. The development reached its first summit in Germany in the eleventh century in a style of great originality and power which, though the obverse of classical Roman art, has become known as Romanesque. It was a style that was to spread in various manifestations throughout the length and breadth of the West and to leave its imprint on most of the art surveyed in this volume.

The Carolingian Renaissance

ITS SIGNIFICANCE

Walafrid Strabo, the ninth-century poet and abbot of Reichenau, in the prologue to his edition of Einhard's *Life of Charlemagne*, remarked of the emperor that 'he made the gloomy and virtually blind reaches of the kingdom committed to him by God, radiant with the fresh light of all types of learning, a light hitherto unknown to our barbarism'.[1] This praise could well be extended beyond the field of scholarship to that of the visual arts, to which also Charlemagne brought new vigour and life in his dominions north of the Alps. Frankish art, earlier sparse and of little distinction, now quite unexpectedly burgeoned forth with a vitality which lasted for more than a century, from Charlemagne's accession as king of the Franks in 768 to the death of his grandson, the emperor Charles the Bald, in 877.

Rome of course had already experienced renaissances (as, for example, under Augustus and Hadrian), turning for inspiration to Greece as later ages were to turn to Rome, and in England, too, during the so-called Dark Ages, there was the seventh-century Northumbrian Renaissance which was itself a significant factor in kindling the literary culture – and to some extent the arts – of Charlemagne's revival. But what is remarkable about the Carolingian Renaissance is that the Franks, a people with only a tenuous artistic tradition, suddenly produced art of outstanding quality in many media and continued to do so for decades. Hitherto, with occasional exceptions such as the Luxeuil manuscripts, Frankish painting had consisted largely of laborious drawings and initials.[2] Now, under Charlemagne and his successors, there was an outpouring of remarkable metalwork, splendid painted manuscripts, and fine carved ivories of which the sheer abundance is amazing when we compare the volume that has survived with the untold losses that must have been sustained through the ravages of time and the destruction wrought by the Vikings and other invaders. Literary sources moreover indicate that churches and palaces were covered with scores of wall paintings, now perished.[3]

WALL PAINTINGS

Charlemagne was himself interested in the wall paintings of churches, and instructed his agents, the *missi dominici* who travelled throughout the empire, to report on their condition.[4] Although few such murals survive, records of their inscriptions, or *tituli*,[5] make it clear that their chief subject matter was Bible stories and episodes from the lives of saints. Charlemagne, for example, caused scenes from the Old and New Testament to be painted on the walls of St Mary the Virgin at Aachen,[6] as did his successor, Louis the Pious, at Ingelheim.[7] More common, however, as at Dijon[8] and St Gallen,[9] were scenes from the New Testament alone. Pictures of Christ were popular too, either unaccompanied or with evangelists or apostles, as were those of saints and episodes

from their lives. At Holzkirchen there was even a painting of the martyrdom of the Anglo-Saxon missionary St Boniface,[10] which took place in 754, only fourteen years before Charlemagne's accession.

The numerous surviving descriptions and *tituli* are almost all religious, and even the few secular paintings of the Carolingian period may have had religious overtones: the picture of the seven liberal arts in Charlemagne's palace at Aachen,[11] for example, may have illustrated the general view that they formed the basis of theology and, indeed, of all education; and the paintings of the great heroes of the past in Louis the Pious's palace at Ingelheim[12] probably reflected the Christian understanding of history, as proposed by St Augustine and elaborated by Orosius, which contrasted the pagan leaders – here represented by Romulus, Remus, Hannibal, and Alexander – who had brought pointless bloodshed into the world with Christians (here Constantine, Theodosius, Charles Martel, Pippin, and Charlemagne), who waged war in order to bring pagan peoples into the Christian fold.[13]

In spite of countless losses, fading, partial destruction, and restoration, the few Carolingian wall paintings that survive confirm that they depended to a large extent on the traditions and expertise of the one country of the West that had always cultivated wall paintings (and mosaics) – Italy.

In the west crypt of Saint-Germain at Auxerre are the only Carolingian wall paintings remaining from the part of the empire that was later to become France.[14] They belong to the second half of the ninth century, probably the third quarter. The main sequence shows three episodes from the martyrdom of St Stephen: he is brought to trial, preaches to the Jews, and is finally stoned to death as he turns with outstretched arms towards the hand of God. The four nimbed bishops probably represent saints buried in the church. The style has some freshness, and is related to manuscript paintings of the Court School of Charles the Bald that will be discussed later. Charles had close ties with Saint-Germain, for he took a prominent part in the translation of the body of the saint, he was a generous donor to the abbey, he often resided there, and he even sent his son Lothar to be educated at its school.[15]

From these fairly securely dated wall paintings we travel east to the Johanneskirche at Müstair in the canton of Graubünden, in what is now Switzerland, to murals difficult to date because of the lack of comparative material.[16] No other Carolingian building has such a profusion of illustration as Müstair. The whole interior was painted in the Carolingian era, though some of the existing paintings belong to the twelfth-century redecoration of the east end. However, since some of the Romanesque work has perished or been removed, significant areas of the original Carolingian programme are again open to view. On the east wall before the three apses was an Ascension, removed – as was a series in the nave on the history of David and Absalom – at the beginning of the twentieth century to the Landesmuseum at Zürich. Still on

the nave walls are a great many of the original sixty-two Christological scenes, disposed in four registers. On the west wall is a grandiose Last Judgement. The three apses had episodes from the lives of the saints to whom they were dedicated – John the Baptist, Peter and Paul, and Stephen – and a number of them are still visible, side by side with areas of Romanesque painting. The compositions of the semi-domes are entirely Carolingian, and they all focus upon Christ. On the middle one is an imposing standing figure of Christ surrounded by the symbols of the evangelists and by choirs of cherubim; on the north side, crowning the scenes of St Peter and St Paul, Christ invests the two apostles with their respective missions; and on the south side is a symbolic gemmed cross with at its centre a medallion containing the bust of the Saviour, and at its four extremities further medallions with busts of Peter and Paul, an angel, and (perhaps) Ecclesia. Throughout the church, decorative borders surround the scenes, some filled with perspectival meander patterns, some with mask-heads at the corners. The heavy browns and muddy greens that are almost all that is left today of the colours make aesthetic assessments of the originals difficult, but it is clear from the heavy modelling of the faces in green, and from the occasional pearling of borders and draperies, that they must have related to Italian painting of the period – they may even have been made by Italian artists.

32. Mals (Malles), San Benedetto, *Donor Portrait*. Wall painting. Second half of the ninth century

The paintings on the north wall of a chapel dedicated to St Benedict at Mals (or Malles)[17] in the Italian Tyrol, once a dependency of Müstair, consist of two zones of which the lower has almost entirely perished. In the upper are scenes from the life of St Paul, the martyrdom of St Stephen, and figures of St Gregory and three other *tonsurati*. St Stephen and St Gregory reappear on the east wall together with a portrayal of Christ, and three other figures are painted in the three altar niches. On panels between the niches are two donors, one in contemporary dress holding his sword, the other a priest offering a model of the church [32]. Donor portraits belong to a long Italian tradition. These are impressive examples, in a style mingling Carolingian art with the indigenous traditions of northern Italy. They are attributed to a period before (Grabar[18] thinks probably not long before) 881.

The more primitive paintings of Naturno (or Naturns),[19] also in the Italian Tyrol, reflect transalpine influences still more strongly. In red, blue, and black, they are more like outline drawings than paintings, and their most natural relationship is with the early manuscript paintings of Salzburg which, as we shall see, were strongly influenced by missionary art from the British Isles. The main surviving scene – St Paul escaping in a basket over the city wall of Damascus – has a certain child-like vigour but is clearly a peasant work without pretensions. Stylistically it seems to belong to the end of the eighth or the beginning of the ninth century, but there is no knowing how long such rustic art may have survived in isolated villages.

Further north, on the soil of present-day Germany, two buildings attract our interest. The first is the Torhalle, or Solarium, of Lorsch,[20] which has on the upper floor restored *trompe-l'œil* architectural wall decoration of painted columns, bases, Ionic capitals, and a moulded architrave. Excavations of the crypt brought to light a few fragments of painted heads, comparable to the eighthcentury murals of Santa Maria Antiqua in Rome, which may not belong to the Torhalle. The second building is the crypt of St Maximin at Trier.[21] On the end wall is a large Crucifixion; on the socle before it two rows of nimbed male and female figures carry palms under a colonnade; and in the vault are painted figures including a standing prophet and two seated evangelists. The linear quality of the Trier murals relates them stylistically to Carolingian illuminated manuscripts, but iconographically they derive from an Italian tradition of monumental mosaics or paintings.

CLASSICAL INTERESTS

There are several reasons why Italy, and especially Rome, should have influenced Carolingian painting. The most obvious is that areas of Italy were incorporated into the Carolingian empire. Besides this, the Franks were indebted to Rome for validating their dynasty and initiating their empire. Next, Rome was the one city of the West with an uninterrupted tradition of great Christian mosaics and murals, and it could therefore offer the Franks the most venerable, and perhaps the most extensive, repository of visual sources for Christian art. Finally, in order to sharpen their own profile as Roman emperors against that of the

Roman emperors of the Byzantine East, it was important for the Carolingians to demonstrate historical links with the city. Like the newly arrived throughout the ages, they were anxious to associate themselves with tradition, which, as then represented by Rome, had a classical as well as a Christian aspect, both of which engaged the interest of Charlemagne's entourage.

The scholars with whom Charlemagne surrounded himself were Christians who had nonetheless a profound sympathy with the literature of Rome's classical past. At their head was Alcuin, formerly master of the cathedral school at York and later abbot of Tours, whom Charlemagne had met in Italy. Alcuin's classicism was such that he could not resist quoting Ovid's *Art of Love* even in a letter to Angilbert, the abbot of Saint-Riquier, asking for relics of saints to be sent to him from Rome,[22] and Angilbert himself was earlier credited with a (now fragmentary) epic poem on Charlemagne and Leo III that draws heavily on Ovid, on Virgil, and on Lucan[23] as well as on the Christian poet Fortunatus, to illustrate the point that, in literary circles, the pagan and Christian worlds were not sharply divided. A Carolingian poem by Modoin, too, evoking the eminent men of the past who had suffered unjustly, mentions not only New Testament figures such as St John the Apostle, St Peter, and St Paul, but also classical writers such as Ovid, Virgil, and Seneca.[24] The nicknames current in the Carolingian court also demonstrate the trend: on the one hand Alcuin was known as 'Flaccus' and Angilbert as 'Homer', and on the other Charlemagne was dubbed 'David' and Einhard 'Bezaleel'. Einhard, moreover, with his Old Testament sobriquet, modelled his biography of Charlemagne on Suetonius's biographies of the old Caesars.

Nor was there a conflict between scholarship and administration. Theodulf, one of the literary talents at Charlemagne's court, was also a *missus dominicus* whose duties included the inspection of the churches of the empire and the wall paintings in them. Theodulf also dispensed justice, and a lengthy Latin poem on his experiences[25] (itself written in the metre perfected by Ovid) gives a smiling account of the inducements offered him in this capacity: clients at Narbonne, for example, tempted him with jewels from the East, with coins from ancient Rome and from Arabia, and with an imported textile portraying a heifer with a bull, and a cow with its calf. But what really intrigued him was a classical vessel engraved with mythological scenes which – if it really existed – gave him a fine opportunity to parade his classical knowledge, for although the outside surface was apparently somewhat worn by age and use, he was nonetheless able to identify all the subjects. He thus emerges as a man with the eye of an art connoisseur and the learning of a classical scholar.

Now we have already met Theodulf as the likely author of the *Libri Carolini*,[26] and it so happens that, in one chapter of the treatise,[27] such classical figures and scenes as were represented on the bowl – the centaur, for example – are pronounced to be contrary to the Scriptures. In other words, classical imagery was not countenanced in the public art of the mural. In the more private world of artistic manuscripts, however, the classical tastes of the educated could be fully indulged in a wealth of symbolism denied to the ordinary churchgoer to show river gods, earth goddesses,

33. Lotharingia: *'Portrait' of Terence*, from a copy of his plays, MS. Vat. lat. 3868, folio 2. 820–30(?). Rome, Vatican Library

personifications of the sun and moon, and hybrid creatures such as centaurs – all of which the *Libri* specifically condemned. The Utrecht Psalter[28] alone has personifications of the sun and moon, of rivers, of the earth, of the winds, and of night and day, besides classical atlantes, classical statues, classical aqueducts, and a representation of the machine used for casting lots in the original classical games. Moreover, a Carolingian illustrated encyclopedia (now known only by a later copy)[29] included a representation of the pantheon of classical gods, and manuscript-painters went further still and made direct copies of classical paintings.

A good example of this is a Carolingian manuscript of the plays of Terence,[30] with their earthy plots, their scheming slaves and lustful males, their seductions and mistresses and courtesans, whose pictures of the actors (complete with their correct classical masks) are so true to their prototype that their late classical model can actually be dated to the third century. We reproduce here the prefatory author-portrait of Terence flanked by two actors [33]. The manuscript was probably made in the 820s in Lotharingia, and the names of the scribe (Hrodgarius) and of one of the artists (Adelricus) are given. A Carolingian illustrated calendar, known only by later copies, had drawings of Roman consuls, of planetary deities, and of Antique representations of the months that seem – so far as we can judge – to have been thoroughly classical both in their conception and in their manner of execution. The text indicates that their source can be dated to A.D. 354.[31] The painted personifications of constellations

34. Lotharingia or north-eastern France: *The constellation Eridanus*, from a copy of Cicero's *Aratea*, MS. Harley 647, folio 10 verso. *c.* 830. London, British Library

35. *Andromeda*, from a copy of Cicero's *Aratea* possibly made for Louis the Pious, MS. Voss. lat. Q.79, folio 30 verso. 830s. Leiden, University Library

in a Carolingian manuscript[32] probably made in Lotharingia, or north-east 'France', about 830 derive from another fourth-century source, and provide splendid examples of those famous 'word-pictures' invented by Porfyrius for the benefit of Constantine the Great. Porfyrius's poems were composed in such a way that the verses outlined a shape – e.g. an altar or a musical instrument – appropriate to the content; moreover the painted part of the picture of Eridanus [34] harks back to the illusionistic style of Pompeii through unknown intermediaries. The classicizing pictures of yet another Carolingian astronomical manuscript,[33] now at Leiden, seem more in keeping with a society that venerated Jupiter than one which worshipped Christ, and they give surprisingly authentic representations of the nubile goddesses [35] and heroic gods of Antiquity. The Leiden manuscript was probably made in the 830s, perhaps for the emperor Louis the Pious or one of his family; as we shall see early in Chapter 9, it was in its turn to influence later medieval art.

Some of the Carolingian manuscript paintings made for the highly educated are indistinguishable from late classical pictures produced half a millennium before. My description of them elsewhere as 'facsimile' art remains valid as long as we recognize that the 'facsimiles' retain the freshness of

the originals, which were drawn primarily from the fourth century A.D., partly because it was then that the Roman empire became Christian, so that the Roman art of the time had the implied *imprimatur* of the Christian emperors, and partly because by that time the scroll, or roll, of Antiquity had been completely superseded by the bound manuscript, which had a far better chance of survival.

Although classical art was to leave its mark in later periods of the Middle Ages – most particularly, perhaps, on early Gothic sculpture – the Carolingian era was the only one to accept it completely on its own terms, neither absorbing the style and rejecting the iconography, nor adopting the iconography and discarding the style. When all this has been said, however, we must remember that the classicizing tendency affected only a very small proportion of Carolingian paintings, the vast majority of which presented Christian themes.

THE CAROLINGIANS AND THE OLD TESTAMENT

The disparity between themes chosen by wall painters and manuscript artists pertained not only to the classical past but also to the Bible: Carolingian wall painters preferred the New Testament, manuscript painters the Old. Any New Testament narrative scenes that do appear in manuscripts are few in number and abbreviated in presentation, and show more concern with commentary than with the text. Their Old Testament illustrations, on the other hand, are large, expansive, and extensive.

A further explanation for this bias is needed than the argument that the artistic manuscripts were made for lay and ecclesiastical princes who had no need of the simple truths of the Gospel story that were conveyed to the unlettered populace in church paintings. It may be that, now that Islam in the south and paganism in the north were posing such threats to Christianity, it was considered desirable to lay more emphasis on the power of God as a protector of his people, which would naturally have led to the Old Testament as a source: in support of this view, the Carolingians did indeed stress the might of God rather than his humanity, presenting him as the 'omnipotent ruler' before whom the nations of the world will tremble.[34] But much more important is the fact that educated Franks were anxious to see a specific parallel between themselves and the Israelites of the Old Testament, whose place they believed they had taken as the objects of God's special care and protection. This attitude, already implied in the Lex Salica,[35] was flattered by the Church and celebrated in literature and art. Thus the sacring of the Frankish kings was associated with Samuel's anointing of David;[36] in the Gellone Sacramentary, their deeds were compared with those of David;[37] and in the writings of popes and lesser churchmen, they were likened to the rulers of the Israelites. Alcuin gave Charlemagne the *nomen* of David (i.e. not simply his name but his honour and dignity as well),[38] and successors of Charlemagne, for example Charles the Bald[39] and Louis the German,[40] were also seen as second Davids.

The perceived links with the Israelites were invoked separately by Alcuin and by Notger when they compared

Aachen Cathedral to the temple of Solomon[41] – the imperial throne at Aachen was actually made in accordance with the Old Testament description of Solomon's throne.[42] The paintings as well as the dedications of imperial manuscripts also stressed the association between Frankish and Israelite rulers, particularly David.[43] The need to do so sprang from the Franks' own tribal religious origins, and also from political motives, for David – like the Franks – came to power by supplanting an existing and legitimate dynasty, and his example could be adduced in support and condonation of the Carolingians' own palace revolution. The similar bias towards the Old Testament that was demonstrated by the leaders of the Frankish Church may have been abetted by the Anglo-Saxons who had helped reform it, for they too tended to identify with the Israelites. It may be no coincidence then that the poet Otfrid, who in the dedicatory preface to his vernacular version of the Gospels made an extended comparison between one Carolingian emperor (Louis the German) and David, had been educated at the Anglo-Saxon foundation of Fulda, one of whose abbots, Hrabanus, made 'a reliquary in the likeness of the Ark of the Covenant' with gilded cherubim.[44]

The Old Testament theme of the Fulda reliquary was repeated in a mosaic commissioned by Theodulf, bishop of Orléans from 799, to adorn the private oratory of his country villa at nearby Germigny-des-Prés.[45] The oratory survived the destruction of the villa by Norsemen in the third quarter of the ninth century, and its mosaic, which was probably complete in time for the consecration of 806, remains *in situ* [36]. On top of the Ark itself are the mercy-seat and the two cherubim mentioned in Exodus XXV, 17–21, and to either side are two much larger cherubim corresponding to those placed within the holy of holies where the Ark was kept when Solomon built his Temple in Jerusalem (2 Chronicles III, 10). The mosaic – whose subject matter is unique for a work of monumental art – mirrors so exactly a description of the Ark and cherubim in the *Libri Carolini*[46] that it has been said to furnish the most convincing evidence for Theodulf's authorship of the treatise.[47] The *Libri* counter the Greek view that, as the mercy-seat, with its overshadowing cherubim, could be compared to an altar with accompanying paintings, so the veneration in which the Old Testament insignia were held justified the worship of religious images, by asserting that, as the insignia were made at the explicit command of God and in accordance with his precise directions, they have nothing whatever in common with any image that is the product of man's own invention; moreover, they together constituted a complex prefiguration of the mysteries of the Incarnation. This helps to explain why Theodulf should have chosen so unusual a theme to appear over the main altar of his oratory. In particular, since the Ark itself was said to designate Christ, through whom men were reconciled to the Father,[48] the mosaic recalled the commemoration in the Mass of the sacrifice by which man's reconciliation was effected. On a more straightforward level, and in line with the Carolingians' wish to be seen as heirs to the Israelites, the decoration was no doubt supposed to suggest that, in its own way, the oratory was a counterpart to the Old Testament Temple.[49]

The heavy restoration of Theodulf's mosaic during the

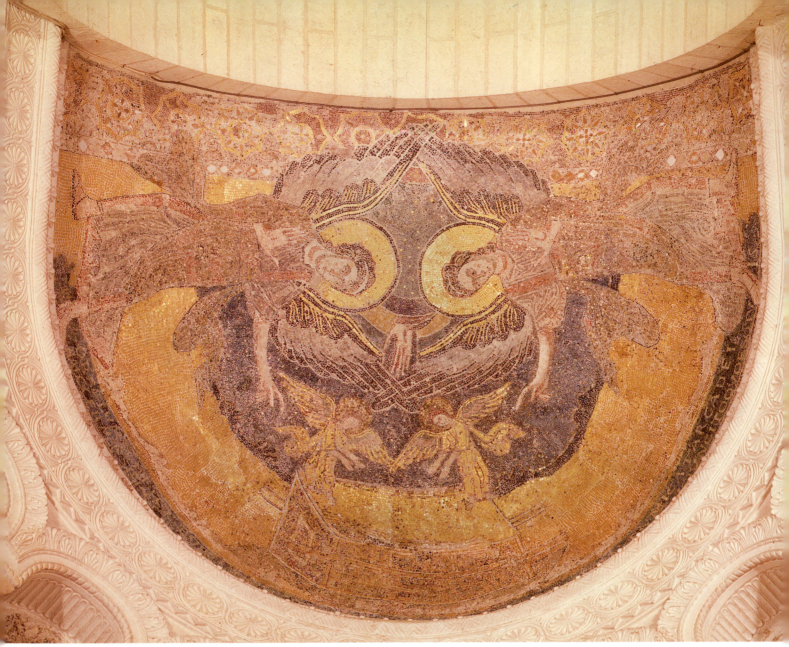

36. Germigny-des-Prés, oratory of Theodulf of Orléans, *Ark and Cherubim.*
Mosaic. 799/806

nineteenth century has not inhibited scholars from making stylistic comparisons between its figures and those of Charlemagne's Ada School of illumination; however, it may simply be that the mosaic and the illumination had each absorbed comparable influences from Italian art.

SOURCES OF INFLUENCE

Since they had no flourishing artistic tradition of their own, the Carolingians had to turn abroad, as Charlemagne himself had done for some of his scholars. Italy, with its extensive traditions of painting and mosaic, was their most obvious source; another was the pre-iconoclastic art of Byzantium; and yet another was the British Isles. Far removed though they were from Rome and Constantinople in terms of geography, the peoples of the British Isles were by no means remote in terms of Christian commitment. It was, indeed, Irish and Anglo-Saxon missionaries who had brought the Christian faith to the eastern parts of the Carolingian empire and, with it, their own traditions of art. Their sense of kinship with the Continental Saxons gave the Anglo-Saxons a special

evangelizing impetus, and they founded great monastic centres such as Fulda and Echternach where the expatriates both cherished Anglo-Saxon painted manuscripts sent out from England and produced fine works of their own. Of the Irish foundations, the most important was St Gallen, whose quantities of Irish illuminated manuscripts shaped its artistic traditions. Thus the naturalized British art that existed on the Continent even before Charlemagne was crowned emperor in 800 was further replenished from England during the Carolingian Renaissance itself.

As we shall see later, the illumination of England and Ireland before about 800 was very similar, and so too was their script. Both were quite different from those of Continental Europe, and since they were the products of island communities, scholars have pedantically described them as

37. Charlemagne's Ada School: Canon Table, from the Soissons Gospels, MS. lat. 8850, folio 10 verso. Late eighth/early ninth century. Paris, Bibliothèque Nationale

'Insular'. This was an unfortunate choice, for in everyday speech 'insular', of course, means 'parochial', which the finest paintings of these British manuscripts are far from being, for they show ingenuity, vitality, and warmth. They influenced a particular style of the Carolingian Renaissance which has been called 'Franco-Saxon' to show that, despite an Irish ingredient, it was fundamentally an Anglo-Saxon mode, nourished into independent life on French soil. Based on geometric interlace and patterning and not without nobility, it was the longest lived of all the Carolingian styles. We shall hear more of it later.

THE ROLE OF CHARLEMAGNE AND THE MONASTERIES

Under Charlemagne's rule, the visual arts flourished to an extent unknown in the West since the fall of the old Roman empire. The emperor personally encouraged them – no doubt for the prestige they would bring his court and empire: for their educative capabilities: and in some cases for their associations with the former Roman empire. Yet he could only work through the organizations to hand. In the case of illumination, this largely meant the monasteries, for, in the West as in the East, it was chiefly they who produced illuminated and other manuscripts.

Because the monasteries were widely scattered and largely independent of each other, Carolingian painting became, in effect, a federal art, nurtured at various centres, progressing at speeds related to locally available talents, and developing in particular directions according to the resources which happened to be at hand. The illuminated manuscripts which were the chief of these resources came on the whole by chance rather than by policy, for the abbots' main concern was with useful and accurate texts; some of them might be manuscripts from Italy with pictures from differing stages of the peninsula's artistic development, and others from England which transmitted very different tastes. In short, there was a random element among the models available that gave rise to distinct local schools, and we must take them one by one, despite the fact that they did share similar artistic points of reference which make it proper for us to speak of a Carolingian aesthetic.

THE SCHOOLS OF CHARLEMAGNE AND HIS COURT

As it happens, the earliest school[50] of painting was not monastic at all, but attached to the court of Charlemagne. It must have been set up soon after Charlemagne became ruler of the whole Frankish kingdom in 771, and its dependence on him is demonstrated by the fact that it came into being with his accession and expired with his death. It is traditionally known as the Ada School[51] because verses at the end of one of its manuscripts refer to its commission by a certain 'Ada the handmaid of God' (*Ada ancilla Dei*) – perhaps a sister of Charlemagne.[52]

There are seven complete manuscripts in the Ada group.[53] The earliest of them is the Godescalc Gospel Lectionary,[54] begun in 781 and completed by 783 [40]; the others consist of a Psalter and five Gospel Books. There is besides a fragment

38. Charlemagne's Ada School: Initial and opening of St Matthew's Gospel, from a Gospel Book from Saint-Martin-des-Champs, MS. 599, folio 16. Late eighth century. Paris, Bibliothèque de l'Arsenal

of a Gospel Lectionary, and a Gospel Book from Saint-Martin-des-Champs, now in the Arsenal Library[55] [38], is also stylistically related. The four finest of the group are the Ada Gospels at Trier[56] [41]; the Harley Gospels[57] of the last decade of the eighth century [42]; the Soissons Gospels[58] [37, 39]; and the Lorsch Gospels, now divided between Alba Julia in Romania[59] [118] and Rome[60] [120].

As befits their provenance, these manuscripts are costly and luxurious, lavishly written in gold and silver (a practice already known to Early Christian, Byzantine, and Anglo-Saxon art), with gorgeous decorative pages and sumptuous full-page pictures in which the rich golds are set off by deep, warm colours. Compared to the poverty of Merovingian painting of the preceding epoch, this resplendence flashes forth like a beacon suddenly lit. It seems to be without past and without parentage. As far as the Frankish homelands are concerned, this is certainly true: it is in Great Britain and Italy that we must seek its ancestry.

The decoration of the manuscripts consists primarily of elaborate Canon Tables at the beginning [37], and frontispiece pages to the individual Gospels incorporating the intricate and elegant initial to the text, followed by the beautifully set out introductory words [38], the whole enclosed in a decorative frame. The lavish use of gold, often set off by rich purples, combines with clarity and precision of outline to

39. Charlemagne's Ada School: *The twenty-four elders and the Lamb*, from
the Soissons Gospels, MS. lat. 8850, folio 1 verso. Late eighth/early ninth
century. *Paris, Bibliothèque Nationale*

give an effect more of *cloisonné* enamel than of painting. Much of the decoration derives from Anglo-Saxon sources,[61] especially the great introductory initials with their segmented forms, bold contours, and fine infillings of intricate and delicate interlace. On rare occasions, the initials contain tiny scenes, such as the Christ in Majesty and the Annunciations to Zacharias and to Mary of the Harley Gospels; even these have Anglo-Saxon precedents, for historiated initials appear already in the early-eighth-century Vespasian Psalter[62] from Canterbury.

But there is more to this sumptuous decoration than the simple transference of British art to the Continent, for only influences from late Antiquity[63] will explain either the marbled columns with their classical capitals of acanthus leaf which are part of the architectural framework in the Soissons Gospels [37, 39], or the classical perspective, which completely transforms the British styles. In spite of its delightful qualities of fastidiousness, liveliness, and vigour, the art of the British Isles was essentially an art of surface decoration. In the products of the Ada School, however, the third dimension enters in: the eye does not simply play over the surface intricacies of the initial, but looks down and through them. In the Soissons Gospels, there is not only a sense of space between the initial and its background of greens and blues, but also a feeling of depth and dimension in the background itself. The same techniques for registering depth are used in the finest of the Canon Tables, where the written entries are disposed within a setting of architectural columns [37].

The decorative aspects of the Ada manuscripts derive from the art of two countries, their illustrations chiefly from one – Italy. However, since more than one phase of Italian development is involved, the resultant styles are varied.

The illustrations take two forms – the tiny and the full-page. The tiny illustrations are found inside the initials, or in marginal areas, and are virtually the only narrative scenes in the Ada Gospel Books and Lectionaries. It is curious that they should be on so small a scale – when compared to the full-page paintings, they seem quite apologetic. Their most significant occurrence is in the Soissons Gospels, where they do not even illustrate the New Testament itself but recondite commentaries on it.[64] So, the shorthand scenes which are lightly brushed into the margins or the spandrels of the decorative and portrait pages, derive from prefaces written for the pre-Jerome text of the Bible by the fourth-century Spaniard, Priscillian, and they present the Annunciation, the Visitation, the Baptism, the Temptation, the Marriage at Cana, the Last Supper, Nicodemus's nocturnal visit to Christ, and the Samaritan woman at the well. The same manuscript's only narrative illustration of any size, the twenty-four elders and the Lamb over a sea of glass [39], illustrates another preface – St Jerome's – and even this is dwarfed by the rest of the painting to which it belongs. It is almost as though the artist felt constrained to insulate himself from the actual text of the Gospels by an apparatus of scholarly commentary.

The full-page pictures are mostly of the evangelists, though there is an enthroned Christ [40] in the Godescalc Lectionary,[65] which was named after its scribe. It was commissioned by Charlemagne and his queen Hildegard on or shortly after 9 October 781 to commemorate both the opening of the fourteenth year of Charlemagne's reign as king of the Franks, and the baptism of his son Pippin by Pope Hadrian in the baptistery of the Lateran in Rome. The baptistery is shown in a full-page picture as the Fountain of Life[66] in a Paradisal setting, surrounded by shrubs and birds and approached by a stag. A similar picture, with all kinds of allegorical elaborations and allusions, appears three times in the Ada manuscripts.[67]

Although over its three decades of activity the Ada School shows variations in development, in accomplishment, and in particular sources of influence, its evangelist 'portraits' remain a coherent group. The first tentative statement of their style appears in the Godescalc Lectionary.[68] The impression these pictures give of uninspired, if ambitious, copying is not without its advantages to the student since it provides a clue to their source which, it has been demonstrated, must have been an Early Christian manuscript embodying a style similar to that of the sixth-century mosaics of San Vitale at Ravenna.[69] The more assured Abbeville Gospels,[70] produced a little later – between 790 and 814 – introduces the architectural

40. Charlemagne's Ada School: *Christ enthroned*, from the Godescalc Gospel Lectionary, MS. nouv. acq. lat. 1203, folio 3. 781/3. Paris, Bibliothèque Nationale

41. Charlemagne's Ada School: *St Mark, from the Ada Gospels*, MS. 22, folio 59 verso. Late eighth/early ninth century. Trier, Stadtbibliothek

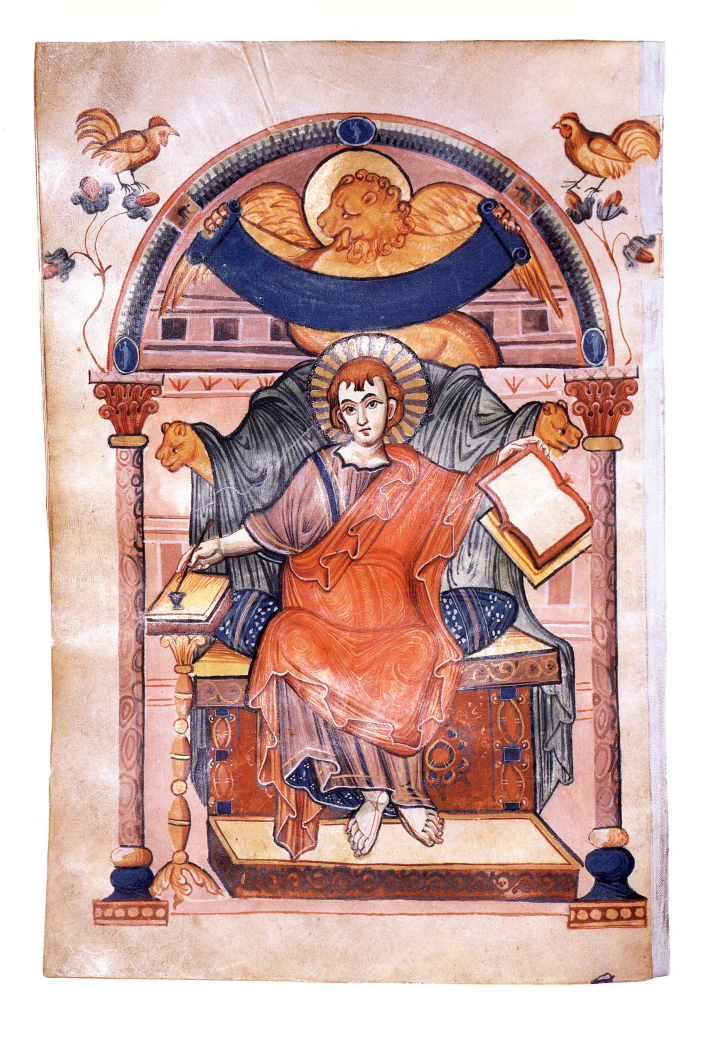

framework that was to become a trademark of the school. Here the influences are from eighth-century Rome,[71] which explains the combination of an ample and almost pneumatic figure structure with a surface decoration of minute patterning.[72] The next stage is illustrated by the evangelists of the manuscript that gives the group its name, the Ada Gospels.[73] Here, the figures are more statuesque and have a new structural solidity [41]. Their draperies fall heavily with their own weight, and are no longer dissolved by gold lines into ornamental patterns. They have deep folds formed into 'hooks' reminiscent of Byzantine art, particularly of the seventh century, when Rome was under strong Greek influence; it has therefore been thought that this is where we should look for our manuscript's prototype.[74] The Ada evangelist figures are later than its other illumination, and later, too, than the evangelists of the Harley[75] [42] and the Soissons Gospels.[76] The final phase of the stylistic progression is represented in the school's last work: the pictures of the Lorsch Gospels[77] [118, 120].

The Ada style was particularly appropriate for a court, combining as it does a wealth of colour with a contrived sense of grandeur. The colours flooding the paintings are rich and almost sensual. Golds are much in evidence, often set off by purples, ochres, or vivid blues. The figures of the evangelists, on thrones surrounded by a heavy architectural framework, project weight and solidity. In contrast, there is a wealth of detail – from the decoration of the columns and thrones to the pointing of every line and fold of the draperies – and it is just this combination of sumptuous colours, balanced weight, and ornate detail that produces the characteristic Ada effect of occasion and ceremony. Among Carolingian styles, this is the first in time, and it is also the foremost in splendour.

A much smaller school associated with Charlemagne's court, though not necessarily with Charlemagne himself, may have been centred at Aachen and controlled by Einhard, who was an artist as well as a scholar and courtier. Koehler refers to its products as the Coronation Gospels Group.[78] Their style has a Byzantine-inspired ease and breadth and apparent spontaneity quite different from the measured, ornate, and compilatory manner of the Ada School, which derived from Britain and Italy. Four complete manuscripts of this second group survive, all Gospel Books. The first, the Vienna Coronation Gospels[79] in Vienna [43], is written in gold on purpled vellum. It has four large evangelist 'portraits', and decorative Canon Tables as well, and is ascribed to the very end of the eighth century. The second, the Aachen Gospels[80] at Aachen, probably of the early years of the ninth century, has a stylistically related picture of the four evangelists [44]. The third is in Brescia.[81] The fourth, in Brussels,[82] has a picture of Christ and the evangelists, and also an unfinished 'portrait' of an evangelist bound in at folio 17 verso [45]. We also know of a fifth manuscript from a fine copy of it[83] made about 840 for Charlemagne's illegitimate son Drogo, bishop of Metz from 826 (archbishop from 844) to his death in 855. It was an illustrated treatise thought to have been made about 810 in connection with Charlemagne's astrological and calendar reforms.

Although there is a slight influence from the Ada School in one of the manuscripts of the Coronation Gospels Group,[84] in all of them it is the classical tradition that prevails. The initials are plain and simple like those of late Antiquity. The Canon Tables have a classical severity. Even the group's single title-page in the Aachen Gospels owes its beauty and economy to pre-medieval traditions. However, it is in the pictures of the evangelists [43, 45] that the classical feeling comes to the fore. Here, there is no reaching out for effect and everything seems easy and spontaneous. The ultimate source is the illusionistic style of Antiquity which is best known perhaps from the murals of Herculaneum; indeed, one distinguished scholar has taken the view that the unfinished evangelist 'portrait' bound into the Brussels Gospels was not a work of the Carolingian Renaissance at all, but a product of the Roman 'Renaissance' of the fourth century that served as a model for Carolingian artists.[85] The evangelists in the Aachen Gospels are, exceptionally, grouped together in a single composition [44]. The air drifting through the sketchily portrayed landscape is almost tangible, and there are masterly effects of light receding in the distance, or breaking in cool bluish-greens on the impressionistically painted hills.

The sudden appearance at Charlemagne's court of this expansive and assured style of Antiquity presents many problems, not all of which have been resolved. It seems likely however that, unlike the Ada style, which was developed by court artists making a synthesis of outside influences, the Coronation Gospels style was brought in by outsiders.[86] The name Demetrius Presbyter in the margin of one folio of the Coronation Gospels, though it may not be a strictly contemporary entry, seems to indicate Greek involvement. Perhaps the manuscript was executed by Greeks from Italy, where Byzantine or Byzantinizing wall paintings (which we shall come to later) are to be found in a comparable idiom at Castelseprio near Milan.

The style of the Vienna Coronation Gospels, like that of the Ada School, disappeared from the court at Charlemagne's death. However, the Hellenistic traditions from which it sprang continued to exert an influence, even if fundamentally reinterpreted. It is as though this classical style had to undergo a process of fermentation before it could produce the more exhilarating effect that the West was looking for, an effect which was to find its fullest expression in the School of Reims.

THE PERSONAL SCHOOLS OF DROGO, LOTHAR, AND CHARLES THE BALD

Drogo – for whom the astrological manuscript of the Coronation Gospels Group was copied – had a small but distinguished studio of artists of his own,[87] including painters who embellished· manuscripts, and carvers who gave them their ivory covers.

Apart from the astrological work, only three of Drogo's artistic manuscripts survive, all of excellent quality. Of his two Gospel Books, the first[88] has decorative Canon Tables; the second[89] has, as well, a sequence of three ornamental

42. Charlemagne's Ada School: *St Matthew*, from the Harley Gospels, MS. Harley 2788, folio 13 verso. *c.* 790–800. London, British Library

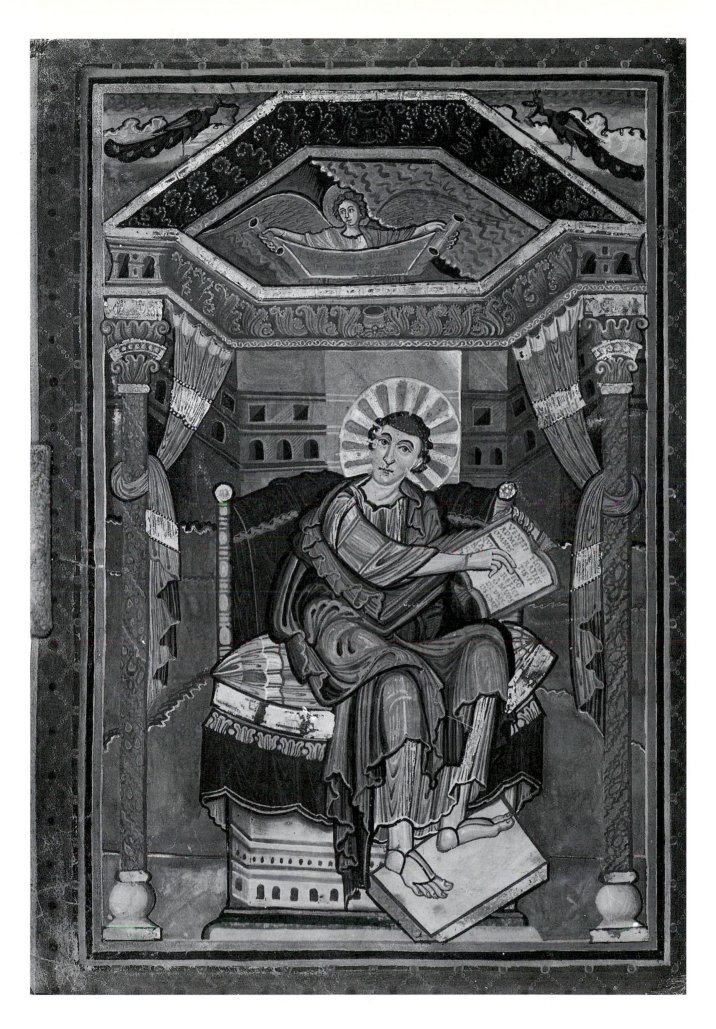

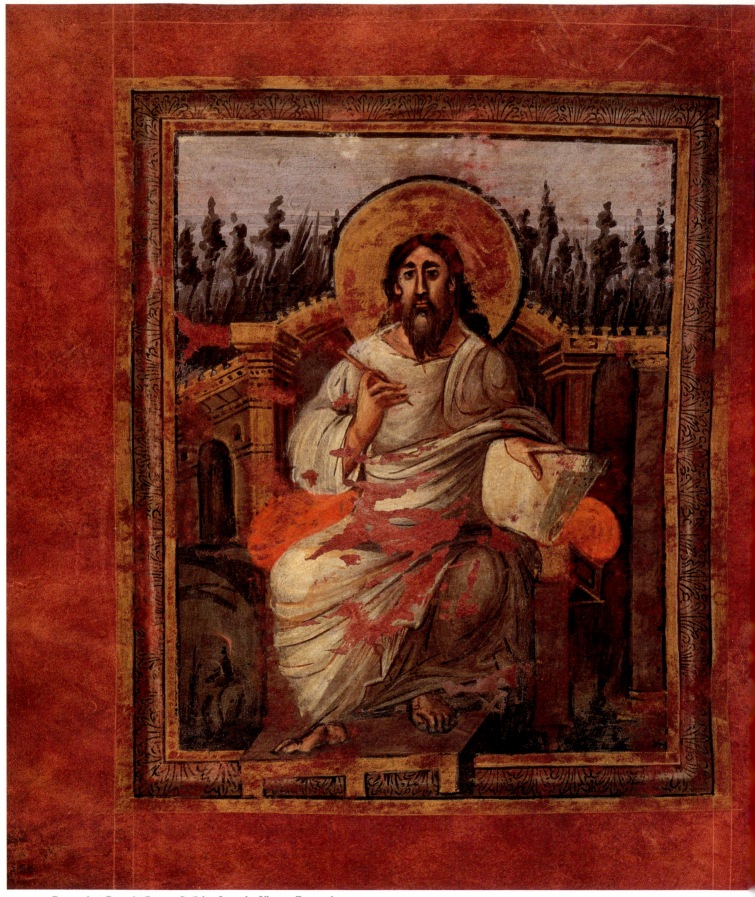

43. Coronation Gospels Group: *St John*, from the Vienna Coronation
Gospels, folio 178 verso. Late eighth century. Vienna, Weltliche
Schatzkammer der Hofburg

44. Coronation Gospels Group: *The four evangelists*, from the Aachen
Gospels, folio 14 verso. Early ninth century. Aachen Cathedral Treasury

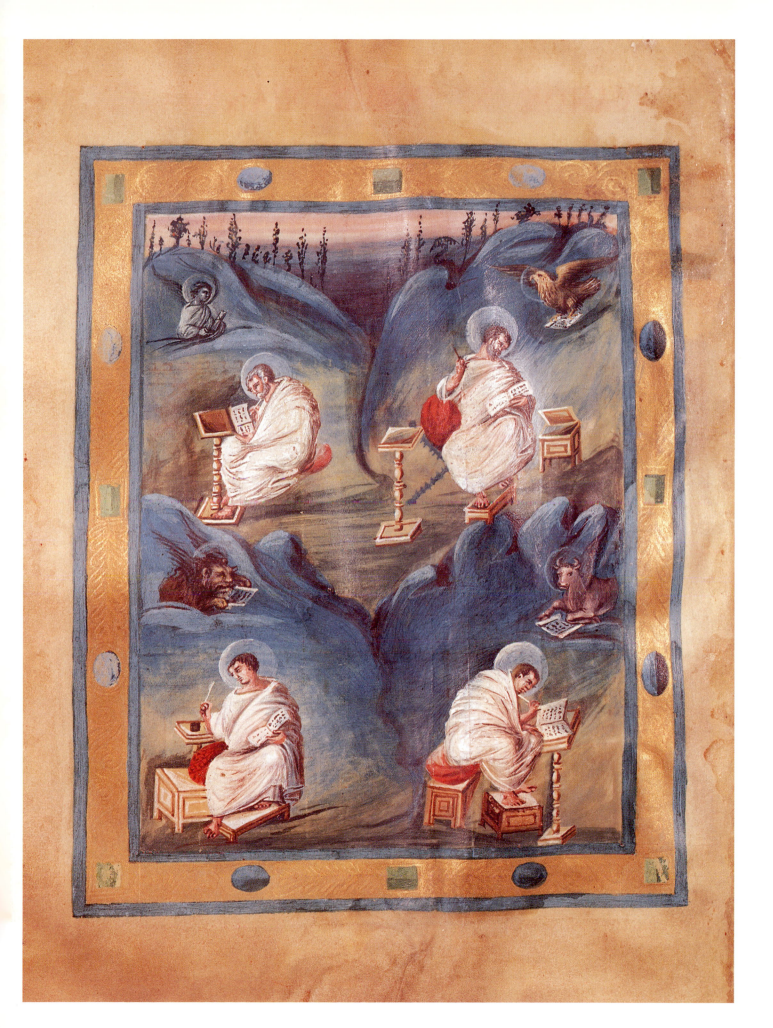

45. Coronation Gospels Group: *Evangelist*, bound into the Brussels Gospels, MS. 18723, folio 17 verso. Early ninth century. Brussels, Bibliothèque Royale

46. Metz: Historiated initial with *The Ascension*, from the Drogo Sacramentary, MS. lat. 9428, folio 71 verso. 844/55. Paris, Bibliothèque Nationale

pages at the beginning of each Gospel, one of them containing an initial formed from the symbol of the relevant evangelist. It also has small scenes of the Annunciation, Nativity, Nativity of the Baptist, and Presentation in the Temple at the beginning of the Gospels of Matthew and Luke, and a number of decorative initials. It is thought to have been made between 840 and 855. The third manuscript, the Drogo Sacramentary,[90] is the finest of the group. It was clearly produced for Drogo's own use, since the archbishop who appears as a celebrant in some initials wears the pallium given in 844 to Drogo himself when he was made papal vicar north of the Alps. This garment points to a date between 844 and Drogo's death in 855, and, since the manuscript was never completely finished, Koehler suggested that it was still being made when he died. The extensive use of historiated initials in this Sacramentary is quite new; twenty-nine have biblical scenes [46], six illustrate the liturgical service, and three relate to the lives or deaths of St Lawrence, St Arnulf, and St Andrew. Traces of the impressionism of the Vienna Coronation Gospels, one of its sources of inspiration, remain in the style of the Sacramentary, but it is now much more linear and has a vivacity of its own which is set off by elegant but solid ornamental work.

The personal school of Charlemagne's grandson, the Emperor Lothar,[91] was probably based in the Aachen–Liège area. It can be dated between 842 and 855, the year of his death. Five of its manuscripts survive. The first of the three pictures of the Lothar Psalter[92] is a somewhat formalized representation of Lothar himself in a garment covered with gems which resembles a robe worn by Constantius II in the now lost calendar of 354. The other two pictures, in a broader and easier style, are of David, the author of the Psalms [47], and of St Jerome, their translator. David is associated with Lothar by means of an inscription to the effect that he had been chosen by God to be ruler from amongst his brothers – just as Lothar felt he himself had been. A second manuscript, a Sacramentary,[93] names Lothar in the text, and we know that he gave a third, a Gospel Book,[94] to the abbey of Prüm in 852. Its evangelist 'portraits' belong to the classical stream of the Vienna Coronation Gospels and owe something also

Detail of plate 62 (enlarged)

47. School of the Emperor Lothar: *David*, from the Lothar Psalter, MS. Add. 37768, folio 5. 842/55. London, British Library

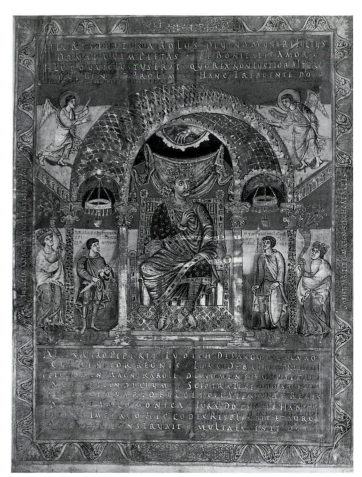

48. Court School of Charles the Bald: *The enthroned Charles blessed by the hand of God*, from the *Codex Aureus*, Clm. 14000, folio 5 verso. Completed in 870. Munich, Bayerische Staatsbibliothek

to Reims. The remaining two manuscripts of the school are also Gospel Books.[95]

Lothar's brother, Charles the Bald, king of 'France' from 840 to 877 and emperor from 875 to 877, began – as we shall see later – by commissioning artistic manuscripts at Tours. After the onslaught of the Norsemen in 853, however, he set up a studio of his own,[96] which came to an end with his death in 877. Its exact location is not known – Reims, Saint-Denis, Corbie, Soissons, and Compiègne have all been suggested, and Compiègne, which was the chief centre of the court, is not to be lightly dismissed. However, it is probably best to settle for an unspecified centre in the area that Charles used as a territorial base – that is, the region around the Aisne and the Oise.[97]

The twelve surviving manuscripts of Charles the Bald's School[98] are all Gospel or Service Books. Among them, the so-called *Codex Aureus* of St Emmeram in Regensburg[99] embodies specific references to Charles, his mother, his father, and his grandfather, Charlemagne; a Prayer Book[100] has an inscription saying that it was commissioned by Charles; and one of the Psalters[101] contains his personal supplication to God above.

Liuthard, the dominant scribe of the school, appears to have been an illuminator as well, since one of the manuscripts[102] bears the comment 'Liuthardus ornavit'. The fact that quite a few of the pictures of the group are by

the same artist, together with a certain uniformity in the decoration, has led to the view that the school was serviced by a small team of scribes and illuminators.[103] Their task was to provide Charles with *de luxe* manuscripts of great opulence. The surviving bindings alone would indicate this: the *Codex Aureus*, for example, is bound with superb relief work in gold, embellished with gems,[104] and one of the Psalters[105] with silver plates adorned with filigree work and large gems and inset with delightful ivory carvings of scenes from Psalms 50 and 56. On a Gospel Book now in Paris[106] are ivory covers carved with representations of the Traditio Legis and of the enthroned Madonna with two angels, and we know from a sixteenth-century account that Charles's Prayer Book[107] was originally bound with ivory carvings of the Annunciation, the Visitation, and the Nativity.[108] This external luxury was matched by an internal lavishness, particularly in the use of gold.

The *Codex Aureus*,[109] or Golden Manuscript, the most famous product of the school, is a Gospel Book written by Liuthard and Berengar and completed in 870. It was later given by the Emperor Arnulf (887–99) to Regensburg where –

49. Court School of Charles the Bald: *Coronation of a Frankish prince*, from the Coronation Sacramentary of Charles the Bald, MS. lat. 1141, folio 2 verso. 869/70. Paris, Bibliothèque Nationale

as we shall see in another chapter – it was to have a significant impact on Ottonian art. Its ceremonial painting of the enthroned Charles being blessed by the hand of God [48] is given warmth and opulence by the use of gold, rich purples, and reds and blues. What is new is the two crowned figures advancing with cornucopias, perhaps inspired by tribute-bearers in such classical sources as the *Notitia Dignitatum*.[110] We shall meet them again in paintings of Ottonian emperors [112, 113, 126]. The Canon Tables of the manuscript, deriving from those of the Court School of Charlemagne, are lent richness by simulated marble and porphyry columns, and liveliness by the nimble evangelist symbols in their arches. Further interest is added by such themes as the Fountain of Life and Christ with angels, supplemented by a decorative repertory including peacocks and other birds. As in other Gospel Books of the school, the text is preceded by four sumptuous pages, the first bearing preliminary verses, the second the relevant evangelist 'portrait', the third the *Incipit*, and the fourth the initial to the text. We have spoken of the effigy of Charles on folio 5 verso, and the manuscript's other full-page pictures include a throng of the twenty-four Apocalyptic elders adoring the Lamb and a splendid Christ in Majesty which is a more animated version of the one in the Vivian Bible of Tours.

A particularly fine production of the school is an unfinished Sacramentary.[111] If its admirable painting of a king, flanked by bishops and being crowned by the hand of God [49], in fact represents – as is generally thought – the coronation of Charles as king of Lotharingia on 9 September 869, it provides a very satisfactory date. One scholar[112] takes the matter further: he argues that, because Charles's succession was effectively challenged by Louis the German, which meant that in August 870 he had to make over to Louis the city of Metz and half his kingdom of Lotharingia, the *raison d'être* of the Coronation Sacramentary had disappeared, and that is why it was never finished. The artist of the coronation scene also painted the equally admirable St Gregory with two scribes. The Sacramentary has, as well, a Crucifixion and, on two facing pages, a lively composition of the enthroned Christ surrounded by angels, and a Christ adored by angels, saints, and martyrs. All these illustrations, like those of the *Codex Aureus*, show many characteristics of the School of Tours, besides an animation and nervous linearism that come from Reims. The Sacramentary also contains thirteen decorative pages, in which the script and some of the initials are in gold.

A reference in Charles the Bald's own Prayer Book[113] to his consort Irmintrude dates it between 842 and 869.[114] It is written in gold, and each prayer begins with a large gold initial on a purple ground. Similarly sumptuous is a picture occupying two facing leaves which shows Charles, in a dark violet mantle with a gold clasp, kneeling in front of Christ on the Cross and being presented with a gold crown adorned with pearls. He makes another resplendent appearance opposite St Jerome in one of his Psalters,[115] where gold, simulated gems, purples, and reds provide a luxurious display. These two pictures are preceded by a spirited representation of David, with his musicians engaged in a swinging dance.

The most important of the varied influences on the Court School of Charles the Bald came from the Schools of Tours and Reims to be discussed later. The impact of Tours can be detected in some of the evangelist types, particularly the broadly conceived and noble ones of the Arsenal Gospels,[116] in the decoration of the Canon Tables, in certain types of ornamental foliage, in the programme of four introductory pages to each Gospel, and even in the script. Reims, for its part, influenced some of the initials and some of the Canon Tables and, in more particular terms, the evangelist pictures in the Darmstadt and two other Gospel Books.[117] A less powerful impact was made by Drogo's School at Metz and by the Franco-Saxon School, whose influence is especially notable in the bold decorative initials of the Darmstadt Gospels, and of a Psalter and a Gospel Book now in the Bibliothèque Nationale.[118]

The sumptuous manuscripts of Charles the Bald were kept during his lifetime in his treasury, and on his death were divided between his son Louis the Stammerer and the monastic houses of Saint-Denis and Compiègne.

THE SCHOOL OF REIMS

If the Ada School was the earliest of the Carolingian ateliers, the Reims School was the most influential, for it completely captured the spirit of the period and represented the quintessential expression of Carolingian art. It owed its development, though not its initiation, to Ebbo, archbishop of Reims from 816 to 835. Its key work (and indeed one of the most significant works of art of the whole Carolingian period), the Utrecht Psalter,[119] can be even more narrowly dated, between 816 and 823.[120] Its hundred and sixty-six pictures each comprise numerous small scenes which are assiduous in their literal illustration of the text: 'Bow down thine ear to me . . . Pull me out of the net,' says one verse of the Psalms, and we are duly shown God reaching forth to direct an angel to succour the psalmist who is standing above a net[121] [50]; 'I am tossed up and down like the locust,' says another, and there is the locust before the psalmist, who is looking up to God[122] [51]. The several hundred such scenes are drawn in bistre and are of tremendous exhilaration. The figures rush from one side of the page to the other, their turbulent draperies agitated as if by gusts of wind. Their heads jut out vigorously: their hands gesticulate impatiently: their fingers are widely splayed. The very landscapes have an inner excitement, the trees reaching impetuously to the heavens, the hillocks whirling along more like clouds sweeping across the sky than solid mounds of earth. The whole world is intoxicated with an inner ecstasy, and it is a measure of the accomplishment of the artists that, despite all this volatile energy, the various scenes which make up each picture do not fly apart, but cohere in a balanced and symmetrical harmony often converging dramatically towards one focal point in the centre of the composition. The skimming line gives vitality to the page, and it also gives tonal values to the figures and objects and endows them with some feeling of depth. It even induces an impression of recession in space.

There has been much controversy about these drawings, but everyone would agree that they ultimately derive from the illusionistic style of late Antiquity which found one expression in the Coronation Gospels Group and is here

CIABITUERITATEMIUAM
AUDIUITDNSETMISERTUS
ESTMEI DNSFACTUSEST
ADIUTORMEUS;

HI CONSCIDISTISACCU
MEUMETCIRCUMDEDIS
TIMELAETITIA;

GAR DNEDSMEUS
INAETERNUMCONFITE
BORTIBI

XXX INFINEM

PSALMUSDOAUID

INTEDNESPERAUI
NONCONFUNDARIN
AETERNUM INIUSTITI

ETPROPTERNOMENTUY
DEDUCESMEETENUTRI
ESME;

EGOAUTEMINDNOSPERA
UI EXULTABOETLAETABOR
INMISERICORDIATUA;

50. Reims: Illustration to Psalm 30 (31), folio 17. 816/23; 51. Illustration
to Psalm 108 (109), from the Utrecht Psalter, MS. 32, folio 64. 816/23.
Utrecht, University Library

CVIII INFINEM

PSALMUSDOAUID

DSLAUDEMMEAM
NETACUIRIS QUIAOSPEC
CATORISETOSDOLOSISU
PERMEAPERTUMEST;

CONDEMNATUS ETORA
TIOEIUSFIATINPECCATUM;
FIANTDIESEIUSPAUCI ETE
PISCOPATUMEIUSACCIPI

TUM INCINERATIONE
UNADELEATURNOMENEI
INMEMORIAMREDEATINI
QUITASPATRUMEIUSIN

galvanized with a new dynamic power; and comparisons made between details of the drawings and certain features of Byzantine art[123] suggest that the late classical influences on the Psalter had been channelled through the pre-iconoclastic culture of Byzantium. We know that Pope Paul I (757–67) had sent a collection of Greek books to the Frankish king Pippin the Short,[124] and though they are unlikely to have contained illumination (they were texts of Aristotle and Dionysius the Areopagite, treatises on grammar, geometry, and spelling, and an antiphonary and a responsary), they do demonstrate how it was possible for Greek manuscripts to reach the heart of the Holy Roman Empire. We can well believe then that, at some point, a Byzantine model had come to Reims from Italy, which had always provided a ready home for the Eastern empire's refugee artists and had willingly embraced Byzantine art.

The effect of Byzantine artists, or at least Byzantine art, in Italy can, in fact, be seen in wall paintings which in some measure point the way towards the Utrecht style. They decorate the choir and apse of the small church of Castelseprio,[125] some twelve miles from Milan. Of a quiet ease and spontaneity, they illustrate the Annunciation, the Adoration of the Magi, the Presentation in the Temple, and further episodes from the infancy of Christ. It is not yet agreed whether they are by an Eastern artist, though they certainly derive from the Early Christian traditions that inspired Byzantine art. Their dating too is still a matter of controversy, attributions ranging from the seventh to the tenth centuries. However, their style bridges the gap between the illusionism of late Antiquity and the idiom of the Utrecht Psalter, and a date towards the end of the eighth century would seem plausible, notwithstanding the fact that this was a period of some instability in the region, when Charlemagne was trying to press home his authority after conquering the Lombard kingdom in 774. These paintings have not yet been electrified into the dynamic ecstasy of the Reims School, and in fact, in the self-contained rhythm of their compositions and their feeling for the structure of the human figure, they are closer to the late Antique than to the Utrecht drawings.

The other illustrated manuscripts of the Reims School are eclipsed by the packed intensity of the Utrecht illustrations, but nonetheless they have their own interest. One of the most important is a Gospel Book at Épernay[126] whose full-page paintings are in the Utrecht Psalter style but with some of its excitement abated [52]. Similarities of details – trees, landscapes, figures, and buildings – show the hallmark of the studio, and dedicatory verses in the Gospel Book tell us that it was made for Archbishop Ebbo under the direction of Peter, abbot of the monastery of Hautvillers. Ebbo became archbishop of Reims in 816 and, since there is no mention in the laudatory verses of his successful campaign to convert the Danes which was concluded in 823, it seems probable that the manuscript was produced between these two dates. Despite the reference to Hautvillers, we may suppose that the Gospel Book was produced at Reims on account of our knowledge of the bibliophilic interests of its archbishop and of the activities of its scriptorium. The Utrecht Psalter is a contemporary manuscript and can be similarly placed and dated, and this we have anticipated.

Other Reims manuscripts evince a much more conscious

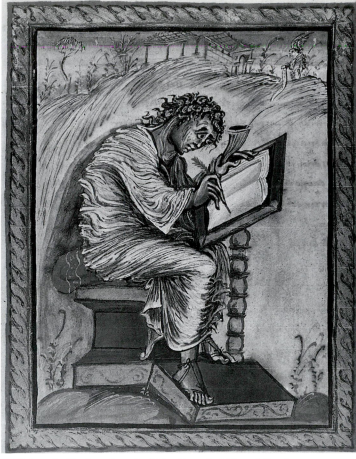

52. Reims: *St Matthew*, from the Ebbo Gospels, MS. 1, folio 18 verso. 816/23. Épernay, Bibliothèque Municipale

antiquarianism, possibly because Archbishop Ebbo had previously been in charge of the imperial library at Aachen which, we must suppose, housed some late classical and Early Christian illuminated manuscripts. An illustrated *Physiologus* from Reims[127] seems to derive from a late Antique exemplar, and an important Terence also from Reims[128] was illustrated in the Utrecht style by an artist who had access to the late classical manuscript that inspired the 'facsimile' Terence referred to earlier [33]. Two 'stray' drawings, detached from their original manuscript and bound up in a tenth-century Hrabanus Maurus at Düsseldorf,[129] are also in the Utrecht idiom. They illustrate miracle scenes from the Gospels: the healing of the leper (Luke v, 12–13), and the healing of the withered hand (Luke VI, 10).

The pictures of two other Psalters are related to those of the Utrecht Psalter in both iconography and style. The Douce Psalter[130] has illustrations to Psalms 51 and 101; the Troyes Psalter,[131] after some damage during the French Revolution, retains a single illustration to Psalm 51. These paintings are not of a particularly high quality (the Douce ones are quite maladroit), but they are of some historical interest because their illustrations to Psalm 51 are similar to the Utrecht one but could not have been copied from it, nor even from each other. This means that they must have been taken from the same archetype, perhaps of the fourth or fifth century.

A Bible now in the Roman church of San Paolo fuori le

Mura contains one of the finest of all sequences of illustrations of our period. As we shall see later, some of its twenty-four (originally twenty-five) full-page paintings were inspired by those of a lost Bible of Tours, and its evangelist pictures derived from a Tours Gospel Book; however, the San Paolo Bible was not made at Tours, and it has been variously assigned to Saint-Denis, Corbie, the Court School of Charles the Bald, and Reims. We shall discuss it in the Reims context because its script, decoration, figure style, and even some of its iconography, reveal intimate associations with that centre.

The Bible opens with a picture (originally at the end of the book) which has intrigued art historians over the years. It shows a crowned and enthroned monarch holding a disc bearing a complex monogram. This has never been satisfactorily explained, though it is not difficult to read into the disc the two words REX SALOMON – and we have already referred to the tendency of the Carolingians to associate their kings with the Israelite ones, for example in the inscriptions under the painting of Charles the Bald in the *Codex Aureus* of St Emmeram which link him with both Solomon and David. There is a bodyguard on the king's right, and in the upper area of the painting are two angels and four female personifications. Two ladies approach the monarch on his left, the foremost of them assuredly his wife, since verses refer to her as a noble consort by whom distinguished issue may be given to the realm. It is now generally agreed that the king himself is Charles the Bald, but there is no agreement about whether the queen is his first wife, Irmintrude, or his second, Richildis. Gaehde[132] thinks she is Irmintrude and suggests that the Bible was made after her coronation and unction in 866. Schade,[133] on the other hand, believes that she is Richildis and that the manuscript was produced after her marriage to Charles in 870. The arguments are finely balanced, but whichever scholar is right (and my own inclination is to Schade's views), the manuscript can still be dated quite closely to the years between 866 and 875.

The Bible is rich in decoration and in colours, including purple, gold, and silver, and, as we have seen, it is lavishly illustrated. Fourteen of its pictures have narrative scenes from the Old Testament, all of admirable quality, including the Israelites crossing the Jordan and storming Jericho [53]. A number derive from pre-iconoclastic Greek illustrations to separate Books of the Bible,[134] some of which conserved elements of Roman triumphal art, and this explains why we can find classical reflections in occasional details of the Bible illustrations: the cavalry skirmishes of the Book of Joshua, for example, have been compared to battle scenes on the columns of Trajan and Marcus Aurelius and on the arch of Septimius Severus.[135]

Three artists were responsible for the paintings in the manuscript. The St Paul Master uses strong contours and opaque colours; the Evangelist Master has a more subtle sense of modelling and shows a sensitive response to the Hellenistic traditions;[136] the third, the Master of Throne Images, has a real flair for narrative painting, and the fluency of his style, his figure types, and aspects of his compositional format all link the manuscript to Reims. More particularly, the third master's dramatic gesture, the ease with which he combines various scenes into a single harmonious picture, and even some of his iconographies, associate his paintings

with the drawings of the Utrecht Psalter.[137] Schade links the Bible with Reims in another way,[138] for he believes that it was associated with a resolution concerning the Frankish succession made at the Diet of Reims of 870, and that it was intended by Archbishop Hincmar of Reims as a diplomatic gift to the pope to encourage him both to lend his support to the proposition and to crown Charles as emperor. On this analysis, the Bible would have been presented when Charles visited Rome for the Christmas of 875.

The Utrecht style influenced not only further manuscripts from Reims or related centres – the Hincmar Gospels,[139] the Loisel Gospels,[140] the Blois Gospels,[141] and others[142] – but also work produced much farther afield in northern 'France' and in England, where it was to provide a major source of inspiration for the Anglo-Saxon Renaissance, as we shall see.

THE SCHOOL OF TOURS

If the Ada School was the earliest, and the School of Reims the most influential, the School of Tours[143] was the most prolific of the Carolingian artistic studios. Tours could boast four religious centres within or near its boundaries – the cathedral of Saint-Gatien, and the Benedictine houses of Cormery, Marmoutier, and Saint-Martin, of which by far the most important was the monastery of Saint-Martin. It lay within the town, and its presiding spirit during its earliest significant endeavours in the field of illumination was Alcuin of York. Alcuin was an Anglo-Saxon scholar who, as we have seen, played an important part in the development of the scholarly and cultural side of the Carolingian Renaissance. He took a special interest in revising the biblical text, and it was moreover by his help that the Carolingian script was extricated from the barbarities of the past and developed into a model of clarity and elegance that was to inspire most of the Western scripts of the future. Alcuin was abbot from 796 to 804, and during his time Tours became something of an Anglo-Saxon centre – not to everyone's satisfaction, for the monks murmured among themselves that the Anglo-Saxons swarmed towards Alcuin like bees round their queen.[144] Despite this, after Alcuin's death Saint-Martin was given another Anglo-Saxon abbot, Fridugisus.

The links forged by the Anglo-Saxon pastors between Saint-Martin and the court brought advantages to both. The emperors were able, after the death of Fridugisus in 834, to treat the abbey as a sinecure for their secular state officials, so that Louis the Pious's seneschal, Adalhard, could be made lay abbot, followed after his death by Vivian, a court official of Charles the Bald.[145] Benefits to the monastery included the opportunity to create a number of spectacular artistic productions in the form of royal presentation manuscripts.

The motive force behind the production of most of the Saint-Martin manuscripts was not, of course, artistic: it was the dissemination of Alcuin's revised biblical text. The abbey thus became a significant centre of supply for other libraries, which was particularly fortunate for future art historians since Saint-Martin's own library was destroyed by the Norsemen as early as the second half of the ninth century. In fact, today our chief knowledge of the development of illumination at Saint-Martin is based upon its 'exported' books, and when we discover that some two hundred of them still survive, and

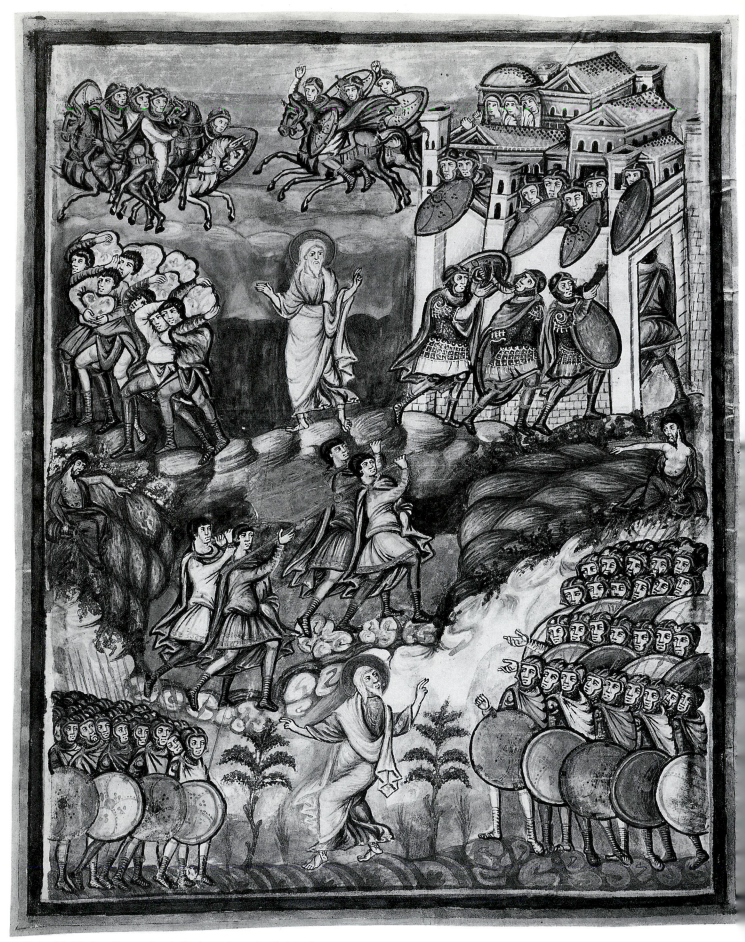

53. Reims(?): *The Israelites crossing the Jordan and storming Jericho*, from the Bible of San Paolo fuori le Mura, folio 58 verso. 866/75. Rome, San Paolo fuori le Mura

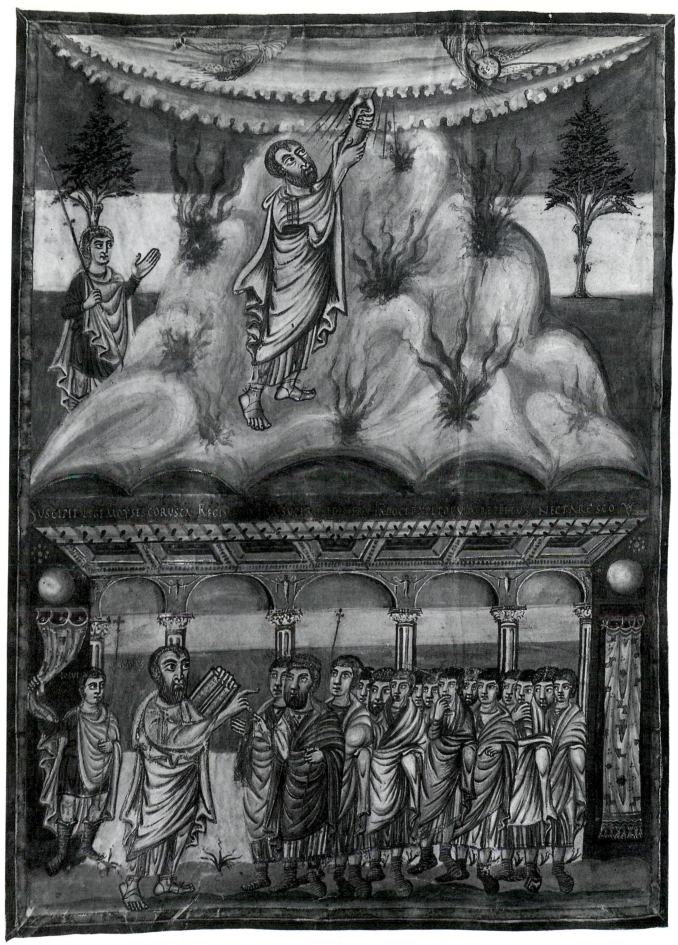

54. Tours: *Moses receiving and dispensing the Law*, from the Grandval Bible,
MS. Add. 10546, folio 25 verso. 834/43. London, British Library

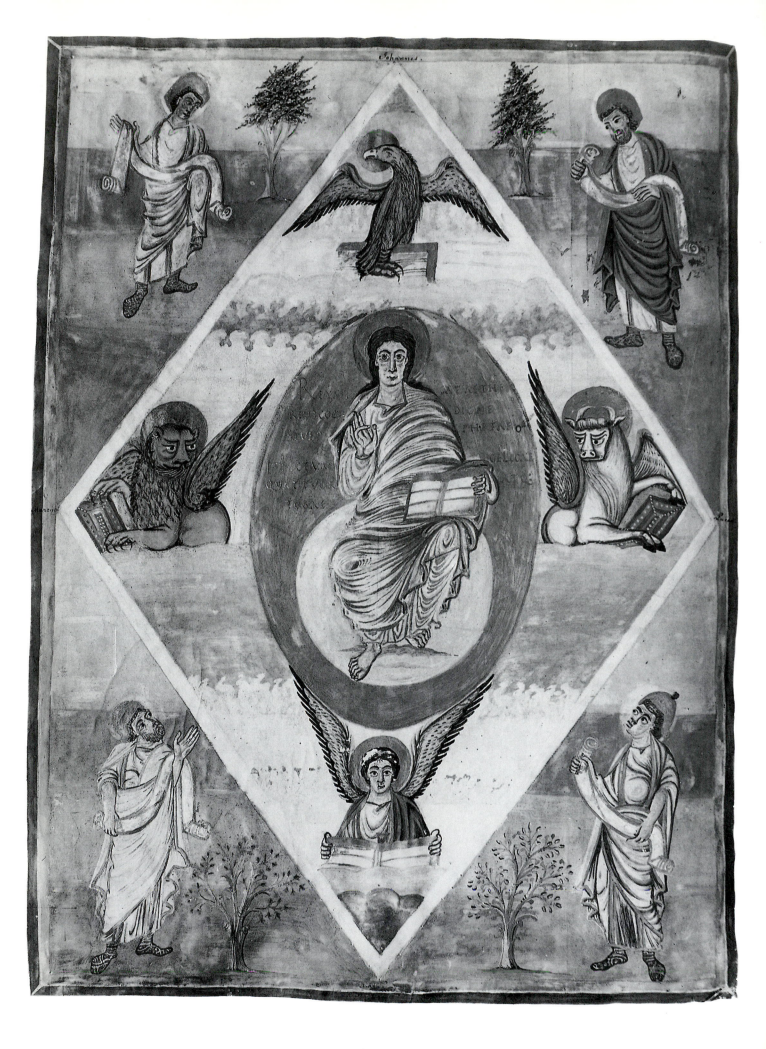

that about sixty of them are illuminated, we can get some idea of what the house's original output must have been.

Eleven of the illuminated manuscripts date from Alcuin's time,[146] and in the light of the attractions that Tours is known to have had for Anglo-Saxons, and the fact that Alcuin asked for manuscripts to be sent to him from York,[147] it is not surprising that their decoration should show a certain influence from England. This is particularly evident in the St Gallen Bible.[148] The relatively modest decoration of Alcuin's abbacy was much enriched under Fridugisus. Initials, hitherto treated largely as an extension of the text, now became bolder and more independent and – like the Canon Tables – made rich use of gold, silver, and colours. To the period of Fridugisus are attributed the earliest surviving illustrations of Tours, in the Stuttgart[149] and London[150] Gospels. The Stuttgart Gospels comprise a full-page Majesty surrounded by symbols of the evangelists and four full-page evangelist 'portraits' in which the thrusting of the figures to the front plane of the picture, and the interest in lighting and in modelling by colour – particularly apparent in the heavy shadowing of the necks and the deep grooving of the folds – betray a stylistic source in Roman illumination between 650 and 750.[151]

Alcuin's task of revision required him to assemble biblical manuscripts of various regions and periods. His interest was in their texts, but a few must have had paintings which became exemplars for the illustrated Bibles of Tours, of which three have survived, as well as some fragments. They show an increasing use of pictures: the Bamberg Bible[152] has two, the Grandval Bible[153] four, and the Vivian Bible[154] eight. The San Paolo Bible – which, as we have seen, partly reflects a lost Tours Bible – has twenty-four. Attention here will concentrate on the full-page paintings of these manuscripts, but their decoration is also attractive and sometimes extensive. The Grandval Bible (probably made quite soon after Adalhard's succession in 834) has fifty-six richly decorated initials, the Vivian Bible (probably presented by Abbot Vivian to Charles the Bald during the emperor's sojourn at Tours at the end of 845 and beginning of 846) has seventy-eight.

Wilhelm Koehler, the greatest authority on Carolingian illumination, thought that the basic programme of the Tours Bible illustrations was epitomized in the Grandval Bible.[155] He believed that the content of its four pictures indicated a programme originating in a Bible made for Pope Leo the Great (440–61) and intended to present a visual counterblast to the heresy of Manichaeism which had recently entered Italy. Inspired by the writings of St Augustine, the pictorial cycle of this hypothetical fifth-century Bible would have brought home specific points that the Manichees denied – the divine creation of man in God's own image, the divine origin of the Law of Moses, the true human nature of Christ who died and arose from the dead, and the unity of the two Testaments. Koehler maintained that certain features of the Grandval Bible – the illusionism of some draperies and heads,

the thick squat body proportions, the heavy staring eyes, and the architectural perspective in the coffered ceiling of one picture [54] – reinforced his theory in their reflection of fifth-century styles. Intellectually satisfying though Koehler's theory might be, however, it no longer seems as secure as it once did, and more recent scholarship favours the view that the Grandval Bible's programme was put together by the Tours artists themselves, drawing on a variety of pictorial models. Schmid sees it as a history of the salvation of the world.[156] Thus the opening illustration of man's creation and fall is followed by the first step towards his redemption with the granting of God's Law to Moses and its exposition to the Israelites [54]. The third picture, at the beginning of the New Testament, is of Christ in Majesty associated with evangelist symbols and figures of prophets [55] – that is, the victorious Saviour promised in the Old Testament and described in the New. Finally, there is a symbolic representation of Christ's redemptive sacrifice and the revelation that it brings. Kessler identifies four sources for the first three of these pictures:[157] an early illustrated Genesis used also, in differing ways, by the artists of the other Tours Bibles; an early illustrated Pentateuch of the West from which, with some variations, two scenes of the life of Moses were adopted in the Grandval, the Vivian, and the San Paolo Bibles; and two manuscripts, one Roman and the other Byzantine, that supplied compositions of Christ enthroned. These offered features which were drawn upon for the miniature of Christ in Majesty which prefaces the Gospels in the Grandval Bible [55] and are also found in the Vivian and San Paolo Bibles, though with slight changes in iconography. Exceptionally, the Bamberg Bible substitutes the sacrificial Lamb for Christ in Majesty.

The last of the Grandval Bible's four pictures precedes the Book of Revelation. The subject is differently placed in the Vivian Bible, and much elaborated in the San Paolo one. It seems to be an invention of the Carolingians – admittedly employing elements found in existing models. Schmid explains it in terms of a commentary by Victorinus of Pettau, who died in 304 during one of Diocletian's persecutions,[158] which interprets the Apocalypse as a series of allegories of the history of man's salvation. In particular, Victorinus explains the opening of the book with seven seals by the Lamb as referring to Christ's revelation of the hidden meaning of the Mosaic Law. In the upper section of the Grandval Bible's picture, the Lamb and the Lion are seen on either side of the sealed book, which rests on a covered altar or throne. Below, an enthroned elder (Moses) holds over his head a veil which three of the accompanying evangelist symbols are apparently removing, while the angel of Matthew sounds a trumpet proclaiming the message of the Gospels.

The Vivian Bible has four further full-page paintings, and these have their parallels in the San Paolo one. The first consists of scenes from the life of St Jerome, the translator of the Bible. The second illustrates the Psalter (or, more correctly, its Preface) with a portrayal of David as king, dancer, and musician, together with accompanying musicians and a bodyguard [56]. The third prefaces the Epistles of St Paul with scenes from his life. The fourth is a dedication picture showing Charles the Bald receiving the Bible [57]. The accompanying verses address him as David, and his face,

55. Tours: *Majesty with evangelist symbols and prophets*, from the Grandval Bible, MS. Add. 10546, folio 352 verso. 834/43. London, British Library

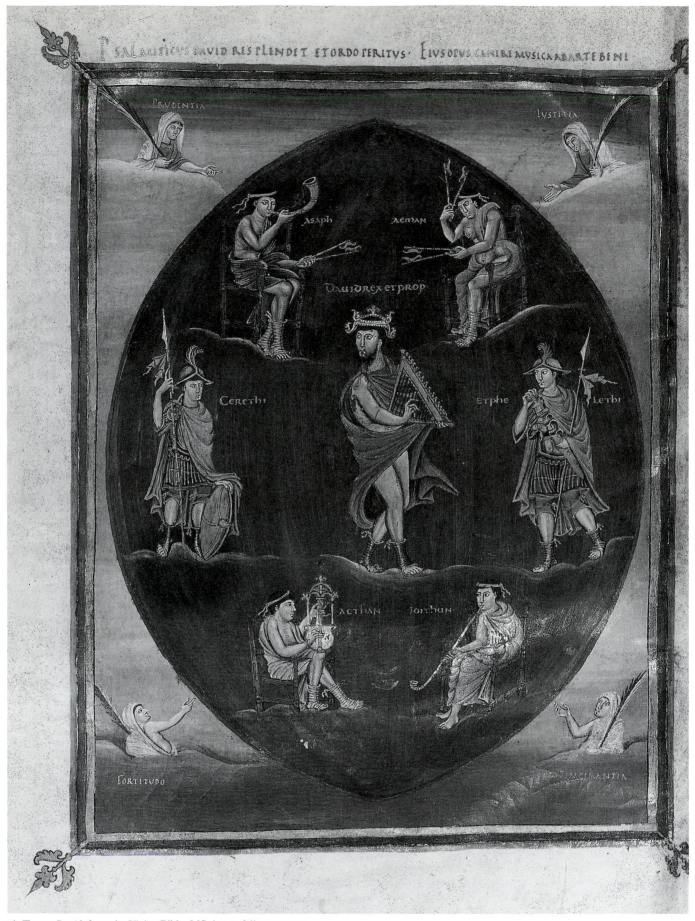

56. Tours: *David*, from the Vivian Bible, MS. lat. 1, folio 215 verso.
Probably completed 845/6. Paris, Bibliothèque Nationale

57. Tours: *Presentation of the Bible to Charles the Bald*, from the Vivian
Bible, MS. lat. 1, folio 423. Probably completed 845/6. Paris, Bibliothèque
Nationale

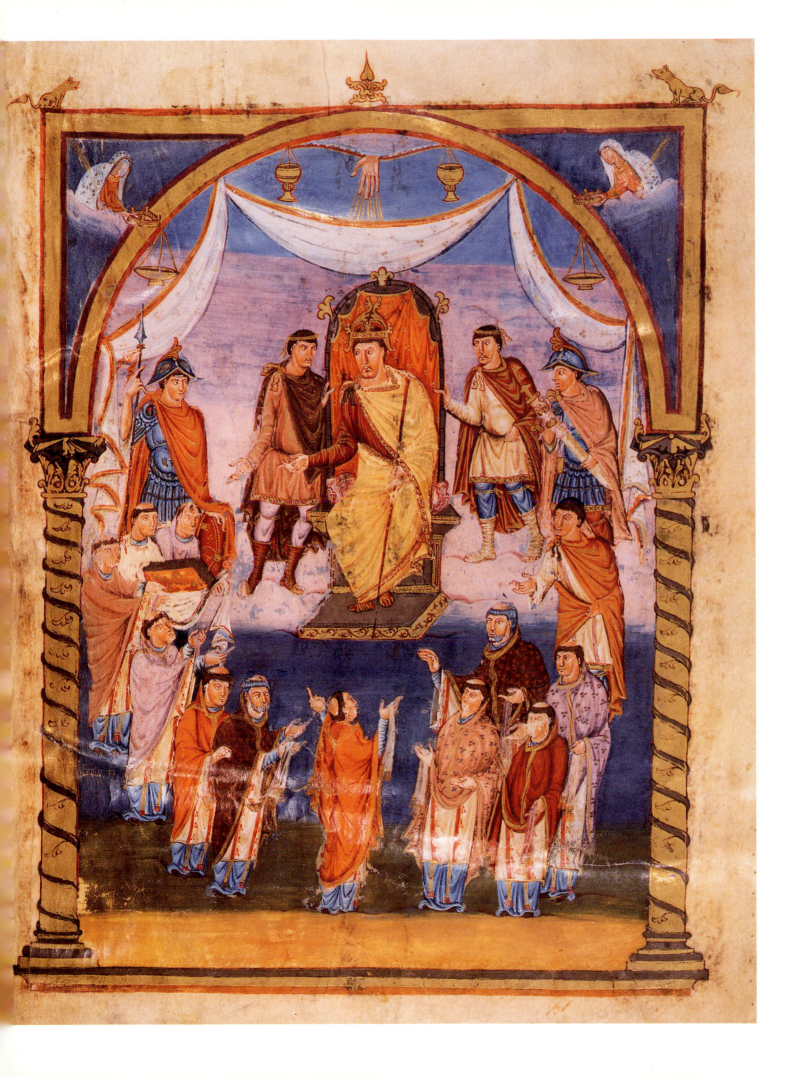

crown, and bodyguard are similar to those of the David painted earlier in the Bible – all of which, of course, accords with the attempts already discussed to relate the Frankish with the Israelite dynasty.

In terms of northern art, this dedication picture is of historic importance since it is a particularly early instance of the representation of a contemporary event. Charles is seated on his throne and is blessed by the hand of God. He is flanked by the *ostiarius* who arranged audiences, and by the *sacellarius* who administered the royal treasury. Dignitaries of the abbey of Saint-Martin are present, and three of them – Amandus, Sigualdus, and Aregarius – are named in the dedicatory poem. The Bible itself is carried by three persons – perhaps those who chiefly produced it – and the picture is given both a physical and a psychological focus. The physical centre is the emperor who, by his size and central position, dominates all the other figures; the psychological one is the sumptuous manuscript he is receiving, for it is to this that the surrounding figures turn their eyes or direct their gestures. There seem to have been some classical influences on the painting, for a very abbreviated form of the same composition is seen in consular diptychs,[159] and the bodyguard on the left adopts a characteristically classical pose. Such classical sources, however, could only have been used to suggest, and not to dictate, and it is obvious that a scene as personal as this must have been created for the event.

Three artists were responsible for the paintings of the Vivian Bible,[160] and their style is very different from that of the Grandval Bible. The earlier Bible's sense of spatial recession in the backgrounds, and its feeling of ponderousness and self-consciousness in the figures, have given way to something a good deal more vigorous which is particularly evident in the Majesty picture [58] by the most accomplished of the painters, who has lengthened the proportions of the figures and concentrated his attention on an excitement of linear movement. In a narrow sense, this indicates a cross-fertilization from the style of Reims, but in a broader sense it represents the natural proclivities of the Carolingian artists.

The tastes of the Vivian artists are found also in the Tours Gospel Books; one now in Berlin,[161] made between 844 and 851, borrows something of the buoyancy and vivacity of the Vivian Bible [59], whilst the Majesty of the Dufay Gospels[162] combines a fine sense of linear rhythm with a nice feeling for balanced composition [60]. However, it is in the illustrations of a Gospel Book made for the emperor Lothar between 849 and 851[163] that the new spirit finds its best expression. The manuscript is the *chef d'œuvre* of the principal artist of the Vivian Bible, who probably also directed the work of the Dufay Gospels; here he charged everything with a new dynamism which snatches up the draperies and the other elements of the picture in a general feeling of linear *élan*. His painting of the Majesty [61] expresses the divinity of Christ by a virtual incandescence of line, and he galvanizes the evangelists with a kind of inner inspiration. Like the Vivian Bible, this Gospel Book has a dedication picture. It is of Charles the Bald's eldest brother, Lothar, enthroned, flanked by two soldiers, and wearing a gold crown and a red mantle threaded with gold [62]. With one hand he grasps his sceptre, with the other he points to the dedication poem written in gold on the adjacent leaf. Both his *gravitas* and the pose of

his bodyguard betray late classical influences, but the surgent feeling of power and the rhythmic balance of the composition are entirely Carolingian. This is the most accomplished of all the Carolingian portraits.

The development of a dynamic style at Tours was, curiously enough, accompanied by a flat-silhouette one[164] using precious metals that was inspired by a late Antique or Early Christian manuscript from Ravenna.[165] The flat refulgence of the gold and silver figures, with their touches of green, brown, and violet, contrasts strangely with the vigorous style just described. In the Vivian Bible and the Berlin and Lothar Gospels this silhouette style is confined to initials, but it extends to full-page illustrations in three other manuscripts – the Arnaldus Gospels,[166] produced between 834 and 843, the Bamberg Bible from Marmoutier[167] of the same period, and the Sacramentary of Autun,[168] made in 844–5.

Both the painted and the silhouette styles reached their zenith at Tours about the middle of the century. After 853 no further development was possible, for that year saw the first of the Viking attacks that eventually reduced Tours and its religious houses to ashes and forced the monks of Saint-Martin to a life of sporadic flight with the body of their patron saint from the brutalities of the dreaded pagans.

NORTHERN FRANCE

The effect of Anglo-Saxon art on Carolingian illumination was concentrated, naturally enough, in the part of the empire nearest to England – that is, the north-eastern coastal areas of 'France', where – particularly in the monasteries of Saint-Vaast and Saint-Amand[169] – the Franco-Saxon School developed about the middle of the ninth century. Its style was essentially a noble interpretation of the Northumbrian initials of the earlier Insular manuscripts with their trellised structure and patterned interweave, though with increased emphasis on the geometry of the structures and with different blends of colour. Particularly noteworthy are the great interlaced initials which introduce each Book of the second Bible of Charles the Bald[170] [63], which was probably made at Saint-Amand between 871 and 877. In terms of clarity of composition and of some of their details, they have been associated with the decoration of the Northumbrian Lindisfarne Gospels, and comparisons can also be made with the Book of Kells which we shall discuss in the next chapter. Other fine products include a Gospel Book[171] probably given to Saint-Vaast by Charles the Bald's wife Irmintrude, and the so-called Gospel Book of Francis II[172] which, unusually for this school, has illustrations as well as decoration. A second Gospel Book with illustrations[173] is remarkable both as the only known Carolingian manuscript to contain a series of scenes of John the Baptist, and because its illustrations relate not to the texts but to the prefaces of the Gospels. The Franco-Saxon, as we have earlier indicated, was the most tenacious of all the Carolingian styles. It continued into the

58. Tours: *Christ in Majesty*, from the Vivian Bible, MS. lat. 1, folio 330 verso. Probably completed 845/6. Paris, Bibliothèque Nationale

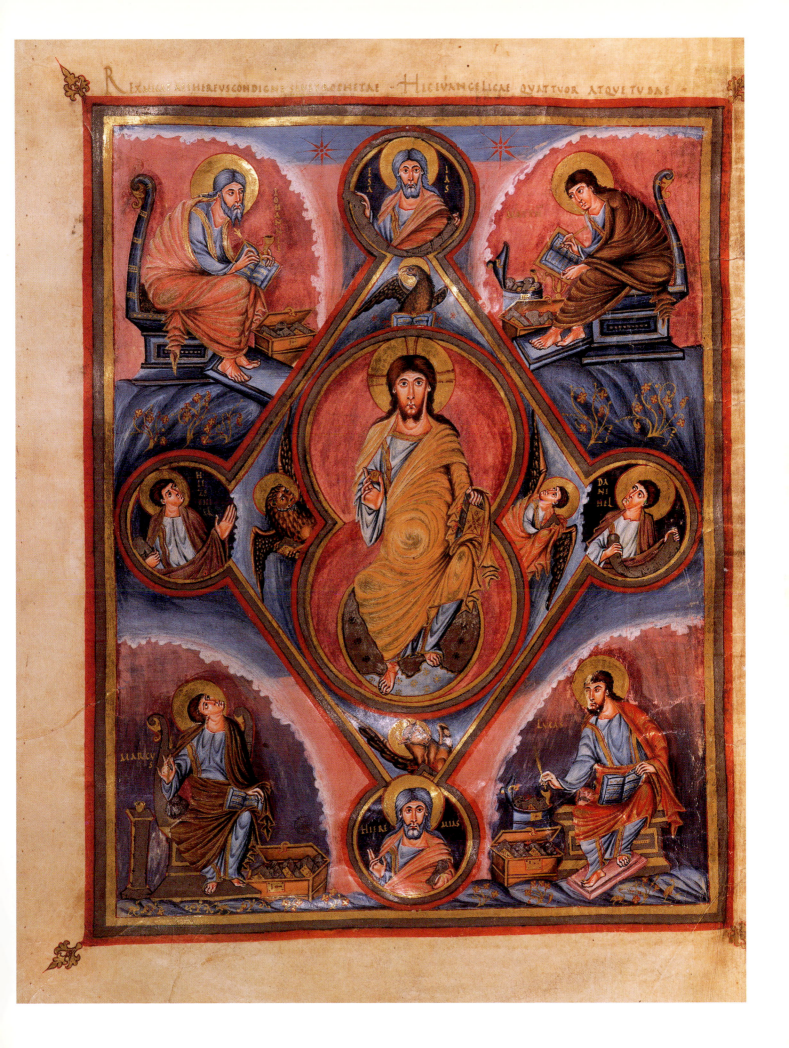

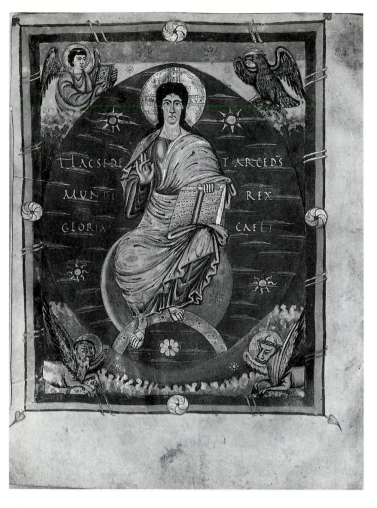

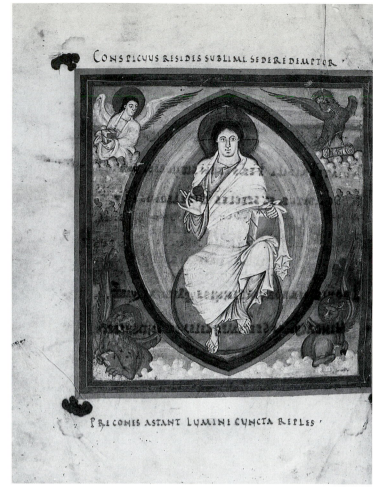

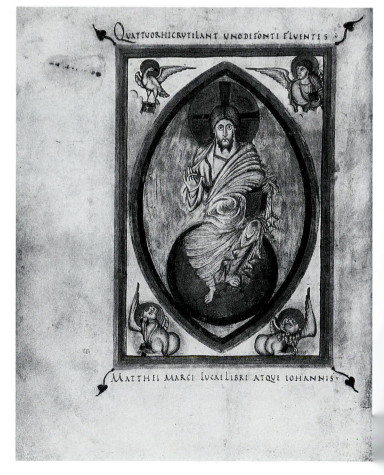

59. Tours: *Majesty with evangelist symbols,* from a Gospel Book, MS. theol. lat. fol. 733, folio 17 verso. 844/51. Berlin, Staatsbibliothek

60. Tours: *Majesty with evangelist symbols,* from the Dufay Gospels, MS. lat. 9385, folio 179 verso. *c.* 850. Paris, Bibliothèque Nationale

61. Tours: *Majesty with evangelist symbols,* from the Lothar Gospels, MS. lat. 266, folio 2 verso. 849/51. Paris, Bibliothèque Nationale

62. (*opposite*) Tours: *The Emperor Lothar,* from the Lothar Gospels, MS. lat. 266, folio 1 verso. 849/51. Paris, Bibliothèque Nationale

tenth century in manuscripts like the Cambrai[174] and Gannat Gospels,[175] and even into the eleventh century in the case of a Gospel Book now in the Arsenal Library in Paris.[176]

Corbie, another notable centre of northern 'France', produced illumination of a different character. To this area, historical circumstances at the end of the eighth century had brought a Byzantine bishop and a Lombard king.[177] The first was George, bishop of Amiens from 769 to 798, a Greek coming from Italy. The second was Desiderius, the last king of the Lombards, who was taken prisoner in 774 and sent to Corbie. It is thus not surprising that Corbie's manuscript painting reflected influences from Byzantium and, more putatively, from Lombardy.

The so-called Corbie Psalter[178] of *c.* 800 has a number of delicately coloured initials, some of them zoomorphic and one or two historiated [64], and it has been suggested that the figures, with their diadems and starkly frontal positions, owe something to Lombard influence. A slightly later manuscript (*c.* 820–30), known from its present home as the Stuttgart Psalter,[179] has a considerable number of brightly

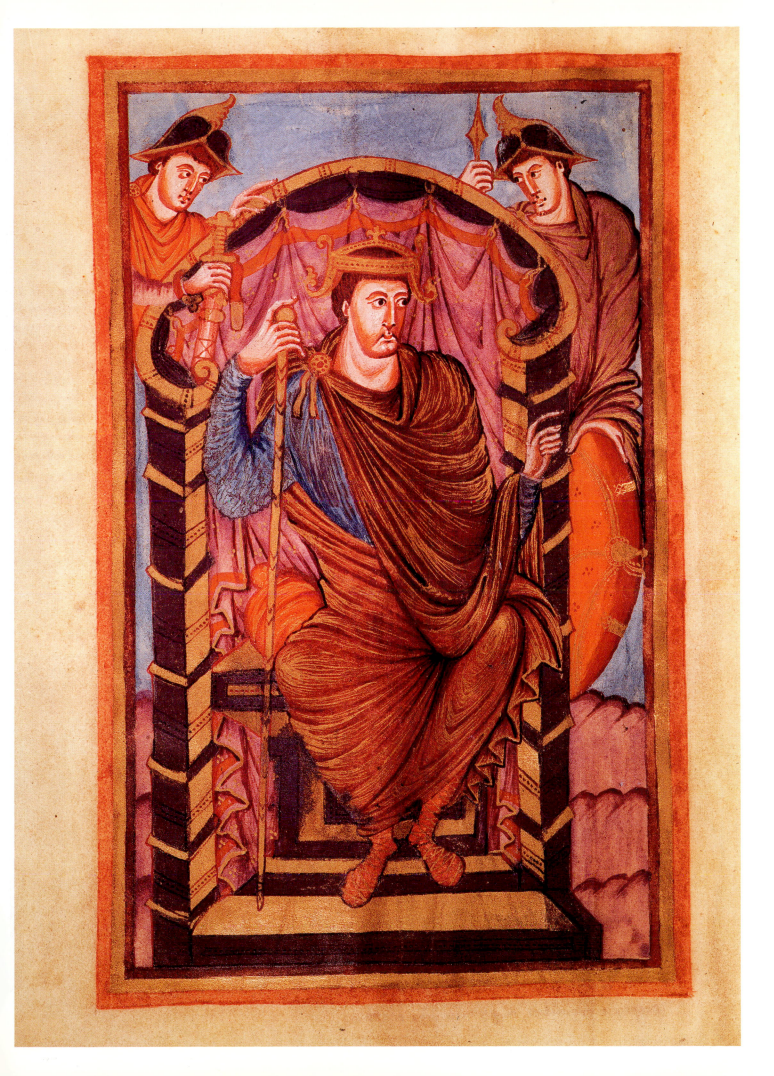

63. Saint-Amand(?): Opening of the Book of Genesis, from the second
Bible of Charles the Bald, MS. lat. 2, folio 11. 871/7. Paris, Bibliothèque
Nationale

64. Corbie: Initial to Psalm 1, from the Corbie Psalter, MS. 18, folio 1 verso. *c.* 800. Amiens, Bibliothèque Municipale

65. Saint-Germain-des-Prés(?): *Crucifixion*, from the Stuttgart Psalter, MS. Bibl. fol. 23, folio 27. *c.* 820–30. Stuttgart, Württembergische Landesbibliothek

coloured pictures[180] [65]. Their style is not particularly sophisticated, but their interpretation is, for they illustrate commentaries on the Psalter which are so recondite that even today scholars have not unravelled the full relationship of all the pictures to the text. The Psalter has been attributed to the Corbie area, but the claims, primarily on palaeographic grounds, for Saint-Germain-des-Prés, near Paris, are more compelling. The initials, by several hands, show influences from pre- and early Carolingian and from Italo-Byzantine sources.[181] The three hundred and sixteen pictures fall into three groups: the literal, the historical, and the exegetical.[182] The literal ones illustrate the text at its most obvious level of meaning. The historical ones depict Old Testament events alluded to in the Psalms, or in their titles – most commonly incidents from the life of the Psalmist himself. The exegetical ones associate particular Psalms with episodes of the New Testament, among them the Crucifixion [65]. Such associations were not only in line with the general principles of patristic commentators, who believed that in some ways David prefigured Christ, but were even anticipated in the New Testament itself, where both Matthew and Luke relate one of the Temptations of Christ to verse 11 of Psalm 90 (A.V. 91): 'For he shall give his angels charge over thee, to keep thee in all thy ways.' Not surprisingly, this particular verse is illustrated in the Psalter with a picture of Christ's Temptation. Even the titles to the Psalms could provide New Testament analogies for those anxious to find them, and because the title of the first Psalm associates it with the entombment of Christ, the very first picture of the manuscript shows Joseph of Arimathaea seeking Pilate's permission to take away the body of Jesus.[183]

Connections between one or two of the literal illustrations of the Stuttgart Psalter and others in the Utrecht Psalter[184] have given rise to the view that some of the pictures of the two Psalters shared a common source thought to go back to Early Christian times. The archetype of some of the New Testament pictures too is thought to have been Early Christian:[185] an illustrated Gospel Book in the tradition of the famous sixth-century St Augustine Gospels from Italy.[186] There are, as well, strong early Byzantine ingredients – indeed, one or two of the illustrations can only be explained in terms of a Greek text of the Psalter, or of a Greek commentary on it.[187] It has been suggested that the immediate source of the illustrations may have been a Latin, perhaps north Italian, Psalter which had already assimilated Byzantine elements.

The Stuttgart Psalter was probably produced under Abbot Hilduin of Saint-Germain, a scholar with a strong interest both in the Greek language and in theology; his treatise on Dionysius the Areopagite will come to our attention in a later chapter. One very strong impression given by the numerous pictures of the Psalter is that they were intended for an academic theologian rather than for an art connoisseur, and since Hilduin was just such a person, we might ask whether he did not dictate the content of some of the more recondite illustrations.[188]

The subject of the Apocalypse attracted artistic interest throughout the Middle Ages; indeed, as early as the seventh century the Anglo-Saxon abbot Benedict Biscop had panel paintings of its themes transported all the way from Rome to the north of England, where he set them up in his monastic church at Monkwearmouth.[189] In the Carolingian period, the Apocalyptic Christ in Majesty, adored by the twenty-four elders, was the subject of a mosaic in the apse of Charlemagne's private chapel at Aachen, and another Apocalyptic theme, the Adoration of the Lamb, appears both in the Soissons Gospels of Charlemagne's Ada group [39] and in the *Codex Aureus* of his grandson Charles the Bald. Further to this, as we have noted, a complex illustration of the Apocalypse is to be found in the Grandval Bible, the Vivian Bible, and the Bible of San Paolo fuori le Mura. As we can see from the Roman mosaics of Santa Prassede and San Marco, the Apocalypse interested the ninth-century Italians too; like the Carolingians, they interpreted it in a more benevolent way than artists of a later period, giving their chief emphasis to its promise of Christian salvation.

Four illustrated texts of the Apocalypse survive from the Carolingian period, all produced in the northern parts of the Frankish empire. They can be coupled off in pairs, the first now at Trier[190] and Cambrai,[191] the second at Valenciennes[192] and Paris.[193] The older of the first pair, the Trier manuscript, was made early in the ninth century, and is known to have been in the library of the Trier house of St Eucharius in the twelfth. The script shows associations with Tours,[194] and the illustrations have been tentatively compared with the slightly later Stuttgart Psalter[195] which, as we have seen, is attributed to Saint-Germain-des-Prés or further north. It may then be that a scribe from the area of Tours was working in a northern French centre, and that the manuscript was later transferred to Trier; Tours did indeed have links with both northern France and Trier, for one pupil of Alcuin's became an abbot of Saint-Amand and another an archbishop of Trier.[196] The view that the Trier Apocalypse was made for a lay person is based partly on the fact that there are no clerics among the elect in an illustration for chapter VII, unlike the equivalent picture in the Valenciennes–Paris cycle.[197] The manuscript has seventy-four full-page coloured drawings. They are thought to derive from a sixth-century cycle, and the large heads, small mouths, staring eyes, and background colours are indeed comparable to some of those in the sixth-century Italian illustrations of the St Augustine Gospels at Cambridge.[198] One or two late Antique elements add other points of interest to the drawings[199] – the angel garlanding the first horseman on folio 19 verso, for example, is reminiscent of classical portrayals of Nike, the goddess of Victory; crowns are interpreted as classical laurel wreaths (see folios 16 verso and 19 verso); and the personifications of the winds also take on a classical form as naked busts with wings at the side of the head.

The Cambrai Apocalypse is largely modelled on the Trier one and borrows forty-six of its pictures. It is known to have been at Cambrai Cathedral from the tenth century and seems to have originated in northern France earlier in the same century.

Like the first pair of Apocalypses, the second derives ultimately, it is thought, from an Italian model of the sixth century. The Valenciennes manuscript[200] is itself of the early ninth century, and it has been argued that its thirty-eight illustrations were telescoped from an original cycle of fifty-two.[201] Its sister manuscript in Paris has forty pictures. The use of interlace in the Valenciennes manuscript is a stylistic trait of Anglo-Saxon art, and this may indicate that the immediate model was Anglo-Saxon, or that the Continental centre in which the manuscript was made was imbued with Anglo-Saxon influences.[202] The classical ingredients of the second cycle[203] are few: the seven-headed beast that rose 'up out of the sea' (XIII, 1) has been modelled on the fish-tailed Capricorn of late Antique paintings of the constellations, and the representation of Babylon is derived from another classical image best known as a constellation – Cassiopeia. Though the Valenciennes Apocalypse has been in northern France for many centuries – it was in the library of SaintAmand from the twelfth – some scholars believe that it was originally made in the Middle Rhine area since its scribe, a certain Otoldus *presbiter*,[204] was also responsible for a Gospel Book from St Martin in Mainz.[205] However, in more recent years, the Liège area has been suggested.[206]

Also attributed to Liège[207] is an early-ninth-century copy, now at Antwerp,[208] of the *Carmen Paschale* by the fifth-century Christian poet Sedulius. Its scenes of the Old and New Testaments are said to come from an Anglo-Saxon cycle which in turn is thought to come from an early Italian one[209] – a view given some support by a reference on folio 68 verso to 'Cuduinus', who may be the Cuthwine, bishop of Dunwich (716–31), who brought back at least one illustrated manuscript from Italy.[210] A manuscript[211] of special interest in documenting the transmission of Early Christian art to the Middle Ages is a ninth-century copy of another fifth-century poem which was to become extremely popular in the Middle Ages, the *Psychomachia* of Prudentius, which allegorized the struggle between Christianity and paganism as a conflict between Christian virtues and pagan vices. The manuscript was at Saint-Amand in the twelfth century and perhaps originated there. Its eighty drawings unquestionably derive from an Early Christian cycle, as do the pictures of another ninth-century Prudentius probably made in Reims and now in Leiden.[212]

SALZBURG AND ST GALLEN

In the Salzburg diocese, illustrated manuscripts were being produced as early as the last twenty or thirty years of the eighth century.[213] Their paintings and drawings show a mixture of influences from fifth-century Italy and the missionary art of the Anglo-Saxons, and one of them is known from the name of its Anglo-Saxon scribe as the Cutbercht Gospels.[214] Its initials and Canon Tables are clearly inspired from the British Isles, and it has, as well, some large-scale pictures of the evangelists. The Montpellier Psalter,[215] made at Mondsee before 778, is probably the earliest manuscript of the group, and the Codex Millenarius,[216] produced at

66. St Gallen: *David and his musicians*, from the Golden Psalter, MS. 22, folio 2. 890/920. St Gallen, Stiftsbibliothek

Kremsmünster or Mondsee about 800, the richest. The Codex gives full pages not only to the pictures of the evangelists but also to their symbols on adjacent leaves. A Salzburg manuscript[217] of the first quarter of the ninth century – a collection of chronological and astronomical material – has the earliest personifications of the months to survive from the Middle Ages.

Apart from Aachen, the chief centre of the eastern or 'German' part of the Carolingian empire was not Salzburg but St Gallen,[218] a house whose art displayed a remarkable tenacity. Founded by the Irish about 613, it was always famed for its collection of Irish manuscripts and, despite Merovingian influences between *c.* 720 and *c.* 840, its initials usually showed an awareness of Irish traditions. As a result of the goodwill of both Louis the Pious (814–40) and Louis the German (843–76), St Gallen became a royal monastery free of all lay jurisdiction. Its efflorescence of scholarship and art from about 840 onwards owed much to Grimald, educated by Alcuin at Tours and abbot from 841 to 872.[219] He it was who arranged the cataloguing of the abbey's library, which consisted of some four hundred manuscripts, fifty-three of them presented by himself.

The style of the St Gallen initials in this mid-Carolingian period is finely expressed in the Folchard Psalter[220] of the sixties, which has more than one hundred and fifty of them, illuminated in gold and silver, of considerable size, and

characterized by clarity, linear rhythms, and animation. In the arcades (rather like those of Canon Tables) that enclose the Litany are half-figures of apostles and illustrations of the life of David, and there is also a representation of Folchard (the scribe) and Hartmut (the patron) dedicating the Psalter to Christ. The artistic influences are from Charlemagne's Ada School and from Reims and Tours. The initials of the late Carolingian period, which we may date from the abbacy of Hartmut (872–83) to Abbot Salomo's death in 920,[221] become more complex, and the decoration proliferates in a Baroque manner so that the form is almost buried beneath a wealth of ornament. The St Gallen School reached the zenith of its artistic reputation under Salomo (890–920), and it was then that it produced its finest artistic manuscript. The Golden Psalter,[222] written in gold, contains over sixty initials, three of them full-page, and a series of illustrations of much panache in coloured outline, among them thirteen scenes of the life of David [66]. Salomo was a trusted supporter and powerful ally of the last rulers of Charlemagne's line, and under him the abbey became a centre of cultural as well as financial wealth. One of his monks was the famous teacher and musician Notker Balbulus, another the poet, carver, and architect Tuotilo, who may have contributed to the workmanship of the ivory covers of the so-called *Evangelium Longum*.[223] This was the golden age of the abbey, and even in the early tenth century St Gallen could still produce late Carolingian drawings of real quality, as is proved by the illustration of the destruction of Jerusalem in its copy of the Book of Maccabees[224] [67]. The drawings of a Prudentius[225] of the late ninth century are more tentatively given to St

67. St Gallen: *The destruction of Jerusalem*, from the Book of Maccabees, MS. Perizoni F.17, folio 17 verso. Early tenth century. Leiden, University Library

68. St Gallen(?): *Fides defeating Cultura deorum*, from a Prudentius, MS. 264, p. 69. Late ninth century. Bern, Burgerbibliothek

Gallen. Its intriguing picture of the Christian faith defeating pagan worship is a shorthand representation of the *Götterdämmerung* of the old gods [68].

This golden age was followed by a brutal age of iron. The attacks of the Hungarians and the raids of the Saracens in the first half of the tenth century saw the eclipse of the house, and when it re-emerged as an intellectual and artistic force its connections were with the Ottonian, not the Carolingian, Renaissance. Even so, the fact that its art managed to survive at all bears witness to the sheer artistic stamina of St Gallen. Other and greater centres were less fortunate. The Carolingian empire, under siege from internal dissension and external attack, disintegrated in the latter half of the ninth century and the first part of the tenth, bringing down with it almost all the major centres of art. The fate of the great centre of Saint-Martin at Tours – five times attacked by Vikings between 853 and 903 and five times evacuated, three times burnt down and three times rebuilt – makes one realize that we are entering a harsh interlude of history when art was not simply a luxury but an irrelevance.

The fires of the Carolingian Renaissance, damped down almost to extinction, yet retained sufficient heat to kindle two later Renaissances, one in England, the other in Germany. Their development will be followed later, but first we shall look at the paintings of a country that influenced continental art but was little influenced by it – Ireland.

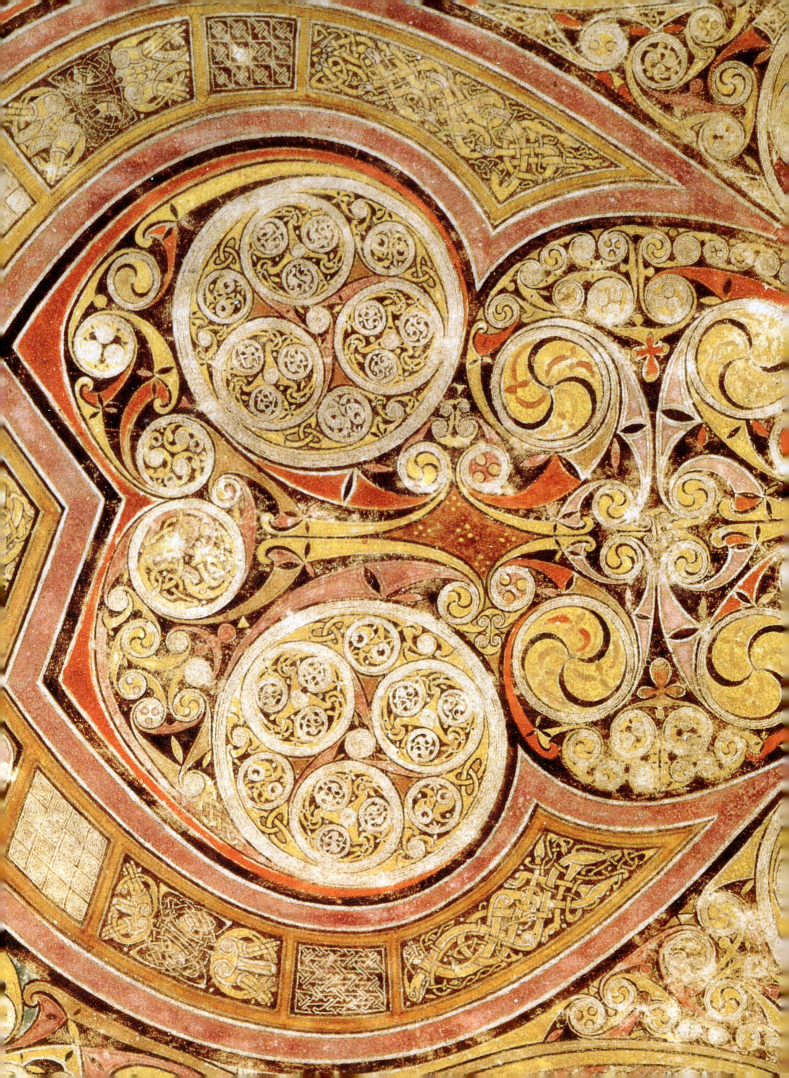

Painting in Ireland: 800–1170

The extensive coastlines of the British Isles made them easy prey to the ravages of the Norsemen, and records of Norse raids on Ireland are frequent. In 795 they plundered a church near Dublin, and thereafter the Annals of Ulster report such devastations almost yearly, culminating in the full-scale invasion of 839, when Turgeis arrived with a fleet to plunder and to burn, and thereafter to set himself up as king of Erin and to raise a pagan temple to Thor in the town of Dublin that he had founded. In a reference to Brian Boru – Ireland's great leader of several decades later – the author of *The War of the Gaedhil with the Gaill* speaks of books 'in every church and in every sanctuary' being 'burned and thrown into water by the plunderers'.[1]

THE BOOK OF KELLS

The Norse raids and invasion both destroyed the Irish art of the past and stultified its current growth, so that illustrated manuscripts of major quality of the ninth and tenth centuries are few and far between. Nevertheless our period opens with – or just postdates – one of the most celebrated of medieval illuminated manuscripts, which has for centuries found a home in Ireland. It is the Book of Kells.[2] This Gospel Book, often dated towards the end of the eighth or the beginning of the ninth century, was happily not destroyed by the Vikings, but their incursions served to obscure its original provenance. It happened in this way. Because of their vulnerability to raids from the sea, communities established on the coasts of the British Isles were often driven to move inland. Thus the monks of Lindisfarne left their ancient Northumbrian home, bearing with them the venerated relics of their patron saint, St Cuthbert, and their most revered manuscript, the Lindisfarne Gospels, and travelled about, finally settling first at Chester-le-Street and then at Durham. The Irish community long established at Iona off the west coast of Scotland similarly decided to migrate, choosing as their new home the island of saints from which their own founder had come, and acquiring a site at Kells in County Meath, where they built a new monastery to which they finally moved *en masse* in 878.

Whether the Book of Kells was made at Iona, as the Lindisfarne Gospels was produced at Lindisfarne, has been a subject of much controversy. The first certain link with Kells dates from as late as the twelfth century – not long before the house itself ceased to exist – when charters were copied into the manuscript. Before that, we have only a reference in the Annals of Ulster to a Gospel Book having

been stolen from the sacristy of the church of Kells in 1006 (really 1007), to be recovered later in a mutilated state, with its gold binding wrenched off. As folios at the beginning and end of the Book of Kells are now missing, it may be that it was the Gospel Book referred to, in which case it was certainly at Kells in the eleventh century. Even so, there is no guarantee concerning its ultimate origin. One view is that it was made in Northumbria – i.e., on Anglo-Saxon soil – and taken thence to Iona and finally to Kells.[3] Another is that it was made in Iona, on Scottish soil, by a community of Irish monks.[4] The third is that it was begun on Iona and completed at Kells.[5] In view of the paucity of evidence, it would be foolish to commit oneself finally to any of these views. All one can say in the present state of knowledge (which has been enriched by a penetrating article by Paul Meyvaert,[6] who dates the manuscript towards the middle of the eighth century) is that it seems probable that the Book of Kells was made and completed on Iona. This view is strengthened by the description of the stolen manuscript by the writer of the Annals of Ulster as the great Gospel of Columba, 'the chief relic of the western world'; in other words, he himself believed that the manuscript had been made on Iona in Columba's day. Although it is true that medieval writers could be over-zealous in their attempts to identify relics, and that the annalist's assertion would entail pre-dating the manuscript by two centuries, yet his statement proves that the monks of Kells themselves believed that the manuscript was brought over complete from Iona in 878.

The Book of Kells is a largish manuscript, now measuring 13 inches by 9 (33 cm. by 25), having been brutally cropped by a nineteenth-century binder who actually sliced off some of the illumination itself. It has been suggested that it was intended as a commemorative volume[7] to be placed on display, presumably on the high altar, which would explain why more interest was taken in the art than in the text: it is handsomely written, beautifully illuminated, and apparently once luxuriously bound, but the text itself is far from accurate.

The manuscript has ten highly decorated pages of Canon Tables and a great many pictures, some of them merged into ornamental pages of the text, others full-page. The full-page paintings included each evangelist at the head of his Gospel, preceded by his symbol; the symbol before Luke and the figures of the evangelists Mark and Luke are now missing. Other full-page pictures illustrated the Gospel story; of these, there remain a Virgin and Child with angels, a seated Christ with angels, the Arrest of Christ [69], and the third Temptation of Christ. The painting of the Virgin and Child is the earliest to survive in Western manuscripts, though the theme is known in carved form a good century earlier on the wooden coffin of St Cuthbert, who was buried at Lindisfarne in 698. The two representations have much in common, and both may derive from a Mediterranean model then in

Detail of plate 71 (enlarged)

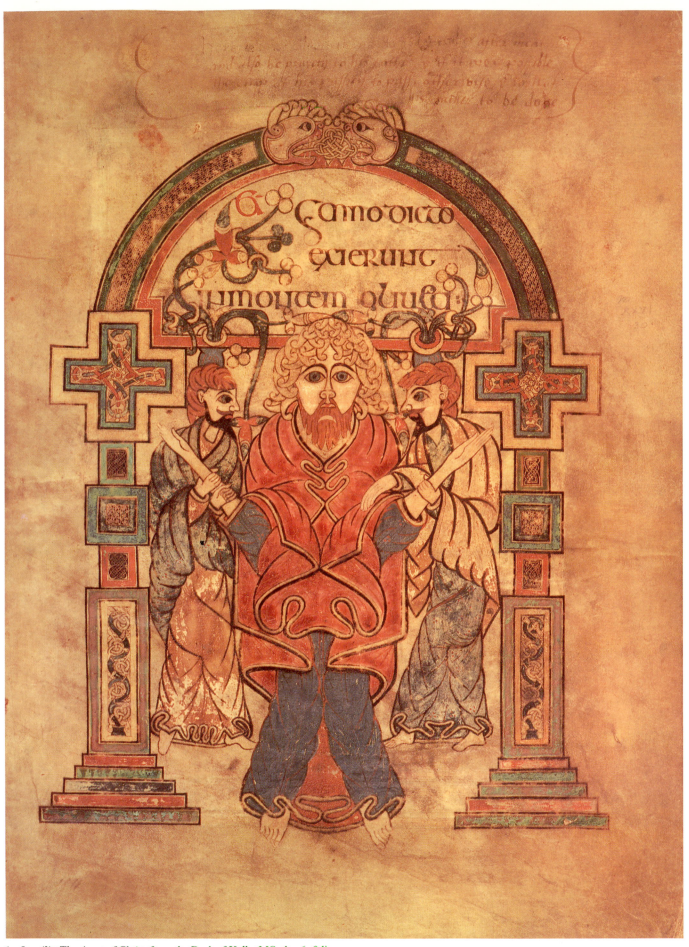

69. Iona(?): *The Arrest of Christ*, from the Book of Kells, MS. A.1.6, folio
114. Mid eighth/early ninth century. Dublin, Trinity College

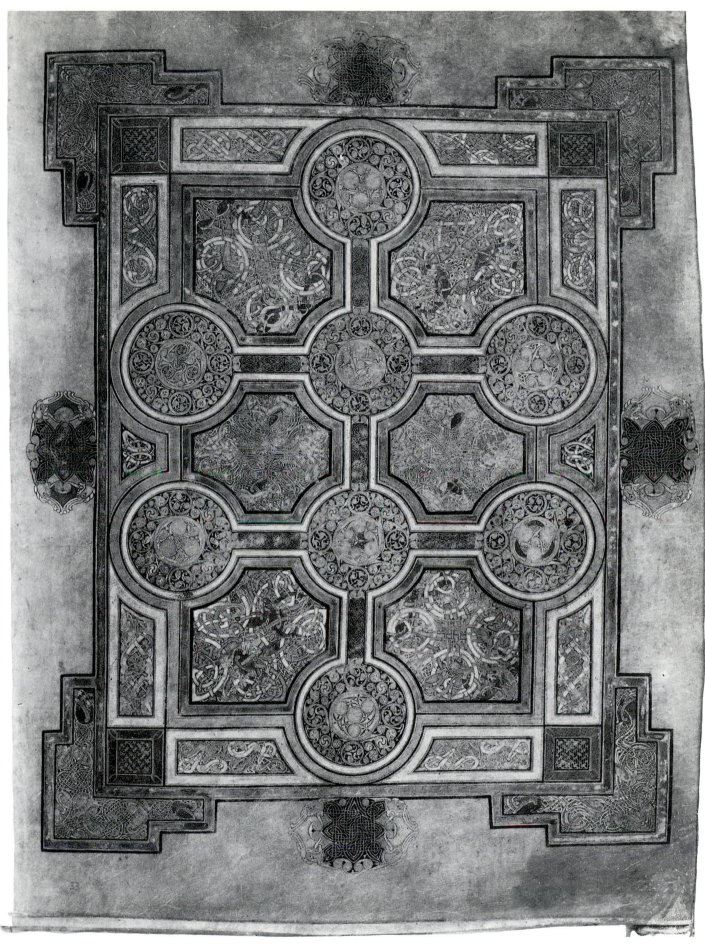

70. Iona(?): Decorative page from the Book of Kells, MS. A.1.6, folio 33.
Mid eighth/early ninth century. Dublin, Trinity College

Northumbria.[8] The Kells Virgin stares relentlessly at the spectator, frontal, but twisting the lower part of her body sideways in a strangely unpersuasive way, and the Christ-child she holds is equally unconvincing – more like a clumsy puppet than a babe-in-arms. The composition of the Arrest of Christ [69] may well derive from early Italian art, for it is similar in a general way to the treatment of the same theme in a sixth-century Italian manuscript,[9] while the portrayal of the devil as a black wisp of a being in the scene of the third Temptation has led to its being associated with the art of the Eastern Church.[10]

The figure style of the Book of Kells has an artless simplicity that, in a more modern period, would be described as naïve. Eyes stare out from faces crowned by a woven interlace of hair, and there is no pretence that a body exists beneath the mantling of draperies [69]. The colour sense, on the other hand, is very sophisticated, and the low-key tones of pink, brown, fawn, lapis lazuli, and verdigris green – all lit up with bright yellows – imbue the manikin-like figures with a haunting, other-worldly quality. The yellow was used partly, no doubt, to simulate gold, which is actually found in only one letter; yet the scriptorium could afford to use ultramarine, which must, in the literal sense, have been worth its weight in gold, since it was imported from beyond the Persian Gulf. Perhaps it was felt that use of the precious metal might offend monastic conceptions of poverty, as was later the case in Cistercian houses.

To the entrancing colour effects is added a decorative subtlety characterized by a lively interlace capable of transforming even some of the naïve figures into ornamental motifs. Indeed, the artists were essentially makers of pattern and decoration – and decoration of such an exceptionally high order was well appreciated in the Middle Ages, as we can see from a twelfth-century description by Gerald of Wales of a very similar manuscript:[11]

... in it there are nearly as many compositions as there are pages, all exquisite with a variety of colours ... Should you look at them in the usual way, superficially and without close attention, they will seem more like a smudge than an integrated whole [litura potius videbitur quam ligatura], and you will not perceive any subtlety at all, when there is in fact nothing but subtlety. If on the other hand you should let your eye examine them more closely, and should penetrate the mysteries of the art much more deeply, you will be able to observe intricacies of detail that are so delicate and fine, so compact and carefully contrived, so involved and interlinked, and still so freshly irradiated by the colours, that you would surely assert all this to have been composed by the skill of an angel rather than that of a man. In truth, the more often and the more carefully I examine the whole, the more dumbfounded I am as at something quite new, and I am always perceiving aspects that are ever more worthy of wonder.

The exuberance and *joie de vivre* of the artists led them to invigorate the initials not only with interlace but with lively creatures and flailing acrobats as well. They filled up spaces in the text with a menagerie of spirited and often contorted creatures, and even profited by corrections in the text to introduce further colourful fantasies. It is in the purely

believed to have in God's creation, something that the early saints understood intuitively – indeed, St Columba himself, according to his biographer,[12] showed special affinities with a wild crane and a horse which inhabited the island of Iona where the Book of Kells was probably made.

One of the scenes in the Book of Kells is of a cat and mouse, and the same theme appears in an eighth-century poem:[13]

> I and Pangur Bán my cat,
> 'Tis a like task we are at:
> Hunting mice is his delight,
> Hunting words I sit all night.
>
> . . .
>
> 'Gainst the wall he sets his eye,
> Full and fierce and sharp and sly;
> 'Gainst the wall of knowledge I
> All my little wisdom try.

The association between this little scene and the verses is of course superficial, but the versifier's conception of himself as a hunter for words hits on an interesting relationship between the artists and the writers of the British Isles of the period, for, as artists were exhilarated by virtuoso decorative skills, so writers were exhilarated by virtuoso verbal displays. St Aldhelm, for example, minted words as fantastical as any of the decorative motifs of the Book of Kells; St Boniface delighted in the complexities of acrostics; and scholars on both sides of the Irish Sea were wont to contrive extremely intricate riddles to tease the mind.

A recent scholar has been tempted to see in the art of the Book of Kells influences from northern France of the Carolingian period,[14] but there is no evidence that the manuscripts she cites – the Amiens and Stuttgart Psalters – were made before this famous Gospel Book. Indeed, superb decorative pages, however, that the genius of the artists finds its fullest expression [70]. At the beginning of the Gospels, the enlarged first letters of the opening words become a scaffolding and trellis-work for a closely packed, almost living interlace that progresses in ever-shifting and elusive patternings, absorbing into itself not only geometrical shapes such as spirals, discs, and step- and key-patterns, but any form of animate life that can be seen or imagined – snakes, dragons, plant life, and humans of any shape or form. The supreme example of this exceptional talent is seen in the artistic overture to the words of St Matthew's Gospel which speak of the conception and divinity of Christ [71]; here the subtle gradations of colour and the particular animation of line give immense vitality to the abounding, always delicately defined ornament.

Even in a page teeming with decorative activity, two areas below are left free for tiny animal scenes where the creatures are not ingested into the decoration, as elsewhere, but are left to a life of their own. Perhaps this was some kind of acknowledgement of the special place beasts and birds were

71. Decorative page for Matthew 1, 18, from the Book of Kells, MS. A.1.6, folio 34. Mid eighth/early ninth century. Dublin, Trinity College

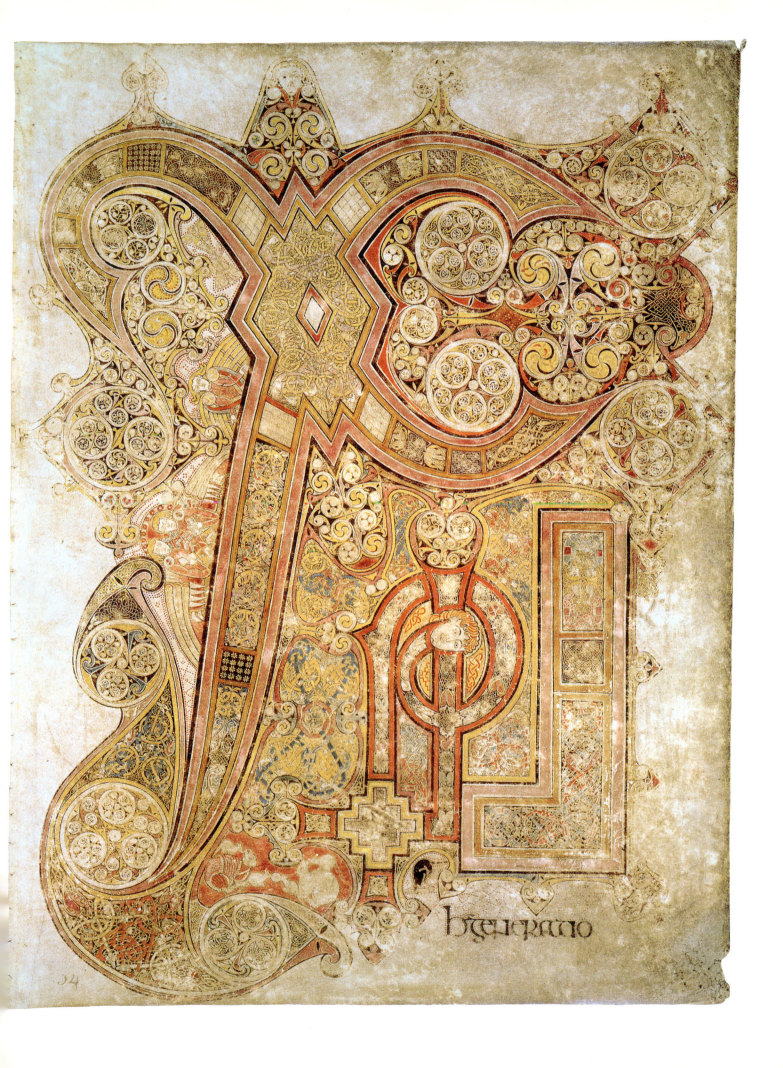

as the Book of Kells is in decorative terms, it is by no means unique, except perhaps in the teeming profusion of its ornament; its suffused colour harmonies and animated intricacy of decoration had been expressed with equal authority some decades earlier in the Lindisfarne Gospels.[15] Seen in its historical context, the Book of Kells is a very late example of a whole school of painting which, as we have earlier observed, has attracted to itself the unfortunate label of 'Insular'.

IRELAND AFTER *c.* 800

The examples of Insular art left by Scotland and Wales are both late and rare, and either, like the Book of Deer,[16] banal, or, like the Ricemarch Psalter,[17] derivative. It is therefore to Ireland and to England that we must turn for our chief knowledge of Insular illumination. The styles of the two countries were very close – so much so that attribution to one country or the other can be difficult: a manuscript now in Leningrad,[18] for example, can plausibly be claimed for both Northumbria and Ireland. Nevertheless, three broad differences may be discerned. Firstly, Insular illumination in Ireland tends to be less geometrically controlled than in England. While the whole Insular aesthetic is, of course, based on the decorative and the abstract – preferring pattern and design to realism, and transforming into an intricate interweave all kinds of motifs, from the pelta and trumpet, the fret and key, the step and diaper, to animals, birds, and humans – the Irish nevertheless had a less clear-cut sense of design and overall control than the English. Secondly, the Irish were even more indifferent to the human figure than the early Anglo-Saxons, tending to transform their evangelists, for example, into a series of coloured shapes or ribbons. A third difference is one of life-span. Basically, although reminiscences of Insular art are occasionally to be detected in the small initials of the late Anglo-Saxon period, the Insular style in England was extinguished by the Viking incursions. The Book of Cerne[19] is the only overall Insular English manuscript to have been ascribed a date after 800 – and even this has been questioned as being too late. In Ireland, on the other hand, the Insular style continued almost unchallenged until the Anglo-Norman invasion of 1170; indeed, examples of it occur even as late as the thirteenth and fourteenth centuries.

In one respect, Irish painting can be compared with folk art – the rugs made by nomadic tribes in the Middle East, for example, or the embroideries produced in the Greek islands, where designs were handed down the centuries from one generation to another, and change never overstepped the boundaries of reordering and rearrangement of the basic elements. We cannot of course tell what may have been destroyed on either side of the Irish Sea by the Vikings, but all the surviving Irish paintings of our period point in the same direction – to an art capable of taste, quality, and sensitiveness, but not of originality.

The only Irish manuscript produced after 800 that is comparable in size to earlier large Insular ones is a Gospel Book at Turin[20] made in the first half of the ninth century. A series of calamities over the centuries has left it a ruin. Before the end of the ninth century it had reached Bobbio in Italy and in the fifteenth all its vellum pages were scraped down and re-used, apart from four illuminated ones, which were removed. Some of the original text from the written pages was later recovered, but even this perished in a fire at Turin in 1904; only a few fragments of initials escaped, as did the four detached pages, though much damaged and shrunk. It has been estimated that they were originally of about the same size as those of an Irish Gospel Book of the second half of the eighth century which is now at St Gallen.[21]

Two of the four surviving folios from Bobbio are carpet-pages of overall decoration. One focuses on patterns and interlaced circles; the other indulges in a more complex decoration incorporating human figures, as in the English Barberini Gospels[22] and the Book of Kells. The other two folios have pictures of a sort. One is of the Ascension of Christ in a composition borrowed by the early Church from classical art in which the winged Victories raising aloft a bust-figure in a mandorla have become winged angels raising a rudimentary bust-figure of Christ, accompanied within its circular frame by two manikin figures, presumably angels. An angel in another circular frame below must represent 'the two men . . . in white apparel'[23] who appeared to the disciples at the time of the Ascension and are mentioned in the text on this page. There are simplified busts of the disciples on the lower half of the page. The last of the four folios is so densely packed that it resembles a patterned textile. A design of repeated rectangles containing an apparently identical three-quarter-length figure surrounds a larger rectangle enclosing a figure with a cross-staff. The angel blowing a trumpet at the top right-hand corner of the page, where he is almost lost to view, indicates that the subject is the Second Coming. Its association with the Ascension picture is underlined by the text on the Ascension page, which records the promise made by the two men in white apparel that 'Jesus . . . shall come in like manner as you have seen him going into heaven' (Acts I, 11).

The other surviving Irish Gospel Books are small and portable, intended for use and not display. Some of them, like the Turin manuscript, are in fragments, and most of these are at St Gallen.[24] One or two of the others are incomplete or damaged, and the Howth Gospels[25] is both. The format and style of the few that survive in good condition follow the traditions of such eighth-century pocket Gospel Books as the Book of Mulling[26] and the Book of Dimma.[27] One, the Mac Regol Gospels,[28] has the advantage of a secure provenance and a reasonably assured date, for the Mac Regol who wrote it is known to have been an abbot of Birr in County Offaly who died in 822. Its evangelist 'portraits' are no more than ribbon-patterns placed in a framework fastidiously filled, like the display pages opposite, with fine examples of traditional decoration.

The Book of Armagh[29] can also be placed and dated, for one of its scribes, Ferdomnach, tells us that he undertook the work at the behest of Torbach, abbot of Armagh (himself a scribe), whom we know to have been in office from 807 to

72. Armagh: Decorative page to St Matthew's Gospel, from the Mac Durnan Gospels, MS. 1370, folio 5. 888/927. London, Lambeth Palace Library

808.[30] The book is in fact a composite volume containing, among other texts, forged statements associating the whole with St Patrick. Any relic of an important saint was of course a great asset, but a convincing association with St Patrick himself would have promoted Armagh's claims to be the earliest and, in consequence, the most important monastery in Ireland.

The illustrations of the New Testament section of the Book of Armagh are of particular interest for their broadly executed style, which is unusual in Ireland. Matthew's Gospel is prefaced by all four symbols of the evangelists, and the other three open with their particular symbols. The Lion of St Mark is filled with a hatched decoration; the Calf of St Luke and the Eagle of St John bear the symbols of the other evangelists on their wings, as if to emphasize the concurring testimony of all the Gospel messages. The main evangelist symbols are not accompanied by the usual display pages opposite, though the Gospel texts (and Matthew's announcement of the Incarnation as well) commence with finely sweeping initials tastefully decorated with animal heads, trumpet spirals, and interlace. Initials of a similar style and linear quality are to be found in two Priscians[31] also presumably from Armagh, one of them dated exactly thirty years on. The Book of Armagh was considered to be so important that a casket or cover for it, now lost, was provided in 937 by the king of Ireland himself. The surviving leather satchel made for it in the eleventh century is appropriately stamped with traditional interlace and zoomorphic patterning.

In textual terms the Book of Armagh is the most important of the small manuscripts, but the Mac Durnan Gospels[32] is far and away the most exquisite. Its paintings are in delicately harmonized earth-colours, thickly applied. They begin with the four symbols of the evangelists on a single, now slightly patched, leaf. Three of the four Gospel openings are signalled by 'portraits' of the evangelists and by display pages opposite of great refinement; the similar adjuncts to Matthew's Gospel have been shifted to the beginning of verse 18 of chapter 1 [72] with its vital message of the Conception and Nativity of the Saviour. An inscription tells us that Maelbrigte Mac Durnan dedicated this book to God, and the knowledge that Mac Durnan was abbot of Armagh from about 888 until 927, when he died of 'a happy old age', supplies a place and a date for the manuscript. It did not remain long at Armagh, for it was soon in the hands of King Athelstan of England (924–39), who presented it to Christ Church, Canterbury. It probably came to Athelstan as a diplomatic gift, for he took an interest both in books and in fostering cordial relations with centres abroad, and is known to have entertained at least one Irish abbot at his court.

The only service texts illuminated in Ireland in the ninth century appear to have been Gospel Books; on the other hand, the only two illuminated texts to survive from the tenth and eleventh centuries are Psalters.[33] They originally had three decorative divisions – a convenient number for a text with one hundred and fifty psalms – though the fact that a particularly handsome Commentary,[34] made earlier in England in the eighth century, also had three divisions gives us reason to suppose that this arrangement had been first conceived for Psalter Commentaries. It was obviously a very

manageable one, and Ireland – true to its own traditions – never abandoned it, though other Western countries experimented with different divisions. The earlier of the two Psalters, attributed to the early tenth century, is now in the British Library. The first of its three pictures was totally destroyed in a fire of 1731, and even the two that remain – David as musician, and David with Goliath – can only be recovered by the use of infra-red photography. The second Psalter, of a century later, has had a happier fate. Its three pictures are of David and the lion, the Crucifixion, and David and Goliath. The interfillings of the borders bear witness to the continuing competence of the Insular artist in traditional decoration, the narrative scenes to his persistent indifference to the human form. The figures are reduced to segments of purple and yellow, and their behaviour is to say the least bizarre: Goliath, for instance, in mid-duel, stands on his very pointed head and makes a gesture indicative of deep meditation. The general attitude of Insular artists to the human condition is summed up by the expression on the face of the animal decorating David's crook as it gazes at the victor: it is one of puzzlement and incomprehension.

The illuminated texts which have come down to us from the ninth, tenth, and eleventh centuries consist chiefly of Gospel Books and Psalters, but they also include two ninth-century copies of the work of the Roman grammarian Priscian, and, from the twelfth century, Missals as well.

Besides continuing the small format of the ninth century, the Gospel Books of the twelfth hark back to the past in other ways. The evangelist symbols of a twelfth-century Armagh Gospel Book,[35] for example, have clearly been influenced by those of the original Book of Armagh, although they evince as well a new Romanesque 'feel' which is especially evident in the drawing of St John's symbol [73]. Moreover in another Gospel Book,[36] of about 1138, the evangelist symbols are boldly segmented in sand-brown, green, and reddish colours, and are set against a background which is made up of blocks of the same tones, giving the impression almost of stained-glass windows.

Apart from evangelist symbols such as these, the twelfth-century manuscripts of Ireland confine their illumination entirely to decorative initials. They make some concessions to the times in the use of solid patches of colour as backgrounds which are becoming heavier and more robust, but they still draw on the traditional Insular repertory, especially interlace and animal heads. Indeed, a Hymnal in Killiney[37] reanimates the delicate and nimble intertwine of earlier calligraphic initials with remarkable ease; and a small Psalter[38] with Cistercian associations shows the dexterity with which the Insular idiom could still be expressed in the twelfth century [74], interpreting the delicate and complex interweave of the traditional decorative vocabulary in terms of drawn-out strands of gold, and further imbuing the illumination with a jewel-like quality by means of its particular blend of colours, especially its combination of yellow and red. Ireland was remaining tenacious to her ancient traditions at the very moment when her artistic freedom – and indeed her whole independence – was about to be taken from her, for this particularly elegant example of late Insular painting only just predates the Anglo-Norman invasion of 1170, which led to the conquest of the country and sounded

73. Armagh: Symbol of St John, from a Gospel Book, MS. Harley 1023, folio 64 verso. Early twelfth century. London, British Library

the knell for most of its monastic and vernacular painting.

After the conquest of Ireland, manuscripts were mostly either brought in from abroad or produced at home by secular professionals content to use imported styles. Yet the Insular tradition persisted even into the fourteenth century in the rare manuscripts still occasionally made in monasteries.

IRISH SCRIBES

In their heyday, the Irish monasteries held their scribes in high regard. An abbot of Iona who died in 802, for example, was called 'an eminent scribe and abbot',[39] which would appear to give both designations equal weight, and Ferdomnach, who died in 846, was praised by the Annals of Ulster as 'a wise and excellent scribe of Armagh'.[40] Ferdomnach it was who 'signed' his work in the Book of Armagh, and there are plenty of other such 'signatures': Diarmait's in a Psalter Commentary of the early ninth century,[41] for example; Dubtach's in a Priscian, along with the information that he completed his work on 11 April 838;[42] Cormac's in the Psalter he copied out in the twelfth century,

adding an appropriate musical touch in requesting the prayers of the reader on four musical staves ruled in red and black.[43] In his own inscription, Maelpatricc, the scribe of a ninth-century manuscript, used the vocabulary of the painter (*depinxit*),[44] suggesting that he was the illuminator as well. It is true that, despite their linear elegance, the initials of Maelpatricc's manuscript would not have strained the competence of an experienced calligrapher, but the illumination of another ninth-century manuscript that was certainly written and painted by a single individual reveals a good deal of decorative sophistication. The scribe-artist here, Mac Regol, declares himself the painter of the manuscript at the beginning of his colophon, and concludes it by inviting prayers for himself as its scribe.[45] The very casualness of his comment suggests that the conjunction of the two skills was not unusual, and it may be that some scribes learned the complexities of Insular decoration and the techniques of Insular calligraphy at one and the same time.

Other inscriptions are almost conversational, and sometimes tinged with humour. 'We are here in Glendalough on the day of Pentecost,' reads one;[46] 'it is a pity that Tuathal is ailing'; 'even more of a pity', it continues later, 'that he died last night and will be buried shortly.' As Tuathal was presumably the abbot of Glendalough who died in 1106, this scribal aside helps to date the manuscript. The scribe of another illuminated Gospel Book[47] gives us his own name as well as that of his scriptorium: it was at Armagh. Then, for good measure, he lists the kings of various parts of Ireland, asks for prayers for himself, and goes on to add, somewhat inconsequentially: 'It is an awful deed Cormac Mac Carthy having been killed by Turlough O'Brien.' Mac Carthy was the king of Desmond, and O'Brien the king of Connacht who died in 1138, so once again the inscription is an aid to dating. Other apparently inconsequential scribal entries were no doubt made to relieve the tedium and physical effort of the work: thus, one calligrapher asks the reader not to complain about his writing since he has cramp in the arm – the result of overwork;[48] another breaks off from his comments on the difficulties of writing the last page with the sudden exclamation, 'The third hour. Time for food!';[49] and yet another addresses his own hand in pensive melancholy: 'You will make the vellum famous, and end up as the white extremity of a bundle of bones yourself!'[50]

After copying out an illuminated chronicle in the eleventh century, an Irish scribe working in Germany added comments which were a mixture of the historical, the biographical, and the inconsequential.[51] He speaks of his 'pilgrimage' away from Ireland – a pilgrimage of exile for which the Irish were famed above other nations in the Middle Ages. They took with them not only examples of Insular art, but also their idiosyncratic views of scribal independence, adding their own personal comments to manuscripts both secular and religious. This relaxed attitude seems to have been taken up in Spain; if so, we owe it to the Irish that we are better informed about the scribes, artists, dates, and provenances of some of the Spanish illuminated manuscripts than we otherwise would have been. It may be this same Irish influence at work in northern Europe that accounts for the fulsome comments on contemporary history in the Lobbes Bible,[52] and the lengthy history of himself and his family given by a scribe in the

74. Ireland: Initial, from a Psalter, MS. Add. 36929, folio 2. Late twelfth century. London, British Library

Manerius Bible.[53] Indeed, we owe much to the outgoing nature of the Irish scribes: they have not only endowed us with information about the manuscripts they were copying but, just as importantly, they strike a refreshingly personal note among the frequently anonymous artistic manuscripts of our period.

Anglo-Saxon Painting: 800–1100

THE VIKINGS

'Never has a terror such as this appeared in Britain before ... The church of St Cuthbert is spattered with the blood of the priests of God and despoiled of its embellishments.'[1] This – the first indication of the Viking presence in the West – was the horrified comment of Alcuin in 793 about the Norse raid on the Holy Island of Lindisfarne. During the next century, the Vikings accelerated their attacks throughout the length and breadth of England to the point that the entries of the Anglo-Saxon Chronicle become an intermittent catalogue of their predatory raids, which culminated in 865 – as they had earlier in Ireland and Scotland – in a full-scale invasion. Three of England's four major kingdoms were overthrown, and the invaders were only halted and eventually forced back by the stand of a famous king of Wessex, Alfred the Great (871–900).

Monasteries and churches, with their stores of precious objects, were obvious targets for these 'plunderers who came by sea' (which is the literal meaning of the word 'Vikings'). They had no use for books once they had torn off their gold bindings, and they must have destroyed many beautifully decorated and illustrated manuscripts. In one curious instance, however, they sold back such a manuscript – a Canterbury one, now in Stockholm[2] – presumably after they had removed its gold binding. A note added to it in the ninth century records:

In the name of our Lord Jesus Christ, I, Ealdorman Alfred and Waerburh my wife obtained these Books [of the Gospels] from the heathen army with our pure money, that was with pure gold ... because we did not wish these holy Books to remain longer in heathen possession.

Even worse than the pillage and vandalism was the complete disruption of the country and its institutions, which led, or contributed, to the extinction of the monasteries which had been the major producers of the illustrated manuscripts. It was only when monasticism was revived in the tenth century that the arts burgeoned forth again, though even then, attacks from Scandinavia continued for more than a century.

ANGLO-SAXON PAINTING BEFORE THE REVIVAL OF MONASTICISM

'I remembered how before it was all ravaged and burnt, I had seen how the churches throughout all England stood filled with treasures and books.'[3] King Alfred's elegiac remark bears witness to an interest in manuscripts which, his contemporary biographer tells us, had been with him since childhood. Apparently, when he was a boy, his mother promised a certain book of Saxon poems to whichever of her sons learned it most quickly, and Alfred was so attracted by the beauty of the initial letter that he made sure that it was he who won it.[4] As a king, his primary and most formidable task was, of course, to hold back the Vikings, but an accommodation with them soon after the war of 886 enabled him to take some modest steps towards replenishing the vast store of books that had been lost. One of the means he chose was a very personal one: it was to send to the bishops of his kingdom copies of his own translation of St Gregory's Pastoral Care, together with an object called an aestel, which some believe to have been a reading pointer with a jewelled handle after the fashion of the famous Alfred jewel.[5] One of the copies survives.[6] Made under Alfred's supervision and given by him to Werferth, bishop of Worcester, it can be closely dated to c. 890–97. Its small but colourful initials, with hints of foliage and tiny animal heads, hark back to the earlier Insular tradition which – as has been pointed out earlier – persisted in some later Anglo-Saxon initials, though not to anything like the extent that it did in Ireland.

Alfred maintained connections with the Continent and with foreign courts, but his grandson, Athelstan (924–39), formed even closer ties than he, partly by means of dynastic alliances, especially between his sisters and powerful princes. A tenth-century poem[7] tells us something of the negotiations for the marriage of one of his sisters to Hugh, duke of the Franks, who offered him 'gifts of a liberality that would have satisfied the most avaricious', including jewels and spices, horses with gold trappings, a gold and bejewelled crown, the sword of Constantine the Great, and the most precious of relics. The poem does not mention illuminated manuscripts, but as they were included in the presentations that accompanied diplomatic negotiations in the next century,[8] we may perhaps assume that they figured also in Athelstan's exchanges with the Continent. This would explain his ownership of the late-ninth- or early-tenth-century Gospel Book,[9] illuminated at Lobbes in a retardataire Carolingian style, which he gave to Christ Church, Canterbury, as he had the Mac Durnan Gospels [72]. The interest of the Lobbes Gospels in our present context is that its St Matthew 'portrait' was copied about 1000 by an Anglo-Saxon artist who converted it from a painting into a drawing. An illustrated Carolingian manuscript of a treatise by Hrabanus Maurus on the Holy Cross was also copied in England,[10] probably before the mid tenth century, no doubt at Canterbury, and perhaps from an exemplar also acquired by Athelstan. The painting of the author Hrabanus presenting his treatise to Pope Gregory[11] is certainly impressive [75]. A rarer kind of presentation picture, involving a royal donor rather than the author, is to be found in the copy of Bede's Lives of St Cuthbert[12] presented by Athelstan in 937, or thereabouts, to Chester-le-Street, where the relics of the saint were kept. The picture of Athelstan deferentially offering the book to St Cuthbert [76] is the earliest surviving painting of an English monarch, and the dainty scrollwork of the surrounding frame, inhabited by a lion and lively birds, acts as a foil to the robustness of the royal 'portrait'.

The copy of Bede was made in England. The so-called

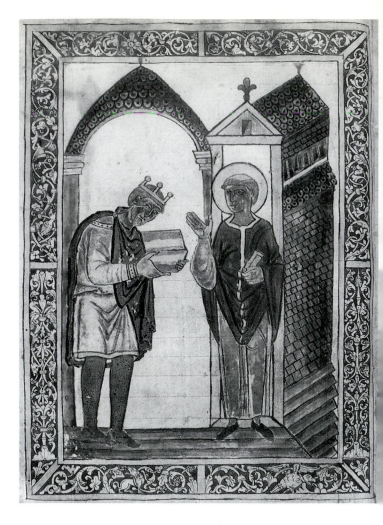

75. Canterbury(?): *Hrabanus Maurus presenting his 'De laudibus sanctae crucis' to Pope Gregory*, MS. B.16.3, folio 1 verso. Before 950. Cambridge, Trinity College

76. Winchester(?): *King Athelstan presenting a manuscript of Bede's 'Lives of St Cuthbert' to the saint*, MS. 183, folio 1. *c.* 937. Cambridge, Corpus Christi College

77 (opposite). Winchester(?): *Christ amid choirs of martyrs, confessors, and virgins*, from the Athelstan Psalter, MS. Cotton Galba A.XVIII, folio 21. 924/39. London, British Library

Athelstan Psalter,[13] however, originated abroad, perhaps in the Liège area, and its Anglo-Saxon elements were added during the king's lifetime – probably at the Old Minster, Winchester. They consisted of the Calendar decoration, and four miniatures in a bland style derived partly from the Carolingian Ada School and partly from pre-Carolingian art.[14] Two of these small pictures show Christ enthroned, first with angels, patriarchs, prophets, and apostles, then with martyrs, confessors, and virgins. They form a pictorial litany probably deriving from a Last Judgement. The third miniature presents an Ascension whose iconography owes something to Byzantium, the fourth a Nativity whose iconography is also Eastern, perhaps refracted through Carolingian art.[15] A reversal of the order of these last two pictures will present us with Christ at the beginning of his human and of his celestial life. The first two seem to have a particular reference to Athelstan's preoccupation with relics, which was well known, not least to Hugh, duke of the Franks, who, as we have seen, included important relics among his gifts to the king. One was part of the lance with which the centurion Longinus pierced Christ's side at the Crucifixion, another was a fragment of the true Cross, and it can hardly be a coincidence that there is reference to both in the two pictures in question: in the second, on folio 21, Christ uncovers his breast to display the very wound made by Longinus's spear [77], and in the first, on folio 2 verso, the lance and Cross are prominent on either side of the Redeemer. As far as I know, this was the first time in Western art that Christ had been associated with these particular two instruments of his Passion, though in the heavily restored mosaic of about 549 from San Michele in

Affricisco at Ravenna, now in Berlin, he appears with the lance and the sponge, held by two angels.

THE REVIVAL OF MONASTICISM

The monasticism quenched by the Vikings was revived in the later Anglo-Saxon period by a deliberate act of King Edmund (939–46). In gratitude for an act of providence which saved his life while he was hunting on the cliffs of Cheddar in 943 or 944, he rode forthwith to Glastonbury and there revived its monastery by installing Dunstan as abbot. This set in motion a wave of monastic reform which ran rapidly through the south of England, the Midlands, and East Anglia. Such a movement had not gone unheralded on the Continent, where the foundation of Cluny in Burgundy, in 910, initiated a concern for reform which was taken up by other religious houses such as Fleury, and was joined by a tributary from Lorraine which also touched houses in Flanders. The three chief leaders of the English Church, all monks, were Dunstan (of Glastonbury), Aethelwold, and Oswald, and they kept in direct or indirect touch with developments on the Continent. Dunstan, to become in turn bishop of Worcester, bishop of London, and archbishop of Canterbury (960–88), spent a year at the reformed monastery of St Peter in Ghent. Aethelwold, who had been with him at Glastonbury and later became abbot of Abingdon and then bishop of Winchester (963–84), caused one of his Abingdon monks to visit Fleury. Oswald, who was promoted to the bishopric of Worcester in 961 and joined with it the archbishopric of York from 971 to 992, had also spent time at Fleury. In 970 King Edgar (959–

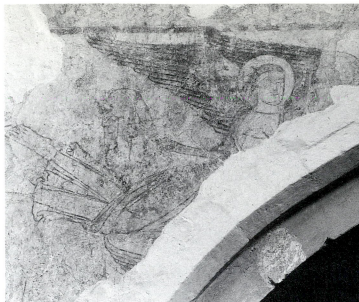

78. Winchester: *King Edgar offering the Charter of New Minster to Christ*, MS. Cotton Vespasian A.VIII, folio 2 verso. 966/84. London, British Library

79. Nether Wallop church, *Angel*. Detail of a wall painting. Late tenth century(?)

75), himself a keen supporter of reform, showed his recognition of the ties formed with the Continent by asking representatives of the monks of Fleury and Ghent to attend a national synod to lay down a code of religious observance for the country.

The three reforming bishops considered that the best way to revitalize the spiritual life of England would be to renew its monastic life. Indeed, the links between monasticism and the episcopacy in the later Anglo-Saxon period were very close: no less than sixty-seven of the one hundred and sixteen bishops appointed between 960 and 1066 to eighteen English sees were drawn from the monasteries,[16] and some of them remained monks, for it was a peculiarity of the English Church that certain cathedrals – Christ Church at Canterbury, the Old Minster at Winchester, Worcester, and Sherborne – had monastic communities attached to them.

Edmund's regeneration of Glastonbury under the abbacy of Dunstan led to the revival of other extinct houses and to the founding of new ones. Dunstan himself went on to resuscitate monasticism at Malmesbury, Bath, Westminster, and Christ Church, and to set up new foundations at Milton, Exeter, Cerne, Tavistock, Horton, and Cranborne. Aethelwold revived the Old and New Minsters at Winchester, and founded houses at Peterborough (966), Ely (970), Thorney (972), and perhaps also at Croyland (c. 966), St Neots (c. 974), and Chertsey (?960). Oswald set up new establishments at Deerhurst (c. 970), Ramsey (c. 971),

Winchcombe (?972), Pershore (c. 972), Worcester (c. 974–7), and perhaps Evesham (c. 975), and he may also have refounded Ripon (?980). The dynamism of reform was such that some sixty years after 943, the approximate date of Dunstan's appointment to Glastonbury, the two or three communities in the land that could then be called monasteries had swelled in number to more than thirty, and there were now some half-dozen important nunneries. This of course led to a renewal of interest in books – including illustrated ones – and to the specialization of one or two of the monasteries in the production of their own illuminated manuscripts.

The links forged with the Continent by mutual interests in reform were reflected in Continental influences on Anglo-Saxon illumination; moreover, both areas were inflamed with a desire to see the house of God enriched and glorified by paintings and other works of art. It is symbolic, therefore, that a charter of reform for the New Minster at Winchester[17] should have a sumptuous frontispiece showing King Edgar offering the document to Christ – clearly made for display in the minster, presumably on the high altar. The picture, in a frame whose foliate decoration owes something to the tradition of the Cuthbert textiles at Durham,[18] is embellished with gold and has a background of imperial purple. The king stands between the two patron saints of the monastery, the Virgin Mary and St Peter, and holds up his charter towards Christ, who appears enthroned in a mandorla supported by angels [78]. The charter, written in gold, carries a date of 966, but its magnificent appearance and lack of the kind of detail that we would expect in a *bona fide* document suggest that it was made commemoratively after the event,[19] though

80. St Dunstan: *Christ as the personification of wisdom*, MS. Auct. F.4.32, folio 1. 943–4/57. Oxford, Bodleian Library

81. Canterbury(?): *Christ as the second person of the Trinity,* from the Sherborne Pontifical, MS. lat. 943, folio 5 verso. Last quarter of the tenth century. Paris, Bibliothèque Nationale

before 984, for all the evidence suggests that it was commissioned by Bishop Aethelwold, and Aethelwold died in that year.

The resurgence of manuscript painting may have been accompanied by a flowering of wall painting, for the style of the New Minster charter is to some extent reflected in the surviving part of a mural in the tiny out-of-the-way Hampshire church of Nether Wallop, not far from Winchester. It shows angels [79] supporting a mandorla, which must originally have contained an enthroned Christ.[20] As it happens, the only other surviving fragment of an Anglo-Saxon wall painting is from the same area: unearthed in excavations at Winchester itself, it shows a complete head and the partial remains of three figures. It can be dated before 903, for the stone on which it was painted was re-used in the foundations of the New Minster, which was consecrated in that year.[21]

LATER ANGLO-SAXON DRAWINGS

The principal driving force in the new movement of religious reform in England was Dunstan. That he was himself an artist is attested both by an unimpeachable contemporary written source[22] and by a drawing from his own hand, entered on the blank prefatory leaf of a manuscript brought from the

Continent;[23] it is a three-quarter-length figure of Christ as the personification of Wisdom, holding the rod that symbolizes her power[24] [80]. The evidence that Dunstan was the artist derives not from the statement at the top of the page that the drawing is 'from St Dunstan's own hand', for this was added later, probably in the early sixteenth century,[25] but from the contemporary inscription over the tiny figure of a monk prostrated before Christ: 'I pray thee, Christ, protect me Dunstan.'[26] Since Dunstan here presents himself as a simple monk, and the manuscript was associated with Glastonbury in the Middle Ages, we may suppose that the drawing was made there at some time before his appointment as bishop of Worcester – i.e., between 943/4 and 957.

Dunstan's broadly conceived figure of the Redeemer derives from the Carolingian Ada style, and its proportions and drapery treatment have been convincingly compared with those of a carving of Christ on the ivory book-cover of the Lorsch Gospels.[27] As Wormald has demonstrated,[28] the Ada style took on a life of its own in England, soon reappearing in another delightful drawing of Christ which was added to a manuscript from Canterbury (or Sherborne),[29] and again, more restlessly, in three full-page drawings of each figure of the Holy Trinity [81] in a manuscript probably made at Christ Church, Canterbury, but known as the Sherborne Pontifical.[30] It emerges, too, in the last quarter of the tenth

century in the second Canterbury monastery of St Augustine's, lending grace to a group drawing of the author with the nuns of Barking in a copy of St Aldhelm's treatise *On Virginity*,[31] and nobility to a drawing of Philosophy in a copy of Boethius's famous *Consolation of Philosophy*.[32] The Roman author speaks of the figure of Philosophy that appeared to him in a dream, waxing and waning, as it were, in size, and the drawing expresses admirably the imperious yet intangible image that he conjures up [82]. In these drawings, the Anglo-Saxons have transformed the feeling of weight, the sumptuous colours, and much of the detail of the original Ada idiom into a floating style, hovering on the surface of the page, which is particularly well suited to illustrations of the visionary and the supernatural.

Anglo-Saxon artists felt a special empathy also with the linear qualities of the School of Reims, whose influence is first observable in four full-page illustrations added about 970 to the Leofric Missal,[33] a ninth-century Sacramentary from northern France. Two of the drawings illustrate a means of divination derived from Coptic sources and known as the Sphere of Apuleius. Since its magical computations were efficacious only in determining whether the patient would live or die, we may be forgiven for assuming that the Sphere was conceived at a time when confidence in medical treatment was low.

Influences from Reims appear in the illustrations of more conventional texts as well, for example a Gospel Book made at Christ Church, Canterbury, in the final decade of the century and known – from its long sojourn in the library of the dukes of Arenberg – as the Arenberg Gospels.[34] Its full-page Crucifixion (reproducing the iconography of the one in the Sherborne Pontifical[35]) is not as fine as the other drawings, whose evangelists, though enlarged in stature, have all the zest, and many of the points of detail, of the Reims style. The airy lightness of that style is also evoked by the coloured drawings of Christological scenes in the Canon Tables. They comprise Christ in the arms of the Virgin; Christ adored by saints, or by apostles, or accompanied by angels; Christ treading underfoot the lion and the basilisk; and Christ with the Holy Spirit, the Lamb, and the Virgin. Two of the scenes derive from the Utrecht Psalter, a particularly seminal manuscript (as we have seen) which by the end of the tenth century had found its way to Christ Church, Canterbury, where its drawings made a particularly strong appeal, being reproduced between 1000 and 1200 in no less than three separate versions.[36]

The first copy, known from the name of a later owner as the Harley Psalter,[37] was written soon after 1000. The iconography of its earliest drawings (later ones were added during the course of the eleventh century and even in the twelfth) accurately follows the Utrecht ones, as we can see from the illustration of Psalm 30 in each [50, 83]. The Harley drawings are also quite close in style, though the sense of solidity imparted by shading has given way to a line left free to whisk effortlessly over the surface of the page. Another important change concerns colour. The uniform bistre of the Reims illustrations against the neutral background of the vellum page gives a unity to the most disparate of scenes; the Canterbury artists, on the other hand, used greens, reds, sepias, and blues to produce a tonal effervescence

82. Canterbury: *Philosophy*, from a Boethius, MS. O.3.7, folio 1. Last quarter of the tenth century. Cambridge, Trinity College

reminiscent – in a minor key – of the shimmer of mosaics.

This coloured version of the Reimsian style became very popular in England. A Canterbury manuscript of the early eleventh century,[38] for example, moderates the breathlessness of the Utrecht Psalter and fleshes out its artistic shorthand to create rural vignettes of rare charm. The months of the year are illustrated by appropriate scenes of ploughing, pruning, digging, sowing, falconing, and so on, all sensitively drawn in brown and touched in with green and red. We shall refer to them again. The influence of Reims is again perceptible in a vivacious drawing of St Mark writing at the behest of an inspiring angel; added to a Gospel Book, probably from Winchester, between about 1020 and 1030, it takes even its iconography from the Utrecht Psalter.[39]

The style recurs yet again in the delicately windswept illustrations of the Bury Psalter,[40] apparently made in the 1030s at Canterbury for Bury St Edmunds. This delightful manuscript is exceptional in a number of ways, not least for its monk artist's self-portrait in the initial B on folio 21. Kahsnitz reads its inscription, now unfortunately incomplete, as: '+ PICTOR HVIVS . . . TAH(?) MITIS'.[41] One or two of the fifty

tiabit ueritatem tuam ; conscidisti saccum meu
Audiunt dns & misertus & precinxisti me leticia.
est mihi . dns fac tus est ut cantem tibi gloria

INFINEM PSALMVS DAVID ·XXX·
NTE DNE SPERAVI & refugium meum estu & uantes uanitatem sup

83. Canterbury: Illustration to Psalm 30 (31), from the Harley Psalter, MS.
Harley 603, folio 17. Early eleventh century. London, British Library

84. Canterbury: *The Ascension*, illustration to Psalm 67 (68), from the Bury
Psalter, MS. Reg. lat. 12, folio 73 verso. 1030s. Rome, Vatican Library

85. Winchester: *The Crucifixion*, from a Psalter, MS. Harley 2904, folio 3
verso. Last quarter of the tenth century. London, British Library

86. Winchester: *The Last Judgement*, from the New Minster *Liber Vitae*,
MS. Stowe 944, folios 6 verso-7. 1020/30. London, British Library

marginal drawings, most of them in brown and red, run right round the text [84]. A few derive their iconography from the Utrecht Psalter, but the artist did not tie himself to its literal tradition, for he interpreted parts of the text as a prophecy of the life of Christ, and could therefore illustrate the Nativity, the Crucifixion, the Ascension, and even two separate versions of the Trinity. The use of long slender scrolls to link one figure with another is characteristic of Canterbury work, and the ease with which the action flows from one group into the next – for example, in the sixteen-figure scene of the Ascension [84] – is a narrative technique used later more extensively in the Bayeux Tapestry.

Naturalized and translated into an Anglo-Saxon idiom, the Reims style recurred throughout the tenth and eleventh centuries, modified among other influences by the 'Dunstan' style which, as we have seen, derived from the Ada School. This particular interaction inspired some of the finest of all Anglo-Saxon drawings, among them a famous miniature in a Psalter of the last quarter of the tenth century:[42] a vivid and ecstatic interpretation of the Crucifixion [85] in which the draperies follow the 'Dunstan' style and the line the vibrancy of Reims. As Wormald so rightly said, it 'is not only a superb drawing, but ... a moving expression of the artist's feelings ... the artist was not only able to represent the dead Saviour with His mother and the Beloved Disciple, but he was also able to express the grief of the Virgin and the eager love of St John. The whole miniature is given thereby a kind of lyrical mysticism which is not met with in contemporary European art.'[43] The manuscript was at one time attributed to Ramsey, but is now thought to be a product of Winchester. We shall meet its highly talented artist again, for he also illustrated manuscripts on the Continent.

Further delightful drawings in the 'Dunstan' style as energized by Reims illustrate the conflict between the Virtues and Vices in a manuscript at Cambridge[44] [89]; what is particularly interesting here is to observe the same mingling

87. Canterbury: Illustration following Psalm 31 (32), from the Harley Psalter, MS. Harley 603, folio 17 verso. 1040/70. London, British Library

88. Winchester: *The Crucifixion*, from the Arundel Psalter, MS. Arundel 60, folio 12 verso. *c.* 1060. London, British Library

of influences in the work of two quite distinct artistic personalities. This interaction continues at a further remove in the eleventh century. One of many examples is provided by a particularly charming drawing on two facing pages of a Book of Life[45] made between 1020 and 1030 at New Minster and listing the names of its members, past and present, three of whom are described as painters.[46] The delicacy and vividness of the Anglo-Saxon line of this Last Judgement drawing [86] lend an unexpected grace to the momentous scene: it has become an animated social occasion, with St Peter as the master of ceremonies and the devils little more than over-mischievous guests.

The Anglo-Saxon artists were quick to metamorphose the Carolingian-inspired 'Dunstan' and Reims styles into distinctively English forms, impregnating them with the feeling for colour and for animated decoration seen earlier in the Insular masterpieces of the pre-Viking period. Though the emphasis on abstract patterns and design of that era was inappropriate for the art of the reform period, which saw a need for straightforward illustration, yet there is across the centuries a kinship attested by the dancing colours, animated line, and decorative emphasis. All this is most obvious in the first illustrations of the Harley Psalter which, as we have noted, brought a new shimmer of colour and a mobile sense of patterning to the Carolingian prototypes. The original cycle of drawings, begun about 1000, was never completed, and the additions made first between 1040 and 1070, then

in the second quarter of the twelfth century,[47] exchanged illusionism for a greater precision, enlarging the size of the figures [87] and exaggerating the patterning, transforming hillocks like coloured puffs of smoke into definite decorative motifs, and even fusing whole groups of figures into contrived designs. It is a tendency to decoration (already apparent in the draperies of the Virgin of the Winchester Crucifixion of the last quarter of the tenth century) that runs through the late Anglo-Saxon period, becoming more and more intensified as the eleventh century advances, and appearing at its boldest just before the Conquest in two Winchester manuscripts, both now in the British Library – the Arundel[48] and the Tiberius[49] Psalters [88, 105]. The patterning of the figures of the Arundel Psalter, drawn in reds, blues, and greens, is especially emphatic.

In the period between the Winchester Crucifixion just alluded to [85] and the Crucifixion in the Arundel Psalter of *c.* 1060 [88], the Anglo-Saxons produced hundreds of coloured drawings whose sensitiveness and spontaneity continue to delight. They usually illustrate biblical manuscripts, but they sometimes adorn other texts, including the *Psychomachia* (*Battle of the Soul*), a lengthy poem very popular among Anglo-Saxon monks, perhaps because the English – like the poem's Spanish author Prudentius (348–410) – had had experience of a Church at war with paganism, but more probably because its theme, the Battle between the Virtues and Vices, had particular relevance to the inner life of every

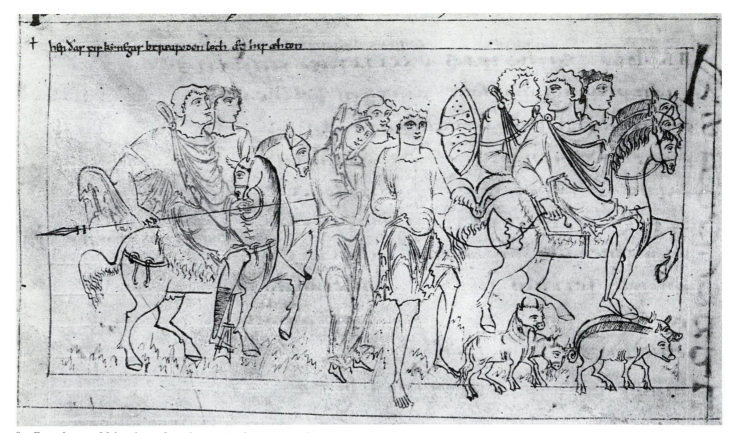

89. Canterbury or Malmesbury: *Lot taken captive*, from a copy of Prudentius's *Psychomachia*, MS. 23, folio 2. Late tenth century. Cambridge, Corpus Christi College

90. Canterbury: *The monks of Christ Church before St Benedict*, from a Psalter, MS. Arundel 155, folio 133. 1012/23. London, British Library

monk. The more than two hundred drawings that exist in various copies of the poem,[50] though occasionally updated in terms of style and even of social background, all have the ultimate authority of a fifth-century picture cycle. The drawings in sepia, green, red, and blue [89] in the Cambridge manuscript[51] already referred to are given particular appeal by their zest and assurance. They were made towards the end of the tenth century, probably at Christ Church, Canterbury, or Malmesbury,[52] and one of their artists was responsible for ten invigorating drawings in another manuscript,[53] usually referred to as the Caedmon manuscript, from one of these two monasteries.[54] It has attracted attention chiefly because of its renderings in Old English verse of the Books of Genesis, Exodus, and Daniel, and for the poem known as *Christ and Satan*, but its drawings, apart from the ten referred to, are disappointing, and attempts to invest them with iconographic interest by claiming that they derive from an Early Christian cycle[55] lack conviction.

The medium of coloured line, sometimes enhanced with colour wash, in the pictures so far discussed lent itself well to the linear and decorative predilections of the Anglo-Saxons. It was also an inexpensive form of art that accorded well with the unostentatious tastes of monks, who were enjoined by their Rule (*cap.* VII) to see themselves as both 'poor and worthless'. This aspect of the pictures was clear to their artists, for they sometimes chose to establish relative importance by using drawings for the lesser personages and full colour for the greater ones.[56] So, a Christ Church Psalter, made between 1012 and 1023, presents the Benedictine monks in colour outline, but St Benedict himself in full colour, complete with gold ornamentation[57] [90]. Similarly, a

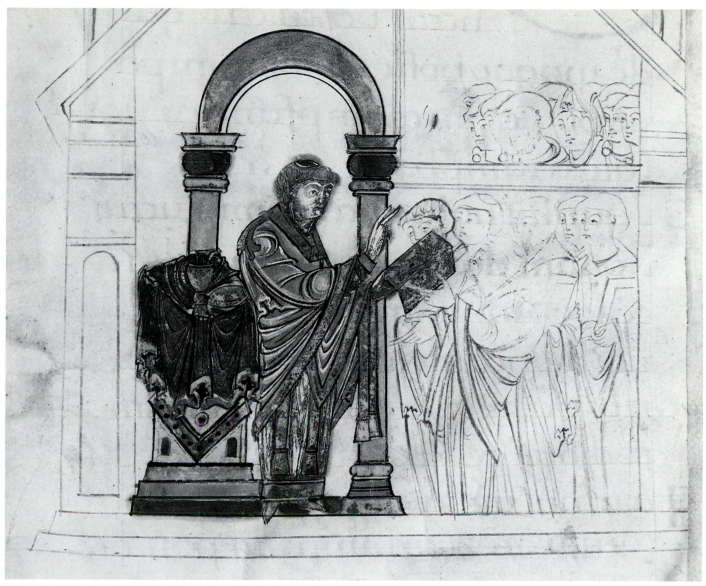

91. Winchester: *A bishop pronouncing a blessing*, from the Benedictional of St Aethelwold, MS. Add. 49598, folio 118 verso. 971/84. London, British Library

slightly later picture from St Augustine's of Abraham with the three angels shows all the figures in outline except for the first angel, who is given body colour because he represents the Lord.[58] Anglo-Saxon manuscripts with illustrations entirely executed in body paint were not of course for the personal use of the monks: they were Service Books and Gospel Books intended to enrich the ritual of the liturgical office in churches and cathedrals.

LATER ANGLO-SAXON PAINTING

As St Dunstan is associated with the early outline drawings of the later Anglo-Saxon period, so St Aethelwold is linked with its early full-colour paintings. Unlike Dunstan – despite the efforts of later medieval writers to make him so – Aethelwold was not an artist, but he was an active patron of the arts who realized that the reform programme would be aided if the liturgy were enhanced by splendid vestments and Service Books. He it was who commissioned the most

sumptuous manuscript to survive from the later Anglo-Saxon period: the Benedictional bearing his name[59] and composed of blessings which only those of episcopal or higher rank could pronounce during Mass. As a Latin poem in gold capitals at the beginning of the manuscript informs us, it was made in a monastery – probably the Old Minster at Winchester – and it can be dated between 971 and 984. Before soliciting the reader's prayers for himself, the scribe, 'a certain monk' called Godeman, relates that the manuscript was made at the behest of 'the great Aethelwold', who 'commanded that many frames should be made in this book, which should be well adorned and filled with various figures decorated with numerous beautiful colours and with gold'. This bare statement does little to prepare us for the manuscript's wonderful profusion of gold and of rich colours in varied tones. A gorgeous picture at the end [91] shows a bishop (no doubt Aethelwold himself) pronouncing a blessing from a book (presumably this one) whose gold binding echoes the gold of the vestments, the gold of the altar-cloth, and the

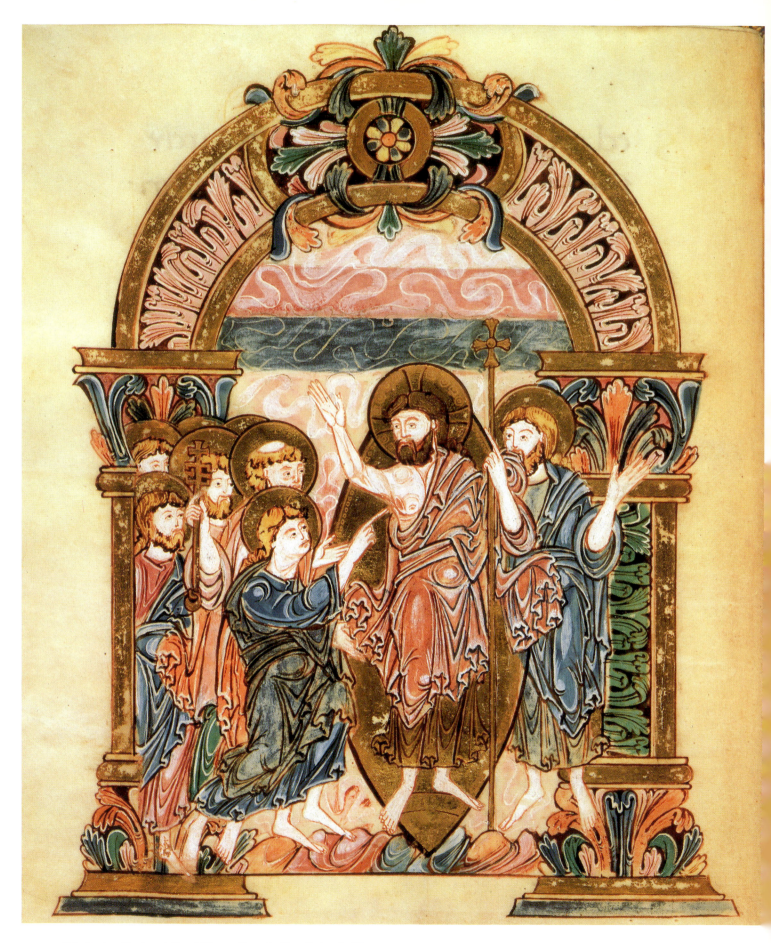

92. Winchester: *The Incredulity of Thomas*, from the Benedictional of St Aethelwold, MS. Add. 49598, folio 56 verso. 971/84. London, British Library

gold of the chalice and the paten. The inventorists of the Middle Ages understood well the contribution made to the splendour of divine service by such magnificent Service Books, for in their catalogues they described them along with the gold vestments and vessels used in the liturgy. To emphasize his importance, the bishop in the reproduced picture is in full colour, while the congregation is in line only. All the other pictures of the manuscript are in full colour and gold.

Fifteen pictures and two pages with borders are probably missing from the manuscript as we have it today,[60] but twenty-eight full-page paintings remain besides the one just described, as well as nineteen splendid, elaborately framed text pages and two full-page historiated initials. The full-page pictures are of apostles, saints, and virgins, and of episodes from the New Testament which, when complete, probably showed seven incidents from the early life of Christ and five preceding and following his Passion. Our reproduction of the Incredulity of Thomas [92] illustrates the way in which the paintings are set within arches, or frames, enlivened by exuberant acanthus. The gold here and in the crowns, haloes, books, and some of the draperies, adds to the impression of radiance and resplendence.

The manuscript is written in a very elegant and beautiful Caroline script, and Carolingian influences are equally apparent in its paintings. An early pioneering study[61] demonstrated that the iconography of the New Testament scenes is related to that of ivory carvings of the Metz School from the turn of the century, and the Baptism of Christ is very similar to one on a casket now in Brunswick. The overall style, too – as in many Anglo-Saxon drawings – owes much to the Ada[62] and Reims Schools: Ada influences are particularly apparent in the statuesque poses, the crumpled veils, and the diagonal folds of draperies, and Reims ones in the swirling clouds. Franco-Saxon elements, too, have been traced in the frames with their bosses,[63] and others from Metz in some features of the ornament.[64] Yet, in spite of everything, the personality of the paintings is unmistakably English. The exuberance which whirls the draperies, the streamered sky, and even the acanthus leaves, into an exhilarating dance of colour and line is very English, and so, too, is the agility of the brushwork, which gives so much buoyancy to the human form that the figures glide effortlessly over the frames instead of being held within them. Here, as in the drawings of the Anglo-Saxons, we are reminded of the excitement of colour and line which, in the late seventh or early eighth century, had found memorable expression in the sinuous and animated patterning of the Lindisfarne Gospels.

Two other sumptuous manuscripts survive from the time of Aethelwold. The first, another Benedictional,[65] has large and elegant gold initials in arches or rectangular frames themselves enriched with gold and chromatic with green and blue foliage within. The second, a volume containing a Benedictional and a Pontifical,[66] was made for Winchester, probably at the New Minster and no doubt for Aethelwold himself. Its Nativity and Ascension have been removed, but the remaining Holy Women at the Sepulchre, Pentecost, and death of the Virgin [93] are closely related to those of St Aethelwold's more lavishly illustrated Benedictional, though the treatment is somewhat broader, and there has been some

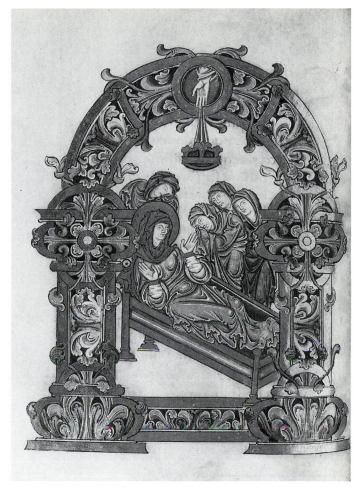

93. Winchester: *The death of the Virgin*, from the Benedictional of Archbishop Robert, MS. 369 (Y7), folio 54 verso. *c.* 980. Rouen, Bibliothèque Municipale

'editing' to fit the scenes into a vertical format. The general colour range is low-key – pale moss-greens, sky-blues, and flesh-colours – so that the sudden strong orange of the flames shooting out in the Pentecost picture lights up the central area like a beacon. The billowing curtains above the gold framework, the dancing acanthus leaves inside it, the energized flames streaming from the Holy Spirit and the restlessness of the draperies of the apostles, all proclaim the continued liveliness of Anglo-Saxon art in the last quarter of the tenth century.

This manuscript was in Normandy, in Rouen Cathedral, by the early twelfth century. For what it is worth, an inscription claiming that it once belonged to an Archbishop Robert was added five centuries after the event, though it is not even clear which Robert is referred to: it might have been either the brother of Ethelred the Unready's queen Emma, who was archbishop of Rouen between 990 and 1037, or the Robert who was archbishop of Canterbury from 1051 to 1052.

A more positive link with this second Robert is provided by the Sacramentary,[67] also now in France, which he gave to the abbey of Jumièges (of which he had been abbot) when he was bishop of London (1044–51). Opinions vary, but its script and illumination would seem to point to Christ Church, Canterbury, as its source. It can be dated between 1016

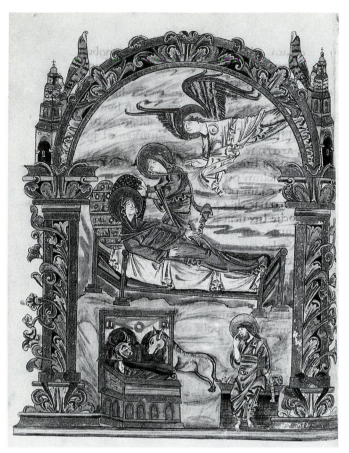

94. Canterbury: *The Nativity*, from the Sacramentary of Robert of Jumièges, MS. 274 (Y6), folio 32 verso. 1016/23. Rouen, Bibliothèque Municipale

and 1023, appreciably later than the Benedictional of St Aethelwold, with which it has little in common apart from the framing of the pictures in arches or rectangular borders, and its use of the New Testament as a source for illustrations – but even then it chooses only two of the same scenes. It is, however, one of the few AngloSaxon manuscripts to vie with the Benedictional in sumptuousness. Gold and rich colours irradiate the Calendar and Paschal tables of the preliminary pages, gold lettering and gold borders add splendour to a number of the text pages, gold enriches the greens, blues, mauves, and rusts of the thirteen full-page pictures, and swirling brush-strokes and a flashing linear movement throughout endow the earlier Reims style with a new restlessness, as is demonstrated by the scene of the Nativity [94].

Gospel Books, too, were lavishly illuminated in gold and rich colours, and often richly bound. One given to Ely by King Edgar had a cover of gold, silver, and precious stones;[68] eight presented to Waltham by Earl Harold were bound in gold or silver gilt;[69] and the last pre-Conquest abbot of Peterborough gave to his house 'a great number of Gospel Books bound in gold and silver'.[70] These precious bindings have all disappeared, but some richly illuminated Gospel Books survive, prominent among them (though now partly stained with damp) the Trinity Gospels,[71] probably made at Christ Church Canterbury in the first quarter of the eleventh century. Like most other illuminated Anglo-Saxon Gospel

Books, it concentrates its artistic attention on the Canon Tables, the 'portraits' of the evangelists, the lavish ornamentation of the opening words of their texts, and on a portrayal of the enthroned Christ. The many pages of Canon Tables – rich in invention as well as in gold – incorporate evangelist symbols, Christ himself, figures of saints, apostles, and angels, and a repertory of peacocks, eagles, lions, and griffins, some of them probably inspired by textiles in Canterbury Cathedral. The evangelists seated beneath their symbols are painted with great vivacity in an architectural structure surrounded by 'Winchester' frames (a phrase which will be explained later). On the ornamental pages opposite, the opening lines of each Gospel are set out in noble gold capitals. Two of their large gold-outlined initials are in a style (already seen in the Salisbury Psalter of 969–78) which was to achieve great popularity in the twelfth century: the so-called 'clambering' style, in which dragons and animals embroil themselves in the initial's structure.[72] But the masterpiece of the Trinity Gospels is its Christ [95]. In a blue mandorla framed by a gold-bordered arch entwined with robust and rhythmically swirling foliage, the figure radiates breadth and presence and even a kind of spiritual exuberance.

Equally admirable is the 'portrait' of St Matthew [96] in another Gospel Book[73] also made at Canterbury (probably towards the end of the tenth century) which had reached York by the 1020s. The figure has the breadth of the Trinity Christ, but a lighter, more buoyant feeling that is particularly apparent in the draperies which, though similar in some ways to those of the Trinity Majesty, lack the gold 'overlay' on the mantle, and so are free to billow out. The open setting, rendered in washes, is spacious and airy, reminiscent of the evangelist 'portraits' in two Gospel Books of the Carolingian Coronation Gospels Group. St John is missing from the Canterbury manuscript, but in the other three evangelist pictures gold of a rather pale hue is sparingly applied to point up details, and to panel the fine initials of each Gospel.

A Gospel Book of *c.* 1020, known as the Grimbald Gospels[74] because it contains a copy of a letter recommending a Continental monk of that name to King Alfred, was at Winchester in the third quarter of the eleventh century but has been assigned to Canterbury because the hand of one of its scribes has been identified also in a number of Christ Church manuscripts.[75] We even know his name – Eadui Basan – for it is recorded in one of his productions now at Hannover,[76] and the anniversary of his death is recorded in a Christ Church obituary of about 1100.[77] Unfortunately, the generously applied silver of the Grimbald Gospels has everywhere oxidized to a smudged black, but originally the paintings must have been very lavish and colourful with their gold and silver, their rich blues and greens, and their more subdued purples. The usual illuminated two-page opening to the Gospel of Mark is missing, but the three surviving evangelist 'portraits' [97] follow the iconographic and stylistic traditions of the Ada and Reims Schools (coincidentally, a stylistically related Gospel Book was later actually donated to

95. Canterbury(?): *Christ enthroned*, from the Trinity Gospels, MS. B.10.4, folio 16 verso. First quarter of the eleventh century. Cambridge, Trinity College

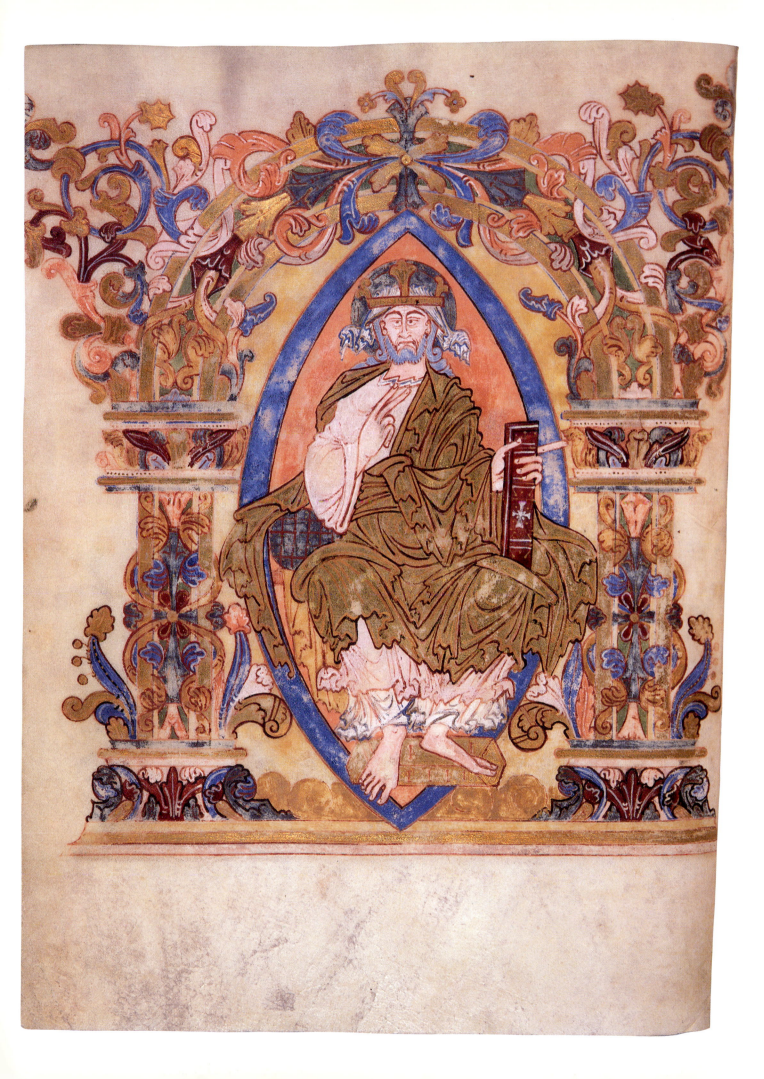

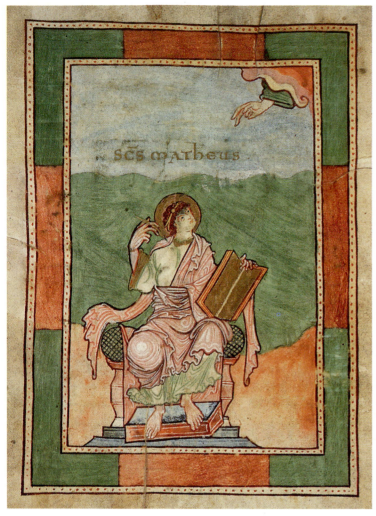

96. Canterbury: *St Matthew*, from a Gospel Book, MS. Add. 1, folio 22
verso. Late tenth/early eleventh century. York Minster, Chapter Library

Reims[78]). In the bold, almost heraldic placing of its evangelists
against neutral backgrounds, the Grimbald Gospels looks
back even beyond the Carolingian period to the much earlier
Lindisfarne and Lichfield Gospels.

INSULAR, FRANCO-SAXON, AND OTTONIAN INFLUENCES

Insular echoes are rare in later Anglo-Saxon painting, though
the horn-blowing evangelist symbols of the Lindisfarne
Gospels do reappear in the Benedictional of St Aethelwold
and the Grimbald and Pembroke Gospels.[79] A remarkable
exception is the wholesale reversion to Insular art of a picture
of Matthew added at the beginning of the eleventh century
on folio 17 verso of a Gospel Book perhaps made at Christ
Church, Canterbury, and now at Copenhagen.[80] The
corresponding picture in the Lindisfarne Gospels is recalled
in Matthew's posture, in his symbol blowing a horn, and
even in the strange head (perhaps that of Christ himself)
which peers so surprisingly from the curtain.[81] In every other
instance, Insular art survived only by undergoing a sea-
change. It came about in this way. It will be recalled that the
Insular art of the British Isles had earlier crossed the Channel

and been absorbed by the Carolingians to produce the Franco-
Saxon style; and it was in this form that it returned home to
be given a third identity by the Anglo-Saxons, who first
confined the Franco-Saxon interlace to the terminals of the
initials, and then invigorated their framework with a dynamic
if formalized plant life which filled the whole of the initial
with its pent-up energies.[82] This new style made a significant
impact in the eleventh century and continued to find favour
in the twelfth.[83] Its earliest and most magnificent
manifestation is in the Winchester Psalter of the last quarter
of the tenth century[84] that we encountered earlier [98].

As the first surrounds to be enlivened with foliage appeared
at Winchester – they are already seen in a mature state in the
Benedictional of St Aethelwold [92] – they have been called
'Winchester' frames. Like the foliated initials, these frames
galvanize geometric shapes with vigorous, if formalized, plant
life, and both initials and frames make lavish use of gold and
of rich colours. The leaf-work blends Franco-Saxon and
Metz sources[85] in a uniquely Anglo-Saxon way.

The Anglo-Saxon use of a Franco-Saxon vocabulary was
limited (to the terminals of initials) but continuous. In
contrast, English interest in Ottonian art lasted only for a few
years before the Norman Conquest of 1066. It is seen at its
clearest in two manuscripts once attributed to Hereford but
now thought to have been made at Canterbury. One, called
the Hereford Gospels, is in fact a Gospel Lectionary.[86] The
other is the Hereford Troper[87] [99] (the trope, which lost
favour in the thirteenth century, was a choral embellishment
of the Mass). The influences from Germany are to be detected
in the evangelist 'portraits' of the 'Gospels' but are much
more powerful in the illustrations of the Troper where,
despite some illusionistic backgrounds, there is little of the
vivacity and lightness of the Anglo-Saxon tradition. Indeed,
the silhouetted, two-dimensional, stumpy figures, painted in
contrasting colours and imbued with a strong metallic sheen,
would be much more at home in a German centre like
Echternach. Echternach indeed (as we shall see later) made
manuscripts for the emperor, and possibly, in the same way
that English illustrated manuscripts had earlier made their
way to Germany, an Echternach manuscript was brought to
England and had its effect on the Troper.[88] We might add
that, although these two Anglo-Saxon manuscripts may have
been made at Canterbury, they were destined for Hereford,
where a German link existed in the person of Walter, a
Lotharingian who served as a chaplain to Queen Edith, the
Confessor's wife, and was bishop of Hereford from 1061 until
1079.

ILLUSTRATION OF SECULAR TEXTS

A fine example of attractive illustration of a secular
manuscript is provided by the 'Tiberius Medley',[89] a
compilation of various texts in the Cotton Tiberius section
of the British Library. Its paintings are both excellent in
quality and interesting in the breadth of their subject matter,
which ranges from the sociological to the geographical and

97. Canterbury: *St Luke*, from the Grimbald Gospels, MS. Add. 34890,
folio 73 verso. *c.* 1020. London, British Library

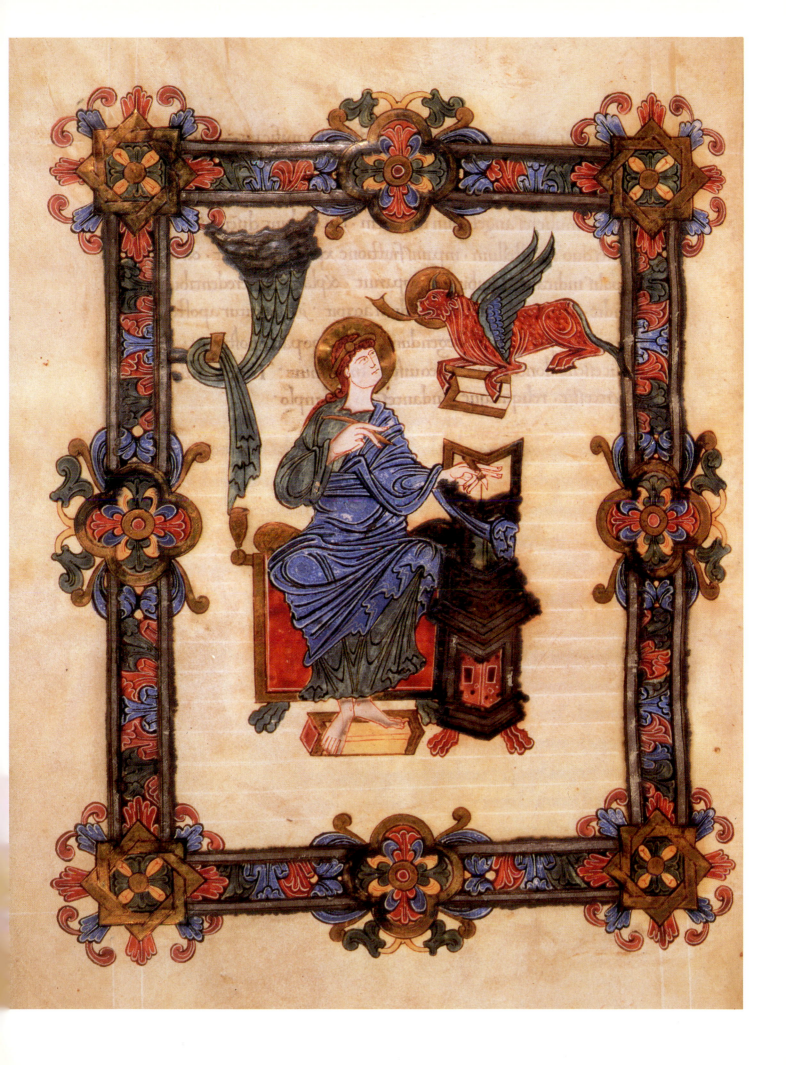

the astronomical. Moreover, it has more secular pictures than any other manuscript of our period.

The earliest sequence deals with the strange prodigies that, from early classical times right up to the scientific Renaissance of the seventeenth century, were believed to inhabit the unexplored areas of the world. Their existence was vouched for by scholars ranging from Ctesias and Megasthenes among the Greeks to Pliny among the Romans, and they were still invoked by Shakespeare in *Othello*, where the Moor beguiles Desdemona with stories of

> ... the Cannibals that each other eat,
> The Anthropophagi, and men whose heads
> Do grow beneath their shoulders.

> (I, 3, 143–5)

Even Sir Walter Ralegh – a more travelled Elizabethan than Shakespeare – gave credence to such monsters, for his account of the discovery of Guiana mentions the Ewaipanoma, who 'are reported to have their eyes in their shoulders and their mouths in the middle of their breasts, and . . . a long train of hair groweth backward between their shoulders'.[90] Many such deviants are pictured in the Tiberius Medley – women with beards who use tigers and leopards as hounds, and others,

98. Winchester: Initial to Psalm 1, from a Psalter, MS. Harley 2904, folio 4. Last quarter of the tenth century. London, British Library

99. Canterbury(?): *The Annunciation to Joachim*, from the Hereford Troper, MS. Cotton Caligula A.XIV, folio 26. Mid eleventh century. London, British Library

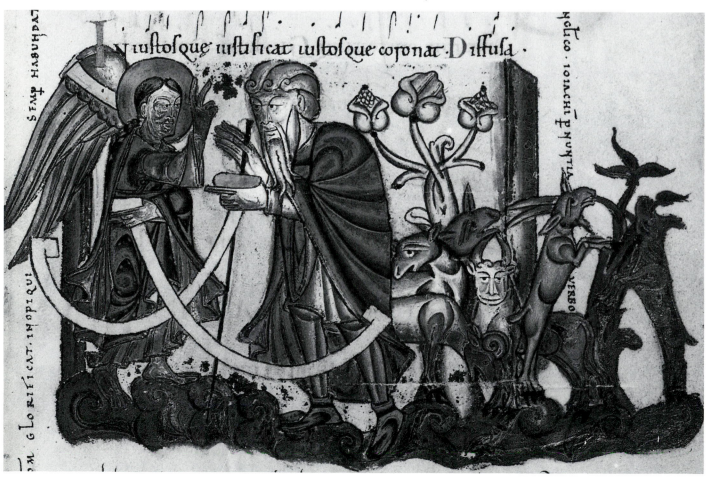

said to be thirteen feet tall, with the feet of camels, the teeth of boars, and the tails of oxen. Men described in the text as breathing out fire and having the mane of a horse and the tusks of a boar are illustrated by a nude male with an equine mane who, for some reason, has the head of a dog [100]. Others are referred to who, though twenty feet tall and with the heads of lions, yet sweat blood and flee if pursued, and yet others have legs twelve feet long and bodies seven feet wide and devour anyone they can catch. Then there are double-headed shaggy beasts with eight legs who flee at any sound, snakes with the horns of rams, and ants who dig for gold but can be diverted from their task by a feast of live camels. An even earlier Anglo-Saxon cycle of such monsters,[91] ascribed to the late tenth century, apparently belongs to a different family of illustrations and is not the equal in quality of the Tiberius cycle.

The Calendar of the Medley is illustrated by admirable pictures of the occupations of the months which bring

100. Canterbury(?): *Human prodigy*, from the Tiberius Medley, MS. Cotton Tiberius B.V(1), folio 80. Second quarter of the eleventh century. London, British Library

101. Canterbury: *January*, from a Calendar, MS. Cotton Julius A.VI, folio 3. Early eleventh century. London, British Library

102. Canterbury(?): *January*, from the Tiberius Medley's Calendar, MS. Cotton Tiberius B.V(1), folio 3. Second quarter of the eleventh century. London, British Library

something new to the classical representations known from copies of drawings and from surviving mosaics. The Anglo-Saxons were the first to present the occupations entirely in rural terms, as we have seen them in the Canterbury manuscript discussed earlier;[92] the nimble Canterbury drawings [101] seem to have been taken from the same exemplar as the paintings of the Tiberius Calendar, though not in exactly the same sequence. Tiberius represents January by ploughing and sowing [102], February by the pruning of vines, March by digging, raking the soil, and sowing, April by feasting, May by sheep-tending, June by reaping, July by getting wood from the forest, August by mowing, September by feeding hogs, October by falconing, November by warming and smithying, and December by threshing.

The third component of the Medley is one of the oldest known maps of the world, and certainly the earliest to give the British Isles a recognizable profile. The fourth, an astronomical poem by Aratus in Cicero's translation, is illustrated with the customary zodiacal personifications by an artist who reveals his independence. He was aware of two series of Carolingian illustrations to the poem, of which one (remarked on earlier[93]) took the form of word-pictures in a fourth-century style [34]. Our man, however, has no sympathy with this esoteric manner and translates it into the Anglo-Saxon idiom of his own day – a path followed later, as we shall see, by another Anglo-Saxon artist who saw the identical Carolingian manuscript when it was still at Fleury.

The date of the Tiberius Medley is agreed – it is attributed to the second quarter of the eleventh century – but its provenance is not. Indications in the texts point towards both Winchester and Canterbury, and recent opinion has veered rather towards Canterbury because its cycle of rural scenes has a close iconographic relationship with the drawings of an earlier manuscript from that source [101, 102]. It is best, however, to preserve an open mind.

A Herbal[94] of the early part of the eleventh century more certainly derives from Canterbury and, more particularly, from Christ Church. The remarkable realism of its plants, herbs, and even serpents, can be attributed to the necessity for accuracy in illustrations that may have been consulted for medical ends. As some of the plant life shown is to be found only in Mediterranean areas, it has been argued that these pictures were meticulous copies of more southerly ones.[95] Many of the hundreds of illustrations were unfortunately damaged in an eighteenth-century fire that did much harm to the manuscript's two full-page paintings. One of them is a frontispiece showing Apuleius Platonicus receiving a treatise (presumably the same as this one) from Esculapius, the god of medicine, and from the centaur, Chiron, who was said to be well versed in the use of drugs. The other is of a monk presenting the book to a bishop or archbishop – perhaps the archbishop of Canterbury – who, with a soldier at his side, transfixes with his staff a lion under his feet.

GOSPEL BOOKS IN SECULAR OWNERSHIP

As there were secular texts in the possession of the religious, so there were religious texts in the hands of the laity, though we tend not to hear of them unless they came into monastic ownership, or had once belonged to saints. Thus it is that we

know of a Gospel Book decorated with precious stones that Countess Goda, the sister of Edward the Confessor, gave among the other contents of her private chapel at Lambeth to the monastery at Rochester;[96] and thus it is that we hear about another lavish Gospel Book that belonged to the Confessor's niece, Margaret, later queen of Scotland, for she was considered to be a saint, and her life was written up by a former monk. The binding of the St Margaret Gospels was of gold encrusted with gems, and its initials and evangelist pictures were highlighted with gold.[97] The binding has disappeared, but the manuscript survives.[98] The poem in it that describes how it was miraculously saved from damage when it was dropped into a river while being transported for use in an oath-swearing ceremony enables us to identify it as the very Gospel Book described by St Margaret's biographer, for he tells the same story. The manuscript belongs to the second quarter of the eleventh century.

Another pious lady related to the Confessor, Judith of Flanders, was even more closely connected to his successor, for she was the wife of Harold's half-brother Tostig. She owned three Anglo-Saxon Gospel Books, all of which remain today.[99] They belong to the same period as St Margaret's, and each has its own 'portraits' of the evangelists facing the sumptuous openings to their Gospels. But a remarkably delicate portrayal of the Crucifixion added later to one of the manuscripts[100] is far superior, and indeed of quite exceptional quality [103]. The personifications of the Sun and Moon turning away their faces to express their grief are among the traditional elements that derive from Carolingian art, but the St John taking down his divine testimony at the scene of the Crucifixion is a specifically Anglo-Saxon conception. The anguish in the face of Christ and the poignancy of his heavily sagging body are also new, and so, too, are the tender gesture of the Virgin as she gently reaches up to staunch the wound in her son's breast with a corner of her wimple, and the action of the patroness Judith in embracing the Cross before which she kneels. This is a masterly and innovatory painting which, in my view, is much later than is generally thought.[101]

ANGLO-SAXON ARTISTS ABROAD

If one result of monastic reform was to bring Continental art to England, another was to take English artists abroad. So Fleury, which had sent illuminated manuscripts across the Channel, received two different Anglo-Saxon artists at the turn of the tenth and eleventh centuries. They may have been despatched to the celebrated abbey on the Loire to observe and assimilate its customs and scholarship, just as the Abingdon monk Osgar had earlier been sent by Aethelwold, and perhaps sought to repay their hosts' kindness by the exercise of their artistic skills. One of them illustrated a manuscript containing works of Boethius.[102] At the beginning is an unfinished drawing of the author's vision of Philosophy, and at the end a full-page miniature of Boethius himself in the guise of an evangelist writing under divine inspiration.

103. Southern England: *The Crucifixion*, from a Gospel Book belonging to the Countess Judith of Flanders, MS. 709, folio 1 verso. Later addition to a manuscript probably itself of the second quarter of the eleventh century. New York, Pierpont Morgan Library

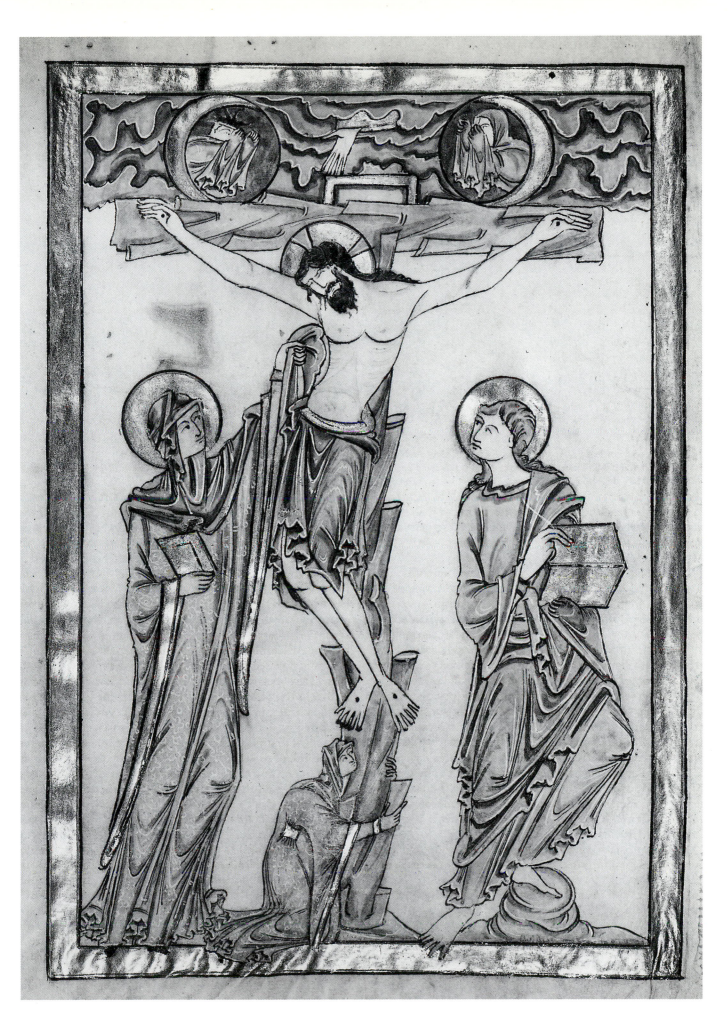

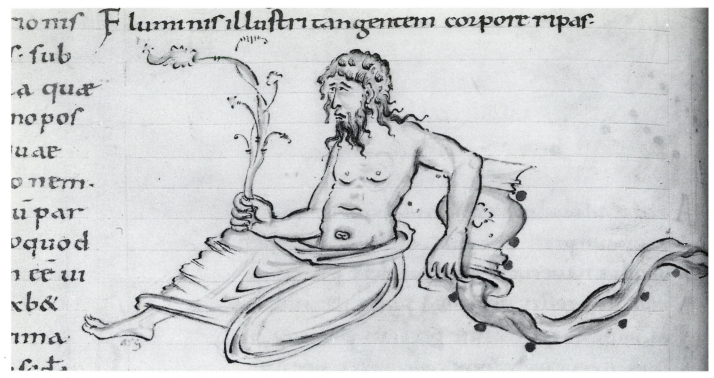

104. Anglo-Saxon, at Fleury: *The constellation Eridanus*, from Cicero's *Aratea*, MS. Harley 2506, folio 42 verso. Turn of the tenth and eleventh centuries. London, British Library

The figure below the Trinity in the facing initial is also probably Boethius, for written on the book lying open upon the stand in the full-page minature are the first words of his treatise on the Trinity.

The second Anglo-Saxon artist to visit the Loire was none other than the author of the exceptionally fine drawing of the Crucifixion from Winchester [85]. At Fleury he illustrated the copy of Cicero's *Aratea*[103] already mentioned in the context of the Tiberius Medley, reacting to the Carolingian version [34] of an arcane fourth-century style in the same way as the artist of the Tiberius manuscript, for he retained the original classical profiles of Perseus, the Centaur, Eridanus [104], and so on, but ignored the word-picture style, imposing his own Anglo-Saxon idiom in a singing line of great sensitiveness. Another Fleury manuscript from his hand is a copy of St Gregory's *Homilies on Ezekiel*,[104] with a masterly full-page tinted drawing of Christ in Majesty with St Gregory on one side and St Benedict on the other. At St Benedict's feet kneels a monk, for whom he intercedes, drawing the Saviour's attention to him by a pointing gesture. The decoration on Christ's mantle is very like that on the Virgin's of the Winchester Crucifixion.

On his way back to England this artist added four evangelist 'portraits' to an unfinished Gospel Book with Franco-Saxon decoration[105] which he may have found at the house of Saint-Vaast at Arras. The manuscript already contained empty frames for him to fill, but the purple and blue backgrounds were added later. His St Luke [188], unusually, holds a palm branch in his left hand. On the last lap of his journey home, at the abbey of Saint-Bertin, close to the Channel coast, the artist undertook a major programme of illumination for a Gospel Book[106] then under way. His highly varied decoration

of the sixteen pages of Canon Tables includes secular scenes of hunting and music-making, peacocks, pheasants, and storks, as well as evangelist symbols, busts of angels, the Lamb of God, and an enthroned Christ whose features are those of the Christ in the Fleury *Homilies on Ezekiel*. Of his four evangelists, three repeat those he had painted in the Franco-Saxon Gospel Book, but here he gives them architectural surrounds. He sets blue, purple, pink, and gold against darker (often green) backgrounds, and gives a 'shadowed' emphasis to the overall profiles. The unusually full pictorial sequence that precedes the opening of the Gospel text begins with a really superb Majesty of swirling vitality [185]. St Matthew follows, sharing the page with four kings and prophets. Next come two pages filled with busts of thirty-six of the ancestors of Christ mentioned in Matthew's first chapter, and an Annunciation and Visitation, and on the page with the Gospel initial are the Nativity and the Annunciation to the Shepherds. The most unusual of the figural scenes on the initial-pages of the other three Gospels is associated with the text of St Mark: here, a swimming line raises Isaiah and John the Baptist upwards to present their prophecies to Christ. This manuscript's wealth of illustration cannot be paralleled in contemporary Gospel Books of either England or France. The iconographical links both with the Carolingian past and with contemporary Germany[107] no doubt reflect the artist's contacts with a variety of illuminated manuscripts during his stay on the Continent. But his most outstanding contribution to the Saint-Bertin Gospels is the fluency and vitality of design which, indeed, characterize all his work and establish him as the leading English artist of the turn of the millennium.

A second Anglo-Saxon working at Saint-Bertin around

this time added to a Psalter there[108] some tinted marginal drawings that well express the tremulous sensitivity characteristic of contemporary English art. He probably came from Canterbury, for his work is iconographically related to the marginal drawings of a later Canterbury manuscript that we have already encountered – the Bury Psalter.

THE ORIGINALITY
OF THE LATER ANGLO-SAXONS

The Bury Psalter is one of a group of manuscripts (to which the Sacramentary of Robert of Jumièges and the Tiberius Psalter also belong) that offer examples of a peculiarly Anglo-Saxon invention.[109] It concerns the representation of Christ's Ascension. While in more traditional versions Christ rises to the heavens in a mandorla (as in the ninth-century wall painting of San Clemente in Rome, and in the Athelstan Psalter), or is raised up by the hand of God issuing from clouds [46], this group invests the scene with dramatic intensity by showing the ascending Christ disappearing from view except for his lower legs and feet, while below, the apostles and the Virgin crane their necks and stare in utter amazement [84]. The Tiberius Psalter also – so far as we know – initiated the tradition, later familiar throughout the West, of illustrating the Psalter with prefatory scenes from the life of Christ. The view that the Psalms of David foretold Christ's life was, of course, already well established in the Commentaries of the early Fathers – and, indeed, goes back to the New Testament itself – but the artist of the Tiberius Psalter seems to have been the first to take it up fully in visual terms[110] by means of full-page Christological scenes [105] (there are scenes from the life of David as well). Another Anglo-Saxon innovation that was to have an extended history has already been noted: the illustration of the complete Calendar with contemporary scenes of country life which was to reach its sumptuous apogee in the famous fifteenth-century illuminations of the *Très Riches Heures* of the duc de Berry.

Indeed, the Anglo-Saxons were never afraid of originality. It is to them that we are indebted for the image of the Creator as the supreme Architect with dividers,[111] whose use by Milton was to be pilloried by Voltaire, but whose appeal persisted, finding its best known expression in William Blake's *Ancient of Days* in the Whitworth Art Gallery. The Anglo-Saxons too were the first – in the Harley Psalter – to show the entry into Hell as the mouth of a ravenous beast,[112] as well as providing a version of the Washing of the Feet hitherto unknown in the West,[113] the earliest surviving St John writing his divine testimony at the foot of the Cross, and the earliest known coronation of the Virgin.[114] They also gave a number of different interpretations of the Trinity when any representation of it was relatively new. A particularly sophisticated one, known as the Quinity of Winchester[115] [106], illustrated the double nature of Christ by showing him both as a babe in arms and as the Son co-equal with the Father, thereby making a particular theological point, for the consubstantiality of the Son had been denied in the fourth century by the arch-heretic Arius; and so it is that at the bottom of the picture we see Arius, in company with Judas, grieving in chains near the brink of Hell. This peculiarly English artistic interest in the Trinity had a literary parallel

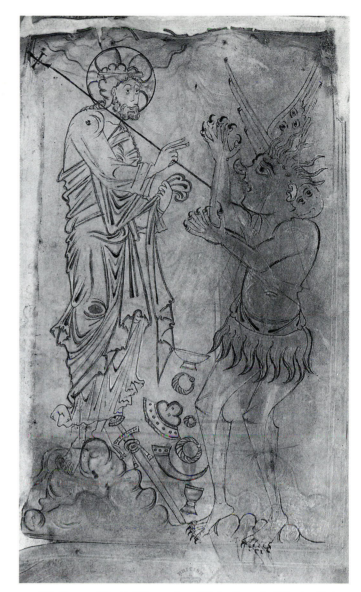

105. Winchester: *The third Temptation of Christ*, from the Tiberius Psalter, MS. Cotton Tiberius C.VI, folio 10 verso. Mid eleventh century. London, British Library

in a devotional work, the *Cursus de sancta Trinitate*, current in England in the eleventh century.[116]

The Anglo-Saxon freshness of approach is well demonstrated by the illustrations of the Grimbald Gospels, for they are novel not only as personal responses to the text but also for their format, with whole scenes set in the roundels and panels of what might almost be called a historiated frame. Because the first chapter of St John's Gospel refers separately to God, to Christ, and to the Holy Spirit (verses 1 ff., 14 ff., and 32–3), the members of the Holy Trinity are shown as separate figures.[117] Because verse 14 tells us that the Word became flesh and dwelt among us, we are given a Nativity scene. Those saved by their belief in God, referred to in verse 12, are shown as souls held by angels, and those said in verse 14 to behold Christ's 'glory, the glory as of the only begotten of the Father', as saints, apostles, and kings, gazing upward to the newly begotten Christ.

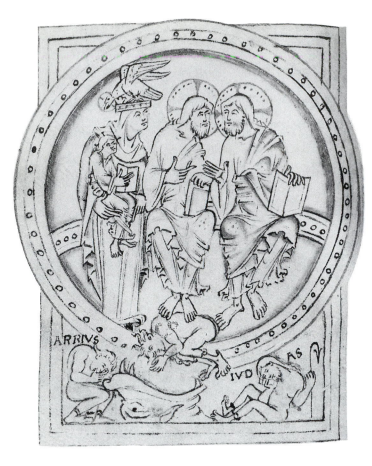

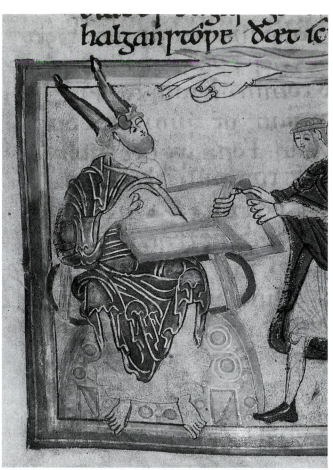

106. Winchester: *The 'Quinity of Winchester'*, from a Miscellany, MS. Cotton Titus D.XXVII, folio 75 verso. *c.* 1023–35. London, British Library

107. Canterbury: *Moses writing down the Law for the priests*, from the Anglo-Saxon Hexateuch, MS. Cotton Claudius B.IV, folio 136 verso. Second quarter of the eleventh century. London, British Library

This freshness of visualization finds its most sustained expression in a Hexateuch made at St Augustine's, Canterbury [107], in the second quarter of the eleventh century.[118] Its text is of particular literary interest because its enterprise in translating into Old English the first six books of the Old Testament anticipates the more comprehensive Wycliffe Bible undertaken in the fourteenth century. Yet it is, in effect, a picture-book, one of a small 'edition' of such manuscripts produced at Canterbury, probably for the laity.[119] Although its pictures were never completed, it still comprises about 550 scenes. Other unfinished Anglo-Saxon illustrated works include manuscripts as important as the Harley Psalter, the Pembroke Gospels, the Besançon Gospels, the Bury Prudentius, and the so-called Caedmon at Oxford. We can only guess why they were not completed. We know from a letter written in the eighth century that the severity of the English winters could freeze the fingers,[120] but this would have led only to postponement of the task in hand, not to its sudden cessation, which would have required a more powerful intervention such as the departure of the artist to another monastery, another office, a bed of sickness, or even to another world.

The unfinished state of the Hexateuch has its compensations, for it presents us with a cycle of paintings in various states of completion, thus providing a valuable insight into methods of work.[121] Apparently the artists progressed in

four stages, and in batches. The first stage was the preliminary sketches on plain vellum. Next, the text was copied out, and the sketches were then blocked in with the ground colours. At the third stage the bodies were outlined and given feet, legs, hands, etc., and such details as the eyebrows, nose, and mouth were filled in. The final process consisted of touching in the highlights, defining the drapery folds, and reinforcing the outlines. The completed pictures (which are in the majority) are in a subdued version of the 'Dunstan' style.

Though others, preoccupied with their search for early models, will dissent, it is my view – despite the influences from Early Christian and Carolingian art to be detected in a few illustrations – that the artist of the Hexateuch was a true original who, like the painter of the Grimbald Gospels, frequently interpreted the text in front of him in a very individual way. That text is not in the traditional Latin of the Vulgate, but in the slightly variant vernacular, and it is significant that some of the pictures even reflect scribal mistakes peculiar to the particular copy on which our artist was working. (The artist of a contemporary Anglo-Saxon Psalter also illustrates verses 12 to 14 of Psalm 7 in a way that can be explained only in terms of a completely personal interpretation of the Old English text,[122] and I might add that the very gestures of our Hexateuch can be dated to a late Anglo-Saxon period.)

The painters of the Hexateuch invented several images

108. Winchester: *King Cnut and Queen Aelgifu presenting a gold Cross to the New Minster*, MS. Stowe 944, folio 6. 1020/30. London, British Library

109. Southern England: *Pompa*, from an Anglo-Saxon copy of Prudentius's *Psychomachia*, MS. Add. 24199, folio 21 verso. Late tenth century. London, British Library

that lingered in the artistic consciousness. Jews continued to be identified by their round hats well into the twelfth century, in countries as far away as Poland.[123] The horned Moses[124] of illustration 107 was at the root of the tradition inherited by artists as great as Giovanni Pisano, Claus Sluter, and Michelangelo. And our painters seem to have been the first artists to place the ass's jawbone, a weapon with no scriptural authority, into the hands of Cain to slay his brother.[125] It belongs to a tradition already at home in Anglo-Saxon literature which continued into Shakespeare's time when Hamlet spoke of 'Cain's jawbone that did the first murder'.

THE TOPICALITY OF THE LATER ANGLO-SAXONS

Like the Franks, the Anglo-Saxons tended to identify themselves with the Israelites of the Old Testament – to such

an extent, or so it would appear, that in the Tiberius Psalter they represented David and his followers as members of the Anglo-Saxon aristocracy, while in the Hexateuch a similar metamorphosis continues over a cycle of three hundred and ninety-four pictures containing five hundred and fifty or so scenes. As we know from parallels in written sources,[126] most of these pictures present Israelite history in contemporary terms, thereby telling us a good deal about the Anglo-Saxons' own social conditions. Thus, Tubalcain on folio 12 is not an Old Testament artificer but an Anglo-Saxon smith at his trade. It is not the tower of Babel that is being raised on folio 19 but an Anglo-Saxon building, by Anglo-Saxon masons. The Old Testament patriarch being shrouded for burial on folio 72 verso is in reality an Anglo-Saxon dignitary, Joseph rides in an Anglo-Saxon carriage (folio 60 verso), and the wine-press worked by Noah and his family (folio 17) comes not from the Holy Land but from Kent (a wine-press, and

vineyards too, are documented in Canterbury itself in the twelfth century[127]). The armour of men, the fashions of women, the bed-curtains and room-dividers in the home, the carts, the animals, and even the bird-scarer in the fields (which is repeated in the Bayeux Tapestry), are all taken by the artists from their own society. The Hexateuch is in no way an artistic masterpiece, but it is a very significant document of the time.

In a way, the visual 'reporting' in the Hexateuch is inadvertent, but elsewhere we find the Anglo-Saxons taking a good deal of interest in the world about them for its own sake; for instance even before 939 there was the topical reference to the recently acquired relics of Athelstan in the illustrations of the Athelstan Psalter [77], and the Benedictional of St Aethelwold has a picture of the manuscript being used by its owner in his own cathedral [91]. In like vein, there is a drawing in an Anglo-Saxon Pontifical[128] of a book – presumably this very one[129] – being held by an acolyte as the bishop knocks on the church door in the formal procedure of dedicating a church that the Pontifical itself sets out. Similarly, the King Edgar who offers up his charter to the New Minster[130] [78] is not a remote symbol of monarchy but a man dressed in the aristocratic fashion of the day. King Cnut's queen, too, in the drawing of the couple presenting a great gold Cross to the New Minster between 1020 and 1030[131] [108] wears one of the costly head-bands then in fashion, a vogue caricatured in another manuscript,[132] where a text reference to wanton display is illustrated by a particularly extravagant example of such headgear [109]. Another ironic observation on contemporary life is provided by a picture in the Tiberius Psalter[133] illustrating verses 8 to 10 of Matthew's fourth chapter, in which the kingdoms and glories of the world shown by the devil to Christ on top of the mountain are represented by the temptations to ostentation faced by the Anglo-Saxon aristocracy: gold bracelets, gold drinking vessels, a gold-enriched sword, and a gold head-dress [105]. In the illustrations of the occupations of the months [101, 102], too, the birds are so well observed that we can identify them as ducks, cranes, and falcons, the ploughs are so accurately rendered that we could make a reconstruction of them today, and the carts, the tools, and the shields are all clearly authentic.

It was in the Bayeux Tapestry [10–12], however, that the Anglo-Saxon eye for visual reporting found its ultimate and most famous expression. Here, it was the specific intention of the designer to present near-contemporary events, so the artist was completely free to give a detailed picture of contemporary life on either side of the Channel – hair-styles, dress, furnishing, domestic utensils, tools, ships, armour, the way craftsmen went about their work, the ritual for the burial of kings, and much else. If the Tapestry were to offer no more, it would provide us with one of the most extended visual observations of contemporary society to be handed down by the Middle Ages.

THE EFFECTS OF THE NORMAN CONQUEST

The primary purpose of the Bayeux Tapestry was, of course, to glorify the victory of the Normans over the Anglo-Saxons.

But the Norman impact on English painting between Duke William's conquest in 1066 and the death of his son William Rufus in 1100 was rather less than glorious. Many precious illuminated manuscripts were sent abroad for the benefit of churches and monasteries in France and Normandy, never to return. The Norman chronicler William of Poitiers speaks vauntingly of the masses of artistic treasures that the Conqueror sent across the Channel[134] but, as we would expect, feelings on the English side were rather different. The college of canons at Waltham, which had been founded by the defeated King Harold, suffered particularly sad losses, and the bitter comment of one of its members concerning the removal to William's foundation of Caen of Waltham's finest manuscripts, together with other treasures, was that the Normans had amputated the limbs of God's Son in one country in order to offer them to the same God in another.[135]

What chiefly attracted the Normans was gold bindings, but manuscripts important enough to be bound in gold were important enough to be illuminated in gold and rich colours, and no one can doubt that many fine illustrated manuscripts left the country. Nor were they replaced, for the Normans in England exercised a frugality with respect to the fine arts that was in stark contrast to the generosity of their Anglo-Saxon predecessors; for example, while the last pre-Conquest abbot of Peterborough presented his house with 'a great number of Gospel Books bound in gold and silver',[136] a post-Conquest archbishop of Canterbury had to apologize because the book he was sending to his own king's daughter had no precious binding.[137] The parsimony of the newly arrived Normans in terms of arts other than architecture was everywhere apparent, and the simple truth is that – like colonists everywhere (and the early arrivals saw themselves as such) – they were more interested in taking precious works out of the country than putting anything into it. This could give rise to some extraordinary double-think: one Norman chronicler who at one point decries English artistic treasures as a reflection of the luxury and avarice of their Anglo-Saxon owners,[138] at another – after they have been shipped to the Continent – can boast of their splendour.[139]

England also suffered a sad disruption of her traditions of illumination. In order to assist in bringing the English Church and all its monasteries under Norman control, Norman monks were introduced into some of the English houses, and Norman abbots – or foreign abbots nominated by the Normans – into virtually all. These new abbots were interested in books, but hardly at all in their artistic adornment: they wanted books to read, not to admire; books for use, not for pleasure. Thus, for nearly half a century between 1066 and 1100, the torrent of Anglo-Saxon illuminated manuscripts was reduced to a trickle, with no embellishment at all in gold or rich colours. Narrative illustration, too, disappeared almost completely, and it is significant that the exception should be in an Anglo-Saxon style: it is an illustrated life of St Cuthbert made c. 1100 at Durham,[140] based on a lost archetype attributed to the period from 1083 to c. 1100[141] and presumably still Anglo-Saxon in tenor. Full-page illustrations, so frequent before the Conquest, became exceedingly rare, and were associated – if the post-Conquest drawing of King David in a Worcester manuscript[142] is anything to go by – with the last bastions of

110. Canterbury: *The blessing of a king*. Drawing added in the first quarter of the twelfth century to a late-tenth-century Winchester Benedictional, MS. lat. 987, folio 111. Paris, Bibliothèque Nationale

111. Canterbury: *St Pachomius receiving the Easter tables from an angel*, MS. Cotton Caligula A.XV, folio 122 verso. After 1072. London, British Library

Anglo-Saxon sentiment, for, quite exceptionally, Worcester's pre-Conquest Anglo-Saxon bishop, St Wulfstan, lived on and continued in office until 1095. Full-page evangelist 'portraits' survive in only two Gospel Books from the final decades of the eleventh century,[143] and they are by no means distinguished. Such other large pictures as we have are on leaves left empty in pre-Conquest manuscripts, for example the vigorous 'Anglo-Saxon' St Jerome drawn soon after the Conquest,[144] a coloured picture of the Crucifixion added in the later eleventh century to a pre-Conquest Winchester Psalter,[145] and a sensitive drawing of the benediction of a king inserted on the blank leaf of another manuscript as late as the first quarter of the twelfth century [110]. The fact that artists were forced to such an expedient points up the post-Conquest policy of producing manuscripts without full-page illustrations.

The Anglo-Saxon vibrancy of line to some extent survived, for example in two very small coloured drawings made at Christ Church, Canterbury, after 1072[146] which show St Pachomius receiving the Easter tables from the angel to whom they had been entrusted by God [111]. Their highly charged idiom is delightful but reactionary, reviving as it does a style of the earlier part of the century which had by now lost its vividness. A more relaxed version of an Anglo-Saxon style is to be found in some attractive tinted drawings of animals in a Bury manuscript of about 1100.[147] As we shall see, the sensitive qualities of Anglo-Saxon line persisted even into the twelfth century.

Between 1066 and 1100, however, these English sensibilities largely gave way to the Norman taste for bright colours, for a rather coarser line, and for a figure style that drew on Anglo-Saxon traditions but lacked its *bravura*. As we shall see in Chapter 9, the focal point of manuscript art

became the initial, a shift in interest which constituted the greatest single revolution brought about by the Normans. At first they concentrated on the decorated rather than the historiated initial, though, curiously enough, the ornament itself drew its repertory of styles from the Anglo-Saxons:[148] the 'clambering' style already referred to, the inhabited scroll, the 'biting head' style, and the use of dragons to embellish or form the initial. All had originally migrated from England to Normandy and were now returning to their first home. In this context, attention may be drawn to a limited movement of manuscripts from Normandy to England which will be discussed in Chapter 9.

The effects of the Norman Conquest on English manuscript painting can be summed up as follows. First, there was a haemorrhage of costly artistic manuscripts, sent to Normandy and not replaced. Secondly, there was a virtual embargo for nearly half a century on the production of rich manuscripts. Thirdly, the narrative cycles and full-page illustrations hitherto endemic in Anglo-Saxon illumination also disappeared almost entirely for some fifty years. Fourthly, the emphasis was now almost exclusively on initials, though their artistic vocabulary remained essentially Anglo-Saxon. Fifthly, although the floating delicacy of some of the finest Anglo-Saxon drawings persisted here and there, for example at Canterbury, it gave way in general to a more insensitive line that was basically Norman.

To this may be added a marked variation in quality. Although Canterbury and Durham maintained good standards, art elsewhere could be quite amateurish, descending occasionally, at Rochester and Lincoln, to unexpected depths of bathos. The old stylistic homogeneity began to break up, too. The paintings and drawings of the Anglo-Saxon period had been so similar over the whole of the country that stylistic analysis is often useless in determining their exact provenance, and other criteria must be resorted to; yet after the Conquest the differences in style were so pronounced that even centres as close together as Canterbury and Rochester can easily be distinguished from one another.

This change perhaps reflected the reorganization imposed upon the monasteries, which, in their different ways, had had the cohesive bonds of their history and culture torn away. To begin with, they were now virtually all ruled by foreigners from various parts of the Continent – some from Normandy, others from France, and two originally from Italy. The composition of their communities varied, too, including – in differing proportions – native-born English, immigrant Normans, and Normans born in England. But perhaps the explanation for the change is simpler. In recent years, palaeographical criteria[149] have led to the ascription of an increasing number of Anglo-Saxon illustrated manuscripts to Christ Church, Canterbury, among them the Bury Psalter, the Bury Gospels, the Sherborne Pontifical, and the Grimbald Gospels, which are thought to have been made there specifically for other monasteries. If these attributions find ultimate acceptance, the similarity of styles among Anglo-Saxon illuminated manuscripts across the country – so different from the manuscripts of contemporary Germany, France, and Italy – may be explained by their having been produced at one or two major artistic centres – Canterbury certainly, and possibly Winchester – and thence dispersed by gift or sale over the breadth of England.

Painting in Germany and Austria: 900–1100

GENERAL OBSERVATIONS

The peoples of the Carolingian empire suffered the traumas not only of Viking irruptions and Hungarian attacks but also of internal dissension and partition, so that when Charlemagne's line came to an end in the tenth century the empire was already a spent force. Thereafter its German areas reverted to their primary tribal groupings, becoming the four great duchies of the Franks, the Saxons, the Swabians, and the Bavarians. The France of the future was at this time little more than a collection of fiefs with sketchy monarchical sentiments, and much of Italy continued as a congeries of small powers. The title of Holy Roman Emperor – now one basically only of prestige – was taken over by the most powerful of the German groups, passing from one dynasty to another – to the Saxons from 919, the Salians from 1024 to 1125, and the Hohenstaufen from 1138 to 1254.

As Charlemagne, the first Frankish emperor, had given his name to the Carolingian dynasty, so Otto the Great, the first Saxon emperor, gave his to the Ottonian, and during the tenth and eleventh centuries this new empire (which extended into Italy) saw a resurgence of art parallel to the one that welled up in England. The stimuli in both countries were provided by the needs arising from religious and, particularly, monastic reform. The reorganization of existing foundations and the establishment of new ones called for new liturgical books and vessels,[1] and on these artistic skills were lavished, partly out of pride of community, and partly also as a simple act of dedication. As a result, the chroniclers of both countries sometimes assessed the qualities of a bishop, or abbot, in terms of the wealth of art that he had provided for his church.[2] As in other lands of the West, monasteries were the main centres for the production of manuscripts and manuscript paintings. The artists of both countries showed an initial reliance on Carolingian traditions but went on to develop contrasting styles: Anglo-Saxon painting was light, vivacious, and spontaneous, German art – while at times attaining religious ecstasy – tended to the solemn and majestic. It was indeed in Ottonian Germany that the Romanesque style was born.

To a degree unknown in Anglo-Saxon England, there was in Germany a consciousness of the power of art to impress and to condition man's outlook on the affairs of this world, as well as to direct his thoughts to the next. Art was used to confirm the authority of those in power; thus the dedication pictures of illuminated manuscripts lay great stress both on the status of the princes of the Church[3] and on the sovereignty of the Ottonian emperors.[4] The illustrations of a Gospel Book given by Henry II to Montecassino [143] were aimed specifically at reminding that house of the relentlessness of imperial justice,[5] but usually the power of the ruling dynasty was extolled in more general terms. Thus, regally enthroned, both Otto II and his son Otto III receive tributes from the provinces of the empire [112, 113, 126], Otto III assumes the dual role of *rex* and *sacerdos*,[6] and Henry II, enthroned in oriental splendour, is accompanied by personifications of his territorial power[7] – as, of course, was the Carolingian Charles the Bald [48], but Ottonian pictures usually go much further in glorifying the emperor's divine authority. In a Sacramentary from Bamberg now at Munich,[8] for example, Henry II is crowned by Christ while saints support his arms and angels bring his sword and lance from heaven [114], and the theocratic overtones are heightened by the emperor's posture, which approximates to that of a bishop celebrating Mass. Henry III and his empress, too, are crowned by Christ[9] [136], but Otto III outdoes them all, for not only is he crowned, or blessed, by God, venerated by princes, and supported by a personification of the earth, but – like Christ himself in medieval art – he sits in a mandorla surrounded by symbols of the four evangelists. Unfortunately this painting from the Gospel Book of Otto III in Aachen Cathedral Treasury[10] is in too poor a state to be worth reproducing here.

All these images are explained by the contemporary development of the concept of the ruler as Christ-like, or Christ-orientated.[11] Hints of such an interpretation had appeared earlier,[12] but such a forceful expression of it in painting is a remarkable indication of the unprecedented capacity of art in our period to propagate and enforce ideas. Comparisons may, however, be made with Byzantine art,[13] for instance with an ivory carving of the emperor and empress being crowned by God, and it is interesting in this context to recall that Otto III's mother was the Byzantine princess Theophano, and that he made no secret of the fact that he valued his Greek inheritance more than his Saxon roots. One or two Ottonian paintings show influences from classical Rome: the pictures of Otto II and Otto III receiving tributes from the provinces of the empire, for example, were to some extent inspired by illustrations in the *Notitia Dignitatum*,[14] a late Roman manual of imperial authority of which a copy was probably made in the tenth century at Trier, which, in my view was to become an important centre of Ottonian illumination.

Whatever the influences, there is something new in the excessive awe of imperial authority that Ottonian art projected. The real power of the Ottonians was less than that either of the Byzantine or of the Carolingian emperors, but in their theoretical claims they outdistanced the first and completely outstripped the second. While Charlemagne had been content to be emperor of the Continental West, remaining on terms of friendship and equality with Byzantium, the Ottonian emperors saw themselves as *rex et sacerdos*, king and priest, universal emperors holding sway over all the territories of the classical Roman Empire. Thus the inscription on the seal of Conrad II declared that Rome (which he controlled) held the bridle of the earth,[15] while the symbols embroidered on a cloak of Henry II[16] [25] seem to go further and claim for him the entire universe. Yet in spite of all these claims to dominion, art under the Ottonians was less subject to imperial control than it had been under the

112 and 113. Liuthar Group: *Otto III receiving tribute from the provinces of the empire*, from the Munich Gospels of Otto III, Clm. 4453, folios 23 verso–24. 983/1002. Munich, Bayerische Staatsbibliothek

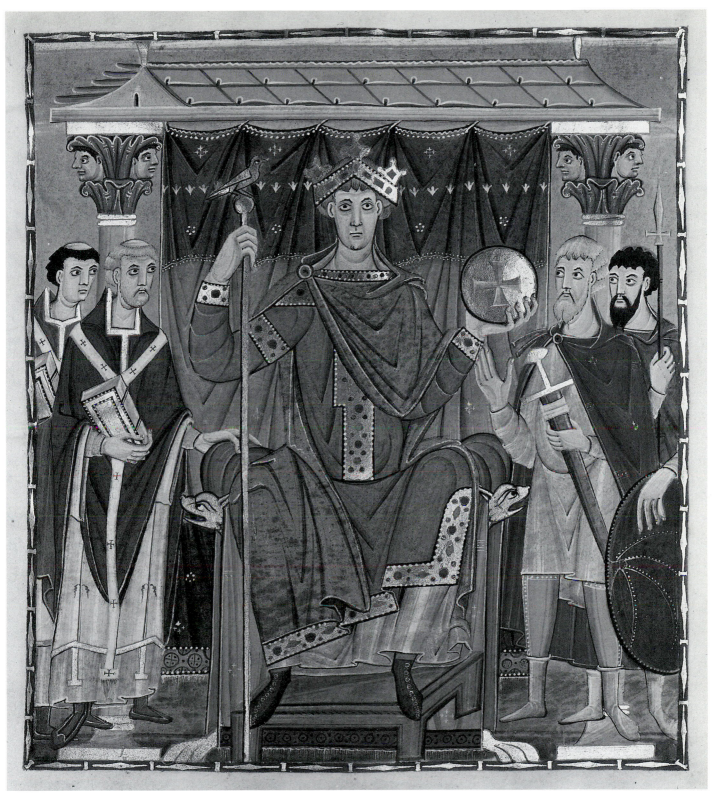

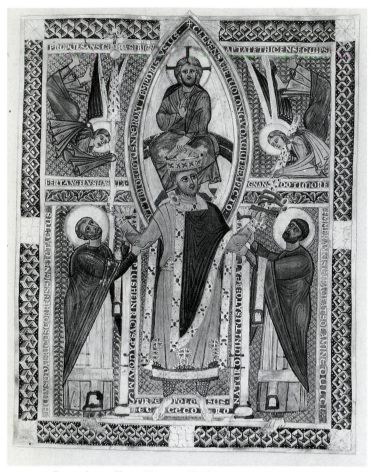

114. Regensburg: *Henry II crowned by Christ*, from the Sacramentary of Henry II from Bamberg, Clm. 4456, folio 11. 1002/14. Munich, Bayerische Staatsbibliothek

Franks. No Ottonian emperor personally advanced art in the way that Charlemagne had, or maintained personal schools of illuminators as Charlemagne and others of his dynasty had, or despatched *missi dominici* to encourage and control wall painting. When Ottonian emperors needed manuscripts, they went to monastic scriptoria, particularly the important ones of Trier, Echternach, Regensburg, and, in the view of many scholars, Reichenau, though smaller centres also might be approached, as when, during the time of Abbot Seyfridus (1048–68), the entire resources of the Tegernsee scriptorium were commandeered to meet the emperor's needs.[17]

The princes of the Church also were not slow to commission splendid artistic manuscripts, particularly in the north-west of Germany, where Charlemagne's own school of painting had flourished and where the new German reform movements were centred. The Saxons however did not share the Franks' sense of emotional kinship with the Israelites, and their attitude to religious reform was different, too, for whereas the Carolingians had been primarily concerned with obtaining correct texts of the whole Bible, the Ottonians, like the Anglo-Saxons, were more anxious to provide rich liturgical books for the divine service. As such texts – Sacramentaries and Gospel Lectionaries, for example – were based on the Gospels, it was on Gospel illustrations that the Ottonian painters tended to focus their attention, resulting in a greater consonance in subject matter than in Carolingian

times between vellum paintings and wall paintings, since both were now primarily Christological in theme.

WALL PAINTING

Wall paintings of the tenth and eleventh centuries in Germany and Austria, now rare, were once legion: scattered references in chronicles speak of them at St Gallen and Petershausen,[18] Reichenau,[19] Hildesheim,[20] Toul,[21] Brauweiler,[22] Deutz,[23] Halberstadt,[24] Iburg,[25] Cologne,[26] Mainz,[27] Zwiefalten,[28] Aachen,[29] Tegernsee,[30] Passau,[31] Eichstätt,[32] and Echternach.[33] Unfortunately, however, it is in quite unparticular terms that we are told that Ralph, abbot of Deutz, adorned his monastery with pictures,[34] that Bernward, bishop of Hildesheim, decorated his cathedral with 'bright and exquisite paintings',[35] and that Gebehard, bishop of Eichstätt, had the chapel of St Gertrude painted with 'wonderful and almost living pictures'.[36] Nevertheless, a few detailed descriptions survive. When Gebehard, bishop of Constance between 980 and 996, built the abbey of Petershausen, he decorated the ceilings with gilt bosses to give the impression of the starry vault of heaven, and covered the walls with paintings of the life of Christ and Old Testament prefigurations of it.[37] At St Gallen, Ulric, abbot from 984 to 990, commissioned wall paintings of the Assumption of the Virgin and the Dormition of St John,[38] and Witigowo, the 'golden abbot' of Reichenau from 985 to 997, ordered paintings of the Virgin and Child, of St Mark and St Januarius, of the early abbots of Reichenau, and of the lives of the early Fathers.[39] One verse account tells us of eleventh-century paintings in Mainz Cathedral of major events from the Gospels and from the Old Testament,[40] another of murals painted (before 984) by a German for the English nunnery of Wilton showing the Passion of Christ and the patron saint of the church, St Denis.[41] Such evidence as we have suggests that the main themes of wall paintings in churches were events from the life of Christ and their prefigurations in the Old Testament, together with representations of the Virgin, of the evangelists, and of local and other saints.[42]

In the former west choir of the abbey church of Lambach,[43] in present-day Upper Austria, are important murals preserved because they were blocked off when a Baroque organ was installed. In low-key earth colours – reddish browns, grass-greens, sky-blues, and yellow ochres – they are on Christological themes which no doubt originally covered the whole of the church. Twenty-three scenes survive, in whole or in part, mostly illustrating Christ's infancy: the story of the Magi, Herod, Joseph's dream [115], the return from Egypt, and the twelve-year-old Christ disputing in the Temple, followed by Christ's Baptism, his temptations, and at least one of his miracles. There are also four single figures, presumably from the Old Testament, one of them identified as Abraham. The iconography shows considerable independence; the artists drew on Apocryphal writings, on

115. Lambach, west choir of the abbey church, *Joseph's dream*. Wall painting. *c.* 1089

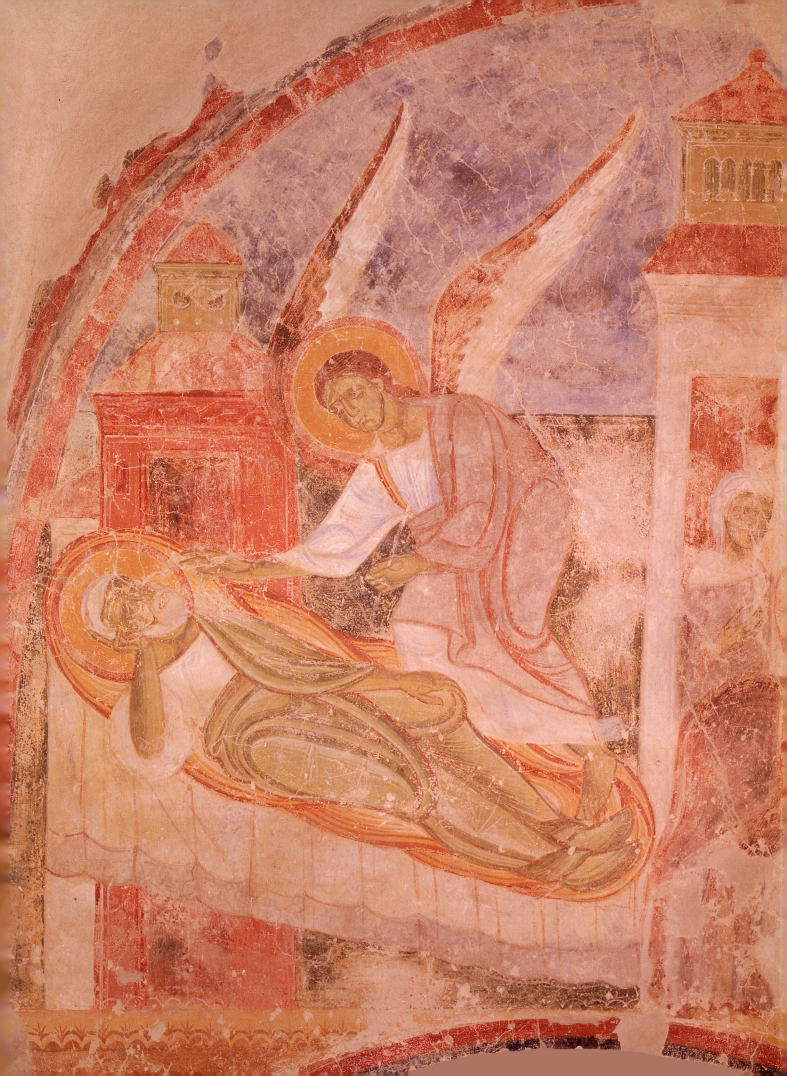

116. Goldbach, St Sylvester, nave, *The stilling of the storm*. Wall painting.
Late tenth/early eleventh century

the works of the Jewish historian Josephus, and on the Lambach play of the three Magi, as well as on the conventional accounts of the Gospels. In style, there is both an awareness of the art of northern Italy, especially that of Lombardy, and some affinity with the so-called Berthold group of illuminated manuscripts at Salzburg – indeed, the painters may well have come from Salzburg, with which Adalbero, the bishop of Würzburg who was the effective founder of Lambach, had a close relationship. The murals are thought to be associated with Adalbero's consecration of two altars at Lambach in 1089.

The main centres of surviving wall paintings in present-day Germany are on an island in the Chiemsee in Bavaria, at Fulda in Hessen, and in the region of Lake Constance. In the chapel of St Michael in the nunnery church of Frauenwörth on the Chiemsee, five out of six large-scale paintings of angels remain. It is a matter of dispute whether they are Carolingian or Ottonian, and also whether they were intended to appear as they do now, or whether, with their red outlines, they are underdrawings of paintings which have lost their top coat.

The surviving murals of Fulda[44] belong to the two small suburban churches of Petersberg and St Andrew at Neuenberg. In the crypt of the Petersberg chapel are fragments of murals showing Christ's Baptism in the Jordan,

the Lamb of God within a medallion, and angels and saints. In the crypt of St Andrew are tinted drawings in ochre, brown, and yellow of Abraham, Melchisedech, and Abel (prefiguring the Mass), of Christ in Majesty, and of three-quarter-length angels and busts in medallions. Executed in a lively manner and giving an impression of lightness, they are more easily paralleled in Anglo-Saxon than in Ottonian art – and indeed Fulda was originally an Anglo-Saxon foundation. The date of these modest but buoyant paintings is usually associated with the consecration of the church which took place in 1023.

On the western reaches of Lake Constance, the paintings are more ambitious but less well preserved. Again in two small churches – St Sylvester at Goldbach near Überlingen, and St Georg at Oberzell on the island of Reichenau[45] – they are closely related and normally ascribed to the late tenth or early eleventh century. The paintings at St Sylvester are more fragmentary than at Oberzell, but they have been less harmed by restoration and therefore offer clearer stylistic criteria for dating. Originally, the pictures on the east wall showed Christ between the donor, Winidhere, who proffers the church, and his wife, each sponsored by a saint.[46] The murals on the side walls, now fragmentary, illustrated the healing of the demoniac, the stilling of the storm [116], and other miracles. In the choir, in better condition, are pairs of apostles by a

117. Oberzell (Reichenau), St Georg, nave, *The healing of the man with dropsy*. Wall painting. Late tenth/early eleventh century

different artist. They were originally assembled around an enthroned Christ which was lost when a Gothic window was put into the apse.

Oberzell[47] has lost wall paintings in the apse, in the aisles, and on the west wall. Those that remain in the nave, however, despite a deterioration which has meant the loss of most of the modelling, are of prime importance as outstanding examples of surviving Ottonian wall paintings. The most significant of them, in the middle of the three tiers, portray Christ's miracles. The compositions are long and rectangular, separated from the upper and lower tiers by a meander frieze, and from one another by formalized patterns. On the north wall are scenes of the Gadarene swine, the healing of the man with dropsy [117], the calming of the storm at sea, and the healing of the blind man; on the south wall, Christ healing the leper, raising the son of the widow of Nain from the dead, healing the woman with the issue of blood and Jairus's daughter (these two in one panel), and raising Lazarus from the dead. The colours are restrained and the compositions well balanced, with an attractive feeling for space. It is clear, despite the damage done by time and the restorer, that the paintings have absorbed Byzantine influences. Their backgrounds, for example, of horizontal broken bands in graduated colours (often green, blue, and ochre) derive from Byzantium,[48] which had itself borrowed them from traditions

of classical painting, where they represented the earth's atmosphere. The closest links of the symbolic architecture and bird's eye views of towns are with Byzantine illuminated manuscripts of the tenth century such as the *Menologion* of Basil II[49] and the Bible of Leo the Patrician.[50] The paintings have a sense of linear movement (perhaps accidentally exaggerated by the loss of surface paint), and there is a restrained authority about the figures, especially the Christ. Their date, though disputed, cannot (as Demus remarks[51]) be far removed from that of the miniatures of the Gospels of Otto III, made between 983 and 1002. In the chapel of St Michael is a much damaged and dilapidated Last Judgement, with a Crucifixion below, of a somewhat later date – certainly after 1100, as we know from the building history of the church.[52] In the Judgement scene, Christ exhibits his wounds to show that he is the Christ of the divine sacrifice. An accompanying angel displays his Cross and, further down, two of the resurrected dead hold up a chalice as another reminder of the Passion.

Associated with these later murals at Oberzell are what remain of roughly contemporary paintings in St Michael's in the village of Burgfelden in Württemberg,[53] a church which had links with the monastic community at Reichenau. Here again, the Christ of the much damaged Last Judgement on the east wall displays the wounds in his hands and feet, and

partly exposes his breast to show the lance-wound, as in a much earlier Anglo-Saxon miniature [77]. Again, two angels hold a Cross – here a particularly large one. These paintings were originally accompanied by parable scenes; Dives and Lazarus and the Good Samaritan can still be faintly deciphered, both of which (as Demus has noted[54]) relate to the subject of charity.

The paintings of Oberzell have attracted special attention because they are relatively extensive, but this accident of survival should not lead us to assign a greater importance to Reichenau than its merits allow. As we have seen, written sources indicate the former existence of other major Ottonian cycles, for example at Petershausen and Mainz. Moreover, there is no certain evidence that the Oberzell paintings were the work of Reichenau monks; and if Reichenau did have wall-painters of her own at this time (as she did in the ninth century),[55] we might ask why they were not lent to her diocesan bishop, Gebehard of Constance, who employed secular artists for the wall paintings he commissioned in the abbey of Petershausen, which he actually founded on land acquired from Reichenau in 983[56]. In fact, wall-painters moved from one part of Europe to another,[57] and at about the time of the Oberzell pictures there was an Italian wall-painter working in Germany[58] and a German one in England.[59] The murals at Reichenau could therefore have been the work of outsiders, and, though he does not share my views, Demus has significantly remarked upon their 'astonishing resemblance' to the murals in the baptistery of Novara in Lombardy.[60]

The supposition that the Oberzell paintings were the work of local artists has, in the past, been used to support the attribution of a contemporary manuscript, the Munich Gospels of Otto III, and others associated with it, to a school at Reichenau, on the basis that the iconography of three of the Oberzell miracle scenes corresponds with versions in Otto's Gospels.[61] As this and its related manuscripts are of quite outstanding quality, it has generally been held that, as well as being a major centre of wall painting, Reichenau housed the greatest of all schools of Ottonian illumination.[62]

MANUSCRIPT PAINTING

THE CLAIMS OF REICHENAU

My own view concerning the claims of Reichenau as an important centre of illumination is a minority one: I believe it to have been an artistic outpost rather than a central headquarters, and that the so-called 'Reichenau' illumination was produced at Lorsch and Trier. As we shall see, this concept serves to align the art of Germany with its movements of reform, and so offers a parallel to the conjunction of art and reform in England, and indeed in some areas of the Carolingian empire. My arguments are set out in detail elsewhere,[63] and here I shall confine myself to a few observations on the large claims made for Reichenau.

First, there is no evidence in any contemporary chronicle, or written source, to support the idea that Reichenau was a great centre whose illumination dominated the tastes of the empire. Nor (with one exception – the Petershausen Sacramentary[64] – which may have passed to Reichenau after

originating elsewhere) is there any evidence that a single one of the famous illuminated manuscripts traditionally attributed to Reichenau was ever there: they bear neither the press-marks of the Reichenau library, nor any inscription that would suggest that they were made for this centre. Two Reichenau monks must indeed have been involved in the making of a sumptuous manuscript (the Egbert Codex) for Archbishop Egbert of Trier, for a frontispiece picture describing them as 'Keraldus Heribertus Augigenses' ('of Reichenau') shows them handing the book to Egbert. Presumably they were associated with the planning or making of the manuscript and had been brought from Reichenau to Trier just as, a little later, two scribes – also identified by name – were brought from Trier to work at Cologne.[65] Indeed, they would have had no need to describe themselves as 'of Reichenau' if they had been working at Reichenau itself. The twelfth-century scribe Manerius refers to himself as being 'of Canterbury' because he was working on a Bible in France, whereas the lengthy eulogy of another Canterbury scribe, Eadwine, does not bother to specify that he was from Canterbury since it was there that he was working.[66]

Moreover, the dedication verses in some of the manuscripts do not support the theory that Reichenau was a centre geared to export production and serving clients in various parts of Germany, for they show that the books concerned were not sold but given, as far as we know, to people unconnected with Reichenau. One scholar has claimed that Reichenau was the seat of the imperial chancellery and the favourite halting-point of emperors on journeys to Italy,[67] which would help explain the 'Reichenau provenance' of some of the manuscripts that came into imperial ownership. The facts are, however, that the Ottonian chancellery was peripatetic, and according to the documentary evidence of the *diplomata* only made two official sojourns at Reichenau in a hundred and twenty years. Furthermore, the only illustration that can be firmly ascribed to Reichenau during the relevant period[68] is of mediocre quality, despite its solemn function of representing the Reichenau community in the presence of the Virgin and Child and of its patron saint, and also to introduce an account of the activities of Abbot Witigowo, the great art patron of the house. As we have seen in Chapter 6, Canterbury in contemporary England was probably a major centre of fine illuminated manuscripts. But its own artistic manuscripts were spendid as well. Whatever Reichenau's claims to fame in other spheres and times, evidence to justify its having been worthy of major commissions from emperors and prelates during the Ottonian period is virtually non-existent. Further research may clarify the position, but meanwhile, it is only fair to re-emphasize that my views are personal ones, and to add that they will shape the comments that follow on the manuscripts of Lorsch and Trier. These latter are still attributed by most art-historians to the school of Reichenau.

Detail of plate 127 (enlarged)

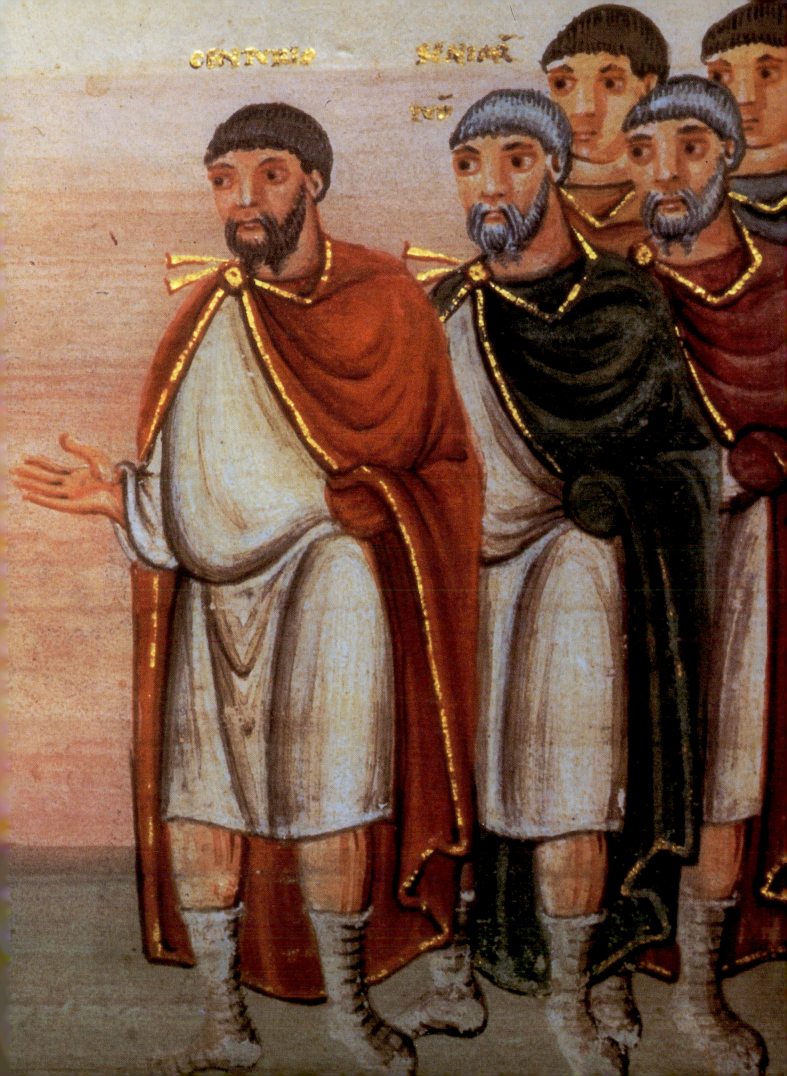

118. Charlemagne's Ada School: *Christ in Majesty*, from the Lorsch
Gospels, folio 36. Early ninth century. Alba Julia, Biblioteca Batthyáneum

119. Lorsch(?): *Christ in Majesty*, from the Gero Codex, MS. 1948, folio 5 verso. 950/70. Darmstadt, Hessische Landesbibliothek

THE SCHOOL OF LORSCH

The earliest Ottonian illuminated manuscripts are often collectively called the Eburnant group, after one of the scribes.[69] Three of them are of particular importance, and they may have been made at Lorsch for a reason that will appear later. The first, both in time and splendour, is a Gospel Lectionary, known as the Gero Codex,[70] produced between 950 and 970. Its dedication verses tell us that it was written by the scribe Anno at the persuasion of Gero, a sacristan, for presentation to a foundation whose patron saint was St Peter – and, despite the fact that the cathedrals of Cologne and Worms were each dedicated to St Peter and each had a priest named Gero during the relevant period[71] – it seems likely that Cologne was the actual destination. It was certainly made in a monastery, since Anno is represented as a monk,[72] and the view that that monastery may have been Lorsch is suggested by the fact that the paintings of the Codex were inspired by a manuscript at that centre – the ninth-century Lorsch Gospels – a product of Charlemagne's Ada School that we have encountered earlier.[73] This influence is most obvious in the full-page Christ in Majesty with the four evangelist symbols, which – despite changes in the general balance, a slight tendency to schematization, and some reduction in detail – has undoubtedly been copied from the Carolingian source [118, 119]. The St John, too, is plainly dependent on the earlier manuscript [120, 121]. Of the two dedication pictures[74] of the Gero Codex, one shows Gero receiving the manuscript from Anno, while in the other he offers it to St Peter, who is impressively painted in a style that combines breadth of conception with a delicate harmony of colour. This second picture too derives from a Carolingian prototype, for it has similarities with a ninth-century portrayal of Hrabanus Maurus presenting a copy of his *De laudibus sanctae crucis* to St Martin.[75]

The illumination of two other manuscripts closely relates them to the Gero Codex. The first, which is roughly contemporary, is the Petershausen Sacramentary,[76] whose Christ in Majesty [122] clearly derives from the one in the Gero Codex, and whose personification of the Church[77] is surrounded by the same ornamental circlet as had appeared round the Gero Codex Majesty. Both Sacramentary compositions have a rather brooch-like quality, and though the draperies and faces remain soft and tractable, the sharp, precise outline of the figures separates them from their backgrounds and produces a crispness of definition that will become a characteristic of Ottonian painting. The Sacramentary was at Petershausen by the twelfth century, when documents relating to the house were copied into it, but its earlier history is obscure. The calendar now at the beginning of the manuscript, though certainly a Reichenau one, is unrelated to the main text and in a different hand, which leads to the supposition that it was produced separately and bound in later with the Sacramentary text.[78] The artistic relationship between the Sacramentary and the Codex suggests that they came from the same scriptorium, and the calendar may have been bound into the Sacramentary either during a later stay at Reichenau before reaching Petershausen, or at Petershausen itself.

The second manuscript related to the Gero Codex is the Hornbach Sacramentary[79] whose scribe, a secular deacon called Eburnant, has given his name to the whole group. His book was made for Adalbert, abbot of Hornbach in Upper Lotharingia during the last quarter of the tenth century, at an unspecified scriptorium – probably the same one that produced the Gero Codex because its dedication verses are similar. Its four dedication pictures show the Sacramentary passing from Eburnant to Abbot Adalbert; from Adalbert to the abbey's patron saint, St Pirmin; from St Pirmin to St Peter; and finally from St Peter to Christ.[80] The breadth and ampleness of the first two pictures give them a Carolingian feel, but the second two are crisp and incisive and unmistakably Ottonian; indeed, we can almost follow in these dedication paintings the movement away from the more expansive Carolingian idiom towards the more sharply defined Ottonian one.

THE SCHOOL OF TRIER

Although some Ottonian manuscripts are explicit about their patronage but not their provenance, it is reasonable, in the absence of conflicting evidence, to assume that patrons commissioned locally. Though others would disagree, this was probably true in the case of one of the greatest of all Ottonian ecclesiastical patrons, Egbert of Trier. The son of a count of Holland, he trained as a monk at the abbey of Egmond and became, in turn, imperial chancellor (976–7) and archbishop of Trier (977–93). Trier in Egbert's life-time was a vital centre of reform and scholarship.[81] From the 940s onwards, its abbey of St Maximin sent out monks to reform such houses as St Moritz at Magdeburg, St Pantaleon at Cologne, Gladbach, Echternach, St Emmeram at Regensburg, and Tegernsee.[82] The neighbouring monastery of Mettlach was a famous centre of learning to which monks and clerics came from all over France to study, and as some of them went on to become bishops and abbots, a local chronicler could boast with some justice that they 'imbued the whole of France with the light of Mettlach'.[83] Trier's reputation for scholarship and reform in the second half of the tenth century was such that it attracted monks and clerics from Fulda and Aachen[84] as well as from England, Flanders, and Holland, resulting in a remarkable mingling of influences, both received and given.

Trier's artistic tradition went back – though not continuously – to the classical period. It probably died out at the end of the Carolingian era, to be resuscitated by Egbert, who made of Trier a significant centre of metalwork which produced for him to present to his own cathedral silver crosses, or crucifixes (the Latin *cruces* can mean either),[85] and to Egmond a silver reliquary and gold cross, or crucifix;[86] it could also satisfy a request from the archbishop of Reims for a gold cross or crucifix.[87] But Egbert is celebrated today chiefly for the splendid manuscripts that he commissioned. The so-called Egbert Psalter,[88] made for the archbishop's use in his own cathedral, by its subsequent history[89] provides us with a spectacular illustration of the role of diplomacy and family ties in the passage of a precious manuscript from hand to hand over the length and breadth of Europe and beyond. It finally reached Cividale (Friuli) (where it has been since the thirteenth century) only after peregrinations to the Russian and Polish courts and to a Swabian monastery, and after spending some time in the hands of a Hungarian saint. Prayers and a series of five Russo-Byzantine pictures added

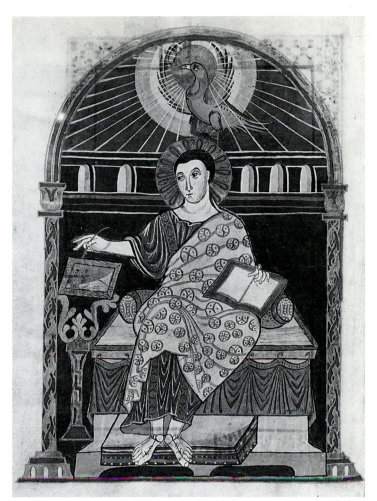

120. Charlemagne's Ada School: *St John*, from the Lorsch Gospels, MS. Pal. lat. 50, folio 67 verso. Early ninth century. Rome, Vatican Library

121. Lorsch(?): *St John*, from the Gero Codex, MS. 1948, folio 4 verso. 950/70. Darmstadt, Hessische Landesbibliothek

in the later eleventh century show it then to have been in the possession of Gertrude, wife of the beleaguered Russian Grand Duke Isyaslav, brought perhaps by Burchard, the provost of Trier Cathedral, as a diplomatic gift; for he it was who, in 1075, was sent by the emperor Henry IV to head an embassy to Isyaslav, who had asked for help in settling a dispute with his brothers. Alternatively, Gertrude could have inherited it from her mother, the Polish queen Richeza, whose father, Count Palatine of Lotharingia and a powerful landholder in the Trier area, may have acquired it during the difficulties that beset Trier in the early eleventh century. By the mid twelfth century the Psalter had made its way to the Benedictine abbey of Zwiefalten in Swabia, for a Zwiefalten calendar-necrology of *c.* 1145–60 is now bound in with it. It is likely to have been among the many rich gifts made by Salome (d. 1144), the wife of Boleslav III of Poland[90] and a Swabian by birth, whose family had close ties with the abbey; she in her turn may have acquired it through dynastic links between the Russian and Polish ruling families (her husband's first wife had been the daughter of the Russian Grand Duke Sviatopolk). From Zwiefalten the manuscript passed to St Elizabeth, daughter of King Andrew II of Hungary, apparently via the Andechs, the Swabian clan to which Elizabeth's mother belonged.[91] From a note which was added to the Psalter in a fifteenth- or sixteenth-century hand we learn that St Elizabeth presented it to the canons of Cividale Cathedral in 1229 at the request of her uncle Berthold, patriarch of Aquileia, who lived at Cividale.

The colourfulness of the Egbert Psalter's history is matched by the richness of its illumination. Like the manuscripts from Lorsch, it has dedication pictures, and these show Ruodpreht (probably the scribe) offering the book to Egbert, who in his turn presents it to St Peter, the cathedral's patron saint. Ruodpreht wears the Benedictine habit, indicating that he was a monk; attempts to identify him by raising the coincidence of a fairly common Christian name to the dignity of historical evidence are unconvincing, and in the absence of any hard facts we may simply suppose that Ruodpreht came from one of the local Trier houses on which Egbert had lavished his generosity. Support for this surmise is provided by mention in the liturgy of a number of Trier saints, and by the 'portraits' of many Trier archbishops in the pictures (the reliquary for the staff of St Peter from the Trier workshop of Egbert also has a series of 'portraits' of Trier archbishops).[92] The paintings moreover have stylistic similarities with those of a known Trier manuscript from the local abbey of St Maria ad Martyres.[93]

The figure styles betray various influences. The dedication picture and the King David [123] have distinct Carolingian overtones, though the David is invested with a power, a compactness, and a swinging sense of rhythm which represent something more than a simple paraphrase of the ninth-century Tours style. Equally clear are influences from Italy – a country that Egbert visited twice, in 970–2 and 983,[94] and one that attracted monks of Trier in the interests of study, or so a letter of Gerbert, the future Pope Sylvester II, suggests.[95]

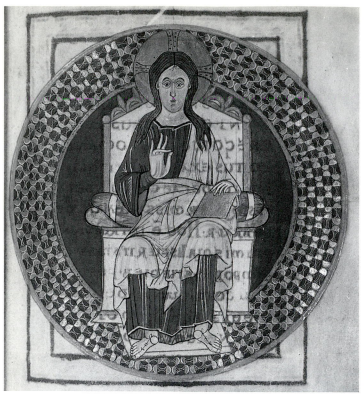

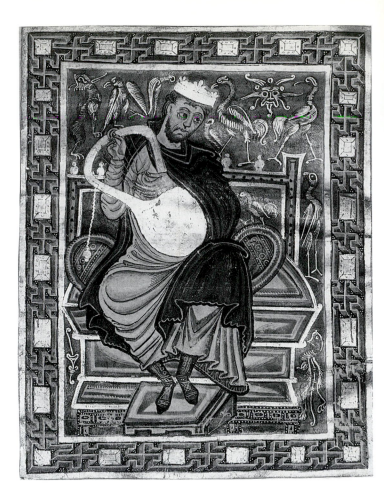

122. Lorsch(?): *Christ in Majesty*, from the Petershausen Sacramentary, MS. Sal. IX.b, folio 41. 950/70. Heidelberg, University Library

123. Trier: *King David*, from the Egbert Psalter, cod. sacr. N.6, folio 20 verso. 977/93. Cividale, Museo Archeologico

124. Trier: *Donor portrait* (Gerard, bishop of Toul?), from the Poussay Gospel Lectionary, MS. lat. 10514, folio 3 verso. 963/94(?). Paris, Bibliothèque Nationale

125. (*opposite*) Gregory Master: *Christ in Majesty*, from the Sainte-Chapelle Gospels, MS. lat. 8851, folio 1 verso. 967/83. Paris, Bibliothèque Nationale

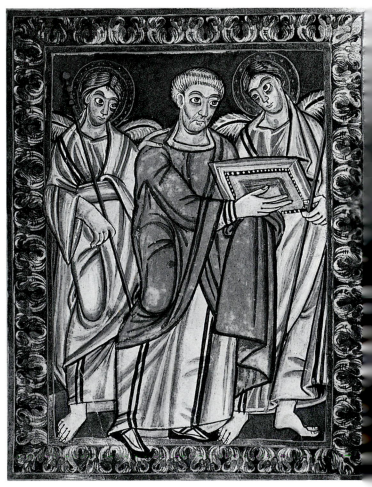

Parallels in Italian wall paintings can be found for the modelling of the heads, the *orans* posture of prayer, the proportions, and the poised balance of the bodies of the standing figures of archbishops, though they are not simply essays in an Italian style: their tranquil expression and composure of stance may come from Italy, but the turbulence of their draperies probably derives from southern England, with which Trier also had associations.[96]

Apart from the pictures, the Egbert Psalter has a number of initials, fifteen of them full-page. They project an Anglo-Saxon feeling of unrepressed vigour, but their pedigree points unmistakably to St Gallen (though they also offer points of comparison with initials of a Sacramentary which may have originated at Reichenau).[97] The St Gallen influence is not difficult to account for. In the second half of the tenth century it was a flourishing centre of painting, and among its artists who travelled to distant parts was Ekkehard II, chaplain to the emperor himself.[98] Otto I's interest in its reform led to a visit from a delegation of prelates from all over Germany,[99] including the archbishop of Trier, the bishops of Würzburg, Metz, and Toul, and also abbots from Lorsch and Weissenburg, who were shown the manuscripts there.[100] The emperor himself visited St Gallen in 972, in company with his wife and his son, Otto II, who took a flattering if regrettable interest in the library, for he asked to see the finest

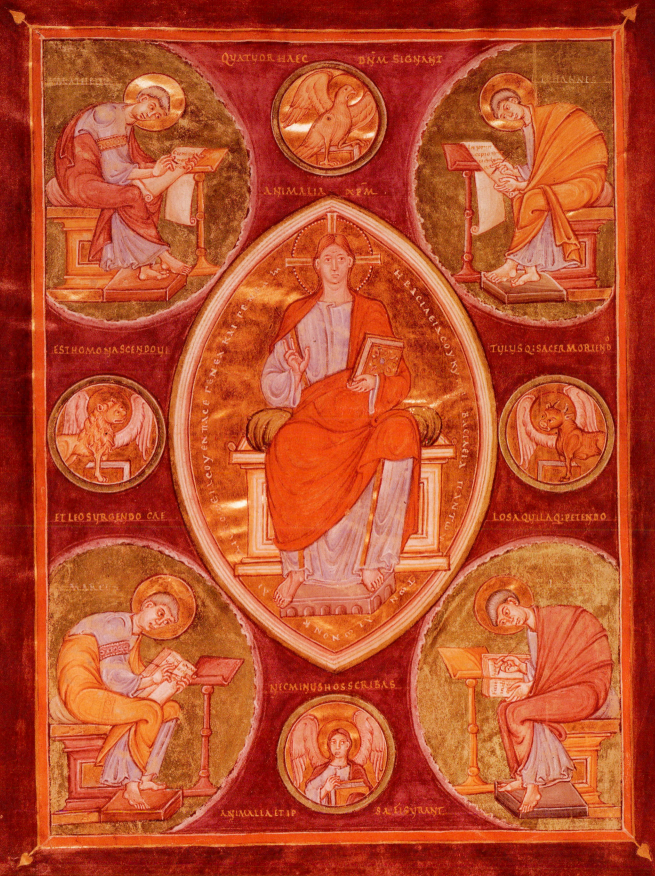

QVATVOR HAEC DNM SIGNANT

MATHEVS IOHANNIS

ANIMALIA · XPM

EST HOMO NASCENDOQVE TVLVS Q: SACER MORIEND

ET LEO SVRGENDO CAE LOS AQVILAQ: PETEND

MARCVS LVCAS

NEC MINVS HOS SCRIBAS

ANIMALIA ET IP SA FIGVRANT

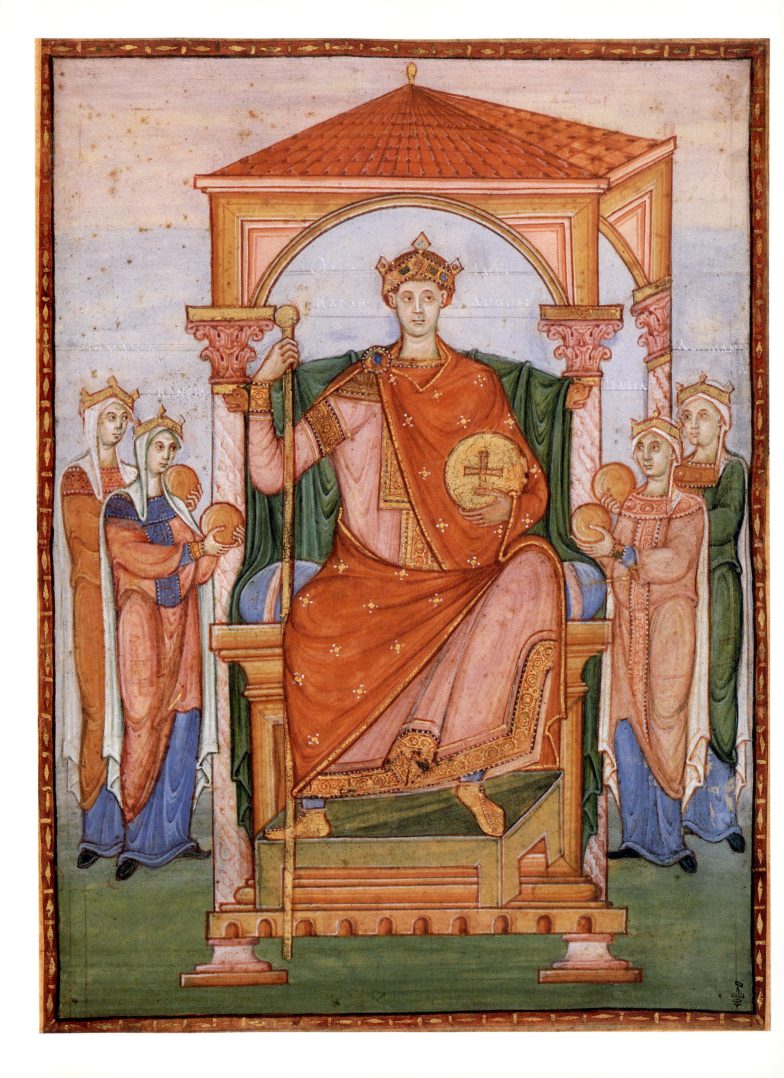

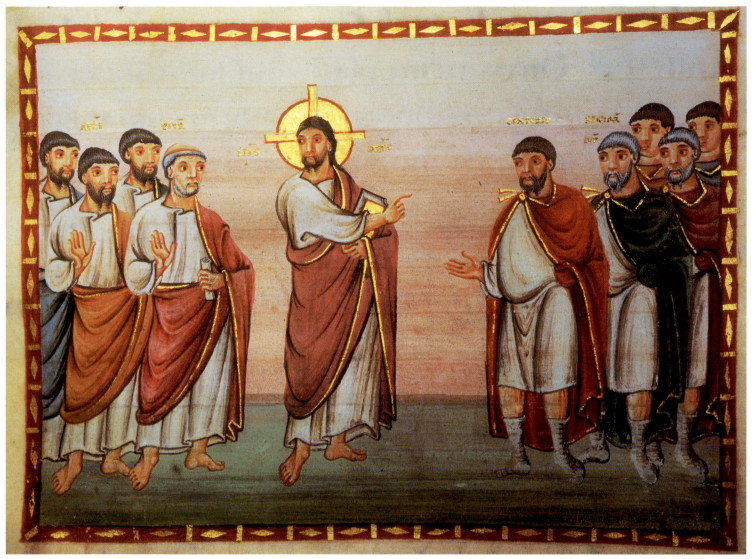

127. Gregory Master: *Christ and the centurion*, from the Egbert Codex, MS. 24, folio 22. 977/93. Trier, Stadtbibliothek

manuscripts and then took many of them for himself.[101] All these contacts with the outside ensured that, at a critical period in the development of Ottonian art, St Gallen manuscripts were known outside their house of origin.

The Poussay Gospel Lectionary[102] is stylistically related to the Egbert Psalter. Its earliest associations are with the diocese of Toul, a suffragan bishopric of Trier. According to a late tradition, the Lectionary had belonged to Pope Leo IX,[103] bishop of Toul from 1027 to 1048 under the name of Bruno, who was the effective founder of the nunnery of Poussay, to which it passed. It had perhaps been made for Bruno's predecessor St Gerard (963–94). Its illustrations include the earliest known Ottonian paintings of such New Testament scenes as the Nativity, the Magi, the Crucifixion, the washing of the disciples' feet, the Marys at the Sepulchre, and Pentecost, and it also has a dedication picture which extends over two adjacent pages.[104] The unnamed donor stands between two angels on the left-hand page [124] and offers the manuscript to Christ on the right. The donor, like the

126 (*opposite*). Gregory Master: *Otto II surrounded by the personified provinces of the empire*, detached leaf from a copy of the Letters of St Gregory. 983/7. Chantilly, Musée Condé

angels, wears the Greek *sticharion*, which (although Greeks were settled at this time in the diocese of Toul) probably derives from Italian art. Other Italian elements include the concept of angels presenting the donor to Christ, which is found in mosaics at Ravenna[105] and Parenzo;[106] the treatment of the head, figure, and draperies, which reflects pre-Carolingian Italian paintings like those of Santa Maria Antiqua; and some similarities with Veronese illuminations of the eighth century.[107] The Christ in Majesty is itself a felicitous essay in an early Italian style.

The fact that the donor of the Poussay Gospel Lectionary is represented, but not identified, is exceptional, for both donors and scribes of rich manuscripts were often named. Illuminators were usually ignored – so much so that the name even of the most accomplished Ottonian illuminator of the tenth century is unknown; he is today referred to as 'the Gregory Master'[108] because his paintings include illustrations for a copy of the Letters of St Gregory. One of his manuscripts has associations with Lorsch,[109] but his work is primarily connected with Egbert and with Trier. He took an interest in the art of the past that was both personal and practical,[110] and he inserted title-pages and four evangelist 'portraits' into an earlier Gospel Book,[111] and a further four 'portraits' into a pre-Carolingian manuscript from Echternach.[112] The only

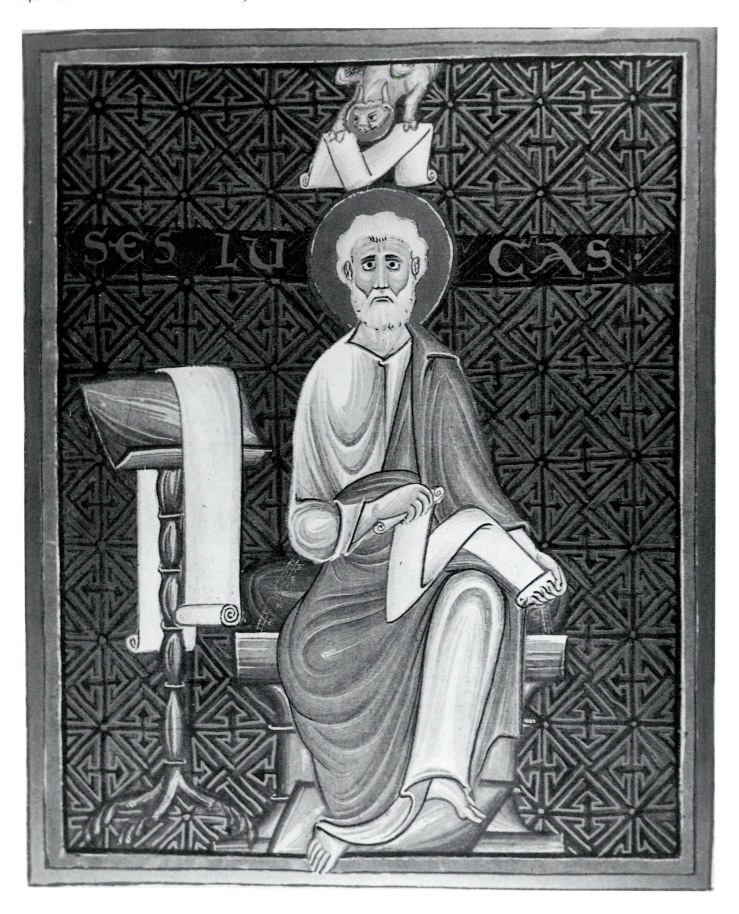

128. Trier: *St Luke*, from the Egbert Codex, MS. 24, folio 5 verso. 977/93.
Trier, Stadtbibliothek

remaining 'portrait' in this manuscript – of Mark – shows a close affinity with the Carolingian School of Tours, indicating that there was at least one illuminated Tours manuscript at Trier.[113] The Gregory Master was also responsible for illuminating the so-called Sainte-Chapelle Gospels,[114] written in gold and dated by emperor medallions on the St Matthew title-page to the years 967–83. Its Christ in Majesty [125] is obviously influenced by Tours, and more specifically by a Majesty akin to that in the Vivian Bible [58].[115] The composition is unquestionably Carolingian, but the figures have an Ottonian crispness of definition; indeed, they are so sharply separated from their backgrounds that one feels that they could be lifted up like carvings of ivory – and in fact one scholar believes that the Gregory Master was an ivory-carver as well as a manuscript-painter.[116]

His crystallization of forms is clearest in the two full-page illustrations to the Letters of St Gregory which gave him his name, and are now on detached leaves at Chantilly and Trier.[117] One is of Otto II, enthroned beneath a baldacchino and surrounded by the personified provinces of his empire, with the faintest of blue atmospheres producing the impression of limitless space behind [126]. The other is of St Gregory dictating his writings under the inspiration of the Holy Spirit, secretly observed by his secretary. Both illustrations have a breadth of treatment and an awareness of spatial planes which suggest the influence of late classical or Early Christian art, and the posture of the emperor in the first picture, with the slight imbalance of his widely placed legs, is, in fact, paralleled in the Christ carved on an Early Christian pyx which was significantly found near Trier.[118] Verses tell us that the manuscript of which these leaves were a part was commissioned by Egbert and magnificently bound in gold and jewels, and that it was made in honour of St Peter (the patron saint of Egbert's cathedral), which suggests that it was intended for Trier. A nostalgic reference to the 'tranquil peace' enjoyed under Otto II further implies that it was produced during the unruly period between 983 and 987, when the succession of the three-year-old infant Otto III led to the unleashing of Henry of Bavaria's ambitions, and to the seizure of the boy-king.

Magnificent as this manuscript must have been in its pristine state, it would have been eclipsed by one of the greatest of all Ottonian illustrated texts, to which the Gregory Master contributed some particularly fine work. This is the Pericope Book known as the Egbert Codex[119] [127, 128]. Originally bound in gold and jewels, it has many small initials in gold and silver, a dedication picture, four full-page paintings of the evangelists, and fifty New Testament illustrations coloured in gold, purple, blue, green, and red. The title-page and the decorative initial opposite (folios 7 verso-8) were probably illuminated by the artist of the Egbert Psalter, whose style also appears in the two introductory pages (folios 1 verso-2) bordered with birds and animals.[120] On the first of these pages are dedication verses sumptuously set out in gold against a background of purple, and on the opposite leaf is the equally lavish dedication picture of the seated Egbert, towering over the small monks on either side of him. These are named as Kerald and Heribert of Reichenau and are presumably the scribes. One of them offers Egbert the manuscript, bound in gold.

The Gregory Master's interest in the art of earlier periods is reflected in one or two iconographic relationships with the illustrations of the late classical Vatican Virgil[121] – compare, for example, the mother beating her breast at the slaughter of the Innocents with the similar anguished action of the women at the death of Dido,[122] and the meeting of Christ and the centurion [127] with the meeting of Aeneas and Dido.[123] Lifted sharply from their backgrounds by their clarity of outline, the figures of the Codex are, of course, in an entirely different idiom from the sketchy illusionism of the Virgil, but there are stylistic connections in terms of the horizontal format, the use of simple frames within the text, the identification of individuals by adjacent inscriptions, the aerial perspective, the balanced grouping, and the organization of space. There are also affinities with the late-fourth-century art of the so-called Itala Manuscript of the Book of Kings;[124] the rather square proportions of the figures and the handling of the draperies are reminiscent of fourth-century carvings such as those of the Brescia Casket and of the wooden doors of Sant'Ambrogio in Milan; and the wig-like hair coming down low over the forehead, and the piercing glance of the eyes, are to be found in fifth-century Italian carvings and paintings. Thus, in a minor way, the Gregory Master is a Western counterpart to the illuminators of Byzantium who, after the period of iconoclasm, sought inspiration in late classical and Early Christian sources. The Byzantines in fact exerted some influence on the Gregory Master, for the Majesty page of his Sainte-Chapelle Gospels has a Greek inscription and a typically Byzantine gold background, and their impact may be seen, too, in the iconography of his narrative scenes in the Egbert Codex.[125] (That this iconography derives from an Early Christian manuscript of the West is not supported by the evidence of such early Western manuscripts as the St Augustine Gospels.[126])

Whatever differences of opinion there may be about the iconographic sources of the Gregory Master's paintings, there can be none about their quality – their delicate sensibility to tonal grades and harmonies, their fine sense of compositional rhythms, their feeling for the relationship of figures in space, and above all their special touch of reticence and poise. Although the Gregory Master chooses to illustrate the Slaughter of the Innocents by showing one mother beating her breast in anguish and another turning away her head in horror, it is not the dramatic content that we are chiefly conscious of but the overall aesthetic balance of the composition.

The Gregory Master's contribution to the Egbert Codex was small in terms of executed work, but he set the artistic standards for the other painters, who did not, however, share his composed approach: they would rather liberate emotions than neutralize them, as we see in the wild gestures and distracted eyes of Martha in the Lazarus scene,[127] the anguish of the three crucified figures in the second Crucifixion scene,[128] and the ecstasy of the two angels at the Ascension.[129] This emotional involvement combines with the Romanesque sense of abstraction derived from the Gregory Master to give great force and intensity to the paintings, as is apparent even in the 'portraits' of the four evangelists[130] [128], whose reminiscences of the Carolingian pictures of the Tours

129. Liuthar Group: *Christ before the high priest and Peter's denial*, from the Aachen Gospels of Otto III, folio 228 verso. 983/1002. Aachen, Cathedral Treasury

130. Liuthar Group: *Daniel writing his prophecy*, from a Commentary, MS. bibl. 22, folio 32. Late tenth/early eleventh century. Bamberg, Staatsbibliothek

School[131] are transformed into monumentality by their use of elliptical and oval forms, while their abstract quality is somehow heightened by the burning intensity of the eyes. The feeling they convey is something fresh in medieval art – a psychological tension compounded of abstract balance and emotional pressures – and this is developed further in the pictures of the so-called Liuthar group,[132] which represent the final stage of Ottonian painting at Trier.

The Liuthar School was active during the later years of Egbert's pontificate and into the early years of the eleventh century. The artists who composed it expressed a common style and iconography, in sharp contrast to the previous diversity at Trier. Their finest manuscripts include two Gospel Books of Otto III, one now in the treasury of Aachen Cathedral [129] and the other at Munich[133] [131], a Gospel Lectionary made for Henry II to present to Bamberg Cathedral,[134] and three other manuscripts all now at Bamberg – two theological Commentaries[135] [130, 132] and an Apocalypse.[136] Liuthar, the scribe or donor of the Aachen Gospels of Otto III who gave his name to the school, appears in the Gospel Book in a monastic habit,[137] so presumably the group was centred upon a monastery. Traditionally, as with other manuscripts I have described, this centre is said to be

Reichenau, but I feel uncomfortable with this ascription. For one thing, the artists of the Liuthar group show an intimate knowledge of the colour harmonies and style of the Egbert Codex,[138] which was never at Reichenau, but remained at Trier in the abbey of St Paulinus after Egbert's death. Again, the liturgical evidence of one of the manuscripts of the group points to Trier,[139] while other manuscripts went to owners with known Trier connections. One of them was Otto III, who gave an important privilege to St Maximin and is represented with his mother on a Trier book-binding;[140] another was Henry II,[141] who was associated with two archbishops of Trier – Megingaud (consecrated in 1008) and his successor Poppo (1016–47). These, combined with certain iconographic considerations,[142] suggest that Trier was the focal point of the Liuthar School, with a possibility – given its reforming activities – that one or two of the relevant manuscripts were made at one of its dependencies.

The Aachen Gospels of Otto III, one of the earliest manuscripts of the Liuthar group, is prefaced with the representation of Otto III in the full panoply of power which was mentioned at the beginning of this chapter. It also includes twenty-one full-page illustrations of the New Testament [129] in which the technique of working direct

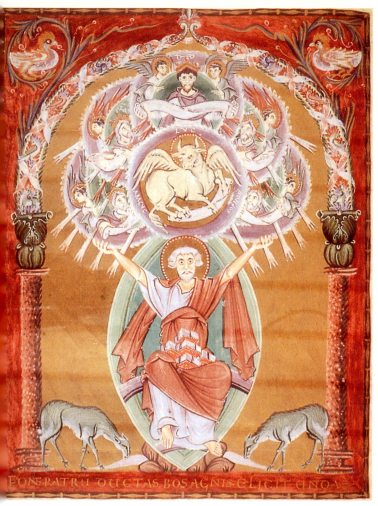

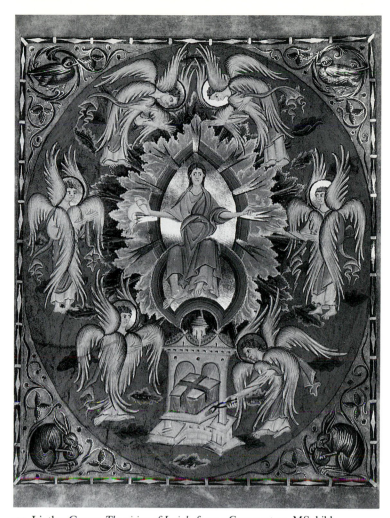

131. Liuthar Group: *St Luke*, from the Munich Gospels of Otto III, Clm. 4453, folio 139 verso. 983/1002. Munich, Bayerische Staatsbibliothek

132. Liuthar Group: *The vision of Isaiah*, from a Commentary, MS. bibl. 76, folio 10 verso. Late tenth/early eleventh century. Bamberg, Staatsbibliothek

with the brush, the tremulous quality of the brush-strokes, the floating colours, the late Antique views of cities, the handling of trees and clouds, and certain features of the decoration, all point to the influence of sixth-century illumination of the Eastern Church. There are, too, hints of contemporary Byzantium in the frequent gold-leaf backgrounds, the heavy modelling of the faces, and in elements of the iconography – all, however, absorbed and re-expressed in entirely Ottonian terms; indeed in other manuscripts – especially the two Commentaries at Bamberg[143] [130, 132] – the Liuthar artists show themselves capable of quite spectacular originality.

The drawing of heads and faces, the styles of drapery, and the range and harmony of colours of the early Liuthar manuscripts all betray influences from the Gregory Master, but the mood is totally different: reticence is exchanged for vehemence, calm for turbulence, objectivity for involvement. This is particularly apparent when whole scenes are taken over from the Egbert Codex, as in the Munich Gospel Book of Otto III and the Gospel Lectionary of Henry II[144] (folios 231 verso and 8 verso respectively): the delicately graduated backgrounds which had softened the immediacy of human feelings are replaced by 'backcloths' which thrust the figures forward and accentuate every impetuous action and gesture in a vibrant manner which is further exaggerated by the lengthening of arms and fingers, and the attenuation of the body; the glowing eyes express the intensity of the emotional

forces within, and the whole figure becomes a tongue to speak with apocalyptic conviction. Indeed, the St Luke of the Munich Gospels, aglow with celestial light and at a peak of transcendental ecstasy, is the very embodiment of divine inspiration [131]. Moreover there are intriguing theological depths: the glory held aloft by St Luke bears, besides his own symbol, busts of five Old Testament prophets, whose number corresponds with the five books piled up in his lap, alluding to the continuity and consummation of divine revelation, while the waters below, from which the lambs take their refreshment, represent the rivers of Paradise. All this, taken in conjunction with the brief inscription beneath, has given rise to the argument[145] that the picture's message is that both the Old and the New Testaments were inspired from a single source, God himself, who will communicate only with true believers.

Another powerful image is projected by Isaiah's vision in one of the Bamberg manuscripts[146] [132]. Here the Lord, who is enthroned in a gold mandorla, is surrounded with blue and purple flames glowing white at the edges and the seraphim outside are caught up in an exhilarating harmony of swaying bodies and rhythmic wings. Agitated glances and dramatic gestures heighten the intensity of the scene, which seems to be galvanized by some unearthly power. Yet despite this emotional energy, all the paintings – like fugues – have their own formal and balanced structure: the Lord of the Isaiah picture is the centre of three ovals – the oval of his mandorla,

the oval circuit traced by the seraphim, and the oval field of the background – and such geometric simplicity lies at the heart of almost all the illuminations of this group.

The best of the Liuthar work was produced between about 990 and 1025, when the Trier tradition passed to a daughter house in the same diocese – the monastery of Echternach.

THE SCHOOL OF ECHTERNACH

The Benedictine abbey of Echternach, founded at the end of the seventh century by the Anglo-Saxon missionary St Willibrord, became for more than a century after the disintegration of the Carolingian empire a community of canons. It reverted to the Benedictine rule in 973, turning for its abbot and forty monks to St Maximin's at Trier. After a troubled period in the early eleventh century, it again resorted to St Maximin's for an abbot to restore its discipline and prestige. He was Humbert, who presided at Echternach from 1028 to 1051 and, true to the Trier traditions, combined a zeal for reform with an enthusiasm for art, for besides presenting his new monastery with gifts of metalwork, he decorated the church 'most beautifully with ... pictures',[147] of which fragments survive in the crypt. Moreover his encouragement of illumination was such that Echternach was able to take over from Trier the provision of manuscripts for emperors; of this a visual record exists in a Book of Pericopes which was written for Henry III between 1039 and 1040, where first a monk and a layman are shown at work on the manuscript in the Echternach scriptorium [28], and then we see the completed volume being ceremoniously presented to the emperor.

Echternach produced a series of splendid Gospel Books, of which two were commissioned by emperors. The earliest, sumptuously illustrated and written in gold, is the Nuremberg Golden Gospels,[148] formerly in the ducal museum of Gotha and now in the Germanisches National-Museum [9, 133]. Its gold and jewelled binding once belonged to a Trier manuscript[149] – perhaps the Sainte-Chapelle Gospels of the Gregory Master, which certainly provided the models for some of the illumination of the Nuremberg Gospels, as is evident from its evangelist 'portraits', its Canon Tables, its initials, and, most particularly, from its Christ in Majesty [133]. This shares with the Sainte-Chapelle Gospels the same distribution of colours, the Greek inscription around Christ, and the 'stained-glass' arrangement of roundels and medallions. The artists who worked on the Nuremberg Gospels varied in ability but they had in common a taste for the decorative most obvious in their reproduction of eastern silks on three double folios of the manuscript [9], but apparent too in the ornamental, almost heraldic, effect of some of the pictures, which seems more proper to silks and textiles than to paintings. This bent produced some vigorous and cheerful patterns, as in the St Luke, but it could descend to fussiness, as in the Christ in Majesty [133], where the strength of the composition has been frittered away by the ornamental vagaries of the Echternach artist. This weakness is even more apparent in the evangelist 'portraits', where the ornamental bands of the Sainte-Chapelle Gospels are degraded into decorative garrulity, and there is so little weight or structure under the draperies that they might be covering mere inanimate cushions.

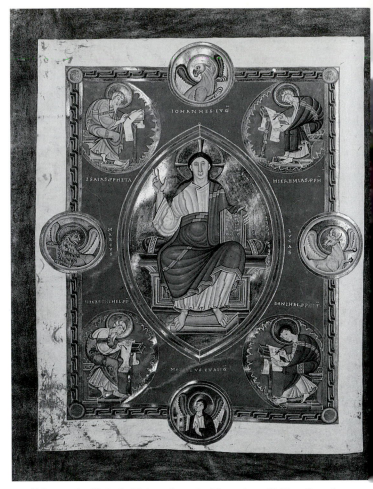

133. Echternach: *Christ in Majesty*, from the Nuremberg Golden Gospels (*Codex Aureus*), folio 5. *c.* 1025–40. Nuremberg, Germanisches National-Museum

134 (*opposite*). Echternach: *Christ in Majesty adored by the Emperor Conrad II and the Empress Gisela*, from the Speier Golden Gospels, MS. Vitr. 17, folio 2 verso. 1045–6. Escorial Library

Among the Nuremberg Golden Gospels' many illustrations are some comparatively rare renderings of Christ's parables. Their iconography derives partly from Byzantium[150] and partly from the Egbert Codex,[151] though here the pictures are separated from the text and given full pages consisting of three vertical panels with explanations on narrow gold strips.

The most important production of the Echternach School was a Golden Gospel Book made between 1045 and 1046 for Henry III to present to the cathedral of Speier and now in the Escorial Library.[152] Its six artists took from the Nuremberg Gospels the simulated eastern silks on decorative purple pages, the evangelist 'portraits', and some narrative scenes, but firmly rejected its decorative excesses; their figures, sharply outlined against plain coloured backgrounds, have a very positive strength and composure. The statuesque figures project liturgical solemnity as they move slowly across the picture in carefully balanced groups. Their power and impact are particularly evident in the Christ in Majesty [134], which is in sharp contrast to its model in the Nuremberg Gospels. At the feet of the Speier Christ are Henry's father, Conrad

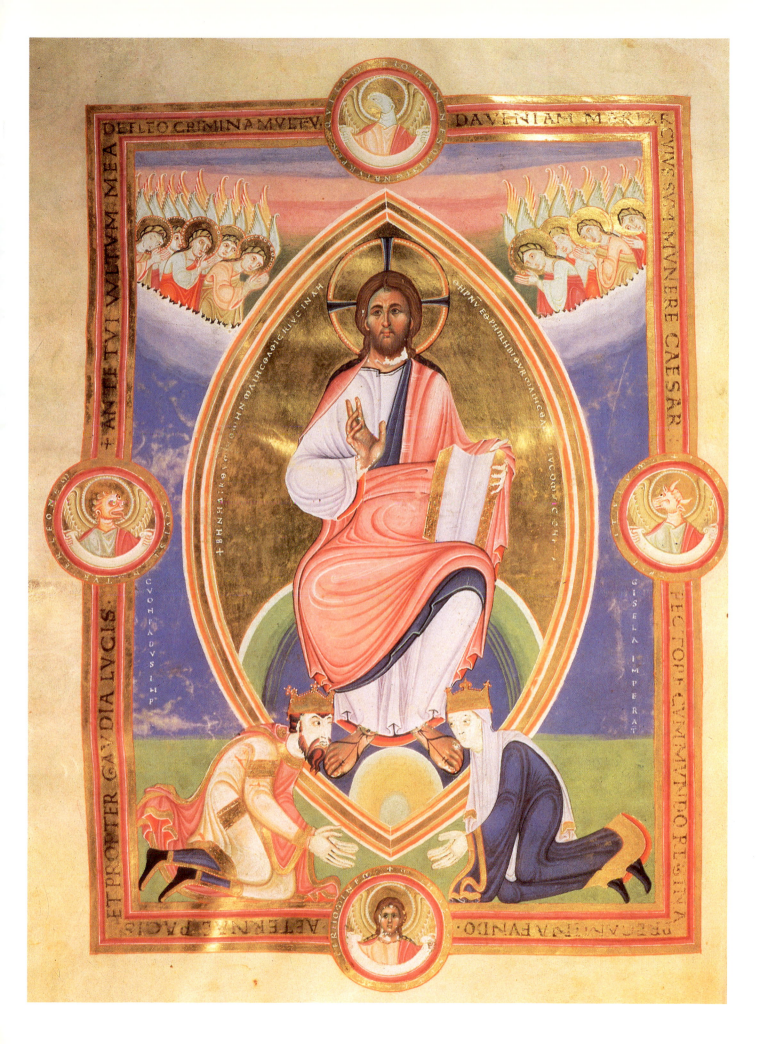

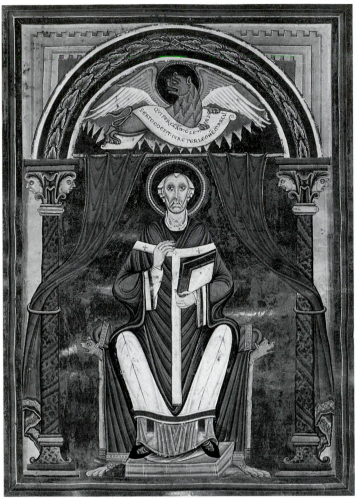

135. Echternach: *St Mark*, from the Speier Golden Gospels, MS. Vitr. 17, folio 61 verso. 1045–6. Escorial Library

II (who founded Speier), with his empress, Gisela. The cathedral itself figures in a second dedication picture, in which Henry, in the presence of his consort Agnes, offers the manuscript to its patron saint, the Virgin Mary. To the strength of these paintings, Byzantine art has added smoothness and finesse, for a Byzantine painter helped to complete them.[153] Besides Byzantine sources, which provided some of the iconography,[154] the German artists drew on the decorative repertory of the Carolingian School of Tours,[155] but for their style they returned to the fountain-head of the Echternach tradition: the paintings of the Gregory Master and the Liuthar School. It is a style both bold and powerful, so that the hard contours of the figure of St Mark [135] seem hardly able to contain the thrusting diagonals within. In their monumentality and impact, in their clarity and strength, and in their expression of the human form by means of abstract components, the Speier figures are truly Romanesque.

The enthroned Christ of the Uppsala Gospels,[156] made for Henry III to present to Goslar Cathedral at its dedication in 1050, is another powerfully forthright image, towering over Henry and Agnes as he places crowns upon their heads [136]; but elsewhere – as in the Luxeuil Gospels[157] – there is a return to the more decorative leanings of the Nuremberg

Golden Gospels. The polarities of artistic taste at Echternach as expressed in its two Golden Gospel Books can be found in other illustrated manuscripts, but none can vie with the Speier Gospels, the greatest achievement of the school.

THE SCHOOL OF COLOGNE

Cologne in Lower Lotharingia, like Echternach, was reformed from Trier, and it was to Trier that Archbishop Bruno (953–65) turned for an abbot to rule the monastery he had built in honour of St Pantaleon, as did Archbishop Gero (969–76) for his foundation of Gladbach. At Cologne, however, illumination made a late start at the turn of the tenth and eleventh centuries, and found full expression only in the course of the first half of the eleventh.[158] Cologne was more closely linked with the emperors than any other diocese, for not only was Archbishop Bruno the brother of Otto I, but during the time of Pilgrim (1021–36) the archbishopric was united with the chancellorship of the empire and, after 1028, it was in charge of imperial coronations. Though the emperors did not turn to Cologne for illustrated manuscripts as they did to Echternach, Cologne produced some attractive and costly work, some of it sumptuous with gold and purple and rich colours. Fifteen Gospel Books survive, besides three illuminated Sacramentaries and one Lectionary.

The Gospel Books include paintings of Christ in Majesty and of St Jerome (the translator of the Gospels) and full-page evangelist 'portraits' as well as one or two representations of the Crucifixion; the Hitda Codex,[159] exceptionally, has a cycle of fifteen New Testament scenes. The illumination of the Sacramentaries is chiefly decorative, but in one (now in Warsaw)[160] there is a Majesty, in another (at Freiburg)[161] a St Gregory, while the third, from St Gereon,[162] has both, as well as eight scenes of a Christological cycle. It may be added that there is no real evidence for the claim that St Pantaleon was the chief centre of production, exporting manuscripts to other areas of the diocese.

It seems that a Trier Gospel Book,[163] illuminated by the Gregory Master probably between 996 and 1002 and now sadly mutilated, was actually at Cologne during the eleventh century. As it was very closely copied in a Cologne Gospel Book (known from its present home as the Stuttgart Gospels[164]), scholars have been able to reconstruct it (and to show that it owed much to the Vienna Coronation Gospels of the Carolingian period, and something also to a manuscript of the Court School of Charles the Bald which had made its way to Trier).[165] They have also been able to demonstrate that the Trier manuscript was the source for the compositions of virtually all the evangelist 'portraits' of the Cologne Gospel Books,[166] and that even the style of the Trier evangelists was closely followed in the Stuttgart Gospels [137], which probably dates from the years between 1050 and 1067. The initials of the Cologne Gospel Books, too, relied to some extent on the Trier manuscript,[167] and it has also been argued that the initials in the Sacramentaries of Cologne show a knowledge of those in a Sacramentary illuminated by the Gregory Master that was then available at Cologne.[168]

It is not surprising that Cologne was also influenced by the Liuthar School of Trier, for one of the Liuthar Gospel Books was specifically made for Cologne Cathedral (in whose

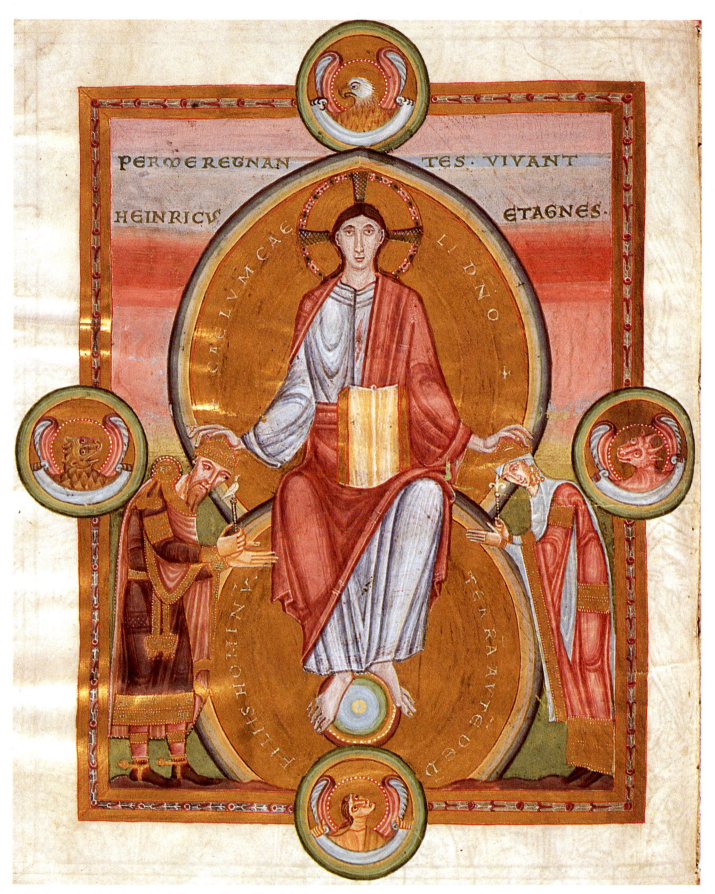

136. Echternach: *Christ Crowning the Emperor Henry III and the Empress Agnes*, from the Uppsala Gospels, MS. C.93, folio 3 verso. Completed in 1050. Uppsala, University Library

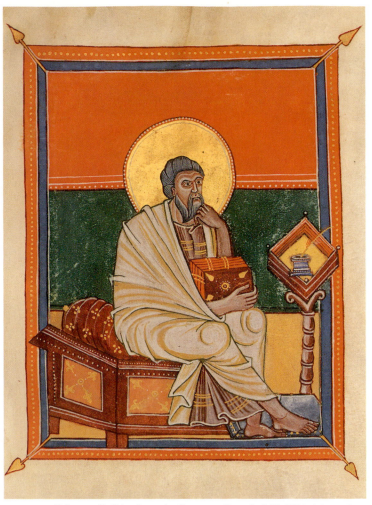

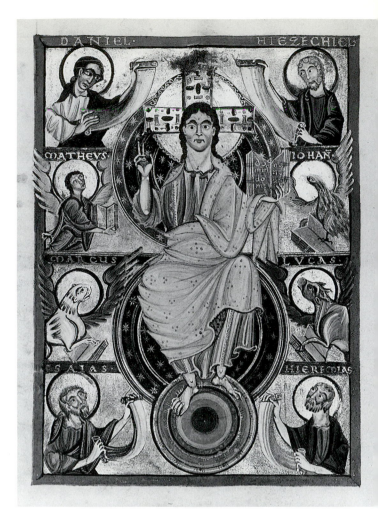

137. Cologne: *St John*, from the Stuttgart Gospels, MS. Bibl. fol. 21, folio 156. 1050/67. Stuttgart, Württembergische Landesbibliothek

138. Cologne: *Christ in Majesty with evangelist symbols and prophets*, from a Gospels, MS. Bibl. 94, folio 9 verso. 1045/75. Bamberg, Staatsbibliothek

library it remains[169]), as a long preface informs us, adding that the manuscript was written at the request of Canon Hillinus by the scribes Purchard and Conrad, 'brothers not only in the spirit but in the flesh'. As they were, according to the preface, 'invited and set to work', it would seem that the Trier manuscript was actually produced at Cologne, a view supported by the schematic portrayal in a dedication picture of the Cologne Cathedral of the day. I have already mentioned this borrowing of two individuals from one centre to help produce a manuscript in another in my discussion of the Egbert Codex. The Trier Gospel Book has lost three evangelist 'portraits', but the St Matthew remains, with a St Jerome and rich Canon Tables.

Influences from the Liuthar School are best seen in the illumination of a Gospel Book now at Bamberg[170] and probably made between 1045 and 1075, particularly in the Christ in Majesty [138], on a page divided vertically by three purple bands containing gold lettering and including evangelist symbols and half-length figures of the four major prophets. It is dominated by a powerful Christ who clearly echoes the Liuthar style in the transcendental solemnity of his face and his intense unblinking eyes. Other Majesties in the Gospel Books and Sacramentaries of Cologne reflect the Tours School of the Carolingian era, and Carolingian influences are evident too in the evangelist 'portraits' of the Gospel Books – particularly from the Court School of Charles the Bald in the earliest ones,[171] from a manuscript akin to the

San Paolo Bible in the architectural settings of a later one,[172] and from the Reims School in the evangelist symbols of three Gospel Books[173] attributed to the period 1030–60. The architectural framework of the sixteen pages of Canon Tables of the Namur Gospels[174] of *c.* 1020–30 also clearly reflects the School of Reims.

Byzantine influences at Cologne are explained by the special interest of Otto II's Greek bride, Theophano. It was an archbishop of Cologne, Gero, who escorted her to the West, and another archbishop, her husband's uncle Bruno, had begun the building of St Pantaleon, which she completed, often visiting the foundation and indeed choosing to be buried there. She also presented an important hanging to the monastery of St Mary. The Byzantine impact on Cologne is evident in the Christological scenes of a Sacramentary from St Gereon (996–1002)[175] which was illuminated by two artists, the second more restrained in his colour and more decorative in his approach than the first. They also worked together on the illumination of a Gospel Book now in Milan.[176] The iconography of some of the scenes in the Sacramentary – the Annunciation and the Nativity, for example – includes Byzantine elements[177] combined with Western features, so

139. Cologne: *The storm at sea*, from the Hitda Codex, MS. 1640, folio 117. *c.* 1000–20. Darmstadt, Hessische Landesbibliothek

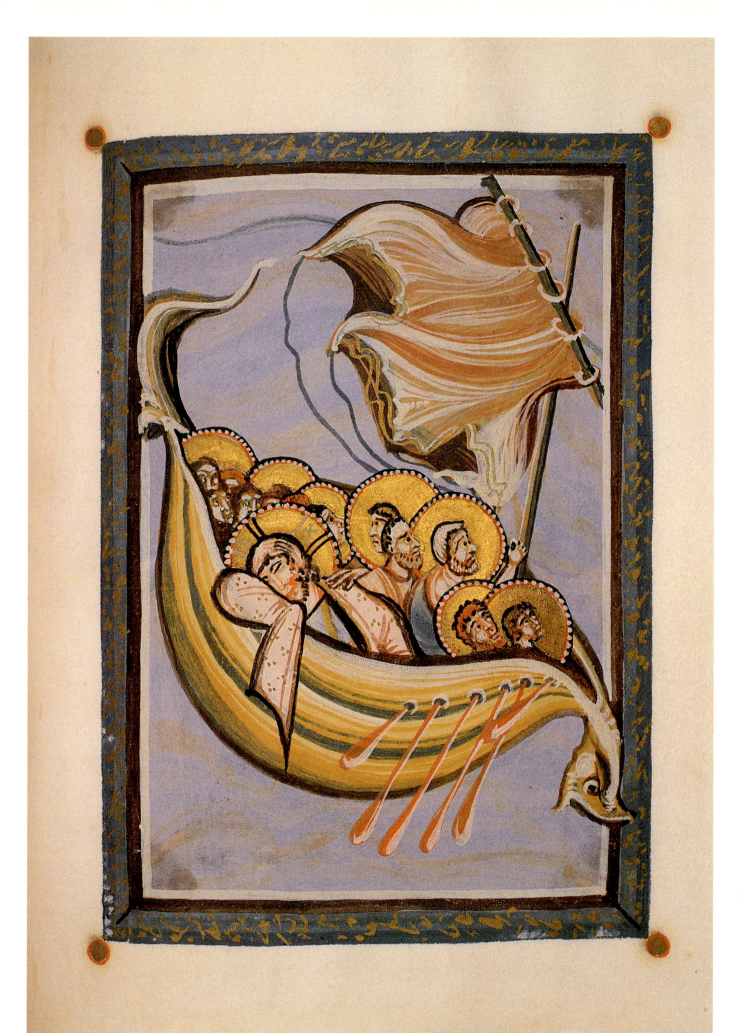

140. Cologne: *The Crucifixion*, from the Gundold Gospels, MS. Bibl. 4°2, folio 9. *c.* 1020–40. Stuttgart, Württembergische Landesbibliothek

141. Cologne: *The Crucifixion*, from the Giessen Gospels, MS. 660, folio 188. *c.* 1000–30. Giessen, University Library

they may have been channelled through a Western intermediary. The style, on the other hand, is directly related to Middle Byzantine illumination.[178]

The Hitda Codex[179] – a Gospel Book made between *c.* 1000 and *c.* 1020 for Hitda, abbess of the Westphalian nunnery of Meschede, who is shown on folio 3 offering the manuscript to St Walburga, the patron saint of her nunnery, on behalf of herself and her sisters – has features such as the undulating ground, the milky-white outlining of the hills, and the highlighting of the garments,[180] which can be paralleled in Middle Byzantine manuscripts such as the Paris Psalter[181] and the Bible of Leo the Patrician.[182] The Hitda figure style is also somewhat Byzantinizing, though the composure has been psychologically disturbed by the Trier intensity of eye and gesture. It is also physically ruffled by a tremulousness of brush-stroke deriving from the Carolingian Reims School but here normally restricted to the figures. Although some of the Hitda compositions have been moulded by Western, especially Carolingian, traditions, there are indications of real originality in the Marriage at Cana, which differs from all other known versions, for it corresponds to the inscription on the facing page rather than to the scriptural account,[183] and in the healing of the lame man at the Bethesda pool.[184]

Cologne differs from the rest of Germany in the painterliness of its art, and Bloch and Schnitzler could even distinguish a large 'painterly group' and a 'special painterly

group'. Cologne artists frequently omitted preliminary sketches, preferring to work direct with an often overloaded brush, which could cause the colours to run. It is this feeling for the fluid qualities of paint, combined with a dramatic use of colour, that gives Cologne illumination much of its individuality.

Despite its twentieth-century connotations, the term 'expressionist' which has been applied to one Cologne painting[185] may reasonably be extended to a handful of others whose very individual emotional and agitated quality extends even to inanimate objects, so that a boat in a picture of the Storm at Sea lunges forward with ominous and threatening prow like some fearful creature of the deep [139]. Such pictures explain the interest of some Cologne painters in the emotional aspects of the key event of Christian history, the Crucifixion: in the Hitda Codex, the Gundold Gospels [140], and the Giessen Gospels of *c.* 1000–30 [141] they dwell on the pain and sorrow of Christ's Sacrifice, focusing attention on the limpness of his body and the poignancy of his face. Similar emotions had been expressed in England in the late tenth century in the Winchester Crucifixion[186] [85], and also in the Arenberg Crucifixion,[187] which actually found its way to Cologne. Whether or not the Arenberg manuscript had any bearing on the new concern there for the vulnerability of Christ on the Cross, it was Cologne in the eleventh century that gave to the sufferings of Christ their most dramatic

expression. Indeed, it was the new sensibilities first expressed by Western artists in the tenth and eleventh centuries that changed the earlier artistic conception of the Crucifixion as an occasion of triumph into the now traditional view of it as a time of anguish.

The vibrant and 'expressionist' phase of Cologne painting was followed by a very different monumental and Romanesque one best represented by the double-page picture of the mission of the apostles in the Abdinghof Gospels[188] of c. 1080.[189] Here, the apostles on one page crowd towards Christ on the other, and the heavy stylization of their figures and draperies (also found in a contemporary Gospel Book in the British Library[190]) is relieved only by the fervour in their eyes and the dramatic gesticulation of their hands. How much further this development would have gone we cannot say, for the school of painting at Cologne was virtually extinguished by the uprising of the citizens of Cologne against its archbishop in 1074 and by another event in which the archbishop was closely involved: the Investiture Contest, which rocked the stability of Church and Empire.

THE SCHOOL OF REGENSBURG

Where the reforming vitality of Trier went, so its artistic influence went too. Yet it developed differently in different centres: the styles of Cologne and Regensburg, for instance, contrast sharply, and whereas at Cologne much of the illumination had a tremulous painterly quality and evinced strong emotions, at Regensburg it was an incisive line and a highly formal organization of the page that found favour.

In his efforts to reform the abbey of St Emmeram, St Wolfgang, bishop of Regensburg from 972 to 994, turned not to his own old priory of Einsiedeln, but to St Maximin's at Trier, a city in which he had taught at an earlier stage in his life. From there he brought Ramwold to be abbot of St Emmeram from 974 to 1001. Ramwold's keen interest in books is reflected in the remarkable catalogue of manuscripts drawn up during his term of office.[191] He returned to Trier during a period of civil insecurity, but later came back to Regensburg with relics[192] and possibly also manuscripts. The Ottonian school of illumination that he initiated at St Emmeram might have continued on its course of producing manuscripts of no particular splendour had it not been for the untimely death in 1002 of Otto III; this meant that the German crown passed to Otto's cousin Henry II, duke of Bavaria, whose seat was at Regensburg, and who plied St Emmeram with lavish royal commissions (we have already observed one effect of Henry's patronage in the magnificent ceremonial robes that he commissioned for Bamberg).[193] Following his death in 1024, St Emmeram's artistic importance declined, to be briefly revived at the end of the eleventh century or the beginning of the twelfth when a manuscript was once again produced for a royal personage.

Trier influence can be seen in the earliest of the school's illustrated manuscripts, a Rule-Book[194] made c. 990 at the request of Duke Henry the Quarrelsome for the nunnery of Niedermünster recently founded in Regensburg by Henry's mother Judith. It has fullpage 'portraits' of Henry and of the abbess Uta, as well as of St Benedict and St Caesarius, the authors of works included in the manuscript. The patterned backgrounds recall the Egbert Codex and the Egbert Psalter, and the rhomb that frames the figure of Uta is an early indication of the school's growing fascination with the organization of picture space by the use of geometrical forms. The figure of Duke Henry is nimbed, which is unusual in a 'portrait' of a secular lord, and indeed somewhat at odds, one would have thought, with his sobriquet.

We move now to another element in the formation of the artistic idiom of Regensburg. In the late ninth century, the Codex Aureus of Charles the Bald[195] had been presented to St Emmeram along with other treasures by the emperor Arnulf, and it now began to act as a stimulus on the artists of the house where it lay, prompting them to imitate its compositions and to emulate its decorative effusiveness in terms of more recent tastes. Under Ramwold the Codex was renovated, so an inscription tells us, by two monks named Aripo and Adalpertus,[196] who did a certain amount of repainting and added, in the style of the Egbert Psalter, a prefatory 'portrait' of Ramwold himself, described in the accompanying inscription as 'the unworthy abbot'.[197] The decoration of the costly Sacramentary[198] made for Henry II some time between 1002 and 1014 for presentation to the cathedral of Bamberg includes five ornamental pages (two of them showing the Hand of God and the Agnus Dei) directly copied from the Codex Aureus, and a paraphrase of its picture of Charles the Bald in the 'portrait' of Henry on folio 11 verso. Besides these Carolingian reminiscences, the picture of Henry being crowned by Christ [114] derives from a Byzantine composition and is executed in a Byzantinizing style, and the Crucifixion on folio 15 is actually accompanied by a Greek inscription. The facial modelling and the breadth of treatment in the St Gregory are also the result of Byzantine contacts, though their impact is somewhat diminished by the floridness of the decorative background – an element of other Regensburg productions as well.

Over-obtrusive decoration does not, however, mar Regensburg's finest work – the Evangelistary that was made c. 1020 for the Abbess Uta of Niedermünster.[199] Here, geometrical organization reaches its highest point. Bands of gold outline the bold squares, circles, ellipses, and rhombs that enclose the figures, whose crisp, metallic definition gives an impression of enamelwork. There is no cycle of pictures narrating the life of Christ after the example of the Egbert Codex, as might be expected in a collection of Gospel extracts: instead, any scenes are relegated to the corner compartments of the pages bearing the evangelist 'portraits'. The first picture of the Uta Evangelistary is another copy of the Codex Aureus's Hand of God, followed by a Virgin and Child with the donor, Uta. The Crucifixion and St Erhard, the patron of Niedermünster, celebrating Mass, represented on facing pages, are accompanied by a plethora of inscriptions that form an integral part of the compositions and imbue them with complex meanings. Among the inscriptions are references to the mystical theology expressed in writings attributed to Dionysius the Areopagite, whose relics Regensburg claimed to hold. The Crucifixion [142] is particularly replete with significance. Christ, his eyes open, is victorious over death and wears the stole of eternal life.[200] The figures and scenes to the left of the Cross, to which Christ directs his gaze, refer to the life he ushers in by the

new age of grace; those on the right signify the ending of the age of the old law and of the reign of death. Texts on the Cross itself explain its symbolization of Christian qualities: the long stem represents Hope, the broad cross-beam Charity. The complex inscriptions and diagrams under the arm of the Cross, referring, *inter alia*, to the medieval theory of harmony, appear to point to a metaphysical relationship between the laws of harmony and Christ's sacrificial redemption of man.

These pictures, with their multiple levels of meaning, demonstrate the intermingling at Regensburg of the developments in scholarship as well as in art that had been brought about by the Ottonian reform movement.[201] Indeed, the carefully constructed symbolism seems to refute St Augustine's opinion that, compared to the depth of meaning conveyed by the written word, paintings were superficial. 'If we see a beautiful script,' he said, 'it is not enough to praise the skill of the scribe for having made the letters even and alike and graceful; we must also read what he has signified to us through those letters ... With a picture it is otherwise than with letters. For when you look at a picture, seeing it and praising it is all there is to do.'[202] But the compositions of the Uta Evangelistary require more than our admiration:

they demand our intellectual powers. This Regensburg tradition spread later to other parts of the West, reaching a point in the twelfth century when paintings such as those of the Floreffe Bible could express such intricacies of thought that today the illustrations are far more difficult to 'read' than the text itself.

The style of the Uta Evangelistary was developed in a Gospel Book[203] [143] made for Henry II, some time before his death in 1024, to present to the abbey of Montecassino. It will be discussed in the next chapter. After this, nothing approached the sumptuousness of the manuscripts of the first quarter of the eleventh century, and it has been suggested that Regensburg artists may have migrated to Salzburg,[204] since Regensburg characteristics are to be found there. From Regensburg itself we have two modest prefatory pictures in a copy of the Rule of St Benedict dating from the second quarter of the century,[205] and a donor portrait in a Pontifical[206] that belonged to Otto, bishop of Regensburg from 1060 to 1089. There is a more extensive programme of decoration in a Benedictional[207] made for Bishop Engilmar of Parenzo (1028–*c.* 1045), including scenes from Christ's life, but this manuscript may not be of Regensburg origin.

It was not until the turn of the century that Regensburg managed to recapture some of its former brilliance, in a Gospel Book[208] made either for Henry IV between 1099 and 1106, or for Henry V between 1106 and 1111. On the first

142. Regensburg: *The Crucifixion*, from the Uta Evangelistary, Clm. 13601, folio 3 verso. *c.* 1020. Munich, Bayerische Staatsbibliothek

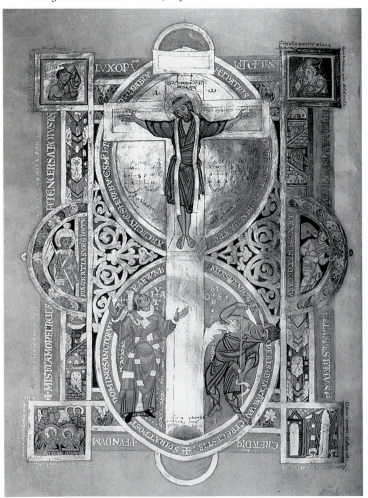

143. Regensburg: *Henry II enthroned, with Prince Pandulf IV of Capua suing for mercy*, from a Gospels, MS. Ottob. lat. 74, folio 193 verso. Before 1024. Rome, Vatican Library

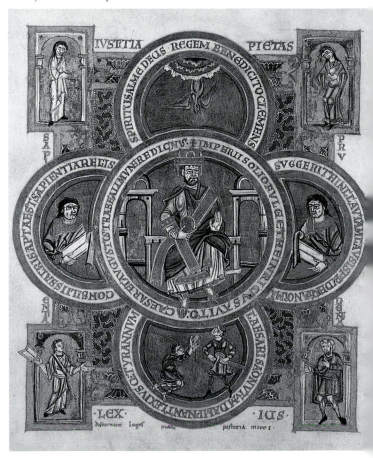

page is an enthroned ruler who could be either of the two Henrys, and on folio 2 verso, Henry IV is flanked by his two sons Henry and Conrad, with below three abbots of St Emmeram; their presence indicates the provenance of the manuscript, which is confirmed by the full-page picture of St Emmeram with a monk and a nun at his feet on folio 3, and by further miniatures including bishops of Regensburg who were also abbots of St Emmeram (the two offices were combined until the tenth century). Unusually, the evangelists have at their feet the personifications of the rivers of Paradise as in the Uta Evangelistary, and the backgrounds of five of the pictures consist of the broad bands of colour used in the manuscript of St Benedict's Rule. The style is much plainer and less ambitious than it was under Henry II: the use of gold is more restrained, the page is no longer ordered by means of complex geometrical forms, and the intricate intellectual inscriptions have all disappeared. Prolonged contemplation was demanded again by Regensburg pictures in the course of the twelfth century, but the earlier resplendence had gone for good, for that century saw paintings in full colour succeeded by a taste for drawings in pen and ink.

THE SCHOOL OF SALZBURG

As Regensburg was reformed from Trier, so Salzburg was reformed from Regensburg when in 987 Archbishop Frederick reintroduced monastic life at St Peter's by appointing the St Emmeram monk Tito as its abbot.[209] During the preceding century the incursions of the Hungarians had effectively extinguished all cultural life in the region, and one archbishop had been killed in battle and another banished by the duke of Bavaria. Following this period of chaotic instability, Frederick encouraged a new flowering of the religious life. He seems to have been a lover of books, for a collection of manuscripts was bequeathed to him by one Perhtarus.[210] Nevertheless, the production of illustrated manuscripts was slow to pick up, and only in the course of the first half of the eleventh century did the illumination of Salzburg develop a truly personal character.

Salzburg's earliest productions are two Gospel Books, both now at Munich,[211] of which one, to be dated c. 1000, belonged to the nunnery of St Erentrud on the Nonnberg within Salzburg, while the other, of the early part of the eleventh century, came from the abbey of Michaelbeuern just outside the town. Both include Canon Tables and evangelist 'portraits'. The Michaelbeuern Gospels is slightly the more sumptuous, for its evangelists have gold backgrounds and face decorative pages combining the initial and the opening words of their Gospels. The Nonnberg Gospels, based on a Carolingian model, completely lacks artistic inventiveness: the postures of its four evangelists are virtually identical, they are all confronted by their symbols issuing from clouds, they all hold an unrolled scroll, and all four pages are in purple framed by a meander pattern in green and red. The Michaelbeuern artist was clearly aware of the Nonnberg Gospels (or its model), and he uses the same basic composition, but his style is more definitely Ottonian, and he varies the postures of his evangelists.

A much fuller programme of decoration characterizes the

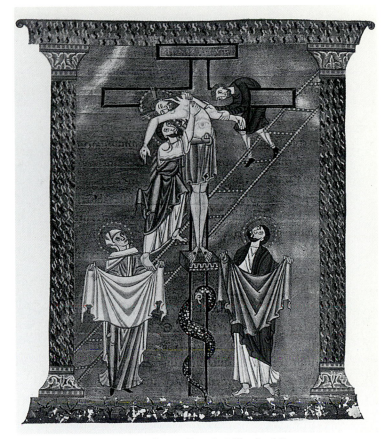

144. Salzburg: *The Deposition*, from a Gospels, MS. 781, folio 222 verso. Second quarter of the eleventh century. New York, Pierpont Morgan Library

school's next surviving product. Its links with the two earlier works are plain, but it nevertheless introduces features that were to become typical of eleventh-century Salzburg. Again a Gospel Book – made for St Peter's probably before 1040 – it is now in the Pierpont Morgan Library in New York.[212] In addition to Canon Tables, evangelist 'portraits', and decorative pages, it has dispersed throughout the text a total of nineteen scenes from the life of Christ [144]. Gold and silver backgrounds lend an air of sumptuousness. All the pictures are framed by a pair of towers, or columns, usually with plants growing in the lower border – a type of frame that was to recur later. The manuscript's taste for rare scenes and unusual iconographies was also to characterize the art of Salzburg. The scene of Christ receiving fish and honey from the disciples after the Resurrection[213] is unprecedented in surviving works, and an unusual formula is chosen for the Washing of the Feet:[214] Christ and Peter do not appear in the foreground, with the other disciples gathered together behind the saint, but occupy a separate panel in the middle with the remaining disciples grouped around. Other details can be matched only in works of the Trier–Echternach circle, particularly of the Liuthar group – and it is indeed to this circle that we must look for the stylistic sources of this important manuscript.

Two quite distinct idioms, derived from Trier and from Byzantium, are to be found in a Pericope Book[215] illuminated c. 1040 by a total of three artists. Three features provide strong arguments for production at Salzburg, specifically for

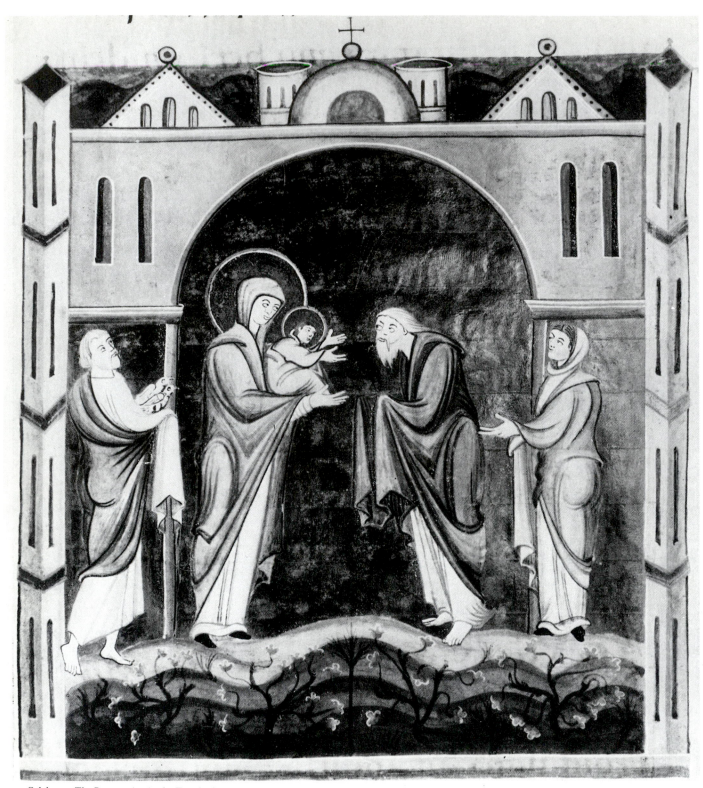

145. Salzburg: *The Presentation in the Temple*, from a Pericope Book, Clm. 15713, folio 24 verso. *c.* 1040. Munich, Bayerische Staatsbibliothek

St Peter's, and not (as previously thought) at Regensburg. They are the copy of a document drafted by Archbishop Conrad of Salzburg in 1131 which is entered on a fly-leaf at the beginning; the inclusion of the normal Pericope for the Feast of St Rupert, the patron saint of Salzburg; and the prominence given to St Peter by his appearance in the

Traditio Legis picture at the beginning of the manuscript. Furthermore, the architectural framework around the pictures is reminiscent of those of the St Peter's Gospels. The Byzantinizing hand apparent in some of the scenes is indeed remarkably close to that of the chief artist of the Regensburg Sacramentary of Henry II, but, as we have

pointed out, Regensburg artists may well have migrated to Salzburg after Henry's death, and this could possibly explain the style here.

The two idioms of the manuscript are even to be found on one and the same page – for the upper register of the picture on folio 1 verso,[216] showing the Presentation of Mary in the Temple, was painted by the Byzantinizing artist, while the lower one, with the angel appearing before the sleeping Joseph, is the work of one of his colleagues. Mary's Presentation had not previously been illustrated in Western art, and the use of an Eastern model is confirmed by the composition, which corresponds with Byzantine versions of the scene. The picture of the twelve-year-old Christ teaching in the Temple[217] follows a scheme quite different from the parallel scene in the Egbert Codex, and in the Pentecost[218] the apostles do not receive their inspiration from the rays of the Holy Spirit issuing from above, but – highly unusually – gather round a multicoloured wheel whose spokes are twelve torches terminating in tongues of flame. Although blank spaces on several pages indicate that the planned decoration was not completed, we nevertheless have twenty-two scenes, including the Presentation in the Temple [145], all on gold backgrounds, which make this manuscript one of the outstanding achievements of south German art in the eleventh century.

This Pericope Book is closely related to another made for St Peter's at some time between 1060 and 1080 which is proclaimed in verses entered on the last folio to be the work of a sacristan (custos) named Berthold;[219] whether he was the patron or the scribe/illuminator is not clear, but we shall assume that his were the pains of actually producing the manuscript from his hope that it will obtain for him remission from his sins. Fourteen of its nineteen miniatures correspond with scenes illustrated in the Munich Pericope Book, and in every case but one the iconography corresponds, though – since his volume is smaller – some of Berthold's pictures are 'excerpts'. He was so dependent on his model that his Flight into Egypt on folio 9[220] is a straight copy of the other manuscript's journey to Bethlehem of Mary and Joseph,[221] without even adding the Christ Child who should now be present. The Salzburg taste for the iconographically uncommon may be observed in the Dormition of the Virgin[222] (not represented in the earlier manuscript), in which Mary's death and her entombment are telescoped into a single scene of the apostles laying her in a sepulchre while Christ, standing behind, tenders her soul to an angel above. Berthold's manner is in the tradition of the Byzantinizing artist of the Munich Pericope Book, intensified by a further wave of Byzantine influence thought to have reached Salzburg via Venice,[223] but in comparison with his predecessor's his figures are stiff and lifeless. Berthold probably also executed the evangelist 'portraits' on rich gold backgrounds of a Gospel Book in the Benedictine abbey of Admont,[224] for they are in architectural frameworks identical to those in his Pericope Book. The pictures demonstrate, too, the continuity of eleventh-century Salzburg art, for the evangelists echo those of the St Peter's Gospels now in New York – the St Matthew indeed is a straightforward copy – and the evangelist symbols, holding scrolls and emerging from clouds, repeat those of the Nonnberg and Michaelbeuern Gospels. Admont was founded

in 1074 by Archbishop Gebehard of Salzburg, who brought with him monks from St Peter's and presented the foundation not only with vestments, chalices, and other liturgical necessities, but also with books.[225] Almost certainly this manuscript was among them.

At Graz[226] is a late-eleventh-century Gospel Book from the abbey of Millstatt,[227] founded between 1086 and 1088, whose evangelist 'portraits' are in a style akin to Berthold's. They are, however, deficient in creativeness, for they closely resemble one another in posture and gesture, and the architectural framework has been dropped in favour of borders of triple coloured bands. Nonetheless, the Byzantinizing manner is in the mainstream of Salzburg's artistic development, which was – as we shall see – to be strengthened and refined in the twelfth century by further Byzantine contacts.

OTHER SCHOOLS

Of other centres of German illumination during the Ottonian period, the most interesting is Fulda, the most eclectic Hildesheim, the most impressive Weser–Corvey, the most uncertain Mainz, the most intelligible Prüm, the most pedestrian the Bavarian Monastery School, and the most controversial Reichenau.

At Fulda[228] – as at Lorsch and Regensburg – early Ottonian illumination was directly inspired by Carolingian sources. They are evident in the calendar picture of the months and seasons in a Sacramentary fragment of about 975,[229] which was copied from a Carolingian model and still retains some of the late Antique flavour of the original archetype, and in the masterpiece of the Fulda School, the Widukind Gospels,[230] with its four masterly evangelist 'portraits' with sumptuous decorative pages en face and its sixteen illuminated Canon Tables. This manuscript – originally bound in precious metals, studded with gems and decorated with ivories – owes its name to the seventeenth-century belief, based more on local sentiment than on historic evidence, that it was given by Charlemagne to Duke Widukind of Saxony after the duke's defeat and subsequent conversion in the eighth century. It was in fact not made until the last quarter of the tenth century, but its illumination must have derived from a lost manuscript of the Ada School of Charlemagne:[231] its Canon Tables have some parallels with those of the same school's Soissons[232] and Harley Gospels,[233] and its Matthew [146] and Mark are very close to those of the Erlangen Gospels,[234] which are based, it is thought, on the same lost Ada School model. On the other hand, the fluttering, restless draperies are paralleled in contemporary Anglo-Saxon manuscripts, and this marriage of English and Carolingian influences has a certain appropriateness, since Fulda was founded by the English missionary St Boniface, who had been closely associated with the fathers of the Carolingian line, Charles Martel and Pippin.

Fulda produced far more Sacramentaries and Lectionaries than it did Gospel Books, and in them – the Göttingen Sacramentary,[235] for example – Carolingian styles tend not only to be accepted[236] but to become coarsened and provincialized. In the first half of the eleventh century, when one of its Sacramentaries[237] reflects elements from Cologne

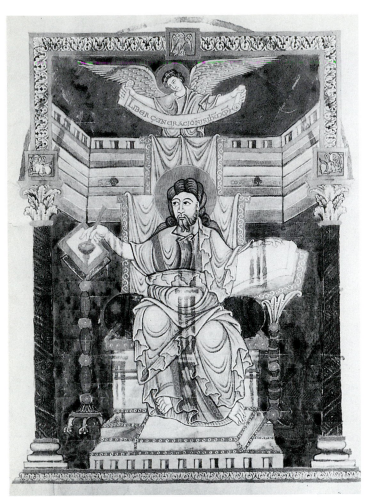

146. Fulda: *St Matthew*, from the Widukind Gospels, MS. theol. lat. fol. 1, folio 14 verso. Last quarter of the tenth century. Berlin, Deutsche Staatsbibliothek

and another[238] elements from Salzburg, Fulda became increasingly eclectic, borrowing and rearranging styles rather than rethinking them.

The illumination of Hildesheim[239] was even more eclectic. Hildesheim was indirectly reformed from Trier through Cologne in 1013, when its bishop was the famous St Bernward (983–1022). A much later biographer claims that he dabbled in a variety of artistic skills,[240] and the illumination of his surviving manuscripts confirms a dilettantish taste, with influences from the Court School of Charles the Bald evident in the Crucifixion in his Sacramentary,[241] from the Ada School of Charlemagne in the Christ in Majesty and the evangelist

'portraits' of the first of his two Gospel Books,[242] and from the Regensburg School in the figure style, symbolism, inscriptions, and general ornamental effect of the second.[243] Among the copious illustrations of the second Gospel Book some intriguing symbolism is to be found, as well as an interesting pen-sketch of St Matthew.

More homogeneous than Hildesheim is the so-called Weser–Corvey School.[244] Its large ornamental initials interpreted Franco-Saxon styles in terms of such sumptuous interwoven colours that the vellum page resembles nothing so much as a rich tapestry. Its impressive illustrations – usually pen-and-ink drawings with a colour wash – show Carolingian styles being merged into an aesthetic that can only be described as Romanesque. Manuscripts of particular importance are to be found in New York,[245] Kassel,[246] and Wolfenbüttel.[247]

Of other centres, Mainz is characterized by competence rather than by creative ability, though more research on it is needed. A small Prayer Book made there for Otto III[248] has none of the splendour of other imperial manuscripts. Prüm in Upper Lotharingia, essentially a tributary of the Trier/Echternach School, yet had an individuality well expressed in the rarefied, wraith-like quality of the pictures of a Gospel Lectionary in the John Rylands University Library in Manchester.[249] The life of the so-called Bavarian Monastery School,[250] which incorporated Tegernsee, Niederaltaich, and Freising, was long rather than inspired, and its modest competence ultimately became quite reactionary. Flourishing chiefly in the eleventh century but surviving into the twelfth, it influenced the murals of the Austrian Rosary Church (or Winter Church) at Maria Wörth in Carinthia which are attributed to the late eleventh century by Swoboda,[251] but have suffered Gothic intrusions. Last among the centres to be mentioned is Reichenau whose traditional position as the key centre of Ottonian illumination is still upheld by the majority of scholars, though, as we have seen, I have taken a different view.

My own opinion, then, is that there were three major schools of Ottonian art – the Trier/Echternach School in Upper Lotharingia, the Regensburg/Salzburg School in Bavaria, and the Cologne School in Lower Lotharingia – and that the most influential of these was Trier. It was at Trier, or at its reform dependencies of Echternach, Regensburg, and Tegernsee, that most of the imperial manuscripts were made, and it was at Trier that the qualities emerged that gave to Ottonian painting its individuality and significance, bridging the ninth and twelfth centuries in its development and guiding art from the Carolingian to the Romanesque period.

Mosaics and Painting in Italy and Sicily: 900–1200

TRADITIONAL ELEMENTS

As the success of the papacy in helping to establish the new Holy Roman Empire was followed by a minor 'renaissance' of mosaic art in Rome in the ninth century, so was the growth of papal power in the twelfth. Mosaics, as we have seen, were associated in the West with ideas of power and splendour, and they were also associated with the traditional. Thus it was to the Early Christian period, to which the finest Western mosaics belonged, that the artists of the twelfth century turned for their inspiration.

An earlier attempt to recover the past is shown by a mosaic now in the Vatican grottoes of Christ between St Peter and St Paul.[1] It was made for the tomb of Otto II in the courtyard of old St Peter's, and can therefore be dated c. 983, the year of the emperor's death. Its attempt to copy the style of drapery and to capture some of the spaciousness of Early Christian mosaics such as those of Sant'Apollinare Nuovo at Ravenna are an embarrassing reminder of the decline of Rome and of the papacy, for the figures are wooden and the heads coarse. The tenth century was a time when secular power passed to local adventurers, and the chair of St Peter to their nominees, and even this sorry mosaic was rare for its time. From the eleventh century there does exist a notable mosaic, but this was made by a Greek artist for a Greek community: it is the Deesis – the Intercession of the Virgin and John the Baptist before Christ – above the door of the church of Santa Maria di Grottaferrata, a few miles from Rome. We must wait until the twelfth century for a resurgence of indigenous mosaic-work at Rome. It was Abbot Desiderius of Montecassino (1058–86) – for the last sixteen months of his life Pope Victor III – who made a deliberate attempt to revive the art of mosaic in the West. He summoned Greek mosaicists from Constantinople to decorate the new abbey church that he was building, causing them also to instruct some of the younger monks in the craft which, as the chronicler of Montecassino acknowledges, had for long been languishing in the West. It is thought that fragmentary mosaics that survive in Salerno Cathedral[2] are the work of the Montecassino trainees. Salerno Cathedral, founded by Archbishop Alphanus in 1080, was consecrated in 1085, and the mosaics were probably by then in place. That they were indeed made by the Cassinese monks is rendered likely by the fact that Alphanus had been a monk at Montecassino, where he was a close friend of Desiderius, and by the stylistic links between Montecassino illumination and the Salerno fragments. The mosaics, on the triumphal arch, comprise the evangelist symbols of St Matthew and St John, with traces of the other two, part of a central medallion whose rim is spangled with stars, and sections of border ornament. The iconography of the evangelist symbols flanking a central medallion recurs on the triumphal arches of San Clemente and Santa Maria in Trastevere, and the idiosyncratic feature

of the jewel on the breast of St John's symbol is repeated at Santa Maria,[3] which suggests that these twelfth-century Roman mosaics can be seen as a continuation of the revival promoted by Desiderius. He probably based the programme for the mosaic decoration of Montecassino on Early Christian precedent, for his intention was to restore the craft to the heights of achievement of those times; and the twelfth-century Roman mosaics, too, very clearly borrow from earlier iconographies and draw on the decoration and symbolism of a vanished age.

The mosaic of the Crucifixion [147] in the apse of San Clemente,[4] made probably before 1128, when Cardinal Anastasius's new church was consecrated, incorporates classical motifs such as putti riding dolphins and blowing trumpets, probably in a deliberate attempt to recapture the 'feel' of the mosaic that had adorned the original Early Christian basilica beneath.[5] An inscription explains that the great bold acanthus scrolls surrounding and overshadowing the Cross symbolize the Church of Christ, which is like the Vine that the Law causes to wither and the Cross to prosper. They derive from the scrolls of the fourth-century Lateran baptistery, and the way in which they are inhabited by delightful birds, and by human figures (here representing Church Fathers and the protagonists of the legend of Sisinnius, the jealous husband of St Clement's disciple Theodora), has parallels in the fourth-century mosaics of Santa Costanza and other churches. The dry treatment of the exhausted Christ – who seems to belong to an Ottonian tradition – and the tight representation of the Virgin and St John are hardly Early Christian in style, but other elements are, including the symbolism of the stags drinking at the rivers of Paradise and of the sheep approaching the Paschal Lamb; moreover the twelve doves, representing the apostles, perched on the arms of the Cross resume the connection made in Early Christian mosaics[6] and sarcophagi between doves and the Crucifixion.

The mosaic in the apse of Santa Maria in Trastevere[7] [148] ranks high in Roman art for its breadth of treatment, jewelled quality of texture, and sombre richness of colour. Christ and the Virgin, flanked by saints, are enthroned together against a gold background in a variant of the Early Christian composition at SS. Cosma e Damiano [1]; the significant difference is that Christ is joined by his mother, whom he embraces – a theme perhaps connected with the annual celebration of the feast of the Assumption at Rome[8] when, to symbolize his respect for his mother, a revered image of Christ was carried in procession from the Lateran to the church of Santa Maria Maggiore. One of the halts along the way was at Santa Francesca Romana, where there was an image of the Virgin, in fact of the early seventh century but believed to have been painted by St Luke. Here the two images were placed side by side on thrones and all present knelt down, beat their breasts, and repeated the Kyrie before

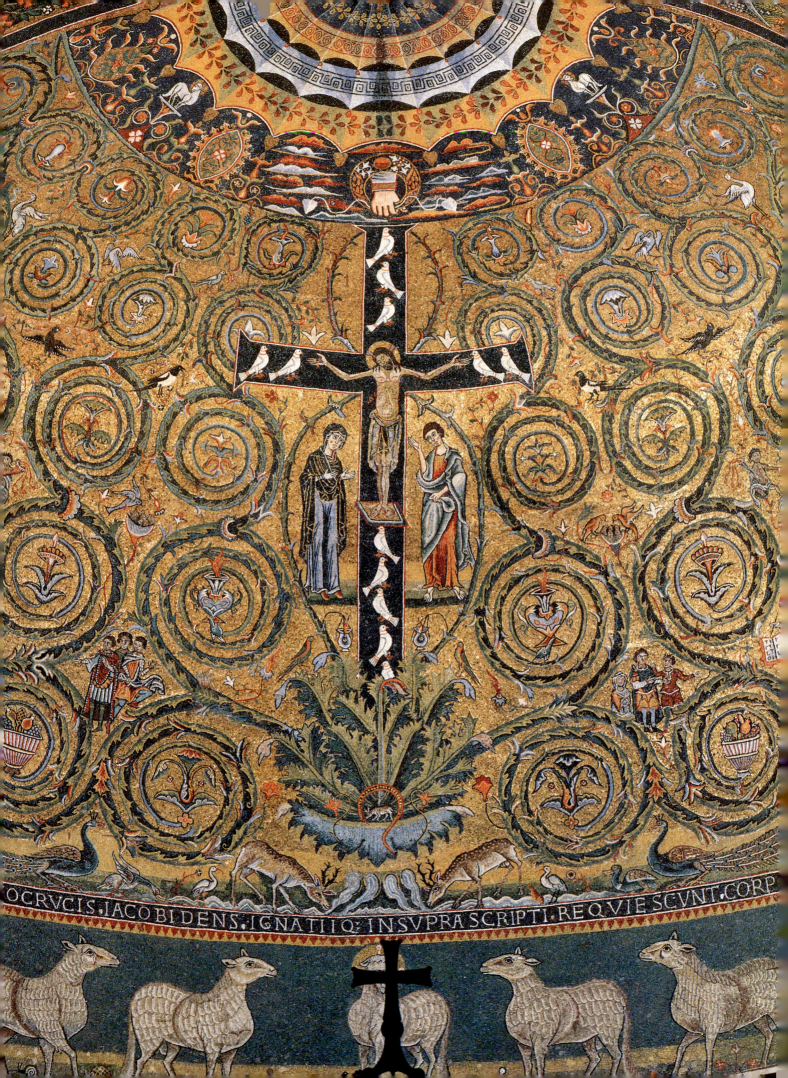

…OCRVCIS·IACOBI·DENS·IGNATII·Q·IN·SVPRA·SCRIPTI·REQVIE·SCVNT·CORP…

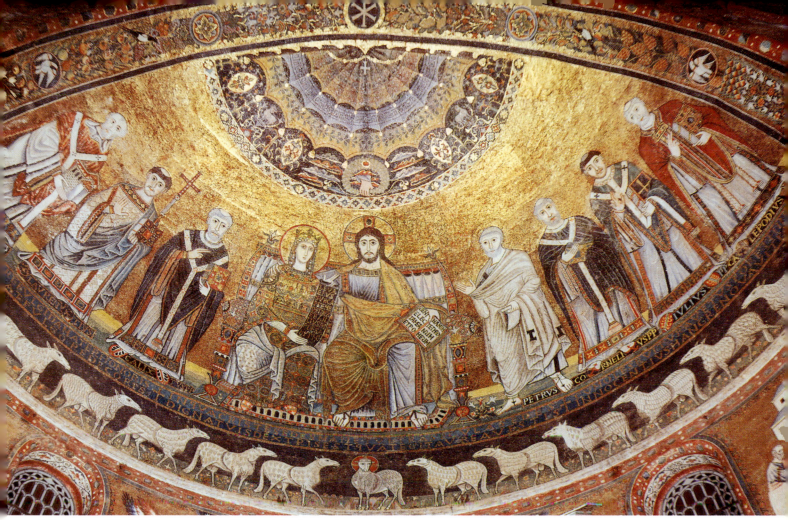

148. Rome, Santa Maria in Trastevere, apse, *Christ and the Virgin enthroned.*
Mosaic. 1140/3

continuing with the procession. That it was this symbolic encounter that was commemorated in the Santa Maria in Trastevere mosaic is confirmed first by the texts held by the two enthroned figures, which are taken from the liturgy for the feast of the Assumption, and second by the similarity of the Virgin – stylistically so different from the other figures – to the Virgin of the Santa Francesca Romana panel painting, fragments of which survive.[9]

In the zone below the main composition, the symbolic sheep of Early Christian iconography approach the Pascal Lamb. The foliage growing out of urns in the borders also belongs to an old Roman tradition, and even the prophets Isaiah and Jeremiah in the triumphal arch (as at San Clemente and formerly at Santa Francesca) are similar to compositions in the sixth-century mosaics of San Vitale at Ravenna. Among the figures to the left of the Virgin is Innocent II (1130–43) carrying a model of the church, indicating that the mosaic was part of his programme of restoration carried out between 1140 and 1143. The mosaic half-figure of Christ, formerly in the church of San Bartolomeo all'Isola,[10] is similar in style and may be by the same hand.

The surviving apse mosaic of Santa Francesca Romana[11] has enjoyed a better fortune than the mosaics of the triumphal arch. Its composition, in which the Virgin is approached by saints within arcades, is similar to those of certain Early Christian sarcophagi, and indeed, as Oakeshott says,[12] it may be deliberately antiquarian, for the St Peter and St James on either side of the Virgin and Child owe much to a fifth-century mosaic in Sant'Andrea in Barbara, now known only through copies. The Santa Francesca mosaic has links with the more masterly ones of Santa Maria in Trastevere, and it is usually – though not invariably[13] – dated to the time of the rededication of the church in 1161. There are, of course, some non-conventional elements in these Roman mosaics of the twelfth century, but on the whole they hold to the Early Christian tradition, as did the wall paintings of Rome and central Italy, which tended to follow in their path.

The taste of the Middle Ages for the translucent and the coloristic was of course expressed with particular richness in mosaics. Glowing and vibrant within the dark basilicas, they riveted the spectator's attention:

The house of God shines with the brilliancy of the purest metals, and the light of the faith glows there the more preciously,

says one inscription in the sixth-century Roman mosaics of SS. Cosma e Damiano.[14] Another,[15] in the seventh-century mosaics of Sant'Agnese, is even more effusive:

From the cut metal pieces emerges a golden picture, and the very light of day is held in an embrace therein. You might think that the dawn was rising beneath clouds drawn together

147. Rome, San Clemente, apse, *Crucifixion.* Mosaic. Probably before 1128

from snow-gripped springs, and moistening the fields with dew; or that the purple peacock himself was agleam with colour akin to the light that the rainbow displays in the heavens.

The attempts of Western wall painters to capture the glory of this resplendent art in a less costly medium were usually far from felicitous. Murals cannot hope to succeed as cheap substitutes for the more sumptuous art of mosaic, and their efforts to emulate its gorgeousness could lead to tastelessness, as in the paintings of women whose crudely daubed cheeks and draperies gaudy with jewels seem openly to confess that, in comparison with the craft of mosaic, painting saw itself as a fallen profession. Imitation could also degenerate unconsciously into parody: the file of female martyrs in the twelfth-century paintings of Castel Sant'Elia[16] near Nepi, north of Rome, clearly based on sumptuous processions in Early Christian mosaics like those of Sant'Apollinare Nuovo, catches something of their hypnotically decorative quality in the delicate patterning of the draperies, but ends almost in caricature because the heads are so wooden and out of phase.

Wall paintings tended also to reflect the Early Christian compositions of many of the mosaics. The apse painting of the Roman church of San Sebastianello al Palatino[17] (formerly known as Santa Maria in Pallara), with its brilliant and contrasting colours, succeeds at least in some of the draperies in capturing something of the jewelled quality of mosaic. For its iconography it draws on the same Early Christian inspiration as the sixth-century mosaics of SS. Cosma e Damiano and the ninth-century ones of Pascal I. Christ, the dominant central figure, holds one hand aloft and carries a scroll in the other. There are two saints on either side. All the mystic symbolism of the early mosaics is here – the palm trees of Paradise, the phoenix of everlasting life, the lambs approaching the Paschal Lamb from the cities of Jerusalem and Bethlehem. The same basic composition, without the ancillary symbolism, may have been adopted by a painting, probably of the twelfth century and now known only by a copy, formerly in the apse of San Lorenzo in Lucina.[18]

The so-called Traditio Legis, familiar from the fourth- or

149. Ferentillo, San Pietro in Valle, nave, *Adam naming the animals*. Wall painting. Late twelfth century

fifth-century mosaics of Santa Costanza,[19] continues the Early Christian iconography in the apses of Castel Sant'Elia near Nepi[20] and of San Silvestro at Tivoli[21] with Christ, towering between St Peter and St Paul, entrusting the two apostles with their respective missions. At Castel Sant'Elia there are, as well, the twelve lambs leaving the cities of Bethlehem and Jerusalem, and the twenty-four elders of the Apocalypse. Between them, the Nepi murals, which can be dated to the early twelfth century, and the Tivoli ones, of c.1200, demonstrate the strength of traditionalism in Rome and its surrounding areas over the wide span of nearly a century. The scenes at Tivoli from the life of St Sylvester, who was thought to have baptized Constantine, may also have been based on earlier Roman models.[22] They have been associated with the papal claims grounded on the supposed Donation of Constantine which were resumed c.1200.

Early Christian, too, are the geometric and animal motifs, and even some of the colour tonalities, of paintings such as those in the nave of Santa Maria in Cosmedin and in the crypt of San Nicola in Carcere, both of c.1120. One scholar[23] considers their colour range to be classicizing, their decoration to be inspired by Antique monuments, and specific motifs to have been borrowed from the palaeo-Christian repertory. All this is marginally reminiscent of Eraclius's nostalgic comments on Italy's past,[24] though he, of course, was a writer on the arts of a later generation than that of the painters here, who were mostly active in the late eleventh and early twelfth centuries.

The paintings of the lower church of San Clemente, to be dated between 1085 and 1115, are intriguing for their references to a past that was pre-Christian: the palmette patterns of ochre, shining out against a dusky background in their wide frames, are reminiscent of classical ceramics,[25] and the soft colouring of the narrative scenes can be paralleled in the Hellenistic painting of Italy. In the figures of the Creation scenes of San Giovanni a Porta Latina and of San Pietro in Valle, Ferentillo, there may even be fleeting evidence of indirect classical influences – at least, Adam stands with particular self-assurance as he names the animals, flaunting his nudity in an unabashed and unmedieval way, and he is endued with roundness and weight by a subtle disposition of flesh tones [149].

Although it would be unwise to read too much into these influences from the classical past, since they are rare and have none of the continuity or self-consciousness of a tradition, they may yet have been powerful enough to restrain Italian art from a wholehearted espousal of the Romanesque aesthetic, for the Romanesque readiness to sacrifice the human figure to formal abstractions was alien to all that classical and Early Christian art stood for.

SOUTHERN ITALY
BASILIAN ART

One legacy of the long Byzantine occupation of various parts of Italy was the wealth of Eastern art on Italian soil – Ravenna, to take but one outstanding centre, had (and still has) an artistic patrimony of splendid Byzantine mosaics. Political power was maintained longest in the south of Italy, where, despite Arab incursions and Ottonian challenges, some

measure of Byzantine authority continued until the Norman conquest of Bari in 1071. Earlier, immigration from the Eastern empire[26] into southern Italy had been accelerated by the iconoclastic troubles, for the iconoclasts' target was not only religious art but also the monks who produced it. As a result, Byzantine members of the Order of St Basil crossed the Adriatic in considerable numbers and by the end of the tenth century had established three monasteries in Campania. The Basilian grottoes and subterranean chapels that still dot the 'heel' and 'instep' of Italy[27] shelter paintings which are simple and unpretentious but in a pure Byzantine style which continued in modest oratories on Italian soil throughout the Middle Ages.

The presence of Eastern art on Western soil is nicely symbolized by the 'portraits' in the chapel of San Lorenzo, near Fasano, of the Eastern and Western founders of monasticism, St Basil and St Benedict. The principal painting is of Christ between the Virgin and John the Baptist;[28] the figures of the chapel are in a purely Byzantine style, and the inscriptions are in Greek. Inscriptions elsewhere tell us about the artists: in a grotto near Carpignano, for example, we can read first that the Christ was painted in 959 by a Greek named Theophylactos for a Greek priest, Leo,[29] and then that another mural was made in 1020 by a Greek named Eustathios for a certain Hadrianos.[30] Such 'signatures' of wall paintings are exceedingly rare in the West, and it may be significant that the two areas in which they are mostly found, Italy and the Crusading kingdom of Jerusalem, both came within the orbit of Byzantine culture.

BYZANTINE INFLUENCES
IN THE CAROLINGIAN ERA

Besides the unbroken strand of pure Byzantine art left by immigrant Greeks, there was a web of powerful Byzantine influence overlaying the indigenous art of southern Italy.

The community of monks and lay-brothers at the abbey of San Vincenzo al Volturno, on the northern frontier of the duchy of Benevento, expanded during the first half of the ninth century from about fifty members to about a thousand,[31] giving rise to an extensive programme of building and decoration. The desire of the Carolingian dynasty for a sphere of influence within the duchy of Benevento seems to have promoted the growth both of San Vincenzo and of the neighbouring monastery of Montecassino. Charlemagne himself visited the area in 787, when he confirmed San Vincenzo's possessions, granted it immunity from lay interference, and asked for books and monks from Montecassino to be sent to the north.[32] Even closer links developed under Charlemagne's successor, Louis the Pious, for his first wife Irmengarde was the sister of Abbot Joshua of San Vincenzo (793–818). According to San Vincenzo's twelfth-century chronicler, Louis lavished gifts upon the house, and even had a classical temple at Capua demolished to provide materials for the construction of a new abbey church.[33]

In all, six churches were built or rebuilt within the monastic complex in the period 783–842. However, the abbey's shifts in fortune from the late ninth century onwards resulted in the loss of most of the buildings and of the paintings[34] that

they housed. A Saracen attack in 881 drove the monks to flee to Capua, where they remained until 914, but the Saracens seem to have been less destructive than the monks themselves, who transferred the abbey to a new site a quarter of a mile away in the late eleventh century, systematically demolishing a number of the old buildings in order to re-use the stone. Excavation at San Vincenzo since 1980 has however brought to light some areas of ninth-century decoration among the ruins, of which the most interesting consist of fragments of single figures of prophets from a wall of the anteroom before the refectory.[35]

One undestroyed part of the great ninth-century abbey was a small crypt chapel which was rediscovered in 1832. Its walls and vaults were covered with paintings,[36] apparently made during the abbacy of Epiphanius (824–42), for he appears at the foot of the Crucifixion scene.[37] The monk kissing the foot of the Virgin in the scene of the Virgin and Child[38] is probably a donor,[39] though he might just possibly be the painter. Other scenes include the Annunciation and Nativity, the Holy Women at the Sepulchre, Christ between St Lawrence and St Stephen, the martyrdom of these two saints, and other saints. The paintings are by no means masterpieces, and there is a certain *gaucherie* in the more ambitious attempts to capture the jewelled richness of Byzantine art. However, the simpler narrative scenes, among them the martyrdoms, have a gusty linear quality and a certain dramatic sense – see, for example, the angel of the Annunciation, floating forward with curving wings and fluttering garments [150].

Features such as the association of the personification of Jerusalem with the Crucifixion scene apparently reflect the influence of the writings of the theologian Ambrosius Autpertus,[40] a Frank who joined the community on the Volturno in his youth and became its abbot in 777. The connections noted by one scholar[41] between these paintings and Carolingian art would not be difficult to explain in view of San Vincenzo's links with the dynasty; but the Byzantine influences are much stronger, as for example in the standing female saints, holding their jewelled crowns in a hieratically frontal composition and wearing Byzantine regalia (as do the archangels and the Virgin), and in the Christ at the summit of the vault, dominating the chapel like the Pantocrator of a Greek cupola.[42] The simple but effective vigour of the figures in the martyrdom scenes, too, seems to derive from Byzantine monastic manuscripts.[43] The iconography of the Nativity scenes is East Christian, and the female personification of Jerusalem also fits into the Byzantine tradition.[44] Although the artist draws on other traditions, too, and was definitely Western, he was clearly influenced by the monastic art of the East, as were the painters of some other Campanian churches.[45]

The wall paintings of the church of Santa Sofia at Benevento[46] are in a style related to that of San Vincenzo. Byzantine precedent is evident in the very dedication, for it was inspired by Justinian's great foundation in Constantinople. The church was built as a palace chapel by Duke Arechis II of Benevento between 758 and 768, but its surviving fragmentary paintings are thought to have been carried out in the second half of the ninth century, following the earthquake that shook the town in 847. The paintings, in the two side apses, show the Annunciation to Zacharias [151],

150. San Vincenzo al Volturno, crypt, *Angel of the Annunciation*. Wall painting. 824/42

Zacharias's dumbness, the Annunciation to the Virgin, and the Visitation. Both figure style and draperies can be paralleled at San Vincenzo, though the Beneventan paintings are more tranquil in mood and more spacious in treatment. An Eastern prototype lies behind the richly robed and crowned figure of the mute Zacharias, gesturing to the congregation with one hand and pointing to his lips with the other, to indicate that he can no longer speak. But there are, too, points of comparison with the miniatures of the Egino Codex,[47] a Homiliary presented c.799 to the church of Santa Maria Matricolare in Verona by Bishop Egino. This was a Lombard production, and until Lombardy was conquered by Charlemagne in 774, the duchy of Benevento was under its rule, and only afterwards became an independent principality. Previously, however, there had been continuous contact between the northern and southern Lombard courts, and it would seem that in the ninth century Benevento became the cultural heir to the Lombard kingdom.[48]

Nothing remains of the scriptural scenes on the walls of the basilica erected by St Paulinus early in the fifth century at Cimitile, just outside Nola, in honour of St Felix, but a poem of St Paulinus[49] relates that their aim was to edify and instruct the peasantry, and to instil virtue into them. More narrowly polemical was the iconographically unique early-tenth-century painting in another of Cimitile's churches, the Basilica dei Santi Martiri, illustrating Christ's command to

St Peter to 'Feed my sheep' (John XXI, 15 ff.).[50] In its original state (it is now very fragmentary), the action of Christ taking St Peter by the hand and gesturing towards sheep gathered around a throne was intended as a justification of the appointment to the see of Nola of Bishop Leo, under whom the Basilica dei Santi Martiri was extensively restored. Leo's ordination in the early 890s by Pope Formosus had been challenged by Pope Sergius III (904–11), who held that Formosus's elevation to the papacy had been irregular, and that all his appointments were therefore invalid. To defend his position, Leo engaged the services of the polemical writer Auxilius, a Frank living at Naples. Auxilius both contested the supposed irregularity of Formosus's election, and asserted that ordination had a validity quite independent of the worth of the individual who dispensed it, for ultimately, he claimed, it proceeded from St Peter, whose vicar the pope was, and who had been authorized by Christ himself. It is precisely this position that the painting seeks to uphold, for the throne, prominently positioned amid the sheep, carries the implication that the successors to Peter's chair derive their authority from the power conferred by Christ upon St Peter beside Lake Tiberias.

Much of Leo's complete interior decoration[51] of the

151. Benevento, Santa Sofia, *Annunciation to Zacharias*. Wall painting. Second half of the ninth century

Basilica dei Santi Martiri remains, if only in a fragmentary state. The scene of Christ and St Peter concludes a Passion cycle that extends over the west and north walls. On the north wall are also two episodes from the earlier phases of Christ's life, and there may have been further Christological pictures (now vanished) on the south wall. On the east wall is Christ in Majesty with seraphim, and the vault originally carried four angels bearing a medallion with a bust of Christ. The decoration of the apse, largely destroyed by a later doorway, appears from one or two surviving areas of paint to have consisted of a Virgin flanked by angels. Among the single figures of saints painted in the window niches and on bare areas of the walls are luminaries of the Eastern Church such as St Pantaleon and St Simeon Stylites. Much of the Cimitile iconography can be paralleled in Roman wall paintings of the eighth and ninth centuries,[52] but stylistic links with the illumination of Benevento suggest that the artists were local.[53]

LITURGICAL ROLLS OF SOUTHERN ITALY

Three south Italian illustrated rolls of the tenth century are in a linearized Byzantine style reminiscent of the San Vincenzo wall paintings. The first (now in five sections) is an illustrated ordination ritual datable between 957 and 984; the second,[54] now dismembered, concerns the ritual of the benediction of the font, and includes a benediction scene and illustrations of biblical episodes relating to baptism. Although they are drawings, not paintings, the pictures of both rolls bear comparison with those of the famous *Menologion* of Basil II from Byzantium.[55] The third roll,[56] an Exultet Roll, can be dated 981–7. Its St Peter, before whom kneels the donor, the priest John, combines spaciousness with linear vivacity in a way that recalls the Archangel Gabriel of the San Vincenzo Annunciation [150].

The Exultet Rolls[57] were mostly made during the eleventh and twelfth centuries. They are often more than five metres in length and generally between twenty-three and thirty-two centimetres wide, and all but two of the twenty-eight that remain were made in Apulia or Campania. They are named from the first word of the service for the blessing of the Paschal candle – 'Exultet iam angelica turba caelorum' ('Let the angelic host of heaven exult') – to which the chronicle of Montecassino refers in its account of the gifts of Abbot Desiderius, which included a silvergilt Paschal candlestick standing 'six cubits high on its porphyry base'. 'Upon it', the writer says, 'the great candle can be solemnly raised to be blessed on Easter Saturday.'[58] This blessing – a significant office in the south of Italy – celebrated the victory of Christ over Death and Night, called upon Heaven, the Earth, and the Church to rejoice, and associated with the general jubilation one or two of the more impressive episodes of the Old and New Testaments.

The Exultet Rolls were lavishly illustrated with pictures which contribute much to our knowledge of the period: their representations of liturgical services are informative about church vestments; their portrayals of contemporary secular rulers[59] – from the emperor Basil II in the East to emperors as late as Frederick II in the West – present a fine range of

152. Bari: *Two Byzantine emperors*, from an Exultet Roll. *c.* 1000. Bari
Cathedral Archives

imperial 'portraits'; their musical notation is interesting to the musicologist; and they provide particularly useful evidence concerning the development of the south Italian, or Beneventan, script. From our point of view, they are invaluable for their rich documentation of the history of painting in southern Italy – indeed, they rank among the most important cycles of graphic art left to us by the Middle Ages. Their illustrations have in common with wall paintings both largeness of treatment and the fact that they constituted public art, for they were displayed during the course of the service; they were then held upside down in relation to the text so that they would appear the right way up to the congregation as the roll was unfurled from the pulpit. Some of them suffered unfortunate repainting during the Middle Ages, and while most of the finest – from Volturno, Bari, and Montecassino – are in their original condition, others, made at Gaeta, Mirabella-Eclano, Sorrento, Fondi, Benevento, and Troia, are in a variable state; however they all manifest an adaptation of a Byzantine idiom to the more linear tastes of the West as well as betraying influences from the Early Christian art of Italy itself – indeed, it has been claimed that they actually originated in Early Christian times.[60]

Eastern influences are particularly apparent at Bari, which

was under Byzantine occupation until 1071. But while one of its Exultet Rolls, of about 1000,[61] commemorates saints of the Eastern Church who are identified in Greek, and includes an illustration based on the Greek text of the Old Testament, most of its pictures reflect the coexistence of East and West: thus below a drawing of two Byzantine emperors [152] stands the pope between deacons. The low-toned colours can be paralleled in Byzantine wall paintings of the Basilian grottoes, but the emphasis on sureness of line rather than modelling by colour places these pictures firmly within the Western orbit. A particularly handsome production from Bari Cathedral is a Benedictional Roll of the early eleventh century[62] that gives the order for the blessing of the font. Its pictures are spacious drawings rather than paintings, their colours laid on rather flatly. In one, on the Byzantine theme of the Deesis, the supplicant prostrating himself before the figure of Christ is presumably the Silvester for whom the Virgin and St John the Baptist intercede.

The dignity and nobility of the best of the paintings of southern Italy are well exemplified at Montecassino, which has left us at least three, and possibly four, Exultet Rolls[63] of the eleventh century. Despite later retouching, one,[64] of about 1060, is particularly delicate in line and pure in colour.

153. Montecassino: *Christ enthroned between angels*, from an Exultet Roll,
MS. Add. 30337. *c*. 1060. London, British Library

The Earth, in some Exultet Rolls personified as an Eastern princess crowned with flowers and leaves, here receives a warmer Carolingian interpretation as a woman half rising from the ground and suckling the animals of the land. The predominant influences, however, are from Byzantium, of whose styles the delicate drawing of Christ between angels [153] is a particularly successful recension. These Exultet Rolls were made under Abbot Desiderius, the begetter of the great efflorescence of Cassinese art.

MONTECASSINO

Montecassino,[65] founded in the sixth century by St Benedict, the father of Western monasticism, as a retreat for the cultivation of humility, had by the eleventh century become the powerful centre of a large monastic state more integrated than the pope's own domain, and more able to withstand

military pressure. Its secular aggrandisement had been encouraged by the earlier patronage of the Byzantine emperors, bestowed when Carolingian protection failed, and continued after the monks fled to Teano, in Campania, when their abbey was sacked by the Saracens in 883, and again when they returned in the mid tenth century to reclaim their lost possessions. Freed from the infidel, this part of Italy became a source of contention between the two Christian empires, and it was the Byzantines that Montecassino supported until Henry II of Germany personally intervened at the head of his army. Atenulf, abbot from 1011 to 1022, then fled from the wrath of the Holy Roman Emperor only to be overtaken by the elements, for he was drowned on his flight to Constantinople. His brother and accomplice, the prince of Capua, was however apprehended, and in a picture in the Gospel Book made for Henry at Regensburg[66] and presented to Montecassino to be a reminder of its 'treason'[67]

he is shown humbly pleading for his life before Henry, the apotheosis of law and justice [143].

But even this did not sever the ties between Montecassino and Constantinople; neither did the appointment to the abbacy in 1055 of Frederick of Lotharingia, one of the papal legates who had excommunicated the Eastern patriarch in Constantinople in 1054, nor that of his successor, Desiderius (1058–86), who had personally arranged an alliance between the Normans and the papacy which was opposed to Byzantine political interests. Indeed, in 1055 the Eastern emperor bestowed upon Montecassino an annual pension of two pounds of gold, and in 1076 another of twenty-three pounds of gold and four precious silks as well. The goodwill between Montecassino and Byzantium was demonstrated when one abbot of the beginning of the tenth century was asked to negotiate between the Lombard princes of Capua and the Byzantine empire, and another of the end of the eleventh was invited to intercede between the Crusaders and Constantinople. Montecassino was a mediator between East and West in matters of art as well, and never more so than under Desiderius himself. His proud bearing in a painting at Sant'Angelo in Formis suggests an aristocratic temperament that the cowl of St Benedict had done little to subdue [154],

and indeed his appointment to Montecassino made him the ruler of a great ecclesiastical state in the heart of Italy where, the monastic chronicler claims, he was 'held in such great honour by all the inhabitants around that not only the lesser people but even their princes and leaders obeyed him like their father and seigneur'.[68]

Desiderius, who was anxious to develop Montecassino as a centre of culture, drew to himself writers such as Albericus, whose poetical themes in some ways anticipate those of Dante, and Alphanus, who translated Nemesius of Euresa from the Greek, as well as scientists such as Constantinus of Africa, whose translations from the Arabic influenced the future course of medical science.[69] But most important for us was his patronage of art and artists. He threw all his considerable energies into the renovation, rebuilding, and embellishment of the churches belonging to Montecassino, and not least into an ambitious transformation of the monastic basilica itself, which was described by no less a personage than the Byzantine emperor as 'the most celebrated and famous church ... praised ... in the West as well as the East'.[70] It was to Constantinople that Desiderius turned both for his bronze doors and – as we have seen – for mosaicists both to embellish his church and to train his monks in their craft. We cannot

154. Sant'Angelo in Formis, apse, *Abbot Desiderius offering the church*. Wall painting. Last quarter of the eleventh century

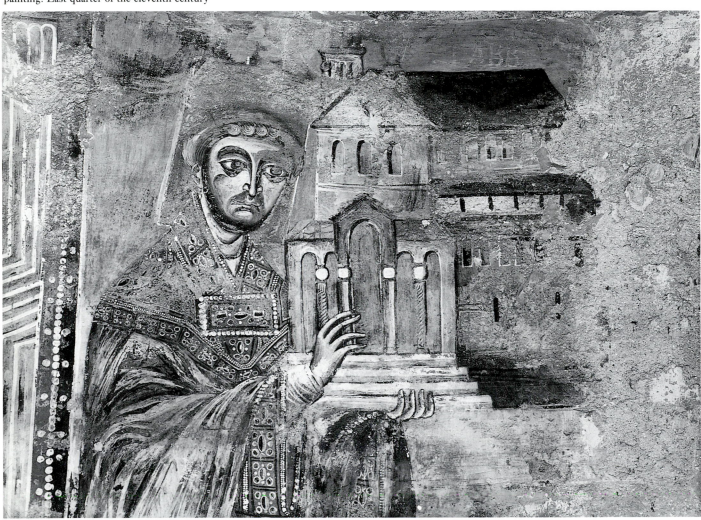

do better than to turn once again to Leo of Ostia's famous account of this important undertaking:[71]

He [Desiderius] sent envoys to Constantinople to hire craftsmen skilled in the arts of mosaic and of stone-cutting, of whom the ones were to decorate the apse, the arch, and the narthex of the main basilica with mosaics, while the others would lay the pavement of the entire church using stone of different varieties. The degree of perfection that had been attained by the masters of these arts who were then despatched to him can be judged from their works: for in the mosaics you would almost suppose you were looking at living figures and all sorts of plant-life, while in the marble pavement you might think that flowers of every colour bloomed in lovely variety. And seeing that western Christendom had lost the talent for these arts for five hundred years and more, and was now, thanks to his efforts and God's help, in a position to recover it in our time, in order that it might not suffer further demise in Italy this man of utmost foresight took care to have several of the boys of the monastery assiduously instructed in the same arts. And from among his own monks he prepared for himself the keenest of craftsmen, not only in these, but in all branches of workmanship that can be accomplished with gold and silver, with bronze, with iron, with glass, with ivory, with wood, with gypsum, and with stone.

Desiderius's basilica is long gone, and all that remains of the Byzantine work that Leo describes are two slabs from the pavement before the altar and some sections of the nave pavement uncovered during the bombardment of 1944.[72] In addition, in the abbey museum are some fragments of wall paintings – we know both from Leo of Ostia and from Alphanus[73] that the narthex was painted with scenes from the Old and New Testaments.

Desiderius also rebuilt the surviving church of Sant'Angelo in Formis near Capua,[74] which was given to Montecassino in 1072, and in it are the impressive remains of a once even more extensive cycle of paintings. The half-figures of St Michael and the Virgin over the doorway, and the scenes from the lives of the anchorites St Anthony and St Paul the Hermit in the porch, are Byzantine work of the end of the twelfth century,[75] executed, according to Demus,[76] by the artist partly responsible for the earlier Monreale mosaics: it is the wall paintings inside that are by the Italian pupils of Desiderius's Greek masters. Perhaps five in all,[77] they presumably began their paintings before Desiderius left Montecassino in 1086, since he wears a square nimbus which can denote the living in his picture in the apse [154]. Opinions vary, but the relationship of these paintings to the eleventh-century manuscript painting of Campania suggests that they belong to the last quarter of that century.

The ensemble is dominated by the brilliantly coloured painting in the main apse, with its contrasts of light and shade. At the top is Christ on a jewelled throne with the dove of the Holy Spirit above and the evangelist symbols around. Below we are faced by three archangels, with the noble figure of the donor, Desiderius, on the left and a much restored St Benedict on the right. New Testament scenes originally unrolled in three zones on the side walls of the nave; on the south, only the lowest zone survives. In the spandrels,

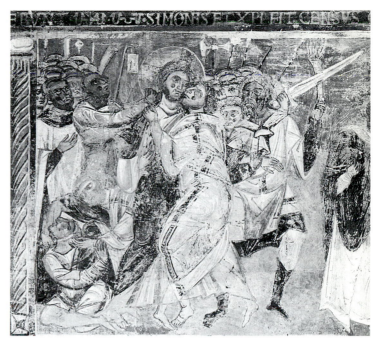

155. Sant'Angelo in Formis, nave, *The Arrest of Christ*. Wall painting. Last quarter of the eleventh century

however, the single Old Testament figures remain, as do the impressive Last Judgement on the entrance wall and some Old Testament scenes in the aisles. The decoration of the left apse has perished, but in the right apse are the Virgin and Child flanked by angels, with standing saints below. The style varies surprisingly, from the hard frontality of the saints in the right apse to the loose texture of the figures in the Expulsion from Paradise: from the linear excitement of the Arrest of Christ [155] to the heavy, almost ponderous treatment of the evangelist symbols.

There are variations of quality, too. In some areas, in emulation of mosaic, the costumes and accessories are over-bejewelled and the colours too bright, while the paintings of the apse snatch at the eye by their vividness rather than beguiling it with subtlety. But when painterly values were allowed to take over, the result could be masterly: the Entombment scene [156], for example, is invested with some tenderness, the Arrest of Christ [155] with dramatic feeling, and the Desiderius portrait [154] with an aloof nobility, while the prophets have a very real gravity.

Byzantine influences permeate the paintings.[78] Eastern iconography is particularly apparent in the Healing of the Blind Man, the Entry into Jerusalem, and the Last Supper,[79] and influence from the 'classicism' of the Macedonian Renaissance is patent in the suave rhythms of the draperies of some of the Old Testament figures, in their statuesque poise and in their grave nobility. In more particular terms, one can compare the Christ in Majesty of the apse to the Christ of Hagia Sophia at Istanbul,[80] and the figures of the Entombment scene to those of the version in Hosios Lukas.[81] Yet although the apprenticeship to Byzantium is enthusiastic and unreserved, the Latin temperament breaks through in the use of the walls of a church as a picture-book of the Bible – which belongs to a Western tradition[82] itself apparently going back to the fifth-century nave paintings of St Peter's and St

156. Sant'Angelo in Formis, nave, *The Entombment*. Wall painting. Last
quarter of the eleventh century

Paul's in Rome[83] – as well as in the Western accentuation of
the Eastern styles.

When, following the iconoclastic controversies, Byzantine
art renewed itself, it turned back to the heritage of Latin and
Greek Antiquity. This ushered in a new golden age of self-
contained equilibrium: everywhere there is an adjustment of
weighted rhythms; every action is controlled by a balancing
one; each point has its counterpoint; all elements contribute
to the whole. This is an orthodox art in St Augustine's sense
of the word orthodoxy – something in which no part is out
of relationship to the whole. Now the heartland of the West,
unlike that of the East, had been settled by pagan tribes who
first needed conversion and then instruction: as a result, a
different attitude evolved whereby narrative wall paintings
became associated with preaching in paint. Symbolism was
important, too, but any taste for melodic balance was far
outweighed by the didactic impulse, which remained
powerful in Latin Christendom even as late as the twelfth
century, when Honorius of Autun described paintings as
being primarily 'the literature of the layman'.[84] All this
emerges in Sant'Angelo, for even when the underlying
composition is clearly based on the Byzantine aesthetic of

equipoise, the artist does not hesitate to distort or even shatter
the balance if by so doing he can underline a particular point,
or draw the eye to a vigorous artistic passage. The distraught
expression of the adulteress brought before Christ, the
anguished gaze of Pilate washing his hands, the dramatic
gesture of the Virgin at the Entombment, all rivet the
attention on a dynamic point or a particular message at the
expense of aesthetic integration. As a result, the Byzantine
influence, though strong, is confined chiefly to externals, and,
despite some masterly areas, there can be unresolved clashes
between two different art forms, the one symbolic with an
aesthetic of internal equilibrium, the other narrative with an
aesthetic of external tension.

Amatus of Montecassino spoke of the widespread influence
of Desiderius's buildings and decoration,[85] and we can still
trace the effect of the Sant'Angelo paintings in churches[86]
such as that of Foro Claudio, whose pictures are comparable
in style if not in quality. Yet it was perhaps through the art
of manuscript painting that Montecassino spread its influence
most broadly. 'Together with these buildings, O father,
receive these many wonderful books'[87] requests one
manuscript's dedicatory inscription, where Desiderius is

157. Montecassino: *Abbot Desiderius offering books and buildings to St Benedict*, from the Lives of St Benedict, St Maurus, and St Scholastica, MS. Vat. lat. 1202, folio 2. 1071(?). Rome, Vatican Library

shown offering bound volumes to St Benedict [157]. Another reads: 'Among the monuments of his greatness wherein he admirably excelled all his predecessors, he ordered this most beautiful book to be written.'[88] These contemporary testimonies to Desiderius's patronage of artistic manuscripts are borne out by those that survive. A discussion of them will be prefaced by a short account of the role played by earlier abbots.

Of the pre-tenth-century manuscripts of Montecassino we know nothing, for they perished either when the abbey was devastated by the Saracens in 883, or in a later fire at Teano. After these disasters, the first abbot to take an interest in illustrated manuscripts seems to have been John (914–34), who was responsible for moving the community from Teano to Capua and who later began the rebuilding of Montecassino. It was he who initiated a new tradition of manuscript painting among the monks, who commemorated him in one such painting by showing him in the presence of St Benedict.[89] A new Cassinese style of decorative initial then developed, influenced from Franco-Saxon or English sources, consisting of interlace often enlivened by small, bounding, harmoniously balanced animals. There are good examples of it in a copy of part of St Gregory's *Moralia in Job*[90] written by the monk Jaquintus under Aligernus (949–86), the abbot who finally ended the exile of the monks and returned them to Montecassino.

The exceptionally fine initials of a manuscript[91] made in 1010 by the scribe Martin prove that artistic recovery was well under way during the abbacy of John III,[92] but it was Abbot Theobald (1022–36) who provided the first major impetus: 'He had several manuscripts made,' says the chronicler, 'of which there was a great lack until his time.'[93] In a copy of the opening books of the *Moralia in Job*[94] there is a miniature of Theobald presenting the volume to St

Benedict, and another of St Gregory conversing with his confidant Peter the Deacon, with an angel behind. The influences on both are from Ottonian sources. The initials of this and other manuscripts demonstrate the increasing sophistication of the Cassinese decoration. Among the foremost of Theobald's books is the earliest surviving copy, datable to 1022–3, of the Carolingian illustrated encyclopedia[95] compiled by Hrabanus Maurus (776–856) during his retirement and popularly known as *De Universo*, though its correct title is *De rerum naturis*. Textually, it owes much to an earlier encyclopedia, the *Etymologiae* of Isidore of Seville (*c*.560–636), but its interest for us lies in the generous scale of its illustrations. They were originally in two 'editions', both relying heavily on classically derived sources such as illustrated copies of Dioscurides, Solinus, and the *Aratea* of Cicero. These Hrabanus pictures are quite unpretentious in their Italian recension, but they provide interesting insights into the Carolingian conceptions of the world and the universe, which seem to have been close to those of Pliny and Cicero.

During Theobald's time, Montecassino received from Henry II the Regensburg Gospel Book already referred to[96] [143]. The abbey's chronicler admiringly noted that it was 'wonderfully decorated with figures in gold' and bound in gold inlaid with gems,[97] adding that it had been offered by the emperor as a token of thanks to St Benedict for his miraculous cure of 1022.[98] As we know, there was more to it than this: it also issued a warning to the monks. This acknowledgement of a religious debt that was also a reminder of a political offence had an extraordinary effect some fifty years later, when its typically Ottonian initials began to influence those of Montecassino,[99] giving them something of the openwork precision of metalwork. This sudden fertilization by a manuscript that had been lying in a monastic library for some decades may seem curious to us, but it is paralleled earlier in the influence of the Lorsch Gospels on the Gero Codex, and at Regensburg itself in the long-delayed effects of the paintings in the Golden Gospels of Charles the Bald on an age of renewed imperial ambition. Indeed, it may be significant that the full impact of the Ottonian imperial manuscript at Montecassino was felt under Desiderius, an ambitious abbot who consciously associated his own creations with those of the most celebrated of Christian emperors, Constantine the Great.[100]

Three illustrated manuscripts of considerable quality have survived from the time of Desiderius.[101] The first of them is a Book of Homilies.[102] The second, which may well have been made for the dedication of the basilica in 1071, deals with the lives of St Benedict, St Maurus, and St Scholastica,[103] and the third – in paleographical terms, a companion volume – is another Book of Homilies.[104] From its dedication picture [159] and from inscriptions we learn that this second Book of Homilies was written by a certain Leo – perhaps the Leo who chronicled Desiderius's activities – and paid for by another member of the community called John. The initials of the latter two manuscripts, as well as those of an artistically less interesting one,[105] are influenced by Henry's Gospel Book, but their primary interest is their pictures. The almost one hundred illustrations, by two hands, of the lives of the three saints begin with the picture of Desiderius offering

158. Montecassino: *The Annunciation*, from a Book of Homilies, MS. 99, folio 5. 1058/86. Montecassino

159. Montecassino: *Abbot Desiderius presenting John, the donor, to St Benedict, at whose feet kneels Leo, the scribe, from a Book of Homilies, MS. 99, folio 3. 1058/86. Montecassino*

books and buildings to St Benedict [157]. The saint, in a blue cowl, is rendered with a convincing sweep of outline, the natural contours of chest, thighs, and legs emphasized by highlights to suggest convexity, while darker tones indicate recession. The influences are obviously Byzantine, and continue in the illustrations to the life of St Benedict where, despite a slightly drier treatment of the heads and a more linear approach to the draperies, many of the figures could almost pass as genuine Byzantine work: their vivacity, svelteness, and rhythmic qualities find parallels in the illustrations of Eastern monastic manuscripts, particularly those of a Psalter in the British Library,[106] and they evince as well a Byzantine restraint also apparent in such scenes as the dragon pursuing a monk, and the saint freeing a brother from the devil, both of which might seem to invite strong dramatic treatment. Despite some expressiveness and eloquence of gesture, the figures are largely elements of a composition whose balance must not be hazarded by emotional involvement between the actors or between them and the spectators. One wonders whether the altar-frontal with scenes from the life of St Benedict that Desiderius

commissioned from Constantinople[107] had any influence on the manuscript cycle.

The illustrations of the two Books of Homilies are no less Byzantine in feeling. They are primarily full-page New Testament scenes, and follow an East Christian iconography. There are occasional reminiscences of Byzantine metalwork – the style of the second Book (Montecassino MS. 98) can be compared to that of the Byzantine bronze doors of San Paolo fuori le Mura – but the major influence is from the spacious and deliberative style of Byzantine imperial painting. The suaveness of some of the pictures – for example, the Annunciation and Ascension in the first Book (Montecassino MS. 99) – might even suggest the participation of Byzantine artists, but this is ruled out by the intrusion of a traditional Cassinese decorative motif into the actual architectural framework of the Annunciation scene[108] [158], and by the outline drawing technique (unlike the painting of the illustrations of the life of St Benedict), which was traditional in southern Italy but found little favour in Byzantine manuscripts. In the dedication picture of the first Book,[109] clearly a Western mutation of a Byzantine style, John, the

donor of the manuscript, holds the completed volume in his hands as he is presented by Desiderius to St Benedict, at whose feet kneels Leo, the scribe [159]. The figures, outlined in pen and heightened in colour, are firmly but delicately drawn, and have spaciousness and weight. The lines are used organically, as in Byzantine art, to suggest the contours of the body and of the limbs below the draperies, but they are also given a new precision, particularly in the definition of forms and the registering of patterns, so that, in a sense, the Byzantine style is being externalized. The combination of a spacious dignity with linear fragmentation could possibly reflect influences from Byzantine ivories, but the interest in the exploration of surface texture is more selective than it would be in Byzantine hands. There is also an emotional involvement between the figures that Byzantine art would normally eschew, for Desiderius places an arm paternally around John, and St Benedict bestows upon him a glance of approbation.

The process – particularly of exploring surface texture – continues in the drawings of St Benedict in another Montecassino manuscript,[110] and finds a parallel expression in the wall paintings of Rome, whither Desiderius was translated as Pope Victor III in 1086.

ROME AND CENTRAL ITALY

In the eleventh century, when Montecassino was the bright focus of art in Italy, Rome was still under an eclipse that had begun in the early tenth century. Our examination of her painting between the eighth century and the eleventh will therefore be brief, beginning with Santa Prassede, where wall paintings of the deaths of martyrs are deliberately associated in theme with the Celestial Jerusalem in mosaic on the triumphal arch.[111] Unfortunately, conjunction with the mosaic serves only to point up the artistic poverty of the painting – its enervated style, its compositional monotony, and its general lack of quality.

Far finer – indeed, the finest that ninth-century Rome has to offer – is the painting in the lower church of San Clemente,[112] where a stretch of wall was added to the nave apparently for the display of a relic from the Mount of Olives, the site of the Ascension, of which a highly dramatic version is painted around the relic's housing. Christ is raised aloft in a mandorla in the presence of the Virgin and apostles. The Virgin's arms are raised in the *orans* posture, and the apostles on either side are painted in a rapid, sketchy style of considerable power. One covers his face in a sudden impulsive gesture, a second recoils with his body but cannot avert his eyes, and others gesticulate to express their amazement. Themselves unperturbed, Leo IV [160] and St Vitus(?) flank the unfolding drama, the pope in the rectangular nimbus allowed for the living, the saint in the circular one of the dead. The composition may reflect a mosaic of the Ascension set up by Constantine the Great in the Church of the Ascension at Jerusalem and made familiar by schematic copies on *ampullae* of the seventh century. The lively expressiveness of the key figures suggests Carolingian influences, and it has been argued that the painting also has stylistic connections both with the illustrations of a Syriac Gospel Book of the sixth century[113] and with the pictures of a contemporary text

of Job, written in Greek but illustrated by Romans.[114] Though he is no longer thought to have been the donor,[115] this painting, and others on a pier to the right, are attributed to the pontificate of Leo IV (847–55).[116] The pier pictures include a Crucifixion which originally showed blood flowing from the hands of Christ, the Miracle at Cana, the Visit of the Holy Women to the Sepulchre, and the Descent into Limbo. Stylistically linked are murals in Santa Maria in Via Lata and Santa Maria in Cosmedin attributed to the third quarter of the ninth century.[117] Others in Santa Maria in Gradellis, within the Tempio della Fortuna Virile, have been quickened by contact with Carolingian art. They include ranks of Greek and Latin saints in one of the five registers, and scenes of the deeds of St Mary of Egypt, whose life had recently been translated into Latin. Both they and the naïve, if vigorous, fragmentary Old and New Testament scenes with Byzantine overtones in the aisle of Santa Maria Antiqua belong to the pontificate of John VIII (872–82).

The tenth century too was a barren time in Rome. The few paintings in the small church of Santa Maria in Pallara, now San Sebastianello al Palatino,[118] include a picture of Pietro, the founder of the church, who died between 973 and 1000, and the interest of other paintings also resides in non-aesthetic qualities – the early date of the inelegant panel painting of the Virgin in Santa Maria in Aracoeli,[119] for example, and the identification of an architect ('Martinus monachus')[120] and possibly a painter ('Sergius pictor'?)[121] in the murals on the entrance wall of the underground oratory of San Saba. Likewise, the inscription on a Crucifixion among the paintings in San Urbano alla Caffarella yields the information that their donor was Bonizo and their date 1011.[122] The quite extensive Christological and hagiographical cycles in this church have intriguing iconographical associations with Syria, but they constitute 'a notable cultural event', as one scholar says,[123] only in the context of the prevailing artistic aridity.

During the eleventh century the papacy first fell prey to the manipulation of local intriguers and then was drawn into the struggle with the empire, which brought warfare and destruction into the very heart of the Eternal City, culminating between 1081 and 1084 in the siege of Henry IV. Later, the pope's own ally, the Norman Robert Guiscard, took a savage revenge on Rome for capitulating to the emperor, and a decade of violence and disorder followed in which popes competed with anti-popes and Desiderius, soon after his elevation, was forced to flee. Not until the very end of the eleventh century and the beginning of the twelfth was normality re-established in Rome, so that the arts of peace-time could be resumed. We do not know how many wall paintings have disappeared from Rome, and those that remain have been variously dated, but it would seem that the recovery after this long period of turmoil was not a sluggish one. Indeed, one of the earliest surviving monumental works of the twelfth century is also one of its most accomplished: the further cycle of paintings in the lower church of San Clemente.[124] It is stylistically so close to the miniatures of Montecassino that it would seem beyond the bounds of coincidence to accept the claim of Bologna and of Demus[125] that the Roman artists simply happened to choose Byzantine it necessary to do so, for – as would be known in Rome –

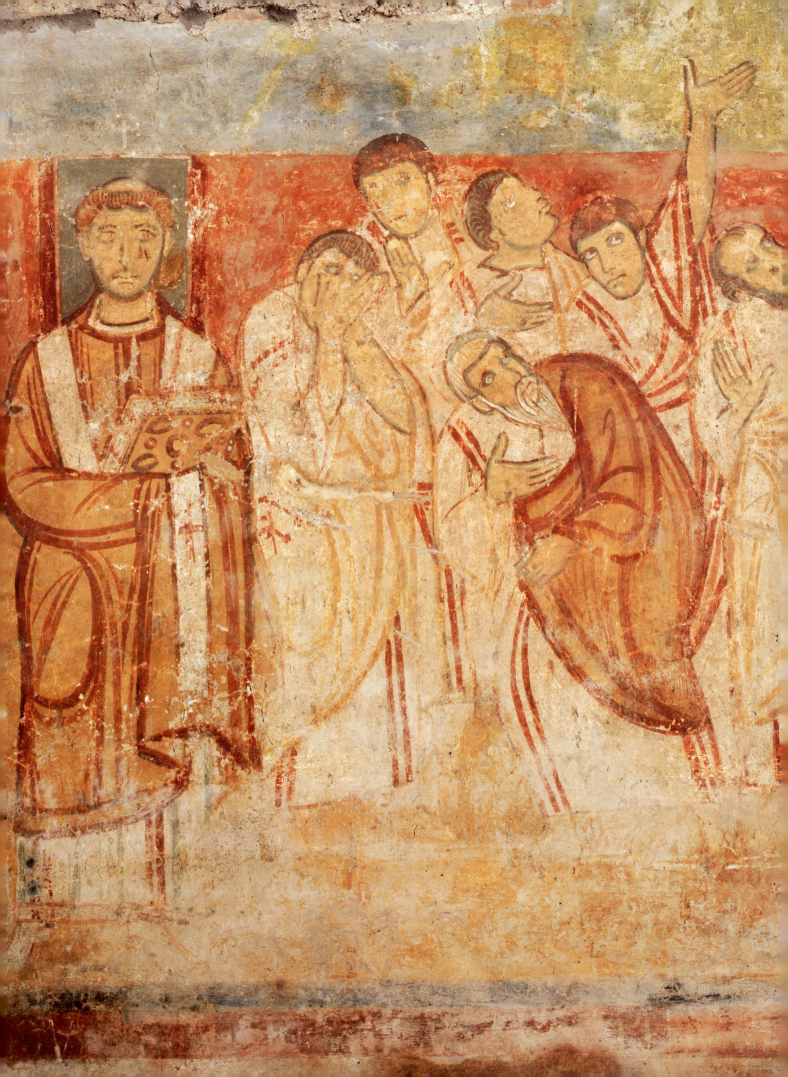

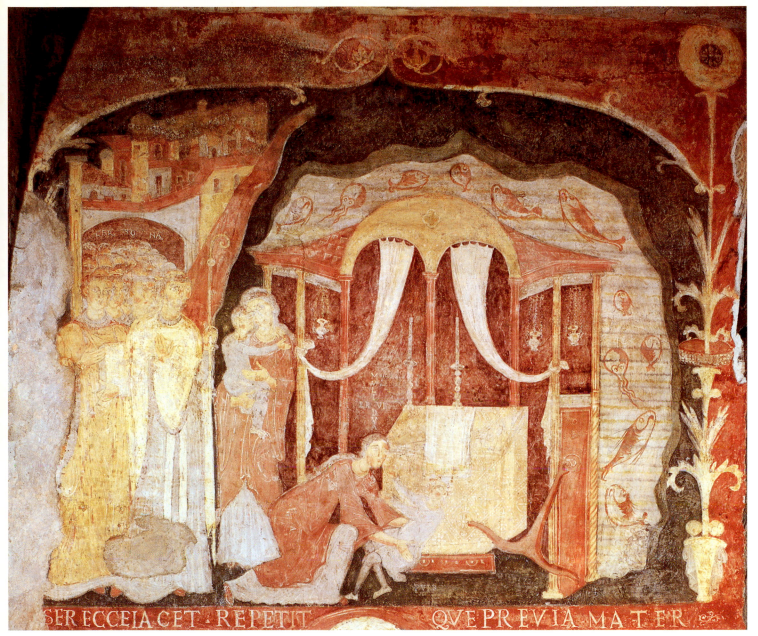

161. Rome, San Clemente, narthex of the lower church, *Miracle at the tomb of St Clement*. Wall painting. 1084/1115

Montecassino continued to cultivate the arts after his death.[126]

Most scholars would place the San Clemente murals before 1115 for two reasons: first because they show no awareness of a basic source for the life of St Clement written by the former Cassinese monk, Bishop Leo of Ostia, some time between 1109 and 1115 at the specific request of Anastasius, the cardinal who held the church of San Clemente;[127] and second because the paintings are stylistically related to a manuscript illustration of 1104.[128] All this would seem to point to the early years of the twelfth century, when the city was beginning to recover from the damage inflicted by Robert

160. Rome, San Clemente, nave of the lower church, *Pope Leo IV and other figures from the Ascension*. Wall painting. 847/55

Guiscard in 1084, though the Italian scholar Matthiae prefers a date between 1084 and the beginning of the twelfth century.[129] Painted on walls that filled in the colonnades between nave and aisles and between nave and narthex, the murals are all by the same workshop.[130] The donors, Beno de Rapiza and his wife Maria, appear twice. Their representation with their children, Clemens and Altilia, offering candles to a bust-portrait of St Clement is associated with a picture of a miracle wrought at the saint's tomb [161]. When St Clement met his death by being cast into the Black Sea off the Crimea with an anchor around his neck, the story goes, angels built him a tomb on the sea-bed which was revealed once a year by an exceptionally low tide, enabling pilgrims to visit it. On one occasion a child was left behind, to be restored the following year to its mother through the merits of the saint, and this is the subject of the painting. First, as the clergy arrive to celebrate the office of St Clement, the woman finds her child safe by the underwater tomb's canopied altar, to

one side of which lies the anchor that caused the saint to drown, and then she is shown holding the child tenderly in her arms. Beno and Maria appear again in a scene of St Clement saying Mass before a group including his convert Theodora. Further paintings show the translation of St Clement's relics from the Vatican to San Clemente; the saint enthroned with other figures; and three scenes from the life of St Alexis, who on his wedding night resigned his married state for a vocation of chastity and then departed on a long pilgrimage, returning seventeen years later unrecognized to become a servant in his own home.

The two, or possibly three, hands involved all practised a style of liturgical richness combined with finesse that is unsurpassed in twelfth-century Rome. The colours are low-pitched – warm ochres, grey-blues, and soft yellows – and the elegance of figure-drawing, the delicacy of craftsmanship, and the overall refinement are reminiscent of finely discriminated miniatures – indeed, it is to the miniatures made at Montecassino during the abbacies of Desiderius and his successor Oderisius that the painting must be compared. They would appear, however, to have undergone even stronger Byzantine influences, expressed in the proportions of the slender swaying figures, the decorative motifs of the draperies, the building up of flesh tones by modelling in green and red, and the jewelling of thrones and vestments. The patterning of the figures in terms of linear rhythms, however, and their incorporation into a tapestry of design and colour, are entirely Western, as is the poignancy of the mother's face as she takes up her long-lost child in the painting of the miracle at St Clement's tomb [161]. At the other end of the scale, a touch of homely, even crude humour is introduced in the panel below the solemn Mass of St Clement where the servants of Sisinnius, victims of a divinely inspired delusion, attempt to carry off a pillar in mistake for St Clement. The oaths uttered by Sisinnius, the jealous husband of the Christian convert Theodora, in his efforts to urge his men on are expressed in an inscription which offers one of the earliest written examples of vernacular Italian.

The San Clemente style strongly influenced the monumental paintings of Rome and the surrounding area during the first half of the twelfth century. One example is the bust of Christ flanked by angels and donors, with the Archangel Gabriel and saints below, in the small apse of the oratory of San Gabriele sull'Appia;[131] another is the murals uncovered after the Second World War in the chapel of St Sebastian in the Old Lateran Palace,[132] though these are a little later, probably of 1100–30. They are of saints and martyrs, part of the Creation, the entombment of St John the Evangelist, the martyrdom of St Sebastian, and the Crucifixion. Some are fragmentary and others are in poor condition, but in some details, particularly in the St John and the St Sebastian scenes [162], we can discern the stylistic associations with San Clemente, observing at the same time the simplification of the earlier delicate patterning into something bolder. The tear-drop pattern over the shoulder and the nested V-folds over the knees are Byzantine in origin, though the visual orchestration concentrates on abstract rhythms, as at San Clemente. Surviving seventeenth-century drawings help in the iconographical reconstruction of the cycle,[133] and demonstrate that the Creation scenes were related to versions in manuscript illuminations of the Roman area which themselves may reflect a much earlier Roman tradition of monumental paintings.

San Clemente also influenced the much more laboured murals of the basilica of Sant'Anastasio at Castel Sant'Elia near Nepi,[134] north of Rome. Their affinities with the illustrations of the St Cecilia Bible of 1110–25 may date them to within a few years either side, though some would put them earlier. In the apse is the traditional monumental Christ between St Peter and St Paul, with St Elias further to one side and on the other perhaps St Anastasius, episodes from whose life appear on the right of the apse. Below is the divine Lamb in a medallion, with twelve other lambs – the apostles – issuing in four groups of three from Jerusalem (and originally from Bethlehem, too). Below again, processions of female martyrs offer their crowns to a now almost obliterated Virgin (or Christ). The elders of the Apocalypse on the east wall of the transept bear chalices instead of crowns. On the north and south transept walls are saints and prophets and scenes from the Apocalypse in various states of preservation. Monastic patronage appears to be indicated by the monk, or abbot, beside one of the archangels accompanying the female martyrs in the apse, and it seems, too, from an inscription[135] that the three artists involved were monks, for they are described as brothers from Rome named John and Stephen with John's nephew, Nicholas; had John and Stephen been siblings, rather than brothers in religion, Nicholas would have been the nephew of both.

Stylistically related murals in the small oratory behind the apse of the Roman church of Santa Pudenziana[136] are probably datable to the early twelfth century, though Matthiae would link them with works carried out under Gregory VII (1073–85).[137] Mostly fragmentary, they consist of evangelist symbols and scenes from the lives of St Pudenziana and her family, including St Paul's baptism of four members of it. Least damaged is the Virgin and Child, flanked by St Pudenziana and St Praxedis, behind the altar [163]. The saints are very Byzantine in appearance, though the whirling movement of the fluid lines of the Virgin's draperies is Western.

Also linked by style to Castel Sant'Elia are paintings formerly in the Grotta degli Angeli at Magliano Romano and now in the Museo di Palazzo Venezia in Rome[138] of Christ in a medallion with the archangels Michael and Gabriel, a Christological cycle, and various saints. The work was commissioned, says an inscription below the figure of Gabriel, by a certain John in memory of his mother, and at the feet of St Nicholas is a man identified as Rigettus.

A much freer recension of the Castel Sant'Elia style characterizes the nave paintings of Santa Maria in Cosmedin[139] associated with the renovations of 1123. Their quality is good, their condition poor, and their subject matter intriguing. Scenes drawn from the lives of Charlemagne and Nebuchadnezzar on opposite walls symbolize the actions of the just and of the unjust ruler, with contemporary reference to the embittered controversy between Church and State.[140] Charlemagne, already the exemplary Christian monarch of legend, is here idealized as summoned by God to a Crusade in Spain, liberating St James's tomb at Compostella, converting the pagans, being acclaimed at St Peter's, and finally making a pious death – in sharp contrast to the fate

162. Rome, Old Lateran Palace, chapel of St Sebastian, *The martyrdom of St Sebastian*. Wall painting. *c.* 1100–30

163. Rome, Santa Pudenziana, oratory, *The Virgin and Child flanked by St Pudenziana and St Praxedis*. Wall painting. Early twelfth century(?)

of a more recent emperor, Henry V, who had been refused Christian burial by the pope, and is one of the more recent unjust rulers symbolized by Nebuchadnezzar, who is shown persecuting the Israelites in an allegory of the current alleged imperial oppression of the Christian Church.

Visual comments on the dispute between empire and papacy made for the secret council chamber of the Lateran[141] are now unfortunately known only by seventeenth-century copies. Among them were representations of five popes in the full panoply of their power treading underfoot the antipopes – puppets of the empire – and of Pope Innocent II crowning Lothar III at Rome in 1133. An accompanying inscription drove the message home by reiterating that the emperor cannot receive the crown until he has submitted to the pope. Here, as elsewhere, art was being brought into the service of a partisan interest.

The tendril patterning of paintings in the Roman church of Santa Croce in Gerusalemme,[142] which are usually linked with the restorations of *c.*1145, is similar to that found at San Clemente. Quite different in style however are the noble and authoritative medallion busts of twenty-eight patriarchs of the Old Testament, and those painted by the best of the three artists have a lively presence. The style is strongly Byzantinizing, as in the murals of San Pietro at Tuscania,[143] north of Viterbo, where the enormous Ascension in the semi-dome of the main apse has a fine sweep, though the detail is disappointing and the Christ, once giant-sized, is now only

fragmentary. In better condition are the accompanying apostles and angels, which give some idea of the original style. The triumphal arch bears associated Apocalyptic symbolism – the Lamb, the seven candlesticks, and the elders with their crowns – and in the right apse is another large-scale Christ, this time with bishop-saints, while in the left apse we see the Baptism of Christ. Scenes from the lives of St John the Baptist and St Peter are in the left aisle, and those on the right choir wall include a dramatic scene of the reconciliation of St Peter and St Paul where the saints hasten to embrace each other under the quietly approving gaze of two flanking groups of onlookers [164]. In the apse of the crypt is an enthroned Virgin with saints. The three artists of these paintings were all Romans, and Matthiae[144] associates their work with the date of 1093 on the ciborium of the high altar, though Garrison[145] – to my mind more plausibly – attributes it to the second quarter of the twelfth century.

The twelfth-century murals of central Italy are often ambivalent – attracted to Romanesque but never quite able to escape the magnetic field of Byzantium – and the same is true of the region's contemporary manuscript paintings, which will be discussed after a survey of their few predecessors.

The efflorescences of illumination in the Carolingian and Ottonian empires between the early ninth and the mid eleventh centuries found no echo in central Italy, which remained a provincial backwater. Ironically, it was only when

164. Tuscania, San Pietro, choir, *The Reconciliation of St Peter and St Paul*.
Wall painting. Second quarter of the twelfth century(?)

the transalpine wells had dried up in their homelands that they began to water the fields of Italian manuscript painting, for it was at this time, when the eleventh century was more than half over, that Carolingian and Ottonian influences, in succession, began to make their mark on the decorative initials of central Italy. The Ottonian impact was the longer lived, and its tight, stiff leaf-work became quite common in manuscripts, two of which – both products of the monastery attached to the church of Santa Cecilia in Rome – are dated: one, a Gradual, to 1071, the other, a copy of Remigius's *Commentary on the Pauline Epistles*,[146] to 1067. Ottonian-inspired initials continued well into the twelfth century in conservative scriptoria of Rome and the papal territories, for example at the abbeys of Farfa and Subiaco.

The Ottonian influence on figure styles, apparent especially in the last quarter of the eleventh century, was not felicitous. The clumsy, somewhat massive figures of Solomon and Tobit in the great Palatine Bible,[147] made between *c.*1080 and 1090, for example, are an advance on the crude outline styles of

earlier eleventh-century manuscripts such as the Santa Cecilia Remigius, but they are no more than a parody of Ottonian art. The figures in two contemporary manuscripts of the region, a copy of Burchard's *Liber Decretorum*[148] and a *Moralia in Job*,[149] also betray some knowledge of Carolingian and Anglo-Saxon (or Channel) art. The illustrations of the *Moralia in Job* lay great emphasis on the relationship of the Old Testament to the New, which is natural, for St Gregory is allegorizing the Old Testament as symbolic of Christ and his Church faced by their enemies, the heretics; the text of the *Liber Decretorum*, however, is far removed from such forms of theological exegesis, yet the artist still introduces a tabloid reference to the inherent relationship between the two Testaments by making his Trinity consist of three Old Testament patriarchs, Abraham, Isaac, and Jacob.[150]

The style of the Palatine Bible spread northwards to the diocese of Chiusi in the neighbouring area of Tuscany, where it is found in a giant Passional[151] of the end of the eleventh century comprising some sixty-nine illustrations. The picture

of St Saturninus[152] demonstrates the sheer casualness of some influences in art, for it is clearly based on pre-Carolingian styles from the British Isles and even conserves an iconography which may have inspired the Alfred jewel.[153] However, most of the illustrations – of which the most competent are the St Leucius, St Tirsus, and St Galenicus on folio 33 verso and the St Faustinus and St Jovita on folio 39[154] – are in a crisper version of the Palatine style.

Inscriptions in a Roman Bible known from its present home as the Munich Bible[155] tell us that it was given to the monastery of Hirsau by Henry IV – presumably before 1084, since he is described as *rex* and not *imperator*, and perhaps in 1075, when he confirmed the monastery's privileges. Its illustrations are oriented iconographically towards the Palatine Bible and stylistically in the direction of Germany and – in the four evangelists preceding the Gospels – the areas known today as north-east France and Belgium. Most of the single figures are laboured and ungainly, though the Solomon is rather more competent.

During the tenth century and the first half of the eleventh, northern Europe was more concerned with lavishly illustrated Gospel Books and Service Books than with Bibles. Some were for the personal use of the patron, often a bishop, so that many of the famous Gospel and Service Books of the Anglo-Saxons and Ottonians are still known by the names of their original owners – the Benedictional of St Aethelwold, for example, the Sacramentary of Robert of Jumièges, the Gero Codex, the Egbert Psalter, and so on. It was only in the late eleventh and twelfth centuries that large-scale illuminated Bibles became generally popular, though there were a few Carolingian ones, including the Bible of Charles the Bald which (if the local tradition is correct that it was Gregory VII who gave it to San Paolo fuori le Mura) may have been the papal gift that sparked off the new interest in great Bibles in Italy – there is certainly a relationship in terms of size and shape and arrangement of text. On the other hand, as we shall see in Chapter 9, Saint-Vaast had already in the first half of the eleventh century produced one giant Bible in three volumes,[156] following the layout of Carolingian Bibles, and it is perhaps more likely that it was north-eastern France that provided the immediate impetus for these new giant Bibles of the Romanesque period. However this may be, it was in Italy – particularly in the papal territories[157] – that giant Bibles were most intensively produced, and it was Rome and the papal states that set the fashion for them in the West and gave the stamp of approval to the programme of illustrations which, with variations, was to become general in Latin Christendom.[158] Beginning with a magnificent title-page and a grand and elaborate initial to St Jerome's Prologue (and frequently also to the Book of Genesis), the Bible's main divisions were thereafter signalled by decorated or historiated initials which grew in number as the twelfth century advanced.

After a German-dominated interlude in the latter half of the eleventh century, Italian decorative initials began to assume a personality of their own, first in Rome and then in central Italy and Tuscany, which took over as leaders after the mid twelfth century. Derived from the Franco-Saxon initials of the Carolingian period,[159] the new Italian initials evolved into structures of great clarity and elegance whose

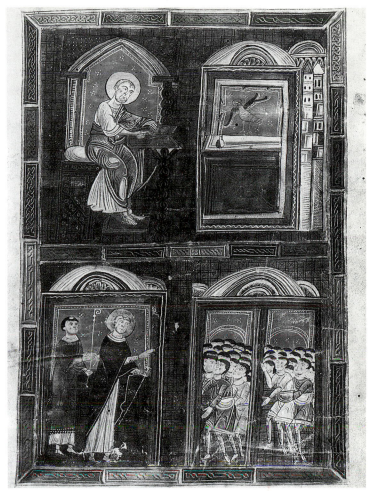

165. Umbro-Roman: *St John writing and St Augustine preaching*, from St Augustine's *Sermons on St John's Gospel*, MS. 193, folio 4 verso. Second quarter of the twelfth century. Madrid, Biblioteca Nacional

style has proved to be of more than artistic significance for, by plotting its gradual progression and refinement, including a lightening of texture and freshening of colour, Garrison[160] has been able to determine relevant dates and chronologies.

The twelfth-century artists exchanged the fumbling modes of the second half of the eleventh century for an ambivalence of their own, for – in the Italian way – they were quite unable to reconcile the Romanesque trends of the north with the perennial influences from Byzantium, as is plain in the St Matthew of a Santa Cecilia Gospel Lectionary[161] which, while hardening its style somewhat in the Romanesque way, still remains in the Byzantine orbit. The illustrations of a Bible from the same scriptorium[162] reflect Byzantine influences at the very time that they renew the stiffness of Italian eleventh-century styles, and as a result, some of the figures look for all the world like stolid peasants parading in the mantles of Eastern emperors; other pictures, however, for instance the St Peter on folio 358 verso, are less provincial. The linearized Byzantinism of this manuscript suggests transmission via Montecassino, and the almost calligraphic drapery folds looped over the legs of Daniel and Amos seem to anticipate the style of the Tivoli tabernacle [167]. The date of 1097 in the St Cecilia Bible is on a gathering which may not originally

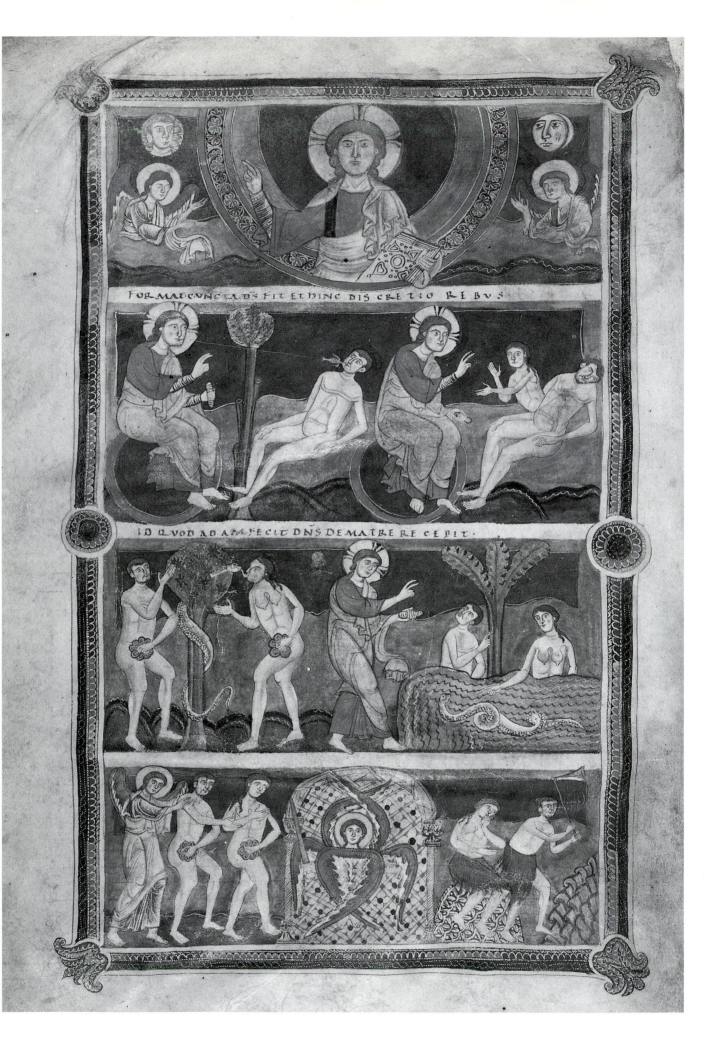

FORMAT CVNCTA DS FIL ET HINC DISCRETIO RERVS

ID Q VOD ADAM FECIT DNS DE MATRE RECEPIT.

have belonged to the manuscript, so opinions are divided, one scholar placing the Bible at the close of the eleventh century, another between 1110 and 1125.[163] The finesse of the initials suggests that the later dating is more likely to be correct. The Santa Cecilia style is ultimately no more than a recension of the current Roman manner, but it exerted influences outside its own scriptorium, for example on the copious, if stilted, illustrations of a Lombard Psalter[164] from the Cluniac house of Polirone near Mantua, and on an Umbro-Roman St Augustine[165] with its satisfying full-page picture of St John writing and St Augustine preaching [165].

The most lavishly illustrated of all the giant Bibles of the Umbro-Roman area is the Pantheon Bible,[166] formerly in two volumes and probably made early in the second quarter of the twelfth century. The most important of the four artists who worked on its forty-eight pictures was responsible for five scenes of the Old Testament and two evangelist 'portraits' of the New. His work embodies the same linearization of a Byzantine style that has been observed at Montecassino, and is indeed closely related to the illuminations of one of the Cassinese Exultet Rolls; and, though the Bible illustrations are not so fluent, there are also some points of comparison with the wall paintings of the lower church of San Clemente. A second artist almost caricatures this style, but is rather more successful in his four illustrations for a contemporary Homiliary-Passional.[167] His manner influenced the illustrations of a giant Bible,[168] originally in the cathedral of Todi, whose frontispiece to the Acts of the Apostles fuses the scenes of the Ascension and of the Mission of the Apostles.[169] A third Pantheon Bible artist was responsible for the Creation scenes [166], whose style and iconography had a widespread influence,[170] taking in both the Todi Bible and the single illustration of what remains of the Angelica Bible,[171] which was made about 1125 for an Umbrian centre. The impact of the Pantheon Bible (or something like the style of its first artist) can also be seen in the Perugia Bible,[172] whose dedication picture shows the donors as a secular, presumably married, couple.

As in the wall paintings of the second half of the twelfth century, so in the vellum paintings of the first half, there is an undercurrent of traditionalism, for the giant Bible scenes of the Creation were based on a Roman iconography of long standing.[173] The fleeting reminiscences of the classical past in the occasional awareness of the substance and structure of the human figure are well illustrated by the Adam and Eve of the Pantheon Bible [166]. It may, as I have suggested earlier, be this traditionalism that prevented a happy assimilation of Byzantine influences into Romanesque, which demands a complete sacrifice of the human figure to an aesthetic of forms and abstractions; this the Italian artist was never prepared to make, as we see in panel paintings as well as in miniatures and murals.

One of the finest Italian panel paintings of our period is the Redeemer[174] long venerated in the cathedral of Tivoli and thought for centuries – like one or two other panel paintings –

166. Umbro-Roman: *The Creation and Fall*, from the Pantheon Bible, MS. Vat. lat. 12958, folio 4 verso. *c.* 1125–30. Rome, Vatican Library

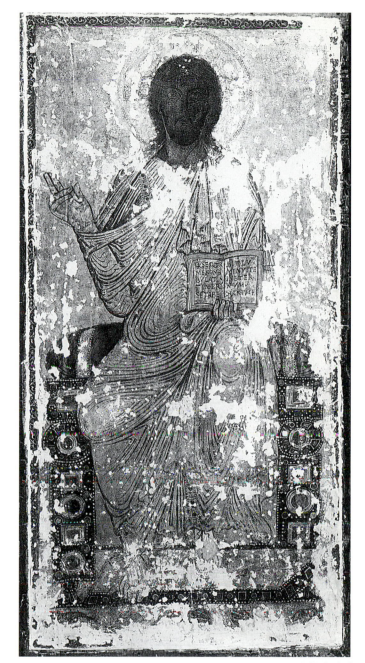

167. Roman: *Christ the Redeemer*. Panel painting. 1110/40. Tivoli Cathedral

to have been made by St Luke himself. In fact it belongs to the period 1110–40 and was probably executed at Rome. Technically speaking, it is a tabernacle – that is, a cult image so sacred that it is normally concealed by doors and exhibited only on special religious occasions such as the eve of the Assumption, when (it is thought) it was carried in procession to be met by an image of the Virgin coming from another direction in a ritual symbolizing the meeting of Christ and his mother at the moment of her death.[175] The shutters that protect the image of the Redeemer reveal, when opened out, two full-length pictures of the Virgin and of St John the Evangelist; in other words, this is a sort of Western Deesis, with the beloved disciple taking the place of St John the Baptist. Below the Virgin are scenes of her Dormition and Assumption, and below St John a representation either of his

last prayer or of his own Assumption. The predominant colours are warm, with reds and blues, mingling into purples at times, strengthened by yellows glowing against the background of gold. The figure of John is particularly fine, with its delicate clarity of definition, and both are unmistakably Byzantine in inspiration. The Redeemer himself has large, all-seeing Byzantine eyes that gleam through the patina of age [167]; his body is painted in a linear and delicate version of the Santa Pudenziana style, whose broad brush-strokes appear to have been translated into threads of red and gold. The cult of the Redeemer seems to underlie similar panel paintings throughout the Lazio region. Eight survive from the twelfth century and the first half of the thirteenth,[176] of which one, now in Tarquinia Cathedral, is notable for such antique features as the carrying of a scroll instead of a book.[177]

A considerably damaged painted cross at Casape,[178] probably the oldest of the Roman School to have come down to us, shows Christ flanked by the Virgin and St John, with an angel above. At Vetralla, the icon of the Virgin[179] derives in some way from the tenth-century Virgin of Santa Maria in Aracoeli, with the addition of two angels. It is in a linear style reminiscent of Roman murals, as is the later icon of the Madonna and Child in Viterbo Cathedral whose iconographic associations with a Madonna at Santa Maria Maggiore place it safely in the second half of the twelfth century.

TUSCANY

Tuscany too produced giant Bibles and other giant manuscripts. Smaller in number, they are more prodigal of illustration, and indeed one of the most lavishly illustrated of all giant Bibles – in two volumes[180] and ascribed to the first quarter of the twelfth century – is attributed to Tuscany because it originally belonged to the cathedral of Florence. Besides a great many decorative and historiated initials, it has forty-three standing or enthroned figures and twenty-five narrative pictures. It is basically in the familiar Italo-Byzantine style of contemporary Rome, with perhaps some traces of Burgundy, particularly Cîteaux.[181] Despite some brick-red, the colours are sombre, and the pictures vary considerably in quality, even the best however being afflicted with a stolid woodenness; but they are interesting because they represent the closest approach that the Italo-Byzantine style made to Romanesque.

As the struggle between empire and papacy is given visual expression in one or two Roman wall paintings, so it is (though now in a more oblique form) in an early Tuscan Gospel Book[182] originally belonging to Matilda, countess of Tuscany. She was the hostess of Gregory VII in 1077 when the empire suffered its most famous humiliation at the hands of the papacy and Gregory kept Henry IV waiting for three days in the snow at Canossa before accepting his proffered submission. The most contentious issue of the dispute between Church and empire concerned the right of the secular arm to appoint to high ecclesiastical office (whence the title 'Investiture Contest'). Another main target of the reformers within the Church, however, was the practice of simony, or the buying and selling of office, abhorrence of which is expressed in the scene on folio 84 of the Gospels showing Christ driving the money-changers from the Temple. This signified his condemnation of simony according to members of the papal camp such as Peter Damian and Cardinal Humbert,[183] and also Anselm of Lucca, who at Gregory VII's recommendation served as spiritual adviser to Matilda:[184] 'It is to be noted', he wrote, 'that ... those who seek Holy Orders by a bribe of money ... are sellers of doves who make the House of God a house of trade.'[185] It can therefore be no accident that in the Christological cycle of the Matilda Gospels, comprising thirty-one pen-and-ink drawings, this episode is given special prominence by alone being assigned a full page.

The interest of another Tuscan manuscript[186] lies in what it has to tell of the way in which the money to pay for it was gathered and disbursed. It is a giant Bible in four volumes, begun in 1168 for the Pisan monastery of San Vito and known as the Calci Bible. A lengthy inscription relates that almost half its cost was defrayed by the money given by fifty-one lay persons specifically for the salvation of their own souls and those of their departed relatives. Sometimes there is mention of their occupations: Burnettus and his son Villanus, who were comparatively large contributors, were smiths; Corsettus, Amicus, and Bonorsus, who gave much smaller sums, were bakers; Petrus and Gerardinus were dealers in fish; and Vivianus was perhaps a quarryman. The smallest amount, only 3 denarii, was given by a man referred to – rather bluntly – as a drunkard ('Ebriacus'). By far the largest contribution came from Mattilda Vecki, who gave 100 soldi to buy 240 sheets of vellum – which proved to be insufficient. Gerard was the name of the man who, either directly or indirectly, made the disbursements, and the priest Gregory seems to have been responsible for obtaining the vellum. The scribes and illuminators were all paid for their work, so they must have been hired seculars. Master Vivianus received the most – fifteen pounds 'and more' – so he was probably in overall charge. His two assistant illuminators – Adalbertus, who received two specific sums for 'the larger letters in gold and colours', and Andreas, who was paid for helping with the letters – got a good deal less than the main scribe, who is not identified. The illumination was on a lavish scale, and the ornamental initials – which are of a certain uniformity[187] – are often further embellished with fillets of gold. Despite some variations of detail, the figure work seems to be by one hand.

Whether by direct influence or parallel development, the styles of Florence and Rome have much in common. Direct influence seems the more likely explanation in view of what we know of an Umbro-Roman artist called the Ávila Master who travelled to Florence about the middle of the twelfth century. His career began in the second quarter of the century with the addition of a frontispiece picture of Christ and David, in a traditional Italo-Byzantine style, to an Umbro-Roman manuscript of Odo of Asti's Commentary on the Psalms.[188] Arriving in Florence in the third quarter, he established a fashion for the styles evolved in Rome and central Italy which can be traced in the work of a whole school of manuscript painting.[189] At this stage, he matures into an artist capable of some nobility. His name derives from his work on a profusely illustrated giant Bible which found its way to the cathedral of Ávila in Castile.[190] It was probably

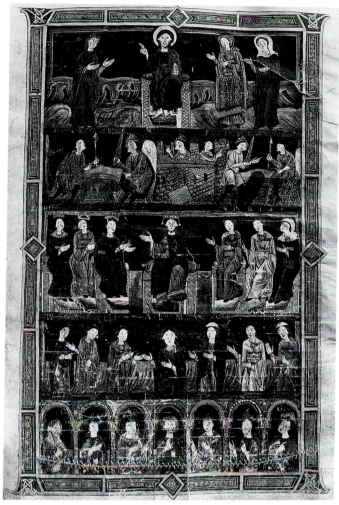

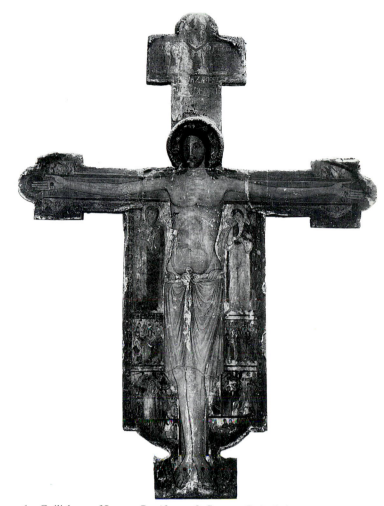

168. Umbro-Roman style in Tuscany: Frontispiece to the Books of Solomon, from a Bible, MS. 2546, folio 13. Third quarter of the twelfth century. Trento, Museo Diocesano

169. Guilielmus of Lucca: *Crucifix*. 1138. Sarzana Cathedral

made in the 1150s, reaching Spain later in the century, when illustrations of the life of Christ were added in a crude but dramatic style. Garrison relates its original paintings to those of a group of manuscripts including a giant Old Testament at Turin,[191] a mutilated giant Bible at Florence[192] completed on 4 October 1140 by its scribe Corbolinus Pistoriensis, and a giant Bible at Trento[193] whose frontispiece is reproduced as illustration 168. They have been associated with Tuscany (one was made for Tuscan use) and their styles are basically Umbro-Roman. They show variations of quality which become particularly erratic when assistants take over.

At Lucca, in spite of some graceful and elegant initials reflecting Channel styles[194] and some pictures peripherally associated with Cistercian illustrations, the basic trends were those of Rome. In the St Barnabas on folio 185 of a giant Passional of about 1125,[195] for example, the drapery styles, the facial types, and the use of green and red tones in the flesh areas reveal a Byzantinism linearized in the Roman way, and specific comparisons have been made with the frescoes of San Pietro in Tuscania.[196] The finesse of Lucchese art is very well expressed in its panel paintings,[197] especially the large and splendid Crucifixions where the format of the background scenes from the life of Christ is reminiscent of

Early Christian art in Italy. One of the most splendid is the great Crucifix of Sarzana[198] [169], painted – so an inscription tells us – in 1138 by a certain Guilielmus. The head and body were somewhat redone in the thirteenth century, but the original draperies are of a fine delicacy. This painting, though more sensitive than much contemporary Roman art, reflects a similar linearization of Byzantine styles – compare, for example, the wall paintings of the Old Lateran Palace chapel. A good many of these Italian Crucifixes survive. They not only reflect but later also embalm the current styles of wall and vellum painting, for they continue them well after the age of Cimabue.

LOMBARDY

The strong hold of Byzantium on Lombardy[199] is exemplified – despite some Ottonian influence – by the remains of eleventh-century frescoes at Sant'Orso, Aosta,[200] where strong colours add drama and movement. Byzantine influence is powerful too at San Vincenzo at Galliano,[201] where the surviving areas of the apse painting present Christ in Glory, flanked by the archangels Michael and Gabriel and by the prophets Jeremiah and Ezekiel. Below are the remains

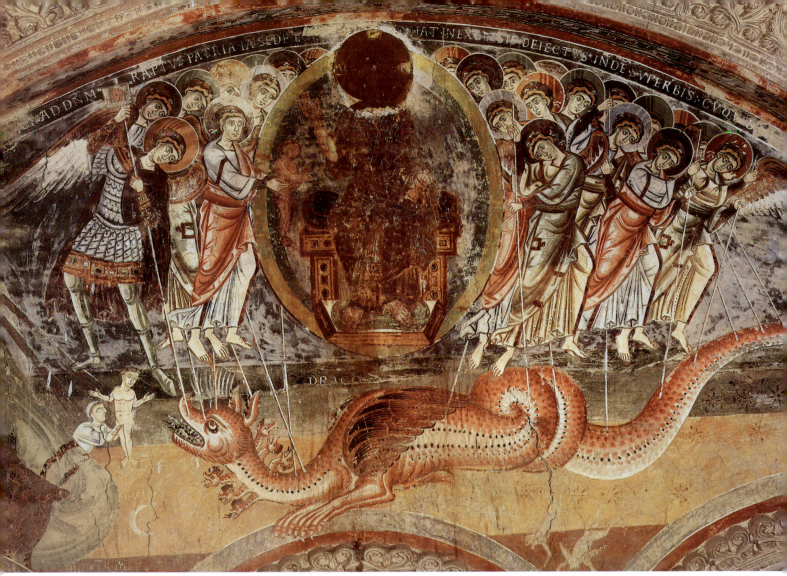

170. Civate, San Pietro, nave west wall, *Angels attacking the Apocalyptic dragon*. Wall painting. Late eleventh or early twelfth century

of scenes of the life of St Vincent. A detail preserved in the Ambrosian Library at Milan shows Ariberto, later archbishop of Milan, offering to Christ a model of the church he consecrated in 1007, the presumed date of the paintings. Their spaciousness of style derives from one of the more 'classicizing' periods of Byzantine art, with which, however, the ponderousness arising from the stilted use of bold highlights is at odds.

The finest of all surviving Lombard wall paintings are at San Pietro di Civate.[202] Only part of the original cycle – chiefly concerned with the Book of the Apocalypse – remains, and after a good deal of oscillation, opinion concerning dating has now settled on the very end of the eleventh century or the beginning of the twelfth. The style is fairly typically Lombard: the angelic hierarchies, for example, can be related to saints in the paintings of San Giorgio in Borgo Vico at Como,[203] completed in 1082, and other figures to the paintings of San Michele at Oleggio in the plain of Novara. Further influences derive from Byzantium and from the tenth-century Macedonian Renaissance, while the Liuthar School of Ottonian Germany seems to be echoed in the intensity of the angels above the archway leading from the narthex to the

nave; iridescent with colour and making a superbly throbbing composition, they thrust out at their magnificent multicoloured foe in the course of that 'war in heaven [when] Michael and his angels fought against the dragon' (Apocalypse XII, 7) [170]. In contrast, the serene picture of Christ in the Heavenly Jerusalem, in the vault of the narthex, is of a tranquillity and freshness which no black-and-white illustration can hope to convey [171]. All the symbolism of the Apocalypse is present – Christ as the Lamb of God, the gates to north, south, east, and west, the twelve precious stones representing the apostles, and so on. The painting has a gentle, pastoral quality – the apple-greens and blues are soft and cool, a stream gushes forth below the Lamb, and the sensitive delineation of the foliage of the trees is comparatively naturalistic. We have no idea of how the influences behind this painting reached Civate – perhaps they derive from a lost early mosaic, or from a classical naturalism revived in a minor form in illustrated texts of natural history· during the tenth-century Byzantine Renaissance – but, after the customary arid repetition of Byzantine formulae, this draught is as invigorating as it is unexpected.

Such freshness and accomplishment make us regret all the

more the loss of so much Lombard wall painting, and our resulting restricted view of it. In and around Verona,[204] on the eastern edge of the old Lombard kingdom, however, is a pocket of fragmentary murals that allows us to chart a relationship with Carolingian and Ottonian art. Indeed, a connection with the transalpine territories can be documented as early as 799, when Egino, bishop of Verona, retired to the abbey of Reichenau to spend the last three years of his life.[205] The decoration of the sacellum of SS. Nazaro e Celso,[206] dated 996 by a now-vanished inscription recorded in 1889, indeed shows stylistic similarities to the exactly contemporary murals of Goldbach and Oberzell: the arched eyebrows, the long, thin nose, and the curly beard of the Christ in a mandorla supported by angels (and originally surrounded by the evangelist symbols) in the vault at Verona are features that can be paralleled in the German works. A quite different style, in which the squat figures bear some resemblance to those of the Carolingian Stuttgart Psalter, is evident in the Crucifixion in San Pietro Incarnario in Verona.[207] The emphasis of Ottonian Germany and Anglo-Saxon England on the sufferings of Christ is absent, and the Saviour, as in earlier times, is the victor over death, his body erect and his eyes wide open. Although a date in the later eleventh century has been suggested,[208] there is justification for preferring the tenth.

Later works of the Veronese region indicate both infiltration by, and an apparent indifference to, Byzantium. On the one hand the Christ in Majesty, perhaps of the later eleventh century, that dominates the western apse of San Giorgio di Valpolicella[209] has a Byzantine massiveness (there are further scenes on the triumphal arch, including Christ's Baptism). On the other, however, the Visitation, the Nativity, and the martyrdom scene in the nave of Sant'Andrea at Sommacampagna,[210] probably of the first half of the twelfth century, are in a totally Western narrative idiom. In the martyrdom scene,[211] a saint is tied to a wheel propelled by a group of tormentors whose leader, in accordance with a longstanding convention for the representation of the wicked, is shown in rigorous profile.

The frescoes of Santa Maria at Bonavigo,[212] close to Legnago, are in a manner so thoroughly Byzantine that their painter must have had first-hand knowledge of Eastern works. They are of the second half of the twelfth century. In the left-hand apse, two standing saints are seen with the nimbed

171. Civate, San Pietro, narthex, *The Heavenly Jerusalem*. Wall painting. Late eleventh or early twelfth century

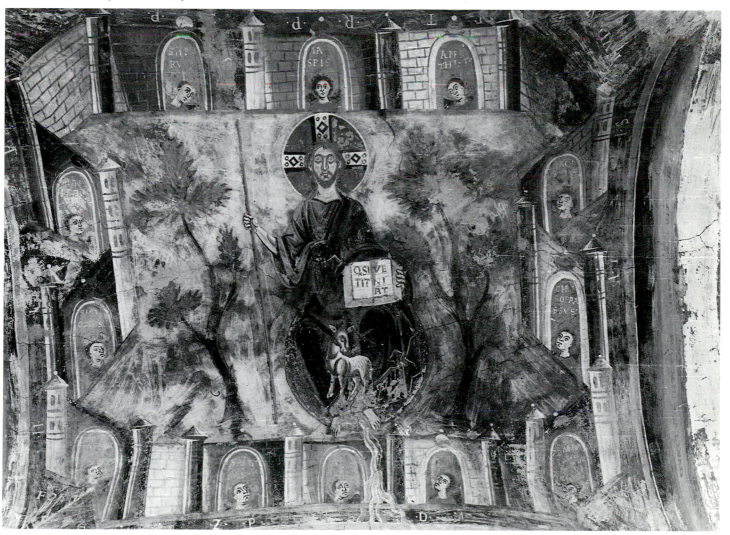

half-figure of a bishop, and in the semi-dome of the right-hand apse the half-figure of a youthful, short-haired, beardless Christ with huge, almond-shaped eyes, blesses with the right hand and holds a closed book in the left. Below him are a nimbed bishop and a holy warrior (St George?) dressed as a Byzantine soldier and carrying a spear. At a later date this church was dependent on the monastery of San Michele at Murano, on the Venetian lagoons, and it is possible that this connection existed already in the twelfth century:[213] if so, it might account for so strongly Byzantinizing a style in so remote a locality, for Venice traded with the Eastern empire and in the eleventh century received Greek artists to work on the decoration of St Mark's, and may therefore conceivably have sent an artist to Bonavigo.

VENICE AND AQUILEIA

The mosaics of St Mark's at Venice are known to the whole world. They were set up between about 1070 and the late thirteenth century, and they have been analysed in considerable detail by Otto Demus,[214] on whose published researches the following account of the eleventh- and twelfth-century mosaics relies.

The present church, the third on the site, was begun in 1063 by a Greek architect who modelled it on the Apostoleion in Constantinople. The decoration was initiated by Doge Domenico Selvo (1071–84), who brought in a mosaic master from Constantinople at a time when the relationship between Venice and Byzantium was particularly cordial. The accession of John II Comnenus in 1118 however led to a war between the two states, whereupon Venice turned to local Greek-trained craftsmen. Then at some time in the twelfth century a calamity occurred – probably an earthquake – that damaged both St Mark's and the cathedral of Torcello, where the apostles in the main apse had been set by the same Greeks who had been responsible for the earliest mosaics of St Mark's in the 1070s.[215]

These earliest mosaics – the Virgin and Child, eight apostles, and four evangelists – adorned the niches around and above the central door leading into the church from the atrium. About 1084 another group of Greek mosaicists took over whose chief craftsman, the master of the figure of Mark, was later to work on the great apse mosaic of the Basilica Ursiana at Ravenna, dated 1112 by inscription. They set up in the main apse of St Mark's the four figures of saints associated with Venice, and may also have executed an enthroned Pantocrator in the conch (replaced in the sixteenth century). Their style continued in a more linearized form in the mosaics of the east dome,[216] of which two-thirds were destroyed in the twelfth-century calamity, so that today only the group of the four prophets Jeremiah, Obadiah, Habakkuk, and Daniel remains.

After an intermission the local mosaicists took over. If the master of the next stage was not Greek-born, he was nevertheless Greek-trained, for in all important respects his five scenes of the life of St John the Evangelist in the north dome[217] are Byzantine. These mosaics belong to the first half of the century, and so do those of the south vault of the central dome[218] representing the Temptation, the Entry into Jerusalem, the Last Supper, and the Washing of the Feet,

together with six prophets (three renewed in the sixteenth century). The sense of modelling here suggests that the chief master had been able to profit from an examination of Byzantine mosaics – probably on Italian soil, for his use as a primary source of an illustrated Byzantine manuscript of the late eleventh or early twelfth century seems to indicate that he was denied access to the mosaics of Byzantium itself. This would explain the dependence on archaic Byzantine styles of the second quarter of the eleventh century of the mosaics of the south dome[219] as well as their inadequacy for the site where the doges made their ceremonial entrances: there is only a central cross with four standing state saints of Venice in the dome itself and four female saints in the pendentives, in a style taken up by the single saints on the ground-floor and tribune arches giving on to the body of the church.

The heavily restored miracle scenes in the north vault of the central dome, the north and east bays of the north transept, and the south and east bays of the south transept are thought originally to have comprised as many as twenty-nine episodes. They rely on a Byzantine source, but not a contemporary one, and their iconography seems to derive from an illustrated manuscript of the eleventh century. Their style continues that of the somewhat earlier mosaics of the choir chapels of St Peter and St Clement,[220] which in all

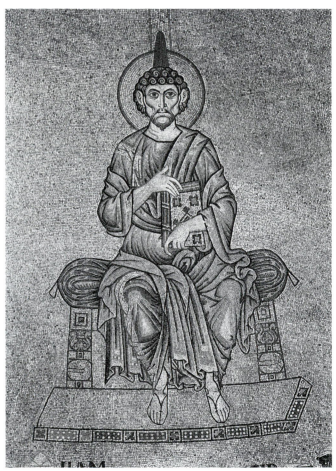

172. Venice, St Mark's, west dome, *St Luke from the Pentecost scene*. Mosaic. First half of the twelfth century

173 (*opposite*). Venice, St Mark's, central dome, *The Ascension*. Mosaic. *c.* 1180–90

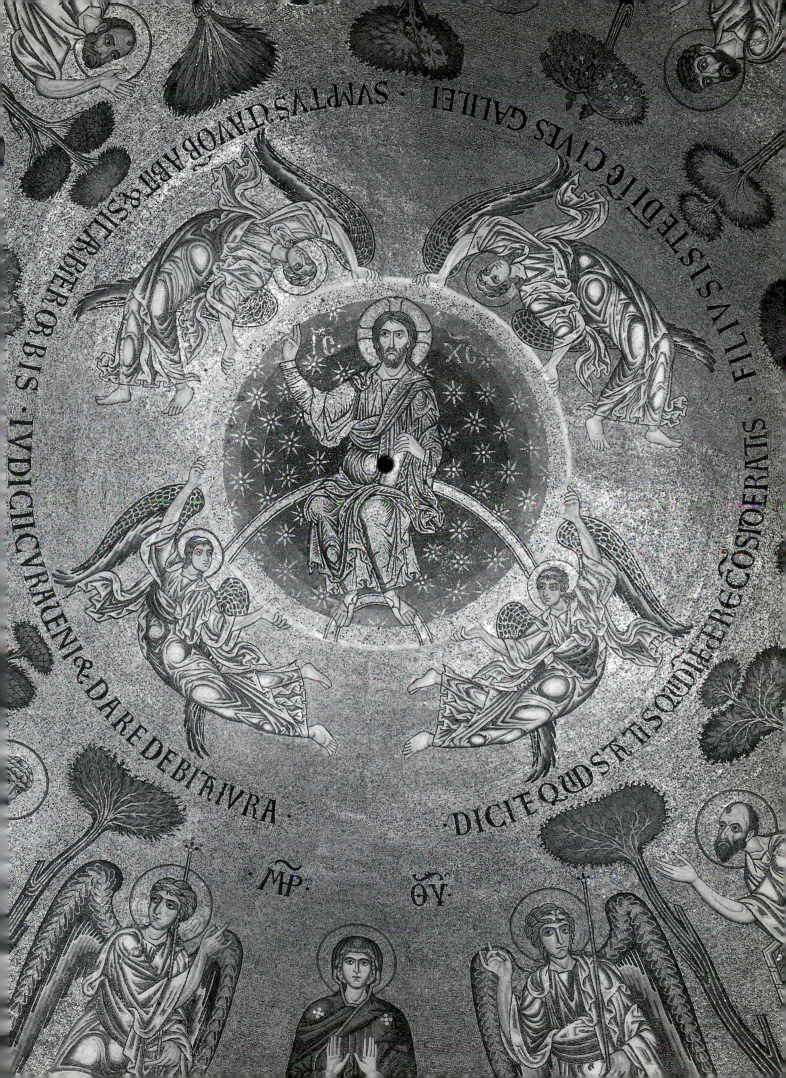

SVMPTVS QVOB AB T ? SILT ER BQR.BIS · IVDICI CVR HENI & DARE DEBIT IVRA · DICIT Q D SAT IS Q D I & RE COS I OP ERATS · FILIVS ISTE DICIT E CIVES GALILEI

ĪĊ XC

MP ΘV

likelihood belong to the first quarter of the twelfth century. One of the episodes in the St Peter chapel shows the Patriarch Helias of Grado successfully petitioning Pope Pelagius for confirmation of his powers over Istria and Dalmatia, and there is another indication of Venetian pretensions in the chapel of St Clement, where, in apparent sanctification of the doge's rule, his throne is placed near the figures of Christ and the Virgin. In the apses are St Peter and St Clement, much restored, together with St Theodore and St Pantaleon. On the south wall of the St Clement chapel is a sacrifice of Cain and Abel, also much restored, and a cycle of the life of St Mark. The translation of his relics to Venice from Alexandria – perhaps based on an earlier one in the church – extends over both chapels, and in the galleries, or organ-lofts, are Church Fathers and two scenes from the lives of St Peter and St Clement. Not only the artists of the two chapels but the materials too – stone and enamels – were local (which means that the mosaics lack the brilliance of colour of the earliest ones at St Mark's), confirming that historical events had closed them off from Byzantium.

The mosaics of the west bays of the south and north transepts[221] comprise one of the most extensive cycles of the life of the Virgin and the infancy of Christ left to us by the monumental arts. Its source – a Middle Byzantine illustrated manuscript of the second half of the eleventh century – was similar to one being used at about the same time in the Mirozh cathedral of Pskov in Russia, and comparisons have also been made in terms of style with the Virgin in the apse of SS. Maria e Donato at Murano.

The figures of the Pentecost in the west dome,[222] still of the first half of the twelfth century, continue to be local in quality, though the Luke master [172] is genuinely talented and may have had Byzantine training. Indeed, the apostles derive from more immediate contemporary Byzantine sources than hitherto – sources that are monumental, not miniature – and a new rapprochement is confirmed by the setting of a Pentecost in a cupola, for which there were models at Constantinople itself, in Hagia Sophia and the Apostoleion, and at Hosios Lukas in the presbytery – the only Eastern example to have survived to our day. At St Mark's, the representatives of the nations mentioned in the Acts of the Apostles are set not, as elsewhere, in the pendentives, but between the windows, where there was an exactly appropriate number of spaces for them.

Contact with the more recent developments at Byzantium seems indicated, too, in the work of the last third of the century – much of it making good the destruction and damage caused by the catastrophe. A new vitality infuses the mosaics set up in the time of Doge Sebastiano Ziani (1172–8) to replace the damaged ones of the east dome.[223] Here, the nine prophets and the Virgin (who mirrors the Virgin of St Sophia in Kiev) have all the vigour and agitation of the recent dynamic phase of contemporary Byzantine art. The Ascension in the central dome[224] [173], probably of the 1180s, reflects the final stage of this style, characterized as it is by a subtle shading of the figures and a rhythmic harmony of composition. Its artist was very much alive to current stylistic developments in Byzantium, and is the first of the Italians to assert his own creativity; indeed he offered such artistic competition to the Greeks that Demus could describe his

Ascension as 'probably the most impressive and best preserved cupola composition of the theme that has come down to us'.[225] This Italian was clearly throwing off his tutelage to the Greeks. Between the sixteen windows are personifications of the Virtues and Beatitudes – a strongly Western element – and the rivers of Paradise alongside the evangelists in the pendentives are also Western. Now the mosaicists who had worked both at St Mark's and at Torcello in the latter part of the eleventh century had been Greek, so it is worth remarking that it was a Venetian mosaicist – either this one or a colleague from the same shop – who now replaced work at Torcello damaged by the earlier catastrophe; his mosaics included figures in the Last Judgement scene and parts of the decoration of the east end.

The Byzantine dynamic style continues in the scenes of the Passion and Resurrection of the west vault of the central dome of St Mark's,[226] finding particularly powerful expression in the Harrowing of Hell [174]. Now much restored, these mosaics are attributed to the 1180s or 1190s, and Demus draws attention to the Western practices of combining several episodes into a single composition and of using inscribed scrolls. That the mosaicists of Venice were finding their true creative selves in the final decades of the century is demonstrated particularly well by their scenes of the lives of the apostles[227] in the lateral vaults of the Pentecost dome (those on the north side are Baroque replacements). Building on the access of power and confidence occasioned by the fall of Constantinople in 1204, they went on in the thirteenth century to enhance further areas of the church with sumptuous decoration.

The grandiose cycle of the mosaics of St Mark's naturally made an impact elsewhere, and influence from the earliest ones can be detected in the remains of the murals of the cathedral baptistery of Concordia Sagittaria in the Veneto,[228] attributed to the end of the twelfth century. The St Mark's mosaics are reflected too in the wall paintings of the cathedral of Aquileia,[229] wall paintings executed by three artists at the turn of the twelfth and thirteenth centuries on the walls and barrel-vaults of the crypt and on the soffits and spandrels of the arcades separating the three aisles. The crypt was dedicated to the Virgin and to the martyrs of Aquileia, and so we have the Virgin in Majesty with evangelist symbols in the middle of the central barrel-vault, and scenes elsewhere from the martyrs' lives, besides the Crucifixion, the Deposition, the Pietà, and the Death of the Virgin. In the Deposition [175], the tightly knit group of mourners on the left is reminiscent of the version at St Mark's, and the expressions of grief have the dramatic intensity of the Byzantine murals of 1164 in the church of Nerez in Yugoslavia. The apostles in the spandrels of the centre aisle, too, have Byzantine affiliations, and may be compared with the figures of the apse mosaic of San Giusto in Trieste.[230] The dado painted to look like a hanging, however, is a markedly Western element. Its scenes in red outline include a specially lively one of a knight on horseback pursuing an archer, also mounted [13].

The murals of Aquileia Cathedral are among the finest to survive from twelfth-century Italy, but this northern part of the peninsula will always be primarily associated with mosaics, and the same is true of Sicily to the south.

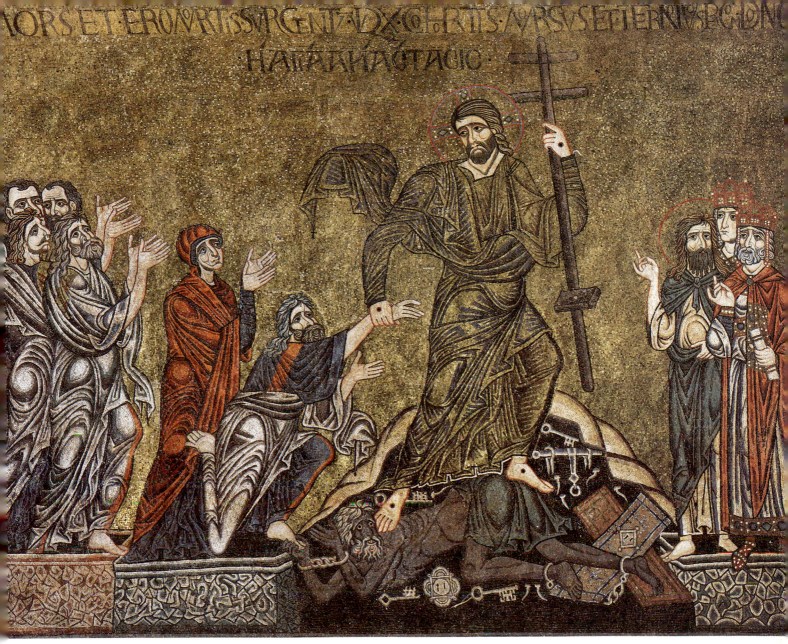

174. Venice, St Mark's, west vault of the central dome, *The Harrowing of Hell*. Mosaic. *c.* 1180–1200

SICILY

Sicily benefited from the cultures of all three of its medieval conquerors – the Byzantines, the Saracens (who remained for over two hundred years), and the Normans (who stayed from 1091 to 1194) – but in the twelfth century its art was oriented towards Constantinople. The Norman kings, no less than the Byzantine emperors, were well aware of the prestige conferred by splendid works of art, and were particularly drawn in this respect to mosaic. So it was that, about 1190, Hugh Falcandus could praise even one of the smaller buildings of Sicily, the Palatine Chapel at Palermo, for its 'wonderful mosaic-work',[231] and in the space of about fifty years, starting *c.*1140, the cathedral of Cefalù, the church of St Mary (the Martorana) at Palermo, the cathedral of Monreale, the palaces of Palermo and of the Ziza, the Palatine Chapel itself, and other buildings now lost, were all richly clothed with mosaics. The Normans also knew that political points could be made

in the medium, and so their contention that the jurisdiction of the Sicilian monarchy was divinely ordained was illustrated in mosaics in the Martorana and at Monreale respectively of Roger II and William II being crowned by the Divine Ruler. The antipathy to papal claims to primacy was expressed in the mosaics of the main apse of the Palatine Chapel by a representation of St James in the full regalia of the primate of Jerusalem;[232] and indeed the cathedral of Cefalù, with its wealth of mosaics, was built as part of King Roger's campaign to strengthen the hand of the Sicilian Church against the claims of Innocent II. However, when William II switched to a pro-papal stance, Pope Clement I, who had supplied some of the earliest evidence of Rome's primacy in his letter to the Corinthians, and Pope Sylvester, who was credited with the baptism of Constantine the Great, were represented in the mosaics of the cathedral of Monreale,[233] whose very construction and magnificent decoration constituted a deliberate attempt by the King and his vice-chancellor Matteo

175. Aquileia Cathedral, crypt, *The Deposition*. Wall painting. *c.* 1200

d'Ajello, with the support of the papacy, to abate the dangerous influence of the archbishop of Palermo, the Englishman Walter of the Mill, who headed a faction of the Sicilian nobility.[234]

These mosaics of Norman Sicily – the most extensive to survive from the twelfth century – are not in fact Western. Although Sicilians worked on the upper walls of the presbytery of Cefalù around 1170[235] and – more extensively – on the latest mosaics of the Palatine Chapel in the 1160s or 1170s,[236] and although the Palatine's Genesis cycle seems to have been modelled on a southern Italian prototype, the fact remains that the mosaics of Norman Sicily were primarily the work of Greek artists (who, as it happens, continued their work elsewhere, especially in the church of Grottaferrata,[237] which belonged to an abbey with a Greek community). The Sicilian mosaics themselves, then, fall outside the context of this volume, though their impact on English and German painting will be dealt with later. On Italian painting they made oddly little impression, except at the cathedral of Anagni[238] in the thirteenth century.

They had little influence either on the illumination of Sicily, although the enthroned emperor Frederick Barbarossa among the illustrations of a manuscript probably made at Palermo shows some knowledge of the mosaics of the Palatine Chapel.[239] The chief interest of this manuscript is again political, for it illustrates the diatribe in which Pietro da Eboli

upheld the claims to the Sicilian throne of the German emperor Henry VI against those of Tancred, the last Norman king of Sicily. The styles of the manuscript are unusually eclectic, including Byzantine, southern Italian, and Saracenic components.[240]

Such eclecticism is absent from the only known Sicilian school of manuscript painting, the School of Messina.[241] It developed under the patronage of Richard Palmer, the English archbishop of Messina between 1182 and 1195 who was also responsible for the decoration of the apse of the cathedral of Syracuse. The illuminated manuscripts he commissioned are of very fine quality. Despite some transalpine influence (traceable, for instance, in their interest in historiated initials), they are heavily indebted to Byzantium, through contact either with the mosaics of Monreale or with the art of Jerusalem, which had its own affiliations with Constantinople. The school's most impressive surviving production is a Missal now at Madrid[242] whose splendid full-page pictures have some Western dramatic overtones but are otherwise saturated with Byzantine influences, as we can see from the Virgin and Child on folio 80 [176]. Indeed, they are Greek in many ways – Greek in style, in inscription, and in iconography. The initials of two Gospel Books of the group – one now in Florence, the other in Malta[243] – betray knowledge of the illumination of Jerusalem, and the paintings of four other volumes in

176. Messina: *The Virgin and Child*, from a Missal, MS. 52, folio 80.
1182/95. Madrid, Biblioteca Nacional

177. Messina: Initial to St John's Gospel, from a Bible, MS. 6, folio 175.
1182/95. Madrid, Biblioteca Nacional

Madrid[244] reflect the mosaics of Sicily and the manuscripts of central Italy [177].

Because of the number of books it contained, the Bible in the Middle Ages was often referred to as a Bibliotheca, or library, and a Bible from Messina[245] is almost literally a library, for it is in no less than seventeen volumes. Its chief artistic interest is its initials, which show a growing conflation of the styles of East and West which would, no doubt, have progressed farther had not the meteoric life of the Messina School – a life as brief as it was brilliant – been brought to an untimely end by the death of its patron, Richard Palmer.

Painting in France and in Jerusalem

MANUSCRIPT PAINTING

HISTORICAL BACKGROUND

After the collapse of the Carolingian empire, its Frankish territories flew apart and became a patchwork of small and hostile provinces owing grudging recognition to a series of unfortunate kings. France as we know it today did not exist, so use of the term in this book is in fact anachronistic; in the twelfth century 'regnum Franciae' usually meant no more than the Île de France, and throughout our period Provence, most of Burgundy, and the eastern areas of the present-day republic were all outside the kingdom. This contrasted with the empire's German lands, which, as we have seen, developed into a wealthy confederation of a few strong duchies acknowledging a central imperial authority and in the tenth century producing an efflorescence of painting without parallel in 'France', whose slow artistic recovery did not begin until the eleventh. 'France' had no settled and wealthy ecclesiastical and secular princes to provide sustained patronage: at the time when Egbert, archbishop of Trier in Ottonian Germany, was able to shower the arts with lavish generosity, his French counterpart, the archbishop of Reims, was powerless – beset by brigands in his own palace.[1] The age that gave birth to the Cluniac order was not one of complete disarray, but 'French' art of the tenth and eleventh centuries was more sporadic and more particularist in character than German art.

NORMANDY

The great monastic reform movement which had swept Germany and England in the tenth century reached Normandy in 1001 when, at the invitation of Duke Richard II, William of Volpiano, abbot of Saint-Bénigne at Dijon, came to head the abbey of the Holy Trinity at Fécamp. Before this time, Norman illumination had survived but precariously on crumbs from the table of Carolingian art, and examples are rare and – like the somewhat wooden presentation scene in a manuscript now at Avranches[2] – not very accomplished. But even after William's arrival development was slow, and was at first centred primarily at Fécamp and Mont Saint-Michel. Artists then were still steeped in Carolingian art, but Ottonian influences were creeping in, and in a Mont Saint-Michel manuscript[3] the very competent St Augustine disputing with a heretic adopts a stance similar to that of the Gregory Master's Otto II [126]. The Gregory Master's flat planes are also in evidence, together with Ottonian colours.[4] But if Ottonian influence was a trickle, AngloSaxon influences formed a flood, well demonstrated in the fine drawing of St Michael and the dragon in another manuscript from the Mount[5] [178].

Pre-Conquest links had been forged by Edward the Confessor, who showed marked favour to Norman monks and clergy; Robert, abbot of the Norman house of Jumièges,

for example, had in turn been bishop of London (1045–51) and archbishop of Canterbury (1051–2). Moreover English works of art were already being sent to Normandy, among them probably the now-vandalized Anglo-Saxon Gospel Book once at Fécamp,[6] and the Anglo-Saxon text of St Gregory from Jumièges.[7] Robert of Jumièges himself took back to Normandy sumptuously illustrated Anglo-Saxon manuscripts, one quite certainly a Sacramentary [94] which he presented to Jumièges,[8] another possibly an Anglo-Saxon Pontifical now at Rouen[9] [93]. Yet another Anglo-Saxon manuscript that reached Normandy before the Conquest, a Psalter 'decorated with various pictures',[10] is mentioned by Orderic Vitalis.

One of the very rare remaining Norman *manuscrits de luxe*, a Sacramentary[11] made at Mont Saint-Michel after the mid-century (very possibly in the 1050s or 60s), may owe its production to the presence in Normandy of Robert's Anglo-Saxon Sacramentary.[12] The Mont Saint-Michel manuscript contains both historiated and decorative initials. One (on folio

178. Mont Saint-Michel: *St Michael killing the dragon*, from St Augustine's *Commentary on the Psalms*, MS. 76, folio A verso. *c.* 1040–55. Avranches, Bibliothèque Municipale

23 verso) reverses a topic touched on in an earlier chapter, for here it is a vision that influenced a painting rather than vice versa. The vision was St Benedict's, who saw the soul of Germanus, bishop of Capua, being carried up to heaven by angels in a fiery sphere. The soul is now St Benedict's own, raised by two angels in a mandorla coloured bright red to accord with his report.[13] The Sacramentary also contains a number of scenes, mostly Christological, either full-page or framed separately from the text [179]. Anglo-Saxon inspiration is patent throughout (one of its decorative initials is completely Anglo-Saxon and some of its miniatures have been compared with others in the Benedictional of St Aethelwold [91, 92]), yet underlying Ottonian influences impart an un-English ornamentalism and indeed a more Romanesque quality to the work. The iconography is influenced from Germany, England, and elsewhere.

Surprisingly, the post-Conquest artists of Mont Saint-Michel looked less to England than to Flanders, to north-eastern France, and to the south. The impact of the north-east is clear in the large and uncompromisingly Romanesque drawing of Gregory the Great in a text of his Homilies,[14] and of the south in the initials of the so-called Redon Bible of the late eleventh century.[15] However, Mont Saint-Michel never again reached the heights of its Sacramentary, even at the time when the art of other Norman houses was approaching its apogee.

It was, of course, the conquest and occupation of England that brought home the full impact of Anglo-Saxon art, which is unmistakable in the last decades of the eleventh century in the manuscripts of such houses as Jumièges, Saint-Ouen (Rouen), and Fécamp: the dragon style, the biting-head style, and the clambering style are all taken up, and the figure styles – though simplified and schematized – are obviously inspired from across the Channel.[16] Yet Normandy was no mere artistic colony of Anglo-Saxon England: other influences were at work from Italy, the home of Lanfranc and Anselm (both monks of Bec before being promoted to the see of Canterbury), and from Flanders, dynastically allied to William the Conqueror by marriage; from here a degree of Ottonian iconography probably derived.[17] Besides this, as we have seen, the Norman attitude to books diverged markedly from the English: for the Normans, the text was paramount, and illustration and decoration became confined more and more to the initial. Except when Anglo-Saxon models were tenaciously followed, we rarely find in Normandy a manuscript lavishly interspersed with full-page pictures and decorative pages.

An understanding of the potential of the historiated initial was, of course, already evident in the Carolingian Drogo Sacramentary, but the Norman interest in it probably stemmed from north-eastern France, where it was an integral part of the text (in England, it tended to be a focus for luxurious 'art pages'). However this may be, its full exploitation as a frequent and dominant element of the page was Norman. There are good examples in a manuscript from Saint-Ouen of St Augustine's *Treatises on St John's Gospel*,[18]

where the figures have a special animation. The initials are in a more vibrant and less severe version of the 'striped' style of north-eastern France that was to play an important part in Normandy in the last thirty years of the eleventh century before being re-adopted in England. It is seen in a splendid Gospel Book, now in the British Library,[19] which must on stylistic grounds be assigned to Saint-Ouen. Its Canon Tables and full-page pictures of evangelists [180] present a felicitous blend of elements from England and north-eastern France. The 'striped' style also occurs in a manuscript now at Bayeux (though it was not necessarily made there),[20] and, in a spirited and refined form, in a Bible made for Bishop William of St Carilef,[21] a Norman dignitary whose manuscripts are of importance.

William of St Carilef, bishop of Durham between 1081 and 1096, spent the years from 1088 to 1091 in exile in his native Normandy. 'He did not', says Symeon of Durham, 'come back empty-handed but took care to send forward to his church [of Durham] . . . many books',[22] of which sixteen have been identified with certainty.[23] Those less positively identified[24] include the last two of a three-volume edition of the Commentary on the Psalms by St Augustine[25] whose final volume bears an inscription to the effect that it was written while the bishop was abroad. The script and illumination of most of the other Carilef books – the colourful patched backgrounds in red, blue, green, and yellow to the initials of his *Moralia* of Gregory the Great, for example, and the colouring, construction, leaf-work, and backgrounds of the initials of his Hrabanus Maurus[26] – can all be closely paralleled in manuscripts still in Normandy. The initials of the second volume of the Carilef Bible[27] (the first is lost) also have links with Normandy, particularly with Saint-Ouen, yet their forms of decoration, their ebullience, and their figure style (though now with a different decorative emphasis) all relate them to Anglo-Saxon art as well. Anglo-Saxon features are such a strong element of the second volume of the St Augustine that a particularly distinguished authority on Anglo-Saxon art believed that its illuminator, Robert Benjamin, was either trained in an English scriptorium or was himself English.[28] This seems quite possible, for we know that after the Conquest Englishmen as well as English manuscripts crossed the Channel. They included the last Anglo-Saxon archbishop of Canterbury, Stigand, and the 'many others of high nobility' referred to by William of Poitiers;[29] the Anglo-Saxon monks mentioned by Orderic Vitalis;[30] and the monk spoken of by St Anselm.[31] The dignitaries doubtless brought other Anglo-Saxons in their train, and among them, or among the monks, there may have been one or two English artists who influenced – or even carried out – the Carilef illumination.

As there were Norman manuscripts at Durham, so there were others at Exeter of the late eleventh and early twelfth centuries which may have been made by Norman monks in England, but are perhaps more likely to have been brought over from the duchy. Their styles relate them to Saint-Ouen and Jumièges,[32] and a figure in one manuscript closely parallels others in a Saint-Ouen work.[33] These Exeter manuscripts manifest the Norman interest in historiated initials, and one has an incipient example of a theme that was to become particularly popular in the West – the Tree of

179. Mont Saint-Michel: *The Assumption of the Virgin*, from a Sacramentary, MS. 641, folio 142 verso. *c.* 1050–65. New York, Pierpont Morgan Library

Jesse;[34] for the Virgin, enthroned between Jerome and Isaiah, carries a sprig that bears obvious reference to Isaiah's 'rod out of the stem of Jesse'. Another historiated initial is actually by the artist of the Carilef Bible, and a further point of contact between the Carilef and Exeter manuscripts is the appearance – very rare at the time – of an artist's self-portrait. The Carilef one, in the lower part of an initial [181] in the second volume of St Augustine's Commentary on the Psalms,[35] is of the kneeling monk painter Robertus Benjamin (presumably the youngest Robert in his community, as Benjamin was the youngest of the sons of Jacob). He points and looks upwards to Christ, but his written comments are addressed to the full-length figure between, who is identified as 'Willelmus episcopus', i.e. William of St Carilef. The Exeter self-portrait, in a tail-piece to a manuscript of St Jerome's *Commentary on Isaiah*[36] [182], has the tetchy line-work and the coloured dots on the cheeks (perhaps derived from Italy) that one associates with Jumièges. The small seated monk faces the reader, and with one hand dips a pen into an ink-horn, while the other holds a knife with which to trim it. Though he was not the only illuminator of the manuscript, he identifies himself as 'Hugo pictor', and adds for good measure, 'Imago pictoris et illuminatoris huius operis'. He seems to have had a penchant for self-identification, for he pictures himself again in an initial E (Exultet) in a manuscript from the monastery of Jumièges.[37] This time he is blessing a Paschal candle, and the accompanying inscription reads 'Hugo levita'. In the original Exultet Rolls of south Italy, the deacon blessing the candle was sometimes labelled as *levita*,[38] but identification by name is highly exceptional. The hand of Hugo has been traced by François Avril in three Jumièges manuscripts.

Norman art varied surprisingly in quality, for although the Gospel Book from Saint-Ouen in the British Library is particularly handsome, another from Jumièges of about 1100 in the same collection[39] makes an embarrassing contrast; its figure style is both effete and over-fussy, and the colour combinations – sulphur yellows, muddy greens and blues and brighter tones – are quite jarring. Its interest in fact is iconographic rather than stylistic, and its emphasis on the Virgin is of importance.

The illustrations of a number of Jumièges manuscripts show a Romanesque hardening of form; the severity of the decided outlines and flat body-colours of the Christ in Majesty in a manuscript at Rouen,[40] for example, is the very antithesis of the Anglo-Saxon impressionism that is palely reflected in the saints on either side. This Romanesque development is expressed with particular felicity in some of the outline drawings and incisive decorative and historiated initials [183] of an admirable early-twelfth-century Bible.[41] Another Jumièges manuscript is interesting because it carries an inscription indicating that it was made for Jumièges by

180. Saint-Ouen: *St John*, from a Gospels, MS. Add. 11850, folio 138 verso. *c.* 1070–1100. London, British Library

181. Normandy: Historiated initial showing the artist, Robert Benjamin, and William of St Carilef, bishop of Durham, from the second volume of St Augustine's *Commentary on the Psalms*, MS. B.II.13, folio 102. 1088/91. Durham, Cathedral Library

182. Normandy: *Self-portrait of the artist, Hugo Pictor*, from St Jerome's *Commentary on Isaiah*, MS. Bodley 717, folio 287 verso. Late eleventh century. Oxford, Bodleian Library

183. Jumièges: *The prophet Malachi*, historiated initial from a Bible, MS. A.6, folio 150 verso. Early twelfth century. Rouen, Bibliothèque Municipale

184. Mont Saint-Michel: *Duke Richard of Normandy making a donation to the abbey of Mont Saint-Michel*, from a cartulary, MS. 210, folio 19 verso. Mid twelfth century. Avranches, Bibliothèque Municipale

Jumièges monks who had migrated to Abingdon in England,[42] to which house its former precious binding no doubt originally belonged.

While owing much to Anglo-Saxon art, the Normans yet transformed what they had borrowed, tempering it with influences from Flanders, Germany, and Italy, and choosing their own bracing colours and points of emphasis to produce an art which was peculiarly Norman (or Anglo-Norman). They also widened quite dramatically the scope of manuscript illumination, taking as their province not only religious works – Service Books, Bibles, lives of saints, and liturgical and moral texts – and the occasional herbal or astronomical treatise, but any and every manuscript, including mathematical, historical, and poetic texts. This broadening of subject matter encouraged scribes unskilled in drawing to turn their hands to work hitherto confined to the trained artist, and this may perhaps account for the variation in quality of Norman work.

The painting produced on both sides of the Channel in the last decade of the eleventh century was Anglo-Norman, rather than English and Norman, though small pockets of an almost pure Anglo-Saxon style survived in England. Moreover it was England that showed the greater stamina, going forward during the first half of the twelfth century to produce some of the greatest manuscript painting in Europe while Norman art was petering out into a trickle maintained, as it happens, by the two houses which had been at the forefront of Norman artistic developments in the first half of the previous century – Fécamp and Mont Saint-Michel. Fécamp produced nothing of quality after the abbacy of Roger d'Argences (1108–39), but Mont Saint-Michel was still turning out fine work in the mid twelfth century, as is clear from one of the drawings of a cartulary[43] [184]. Nevertheless, Normandy's *floruit* was the second half of the eleventh century, a period when it was most closely in touch with England.

At the turn of the tenth and eleventh centuries, when Ottonian art in Germany was being nurtured by emperors and powerful princes of the Church, the patron of the most important centre of painting in France was the abbot of a small Flemish community who was himself one of the chief artists of his scriptorium. This was Odbert[44] of Saint-Bertin, a Benedictine house near the north-east coast of France, who was in office between 990 and 1007 (or 1012) and who we know, from inscriptions[45] and from palaeographical evidence,[46] had a number of manuscripts made for his abbey. We learn that he was a practising artist from the statement 'Odbertus decoravit' in one of the most important of these manuscripts, the Saint-Bertin Psalter,[47] which provides us with enough stylistic evidence to allow us to attribute to him illustrations in other manuscripts.

Odbert's was a style whose debt to Carolingian art gained significance only when cross-fertilized by currents from England. When Carolingian influences alone were in play they produced little more than reproductions of the past, as is clear from Odbert's illustrations for two copies of an *Aratus*, the finer of which is at Boulogne;[48] the other, whose illustrations are drabber in colour and harsher in line, is at Bern.[49] Odbert's Carolingian model still survives[50] [35] to prove how faithful his copies were; and, as the Carolingian pictures themselves were accurate copies of late Antique illustrations, Odbert's paintings are, in effect, reflections of reflections. It is a little ironic to think of the Benedictine abbot, at some time near the apocalyptic year 1000, painting the virile classical gods and voluptuous goddesses of the astrological illustrations. Technically, these pictures are adequate, but there can be no development from them. The really seminal source for Odbert's painting was Anglo-Saxon England, then experiencing an artistic efflorescence. The artistic association between Flanders and England is not surprising in view of their mutual interest in monastic reform,[51] but a special relationship with Saint-Bertin was created by more particular factors. To begin with, Saint-Bertin monks had earlier settled in England both to promote reform and to escape its worst excesses.[52] Then, Saint-Bertin was near the English gateway to the Continent,[53] and therefore a convenient reception point for English ecclesiastical dignitaries travelling to and from Italy, such as Ethelgar, archbishop of Canterbury (988–90), who, we know from a letter written by Odbert himself,[54] visited Saint-Bertin twice; the same letter also pressed his successor, Sigericus, to visit the house.

There is evidence too of visits by Anglo-Saxon artists who stayed long enough to work on some of the Saint-Bertin manuscripts. As we shall see, it was Odbert who was responsible for the historiated initials and three prefatory full-page paintings of the Saint-Bertin Psalter,[55] but a second artist who added marginal illustrations to seven of the psalms was clearly an Anglo-Saxon – probably from Canterbury.[56] Stylistically, his tinted drawings express to perfection the tremulous sensitiveness of contemporary English art, and iconographically they relate to a later Anglo-Saxon manuscript, the Bury Psalter,[57] which belonged to Bury in the Middle Ages but was probably made at Canterbury. A

second Anglo-Saxon artist at Saint-Bertin was responsible for the late-tenth-century Winchester Crucifixion [85] and (apart from two small decorative initials by Odbert) for all the decoration and illustration of a lavishly painted Gospel Book from Saint-Bertin which is now at Boulogne.[58] It has several pages of Canon Tables, enlivened at times with vivacious drawings, an excellent full-page Christ in Majesty [185], and pictures of the evangelists, with sumptuous 'title-pages' to the Gospels on the facing leaves. These linearized paintings, in full colour, with purple, gold, blue, and green predominating, have all the swirling vitality of English work, but their composition and format also reflect German influences,[59] for the architectural settings of the evangelists can be paralleled in Ottonian illumination, and the narrative scenes of the 'title-pages' to the Gospels derive from Fulda.[60]

That Odbert was influenced by his Anglo-Saxon artists is clear from his Christ in Majesty for a Gospel Book now at Saint-Omer[61] [186]. Despite the addition of the symbols of the four evangelists, and the interpretation of the original painting as a coloured line-drawing, it is basically a copy of the Anglo-Saxon artist's Majesty in the Boulogne Gospel Book [185], from which the fluttering drapery-end above the knee, the fall of the garment over the body and legs, and the billowing folds around the ankles all derive. However the substitution of something drier and firmer for the fluid spontaneity of the original is typical of Continental adaptations of Anglo-Saxon art. Odbert must also have had access to now-vanished Anglo-Saxon manuscripts one of which clearly lies behind his splendid Gospel Book now in the Pierpont Morgan Library, New York.[62] Besides three full-page evangelist 'portraits', with sumptuous 'title-pages' to the relevant Gospels opposite [187], the book contains fine decorative initials and narrative scenes together with symbolic figures set within the large initials of the 'title-pages' and within the frames of two of the evangelist 'portraits'. There is besides a dedication picture showing two figures – presumably Odbert and his scribe – offering the book to St Bertin. Odbert's illustration and decoration capture the English animation with great conviction. The evangelists are painted with exuberant linearity against their purple backgrounds; the draperies cascade in profusion over their legs, and even the curtains above are in motion. But it is clear that Odbert was not himself an Anglo-Saxon, for the stolidity of the heads and the woodenness of the hands conflict with the spontaneity of the draperies; moreover Anglo-Saxon styles of the present are tempered with a completely different one of the past. So, while both figures and initials accord with contemporary English taste, the borders do not, and instead of being so exuberant that the figures within may ignore them at will, they are here severe and disciplined. One on folio 51 [187] is filled with a carefully controlled decoration deriving from English styles of some sixty or seventy years before; its closest parallel is in the Anglo-Saxon *Lives of St Cuthbert*[63] given by King Athelstan to the shrine of St Cuthbert c.937 [76]. The result is a dissonance between the emotional vibrancy typified by the draperies and the meticulous decoration of the rigid frame that no Anglo-Saxon artist would have countenanced – yet the mingling of styles gives Odbert's work a distinctive and pleasing flavour of its own.

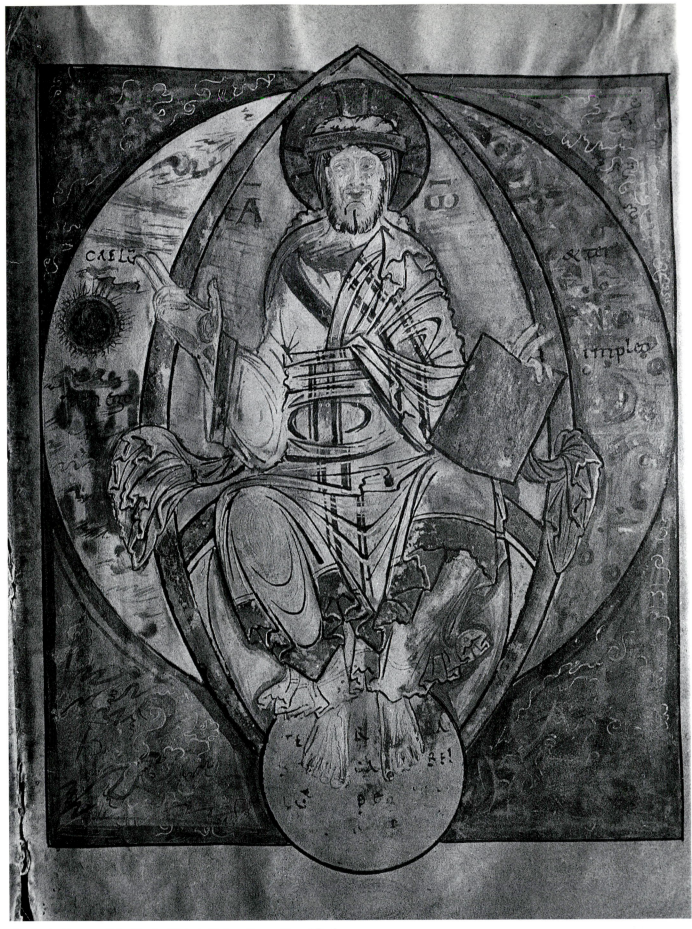

185. Anglo-Saxon, at Saint-Bertin: *Christ in Majesty*, from a Gospel Book,
MS. 11, folio 10. Turn of the tenth and eleventh centuries. Boulogne-sur-
Mer, Bibliothèque Municipale

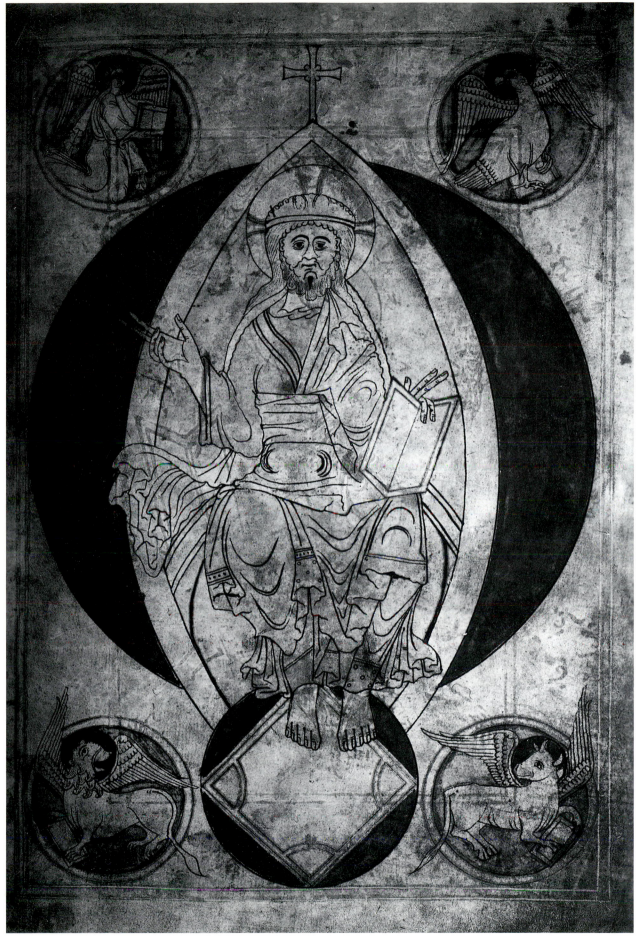

186. Odbert of Saint-Bertin: *Christ in Majesty*, from a Gospel Book, MS.
56, folio 35. 990/1012. Saint-Omer, Bibliothèque Municipale

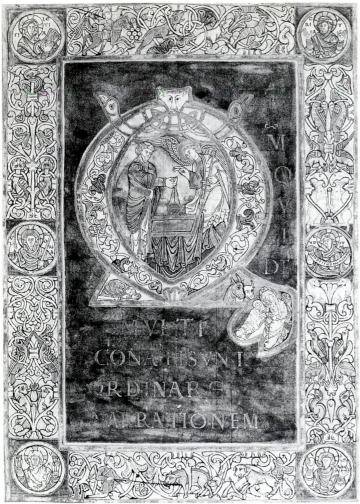

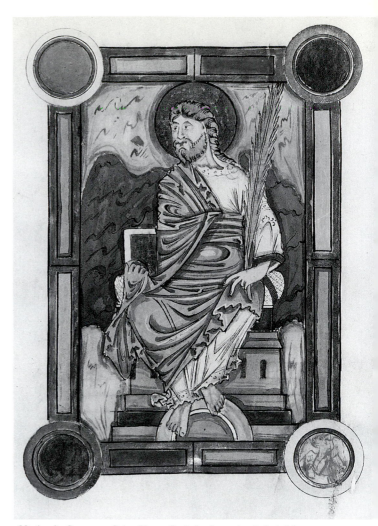

187. Odbert of Saint-Bertin: Title-page to St Luke's Gospel, with initial showing *The Annunciation to Zacharias and the Nativity*, from a Gospel Book, MS. 333, folio 51. 990/1012. New York, Pierpont Morgan Library

188. Anglo-Saxon, at Saint-Vaast: *St Luke*, from the Anhalt Morgan Gospels, MS. 827, folio 66 verso. Turn of the tenth and eleventh centuries. New York, Pierpont Morgan Library

they were already well developed in the Drogo Sacramentary of the Metz School[66] and were to be found in the Corbie Psalter[67] as well. (In Anglo-Saxon manuscripts they are chiefly confined to title-pages – a practice also followed by Odbert both in the Morgan Gospels [187] and in this very Psalter, although his primary use of them was as part of the ordinary text.) Also perhaps Carolingian-inspired is Odbert's greater interest in commentaries on the Psalter than in the text itself, as observed earlier in the Corbie and Stuttgart Psalters,[68] though it does also occur in such Anglo-Saxon manuscripts as the Bury Psalter. The forward-looking aspects of Odbert's style include first the very proliferation of historiated initials, which foreshadows the Romanesque future; and second – despite possible influences from lost Anglo-Saxon sources – the Christological nature of twenty-four of the scenes inside the initials, an association between the text of the Psalter and the life of Christ that was to become part of the tradition of Psalter illustration in the West.

The fresh vigour imparted by Odbert to the art of Saint-Bertin did not survive his death, but his example was taken up at the important Flemish house of Saint-Vaast at Arras, whose close artistic relationship with Saint-Bertin is witnessed by the decorative details of its manuscripts.[69] It was influenced too both by the Carolingian past (when it had

been an important centre of the Franco-Saxon style), and by England (with which it had independent links). The Anhalt Morgan Gospels of the late tenth century[70] probably comes from Saint-Vaast, though a Saint-Bertin provenance cannot be entirely discounted. In any case its illumination offers a curious example of the mixture, or rather juxtaposition, of Carolingian decoration and English figure styles that was to become typical of Saint-Vaast. The manuscript was originally decorated with large borders and initials in the Franco-Saxon idiom, but the work was left unfinished and, as we have seen,[71] evangelist 'portraits' were added around the turn of the millennium by the same English artist as worked on the Saint-Bertin Gospels now in Boulogne. With the exception of St Luke[72] [188], these 'portraits' correspond very closely to those in the Boulogne Gospels.

The two styles that had accidentally come together in the Anhalt Morgan Gospels were blended in the giant three-volume Saint-Vaast Bible.[73] Made in the second quarter of the eleventh century, with some additions of the third quarter, it was ruthlessly vandalized in the nineteenth century but still retains decorative pages, borders, and initials, and twelve half-page or whole-page illustrations (basically drawings in colour outline or with colour wash). The decoration consists chiefly of Franco-Saxon geometric interlace, which gives to the large initials and the borders a finely ornamental effect.

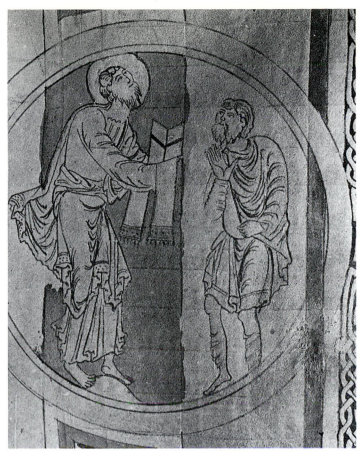

189. Saint-Vaast, Arras: *The priest Ezra with the Book of the Law*, detail of a historiated initial from the Saint-Vaast Bible, MS. 559, vol. III, folio 29. Second quarter of the eleventh century. Arras, Bibliothèque Municipale

190. Saint-Quentin: *Tortures of St Quentin*, from the Life of the saint, folio 43. Second half of the eleventh century. Saint-Quentin, Chapter Library

This interlace is occasionally 'modernized' with Anglo-Saxon elements such as a combination of bird-heads, interlace, and acanthus leaves, but the chief Anglo-Saxon ingredients lie in the figure style, which is itself sometimes reminiscent of the Carolingian past.[74] The artists at work on the Bible identified with cross-Channel styles to varying degrees. The draughtsman of the figures on folio 29 of volume III [189] had some feeling for the English idiom (if coupled with some knowledge of Carolingian art) – his figure proportions and fluttering draperies remind one of the drawings of the Sherborne Psalter of the late tenth century – while the scenes of Elijah and Elisha on folio 144 verso of volume I[75] may be stylistically compared to drawings in the Bury Prudentius,[76] though they lack something of the spontaneity of Anglo-Saxon drawings. Again, the figures on folio 128 verso transpose the Anglo-Saxon proportions and floating quality into a quieter and more restrained key. Thus did AngloSaxon styles, themselves inspired by Carolingian art, recross the Channel and become domiciled in the north-eastern part of France, where they were to take up a life of their own. As other areas of northern France also shared some styles with England, we can almost speak of a Channel School.

Brieger has shown that two of the surviving pictures of the Saint-Vaast Bible are, in effect, refutations of heresies.[77] The first, prefacing the Song of Songs, suggests in allegorical form

that only those faithful to the visible Church can hope to achieve salvation. The second, preceding the Book of Ecclesiasticus, shows how Christ will crush the enemies of the Church, and how only members of that Church will merit salvation, which is to be obtained not solely by the exercise of virtue, but also by comprehending the divine wisdom of the Old Testament as well as the New through the traditional interpretation of the Church as achieved through knowledge of the liberal arts (here personified as the seven daughters of wisdom). As we shall see in the chapter on Spanish painting, heretical attacks on the Old Testament had a long history. They continued unabated throughout the eleventh and twelfth centuries, and were opposed in painting by the increasing attention given to incidents in the Old Testament that were referred to in the New, thus making the one Testament validate the other. The parallel development in theology is well summed up by the title of one of the sections of Peter the Venerable's tract against the heretic Peter of Bruys: *Probatio totius Veteris Testamenti ex Evangelio*.[78]

When Anglo-Saxon art met Ottonian art on the Continent, a fusion took place which produced a new idiom, Anglo-Saxon in spirit but Ottonian in externals. If the two were alike in vitality, they were totally different in their attitudes to the representation of the human figure. The Ottonian artist was bent on registering psychological essence, and even when

191. Saint-Omer: *St Omer set upon by his adversaries*, from the Life of the saint, MS. 698, folio 34. Second half of the eleventh century. Saint-Omer, Bibliothèque Municipale

192. Cambrai: *St Matthew*, from a Gospel Book, MS. 24, folio 15. Second half of the eleventh century. Amiens, Bibliothèque Municipale

his figures are reduced to symbols, we are persuaded of the reality of their emotional and spiritual passions by their fervent glances and excited gestures. For the AngloSaxon, on the other hand, the delineation of the human body was an aesthetic rather than a psychic experience, a departure point for an exhilarating exercise in the shimmering mobility of line and colour, and he gave equal animation to his leaf-work, decoration, and draperies. In this mingling of influences the English abstract dynamism may have prevailed, but the stylistic details of figure and drapery were nonetheless Ottonian. This is demonstrated by the illustrated Life of St Quentin[79] produced at Saint-Quentin in the second half of the eleventh century. Although the decorative features of this manuscript are German in origin, and the loose-limbed proportions of the figures and their rather boyish faces go back ultimately to the style of the Gregory Master, yet their inner quality of spirit and zest is quite evidently Anglo-Saxon, and very far removed from the rather self-conscious gravity of the Trier master. The gold or richly coloured backgrounds of Ottonian art give way to an empty vellum background, and the figures running lightly across it have none of the intensity or seriousness of German art: St Quentin undergoes the most cruel of tortures [190] with a kind of absent abandon as his pagan persecutors flit over the page and seem to torment him with more good humour than malice.

The figures of another Flemish manuscript of the second half of the eleventh century, the Life of St Omer from Saint-

Omer,[80] dance like nimble Anglo-Saxons, but their clarity of outline is Ottonian [191]. Also largely Ottonian is the substance of the draperies, but an Anglo-Saxon exuberance sends them fluttering in steep folds behind the figure or, more rarely, swirling dramatically over the head, recalling the more floating drawings of Anglo-Saxon *Psychomachias*.

At Cambrai, Ottonian influences, refracted through Liège, combined with Anglo-Saxon ones to produce in a Gospel Book now at Amiens[81] a parody of the figure styles of the area. The evangelists' arms are long and gawky and their hands misshapen, yet dramatic distortion lends them some vigour. The bold, heavy outline is Ottonian, the figure style and types of head are influenced by Liège, but the contortions of the limbs and the turbulence of the draperies indicate contacts with England. The figure of St Matthew [192] is reduced to a vortex of swirling stripes which derive from, and simplify, the impressionistic brush-strokes and floating colours of English painting.

At Saint-Amand, the use in a three-volume illustrated copy of St Augustine's *Commentary on the Psalms*[82] of historiated initials bears witness to continued Carolingian influences, while Ottonian ones are evident in the second half of the eleventh century in the first Life of St Amand[83] (so called to differentiate it from two twelfth-century lives of the saint to be discussed later) [193]. That the dedication picture of a further Saint-Amand manuscript, showing monks offering their own copy of Cassian's *Collationes* to the author,[84] is on the other hand Anglo-Saxon in inspiration is apparent in

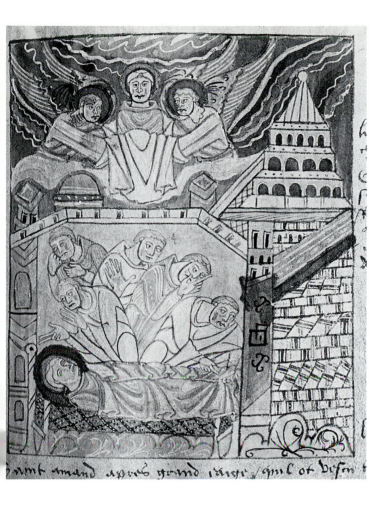

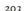

193. Saint-Amand: *The death of St Amand*, from the first Life of the saint, MS. 502, folio 30. Second half of the eleventh century. Valenciennes, Bibliothèque Municipale

194. Saint-Amand: *Cassian*, from his *Collationes*, MS. 169, folio 2. Second half of the eleventh century. Valenciennes, Bibliothèque Municipale

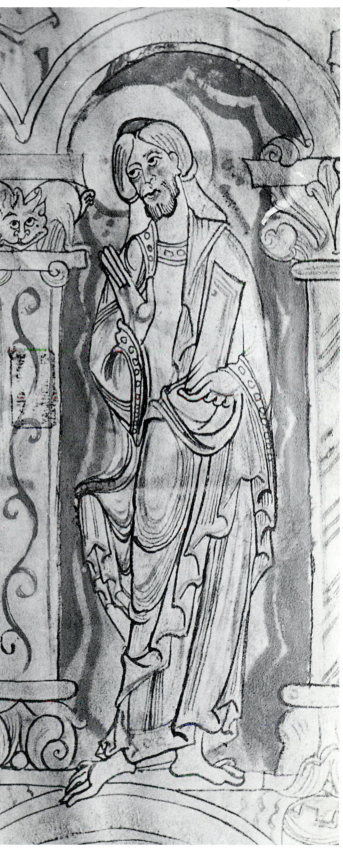

Cassian's long, loose-limbed proportions and in the zigzag fall of his draperies [194], as well as in the still buoyant quality of the drawing, despite its heavier line.

Towards the very end of the eleventh century, Saint-Amand produced a giant Bible, formerly in two volumes and now in three,[85] known from the name of its donor as the Alardus Bible.[86] It has a number of historiated initials, including a fine one to Genesis, with scenes of the Creation, the Fall, and the story of Cain and Abel, but the artist's real forte is his decorative and coloristic sense. This he was able to indulge again in another three-volume work, the *Commentary on the Psalms* just mentioned,[87] which can be dated from a list of popes entered on a blank page to *c.*1086–7.[88] Its donor, a certain Floricus, is also known, and Boutemy thinks he may have been the Abbot Floricus (perhaps a former monk of the house) whose name appears in the funerary roll of Abbot Hugh I of Saint-Amand (d.1107). The over one hundred and forty decorative initials in the first two volumes offered ample opportunity for the artist to display his gifts for liveliness of colour, for inventiveness (not to say fantasy), and for the interweaving of human and plant life.

In the twelfth century, Saint-Amand was the most active centre of manuscript painting in north-eastern France. Its middle years saw a limited impact from England (later itself to be influenced from this area of France[89]) which finds particularly fine expression in a drawing of the Crucifixion[90] [195]. Its style was brought to the Continent by a talented

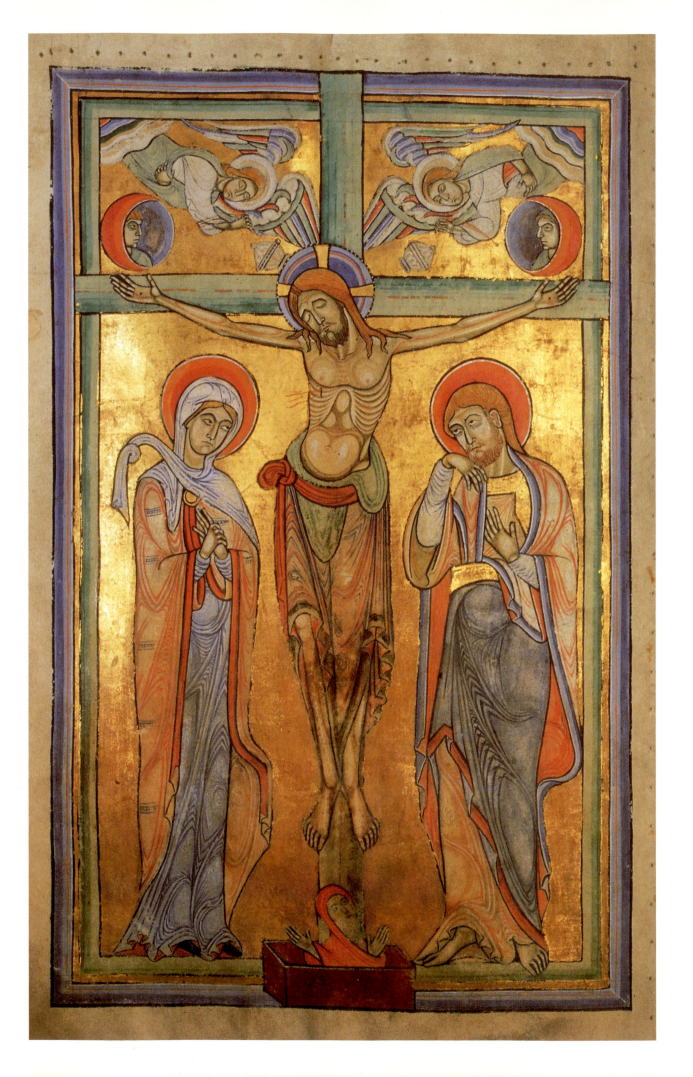

English artist [352] who had worked in north-eastern France for an abbot of Liessies[91] who had then moved to Saint-Vaast. Other illumination from Saint-Amand also shows connections with England.[92] This mid-century development owes much to an energetic but unnamed librarian who between *c*.1145 and 1158 commissioned eighty-six books.[93] The catalogue that lists them includes the titles of a further twenty volumes added between 1158 and 1170,[94] but even this does not reveal the full extent of Saint-Amand's production, for it is known that the account for the later years made no attempt to be exhaustive.[95]

Seven of the mid-century volumes were 'signed' by an illuminator named Sawalo,[96] and five of these, each inscribed 'Sawalo monacus sancti Amandi me fecit', make up the giant Sawalo Bible,[97] attributed to the decade between 1155 and 1165.[98] Sawalo also added his name to a copy of Hilary of Poitiers' treatise on the Trinity[99] of about 1165[100] and to a copy of Peter Lombard's *Sentences*[101] made between 1165 and 1170.[102] He even 'signed' with the inscription 'Sawalo monacus me fecit' a knife-handle which he carved with two full-length figures of a man and a woman.[103] Moreover stylistic comparisons prove him to have worked on more than thirty other manuscripts.[104] He was active between *c*.1145 and *c*.1170, chiefly for his own house, though seven manuscripts, all attributed to the 1150s, for the sister house of Sainte-Rictrude of Marchiennes (also founded by St Amand) have initials by him.[105]

Sawalo's figural work – Christ and his Church in the third volume of the Bible, Christ enthroned in the fourth, Christ in a mandorla in the fifth, and Hilary of Poitiers and Peter Lombard in the manuscripts of their works – does him no great credit, but his decoration is unmistakably fine: the lively, closely executed, spiralling foliage on the ornamental page at the beginning of each of the volumes of his Bible resembles a colourful carpet into which he has 'woven' in gold the initial letters and the first words of the relevant Book. The refreshing and elegant effect of these 'tapestries' is, regrettably, lost in any black and white reproduction [196]. At first sight, his manner seems to represent a creative adaptation to twelfth-century tastes of the Franco-Saxon ornamental style which had flourished at Saint-Amand during the Carolingian period, but it was probably inspired more directly by the revival of the Franco-Saxon idiom in the Saint-Vaast Bible. He drew also on Marchiennes,[106] on the Mosan houses of Saint-Hubert, Bonne Espérance, and Le Parc,[107] and on the earlier illumination of his own house, particularly that of the Alardus Bible and of the first Life of St Amand.[108] Yet, far from being merely derivative, Sawalo was a creative artist of the first order producing suave, sophisticated ornamentation with rich colours, elegant dragons, and lively foliage. His style was taken up regionally, finding its way into the manuscripts of Marchiennes and Anchin, and into the foliate initials of the Floreffe Bible,[109] which we shall meet later.[110]

North-eastern France had a particular penchant for illustrated lives of local saints, and within less than a century

196. Sawalo of Saint-Amand: Decorative page to St Matthew's Gospel, from the fifth volume of the Sawalo Bible, MS. 5, folio 16 verso. *c*. 1155–65. Valenciennes, Bibliothèque Municipale

Saint-Amand produced three,[111] of which the first (see above) was used as one pictorial source for the other two. The second Life of St Amand,[112] made between about 1145 and 1158,[113] contains one double-page and five full-page pictures of considerable accomplishment. Their heavy contours suggest a kinship with stained glass, and they are resplendent with gold and bright colours in the backgrounds, and with rich combinations of rusts, greens, and plum colours in the figures, which are also highlighted with gold. Baudemond, the legendary author, is given special prominence, for he is the subject of the very first painting, and appears in another picture with St Amand, who is given a square nimbus, possibly to indicate that he was alive when he was supposed to have dictated this account to Baudemond [197]. The third Life of St Amand[114] contains the lives of three other saints as well, and its completion has been dated from internal evidence to the years 1169 to 1171. Its twenty-nine paintings are rendered sumptuous by their backcloths of gold and by their delicate nuances of colour, ranging from soft rusts, blues, greens, and yellows to chocolate brown [198]. The fine verso drawings – in fact, the original preliminary sketches – are by another hand and were begun around 1160.[115] The initials, like the pictures, exist in two versions. Five of the later ones, which were on pieces of vellum pasted over the earlier initials, have become detached by damp, enabling us to see that four

195. Saint-Amand: *Crucifixion*, from a Sacramentary, MS. 108, folio 58 verso. Mid twelfth century. Valenciennes, Bibliothèque Municipale

of the originals underneath were by Sawalo.[116] The influences on the illustrations of the third Life are from the Mosan area, and some of their figures may be compared to those of the Floreffe Bible.[117]

Mosan influences, it may be added, are also evident in the initials of the Alardus Bible[118] and in a mid-century Gospel Book from the monastery of Hénin-Liétard[119] whose stylized evangelist 'portraits' are set against gold and accompanied by figures in half-medallions. These half-medallion 'frames', reminiscent of the School of Regensburg, are used also in an earlier Saint-Bertin painting[120] – in effect a visual obituary of Abbot Lambert, who died there in 1125. It shows the abbot's soul being carried aloft by two angels to the welcoming arms of Christ, who sits in a mandorla flanked by four half-medallions containing personifications of Charity and Patience, and the figures of the Virgin and Abbot Martin. The simple colours and absence of gold demonstrate the more unassuming styles of manuscript painting in the first half of the twelfth century, before the middle decades brought in a vogue for splendour so evident in the second and third Lives of St Amand.

In the twelfth century, scribes were more liberally acknowledged in the manuscripts of north-east France than in most other areas of the West. They are quite often identified in the texts, and also sometimes depicted, and even identified, in the illumination. At Corbie, the monk-copyist, Herbert Dursens, is three times portrayed presenting the book he has written to saints,[121] and other houses are equally liberal in their acknowledgements.[122] One manuscript from Anchin even had a picture of a dead scribe, Balduinus, as well as of the live one, Johannes, probably his continuator.[123] Artists are not often shown, although the illuminator, Felix, appears with Richer, the sub-prior who had commissioned the work, in a Corbie manuscript.[124] Anchin seems to have been particularly generous to its illuminators, allowing Oliverus to be named and portrayed along with Rainaldus, the scribe, in one manuscript,[125] and another two monks – unnamed but presumably also the artist and scribe – in a second.[126]

North-eastern France was exceptional too in the majesty with which it portrayed certain saints – however, less in the stories of their lives than in copies of their works – though it must be added that large-scale author-'portraits' of uncanonized writers such as Peter Lombard[127] and Gilbert de la Porrée[128] also occur. The French artists achieved their monumentality by drawing on the geometrical aloofness of Ottonian art (as seen, for example, in the St Mark of the

197. Saint-Amand: *St Amand dictating the account of his life to Baudemond*, from the second Life of the saint, MS. 501, folio 58 verso. *c.* 1145–58. Valenciennes, Bibliothèque Municipale

198. Saint-Amand: *King Dagobert at the feet of St Amand, and the baptism of Dagobert's son*, from the third Life of the saint, MS. 500, folio 60 verso. *c.* 1160–71. Valenciennes, Bibliothèque Municipale

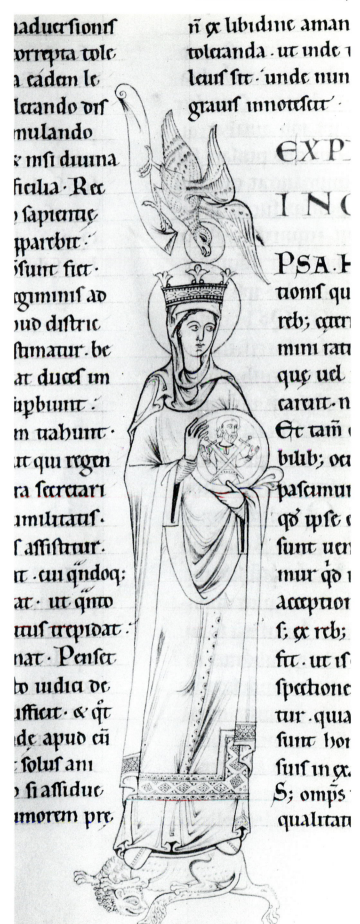

199. Saint-Amand: *St Gregory*, from the Letters of St Gregory, MS. lat. 2287, folio 1 verso. *c.* 1160–80. Paris, Bibliothèque Nationale

200. Saint-Bertin: *The Virgin*, from St Gregory's *Moralia in Job*, MS. 12, vol. 2, folio 84 verso. Twelfth century, second half. Saint-Omer, Bibliothèque Municipale

Golden Gospels of Speier [135], which was transmitted to Mosan paintings like the Christ of the Stavelot Bible [268][129]) and adding their own Gallic splendour by means of rich colours and decorative detailing. A St Gregory[130] of the 1160s or 1170s from Saint-Amand [199] shows how, in Romanesque fashion, the proportions of the figure have been deliberately distorted to emphasize the torso and enhance its massiveness, though there the combination of finesse and colourful resplendence is specifically French. The delicately foliated backgrounds are in gold and deep sky-blue, the tasteful hatching of the dalmatic is in slate-blue and pale grey, and the warmth of the red chasuble is enriched with 'mosaic' designs. The grand, richly coloured seated St Augustine in a Marchiennes manuscript[131] makes few concessions to reality in terms of body structure: it is in effect a powerful and even intimidating icon, as is a St Gregory from Saint-Martin at Tournai.[132] This vogue for richly coloured effigies, already seen at Saint-Amand,[133] was to extend to Anchin[134] and even to cross the Channel into the illustrations of Canterbury.[135]

Some twelfth-century draughtsmen were masters of line, as witnessed by the firmness and sweep of the illustrations to St Gregory's *Moralia in Job* from Saint-Bertin.[136] In accordance with a tradition that is ultimately Byzantine, the noble figure of the Virgin [200] holds a medallion bust of a

man we know to be Job, for Gregory compares his sorrows to those of Christ.[137] The date at the end of the twelfth century ascribed to this work would appear to be rather too late. The vigorously drawn but very different initials of a manuscript from Saint-Sépulcre at Cambrai[138] are close to those of Cîteaux.

The Gospel Books and Bibles of north eastern France rarely received the sumptuous treatment lavished on texts by, or relating to, saints. An exception is a giant Bible[139] of the late twelfth century, originally in three volumes and now in two, from the Premonstratensian house of Saint-André-au-Bois, whose impressive decorative and historiated initials include a noble, partly gilded figure of King Ahasuerus before the Book of Esther, scenes of the life of David against a gold background before the first Book of Samuel, and a modest Tree of Jesse before the Gospel of St John. The contorted creatures of its decoration resemble the somewhat stereotyped versions to be found in manuscripts made in France for St Thomas Becket,[140] though there is nothing conventional about the frenetic eccentricity of line and the wild abandonment of the figure forming part of the initial on folio 94 of volume 1 [201]. The community of Saint-André was small, so that the Bible is likely to have been written and illuminated for them by secular professionals, perhaps in Paris, with which the decoration has some associations.

PARIS AND ITS ENVIRONS

Even more splendid than the Saint-André-au-Bois Bible is a contemporary great Bible in the Sainte-Geneviève library in Paris.[141] It is handsomely written and its layout is consummate: the beautifully set out Canon Tables incorporate elegant architectural designs as well as Gospel scenes and imagery taken from Bestiaries, eastern textiles, and classical legends, all rich with gold and colour; so, too, are the one hundred and twelve historiated and decorative initials, the full-length historiated initial to Genesis being particularly magnificent. The highly polished professionalism of the execution we owe to a team of nine artists, working three to a volume and managing to maintain a consistent house style despite some individual touches in their interpretation of the text; an example of this is the illustration to verse 1 of Psalm 52 (A.V. 53) – 'The fool hath said in his heart, There is no God. Corrupt are they, and have done abominable iniquity' – where a man genuflects before a goat squatting on an altar, the symbol then, as in other centuries, of all that is profane and lascivious [202]. Letters or simple marks (usually next to painted initials in the second and third volumes) may have been the equivalent of masons' marks – i.e., a way of identifying the amount of work accomplished by a single artist, so that individual payments could be assessed. This of course implies piece-work by secular painters working as a group.[142] The scribe of the Bible, so he tells us, was Manerius of Canterbury. He goes on to expound the etymology of his own name – 'one who is expert in writing' – and the names of other members of his family[143] (his brothers', according to him, having less favourable meanings) and to speak with considerable warmth of his mother, Liveva (Leofgifu), who lived in good health until she was over eighty (Urry traced her name in a Canterbury rent-roll of 1166 or 1167, where she is described as a widow[144]).

The Manerius Bible has stylistic associations with a fragment of another once at Pontigny,[145] and much closer

201. Paris(?): Initial from the Bible of Saint-André-au-Bois, MS. 2, vol. 1, folio 94. Late twelfth century. Boulogne-sur-Mer, Bibliothèque Municipale

202. Paris(?): Initial to Psalm 52, from the Manerius Bible, MS. 9, folio 209. Late twelfth century. Paris, Bibliothèque Sainte-Geneviève

203. Ingelard of Saint-Germain-des-Prés: *The Crucifixion*, from a Psalter Hymnal, MS. lat. 11550, folio 6. 1030/60. Paris, Bibliothèque Nationale

204. Saint-Denis or Saint-Vaast: *Christ in Majesty*, from a Sacramentary,
MS. lat. 9436, folio 15 verso. Mid eleventh century. Paris, Bibliothèque
Nationale

ones with a two-volume Bible which in the fifteenth century was at Saint-Germain-des-Prés.[146] The small white lions and other ornamental features link it too with the decoration of highly professional *manuscrits de luxe* once in the library of Christ Church, Canterbury.[147] These were copies of biblical glosses then current in French theological circles that were made in France for Thomas Becket and his supporter Herbert of Bosham, who had shared his exile there. I once attributed them to Pontigny,[148] where both men were staying when two of the volumes were envisaged, but de Hamel's view that they were the work of seculars in Paris[149] has a certain appropriateness, since four of the manuscripts reproduce a text then central to the teaching of the University of Paris – the revised Great Gloss of Peter Lombard. The Manerius Bible itself has been variously attributed to Saint-Bertin, to an area in Champagne or northern Burgundy, and to Troyes (it was acquired by its present library from the Troyes house of Saint-Loup in 1748), but one might now consider the possibility that it, as well as the Pontigny and Saint-Germaindes-Prés manuscripts, was made by professionals working in Paris. Some aspects of the decoration of all three – the tadpole-like creatures with large heads and snaking bodies, and the full-length human beings forming the stems of initials – relate them to manuscripts from the library of Chartres,[150] and recent research has indicated that some of the Chartres manuscripts were made in the capital city.[151]

It will be recalled that in an earlier chapter[152] the lavishly illustrated Carolingian Stuttgart Psalter was tentatively attributed to Saint-Germain-des-Prés. More securely to be located there are some eleventh-century illuminated manuscripts associated with the artist and scribe Ingelard,[153] who worked at Saint-Germain under Abbot Adrald, or Adelard (1030–60). His figural drawings are heightened with background colour in a manner well known in north-eastern France, and it is with the Channel School that his style shows the closest links. Particularly fine, with a simple but effective dynamic, is his Crucifixion with the Virgin and St John in a Psalter Hymnal,[154] drawn in bistre against a violet ground, lightened by the yellow of haloes and relieved by the green of the Cross [203]. His work on a set of saints' lives in four volumes[155] included some decorative and historiated initials and two miniatures: of King Dagobert prostrating himself before St Denis and two other saints, and of Heaven, where the figures have a certain individuality. Ingelard also drew some ornamental initials and a historiated figure of St Germanus in a Life of St Germanus,[156] historiated initials for a copy of Hrabanus Maurus's well known work on the Holy Cross,[157] and some five Infancy scenes and drawings of constellations (almost antique personifications in modern dress) for a manuscript containing various texts.[158] His style influenced two manuscripts from Saint-Maur-des-Fossés[159] and also perhaps an early-eleventh-century Psalter Hymnal from Saint-Denis.[160]

Also from Saint-Denis is an impressive Sacramentary of the mid eleventh century,[161] though some would argue that it was made at Saint-Vaast.[162] Its picture of St Denis with companions receiving Communion from Christ, and others of the martyrdom of St Stephen and of Christ in Majesty with seraphim and adoring angels [204], are in a Carolingian style strongly tempered by Ottonian influences from Cologne (compare the illumination of the St Gereon Sacramentary);

their harmonies of colour and of composition, together with a certain liveliness and elegance of figure style, make them attractive if somewhat derivative works of art.

Very little illumination can be securely attributed to Paris and its environs even in the twelfth century, so we may perhaps mention here the illumination of the Augustinian house of Saint-Victor, especially the bright and lively initials of a Bible[163] of the second quarter of the twelfth century which are associated with those of manuscripts given by a son of Louis VI to Clairvaux.[164]

EASTERN FRANCE

In the first half of the twelfth century shafts of English influence, which had entered northern France in the eleventh century, reached south-eastwards to Burgundy, where the wind of reform at Cîteaux was fanning the flames of art into a blaze unparalleled, in terms of miniature painting, in contemporary France. It was to Cîteaux, which gave its name to the new Cistercian movement, that St Robert of Molesme had led his band of zealous monks in 1098. There they cleared the forest-lands to build their 'New Monastery', and new it certainly was, for the Cistercians looked beyond the tightening of discipline and liturgical observance of the earlier reformers to a recovery of the very spirit of primitive monasticism. Their attempt to reclaim their souls by means of personal toil and labour led to the reclamation also of many a terrestrial wilderness of medieval Europe. They were far, however, from being simply muscular Christians, for they aimed to produce basic texts – an equally laborious task in its way, as is demonstrated by the statement at the end of the second volume of an early Bible that the text had been established by the collation of Latin Bibles from various centres and by consulting with Jewish scholars on the Hebrew originals of the Old Testament. This was the community that was to become the most important centre of manuscript painting in France in the first half of the twelfth century.

It was, ironically, Cistercian reforming zeal that brought the dazzling artistic life of Cîteaux to an end, for a ban was imposed on all forms of artistic representation by St Bernard, who joined Cîteaux with thirty followers in 1112 and was, until his death in 1153, one of the most formidable personalities of Europe. Reacting violently against the lavishness of contemporary religious art (specifically that of the Cluniacs) as a superfluous luxury which distracted the mind from religious meditation, he managed to prevail upon his own order, one of the most artistically endowed of the West, to forsake its inheritance. But his thundered imprecations, which are known to everyone, betray his own sensitiveness to art, for they reveal a visual perceptiveness of a very high order. As St Augustine's particular virulence towards heresy is partly explained by the fact that he himself had once been a heretic, so St Bernard's implacable hostility towards art may be partly explained by his own susceptibility to its more sensual aspects. The power that it could exercise in the twelfth century has been mentioned earlier,[165] and it was no doubt a power of which St Bernard was well aware when he declared that art should be controlled in churches and interdicted completely within his own order. The ban is incorporated in a statute said to have been issued in 1134, but this may well have been pre-dated by zealots for polemical

205. Cîteaux: Historiated initial, from the Letters of St Jerome, MS. 135, folio 95 verso. *c.* 1115–25. Dijon, Bibliothèque Municipale

monk of Sherborne); one or two of his own monk-artists were themselves probably English.

English art of the earlier twelfth century was different in style, if not in spirit, from the Anglo-Saxon art which had pervaded northern France in the eleventh. Norman influences meant that decorative and historiated initials absorbed much of the creative activity of manuscript painters, and that simpler and more pungent colour harmonies were accepted. There were influences also from north-east France, Germany, and Italy, but the essential Anglo-Saxon tradition of dynamic line and movement persisted, and English initials of the twelfth century are animated by running and climbing human figures, by snarling and pouncing animals, and by contorted serpents and dragons [cf. 327]. Everything is caught up in a general sweep of movement. This zest was transmitted to the early Cistercians, and their initials too are alive with savage dragons, irrepressible birds and beasts, and a busy intertwine of human figures and animals [205]. More specifically, there must have been some Canterbury illumination at Cîteaux, since in Dijon MS. 135,[175] for example, the decorative motifs, the choice of colours, the forms of foliage, and the vigorously patterned treatment of birds and animals can all be paralleled in Canterbury manuscripts.[176] For points of comparison with the figure styles, however, we would have to look rather to Shaftesbury, to St Albans, and especially to Bury St Edmunds.

The Cistercian 'striped' style also came from England, where it developed from Anglo-Saxon art domiciled in north-

206. Cîteaux: *King David*, from the third volume of the Bible of Stephen Harding, MS. 14, folio 13 verso. *c.* 1110–15. Dijon, Bibliothèque Municipale

reasons, and its effective date was more probably 1152, when the constitutions and statutes were redrawn and submitted for papal approval.[166] The fine manuscripts known from the second half of the twelfth century at the Cistercian monasteries of Pontigny, Morimondo, Jervaulx, Rievaulx, Clairvaux (St Bernard's own house), and Cîteaux itself[167] may be supposed to have been gifts,[168] for the more certain splendours of art in the mother-house of Cîteaux are confined to the first half of the century.[169] Its styles were varied and its influences mixed, which is but natural in a centre which gathered manuscripts for copying from many areas,[170] and also sheltered monks of several nationalities.

The scratchy red pen-work initials against blue backgrounds in the first two volumes of a famous Bible of Cîteaux, the 'Bible of Stephen Harding'[171] completed in 1109,[172] bear clear testimony to a Norman influence that emerges also in initial and figure styles, and there seems to have been a particular connection between Cîteaux and Jumièges. Flemish influences too are discernible in initial and figure styles, in some types of foliage, and in the layout of title-pages, which can be particularly delicate and elegant – we know of definite associations between St Robert, the founder of Cîteaux, and Flanders[173] which brought to the Burgundian house illustrated Flemish manuscripts some of which survive.[174] However, during the efflorescence of its artistic activity the primary influences on Cîteaux came from England, which provided the house with an English abbot from 1109 to 1133 in the person of Stephen Harding (a former

eastern France [192] and repatriated via Normandy to become very popular in the first half of the twelfth century. The colours were applied with a lively brush, following lines which were often curved and supple, to produce some rhythmic and spirited work, for example the initial Q to a text of St Gregory,[177] where the tumbling folds in red, green, pale blue, and ochre reflect the English flamboyant sense of decoration. More disciplined is the fine David [206] in the third volume of Stephen Harding's Bible, which can be compared to a figure from the St Albans Psalter[178] to be discussed later.[179] The earliest figure styles at Cîteaux also developed along similar paths to the English ones, gradually toning down the pungency and drawing out the figures to make them more elegant in proportions and more grave and dignified in feeling until they reach the accomplished stage of the third volume of the Stephen Harding Bible[180] and of the last two volumes[181] of a five-volume collection of saints' lives known as the Cîteaux Lectionary [207]. Their linear emphasis, the elongation of the figures, and the rather delicate mood of contemplation offer some interesting points of comparison with the drawings of the English Bury St Edmunds Gospels.[182]

St Bernard inveighed bitterly against the meaninglessness of much Cluniac sculpture, yet many of the early Cîteaux initials were equally capricious – indeed, the artistic *joie de vivre* of the new reformers seemed irrepressible, particularly in the pioneering years. They also had a profound awareness of the contemporary scene. In an abbey recently built within the wildest of forests, and in a text largely complete by 1111,[183] they recorded a series of remarkable and delightful pictorial observations – a monk beginning to fell a tree while a lay brother trims the upper branches;[184] two monks splitting a tree-trunk[185] [208]; others cutting the corn,[186] threshing the harvest,[187] gathering grapes from the vineyard,[188] and measuring out cloth.[189] Though transformed into rhythmic compositions to conform to the geometric demands of the initials, these little vignettes are all clearly taken from the life – the harsh life of the pioneer, reclaiming wild forest-land and tearing his habit on trees and brambles; they are valuable historically as contemporary records of the early life of the primitive Cistercians, and art-historically for their fresh sense of observation.

A reference to secular pride in the last volume of this four-volume work is illustrated[190] not symbolically, as artists from elsewhere would probably have chosen to do, but by a satirical painting of a sumptuously clad rider[191] out falconing on a richly caparisoned horse [209]. His over-ornate shoes, his extravagant red cloak with its white and blue diapered lining, and his long, flowing, womanish hair are the very essence of the effeteness that results from pride, contrasting sharply in other initials with the torn habits of the toiling Cistercians (many also from wealthy backgrounds). Orderic Vitalis, one of the many writers of the period to attack the foppish garments and the long hair of the courtiers, might almost have been describing this very rider when he said, 'They add excrescences like serpents to the tips of their toes ... they love to deck themselves in long, over-tight shirts and tunics,' going on to criticize their extravagant sleeves and over-long mantles.[192] The artist's ironical shaft was clearly in the tradition of the sharp and sceptical observations of English painters before the Conquest,[193] when luxurious fashions had

207. Cîteaux: *St Maurilius*, from the Cîteaux Lectionary, MS. 642, folio 67 verso. *c.* 1115–25. Dijon, Bibliothèque Municipale

also been lampooned, and the social mores of the time had been critically observed. In the Cistercian manuscript, the artist's powers of perception are put to more benevolent use in his studies of birds in the river below, which are easily recognized as cranes and shovellers.

This freshness of approach also permeates more strictly theological paintings, and the Cistercians played a significant part in the development of the theme of the Tree of Jesse[194]

which was to become so important in later Romanesque and Gothic art. Their order was dedicated to the Virgin, and their illustrations stressed Christ's lineal descent from Jesse through her which rendered her son human as well as divine. From the early days of the Christian Church a deviant belief had obtained that, since the world of the flesh pertained to the devil, Christ could not really have been born of a woman. This belief gained renewed currency in the eleventh century, culminating in the twelfth in the assertion of the Cathari that Christ 'was not truly born of the Virgin and did not truly have human flesh'.[195] It was to refute this that the Cistercians – who, led by St Bernard, were in the forefront of opposition to the heresy – emphasized the role of the Virgin in conceiving and bearing a child of human flesh, and also went out of their way to picture Christ's line rising from the genitals of Jesse in an entirely human manner. They also attacked other heresies by visual means, as in the illustration of the Bible of Stephen Harding which subtly refutes one of the unorthodox views of the heretic Arius.[196] Later in the twelfth century the West intensified the anti-heretical meanings of its Jesse Trees by incorporating into the branches more and more Old Testament prophets and kings, thereby asserting the significance – and even the relevance to the Christian faith –

208. Cîteaux: *Monks splitting a tree-trunk*, from St Gregory's *Moralia in Job*, MS. 170, folio 59. Completed on 24 December 1111. Dijon, Bibliothèque Municipale

209. Cîteaux: *A knight falconing*, from St Gregory's *Moralia in Job*, MS. 173, folio 174. *c.* 1111–15(?). Dijon, Bibliothèque Municipale

210. Cîteaux: *The Tree of Jesse*, from the Cîteaux Lectionary, MS. 641, folio 40 verso. *c.* 1115–25. Dijon, Bibliothèque Municipale

211. Cîteaux: *The Tree of Jesse*, from St Jerome's *Commentary on Isaiah*, MS. 129, folio 4 verso. *c.* 1115–25. Dijon, Bibliothèque Municipale

of those Books of the Bible repudiated by some heretical sects.

Two particularly fine pictures of the Tree of Jesse have come down to us in separate but more or less contemporary Cîteaux manuscripts. One, in the Cîteaux Lectionary, shows the Virgin and Child encircled in symbolic branchwork above Jesse[197] [210]; the other, in a text of St Jerome, is a painting of great authority in which the Virgin dominates the picture space by her imposing presence[198] [211]. The vibrant sense of movement in the first picture reflects influences from the north, but the fall of the drapery folds betrays the impact of Byzantium, and the Virgin offering her breast to the Christ Child is actually labelled 'Theotokos'. Above is the dove of the Holy Spirit, and on either side Old Testament allegories of Mary's virginity lend emphasis to the view that the New Testament is the fulfilment of the Old. The Virgin of the other Tree is grave and aloof – a powerful matriarch, the protectress of a divine offspring who will redeem the world. The Byzantinism of the 'damp-folds' of her garments is of a kind already assimilated to the Romanesque tastes of the West, and the heavily pleated draperies are known earlier from Saint-Omer. A similar assimilation of Byzantine styles

to Romanesque tastes produced such powerful works as the St Martin on folio 113 of the fourth volume of the Lectionary [212], where the 'damp-folds' contribute to the powerful rhythmic swings and cadences of a Western aesthetic. Some of the saints follow the recognized Byzantine convention for patriarchs, one hand held in blessing, the other clasping a jewelled Bible which is reverently shielded from the bare arm by drapery, and Byzantine influence may also be responsible for the independence of the human figures which are not – like the foliage and animals – ingested into the initials but are set in front of them [213] or to the side.

The Lectionary artist participated in the decoration of a Martyrology[199] from Saint-Bénigne at Dijon, also in Burgundy, and (with two others) in the initials of the Saint-Bénigne Bible.[200] This has led to the suggestion that the Bible was made at Cîteaux,[201] and indeed it shares both an early interest in the Tree of Jesse and a predilection for English structures to the initials; however the overall impression is quite different from anything we know from the Cistercian house, and its many historiated initials, made lively by their colours and by the nimbleness of the activity inside them, are rendered slightly exotic by a garnishing of white dots which comes perhaps from Spain. The Bible is attributed to the early twelfth century.[202]

Byzantine influences were strong too at Cluny, also in Burgundy, and one of the most powerful centres of Christendom. Unfortunately Cluny became a focus of hostility in post-medieval times, and the destruction of her manuscripts during the French Revolution has left little on which to base a judgement of her painting, though this has not deterred some from making extravagant claims on her behalf. The illumination that does survive[203] is not impressive, showing none of the interest of Germany or England in the development of narrative painting and consisting chiefly of decorative initials undistinguished by any particular felicity. The Cluny chronicle itself shows little concern for vellum paintings, describing a Bible made between 1109 and 1122, and clearly one of the glories of the library, merely in terms of the splendour of the binding and the accuracy of the text,

212. Cîteaux: St Martin, from the Cîteaux Lectionary, MS. 641, folio 113. c. 1115–25. Dijon, Bibliothèque Municipale

213. Cîteaux: *St Symphorian*, from the Cîteaux Lectionary, MS. 641, folio 10 verso. c. 1115–25. Dijon, Bibliothèque Municipale

214 (*opposite*). Cluny: *Pentecost*, from the Cluny Lectionary, MS. nouv. acq. lat. 2246, folio 79 verso. Early twelfth century. Paris, Bibliothèque Nationale

ECCE EGO MITTO...
SUPRA PATRIS MEI IN VOS

uuerat
i co
rerur
bum
nobis;
NA
ut
o sit;
er;
is in
us su
gau
u uirm
i xpi
idere
qd
recon
dixe
ris par
obis
e utiq;
le et

with no reference whatsoever to any paintings.[204] Now it is true that indifference to illumination is common to most chronicles, but it cannot be without significance that the gravest charge that the later *Dialogue between a Cluniac and a Cistercian* – a polemical work of the 1160s that carried on the Cistercian attacks initiated by St Bernard on the luxury of Cluny – can bring against that house is that she used gold in her initial letters[205] (a common practice at the time) while making no mention of any large-scale decorated and illustrated manuscripts. Doubtless Cluny had a fair number, but we should not too readily suppose that the little manuscript painting that survives is the tip of a huge lost Atlantis of Cluniac art. We should, in any case, remind ourselves of the fact that no illumination at Cluny would have been made by the monks themselves. They simply did not have the time. Cluny had so multiplied and extended her liturgical services and ceremonies that there was no opportunity for anything but choir activities, as those with experience of the wearing round complained. One of them, writing around 1080, said that they left barely half an hour free for other activities in the whole day.[206]

The finest surviving Cluniac manuscript of the twelfth century is an admirable Lectionary, now in Paris, (Bibliothèque Nationale MS. nouv. acq. lat. 2246) which belongs to the earliest decades. Some of its paintings have been removed, but there remain an Annunciation, a Pentecost [214], a Dormition and Assumption of the Virgin, a liberation of St Peter from prison, and a Crucifixion. Here – exceptionally – St John the Evangelist, the traditional witness of Christ's sacrifice, is replaced by the prophet Isaiah, and this may be explained by Isaiah's allusion to the suffering servant and by contemporary efforts to counter heresy by emphasizing the Old Testament and relating it to the New. Ottonian influences are perceptible in the purple backgrounds, and Byzantine ones in the so-called 'damp-folds' of the draperies and in the proportions of the figures.[207] A single picture of St Luke, presumably cut from a Bible and now in America, is claimed to be by the same hand,[208] and it is certainly in a very similar style.

A copy of St Ildefonsus's *De Virginitate*,[209] an impassioned treatise against those who disbelieved in the virginity of Mary, probably made in the final quarter of the twelfth century, has been attributed to Cluny, though one view (which I do not share) ascribes it to Spain.[210] It is illustrated with no fewer than thirty-five pictures, some of them full-page. The metallic elegance of the initials is clearly Ottonian-inspired,[211] and so too is the figure style of the pictures. Despite its small format, the volume emulates the 'display' manuscripts of the Carolingian and Ottonian emperors[212] with its opulent sheen of gold and its rich purples and blues in both text borders and pictures, though the latter have lost the passion of Ottonian art without achieving the power of Romanesque. The two final paintings,[213] however, are of a higher standard than the rest. They illustrate an old colophon, included in this manuscript, which relates that a copy of the work was made by a monk named Gómez for Gotiscalc, bishop of Le Puy, when he visited Spain in 951, and show Gómez first writing the work and then presenting it [215]. The ornate style is quite obviously inspired from Byzantium, modified by Ottonian reminiscences and now heightened to a colourful effect achieving something of the resplendence of mosaics.

215. Cluny(?): *The scribe Gómez presenting his work to Bishop Gotiscalc*, from St Ildefonsus's *De Virginitate*, MS. 1650, folio 102 verso. Last quarter of the twelfth century(?). Parma, Biblioteca Palatina

Cluny is on record as having offered a helping hand to a until the time of its fifth prior, Guigo I (1110–36). Like the Cistercians, the Carthusians despised luxury of every kind, wearing as an antidote to pride garments so mean that they were repulsive to look at.[214] But books they did not reject. Declining a gift of rich plate from the sympathetic count of Nevers, they gladly received the parchment and ox-hide which he offered in its stead, for the first could be used for making manuscripts, and the second for binding them.[215] 'They abase themselves in every kind of poverty,' wrote Guibert of Nogent, but 'they are amassing a very rich library.'[216] It was in this connection that Cluny offered its aid, for its abbot, Peter the Venerable (1125–63), speaks of Cluniac manuscripts being despatched to the Grande Chartreuse,[217] presumably for copying. He was ready to send as far afield body of monks who, like the Cistercians, hoped to find a new spiritual purity by returning to the earlier ideals of Christianity. In 1084 these pioneers, led by the scholarly St Bruno, set themselves up as a semi-eremitical group in a wild, often snow-covered area of the Alps north of Grenoble from which they took their name as the monks of the Grande Chartreuse, or Carthusians, as the Cistercians had taken their

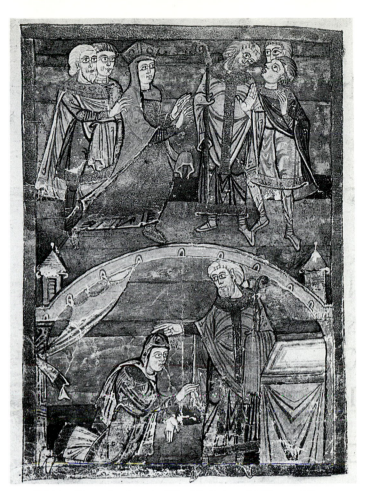

216. Toulouse: *Josephus presenting his 'De Bello Judaico'*, MS. lat. 5058, folio 3. Late eleventh century. Paris, Bibliothèque Nationale

217. Poitiers: *Illustration from the Life of St Radegund*, MS. 250, folio 27 verso. Late eleventh century. Poitiers, Bibliothèque Municipale

from Cîteaux. The order was not, however, formally initiated as Aquitaine, to the Cluniac house of Saint-Jean-d'Angély, for one text that the Carthusians were anxious to consult or copy,[218] and his correspondence brings to light an unusual hazard for a book separated from its library: it became a meal for a bear.[219]

It was for their texts that the Carthusians desired books, but two illustrated manuscripts of some interest do survive from the Grande Chartreuse. The first, a three-volume Bible[220] of about 1100 or soon after in which are recorded the very earliest donations made to the Carthusians, has large initials on coloured grounds whose highly formalized interlace and animal- and bird-head decoration are reminiscent of north-eastern France, though the lace-like edging of the foliated scrollwork is not. The second, a four-volume Bible[221] of much later date – probably the last quarter of the twelfth century – introduces the Book of Genesis with a full-page initial I incorporating the Creation, the Tower of Babel, the Drunkenness of Noah, and other scenes, with Anti-Christ between the Annunciation and Joseph below. Opposite are the first few words of the Bible, presented on a display page in gold on coloured grounds. The many initials are decorated in a Byzantinizing style by four, if not five, different hands.

CENTRAL, WESTERN, AND SOUTHERN FRANCE

Illuminated manuscripts from central, western, and southern France are not plentiful, but many of them are rich in quality, and two have links with wall painting. The first is a copy of

the *De Bello Judaico*[222] of Josephus, a Jewish historian of the first century A.D. who was much read in the tenth and eleventh centuries. There are 'portraits' of him in both English and Mosan copies of his works, but our French artist goes further, devoting a double page to a drawing in bistre, brightened by passages of rust, green, blue, and yellow, of the author presenting his book to the emperors Titus and Vespasian (a detail of the right-hand page is shown in illustration 216). The style is akin to that of a St Gallen copy of the Book of Maccabees of the first half of the tenth century[223] [67], and of a Liège *Psychomachia* of the second quarter of the eleventh.[224] The fluted folds of Josephus's draperies suggest additional acquaintance with the illumination of north-eastern France, particularly Saint-Omer. The manuscript, at one time attributed to Moissac, is now given to the vicinity of Saint-Sernin of Toulouse,[225] and it is generally recognized that this Toulouse style made a significant contribution to the style of the wall paintings of Vicq-sur-Saint-Chartier which – it may be added – have associations also with a Mont Saint-Michel Cartulary,[226] as will be seen by comparing the Vicq Christ in Majesty with the central figure of the drawing of the donation made by Duke Richard II of Normandy [184].

The second manuscript with mural links is an illustrated Life of St Radegund[227] made at the end of the eleventh century in the Poitiers house of Sainte-Croix. Its twenty-two full-page, or half-page, paintings are in a style [217] which, though possessed of a new and engaging vivacity of its own, originated in the Schools of Tours and of the Court of Charles the Bald, and was soon to influence the greatest surviving ensemble of paintings of Romanesque France – those of

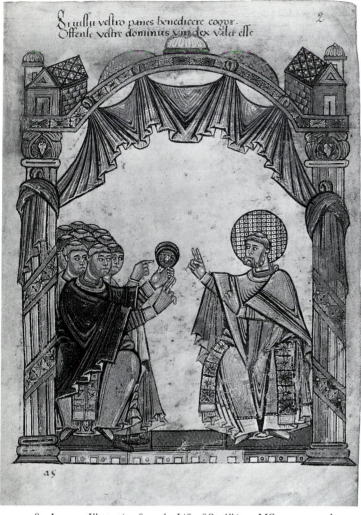

218. Angers: *Illustration from the Life of St Albinus*, MS. nouv. acq. lat. 1390, folio 2. Late eleventh century. Paris, Bibliothèque Nationale

Saint-Savin-sur-Gartempe [230].

The suggestion that the sombre-coloured pictures of the Life of St Albinus from the abbey of Saint-Aubin at Angers[228] are related to the almost vanished wall paintings of the church of Saint-Jean-Baptiste at Château-Gontier[229] has some historical logic, since Saint-Jean belonged to Saint-Aubin, but a comparison of styles offers no real artistic justification for the idea. The chunky, massive qualities of the manuscript figures [218] reflect Ottonian influences such as those of the Gospel Lectionary of Henry II, and the pictures have a spacious, even monumental quality that renders them precociously Romanesque for the end of the eleventh century to which they are attributed. Their artist contributed to an Angers Psalter three full-page paintings of David harping, of his musicians Asaph, Heman, Jeduthun, and Ethan, and of his combat with Goliath.[230] He also illuminated a great two-volume Bible from Saint-Aubin[231] whose most important picture is a large-scale and impressive Christ seated in a glory formed by two highly ornamental circles [219]. Despite its lack of weight, the figure has an aloof grandeur that would well become a large mural – and it so happens that the abbey then had a resident wall painter named Foulque who – as we saw in an earlier chapter – had been engaged by Abbot Gerard (1082–1106) and the monastic community on a contract for

life[232] which describes him as 'well versed in painting' and requires him to paint 'their whole monastery' and 'anything they instruct him to paint'. It may be, as some think, that this included manuscripts, and certainly these from Saint-Aubin bring a new style to the Anjou area, though the name 'Foulque' is said to suggest that he was Angevin himself.[233] The weight of paleographic opinion favours a date in the ninth century for the Saint-Aubin Bible,[234] which would mean that two centuries elapsed between writing and illumination.

Equally remote from one another are the life-times of Christ and of St Martial, the evangelist of Aquitaine whose body lay in the abbey founded in his honour at Limoges. Yet the Limoges monks vigorously promoted the idea that the two were contemporaries, and indeed that St Martial had been a relative of St Peter and a witness of several of Christ's miracles; as a result, in 1031, a Church Council conveniently declared him to have been an apostle, which greatly enhanced the prestige and influence of the house. Destroyed by the Norsemen when they began their irruptions into the Carolingian empire, the abbey had been refounded in 848 by Charles the Bald, but was devastated again in 888, though this time not completely, for after a few years the monks were able to make their return. Some of the books kept in the crypt were destroyed by a fire during the abbacy of Guiges (974–91), but others which were kept elsewhere and so escaped the flames[235] included manuscripts given to the community by Charles the Simple. They came from the rival king, Robert I, killed in battle in 923 and one of them is generally thought to be a sumptuous Gospel Book from the Saint-Martial library[236] which was made at Tours in the Carolingian period.

Tours certainly inspired the art of the first Bible of Saint-Martial,[237] brought to general scholarly attention by Émile Mâle, who pointed out the connection between the teeming animals at the bases of its Canon Tables and the carvings of animals at Souillac.[238] This animal life, and even more the foliated decoration in the large and delightful initials which introduce each book, owe much to Tours. Indeed, the Saint-Martial style is so close to Carolingian art that it has given rise to two schools of thought, one taking the Bible to be a delayed production of the Carolingian Renaissance and dating it to the late ninth or early tenth century,[239] the other seeing in it a revival of a Carolingian style that occurred in the second half[240] – and even the latest years[241] – of the tenth century. If it could be confidently placed in the revival context of the second half of the tenth century – the date that I prefer – it would have claims to be the finest surviving French great Bible of its time. It is in two volumes. Its scribe – Bonebertus – is named on folio 219 verso of the second volume, and Gaborit-Chopin believes that he was the artist, too, for she finds the same script partnered by the same illumination in another Saint-Martial manuscript,[242] and traces the influences of his style on other Limousin manuscripts,[243] including a Lectionary of the late tenth or early eleventh century.[244] The Lectionary artist also illuminated a Troper[245] and a collection of the lives of saints[246] with highly conservative foliate decoration and a figure style influenced by Ottonian and south Italian art.[247]

219. Angers: *Christ in Majesty*, from a Bible, MS. 4, folio 208. Late eleventh century. Angers, Bibliothèque Municipale

P OST MORTEM

IOSUE CONSU

LUERUNT FILII

ISRAEL dñm dicentes. Quis ascen

det ante nos contra chananeum et erit

dux belli. Dixitque dñs. Iudas ascendet.

220. Limoges: *God addressing Judah and the Israelites*, from the second
Bible of Saint-Martial, MS. lat. 8, vol. 1, folio 91. Late eleventh/early
twelfth century. Paris, Bibliothèque Nationale

221. Limoges: *Pope Damasus addressing St Jerome*, from the second Bible of Saint-Martial, MS. lat. 8, vol. I, folio 4 verso. Late eleventh/early twelfth century. Paris, Bibliothèque Nationale

There is no controversy about the date of the second Bible of Saint-Martial, also in two volumes:[248] it is generally agreed that it belongs to the end of the eleventh or the beginning of the twelfth century. It is the abbey's chief masterpiece. Its decorated initials bring to a new peak an Aquitanian style introduced to Limoges in the early eleventh century, in which ultimately Franco-Saxon interlace is enriched by vegetal rinceaux against a coloured background. The first stirrings of Romanesque at Limoges are evident in the clarity and precision of one or two of the pictures, particularly God addressing Judah and the Israelites on folio 91 of volume I [220], where the assurance of line, the fastidiousness of

decoration, and the harmonies of colour of its remarkable artist appear at their best. Elsewhere – for example, in the Pope Damasus addressing St Jerome on folio 4 verso of the same volume – we can sense something of the delicacy of his rhythmic taste [221]. The Bible contains a number of historiated initials, and among its rich decorative motifs many offer an abridged anthology of contemporary natural history – tiny dogs, foxes, hares, goats, fish, an owl and other birds abound, as well as griffins, elephants, lions, birds of prey, stags, and even monkeys, some of them clearly inspired by imported silks. This Bible's main artist – he was responsible for most of the illumination and all the designs – also

222. Limoges: *The Ascension*, from the Sacramentary of Saint-Étienne de Limoges, MS. lat. 9438, folio 84 verso. 1095–1105. Paris, Bibliothèque Nationale

decorated a Lectionary, a text of St Gregory, and other works.[249] Of his two helpers on the Bible, one went on in the early twelfth century to illuminate a Life of St Martial[250] and further manuscripts,[251] the other to illuminate a Rule of St Benedict,[252] which has a fine full-page Christ in Majesty with St Martial and St Benedict.

Though lacking the linear refinement of this Bible, the illumination of a contemporary Sacramentary, made for Limoges Cathedral,[253] is also Romanesque in its impact. It is rendered opulent by its arresting colours, chiefly lapis lazuli, scarlet, and malachite green, all set off by gold. Its full-page New Testament scenes [222] begin with the Nativity and end with Pentecost. The same artist has been credited with the illumination of a copy of St Gregory's *Homilies on Ezekiel*[254] and of two great Bibles[255] (one of them made for Saint-Yrieix, Haute Vienne), and also with the murals in the crypt of Limoges Cathedral, now badly damaged, though the Annunciation is still in reasonable condition.[256] It is not known to which community this artist was attached. His surviving work seems to have been made for chapters of canons, yet he is patently aware of the art of Saint-Martial, and especially of the second Bible. He must have been active

at the very end of the eleventh century or the beginning of the twelfth; his Sacramentary can be confidently dated after 1095 since its Calendar alludes to the consecration of the cathedral by Pope Urban II in that year.[257]

The artist must then have been active during the abbacy of Adémar (1063–1114), himself Limousin by upbringing. The first abbot to be appointed after Saint-Martial became Cluniac in 1062, Adémar provided murals for the whole monastery,[258] and some of the house's finest manuscripts – notably the second Bible – were produced during his abbacy, though afterwards there was an artistic decline. Before his time, as it happens, there had been another Adémar who had enriched the library of Saint-Martial. He was Adémar of Chabannes, who died in 1034 in the Holy Land and is known chiefly as a homilist, chronicler, and poet. He was, however, an artist, too, and some of the books he bequeathed contain initials and drawings from his own hand.[259] His most interesting manuscript is a Miscellany now in Leiden[260] with sketches of animal fables (one or two related to the border embroideries of the Bayeux Tapestry), of battles between Virtues and Vices, of scenes of the life of Christ, and of constellations. The drawings are far from sophisticated, and appear to be jottings from manuscripts or other *objets d'art* intended as models for the production of illuminated manuscripts – in some cases he has even indicated by letters the colours that should be used. The Miscellany is fascinating as the earliest medieval example known to us of a collection of artist's models and motifs. Adémar was a musician, too, and we are reminded that Limoges from the end of the tenth century was one of the chief musical centres of the Western world by a mid-eleventhcentury Troper[261] formerly in the Saint-Martial library[262] that probably originated in the Toulouse region.[263] Its musicians, jugglers, and dancers illustrating the varying tones of the Gregorian plainsong (or something like them) were to influence capitals in the ambulatory of the abbey church of Cluny, but their own warmth and exuberance of colour reflect influences from Spain.

Such influences are very patent at Saint-Sever-sur-l'Adour in Gascony, about sixty-five miles from the Spanish border. From this house comes a famous Apocalypse,[264] one of only two remaining of the first edition of the Spanish theologian Beatus,[265] and the only illustrated Beatus Apocalypse to survive from a centre outside Spain. French ingredients include the Christ in Majesty on folios 121 verso and 122 [225], but basically the manuscript derives from the Apocalypses of Spain, and particularly from the illumination of León of c.1045 to c.1065.[266] The name of Abbot Gregory Muntaner – 'Gregorius abbas nobilis' – at the centre of the decorative frontispiece in a frame containing imitation Arabic script enables us to date the Apocalypse between 1028 and 1072 (probably later rather than earlier in Gregory's rule). Delisle thought that the name Stephanus Garsia Placid[us] on folio 6 referred to one of the painters, but Avril goes further and suggests that he was the principal one (there were two others), and also one of the scribes.[267] There is no evidence that Saint-Sever had a scriptorium of any importance, and Vezin has therefore argued that Abbot Gregory brought Stephanus in from outside, probably from within the area of south-western France.[268]

As in the Spanish Beatus manuscripts discussed in the next

223. Saint-Sever-sur-l'Adour: *The torment by locusts*, from the Saint-Sever Apocalypse, MS. lat. 8878, folio 145 verso. 1028/72. Paris, Bibliothèque Nationale

224. Saint-Michel-de-Cuxa(??): *St John before Christ*, from the Perpignan Gospels, MS. 1, folio 111 verso. Second half of the twelfth century. Perpignan, Bibliothèque Municipale

chapter, the illustrations of the main text are supplemented by scenes that emphasize the divinity of Christ or refer to the events of the Last Days. They include the Adoration of the Magi, the Annunciation to the Shepherds, a combat between a bird and a serpent to symbolize Christ's triumph over evil, and illustrations of the Book of Daniel.

It was again Émile Mâle who brought this fine manuscript to special prominence by placing it at the head of those that influenced the masterpieces of Romanesque sculpture.[269] In particular, he associated the composition of the great tympanum of Moissac with the painting in the Apocalypse of the Vision of the Lord which fills folios 121 verso and 122 [225]. Here the enthroned Christ is surrounded by an inner circle of evangelist symbols and an outer half-circle of the twenty-four elders, each with harp and viol, with adoring angels around (see chapters IV, V, and VII of the Apocalypse). Mâle's claims have been disputed,[270] and it has even been argued that the scene derives from a commentary by Ambrosius Autpertus,[271] but Mâle was cautious in his proposals, and it can hardly be doubted that miniature and sculpture both belong to the same iconographic tradition, which was probably Carolingian rather than Spanish, for a similar circular scheme is found in an Adoration of the Lamb in the *Codex Aureus* of St Emmeram.[272]

Countless details go to prove that the vast majority of the numerous illustrations of the Saint-Sever Apocalypse are in the mainstream of the Beatus tradition in Spain, some of whose torrid inspiration and bright colours they also share. They are now, however, controlled by a clarity of line and an

225 (*overleaf*). Saint-Sever-sur-l'Adour: *The adoration of the Lord*, from the Saint-Sever Apocalypse, MS. lat. 8878, folios 121 verso-122. 1028/72. Paris, Bibliothèque Nationale

orderliness of composition that owe something to Limoges,[273] and a good example of the style is the illustration on folio 145 verso [223], which shows the world being tormented in its last days by monstrous locusts, presented as winged insects with the heads of men, the hair of women, the bodies of horses, and the teeth of lions, as described in the ninth chapter of the Apocalypse. The Book does not lend itself to realism, which indeed is entirely absent from the early Beatuses of Spain, but the French manuscript makes occasional tentative approaches to it.[274] There is, too, some more rational use of colour than we find in Spain, as for example the red background to the upper zone of the sounding of the first trumpet on folio 137 verso to signify that the heavens are filled with fire and blood, and the dominant greens and blues of the scene on folio 139 verso, where we are told that the mountain falls into the sea and destroys a third part of the ships of the world. It is curious that – apart from the tamer and more domestic version of the style in the musicians and dancers of the Troper already mentioned[275] – these magnificent Saint-Sever paintings gave rise to no developments.

In Roussillon, where French and Spanish cultures overlapped, Carolingian and Spanish styles mingled, as is demonstrated by an important but little known Gospel Book of the second half of the twelfth century now at Perpignan.[276]

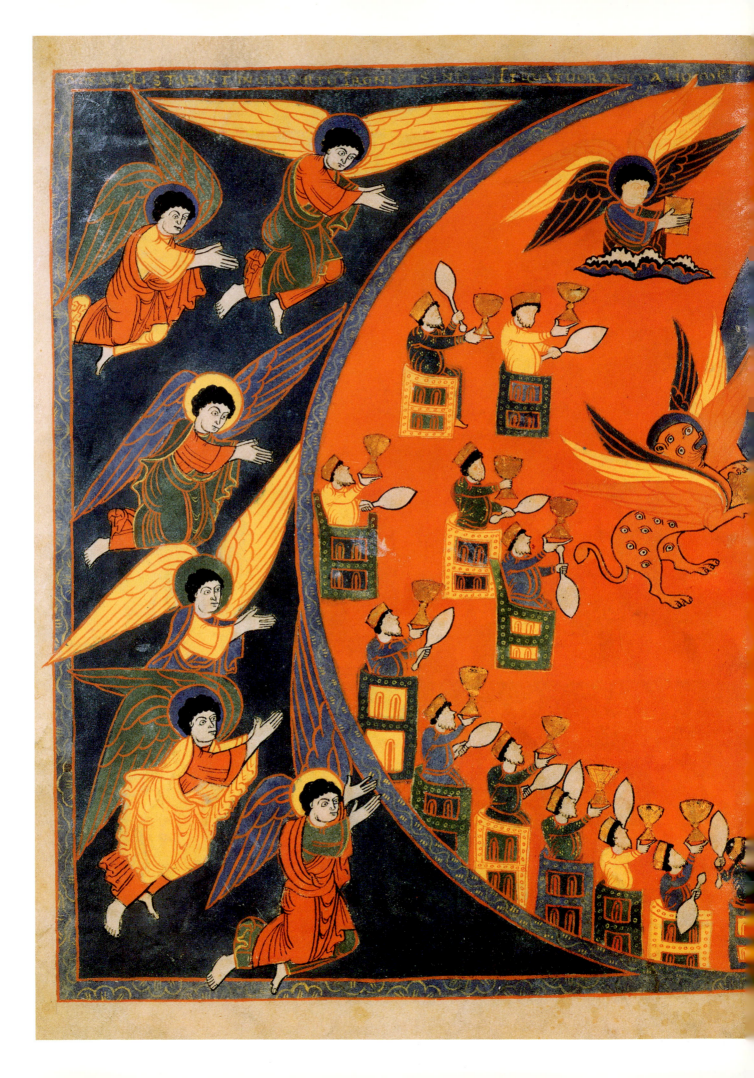

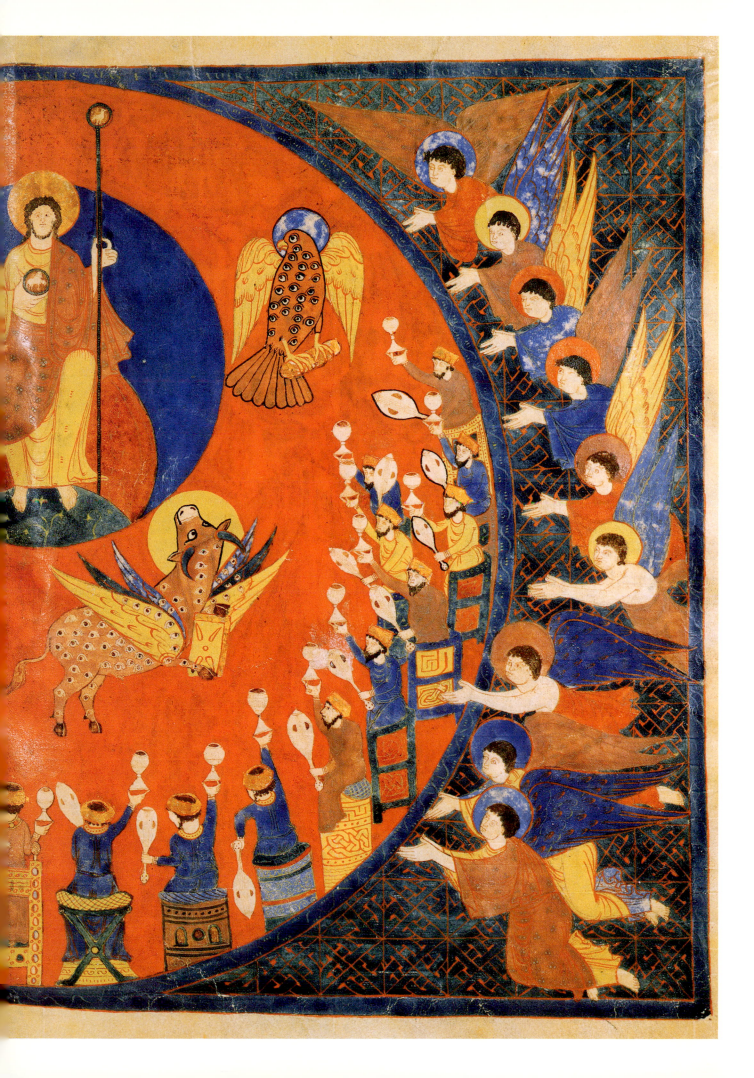

Its exact provenance is uncertain, and there is no compelling reason for its ascription to the monastery of Saint-Michel-de-Cuxa. The animals and human figures that enliven its warmly coloured Canon Tables resemble those of the Carolingian manuscripts of Tours and of the later Bible of Saint-Martial-de-Limoges, though here the boar, rabbit, cock, hen, ram, lobster, and goose on folios 8 verso-10 and 12 are quite realistic. More formalized and exotic, suggesting indirect influences from the East, are the elephants and griffins, while the centaurs and mermen indicate indirect influence from Antiquity. On the other hand, the style of the Christ in the handsome frontispiece to St John's Gospel on folio 111 verso, richly coloured in reds, greens, and yellows, may owe something to Carolingian traditions [224]. John, holding his half-open Gospel towards which Christ gestures, gives an unexpected skipping action as if to be off, like Puck, to 'put a girdle round the earth', but it is of the heavens that the inscription (from Sedulius) speaks, commenting that by his words John aspires to the stars like a soaring eagle (his symbol). The decoration of the initials has Spanish reminiscences, and the important series of drawings recalls the style of the Ripoll and Roda Bibles [251, 252]. The second of the three prefatory full-page drawings is a *Gnadenstuhl* type of Trinity, with God the Father towering behind the crucified Christ (though not actually supporting the Cross), accompanied by the dove of the Holy Spirit. The first of the prefatory drawings is a Christ in Majesty, the third, on folio 13, a Lamb surrounded by saints. In a fourth drawing, following the Canon Tables on folio 14 verso, the Virgin and Child are shown encompassed by saintly figures including an abbot, a bishop, and a king. Notwithstanding Boinet's helpful comments,[277] the iconography of the drawings of the seven scenes of the life of Christ on folios 107–8 would repay further investigation.

The richest manuscript of central, western, and southern France is also the latest; it is one of the most impressive of all the great Bibles of France.[278] It was made towards the end of the twelfth century by a group of artists, probably professionals who travelled from one religious centre to another, so that its provenance is uncertain, for it did not reach its later home, the Cluniac house of Souvigny, near Moulins, until 1457. According to Cahn,[279] its text is the same as that of a Bible now in Clermont-Ferrand,[280] and it is associated stylistically with a Bible from Saint-Sulpice at Bourges,[281] which would suggest that it originated somewhere in central France; but the story is complicated by other artistic relationships, not least with a Bible owned in the thirteenth century by Fressac,[282] near Nîmes.

The Souvigny Bible contains a number of rich historiated initials,[283] and – on panels separated from the text – illustrations to Genesis, Kings, Tobit, Esther, and the Acts of the Apostles; especially impressive are the scenes from the life of David [226] that preface the Book of Kings. The strong Byzantine influences impart an emotive impetus to some initials and a more relaxed feeling to others, a puzzling difference that may reflect either the length of time which it took to complete the Bible, or the fact that some of the artists were much younger and more up-to-date than others. Though its importance has always been acknowledged (Jean Porcher's comment was that its miniatures comprised 'la plus importante série de peintures bibliques romanes qui soit en France, sinon la plus originale'[284]), the Bible has not so far attracted the detailed research it deserves.

WALL PAINTING

GENERAL OBSERVATIONS

Abbot Suger noted that he 'summoned the best painters I could find from different regions' to carry out the wall paintings of Saint-Denis,[285] and this remark must go far to support the presumption that, although most of France's medieval murals were executed by local or regional painters, the trends were set by artists who were prepared to travel. Their seminal paintings have unfortunately almost all disappeared, which makes it difficult to gain an accurate developmental picture, for although the wall paintings that survive sound impressive in numbers – they amount in all to some one hundred and thirty – they are often disappointing in quality and condition, and many are simply fragments. They are largely concentrated in two areas, of which the more important follows the course of the Loire and is particularly rich in Maine, Anjou, and Touraine; the other is along the Rhône and its tributary the Saône. Some are also to be found on the French side of the Pyrenees, and a few in other areas. But, as our written sources confirm, these clusters bear no relation to their original distribution, which must have covered the whole country, and the reasons for these pockets of survival are still a matter of speculation: they may be connected with low rainfall (for damp is a great destroyer of murals), and are certainly related to the intensity with which Gothic architecture replaced Romanesque – the Île de France and other areas of the north and east where Gothic was particularly developed must have sacrificed many wall paintings to the vogue for replacing walls with stained-glass windows.

French wall paintings have in the past traditionally been grouped by technique rather than style, and this resulted in a basically twofold division. The first group used what is sometimes called the Greek method, described by Theophilus and typified by the paintings of Berzé-la-Ville, which involved the application of successive coats of pigment, together with glazes, with a base of glue. The second technique, once sometimes referred to as the French method and used for the vast majority of the wall paintings, consisted of mixing simple earth colours with lime and water and applying them without glazes to a dampened wall. The first technique – found generally in the east of France, in Burgundy and to some extent Auvergne – tended to produce brilliant paintings on dark blue grounds; the second, which preponderated in the west along the river Loire, produced matt paintings on light grounds. But this division by method rather than by style has several disadvantages. To begin with, the number of paintings in the first category is extremely small; secondly, a mixture of the two methods was sometimes practised, for example in the Auvergne; and finally, though technique may influence style, the two should not be confused, and the same

226 (*opposite*). Central France(?): *Scenes from the life of David*, from the Souvigny Bible, MS. 1, folio 93. Late twelfth century. Moulins, Bibliothèque Municipale

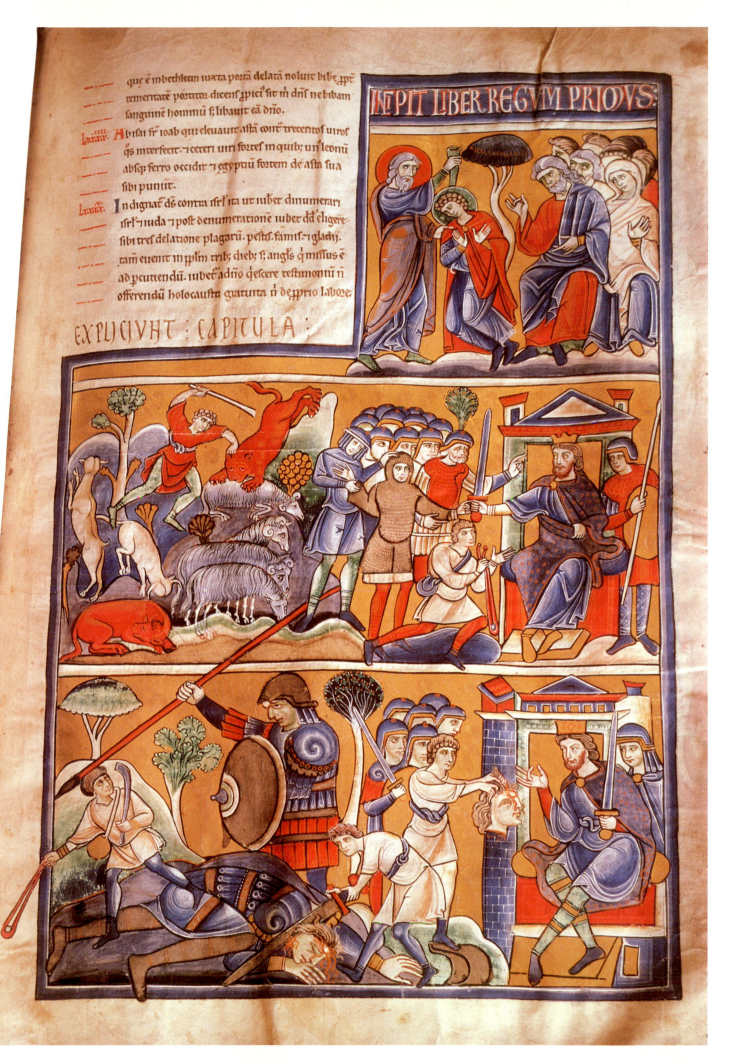

que e ībethleē iuxta portā delatā noluit bibe ꝓpᵗ
temeritatē portoꝝ dicens ꝓpici᷎ sit m dn̄s ne bibam
sanguinē hominū s; libauit eā dn̄o.

lxxiiii. Abisai fr̄ ioab qui eleuauit astā cont̄ trecentos uiros
q̄s ɪnterfecit. ⁊ ceteri uiri fortes in quib; uꝰ leonū
absꝗ ferro occidit ⁊ egyptiū fortem de asta sua
sibi punit.

lxxv. In dignat̄ ds̄ contra isr̄l̄ ita ut iubet dinumerari
isr̄l̄ ⁊ iuda ⁊ post denumeratione iubet dd̄ eligere
sibi tres delatione plagarū. pest᷎. famis. ⁊ gladii.
tam euenit ɪn ipl̄m trib; dieb; s; angl̄s q̄ missus ē
ad puenendū. iubet a dn̄o q̄escere testimoniū n̄
offerendū holocaustū gratuita n̄ de ꝓprio labore.

EXPLICIVNT : CAPITVLA :

INCIPIT LIBER REGVM PRIORVS :

artist might conceivably have worked in both techniques, just as some later artists worked in watercolour as well as oil.

EASTERN AND SOUTHERN FRANCE

With one possible exception, all the French murals that survive from the period between the Carolingians and the twelfth century are in east, south, and central France. Despite the fact that so few remain from the original proliferation of Carolingian wall paintings, their influence persisted into the Romanesque centuries, as we see from the survival then of the stepped pattern, the interlace of ribbon-ornament, the medallion and lozenge, and in the division of the background into horizontal bands. (The latter originated in later classical art as a naturalistic attempt to distinguish between the earth and the atmosphere, but was now used for exactly the opposite purpose – as a decorative backdrop to isolate the figures from reality.) It is of course possible that the later wall-painters made use of Carolingian illuminated manuscripts as their immediate source of inspiration, but it is far more probable that they often used extant wall paintings of the Carolingian period. This seems likely to be true of the much damaged paintings in the grotto at Saint-Pierre-Colamine (Puy-de-Dôme), whose detail and colour recall some elements of Carolingian murals. They are so heavily rustic that any dating of them is a risk, but it was one that Deschamps and Thibout were willing to take, for they placed them 'à une date voisine de l'an Mille'.[286] Their subjects are taken from the Passion and Resurrection of Christ: Christ taken before Pilate, the crowning with thorns, the Deposition, the holy women at the tomb, the appearance of Christ to the Magdalen, and (above the entry) the Virgin and Child.

A painting which survives in damaged condition in the shallow vault of the chapel of Saint-Michel-d'Aiguilhe (Haute Loire),[287] built on its daunting site in the tenth century and extended in the eleventh, may belong to the period of first completion – that is, around 984. Its original colours were red and yellow ochre, grey, black, and white, and its composition is similar in many ways to the crypt painting of Ternand (Rhône) attributed to the Carolingian period.[288] Christ appears in Majesty, with St Michael (on a smaller scale) and symbols of the evangelists in roundels. Details of apostles and saints can also be discerned, together with vestiges of a Last Judgement, showing on the one hand the punishments of Hell and on the other the rewards of the Heavenly Jerusalem.

Scenes of the Old and New Testaments in the south transept of the cathedral of Le Puy (Haute Loire)[289] were lost in the nineteenth century, but others in the north transept, attributed to the mid eleventh century, have survived, though much restored. Some of them are decorative (chiefly birds and animals), others – such as the Judgement of Solomon and the martyrdom of saints – are narrative, but it is the single figures that attract attention. They are of varying sizes; the long, loose figure of St Michael, standing on a dragon and gazing at the spectator with large, fixed eyes, is over five and a half metres high. The colouring is in rust-reds and blues set off with yellows, and the archangel's vestments have simulated large precious stones. The model may have been a St Michael from Monte Gargano, a famous centre of pilgrimage on the Adriatic coast after the saint's appearance there in 492.

A damaged Christ in Majesty in the apse of the chapel of the Château des Allinges in Haute Savoie[290] is painted in red and yellow ochres and in deep green, grey, and white. Evangelist symbols in segments of circles are attached to the mandorla, and on the far sides are the Virgin and St John, each with a seraph. Three of the four three-quarter-length figures below are identified as the Virtues Caritas, Humilitas, and Paciencia. On an adjacent wall is St Martin with cross and book. These paintings may be attributed very generally to the eleventh century. A fragment of a Crucifixion in the ruined priory of Domène (Isère)[291] can be dated more precisely, for it is probably associated with the dedication of the church in 1058.

In the seventeenth century traces of gold could still be seen in the now-vanished paintings of Christ with apostles and martyrs on the choir vault of the church of Saint-Pierre at Vienne (Isère).[292] Two painted figures on the tympanum have also all but disappeared, but the slightly damaged condition of the John the Evangelist, one of the twelve larger-than-life figures that originally filled arcades in the two lateral walls, does not obscure its fine quality. It may belong to the third quarter of the eleventh century.

Almost certainly of that date are the murals of the monastic church of Saint-Chef-en-Dauphiné (Isère),[293] attributed to the period of the church's restoration around 1056 and the finest of the eleventh century to survive in France. Those in the choir and transept illustrating God's message to Zacharias, the Annunciation, and the Transfiguration (Christ with Moses and Elijah) are so restored that it would be a travesty to describe them as medieval, but those in the chapel of St Michael and St George in the upper storey of the north transept have happily, in view of their admirable quality, escaped such well-intentioned mutilation. They include a Christ in Majesty with symbols of the evangelists, three archangels, and a St George with a head modelled in stucco. The special jewel in this tiny casket of a chapel is the Heavenly Jerusalem in the apex of the vault [227]. Despite the multiplicity of figures, there is a feeling of space. Christ enthroned in a mandorla in the centre bends his arms upwards in seeming approbation. On his knee is a book open at the text 'Pax vobis ego sum'. Below, in the blue of her virginity, his mother prays in the company of seven angels, and on each side is a group of six angels and a seraph on whose three pairs of wings are the eyes mentioned in the Apocalypse (IV, 8). Other references to the Apocalypse occur in the Lamb of God over the schematically represented Heavenly City above ('And he carried me away in the spirit ... and showed me that great city, the holy Jerusalem ... and the Lamb is the light thereof'; XXI, 10 and 23), which is guarded at each of its two visible gates by an angel (XXI, 12); simple heads within symbolize the elect. On one side, an angel takes one of the saved gently by the hand; on the other, the fate of two souls is under consideration. There is an air of calm, the colours are gentle with subtle gradations of greens and browns, and the figures have the lightness and authority that one finds in such ninth-century Roman mosaics as those of Santa Cecilia in Trastevere and Santa Prassede. The heavenly

227. Saint-Chef-en-Dauphiné, Saint-Georges, *The Heavenly Jerusalem*. Wall painting. *c.* 1056

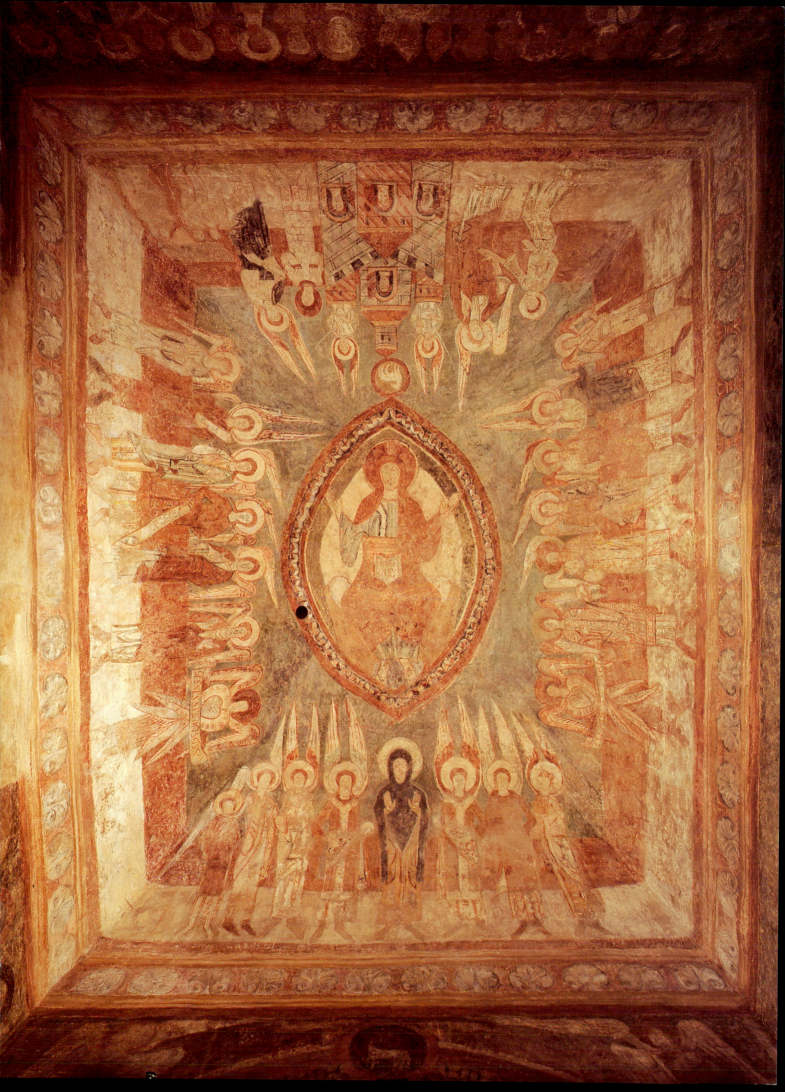

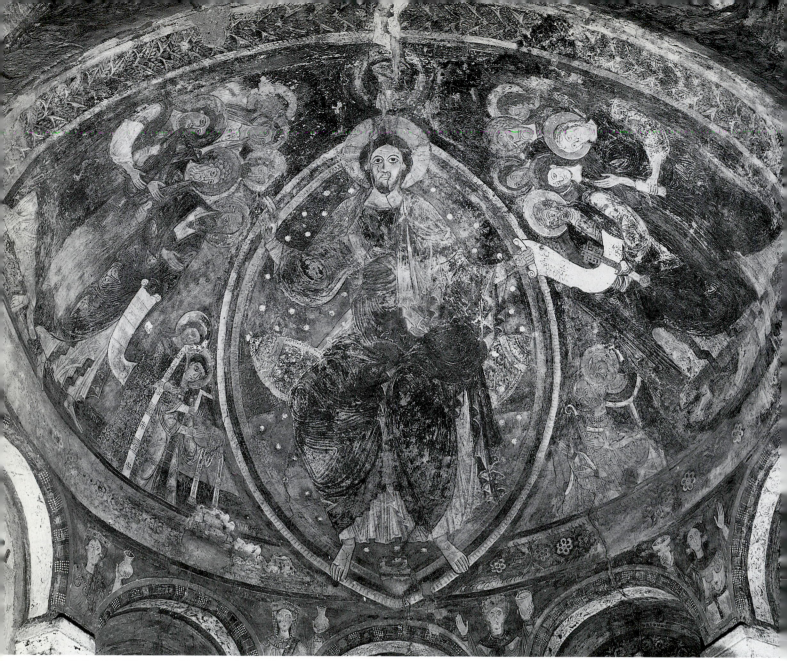

228. Berzé-la-Ville, apse of the upper chapel, *Christ in Majesty*. Wall painting. *c.* 1100–40

world is separated from the earth beneath by a frame decorated with shell-like motifs, and at the base of the vault there are tiers of prophets and saints, of the four evangelists, and of two saints on horseback (presumably St Michael and St George). On the abutments of the chancel arch are two angels.

Eastern France can boast also one of the most impressive murals of the twelfth century; it is in the priory of Berzé-la-Ville (Saône-et-Loire),[294] originally a daughter house of Cluny, whose manuscript paintings we have just discussed. Cluny, founded in 910, was in the twelfth century the head of one of the greatest monastic orders in Christendom, in firm control of an international organization subject only to the papacy, which was itself the first to recognize Cluny's spiritual prestige: the autocratic Gregory VII did not disdain to solicit her prayers, and it is to the presence of her great abbot, St Hugh, that one of his predecessors, Stephen IX, is said to owe rescue on his death-bed from the torments of the devil; it was also to St Hugh that Urban II turned for

guidance, begging him to come to Rome on the day of his consecration, or at least to send some of his monks. These Italian connections are reflected in the Berzé paintings.

There are in the lower chapel some traces of decorative paintings and, in the nave of the upper, figures of saints and scenes from the Gospels of which only the Entry into Jerusalem can now be distinguished. The unidentified nimbed abbots on either side of the arch leading into the apse no doubt represent two of Cluny's former saintly pastors, while in the apse itself is the most significant of all Berzé's paintings [228]. Above the central Christ, seated in a mandorla, the hand of God the Father holds a crown, and on either side are the twelve apostles, most prominent among them the two saints to whom Cluny was dedicated, St Peter and St Paul, with St Peter holding his key and receiving from Christ a scroll. Below are four saints, the two on the left alone identified as the deacons St Vincent and St Lawrence. In the blind arcade to the right of the semi-dome the prominent Roman saint and martyr, St Lawrence, is roasted on a grid,

while on the left are scenes from the life of the patron saint of the priory, St Blaise. The half-figures of saints (including some of the Eastern Church) particularly venerated at Cluny who appear at floor level, underneath the apse windows, complete what is clearly a pious memorial to the traditions, associations, and aspirations of this great monastic centre.

The Berzé painting is extremely fine. Its vibrant and warm dark and russet browns and olive greens are richly orchestrated against backgrounds of deeper tones, such as heavy bluish-greens; the atmosphere is one of brooding meditation and liturgical mystery; and the composition is so organized on the curving wall of the semi-dome that, from the right viewing point, the whole complex scene falls into a rhythmically interrelated whole. The primary influences are unmistakably from Italy, and parallels for the rich linear texture are to be found in the murals of the chapel of St Sebastian in the Old Lateran Palace at Rome [162]. The Italo-Byzantine influences are comparable to those of Cluny's manuscript paintings, particularly in the Cluny Lectionary, though the Lectionary has none of the textural richness of the murals, and the colour harmonies are quite different. Berzé's iconography, too, seems to derive from Italy – compare the eleventh-century painting in the apse of Aquileia Cathedral,[295] where, however, the Virgin is the central figure. As to date, the Berzé paintings are often ascribed to the period just before St Hugh's death in 1109, when he favoured the priory as a place of retreat from the burdens of office, but this evidence is highly circumstantial, and a date about 1100–40 – close to that of the paintings of the Old Lateran Palace, which have been ascribed to the first thirty years of the twelfth century – seems more likely.

Pleasingly spacious, despite fading and deterioration, is the painting of the patron of the order in the Augustinian church of Saint-Sernin at Toulouse.[296] The colouring is quiet, in soft browns and blues and some gold. St Augustine sits in the conventional pose of the teaching philosopher as seen also in his author-portrait in a copy of the *De Civitate Dei* in the Laurenziana Library [330]. A nimbed figure on his left takes notes, and another, standing on his right, holds his episcopal staff. The painting – originally in the cloisters and now in a niche on the north side of the ambulatory – seems to date from the years preceding the mid twelfth century.

Technically French, though they belong in a Spanish and Catalan artistic context, are the wall paintings in three churches yet farther south. The first, the chapel of Saint-Martin de Fenollar in Roussillon[297] in the Pyrénées Orientales, now in virtual isolation on private farmland, is – as a local bus driver once commented to me – about the width of his vehicle, and it is about ten metres long. Originally covered inside with paintings in varying tones of sea-green, yellow ochre, and azure, the chapel was converted after the French Revolution into the outbuilding of a farm, losing some of its murals when a door for carts was cut into the south wall. Their subject matter cannot now be reconstructed, but the feet of the beasts to be fragmentarily discerned on either side of a tree, are reminiscent of the Gerona Apocalypse (see folios 63 and 156 verso). Elsewhere, the surviving paintings are in reasonably good condition. In the vault is an elongated Christ in Majesty surrounded by the winged evangelists carrying their symbols in Spanish fashion, except for Matthew with a book. The elders of the Apocalypse sit

with their vessels and musical instruments along the base of the vault, and in the semi-dome of the apse above the altar is the crowned Virgin *orans* flanked by two angels in a diamond frame. On the nave walls are the Annunciation, the Nativity, and the Adoration of the Shepherds(?) and of the Magi, with, further down, paintings simulating drapery.

The paintings at the church of L'Écluse,[298] also in the Pyrénées Orientales, are in a similar colourful if unrefined style. In the middle aisle of the three is a half-length Christ in Majesty with an angel and the evangelist symbols, and on one of the walls an Adoration of the Magi. The paintings of the third church, the cemetery chapel of Saint-Jean-Baptiste at Saint-Plancard (Haute Garonne),[299] are in this same Spanish tradition. The most interesting is the enthroned Christ in the apse, surrounded by the seated evangelists accompanied by their symbols as in Insular manuscripts such as the Lindisfarne and Stockholm Gospels. Other murals are of the Adoration of the Magi, the Crucifixion, the Ascension, and the Last Judgement.

CENTRAL FRANCE

The pinnacle of French wall painting for the whole of our period is reached in central France at the turn of the eleventh and twelfth centuries in the Benedictine chapel of Saint-Savin-sur-Gartempe (Vienne).[300] Over the entrance the enthroned Christ, accompanied by angels carrying the instruments of the Passion, holds out his arms in welcome. Of the separate scenes of the Apocalypse that covered the barrel-vault of the front porch there remain the Heavenly Jerusalem, the twelve apostles (with adoring angels above), the war between the good and evil angels described in Apocalypse XII, 7–8, the loosing of the four angels (IX, 13–21), the locusts (IX, 1–10), the dragon threatening the woman (XII, 1–17), a fragment of the death of the two witnesses (XI, 3–13), and the seven angels with trumpets (VIII, 2). In the gallery above the porch are scenes from the Passion of Christ and pictures of the Entombment, the three Marys, and the Angel of the Resurrection, on the tympanum of the bay that gives on to the nave is a fine and monumental Deposition, and the pilasters of the lateral walls of the gallery have full-length figures of bishops and saints of Poitiers.

The narrow barrel-vault of the long nave has a whole pictured Pentateuch, taking us from the creation of the world to the reception of the Covenant, and continuing with the story of Moses and his journey with the Israelites to the Promised Land. In patristic commentaries, the history of Moses symbolizes that of Christ, so this cycle presents us with the entire epic of man's sin and redemption. The scenes roll on in four separate 'friezes', illustrating the creation of plants, of the sun and moon, and of Adam and Eve; the Temptation, the Fall, and the Expulsion from Paradise; Cain and Abel; Enoch raised to Heaven; incidents from the life of Noah; the building of the tower of Babel [229]; and scenes from the stories of Abraham, Joseph, and Moses, concluding with the receiving of God's laws on Mount Sinai. The first two scenes and the last three are out of sequence – it is said,[301] because the painters had to use the scaffolding set up for the builders as it became available.

On the barrel-vault and curving walls of the crypt below is a detailed sequence of scenes from the passions of two local

229. Saint-Savin-sur-Gartempe, nave vault, *The building of the tower of Babel*. Wall painting. Late eleventh/early twelfth century

230. Saint-Savin-sur-Gartempe, crypt, *The torture of St Savin and St Cyprian*. Wall painting. Late eleventh/early twelfth century

martyrs, St Savin and St Cyprian. They are first tried, then tortured [230], interrogated and tortured again, and finally we are shown their miracles and martyrdoms. On the east wall, in less good condition, are a Christ in Majesty with evangelist symbols, with three saints in arcades on each side.

The date of all these paintings has been in hot debate for over a century, and opinions have ranged from the middle of the eleventh century to the beginning of the thirteenth. Today, it would be agreed that they were made at the end of the eleventh century or perhaps the beginning of the twelfth; they are by the same workshop, though different influences are apparent in the four pictorial programmes.

The crypt paintings are ultimately Carolingian in style. They have been likened more than once to the miniatures of manuscripts (though they may of course depend on murals now lost); the noble figure of the proconsul Ladicius, in particular, is reminiscent of the Tours School of the ninth century, and is in an idiom that persisted in France. It emerges in paintings like those of the Poitiers Life of St Radegund[302] [217] which the murals – though more mature, more painterly, and more strongly highlighted – resemble in the bold outlining of the figures and their somewhat stocky proportions, in the sharply upturned eyes, the wig-like rendering of the hair, the occasional forward thrust of head and neck, and the schematized curves of the chest.

The paintings of the Apocalypse in the porch are completely different in style, and their sweeping contours, buoyant rhythms, and curving highlights contribute to the general vivacity.

The Old Testament scenes in the nave give the impression of being large-scale drawings with colour-wash rather than paintings, and this may be partly due to the fading of their colours, which today appear as pale greens, slate blues, and russet browns, with some predominance of yellow. Some of the heads relate to those of Saint-Chef, but the figures themselves have affinities with Channel styles. It is to the north of France that we would wish to look for direct analogies, but all that remains from a region that must once have been rich in Romanesque wall painting, now lost in the incursions of Gothic, is one damaged scene by a French artist, together with fragments of others, in the Breton church of Saint-André-des-Eaux.

Some pointers to the stylistic sources of the nave paintings of Saint-Savin are, however, afforded by the art of illumination: the long, loose-limbed figures can be associated with eleventh-century paintings and drawings in the

231. Poitiers, baptistery of Saint-Jean, *The Emperor Constantine on horseback*. Wall painting. First half of the twelfth century

manuscripts of Saint-Vaast and Saint-Amand [189, 194], and Saint-Amand too used hatched highlights similar to those on the figure of God in the scene of the blessing of Abel. It is however to earlier Anglo-Saxon manuscript paintings that we should look for parallels for the eloquent language of the hands and their fastidiousness of gesture, the buoyant energies that raise the arms and cross the legs on pirouetting feet, that whisk the hems of draperies around the ankles and enable the figures to swim effortlessly across their frames; these relationships even extend to particular points of detail like the structure of Noah's ark. There is furthermore only one parallel for the irrepressible forward movement of the scenes rolling across the vault of the nave, and that is the Bayeux Tapestry, which was probably in northern France when the cycle was being painted. It may be added that the sources for the iconography of the Apocalypse scenes in the porch have been traced to the Channel area,[303] and of the Old Testament scenes to illustrations in Anglo-Saxon manuscripts.[304]

The influence of the Saint-Savin murals was great, especially in Poitiers and the surrounding area. A dignified St Quentin in Poitiers itself is thought by some to anticipate rather than follow the more famous cycle. It is one of four survivors of a larger-than-life 'gallery' of saints and bishops of Poitiers on pillars of the lowest storey of the bell-tower of Saint-Hilaire-le-Grand and on a soffit of an arch.[305] On the east and west walls of the baptistery of Saint-Jean, also at Poitiers, are murals of an equestrian Constantine [231] and three other mounted Early Christian emperors which have the spaciousness and movement of the Apocalypse scenes at Saint-Savin and are probably contemporary with them.

The paintings in the priory church of SaintJean-Baptiste at Château-Gontier (Mayenne)[306] are associated with those in the nave of Saint-Savin by their colour harmonies, by similar drawing techniques, and by points of detail such as the similarly stylized Tree of Knowledge in each. They may actually be by one of the Saint-Savin team of painters, though their iconographies are different. It is sad that the very event that brought about their discovery – a fire resulting from the bombardment in June 1940 that stripped away the nineteenth-century wall paintings to reveal much earlier ones beneath – led also to the partial destruction of the church's walls and roofing, so exposing the paintings to the elements and bringing about their rapid deterioration. The best impression to be had of them now is from the watercolour copies made immediately after they came to light. Only the paintings of the choir and transept were Romanesque; those in the nave belong to the later thirteenth or early fourteenth century. In the choir, even at the time of discovery, no more could be made out than the figures of three Apocalyptic elders, but they point to the former existence of a Christ in Majesty at the eastern end of the vault, which was replaced in the seventeenth century. The transept vault was painted with scenes from Genesis – six episodes of the Creation and Fall in the north wing, and incidents from the life of Noah in the south – and it is these especially that help to establish the links with Saint-Savin.

An earlier style, ultimately going back to the Carolingian Schools of Tours and Reims[307] but showing some kinship with the nave paintings of Saint-Savin, characterizes the now fragmentary murals in the tower of the abbey church of Saint-Julien at Tours. They must have been made at about the time of the consecration of the newly rebuilt tower in 1084. From good nineteenth-century copies, Grabar[308] was able to establish that iconographically they were directly inspired by the miniatures of the Ashburnham Pentateuch, a seventh-century manuscript then at Tours which some believe to have been produced in Spain.[309] The murals showed the passage of the Israelites through the Red Sea, with scenes below of Moses breaking the Tablets of the Law, the Israelites adoring the golden calf, the idolaters being killed by the Levites, and the Ark of the Covenant. Grabar contends that the now destroyed Romanesque church of Saint-Julien was originally filled with the complete Pentateuch cycle, and concludes that, far from abridging them, the wall-painters actually expanded on the models provided by the Ashburnham miniatures. 'Cet exemple', he goes on to say, 'apporte un démenti aux théories selon lesquelles les versions les plus anciennes d'illustrations médiévales étaient nécessairement les plus complètes.'[310]

In Saint-Martin, also at Tours, were murals different from those at Saint-Julien but also ultimately Carolingian in style, this time deriving from the Palace School.[311] The prime survivor of the paintings of saints and Virtues, formerly on the pillars of the Tour Charlemagne, is now in the Musée Gouin at Tours. It is of great hieratic delicacy, and its date must be associated with the building of the tower in 1050.

Figures in the church of Vicq-sur-Saint-Chartier (commune of Nohant-Vicq, Indre),[312] which belonged to the abbey of Déols, still hark back to Carolingian art, presumably at second hand, while the curved bands and disposition of highlights on the figure behind Judas in the scene of the Betrayal may be compared with the similar treatment of the second of the two saints being thrown to the wild animals in the crypt paintings of SaintSavin. The heavily pleated and sharply highlighted draperies that characterize the Visitation are reminiscent of the 'umbrella' folds in the manuscript paintings of Saint-Omer in north-eastern France (compare illustration 191), though they lack their panache and are considerably conventionalized. The faces have a doll-like repetitiveness, and the paintings as a whole give the impression of having been painfully copied from another source. Their themes are wide-ranging. On the east wall of the aisle are Christ the Judge and the sacrificial Lamb, with the twelve apostles above, and below are four scenes of the Annunciation, Mary being reproached by Joseph, and the Journey and Adoration of the Magi. To left and right of the chancel arch are the Presentation and a badly worn Deposition, while two knights on the soffit of the arch personify the war of Virtue against Vice. In the chancel are on the east wall St Michael and the war of the angels; on the west wall the Last Supper with figures of prophets below; on the north wall scenes from the life of St Martin and others of Christ washing the feet of the disciples, of the Betrayal, of the Crucifixion, and of Dives and Lazarus; and on the south wall the cleansing of Isaiah's lips, the Entry into Jerusalem, and the expulsion from the Garden of Eden. Finally, in the apse are Christ in Majesty, the Visitation, the

232. Auxerre Cathedral, crypt, vault of the apsidal chapel, *Christ and four angels on horseback*. Wall painting. 1087/1114(?)

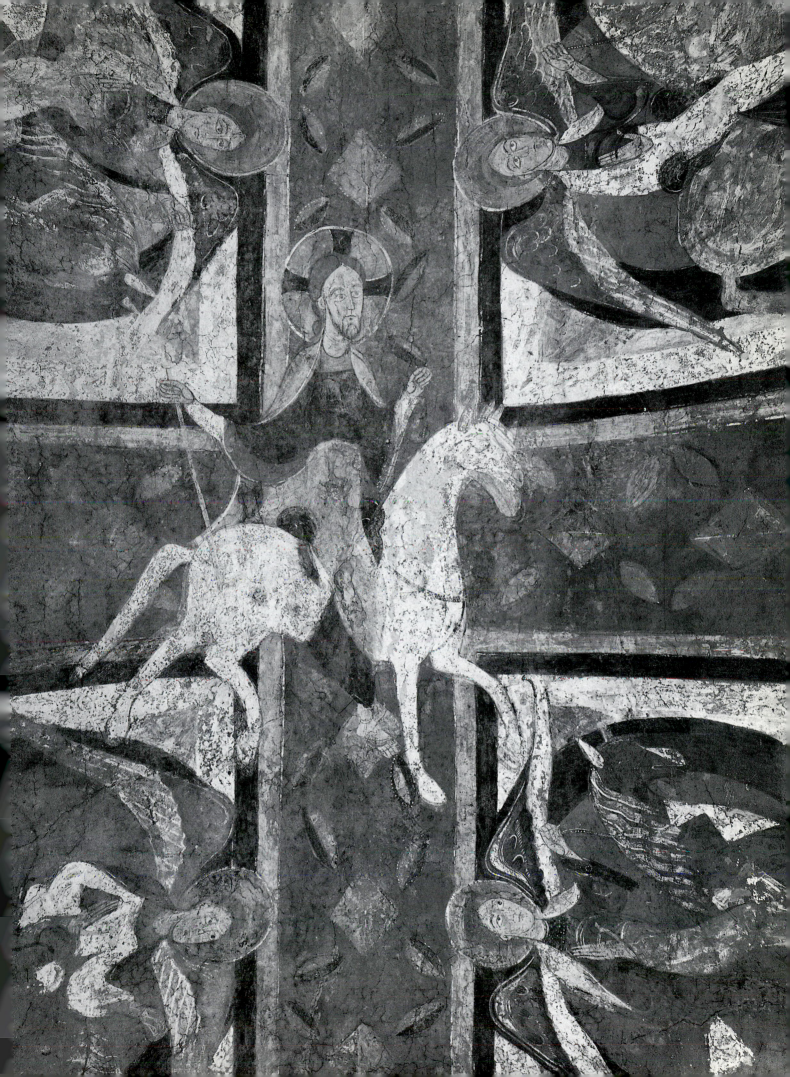

martyrdom of St Peter, and Christ before Herod (or Pilate). The colours include a sombre dark rust lightened by a subtle use of pale grey-greens. Stylistic analogies with manuscript paintings suggest a date in the 1140s or 50s.

The flaccid and ungainly choir paintings of Saint-Pierre-les-Églises (Vienne)[313] once enjoyed some esteem as examples of late Carolingian art, but they are now thought to be twelfth-century paintings of a reactionary kind. They presumably drew on much earlier miniatures for their scenes of the Annunciation, the Visitation, the Nativity, the story of the Magi, and the Apocalypse.

On the ceiling of the south bay of the apsidal chapel in the crypt of Auxerre Cathedral[314] is a painting in gentle yellows, rusts, and offwhites that breathes a pleasing, almost leisurely air of spaciousness; its unhurried pace is a little reminiscent of a painting of riders in the 1086 copy of Beatus's commentary on the Apocalypse in the cathedral of Burgo de Osma. Intriguingly, Christ is shown on horseback at the centre of a large jewelled cross [232] in each of whose quarters is an angel also on horseback. Reference may possibly be intended to the description in the Apocalypse of the appearance of the Word of God mounted upon a white horse and accompanied by a heavenly army on horseback (XIX, 11–14). The date of the painting is controversial. The chronicle of the local bishops, the *Gesta Pontificum Autissiodorensium*, relates that Humbaud, bishop of Auxerre from 1087 to 1114, had paintings made in the chevet and the crypt,[315] and, since it makes no reference to murals commissioned by any of his successors, Deschamps and Thibout were led to believe that the painting was made under Humbaud, though touched up later.[316] Demus rejects this date as too early, preferring one in the middle of the twelfth century.[317] More recently Denny – associating the theme of the painting with the Crusading interests of Bishop Humbaud, and its iconography with Carolingian Apocalypses – has suggested a date *c.*1100.[318] There can be no certainty, but I now incline to the view that this charming picture was, indeed, made under Humbaud.

The figures of the murals in the church of Saint-Aignan at Brinay-sur-Cher[319] are more elongated and – perhaps because of deterioration – appear to be of inferior quality to those of the Auxerre ceiling, but they are painted in similar gentle colours and evince a similar lilting sense of movement. They include labours of the months as well as prophets and saints, but they are primarily concerned with episodes from the Gospels, in two tiers. On the north wall of the chancel are (above) the Annunciation, Visitation, Nativity, and Annunciation to the Shepherds, and (below, in a poor state) the story of the Magi. On the east wall (above and to either side of the central window) are the Massacre of the Innocents and Joseph's dream, and (underneath) Christ being presented in the Temple and the Flight into Egypt. Finally, the south wall illustrates the Apocryphal story of the fallen idols, the Baptism of Christ, the first two Temptations, the angels ministering to Christ after the third Temptation, and the Marriage at Cana.

Associated with this Auxerre/Brinay group, and of about the same date, are paintings in the barrel-vault of the choir of the church of Saint-Nicolas at Tavant (Indre-et-Loire).[320]

233. Tavant, Saint-Nicolas, crypt, *The sorrowing Virgin*. Wall painting. Early twelfth century(?)

234. Tavant, Saint-Nicolas, crypt, *Enthroned figure*. Wall painting. Early twelfth century(?)

In variable condition, they present scenes from the Gospels: the Annunciation, Visitation, Nativity, Massacre of the Innocents(?), Annunciation to the Shepherds, and Flight into Egypt. In the vault of the apse is a Majesty whose Christ, small of head and ample of draperies, is accompanied by angels and by symbols of the evangelists. The pictures in the crypt – chiefly single or double figures – differ from those in the choir in their freedom and spontaneity and in being unprogrammed: indeed their motifs appear so entirely unassociated that one wonders whether they may simply have been intended as devotional themes for the monks of this subsidiary priory of Marmoutier to reflect upon. Lust thrusting a spear into her bosom, and the knight fighting a dragon, would recall to them their duty to eschew vice and pursue virtue. The crucifixion of St Peter, and the paintings of female saints, would offer them examples of Christian steadfastness in adversity. A constant reminder of the original sources of sin would be provided by the paintings of Adam and Eve and of their progeny, the righteous Abel, and Cain who 'did the first murder'. Their knowledge of how redemption from original sin was brought into the world would be continually brought to mind by the paintings of the Virgin [233], of Christ's Deposition from the Cross, and of his Descent into Hell. And the Apocalyptic symbolism of the two candlesticks borne by angels in the vault, and of the Christ in Majesty on the end wall, would signify to them the ultimate victory of the true faith. David, who is also represented, was of course a symbol of Christ and the author of the Psalms which all monks read daily.

These figures, painted – one is tempted to say delineated, since they are so deftly linear in style – in earth colours in which russet-browns and greens predominate, achieve an élan which sets them well above the careful pedestrianism of so many other surviving murals. Their expressiveness is such that they can give to the Virgin an air of resignation [233], to Lust a feeling of abandonment, to the face of Christ an impression of sadness, and to the face of David a mood of complete absorption in his music. Stylistically, they betray influences from the north, and the reduction of the drapery folds of an enthroned figure to a flow of swirling streams of colour [234] has parallels with earlier paintings at Cambrai [cf. 192].

The priory church of Saint-Gilles-deMontoire (Loir-et-Cher)[321] is unique in boasting in its choir no less than three paintings of Christ in Majesty. The one in the east apse [235], it has been rightly remarked, has something of the lightness of touch of the Tavant paintings, and a rhythmic, almost rhapsodic quality is imparted by the flow of curves – the curves of Christ's draperies, the curves of the figure-of-eight mandorla in which he sits, and, not least, the curves of the lilting angels and evangelist symbols around. Its iconography – the enthroned Christ surrounded by the four evangelists – is conventional enough, but the four encompassing angels supporting Christ's mandorla imply an artistic elision of Christ in Majesty and the Christ of the Ascension which has been explained[322] by a reference to the first chapter of the Acts of the Apostles: 'this same Jesus, which is taken up from you into heaven, shall so come in like manner as ye have seen him go into heaven' (verse 11).

There is nothing of the Tavant lightness of touch in the other two Majesties, which are by a very different artist whose

235. Saint-Gilles-de-Montoire, priory church, east apse, *Christ in Majesty*. Wall painting. Second quarter of the twelfth century(?)

emphasis is on the weight and sharp detailing of the heavy draperies. The Majesty of the south apse is surrounded by rippling bands of blue, white, and red, while the apostles below in the north apse perhaps indicate Pentecost. The same artist painted on the triumphal arch the bust-figure of Christ placing crowns on the heads of the two Virtues Castitas and Patientia clad as knights and piercing with their lances two monsters identified as the Vices Luxuria and Ira.

Analysis of the murals at Saint-Gilles is complicated by overpainting and by their poor state (especially that of the Majesty of the north apse), which means that study must depend to some extent on watercolour copies made in the nineteenth century. Most recent opinion dates them to the second quarter of the twelfth century.

Two scenes, excavated from the crypt of the former abbey church of Château-Landon (Seine-et-Marne)[323] and now on canvas in the Asile Départemental, illustrate episodes from the life of St Severin, who was thought to have been buried on this site. One presents him healing Clovis, the first Christian king of the Franks, and the other shows him celebrating Mass with the king and his consort. Their style is individual, with a highly developed decorative sense expressed in the delicate patterning of the textiled altar frontal and in the background scheme of rippling lines. The predominant colours are shades of red and grey-blues, and the probable date is the middle of the twelfth century.

Murals rescued from overpainting in the west gallery of the church of Saint-Léger d'Ébreuil (Bourbonnais)[324] have a decorative sense of a simpler kind. They are not quite the 'légende dorée qui se déroule sur ses murs' that one scholar claims,[325] though they do present 'portraits' and martyrdoms of saints associated with the Auvergne and the Bourbonnais which have a certain quiet elegance born of delicate colouring and a flat and lucid figure style. On account of deliberate archaizing, it is difficult to assess their date, but their decoration suggests the end of the twelfth century.

The surviving murals (in poor condition) in the round chapel of St John at Le Liget, Chemillé-sur-Indrois (Indre-et-Loire), were also once attributed to the years around 1200,[326] but have now been placed by Munteanu,[327] on closely argued documentary, architectural, and stylistic grounds, between 1130 and 1150.[328] Their themes she associates with those of the most famous of all rotunda churches – that of the Holy Sepulchre in Jerusalem.[329] They illustrate the Nativity, the Presentation, the Deposition, the holy women at the Sepulchre, the Death of the Virgin with her soul being taken up by Christ before the witnessing apostles, and the Tree of Jesse. On either side of the window recesses, in various states of preservation, saints are paired in terms of their ecclesiastical ranking, with the most important nearest the central window.

Munteanu claims that the artist of Le Liget was also responsible for some of the murals of the crypt of Saint-Aignan-sur-Cher (Loir-et-Cher)[330] – a connection hitherto hard to make on account of their differing states of preservation; however comparison between the head of one of the apostles in the Dormition scene at Le Liget and the head of a figure of St Giles at Saint-Aignan[331] carries conviction. The St Giles belongs to a cycle in the south ambulatory chapel of the crypt which includes his gift of his cloak to a beggar [236]. The linearization of his garment in the scene of him praying for a ship in distress points to a date in the second quarter of the twelfth century. Demus remarked that one of the themes of the series – healing[332] – is taken up in the apse, where St Peter heals as he receives the keys from Christ. The fine Lamb of God in a medallion held by angels in the roof-vault, it may be added, takes up a Carolingian theme which finds more robust Romanesque expression in the choir of Méobecq (Indre).

The murals at Saint-Jacques-des-Guérets (Loir-et-Cher)[333] are very much later in date; indeed, the new Gothic pliancy that softens their style points to the very end of the century. The influence of Limoges enamels[334] is apparent in the near-*cloisonné* effect of some of the figures, painted in linear divisions in subtle pale greens, grey-browns, and varying tones of blue and yellow; and the Cross of the Crucifixion, studded with simulated jewels and bordered in yellow to imitate gold, has been influenced by other forms of metalwork. Unfortunately the murals are in varying condition, besides being in some cases overpainted, and in others cut back by the enlargement of windows. Apart from the earlier Nativity and Massacre of the Innocents on the north wall, the scenes are all thought to have been painted by two artists, in a style similar to that in other churches nearby. They include, on the curving east wall, Christ in Majesty and the Last Supper, the Crucifixion, the Resurrection of the Dead, the martyrdom of St James, and

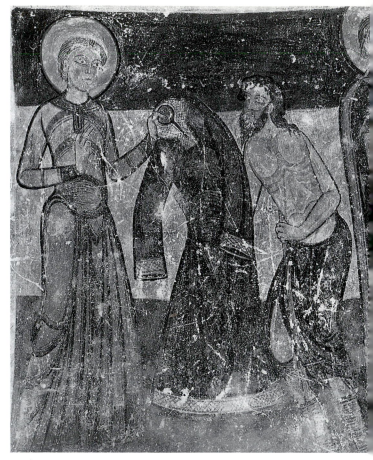

236. Saint-Aignan-sur-Cher, crypt, south chapel of the ambulatory, *St Giles giving his cloak to a beggar*. Wall painting. Second quarter of the twelfth century

battles between Virtues and Vices; and on the south wall, St Nicholas and the three dowerless maidens, the Virgin, the raising of Lazarus (which includes an antique sarcophagus), and the Harrowing of Hell.

The delightful and delicately coloured murals in the apse of the chapel of St Catherine in the church of Notre-Dame at Montmorillon (Vienne)[335] incorporate Romanesque features such as the 'damp-folds' of the Virgin's draperies, though the breeze of Gothic gives them a light and very un-Romanesque buoyancy. They belong to the very end of the twelfth century, and their emphasis on the Virgin anticipates the development of her cult in the next. Seated in a mandorla, she is crowned by angels [237] as the Christ Child on her lap, whose hand she tenderly kisses, reaches out his other hand to crown a personification of Ecclesia holding the Host (considered by some to be St Catherine with a ring). Other nimbed figures represent either saints or the five wise virgins. The background is patterned in swathes of blues and greens. The silver of Ecclesia's face has oxidized, as in some manuscript paintings, leaving her with a sadly darkened countenance. Below are vigorous scenes of the conversion of the Alexandrian philosophers by St Catherine and their later martyrdoms and salvation. The rather wilful linear complexities of some of the draperies, reminiscent of such northern French work as the Saint-André-au-Bois Bible [201], derive from the dynamic style of painting that was emerging in different parts of the Byzantine empire in the late Comnenian period.

THE CRUSADING KINGDOM OF JERUSALEM

The impact of Byzantine art – widespread, as we have seen, throughout the West – was nowhere more powerful than in the Latin kingdom of Jerusalem, set up in 1099 by the victorious warriors of the First Crusade with Godfrey of Bouillon as their ruler. As Suger proudly recorded in the stained glass of Saint-Denis,[336] these early Crusaders were largely Frenchmen, and since the new realm was basically a French plantation, it is appropriate to include it here.

The church of the Holy Sepulchre in Jerusalem was said to be on the site of the Resurrection and was therefore the most venerated church of Christendom. It had been built, by Arab consent, only half a century before the arrival of the Crusaders by Byzantine architects to replace the shrine the Arabs had destroyed. This mid-eleventh-century structure was repaired during the first half of the twelfth century by the Franks, who probably employed Byzantine artists to renew and extend the original Byzantine cycle of mosaics,[337] described on first erection by a contemporary Persian observer[338] (to whom the craft of mosaic was apparently unknown) as paintings covered with a fine layer of glass; it included prophets, the Christ Child, the Annunciation, the

237. Montmorillon, Notre-Dame, apse of the chapel of St Catherine, *The enthroned Virgin and Child, with a personification of the Church.* Wall painting. Late twelfth century

Entry into Jerusalem, the Harrowing of Hell, and the Ascension.[339]

Scarcely less sacred in the eyes of Christian believers was the church of the Nativity at Bethlehem, built by Constantine and early embellished with mosaics later despoiled by the Arabs.[340] These mosaics were renewed under the Franks and – as a surviving inscription[341] tells us – the work was completed in 1169. It was of such magnificence that even in the Arab world it became a byword for quality,[342] while a fifteenth-century Italian account[343] relates that the whole church was cased in white polished marble and embellished on either side with mosaic figures from the New Testament and corresponding ones from the Old, rather like those in St Mark's at Venice. According to contemporary inscriptions the artists were called Ephrem and Basilius,[344] and, despite the current Frankish fashion for Greek names, it seems likely that they were indeed Greeks who, like the earlier mosaicists at Montecassino, had been invited to come from Byzantium. The claim of a contemporary Byzantine observer[345] that it was the Byzantine emperor himself who was ultimately responsible for the work of adorning 'the entire church with golden mosaic work', should not strain our credulity, for at that time there was a *rapprochement* between the Crusading Kingdom and Constantinople, the wife of the king of Jerusalem being the niece of the Byzantine emperor Manuel. Manuel's particular interest in reuniting the Eastern and Western Churches may even be reflected in the portrayal on the south wall of the seven General Councils of the Church, with statements setting forth the chief doctrinal decisions of each.[346] The Provincial Councils were shown on the opposite wall, and on both were mosaics of the ancestors of Christ, labelled alternately in Latin and Greek. The whole scheme was Byzantine in feeling, apart from the Western motif of the Tree of Jesse on the end wall. The Tree has now disappeared, but appreciable sections of the Councils remain, together with some of the ancestors of Christ and three angels. Of the four surviving New Testament scenes in the transepts, the Ascension and the Transfiguration are fragmentary, but the Entry into Jerusalem and the Incredulity of Thomas are almost complete. Besides all this, the round columns of the church were painted with single figures of saints, identified in Latin and Greek and reflecting both Western and Eastern interests. They are now considerably faded, and they and the remaining mosaics are too indistinct to admit of reliable assessments, yet the possibility remains that, in this joint enterprise of East and West, the mosaicists were Byzantine, and the painters were Latins with a close understanding of Byzantine art.

Attached to the Church of the Holy Sepulchre in Jerusalem was a scriptorium[347] in which Western artists probably began to produce *manuscrits de luxe* in the first quarter of the twelfth century, though the earliest surviving examples are from the second. Both their general sumptuousness and their figure styles mirror Byzantine tastes, indicating how anxious the small court of Jerusalem was to emulate the splendours of Byzantium. As Greek illuminators showed little interest in decorative initials, the Jerusalem painters had to draw on Western sources for them, imbuing them even so with a Byzantine lustre. The curious fact that the Crusading Kingdom of Jerusalem – which saw itself as an extension of French soil, with its own French royal family and its own French nobility – should turn for its style of initials not to

France but to England and to southern Italy[348] may be explained by the presence as prior of the Holy Sepulchre (before his elevation to the archbishopric of Tyre in 1127) of an Englishman, William, who made at least one journey to southern Italy.

At once the most important, the earliest, and the most lavish of the Jerusalem manuscripts is a Psalter made between 1131 and 1143 for Melisende, queen of Jerusalem.[349] As often in twelfth-century England, it is prefaced by a cycle of illustrations of the life of Christ. The initials also reflect strong English influences, especially from Canterbury, though the English buoyancy is now disciplined, and the technique – borrowed from Montecassino – of drawing the initials in black on a gold background gives them a new exoticism. The illustrations are redolent of Byzantine art of the previous century,[350] and may derive either from the eleventh-century mosaics of the church of the Holy Sepulchre, or from eleventh-century painted manuscripts perhaps given to the court of Jerusalem by Byzantine emperors.

Of the four artists who worked on the Melisende Psalter[351] the most important was a Western painter trained in a Western atelier but with some experience of a Byzantine one. He signs his work with the Greek name Basilius, inscribing it – as did his great contemporary, Gislebertus, sculptor of Autun – at the feet of Christ the Judge, in no spirit of ostentation but no doubt, as we have noted in the cases of other artists, in the pious hope that his work would be taken into consideration by Christ on Resurrection day. Basilius was responsible for the Christological cycle of twenty-four pictures which begins with the Annunciation and ends with Christ between the Virgin and St John the Baptist in intercession at the Last Judgement. This Deesis [238] is virtually a copy of a Byzantine model – even the names remain Greek. The Nativity on the other hand is a compendium of Byzantine influences. Yet Basilius was undoubtedly a Western artist, for he never quite mastered the Greek idiom: his colours come from a Byzantine palette but are laid on without the Byzantine refinement; his compositions derive from Byzantium but lack the Byzantine spaciousness and fluidity; his figures originate in Eastern art but have none of the Eastern inner necessity. His interest is in externals, particularly in the crystallization of shapes and forms and in the texture of draperies. As he signs his Greek name in Latin characters, so his pictures are transliterations of Byzantine art into a Western idiom. As for the painter of the remaining figures, which are of saints [239], he is not so much incapable of understanding the Byzantine idiom as completely indifferent to it. In his concern – even more pronounced than his colleague's – for rendering the human figure in terms of abstract shapes and rhythms, he typifies the Western artists of the time, who were less concerned to understand the art of the East than to assimilate it to their own Romanesque tastes.

Despite further influences from England and Italy in the

238. Jerusalem: *Deesis*, from the Psalter of Queen Melisende, MS. Egerton 1139, folio 12 verso. 1131/43. London, British Library

239. Jerusalem: *St Peter*, from the Psalter of Queen Melisende, MS. Egerton 1139, folio 206 verso. 1131/43. London, British Library

first half of the twelfth century, in the second half the
sumptuous manuscripts of Jerusalem become increasingly
subservient to Byzantium – so much so that the evangelist
'portraits' of two Gospel Books[352] of the third quarter of the
century, however appealing they may be, are straightforward
copies of Byzantine originals.[353] These manuscripts fulfil their
function as status symbols of a small court, but artistically
they are no more than beautiful reflections.

The surviving Crusading icons, now on Mount Sinai[354]
but almost certainly made in Jerusalem, no doubt owe their
survival to the remoteness of the Mount, the home since the
sixth century of a Greek monastery with which the Crusaders
developed a close relationship, building a chapel for their
own Latin rite not far from its western entrance. Weitzmann,
who has identified the icons, suggests that they were
specifically made for this chapel, or left there as gifts. They
show the same dependence on Byzantium as the manuscripts
of the Holy Land, and three of them are of the twelfth
century. In the first, the enthroned Christ, holding an open
Gospel Book, has one hand raised in blessing [240]. Belonging
to the century's middle years, it is Byzantine in its figure
proportions, but very Western (perhaps English) in its face
and draperies. The second icon, of the same period, showing
the Crucifixion with the twelve major religious feasts, is so
strongly Byzantine that the artist has all but lost his Western
identity. The third is in a successful imitation of a Byzantine
style, but its subject matter has a pronounced Crusading bias,
for it gives pride of place in the centre of the upper of two
rows of three standing saints to St James the Greater, who was
martyred in Jerusalem and upon whom Jerusalem's patriarchs
based their claim to the apostolic succession. Two of the
saints in the lower row, St Martin of Tours (in the full
episcopal vestments of the Latin Church) and St Leonard of
Limoges, are specifically of the West.

Thus, however strong the influence of Byzantium, the
painters of Jerusalem did not cut themselves off completely
from their French roots. But France herself was artistically
far less closely associated with this plantation of hers in the
Holy Land than with her neighbour, Spain, as we shall
discover in the next chapter.

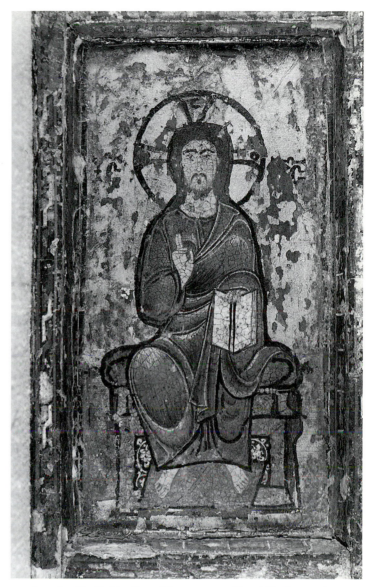

240. Jerusalem(?): *Christ enthroned*. Icon. *c.* 1150. Mount Sinai, monastery
of St Catherine

Painting in Spain

MANUSCRIPT PAINTING

HISTORICAL BACKGROUND

Different as they were in so many ways, the manuscript paintings of England, Germany, and France had one thing in common: they drew sustenance from the Carolingian tradition. Spain – uniquely – did not, and as a result her art seems somehow remote from normality, like the strange and exotic birds discovered by earlier explorers in areas long cut off from the mainland. It is difficult to understand why Spain stayed detached: it cannot be put down to her remaining outside the Carolingian empire, for England did too, nor to isolation from the rest of Europe, for she had contacts with Italy and France. It is therefore to her own particular history that we must look for an explanation.

After the breakdown of the Roman empire, in the fifth century, the Visigoths took possession of the Spanish peninsula, just as the Frankish and Burgundian tribes assumed control of the area now known as France. The Visigoths, however, were in the early eighth century themselves displaced by Muslim Arabs from North Africa who occupied virtually the whole of Spain and might well, as we have seen, have overrun France as well had they not been turned back at Poitiers in 732 by Charlemagne's grandfather, Charles Martel. In Spain, a pocket of Christian resistance remained in the Asturian mountains of the north, supplemented by smaller bodies in Galicia, Navarre, Aragon, and Catalonia, and it was these groups who – with many fluctuations of fortune – gradually wrested areas from the Muslims and welded them into kingdoms, moving slowly further and further south until at the beginning of the thirteenth century the situation was reversed and it was the Muslims who were confined to a small enclave in the south.

The Arabs were a more cultivated and more tolerant race than the Visigoths they displaced, and in general they shunned religious persecution: indeed the Christians who died for their faith in Córdova in the 850s[1] may be said to have flung themselves upon martyrdom, and some certainly needed persistence to secure their aim. The Muslims made no attempts to proselytize and allowed Christians to worship in their own way, reaping the benefit of their tolerance in the form of a special tax. The Arabs were in fact themselves divided, and had the Christians been more restless, or more united, their liberation might have been achieved in far fewer than the seven hundred odd years that it actually took them, from the early eighth century until the time that Columbus discovered America.

Religious dissension between Muslim and Christian was retrospectively exaggerated after the eleventh century by chroniclers anxious to re-edit the past in order to invest the whole of the Reconquest with the newly fashionable ideals of 'Crusade'. In fact, the earlier differences between the two races had been as much political as religious; Christian rulers had not scrupled to ally themselves with Muslims even against other Christians, while the Muslims had been equally prepared to seek Christian support for their own ends. The purpose even of Charlemagne's foray across the Pyrenees in 778 – celebrated some time after the event in the *Song of Roland* as a Crusade against the infidel – was to assist one Muslim faction against another, and Roland died at Roncesvalles not in an epic stand of the Cross against the Crescent, but at the hands of the Basques. In the eleventh century, too, the most famous of Spanish Christian leaders, the redoubtable El Cid, was prepared to ally himself with Muslims, and the poetic accounts of his exploits lay emphasis less on religious faith than on feudal equity. Religious intolerance had to be fanned by forces far from Spain, and it was Cluny and Rome that instilled Crusading zeal, particularly Pope Alexander II (1061–73), who encouraged contingents from Italy and southern and northern France to support the Spanish Christians, thereby preparing the way for the more general Crusading movement.

Despite all this, the northern monasteries of the seventh and eighth centuries, remote from the Muslims, must have found the rule of Islam over most of the land as horrifying as it was inexplicable. To add to their bitterness, the true faith was being corrupted from within by a new heresy promoted by Christians actually seeking theological accommodation with the infidel.

THE TRADITION OF THE APOCALYPSE IN SPAIN

Spain had always been rife with schisms and heresies. During the fourth and fifth centuries a particular Spanish heresy known as Priscillianism had spread in the peninsula, and it was still prevalent in the sixth. The Visigoths themselves had until the end of the sixth century embraced Arianism, which postulated that Christ had a different nature from God the Father – a heresy which continued to engender passionate feelings in the seventh century, when Paul of Mérida significantly described one of its former episcopal adherents in Apocalyptic terms as 'an impious man who was the servant of the devil, the angel of Satan and the herald of Antichrist'.[2]

The eighth-century heresy of Migetianism was followed by the greater one of Adoptionism, which had its roots in the past and which, according to its adversaries, divided the whole Church in Spain.[3] It had the active support of two distinguished Spanish churchmen, Elipandus, bishop of Toledo, and Felix, bishop of Urgel, and was basically an attempt by some unorthodox Christians to come to terms with Islam. The Muslims accepted Christ as a prophet, but could not accept his divinity; Adoptionism therefore put forward the compromise view that Christ was not inherently divine – i.e. divine at birth – but was so holy that he was later adopted by God and promoted to divinity.

A preoccupation with the Book of the Apocalypse is the mark of Spanish manuscript illumination, and I would suggest that it was so extraordinarily popular both because it offered orthodox Christians an acceptable explanation for the existence of heretics like the Adoptionists and infidels like

the Muslims, and because it provided them with a meaningful perspective on the events of their times. The edition most favoured was one with a commentary by Beatus of Liébana, a monk of northern Spain who was a teacher and adviser to Queen Adosinda, wife of King Silo (774–83), and a sworn foe of heresy, particularly of Adoptionism.[4] He died about 798, two years before Charlemagne became Holy Roman Emperor. His commentary on the Apocalypse, like so many others of the Middle Ages, was basically a patchwork of relevant texts from the early Fathers in which the allegorical and deeper meanings of the sacred word were explored at length. As he drew so heavily on St Augustine, a man of great poetic imagination, and as he was introducing a book with the intoxicating prose of the Apocalypse, the sheer dryness of his own work – comparable to that of the equally forbidding treatises of political prophets of more recent times – comes as something of a surprise. Yet the well over twenty illustrated copies of Beatus's Apocalypse that have come down to us[5] can represent only a small proportion of those originally produced, and no other illustrated Book of the Bible was copied and recopied with such assiduity in Spain. One small but significant indication of the respect it enjoyed is the fact that, whereas in England the most precious charters of a monastery or church would be copied into Gospel Books for preservation, in Spain they are rather to be found in Beatus manuscripts.[6] The Visigothic rite that required the Apocalypse to be read and explained during the Paschal season cannot account for its huge popularity,[7] for by the end of the eleventh century that rite was no longer in force, yet more illustrated copies of the Apocalypse survive from the twelfth century than from the eleventh. Furthermore, this Visigothic rite applied chiefly to secular churches, and the Beatus manuscripts were primarily made for monasteries.

The real explanation for the power exercised by the Apocalypse over the Spanish mind must surely, as just suggested, lie in the consonance between its message and the religious situation in Spain, where domestic heresy was ulcerating the body of the orthodox Church and the tremendous and apparently triumphant cancer of Mohammedanism was rampant in the land. The one source of explanation, solace, and hope for the true believer was the Book of the Apocalypse, the key to all books,[8] as Beatus told his readers. Its ominous prophecy that one day the world would be ruled by Antichrist seemed to have been exactly fulfilled: 'Woe to you earth and sea! for the devil is come down unto you having great wrath because he knoweth that he hath but a short time' (Apocalypse XII, 12). Its message could be applied equally to the Muslim enemies without the Christian Church and to the schismatics within, as Beatus himself, in the treatise against Adoptionism written with his pupil Etherius, claimed when he declared that the followers of Antichrist currently within the bosom of the Christian Church[9] had been foreseen in the Apocalypse.[10] No less than one hundred and four chapters of the treatise are devoted to the relationship between Adoptionism and Antichrist,[11] and Beatus's renewed stress on the theme of Antichrist in his Apocalypse commentary was not lost on its artists, for they included in their illustrations complex computations of the numbers and names of this dreaded monster.[12]

They also launched visual broadsides against Adoptionism (and, for that matter, Mohammedanism), illustrating with genealogical tables of Christ's Old Testament forebears[13]

arguments in Beatus's treatise[14] that stressed that the Saviour was God and Man. Beatus claimed that, since God had given His word to Old Testament patriarchs that redemption would come of their seed, then Christ, the fruit of this celestial promise, must necessarily be divine, and contended further that Christ could only have transcended his carnal inheritance from Adam by being conceived and born divine. Focusing therefore on the very aspect of the true faith that the heretics and unbelievers denied – the essential and inherent divinity of Christ as the true Redeemer – the artists added New Testament scenes[15] (themselves influenced by Beatus's commentary[16]) which bore particular witness to Christ's divine nature; they included the Annunciation to Mary,[17] an acknowledgement by God himself of the Child's divinity; the Annunciation to the Shepherds,[18] which showed God's angels proclaiming that same divinity; the Magi[19] recognizing the divine birth by their visit; and an illustration of an apocryphal account of an angel thwarting Herod's pursuit,[20] thus proving that God recognized the Child as his own. Important too was the emphasis on the celestial inspiration of those who wrote the Gospels or preached Christ's message, so that the Books of the Gospels are handed to the evangelists by the Deity, or are held by an angel, or angels,[21] as in the sumptuous Apocalypse of San Isidoro de León [241], which was written by Facundus ('Memoria eius sit semper') for King Ferdinand

241. Facundus: *Angels with the Gospel of St Mark*, from the Apocalypse of San Isidoro de León, MS. Vit. 14–2, folio 9. Completed in 1047. Madrid, Biblioteca Nacional

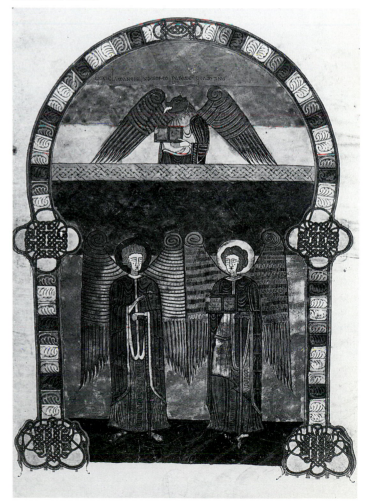

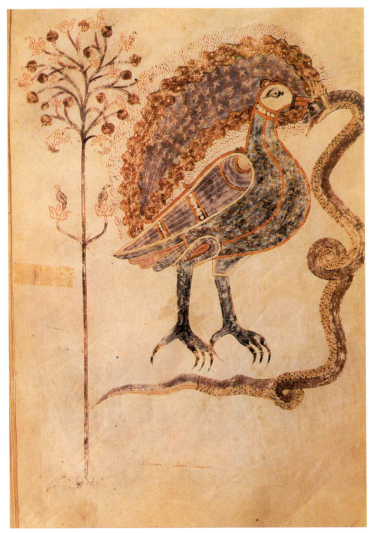

242. Spain: *A bird killing a serpent*, from the Gerona Apocalypse, MS. 7, folio 18 verso. 975. Gerona, Archivo de la Catedral

the final victory of the true Christian. Daniel named Babylon as the kingdom of the heretics, and so Babylon, as well as the visions of Nebuchadnezzar, is pictured in these Beatuses.[29]

In the Muslim-dominated south, where Christians who wished could embrace the Islamic faith and attain the social position of the infidel by the simple expedient of pronouncing the formula 'There is but one God and Mohammed is his prophet', faithful believers were fortified by identifying the Antichrist of the Apocalypse with the Prophet of Islam, a concept which those seeking martyrdom did not hesitate to hurl in the face of the Muslims. So the Córdovan martyr Isaac denounced Mohammed as the false prophet who had cast his followers into the pit, and a monk who met his death in Córdova after journeying there from the Holy Land asserted that Mohammed was 'the minister of Antichrist, deluded by Satan in the form of an angel'.[30] In the same spirit, one or two copies of the Apocalypse include a crescent in the headdress of the Whore of Babylon, or colour the Beast on which she sits in the black and green of Islam.[31] In others there are prefatory pictures of the Cross of Oviedo,[32] which was carried before the founder of the Asturian dynasty, Pelayo, when he defeated the Muslims and initiated the Christian Reconquest. This 'Victory Cross', encased in gold and precious stones by Alfonso the Great (866–910) and now enshrined in Oviedo Cathedral, quickly became a symbol of Christian resistance and reconquest, and is inscribed in depictions of it in some manuscripts with the observation that by this sign the pious man is preserved in safety, for by its potency the enemy is conquered.[33]

It is recorded that when a certain Christian ruler of northern Spain was invited to join the European Crusades he retorted that Spain was always on a Crusade,[34] and this state of mind is evident in the illustrations of the Beatus Apocalypse.

PAINTERS AND SCRIBES OF THE SPANISH APOCALYPSES

Spanish manuscripts are set apart from those of the rest of the Latin West in terms of their method of dating as well as of their art, for they adhered to the chronology used by the Christians of Roman Spain, beginning in 38 B.C. Here, this thirty-eight-year gap with the normal conventions will be silently adjusted. Spain is also unusual in recording with considerable frequency – perhaps as the result of Arab influence– the year and month of a manuscript's completion, and the names of scribes and even of artists are also often found: in two hundred and fourteen manuscripts of the tenth and eleventh centuries, there are no less than fifty-nine identifications of the calligrapher or illuminator.[35]

The expansiveness in which the Spanish scribe was allowed to indulge may, as suggested earlier, have stemmed from Irish example. One says,

The labour of the writer is the refreshment of the reader. The former grows weak in body, the latter grows strong in mind. Therefore, whoever you are who are deriving profit from this work, do not disdain to remember the toiling worker … He who does not know how to write reckons it no hardship. If you want a detailed account of it, let me tell you that the work is heavy: it makes the eyes misty, bows the back, crushes the ribs and belly, brings pain to the kidneys,

I and Queen Sancha of León[22] and completed in 1047. A pictorial allegory of Christ's divinity – a bird killing a serpent – is given in several manuscripts;[23] the one in the Gerona Apocalypse of 975 [242] follows the text commentary that, as a legendary Eastern bird disguises itself with a coat of mire, thereby taking the serpent off its guard, so Christ concealed his divinity in a cloak of human nature in order to conquer the Evil One.[24]

The Apocalypse both accounted to the monks of northern Spain for the traumas of their own world, and offered them hope and solace in the form of future salvation for the steadfast Christian. A symbol of this to which Beatus alludes[25] was Noah's ark, a figure of the true Church[26] that saves those who enter and remain in her, while those outside are lost. It is illustrated in nine Beatus manuscripts.[27] Included in some Beatus copies are two other pictures which had from very early times typified the victory of the true Christian: the three children in the fiery furnace, and Daniel in the lions' den. These of course belong to the Book of Daniel, a commentary on which was included in a number of Beatus manuscripts for – as the Spanish theologian Isidore of Seville pointed out[28] – it too was concerned with the rule of Antichrist before

and makes the body ache all over. Therefore, O reader, turn the leaves gently, and keep your fingers away from the letters, for, as the hailstorm ruins the harvest of the land, so does the injurious reader destroy the book and the writing. As the final harbour is welcome to the sailor, so is the final line to the scribe. Deo gratias semper.[36]

To such scribal loquacity we owe a good deal of information – for example that one of the earliest surviving Beatuses, datable to the middle of the tenth century,[37] was made at the behest of Abbot Victor in a monastery dedicated to St Michael[38] and written and illuminated by a single individual, Magius. Magius also participated in the execution of a Beatus[39] from San Salvador de Távara whose lengthy colophon relates that it was begun by 'the chief painter, the good priest Magius'. When he died on 29 October 968 after a three weeks' illness, it goes on, his pupil Emeterius was called in, and he completed the work between 1 May and 27 July 970 in the tower of the monastery (we see him at work on folio 139 [243], in a tower whose external walls and internal structure are both laid bare). The account concludes with a sigh of relief: 'Thou lofty tower of Távara made of stone! There, over thy first roof, Emeterius sat for three months, bowed down and racked in every limb by the copying. He finished the book on 27 July in the year 970 at the eighth hour.' The same year saw the completion at the monastery of Valcavado of a Beatus[40] commissioned by Abbot Sempronius and illuminated by the painter Obeco. Yet another tenth-century Beatus is inscribed as having been illuminated by a woman painter named Ende (or En) in collaboration with Brother Emeterius, presumably the one from Távara. Some think that they belonged to a 'double house' for nuns and monks, others that the manuscript was copied out in one house and illuminated in another.[41] It was produced in 975 and bequeathed to Gerona Cathedral towards the end of the eleventh century.

Some colophons are diffident – in a Beatus of 1086 the scribe writes briefly, 'Remember Martin, the sinner'[42] – but others are more forthcoming, as in a Beatus from Santo Domingo de Silos where we are told that the manuscript was begun in 1073 by order of Abbot Fortunius, that the scribes were Nunnius and Dominicus, that the painter was the prior Peter, and that the manuscript was completed only in 1109 under Abbot John, after the deaths of both Fortunius and his successor, Nunnius (the scribe).[43] Not all colophons are as effusive, but 'signatures' are often accompanied by pleas for prayers, as in these three: 'Pray for the scribe, the priest Vincent';[44] 'O pious reader, remember Alburanus the scribe';[45] 'May each of you who comes here, eager to read, see fit to pray for me, the unworthy priest Obeco: perhaps my transgressions may be removed and I may reach our Lord and Redeemer and not be undone'.[46] In a fourth manuscript,[47] Emeterius hopes that the master who trained him has been granted eternal life.

It has earlier[48] been emphasized that 'signatures' were often unspoken requests for prayers, and their abundance in the Beatus manuscripts calls to mind the fact that, of all biblical Books, the Apocalypse was the most preoccupied with the end of the world and the life thereafter: indeed verses in one early Beatus record that its paintings were made to remind the prudent of the coming Day of Judgement and all its terrors.[49]

243. Emeterius of Távara: *The Távara scriptorium, with Emeterius and the scribe Senior at work*, from a Beatus, MS. 1097B (formerly 1240), folio 139. Completed in 970. Madrid, Archivo Histórico Nacional

MOZARABIC ART

As the dry and lengthy commentary of Beatus is no match for the glowing prose of the Apocalypse itself, so the vivid but simple folk art of the Beatus paintings does not measure up to the majestic sweep and rich oratory of St John the Divine.

In spite of all the variations, in 1931 Neuss was able to establish that at quite an early stage the original Beatus tradition divided into two broad streams, the illustrations of the second being more complex and elaborate than those of the first. The earliest are in a style known as Mozarabic,[50] *mozárabes* (meaning the unconverted) being the name given to staunch Christians in Arab-occupied Spain. Thus 'Mozarabic art' was art produced by Christians in Muslim-dominated areas. To pass to it from other Western cultures is like stepping from a European garden into a tropical greenhouse full of exotic flowers: the insistent brightness of colour seems unreal and a little suffocating. Its origins are rooted in history, beginning with the Visigothic tribes who flooded into Europe in the fifth and sixth centuries, bringing with them arts both

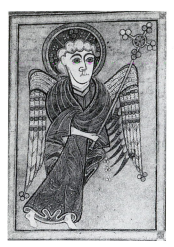
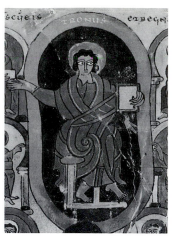

244. Iona(?): *The symbol of St Matthew*, from the Book of Kells, MS. A.1.6, folio 27 verso. Mid eighth/early ninth century. Dublin, Trinity College

245. Spain: *The Lord enthroned*, detail of the Heavenly Jerusalem, from the Morgan Beatus, MS. 644, folio 223. Mid tenth century. New York, Pierpont Morgan Library

highly competent technically, and with a strong feeling for colour and design. Their ornamental bias found its happiest expression in the setting of jewels, as exemplified by a pair of Visigothic eagle-shaped fibulae, now in the Walters Art Gallery at Baltimore, which are of gilt bronze overlaid with gold, set with garnets and blue and green stones, and with a cabochon crystal as a central boss on the breast and a large amethyst to represent the eye.[51] The Visigothic jeweller's concern with glowing colours was shared by the Mozarabic painter, who was almost entirely indifferent to form and tended to interpret figures in terms of adjacent colour areas. A waxlike surface can add something of the sheen of precious stones, and the vibrancy of some Mozarabic paintings rivals that of gems – see for example the flame-like quality both of the León Bible [250] and of the Adoration of the Lamb in the San Millán Beatus. Yet when this has been said, Mozarabic painting lacks the disciplined control that jewels receive from their settings.

Jewellery is a craft of embellishment, and it is the very attempt of Mozarabic painters to bend an art of adornment to narrative purposes that makes their work difficult to comprehend. It is as if someone has tried to convey a pictorial message by arranging differently coloured precious stones on a richly painted surface. The figures are areas of segmented colour with little physical or psychological relationship, and it is only the pairs of eyes (as in two paintings of Christ appearing among the clouds, one in the Beatus of Magius[52] (folio 16) and the other in a Beatus in the British Library [247]) that alert us to the fact that they are meant to represent human beings. The dominant impression of these paintings is of bright colours and of other-worldliness – very close in fact to the visionary world of the Middle Ages, where the perceptions of the mystics were often expressed in terms of colour and luminosity.

The sculpture of the Visigoths also is reflected in some Mozarabic art[53] – the narrow silhouettes of figures in one or two of the manuscripts,[54] the faces with their large almond-shaped, bulging eyes and the nose reduced to two parallel lines, and the heavy lacklustre line[55] are reminiscent of some Visigothic sculpted draperies.[56]

It is uncertain whether the Insular influences that appear in some Mozarabic art emanated from the British Isles or from religious houses set up on the Continent by British missionaries. They result in draperies reduced to the 'swathed', almost cross-banded pattern-work of the early Morgan (folios 26, 17 verso, 118, etc.), Valladolid, and Escorial[57] Beatuses, all of the tenth century, for which it is not difficult to find parallels in the Book of Kells,[58] the Mac Durnan Gospels [72], and the Gospels from St Gallen: a good comparison is afforded by a detail of the symbol of Matthew in the Book of Kells [244] and a detail of the Lord enthroned from the Morgan Apocalypse [245]. It might be argued that Spain was simply paralleling developments in the British Isles by reducing a classical style to decoration – see, for example, two earlier works of art in Spain, a late classical sepulchral mosaic[59] in a more naturalistic version of this kind of style, and a seventh-century capital from Córdova where St Matthew's symbol[60] marks a transition towards decoration. But it is far simpler to explain the relationship between Mozarabic and Anglo-Irish art by positing a direct association between the two, especially in view of the detailed comparisons that may be made.

The first occur in the early Beatus of Magius. Here the Christ on folio 83 has similarities to the Christ in a Northumbrian manuscript now at Durham;[61] the evangelist symbols on folios 2 and 3 verso are in the patterned, almost heraldic manner of Anglo-Irish symbols; and the backgrounds of folios 2 verso and 3 recto are covered in the mosaic-like patterning familiar in Anglo-Irish art.[62] Then – although the motif ultimately derives, of course, from late Antiquity – the two angels holding a casket containing St Mark's Gospel beneath his symbol on folio 21 resemble a composition in an Anglo-Saxon manuscript from Trier, where angels hold a placard instead of a casket.[63] Again, the reduction to a lobed pattern-work of the figure of Christ in the Escorial Beatus[64] can be paralleled both in an Anglo-Saxon manuscript from Echternach[65] and in the Dimma Gospels from Dublin.[66] More general affinities with Anglo-Saxon figure styles in the Burgo de Osma Beatus,[67] and the presence in these manuscripts of Anglo-Saxon, or Irish, interlace,[68] seem to offer further confirmation of the view that influences from the British Isles were percolating into Spain.

Although in the tenth century, as Nordenfalk has said,[69] influences were also trickling in from Carolingian art, Mozarabic painting is best understood within its own tradition of Visigothic art, and it has even been suggested[70] (without supporting evidence) that Beatus was himself conversant with Visigothic illustrations of the Apocalypse.

In Spain during our period – as elsewhere from time to time – religious hostility did not necessarily evoke artistic intolerance, and appreciation of the other's work was common to both Muslim and Christian. We have seen that Arabs were commissioning mosaics from Christians in the eighth and tenth centuries, and even at the height of the Crusades, when the Arabs were fighting fiercely for their faith, they still looked for their monumental (but decorative) mosaics to their religious adversaries. The Christians, for their part, prized Muslim textiles and metalwork; popes presented Saracenic textiles to the altars of Roman churches,[71] a German monk extolled the variety of Arabic workmanship in metals,[72] and a saint blessed water brought to him in a Saracenic vessel.[73] Art thus ignored religious division, and this was assisted by

the fact that orthodox Muslim art was decorative and so presented no religious scenes that a Christian would find unacceptable. The Christians moreover saw Arabic script as a superb form of decoration, and incorporated it into reliquaries such as the silver Arca Santa in Oviedo Cathedral, into carvings such as those at San Juan de las Abadesas, and even into a Beatus manuscript, for it is interwoven into the Saint-Sever Beatus's frontispiece. It even influenced the patterning of the late Romanesque wall paintings of Santa María de Tahull, San Pedro de Sorpe, Esterri de Cardós, and Santa Eulalia de Estahón. So – strange as it may seem at first sight – the art of Islam was yet another influence on Spanish painting.

The Muslims were too few in number to saturate the area of the peninsula they had conquered, so they and the Christians had perforce to mingle. Mozarabic Christians in fact settled down peacefully under Islamic rule: intermarriage was frequent, and the two cultures influenced each other at almost every point. Relations were good even at the highest level, for in 961 the bishop of Elvira dedicated a calendar to Hakam II, caliph of Córdova,[74] and in the eleventh century the Muslim ruler Motamid-ibn Abbad (whose wife was a Christian) restored and renovated Christian churches in Seville.[75]

It is one of the truisms of the twelfth-century Renaissance in Europe that it owed much of its impetus to the intellectual ferment of the Arab culture in Spain. But appreciation for Islam was already being expressed by Christians in Muslim Spain in the mid ninth century, moving Alvar, from the more intolerant fastnesses of the north, to berate his brothers of the south for their easygoing attitudes: they 'take delight in Arab poetry and their thousand stories', he said, and examine the religion and philosophy of the Muslims 'not in order to refute their errors, but on account of their elegance of diction and clarity of expression'. 'Are not all our young Christians ... skilled in heathen learning,' he continued, 'eagerly turning over the pages of the Chaldeans? ... Innumerable crowds are found who can most learnedly explain the beautiful order of Chaldean words, and can add the final flourish which their language requires with greater skill and beauty than the heathen themselves.'[76] In the eleventh century Arab tastes and fashions spread even to the Christian kingdoms of the north, and Sancho I of Aragon habitually signed his name in Arabic script,[77] while his contemporary Alfonso VI of Castile, who before his accession spent several years at Toledo and Seville, surrounded himself with Arab musicians, poets, and sages, and was even known to dress in Moorish costume.[78]

Intercommunication between some Christian and Arabic scriptoria is vouched for by the survival of a number of Christian manuscripts with Arabic comments or additions, including an eighth-century Bible,[79] a ninth-century St Augustine,[80] and at least three texts of Isidore from the eighth, ninth, and tenth centuries.[81] Furthermore, from the eleventh century there is a complete Arabic text of the Spanish Councils.[82] The names of some of the scribes of Christian scriptoria (Sarracinus, Zarrazenz, etc.[83]) proclaim them to be of mixed blood, and it can hardly be an accident that one of the earliest Latin manuscripts to use Arabic numerals included a certain Sarracinus among its scribes.[84] Even the monks in the north had at times to acknowledge the realities of the situation, as in a colophon of a copy of the Dialogues of St Gregory, written in 938: 'I, the most lowly priest Isidore, the scribe of this book, have completed it at the request of the

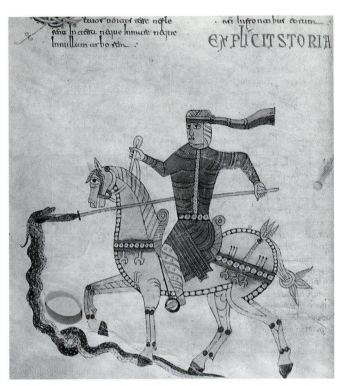

246. Spain: *Horseman in Sassanid dress killing a serpent*, from the Gerona Apocalypse, MS. 7, folio 134 verso. 975. Gerona, Archivo de la Catedral

Abbess Gundissa on 29 October of the year 976 [Spanish style] ... during the reign of Habdirrahmen, son of Muhammed, nephew of Habdalla, in the twenty-seventh year of his rule, in the month which in Arabic is called Almuharram.'[85] Even in Beatus illustrations figures (including Christ himself) sometimes sit cross-legged, a posture common throughout the East, and others wear the Arab turban.[86] Titus Burckhardt has further pointed out that, in the Gerona Apocalypse, the representation of the heavens as concentric circles reflects Arabic ideas, as do the attributes of the blessed – seated on thrones, crowned with flowers, and holding cups in their hands.[87] He also remarks that the colours of the Gerona pictures are reminiscent of Oriental pottery and enamels, and that they illustrate a horseman in Sassanid dress [246]. More recently, John Williams has commented that the kneeling posture of a Christ in Majesty in a *Moralia in Job*, completed in 943, is more in keeping with an Islamic formula than a Christian one.[88]

Westerners acquired some Arabic works of art from Muslim craftsmen travelling to Christian kingdoms: eleventh-century records speak of Muslims finding employment as ivory-carvers or metal-workers with Christian rulers and even with Christian abbots.[89] Others came as gifts, such as the 2,285 pieces of silken stuff of various colours and patterns conferred by the Muslim leader Almanzor on his Christian allies after a victory in 997,[90] or the exquisite silk, adorned with arabesques, placed in a spontaneous gesture in 1063 by the Muslim ruler Muradid on a sarcophagus containing the relics of St Isidore which the bishop of Astorga was conveying from Seville.[91] Christians travelling northwards on pilgrimages from the Arabic south would also make donations to churches; this was how the Catalan church of Estany acquired its rich collection of Hispano-Moresque textiles.[92] Muslim works of art were also taken as plunder,

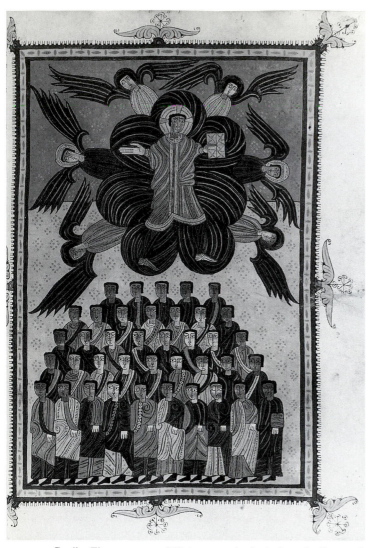

247. Castile: *The appearance of Christ among the clouds*, from the Beatus of Santo Domingo de Silos, MS. Add. 11695, folio 21. 1109. London, British Library

248. Navarre(?): *The fall of Babylon*, from a Beatus, MS. nouv. acq. lat. 2290, folio 147 verso. Late twelfth/early thirteenth century. Paris, Bibliothèque Nationale

like the twenty-one engraved and gilded silver vases from Spain given in 1002 by Count Raymond of Rouergue to the French abbey of Sainte-Foy at Conques, which the monks made into 'a great cross which retained the richly engraved Saracenic ornament'.[93]

In the twelfth century, Theophilus singled out metalwork as the craft in which the Arabs excelled,[94] but they were renowned too for their decorative textiles, made primarily at Cádiz and Seville, which may have influenced the illustrations of a comparatively late Beatus manuscript from Santo Domingo de Silos.[95] Looked at in terms of narrative art, the squat, heavily swathed figures of this Beatus, in closely serried ranks, gazing fixedly with gimlet eyes, are frankly ridiculous [247], but viewed as decorative surfaces they emerge as the cheerful and colourful textile designs that they are. The schematized trees and fauna of some Mozarabic Canon Tables are strongly Saracenic, and the dragons with pear-shaped and highly decorative tails have Sassanid ancestors in stone.[96]

Mozarabic art never approached Arab sophistication, but in a lower key it shared the Arab interest in surface pattern. The figures and animals of the early Morgan Beatus[97] and the Madrid Beatus of 1047[98] resemble Moorish ivory-carving, and most other manuscripts – such as the Gerona Apocalypse of 975 – have some close surface decoration. Sometimes this

took the form of dragons and animals, and this extended also to backgrounds, to human figures, and to architecture, as in the Beatus of 968–70 from Távara.[99] Indeed, almost all Mozarabic paintings have a patina of decoration – an artificial garnishing of ornamentation sown or scattered over the surface to give an exotic air – and this continues in the Beatus manuscripts of the twelfth and early thirteenth centuries [248], creating a colourful and spangled effect.

These late Beatus paintings, such as the later Madrid and Pierpont Morgan ones,[100] are in the more international style of mature Byzantine-influenced Romanesque. Yet the Mozarabic inheritance seems to have inhibited full acceptance of the Western Romanesque idiom: the kings and queens of the Book of the Testaments of Oviedo Cathedral made between 1126 and 1129, for example [249], continue the rich colours, the surface texture, and the articulation of detail of the Mozarabic tradition, as well as the Mozarabic indifference to form which gives the figures a deflated appearance that no Romanesque artist would have countenanced.

BIBLES

The Mozarabic style also finds marginal expression in the Spanish Bibles of the tenth century.[101] A particularly

249. Oviedo: *King Bermudo II offering a charter and Queen Gelvira indicating an open book*, from the Book of the Testaments, folio 49 verso. 1126/9. Oviedo Cathedral

250. San Martín de Albeares: *St Mark*, from the León Bible, MS. 6, folio 211. 920. León, Archivo de la Catedral

important one of the first half of that century, commissioned by Abbot Maurus and produced in 920 at San Martín de Albeares by the monks Vimara and John, is now at León Cathedral.[102] The single angels before each Gospel, with the symbol of the appropriate evangelist, are striking indeed, and it is unfortunate that their flame-like vibrancy and fine colour can only be hinted at in a black and white reproduction [250]. A Bible dated 960, also now at León,[103] was produced in the monastery of St Peter and St Paul at Valeránica, near Burgos, by Sanctius and by a scribe called Florentius, who are pictured at the end[104] congratulating one another on the completion of their task. Florentius's name appears in another dated manuscript,[105] and he was responsible too for a large illustrated Bible (dated 953 or 943), which was in the seventeenth century in the Castilian monastery of Oña but is now – apart from twelve leaves – lost to us.[106] According to Williams, the illustrations of the León and Oña Bibles were based on the same lost sixth- or seventh-century model,[107] used also for an early-thirteenth-century Bible from San Millán de la Cogolla.[108] Williams makes an interesting comparison between the consecration of the tabernacle in the León Bible and that of the third-century murals of the synagogue of Dura-Europos in Syria.[109]

The Old Testament part of the León Bible – particularly the Books of Daniel, Exodus, and Kings – is well illustrated.

There are iconographical relationships with some of the Beatus Daniel scenes,[110] and stylistic ones with such Beatuses as the one from Urgel. The Bible's Adam and Eve resemble those of the Beatus genealogical tables. Drawn with somewhat naïve eloquence, their clumsy attempts to cover themselves with fig-leaves give them the vulnerable nakedness of plucked chickens. It seems probable that Bibles were illustrated in Spain in pre-Muslim times. Some would argue that the celebrated seventh-century Ashburnham Pentateuch[111] is Spanish, and others believe that it had an effect on early Beatus illustrations,[112] but its Spanish origin is by no means certain;[113] yet there do seem to have been one or more illustrated Bibles in the Spanish peninsula in the sixth or seventh century.[114]

Before the twelfth century, Catalonia had much closer artistic links with the West than the rest of Spain. This was a result of Charlemagne's anxiety, in the light of his grandfather's experience of Islamic invasion across the Pyrenees, to secure his kingdom against the Arab threat by forming a Spanish March under Frankish authority. At his death this territory extended from the southern slopes of the Pyrenees to Tortosa on the coastline and Huesca on the plain, and here it was that Spanish rulers of Visigothic descent were able to establish themselves under Frankish protection. The Spanish March remained under Carolingian

suzerainty until about 877, when the county of Barcelona achieved independence under Wilfred the Hairy, who united to Barcelona the counties of Urgel and Cerdaña, extended his power to Montserrat, and is said to have founded the monastery of Ripoll. In the eleventh century, Count Ramón Berenguer extended the frontiers of the march southwards by conquest and northwards by marriage, and at his death in 1076 he held almost as much territory north of the Pyrenees as in the Spanish peninsula. Catalan Spain, then, was at first attached to Frankish areas, but later reversed the situation.

These links drew Catalan magnates to Europe, and in 967, during a visit to France, Count Borrell II came upon a certain Gerbert in the monastery of Aurillac and persuaded him to complete his education in Spain. Gerbert went on to become abbot, archbishop, and finally pope, and was considered the greatest scholar of his day. Another noble, Count Oliba of Besalú[115] – nicknamed the goat because of his habit of scratching the earth with his foot – visited Rome, stayed for a year at Montecassino, and even persuaded the doge of Venice and rebuilder of St Mark's, Peter Urseolus, to return with him to live in retirement in the Spanish March. One of Oliba's sons, another Oliba, who became abbot of Ripoll in 1008 and bishop of Vich in 1018, also visited Italy and was in close touch with France. He was a friend of Gauzlin, abbot of Fleury, two of whose monks had been born at Barcelona and educated at Ripoll; one of them, John, became abbot after Gauzlin's death.

Some think that it was at Ripoll that Gerbert completed his education. It was certainly an outstanding academic centre whose scrupulous scholarship prompted the despatch of two monks to Naples on a special mission to collate a single manuscript – a concern for textual accuracy that anticipates the early Cistercians. Oliba doubled the number of manuscripts in the library, and the inventory of books left at his death in 1046 records four Bibles, one identified with a Bible now in the Vatican Library[116] and attributed to Ripoll because of similarities between its pictures – particularly the Exodus scenes – and the later carvings on the façade of the main western portal of the abbey church of Santa María de Ripoll.[117] It is the most profusely illustrated Bible of our period – only the Carolingian Utrecht Psalter with its derivatives, and the Anglo-Saxon Hexateuch,[118] can compare with it, and these are no more than parts of Bibles. The only other complete Bible with illustrations as lavish as these is a sister Catalan Bible from San Pedro de Roda,[119] and even this lacks Ripoll's extensive cycle of New Testament scenes. The pictures of the Ripoll Bible are not, however, particularly accomplished, and their lack of linear discipline gives them an air of imprecision. An awareness of Mozarabic traditions is evident in the mêlée of colour and the bright patterning. The strong influences from Byzantium (probably filtered through Italy) are especially clear in the style and iconography of the opening sequence of episodes from the life of Moses. Perhaps the finest illustration is of Ezekiel's description of the valley of dry bones and the measuring of the city on folio 209 [251]. The Ripoll Bible has stylistic links – exaggerated by some – with the Roda Bible (Santa María de Ripoll and San Pedro de Roda were linked by ties of fraternity) as well as with the initials of a copy of the Homilies of St Gregory[120] itself thought to come from Ripoll.

Abbot Oliba brought back to Ripoll relics from both Italy and France, and if influences from the first appear in the Ripoll Bible, others from the second emerge in the Bible from Roda. Attributed to the second quarter of the eleventh century, it is in four volumes, and the Franco-Saxon interlace of the large initial that opens volume 1 gives an immediate indication of its stylistic affiliations. Pictures in volumes 2 and 3 have something of the small-proportioned sketchiness of the Drogo Sacramentary, though the effect is less impressionistic on account of the harder line and the flat body-colours. The best pictures, in volume 3, are drawn with clarity and confidence. In the dream of Mordecai on folio 122 verso and the Hosea scene on folio 74 verso [252], the elongation of the figure, the heart-shaped arrangement of the hair, and the particular fall of the draperies – sometimes fluttering over the knee and sometimes billowing out at the back – point to connections with northern France; Saint-Omer especially is recalled by the 'umbrella' drapery folds of Isaiah's vision and Zechariah's calling in the same volume (folios 2 verso and 91), and by those of the sails in the scene of Jonah on folio 83 verso. Initials composed of human and animal figures in volume 3 recall comparable initials of northern France from the time of the Corbie Psalter onwards. The tenuousness of line of such illustrations as Joel receiving the Word and Malachi preaching on folios 77 verso and 96 of volume 3 are again reminiscent of northern France and of what have been described as Channel styles, and this quality of line continues into some drawings added to volume 4 in the late eleventh or even the twelfth century. This linear texture may be associated with Anglo-Norman art of about 1100, particularly from Durham and Canterbury.

These later drawings, by three or four different hands, comprise an Apocalypse cycle[121] whose iconography is related not to the Beatuses but to the Apocalypse scenes of Castel Sant'Elia and of thirteenth-century murals at Anagni Cathedral. It has been suggested that the Roda artists had at their disposal either a model brought from Italy itself – probably from Rome – or a Carolingian manuscript through which Italian influences were channelled;[122] in either case it is a further demonstration of Catalonia's openness to the rest of Europe.

Of a later Bible[123] from Castile, probably belonging to the third quarter of the twelfth century, only the first volume survives. The influences from Germany and from France are so strong that it has in the past been claimed for Augsburg or for the Cluny School. Its most impressive illustration is that to the Book of Genesis with scenes from the Fall to Cain's attack on Abel; here the pictures of the lower panel are unmistakably Spanish, but the Deity in the Expulsion scene above could as easily be German, and indeed German at its most fully Romanesque. It will be evident that the Bible's provenance is uncertain; it has most recently been ascribed to San Pedro de Cardeña in the province of Burgos,[124] and it is at Burgos that the manuscript is now housed.

The illumination of a roughly contemporary Bible now in Portugal[125] might also have been the work of an

251. Santa María de Ripoll: *The valley of dry bones and the measuring of the city*, from the Ripoll Bible, MS. Vat. lat. 5729, folio 209. Second quarter of the eleventh century. Rome, Vatican Library

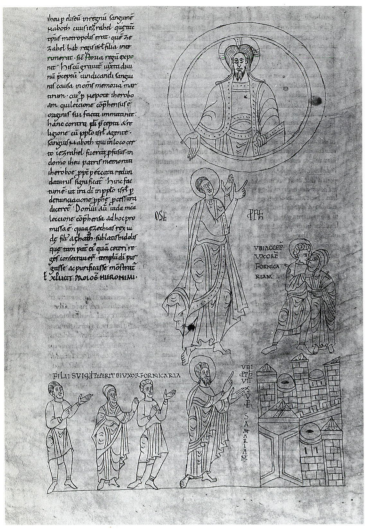

252. San Pedro de Roda: *The prophet Hosea instructed by the Lord to take a wife*, from the Roda Bible, MS. lat. 6, vol. 3, folio 74 verso. Second quarter of the eleventh century. Paris, Bibliothèque Nationale

Englishman or a Frenchman, and in a purely physical sense a Bible at León[126] *is* French, for, as Hugo of Bury St Edmunds[127] sent to Ireland for vellum for his Bible, so the supervisor of this León Bible sent to France for the vellum for his; the relevant inscription also yields the information that the manuscript was completed on 26 March 1162 after six months' work by the scribe and one month's by the artist. The Byzantinisms of the illustrations seem to have been mediated through France, but the subjects are taken from the earlier León Bible of 960, and there is an added element of traditionalism in the theme seen in early Beatuses of a bird overcoming a serpent to symbolize the triumph of Christ's Incarnation.

There is still much to learn about these later Bibles, but what is abundantly clear is that twelfth-century Spanish illumination – like Spanish wall painting – was open to extraneous influence.

WALL PAINTING

PRE-ROMANESQUE

The only surviving pre-Romanesque wall paintings of Oviedo, which claimed to be the capital of Christian Spain,

are so purely decorative that they would have been as fitting for a Muslim mosque as for a Christian church.[128] The most important are in the church of San Julián de los Prados,[129] popularly known as Santullano, built by Alfonso II of Asturias probably between 812 and 842. What remains consists partly of abstract and floral motifs. Some of the detail has a late classical and Early Christian feel, as for example in the panels in the nave and transept, where the decorative 'stage' architecture is reminiscent of the Pompeian paintings in the Villa dei Misteri.[130] Some panels have doll's-house architecture, and the ancillary furniture of others can be paralleled in the Early Christian mosaics of Ravenna and Salonica. The kings of Asturias, who founded the Christian capital of Spain, seem to have followed, in their own small way, the example of Charlemagne in turning back to the classical and Early Christian era for sources of artistic inspiration, and fragmentary evidence of similarly inspired decoration, which later also absorbs Muslim ornamental motifs, is found in other Asturian churches. The only indication of human representation however is an uncouth drawing of a seated and a standing figure at San Miguel de Lillo.[131]

In Catalonia, pre-Romanesque murals are largely confined to a group of three churches near Barcelona – San Pedro, Santa María, and San Miguel at Tarrasa. Crudely delineated in reddish-brown, they are drawings rather than paintings, and may reasonably be ascribed to the tenth century, for the Santa María figures have something of the quality of line of Spanish manuscript drawings of that time.[132] At San Pedro[133] there is a mural retable with four niches containing symbols of the evangelists, with angels in the spandrels between, and in two niches above are Christ bearing the Cross and an apostle, both flanked by seraphim. At Santa María[134] the much more fragmentary paintings are in the vault of the main apse. Their lost central figure must originally have been the focus of the two surrounding circles of other figures, themselves now so fragmentary that their precise identification is problematic, though pictorial references to the Passion of Christ may indicate that the composition represented Jerusalem at its two levels of meaning: the earthly Jerusalem of the Gospels, and the heavenly Jerusalem of the Apocalypse made possible by Christ's death. The general organization is reminiscent both of the Ancient of Days in the Gerona Beatus (Daniel VII), where God is the focus of two encircling bands of angels,[135] and of Early Christian mosaics, including a Spanish one not far from Tarrasa.[136]

The also fragmentary picture in the apse of San Miguel[137] represents the Ascension, and the paintings of some of the apostles – half sitting and half kneeling in a garden conventionalized to ornament – are still in good condition. It may be quite coincidental that the hand at the cheek is reminiscent of a similar gesture in Anglo-Irish manuscript painting on the Continent,[138] but on the other hand we have already suggested that Spanish manuscript painting was influenced from England or Ireland.

Paintings – in fact, little more than crude coloured drawings – from the main apse of the tenth-century church of San Quirce de Pedret (Barcelona),[139] uncovered when the Romanesque murals were removed, are now in the Solsona

Detail of plate 256

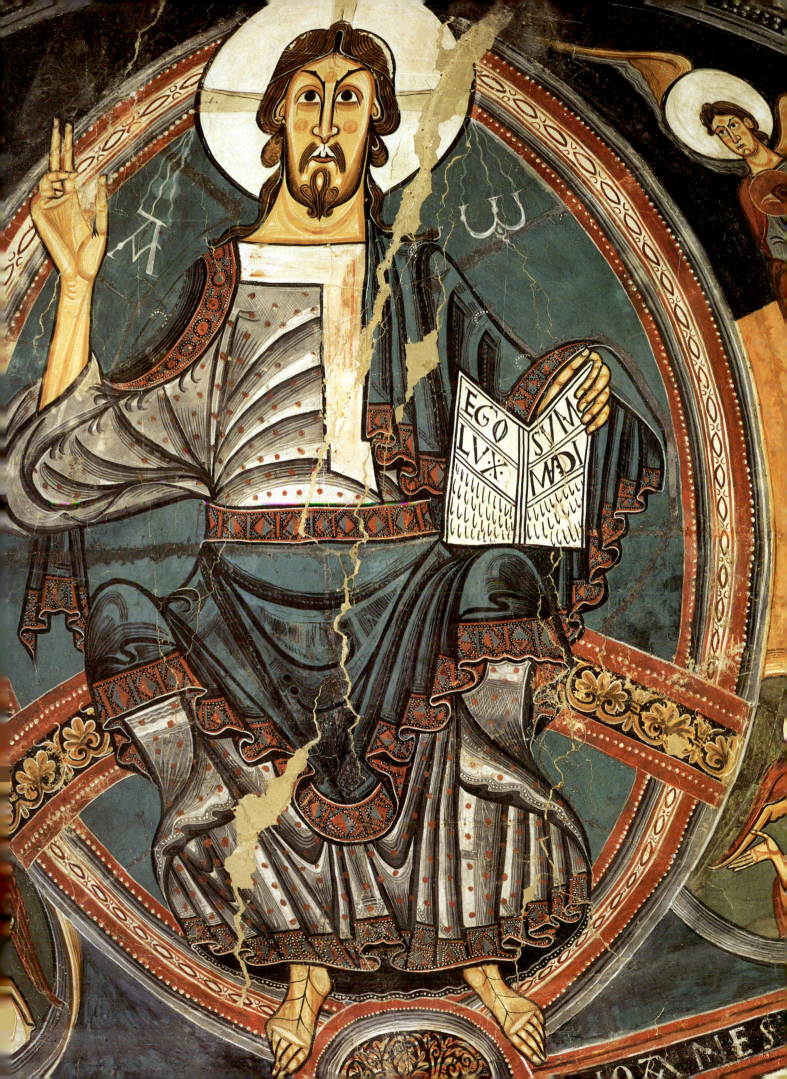

Diocesan Museum. Like most 'folk' art, they are difficult to date. Placed by some scholars as early as the tenth century, they may well in fact be as late as the second half of the eleventh, for one of the pictures seems to allude to the Crusading concept,[140] and it was only in 1061 that Pope Alexander II declared the conflict with Islam in Spain to be a Crusade. Its huge cross, with a knight on horseback accompanied by the peacock-symbol of immortality in a circular 'frame' at its centre, calls to mind the illustrations in the Beatus manuscripts of the Oviedo Cross, with its own militant associations.[141] Another painting is of a figure with arms outstretched in the form of a cross within a circular border; the bird above possibly symbolizes the Holy Spirit. A fragment of a Crucifixion was also discovered on a column in the nave. Late as these clumsy pictures probably are, they are still pre-Romanesque in style.

ROMANESQUE

Most of the larger Spanish Romanesque paintings are concentrated in Catalonia, for this region was less affected by the Muslim conflict than the rest of Spain. Catalonia is, indeed, richer in Romanesque panel paintings and wall paintings than any other comparable area of the West outside Italy, and it will therefore occupy most of the rest of this chapter.

MOZARABIC INFLUENCES

Mozarabic influence is not widespread in Spanish wall painting. What there is – mediated no doubt through manuscript paintings – is discernible in the almost chinless, pear-shaped heads, the low foreheads and large eyes of the figures in the apse of the Catalan church of Esterri de Cardós (Lérida), and in the style of the nave paintings of Santa María de Tahull (Lérida). (The paintings of both churches are now in the Museo de Arte de Cataluña in Barcelona – hereafter called the Barcelona Museum – where many of the Catalan murals are now housed.) Mozarabic influences will account as well for the Creation scenes of the Ermita de la Vera Cruz of Maderuelo (Segovia), now in the Prado, and the Christ of the Apocalypse from the apse of Santa Coloma (Andorra), now in a private collection. These paintings are in different styles, yet all exhibit some of the typically Mozarabic decorative texture and deflated formlessness, and the Mozarabic taste for close surface decoration may also explain the frequent sprinkling of pattern. In general, however, close and specific relationships with Mozarabic art are very few, and Spanish wall painting followed the course of illumination only in respect of the particular messages offered by both.

To outline once more our previous argument, the popularity of the Apocalypse in orthodox Christian Spain seems to have sprung from the threats posed by the Muslim infidel on the one hand and the Christian heretic on the other, leading to a visual emphasis both on the eschatological future and on those aspects of the Christian faith particularly questioned by the Muslim or the heretic – especially the inborn divinity of Christ and the divine inspiration of the New Testament message. Thus the Beatus manuscripts illustrated New Testament scenes relating to the innate divinity of Christ – the Annunciation to Mary, the Annunciation to the Shepherds, and the worship of the Magi – and further associated the evangelists and their Gospels with evidence of divine inspiration. Spanish Romanesque wall painting followed a similar path, favouring particularly the episode of the Magi's acknowledgement, by their gifts, of the birth of a divine Saviour, which dominates the apse of Santa María at Tahull [258] and finds admirable expression at Santa María de Barbará (Barcelona) and Santa María de Esterri d'Aneu (Lérida). The Annunciation to the Virgin is also popular,[142] and so is the Annunciation to the Shepherds,[143] one focal point of the Panteón de los Reyes in San Isidoro at León [259]. All this does not mean of course that Spanish monumental painting confined itself to themes of earlier manuscripts – only that it gave expression to the same Spanish consciousness.

The most frequent picture of all in Spanish churches is the apse painting of Christ in a mandorla with the Virgin and the apostles below, as at San Clemente de Tahull and Santa María de Mur (Lérida) [256, 260]. It is of historical and iconographic interest that this derives from earlier Ascensions[144] where Christ, watched by the astounded apostles and Virgin, disappears into Heaven in a mandorla (see illustration 160 for detail), but in Spain the mood and significance are quite different. The pictures now are hieratic and timeless. Christ is not ascending to God; he *is* God – the God of the Apocalypse – and is often surrounded by Apocalyptic symbols. In no other country is the Christ of the Apocalypse given such emphasis, or associated so unremittingly with the apostles and the Virgin. And, just as the evangelists were linked with concepts of celestial power and inspiration in the Beatus manuscripts,[145] so in these wall paintings – and in panel paintings, too – they and the apostles are associated with the Apocalyptic Christ of the final Judgement. Again, as the Beatus painters emphasized the spiritual authenticity of the Gospels, so the wall painters draw attention to their significance by having their evangelists hold their testimonies dramatically aloft,[146] or pointing meaningfully to them, as at Santa María de Tahull [257].[147]

ITALIANATE INFLUENCES

Spanish wall painting was influenced too by Italy, which is understandable because some Spanish houses were affiliated to Montecassino, the great source of the Benedictine tradition in the West, and others were subject to the rule of the Italian priory of San Michele at Chiusi, on the ancient road from Piedmont to Rome. On a much broader level, the growing popularity of pilgrimages to Rome, or through Rome to the Holy Land, drew increasing numbers of the Spanish to Italy, where they could view Italian art at first hand. Links forged by piety were no doubt strengthened by economic interests, and Catalonia had commercial links with both Pisa and Genoa, whom she joined in an expedition against the Balearic Islands in 1114, embarking with Genoa alone on the conquest of Almería in 1147.[148]

The most significant iconographic indication of Italian influence on Catalan wall painting is the unusual feature of the figures of the archangels Michael and Gabriel, bearing scrolls which are inscribed PETICIUS and POSTULACIUS to indicate their role as advocates, in the twelfth-century apse paintings of Santa María de Esterri d'Aneu, Esterri de

253. San Pedro del Burgal, apse, *Donor portrait (Lucía de Pallars?)*. Wall painting. Late eleventh century. Barcelona, Museo de Arte de Cataluña

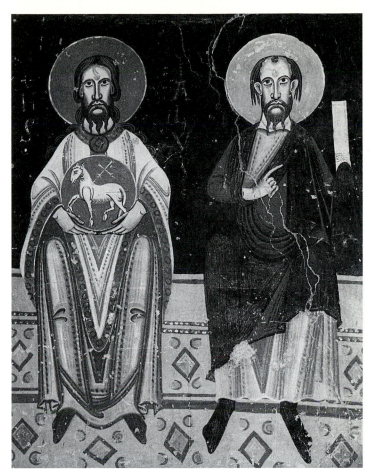

254. San Pedro del Burgal, apse, *St John the Baptist and St Paul*. Wall painting. Late eleventh century. Barcelona, Museo de Arte de Cataluña

Cardós, and Santa Eulalia de Estahón (Lérida) (all now in the Barcelona Museum). This theme derives from the apse of the Lombard church of San Vincenzo at Galliano.[149] Also of Italian or Italo-Byzantine origin are the rendering of Ecclesia as a woman seated on a church at San Quirce de Pedret,[150] and of the Virgin surprised at her spinning while an inquisitive maid listens from behind a curtain in the Annunciation scene at San Pedro de Sorpe (Lérida).[151] Of stylistic evidence, the most important is to be found in the later paintings of San Quirce de Pedret, attributed to the turn of the eleventh and twelfth centuries and convincingly compared with those of Civate in Lombardy.[152] Indeed, it would now appear that the San Quirce master was either Lombard himself or had been trained by a Lombard master; he reveals moreover an interest in Italian saints not directly connected with Pedret.[153] Some of his paintings are fragmentary, but all are lively in colour. They feature Christ in Majesty, scenes from the lives of St Quiricus and St Julita, and episodes from the Old and New Testaments including such Apocalyptic themes as the four horsemen, the twenty-four elders, and the seven-branched candlestick. They are today divided between the Barcelona Museum and the Diocesan Museum of Solsona.

In spite of stylistic differences attributed to the passage of time, the early-twelfth-century murals of Santa María de Esterri d'Aneu (Lérida), also now in the Barcelona Museum, are considered by most scholars to be the work of the Pedret master.[154] Enough of the apse painting survives to give some idea of its former excellence. It was originally dominated by a Virgin and Child, approached on either side by the three

Magi and flanked by St Michael and St Gabriel; of these, only the splendid figure of one of the Magi is now complete. On the wall below, still in good condition, the prophets Isaiah and Elijah prostrate themselves before two seraphim, with between them the four fiery wheels of Ezekiel's vision, and to the left is a vigorous picture of a deacon who may be the patron of the work, for a comparable figure is known to have been the sponsor of the apse paintings from San Pedro del Burgal (Lérida). They probably belong to the end of the eleventh century and are now, much restored, in the Barcelona Museum. Despite considerable restoration, it is clear that the Santa María de Esterri murals, though less decorative, are close to the San Pedro ones stylistically. The San Pedro patroness is a countess (*comitisa*), probably belonging to a local aristocratic family, the Pallars.[155] She stands holding a candle [253] with the seated Virgin and saints below [254], offering admirable examples of Spanish Romanesque with their assured heads, strong features, intimidating looks, and categorically outlined bodies.

Perhaps the most interesting feature of the San Pedro paintings is the fact that they incorporate the earliest allusion to the Grail in art or in literature. It is held by the Virgin, as in the Romanesque wall paintings of San Clemente de Tahull, Santa Eulalia de Estahón, Añós (Andorra), and San Román dels Bons (Andorra), and on an antependium from Martinet (Lérida).[156] The Grail generally takes the form of a chalice, though at San Pedro it is a rather shallow vessel which one scholar interprets as a lamp,[157] and at San Clemente de Tahull [256] it is a dish. The Grail is a subtle and complex concept which cannot be explored fully here, but it may be said that

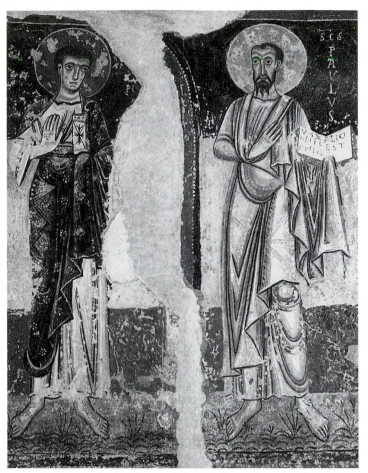

255. Orcau, castle chapel, apse, *St John the Evangelist and St Paul*. Wall painting. Turn of the eleventh and twelfth centuries. Barcelona, Museo de Arte de Cataluña

in its Christian sense it represents a relic of the Passion – usually the chalice of the Last Supper containing Christ's own blood – and in the paintings the divinity of Christ's blood is symbolized by rays of light that issue from the vessel. The Spanish artists may have associated the Grail with the Virgin because they saw her as the human Grail that had carried the blood and divinity of Christ.[158] The Virgin and the Grail are accompanied in these paintings by Christ in Majesty, which brings us back to the recurrent Spanish visual emphasis on the dual nature of Christ, both divine and human, in opposition to Muslim and heretical beliefs.

Other murals contemporary with those of San Quirce de Pedret that owed a great deal to Lombard painting (although it is not known whether the influence was direct, or indirectly derived through the San Quirce Master[159]) were in the chapel of the castle of Orcau (Lérida). Now in the Barcelona Museum, they show a more sophisticated decorative sense than those of San Quirce. Their three surviving apostles – probably from a row below Christ in Majesty in a popular composition – are very fine, dignified in appearance and slender in build, their draperies cascading over the knees to impart a sense of movement [255].

A damaged Annunciation and a very deteriorated Crucifixion from San Pedro de Sorpe, also now in the Barcelona Museum, are very close in style, but their attribution to the Orcau Master himself[160] opens up a considerable time-gap, for the Orcau paintings are given to the turn of the eleventh and twelfth centuries, and the Virgin and Child in the San Pedro apse is usually dated after 1123 because it derives from the Virgin and Child [258] from Santa María de Tahull (Lérida) itself associated with the consecration of the church on 11 December 1123. The San Pedro Virgin is much flatter and of a rather uncompromising angularity, but the rich decoration of the lower draperies, with close white dots to give an effect of pearling, introduces a certain splendour.

THE MASTER OF SAN CLEMENTE DE TAHULL

Influences from France have several roots. Cluny had extended her monastic authority into Spain as early as the tenth century, and Cîteaux was to do the same in the twelfth. Then, when Pope Alexander II declared the war against the Muslims in Spain to be a Crusade, large contingents of Frenchmen crossed the Pyrenees to wage holy war against the infidel. Finally, by the twelfth century the tomb of St James at Santiago de Compostela in Galicia had come to be regarded as one of the major shrines of Europe, and French pilgrims flocked to it in such numbers that the major route there became known as the *camino francés*; indeed, the only surviving twelfth-century guide book to Compostela was written by a Frenchman.[161]

French influences did not, however, march into Spain but slipped in almost unobtrusively; yet they had an effect on the linear play of the draperies of the greatest of all wall painters of twelfth-century Spain – the Master of San Clemente of Tahull (Lérida).[162] His paintings there (now in the Barcelona Museum) are ascribed to the time of the consecration of the church, which – according to an inscription using colours from the master's palette – took place on 10 December 1123. His apse composition is typical of Catalonia: a Christ in Majesty surrounded by symbols of the evangelists with apostles and the Virgin in arcades below, here flanked by seraphim [256]. It is painted with a vigour and monumentality that enshrine all that is best in Spanish Romanesque: the dominating figure of Christ has tremendous power; the angel holding the eagle of St John combines force with animation; and St Mark's lion throbs with a savage dynamism. Paintings by the same master on the soffit of the arch and on the abutment included a sensitively delineated hand of God within a medallion, and a less successful rendering of a dog licking the sores of Lazarus. The little that remains of the work of a second, inferior artist who painted parts of the chancel arch and the lateral apses includes angels from what was probably a Last Judgement. He was also responsible for the western parts of Santa María de Tahull.

The style of the Master of San Clemente had some influence on the paintings of San Miguel d'Engolasters (Andorra),[163] also now in the Barcelona Museum, on the traditional theme of Christ in Majesty with the symbols of the evangelists and angels. His work too had stylistic and iconographic echoes in the murals of Esterri de Cardós[164] (attributed to the second quarter of the century), though it could not lift them above their provincial and deflated level. The apse decoration of Esterri de Cardós was copied in the mid century at Santa Eulalia de Estahón, where there is a

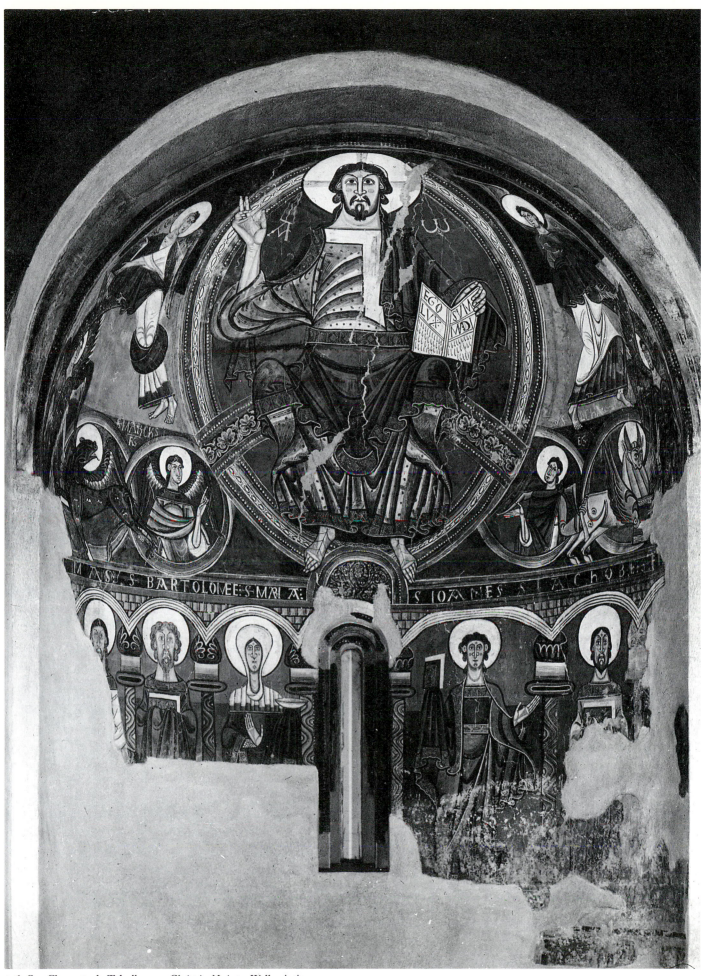

256. San Clemente de Tahull, apse, *Christic in Majesty*. Wall painting. *c.*
1123. Barcelona, Museo de Arte de Cataluña

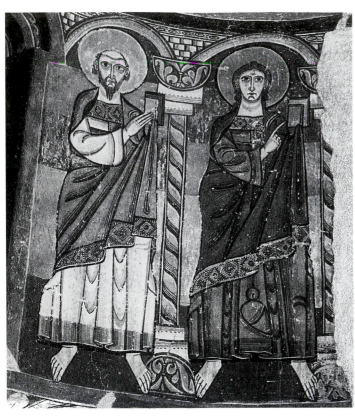

similar Christ in Majesty with evangelist symbols, seraphim, and the archangel-advocates referred to above in an Italianate context. Below, this time, are saints, with an intervening Baptism of Christ. Both the Esterri and the Santa Eulalia paintings are in the Barcelona Museum.

Santa María de Tahull[165] was consecrated, as we have seen, the day after San Clemente, and it attracted another talented artist who was influenced by the San Clemente Master, even to using a similar palette. In the lower region of his apse paintings (now also in the Barcelona Museum) are animals, real and mythical, set heraldically within medallions; above, apostles in arcades point forcefully to their writings or attributes [257]. In the semi-dome, the massively set Virgin in Majesty holds the Christ Child squarely in front of her as she is approached on either side by the Magi [258]. The Magi and apostles too have powerful, block-like proportions, dramatically highlighted. The composition is extended to the soffit of the arch before the apse by the Lamb of the Apocalypse in the crown, and on the right by the offering of Abel, presumably once balanced by Cain's offering on the left. The very boldness of these paintings throws into relief

257. Santa María de Tahull, apse, *St Paul and St John the Evangelist*. Wall painting. *c.* 1123. Barcelona, Museo de Arte de Cataluña

258. Santa María de Tahull, apse, *The Virgin and Child*. Wall painting. *c.* 1123. Barcelona, Museo de Arte de Cataluña

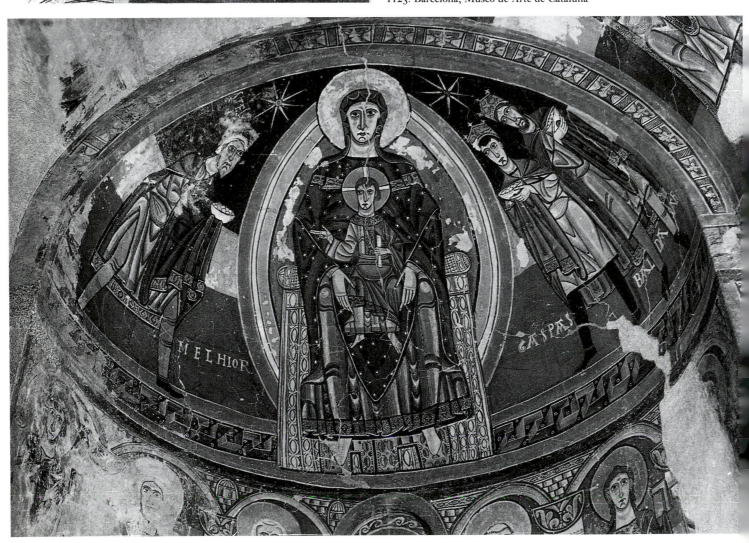

the weakness of the murals in the nave and aisles, which are by the San Clemente assistant. It is hard to resist the view of Cook and Gudiol Ricart that two talented artists were brought in to paint the apses of the two churches, while a painter with fewer artistic pretensions was left to complete the rest.[166] At Santa María, the lesser painter was responsible for episodes from the Old Testament and from the New (the Magi and the naming of John the Baptist, for example), and for a Last Judgement originally associated with a battle scene with angels. His lacklustre style renders his living David as inanimate as his dead Goliath.

CASTILE

The Master of San Clemente and the Master of Santa María de Tahull are to be numbered among the more important Western wall painters who travelled from place to place: the first was responsible also for paintings in the cathedral of Roda de Isábena (Huesca) in Aragon;[167] the second journeyed in the second quarter of the twelfth century from Catalonia to Castile to execute murals which today are well preserved. They were at the hermitage of the Vera Cruz near Maderuelo (Segovia)[168] and at the hermitage of San Baudel de Berlanga (Soria),[169] two small churches almost identical in shape and size. The entire surface of the barrel-vault of the Vera Cruz chapel – now reconstructed with its original decoration in the Prado Museum in Madrid – is filled with a Christ in Majesty in a mandorla supported by angels. The other pictures (now incomplete), in reds, oranges, and yellows, include an Agnus Dei set against a cross supported by angels; scenes from Genesis; the apostles; the Adoration of the Magi; and Mary Magdalene anointing Christ's feet. The Santa María master does not here recapture the breadth and massiveness of his Catalonian work, but his firmness of line confers a certain strength, as at San Baudel, where he was joined by two lesser painters. Here his New Testament scenes in the upper zone of the walls (now removed to museums in America), including representations rare in Spain of Christ's miracles and Passion, have survived in quite good condition. Underneath were scenes of stag-hunting and falconing on a monochrome red background (comparable to scenes of the chase in Byzantine paintings at Kiev[170] and Palermo[171]). These are now in the Prado at Madrid, together with decorative pictures from the structure supporting the choir tribune including a design of heraldic birds in medallions clearly derived from textiles, and a painting with Moorish echoes of an elephant with a howdah.

The murals of San Baudel and the Vera Cruz influenced an extensive cycle discovered in the early 1960s in the small parish church of San Justo[172] on the outskirts of Segovia. Exceptionally, it once bore, it seems, the 'signature' of one of its two artists, of which all that remains following the installation of a Baroque altarpiece is '... a pictor'. In the apse are a large-eyed Majesty, the twenty-four elders of the Apocalypse, a Crucifixion, and a Descent from the Cross, and on the inner curves of the arches Adam and Eve, Cain and Abel, and saints, birds, and beasts. In the vault is an Agnus Dei, and on the lateral walls are the Arrest of Christ and the Last Supper.

The most splendid paintings of Castile are those in the Panteón de los Reyes[173] [259]. Exceptionally, they are still in place in this mausoleum of the royal family of León-Castile

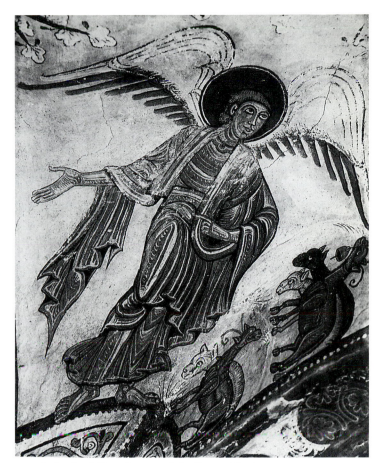

259. León, San Isidoro, Panteón de los Reyes, *The Annunciation to the Shepherds*. Wall painting. 1164/88

at the west end of the collegiate church of San Isidoro in León which was rebuilt under Ferdinand I and consecrated in 1063.[174] Six of the Panteón's nine roof bays teem with paintings, and yet others cover the upper parts of the walls. All are untouched by the hand of the restorer, and barely touched by the hand of time. It is teasing that the pictures of Ferdinand II (1157–88) and his queen Urraca, genuflecting on either side of the Crucifixion on the east wall, are not a sure guide to dating: the difficulty is that the king had two wives named Urraca, his first being Urraca of Portugal (1164–75) and his third Urraca López (1181–8). The suggestion of two scholars that neither is in question, and that the two represent Ferdinand I (1035–63) and his daughter Urraca (d. 1101),[175] a benefactress of the church, raises a needless complication, for it would place the paintings earlier than their style will allow. The best we can say at present is that they date from after 1164 and before 1188.

Three of their themes – the Annunciation to Mary, the Annunciation to the Shepherds, and the Adoration of the Magi – emphasize the innate divinity of Christ, as in the Beatus manuscripts. Other subjects include the Massacre of the Innocents, the Last Supper, the Arrest of Christ, incidents from the Passion (now fragmentary), angels, prophets, and saints. The impressive Christ in Majesty in the central bay at the eastern end includes evangelists (with their Gospels) with the bodies of angels and the heads of their symbols, a mode of representation known from Insular art, but also familiar in the manuscript painting of Spain, whence no doubt it derived. In another painting, Christ is associated

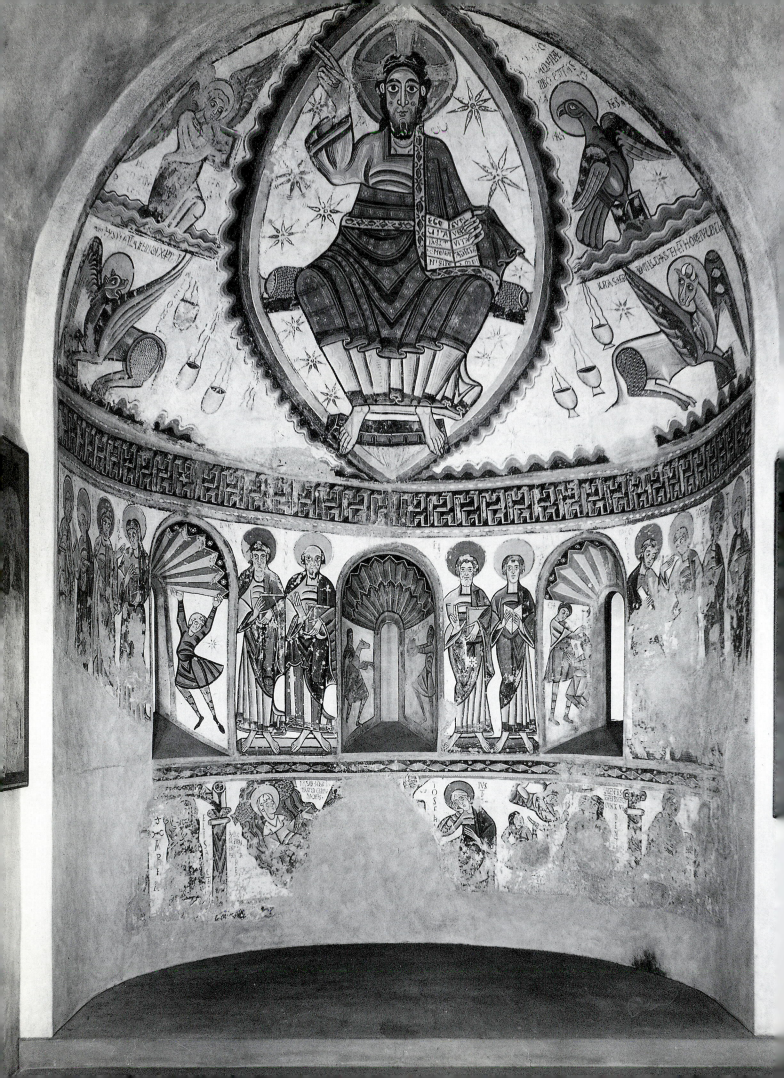

with the Apocalypse by a kneeling St John and the angel, and by the symbolism of the candlesticks, the book with seven seals, and the seven churches of Asia Minor. Touches of a personal nature include the appearance in the scene of the Last Supper of a cupbearer labelled 'Marcialis Pincerna', in apparent reference to the extravagant claim of Limoges[176] that St Martial was a contemporary disciple of Christ.[177] Such particular diversions have contributed to the formation of the view of some scholars that the overall scheme lacks cohesion; yet the paintings do draw out the three primary strands of the Christian story – the divinity of Christ, his afflictions on earth, and his ultimate victory in Heaven.

It is difficult to isolate the influences at work in these paintings. The faces and some of the decoration have been associated with Italo-Byzantine work, the positioning of the figures with Poitevin art, and the draperies (not very convincingly) with the wall paintings at Brinay and Saint-Aignan-sur-Cher. The pastoral quality of the charming Annunciation to the Shepherds is reminiscent of a much earlier period: two of the shepherds play a horn and a pipe and another feeds a dog, while the angel, by an expansive gesture of his hands, transmits the news that suffuses his face with tranquil expectancy [259]. The figures have vitality and relish, and the billowing draperies give a sense of rhythmic patterning. Though these are not great paintings, they are certainly refreshing ones.

FRENCH INFLUENCES IN CATALONIA

In Catalonia, further French influences are to be found in what remains of the paintings of San Saturnino de Osormort (Barcelona)[178] (after the church burned down in 1936 the surviving murals were moved to the Episcopal Museum of Vich). Attributed by Demus to the middle of the twelfth century, they include a Majesty from the vault, a row of apostles below, and, further down, scenes of the Creation and the Fall. The proportions of the figures, the lantern jaws, the threaded hair, and the forms of draperies (though now more simplified) all reflect something of the nave paintings of Saint-Savin-sur-Gartempe. The scenes themselves 'shadow' the Saint-Savin iconography, which also influenced Old Testament scenes from the nave of the small Aragonese church of San Julián in Bagüés[179] (displayed in a reconstructed interior in the Museo Diocesano in Jaca). Originally the entire church was decorated. The nave paintings are better preserved than those of the apse, and the programme incorporates scenes from Genesis and from the life, miracles, and ultimate Sacrifice of Christ, with his Ascension in the semi-dome and his appearance in glory on the tympanum of the doorway in the reconstructed north wall. As Wettstein comments, it is difficult to establish precise stylistic parallels for the Bagüés paintings,[180] and the hand of their artist is not to be detected elsewhere.

The master of Osormort, on the other hand, worked also in San Martín del Brull and in the cemetery chapel of San Juan de Bellcaire (Gerona)[181] (the Bellcaire murals are today divided between two collections). The paintings from the apse of San Martín,[182] now in the Episcopal Museum of Vich,

represent the Majesty, the Nativity, the Annunciation to the Shepherds, the Adoration of the Magi, and scenes from Genesis. The poorly preserved paintings of the Crucifixion and martyrdom of St Stephen in the apse of the church of Marenyá[183] (Gerona) show affiliations to the Osormort master's style.

The powerful but unsophisticated paintings from Santa María de Mur (Lérida),[184] now mostly concentrated in the Boston Museum of Fine Arts, include a Christ in Majesty [260] which is in some ways a tightened-up version of the one at Vicq-sur-Saint-Chartier. The style – perhaps of the mid twelfth century – is close to that of paintings from San Martín Sescorts (Vich)[185] now in the Vich Episcopal Museum. The immediate source of both is the cycle from San Pedro de Seo de Urgel (Lérida)[186] – today in the Barcelona Museum [261] – whose apse murals of a Majesty with the Virgin and apostles may be attributed to the first quarter of the twelfth century. The San Pedro figures combine dignity with liveliness, and the 'pearling' of the draperies lends an air of conscious display which combines with the warmth of colouring to call to mind the panel paintings of Spain.

PANEL PAINTING

Spanish Romanesque panel paintings were made as altar frontals in a country which could not often afford to create them from precious metals, especially when inset with gems.[187] This has meant that more Romanesque paintings on wood survive in Spain than in any other country of the West, for such paintings had no bullion value and could not be melted down to satisfy later economic appetites which (as in England) often partnered religious reform. They were produced, according to Cook and Gudiol Ricart,[188] at three major centres, all in Catalonia: at the Seo de Urgel, where their styles were akin to those of murals; at Ripoll, which drew upon the traditions both of wall painting and of manuscript illumination; and at Vich, whose products are more closely related to miniatures. They vary a good deal in quality, but the tonal effects of their glowing colours stamp them all with the unmistakable personality of Spain. None can be reliably dated before the twelfth century,[189] and in the absence of inscriptions and helpful documents, dates for them can be offered only on the basis of style.

Two of the finest of the surviving altar frontals, both in the Barcelona Museum, have been attributed to Urgel on the strength of their stylistic kinship with the murals of San Pedro de Seo de Urgel.[190] In the lateral compartments of the first, from Seo de Urgel itself, the heads of the apostles rise one above another in a pyramid – an inverted perspective originating in late Antiquity and adopted as a convenient formula by an age more interested in the perspective of values than the perspective of space. The apostles look towards a central Christ in Majesty [262] whose starkly Romanesque quality suggests the decades between 1110 and 1130, though the frontal has been attributed to the end of the eleventh century or the beginning of the twelfth.[191] The second altar frontal, originally at Hix (Roussillon),[192] is plainly a sister piece in terms of workmanship, and indeed almost a twin sister in terms of date. Its central Christ in Majesty [263], like the first, has some of the power of the best wall paintings. In four frames on either side are the twelve apostles in pairs and four figures connected with the life of St Martin. A third

260. Santa María de Mur, apse, Christ in Majesty. Wall painting. Mid twelfth century(?). Boston, Museum of Fine Arts

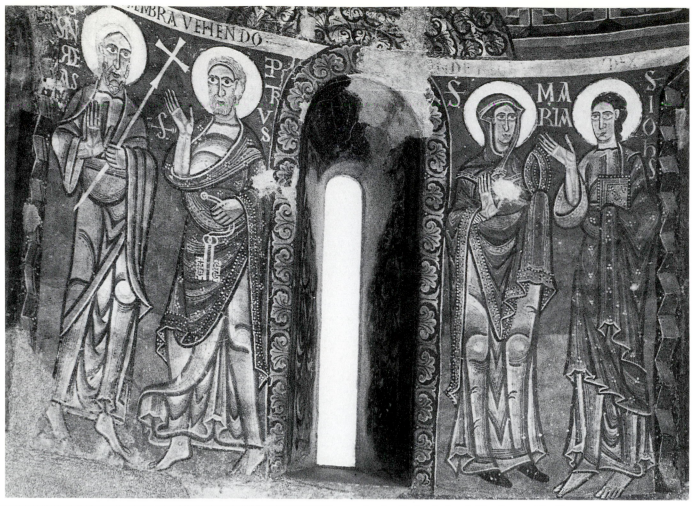

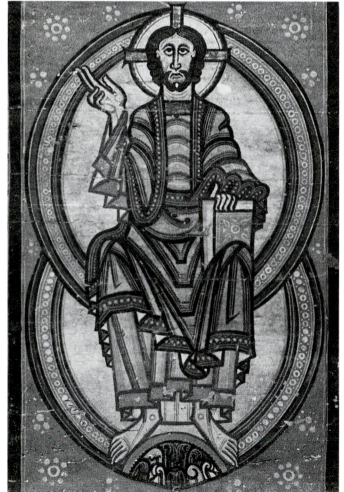

261. San Pedro de Seo de Urgel, apse, *The Virgin and apostles*. Wall painting. First quarter of the twelfth century. Barcelona, Museo de Arte de Cataluña

262. Urgel: *Christ in Majesty*. Detail of an altar frontal from Seo de Urgel. 1110–30(?). Barcelona, Museo de Arte de Cataluña

altar frontal claimed for Urgel,[193] originally from Martinet (Lérida) and now in the art gallery of Worcester, Mass., is of the Ascension, with the Virgin and apostles below. A fourth, perhaps of the second half of the twelfth century, from Santa Julita de Durro (Lérida)[194] and now in the Barcelona Museum, is said to be by the artist of the apse painting of Santa María de Valencia de Aneu (Lérida).[195] The panel's central Madonna and Child are accompanied by scenes from the Passions of St Julita and St Quiricus. Its chief interest is its colours.

The major panel paintings attributed to Ripoll are housed in the museums of Vich, Barcelona, and Solsona. An altar canopy at Vich from Ribas,[196] with Christ in Majesty surrounded by angels and archangels, is a particularly fine example of Spanish Romanesque, to be attributed to the first half of the twelfth century. Stylistically associated with it is a well executed antependium from Esquius, near Torelló,[197] now in the Barcelona Museum, and perhaps of the middle decades of the twelfth century. Its central Majesty is surrounded by evangelist symbols and accompanied by the apostles [264]. An antependium from the parish church of Sagars, now in Vich,[198] of somewhat later date – it may be assigned to the last quarter of the century – has a Christ in Majesty accompanied by four scenes of the Passion of St Andrew. Its side pieces, now in the Solsona Museum, present pungent scenes of the Fall, the Visitation, the Nativity and

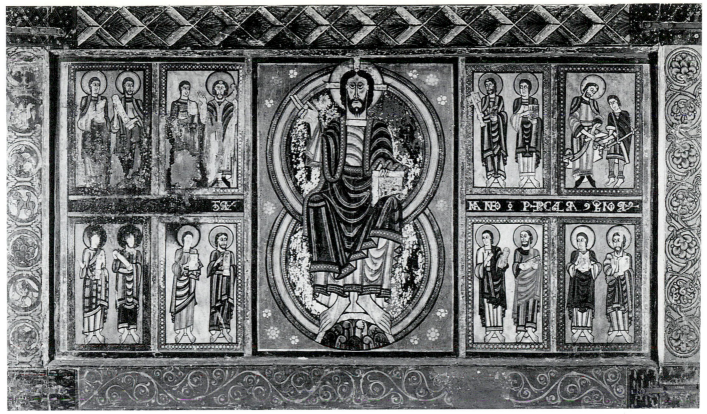

263. Urgel: *Christ in Majesty with apostles*. Altar frontal from Hix. 1110–
30(?). Barcelona, Museo de Arte de Cataluña

264. Ripoll: *Christ in Majesty with evangelist symbols and apostles*.
Antependium from Esquius, near Torelló. Mid twelfth century(?).
Barcelona, Museo de Arte de Cataluña

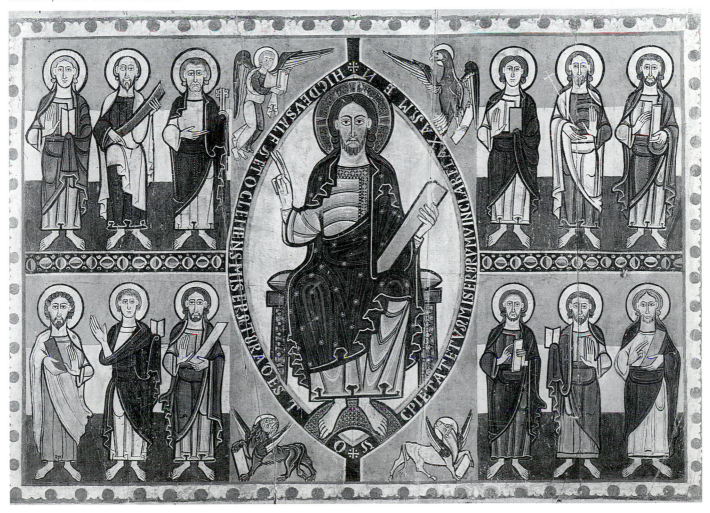

the Adoration of the Magi, Christ's entry into Jerusalem, the Arrest, and the Deposition.[199]

The panel paintings attributed to Vich usually lack the boldness of the most important examples from Urgel, concentrating rather on detail and decoration, as in an altar frontal from Montgrony (Gerona), now in the museum of Vich,[200] with its scenes from the life of St Martin flanking the central Christ in Majesty. Here the artist's decorative impulse has led him to cover St Martin's horse with ornamental circles, and even to substitute acanthus scrolls for evangelist symbols at the corners of the central frame. The possible date here – the middle years of the century – would be appropriate also for the lateral panels from the altar of San Juan de Mataplana (Barcelona), each with a full-length angel,[201] one now in the Barcelona Museum and the other in the gallery at Vich. The Vich decorative sense reappears in a frontal[202] in the Vich Museum with scenes from the life of St Margaret bordering a central Virgin and Child framed in a mandorla borne by four angels. The figures tend to be masked by a decorative webbing of line with a linear garrulity exceeded in another frontal from the Vich area in the same

museum.[203] Here one or two of the figures have the tormented quality of line seen in the final decades of the twelfth century in manuscript paintings such as those of the Bible of Saint-André-au-Bois [201]. The Virgin and Child in its central panel are surrounded by symbols of the evangelists, and on each side are scenes from the Virgin's life. A late-twelfth-century altar frontal also in the Vich Museum,[204] and attributed to Vich, has a central Majesty with scenes from the life of St Lawrence.

Of particular interest for its artistic associations is a Vich altar frontal from the parish church of Espinelvas (Barcelona), now in the Vich Museum.[205] Its illustrations show the three Magi [265], the Entry into Jerusalem, and six prophets all surrounding a Virgin and Child, and its special significance, long recognized, is that it is by the painter of the south transept apse of Santa María de Tarrasa (Barcelona).[206] Interest in the lives of saints is rare among the wall painters of Spain, who preferred to leave such themes to the panel painters, and so it can hardly be a coincidence that the decoration of this apse (representing the second phase of painting at Santa María) is both concerned with a saint and also by a panel painter. It presents the martyrdom and apotheosis of St Thomas Becket of Canterbury in fresh and arresting colours – warm rusts, bluish-green, and a greyish-blue [266]. On the left, the four knights remonstrate with Becket. In the centre, valiantly resisted by Edward Grim,

265. Vich: *The three Magi*. Detail of an altar frontal from Espinelvas. *c.* 1187. Vich, Museo Arqueológico Artístico Episcopal

266 (*opposite*). Santa María de Tarrasa, apse of the south transept, *Martyrdom and Apotheosis of St Thomas Becket*. Wall painting. *c.* 1185–1200

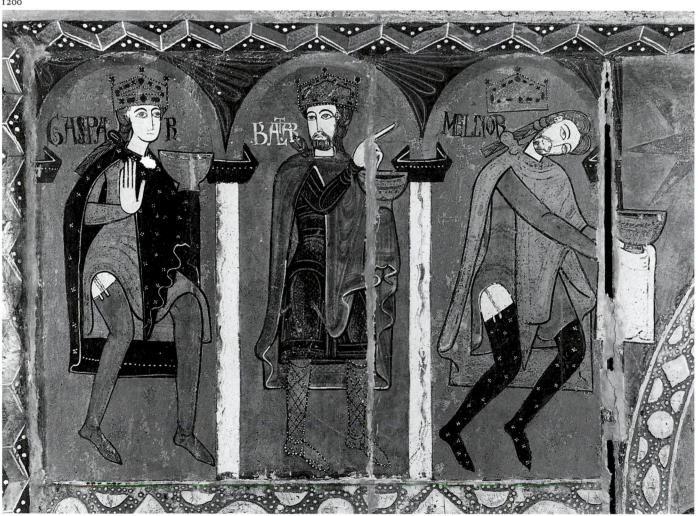

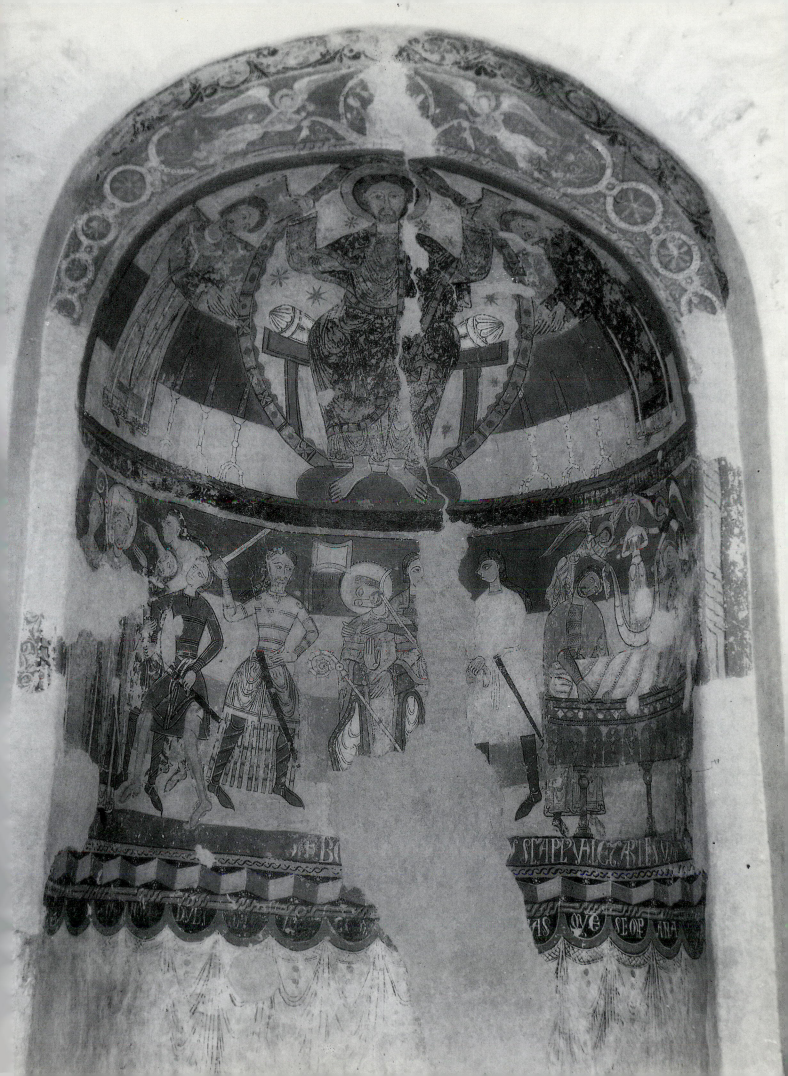

they strike at the archbishop with their swords, and on the right the saint's soul ascends to heaven. Finally, in the semi-dome, Becket stands on one side of the enthroned Christ with Grim on the other. Now Edward Grim was a secular clerk who had met Becket only a few days before his martyrdom, yet was the only person to remain at his side throughout the attack. His attempt to parry the murderous blow succeeded only in deflecting the sword which, after wounding him in the arm, found its home in Becket's scalp. A careful collation with the historical sources, including Grim's own account, will show how closely the artist followed the course of the martyrdom as it was known from contemporary English writers.[207] The fact that Becket is shown as a saint (he was canonized in 1173), and that Grim appears with him in heaven and must therefore have died before the picture was painted, should help, in the dating. However, the date of Grim's death is not precisely known. All that can be said is that internal evidence in Grim's own *Vita S. Thomae* indicates that he was still alive between the end of 1174 and the beginning of 1178; and that a comment in Herbert of Bosham's life of the martyr, written in 1189 at the very latest, shows Grim then to have been dead.[208] The painting's style points to the late years of the century, and a date might therefore be ventured between 1185 and 1200, most likely in the 1190s. It is worth noting here that the Espinelvas altar

frontal by the same artist has been tentatively associated with a consecration of 1187.[209]

The two features that make this Tarrasa wall painting unusual are its accuracy in recording a recent event, and the fact that a Spanish mural has been allowed to remain *in situ*. It is also interesting because it extends the Spanish Apocalyptic tradition to a near-contemporary event: the seven candlesticks of the Apocalypse (I, 12–13) are shown on either side of Christ, and the open books that he holds over the heads of Becket and Grim presumably refer to chapter XX, verse 12 of St John's vision: 'And the dead were judged by those things which were written in the books according to their works.'

Murals of about the same date at Sigena in Aragon were not only on English themes but actually by English artists. They exerted a strong influence on a series of imposing paintings from the chapter house of San Pedro de Arlanza (Burgos)[210] (now partly *in situ* and partly divided between museums in New York and Barcelona). These latter are of heraldic animals, more than life-size and endowed with all the power and grandeur of Romanesque at its best, and they belong to the very end of the century. They are so close to the Sigena murals that some scholars believe them to be the work of the Sigena master himself. His paintings in Spain will be discussed at length in Chapter 12.

Painting in the Empire and Scandinavia: 1100–1200

The shifts of European national frontiers over the centuries present problems to later historians. In the Middle Ages the nation-states of today either had not come into being, or existed in different forms: for example, the areas now known as Belgium, Switzerland, Austria, and Czechoslovakia were in the twelfth century within the German empire, and so were Alsace, the kingdom of Burgundy, and parts of Italy. A writer therefore has two choices: he can either speak of Europe in medieval terms and be incomprehensible to the modern reader, or he can speak of Europe in modern terms and to some extent belie the past. It is the second course that has been chosen here, and we find it unacceptable only in one instance – that of Alsace (Elsass), which in geography, language, history, traditions, sentiments, and art was an integral part of Germany; its paintings can no more be dislodged from that country than can the great Anglo-Saxon monument of Dark Ages sculpture, the Ruthwell Cross, be torn from its Anglo-Saxon roots and discussed in terms of its site in present-day Scotland. Alsace is therefore placed squarely in its German context, and both in this chapter and in the one on stained glass the quintessentially German nature of its art will be apparent. Sweden and Denmark were, of course, never part of the empire, and are included in this chapter only because their paintings were so strongly influenced by Germany.

BELGIAN FLANDERS AND THE MEUSE VALLEY

During the later part of our period, Belgian Flanders and the Meuse valley were extremely prosperous areas of much cultural distinction, and vital centres of metalwork. It is tempting to associate the appearance of Byzantine influences on their vellum paintings with the First Crusade, in which contingents from this area participated, and in particular with Godfrey of Bouillon, a local magnate and one of the greatest secular leaders of the Crusade, but such influences predate those times; the route that brought them to the north must therefore remain a matter of speculation. However they arrived, they combined with native traditions to produce a Romanesque art as mature as it was precocious.

The three major Mosan manuscripts of the last quarter of the eleventh century were all written by the same scribe. Thanks to his lengthy colophons, they can all be assigned a scriptorium, and two can be dated. The scribe was a monk of Lobbes named Goderannus, who seems later to have moved to Stavelot, for his earliest manuscript was written for the first house and the other two for the second. Obviously his reputation at Lobbes lived on, for its later chronicle made special mention of his calligraphic skill.

The first of the three manuscripts is the Lobbes Bible, now in the Seminary of Tournai.[1] Goderannus's colophon gives a completion date of 1084, and he reminds us that he was writing within the empire by his reference to the contemporary Investiture Contest, remarking that the Emperor Henry IV was then besieging Rome in an attempt to crush the rebellion of 'that Gregory who is also called

Hildebrand'. The second manuscript is the Stavelot Bible,[2] which, even with the help of Brother Ernesto, took four years to produce; it was completed in 1097, the year of the First Crusade, to which the colophons of both volumes of the Bible refer.[3] The third manuscript, a Josephus,[4] for which Brother Cuno prepared the parchment, is of less artistic interest than the others, and is undated, but we may suppose it to have been made within a few years of the Stavelot Bible, to which it is stylistically related.[5]

The Lobbes Bible has twenty-seven highly-developed examples of the historiated initials that were a distinguishing feature of the great twelfth-century Bibles. Their style is extremely linear – so much so in such scenes as that of Jeremiah on folio 196 verso that it becomes excessive, as in some other miniatures of the Mosan area. There are Carolingian influences, but the iconography is partly Byzantine, and the figure style primarily Italo-Byzantine. The Byzantine 'damp-fold' has occasionally (as on folio 116) hardened into such metallic segments that it seems to have been transmitted to this distinguished centre of metalwork by metalwok itself. Metalwork was indeed a dominant influence on most Mosan illumination, as is particularly evident in the Bible from Stavelot.[6]

With one magnificent exception, the numerous illustrations of the two volumes of the Stavelot Bible take the form of historiated initials. They are by several hands – one scholar claims four[7] and another five[8] – and are influenced decoratively by the Channel School and by Ottonian art, and in terms of figure style by Carolingian, Italo-Byzantine, and Ottonian work. One or two betray the characteristic Mosan interest in theological subtleties – for example, the scenes of the grand initial I that introduces the Book of Genesis include typological themes (most obviously the sacrifice of Isaac, which was held to prefigure the Crucifixion) – and they exemplify the divine scheme for the redemption of the world envisaged by Origen and by Gregory the Great as encompassing five ages: from Adam to Noah, from Noah to Abraham, from Abraham to Moses, from Moses to Christ, and from Christ onwards.[9] On the right are the five hours from the parable of the labourers in the vineyard, thought to allude to these five ages, and other scenes illustrate events from the lives of the four Old Testament patriarchs and of Christ himself. Also theological in content is the initial V on folio 4 verso of volume II; it is, besides, partly based on numerology,[10] which St Augustine categorized as a high form of intellectual activity in his De Ordine. It shows Job blessing his ten children, who are divided into groups of four, three, and three, in accordance with recondite views put forward by Gregory the Great in his commentary on Job. Gregory also associated Job's seven sons and three daughters with the seven gifts of the Holy Spirit and the three virtues, Faith, Hope, and Charity,[11] a particular theological refinement reflected in the giant Floreffe Bible,[12] also from this area.

Some of the more vibrant and delicate pictures of the Stavelot Bible – including the initial on folio 84 of the first volume showing Jael killing Sisera [267] – were inspired by

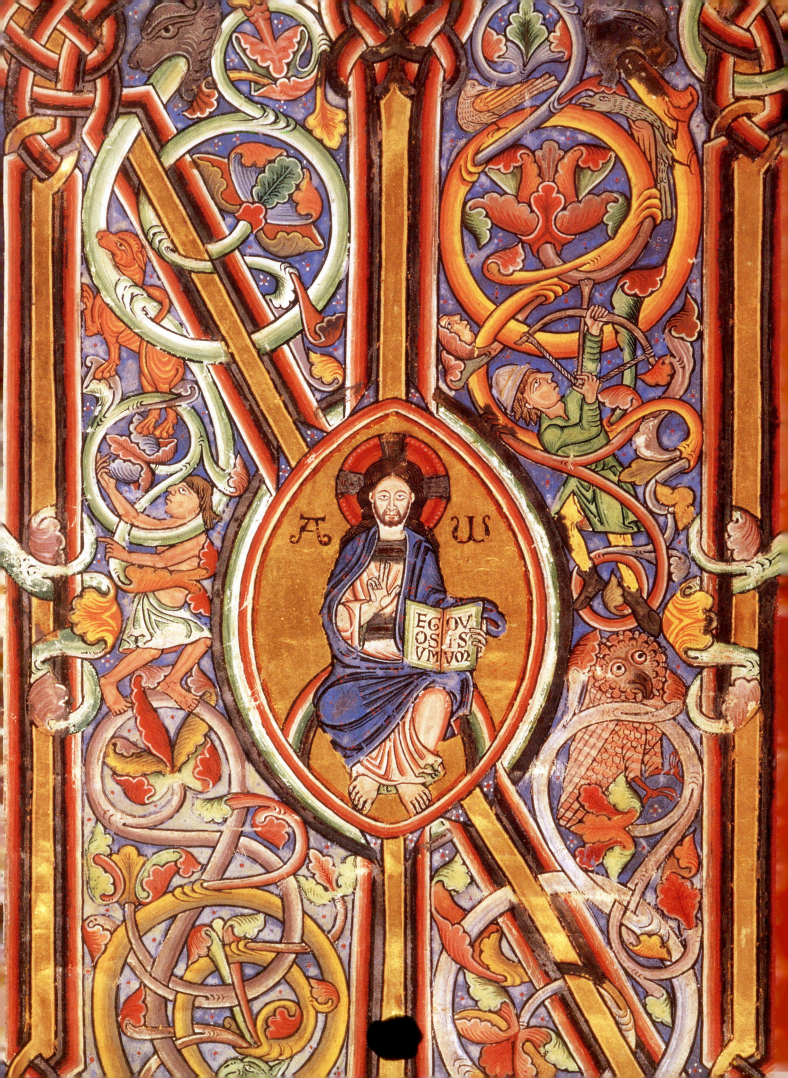

(*opposite*) Detail of plate 273 (enlarged)

267. Stavelot: *Jael killing Sisera*, initial to the Book of Judges, from the Stavelot Bible, MS. Add. 28106, folio 84. 1093–7. London, British Library

268. Stavelot: *The apostle James*, initial to the Epistle of St James, from the Stavelot Bible, MS. Add. 28107, folio 197 verso. 1093–7. London, British Library

the Carolingian Reims style, and the drawings of this group demonstrate the ease with which the medieval artist could pick up a manner of the distant past and infuse it with fresh animation. The Reims influences may be a late acknowledgement that Ebbo of Reims, with whom the style was so closely associated, had also been an abbot of Stavelot.[13] A trained eye will also detect in the pictures a slight infusion of Byzantine influence, given linear emphasis by its transmission through Italy.

Ottonian influences from the German past, cross-fertilized by the Italo-Byzantine present, inspire the most majestic and impressive of all the illustrations: the full-page Christ in Majesty[14] [269]. The 'damp-folds' of the lower drapery are Italo-Byzantine, but the real line of descent is from Ottonian Majesties, particularly those of Echternach, with which Stavelot had been closely associated; compare the Stavelot Christ with the Christs of the Uppsala and Escorial Gospels [136, 134]. But the Stavelot figure is more impressive even than its Ottonian predecessors, for its monumentality is heightened to claustrophobic tension by being squeezed into the frame, giving an impression of size and power that nothing can contain. Twelfth-century France [199] and England [359] both took up this device, though seldom with such success. The Romanesque maturity of the Stavelot Christ is such that some believe it to be a later addition, but contemporary German metalwork is every bit as precocious, as we can see from the slightly later bronze font of Reiner of Huy.[15] *Repoussé* metalwork is indeed called to mind by the modelling of the face, and the feeling of taut weight in the draperies, of an admirable initial-figure on folio 161 verso of volume II of the Bible. In other figures – for example the apostle James on folio 197 verso of volume II [268] – the disposition of highlights on

the draperies calls *champlevé* enamels to mind. Moreover the sword-shaped folds of the draperies of the Christ in Majesty, though Byzantine in origin, have parallels in the work of goldsmiths such as Roger of Helmarshausen and Eilbert of

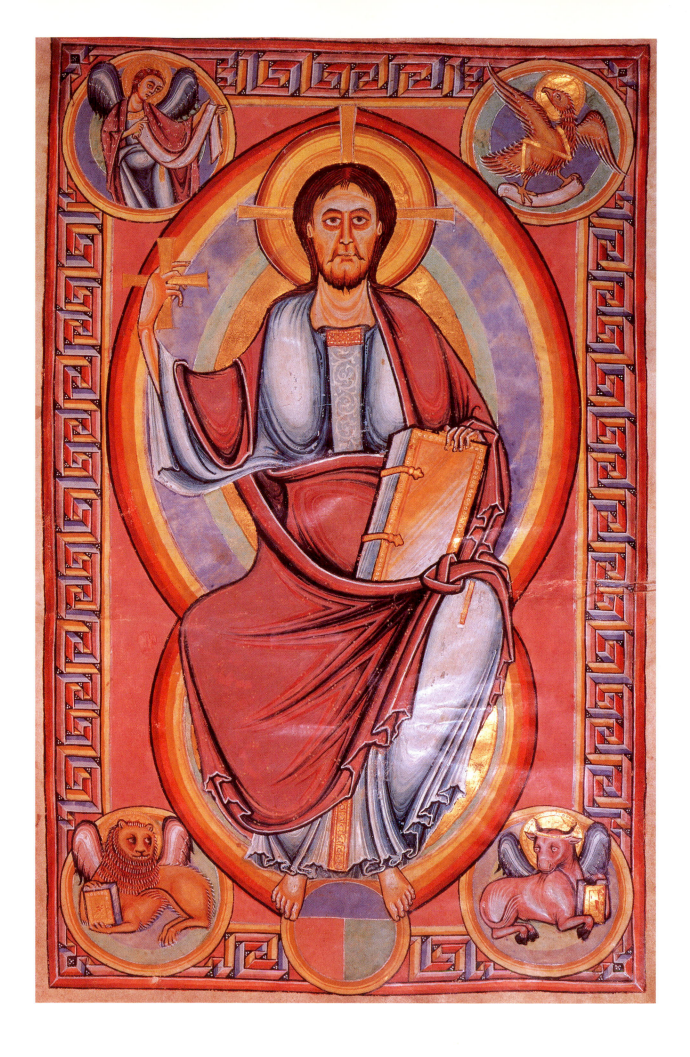

Cologne, and one of the initials has all the appearance of being ornamented with a metal clasp and a riveted quatrefoil.[16] In its turn, as Hanns Swarzenski has pointed out,[17] metalwork was to be influenced by some of these very miniatures in its use of foreshortening, back views, and fluent *contrapposto*.

Byzantine and Ottonian influences were also at work in a Breviary[18] made for Saint-Laurent in Liège, a house which, during the vicissitudes of the Investiture Contest, saw an abbot of the imperial party displaced by Abbot Beringer, Beringer himself driven out in 1092 in favour of his imperialist rival, and his own reinstatement once more in 1096. According to Usener,[19] the Breviary was made between this latter date and Beringer's death in 1116. As well as initials in gold, it has a *Noli me tangere*, and an illustration of two groups of adoring angels, with a bishop leading a body of the faithful, thought originally to have been complemented by an enthroned Christ on a facing page. Byzantine traits are evident in the heads of Christ and Mary Magdalene in the *Noli me tangere* and in details of the draperies in both miniatures, though the drapery folds have hardened into ornament in accordance with a Western formula.[20] The Ottonian influences in the Breviary continue in the initials of a Psalter made for Waulsort or its priory of Hastières,[21] in a Bible from Saint-Hubert-des-Ardennes,[22] and in a Saint-Trond Bible[23] of about 1120.

The many drawings in a copy of the Dialogues of St Gregory from Saint-Laurent[24] have clearly been influenced by the goldsmith work of Liège, and metalwork also had an impact on a much later picture of a physician in a manuscript in the British Library[25] which has been attributed to the Mosan area [270]; it combined with influences from Ottonian and Byzantine art to give the illumination of the Meuse valley

269 (*opposite*). Stavelot: *Christ in Majesty*, from the Stavelot Bible, MS. Add. 28107, folio 136. 1093–7. London, British Library

270. Mosan(?): *Physician*, from a book of medical treatises, MS. Harley 1585, p. 14. *c.* 1170–1200. London, British Library

its distinctive personality. This can be well observed in a few select manuscripts of the third quarter of the twelfth century which were probably made near Liège. Among them is the Averbode Gospels,[26] whose painting of a lion on folio 57 [271] has something of the strength and robustness of a bronze statue. The draperies of some of the other pictures have a lushly linear quality reminiscent of the rich texture of the folds in eleventh-century metalwork. Byzantine influences endow the figures of the manuscript with a certain spaciousness, and their brooding melancholy is echoed in the sombre greenish-blue colours, lightened though they are by gold, orange, and blues.

The most magnificent of the manuscripts of the Liège region is the two-volume Floreffe Bible,[27] made between 1153 and 1172[28] and in the possession of Floreffe during the Middle Ages, though it was probably made in a Liège scriptorium. Here again the draperies are sometimes divided into segments reminiscent of *champlevé* work, the compositions have the architectural ground-plan, incorporating inscriptions, found in metalwork, and the backgrounds show the crisp colours and sharply separated zones of enamels. Comparable bright lucid colours are seen in the enamels of the contemporary portable altar of Stavelot,[29] which has a not dissimilar figure style, and shares also with the Bible an (admittedly widespread) interest in the typological and allegorical: in the Gospel of St Luke there is a Crucifixion accompanied by the prefiguring Old Testament sin-offering of the calf and related quotations from both Testaments [272]. Conversely, scenes from the New Testament, including the Transfiguration and the Last Supper, illustrate the Old Testament Book of Job. Stylistically and iconographically, the typological images of the second volume of the Floreffe Bible are associated with those of a Gospel Book,[30] probably from the same scriptorium, whose illustrations take up Rupert of Deutz's Trinitarian conception of the Bible in terms of the work of the Father, the Son, and the Holy Ghost.[31]

Floreffe was founded in 1120 as a house of the new order of Premonstratensian canons, doughty fighters against heresy, who often stressed in their miniatures the essential authority of the Old Testament – a status denied it by most heresies. The earliest statutes of the Premonstratensians made special provision for scribes to have free access to the kitchens to dry their vellum and make their ink, and also excused them from certain offices; with such incentives, they were encouraged to build up libraries, and Bibles proved to be their special interest. One of them – the now incomplete Bible of the Premonstratensian house of Bonne-Espérance in Hainaut[32] – is associated with the later Floreffe Bible by its forms of decorative foliage. It was, by its own statement, copied out by Brother Henry between 26 August 1132 and July 1135. This entry is dated 1140, which would seem to imply that some of the work – presumably the illumination – went on for another five years after the completion of the text. But it seems hardly likely that it could take as long as that, so perhaps the community had trouble in finding the right artist. Influences from metalwork are again apparent here, particularly in the paintings of prophets in the historiated initials.

The style of the artist of the Bonne-Espérance Bible strongly influenced the illustrations of a Sacramentary of

271. Liège region: *Lion*, from the Averbode Gospels, MS. 363C, folio 57. Third quarter of the twelfth century. Liège, Bibliothèque de l'Université

272. Liège(?): *The Crucifixion and the sin-offering of the calf*, from the Floreffe Bible, MS. Add. 17738, folio 187. 1153/72. London, British Library

273 (*opposite*). Mosan: Initial page to Genesis, from the Parc Bible, MS. Add. 14788, folio 6 verso. Completed in 1148. London, British Library

Liège,[33] and a cycle now in Berlin[34] that was neither completed nor ever united with its intended manuscript (perhaps a Psalter). The ten leaves in Berlin, six illustrating the Old Testament and four the New, largely in two registers, are thought to be Mosan. They have been dated variously to the thirties, sixties, seventies, and eighties of the twelfth century: as they are undoubtedly stylistically later than the Bonne-Espérance Bible, a date in the 1150s or 1160s may be appropriate. Some of the pictures have late Antique elements (a few from the fifth century),[35] and there are stylistic and iconographic links both with Mosan (Stavelot) enamels and, as Hanns Swarzenski has shown, with Reiner of Huy's famous bronze font at Liège (1107–18),[36] to whose scenes of the Baptist preaching, baptizing the Jews, and baptizing Christ the equivalent miniatures are very close. The iconography of the first two scenes was earlier claimed as a new invention, to be ascribed to Reiner; but opinion now has it that the illuminator and the metalworker, albeit of different generations, simply had access to the same cycle of miniatures. Slightly later miniatures from the same scriptorium as the Berlin cycle are on two other leaves now in the possession of the University of Liège[37] and of the Victoria and Albert Museum.[38]

Influences from nearby France – particularly Saint-Bertin – are so strong in a four-volume Mosan great Bible of the third quarter of the twelfth century, now in Brussels,[39] that some consider it to be French and not Mosan. North-eastern French influence was also at work in a more splendid and more securely located Bible[40] made for the Premonstratensian house of St Mary of Parc near Louvain. The impact of the Floreffe Bible is also discernible in some of the figures; of Cologne in the initials; and of England in the sudden fantasies within the scrollwork. The Books of each of the three volumes – completed, according to two colophons, in 1148 – are introduced with a fine historiated

initial; the Genesis initial is a masterpiece of Romanesque decoration, combining clarity and sumptuousness to a near-matchless degree [273].

The scribe of a Bible fragment in Brussels[41] comprising the Books of Solomon, the Prophets, the Acts, and the Epistles is described by a local chronicler as a supremely skilled calligrapher (*scriptor peritissimus*).[42] His name was Godfrey, and he clearly produced the work, at the turn of the century, for his own community of Saint-Martin de Tournai, refounded in 1092. Its first abbot, Odo of Orléans,[43] was (so the chronicler Heriman relates) so wrapped up in matters spiritual and intellectual that the community would have starved had not the prior taken it upon himself to supervise its administration. This left Odo free to follow his heart and to build up the library, and Heriman has much to tell of the activities of the scriptorium. Apparently anyone entering the cloister during Odo's term of office would be sure to find a dozen young monk-scribes silently at work.[44] One was the Godfrey just mentioned who, though he died young, produced besides the Bible fragment a six-volume copy of St Gregory's *Moralia*, a Missal, two texts of St Augustine, and a number of other books. Another scribe, Gislebertus, copied a Bible and two Lectionaries before he died in 1146. Heriman himself, a later arrival, produced four Breviaries and several texts of St Augustine. His account of Alulfus, who joined the community in 1095, gained a reputation as a diligent copyist, and died in 1143 – nearly half a century after he had made his profession – may serve to alert us to the dangers of trying

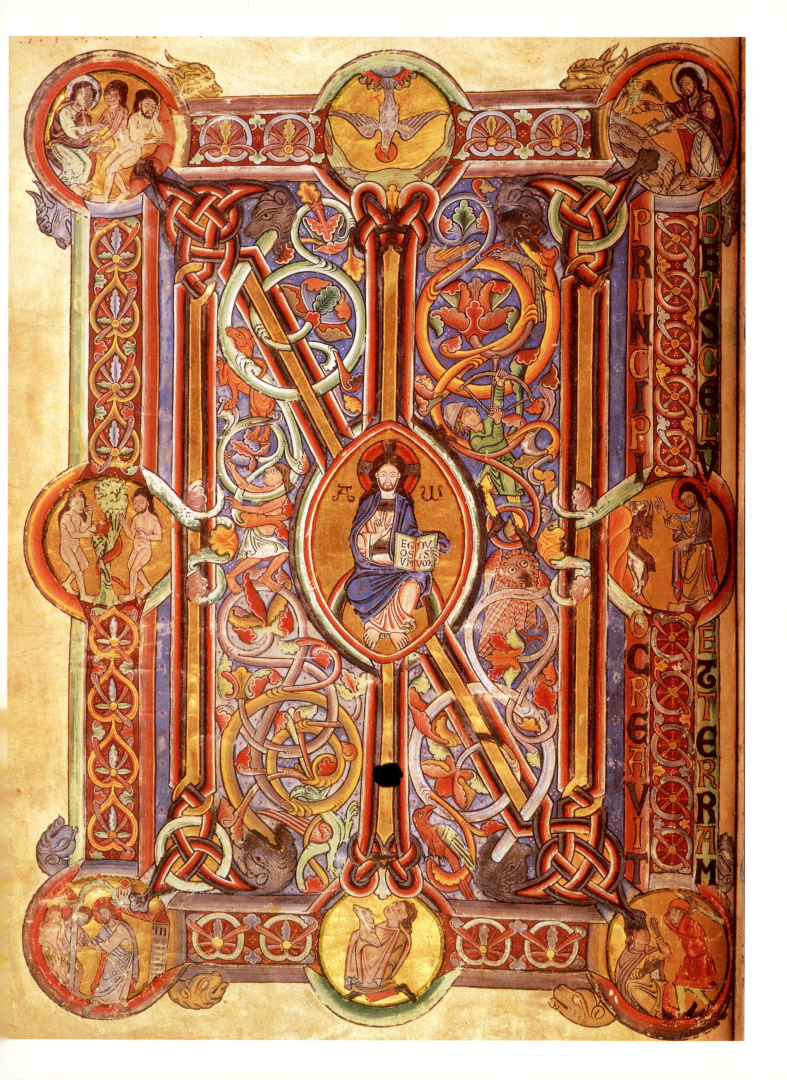

PRINCIPIO DEVSCELV ET TERRAM CREAVIT

to tune the dating of manuscripts too finely in paleographic terms.

Orderic Vitalis has a similar tale to tell of the Norman house of Saint-Évroul. Thierry, who became abbot in 1050, was himself a brilliant calligrapher.[45]

He copied a book of Collects, a Gradual, and an Antiphonary ... with his own hand [and] by gentle persuasion he induced some of the companions who had accompanied him from Jumièges to copy precious volumes of the divine law. Ralph, his nephew, wrote a Heptateuch and a Missal for the daily use of the convent; Hugh, his friend, a Commentary on Ezekiel and a *Dialogue* [of St Gregory] and the first part of the *Moralia*; Roger, the priest, the Chronicles and books of Solomon, and the third part of the *Moralia*. With the aid of these and other scribes whom he persuaded to undertake the task, the reverend father secured in the eight years of his abbacy copies of all the books of the Old and New Testaments and the complete works of Pope Gregory the Great for the library.

Many excellent copyists, continued Orderic, were trained in this school, filling the monastic library with the treatises of Jerome and Augustine, Ambrose and Isidore, Eusebius and Orosius, and other Fathers.

Both Saint-Évroul and Saint-Martin de Tournai were concerned more with texts than with their embellishment, but the Tournai Bible fragment copied out by Godfrey has some pleasing ornamental and historiated initials with general and (in the illustrations to Ecclesiastes and Ecclesiasticus) quite specific links with the illumination of Saint-Amand.[46] Likewise, the 'portrait' of St Gregory in a Tournai manuscript now in Paris is dependent on a St Augustine in a Marchiennes manuscript;[47] the picture of a scribe in another is close, even to the colours, to one in a SaintAmand manuscript;[48] and in a third – a collection of texts dealing with St Martin – the 'portrait' of the saint seems to be the work of an illuminator from Saint-Amand itself.[49]

The styles of north-eastern France also influenced the wall paintings of Tournai Cathedral.[50] Half of those in the former chapel of St Catherine above the porch have been lost; the rest were in the seventeenth century concealed from view and, though damaged, have happily escaped the attentions of later restorers. They can be dated to the time of the foundation between 1171 and 1178 of a benefice associated with this chapel. The upper register of the paintings goes round three of the walls, the lower round four. They include a picture of the Crucifixion with the Virgin and John and the Church and Synagogue, but their main concern is St Catherine's life, Passion, death, and ultimate salvation. A jocular note is sounded at the beginning by the sturdy dwarf who apparently supports the vault single-handed [274], a piece of light relief paralleled at Tavant by the two men holding up a beam.

By the same artist are wall paintings on a larger scale over two altars in the main cathedral: St John the Divine's in the south transept has a (repainted) Heavenly Jerusalem, originally part of a larger ensemble; and St Margaret of Antioch's on the eastern side of the north transept has detailed scenes of her life and Passion and pictures of other saints and personified Virtues in seven registers. The paintings must

have been made after 1174, when the chaplaincy of the altar of St Margaret was established, and we may reasonably date them between then and 1190. Basically, their style elaborates on mid-century Mosan illumination of the kind to be seen in a Liège copy of the *Dialogues* of St Gregory,[51] though the highlighting is somewhat heavier. There seem to be influences also from Saint-Bertin,[52] while the ruffled drapery at the waistline of St Margaret's tormentor suggests Paris.

A bust-figure left virtually as a drawing in the chapel of St Mary Magdalene over the north porch of the cathedral has a calm nobility lacking in the more hectic figures elsewhere. Its composure recalls such earlier Mosan metalwork as the font of Reiner of Huy and the head-reliquary of Pope Alexander from Stavelot, as well as a much more linearized drawing added to a Tournai manuscript[53] of the well known incident of St Martin dividing his cloak with a beggar, though this has a certain gentleness that suggests the early thirteenth century.

THE RHINELAND

The artist of the Tournai murals also painted the church of Knechtsteden, near Cologne,[54] in a style influenced by the mosaics of Cefalù Cathedral.[55] In the apse is a large-scale

274. Tournai Cathedral, chapel of St Catherine, an artistic joke: *A dwarf 'supporting' the vault*. Wall painting. 1171/8

275. Schwarzrheindorf, St Clemens, lower church, semi-dome of the north arm, *The Crucifixion*. Wall painting. *c.* 1150–70

Christ in Majesty in a mandorla, with symbols of the four evangelists and figures of St Peter and St Paul, and between the windows below are the apostles (one now missing). The paintings have fared less well than those at Tournai, and as a result of heavy restoration the figures, especially the apostles, have a curiously starched appearance. Knechtsteden is now a parish church, but it was originally part of a Premonstratensian house founded in the twelfth century by a provost of Cologne and financed later by Albert, a provost of Aachen, who is shown prostrating himself at the feet of the Christ in Majesty in the apse. As in 1162 Albert agreed that any unspent money from his contribution to the fabric might be used for its internal decoration, it has been assumed that the paintings date from after this time. Albert seems to have died before 1184, and the church was very probably complete before 1181.

A provost also founded the church of St Clemens at Schwarzrheindorf[56] near Bonn. He was Arnold von Wied, provost of Cologne, who was promoted archbishop before the church was dedicated in 1151. Some time after his death in 1156, his foundation was enlarged to accommodate a community of Benedictine nuns who were installed before 1172 by his sister, Hedwig. The series of paintings in the lower church probably belongs to the 1150s or 1160s, that in the upper church to the period around 1170. Both have

suffered from later restoration. The earlier paintings are the more accomplished. They are, as Demus points out, in the style that German art historians call *weichfliessend* (soft-flowing), and they fill the four arms of the lower cruciform church, the cells around the central octagon, and the semi-domes at the end of each arm. When seventeenth-century limewash was stripped off, it took with it some of the surface paint, exaggerating the linear aspect of the murals. Their principal theme, originally illustrated in twenty scenes, is the building of the New Jerusalem after the destruction of the Old, a programme taken from the Book of Ezekiel but also owing something to the writings of the influential twelfth-century Rhineland theologian Rupert of Deutz.[57] Ezekiel's communion with God in the east vault is now fragmentary; his prophecy of the destruction is in the west vault, the actual destruction in the north one, and the building of the New Jerusalem occupies four scenes around the central octagon of which the last, Jehovah's appearance in the gate of the Temple, illustrates Ezekiel XLIV, 1–3. These verses, which speak of one gate remaining closed in expectation of a future Prince, were interpreted by medieval commentators as a reference to the Virgin Birth. Here it paves the way for the Christological scenes in the semi-domes of the Cleansing of the Temple, the Transfiguration, and the Crucifixion [275] (the Christ in Glory in the east semi-dome has been

completely repainted and its iconography changed). Four seated monarchs in niches of the south and north arms have been interpreted as four great rulers of the Roman or Holy Roman empires, or as allusions to the four empires of the Book of Daniel, or to the kingdoms of the world that will make way for the kingdom of Christ. Personified Virtues battle with Vices in the recesses of two windows of the west arm.

In the paintings in the upper church,[58] local figures are used to illustrate the theme that saintliness in the present life will lead to blessedness in the next; thus in the semi-dome of the apse the two founders of the church, Arnold von Wied and his sister the abbess Hedwig, prostrate themselves at the feet of Christ, and the Baptist is joined at Christ's side by three saints to whom the altars in the lower church were dedicated. The ten saints on the wall below also had local connections. The two nuns in the group to the right of the Virgin in the Apocalyptic scenes on the groin-vault before the apse allude to the conversion of Arnold's foundation into a Benedictine nunnery. In the other quadrants of the vault are Christ flanked by apostles and by groups of the elect, and the Church triumphant, and in the centre is a medallion with the Agnus Dei. On the side walls are St John the Divine recording his great vision and a Presentation in the Temple where Jesus is not the forty-day-old infant of the Scriptures but a child of about ten years old – in allusion, Verbeek suggests, to the Benedictine practice of accepting adolescents as oblates to the Order.[59] An example of this is the English-born Orderic Vitalis who, at the age of ten, was given to a Norman monastery by his father with the promise that he would thereby secure eternal life for himself.

The workshop, probably based at Cologne, which was responsible for the lower church murals seems to have been responsible also for the paintings of the chapter house of the former Benedictine abbey of Brauweiler nearby.[60] By turns whitewashed, uncovered, overpainted, restored, and de-restored, they are but shadows of their former selves, yet something lingers of their original quiet dignity. Of the third quarter of the century, they are in the softflowing style of Schwarzrheindorf[61] and relate to St Paul's inspired account in chapter XI of the Epistle to the Hebrews of faith and the witnesses of faith. 'Seeing we are compassed about with so great a cloud of witnesses,' is his final exhortation, 'let us lay aside every weight ... and run with patience the race that is set before us' (XII, 1). The paintings flesh out some of the apostle's words:[62] his reference to those who 'escaped the edge of the sword' (XI, 34) is ingeniously illustrated by the miraculous bending of the executioner's sword at the martyrdom of St Aemilianus; the 'women [who] received their dead raised to life again' (XI, 35) are exemplified by Elijah's revival of the son of the widow of Zarephath; those who 'were sawn asunder' are represented by the martyrdom of Isaiah, and those who 'were slain by the sword' by the martyrdoms of the fourth-century saints Peter and Marcellinus. Paul's description of Christ as 'the author and finisher of our faith' is illustrated by the blessing half-figure in the middle bay of the east side, accompanied by the Virgin and John the Baptist as intercessors.

There was also at Cologne in the twelfth century a school of manuscript painters, one of whose early productions was

276. Cologne: Frontispiece, from the Lectionary of Archbishop Friedrich, MS. 59, folio 1. *c.* 1120–30. Cologne, Dombibliothek

a copy of Rupert of Deutz's *On the Victory of God's Word*[63] – possibly the very copy presented by the author to his friend and supporter Abbot Conrad of Siegburg. If so, it must have been made before 1126, and probably after 1120. Its large decorative initials are strongly influenced by northern France. A particularly fine example of its vigorous scrollwork, sometimes enclosing lively figures and animals, is on folio 6, where, on pirouetting feet, St Michael advances with upraised sword towards a defiantly crouching dragon which, curiously enough, wields a sword of its own.

Another manuscript of the 1120s,[64] known as the Lectionary of its owner, Archbishop Friedrich of Cologne, contains some of the writings of St Jerome. The geometrical composition of the prefatory painting [276] is reminiscent of Regensburg illumination of the Ottonian period. At the corners of the broad borders are large medallions enclosing personifications of the cardinal Virtues, and in the borders themselves busts of seven prophets and six apostles, together with the Baptist, hold scrolls with admonitory inscriptions. Within this framework of divine witnesses, an enthroned Christ raises one hand in blessing and holds in the other a scroll inscribed with a verse from St John's Gospel (XIV, 23). Archbishop Friedrich, seated under an arcade below, also holds a scroll, inscribed with a quotation from the Psalms concerning meditation on God's law (118 – A.V. 119 – 97)

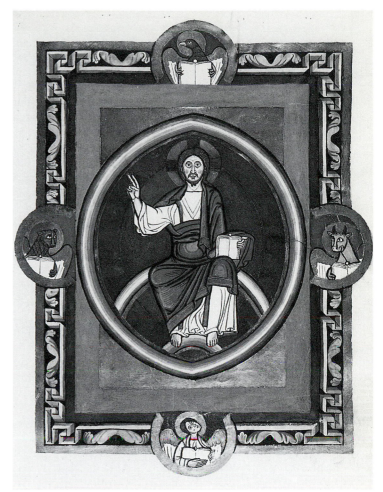

277. Cologne: *St Pantaleon*, from the St Pantaleon Gospels, MS. 312a, folio 10 verso. *c.* 1140. Cologne, Stadtarchiv

278. Cologne: *Christ in Majesty*, from a Gospels, MS. 508, folio 24. *c.* 1130. Darmstadt, Hessisches Landesmuseum

which is represented by the books in book-chests on either side of him. There is such a close stylistic connection with paintings on two detached leaves that can be shown to have originated in the monastery of St Martin's that it is generally agreed that the Lectionary comes from St Martin's too.[65]

Also from St Martin's is a copy of Bede's *Ecclesiastical History*[66] with a full-page drawing of a kneeling figure being presented by one patron of the abbey, St Eliphius, to the other, St Martin, to whom the supplicant offers the book. The use of columns and architectural detailing to suggest an indoor context derives from Cologne illumination of the Ottonian period. In a second full-page drawing, the enthroned Christ has the world as his footstool while evangelist symbols around hold scrolls inscribed with the first words of their Gospels. The linear effusion of this picture is typical of the Cologne goldsmith Eilbert (to whom we shall refer again), and in the draperies Byzantine influences are converted into lively Romanesque abstractions. The pictures of a Lectionary[67] made for Siegburg in the second quarter of the twelfth century are in a similar style but with a new Romanesque edge. They portray various saints, including Siegburg's patrons St Maurice and St Michael (in combat with the Apocalyptic dragon accompanied by two angels), the Tree of Jesse, and the Holy Women at the Sepulchre.

Pre-eminent among the miniatures of the Cologne School are the illustrations of the St Pantaleon Gospels.[68] The full-page St Pantaleon [277] is somewhat similar in style to the St Eliphius in the Bede manuscript, but lent a new air of opulence by the sumptuous colours. The saint is attired in rich red, with touches of purple and blue and some gold as well; the background is lapis lazuli and green, and a slender gold frame encloses borders of formalized but colourful foliate decoration. The 'portraits' of the evangelists, their heavy draperies very Byzantinizing, are also lavish with colour. They look back iconographically to the evangelists of the Ottonian St Gereon Gospels of Cologne – St Mark, for example, turns to examine the sharpness of his quill just as St John had done in the earlier manuscript. The inclusion of St Pantaleon establishes that the manuscript was made for his Benedictine abbey in Cologne: Boeckler thought it likely that it was actually produced within the house.[69]

It is less easy to determine the origin of another Gospel Book, previously belonging to the abbey of St Vitus in Mönchen-Gladbach and now in Darmstadt,[70] for although parallels for its miniatures can be found in the St Pantaleon Gospels, the style had by now become general in Cologne. In addition to the normal programme of Christ in Majesty and the evangelist 'portraits', there is a seated St Jerome, the

translator of the Gospels, holding an open book with the hand of God above. Although the illumination was never completed – colour has been added only in small areas to the pictures of the evangelists and St Jerome – this manuscript may have been the major model for another, also of Mönchen-Gladbach provenance and also now at Darmstadt.[71] The kneeling half-figure of a monk on folio 159 recto is thought to represent Abbot Walter I of Mönchen-Gladbach (1128–40).[72] Like Abbot Wedric in one of his 'portraits' in the Liessies Gospels, Walter is associated with the initial I of St John's Gospel, and the likely connection with him would place the manuscript in the 1130s. Boeckler's suggestion[73] that it may have been made at Mönchen-Gladbach itself is now generally rejected in favour of a Cologne origin. The other, unfinished Darmstadt manuscript must be just a few years earlier, and its Christ in Majesty [278] – the only miniature to have been completed – is so close to another Majesty on vellum that an identity of hand has been suggested.[74] This second Majesty is the one used by Eilbert of Cologne, and encased by him in rock crystal, as the centrepiece for the top of his portable altar [31]. The backgrounds of the *champlevé* enamels with apostles and Christological scenes that surround it resemble those of the St Pantaleon Gospels in their panels of green and blue, one inside the other, but such treatment was not of course confined to Cologne or, for that matter, to Germany.

The Christ in Majesty and Crucifixion in another

279. Rhine-Weser region: *The Annunciation to the Shepherds*, from a Pericope Book, MS. lat. 17325, folio 8 verso. *c.* 1140. Paris, Bibliothèque Nationale

manuscript[75] probably from St Pantaleon's have links both with enamelwork and with the Mosan illumination of the Floreffe Bible. Other manuscripts in the group include a *Moralia in Job* now in Paris,[76] and a Gospel Book[77] from St Aposteln of about 1140. Boeckler also ascribed to Cologne a Book of Pericopes now in Paris[78] of about 1140, but the style of its paintings of evangelists and Christological scenes set in 'frames', with borders decorated with foliate or meander patterns [279], is quieter than that of most Cologne miniatures, and Schnitzler has persuasively argued for an origin in some other centre of the Rhine-Weser region. Because its Christological scenes conclude with the baptism and burial of the Virgin, it has been surmised that it was made for a nunnery.

The Rhineland manuscripts so far discussed are chiefly Service Books; other texts that attracted fine illumination include a now-fragmented late-twelfth-century Middle Rhine copy of the *Speculum Virginum* one of whose leaves, now in Bonn,[79] bears illustrations of rural life unusually fresh in their nimbleness and linear delicacy. Another leaf, now in Hannover,[80] illustrates vigorous, rhythmically rendered sword-battles meant not as real skirmishes but as allegories [280]. Finally there is an illustrated twelfth-century copy of one of the visionary works of Hildegard of Bingen[81] that deserves particular attention because she was such a remarkable woman.

Hildegard, born in 1098, entered the Benedictine convent of Disibodenberg when she was eight years old. In 1136 she was elected abbess in succession to her teacher and friend, Jutta, sister of the count of Sponheim. Between 1147 and 1150 a new convent was built for the community on the Rupertsberg near Bingen, and there Hildegard remained until her death in 1179. She achieved a considerable reputation as a seer, and became the correspondent of such great men of her day as Popes Eugenius III, Anastasius IV, Hadrian IV, and Alexander III, the Emperors Conrad III and Frederick I, Henry II, king of England, the archbishops of Mainz, Trier, Cologne, and Salzburg, and perhaps the most formidable personality of the twelfth century – St Bernard. She wrote medical treatises, homilies, the lives of St Disibode and St Rupert, a book of dialogues on the Virtues and Vices, hymns with strikingly inventive melodies, a secret language (the *Lingua ignota*), and, most memorably for the history of art, two books of visions – the *Scivias* (1141–50), and the *Liber divinorum operum simplicis hominis* (1163–70), an account of ten grandiose visions of the cosmos indicating man's place and progress in it of which the only illustrated copies to survive date from after the end of our period.

We have spoken in an earlier chapter of paintings inspiring visions; conversely, in this area of Germany the visions of the *Scivias* were recorded by painters. Both the preface to the *Scivias* and a letter to the theologian Guibert of Gembloux note that from the age of five Hildegard had had visions in which 'my soul ascends to the height of the firmament'.[82] In her forty-third year, she was instructed by a voice issuing from a brilliant glory to set them down, and this was done by Volmar, one of the monks from the Disibodenberg, at the behest of his abbot, Kuno. There was a picture of Volmar at work in the first illustrated manuscript of the *Scivias*,[83] which was studied by Goethe but has been missing since 1945 and

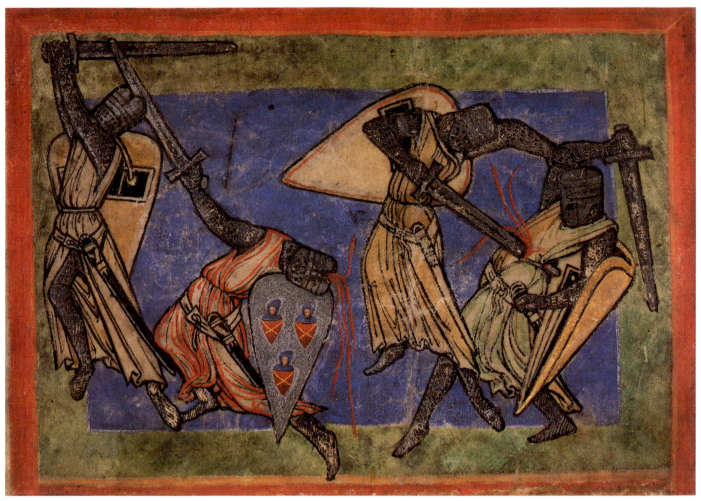

280. Middle Rhine: *Allegorical battle scene*, detached from a *Speculum Virginum*, Inv. no. 3984. Late twelfth century. Hannover, Kestner Museum

is known to us only by reproductions published by Böckeler and others.

In Baillet's view, the lost manuscript was made in close consultation with Hildegard herself at the Trier monastery of St Mathias, whose abbot, Ludwig, was one of the abbess's greatest admirers. If so, it can be dated between 1150, when the original record of the visions was completed, and 1179, the year of Hildegard's death – probably near to the later date, for it has affinities with Trier works of *c*.1180. The *Scivias* records intimations of the divine scheme of the cosmos and man's place within it, together with his path to salvation and the Church's role in securing it. Among them was a vision of a monumental Synagogue sheltering Moses and the prophets of Israel about her (folio 35), reproduced here [281] from the thirty-five illustrations of the former Wiesbaden volume. Baillet believed that six or seven artists participated in the illumination of the manuscript. Considerable originality was required – and obtained – from them, for the visions were replete with symbolic forms and figures: the illustrator of Hildegard's world-egg (folio 14) for example – 'a vast form that was round and shadowy and in the shape of an egg', encompassed by bright fire without and containing the manifest cosmos within itself – succeeded in producing

a painting that is quintessentially medieval and yet right outside the time-scale of the more conventional art of the period.

A great two-volume Bible attributed by some scholars to the Rhineland and now in Pommersfelden[84] presents interesting problems of both date and provenance. It was illustrated by two artists, of whom one – possessed of a certain vigour but no great talent – contributed a series of drawings, and the other a single painting of God the Creator [282] – a careful, indeed over-careful, copy of an Italo-Byzantine prototype complete with linearized nested folds. If the twelfth-century inscription claiming that the Bible was presented by Canon Hongarus to the church of St Castor in Koblenz during the episcopacy of Archbishop Udo of Trier is correct, it must date from before 1078. However, I tend to accept the view that the painting, in its greens, yellow ochre, blue, and dominant brick red, is stylistically too advanced for this, and must be an addition of the early twelfth century, or at least a later overpainting. The Koblenz connection suggests an origin for the Bible in the Middle Rhine region, but the alternative ascription to Trier is perhaps more likely in view of the stylistic comparisons established between the uncontroversial pictures of the Bible and Trier manuscripts.

281. Trier(?): *Synagogue*, from the lost manuscript of Hildegard of Bingen's *Scivias*, MS. 1, folio 35. 1150/79. Formerly Wiesbaden, Hessische Landesbibliothek

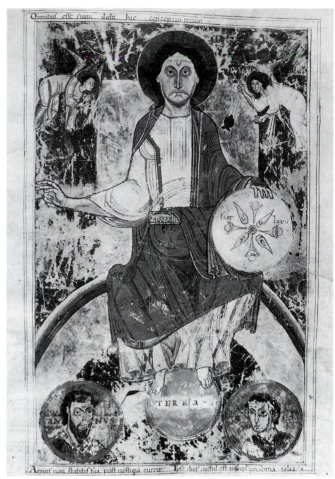

282. Trier(?): *The Creator*, from the Pommersfelden Bible, MS. 333, folio 2. Early twelfth century(?). Pommersfelden, Gräflich-Schönborn'sche Schlossbibliothek

Another two-volume Bible whose provenance was for long doubtful is the Worms Bible,[85] so called because in the seventeenth century it was in the possession of the collegiate church of the Virgin on the outskirts of that city. It has recently, however, been satisfactorily assigned to the house of regular canons at Frankenthal, just to the south, for the hands of its scribes can be traced in other Frankenthal manuscripts.[86] Frankenthal, founded in 1119 by Eckenbert, chamberlain of Worms, was by the mid century the home of an active scriptorium. The Bible was its most sumptuous product, for it alone has painted decoration. Annotations in the margin indicate that it was put to liturgical use. The illumination includes three author 'portraits' (two of St Jerome and one of David), a handful of small and delicate marginal drawings, Canon Tables, and a hundred and two initials, of which twenty-eight are historiated. The author 'portraits', the Canon Tables, and sixty of the initials are painted; the remaining initials are in pen-and-ink against coloured backgrounds. Cohen-Mushlin's painstaking analysis of the stages of production has established that it was the work of four scribes, of whom two were responsible for the pen-and-ink initials, and one also carried out all the underdrawing for the painted decoration. The painting itself was the work of a team of artists – Cohen-Mushlin counts as many as seven – who do not seem to have contributed to any other Frankenthal manuscripts and may therefore have been brought in specially from outside.

A colophon on the first page of the Worms Bible has unfortunately been cropped by a binder, but the date of 1148 is still plainly visible, and the wording has been reconstructed as *anno m.c. xlviii inceptus est liber [iste]* ... ('this book was begun in the year 1148').[87] The view of those who doubted

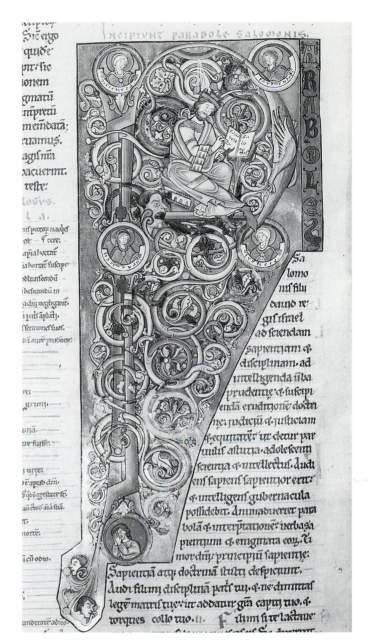

283. Frankenthal: Initial with the prophet Hosea, from the Worms Bible, MS. Harley 2803, folio 264. Begun in 1148. London, British Library

284. Arnstein: Initial to the Book of Proverbs, from the Arnstein Bible, MS. Harley 2799, folio 57 verso. 1172. London, British Library

whether this date applied to the illumination, arguing that the latter's advanced style would place it in the years around 1160, has been refuted by the discovery that the pen-and-ink decoration and the underdrawing were carried out in conjunction with the copying of the text. Both text and illumination in the last part of the second volume are the work of a single individual who was one of the original team of scribes:[88] in other words, the visiting artists must by now have moved on. From what we know of similar great Bibles, the entire project is likely to have been completed within three or four years of its inception.

The most impressive feature of the Worms Bible is its gallery of painted initials, enriched with delicious mauves and greens and resonant blues and golds. Most of the historiated initials show the single figure of the Book's author standing alongside the initial [283], but one or two contain a scene, including the picture of the recumbent Job,[89] clad in a loincloth and sorely afflicted with boils, being stabbed in the ankle by the lance of Satan, a horned demon perched in the upper scrollwork of the letter. No other manuscripts have as yet been attributed to the painters of the Worms Bible, so it is difficult to identify their place of origin, but their style shows some links with slightly earlier works of the Cologne area,[90] and it seems possible that they were trained there before setting out on their travels.

The Worms Bible, now in the Harleian collection of the British Library, was acquired in the early part of the eighteenth century by Edward Harley, who in 1720 purchased another Rhineland Bible[91] which was copied by a monk called

Lunandus for the house of St Mary and St Nicholas at Arnstein and has been dated by analysis of the annals originally incorporated in it to the year 1172.[92] The Arnstein house was Premonstratensian, which would explain the influences from the Bible of Floreffe, which belonged to the same order; one of the initials is even borrowed from the earlier Bible. The initials, on the whole richly but tastefully coloured, present bold figures in gardens of luxuriantly foliated scrollwork [284]. The artist of this Bible also illuminated[93] a Legendary in three volumes[94] and a copy of Hrabanus Maurus's popular work De laudibus sanctae Crucis,[95] both from Arnstein.

SAXONY

The medieval admiration for opulence in art explains the response of German manuscript painting to work in precious metals, whose own appeal to medieval tastes is attested by

dozens of quotations from the chronicles and poetry of the West.[96] It is well known, for example, that Suger, who had not a word to say about the sculptures of Saint-Denis that were revolutionizing the styles of Europe in the twelfth century, devoted meticulous attention to his abbey's works in gold – its golden altar frontals, gilded doors, golden chalices, golden crucifixes, and golden reliquaries.[97] Such interest in precious materials was often allied to an appreciation of fine craftsmanship, as encapsulated in a phrase of Ovid's which became a well-worn cliché,[98] surviving even to the time of Shakespeare who, in *Cymbeline*, describes Iachimo's tapestry of silk and silver as

> a piece of work
> So bravely done, so rich, that it did strive
> In workmanship and value.
>
> (II,iv,71–3)

The illumination of the most lavish manuscripts of our period aspired to the preciousness of goldsmiths' work, and in Germany in particular there were intimate connections between the styles of the two crafts, perhaps because – as Theophilus, i.e. the goldsmith Roger of Helmarshausen [30], had indicated – Germany was the chief centre of goldsmiths' work in Continental Europe.[99] The treatment of draperies, heads, and hair, the decoration of the arcades, and the use of medallion figures in one of Roger's most famous pieces, the portable altar of Liborius and Kilian, dated *c.*1100, were all to influence the manuscript painting of Helmarshausen, which shows the further effect of goldsmiths' work in the tendril ornament of some of its backgrounds.[100]

Helmarshausen developed as an important centre of manuscript illumination around the middle of the twelfth century, especially during the time of Duke Henry the Lion. The first group of manuscripts of this period, placed by Jansen in the 1150s and 1160s,[101] have obvious links with the manuscript painting both of the Mosan area, and – chiefly in the treatment of hair and the folds of the draperies – of the Rhine valley. But the influences from metalwork are also already clear, not least in the earliest manuscript of the group, a Gospel Book of the 1150s,[102] where the draperies of the evangelists are akin to those of Roger of Helmarshausen – the evangelist symbols in the Canon Tables are especially close to his work.[103] The conspicuous gold and purple of this Gospel Book recur in two others which are stylistically linked[104] and are again influenced by goldsmiths' work, particularly in the anthropomorphic evangelist symbols of the first of them (now at Uppsala), which have been compared to those of the Modualdus Cross in the Schnütgen Museum, Cologne;[105] this has been attributed to the workshop of Roger of Helmarshausen, if not to his own hand.[106] These two Gospel Books were made for the monastery of St Lawrence at Lund, with which Helmarshausen had ties of fraternity, and to which it may even have lent artists, as it may have done also to Corvey, for the Corvey Fraternity Book of *c.*1160[107] has a dedication and votive picture and decorative tables by a Helmarshausen artist. Another manuscript apparently illuminated by Helmarshausen artists for an outside community is a Gospel Book formerly at Kruszwica (Kruschwitz) and now at Gniezno (Gnesen).[108] It is quite generously illustrated; as well as 'portraits' of the four

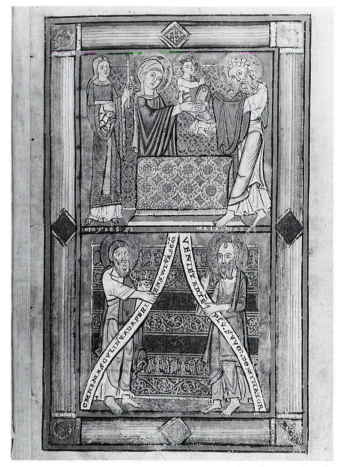

285. Helmarshausen: *The Presentation in the Temple and two prophets*, from the Psalter of Henry the Lion, MS. Lansdowne 381, folio 8. 1168/89. London, British Library

evangelists, it has four or five pages of illustrative miniatures before three of the Gospels, mostly divided into two registers, so that the number of scenes is quite considerable. This manuscript acts as a bridge between Jansen's first group of manuscripts and his second.

The second group is particularly associated with Duke Henry the Lion of Saxony (1129–95), and there are correspondences between some of the scenes in the Gniezno Gospels and others in Henry's own Gospel Book. Henry was virtually sovereign in the north of Germany until his downfall in 1180. Thereafter he immersed himself in cultural pursuits, and it is largely owing to him that Helmarshausen became a major centre of illumination, for he commissioned some splendid manuscripts there, including a Psalter now in the Walters Art Gallery.[109] A Crucifixion illustrates Psalm 51, and on folio 6 verso is an aristocratic lady at prayer identified by Goldschmidt as Gertrud, Henry's daughter by his first wife;[110] however, the script and illumination of the Psalter indicate a date in the middle years of the twelfth century, which is too early for Gertrud, and the lady is therefore more likely to be Henry's first wife Clementia of Zähringen, whom he married in 1147.[111] Another Psalter commissioned by Henry the Lion[112] has a Crucifixion picture with 'portraits' of Henry and his second wife, Matilda. The figures of this manuscript have the long, slender proportions and the fluttering folds of English art [285], which is hardly surprising considering that

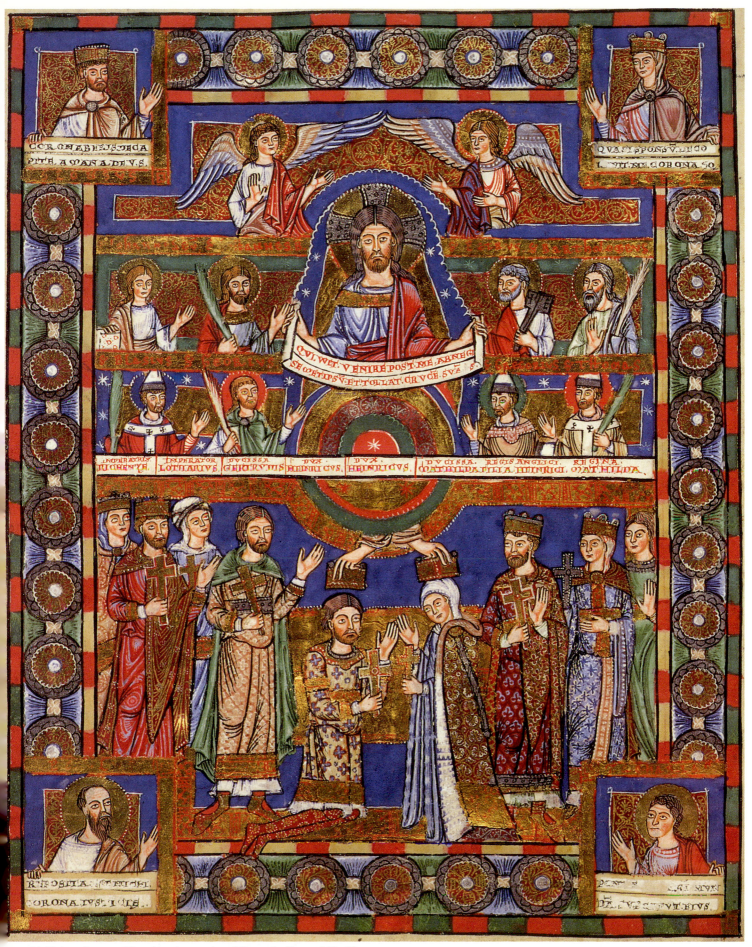

286. Helmarshausen: *The spiritual coronation of Henry the Lion and Matilda*,
from the Gospels of Henry the Lion from Brunswick, MS. Guelph 105
Noviss. 2°, folio 171 verso. *c.* 1188. Wolfenbüttel, Herzog August Bibliothek

Matilda was the daughter of the English king Henry II, and that Henry the Lion stayed in England during his two periods of exile in 1182–5 and 1189.

Helmarshausen's most sumptuous manuscript is unquestionably the one known as the Gospel Book of Henry the Lion,[113] made about 1188. As in the enamels of the portable altar of Stavelot, its burnished and resplendent gold is set off with rich greens, lapis lazulis, and reds, a richness of effect enhanced by a highly discriminating craftsmanship already evident in the delicate detailing of the background and of the cloaks and vestments of the first painting. Indeed, we have here all the richness of material and quality of workmanship that the Ovidian cliché required. The Gospel Book was made for Henry's cathedral at Brunswick, dedicated to St Blasius and built to house the relics brought back from his pilgrimage to the Holy Land in 1172/3. The manuscript was intended to be displayed on the altar of the Virgin, consecrated in 1188,[114] which is why, in the painting on folio 19, the patron saint of the church points to the Virgin and Child above as he receives the Gospel Book from Henry. In one miniature, Henry and Matilda are crowned by two hands emerging from the heavens [286] in what is meant to be a heavenly rather than an earthly coronation,[115] for the reference is to the crown of life promised to the faithful by John the Divine (Apocalypse II, 10). The richness of attire of the ducal couple, however, seems at odds with the message held by the half-figure of Christ above: 'If any man will come after me let him deny himself and take up his cross and follow me' (Matthew XVI, 24). Like them, Henry's parents and grandparents, and Matilda's father and grandmother, hold gold crosses in witness of their Christian faith, and it is ironic that, not far from the figure of Henry II with his cross, Thomas Becket in the upper zone holds a palm to symbolize the martyrdom provoked by the English monarch's too hasty words. Opposite is another resplendent picture of God enthroned, the focus of his own actions during the first six days of Creation, with the half-figures of Moses, David, Solomon, and Boethius holding relevant texts in square compartments at the corners.

These are but three of the twenty-four sumptuous full-page illuminations in the manuscript, most of them devoted to Christological scenes, two to a page. One or two indicate influences from medieval drama,[116] and others incorporate Old Testament prophecies. Theological symbolism is well expressed in the Entombment and the Holy Women at the Tomb on folio 74 verso with, in its corner roundels, symbols of revival, or Resurrection, taken from the Bestiaries – the pelican reviving its young with its own blood, the phoenix rising newly born from its nest, the lion reviving its cubs, and the eagle renewing both its plumage and its vision by dipping itself three times in the water. A sequence beginning with the ancestors of Christ in roundels on folio 19 verso continues with scenes that take us from the Adoration of the Magi to the Ascension. There are moreover ten full-page carpet pages containing initials and/or part of the text in gold and silver on coloured or purple grounds; eighty-four large initials (seven very large) in burnished gold and silver; some sixteen hundred small but rich initials; seventeen sumptuous pages of Canon Tables with their own miniatures; and some pages with gold writing. According to the dedication verses,

this opulent manuscript was made by a monk called Heriman who seems to have been not only the scribe but also the artist of the main pictures.[117] It passed from Germany to Bohemia in the fourteenth century, and in the nineteenth to Austria, where it was lost to sight just before the Second World War, re-emerging in 1983 to be sold at Sotheby's for the highest price paid for any work of art at the time – over £8,000,000. It is now back in its country of origin.

Though not so lavish as Henry the Lion's Gospels, the Hardehausen Gospels[118] of the same group is by normal standards richly decorated and fairly copiously illustrated. Its dedication picture showing a monk handing the manuscript to a nun in the presence of St George suggests that the Gospels was probably made at Helmarshausen for Lippoldsberg, a nunnery in the diocese of Paderborn which was dedicated to St George. It probably belongs to the 1190s, and its illumination introduces a new and more powerful sense of modelling into the art of Helmarshausen.

The final group of illuminated manuscripts from this centre, also attributed to the last decade of the twelfth century, sees a transition to styles more in touch with England, as in a Gospel Book of the 1190s, now at Trier,[119] which was illuminated by three hands and has miniatures of the Tree of Jesse, the Baptism of Christ, the Crucifixion [287], and the Last Judgement, with evangelist 'portraits' as well. The colours, the drapery style, and the use of tendril ornament against rich gold backgrounds show that the first of the three artists, who was responsible for the pictures and the decoration of the Gospels of Matthew and Mark, was still working closely in the tradition of the Gospels of Henry the Lion. However, the second artist was already beginning to break away, and the third has completely lost touch with the old style: his colours are brilliant, and his draperies are stylistically related to those of such contemporary English manuscripts as the last Canterbury copy in the tradition of the Utrecht Psalter now in Paris [343].

A Helmarshausen Gospel Book[120] which is dated 1194 by inscription has 'portraits' of the evangelists (except for John), and a Christological cycle from the Annunciation to the Ascension and Last Judgement. Two very different illuminators were at work here, one conservative, the other more progressive. The conservative one, who was responsible for the evangelist pictures, was still very conscious of the pre-Heriman traditions at Helmarshausen, but the other, who painted the Gospel scenes, was influenced by the English illumination not only of his own day but also of the Anglo-Saxon past – the particular fall of his draperies and their fluttering ends are especially reminiscent of the styles of such Anglo-Saxon manuscripts as the Winchester Psalter of the late tenth century [85] and the Grimbald Gospels [97].

Other Saxon manuscripts have their own interest, though none is as lavish as the most opulent Helmarshausen manuscripts. Two are great Bibles. The first, in two volumes, belonged to the house of canons of St Pancratius in Hamersleben,[121] and is attributed to the 1160s or 1170s. Its

287. Helmarshausen: *The Crucifixion*, from a Gospels, MS. 142, folio 90 verso. *c.* 1190–1200. Trier, Dombibliothek

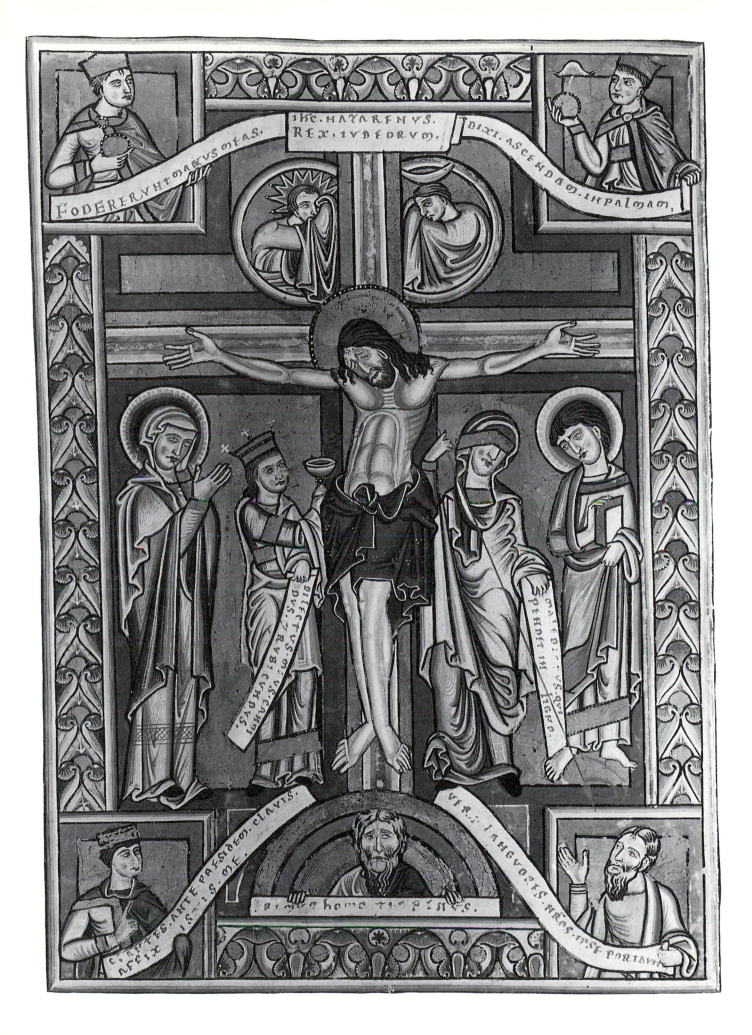

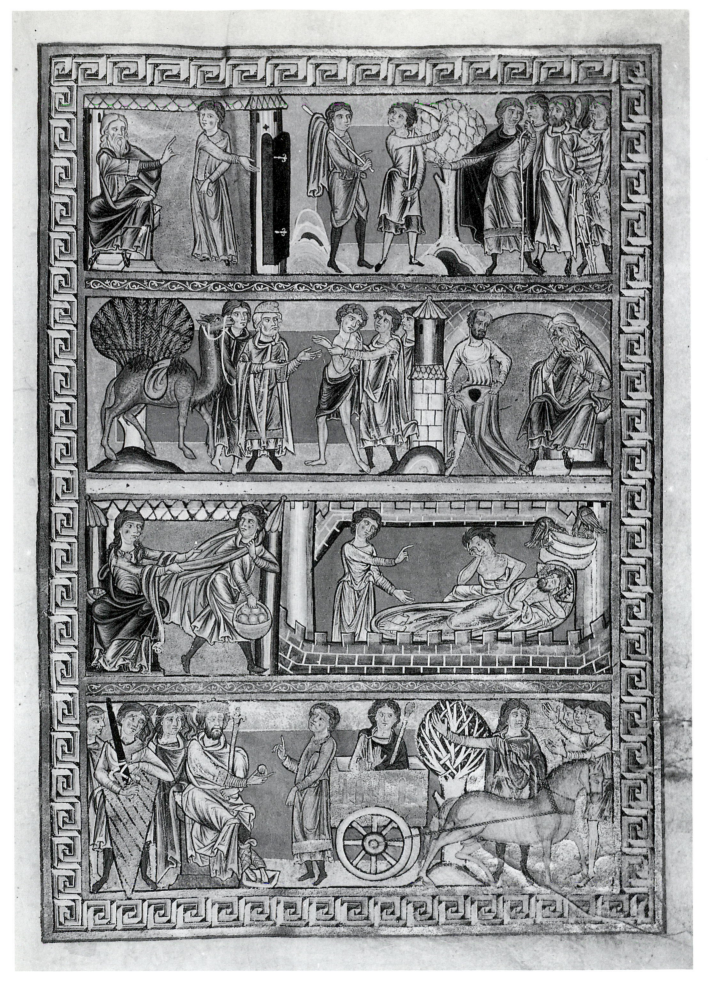

289. Idensen, parish church, nave vault, *Baptism scene*. Wall painting.
1120/40

prefatory painting is dominated by a picture of the house's patron saint. Although it has the monumentality of similar subjects from north-east France, it has none of the mellifluous quality of the best French work, and indeed the stolid stance of the saint is more reminiscent of figures in the early great Bibles of Italy. The Lilliputian figures around him include the early priors of Hamersleben. Two clerics prostrate at his feet offer him the Bible, and three other figures hold open another tome – presumably the Bible's second volume – to show the first words of the four Gospels. Two detached leaves from the Bible are today in Berlin, and a Psalter belonging to the same house is closely related to it in style.[122]

The second great Bible, in three volumes, now in the library of Merseburg Cathedral,[123] is generally – though not with complete certainty – thought to be Saxon. It is ascribed to the very end of the twelfth century, or even the beginning of the thirteenth. The *In Principio* page (folio 9 verso) is packed with incidents organized with a clarity typical of Germany. The page of scenes from the life of Joseph on the preceding folio, unrolling in four 'friezes' inside a frame [288], is an unusual opening for the illumination of any Bible, perhaps (as one scholar has suggested[124]) to be explained by the fact that events in Joseph's life – particularly his rejection, betrayal, and ultimate triumph – were seen to anticipate events in the life of Christ. The 'strip' arrangement suggests reminiscences of the Ottonian Echternach School, the

disposition of draperies influences from Parisian art, and the preferred backgrounds of panels of blue inset with green possibly influences from England. But, when all this has been said, the overall style is very typical of north German Romanesque.

The most important, and best preserved, of the north German Romanesque wall paintings are in the parish church of Idensen in Lower Saxony,[125] founded as the private chapel of Bishop Sigward of Minden (1120–40) who (a later chronicler relates) 'decorated it with paintings within';[126] these murals are therefore usually associated with his episcopacy. They have some of the geometric and compositional discipline of the miniatures of Helmarshausen,[127] and it is thought that their artists – probably three in all[128] – came from there. Enlivening the whole interior with their rusts and browns against blue backgrounds, they represent a Majesty in the semi-dome of the apse; bishop-saints on the blind arcades of the apse wall and of the arch before the apse; half-length figures of Virtues on the soffit of this arch; paired scenes of Noah's ark and Baptism [289], the tower of Babel and Pentecost, the Wise and Foolish Virgins and the Last Judgement on the curved vault of the nave; and the martyrdom of St Ursula and the 11,000 virgins (to whom the church was dedicated) on the west wall. There are also scenes from the lives of the two patron saints of Bishop Sigward's own cathedral: Peter in the chapel of the north transept, and fragments of a sequence, possibly relating to the Passion of Gorgonius, in the southern side chapel. It has been pointed out[129] that, with some variations, this programme of a Majesty in the apse, Old and New Testament scenes in the nave, and histories of saints in

288. Saxony(?): Scenes from the life of Joseph, from the Merseburg Bible, MS. 1, folio 8. Late twelfth/early thirteenth century. Merseburg, Domstiftsbibliothek

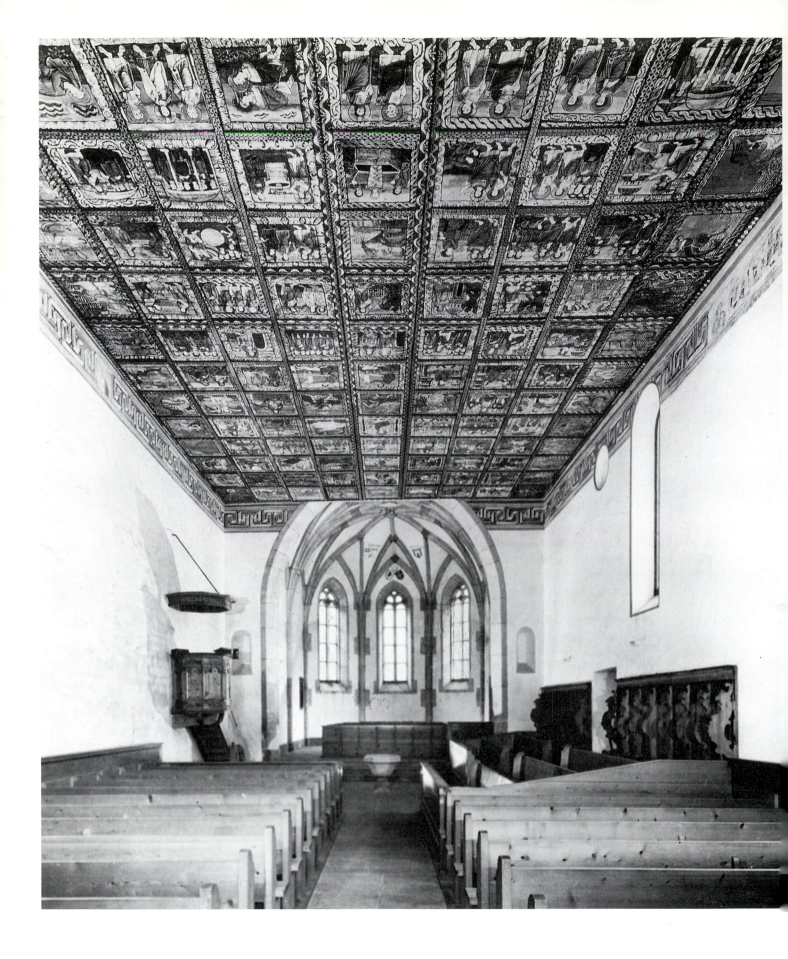

290. Zillis, St Martin, the painted ceiling. *c.* 1140–60. 291 (*opposite*). Detail,
The Flight into Egypt

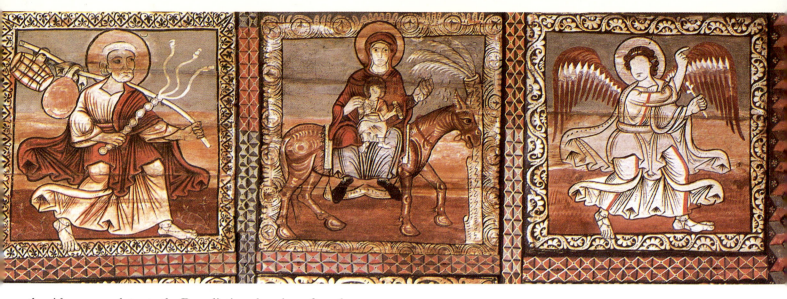

the side-arms, relates to the Benedictine churches of southern Italy – for example, Desiderius's church of Sant'Angelo in Formis – and essentially goes back to the Early Christian murals of St Peter's and St Paul's in Rome. The differences are that the Old and New Testament scenes at Idensen are not narrative but typological, and not on the side-walls but in the vaults. There are also some personal touches in the murals which suggest that Sigward himself had played some part in devising the programme. The mural of the Last Judgement – the end of the Christian's spiritual journey – may therefore have some connection with the fact that Sigward planned this chapel as his last resting-place. And it was perhaps also he who arranged that the Baptism on the vault of the nave with seven deacons in attendance [289] should be seen in ecclesiastical and liturgical terms rather than in its usual New Testament form.[130] It has been argued that this Baptismal scene represents the first of the sacraments of the Church, and that the Pentecost scene, with its emphasis on the descent of the Holy Spirit, symbolizes the sacrament of Confirmation.[131]

The Last Judgement at Idensen is not associated with the Resurrection of the Dead, as in other wall paintings such as those of Oberzell and Burgfelden,[132] and the particular emphasis on St Peter as a teacher and miracle-worker (the usual scenes of his imprisonment and crucifixion are omitted) is again not found in other monumental paintings. The iconography of the St Peter scenes draws on a Byzantine tradition, as exemplified in the Sicilian mosaics of the Palatine Chapel and of Monreale, and the style also shows influences – very evident in the modelling of the heads – from Byzantium. However, its forcefulness is entirely Western.

The most famous of all the monumental paintings of Saxony is, of course, the painted Tree of Jesse on the ceiling of the abbey church of St Michael in Hildesheim,[133] preserved by prudent precautions from the immense damage inflicted on the church in the Second World War. It is arguably the most impressive of all existing monumental Trees of Jesse – immaculate in style, architectural in composition, and more comprehensive than the Jesse Trees in the stained glass of Saint-Denis and Chartres. It used to be thought that this immense panel painting was intended to promote, or to celebrate, the canonization of St Bernward (the founder of the church) in 1192, but it is now attributed to *c.*1230 and we shall therefore not dwell on it here.

SWITZERLAND

As the Hildesheim Tree of Jesse is thought to be thirteenth-century, the distinction of possessing the only ceiling painting on wood to remain from the twelfth century belongs to Switzerland. A number of others probably once existed – one chronicler speaks of a panelled ceiling with pictures of John the Baptist adorning a newly restored chapel at Petershausen dedicated to him in 1129[134] – but the Swiss example is the only one to survive and as such will receive special attention. It is in the parish church of St Martin in the small village of Zillis (Graubünden), within the see of Chur. Originally Carolingian, the church was replaced in the twelfth century by a one-aisled structure of which the flat ceiling[135] [290] was part. It used to be dated in accordance with an entry made before 1147 in the necrologies of Chur which named a 'lopicinus pictor', but more recent opinion attributes it to around 1160. One might perhaps settle for a date somewhere between the two.

Unlike the Hildesheim ceiling, which is one overall board, the ceiling at Zillis consists of a great many small square wooden panels painted in the workshop and affixed one at a time. The resulting 'chess-board' is twice as long as it is wide. Each square has a painting, separately 'framed', even when several squares are joined together to form a composite picture, as in the Massacre of the Innocents. Similar aggregations of juxtaposed squares occur in the very early manuscript art of Italy;[136] in later ivory carvings, reliquaries, and portable altars; in the backgrounds of Romanesque panel paintings of Crucifixions such as the great Crucifix of Sarzana [169] made by Guilielmus in 1138; and in the painted altar frontals of Spain [263, 264]. At Zillis, bold wavy lines in the central area of the ceiling mark out the form of the Cross.[137] The figures are short and squat, no doubt to fit into their square format. The painting is competent, in earth colours of grey-greens, rusts, and browns; the line is bold, and the ornamental borders are vigorous. The panels total one hundred and fifty-three – the number of fish caught by the disciples in the miraculous draught described by St John the Evangelist (XXI, 11),[138] and thought by St Augustine to have a mystic significance; so, given the preoccupation of some medieval theologians with the symbolism of numbers, this coincidence may not be an accidental one. The vast majority of the pictures are scriptural, but the last but one row to the

west has scenes of the life of the church's patron saint, St Martin. At each of the four corners of the ceiling is an angel with two trumpets, clearly corresponding to St John the Divine's vision of 'four angels standing on the four corners of the earth' (Apocalypse VII, 1). The sixth-century geographer Cosmas Indicopleustes thought that the earth was flat, and that its corners supported the heavens, so that they might well have been considered appropriate places for angels to stand on. Moreover the ocean extending between each of the corners both emphasizes the idea that the angels are on dry land and complies with the received view of writers such as Isidore of Seville that the *terra firma* of the world was surrounded by sea. The waters are inhabited by such creatures as a fish-elephant, a fish-goat, a fish-unicorn, a fish-wolf, a fish-horse, a fish-bird, and so on, reflecting a tradition that the sea contained the fish-equivalents of everything on land – a view which drew strength from a remark in the Book of Lamentations (IV, 3) that sea-creatures were suckled at the breast, and which reached its peak in the Renaissance. The Middle Ages thought that the strangest of the imagined land animals (they were mostly classical in origin) were bred in the furthest reaches of the world, and this, no doubt, is why the artist has chosen to place the prodigies of the fish creation in the outermost oceans.

Of the two boats on these oceans, one is thought to bear Jonah going forth on his fateful journey. The two men fishing with a net in the other may allude either to Matthew's description of Peter and Andrew 'casting a net into the sea' (IV, 18), or to his later reference to the kingdom of heaven being 'like a net that was cast into the sea' (XIII, 47). Bearing in mind that the adjacent painting is of an angel of the Apocalypse, the second interpretation seems the more likely, for Matthew goes on to say that the catch from the sea was later taken to the shore where the good was to be divided from the bad, as 'at the end of the world, the angels shall come forth and sever the wicked from among the just' (XIII, 49).

These scenes – unusual as they are – are but visual marginalia to the main paintings, which are almost entirely devoted to the Christian story, drawn from the conventional Scriptures, with passing allusions to Apocryphal accounts of the young Christ bringing clay birds to life and of the tree that spontaneously offered its fruit to Mary as she fled into Egypt [291]. Starting from the east, the ancestors of Christ and allegorical figures of the Church and Synagogue are followed by scenes of the Nativity, of the infancy of Christ, of John the Baptist, of the Baptism of Christ, his temptations, miracles, and teachings, his sending out the apostles, his Transfiguration, and his Entry into Jerusalem, where the willow branches that replace the traditional palms reflect the local Graubünden custom at Palm Sunday processions.[139] The culminating scenes are the Betrayal, the Last Supper, Gethsemane, the Arrest, and the Crowning with Thorns. The Zillis ceiling clearly fulfilled what the twelfth-century German theologian Honorius of Autun considered to be the primary purpose of painting – to act as a book for laymen – by offering a clear and colourful statement of all the elements of Christ's redemptive mission to those who could not read. The climax of the story, the Crucifixion, may have been lost when the Romanesque choir was rebuilt in the sixteenth century.

At the top of the nave walls, the artist of the St Martin episodes[140] punctuated a decorative meander pattern with female half-figures, perhaps the Sibyls of Antiquity.[141] They were supposed to have foretold the coming of Christ which is pictured in the ceiling above, and wear crowns, which have been seen as symbols of Christ's triumph.

Of the more usual Romanesque murals of Switzerland, most are to be found in the cantons of Graubünden and Ticino. At the Johanneskirche at Müstair[142] there are both Carolingian and Romanesque wall paintings, for the three apses and the east wall above them were overpainted in the twelfth century. As some areas of the later painting of the apses have flaked away or been removed, the art of the two periods is there to be seen in the closest juxtaposition, though unfortunately extensive mid-twentieth-century restoration has made stylistic assessment difficult. The Carolingian Ascension on the east wall was replaced by Romanesque paintings on the general theme of sacrifice, as Beat Brenk has pointed out[143] (their remaining fragments are in the Landesmuseum at Zürich). It was the sin of the first parents that led to the need for sacrifice, and so the Fall and the Expulsion of Adam and Eve were painted before the south apse. In the middle were the offerings of Cain and Abel, representing acceptable and unacceptable sacrifice, and on the north was a nimbed Lamb to indicate the sublime sacrifice of Christ.

The Romanesque Ascension in the semi-dome of the south apse has not survived, though the episodes from the life and martyrdom of St Stephen, a joint patron of the church, are still extant. The north apse was dedicated to St Peter and St Paul, and its Romanesque paintings follow their Carolingian predecessors in presenting scenes from their lives, though with a somewhat different choice of episodes; it has been argued that the one of Peter feeding consecrated bread to two dogs (now removed to a museum within the convent attached to the church) derives from Italy.[144] The Carolingian scheme for the middle apse, dedicated to St John the Baptist, consisted of scenes from his life below a Majesty in the semi-dome; the Romanesque version had the Baptist only in the lowest register (where the final episodes of his life, from Salome's dance to his burial, are still to be seen) with above, apparently, the parable of the wise and foolish virgins (of which fragments remain in the museum) – a theme that recalls the fact that, some time before 1163, the Benedictine monastery at Müstair became a nunnery. At the right-hand end of the dado of the apse is a 'portrait' of a woman, identified by an inscription as Friderun, offering to the Baptist a textile and an embroidered cushion (perhaps to support the Missal on the altar). Friderun may have been the wife of Gebhard of Schleiss, referred to in a document of 25 March 1160, who may himself have appeared at the left in a part of the painting now lost.[145]

Gebhard was the vassal of Ulrich III of Tarasp who, with his wife, once figured in a wall painting in the crypt of the nearby monastic church of Montemaria in Burgusio[146] in the Italian Tyrol. Burgusio had close ties with Müstair, whose paintings it influenced, as is particularly evident from some unrestored fragments in the Müstair museum: the one showing St Peter, from the dispute with Simon Magus, indicates that Müstair's twelfth-century paintings must have

been quite impressive in their original state. The programme at Burgusio probably belongs to 1160, the date of the consecration of the crypt; particularly fine is the serene painting of Christ in Majesty in the semi-dome of the apse. The first five abbots of the house were Swabian, and the artist may have been Swabian too.[147]

The Romanesque paintings at Müstair are not much later than those at Burgusio – perhaps of c.1165–80. Earlier ones in a room on the west side of the north court (possibly the former chapter house) were perhaps made at the time of a known consecration of 1087,[148] and represent the Crucifixion with the two thieves, the Virgin and St John, the Church and Synagogue, and also the Deposition, what is apparently the Holy Women at the Sepulchre, and the Resurrection.

To complete our survey of Swiss Romanesque wall painting, we turn first to the fragmentary Christological scenes in Santa Maria in Pontresina,[149] which have some stylistic associations with the twelfth-century murals at Müstair; other fragmentary paintings of the first quarter of the twelfth century, possibly of the Last Judgement, in Sant'Ambrogio in Negrentino (Ticino)[150] have stylistic analogies with those of San Pietro al Monte (Civate). In west Switzerland, the heavily repainted murals at Chalières[151] of Christ, the apostles, and the sacrifice of Cain and Abel probably belong to the second half of the eleventh century. Even more crudely restored are paintings of the end of the twelfth century in the barrel-vaulted portico at the west end of the church of the Cluniac abbey of Payerne.[152] It has been suggested that one of their chief themes – the Last Judgement – was aimed at those erring monks whom the Benedictine Rule required to remain in penance outside the church during prayer.[153] The same authority links the presence of an abbot among the blessed and of a bishop among the damned with the exemption from diocesan control of the Order to which the house belonged.[154]

Manuscript painting within the territory of Switzerland was largely confined to two Benedictine houses – Engelberg and Einsiedeln. Engelberg,[155] founded in 1120, came to prominence as a scriptorium under its second abbot, Frowinus (1147–78), formerly a monk of St Blasien in the Black Forest, to whom verses are dedicated in more than thirty of its surviving manuscripts. Most of their decoration consists of initials, but in the Bible[156] he commissioned for the house there is one picture of Frowinus ordering the scribe Richene to carry out the work and another of him presenting it to the Virgin. Besides the primary influences from Bavaria and Swabia there are others from northern France, but no one could describe the resulting amalgam as felicitous – indeed, an artist of the end of the twelfth century thought so little of it that he replaced some of the initials with more sophisticated ones of his own;[157] these included historiated initials, among them a portrayal of Daniel interpreting Nebuchadnezzar's dream which is evidently by the same hand as a drawing of St Augustine confronting three heretics in a copy of that saint's work on the Trinity.[158]

The house of Einsiedeln, founded by a canon of Strasbourg, has handed down to us two eleventh-century commentaries[159] and a Bible,[160] all with line drawings; those in the Bible have been compared, in terms both of style and of their physical relationship to the text, to some in the well-known Catalan Bibles from Ripoll and Roda,[161] but the evangelist 'portraits' were inspired by Carolingian art and are particularly close to those of the St Emmeram Codex Aureus. The most powerful pictures to survive from Einsiedeln, however, are not miniatures but the visual guides for the illuminator or wall painter referred to in Chapter 1. They are on three leaves, bound with an alien text.[162] The figures are firmly drawn [7], and the reinforcement of their outlines with brown paint strengthens their impact. The style of these uncoloured drawings, which can be dated to the first half of the twelfth century, is clearly Byzantine or Italo-Byzantine in origin, and their decorative detailing gives them a rich air of ornamental display.

SWABIA AND ALSACE

The house of Hirsau was refounded in 1065 by monks from Einsiedeln, so that some Swiss influence may have been at work on the manuscript painting of Swabia. The driving force of the new community of Hirsau was William, its second abbot (1069–91), who was soon building up a stock of books, most of which have now disappeared; even the one significant illuminated manuscript attributed by Boeckler to the house has been disputed by Löffler.[163] It is a Martyrology or Passionary in three volumes,[164] probably of the second quarter of the twelfth century, and boasts a number of attractive initials decorated with foliage and dragons and others with 'portraits' of the saints concerned or scenes from their lives. The martyrdoms are often particularly lurid examples of their kind, as when St Primus, nailed to the stem of an initial T, looks helplessly on as molten lead is poured down the throat of his companion, St Felicianus. Further scenes occur as independent illustrations at the beginning or end of sections, and all are in a pleasing linear style.

William was active in promoting new foundations from Hirsau, and one of them, Reichenbach, included a 'portrait' of him in one of its manuscripts.[165] Another, Zwiefalten, produced most of the surviving Swabian illuminated manuscripts. In the absence of solid evidence, it is difficult to sustain the thesis of Hirsau influence upon them, though it does receive a crumb of support from the pronounced linearism that the Zwiefalten illumination has in common with the one possible Hirsau manuscript that we have discussed, pursuing it, indeed, with such single-mindedness that most of Zwiefalten's decoration and illustration take the form of drawings in coloured inks, as in the decorative and historiated initials and the four full-page pictures of a Collectarium of the 1120s.[166] The first of the pictures (folio 9 verso) ingeniously combines the reference to Wisdom and her house in Proverbs IX with the vision of the One on the Throne in Apocalypse IV-V to create an unusual image of adoration: the wisdom and power of the Lord are represented symbolically within the temple, surrounded by a mandorla containing faces to express the 'lightnings and thunderings and voices' envisaged by the Apocalypse as proceeding from his throne. Personifications of light and darkness, winter and summer, with the twenty-four worshipping elders appear as busts in the borders.

In a manuscript Miscellany[167] to be dated between 1138 and 1147, cosmological themes are rendered in the lucid and

292. Zwiefalten: *The cycle of the year*, from a Miscellany, MS. hist. fol. 415, folio 17 verso. 1138/47. Stuttgart, Württembergische Landesbibliothek

geometric manner in which the Germans excelled: on folio 17 verso, the sun, the moon, the zodiac, the year, the occupations of the months, the winds, the seasons, and the four cardinal times of the day are organized into a systematic composition [292]. The illustrations of another section demonstrate that the artist had access to the same model as the illuminator of the 'Hirsau' Martyrology, though he made a different use of it,[168] for the Hirsau artist placed many of his scenes in historiated initials, while the Zwiefalten one chose instead a variety of quatrefoils, ellipses, circles, and so on, assembled on twenty-two full pages to give an impression of stained glass.[169] The final picture of this miscellaneous manuscript illustrates the Rule of St Benedict with a symbolism, including the ladder of virtues and the snaring of the Leviathan, that was to be raised to new heights of sophistication in the greatest of all Swabian manuscripts – the *Hortus Deliciarum* that we shall come to later. After the Miscellany there was a falling off of quality, and not even the

well-conceived historiated initials of a Josephus of the second quarter of the century[170] can conceal the general decline.

Tenuous links exist between the manuscript painting of Zwiefalten and that of the Swabian house of St Martin at Weingarten,[171] founded in 1056 by Duke Welf IV, who was to marry Judith of Flanders, a cultivated noblewoman, earlier the wife of the far from cultivated brother of the last Anglo-Saxon king. She found in Weingarten a centre on which to lavish artistic patronage. Her gifts included illuminated manuscripts made in England or Flanders, and therefore not dealt with here, though they had a later marginal influence on Weingarten. Of the illustrated works commissioned by Abbot Kuno (1109–32) two Service Books, a Psalter, and a Bible in three volumes survive.[172] The initials of the Bible – some never completed – are rich with gold and silver, blues and greens, and there were scenes of Christ and Moses on a frontispiece earlier detached from the manuscript.[173] The Christological scenes of one of the Service Books[174] hark back to the Liuthar group of Ottonian Trier, and a later Life of St Martial[175] looks westwards towards France; another manuscript, a world chronicle of the final quarter of the century, has a well known if undistinguished picture of Barbarossa and his two sons.[176] Weingarten maintained a trickle of illumination throughout the twelfth century, but the decades of its real glory belong to the thirteenth.

In the meantime, at the nunnery of Hohenbourg in Alsace (now in France but then attached to the duchy of Swabia) a work was being created which was not only the finest masterpiece to be made on Swabian soil, but also one of the greatest artistic manuscripts to emerge from the Middle Ages. It is the celebrated *Hortus Deliciarum*,[177] or Garden of Delights.

The house of Hohenbourg was rescued from decline in the twelfth century by the personal intervention of the dukes of Swabia, and it was the most famous of these, the great Barbarossa, who installed Rilinda at the head of the nunnery some time between 1147 and 1162. She was succeeded, probably in 1176, by Herrad, and the text of the *Hortus* implies that it was Herrad who was responsible for the manuscript. However, since she is pictured in it alongside Rilinda, and they also appear together in a carving at the feet of the Virgin and Child, presenting an open book which may be this one, we might suppose that the original project was not Herrad's alone. If so, it might have been begun before Herrad became abbess, though the major part certainly belongs to her time, with perhaps one or two additions following her death, which occurred some time after 1196. It was clearly intended for the edification of the nuns of Hohenbourg, for verse and prose exhortations at the beginning of the text encouraged them to conquer the trials and tribulations of this world in order to achieve the rewards of the next, and explained that this *Hortus* was to help them on their journey. Like a bee, Herrad wrote, she had amassed this work from various flowers of philosophical and divine writings to construct a comb flowing with honey for the refreshment of their souls.

The *Hortus* was fortunate to escape a fire of 1546, which so devastated the nunnery that the building had to be abandoned. The manuscript then passed to the bishop of Strasbourg, and later to the Chartreuse of Molsheim. After

293. Hohenbourg: *The woman clothed with the sun*, from a nineteenth-century copy of the *Hortus Deliciarum*, folio 261 verso. Originally of *c.* 1170–1200

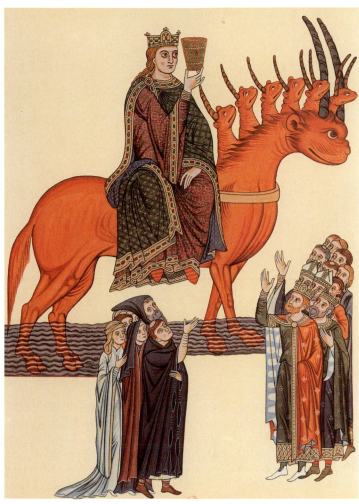

294. Hohenbourg: *The Whore of Babylon*, from a nineteenth-century copy of the *Hortus Deliciarum*, folio 258. Originally of *c.* 1170–1200

the French Revolution it came into the possession of the municipality of Strasbourg, escaping yet another fire in 1860 only to be destroyed by Prussian shells in August 1870. Fortunately, much of the text had by then been published – its 1,250 German glosses made it of special interest to students of the language – but the pictures with their 346 scenes had not, and all that we have today are line-drawings of about half the original paintings and a very few coloured copies which, a canon of Strasbourg Cathedral wrote, were but pale reproductions of the splendid and brilliantly coloured miniatures that had been destroyed.[178] There are however two small sources of solace for their loss. One is a long strip of parchment[179] (originally for a flabellum, or ornate fly-whisk, used during the divine service) bearing scenes of the life of John the Baptist by the hand of one of the painters of the *Hortus* (unfortunately not the main one). The other is that the few coloured copies made for Comte Auguste de Bastard in the nineteenth century can be inferred from other evidence[180] to be reasonably accurate reproductions.

The manuscript has been reconstructed by Rosalie Green, Michael Evans, Christine Bischoff, and other dedicated scholars from tracings, coloured copies, and a few printed plates, and we therefore now know that its pictures were concerned with the unrolling of the divine purpose from the first day, when Lucifer was as yet free to enjoy the *Hortus Deliciarum* of the original Paradise, to the Last Judgement,

when true Christians could await the *Hortus Deliciarum* of the Heavenly Jerusalem safe in Abraham's bosom. The first act of this spiritual drama, embodied in numerous Old Testament scenes, was followed by a second, profusely illustrated with events largely from the life of Christ with some from those of the apostles. The final act – an account of the Church in its post-apostolic phase – gave full rein to allegory: of the Church, of virtues and vices, and of good and evil. This vast survey of divine history concluded with vivid renderings of the last days, when Antichrist and the Whore of Babylon would wreak their destruction and then themselves be overthrown. At the end, a visual coda presented Herrad and the living sisterhood of Hohenbourg facing a page illustrating the personified history and aspirations of the community, with figures of Christ, the Virgin, St John the Baptist, St Peter, Duke Adalric (the founder of the nunnery), and St Odilia (its first abbess and patron saint) with the original community. On the edge of this celestial throng, the departed abbess Rilinda looked supportively towards her sisters on earth as she stood by the side of a cross inscribed with words of encouragement. Together, the two pages formed a composition which not only spanned the centuries of Hohenbourg's history, but also charted the passage from the here to the hereafter, and the final inscription expressed the hope that Herrad's nuns, 'snow-white flowers giving off the perfume of virtue', would succeed in obtaining the vision

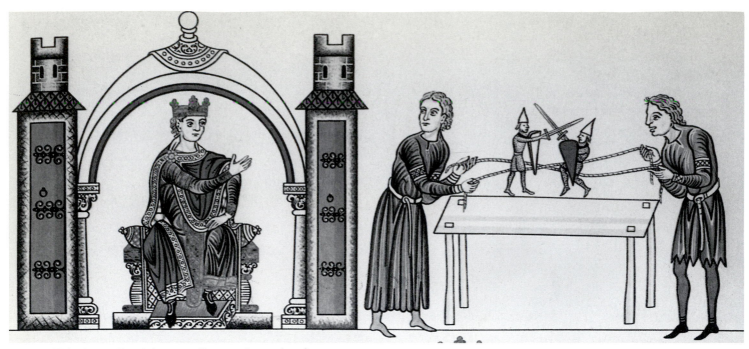

295. Hohenbourg: *King Solomon watching a marionette show*, from a nineteenth-century copy of the *Hortus Deliciarum*, folio 215. Originally of *c.* 1170–1200

of the heavenly bridegroom at present concealed from them.

From the few coloured reproductions considered reliable, it appears that the artists had a subtle coloristic sense, and were particularly fond of varying shades of green, blue, red, and beige; the reds in the copy of the scene of hell-fire still have such warmth that we must assume that the original ones gave a realistic and daunting impression of heat to the flames that flickered against the black and unlit background.

It is thought that three artists participated in this enormous enterprise,[181] whether male or female we do not know. The chief of them had a breadth and assurance of treatment particularly appropriate to the representation of the grander themes. Some of the subjects were illustrated also in contemporary wall paintings (now lost) at Regensburg,[182] and because they are such rare themes a possible association between the two undertakings has been suggested – a view which the monumentality achieved by the chief artist in some areas of the *Hortus* would tend to confirm. This artist's majestic style was particularly apparent in two Apocalyptic figures: the 'woman clothed with the sun and [with] the moon under her feet' (XII, 1) [293] who was identified in the accompanying text as the Church, and the great Whore of Babylon (XVII, 3–4, 6) who sat 'upon a scarlet coloured beast ... having seven heads and ten horns ... [with] a gold cup in her hand full of abominations' [294]. The text requires the Whore to be attired in great splendour, and this was well caught by a rich overlay of colour and gold. The noble figure of the Deity in the opening picture of the Creation of the Angels had affinities with some splendid drawings from Regensburg and Salzburg [304], and even closer links (not necessarily as a result of direct transmission) with figures in the mosaics of the Palatine Chapel in Palermo and of the cathedral of Monreale.[183] Other pictures seem to be related to the contemporary productions of the Salzburg/Regensburg School, particularly such manuscripts as the Salzburg Antiphonary and an Ambrose from Regensburg that we shall come to later [314].

Such experts in Byzantine art as Kitzinger and Cames[184] have emphasized the Byzantinizing aspect of the *Hortus Deliciarum*, and Demus attributes the 'remarkable affinities' between some figures of the manuscript and others in the Byzantine mosaics of Monreale[185] to the use of a similar model-book, probably from Sicily; the latter, he believes, had associations with the leaves now in Freiburg [5], which may even derive from it.[186] Green, on the other hand, suggests inspiration from an illustrated Byzantine Gospel Book to which the artists had access.[187] These Byzantinizing elements in the *Hortus* were especially evident in the iconography of such New Testament scenes as the Nativity, the Adoration of the Magi, the Flight into Egypt, the Baptism of Christ, Christ meeting the Samaritan Woman, Gethsemane, the Betrayal of Christ, and the Ascension.[188] The Last Judgement was particularly close to Byzantine sources, and it has been compared to a mosaic at Torcello and to two icons on Mount Sinai which, in Weitzmann's view, themselves derive from 'a monumental mosaic or fresco' in a church of Constantinople.[189] As Green showed some time ago, the Adam and Eve cycle is specially interesting because it preserved iconographical elements of that famous and much damaged relic of Early Christian illumination, the Cotton Genesis.[190]

To the iconography borrowed from the Eastern Church the artists of the *Hortus* added elements of their own: the Crucifixion, for example, is attended by personifications of the veiled and humiliated Synagogue and of the Church triumphant, and the symbolism of the Byzantine Ladder of Virtues is transformed by extending its application. Furthermore, the rare opportunity to compare one of the Hohenbourg pictures with a Byzantine counterpart afforded, for example, by the Lamentation over the dead Christ demonstrates the ennobling effect of the serene and spacious style of the German artist.

The effect of Ottonian art, particularly of the School of Echternach, can be observed in certain areas of format, subject

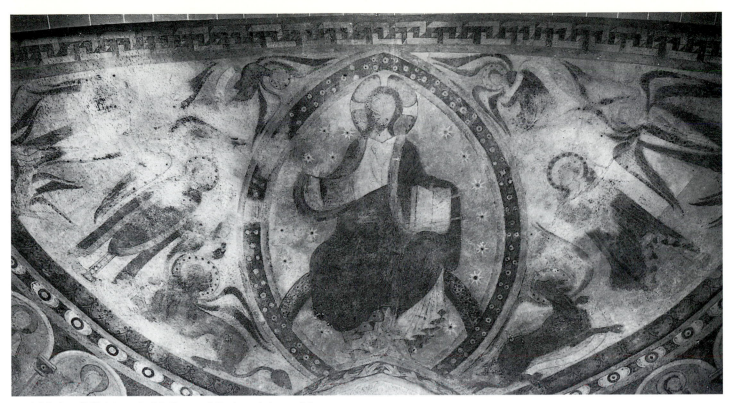

296. Niederzell (Reichenau), *SS. Peter and Paul*, semi-dome of the apse, *Christ in Majesty*. Wall painting. *c.* 1120–30

matter, and iconography;[191] for example, on the reconstructed folio 92 verso of the *Hortus*. Three scenes from the Magi story and another of the Presentation of Christ in the Temple can be associated with a similar sequence on folio 19 of the earlier Nuremberg Golden Gospels from Echternach, and, despite some iconographic discrepancies, the pictures of Christ being mocked, beaten, denied by Peter, and led before Pilate call to mind a sequence on folio 82 of the Echternach Golden Gospel Book in the Escorial. Since illustrations of parables were particularly rare, there may also have been family connections between those in the illumination of Echternach and those in the *Hortus*; this, however, must remain a hypothesis, for most of the *Hortus* parable scenes are identifiable only from written comment in the retrieved text.

The strain of creativity in the *Hortus* artists is attested (as in the artistically inferior Canterbury Hexateuch) by their occasional personal interpretations of the text before them. For example, the written theological subtleties are given appropriate visual expression in the picture on folio 84 (adumbrated in the Zwiefalten Miscellany) of God capturing Leviathan with a fishing-line strung with the heads of patriarchs and prophets and baited with the crucified Christ; the vanity of human life is well illustrated by the unique painting on folio 215 of Solomon watching a marionette show of two puppet knights fighting [295]; and the forces of evil are allegorized as the sirens tempting Ulysses in an apparently classicizing picture.[192]

The reconstruction of the *Hortus* shows that the original manuscript was exceptional for its breadth of subject matter, the coherence of its grand programme, and the sheer brilliance of its art. It is also virtually the only twelfth-century Alsatian illuminated manuscript of which we have knowledge, for the others were also destroyed in the shelling of 1870. An

Evangelistary[193] of *c.*1200 or not long after which came into the possession of the monastery of St Peter in the Black Forest does, however, survive. The stylistic associations of its illustrations both with the *Hortus* and with the stained glass at Strasbourg[194] indicate its Alsatian origin, so the art of illumination seems to have continued to flourish in the region right up to the end of the twelfth century.

The wall paintings of Swabia have not fared so well as its manuscripts: there is no trace for example of the murals that we presume to have existed in houses as important as Hirsau and Zwiefalten. Only in SS. Peter and Paul at Niederzell (Reichenau) are there any significant survivals,[195] and even these are in a fragmentary state, the overall harmony of their composition spoilt by a fifteenth-century window. They are attributable to the 1120s. Their main focus must have been the Christ in the semi-dome of the apse [296], enthroned in a mandorla studded with simulated jewels and accompanied by evangelist symbols, two cherubim, St Paul, and another figure. In two rows below, under arcades, are ten (formerly twelve) seated apostles and ten (formerly twelve) standing prophets. The figure style is reminiscent of the Ottonian murals of Oberzell (Reichenau).

AUSTRIA

In the twelfth century Austria, like Switzerland and Alsace, was not as it is today. Founded in 800 by Charlemagne as the *Ostmark*, or Eastern March, of his empire, it had to be rehabilitated by Otto I after its devastation by the Hungarians, and attained quasi-independence as a duchy only in 1156, when Salzburg still lay outside its boundaries. Salzburg had enjoyed a special prominence at least since the eleventh century, when a Byzantine emperor presented Archbishop

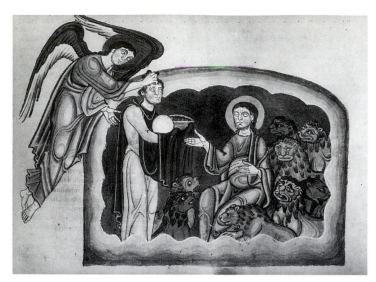

297. Salzburg: *Daniel in the lions' den*, from the Walther Bible, MS. perg. 1, folio 91. Second quarter of the twelfth century. Michaelbeuern, Stiftsbibliothek

Gebehard (1060–88) with a costly gift.[196] In the thirteenth century its archbishops were created Princes of the Empire. Byzantine influences – probably transmitted through Italy – were much in evidence in the twelfth century, and Italian influences are already seen in a Bible[197] made at St Florian at the turn of the eleventh and twelfth centuries whose initials are indeed so Italianate that the manuscript has been claimed for Italy itself. The strong later Italo-Byzantine impact on Austria's figure styles is particularly evident in the Walther Bible[198] of the second quarter of the twelfth century, so called because it was purchased by an abbot of that name (1161–90) for his monastery of Michaelbeuern. Unfortunately the second volume is lost, and so also is most of the illumination of the first, though early-twentieth-century photographs of it remain. Only three miniatures survive, painted by two artists, one of whom worked in line and the other, the so-called 'Genesis Master', in a fuller painted style typified by the scene of Daniel in the lions' den [297], which demonstrates a knowledge of Italo-Byzantine art.

The second quarter of the twelfth century saw a remarkable blossoming of manuscript painting at Salzburg. One of its best productions was the Admont Bible,[199] originally in one volume but divided in two in the thirteenth century. By 1263 it was in the western Hungarian area of Zala, in the monastery of St Peter at Csatár, whose patron, when pawning it, felt it necessary to compensate the Benedictine community for the loss of such a highly valued possession with two villages and two profitable estates.[200] Some Hungarian scholars believe it to be Hungarian, but all its stylistic links are with Salzburg, where it is placed by general opinion. It later came into the possession of the community of Admont, founded by an archbishop of Salzburg in the latter part of the eleventh century.

The Bible was probably made in the 1140s. Its illustration was never completed, though it still has thirty pictures, some full-page, with two detached ones now in the École des Beaux-Arts in Paris.[201] The illumination is enlivened by rich colours, and its gold backgrounds are in the powdered rather

298. Salzburg: *The prophet Haggai*, from the Admont Bible, MS. S.N.2701, folio 249. *c.* 1140–50. Vienna, Österreichische Nationalbibliothek

than the more usual gold-leaf form. Some of the larger pictures are in two zones, with the upper ones focusing on the primary and the lower ones on the more subsidiary points of the narrative:[202] the upper zone of the frontispiece of the Book of Ruth, for example, shows the dramatic episode of Boaz waking up at night to find Ruth at the foot of his bed, and the lower zone illustrates the earlier, less important incident of her gleaning in his field. These paintings extend and expand on those of the Walther Bible, and provide new illustrations for the four Books of Kings and for most of the Books of the Prophets. They also impart a fresh vitality, and the scene of Daniel in the lions' den on folio 228 [299] will give some impression of their power. Much of the iconography derives from Byzantium, as does the use of antique personifications and the modelling of the flesh tones; an occasional sharp linearization seems to point to Italy or Sicily as the likely intermediary. Some of the figures – like the prophet Haggai on folio 249 [298] – are particularly accomplished, and their poise and elegantly drawn-out proportions are reminiscent, perhaps coincidentally, of some of the monumental figures of Cîteaux manuscript paintings,

299. Salzburg: *Daniel in the lions' den*, from the Admont Bible, MS. S.N.2701, folio 228. *c.* 1140–50. Vienna, Österreichische Nationalbibliothek

incorpore; sed iuisse siue incorpore si
ve extra corpus nescio ds scit; his a ta
libus argumentis apocrifas inlibro ec
clesie fabulas arguebat, sup quare lec
toris arbitrio iudiciu relinquens; illud
admoneo n haberi daniele apt hebreos
int pphas; s; int eos quia AGIOGRAFA
conscripserit; In tres siquide partes om
nis ascro scriptura diuiditur; inlegem
inpphas; INICIATIUT PAGA ide inquinq,
æ in octo. æ in undecim; De quo non est
hui temporis disserere; que aut ex hoc
appha immo contra hunc libru porphi
rius obiciat; testes s methodius; euse
bius; apollinaris; qui multis uersuu
milib; ei uesanie respondentes; nescio
an curioso lectori satis fecerit;
Vnde obsecro o paula æ eustochiu fun
datis apme addnm preces; ut quadiu
in hoc corpusculo su; scriba aliquid gra
tum uobis uale ecclie; dignu posteris;
psentiu quippe iudiciis non satis mo
ueor; que in utraq; parte aut amore la
buntur; aut odio;

EXPLICIT PROLOGVS DANIE
LIS PROPHETE;

300. Salzburg: *The Adoration of the Magi*, from the Pericope Book of St Erentrud, Clm. 15903, folio 17. *c.* 1140–60. Munich, Bayerische Staatsbibliothek

301. Salzburg: *Christ appearing to the disciples*, from the St Peter's Antiphonary, MS. S.N.2700, p. 662. 1147/67. Vienna, Österreichische Nationalbibliothek

which were also Byzantine-inspired. Swoboda thought that six artists worked on the Admont Bible,[203] though one certainly dominated the rest.

The numerous miniatures of the Pericope Book of St Erentrud[204] are stylistically associated with those of the Admont Bible and their colours are similarly strong. The iconography of the Christological scenes is very Byzantinizing, while the unusual psychological intensity, only hinted at in the picture of the Magi on folio 17 [300], owes something to Ottonian art.

One of the most sumptuous of all the manuscripts of the Salzburg School also has associations with the Admont Bible; it is an Antiphonary from St Peter's[205] assigned to the period 1147–67. As well as richly decorated initials, it has dedication pictures and no less than fifty biblical scenes, two to a page, some of them iconographically related to the St Erentrud Pericope Book, while others – for example, the Nativity and the Harrowing of Hell – demonstrate a further knowledge of Byzantine art; this will account also for the drapery styles, the heavy modelling, and the strong highlights, which combine with the feverish glances of the figures to produce very dramatic effects. When the bright body-colours are eschewed, the pictures, against backgrounds of blue and green, become tinted drawings revealing to the full a remarkable quality of line and an attractive clarity of composition [301]. Dependent on the style of this

Antiphonary[206] are three full-page miniatures of the so-called Walther Breviary,[207] made for Michaelbeuern in the 1160s. Its namesake, Abbot Walther (1161–90), appears both in a dedication picture on folio 1 verso and, kneeling in supplication, in the Annunciation scene on folio 56 verso.

These drawings herald the broader blossoming of twelfth-century art at Salzburg which finds full expression in a group of illuminated manuscripts of the third quarter of the century[208] in which Byzantine influences are as strong as ever, though now completely absorbed into the Romanesque aesthetic. Indeed, despite an occasional over-effusiveness of line, the pictures reveal a vivacity of rhythm, a dignity of pose, and a majesty of conception which place them exceptionally high in the canon of Romanesque. A drawing in a text of St Augustine[209] of St Rupert receiving a manuscript from Archbishop Eberhard is firmly linear, and the drawing in a book of Necrologies[210] of Christ raising Lazarus from the dead has a quality of calm and a fine compositional balance [302]. Also of excellent quality are the vignettes of the early story of Adam and Eve around the first initial of a three-volume Bible[211] [303]. They were probably influenced by Hirsau or Regensburg, though the geometric construction of the initial is Italianate. On the other hand, the commanding figure of Christ in Majesty on the fly-leaf of a manuscript in Vienna[212] [304] is Byzantine in its posture, its drapery folds, and its weighted rhythms, though

302. Salzburg: *The Raising of Lazarus*, from a Book of Necrologies, MS. A.IX.7, p. 128. Third quarter of the twelfth century. Salzburg, Stiftsbibliothek St Peter

303. Salzburg: Genesis initial, from a Bible, MS. A.XII.18, folio 6. Third quarter of the twelfth century. Salzburg, Stiftsbibliothek St Peter

thoroughly Western in being drawn instead of painted, and in the Romanesque strength and clarity of the figure.

At the same period at Mondsee, an abbey about twenty miles east of Salzburg, a series of manuscripts was produced which were associated with a scribe and artist named Liutold.[213] He first comes to attention as the author of four epitaphs commemorating Abbot Conrad II, who was murdered in 1145, and he seems to have been active from the later 1140s until *c*.1170. Two of his manuscripts are introduced by quite lengthy verses in which he expresses his fervent hope that his labours will secure him eternal life. The verses that preface his most sumptuous work, a Gospel Book now in Vienna,[214] inform us that he both wrote it and 'decorated it to the best of his abilities' (though the hands of two different artists can be detected in the illumination). The 'portraits' of the evangelists and eight scenes of the Annunciation, the Nativity, and incidents from Christ's Passion and Resurrection are stylistically strongly akin to the art of the metropolis, but the simple construction of the evangelist 'portraits', with the writer holding a long scroll and sitting beneath his symbol which issues from the clouds, harks back to the scheme of the early-eleventh-century Gospels from Michaelbeuern.[215] Liutold's second important production was a Passional[216] with four historiated initials and two pen-and-ink drawings in which the terrain covered

with vegetation at the bottom of the picture of St Peter investing St Eucharius[217] seems again to have been inspired by Salzburg art of an earlier period. Liutold's hand is to be traced once more in the large initial with pictures of Archbishop Frederick of Cologne and Rupert of Deutz in a manuscript of Rupert's Commentary on the Apocalypse.[218] Rupert had pursued part of his career at Siegburg, where Abbot Conrad II had formerly been a monk, and this may help to explain the choice of subject. A number of other manuscripts, including the Walther Breviary, have been assigned to the 'Liutold group', though without convincing justification.

Salzburg itself continued to produce important illuminated manuscripts until the very end of the century, and also to absorb further waves of Byzantine influence, as we can see in the accomplished and richly illuminated St Erentrud Orational[219] of about 1200 with its zodiac illustrations in the Calendar, its numerous initials, some full-page and many historiated, and its one independent picture of Christ between St Peter and St Paul [305].

Although Salzburg had some influence on the illumination of Lower Austria, particularly on the types of heads and the treatment of drapery folds[220] at Heiligenkreuz and Klosterneuburg,[221] the manuscript painting of the area was generally of a much simpler kind, partly no doubt because

304. Salzburg: *Christ in Majesty*, drawn on a fly-leaf of a theological work, MS. 953. *c.* 1180. Vienna, Österreichische Nationalbibliothek

305. Salzburg: *The 'Traditio Legis'*, from the St Erentrud Orational, MS. 15902, folio 113 verso. *c.* 1200. Munich, Bayerische Staatsbibliothek

(with the exception of Klosterneuburg) the houses concerned were Cistercian, and therefore averse to artistic embellishment. Lower Austrian styles were related, particularly those of Heiligenkreuz and its daughter house, Zwettl. In the third quarter of the century, both favoured decorative initials, though Heiligenkreuz also produced one or two historiated ones, of which the most interesting, in a copy of St Augustine's *City of God*,[222] shows Plato writing at the behest of Socrates, with at his ear a head inscribed *Deus Socratis*, perhaps to indicate that Plato's source of inspiration was Socrates' celebrated *daimon*. The most important production at Zwettl was a three-volume Lectionary[223] to be dated *c.*1175 which has a number of initials and miniatures with figures and scenes from the Old and New Testaments. Twenty-seven full-page illustrations of constellations in a text from Klosterneuburg of Bede's *On the Nature of Things*[224] of about 1175 are considered so exceptional that they are thought to have been made by outsiders.

That Salzburg influenced the illumination of Upper Austria too is clear both from a Missal made for the house of St Florian[225] which shows similarities to the Walther Breviary,[226] and from a stylistically related Book of Pericopes[227] from Passau which belongs to the second half of the century.

Salzburg was not only a distinguished centre of illumination but also a prominent centre of wall painting. Indeed, Buberl[228] took the view that it was the wall paintings commissioned by Archbishop Conrad (1106–47) for new buildings – rendered necessary by a devastating fire of 1127 – that primed the pump of artistic activity in Salzburg in the second quarter of the twelfth century and in its middle decades. Of the murals that we know from historical records were painted for the cathedral and the abbey church of St Peter, all that is left is the statuesque and Byzantinizing personification of Terce (the third hour of the monastic office) in the abbey church of St Peter [306]; stylistically very close to figures in the Admont Bible,[229] it probably belongs, like them, to the 1140s. Some equally fine but better preserved, more than life-size half-figures in St Maria am Nonnberg[230] are a little later, though still mid-century. Twelve remain, in differing states of preservation, in niches in the west and north walls of the Romanesque church of the nunnery; nine have been identified with varying degrees of probability as St Augustine, St Benedict, St Rupert (founder of Nonnberg and patron of Salzburg), St Gregory, St Wolfgang, St Laurence, St Pantaleon, St Florian [307], and St Stephen. Their two artists employed the methods of painting advocated by Theophilus only a few years earlier, and they are stylistically

related to the manuscript art of Salzburg, most particularly to the drawing of Eberhard presenting a book to St Rupert in the Salzburg manuscript of St Augustine referred to earlier. The paintings of feet above the half-figures presumably belonged to other large-scale figures now lost.

The murals in the small Johanneskapelle,[231] just outside the village of Pürgg in Styria [308], are so close in style to the illumination of the Walther and Admont Bibles that von Baldass takes the view that they were made by the same Salzburg workshop.[232] Weiss on the other hand, noting that some of their details suggest a later date, emphasizes their connections with the Walther Breviary[233] and dates them – quite persuasively – around 1165.[234] The abbey of Admont owned estates at Pürgg, and one of the two donors shown in the paintings is thought to represent one of its abbots, Gottfried I, who died in 1165. There may also be a reference to a series of homilies he wrote in the painting of the Feeding of the Five Thousand.[235] The other donor is believed to be Ottokar III, margrave of Styria, who died in 1163.

Many of the paintings that originally clothed the whole church are still in place, and now that the unfortunate effects of nineteenth-century restorations have been reversed, they are in reasonably good condition. Their wide-ranging themes include the Lamb of God with evangelist symbols, saints, figures from the Old Testament, and scenes from the New. Byzantine influences are apparent in the iconography, especially in the scenes of the Annunciation, the Nativity, and the Feeding of the Five Thousand, and also in the admirable style of such figures as those of the Virgin in the Annunciation and the Nativity. The themes of two of the paintings are unusual: one, showing the virtues of Mercy and Truth and (originally) Righteousness and Peace mentioned in Psalm 85, may allude to St Bernard's sermon associating them with the coming of the Redeemer;[236] the other is an unusual representation of a castle being defended by mice and assaulted by cats [309]. This should not be taken at face value as one of those 'vain' and 'meaningless' paintings pilloried by the *Pictor in Carmine*, for it probably alluded to a serious allegorical text yet to be identified but for a time thought to be a Byzantine work by Theodoros Prodromos; though this source is now rejected, it would fit in with the fact that the duke of Austria of the time was married to a Byzantine princess.

BAVARIA

In the twelfth century Salzburg, the foremost art centre of the south-eastern empire, naturally influenced the painting of Bavaria, to which it then belonged. Indeed, Sedlmayr believed that some of the most important surviving Bavarian murals of the period, those in the church of the nunnery of

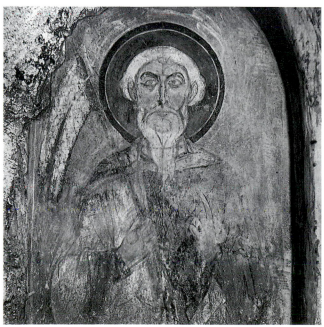

306. Salzburg, St Peter, nave south wall, *Personification of Terce*. Wall painting. c. 1140–50(?)

307. Salzburg, St Maria am Nonnberg, west wall, *St Florian*. Wall painting. c. 1150

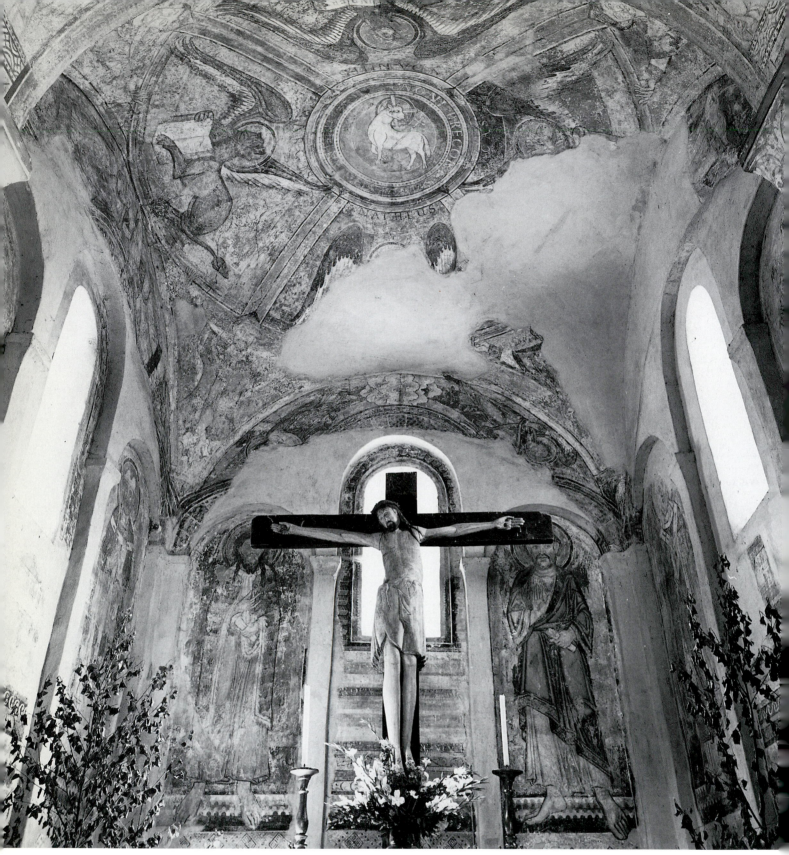

308. Pürgg, Johanneskapelle, east end. Wall paintings. *c.* 1165

Frauenwörth, were made by Salzburg artists,[237] and certainly their style is Salzburg-dominated. They are more dynamic than those of Nonnberg, but they share some of the Nonnberg stylistic features and employ the same techniques for wall painting, as advocated by Theophilus. Sedlmayr ascribes the Frauenwörth murals to the time of Archbishop Conrad I

(1106–47), but Demus compares them to the miniatures of the Pericope Book from Passau,[238] and places them as late as the 1160s.[239] Perhaps a date between 1140 and 1160 might be appropriate. The paintings are in the choir, on the soffits of the arches, and high up on the walls above the Gothic vaulting. On the arches are the remains of a Paradise with

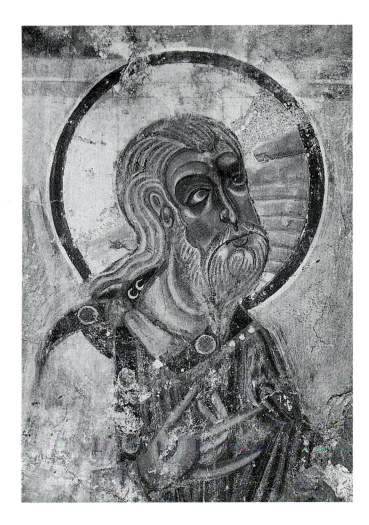

309. Pürgg, Johanneskapelle, nave south wall, *Battle between cats and mice.* Wall painting. *c.* 1165

310. Frauenwörth, nunnery church, choir, *The prophet Isaiah*(?). Wall painting. *c.* 1140–60(?)

the Tree of Life, doves, and a bust of Christ, and on the walls, considerably damaged, are symbols of virginity including Ezekiel's vision of the 'porta clausa' through which only the coming Prince could enter (XLIV, 1–3) which, we have already seen, was traditionally interpreted as a prophecy of the Virgin Birth. Here we reproduce a head thought to be that of Isaiah [310].

The church of Frauenwörth was under the patronage of the Virgin, and so also was the infirmary chapel dedicated in 1123 at the abbey of Prüfening, just outside Regensburg. According to the monk Boto, writing in the third quarter of the twelfth century, its paintings consisted of a Marian cycle comprising the Nativity of the Virgin, the Annunciation, the Nativity of Christ, the Presentation in the Temple, and the Assumption.[240] This description forms part of Boto's relation of a vision he had in his younger days, at the time the paintings were being made, of the Virgin walking through the chapel, carefully inspecting the paintings, and joyously expressing her thanks to the community for showing their veneration of her in this manner. Unfortunately the chapel has gone, so nothing remains of this work, but there are important survivals in the main abbey church, dedicated to St George.[241] The paintings of the central apse were lost in a seventeenth-century rebuilding, but those of the main choir survive, their iconography more or less intact; their style, however, we can no longer judge on account of a thoroughgoing restoration at the end of the nineteenth

century, which fortunately spared further fragmentary paintings in the two lateral choirs and on the four pillars of the crossing. The church, consecrated in 1119, had been vaulted by 1125, and it is likely that the decoration was carried out in the immediately following years, though the figures on the crossing pillars apparently belong to a second campaign[242] and may be as late as the mid century.

A coherent programme underlies the paintings. In three registers on the north and south walls of the main choir are arrayed a host of prophets, martyrs, confessors (both clerical and lay), monks, and hermits, all but the monks and hermits richly attired in Byzantinizing garments. The figures in each of the top two registers grasp a lengthy scroll inscribed with the praises sung to the Lord in the Te Deum and incline their heads towards the apse, where Christ must originally have appeared as the King of Glory of the Ambrosian hymn. This congregation of the faithful Church adoring Christ seems to be symbolized in the vault of the choir by the majestic enthroned Ecclesia, identified by a surrounding inscription as the bride of the Song of Solomon who reigns with the bridegroom, Christ, in eternity. The programme appears to owe something to Honorius of Autun, who wrote on the Song of Solomon and is believed to have spent a part of his life in Regensburg.[243] Ecclesia's inscription describes her as being 'resplendent with the gems of the virtues', and indeed the three divine virtues, Fides, Spes, and Caritas, and the three monastic ones, Mansuetudo, Continentia, and

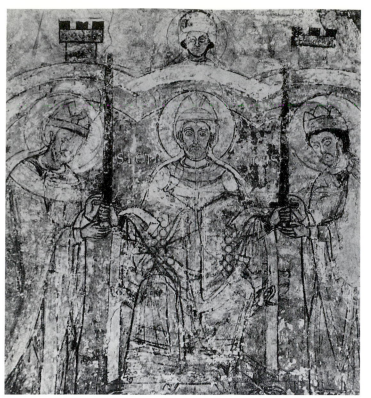

311. Prüfening, St George, north-east pillar of the crossing, *St Peter entrusting the spiritual and secular swords to a bishop (or pope) and a king.* Wall painting. *c.* 1150(?)

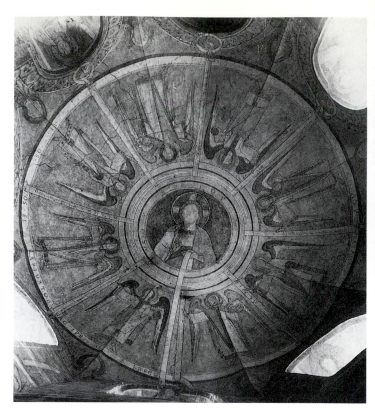

312. Regensburg Cathedral, Allerheiligenkapelle, dome, *Christ surrounded by angels.* Wall painting. 1155/64

Castitas, are personified on either side of the hand of God, on the soffit of the arch before the choir.

At the foot of each of the choir walls is a single figure: the king is thought to represent Henry V (d. 1125), monarch at the time of the foundation,[244] and the bishop opposite to be Otto of Bamberg (d. 1139), the founder of Prüfening. It has been argued that their appearance in association with the 'living Church' in the registers above demonstrates the view that the Church embraces within itself both *regnum* and *sacerdotium*, both worldly and spiritual rule[245] – a basic belief of the reformers of the later eleventh and early twelfth centuries with whom Prüfening was in tune: indeed, its first abbot had come from Hirsau, the great focus of the reform movement in southern Germany. On the north-east pillar of the crossing, St Peter, the first head of the Church, invests a bishop (or pope) and a king with their powers by offering each a sword [311], to illustrate the same reformist theme. It was to recur, with a slightly different iconography, on one of the now lost tapestries of the abbey of SS. Ulrich and Afra at Augsburg[246] (itself a centre of Hirsau reform), where the Old Testament figures of Moses, Aaron, and Hur were also included; these must also be the figures on the south-east pillar at Prüfening, prefiguring the investiture scene opposite with its representation of Moses' delegation of power to Aaron and Hur (Exodus XXIV, 14).

The walls of the two lateral choirs bore scenes from the lives of St John the Baptist and St Benedict, to whom the altars were dedicated. Fragments survive in an unrestored condition. In the north choir there are illustrations of the Baptist preaching in the wilderness, his appearance before Herod, his beheading, and his apotheosis. On the vault – appropriately enough, since John had referred to Jesus as the Lamb of God – is the Apocalyptic Lamb in the Heavenly Jerusalem. Some of the fragments of the St Benedict paintings in the south choir are indecipherable, but one identifiable scene would have had a particular significance for the Prüfening monks:[247] the story of the unsuccessful attempt made by the monks of Vicovaro to poison the saint because they were so discontented with the strictness of his rule. This had an obvious parallel with the fate of Prüfening's first abbot, Erminold, who, because of his stern discipline, was struck down and killed in 1121 by a disaffected monk 'aroused by the incitement of the devil'.

In the Allerheiligenkapelle,[248] the chapel of All Saints built by Bishop Hartwig (1155–64) in the cloisters of Regensburg Cathedral for his own lying-in-state and burial, the paintings significantly include a scene of the elect on the Day of Judgement. The chapel, unusually for northern Europe, incorporates a dome over a high drum. Kitzinger points out its relationship to the domed churches built by Roger II in Sicily in the preceding two decades,[249] and – though in fact the German composition is more formalized – rightly associates the bust of the Almighty with surrounding angels in the dome [312] with a mosaic in Roger's Palatine Church in Palermo[250] which is dated 1143 by inscription. The Sicilian influence may be explained by Hartwig's connections with the south; he was related to the duke of Carinthia and the margrave of Istria, and he was, besides, himself in Italy for two years. Endres has done much to clarify the programme of the paintings, today but shadows of their former selves after limewashing, being uncovered in the nineteenth century, and restoration and de-restoration. Endres sees it as an illustration of the readings for the vigil and day of All Saints from chapters IV, V, and VII of the Apocalypse, as interpreted by Rupert of Deutz.[251] So, below the apex of the dome are half-figures of eight of the elders of the Apocalypse and

personifications of the three cardinal virtues, Faith, Hope, and Charity. In the squinches are the 'four angels standing on the four corners of the earth', and in the central apse is an equally large-scale figure of the 'angel ascending from the east'. On the soffit of the arch before the altar and in the window recesses behind it are scenes of the 'sealing' of the twelve tribes of Israel, and in the side apses are the chosen of the Lord from both the spiritual and the secular spheres. Scrolls like long streamers cut across the compositions in the manner typical of Regensburg and Prüfening.

The impact of Salzburg was even greater on the manuscript paintings of Bavaria than on its murals. A particularly good example is the great Bible, known after the library which houses it today as the Erlangen Bible,[252] which was acquired in the Middle Ages, either upon its completion or some years later, by the canons of St Gumpertus at Ansbach (Franconia). Georg Swarzenski has given reasons for supposing that the Bible originated in a centre that produced manuscripts for export[253] whose location is unknown, but which certainly had close associations with Salzburg, for the taste for architectural frames to the pictures is a Salzburg one, and so too is the basic style of the initials. The Bible's cycle of paintings resembles those of the Walther and Admont Bibles, and echoes of the manuscripts linked with Archbishop Eberhard of Salzburg (1147–64) are noticeable in the drapery style; some would therefore give the Bible to Salzburg itself, though others argue from its Ansbach ownership and from some iconographic and stylistic connections with Regensburg work that it came from somewhere north of Salzburg, in present-day Bavaria – Lutze, indeed, saw it as representing 'a Bavarian filiation' of the Salzburg style.[254]

The Bible has sixteen historiated initials, sixty-five decorative ones mingling foliage, birds, and dragons (some are pen-and-ink and others painted), and thirty-nine pictures in two main formats: in the first, the scenes are set in a lozenge or oval or roundel against a design of stylized foliage which binds them together [313]; in the second, the scenes are in registers within a surrounding rectangular frame, punctuated by architectural detailing. Both offer scope for lavish illustration, and the Bible has indeed the largest Romanesque cycle of manuscript illustrations to have come down to us from Germany or Austria. It is much richer than the cycles either of the Walther or of the Admont Bible, and elaborates what it borrows by original interpretations of its own, for example by focusing on the life and miracles of St Peter in the scenes introducing the Acts of the Apostles; by prefacing the Apocalypse with key events from the life of Christ; and by illustrating the minor prophets with examples of the theological or typological fulfilment of their prophecies taken from St Jerome's letter to Paulinus.[255] Thus Hosea's exclamation 'O death! I will be thy death!' (XIII, 14) is associated with Christ facing a personification of death; Joel's instruction to the bridegroom to leave his chamber (II, 16) is related to the mystical marriage of Christ and his Church; Nahum's reference to the feet of the herald of peace upon the mountains (I, 15) is conceived as an anticipation of the Sermon on the Mount, and so on. The figures themselves have a certain liveliness, but the artistic merit of the paintings lies chiefly in their finely controlled ornamental sense, which integrates the illustrations into an overall work of art.

The Erlangen Bible contains notes[256] which throw an interesting light on how money might be raised to buy an expensive manuscript towards the end of the twelfth century. They imply that the canons of Ansbach negotiated the purchase through the agency of a deacon of the church, Gotebaldus (whose death in 1195 provides a *terminus ante quem* for the manuscript: its style indicates a date not more than twenty years earlier). The Bible cost twelve talents, and Gotebaldus's one talent was the only church contribution: the rest of the money was given by secular donors as an act of piety. As we know, the Italian great Bible at Certosa di Calci[257] was similarly acquired with the help of secular donations, and they were occasionally invited for the purchase of other art objects such as a splendid ciborium for the monastic church of Petershausen.[258]

Within the area covered by present-day Bavaria the key centres of manuscript illumination in the twelfth century were Regensburg and Prüfening. They are normally bracketed together as the Regensburg–Prüfening School, not so much because of their geographical proximity as because of the impossibility of distinguishing their manuscripts on the basis of either script or illumination. Boeckler has shown that this joint school was initiated by Prüfening,[259] which indeed was better placed for the office than St Emmeram, deeply involved

313. Salzburg/Bavaria: *The conveyance of the Ark of the Covenant to Jerusalem*, from the Erlangen Bible (once owned by canons of Ansbach), MS. 1 perg., folio 161 verso. *c.* 1175–95. Erlangen, University Library

314. Regensburg: The Creation of the Stars, from a copy of works of St Ambrose, Clm. 14399, folio 52. *c.* 1165–70. Munich, Bayerische Staatsbibliothek

315. Prüfening: *Man as microcosm*, from the Prüfening Miscellany, Clm. 13002, folio 7 verso. 1158/65. Munich, Bayerische Staatsbibliothek

as the Regensburg house was in the Investiture Contest: in 1104 its abbot Pabo, a keen supporter of the papal cause, was driven out by adherents of the imperial party, only to be reinstated at some time between 1117 and 1124 as a result of pressures from Rome, but to be again expelled in 1132, and finally reinstalled in 1141. St George at Prüfening was a much younger monastery than St Emmeram – it was only founded in 1109 – but it was particularly fortunate in its first two abbots, Erminold and Erbo, who took a special interest in books.

The Regensburg–Prüfening School was to a large extent dependent on Salzburg, and it has in fact been described as an offshoot of it.[260] Thus in a Regensburg copy of *c.*1165–70 of works by St Ambrose,[261] seven full-page pictures of the Creation [314] were largely borrowed from the Admont Bible;[262] a mid-twelfth-century Isidore from Prüfening[263] has a drawing of Adam holding a full-page table of consanguinity which is linked with a similar representation in a Salzburg manuscript;[264] and a delicately penned martyrdom of St Andrew in a Prüfening collection of the Lives and Passions of apostles and saints[265] of about 1175 has similarities with pictures in two Salzburg sources.[266] Yet by focusing on the essentials of the composition Regensburg–Prüfening was able to shape a distinctive artistic personality of its own, producing pictures both lucid in statement and economical in detail. An example in the section of a Prüfening Miscellany[267] completed in 1165 is a portrayal of man as microcosm of the world [315] whose clarity of exposition is reinforced by the geometrically

disposed inscriptions, rapidly conveying what Honorius of Autun took some pages to expound: that man is an image of the universe in miniature, his bodily nature created from the four elements, his five senses deriving from the same elements, and his head a likeness of the solar system, its seven orifices corresponding to the planets. There is something comparable in the *Hortus Deliciarum*.

One Prüfening manuscript,[268] probably made between 1160 and 1165, has an intriguing picture, referred to in Chapter 3, of the celestial aspirations of its scribe-artist. In the upper half, Isidore, the author of the text, sits behind his writing-desk and requests the man who had persuaded him to write it, Bishop Braulio, to encourage also the reading of it. In the lower half – which is of greater interest here – the scribe-artist, who has been identified as the monk Swicher of Prüfening, portrays himself after his death, with this very book beside him being used to tip in his favour the scales with which the archangel Michael is weighing his good deeds against his bad [27]. A thwarted devil flees the scene, while an angel emerges from behind a cloud to gather up his soul as the enthroned Christ at the foot of his pallet gestures in welcome.

The Prüfening Miscellany mentioned above[269] is of two dates: 1158 and 1165. The later part includes on folio 5 verso a catalogue of the works of art belonging to the house, attractively written on a kind of banner with two 'ribbons', one held by St Paul, the other by the metropolitan archbishop Eberhard, inscribed with an anathema against anyone who

should diminish these monastic treasures. St Benedict's insistence in his Rule that God and his angels are ever present (cap. XII) is reflected both in the picture of Christ and two of his angels, and in the catalogue's assertion that it was written in the sight of the Lord. Bust-figures represent the abbey's patron saint, its founder, and the current and the most recent abbots, Eberhard and Erbo, all of whom are referred to in the preamble. The community itself is symbolized by a group of heads singing their approval below.

Folios 3 verso and 4 of the same manuscript embody a theological and moral symbolism (to be copied at Scheyern in the thirteenth century[270]) that epitomizes the careful thought underlying the more profound works of art of the Middle Ages. On the simplest level, the twelve scenes – six to the left and six to the right [316, 317] – contrast virtues and vices. There is however much more to it than that, for the pages have been composed with extreme subtlety and were clearly intended for the discerning. Latin hexameters at the top advise against carnality and recommend a life irradiated by reason. Expanding on the contrasts and connections between the two modes of existence, the pictures go on to suggest that vice is essentially a distorted reflection of virtue, an abuse of what virtue puts to good ends. In the scene exemplifying Greed (folio 3 verso, top left), the Daughter of Babylon holds a scroll reading 'Let us fill ourselves with costly wine' (Wisdom II, 7), while in the balancing picture of Charity (folio 4, top right), David's scroll is inscribed 'They shall be made drunk by the richness of thy house' (Psalm 35, 9): thus the wine of the vine and the wine of the spirit are shown to be related but opposed. Other instances of relation/opposition are offered by similar figures holding quotations. The very forms of some of the drawings press home the same point: the horse-drawn chariot that hastens Ahab to his death (folio 3 verso, bottom right) has its counterpart in the horse-drawn chariot that raises Elijah, Ahab's scourge, to heaven (folio 4, bottom left), and the self-seeking Haman is shown ending his life on the very gallows he had set up for the long-suffering Mordecai, whose own elevation to wealth and glory is shown opposite (middle registers, left and right respectively). These miniatures have in common with the lost tapestries of Germany, described earlier, a reliance on the viewer's ability to pick up the complex theological and scriptural allusions in their combination of pictures, hexameters, and inscriptions. Clearly intended for unhurried contemplation, they remind us that, for the educated observer, medieval art was to be reflected upon as well as to be enjoyed.

Symbolism also infuses the cycle of dozens of coloured drawings in a Regensburg manuscript[271] of c.1170–5 on the theme that, from Adam until the birth of Christ, some had always been vouchsafed a vision of the Redemption that would be achieved through Christ's sacrifice on the Cross. That such visions were bound to be imperfect is expressed pictorially by the deliberate incompleteness of the Crucifixion scene on folio 8 verso, where only Christ's head, hands, and feet are shown. It has to be admitted that the evidence proffered by the text to support this theory is highly strained: for example, a false witness is the only link between Naboth's death by stoning (I Kings XXI, 13) and the Crucifixion of Christ, and Job scraping his boils on a dunghill is given as a somewhat tenuous prefiguration of Christ scraping away the depravity of the world by his Crucifixion. The play on words and numbers to sustain the argument is remote from our present ways of thinking and has its origin in the orthodox Pauline view that imperfect man can only 'know in part' and 'see through a glass darkly' (I Corinthians XIII, 12); indeed, St Paul's contention that a better understanding of God's divine plan might be had by seeing the Old Testament as an allegorical foreshadowing of the New is the ultimate basis of much of the symbolism of medieval art.

A full-page coloured drawing in a mid-twelfth-century text of St Ambrose[272] probably made for the abbey of Michelsberg at Bamberg is stylistically associated with the Regensburg–Prüfening School. Its primary interest for us is that in the roundels surrounding the central panel [318] are sketched out the processes by which the Romanesque manuscript was made. In two of them the skin is shown being stretched and then cut to size; in another two a monk examines his pen after trimming it, and another sets to work on the drawing; in further roundels the sewing and binding of the manuscript are shown, and the final fruit of the work is displayed centrally at the top and bottom of the page. The focus of the whole is the patron saint, St Michael, being adored by representatives of the monastery below: they may be offering him the skills that went into an illuminated manuscript. The monk drawing the gable under the feet of the saint exemplifies a conceit of the time that will be discussed in the next chapter – that of the artist inhabiting the world of his own creation.

BOHEMIA

The impact of German art was very strong in Bohemia,[273] an area that from time to time attained the status of a kingdom. Artistic influences here followed in the wake of religious reform, which stemmed largely from Premonstratensian circles in the Rhineland and especially from the abbey of Steinfeld in der Eifel, itself closely connected with Cologne:[274] indeed Gezo, the abbot of the Bohemian house of Strahov from 1143–60, had been canon and *custos* of Cologne Cathedral before moving to Steinfeld and thence to Bohemia. Godescalc, abbot of Bohemia's second Premonstratensian house at Želiv (Selau), founded in 1148, also came from Steinfeld, and had been brought up in Cologne.

The earliest remaining Bohemian manuscript with Romanesque illumination is the splendid *Codex Vyšehradensis*,[275] a Gospel Book probably made for the coronation of King Vratislav I in 1085. It has a number of decorative initials and, in an initial on folio 68, a 'portrait' of Bohemia's patron saint, Wenceslas. There are, besides, the traditional evangelists and a Christ in Majesty, as well as a particularly early portrayal of the ancestors of Christ, shown as busts inside linked medallions and lozenges on four highly ornamental pages. Four Old Testament scenes presage the Redemption, and there are thirty scenes from the New Testament, mostly set in two or three panels to the page, with explanatory texts. The scenes are iconographically rich and have a liveliness deriving largely from a happy combination of rich and more delicate colours. The manuscript is thought by Czech scholars to be Bohemian, though the style is dominated by Germany, especially by the

316 and 317. Prüfening: *Vices and Virtues*, from the Prüfening Miscellany,
Clm. 13002, folios 3 verso–4. 1158/65. Munich, Bayerische Staatsbibliothek

IQRENTES·AVT·DÑM·N·MIN·OI·BOHO·

FILII·IACOB IOSEPH PRVDENTIA PRI· HIERL'M FOR DAVID

CARITAS FILIA·SYON

HOS·AVT·SVRREXION? 7 ERECTI·SVO? ET·E·XALTABVNT· CORNVA·IVSTI·

IOSVE AARON MOYSES MANSVETV? MARDOCHE? AMAN LONGANIMIT?

MICHI·AVTE·ADHERERE·DO·BONV·E· HVMILIBVS·AVT·DAT·GRAM·

HELYSEV? HELYAS SOBRIET? SAMVEL D·D HVMILITAS

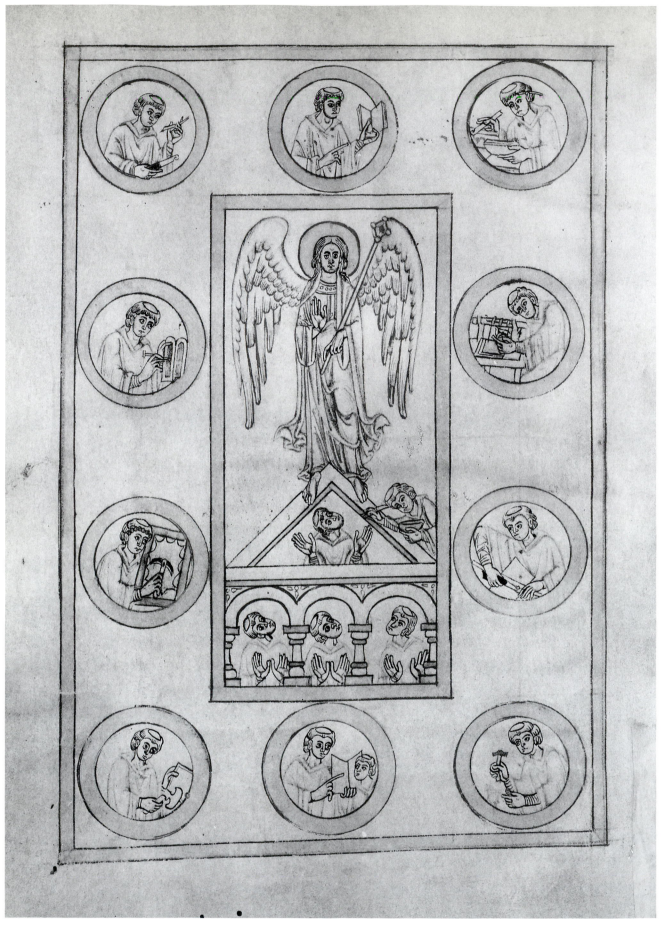

318. Bamberg(?): *St Michael surrounded by scenes showing the stages in the production of a manuscript*, from a St Ambrose, MS. Patr. 5, folio 1 verso. Mid twelfth century. Bamberg, Staatsbibliothek

so-called Bavarian monastic school, and is related to that of three other manuscripts, two now in Poland (which will be referred to in the Polish context) and a Gospel Book in the St Vitus Chapter Library in Prague.

The influences from Cologne that prevailed in twelfth-century Bohemia are especially evident in the two most important Bohemian manuscripts of the period, a copy of St Augustine's *City of God*,[276] and an unfinished Breviary.[277] Both were illuminated by a certain Hildebert, who was blessed with a refreshing tendency to irreverence. His best known picture – added to an almost blank leaf at the end of Book XI of St Augustine's text – shows him venting his anger on a mouse who has knocked his roast chicken from the table and is now nibbling his cheese. Hildebert calls on God to send the creature to perdition [319], but does not intend to leave the Almighty unassisted, for he has picked up a missile to speed the animal on its way. A carved lion supporting his drawing-board modestly averts its eyes from this fractious scene, and an assistant below, one Everwin, continues unconcerned with his sketch of foliate decoration. (It was Everwin who collaborated with Hildebert on a number of decorative initials in the St Augustine.)

The sharp linearization of the draperies in Hildebert's self-portrait is so close to the style of two Cologne manuscripts[278] that we must suppose that he had either been trained at Cologne or had at least served under a Cologne master. He and Everwin – both seculars – make another personal appearance in the Bohemian Breviary, where the assistant rushes towards his master, who is putting the final touches to an inscribed scroll. At the other end of the scroll is a seated scribe dressed as a religious. This scene is but a visual footnote to the main picture, a somewhat crowded one of St Gregory with local personalities.[279] They include Bishop Heinrich Zdik of Olomouc (Olmütz), in office from 1126 to 1151, who was instrumental in introducing the Premonstratensians to Bohemia, and a duke – probably Sobieslav Udalrich, who had given encouragement to the new Premonstratensian house of Strahov, which is represented by the abbot and some of the community. An exceptional element is the two laymen who support the structure in which St Gregory sits who are thought to represent the builders of the abbey. The identification of local dignitaries enabled Boeckler to date the manuscript between 1135 and 1151, and he suggested that the miniature commemorated the settling of Premonstratensians in the new house in 1142–3.[280]

The influences from Cologne which, with others from Bavaria, are seen in the initials of the Breviary reappear at the very end of the century in another copy of St Augustine's work[281] which has, on folio 1 verso, a painting of the City of God [320]. Its focus, the Trinity, recalls earlier manuscripts of Cologne in both style and iconography,[282] and the figure of God in particular, supporting in his extended hands discs bearing images of the Holy Lamb and the Holy Dove, is reminiscent of a similar subject in the Gospel Book from St Aposteln. Around are the symbols of the evangelists, and the fact that the blessed include a special contingent from Bohemia prompted one Czech scholar to describe the illumination as 'l'un des plus anciens témoignages de la prise de conscience nationale en Bohême'.[283]

Bavarian influence also had an impact on Bohemian wall

319. Bohemia: *The artist Hildebert disturbed by a mouse*, from St Augustine's *City of God*, MS. A.XXI/I, folio 153. *c.* 1135–50. Prague Cathedral, Chapter Library

paintings, of which the most important, dated by a later but still valid inscription to 1134, are in the round chapel of the castle of Znojmo.[284] Restoration in the nineteenth century and de-restoration since have not robbed them of their quiet charm. In the apse is a Christ in Majesty (in poor condition), in the dome are seated evangelists and seraphim, and lower down on the round walls are Infancy scenes. The castle was the residence of a scion of the ruling Přemysl family, and, in two registers between the dome composition and the Infancy scenes, twenty-seven members of the dynasty are shown, complete with shields and banners [321]. The sequence opens with the supposed origins of the line, including the messengers from the legendary Princess Libuša approaching Přemysl the Ploughman in order to invest him with the cloak of princedom. The princely donor offering a model of a church and the lady holding a vessel on the triumphal arch are presumably also members of the family.

The paintings in St Clement at Stará Boleslav[285] of the apostles, scenes from the life of St Clement, and allegorical figures are more conventional. They are in poor condition, but the allegorical figure on the west wall that has suffered least conveys something of their original fine quality. It has stylistic affinities with the murals of Prüfening, to which it can be related in date.

The apse of the church of St Peter and St Paul in Albrechtice is dominated by a mural of Christ in Majesty. On each side are figures, with busts on the soffit of the arch in front. Below Christ are seated apostles and, further down, a cross flanked by two angels with the saved on their right, and on their left the damned being hustled away to hell. The

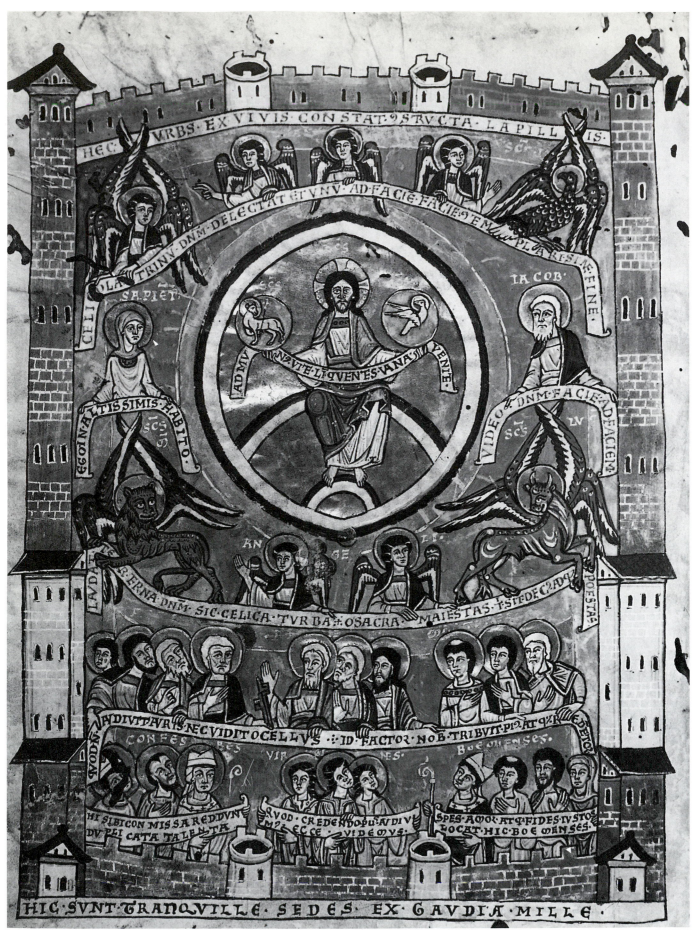

320. Bohemia: *The City of God*, from St Augustine's *City of God*, MS.
A.VII, folio 1 verso. End of the twelfth century. Prague Cathedral, Chapter
Library

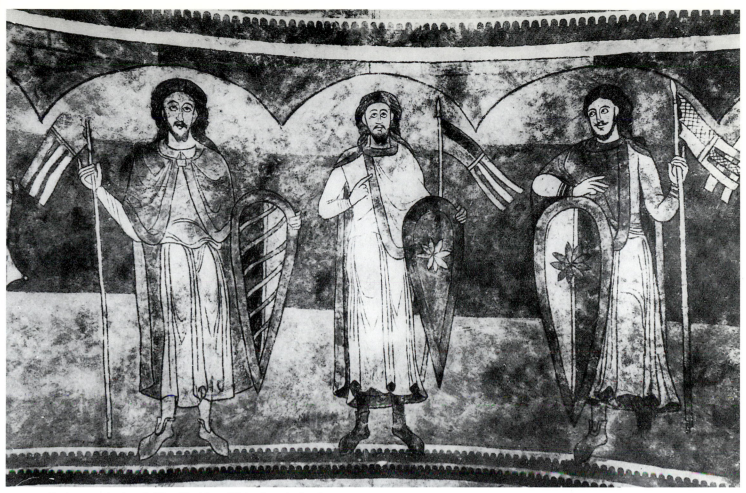

321. Znojmo, castle chapel, *King Vratislav of Bohemia and other figures.*
Wall painting. 1134

paintings probably belong to the third quarter of the twelfth century.

The murals in the church of St James at Rovná[286] are partly of the end of the twelfth century and partly of the second quarter of the thirteenth. Of the twelfth-century work, the Majesty in the apse has all but disappeared, and the other paintings are considerably damaged, although the apostles standing under arcades on either side of a second figure of Christ below the Majesty are recognizable if incomplete. Beneath them are fragmentary scenes from the life of St James, and figures of Cain and Abel can just be made out on either side of the triumphal arch. On the side walls are twelfth-century paintings of the Infancy and other Christological scenes, all in very poor condition.

POLAND

Bohemia was briefly united with Poland under Boleslav the Mighty (992–1025), and Poland's first experience of illustrated manuscripts was in the wake of alliances and diplomatic missions. Thus the sumptuous Egbert Psalter, discussed in an earlier chapter,[287] may have been brought to Poland by Richeza, daughter of the Count Palatine of Lotharingia, when she married Mieszko, son of Boleslav the Mighty, about 1013, and an *Ordo Romanus*[288] which reached Poland around 1027 was a gift to the same Mieszko from Matilda, wife of Duke Frederick of Upper Lotharingia, who

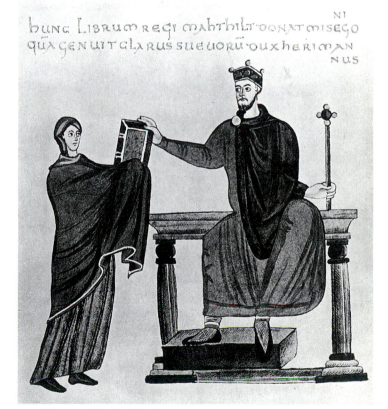

322. Trier region(?): *Matilda of Lotharingia presenting the manuscript to King Mieszko II of Poland,* from a nineteenth-century copy of a lost *Ordo Romanus,* folio 3 verso. Originally of *c.* 1027

was seeking allies against the Emperor Conrad II. The *Ordo Romanus* is important in providing, in the picture of Matilda making the presentation to the king [322], the earliest known 'portrait' of a Polish monarch. It belonged to the tradition of ruler 'portraits' initiated by the Gregory Master in his Otto II painting now in the Museé Condé [126] and perpetuated in another imperial painting now at Bamberg.[289] Though clearly intended for Poland, the picture of Mieszko was presumably painted in Germany, in the Trier area. The original manuscript is lost, and our reproduction of the dedication page is taken from a copy made by A. Dethier in 1842.[290]

Other alliances seem to have brought Bohemian art to Poland, for a sumptuous, richly decorated late-eleventh-century Gospel Book in the cathedral of Gniezno (Gnesen)[291] is thought to have been a gift from Judith, daughter of Vratislav of Bohemia, who married Vladislav Herman in 1080. It is written in gold, and its full-page pictures against gold backgrounds include evangelist 'portraits', Gospel scenes, sometimes two or three to a page [323], and episodes from the life of the Virgin. The paintings are stylistically and iconographically akin to the Vyšehrad Gospels, itself German in inspiration. The cathedral of Płock has a closely related golden Gospel Book (now in the National Museum Library of Cracow[292]), also of the later eleventh century, which is in a quieter style. Its evangelists, patriarchs, and prophets are

set within diamond frames. Scenes from the life of Christ include on folio 8 a roundel supported by two angels containing a curious picture of Christ sitting on the knee of King David. In two further roundels above and below are figures of patriarchs.

Indigenous painting seems to have started only in the twelfth century in scriptoria at Tyniec, Lubiń, Cracow, and possibly Płock and Lubiaż. A Pontifical of the bishops of Cracow[293] of the turn of the eleventh and twelfth centuries was certainly made in Poland, for its original litany includes the Bohemian-Polish saints Wacław and Wojciech (Adalbert). Its colourful initials are apparently of north French inspiration. The much more sophisticated illumination of a Bible fragment from Płock Cathedral,[294] made in the second quarter of the twelfth century, was lost in the Second World War. Its initials were set against coloured backgrounds and decorated with an acanthus-leaf interlace of great elegance, with figures relating to the main text in 'bowers' to the side. So, on folio 14, the figure of Jeremiah illustrated the opening of his Book, and on folio 159 the Book of Tobit had a picture of the angel appearing to Tobit's son. The initials were clearly of Mosan inspiration, which Sawicka explains by the associations cultivated by Bishop Alexander (1129–56) with Liège;[295] indeed, she goes so far as to suggest that the manuscript was made in a Mosan scriptorium and completed in Poland by artists aware of Mosan models. The full-page

323. Bohemia(?): *The Descent from the Cross, the Resurrection of the Dead, and the guards sleeping at the Sepulchre*, from a Gospel Book, MS. 1a, folio 49. Late eleventh century. Gniezno Cathedral Library

324. Poland: Initial page to Genesis, from a lost Bible, MS. Lat. F. vel. I. 32, folio 6. Third quarter of the twelfth century. Formerly Warsaw, Biblioteka Narodowa

picture of David, Pythagoras, Tubalcain, and Jubal on folio 211 verso was, Sawicka believes, a Polish addition, and it was certainly very different in style and quality from anything else in the manuscript. Another lost manuscript from Płock, a Book of Homilies[296] of the third quarter of the twelfth century made for the cathedral there, had some fine initials which also showed Mosan influences, but the real peak of Polish illumination was reached in a Bible destroyed in 1944. Made in the third quarter of the twelfth century, it originally belonged to the college of canons of the Annunciation of the Blessed Virgin Mary at Czerwińsk.[297] Mosan features were apparent in all this Bible's (mostly decorative) initials and particularly in the first full-page initial to the Book of Genesis on folio 6 [324], where the scaffolding of the first IN (Principio) letters was decorated with roundels containing Genesis illustrations; further such scenes appeared among the rich and elegant scrollwork. The composition of a full-page IN (Principio) initial in a Saint-Trond manuscript[298] is very similar, with scenes in roundels set into the framework of the initial, though its pictures are not all from Genesis, and the Saint-Trond initial is more painterly and lacks the linear elegance of the Polish one.

Influences from the empire are also apparent in a wall painting discovered in 1952 in the apse of the west choir of the collegiate church of the Assumption and St Alexis at Tum, near Łeczyca.[299] The Christ in Majesty is badly damaged, and the rest of the composition is difficult to decipher but seems to include John the Baptist and the Virgin on either side of Christ: in other words, it is a Deesis. Four Tetramorphs seem also to have been part of the scheme, and there are remnants of threequarter-length apostles standing below. Dabrowski connects the work with the last phase of the building of the church, just before its consecration in 1161.[300] The mural cannot be paralleled on Polish soil, and has been stylistically associated with the lower Rhine or lower Lorraine. Its German air may possibly be connected with the fact that, at the time it was being painted, an artist with the German name of Gunter was executing a mural for Bishop Alexander in his cathedral of Płock.

DENMARK AND SWEDEN

Though outside the borders of the empire, the kingdoms of Denmark and Sweden had artistic links with the German lands, particularly with neighbouring Saxony. The ties between the monastery of St Laurence at Lund and Helmarshausen – which may even have lent some of its artists to Lund – have already been noted.[301] In the church of Finja (Scania)[302] something akin to the rather statuesque style of Helmarshausen is discernible in the monumental Christ in Majesty in the apse and in the Last Judgement on the east wall of the nave. The execution is excellent and the decoration rich, and it has been suggested that the artist may also have worked on the lost murals of Lund Cathedral, which may have been completed in time for a consecration in 1145. If so, the Finja murals too can be assigned to the mid twelfth century. Saxon influence may also be detected at Tamdrup[303] in the Jutland peninsula, where the paintings on the soffit of the chancel arch, to be dated c.1140 and among the earliest to survive in Denmark, show Cain and Abel making their

offerings to a three-quarter-length medallion figure of the Lord, who makes a gesture of blessing towards Abel. The faces have unfortunately been obliterated, but the highly linear draperies recall the metalwork techniques of Roger of Helmarshausen. There is a Saxon feel too about the figures of the fragmentary Last Judgement of the church of St Ibbs at Roskilde (Zealand),[304] where the composition is still Romanesque although it belongs to the thirteenth century.

Influences from the Channel area as well appear to have been at work on the style of the extensive cycle at Raasted in Jutland,[305] probably of the later twelfth century, and – unexpectedly – there are reminiscences of the apse programmes of Romanesque Spain in the late-twelfth- or early-thirteenth-century paintings of Lackalänga (Scania),[306] with its twelve apostles below Christ in Majesty. Italy, on the other hand, seems to have had an impact on the pictures of a donor carrying a model of the church on the chancel arch at Öfraby (Scania)[307] and at Slaglille (Zealand), and the punctuation of the border around the apse at Öfraby with heads in medallions suggests a knowledge of early Italo-Byzantine art, possibly obtained from manuscripts. Byzantine influence reached the island of Gotland in the Baltic Sea by a rather different route: it arrived via the school of Novgorod, for Gotland was on the main trade artery between Russia and western Europe and even had a Russian church at Visby on its west coast.[308] Russo-Byzantine characteristics are prominent in the unrestored painting of c.1200 of two saints in Byzantine attire on the intrados of the tower arch of the parish church of Garde,[309] where the colours and the sweeping scrollwork are typically Russian. Two similar saints appear in the contemporary murals of Källunge in northern Gotland,[310] where there are also a series of fragmentary Gospel scenes, a St George and the dragon on the east wall of the nave, and remnants of a Last Judgement on the west wall.

There are frequent family resemblances among the paintings of Danish churches: for example the apses of Alsted, Slaglille, Hagested,[311] and Saeby [325], all in Zealand, have a Christ in Majesty surrounded by symbols of the evangelists, with the Virgin and St John accompanied by two archangels or other figures to either side. A favourite theme for the under-surface of the chancel arch was the sacrifice of Cain and Abel, traditionally a prefiguration of the sacrifice celebrated in the Mass: at Ørreslev,[312] in Jutland, is an example closely related to the one at Tamdrup, though more vigorous.

Despite outside influences, the Romanesque murals of Scandinavia preserve a distinct identity. An unusual feature of the Gospel scenes painted on the square east end of the church of Raasted (Jutland)[313] is a Crucifixion that telescopes the beginning and end of Christ's ordeal on the Cross into a single scene of three small figures hammering the nails into Christ's hands and feet at the same time as Longinus pierces his side with his lance. Haastrup thinks the paintings may be of the second quarter of the twelfth century.

Rather surprisingly, the late-twelfth-century paintings on the east end of the church at Skibet (Jutland),[314] uncovered in 1951–2, include, below scenes of the Raising of Lazarus and the Transfiguration, a frieze of knights on horseback. Because this apparently incongruous subject matter is set so close to the altar it has been suggested that it refers to the Grail legend, but no convincing justification is offered, and

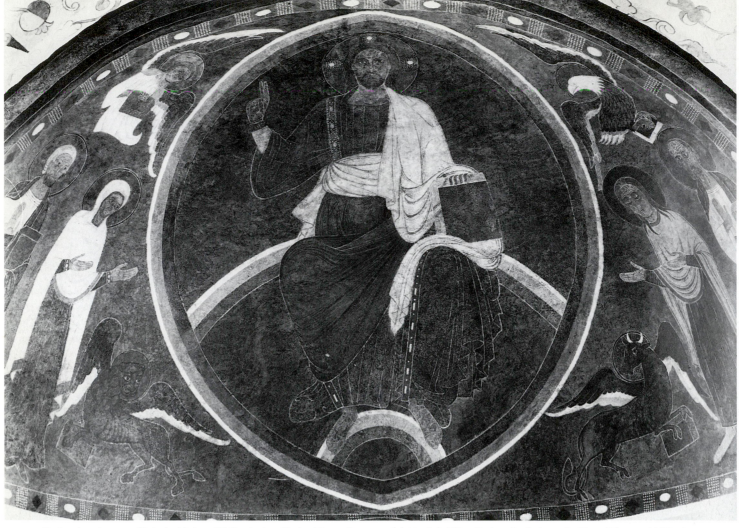

325. Saeby church, apse, *Christ in Majesty*. Wall painting. Early thirteenth century(?)

326 (*opposite*). Bjäresjö church, choir vault, *Tree of Jesse and biblical scenes*. Wall painting. First half of the thirteenth century

for the present its precise allegorical significance must remain in doubt – though it may be added that in the early thirteenth century (at Højen and Hornslet, for example) knights in combat became a feature of the nave decoration of Danish churches.

Restorations of 1963–5 at the church of Vä (Scania)[315] revealed what are perhaps the most accomplished Scandinavian paintings of the period. The church was given to the Premonstratensians by King Valdemar the Great shortly before 1170, when the donation was confirmed, and this provides an approximate date for the paintings. On one side of the entrance to the eastern apse King Valdemar offers a reliquary, and on the other his queen, Sophia, presents a model of the church. In the semi-dome of the apse is a Majesty in which Christ's feet rest on a globe bearing a picture of a basilica symbolizing the universal Church. Fragments in the chancel may have belonged to Gospel scenes. The barrel-vault of the chancel is richly decorated with an interpretation of the Te Deum, St Ambrose's hymn of praise to the Almighty which also inspired wall paintings at Prüfening in Bavaria.[316] At Vä, however, the cherubim, seraphim, angels, archangels, prophets, and saints of the heavenly choir appear either singly or in pairs, holding scrolls inscribed with verses from the Te Deum, within medallions set against a blue background sown with stars.

The elaborate Tree of Jesse flanked by scenes from the Old and New Testaments [326] in the barrel-vault of the church of Bjäresjö (Scania)[317] has parallels both in French manuscript painting of the turn of the century and in the ceiling painting of *c*.1230 of St Michael's at Hildesheim. In the apse at Bjäresjö are a Trinity with the apostles, the Virgin, and St John; on the chancel arch is a half-figure of Christ and other figures, and a Majesty is painted above the arch leading to the choir. The murals are quite extensive, but so restored as to make dating hazardous; however, the hint they offer of the spirit of Gothic would, in this area, point to the thirteenth century rather than to the twelfth.

It would be pleasant to take the Romanesque elements that persist into the thirteenth century in the paintings of Norway's stave churches as an excuse for dwelling on them, for the clean lines and fresh colours of these murals are particularly appealing. However they lie chronologically outside our period, and belong stylistically to the Gothic aesthetic.

No indigenous illuminated manuscripts of significance remain from Denmark or Sweden, or from Norway. Scandinavia does however possess one or two artistic manuscripts from other countries, the most splendid among them being the Copenhagen Psalter from England which will be discussed in the following chapter.

Painting in England: 1100–1200

PAINTING FROM c. 1100 TO c. 1130 (EXCEPT ST ALBANS)

As we have seen, the immediate consequences of the Norman Conquest were unfortunate for the painting of England, and even the revival of manuscript illumination in the early twelfth century was to have a Norman focus: the initial. Into it, the English channelled their creative energies, endowing it with a vivacity, a richness, and an imaginative ingenuity unequalled even in this, the greatest century of the art of the initial.

In the earlier decades at Canterbury, the general ebullience of the initials already signals the recovering dynamism of English art as a whole: dragons and humans entwine vigorously with one another [329], confront one another, flee from one another, or pursue one another around the structure of the initial like playful puppies.[1] A lion turns from one bird in flight to roar defiance at another;[2] men grasp animals and birds, and the animal- or bird-headed terminals of initials seize animals or fish or human beings.[3] An adolescent centaur fires an arrow at a dragon attacking a nude male who cheerfully points to a reference to discord in the text.[4] But there is nothing of discord in the style: everything participates in the rhythmic flow, as when the two men who step out

dancingly towards each other, the dragons that encircle them, and the serpents that pretend to attack them are all choreographed to follow the cadences of the same ballet [327]. It is a ballet in which all kinds of strange and colourful creatures participate, and from every conceivable source – twoheaded birds, griffins, and peacocks from eastern textiles;[5] half-human and half-animal centaurs from astronomical charts;[6] the ass playing a lyre and the siren, half-maiden and half-bird, originally at home in the classical world;[7] and outlandish creatures such as the amphisbaena (the snake with a head at each end) and the cynocephalus (a human being with the head of a dog) that originally illustrated books of natural history[8] (a comparable creature appears in illustration 100).

The figures in these Canterbury initials sometimes retain traces of Anglo-Saxon vivacity,[9] as demonstrated by the historiated initials of a Martyrology from Canterbury[10] [328] which also prove that the old capacity for merging narrative scenes has not been lost. These initials have something, too, of the delicate restiveness of Anglo-Saxon line, a quality that had virtually disappeared from manuscripts just before the Conquest; it would therefore appear that the Norman incursion actually provoked an Anglo-Saxon reaction in certain very small pockets of art. The Anglo-Saxon feeling

(opposite) Detail of plate 347 (enlarged)

327. Canterbury: Initial M, from the second volume of Josephus's *Jewish Antiquities*, MS. A.8, folio 91. c. 1130. Cambridge, St John's College

328. Canterbury: *Initial showing St Michael transfixing the dragon*, from a Martyrology, MS. Arundel 91, folio 26 verso. First quarter of the twelfth century. London, British Library

329. Canterbury: Initial M, from the first volume of Josephus's *Jewish Antiquities*, MS. Dd.1.4, folio 64 verso. *c.* 1130. Cambridge, University Library

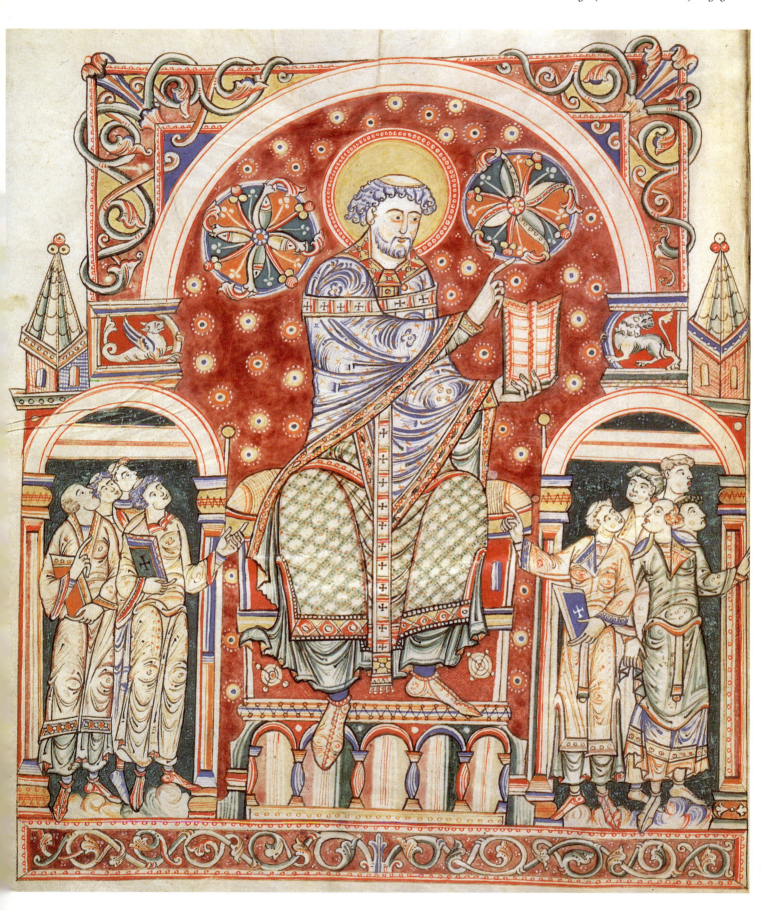

330. Canterbury: *St Augustine*, from his *City of God*, MS. Plut. XII.17, folio 3 verso. *c.* 1120. Florence, Biblioteca Medicea-Laurenziana

for contemporary events also resurfaces – though rarely – in such scenes as the keeper training his bear[11] and the schoolboy being chastised.[12] As we have seen, this tradition was eagerly taken up at the Cistercian house of Cîteaux, which was ruled for nearly twenty-five years by the Englishman Stephen Harding.

The aversion of the Normans in England to full-page pictures in manuscripts continued throughout the first two decades of the twelfth century, with some relaxation towards the end of this period; about 1120 at St Albans, for example, a copy of Prudentius's *Psychomachia*[13] was produced with forty-six illustrations which – if not full-page – are at any rate almost half-page. These drawings, tinted chiefly in red and green, derive – in part at least – from an Anglo-Saxon original, and therefore retain traces of the old buoyancy. Their style anticipates some of the characteristics of the Alexis Master, whom we shall meet later.[14] The coloured drawings in a copy of St Augustine's *City of God*[15] produced at Canterbury about 1120 also have Anglo-Saxon sympathies and retain much of the old spiritedness. The four full-page illustrations are of extremely good quality: they are of the pursuits of war and peace and the weighing of souls at the Last Judgement (both in the same picture); the City of God; scholars discussing the views of St Augustine; and St Augustine himself [330], a splendid 'portrait' with much of the old exuberance but also with a new power that heralds the Romanesque future.

The Norman aversion to independent pictures in manuscripts did not extend to other areas of art: it was a Norman, after all, who commissioned that ambitious cycle of narrative pictures, the Bayeux Tapestry [10–12], which was made at Canterbury. Here, paintings embellished the cathedral which was newly rebuilt by Prior Ernulf (1096–1107) and continued by his successor Conrad; indeed William of Malmesbury, a reliable observer,[16] declared that there was nothing in England to compare with the multicoloured pictures of Canterbury, and the chronicler Gervase drew special attention to the splendid ceiling paintings.[17]

Murals had existed in the pre-Conquest churches of England – even the tiny church of Nether Wallop in Hampshire had them[18] [79] – and they continued under the Normans. The little church of Hardham in West Sussex[19] was originally replete with over forty scenes or subjects in two tiers, most of which survive. On the west wall are the Last Judgement and the horrors of Hell; beside the chancel arch the labours of the months are represented; on the nave north wall are episodes from the life of St George; the story of the Fall is told on the west wall of the chancel; and over both nave and chancel extend numerous scenes from the New Testament, including the Annunciation, Visitation, and Nativity, the Adoration of the Shepherds and of the Magi, the Flight into Egypt, the Massacre of the Innocents, and the Baptism. The rib cages of the Adam and Eve of the Temptation [331] are highly exaggerated – perhaps as a reminder that Eve was bone of Adam's bone (Genesis II, 23). The technique, as in many English churches of the twelfth century, is true fresco and the colours are bright and simple – red and yellow ochre and white and black. The figures are

tall, narrow, high-waisted, and given to gesticulation. The Hardham paintings and the paintings of other Sussex churches have been linked to those of Lewes Priory (hence the term 'Lewes Group') and claimed therefore to have Cluniac connections,[20] but this is incapable of proof since the Lewes paintings have long since vanished. Other scholars see German influence at Hardham. My own view has always been that these paintings are simply Norman. It is true that the hunched shoulders and expressive gestures are Anglo-Saxon traits, but they appear also in many Norman manuscript paintings, and the drapery styles, facial types, and extravagant gesticulations are specifically associated with the illumination of Jumièges and Saint-Ouen. Of course, if the Norman artist had settled in England, he could be considered to be Anglo-Norman.

The style of the Hardham paintings points to the very beginning of the twelfth century, a date supported by the contemporary cult of St George, whose appearance to the Crusaders at the battle of Antioch in 1098 seems to be illustrated in one of the pictures.[21] His miraculous intervention would have had a special interest for the Normans, for he had come to the aid of an army of Normans from south Italy with Bohemond at their head; that this event had taken place within living memory would account for there being no less than eight scenes from the life of St George in this minor church. Two other churches of this group, at Coombes and Westmeston (the latter destroyed but known from surviving records), may also have included St George in their stylistically related murals.

The wall paintings of Clayton,[22] another rural church of West Sussex, are in the same or a very similar style. Remains of scenes associated with the Last Judgement, Heaven, and Hell survive on every wall of the nave but the west. On the east wall, Christ in Majesty [332] is flanked by apostles above the arch, and there are scenes of the Traditio Legis below.

The Lewes Group embraces five churches in all if we include Plumpton. Here, paintings discovered in the nineteenth century were subsequently destroyed, but others that came to light in 1955–8, including elements of a Last Judgement programme, have had a happier fate. All the paintings of the group use similar simple colours – red and yellow and white and black – and a similar two-tier format. The separation and punctuation of the scenes by architectural details, and the identification of the figures by means of inscriptions beside the heads, have been compared to practices in the far more vigorous Bayeux Tapestry.[23] As Park has shown,[24] some of the iconography is unusual: at Hardham, Eve does not spin but milks a cow, and in another scene the naked and guilty couple sit back to back as they try to cover their nakedness; at Coombes, a male figure (presumably Zacharias) appears in the Visitation scene, and Joseph is present at the Annunciation. There are Ottonian influences in the iconographies of the Annunciation, the Washing of the Feet, the Last Supper, and the Dives and Lazarus scenes at Hardham, and Anglo-Saxon ones[25] in the Christ-figure raising his hands to display the wound in his side in the Clayton Last Judgement cycle [332] (compare illustration 77, from the Athelstan Psalter) and in the angels supporting

331. Hardham, church of St Botolph, *The Temptation*. Wall painting.
Beginning of the twelfth century

332. Clayton, church of St John the Baptist, *Christ in Majesty*. Wall painting. *c.* 1100

the Cross both here and in the Plumpton Last Judgement (destroyed but known from records). Twelfth-century paintings in other small Sussex churches are known from fragments and post-medieval copies; it is not however known whether their survival beyond the Middle Ages is attributable to their rural remoteness, and consequent deliverance from the assiduous limewashing of the Protestants, or to the removal of any limewash by later restorers.

In Surrey, paintings in the church of Witley[26] attributed to the first third of the twelfth century[27] are similar in colour range to the Lewes Group, but different in the heads and postures. Again in the English fresco technique, they are in three tiers on the south wall of the nave. Many of the scenes are unidentifiable, but the emphasis in the middle tier is certainly on the Resurrection, for it is possible to decipher the three Marys watching at the Sepulchre before the Resurrection (an unusual subject), the same three Marys at the empty Tomb, Christ appearing to them, and (more doubtfully) the Harrowing of Hell. On the west wall of the church of Chaldon,[28] also in Surrey, a forbidding Harrowing of Hell in a silhouette style includes the weighing of souls and the descent of the condemned into Hell – unusually, by way of a ladder. Unusual too is the spiked bridge, held

between two nightmarish devils, bearing a smith and other tormented souls. Below are more souls in anguish, including a squatting usurer being forced to swallow his own coins. This considerably restored painting is much later than those of the Lewes Group.

The mid-twelfth-century murals of Copford in Essex,[29] uncovered in the seventeenth and nineteenth centuries, have been spoilt by later repainting, and of the pictures that originally covered the walls and ceiling only the Raising of Jairus's daughter [333] is in anything like its original condition. The narrow and over-long proportions of the figures and their somewhat voluminous draperies recall the Sussex paintings, but their movement is more fastidious and the atmosphere gentler and less feverish. Other murals in eastern England, at Ickleton church,[30] a few miles south of Cambridge, are of the second quarter of the twelfth century. Recovered only in the 1980s from the limewashing of the Reformation, they present, in two registers in the eastern part of the nave, scenes from the Passion of Christ and from the martyrdoms of apostles, with the emphasis on the Christological sequence above. They may have led up to a carved Crucifix over the crossing arch.[31]

The wall paintings at Kempley[32] in Gloucestershire are

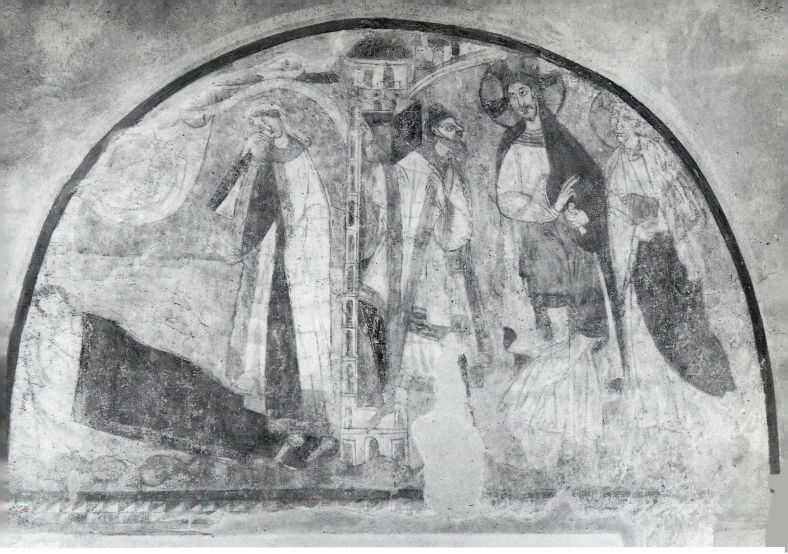

333. Copford, Essex, church of St Mary, *The Raising of Jairus's daughter.*
Wall painting. Mid twelfth century

also of the second quarter of the twelfth century but in a completely different style. Like Copford, they show Christ in Glory, the apostles, and Peter with the keys, and they too have been unsympathetically restored. They nevertheless bear witness to the fact that, even in the smallest churches, England in the twelfth century was still following the Western practice of producing wall paintings to keep congregations in mind of the works of Christ and of his saints. In that century, England was fortunate in having saints of her own, besides holy men and women with a local reputation for sanctity among whom one, Christina of Markyate, who had close links with the abbey of St Albans, has special relevance to a study of English Romanesque painting.

MANUSCRIPTS OF ST ALBANS

The primary chronicle of St Albans, the *Gesta Abbatum Monasterii Sancti Albani*,[33] compiled in the thirteenth century from earlier sources, gives a reasonably balanced[34] account of the activities of the abbots of the house from pre-Conquest times. It is far from sycophantic, exposing as it does the complete contempt of the Norman abbot Paul of Caen (1077–93) for the Anglo-Saxon traditions of his house, as well as

his nepotism; on the other hand it tells of his love of books, and of how an unexpected stroke of good fortune – a permanent endowment for secular and professional scribes set up by a Norman knight – enabled him to expand the abbey's collections. By these means, Paul had 'noble volumes, necessary for the church, copied by expert scribes sought from afar' and provided St Albans with twenty-eight 'notable books', which were supplemented by others.[35] Paul's successors until 1146 were all Normans, at least by descent, and all attracted the same criticism – that they were foreigners surrounding themselves with their family and friends – and the same praise – that they fostered the collection and production of manuscripts. Thus Richard d'Aubigny (1097–1119) gave manuscripts to the house and increased the financial support of its scriptorium,[36] and Geoffrey Gorron (1119–46) also presented manuscripts besides obtaining (or so it can be inferred from one comment) the services of three professional scribes.[37] The post-Conquest abbots of St Albans, right up to the end of the twelfth century, were clearly 'book men' to whom such professional scribes were available. Until about 1120 they seem to have favoured handsomely written books[38] with run-of-the-mill decorative initials of obvious Norman workmanship or inspiration. With

one exception already mentioned, a *Psychomachia* derived at least in part from an Anglo-Saxon original, these manuscripts had no pictures, and it was not until the abbacy of Geoffrey Gorron that illustrations suddenly gushed forth like a released torrent.

Geoffrey, a secular clerk of Le Mans Cathedral, was invited to St Albans by the abbot to head the grammar school there.[39] His removal from France was so leisurely, however, that by the time he arrived his post had been filled by someone else and he had to make do with a similar position at Dunstable. While he was staging a miracle play of St Catherine there, some valuable copes he had borrowed as 'props' from St Albans were accidentally destroyed by fire, and he was so desolated that he offered himself to St Alban as an oblate, making further amends for the calamity, on becoming abbot, by commissioning some exceptionally rich copes for his house.[40] These, however, did not even survive the century, and the chief artistic monument to his rule is now the St Albans Psalter,[41] one of the most lavishly illustrated and most influential manuscripts to survive from twelfth-century England; it is the richest in spiritual connotations, and is furthermore closely associated with a local holy woman named Christina.

THE ST ALBANS PSALTER

Christina,[42] born at the very end of the eleventh century of a wealthy Anglo-Saxon family of Huntingdon, was later forced by her parents into marriage despite her vow of virginity. She refused to consummate the union (it was later annulled), and subsequent ill-treatment drove her to run away from home. Later she came under the guardianship of a saintly hermit called Roger, who was also a monk of St Albans. About four years after his death in 1121 or 1122, and after much further adversity, she was able to return to and take possession of Roger's hermitage at Markyate, in accordance with his expressed wishes. Abbot Geoffrey of St Albans first came into contact with her some time after January 1123.[43] At first somewhat sceptical, he gradually came to revere Christina for her sanctity and to show her every deference, consulting her about the affairs of the abbey and asking only, in the words of a contemporary witness, 'for her intercession with God'.[44] A historiated initial in the St Albans Psalter [334] shows her doing precisely this – pleading with Christ for Geoffrey and his monks.[45] It illustrates Psalm 105 (A.V. 106), which ends with a prayer to God to extend his salvation to his people, and an inscription above specifically requests mercy for his monks. The painting is on a piece of vellum which was pasted into the manuscript long after it had been produced, at a time, it would seem, when the Psalter was being adapted for Christina's use[46] and at a time also when two other artistic contributions were added before the text.

The first of these additions, a single page of scenes illustrating a French poem on the life of St Alexis,[47] has obvious reference to Christina, for Alexis too decided to maintain the purity of his life despite his marriage. The drawings show Alexis exchanging tokens of chastity with his bride on their wedding night, leaving home, and finally embarking on a ship which, so the text relates, will take him

on a pilgrimage to Jerusalem. His story must have given Christina some comfort, for she had been sorely pressed to yield her vow of virginity to the claims of marriage.

The second addition, a sequence illustrating the story of Christ at Emmaus, also had a special relevance for Christina.[48] St Luke relates (XXIV, 13–31) that when Christ reappeared to two of his disciples after the Resurrection, they did not recognize him; one of them thought he was a pilgrim (*peregrinus*) in Jerusalem (which is why Christ was usually portrayed as a pilgrim in Emmaus scenes in medieval drama and art). Christ accompanied the disciples on their journey to Emmaus, where he joined them in a meal, later vanishing from their sight. The story is often recounted in two pictures, but here it is told in three because Christ (according to Christina's biographer, who had it from her own lips)[49] appeared to Christina three times in circumstances paralleling those on the road to Emmaus. In the drawings Christ is shown as a pilgrim in conformity not only with the Gospel narrative but also with Christina's own mystical experience – she was accustomed, according to her biographer, to refer to him as her 'beloved pilgrim'.[50] The scriptural account parallels Christina's experience throughout, and so it is told in the pictures. In the first, the disciples fail to recognize Christ, as Christina did at their first encounter.[51] In the second, the disciples share a meal with their Saviour [335], as Christina and her sister had done.[52] In the third, Christ disappears from sight, as he did at Markyate after his third appearance to Christina.[53] Thus the second pictorial cycle

334. St Albans: *Initial showing Christina of Markyate pleading for the monks of St Albans*, from the St Albans Psalter, p. 285. c. 1120–35. Hildesheim, St Godehard

335. The Alexis Master, St Albans: *The supper at Emmaus*, from the St Albans Psalter, p. 70. *c.* 1120–35. Hildesheim, St Godehard

illustrates Christina's personal communion with Christ, as the first emphasized her commitment to virginity. They are apparently unique in Romanesque art in paying tribute to a local saint during that saint's lifetime.

There are of course many other pictures in the St Albans Psalter, including four full-page illustrations from the lives of the Psalmist and two saints: the martyrdom of St Alban and David with his musicians (both repositioned when the manuscript was adapted for Christina); scenes from the life of St Martin; and another picture, in a very large Beatus initial, of David as musician. Forty full-page biblical paintings precede the text, beginning with the Fall and the Expulsion of Adam and Eve from Paradise [336] to explain how original sin entered into the world, and continuing with thirty-eight paintings of the life and sacrifice of the Redeemer of that sin.

Full-page narrative pictures had only appeared on sufferance in England from the time of the Conquest, and the sudden flood of them in the St Albans Psalter comes as a complete surprise. Both this and the illustration of Christological scenes represent a return to pre-Conquest

days, and some areas of the iconography have Anglo-Saxon connections too, particularly the disappearing Christ of the Ascension, and elements of the scenes of the Nativity, the Annunciation to the Shepherds, the Presentation in the Temple, the Temptations of Christ, and the three Marys at the Sepulchre.[54] Also Anglo-Saxon in origin is the use of rich colours to record the sublime acts of God and of Christ, and of simpler coloured drawings (by the same artist) for the lesser themes, i.e. the parallels to Christina's life on earth.

In style, on the other hand, these pictures reject everything that Anglo-Saxon art had stood for. They have nothing of the insubstantiality and sense of atmosphere of pre-Conquest art, preferring a ceremonial to an evanescent approach, with rich and positive colours, and figures deliberate and composed in their movements, grave and momentous in their actions. The pictures can best be described as liturgical. Their backgrounds are flat panels of solid colour, often purples, greens, and blues, and the figures are compressed into elongated shapes with solid cores which – if less rigid – have rightly been compared to the 'statue-columns' of Romanesque architecture. Anglo-Saxon figures are timeless because they are outside time: the St Albans figures are timeless because they are frozen within it.

The most important by far of the artists of the St Albans Psalter was the Alexis Master, who painted the full-page illustrations as well as the Emmaus and the Alexis additions after which he is named. The sources of his style include the art of north-eastern France, a debt insufficiently noticed despite the obvious influence of the eleventh-century paintings of Saint-Omer [cf. 191] on the tightly wrapped garments of the Alexis Master's figures and their suggested cores of solidity. Their high-waisted proportions, long legs, and narrow silhouettes [336], too, are clearly close to the styles of eleventh-century northern France [cf. 194], which were themselves influenced from England. On the other hand Pächt, who has studied the style of the Alexis Master in the greatest depth, has demonstrated that some of the decorative motifs derive from Ottonian manuscripts, and that the backdrop of sharply defined coloured panels had been anticipated at Echternach and Regensburg;[55] the spatial layers of the backgrounds are also originally Ottonian.[56] Ottonian too, we may add, are the particular dynamics of these paintings, for the contrast between the intensity of eye and the abstraction of the figures is found in the Liuthar group of paintings at Trier. From Italy, Pächt points out – and most particularly from the wall paintings of San Clemente at Rome, which happen to include the legend of St Alexis – come the slender 'stage architecture' backgrounds of the St Albans figures, and from the murals of Rome and central Italy one or two elements of the decoration.[57] Pächt also traces to Italy some elements of the iconography[58] and marginal elements of the figure style such as the 'combed' highlights of the draperies, though both are ultimately Byzantine.[59] The Alexis Master, then, took elements from England, Flanders, the Lotharingian area of Ottonian Germany, and central Italy to fuse into an intensely personal artistic idiom that was to have a powerful influence on English painting.

Before turning to the effects of the Alexis Master's work,

336. The Alexis Master, St Albans: *The Expulsion of Adam and Eve from Paradise*, from the St Albans Psalter, p. 18. *c.* 1120–35. Hildesheim, St Godehard

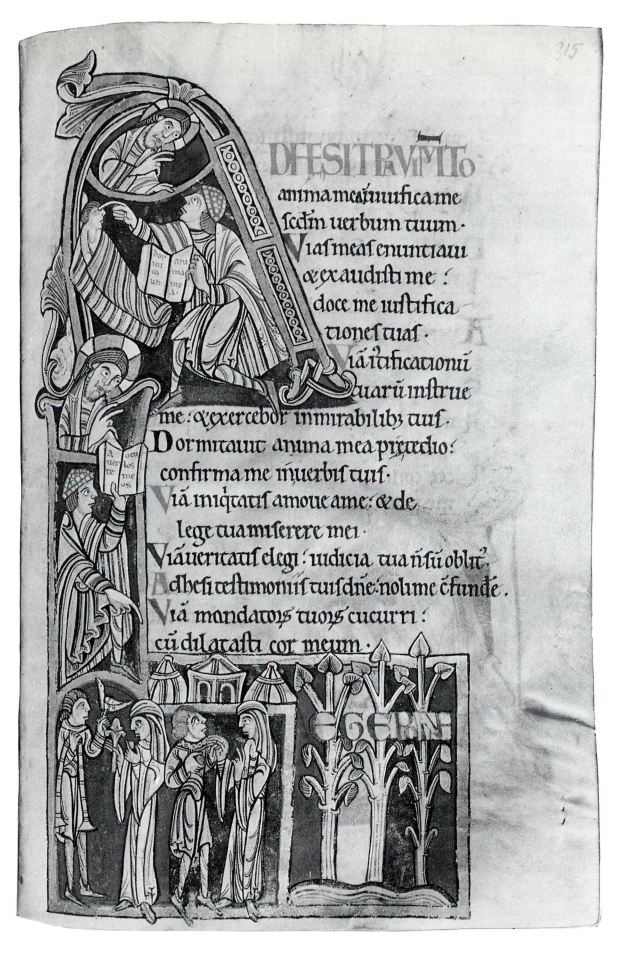

337. St Albans: Illustration to Psalm 118 (119), from the St Albans Psalter,
p. 315. *c.* 1120–35. Hildesheim, St Godehard

however, a discussion of the historiated initials of the Psalter is appropriate. In sheer numbers they are without parallel, for there are as many as two hundred and eleven. Some of the underdrawings may be by the Alexis Master, but they are chiefly the work of two other artists indebted to him for their choice of colours, their disposition of draperies, their figure proportions, and their affection for the profile, but for no more, for their figures eschew the solidity and the composed and grave mien of the full-page paintings and are as weightless as the figures of Japanese prints, with garments that seem to hang on invisible frames and limbs at all angles, as in the earlier Norman art of Jumièges and Hardham.

These coloured drawings are best understood not as beguilements for the eye but as spurs to spiritual contemplation. The life of a monk was dominated by two basic texts: the Psalter, sung in its entirety by all monks in the course of each week and so basic to their lives that they came to know it by heart (one later abbot of St Albans could even recite it backwards); and the Benedictine Rule, of which a chapter was read every morning. The function of the illustrations in the initials of the St Albans Psalter was to interpret one text in terms of the other.[60] The monk was enjoined by the Rule to cut himself off from the secular world in life-long spiritual fellowship and in chastity; to dedicate himself to glorifying God in liturgical service (the *Opus Dei*); to cultivate obedience and the other Christian virtues; and so to discipline both body and mind that he became imbued with the very spirit of humility. The task of the artists of the Psalter's initials was to illustrate phrases from the Psalms that upheld these precepts, and of these they found dozens. Just one example will be quoted here: the illustration of verse 37 of Psalm 118 (A.V. 119),[61] 'Turn away mine eyes from beholding vanity' [337]; this is a highly condensed account of the particular temptations that the monk should eschew – carnal love, cupidity, and all the lusts, pomps, and vanities of the secular world. The artists took for granted in the onlooker both an understanding of the methods of analysis used in medieval theology and knowledge of a well known monastic text,[62] and, viewed in this light, the drawings yield such depths and breadths of meaning, so many insights and such subtleties of reference, that the more one studies them, the more one is convinced that their purpose was to open up for meditation a whole world of spiritual associations.

That the Psalter was not originally intended for Christina is proved by the masculine form of the prayers. Indeed, at the time the manuscript was being made – probably before 1123[63] – Christina was still a recluse, sheltered in concealment by Roger the hermit, and for her the many illustrations eulogizing life in community could have had no relevance. It was only later that she met the abbot who persuaded her to make her own monastic profession at St Albans[64] and became, as her biographer emphasizes, a spiritual member of the community. It was then, in my view, that Abbot Geoffrey presented her with this manuscript, a particularly appropriate gift for one who had a Psalter 'open on her lap at all hours of the day';[65] then that, in tribute to her, the Alexis and Emmaus scenes were added; and then that her new links with St Albans were celebrated by the incorporation of the picture of herself with Abbot Geoffrey[66] [334]. Christina's biographer does not give the date of her profession, but the context in

which it is recorded suggests 1130 or not long after.[67] If, therefore, the Psalter was indeed begun before 1123, a date between 1120 and 1135 for the complete work would not be far astray.

OTHER MANUSCRIPTS OF THE ALEXIS MASTER

The Alexis Master also illustrated a St Albans manuscript[68] of the prayers and meditations of St Anselm[69] that was during the Middle Ages at Verdun, where its presence may be explained by the fact that an English expatriate, Henry, a former royal chaplain, was bishop of Verdun from 1117 to 1129 – dates congruent with those just suggested for the St Albans Psalter. Of the original fourteen full-page pictures of the Anselm manuscript the only one to remain is the St Peter receiving the keys from Christ.

Further surviving manuscripts illustrated by the Alexis Master include a Gospel Book now at Hereford Cathedral[70] which has a single three-quarter-page picture. Letters copied into another of his manuscripts which contains texts of the Miracles and Passion of St Edmund[71] confirm what the subject matter already demonstrates: that it was made for Bury St Edmunds. It has been argued that the letters also pinpoint the date of the manuscript,[72] but it would perhaps be wisest to place it more generally in the decade between 1125 and 1135. The thirty-two prefatory full-page pictures have been attributed to a colleague of the Alexis Master,[73] but this view fails to allow for the slight variations that can occur in the work of any one artist; they must surely be permitted to the master himself, and explain why these miniatures are less finished and more dramatic than those of the St Albans Psalter. The colours, applied by a second artist,[74] are brighter than the master's normally are.

The production of this illustrated text on St Edmund may have been prompted by the threats of King Henry I to tax the abbey and to appropriate its revenues,[75] upon which the enthusiastic rendering in the manuscript of the retribution wrought upon King Sweyn for his imposition of the Danegeld may be an implied comment. The main burden of the illustrations is the life and martyrdom, and a few of the miracles, of St Edmund, and we know from written records that many of the scenes were repeated in a later textile at Bury. For events of the saint's Passion, especially his scourging and burial, that had obvious parallels with those of the Passion of Christ the Alexis Master used the same iconographies as in his Christological cycle in the St Albans Psalter.

The most impressive of the paintings is the coronation of St Edmund in Heaven on folio 22 verso [338] in which the motif of two monks embracing the saint's feet may have been borrowed from Canterbury.[76] Edmund sits stolidly and massively with staring eyes, like some primitive cult figure, as an angel places a palm in his left hand, another presents him with a sceptre, and two more place a crown on his head. The crown unexpectedly recalls Christina, for it is similar to the 'golden crown thickly encrusted with precious stones . . . with a cross[77] of gold on top' and with two bands, or fillets, hanging down on either side of the face[78] which she saw Christ himself wearing in one of her visions. Both approximate to a mitre, which also has bands or fillets, and it was indeed to

text that make one wonder whether he had actually read the passages in question.[83]

The Alexis Master produced nearly ninety full-page pictures for the four manuscripts just discussed, and was clearly a specialist in the larger scale. But the initials by other artists were no mere appendages to the pictures: the spiritual depths of those in the St Albans Psalter have already been noted, and the lively humans and animals in the initials of the Verdun Anselm lend vigour to the pages, as do the fewer initials of the Hereford Gospel Book. The many initials of the Bury Miracles and Passion of St Edmund also offer much variety with their mixture of the decorative and illustrative.

The Alexis Master was so productive and influential that it would be gratifying to know his real name. Pächt[84] believes that he was a metalworker-monk of St Albans called Anketil who is mentioned in the *Gesta Abbatum*; but the chronicle says nothing of his being a painter and, as Pächt himself points out, this part of the text is a later interpolation, fabricated to authenticate the relics of St Alban. Thomson[85] has implied that the Alexis Master was a professional artist, attached to St Albans for a decade or two, who had his own 'studio' to which he recruited some local artists, and it is indeed likely that he was a secular painter, like Hugo at Bury St Edmunds a little later; St Albans, we may recall, had long been accustomed to employ secular scribes.

ENGLISH PSALTERS AND THE INFLUENCE OF THE ALEXIS MASTER

THE SHAFTESBURY PSALTER

Revived by the Alexis Master, the Anglo-Saxon practice of illustrating Psalters with full-page pictures of scenes from the life of Christ was taken up in a number of English Psalters. One,[86] probably of the 1130s, is ascribed on liturgical evidence to the nunnery of Shaftesbury in Dorset, about which little is known except that it had royal connections. The illuminator also made a full-page drawing of St John Chrysostom in heaven in a manuscript belonging to Hereford Cathedral[87] and another drawing in a copy of Boethius's famous work on the Consolation of Philosophy.[88] There are similarities between his style and that of an ivory figure excavated at Milborne St Andrew in Dorset, and the general view is that he, or she, was working in the West Country. Oakeshott believes that the same artist also worked on the Bible of St Hugh,[89] to be discussed later.

The paintings of the Shaftesbury Psalter are rich in colour and of great dignity. Three of them – the Marys at the Tomb [339], the Ascension, and Pentecost – have been influenced by the St Albans Psalter; the others represent (at the front of the manuscript) God sending Gabriel to the Virgin and a Tree of Jesse, and (at the back, both illustrating prayers) the enthroned Virgin and Child and St Michael holding souls ready for the Last Judgement. The nun who, in two of the pictures, supplicates first Christ and then the Virgin (the patron saint of Shaftesbury) is presumably Shaftesbury's abbess – possibly the Emma referred to as the head of the house in 1136,[90] though the records are far too fragmentary to allow any degree of certainty, and it is not known for how

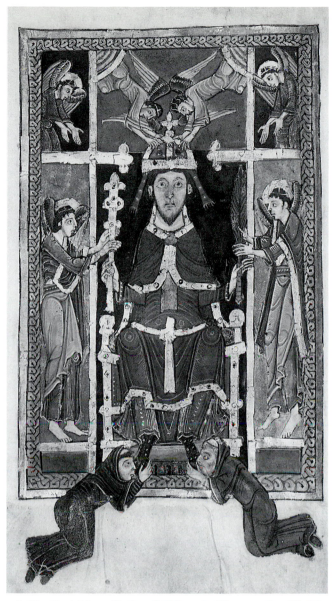

338. The Alexis Master(?), Bury St Edmunds: *The coronation of St Edmund in heaven*, from the Miracles and Passion of St Edmund, MS. 736, folio 22 verso. *c.* 1125–35. New York, Pierpont Morgan Library

a mitre that Christina compared a crown that she saw in another vision.[79] Perhaps both were inspired by a picture by the Alexis Master himself that she had seen at St Albans. It is a type of crown more German than English,[80] and the Alexis Master's acquaintance with German art is evident in the very iconography of this scene, which has been rightly compared to the coronation depicted in the Sacramentary of the Emperor Henry II[81] made at Regensburg [114].

The copy of the Miracles and Passion of St Edmund was written out not by a St Albans scribe, as usual with the Alexis Master's manuscripts, but by a scribe from Bury St Edmunds, and its initials too belong to a Bury rather than to a St Albans tradition.[82] This suggests a visit to Bury by the Alexis Master. If so, it must have been a rushed one, for not only (as we have seen) did the colouring have to be completed by a second artist, but there are also discrepancies between pictures and

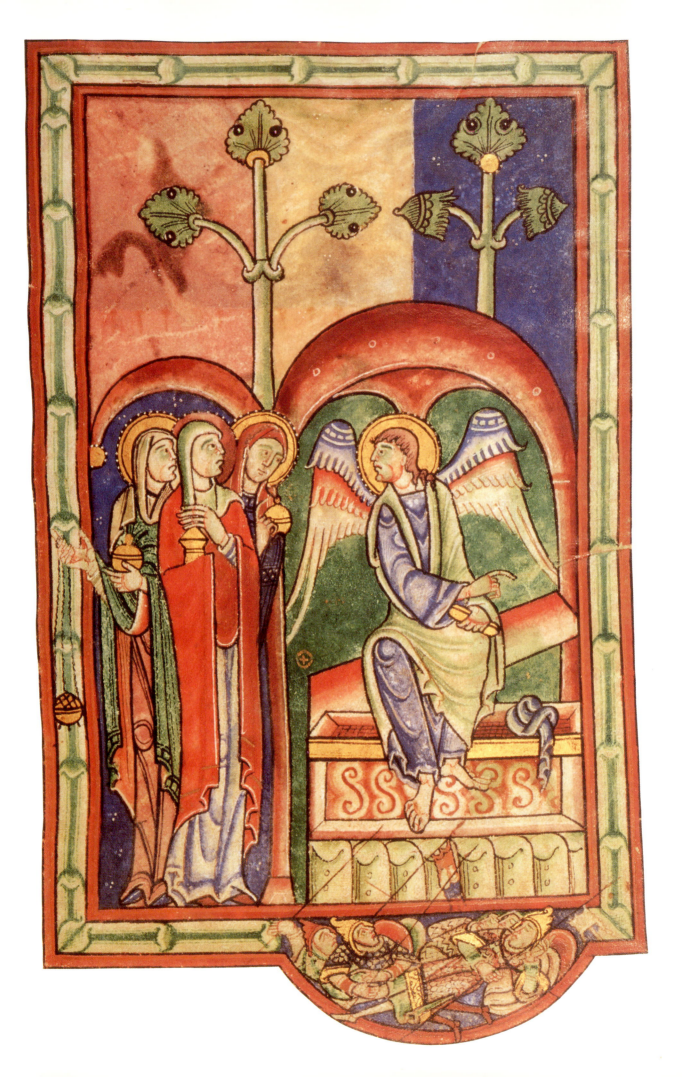

long she was in office. The David of one of the manuscript's four historiated initials gazes up at Christ and at the same time points to his Psalter as a reminder of the tradition, mentioned by Christ himself (Luke XXIV, 44), that some of the Psalms prophesied the Redeemer. It has been observed that the style of this picture is reminiscent of miniatures in Stephen Harding's Bible at Cîteaux.[91] In other illustrations, the emphasis on the profile and the 'combed' highlights of the draperies recall the Alexis Master's style, now reinterpreted in terms of patterning and design in a process that continues at Bury St Edmunds and also at Canterbury.

THE BURY ST EDMUNDS GOSPELS

The impact of the Alexis Master's postulated visit to Bury St Edmunds can be traced in a series of drawings in dark brown ink,[92] in part coloured by a contemporary,[93] which are now ascribed to the decade between 1135 and 1145. In a sequence that may have been liturgically determined,[94] the thirty-six pictures, on twelve pages, illustrate Christological scenes, including the parables and a final Last Judgement. They may – as one would expect – have been intended to introduce a Psalter, although one scholar suggests that the lack of any Old Testament pictures indicates a Gospel Book or Lectionary.[95] They were certainly not meant for the Gospel text with which they are now bound, for their leaves have had to be trimmed to fit; they predate that text by a few years;[96] and stylistic evidence suggests that they were made in the Bury scriptorium[97] whereas the text apparently was not.[98] In fact, what we have is a composite manuscript, probably put together in the twelfth century at Bury, although this is seemingly contradicted by an inscription on the first page of the text, which says that the manuscript was given to the abbey by Reginald of Denham, sacrist of the house in the early fourteenth century. These apparently conflicting statements may be reconciled if we accept that the manuscript was the subject of a practice common in religious houses when they wished to tide themselves over a temporary financial embarrassment: they pawned their artistic treasures. Indeed, if we are to believe a scathing poem on the evils of the age written by a twelfth-century Englishman,[99] churches allowed themselves to be despoiled (if only temporarily) of chalices, fine crucifixes, gold cloths, good paintings, chasubles, veils, albs, hangings, stoles, and draperies in this way. A donor of manuscripts to Worksop Priory in the twelfth century had even to anticipate in his deed of gift that his offering might be pawned.[100] Now when such objects were redeemed, those who put up the money were not averse to saying that they had actually given the works of art concerned, as in the twelfth century Henry of Blois was said to have presented as 'gifts' to Winchester Cathedral four Gospel Books that he had merely bought back from pawn;[101] the same is true in the same century of several *objets d'art*, including Gospel Books, 'given back' to his abbey by Samson, the best known of all abbots of Bury St Edmunds.[102] Thus Reginald of Denham

340. Bury St Edmunds: *The Ascension of Christ and the Beheading of John the Baptist*, from the cycle of drawings bound in with the Bury Gospels, MS. 120, folio 5 verso. *c*. 1135–45. Cambridge, Pembroke College

may simply have done what others had done before, and registered as a gift a Bury Gospel Book that he had merely recovered from a moneylender.[103]

The splendid initials of the text include a rare picture of Mark wearing the heads of all four symbols of the evangelists and cutting off his thumb, as St Jerome says he did in his prologue to Mark's Gospel.[104] These initials should not be overlooked, but discussion here will be confined to the illustrations of the prefatory pages. Most of them deal with the Passion, Resurrection, and Ascension of Christ (illustration 340, where it is coupled with the Beheading of John the Baptist), and in this sequence the elision of the figures of God the Father and God the Son in the Pentecost on folio 6 is unusual and probably unique.[105] The rare scenes of Christ's parables and miracles (especially those of the wicked husbandmen and good Samaritan)[106] find their only parallels in Ottonian art, particularly the manuscript paintings of Echternach,[107] whence scenes of the woman taken in adultery, the dance of Salome, and the death of the Baptist[108] seem also to derive. This source also influenced the placing of the Bury drawings in horizontal compartments.

339. South-west England: *The three Marys at the Tomb*, from the Shaftesbury Psalter, MS. Lansdowne 383, folio 13. *c*. 1130–40. London, British Library

All this, taken together with the Ottonian ingredients in the St Albans Psalter and the Miracles of St Edmund, points up the influences from Germany that were entering England in the years after 1120 – influences from the Ottonian past and not from the German present, whose sources can only be a matter of conjecture.

It has been surmised in an earlier chapter that an Ottonian illustrated manuscript reached England in the second half of the eleventh century and had a fleeting impact on work produced for Hereford. This was just before the Norman Conquest put a virtual end to independent pictures in manuscripts, and (accompanied perhaps by others) it may have renewed its influence when independent pictures were again in favour some sixty or seventy years later. It is much more likely, however, that the Ottonian influences were connected with more recent events, particularly the marriage of the English king's daughter Matilda to the German emperor, Henry V. Now St Albans had close connections with the English court – indeed, it kept an apartment reserved for the queen's exclusive use[109] – so that if illustrated manuscripts entered the country as a direct result of this dynastic alliance their impact on St Albans at an early date might be explained. Moreover, the former personal chaplain of Matilda on the Continent, Henry, bishop of Verdun, owned a manuscript made at St Albans, which further suggests a link between St Albans and the English royal family. Although the records show that this granddaughter of the Conqueror was more anxious to benefit a famous Norman religious house[110] than an English one, gifts usually accompanied marriage negotiations, and this may have resulted in German works of art finding their way to court circles in England; again, Matilda may have brought Ottonian manuscripts with her when she returned to England in 1126, after her husband's death.

Other influences on the Bury pictures include a few from Byzantium (see the Deposition and Crucifixion),[111] some from the Anglo-Saxon tradition (see the Harrowing of Hell and the Ascension),[112] and yet others from the work of the Alexis Master, for example in the iconography of the Entry into Jerusalem, the Marys at the Sepulchre, and the sequence of Christ at Emmaus, and in such points of stylistic detail as the emphasis on the profile and the rendering of garments and hair-styles. The spiky style, already seen in the St Albans Psalter and in earlier English works of art,[113] was considered very *avant garde* in the 'punk' style of the later years of the present century.

Although, as coloured drawings, the Bury pictures have none of the sumptuousness of the St Albans Psalter paintings, they have their own presence and quiet dignity as well as a pronounced homogeneity that arises from the conversion of the St Albans style into a rhythmic patterning of line and colour. The same is true of four detached leaves with stylistic and iconographic affinities with the Bury drawings[114] that are now separately owned by the British Library, the Pierpont Morgan Library, and the Victoria and Albert Museum.[115] Recalling that the Alexis Master specialized in full-page pictures, that the Bury St Edmunds cycle was once apparently without an associated text, and that, as we shall see later, a full folio of pictures associated with the Winchester Bible led a curiously independent life of its own, one may perhaps wonder whether the making of full-page pictures, or cycles of pictures, was not sometimes treated as an enterprise quite separate from the illumination of the manuscript itself.

THE EADWINE PSALTER

Before embarking on a discussion of the Eadwine Psalter proper, we shall give an account of the four detached leaves just alluded to. Their rectos and versos are divided into enough compartments to contain some one hundred and fifty scenes comprising the most extensive – as, in iconographic terms, they are the most intriguing – Old and New Testament cycle to survive from the first half of the twelfth century. Even so, the series is not complete. It must have been intended for a Psalter, for the Old Testament part concludes with scenes from the life of David. As Christ specifically told his apostles that he had come to fulfil the law of Moses and the prophecies of the Psalms (Luke XXIV, 44), some of the pictures focus on Moses and David, but most concern Christ's own life, death, and afterlife. The largest of all is the Tree of Jesse [341], symbolizing the transition from the Old Testament to the New, with single figures in the lower curving branches and complete scenes above, crowned by a bust of Christ.

Of the two artists involved in these miniatures, one looks back to the style of the Alexis Master or one of his followers (he has an affinity with the artist of the Bury Gospels), while the other is very up-to-date, for his treatment of faces and draperies (see the scenes on the verso of the Victoria and Albert Museum leaf) links him with a contemporary, the Lambeth Master, one of whose manuscripts was completed in 1146.[116] In stylistic terms, these tiny pictures should be placed in the 1140s. Iconographically they belong to the same milieu as the pictures of the St Albans Psalter and the Bury Gospel Book and, like them, they have affiliations (sometimes exaggerated by scholars) with Ottonian illumination. The illustrations for which no associations, even of a general kind, can be traced we should not be afraid to ascribe to the inventiveness of the artist, for there is ample evidence for originality in the art of our period. Gerald of Wales, for example, relates that King Henry II had his chamber in Winchester Castle painted with a mural of his own devising that symbolized the relationship between himself and his children. It showed an eagle 'with four eaglets perched upon it: two were upon the two wings and the third upon the kidneys, digging at their parent with talons and beaks, while the fourth ... sat upon the neck and awaited its opportunity to tear out its father's eyes with ferocity'. These four eaglets, Henry explained to his circle, 'are my four sons, who will not cease to haunt me until I die'. Thus, says Gerald, the king 'first pictured to himself inwardly ... the afflictions that were to come through his progeny, then brought his mental concept into the open and had it skilfully painted'.[117] The Bayeux Tapestry, too, was obviously an original work,[118] and so presumably were the embroideries recounting the deeds of

341. Canterbury: *The Tree of Jesse and other scenes*, detached leaf probably intended for the Eadwine Psalter, MS. 724 verso. c. 1140–50. New York, Pierpont Morgan Library

Byrhtnoth of Essex, the sea victories of the Anglo-Saxons, and the death of Theodoric of Avesnes.[119] There was of course more freedom in secular art, for in general, religious works understandably preserved traditional iconographies: after all, the older the ultimate pictorial sources, the closer to scriptural times, and therefore to authenticity, they would seem to be. Yet the greatest medieval authority on Church symbolism, Durandus, bishop of Mende, could write that painters, like poets, have their freedom,[120] and originality in the religious art of our period is not hard to find: the Christological cycle of wall paintings at Lambach is so creative that with two exceptions, Demus tells us, 'none of the pictorial compositions corresponds to a known type; every one is new and original'.[121] There is demonstrable originality too in such miniatures as those of the Liuthar manuscripts given to Bamberg,[122] the Canterbury Hexateuch,[123] the Grimbald Gospels,[124] the Hitda Codex,[125] and so on, and in the historiated initials of the St Albans Psalter[126] and other manuscripts.[127] In the field of religious textiles, the Quedlinburg tapestry seems to have been a new creation, and a very real inventiveness is implied by the descriptions of the hangings formerly at Augsburg.[128] We are therefore justified in supposing that the artists of the detached leaves possessed similar qualities.

Their pictures, as we have seen, were intended for a Psalter, and a Canterbury provenance for them is suggested by two considerations. The first is the fact that their format – they are set in the square compartments into which the page is divided – parallels a similar one in the most venerable manuscript that Canterbury possessed.[129] The second is that this cycle inspired a similar one created at Canterbury in the final decades of the twelfth century. This was for the last copy in the tradition of the celebrated Carolingian Utrecht Psalter.[130] Now the Eadwine Psalter[131] was an earlier copy of this very manuscript, and all the evidence indicates that this was the destination of the four detached leaves. They belong to the same period, and, allowing for the fact that they have been trimmed down to their painted borders, they would have fitted the Eadwine Psalter physically. There are also, as we shall see, stylistic connections, and furthermore the Preface to the Eadwine Psalter contains references to incidents of the Old and New Testaments which were originally illustrated in this particular cycle of miniatures.

The Eadwine Psalter is a manuscript of considerable size which – presumably in order to create a tool for study and teaching – brings together St Jerome's three versions of the Psalms in three columns, together with interlinear French and Old English translations and with a Latin commentary. All is set out in such a beautifully proportioned and admirable manner as to create a consummate example of the art of the book. The calligraphy is masterly, and the text is embellished with initials in golds, bright blues, and reds that shine out like the colours of stained-glass windows. The 166 illustrations of the Psalms and Canticles are by three artists who drew on the Utrecht Psalter for their iconography[132] though in three of the earliest pictures there are added interpretative scenes reflecting a Psalter commentary.[133] Stylistically, however, the Eadwine drawings are very different from the Carolingian ones. To begin with, they are not in bistre but in jewel-like colours that tumble over the page in an exuberance that no

black and white reproduction can hope to recapture. The illustration to Psalm 30 (A.V. 31) [342] should be compared with the corresponding illustrations in the Utrecht Psalter [50] and its other two derivatives [83, 343]. In the backgrounds, a particular decorative sense turns the feathery hillocks of the Utrecht Psalter into delicately patterned shell-like forms, and its light sketches of trees into ornamental designs. Despite all differences, however, the Utrecht spirit imparts to the twelfth-century illustrations a lightness and vivacity unknown at St Albans, or for that matter at Bury St Edmunds. But it is apparent both from the profiled heads and from the draperies[134] that it is to the circle of the followers of the Alexis Master that the Eadwine artists belong, though, as in the Bury Gospels, the curved paint-strokes that in the St Albans Psalter indicated the convexity of the chest are now transformed into patterns.

Stylistically, the illustrations of the Eadwine Psalter should be attributed to the second quarter of the twelfth century, probably to the years between 1135 and 1150. Closer pinpointing may be assisted by the drawing of a comet, unconnected with the text, in the lower margin of folio 10. It seems to have been a visual observation by one of the scribes, who also occasionally added human and animal heads as decorative motifs at the base of the page. His comet is schematic but reasonably accurately drawn, and he remarks of it, in Old English, that 'The star that is called comet has this kind of light' (a reference presumably to its luminous tail), adding that in English it is called the hairy star and that it is an augury. Now the prognostications of comets were always applied to the short-term future, as Shakespeare's Bedford reminds us: 'Comets, importing change of times and states, Brandish your crystal tresses in the sky.'[135] The appearance of Halley's comet in 1066 was also interpreted in immediate terms: 'Blazing from heaven, the streaming hair of a comet proclaimed to the English foreordained destruction', declared one writer,[136] and of course the artist of the Bayeux Tapestry implicitly associated the same comet with the Norman invasion. The Eadwine scribe must therefore have been recording a recent comet. It was for many years thought to have been the comet of 1145, but some years ago I proposed the one visible in 1147[137] because the Annals of Christ Church, where Eadwine was a monk, make no mention of the 1145 comet yet give a very precise record of the one that appeared in 1147.[138] The suggestion that the scribe of the Annals was guilty of inaccuracy in his recording[139] is not borne out by other documentary accounts:[140] the eighteenth-century cometologist Alexandre Pingré referred to contemporary notices of the appearance of the 1147 comet on the Continent and in China and Japan,[141] and its existence is confirmed by modern scientific scholarship.[142] Perhaps the 1145 comet[143] escaped notice in the Annals because adverse weather conditions prevented its being sighted.

Another comet is recorded by Roger de Howden in 1165,[144] though there is no confirmation of this elsewhere (one is however more reliably recorded in 1166), and Howden is not the most accurate of historians; the reason for mentioning it here is that Urry, a former archivist of Canterbury Cathedral, believed that he could perhaps detect the hand of one of the Eadwine scribes in Rental Roll B of Christ Church, which he placed between 1163 and 1167, noting that there were

342. Canterbury: Illustration to Psalm 30 (31), from the Eadwine Psalter,
MS. R.17.1, folio 50. *c.* 1147. Cambridge, Trinity College

343. Canterbury: Illustration to Psalm 30 (31), from the Paris Psalter, MS.
lat. 8846, folio 50. *c.* 1170–90. Paris, Bibliothèque Nationale

some grounds for assigning it even more precisely to 1166 or 1167.[145] Some weight is added to the case for dating the entire Eadwine Psalter to the 1160s by the facts that a famous painting of Eadwine at the end of the manuscript (to be discussed later) belongs to the sixties in terms of style, and so do plans bound into the manuscript (also to be referred to again). Nevertheless, such a late date for the main illustrations almost beggars belief, for it would involve three separate artists deliberately setting out to reproduce the style of their fathers' generation, with such success that they have misled all who have studied the manuscript since. In fact the scripts of the Eadwine Psalter are characteristic of the middle decades of the century generally, and something close to them already exists in a document in the cathedral archives recording the profession of obedience of Patrick, bishop of Limerick, to Archbishop Theobald in 1140.[146] As this calligraphic style was in vogue for about twenty years or so, it is far from impossible that a single scribe should have been practising it both in the 1140s and in the 1160s – we saw in an earlier chapter that Alulfus, a scribe of Saint-Martin at Tournai, was attached to his community for as long as forty-eight years.[147]

As the Canterbury Annals record the appearance of the 1147 comet on 14 May, and the drawing of it occurs on a very early folio, we can infer that the Eadwine Psalter was begun in the late spring of that year.[148] It is not known when it was finished, but the copying out of a manuscript as massive as this, with six running texts all carefully co-ordinated and fastidiously laid out, and then meticulously decorated and illustrated with well over 150 coloured drawings, must have taken an exceptionally long time.

THE PARIS PSALTER

The last copy in the tradition of the Utrecht Psalter already referred to is now in the Bibliothèque Nationale in Paris.[149] It probably belongs to the 1170s or 1180s. Work on it must have been abandoned suddenly, for not only does it stop short just before the end of verse 6[150] of Psalm 98, but the illustrations were discontinued after Psalm 52. By the fourteenth century the Paris Psalter had reached Catalonia, where a Catalan artist added fiftytwo pictures of his own[151] within frames outlined during production at Canterbury.[152] Except for the illustrations to Psalms 40, 41, 45, 46, 47, 49, and part of 53,[153] which follow underdrawings already made at Canterbury (the pictures to Psalms 42–4, 48, and 50–2 are entirely English), the Catalan pictures do not, of course, relate to the Utrecht sequence. When exactly the manuscript reached Spain we do not know, but the fact that the mural of the martyrdom of Becket at Santa María de Tarrasa depended very much on contemporary sources from Canterbury[154] would indicate that, already around the 1190s, there were some contacts between Canterbury and Catalonia.

Traditionally it has been assumed that the English pictures of the Paris Psalter were copied from the Eadwine Psalter – a view supported by the fact that the illustration to Psalm 3 includes a small scene of the death of Absalom not found in the Utrecht Psalter but introduced into the Eadwine Psalter in response to a title to the Psalm that the scribe had intruded into the picture space.[155] In recent years, however, a claim has been made that the Paris Psalter's illustrations derive

directly from a lost model on which the Eadwine and the Paris manuscripts both depended[156] – a theory prompted by claims that, while the Paris Psalter's pictures in general correspond to those of the Eadwine Psalter iconographically, they also include features of the original Utrecht Psalter drawings not repeated in the Eadwine Psalter. Yet we have only to take any corresponding pages of the two manuscripts and illustrate them side by side [344, 345] to see that the scribes at any rate were copying from the Eadwine texts:[157] indeed they were so meticulous in this that they even transferred to their own copy a scribal error particular to the earlier manuscript. With the pictures things were certainly different, and the explanation for the reflections in them of elements of both the Eadwine and Utrecht Psalters is that, working as the artists were at Canterbury, they had access to both; in fact, the Eadwine Psalter must have been in such demand by the scribes for copying purposes that the artists would have found it useful to draw also on the Carolingian source which, a thoroughgoing analysis has shown, they turned to more often than they did to the Eadwine Psalter.[158]

As we have already indicated, the Paris Psalter contains (on its prefatory folios) a copy (albeit with discrepancies due to losses[159]) of the extensive cycle of miniatures associated with the Eadwine Psalter. This was no unimaginative copy, however, for the artists expressed their own ideas from time to time, omitting some scenes and adding others, and also making changes to the immediate pictures in front of them – giving five scenes instead of three to the Temptations of Christ, completely changing the appearance of the Tree of Jesse, which is given a whole page instead of half a page, and varying the number of figures in a particular scene.

There is a considerable degree of freedom too in the main cycle of Psalter illustrations, groups of figures being reduced or increased in number,[160] figures changed from women to men or from men to women,[161] and sometimes new scenes being introduced to fill up areas previously blank. The cowled figure holding up an unstoppered vessel added to the left of the illustration to Psalm 11[162] seems to be based on a personal whim, but the king tumbling from his throne who fills a blank space at the bottom right of the Psalm 51 composition[163] must have been suggested by the text, which begins by asking, 'Why boastest thou thyself in mischief, O mighty man?', and a few verses later observes, 'God shall likewise destroy thee for ever, he shall take thee away, and pluck thee out of thy dwelling place.' There are one or two further instances – particularly in the later pictures – where modifications are made to the iconography of the earlier manuscripts in response to the text.[164]

More pronounced than the iconographical variations from the earlier manuscripts, however, are the differences in style. The artist of the Paris Psalter redesigns architectural features,[165] changes costumes,[166] arrays military figures in contemporary armour,[167] and consistently gives his demons a monstrous rather than a basically human appearance.[168] Moreover the scenes within a composition are separated by two new means: until Psalm 34, undulating bands of 'landscape' are used which, despite their gradations of colour and a certain sinuousness, are reminiscent of the leads of a stained-glass window; but from Psalm 35 onwards, a more formal division is made into two or three registers, with

344. Canterbury: Illustration to Psalm 4 and the first verses of the text, from the Eadwine Psalter, MS. R.17.1, folio 9. c. 1147. Cambridge, Trinity College

345. Canterbury: Illustration to Psalm 4 and the first verses of the text, from the Paris Psalter, MS. lat. 8846, folio 9. c. 1170–90. Paris, Bibliothèque Nationale

architectural columns marking off individual scenes. Above all, the illustrations of the Paris Psalter differ from those of all previous representatives of the Utrecht Psalter tradition in being not drawings but paintings, and remarkably sumptuous ones, gleaming with bright colour against *de luxe* backgrounds of burnished gold. This change of medium, and the resulting substance and weight of the figures, completely change the aspect of the pictures. The airy spaciousness of the prototype and its earlier copies is completely gone, and the figures begin to crowd the compositions instead.

The pictures of the Paris Psalter, including the preliminary cycle, are in a uniform, richly Byzantinizing style. They seem to be the work of a single studio, with a possible division of labour between underdrawing and final painting, and, though attention has been drawn[169] to parallels with the style of the Master of the Parable of the Sower, who (as we shall see in the next chapter) provided stained glass for Canterbury Cathedral, the fact is that the associations of the figure style of the Paris Psalter are not with Canterbury at all but with Winchester: its heavy 'Byzantine' modelling is closest to the illumination of the Winchester Bible that we shall also come to later, falling somewhere between the modelling characteristic of the Genesis and Morgan Masters on the one

hand, and of a third contributor to the Bible, the Master of the Gothic Majesty, on the other.[170]

Because it is easier to find parallels to the style of the Paris Psalter outside Canterbury, it seems probable that its artists (or artist) were travelling seculars engaged by Christ Church for this particular project. If so, it broke the Utrecht Psalter tradition, but was in line with contemporary trends, for in the second half of the twelfth century secular artists were coming more and more to the fore throughout Western Europe.

THE GREAT BIBLES AND RELATED PAINTINGS

THE BURY BIBLE

It is not surprising that the scribe of the Eadwine Psalter, so obviously a giant Psalter, should also have copied out a great Bible,[171] a genre of manuscript as popular in twelfth-century England as in the rest of Romanesque Europe. The paintings of some of these English great Bibles are among the most significant of their time in the West, and one of the earliest[172] – the Bury St Edmunds Bible[173] – is also one of the noblest.

346. Master Hugo, Bury St Edmunds: Initial F, from the Bury Bible, MS. 2, folio 1 verso. *c.* 1135. Cambridge, Corpus Christi College

347 (*opposite*). Master Hugo, Bury St Edmunds: *Moses expounding the Law to the Israelites,* from the Bury Bible, MS. 2, folio 94. *c.* 1135. Cambridge, Corpus Christi College

At Bury St Edmunds, records were made not only of the deeds of kings and bishops but also of the activities of the Bury sacristans[174] – officers of the greater houses who were responsible for the internal decoration and maintenance of the monastic church – and from these records we learn that an artist named Hugo 'incomparably painted' a Bible – presumably this one – and also engraved the double doors at the front of the church, excelling 'himself wonderfully in this work as he excelled everybody else in others'.[175] Later, during rebuilding and refurbishing after a disastrous fire of 1150 or 1152,[176] Hugo is recorded as having engraved 'in his incomparable manner' a Crucifix with the Virgin and St John for the choir.[177] The two monastic officers who commissioned the Bible served together between c. 1125 and c. 1136,[178] and as the style of the illumination can only belong to the end of this period, we may, like Kauffmann,[179] place it c. 1135, though McLachlan would date it between 1135 and the early 1140s.[180] The calligrapher must have been a layman, for he was paid for his work,[181] and it seems probable that Hugo was a secular as well; he was not claimed by the Bury community as a monk, and his title of *magister* probably indicates that he was master of the works, or of the workmen.[182]

Of the original two tomes of Master Hugo's Bible only the first survives, divided in more modern times into three volumes. In its three historiated initials, the figures of Isaiah, Amos, and Micah precede their respective Books. The thirty-nine superb decorative initials, characterized by strong colours, balanced compositions, and luxuriant foliage, are sometimes enlivened by unexpected intrusions – a mermaid or an owl, a centaur or a griffin; the bear-keeper with his bear in the initial on folio 220 is paralleled in a Canterbury manuscript.[183] The most splendid of the decorative initials is the prefatory one, the almost full-page F (Frater) at the beginning of St Jerome's letter to Paulinus on folio 1 verso [346]. Set within its own frame, it is replete with lively, vigorous, and clearly defined scrollwork and foliage. Piquant human, bird, and animal life, including two apes peering out from the upper scrollwork, enliven the decoration, and roundels in the upright of the initial include a charging centaur and a man with a wooden leg in pursuit of a rabbit. Great as we shall see the artist to have been, he was not a man to forgo a little fun.

One or two of the initials have been removed, but the illustrations – the real glory of the Bible – have suffered considerably more from depredations made all the easier by Hugo's practice of painting his pictures on separate sheets of fine vellum and pasting them on to the relevant folios. We know from the sacristans' records that Hugo obtained the vellum from Ireland,[184] just as the León Bible of 1162 was made from vellum brought from France.[185] The illustrations, some of them full-page, prefacing the Books of Genesis, Exodus, Leviticus, Joshua, and Judges – about half the original number in the surviving volume – have gone; of the six large-scale pictures, containing ten scenes in all, that remain we reproduce as illustration 347 the one on folio 94, with its two scenes of Moses expounding the Law to the Israelites. Their combination of magentas, greens, rich blues, and bright reds, thrown into relief by areas of black, produces striking and sometimes uncanny effects, and, as in the St

Albans Psalter (and indeed some areas of Mosan illumination[186]), they have rich backgrounds consisting of one rectangle of colour set inside another, comparable to backgrounds in the contemporary German metalwork of Eilbert of Cologne[187] – and Hugo was also a metalworker. Hugo absorbed elements from the Alexis Master – his strong contours, for example, his use of full-page and three-quarter-page pictures in double frames, and above all a certain sense of solidity – but he far surpasses the St Albans painter in artistic genius: indeed, he is one of the great international artists of the twelfth century.

One is tempted to associate the fact – pointed out by Kauffmann – that most of Hugo's surviving scenes have iconographic parallels in Byzantine art[188] with the abbacy of Bury at the time of an Italian who had formerly ruled over the Roman house of San Saba, with its mixed community of Greeks and Italians. However, two earlier archbishops of Canterbury, Lanfranc and Anselm (the same abbot's uncle), were Italian and there were no Italo-Byzantine repercussions, so it would be prudent to attribute the Byzantinisms in Hugo's work to the general tide of influences from the art of the Eastern Church. Two of his pictures, however, are very much of the West: the vision of Ezekiel; and the illustration to 1 Samuel of Elkanah handing robes to his two wives, which derives specifically from Western commentaries on the Vulgate text.[189] Byzantine influences include, in the decoration, use of the so-called 'Sassanian' blossom, which gives an expansiveness to some of the foliage,[190] and, in the figures, the sophisticated modelling and the 'damp-folds' of the draperies. These were not of course innovations in the art of the West, but Hugo's genius was such that he could shape them into a personal and Romanesque idiom combining curvilinear elegance with a feeling of weight, graceful but statuesque, free-flowing but deliberative. The reproduction in illustration 347 can at least give some idea of the sheer majesty of Hugo's creations. His influence at Bury has been traced in the illumination of eight manuscripts, seven now at Cambridge and one at Oxford,[191] but more important, as we shall see later, was his effect on other houses: indeed, many of the great manuscript paintings of England over the rest of the century bear some impress from his style.

Hugo's influence was strong also on the finest twelfth-century mural to remain on the soil of England – a wall painting of St Paul in Canterbury Cathedral[192] [348]. It is in the upper left corner of a chapel formerly dedicated to St Peter and St Paul and now known as St Anselm's Chapel, and owes its survival to the fact that it was concealed until the end of the nineteenth century by a buttress built in the thirteenth. It shows St Paul shaking the viper from his hand on the island of Malta (Acts XXVIII, 3 ff.). The nobility of the head is partly attributable to the use of Byzantine modelling, and the draperies have been compared by Kitzinger[193] to those of the St Paul in the scene of the Dormition of the Virgin, dated 1105/6 by inscription, in the Cypriot church of Panagia Phorbiotissa of Asinou, near Nikitari. However, the immediate derivation of the Canterbury St Paul is not from Byzantium but from Hugo: it uses his palette of blues and moss-greens and his superimposed rectangles of colour to form a background, and, more importantly, the figure is stamped with the Romanesque qualities of power, repose,

348. Canterbury Cathedral, St Anselm's Chapel, *St Paul and the viper*. Wall painting. *c.* 1163

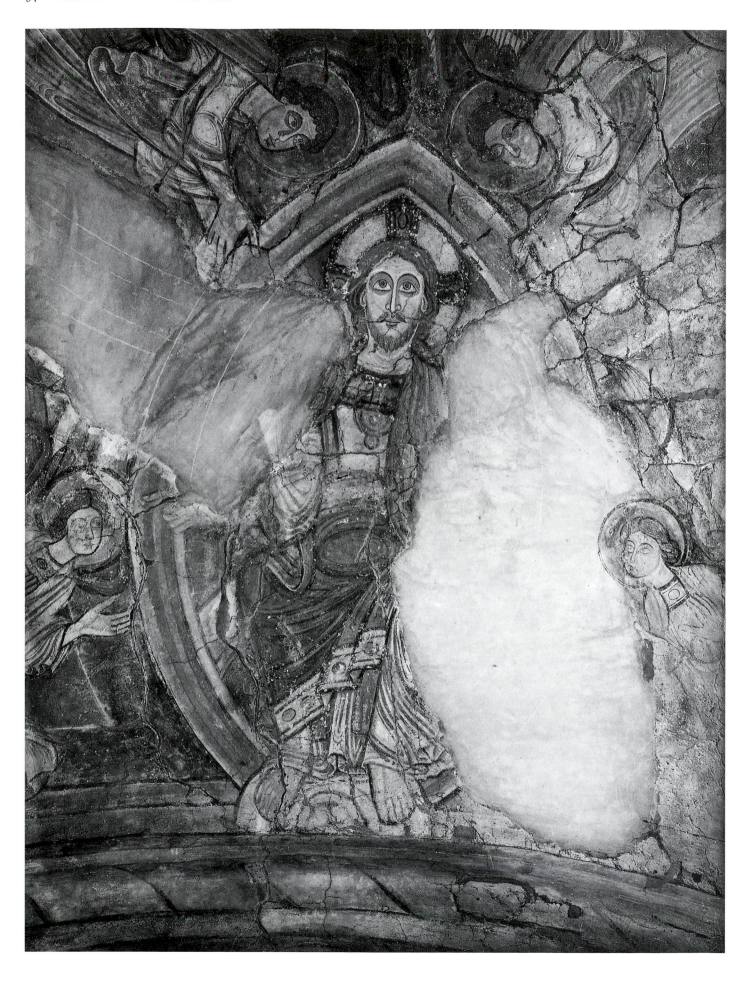

and universality that were the hallmark of Hugo's style. The hands are more solid and the face has the warmth and humanity of a later period,[194] but the style is still very close to the Bury Master's, even to the foliate decoration of the draperies. The painting must, however – as scholars have shown – post-date the period 1155–60,[195] when Prior Wibert's new towers were going up, and cogent arguments have been put forward for an even closer dating to 1163, when – on 7 April – Anselm's remains were translated to the chapel.[196] The archbishop of the time, Thomas Becket, had a special regard for Anselm, and began a process which might well have led to Anselm's canonization in the twelfth century instead of the fifteenth had it not been for the circumstances that led to Becket's being canonized first. The archbishop may also have had a personal interest in St Paul for, according to late sources, he was reminded of Paul's conversion when he was himself persuaded to abandon secular wealth for a life dedicated to the Church.[197] The other murals of the chapel have vanished, leaving only this one to testify to the heights that twelfth-century English wall painting could achieve and – considering its relationship with Hugo's work of almost three decades earlier – to the tenacity to tradition of some English wall painters.

A similar conservatism characterizes the wall paintings at crypt level in St Gabriel's Chapel[198] which used to be dated *c.* 1130 but are now – on architectural evidence cited by Kahn – given to the period soon after *c.* 1155: Kahn has found resemblances between them and fragmentary murals in the infirmary chapel which, also on architectural evidence, can be dated after *c.* 1155 and before 1174.[199] The focus (now damaged) of the St Gabriel's Chapel paintings is in the semi-dome of the apse [349]: a Christ in Majesty in a mandorla supported by four angels. Christ gazes out into eternity with the fixity of the Christs of Byzantine art, but the angels, painted in purple, yellow, and blue, have a rhythmic vigour reminiscent of the figures of the Canterbury initials of the first half of the century, and their under-draperies have the exuberance of initials in the first volume of the Dover Bible. The figures on the walls, on the other hand, are in a rather conventionalized version of Italo-Byzantine art. On the north wall are Gabriel appearing to the dumb Zacharias before the people, and Zacharias and Elizabeth naming John the Baptist, and on the south wall the Annunciation and the Visitation (an Adoration of the Magi has been lost). On the soffits and vaults are remains of the personifications of the seven Apocalyptic churches, and – from a later programme of painting, probably of the eighties – traces of angels and seraphim and scrollwork in which Italo-Byzantine influences are reflected in the angular treatment of the 'damp-folds', the bejewelling of some garments and footwear, the strong highlighting of the necks, and the close circular curls of the hair. Similar influences are to be found in Canterbury illumination of the first half of the century, as is demonstrated by a splendidly decorated two-volume copy of Josephus[200] in which the scene on folio 64 verso, of the Jewish author

dictating his text to a cowled scribe identified as Samuel, is set among arches with capitals and marbled columns that seem to anticipate those of the scene of the naming of John in the wall paintings.

THE LAMBETH BIBLE

The pictorial style of the Lambeth Bible,[201] so called because its first volume is in the library of Lambeth Palace, transports us into a totally new world of exhilarating line and design. Although there is little in it, from the forms of the heads to the lines of the drapery, which cannot be traced back to Hugo, its spirit is entirely different: gone are the weight, the poise, and the balance of Hugo's figures, and everything is expressed in terms of line. The highlights between the eyes are converted to pattern and so too are the beards, while the drapery folds are developed into swaying contours and arabesques. In fact the Lambeth figures, their flat pastel shades set against richer backgrounds of gold or blue or green, are transformed into an extravaganza of line and pattern – into swirling designs, like ripples fanning out over a pond, that lead the eye around and across the page. Likewise the scenes on folio 66 verso from the Book of Numbers – Moses on Mount Sinai, Moses numbering the tribes of Israel, the duties of the Levites, and the offerings made before the tabernacle [350] – form intricate webs of design, living patterns floating effortlessly across the page. With their charming colour harmonies and delightful rhythms, they look back to the roots of English art – to the love of animated design that the Saxons had brought with them to England, and which inspired the decorative pages of the Lindisfarne Gospels.

As far as Byzantine influences[202] are concerned, there is clear evidence of these in the iconography, and the illustrations on folio 6 of the dream of Jacob and of Abraham receiving and entertaining the angels are so close to the corresponding scenes in the Siculo-Byzantine mosaics at Palermo[203] that they could only have been derived from a similar model. Influences from Italy and the Mosan area have also been detected,[204] and the scenes of Ezekiel and of Daniel have been associated with ones in the Roda Bible:[205] perhaps they ultimately derived from a common source.

One of the really great paintings of the Bible is the Tree of Jesse on folio 198. Nowhere else is this popular theme rendered with such lilting rhythms and delicate colour sensibilities [351]. The backgrounds are in gold and lapis lazuli, and the figures are in gentler tones, such as shades of salmon-pink and blue, with touches of brick red. In the supple branches of the tree growing from the loins of the recumbent Jesse are figures that link the Old Testament with the New. Lower down are four of the prophets who foretold the birth of Christ, among them Isaiah holding the very prophecy which is the subject of this painting: 'there shall come forth a rod out of the stem of Jesse, and a Branch shall grow out of his roots' (XI, I). In the central branches are personifications of Mercy, Truth, Righteousness, and Peace, the four Virtues of Psalm 85 whose reconciliation, according to St Bernard, was brought about by the promise of the birth of the Redeemer.[206] (As we shall see shortly, the artist of this painting may at some time in his career have actually met the

349. Canterbury Cathedral, St Gabriel's Chapel, apse, Christ in Majesty. Wall painting. *c.* 1155–60

ance popłin armati & ordinati. Egypto.
Diuerticula filioʒ isrł'. exquo pfecti fe exe
unt dns ut dispdant oms inhabitantes
chanaan· qd sirelicti fuerint eē sudes in

tel homicida contigere debeant ostendit.
De filiab; salfat iubetur ut sint intribu ple
bis patris sui. Expliciunt capla.
Incip lib numeri q̃ appellat hebraice uagedab

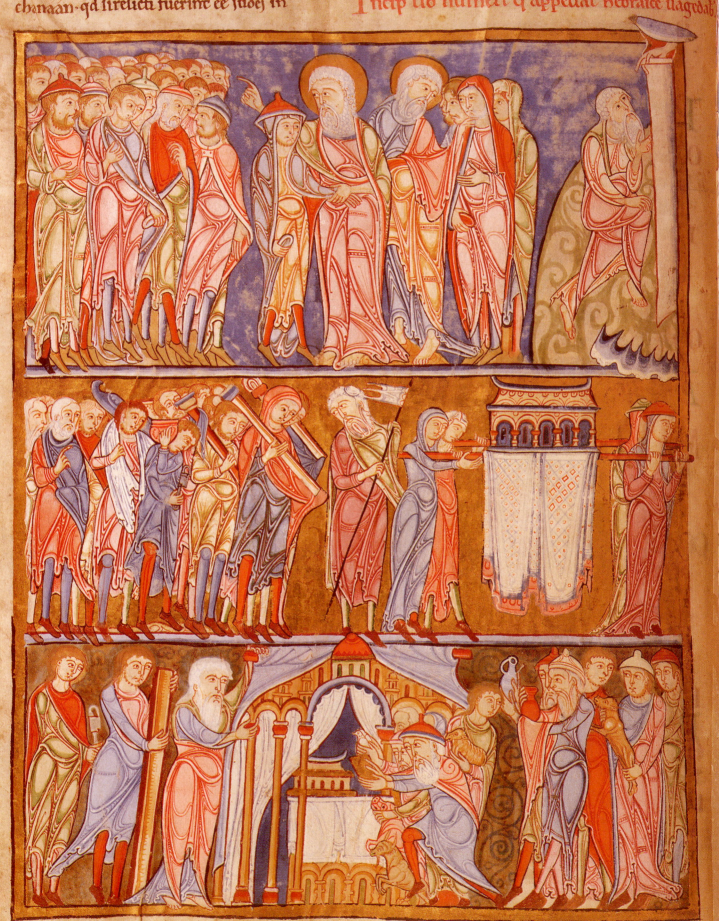

350 (*opposite*). Canterbury or St Albans: Illustration to the Book of
Numbers, from the Lambeth Bible, MS. 3, folio 66 verso. *c.* 1145–55.
Lambeth Palace Library

351. Canterbury or St Albans: *The Tree of Jesse*, from the Lambeth Bible,
MS. 3, folio 198. *c.* 1145–55. Lambeth Palace Library

saint.) In the two uppermost branches of the tree are the Synagogue with Moses and another prophet, and the Church Triumphant with apostles. In front of the main trunk stands the Madonna, clad in the blue of her virginity, beneath a roundel framing a bust of her son surrounded by seven doves to personify the seven gifts of the Holy Spirit to which Isaiah's prophecy refers: 'And the spirit of the Lord shall rest upon him, the spirit of wisdom and understanding, the spirit of counsel and might, the spirit of knowledge and of the fear of the Lord' (XI, 2). Half-figures in medallions at the corners of the page represent further prophets or ancestors of Christ.

Of the twenty-three historiated initials in the first volume of the Lambeth Bible, five extend the considerable length of the page. Two, however, were left unfinished and four not even begun, and the manuscript has also lost five folios, which may have carried pictures. Yet this is nothing compared to the vandalization of the second volume, now at Maidstone,[207] which was stripped at some early date of all its full-page pictures and most of its initials. The remaining initials indicate that the second volume was illustrated in a similar style to the first, one with an elegance and grace rising far above the style of the leaves detached from the Eadwine Psalter though clearly having some general associations with it.

A sixteenth-century note at the end of the second volume indicates that it was at Lenham in Kent from 1538, and the idea that it came from Canterbury is suggested by references to John Hales, a dignitary of Canterbury married to a lady from Lenham, and to Sir Christopher Hales, another Canterbury worthy who represented Christ Church and was a commissioner for the dissolution of that house.[208] This does not, of course, prove a Canterbury origin for the Bible, and Bury St Edmunds and St Albans have also been proposed. The Bury connection is suggested by Hugo's influence on the work of the Lambeth Master but – as earlier emphasized – the idioms of the two artists are completely different. Moreover it is highly unlikely both that Bury would have needed another great Bible besides Hugo's, and that it would have commissioned anyone but Hugo at a time when he was probably still active.[209] The view taken by one scholar that the Prefaces to the Lambeth Bible support a Bury origin for the Bible[210] has been convincingly discounted by another.[211]

The arguments in favour of St Albans are much stronger. They are three in number. The first is the similarity of an initial I in a St Albans copy of Josephus,[212] composed of medallion scenes of the Creation, to the In Principio initial in the Bible. The second is that the style of tiny pictures in a calendar, probably from St Albans,[213] has close affinities with the style of the Lambeth Master, though they do not seem to be by his hand;[214] they were made between 1140 and 1158, and perhaps between Easter 1148 and Easter 1149.[215] The third is that St Albans had in its possession in the thirteenth century a bifolium with two twelfth-century pictures of the Deposition from the Cross and the Marys at the Tomb[216] which are very much in the idiom of the Lambeth Master. As they are unfinished, they lack the firmness and weight of a completed painting, though they have a strangely ethereal quality of their own.

The claims of St Augustine's, Canterbury, are also weighty.[217] As we have seen, there is some evidence that the Bible was at Canterbury before the dissolution of the monasteries. There are moreover links between the illumination of the Lambeth Bible and that of earlier Canterbury manuscripts which can be summarized as follows: the illustration in the initial to the opening verse of Psalm 110, 'The Lord said unto my Lord', is close in iconography to a comparable illustration in the Utrecht and Eadwine Psalters; decorative initials in the Bible have some similarities in colour and foliate decoration to those of a St Augustine's manuscript,[218] and a particular initial, on folio 35 verso of the Maidstone volume, uses a mask-head as a terminal in much the same way as another initial in a manuscript known to come from Canterbury;[219] the figure of yet another initial has some resemblances to a larger-scale figure in a St Augustine's manuscript;[220] and finally, the Lambeth Master's partiality for disintegrating the figure into oval and pear-like shapes and for projecting the drapery at the hems seems to be anticipated in the work of an earlier Canterbury artist who, however, lacked his talent for elegance and compositional equilibrium. The balance of probabilities, despite the strong case for St Albans, is that the Bible was made at Canterbury.

But it is possible that in all this we are following the wrong hare and should be thinking in terms not of artist monks who were tied to a given monastery, or secular artists like Hugo of Bury who were content to attach themselves to one, but of peripatetic artists who followed the routes laid down by their various commissions and were never long in any one centre: we know indeed that the Lambeth Master worked in France as well as in England.

A date for the Lambeth Bible will be suggested at the end of the account of the Wedric Gospels.

THE WEDRIC GOSPELS

The Wedric Gospels,[221] illuminated by the Lambeth Master in France, was destroyed during the Second World War. In two surviving pictures earlier detached and now at Avesnes,[222] however, we can see that the master used much the same palette as in his Bible, though his line here was bolder and less fluid. Our only knowledge of the rest of the manuscript comes from one or two photographs taken before its destruction, and from earlier descriptions which emphasize its general sumptuousness and the gold and various colours of its magnificent initials.

The first of the surviving leaves bears a full-page picture of St Mark seated at work on his Gospel within a rectangular frame inset with medallions and half-medallions of which two contain representations of Ezekiel and of the Baptism of Christ. Ezekiel holds the quotation from his vision (I, 6) which was one of the principal sources for the evangelist symbols of medieval art. There are also four busts with scrolls in the medallions of which only one can be identified: it may be significant that it is of the English theologian Bede.

The second leaf bears a noble picture, also full-page, of St John [352] within a frame inset, as in the Anglo-Saxon Grimbald Gospels, with medallions containing scenes, here of events from the evangelist's life. One medallion, however, encloses the half-figure of an abbot identified as Wedric[us] who reaches out to offer an ink-horn to the evangelist. Photographs show that Wedric also made an appearance in

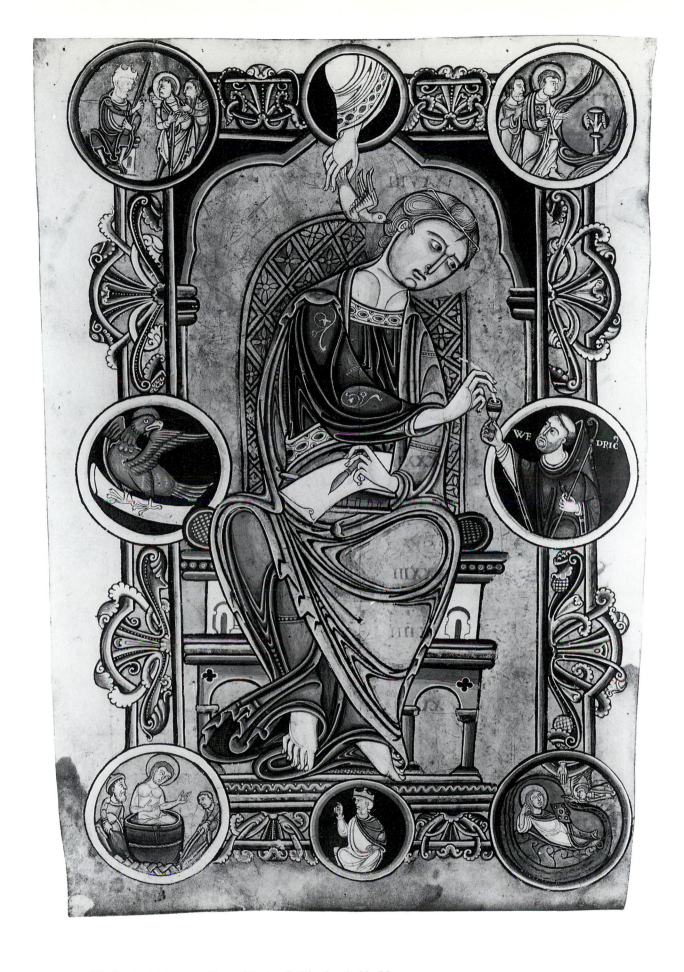

352. The Lambeth Master working at Liessies: *St John*, detached leaf from
the Wedric Gospels. 1146. Avesnes, Société Archéologique

353. Canterbury: Initial S, from the Dover Bible, MS. 4, folio 241 verso.
c. 1155–65. Cambridge, Corpus Christi College

354 (*above, right*). Bridekirk, St Bridget, font. Third quarter of the twelfth century

355 (*below, right*). Weissenau: *Initial R, with self-portrait of the artist, Rufillus,* from a Lectionary, MS. 127, folio 244. Later twelfth century. Geneva, Biblioteca Bodmeriana

the centre of the great introductory initial to the Gospel of St John, where he held up this very Gospel Book, open to reveal the inscription: *Wedricus abbas me fecit.* Now as 'the Word was God' occurs in the opening sentence of St John's Gospel, Wedric was no doubt offering this splendidly embellished copy of it (an inscription described the book as *decus*) to remind the Almighty of the efforts he was making to disseminate that Word. Wedric has been identified with a Wedric who was abbot of Liessies in north-eastern France between 1124 and 1147, moving on to hold a similar office at Saint-Vaast[223] from 1147 to 1155 and taking influences from this English style with him [195]. According to an inscription in the destroyed manuscript, it was written in 1146, the year when St Bernard visited Liessies,[224] probably in connection with the arrangement whereby Liessies could send monks to Clairvaux to copy out books. It was on this visit that, as I suggested earlier, the artist may have met the saint, and 1146 is at any rate a year that gives a convenient anchorage for the dating of the Lambeth Bible, which may be reasonably placed between 1145 and 1155.

THE DOVER BIBLE

More certainly produced at Canterbury was another great Bible, datable between *c.* 1155 and *c.* 1165, that I have elsewhere suggested was written by Eadwine himself.[225] Known as the Dover Bible[226] because it was later passed on to a cell of Canterbury at Dover, it is unlike the earlier English great Bibles in confining all its illustrations to initials, some of them extending the full length of the page. They comprise the most splendid and colourful repertory of the art of the initial that we have so far seen in England. The first volume is completely different in style from the second, and neither can be associated with any of the Canterbury paintings so far discussed: the reason is no doubt that the work was carried out by visiting secular artists, and some confirmation of this is provided by a picture in the second volume of a painter busy at his work [353]. He takes up the stance of a wall painter, holding a paint-pot in one hand and with the other painting the diagonal of the initial as if it were a sloping wall. His assistant meanwhile, in the upper part of the initial,

356. Canterbury: *St Matthew,* from the Dover Bible, MS. 4, folio 168 verso. *c.* 1155–65. Cambridge, Corpus Christi College

dit. & petr auriclam abscidit. ihs raur tertio
condemnat & inludit. Petr tercio abnegat &
lacrimat. ihs pilato traditur. & iudas laqueo
se suspendit. de agri figuli iudicium pilati. & de
baraba latrone. XXVIII.
Passio ihu & sepultura & resurrectio ei. itemq;
mandata & doctrina ei de baptismo.

BERGENERA

pounds up the lapis lazuli for the rich blues of his master's palette. The scene illustrates the third Epistle of John, to which (unlike the other pictures in the Bible) it has no apparent relevance. What is particularly interesting to us is that it shows the artist and his assistant as laymen, which suggests that the painters of the Bible were seculars too, for surely no monk would feel impelled to hand down a visual record of a lay artist. If the miniaturists were in fact secular, it would explain the discrepancies of styles in the Dover Bible, since the artists would have brought their own separate – and disparate – tastes and traditions with them.

Our artist here is inside the initial he is still working on, i.e. inhabiting a world of his own creation, and in this, I would suggest, he was responding to an artistic conceit of the time. Roughly contemporary examples of it include the sculptor, Richard, chiselling out the decoration of his font at Bridekirk, Cumbria [354]; a monk called Rufillus inhabiting the initial he is painting at Weissenau in Germany[227] [355]; another in a mid-twelfth-century picture from the abbey of Michelsberg still at work on the drawing he is producing [318]; and a German glass painter called Gerlachus standing inside the stained-glass window he is actually painting [396]. This Western concept is very different from the representation in earlier Byzantine manuscripts of evangelists in the act of writing the texts of their own Gospels;[228] teasing the beholder and upsetting his logical norms, it is a *jeu d'esprit* that belongs to a particular period: the third quarter of the twelfth century.

The pictures of the second volume of the Dover Bible can be very original in their subject matter. Verse 16 of the first chapter of the second Epistle of Peter, contrasting invented tales with the eye-witness testimony of those who had seen the divinity of Christ,[229] reads, 'We have not followed cunningly devised fables' – and so the artist gives us two delightful fable-scenes, the fox and the cock, and the wolf and the crane. 'Love righteousness, ye that judge the earth,' says the Book of Wisdom (I, 1), and the artist responds with a picture of a medieval judgement scene. Presumably because they are by an older and more conventional artist, the paintings of the second volume are more traditional in style than those of the first. They epitomize a peak of the Romanesque style in England, as we can see from the hand-on-hip figure of St Paul on folio 261, frozen, as it were, in the middle of some serene and ritual dance, and again in the gravely poised and monumental figure of St Matthew, surely one of the masterpieces of English Romanesque [356]. There was some stylistic influence from north-eastern France, for instance on the geometric conception of St Peter on folio 237, which is found across the Channel in the eleventh and twelfth centuries,[230] and in the closely decorated and sumptuously coloured cloak of the figure of the sacrificing priest on folio 191 verso [cf.199]. Influences from ItaloByzantine art are at two or three removes, in forms long established in the West. The iconography is occasionally reminiscent of Ottonian art (the picture of Solomon crowning two figures on folio 139 verso, for example, is akin to a composition from Echternach)[231] and occasionally of north-eastern France, for the illustration to St Luke's Gospel can be paralleled in a manuscript from Saint-Sépulcre;[232] at first sight the evangelist seems to be slaying his own symbol, but the representation

is in fact of the priestly sacrifice of the Old Testament which prefigures the sacrifice of Christ himself.[233]

As we have indicated, the initials of the first volume are much more forward-looking than those of the second, yet it seems that they were made at the same time, for inscriptions in them are apparently by the hand of the original scribe. The new ease of posture of the gracefully coloured figures is no doubt explained by the immediacy of the Byzantine influences now reaching Canterbury, which had earlier been received at second hand; now they are so fresh and strong that, far from being absorbed into the Romanesque aesthetic – as abstract and timeless as Stonehenge – they actually erode its inflexible quality. The result is that the Romanesque style, so dominant in the second volume, is in the first warmed into a more human life. An example that will serve for many is the picture of the prophet Daniel on folio 245 verso [357] pointing with one hand to Christ above, and holding in the other a scroll containing his prophecy of the coming of the Redeemer. Compared to previous work in England, the figure is possessed of a new sense of reality, and his red and green draperies fall in a reasonably natural way, despite some over-effusiveness in the lower folds. This Daniel is so close to the Noah of the Monreale mosaics[234] that we must suppose a similar stylistic source for both, though the Dover Bible is earlier: Daniel has the same threaded hair and hair-style as Noah, the same loop of drapery over the waistband at the back, a similar flying drapery-end, and similar zigzag folds over the knee. Other representations of prophets in this first volume can be compared just as convincingly with figures from Monreale or Cefalù, and the linear emphasis that deprives the Canterbury figures of some substantiality is apparent also in the Monreale mosaics.

357. Canterbury: *Daniel*, initial to the Book of Daniel, from the Dover Bible, MS. 3, folio 245 verso. *c.* 1155–65. Cambridge, Corpus Christi College

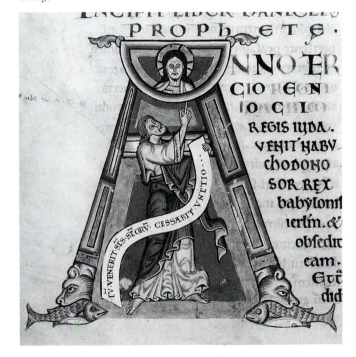

of Kings (folio 117 verso), where two scenes of the David and Goliath story[236] are brought together that were independent in Byzantine art.

THE EADWINE 'PORTRAIT'
AND THE COPENHAGEN PSALTER

The artists of the Dover Bible may have been secular, but its scribe was not. He was the main scribe of the Eadwine Psalter – in my view, Eadwine himself, who is known to have been a monk both from a prayer on folio 262 of the Psalter's text which refers to him in Benedictine terms[237] and from a famous 'portrait' of him, tonsured and in monastic dress, at the end of the volume [359]. Discussion of this painting has been delayed until now because it is best understood in the context of the Dover Bible. The picture of Eadwine is very large – larger, indeed, than any 'portrait' of apostle, saint, or king in the manuscript paintings of our period. Grand in scale, it is massive too in appearance, a massiveness intensified by the trefoiled arch above, which is too small to contain it and engenders a feeling of claustrophobia similar to that already noticed in Mosan art at the close of the eleventh century. It is, however, in north-eastern France that such massive 'portraits', normally of saints, are chiefly to be found. North-eastern France, too, as we have also seen earlier,[238] was particularly generous in its acknowledgement of the work of the scribe, and Baudemond – albeit not a contemporary calligrapher – was another who was pictured on a large scale.[239] Thus the Eadwine 'portrait' seems to conflate the French interest in monumental 'portraits' with the French interest in scribes.

The Eadwine picture is decorative rather than realistic – the hair, for example, is blue, and the cowl is green and cream. The rounded modelling of the head, in green, indicates some knowledge of Byzantine art, and the figure style has links with that of the second volume of the Dover Bible, which has other associations with one or two of the main illustrations of the Psalter, for example to Psalm 4. The Eadwine 'portrait' can be especially compared with two particular figures: the St Matthew [356], who, though smaller, has much of the monumentality of the Eadwine portrait and a comparable feeling of substance and poise; and the Solomon[240] who, though much slighter, has an overall floral patterning on the draperies somewhat akin to that on Eadwine's. This ultimately derives from the Bury Bible – though Zarnecki[241] points out that it is most closely paralleled in the Copenhagen Psalter,[242] for which reason he believes that the Eadwine picture belongs to the period around 1170; we can certainly accept that the 'portrait' is stylistically later than the main illustrations of the Eadwine Psalter.

The Copenhagen Psalter, named after its present home, originally came from an Augustinian house in the north of England. It is lavishly illustrated and richly coloured in gold, green, blue, red, brown, and beige, with sixteen introductory full-page pictures, chiefly of Christ's life and Passion. Of the hundred and sixty-six initials in the text, some are historiated with scenes illustrating the Psalms either in simple historical terms or as prophecies of Christ. Iconographic relationships have been traced with the Gough Psalter[243] and stylistic ones with the Glasgow Psalter,[244] but the Copenhagen Psalter is

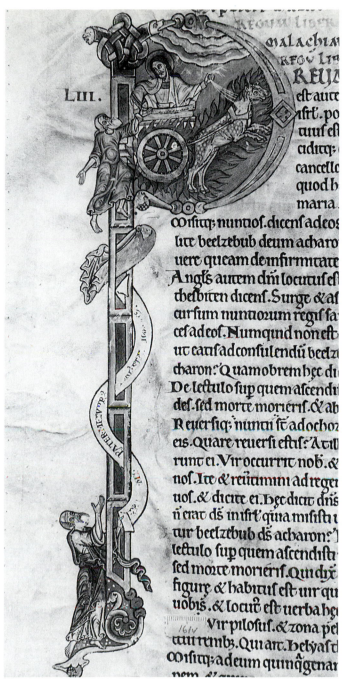

358. Canterbury: *Elijah and Elisha*, initial to the second Book of Kings, from the Dover Bible, MS. 3, folio 161 verso. *c.* 1155–65. Cambridge, Corpus Christi College

The iconography as well as the style of Byzantium is drawn on in this volume, for example in the illustrations of the Books of the Prophets with each author holding a scroll inscribed with an extract from his prophecy; indeed, they straightforwardly transpose figures from a Greek context to a Western one. On the other hand, the artist will bring together Byzantine scenes in unprecedented ways to fill up his extended initials, as in the initial to the second Book of Kings (volume 1, folio 161 verso), where the Byzantinizing figure of Elisha at the base looks upwards to another Byzantinizing scene above of Elijah being taken to Heaven in the fiery chariot[235] [358], and in the initial to the first Book

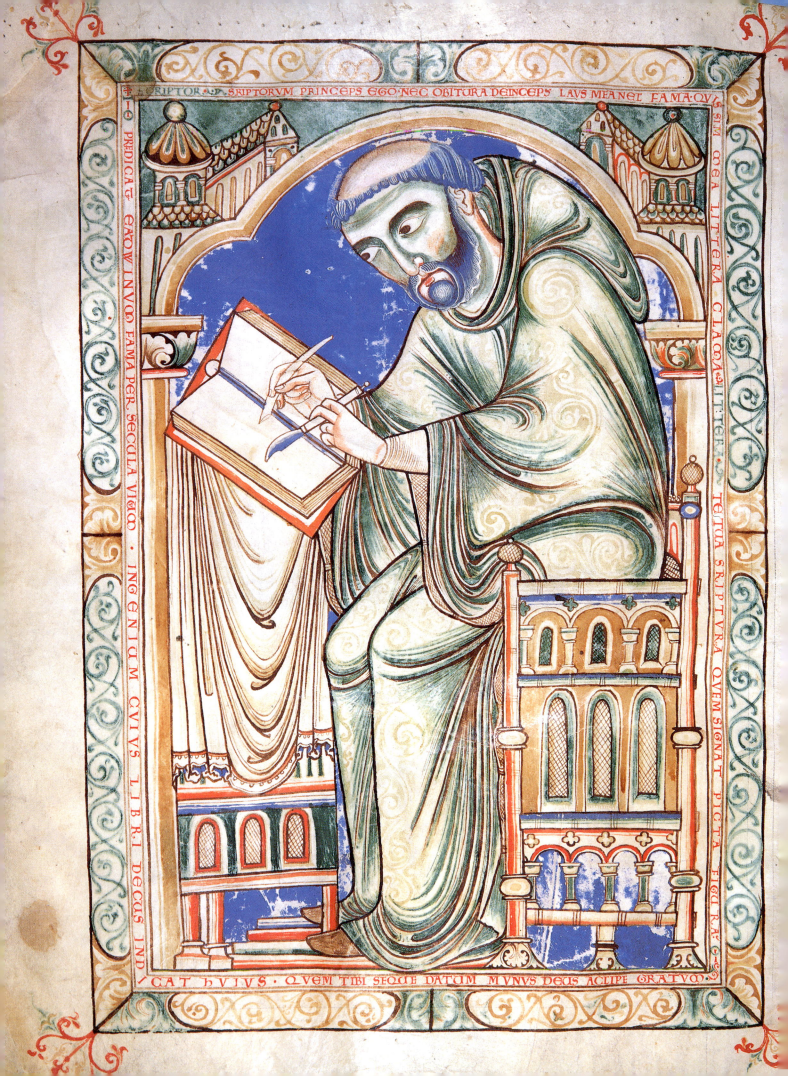

✠ SCRIPTOR SCRIPTORVM PRINCEPS EGO NEC OBITVRA DEINCEPS LAVS MEA NEC FAMA QVIS SIM MEA LITTERA CLAMAT

PREDICAT ERGO INVGO FAMA PER SECVLA VIGO · INGENIVM CVIVS LIBRI DECVS IND/CAT HVIVS · QVEM TIBI SEQVE DATVM MVNVS DEVS ACCIPE ORA TVO

QVE TVA SCRIPTVRA QVEM SIGNAT PICTA FIGVRA

far more impressive than either. Its chief artist[245] is one of the great masters of his period. In his own gentler and more sophisticated way, he takes over the lightly indicated foliation of the draperies of Hugo's Bury Bible and elaborates it into overall arabesques best appreciated in the Visitation scene [360].

The draperies of the Eadwine 'portrait' are certainly close to these, but Eadwine himself is more massive and somewhat more Romanesque than any of the figures in the Augustinian manuscript. For this reason, the Eadwine picture may perhaps be placed slightly earlier than the Copenhagen Psalter, whose precise date is itself unknown, though it was probably written before 1173 since Becket, who was canonized in that year, does not appear in the Calendar.[246] One school of thought holds that its illumination was begun about 1170 and completed by two younger artists during the course of that decade.[247] The Visitation belongs to the original decoration, and can perhaps be placed within the few years preceding 1173; if therefore the 'portrait' of Eadwine is allowed to be older, it was probably added to his Psalter at some time in the sixties.[248]

The 'portrait' is one of a number of instances of drawings and paintings added on blank leaves of manuscripts in England; others are in the Athelstan Psalter[249] [77], the Leofric Missal,[250] a Psalter from St Augustine's,[251] a Portiforium from Worcester,[252] a pre-Conquest Psalter from Winchester,[253] a Benedictional from Christ Church,[254] and a tenth-century Psalter from St Augustine's.[255] Eadwine's picture was painted on the blank folio 283 at the end of the volume which had always been part of the manuscript.[256]

Bound in at the end of the Psalter are two further additions: the famous plans for a project initiated by Prior Wibert (1153–67) for a new and extensive system to provide the monastery with water from springs and to equip it with an efficient means of drainage.[257] The larger plan was folded in half to make two folios, and the smaller was left as one. Willis surmised that the larger plan was made in the years around 1165, but most architectural historians today would venture no nearer than some point in that decade. It is tempting to suggest the same decade for the binding of the plans into the volume, given the new dating of the Eadwine 'portrait', but (unless the volume was anyway not yet bound) that would imply its disbinding, a particularly daunting task which Dr Cockerell, who had actually undertaken it, told me would hardly have been embarked upon simply for the interposition of plans.[258]

The view – prompted by the request to God at the end of the inscription round the border to receive both Eadwine and his book – that the 'portrait' was a visual obituary[259] is not borne out by the part of the inscription written in the first person. Moreover, as we have seen on a number of earlier occasions,[260] a medieval scribe, artist, or patron would frequently offer the fruit of his talent or patronage to God or his saints, seeking in return the divine favour – usually entry into the ranks of the elect. We shall also see later, in illustration 396, another 'portrait' associated with a request

359. Canterbury: *The 'portrait' of the scribe Eadwine*, from the Eadwine Psalter, MS. R.17.1, folio 283 verso. *c.* 1160–70. Cambridge, Trinity College

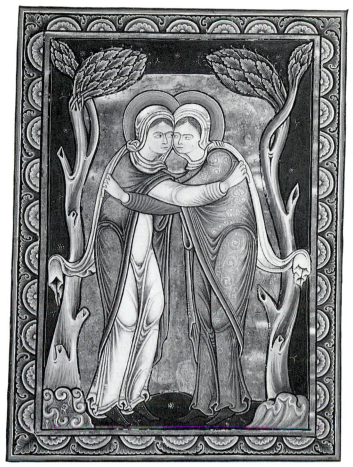

360. Northern England: *The Visitation*, from the Copenhagen Psalter, MS. Thott 143 2°, folio 8 verso. *c.* 1170–3. Copenhagen, Kongelige Bibliotek

for the divine favour by a living artist in stained glass of our period. If indeed Eadwine had been dead when his 'portrait' was made, some positive indication of it would have been given, as in a picture in a copy of St Augustine's *De Trinitate* from Anchin, where one of the two monks who produced the book, John, is shown offering it to Christ, while the other, Baldwin, is in his tomb.[261] Again, Abbot Lambert of Saint-Bertin was shown lifeless, his soul ascending to Christ, in an obituary picture made shortly after his death in 1125.[262]

Both the impressiveness of the painting of Eadwine and the inscription round it bear witness to the reputation enjoyed by the great calligraphers of the Romanesque period. The inscription is an extravagant verse eulogy, singing Eadwine's praises as the Prince of Scribes whose fame and acclaim will never die but will live through the ages. As the artist inhabiting his own creation was a visual conceit, so this was a literary conceit peculiar to the twelfth century. Panegyrics of monarchs and rulers are of course common throughout our period – indeed, under the Carolingians and Ottonians they reached heights of real absurdity. What was new in the twelfth century was the extension of such panegyrics to contemporary writers. At the beginning of the century, in his acknowledgement of a lengthy poem by the Canterbury monk Reginald, Abbot Lambert of Saint-Bertin remarked that writers do not die but live on like gods,[263] and later in the century a secular poet, Walter of Châtillon (who had served King Henry II of England), ended his epic poem, *Alexandreis*, by saying that his own name and his patron's will live on

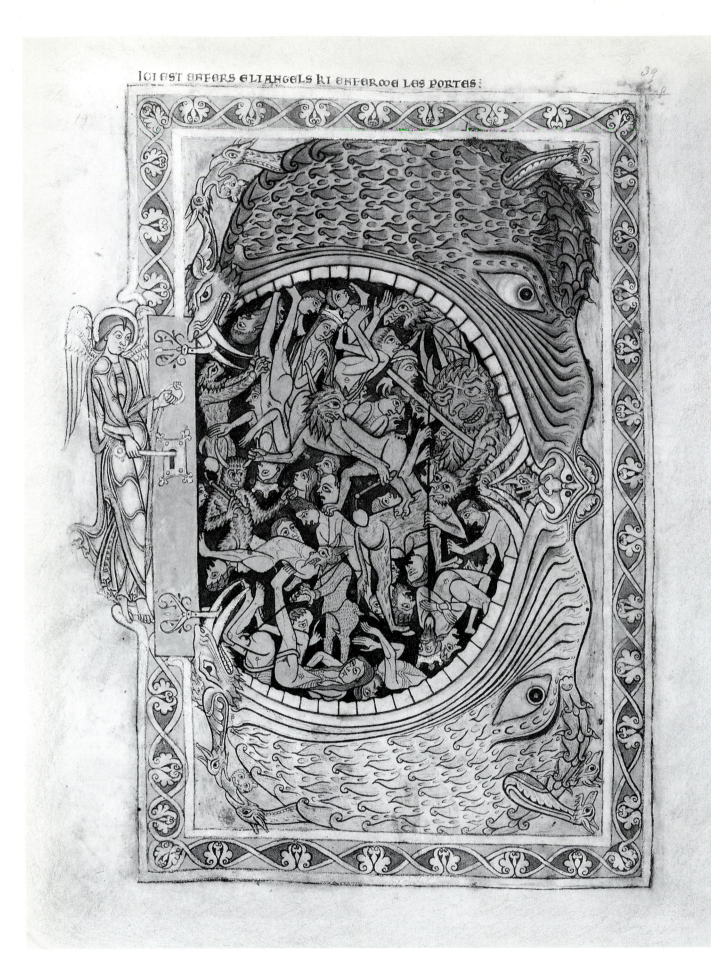

361. Winchester: *The entrance to Hell*, from the Winchester Psalter, MS.
Cotton Nero C.IV, folio 39. *c.* 1145–55. London, British Library

together and 'never perish in any age'.[264] Between the view of the writer's eternal fame put forward by Lambert and Walter and Eadwine's conception of his own, there has, however, been a vital shift of emphasis from extravagant estimation of the writer as poet to extravagant estimation of the writer as calligrapher: a conceit used to extol the poet has now been transferred to the craftsman.

THE WINCHESTER PSALTER

As with monarchs and writers, so with patrons: exuberance of esteem pervades the inscriptions. One in a work commissioned by Henry of Blois, the brother of King Stephen, claims that he equalled the Muses in intellect and exceeded Cicero in eloquence, and for good measure goes on to suggest that deferment of his translation to heaven would be to the benefit of England.[265] Not everyone took as ingratiating a view of the bishop – St Bernard described him as the whore of Winchester – but there can be no doubt of his power and influence. He was educated in France, and later held the bishopric of Winchester (1129–71) in plurality with the abbacy of Glastonbury. A grandson of the Conqueror, he nevertheless reminds us more of his great-uncle, Odo of Bayeux, in that, prepared for war, he yet maintained a love of the arts of peace. Thus, though during the civil war of Stephen's reign he started fires in his own episcopal city which, according to a contemporary chronicler, reduced it largely to ashes and destroyed two abbeys and over forty churches,[266] he yet commissioned splendid works of art including gorgeous enamels and perhaps also one of the finest of all twelfth-century Psalters,[267] the Winchester Psalter,[268] which is included in this section because of its stylistic links with the Bury, Lambeth, and Winchester Bibles. It was made before 1161, probably at the Old Minster, otherwise known as St Swithun's Priory, Winchester,[269] and though slightly damaged by fire in the eighteenth century, its pictures remain of outstanding quality.

Despite inscriptions in Old French, the language of the upper classes of England in the twelfth century, there can be no question about the Englishness of the pictures (some of the prayers, too, derive from Anglo-Saxon sources[270]). The Psalter follows the English tradition of incorporating introductory scenes, chiefly of the New Testament. A detail of the picture of the third Temptation of Christ on folio 18 [362] shares the satirical approach to the lavishness of contemporary attire of Anglo-Saxon art before the Conquest [109];[271] here the devil is so extravagantly dressed that the hem and sleeve of his garment are knotted up in order to clear the ground. The iconography, too, harks back to Anglo-Saxon times – see for example God's command to Noah, Jacob's dream, the Ascension, and Pentecost – and so does the 'framing' of pictures with borders over which the figures may trespass. The entrance to Hell [361] is a formidable reinterpretation of a drawing in a pre-Conquest Winchester manuscript[272] [86], showing a gruesome creature with bloodshot eyes and cavernous jaws opened wide to reveal the damned in torment inside. They include lay folk and kings, a queen and priests, but not apparently a bishop!

This is one of seventy-seven pictures trimmed and inlaid in vellum on thirty-eight (probably originally forty)[273] pages. Some Mosan and French elements have been detected in

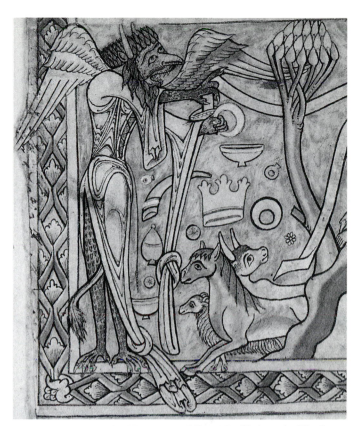

362. Winchester: *The third Temptation of Christ* (detail), from the Winchester Psalter, MS. Cotton Nero C.IV, folio 18. *c.* 1145–55. London, British Library

363 (*overleaf, left*). Winchester: *The death of the Virgin*, from the Winchester Psalter, MS. Cotton Nero C.IV, folio 29. *c.* 1145–55. London, British Library

364 (*overleaf, right*). Winchester: *The Virgin as Queen of Heaven*, from the Winchester Psalter, MS. Cotton Nero C.IV, folio 30. *c.* 1145–55. London, British Library

them,[274] but their style is most closely linked to that of the great Bibles of England. The iconography shows the usual infiltration of Byzantine or Italo-Byzantine influences, but is more particularly associated with English Psalters of the St Albans tradition, especially the Shaftesbury Psalter, with which it shares the rare scene of God instructing the archangel Gabriel to give his message to the Virgin.[275] There are scenes from the Book of Genesis, and illustrations from the lives of Christ, David, and the Virgin compiled from Christological cycles including the one in this very Psalter.[276] The ornately impressive Tree of Jesse is related to the one in the Shaftesbury Psalter, and there is also an eerie portrayal of the dead rising from their graves at the sound of the Last Trumpet.

The pictures are not now in their original sequence, though this was re-established by Wormald,[277] who suggested that two leaves with the Creation and Adam and Eve have been lost. Haney has pointed out that the cycle as a whole has strong correspondences with the readings for Matins in the Breviary of the Winchester abbey of Hyde, and further comments that it can be seen as an elaboration of the central feasts of the liturgical year – Christmas and Easter.[278] She sees it, however, not as a manuscript intended for public and

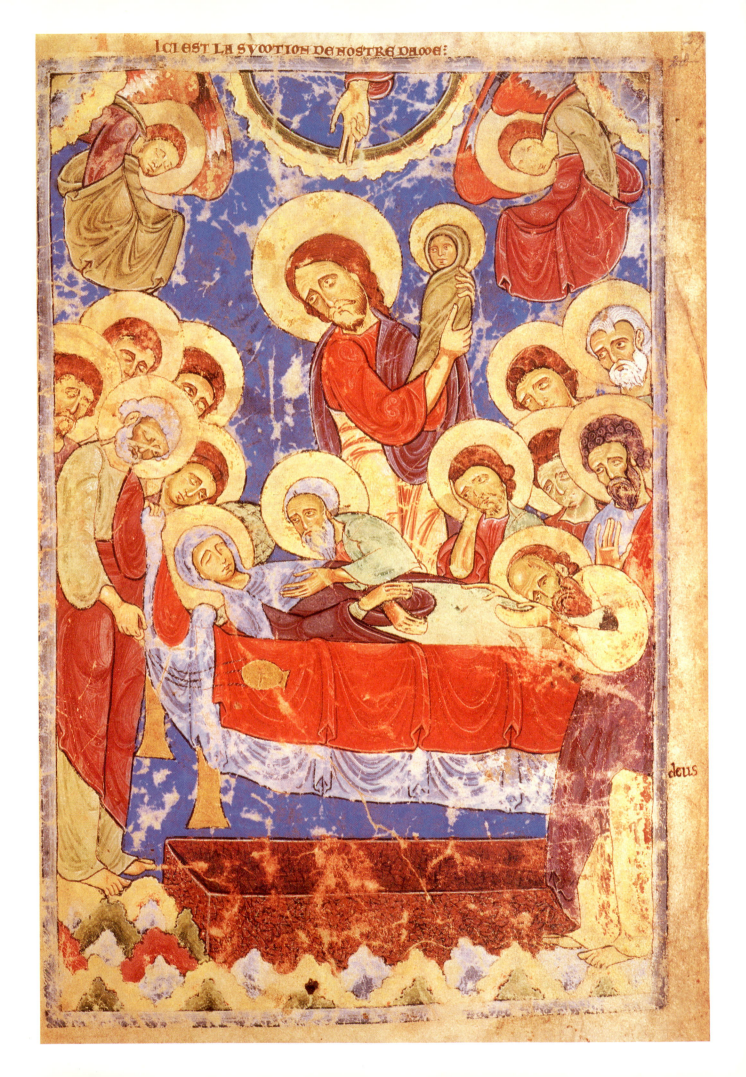

ICI EST LA SVOTION DE NOSTRE DAME:

deus

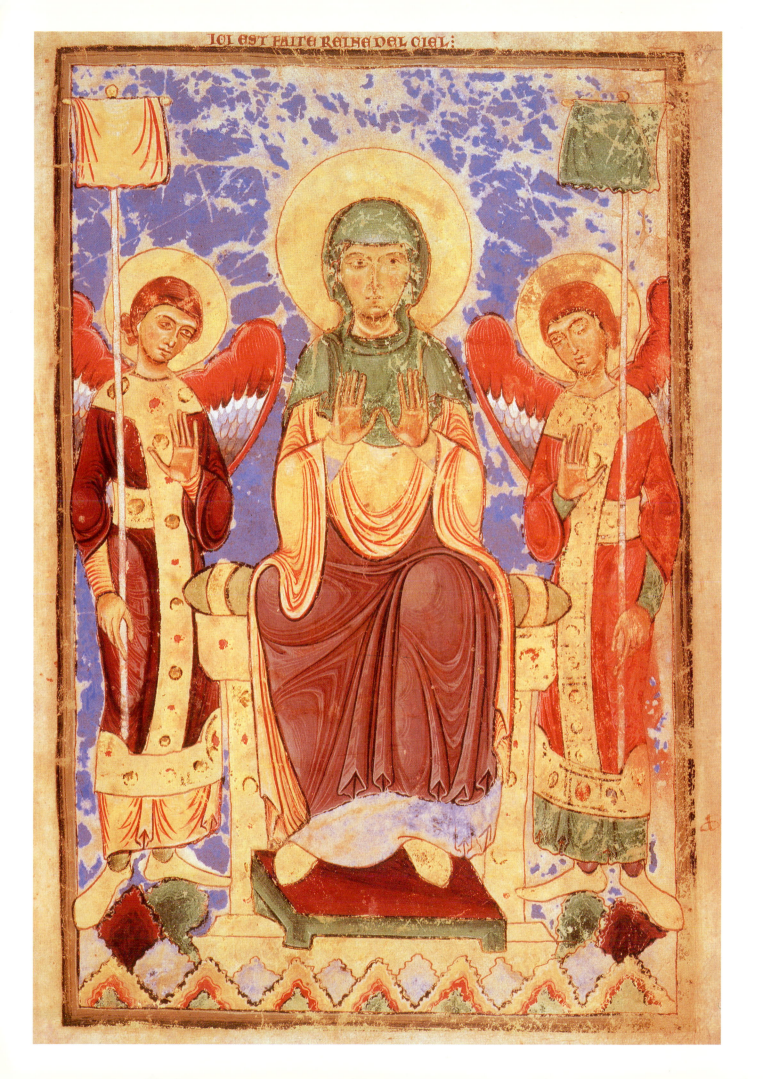

liturgical use but as the private prayer book of someone with Benedictine associations.

Since the Byzantine or Italo-Byzantine influences on the iconography are not at first hand, it comes as a surprise to encounter two pictures that are as Byzantine as anything we shall meet in the art of the medieval West [363, 364]. They originally formed a painted diptych of Christ and the Virgin, on facing pages:[279] on one side, Christ gently and tenderly gathers up his mother's soul at her death, and on the other the Virgin re-emerges as the Queen of Heaven, enthroned in glory. It is only the delicate patterning in the lower draperies that betrays the fact that the artist of these noble, essentially Byzantine paintings was English and not Greek. He was clearly copying from an Eastern diptych which had somehow found its way to Winchester, perhaps as a result of the visit of the archbishop of York to his uncle Henry of Blois following his own sojourn at the court of King Roger of Sicily.[280] The Psalter diptych is lent brightness by the pale lapis lazuli backgrounds, warmth by the reds and browns of the figures, and variety by paler reds and blues and greens. The other prefatory pictures, however, are basically tinted drawings coloured in parchment-yellows and browns, though some towards the end are untinted, and some were overpainted not long after completion. In style they fall somewhere between the Bury Bible and the Lambeth Bible, with a strong leaning towards the latter. Like the Lambeth Master, the artist animates whole areas of his picture space with linear rhythms, and his swaying, decorative sense finds particularly delightful expression in the picture of two angels exhibiting the Cross of Christ's Passion on folio 35.

The great contribution made by this master to the art of England was a sense of the dramatic. The facial expressions convey a wide variety of moods – benevolence, savagery, astonishment, malevolence, and submission (folios 10, 14, 11, 2, and 14 again). Even the pig about to be slaughtered in a Calendar illustration (folio 45) has a look of pitiable anxiety.[281] The fierce brutality and hatred on the faces of the crowds in the scenes of the Betrayal and Flagellation [365] amount to caricature, if we may extend the meaning of the word beyond the normal sense of parodying known individuals to include the critical observation of particular types; in this sense, we have among these pictures the earliest examples of caricature in the narrative art of the Middle Ages. Their dramatic impact was inspired by illustrations to the works of the famous Roman dramatist, Terence.

Terence was particularly popular throughout our period, and many illustrated texts of his plays survive.[282] The earliest pictures [33] were obviously copied from a late Antique exemplar,[283] but later they tended to follow the classical tradition only in terms of iconography. Their styles, in contrast, reflected the fashions of the day: one, made at Reims in the Carolingian period,[284] was in the current 'illusionistic' manner of the Utrecht Psalter, another, probably produced at Fleury at the turn of the tenth and eleventh centuries,[285] was in the style of that period, and yet another, illustrated at St Albans (or possibly Winchester) in the mid twelfth century, was in the contemporary Romanesque idiom[286] – a manner which lent an exaggerated and hardened appearance to the Roman dramatic masks of the illustrations, and a grotesque and menacing aspect to the characters wearing them. Exactly

the same impression is given by some of the figures of the Winchester Psalter: one or two even have the exaggerated, half-open mouths of the dramatic masks (compare the face of the seated figure of Pilate on folio 21 [365] with that of Symo wearing his mask in Terence's *Andria* [366]). The Terence manuscripts preface each play with a page on which all the characters' masks are displayed together, and it is from the gallery of human moods offered by such a page as the one for the *Andria* in the St Albans Terence[287] [367] that the Winchester artist would seem to have taken the idea of using facial expression to give psychological intensity to his characters. The masks in the St Albans Terence endow the characters with over-large heads, and it will be noticed that some of the Winchester Psalter figures produce the same effect.

Elements of the Psalter style are to be found in the illustrations of an English copy of Pliny that was in the Middle Ages at Le Mans,[288] the birthplace of Henry II and an important centre of his Anglo-French empire. Further

365. Winchester: *The Betrayal and Flagellation*, from the Winchester Psalter, MS. Cotton Nero C.IV, folio 21. *c.* 1145–55. London, British Library

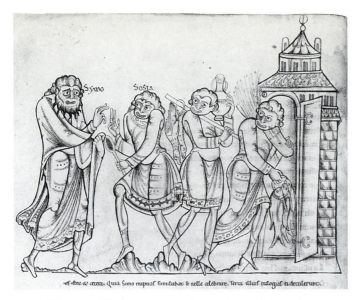

366. St Albans (or Winchester): *Scene from the 'Andria'*, from a Terence, MS. Auct. F.2.13, folio 4 verso. *c.* 1145–55. Oxford, Bodleian Library

367 (*right*). St Albans (or Winchester): *Prefatory page showing masks for the characters of the 'Andria'*, from a Terence, MS. Auct. F.2.13, folio 3. *c.* 1145–55. Oxford, Bodleian Library

368 (*below*). Sherborne: *St John*, from a Cartulary, MS. Add. 46487, folio 52 verso. *c.* 1146. London, British Library

north, a personal link between the Psalter style and Henry II is provided by paintings in the choir vault of a leper hospital that he founded in 1183 in Le Petit-Quevilly.[289] They are by an English artist who re-expressed the Winchester idiom in gentler, more flowing terms. His scenes are within roundels, and take us from the Annunciation to the Baptism of Christ (see illustration 369 for a detail of the Flight into Egypt). A more statuesque version of the Psalter style is seen in a cartulary of Sherborne[290] [368] known from internal evidence to have been made in 1146 or shortly after. This date supplies a useful pointer to the date of the Winchester Psalter itself, and incidentally to that of the Terence as well: both may be ascribed to the period 1145–55. All this, in turn, helps to establish the date of one of the most famous of the English great Bibles, the Winchester Bible, some of whose initials are in the Winchester Psalter style.

THE ST HUGH'S BIBLE
(THE AUCT. BIBLE)

The Winchester Bible (to which we shall come later) is to be distinguished from another which was also at Winchester in the Middle Ages. Once known as the Auct. Bible because it is in the Auctarium collection of the Bodleian Library,[291] it has recently acquired the more euphonious title of St Hugh's Bible, for reasons that will appear. Thomson thinks that both its volumes were made at Winchester,[292] though Oakeshott believes the first volume to have been written and decorated at St Albans and only the second to have been decorated at Winchester where, he thinks, it was also substantially written.[293]

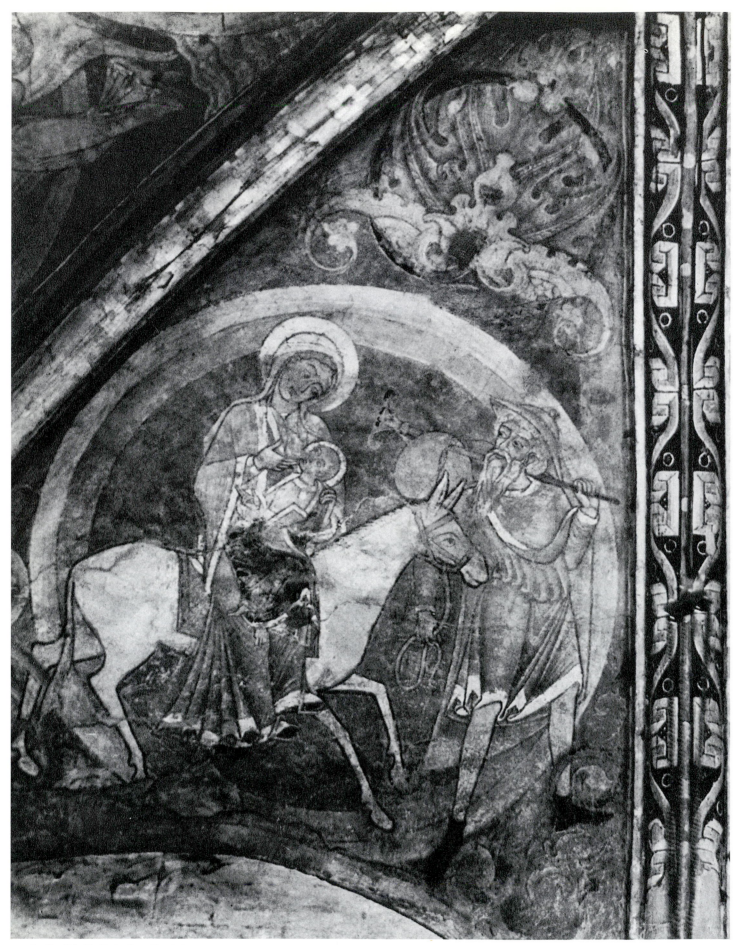

369. English: Le Petit-Quevilly, Saint-Julien, choir vault, *Flight into Egypt*.
Detail of a vault painting. *c.* 1183

370. St Albans or Winchester: Initial, from St Hugh's Bible, MS. Auct. E. inf. 1, folio 304. *c.* 1160–85. Oxford, Bodleian Library

371. The Master of the Leaping Figures, Winchester: *Initial with the calling of Jeremiah*, from the Winchester Bible, folio 148. *c.* 1150–80. Winchester Cathedral Library

St Hugh's Bible is unusual among English great Bibles in having originally had no illustrations, for on Oakeshott's analysis even its single historiated initial was a later Winchester contribution.[294] Thus all the artistic energy has gone into the fifty-nine decorative initials. They are by two illuminators. The work of one recalls the English Pliny at Le Mans,[295] and its bright colours and dotted patterns give an effect of rich brocade. The other artist, who decorated most of the first volume, worked in a very different mode. Because he loved to paint figures caught up in curling stems and tendrils he has been called the Entangled Figures Master.[296] The theme was by no means new, for it was particularly popular in initials of Canterbury in the first half of the century, where the light scrollwork and the swirling figures joined forces to lend excitement to the initial [cf. 327]; here, however, the figures are entrapped by the scrollwork, which has hardened into heavy tendrils. Moreover the figures themselves are not the zestful creatures of earlier Canterbury days but the solid, lanky ones of St Albans. Transfixed by creatures of menace whose dragon-bodies are almost indistinguishable from the very scrollwork, they peer out apprehensively from the imprisoning tendrils at secretly watching faces [370]: they are in the world of the nightmare, petrified by their own impotence.

The Entangled Figures Master is thought to have illuminated both the Shaftesbury Psalter and its related manuscripts,[297] and a small Psalter in the Bodleian.[298] This has been dated on no very compelling evidence to 1168, but a more certain pointer to a date for the Bible is provided by a much quoted anecdote from the life of St Hugh. At some time between 1180 and 1186,[299] when he was the first effective

prior of Henry II's new Carthusian foundation at Witham in Somerset, the king responded to his disquiet at the inadequacy of the library by giving him money for vellum, and urging him to seek out professional scribes. (Henry's assumption that monks would at that time turn to professional calligraphers for their manuscripts is itself worth noting.) The king later fulfilled a promise he then made to find Hugh a copy of the Old and New Testaments by persuading the cathedral priory of St Swithun's at Winchester to part with a Bible of their own; but when Hugh learned that it had belonged to another community, he returned it to Winchester.[300] Now it has been convincingly argued that this Bible was the one at present under discussion;[301] if so, it must have been made before Hugh was promoted to the bishopric of Lincoln in 1186. The story has it that the Bible had recently been completed when Hugh received it, but this may refer only to the additions made at Winchester, and we might cautiously date it to the period between 1160 and 1185. Oakeshott considers that the monks of Winchester needed St Hugh's Bible as an accurate text from which to correct their own great Bible, known today as the Winchester Bible. Originally in two volumes, but recently divided for greater convenience into four, it was made at Winchester and remains to this day in the cathedral library there.[302]

THE WINCHESTER BIBLE

If the Israelites of old had offered calves as a sacrifice to the Almighty, the Winchester monks of the New Dispensation were prepared to see a whole herd of them sacrificed to the perpetuation of his Word, for they used the skins of two

372. The Apocrypha Master, Winchester: *The burial of Judas Maccabeus*, from the Winchester Bible, folio 350 verso. *c.* 1150–80. Winchester Cathedral Library

hundred and fifty for the vellum leaves of the Winchester Bible.[303] On to these, once prepared, the Bible text was copied out in a script of the utmost refinement, and embellished with initials in the richest of colours. Fifty-three of the finished ones were historiated, and the other sixteen were decorated; many more were either never begun or never completed – there are scores of unfinished ones in the New Testament alone – and, besides this, illumination seems to have been removed from some areas.

Not only do the initials have all the splendid quality of others in the great Bibles of England: they have the added interest of occasional directions in the margins[304] to the original artists. Such instructions were normally erased once they had been carried out, so they share an exceptional degree of rarity with others in the Puiset Bible[305] and, fragmentarily, in the Bury Bible.[306] Some can still be deciphered, for example the Latin injunction before 2 Chronicles: 'Make [a picture of] Solomon praying in the temple with hands extended to God ... [before?] an altar, and the right hand [of God] in a cloud'[307] – and this is exactly what the artist has done. Someone, perhaps one of the more learned members of the community, had clearly gone through the text and decided which passages should be illustrated and in what manner.

Six artists participated in the programme. The first[308] is particularly close to the Winchester Psalter in style, his lissom and waspwaisted figures compacted sources of energy, forever

in action – Elisha leaping up to catch the cloak of Elijah, David battling with the lion, the Egyptian smiting the Hebrew, the young man slaying the Amalekite. On account of this springing agility, apparent even in the calling of the prophet Jeremiah on folio 148 [371], the artist has been called the Master of the Leaping Figures. He designed thirty-four of the initials and was probably responsible for the overall planning of the rest. He did not complete many, but Oakeshott – who has studied the Bible in the greatest depth – has made use even of this unfinished state to shed light on the stages by which the illumination was produced.[309] It began with the underdrawing, continued with the gilding, and ended with the final painting. This analysis shows that the concern of the second artist was simply to blend his skills with those of the first. In other words, the studio was painting corporately, without thought of personal assertiveness, and this helps to explain why the affirmation of distinct artistic personalities by means of signatures was rarely countenanced in our period.

A second artist has been called the Apocrypha Master[310] because his real masterpieces are full-page drawings to the Apocryphal Books of Judith and 1 Maccabees. They are of particularly fine quality, so it seems odd that they were apparently added to the Bible almost as an afterthought. Their fine dramatic sense is well illustrated by the anguished glance and vivid gesture in the burial scene of Judas Maccabeus [372]. It comes as no surprise that their creator was responsible too for the best of the pictures in the Terence manuscript of St Albans,[311] and also probably for the general planning of its illustrations.[312] What is not known is whether he worked on the Terence at St Albans or at Winchester; it was certainly at St Albans in the thirteenth century, but that does not constitute proof that it was made there.

The work of a third artist, called the Amalekite Master[313] after the scene of the slaying of the Amalekite in the initial for the second Book of Samuel, which he completed, is characterized by a Byzantine sense of modelling in the hands and feet, and by the individuality of his characters. It was he who provided the figures for the Beatus initial added to the Psalter part of St Hugh's Bible.

Another artist is known as the Morgan Master[314] because his paintings are on a detached leaf now in the Pierpont Morgan Library. The leaf was obviously intended for the Winchester Bible, though never actually inserted, and it has been conjectured that when work on the Bible came to an abrupt end, the painter took it to show potential patrons.[315] It is hardly likely, however, that a single leaf could have survived the Middle Ages outside a monastic library, and the most obvious possibility is that it was kept at Winchester itself. It bears on both sides pictures illustrating the first Book of Samuel (the first Book of Kings in the Vulgate recension); the recto ones relate to the life of Samuel, and those on the verso to the life of David [373]. The designs were prepared by the Apocrypha Master, whose measured rhythms and dramatic sense are still apparent on the recto side. On the

373. The Morgan Master, Winchester: *Scenes from the life of David*, detached leaf intended for the Winchester Bible, MS. 619 verso. *c.* 1150–80. New York, Pierpont Morgan Library

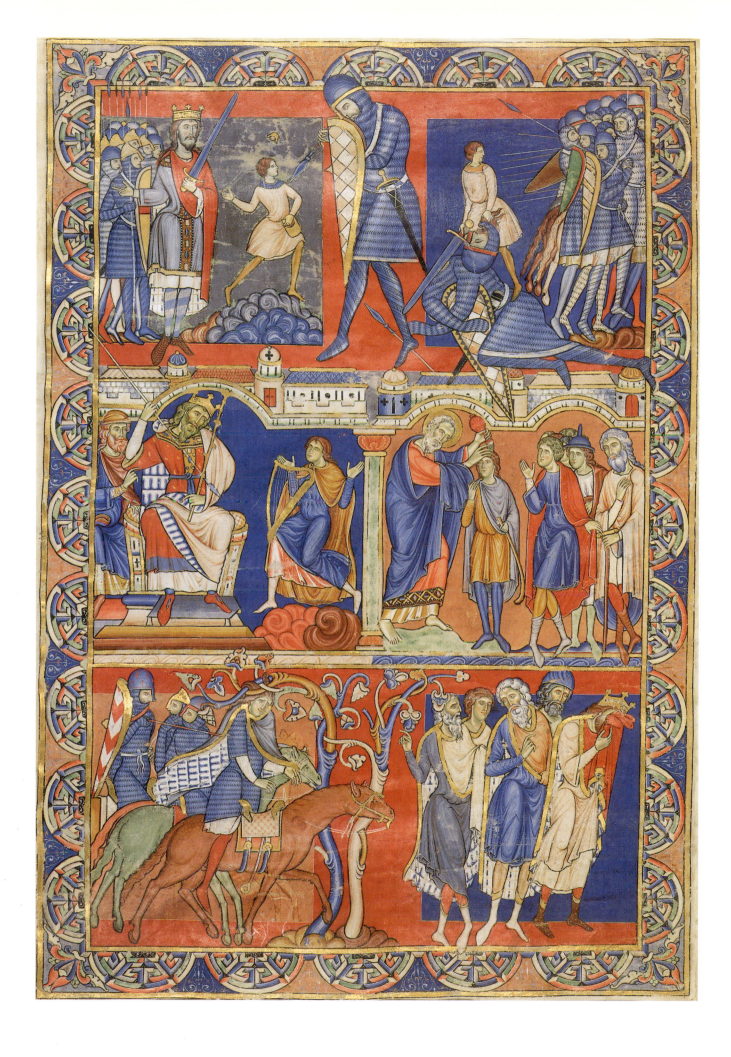

374. The Master of the Gothic Majesty, Winchester: *Isaiah receiving the Word of God*, from the Winchester Bible, folio 131. *c.* 1150–80. Winchester Cathedral Library

verso, however, the artistic personality of the Morgan Master takes over. His colours are sumptuous, his beautifully modelled heads are of a grave, almost tragic mien, and his figures are imbued with authority, and even a sense of destiny. Given the monumentality of his pictures, it is not surprising to learn that he was probably a wall painter too, as we shall see shortly. The painting of David in the Westminster Psalter[316] is also his; its subtle colour gradations and sense of modelling seem to derive from Byzantine mosaics and paintings of the second half of the twelfth century.

The Genesis Master[317] is so called because one of his initials illustrates the Book of Genesis. His strong histrionic sense, reflecting the recent trend towards dynamism in Byzantine art, finds expression in dramatic highlighting, in intensity of gaze, and in the fierce concentration of the brows. His is the very first initial of the Bible, the Ambrose before St Jerome that illustrates the preface.

A final artist is called the Master of the Gothic Majesty,[318] though he is in fact more classicizing than Gothic. His style is associated with the Morgan Master's, but is quieter and less forceful, as is demonstrated by his initial to Isaiah showing the prophet receiving the word of God [374].

The last three artists – the Morgan Master, the Genesis Master, and the Master of the Gothic Majesty – seem to have had a close knowledge of developments within the Byzantine tradition, and the first two may have visited Sicily and seen the Byzantine mosaics of Palermo and Cefalù at first hand.[319] At that time the relationship between Sicily and England was so close as to lead to the marriage of Henry II's daughter Joan to William II of Sicily – an alliance to which we shall return. These artists employed gold of a particular brilliance in their backgrounds, and this has been put down to their desire to emulate the sheen of Byzantine mosaics.[320] The attempts to place the biblical characters of the final paintings in some sort of historical context are also attributed to exposure to the recent Byzantine-inspired art of Sicily;[321] hitherto, such figures had been dressed in the styles of contemporary England, but now their costumes, if not quite accurate in historical terms, are at least not blatantly anachronistic.

The obvious differences in style among the six masters of the Winchester Bible do not necessarily indicate a wide disparity of date; probably no more than two decades, or thereabouts, separate the first style of the Winchester Bible from the last. The first manner has been related to that of the Winchester Psalter,[322] which seems to belong to the middle years of the century, and we have suggested that the St Albans Terence, with which the Apocrypha Master was involved, may be attributed to the same date: we may therefore deduce that the Winchester Bible was itself begun in the 1150s. One distinguished paleographer tells us that the final touches were added to its script in the 1170s,[323] and, since the illumination had clearly to await the text, we might ascribe the whole of the production of this great manuscript to the period between *c.*1150 and *c.*1180.

We do not know whether the Bible was abandoned so abruptly because the money ran out, or for other reasons; what we do know is that the artists' style lived on in wall paintings, of which some are in the Holy Sepulchre Chapel in Winchester Cathedral itself. Damage caused by structural alterations led to their being covered over *c.*1220 with further murals, and they came to light again only in the 1960s, when a fair part was still in reasonable condition.

Chapels of the Holy Sepulchre were shrines in which to commemorate and bring to mind the key elements of the Christian year – the Crucifixion, Entombment, and Resurrection. The ritual involved the removal from the altar and burial of a symbol or representation of the crucified Christ on Good Friday (the *Depositio*), and its return to the altar on Easter Sunday (the *Elevatio*). There followed a liturgical drama recounting the visit of the Marys to the empty sepulchre and their encounter with the angel there (the *Visitatio Sepulchri*). At Winchester, the tradition of these ceremonies went back at least to the tenth century, and it is in this context that Park convincingly sees the Holy Sepulchre murals.[324] They portray the events on which these Easter rites were based: the Deposition, the Entombment, and the Marys at the Sepulchre with the angel announcing the Resurrection [375] – themes that were all reinstated in the thirteenth-century paintings. There was also a Harrowing of Hell, and on the south wall a Resurrection of the Dead at the last trump. When the Romanesque paintings were uncovered, underdrawings in red were also found on the south wall (since

375. Winchester Cathedral, Holy Sepulchre Chapel, *The Deposition, the Entombment, and the Marys at the Sepulchre*. Wall painting. *c.* 1190–1200(?)

376 and 377. Sigena, chapter house, first arch, details of *God giving the command not to eat of the Tree of Knowledge*, and *The sleeping Adam* (photographs taken before the fire of 1936). Wall paintings. 1183/8

transferred to the north) which may have belonged to a Passion cycle. The three remaining fragmentary scenes appear to be of Christ being struck as the high priest Annas questions him, Christ before Pilate, and the denial of Peter.[325] Their technique confirms that the true fresco technique was familiar in England in the twelfth century,[326] even though it is not mentioned by Theophilus – another indication that he knew nothing of the art of England. In fresco work, the artist first made a sketch in red outline on the wall and then covered it with a thin film of plaster on which he made his final painting while the plaster was still wet. In the Holy Sepulchre Chapel, this upper film has been lost, but the underdrawing has remained. An eighteenth-century drawing of two of the life-size figures of prophets formerly on the north wall of the cathedral transept would seem to indicate that they, too, were by the painter of the Holy Sepulchre Chapel.[327] They have been related in style to paintings of two saints (probably Cuthbert and Oswald) on jambs in the east wall of the Galilee Chapel of Durham Cathedral, built c.1175.

The links between the murals of the Holy Sepulchre Chapel and the miniatures of the Winchester Bible's Morgan Master are close, but the two undertakings are not by the same artist. The wall paintings have lost much of the Romanesque tension still in evidence in the Bible illustrations and seem to be somewhat later, perhaps of the 1190s. Yet, though I cannot subscribe to the view that the Morgan Master was responsible for the wall paintings at Winchester, it is difficult to resist the view that he painted murals at Sigena in Spain.

THE SIGENA MURALS

The convent of Sigena[328] in the province of Huesca was founded by Queen Sancha of Aragon, who decided to build a nunnery on the spot where an image of the Virgin had been discovered, apparently miraculously,[329] in 1182.[330] The queen was in Huesca in that year[331] and her decision was made in the next. According to de Funes,[332] the image was still in the choir of the Sigena church in his day (1626) – a claim repeated by del Arco in 1921.[333] However, del Arco's description is of a Gothic sculpture, and he probably had in mind a fourteenth-century polychrome wooden carving of the Virgin and Child that remained at Sigena until 1936.[334]

Queen Sancha's new foundation was intended to vie with the splendid royal monastery of Santa María de Poblet that her husband Alfonso II and his father had raised as a burial-place for the kings of Aragon, and it was to become the final resting-place for the queen herself and for three of her children, including King Pedro II. Although sumptuous, it was expected to house no more than some thirteen nuns,[335] with separate accommodation for priests and others to minister to their needs. The house was affiliated to the Order of St John of Jerusalem under a Rule drawn up by Bishop Ricardo of Huesca (1187–1201), and the dedication of its church took place on 21 April 1188; the new nuns were received two days later,[336] and for commemorative purposes it was 23 April that came to be accepted as the foundation date.[337] On that day there were present at Sigena Queen Sancha, King Alfonso, and some of the greatest of the realm, together with their retinues; on that day, too, the king dubbed his son a knight and gave his eldest daughter, Dulce, to the

nuns (all from aristocratic families) as an oblate, and we must suppose that the convent, and its chapter house (which features in the original Rule[338]), were all ready, furbished and decorated for the great event. Thenceforward the links with the royal family continued. Queen Sancha took the habit of a lay sister at the inauguration ceremony and, after her husband's death in 1196, joined the community as a full member, waiting until 23 April 1197[339] in order to commemorate the foundation date of 23 April 1188 – by which time the murals in the chapter house were surely completed.

These chapter house murals,[340] as we shall see, were made by Englishmen, Englishmen who, it has been persuasively argued, had worked at Winchester and visited Sicily and were now, of course, in Aragon. Now as it happens the English king, Henry II, had involvements in just these three areas. His interest in Winchester has been touched on in connection both with the St Hugh Bible from Winchester and with the wall paintings he commissioned for his castle there. As to Sicily, he kept in close touch with its king, William II, who successfully proposed marriage to Henry's daughter, Joan; and, since she lived at Winchester, we may further note that the Sicilian envoys visited that city in 1176 and it was from there that Joan embarked on her journey to Sicily.[341]

Henry II's interest in Aragon stemmed from its proximity to his Aquitanian territories in France. According to a letter from John of Salisbury, two years before he gave his daughter Eleanor in marriage to the king of Castile in 1170, Henry had been planning to marry her, or her sister, to the king of Aragon.[342] An even earlier arrangement to marry his son Richard to a daughter of Count Ramón Berenguer IV of Barcelona had only been frustrated by the death of the young princess, and Ramón was the father-in-law of Doña Sancha, to whom, as it happens, Henry was himself related.[343] He also personally met Queen Sancha's husband, Alfonso II of Aragon, on two occasions. The first was in 1172, when he journeyed to Montferrand in Auvergne to arrange the marriage of his youngest son John to the eldest daughter of Humbert of Maurienne;[344] the second was when Alfonso helped Henry to put down a baronial revolt in Poitou and Gascony.[345] Now as this was in 1183, the very year in which Doña Sancha decided to build the convent at Sigena, it may not be a coincidence that it was to England that she turned for artists to decorate her new foundation: in short, the commission may have been influenced by relations between the two royal courts of Aragon and England.[346]

When Henry II's Sicilian son-in-law, William II, died in 1189, Hugh Falcandus, fearful for the future of Sicily now that it was to pass to a German dynasty, wrote an elegiac description of the beauties of Palermo,[347] extolling particularly the mosaics of the Old and New Testaments in the royal chapel there. The paintings at Sigena were also of the Old and New Testaments, less glittering than the Siculo-Byzantine mosaics that Falcandus praised, but nevertheless surpassing them in monumentality and repose. The nuns entering the chapter house would have found themselves in the visual embrace of the key events of divine history, beginning with the Creation and the Temptation, the Expulsion of Adam and Eve, and the story of Cain and Abel, and continuing with Noah's Ark, the Sacrifice of Isaac, the Crossing of the Red

Sea, and Moses receiving the Law, going on to the Annunciation and the Visitation, the Nativity and the Annunciation to the Shepherds, and finally to the raising of Lazarus, the Flagellation, the Crucifixion, the Entombment, and the Harrowing of Hell. There were as well seventy 'portrait' busts of the ancestors of Christ. Every inch of the large rectangular hall was covered with paintings – the New Testament scenes on the four walls, the Old Testament ones on the spandrels of the five arches, and the ancestors on the soffits of the arches.

We have unfortunately to speak of these murals in the past tense, for they were largely destroyed in 1936 during the Spanish Civil War. What remained was taken to the Museum of Catalan Art in Barcelona, but despite reconstruction and renovation the paintings are chiefly known today from black and white photographs taken before the destruction, which fortunately still indicate the remarkable quality of the originals. On the left of the first arch was God forbidding Adam and Eve to eat of the Tree of Knowledge, and on the right were the temptation of Eve and the sleeping Adam (illustrations 376 and 377 show details of God the Father and of the sleeping Adam). The sole, small piece of decoration to survive with some of its original colours suggests that these must have been as rich as those of the Winchester Bible.

Stylistic comparisons have established that the Sigena murals are indeed by the same hand as some of the miniatures of the Winchester Bible: heads in the scenes of the Nativity and Annunciation to the Shepherds are particularly close to heads in the Bible.[348] Other links have been provided by epigraphic parallels.[349] Some of the Byzantine iconographies of the murals were mediated through Winchester, and the Winchester Bible anticipated the compositions of four of the major Old Testament scenes – the Creation of Eve, Noah's Ark, the Sacrifice of Isaac, and Moses' reception of the Law.[350] It has been persuasively argued that the leader of the Sigena team was the Morgan Master, who had with him the Gothic Majesty Master and perhaps the Genesis Master too.[351]

Slight divergences between the styles of the murals and of the Bible have been attributed to a quickening by fresh contacts with Byzantine art. The Morgan Master is thought to have made two visits to Sicily, the first before starting on the Winchester Bible (when he was especially influenced by a particular group of mosaics in the Palatine Chapel, notably a standing figure of St Cataldus[352]) and the second before his work on the Sigena murals, which would explain the awareness of the Monreale mosaics, which were probably not set in place until the 1180s.[353] What he now most readily absorbed from Byzantine art was a technique for representing relaxed posture and the natural and easy fall of draperies though, like other great artists, he made these borrowings his own. The word 'great' is not used lightly here, for the paintings at Sigena were among the greatest not only of the twelfth century but of the entire Middle Ages: the power and poise of their figures, their composure and majesty, can be sensed even in the monochrome form by which we largely know them today.

As it happens, the Sigena murals represented the Romanesque wall painting of England not only at its highest but also virtually at its conclusion, for a period of transition had by now begun in the West which will be the subject of our final chapter. Before embarking on this, however, we shall devote an intervening chapter to those paintings of the West that were not on walls, nor on panels, nor yet in manuscripts. They were on glass.

Stained Glass: 1100–1200

BEFORE THE TWELFTH CENTURY

As we have seen, some Italian painters strove – with no great success – to emulate mosaics in their murals. But stained glass, in fact, is a far more appropriate medium for such an attempt, since it can achieve by transmission of light the effect of effulgence and rich colour that mosaics attain by reflection. Similar terms of praise were therefore significantly used for both arts; the seventh-century mosaics of Sant'Agnese in Rome[1] and the early-thirteenth-century stained glass of Lincoln Cathedral[2] were both compared to the rainbow in their brilliance and multiplicity of colour. Coloured glass had been used by the Romans and earlier races to make vessels; however stained glass as we think of it today – that is, window glass primarily with coloured figures – was developed in the medieval West. None of the earlier known glass measures up to the criteria just outlined. Fragments of a disc of glass, probably of the sixth century, excavated from Ravenna, with the remains of a picture of Christ blessing,[3] are uncoloured and may not have been intended for a window; pieces of painted glass recovered from the eighth-century site of a Muslim palace are non-figural;[4] and a painting on glass of the Byzantine emperor Constantine VII, described by an Arab historian as existing in 949,[5] was apparently only a small-scale work to adorn a gold casket. It was in the West that the craft of making coloured windows with figures and decoration was developed and enthusiastically taken up,[6] and this, rather than painting in oils, which was also known to the twelfth century,[7] is technically perhaps the greatest of all the contributions made by the Middle Ages to the pictorial arts.

Stained-glass windows were known to the Carolingians and Ottonians. An account of a miracle set down in 864 relates that the sight of a blind man who spent the night at the tomb of St Ludger, bishop of Münster (d. 809), was through the saint's merits sufficiently restored for him to be able to make out images painted on the windows of the church.[8] We learn that Archbishop Adalbero of Reims (970–89) adorned his cathedral 'with windows containing various histories',[9] and a copy of a letter of Abbot Gosbert of Tegernsee, datable between 982 and 1001, speaks of 'glass coloured with different paintings'.[10] Again, there is a comment on a rendering of the martyrdom of St Paschasia in a window at Saint-Bénigne at Dijon which has been convincingly attributed to the tenth century.[11] The craft of stained glass was unquestionably well established by the middle decades of the first half of the twelfth century; Theophilus devoted a large section of his treatise on the arts, written towards that time, to the complex technical processes involved.[12] As Émile Mâle remarked as long ago as 1905: 'Les grandes lois de la peinture sur verre étaient si parfaitement connues dès 1140, que le XIIe et le XIIIe siècles n'auront presque rien de nouveau à trouver.'[13]

In the Middle Ages, as in other periods of history, imitation jewellery was made of coloured glass, as the Italian writer Eraclius reports in his somewhat desultory treatise on the arts[14] possibly written in the late twelfth century. In his own more firmly dated treatise, Theophilus devotes a complete chapter to the simulation of jewellery in stained-glass windows by the use of stained glass itself,[15] as can still be seen today at Augsburg and Strasbourg.[16] The practice may help to explain the poetic descriptions by German poets such as Heinrich von Veldeke[17] and Wolfram von Eschenbach[18] of windows ornamented with real precious stones.

Medieval stained glass not only emulated the costly, it was itself very costly: Theophilus, almost without thought, places the 'precious variety of windows' in France in the context of the gold-work of Italy and of the gold- and silver-work of Germany,[19] and Suger, who had lavish tastes, instinctively associates the stained glass of Saint-Denis with gold and silver too.[20] Both Theophilus[21] and Suger[22] remarked upon the cost of the sapphire or blue glass which French craftsmen obtained by melting down glass vessels. (Maintenance, too, was expensive: we know both from Suger[23] and from a later Cologne source[24] that a master craftsman had to be retained to preserve and repair existing glass.) In presenting windows to Poitiers Cathedral[25] and to St Fides at Sélestat (Schlettstadt),[26] Henry II and his consort in one case and Frederick Barbarossa in the other must have been aware of the value of their gifts, for the first was marked by donor portraits and the second by an inscription. Again, when Henry the Lion destroyed Bardowick in 1189, he had the stained glass of the cathedral removed for use elsewhere;[27] indeed, stained glass was carefully re-used in various quite wealthy parts of the West – at Canterbury and York, at Strasbourg and Le Mans, at Bourges, Châlons-sur-Marne,[28] and so on.

Even plain glass was costly, so that English monarchs of considerable wealth would use oiled linen cloth to light their homes.[29] As late as the fifteenth century, according to the Bologna manuscript of the *Segreti per Colori*, specially treated linen was being varnished in Italy to look like 'crystal', and sheepskins and goatskins were being processed, varnished, and painted to resemble stained glass.[30] It was, therefore, only at a time of affluence that glass – and particularly stained glass – could be used to any extent, and the fact that the Romanesque period was such an era – at least in limited centres of wealth – is attested by documents which show that, after the mid eleventh century, gifts and endowments were beginning to flow more freely to monasteries than ever before.[31] It was, then, to economic factors, and not to a sudden interest in luminosity or in spiritual or theological perceptions about light, that the growing popularity of stained-glass

windows in the West (particularly for churches) was due. A preoccupation with light and luminosity had in fact been a constant throughout the Middle Ages. Verses inscribed at the end of the fifth century or the beginning of the sixth over the entrance of the monastery of St Andrew founded by Bishop Peter III at Ravenna read:[32]

Light is captured here, yet reigns in freedom . . . See how the marble is freshened by the bright rays, and every stone is stamped with heavenly purple. Peter's gifts shine out through the worth of their originator.

The same absorption with light is apparent in such sixth- and seventh-century inscriptions as those quoted in Chapter 8 from the mosaics of SS. Cosma e Damiano and Sant'Agnese:[33]

The house of God shines with the brilliancy of the purest metals, and the light of the faith glows there the more preciously.

From the cut metal pieces emerges a golden picture, and the very light of day is held in an embrace therein. You might think that the dawn was rising beneath clouds drawn together from snow-gripped springs, and moistening the fields with dew; or that the purple peacock himself was agleam with colour akin to the light that the rainbow displays in the heavens.

In the eighth century, too, a monk of Manlieu was as enthralled by light as Suger was to be. The chapels of his monastery, he said,[34]

gleam as the sunlight pervades them: the noble chapel of St Mary, ever Virgin, Mother of God, sparkles . . . while the chapel of the apostles is no less resplendent . . . the altars of the saints look bright . . . and the walls of the buildings glow with a glorious brilliance . . . the capitals of the columns [of the cloisters] are sculpted and painted and their surface glistens with various depictions.

Then in the next century, as Sedulius Scottus relates, his patron Bishop Hartgarius caused a church

to shine with a variety of ornament . . . it is bright with beauty and glitters with painted decoration. This church glistens and glows in honour of Peter and Paul.[35]

Thus it was not the interest in lightness and brightness that was new in the twelfth century, but the availability of resources to cater for it in terms of stained glass.

Both Suger and Theophilus gloried in the ability of stained glass to transmit light; as Theophilus put it, it could irradiate interiors 'with a variety of colours, without excluding the light of day and the rays of the sun'.[36]

Besides all this, a figured stained-glass window was, in effect, a mural on a translucent wall, and tended therefore to be conceived on a broad and sweeping scale. As Grodecki says,[37]

Monumental by virtue of its architectural function, the coloured window of the twelfth and thirteenth centuries was monumental in formal conception also. It was a mosaic of glass, painted and assembled to be seen from far off, on the same scale as an architectural vista . . . When, in the restorer's workshop or the museum, we make a close examination of these windows, designed for distant contemplation, we

378. *Head (of Christ?)*, from Wissembourg. *c.* 1030–70(?). Strasbourg, Musée de l'Œuvre Notre-Dame

remark an extreme breadth of treatment aiming only at the effect of the whole.

Hardly any stained glass survives from before the twelfth century. A reconstructed head from Lorsch placed by Gerke in the Insular/Carolingian context of the ninth century[38] was given by Boeckler to the eleventh century and may in fact be of the twelfth. Rode argues that a fragment excavated at Cologne Cathedral is Carolingian, but it is no more than white glass with a simple pattern of decorative tendrils;[39] furthermore a head excavated at Schwarzach and attributed by Becksmann to the late tenth century[40] is quite tiny. Another from Magdeburg, inadequately photographed and unfortunately destroyed during the Second World War, has been attributed to the second quarter of the eleventh century.[41] A highly stylized head from Wissembourg (now at Strasbourg[42]) [378], restored in the nineteenth century and perhaps belonging to the abbey church built between 1030 and 1070, may have been part of a Christ in Majesty; it is in a technique outlined by Theophilus in his treatise.[43]

The difficulties presented by these fragments are more than equalled by the manifold problems posed by the more complete windows of the twelfth century. In the first place, many such windows are so restored as to give a totally false idea of their original condition. Secondly, survival has been haphazard, so that we can form no picture of the twelfth-century distribution. Stained-glass windows have been the victims of fire (the Great Fire of London in 1666 alone destroyed St Paul's Cathedral and eighty-six churches with all their glass); of war, which is why present-day Belgium and Holland have virtually no medieval glass (between them, the Hundred Years War, the Thirty Years War, and the two World Wars of our own century have inflicted an enormous toll); of changes in architectural fashion, particularly when the Romanesque taste was superseded by the Gothic, and

again when the Baroque preferred plain glass, to allow more light to a church's works of art; and finally of Protestant destruction and iconoclasm, especially in England and parts of France. (The only Christian iconoclasts of the medieval period were the Greeks, so it is ironic to find Calvin justifying his own iconoclasm by referring to the Greeks' over-superstitious reverence for painted images.[44]) We need always therefore to keep it in mind that the surviving stained glass of the twelfth century is simply glass that the forces of destruction have passed by.

The earliest references to stained glass, and also the earliest surviving examples of it, come from the German part of the West; yet at some time between 1110 and 1140, a writer who was himself German implied that the leading exponents of the craft came from *Francia*[45] (a term which at the time probably meant no more than the Île de France). Our own survey will begin with the whole of the France of today (excluding Alsace), a point of departure that at the outset provides an opportunity to acknowledge the debt that all students of the stained glass of France owe to the researches of that eminent French scholar Louis Grodecki.

FRANCE

THE ÎLE DE FRANCE

Partly because of its historic importance, partly because of its fine quality, and partly because its patron, Abbot Suger, expressed such a personal interest in it, the stained glass of Saint-Denis[46] is the most celebrated of the twelfth century among scholars. Suger composed his account of the rebuilding and refurbishing of Saint-Denis (which is known by the title given it in the seventeenth century, *Liber de Rebus in Administratione sua Gestis*[47]) at some time between March 1144 and the beginning of 1149. In it, he tells us that he commissioned fourteen stained-glass windows for the chapels of the ambulatory at the east end of the abbey church, so that 'the whole [church] would shine with the wonderful and uninterrupted light of the brightest of windows'.[48] The glass is usually attributed to the years between 1140, when the choir was begun, and 1148, when the rebuilt church was dedicated.

The windows have suffered cruel vicissitudes. Some were already dismantled in the thirteenth century, and the rest have been variously displaced and restored in the sixteenth, seventeenth, and nineteenth centuries. Their worst period was the French Revolution. In 1799, after the Commission Temporaire des Arts had decided to conserve them, they were removed to a Museum of French Monuments which was itself suppressed in 1816, when the glass was returned to Saint-Denis. By then, however, much of it had been smashed (a large part in transit), much of it damaged, and part of it sold. It is on account of these sales that examples of Suger's glass are today dispersed among ten or more centres in England, Scotland, France, and America,[49] and more is still coming to light: even while this book was being prepared for the press, an article was published which demonstrated that a stained-glass Dream of the Magi and a prophet Isaiah in the fourteenth-century chapel at Raby Castle, County Durham, are of Saint-Denis origin.[50]

Suger, a man of humble background, became not only the head of the royal abbey of Saint-Denis, one of the greatest religious houses of France, but also, during Louis VII's absence on the Second Crusade, the country's regent. His gifts of sagacity, energy, and administrative talent no doubt helped him to these high offices; his other attributes included a curious mixture of humility and self-assertion, combined with a fierce patriotism, and many of these traits – together with some of his personal interests – are reflected in his stained glass.

Suger's (totally restored) 'portrait' in stained glass at the feet of the Virgin in an Annunciation scene is well known, and it was indeed quite common for twelfth-century patrons to have themselves represented seeking the intercession of Christ or his saints: what was not common, however, was for a patron to have three other 'portraits' of himself placed in different parts of the church, and thirteen inscriptions referring to him as well. This Suger did. Self-effacement was clearly not one of his virtues.

Another of Suger's windows reflects his official interests as abbot, and requires some background information. It was at the as yet unreformed house of Saint-Denis that Peter Abelard, brutally deprived of his manhood some time about 1119, sought rest and respite from the world. But his cruel experiences had by no means tamed his provocative intellect, and this drove him to touch the most sensitive nerve of the community that had received him by casting doubts on the identity of the patron saint over whose tomb the abbey had originally been built.[51] The monks believed St Denis to be Dionysius the Areopagite, who was converted, according to the Acts of the Apostles (XVII, 34), by St Paul. Hilduin, a ninth-century abbot of the foundation, had written a treatise to establish the fact; but Abelard – in jest, he later claimed – pointed out that Bede had given contrary information. It was a jest that was to turn very sour, not least for Abelard himself, for the incensed monks threatened to hand him over to the king's justice on the treasonable charge of demeaning a saint who was also the patron saint of France, and he found it prudent to escape secretly from the monastery to a life punctuated by further controversy and hostility. It is now known that Abelard was as much misled by Bede as the monks had been by Abbot Hilduin, and that the real St Denis was a martyr of the third century; however his attack on a venerable tradition became a *cause célèbre* with which Suger had to deal when he became abbot, and it is in this context that we should see his St Paul window, for it is a tacit reaffirmation that the abbey's special relationship with St Paul, mediated through the person of its patron, really did exist.

Little of the original window remains today (it is in the St Benedict Chapel, formerly the St Peregrinus Chapel), and even the two authentic roundels are heavily restored.[52] In one, Christ removes the veil from the face of Synagogue with one hand as he crowns Ecclesia with the other – that is, he reveals the mystery of the Old Law by promulgating the New. In the other (misrepresented though it is by restoration), the Old Covenant giving way to the New was in its original state symbolized by the Cross being placed by God within the Ark of the Covenant with its insignia (cf. chapters 9 and 10 of St Paul's Epistle to the Hebrews), showing how the all-atoning sacrifice of Christ grows out of and supersedes the rituals of the Old Testament. The four curiously placed

379. Saint-Denis, chapel of St Benedict, Suger's Moses window, *Moses and the brazen serpent.* 1140/8

wheels of the chariot carrying the Ark make recondite allusion to the four Gospels, and the four symbols of the evangelists make more obvious reference to their authors.[53] The themes of the other panels, which now exist only in nineteenth-century reconstructions, can be authenticated by means of Suger's records in the *De Rebus Gestis.* The key image of the whole window was St Paul refining the grain of the Old Testament into the flour of the New, which an accompanying inscription explained symbolized his revelation of the inner meaning of the Law of Moses. All this may seem abstruse today, but Paul was particularly known in the Middle Ages for his interpretations of Old Testament incidents in the light of the life of Christ, and the purpose of the window was to illustrate his views on specific relationships between the two Testaments as expressed in his Epistles.[54] The other subjects portrayed were the unveiling of Moses and the opening of the Apocalyptic book of seven seals by the Lion and the Lamb.

This window, then, communicates both one of Suger's cares as an abbot, and also something of his theological interest in exploring the typological and allegorical relationships between the two Testaments – a way of thought normal in the West which finds further expression in the adjacent Moses window, to which the St Paul window was linked by its first inscription. The surviving, though restored, roundels of the second window show the finding of the infant Moses, God appearing to Moses in the burning bush, the Red Sea swallowing up the host of Pharaoh, Moses receiving the tablets of the Law, and Moses raising the brazen serpent in the desert [379]. The inscriptions (recorded by Suger)[55] prove that the scenes were chosen specifically for ease of interpretation in Christian terms: the bush that burns but is not consumed can be likened to the man who is full of divine fire but is not devoured by it; the death of Pharaoh's army by water contrasts with the water of baptism which brings spiritual life; and the brazen serpent that kills all serpents symbolizes Christ on the Cross, who destroys our enemies.

The St Paul and Moses windows were but two of the fourteen that Suger set up in the seven chapels of the ambulatory, two to a chapel; two of the others are thought to have represented typological relationships in twenty-four scenes focusing particularly on the Passion.[56] Apart from an eighteenth-century drawing, all that remains of them today is a single roundel in the chapel of St Genevieve (formerly of St Cucuphas), so that all we can say of the scheme is that this roundel indeed represents an Old Testament event that

was thought to symbolize the Crucifixion in the Middle Ages, namely Ezekiel's vision of the signing of the foreheads of the righteous with the symbol of the Tau (Ezekiel IX, 4).

Suger tells us that his sequence of windows began with the Tree of Jesse[57] – a particularly well known symbol of the connections between the Old Testament and the New. Of a reconstructed version to be seen today in the Lady Chapel, the four central panels of Christ, the Virgin, and the two kings just below are largely authentic, and a side panel with a prophet has some genuine elements.[58] The colours are warm, with azure blue and reds and greens predominating. The ancestral kings appear frontally in the tree, which leads up to the Virgin seated below her Son, who is in the uppermost branches with doves around to represent the seven gifts of the Holy Spirit. The kings are naturally crowned, but the inscriptions held by the prophets in the half-medallions on either side lay exceptional emphasis on Christ's royal ancestry, reflecting Suger's pride in the royal nature of his own abbey, founded by a Merovingian king and now the final resting-place for French monarchs.

The window accompanying the Tree of Jesse, showing incidents from the early life of Christ, is almost all modern; only an excessively restored Nativity scene, a reconstructed picture of the sleeping Joseph warned by an angel, and a heavily restored Annunciation (the one with the figure of Suger at the feet of the Virgin) have even marginal claims to authenticity. Original scenes to be found elsewhere probably include one now in the Pitcairn Collection of Pennsylvania which – like one of the ceiling paintings of Zillis – illustrates an apocryphal account from the Gospel of Pseudo-Matthew of a tree lowering its branches to offer its fruits to the Virgin and Child as they pass on their flight into Egypt,[59] and a panel showing Herod and his counsellors seeking to discover Christ's birthplace is now in the Dépôt des Monuments Historiques at Champs-sur-Marne.

An abbot who could declare that the French were the natural rulers of the English[60] was an obvious patriot, and in one window Suger set out to glorify the French past in the depiction of a real Crusade, while another related to a legendary Crusade, or at least an armed pilgrimage.[61] In the eighteenth century, these windows were in either the extreme south or the extreme north chapel of the ambulatory. The real Crusade was the First, preached in 1095 by a French pope in a French town to the French people – to the 'race of Franks ... chosen and beloved by God ... [and] set apart from all other nations', as Urban II described them. He went on to remind his audience of the deeds of their ancestors, especially of 'Charlemagne ... and your other kings, who have destroyed the kingdoms of the pagans and extended the territory of Holy Church in these lands'. The First Crusade was, in effect, a French campaign, and indeed the Muslims referred to all the early Crusaders as Franks. The victories were therefore French victories, and that is how Suger represented them in his glass. 'Jerusalem taken by assault by the Franks', reads one of the inscriptions, and there were further scenes of the Franks conquering Nicaea, taking Antioch, and subduing the Arabs at Ascalon. Only one of the roundels seems to survive – now in the United States, in the Pitcairn Collection, it relates to the legend of Charlemagne rising from the dead to lead the march of the Crusading

army[62] – but copies of ten of the missing ones were made for and published by Montfaucon before the Revolution.[63]

In the second and complementary window – as we know from copies of two of the roundels made for Montfaucon – Charlemagne was shown receiving envoys from the Byzantine emperor in Paris, and then meeting him in Constantinople. It seems probable that these scenes reflected the Latin text of a legendary journey made by Charlemagne and his army to Byzantium and the Holy Land in response to a supposed invitation from the Emperor Constantine VI.[64] After liberating Jerusalem and returning to Constantinople, the text relates, Charlemagne received relics of the Passion, of which two were later thought to have been transferred by Charles the Bald from Aachen to Saint-Denis, where they were 'authenticated' by King Louis VI in a ceremony in 1124.[65] A panel of a triple coronation in the Pitcairn Collection is probably the sole survivor of this window. Its meaning is not entirely clear, but it has been suggested that it represents Pope Stephen II's coronation of Pepin the Short with his two sons, Charlemagne and Carloman, at Saint-Denis in 754;[66] this would tie in with other indications that, as well as commemorating and inciting Crusading zeal, the window was intended to glorify the associations of Saint-Denis with the royal line. This window and its partner are thought to have been installed in 1145, the year after the Western world had been shocked by the Muslim capture of Edessa into a realization that Jerusalem itself was under threat. In the very next year Pope Eugenius III preached the Second Crusade, which was actually launched in 1147, with Louis VII at the head of the French contingent. As we have seen, during his absence Suger deputized as regent of France. A highly speculative theory has been put forward that other glass linked to Crusading themes, now lost, inspired the subject matter of thirteenth-century replacement glass in another chapel, and indeed two of its themes would have been relevant to the situation in the twelfth century, when the Muslims were seen as a threat to the Crusading kingdoms: one was the martyrdom of the Theban legion, the Christian force said to have been slaughtered by the pagans in the early centuries of the Christian faith; the other was the Massacre of the Innocents.

We are on more certain ground in saying that the stained glass of another of Suger's chapels, perhaps the chapel of St Benedict in the crypt,[67] had scenes of the life and miracles of St Benedict, for some of its panels still exist in various collections. The finest are in the Musée de Cluny, including a fragment with two monks witnessing the ascent of the saint's soul to heaven [380]. A panel from another window, now at Champs-sur-Marne,[68] showing the martyrdom of St Vincent, also recalled the abbey's royal connections, for a relic of St Vincent was presented to Saint-Denis by Dagobert, the first French king to be buried in the abbey. Fragments of other authentic glass survive in situ in the chapel of St Lazarus (formerly of St Osmanna). Their pictures of griffins were probably inspired by imported fabrics – a reminder that Suger's church acquired a number of textiles (in all likelihood imported) during his abbacy.[69]

The stained-glass windows of Saint-Denis bear all the signs of having been planned by one mind, but that they were executed by different artists is clear from the disparity of

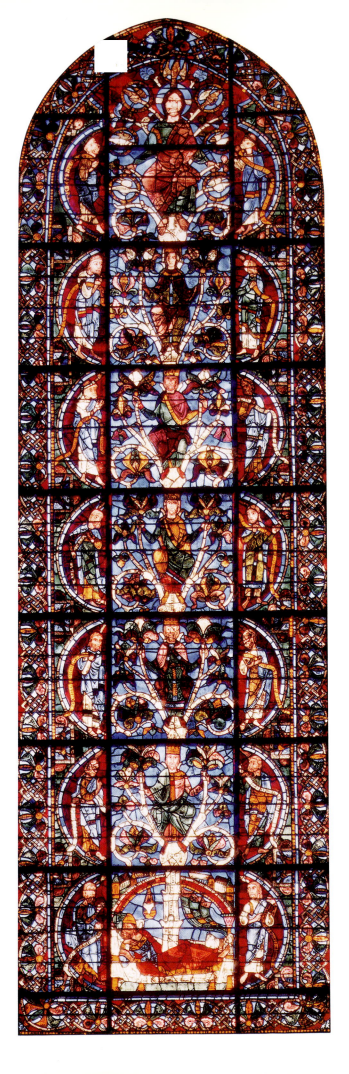

380. *Two of St Benedict's disciples watching the ascent of his soul*, from the St Benedict window at Saint-Denis. 1140/8. Paris, Musée de Cluny

381. Chartres Cathedral, west front, the Tree of Jesse window. *c.* 1145–55

382 (*opposite*). Chartres Cathedral, choir south side, *the Belle Verrière. c.* 1180

styles, and is confirmed by Suger's own account: 'We caused a splendid variety of new windows ... to be painted by the choice hands of many masters from various regions.'[70] Where these regions were has long interested scholars. One must have been within northern France, for, though the linearized version of Byzantine folds in the St Benedict panels [380] is familiar from various areas of the West, the way in which the draperies cling to the body is most closely paralleled in the manuscript paintings of north-eastern France and England [cf. 195, 350]. In reflecting that a comparable style is to be found at Cîteaux in Burgundy, we should remember that this centre was itself much influenced from England. Grodecki believed that another region involved was the Meuse valley, and associated the style of the surviving roundel of the Passion windows with general developments there.[71]

Grodecki proposed a date *c.*1145 for the work of the main atelier of glass-painters who, in his view, were responsible

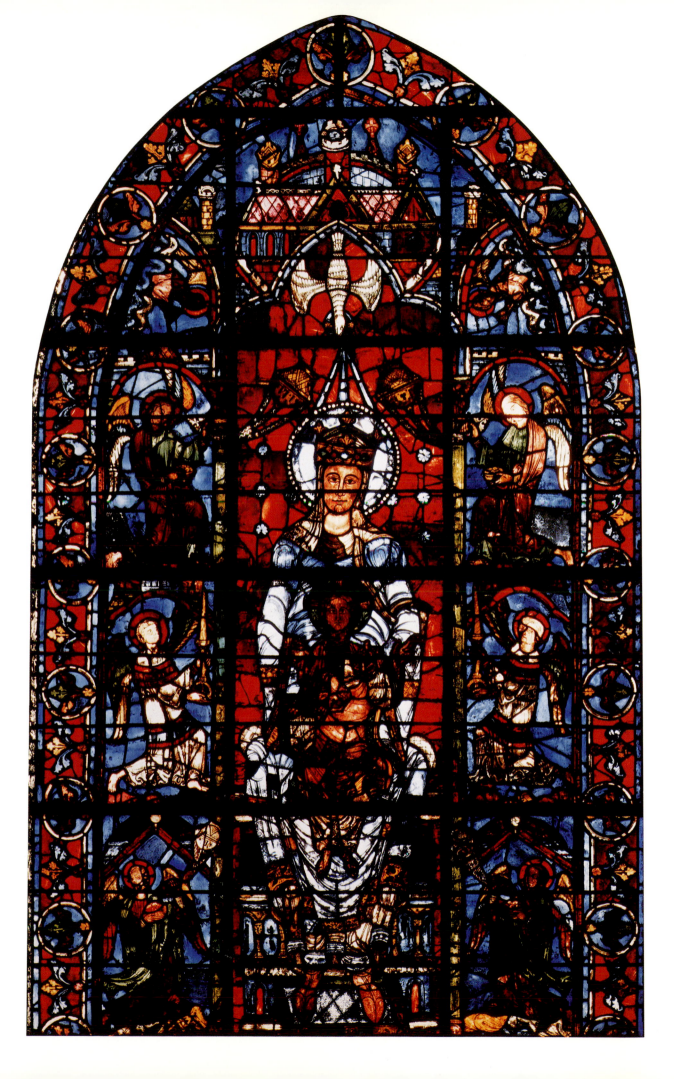

for most of what survives of Suger's glass: the Tree of Jesse, the scenes of Christ's childhood, the Paul and Moses windows, and the St Vincent panel.[72] He ascribed the major influences on this atelier to the north of France and the Mosan area; no really telling stylistic comparisons for the Mosan connections are advanced, but on the other hand the disappearance of wall paintings from the crucial area may have deprived us of links that could have proved vital. Hayward detected influences from various sources: from Burgundy in the elegant folds and rich ornamentation of the Tree of Jesse; from Lotharingian metalwork in the Paul and Moses panels; and from Normandy (not, in fact, a very convincing parallel) on the St Benedict scenes.[73] The fact is that the stylistic origins of the Saint-Denis glass cannot be defined in as certain and clear a manner as we would like, and this is a pity in view of its major influence on other glass, including the roughly contemporary stained glass of Chartres Cathedral,[74] whose three great western windows are attributed to the years between 1145 and 1155.

The glass of Chartres, too, has had its misfortunes, beginning with a catastrophic fire in 1194 which led to loss, damage, and replacement, and continuing with further restoration and replacement in the fifteenth, sixteenth, seventeenth, and especially the nineteenth centuries. As a result, only the head of the prophet Balaam out of twenty-four in the Tree of Jesse window [381] is original, and the other two windows, which suffered less, have also been heavily restored. The visual message of these three windows is simpler than at Saint-Denis. They show Christ in his three essential aspects: as the Redeemer prophesied in the Old Testament; as God incarnate in a human child; and as the sacrificial victim ready to meet his Passion and death. The first of these themes is epitomized in one of the flanking windows by the Tree of Jesse. The third, in the other flanking window, is illustrated by fourteen scenes presenting the Christ of Sacrifice, beginning with the Transfiguration – when, according to St Luke (IX, 31), Christ discussed the manner of his death with Moses and Elijah – and ending with two scenes from Emmaus. The theme of Christ's infancy is reserved for the central and dominant window, the largest to remain from the Romanesque period. In its crown is the Virgin, the patron saint of Chartres, with the Christ Child and angels, and below are twenty-two scenes of Christ's birth and infancy, in alternating squares and roundels; they include some from the apocryphal Gospel of Pseudo-Matthew, with appended portrayals of the Baptism and the Entry into Jerusalem. All three windows owe a debt to the glass of Saint-Denis[75] – most especially the Tree of Jesse which, though in a more linear style, is a recension of the earlier glass to suit a longer window. In spite of the fact that it is derivative, the Chartres tree nonetheless improves on Suger's in terms of monumentality, assurance, and homogeneity.

The most celebrated of the twelfth-century windows of Chartres, the 'Belle Verrière' on the south side of the choir [382], is in a rather different style. The Madonna is shown with the Child holding a book inscribed with a quotation from a prophecy of Isaiah to which Luke refers, thus linking Christ himself to the Old Testament.[76] The colours are chiefly warm reds and cool blues in equal proportions. The window (now set in a bay of the thirteenth century) is thought to have been made c.1180, and remains one of the most famous of the twelfth century, despite late restorations that have given a characterless thirteenth-century face to the Child and an insipid nineteenth-century one to the Virgin; in fact, only the general aspect and stance of the two figures are really Romanesque. The angels around the Virgin and Child, and the scenes of the public life of Christ in the lower registers, were added in the thirteenth century, and later hands have re-orchestrated the colours of the Virgin and redesigned her drapery folds.[77]

An Ascension panel of c.1175 from the abbey church of Saint-Pierre at Chartres, now in the Dépôt des Monuments Historiques at Champs-sur-Marne, is of interest for two reasons: first because it may be obliquely alluded to in a written source[78] which observes that Abbot Stephen (1172–93) adorned the church with stained-glass windows; and second because it follows the Anglo-Saxon iconography of the Ascension with Christ disappearing into the heavens.

The little Romanesque glass that survives in Paris itself consists primarily of panels of c.1180 installed between 1725 and 1727 in the south rose of Notre-Dame[79] – whether from some other part of the cathedral or from a different church altogether is not known. Of high quality, they are notable too for seven rare illustrations of the life of St Matthew including scenes of him taming dragons, and meeting with [383] and converting the king of Ethiopia and his daughter. The figures

383. Paris, Notre-Dame, south rose, *St Matthew before King Egippus*. c. 1180

have breadth against their background of foliate decoration, and the draperies combine a feeling of weight with a fine sense of suppleness.

We may suppose that glass in a similar if less sophisticated style in the abbey church of Saint-Germer-de-Fly (Oise), on the borders of Normandy and the Île de France, was also made by Parisian artists, probably in the 1170s.[80] It is likely that the thirteen surviving panels belonged to the central

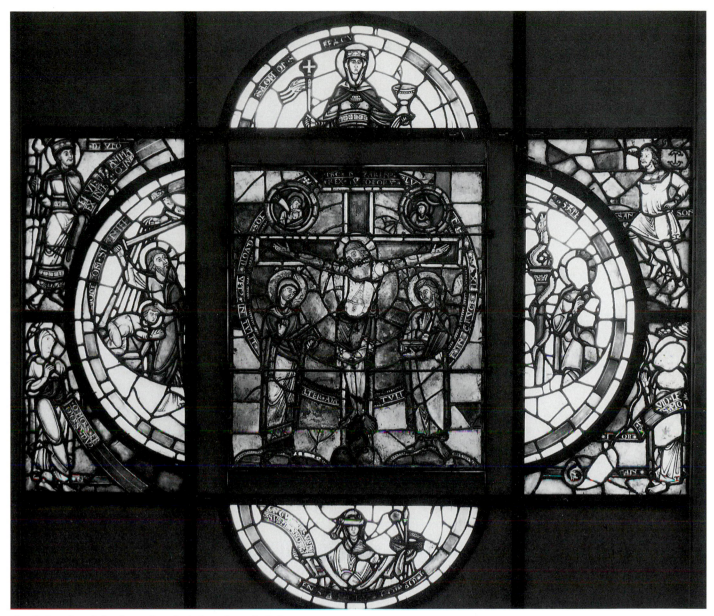

384. *Redemption window* (central section), from the cathedral. *c.* 1147.
Châlons-sur-Marne, Cathedral Treasury

windows of the radiating chapels before being adapted for a Lady Chapel built between 1259 and 1266. They are now set, with other elements, in the window immediately to the left of the central one behind the altar of the chapel. The subject matter ranges from the Annunciation to the Ascension and includes personifications of Fides and Infidelitas and of Ecclesia and Synagogue. The Crucifixion is set between the Tree of Knowledge and the Tree of Life, which symbolize the origins of sin and salvation.[81] Their rather unusual mushroom-shaped branches are similar to those in a late-eleventhcentury Anglo-Norman painting[82] and in the Mosan Alton Towers triptych of *c.*1150 in the Victoria and Albert Museum; they were to recur later in the central window of the tribune of Saint-Remi at Reims. Grodecki's reconstruction of the window with the Crucifixion panel shows that it took the form of a large quadrilobe, with the personifications of Church and Synagogue and of Fidelity and Infidelity in its

outer segments, rather like the window with which our next section begins.

CHAMPAGNE

There is in the cathedral of Châlons-sur-Marne[83] a window identical in format to, though differing partly in subject matter from, the window at Saint-Germer: the personifications of Church and Synagogue in half-roundels above and below the central Crucifixion are the same, but in the side segments are typological scenes of Abraham and Isaac and of Moses with the brazen serpent [384]. These subjects had been recognized from the earliest centuries of Christian art as Old Testament symbols of Christ's sacrifice, but other typologies presented or implied in the Châlons glass are much less traditional. One is the capture of Leviathan, a type of the Saviour defeating Satan[84] to be found in more

sophisticated form in the *Hortus Deliciarum*.[85] It derives from Job XLI, 1 – 'Canst thou draw out leviathan with a hook? . . .' – as interpreted by Rupert of Deutz, who saw the Leviathan as the Devil who will be caught by the bait of Christ's humanity and destroyed by the barb of his divinity. A second typology refers to the first Passover, in which the doors of the Israelites are marked with the blood of the lamb (Exodus XII, 1–30), and a third shows the widow of Sarepta gathering sticks (I Kings XVII, 10). The signing of the foreheads of the righteous with the Tau (Ezekiel IX, 4) represents a well-known figure of the Passion, and other links between the two Testaments are provided by two prophets holding texts alluding to Christ: David's reads, 'thou hast delivered my soul from the lowest Hell' (Psalm 85 (A.V. 86), 13), and Hosea's assures death, 'I will be thy death' (XIII, 14). The panel of Samson carrying off the gates of Gaza, generally seen as a type of the Resurrection, may originally have belonged to another window on the theme of the Resurrection.[86] Until 1882 the panels of the Redemption window were dispersed within the Gothic windows of the cathedral. After 1945 they were reassembled, in their surmised original format, in the cathedral treasury.[87]

Grodecki says of this glass, to which he devoted much study, 'all the scenes or figures . . . hinge upon the Mosan typological principle and reproduce Mosan enamels or resemble them in a striking fashion. Moreover, if the iconography is Mosan, so is the style.'[88] Indeed, a comparable format and related iconographies are to be found in a slightly later Mosan portable altar from Stavelot which is now in the Brussels Museum, and stylistic associations with Mosan illumination include David's low brow and pointed moustache, which are closely paralleled in a Lectionary from Saint-Trond; the stance of Hosea, which is similar to that of Christ on folio 179 verso of the Floreffe Bible; and the presentation of the Sacrifice of Isaac, which bears comparison with the corresponding episode of a Mosan manuscript leaf in the University of Liège.[89] The black and white of illustration 384 can give no hint of the glowing red and other colours of the glass, but it conveys the delightful clarity of the composition, which is again a very Mosan feature. Indeed, there are so many Mosan characteristics in this window that we must suppose it to have been made by a Mosan master.[90] Its date must be close to 26 October 1147, when the rebuilt cathedral was consecrated by no less a person than Pope Eugenius III.

The four surviving panels of a second Romanesque window at Châlons-sur-Marne,[91] also now in the treasury, show how the relics of the patron saint of the cathedral, St Stephen, were discovered after promptings from a series of visions. Of a third window, in a cruder style, which is concerned with the infancy of Christ, the remaining panels – all in poor condition in the treasury – show the Magi before Herod, the Presentation in the Temple (in two separate halves), the Flight into Egypt, and the unusual theme of Isaiah's prophecy of the Ascension.

A small window of admirable quality in the former abbey of Orbais[92] in northern Champagne shares with the Châlons Redemption a compositional clarity and an interest in exploring ways in which the Old Testament foreshadows the redemptive role of Christ [385]. The figure style, however, is more relaxed, pointing to a date in the last quarter of the

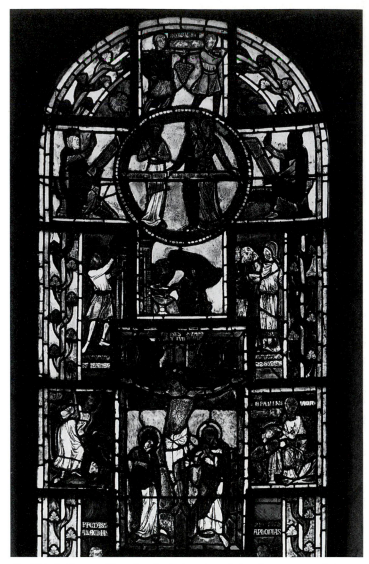

385. Orbais, former abbey church, *Redemption window*. Last quarter of the twelfth century

century. Besides the Crucifixion, there are representations of David, Moses, the sacrifice of Isaac, the first Passover, the Signum Tau, the taking of fruit from the Promised Land, the benediction of Ephraim and Manasseh, and (exceptionally for these typological programmes) the daughters of Jerusalem.

It seems likely that the oldest stained glass of Champagne was originally in its most important centre, Reims. We know that already before 989 the city's cathedral could boast windows with representations of 'various histories',[93] and that at some time between 1055 and 1087 Reims could supply the abbey of Saint-Hubert in the Ardennes with a glazier to make 'beautiful windows' – presumably of stained glass.[94] However, the earliest glass now at Reims is of the twelfth century, and it is not in the cathedral but in the old abbey church of Saint-Remi, which was built over the saint's tomb. The glass has suffered most cruelly over the centuries, especially during the First World War, when nine complete windows in the chevet were shattered by bombardments. It was, according to legend, at Reims that St Remi baptized Clovis, the first Christian monarch of the Franks, with oil brought down from

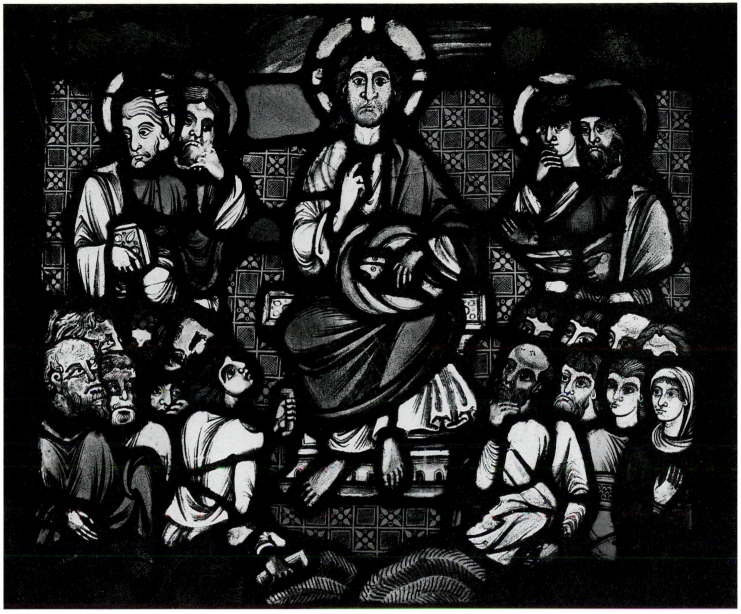

386. *Multiplication of the Fishes*, from Troyes Cathedral(?). *c.* 1180–1200.
London, Victoria and Albert Museum

heaven by a dove – a rite seen by Hincmar, archbishop of
Reims from 845 to 882, as amounting to a royal consecration.[95]
Hincmar further asserted that some of the miraculous oil
remained at Reims, and implied that it was the special right
of the archbishop to carry out royal coronations – indeed
Louis the Pious had chosen to be crowned at Reims in 816,
and after Hincmar's time it became the accepted coronation
centre of the French kingdom, albeit the ceremony usually
took place in the cathedral. All this does, however, help to
explain why the glass in the nave of Saint-Remi included a
sequence of kings of France – originally probably twelve, of
which seven survive, one identified by inscription as
Chilperic. The five figures of apostles that also survive – four
in the nave and a fifth, St Andrew, in the choir tribune –
may have belonged to a series of twelve that complemented
the twelve kings.[96]

The nave of Saint-Remi was embellished in the first half
of the twelfth century by Abbot Odo (1118–51), and it is
thought that he, perhaps in his last years of office, was

responsible for the stained glass; its royal 'portraits' certainly
reflect his known interest in the connections between the
French monarchy and Reims, which he expressed by raising
funerary monuments to the last two Carolingian kings, Louis
IV and Lothar, both buried in the church.

Odo may also have commissioned a further stained-glass
cycle of the Old Testament ancestors of Christ of which only
a small part remains. One or two of the inscriptions, for
example 'Eliakim' and 'Joseph', can still be deciphered, as can
'Abiud' on a figure from the series now in the Metropolitan
Museum in New York; all are taken – perhaps not
surprisingly – from the 'royal' genealogy of Jesus given by
St Matthew. The remaining figures were clearly not intended
for their present position at the east end of the choir tribune,
for they have had to be adapted to fit the bays they now
occupy. We might date them, together with two nimbed
women from a Visitation that now accompany them, to
*c.*1140–50.[97]

Within two years of taking office, Abbot Pierre de Celle

(1162–81) began the complete reconstruction – including a large-scale glazing programme – of the choir of Saint-Remi, and work continued after his death and into the 1190s. Still in its original position in the central window of the choir tribune is the Crucifixion, with the Saviour flanked by the mourning Virgin and St John; the two trees with mushroom-shaped branches, just visible over their heads, have been referred to in another context.[98] The chalice and skull beneath Christ's feet are a reference to the tradition that Golgotha, the hill on which the Cross was raised, was the very place where Adam had been buried. When the window was virtually remade after severe damage in the First World War, the restorer took the opportunity to remove details added for no very good reason in the nineteenth century, including personifications of Ecclesia on a four-headed animal and the Synagogue on an ass.[99] Unfortunately significant areas of nineteenth-century glass, notably the heads of Christ and the Virgin, remain – and yet, despite all, the window still reflects something of the extended figure proportions, the sense of equilibrium, and the monumentality of the original glass, which may be dated c.1185–1200.

In order to honour the abbey's patron, St Remi, one of the city's early bishops, the upper windows of the new choir portrayed a long cycle of the bishops and archbishops of Reims, each seated figure surmounted by a prophet or an apostle, with St Remi in pride of place in the central window beneath the Virgin and Child. Today, all is by no means as it was. The central window was virtually destroyed in 1915, and the present figures are modern replacements (the upper part of the original painting of the Virgin survived, however, and is now in the south arm of the transept); the rest of the cycle has been heavily restored and is in an incorrect sequence. The last archbishop to be portrayed is Henry of France (1162–75), the brother of Louis VII; this implies that the programme was carried out during the lifetime of his successor, Guillaume aux Blanches-Mains (1175–1202), which is in line with what we know of the building activities at Saint-Remi. The date 1185–1200, which is suggested by the historical evidence, also seems appropriate in terms of style, since through all the restoration one can still glimpse in these figures the grandeur of Romanesque being softened by anticipations of Gothic.

In one way the Romanesque windows of the cathedral of Troyes[100] have suffered worse than any others, for not a vestige remains in situ, and what has come down to us is scattered through the museums of the world.[101] This highly unusual state of affairs has prompted scholars to ask whether these remnants were made for the cathedral at all, for our only reliable information is that the glass was there in the early part of the nineteenth century. One view is that it was indeed made for the cathedral; that, following a fire in 1188, it was adapted to the thirteenth-century rebuilding (there is evidence that some of it was modified at this period); and that it was dispersed as a consequence of renovations carried out between 1849 and 1866.[102] Another opinion has it that it was originally made for a different Troyes church and at some juncture brought to the cathedral but never used there.[103]

There are four themes to the Troyes glass: the public life, or perhaps the miracles, of Christ [386]; his temptations (an exceptional subject for stained glass); the death of the Virgin;

and the life and miracles of St Nicholas. Its style has been associated with the illumination of Champagne, and especially with two volumes of the four-volume Capuchin Bible[104] whose artist worked on manuscripts (notably a Commentary of Peter Lombard on the Psalms[105]) which in the Middle Ages formed part of the library of Clairvaux. It also shows affiliations with Mosan styles, especially the picture of a physician discussed in an earlier chapter.[106] The connections with the Capuchin Bible are, however, the closest, and Grodecki has gone so far as to claim that the painter of the Troyes glass and the painter of parts of the Capuchin Bible were one and the same;[107] the glass-painting does indeed eschew the breadth of treatment natural to it and concentrates instead on precision and accuracy, qualities to be looked for rather in miniatures. The virtuosity of some manuscript-painters has been alluded to in another chapter, but this is the only example that has come to light of one who may also have painted windows. The Troyes windows may be dated to the 1180s or 1190s and offer some of the finest examples of twelfth-century glass-painting left by a French artist.

WESTERN FRANCE

The cathedral of Le Mans has been described as a museum of stained glass,[108] and aptly so. It took on this aspect when, after Huguenot devastation in the sixteenth century, the glass of various dates from twenty different windows (mostly in the former nave) was regrouped and relocated (and later heavily restored). The most famous window, now in the south aisle, is ascribed to the years 1140–45.[109] It is an Ascension with the figure of Christ being borne aloft now lost, leaving only the two lower registers showing the Virgin and apostles gazing up to heaven [387]. The figures – draped in bright yellows, blues, greens, and off-whites – are mostly original, but the backgrounds of hot reds and cool blues are not. The scene is alive with an excitement generated partly by the artist's vivacity of touch, and partly by the animation of the elongated figures as they gesticulate upwards. Their high-waisted proportions are familiar from French Romanesque sculpture such as that of Autun, but it is to the north, and particularly to the Channel area, that we must look for a proper understanding of their style. As has been suggested in an earlier chapter,[110] these northern traditions penetrated as far as Saint-Savin, where we find among the figures [229] the same floating quality and delicacy of step as at Le Mans. The excessively long legs of the figures in the upper register call England to mind, particularly the Lambeth Master [351], who was working in both France and England at the time, and also the Alexis Master [336], whose patron, Abbot Geoffrey, had come to St Albans from Le Mans.[111] It was perhaps inevitable that artistic exchanges between England and this part of France should take place during the second quarter of the twelfth century, for the two areas were associated through the person of Geoffrey Plantagenet, who was related by marriage to the English royal family, and

387. Le Mans Cathedral, south side-aisle, *The watching Virgin and apostles* from *The Ascension window*. c. 1140–5

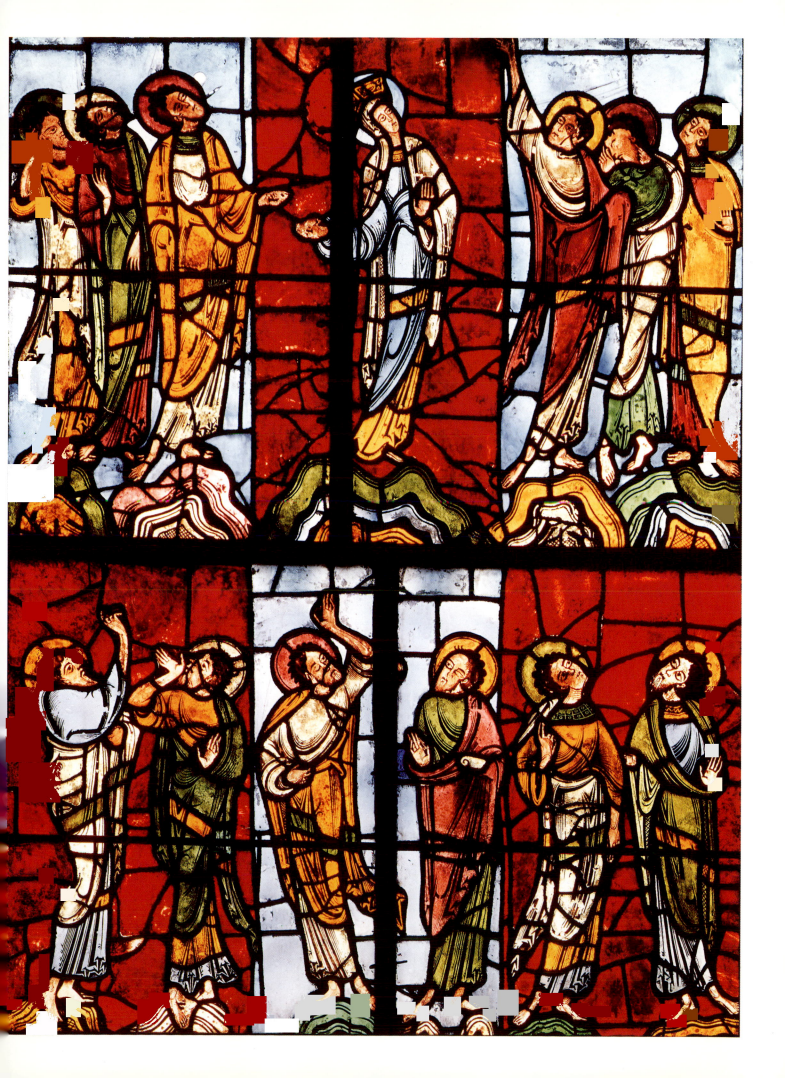

388. Le Mans Cathedral, south side-aisle, *Last Judgement window*(?), detail of four apostles. 1160s

389. Le Mans Cathedral, west end, *St Paul appearing to St Ambrose in a dream. c. 1190*

390. (*opposite*) Poitiers Cathedral, chevet, *Crucifixion window. c. 1165–70*

whose son, born in his own city of Le Mans in 1154, was to become king of England as Henry II.

From three windows which illustrated the childhood of Christ, his Passion, and the story of St Peter survive scenes of the sleeping Magi, of Pilate washing his hands, and of St Peter being led from prison. Assigned to the middle of the century,[112] they are characterized by rather conventionalized decoration.

It has been surmised that a monumental Last Judgement window in the Romanesque transept was the original setting of glass now in the south aisle showing a much damaged Christ displaying his wounds above a Cross held by two angels with four seated apostles in between [388]. The apostles, in solemn debate, have a fine presence and wear garments with sharply defined Byzantine 'damp-folds'. Originally, no doubt, the remainder of the apostles accompanied them, in other roundels. These panels are attributed to the 1160s,[113] as are others in a more ornate style, now in the north aisle, which include five scenes of the martyrdom of St Stephen; one of them shows Paul – then Saul – as a witness, having consented (so it is said) to Stephen's death. The figures are basically authentic, and the close and precise patterning gives a delicate and pleasing decorative quality to the birds and animals in the scene of the exposure of the saint's body. In contrast, the sadistic expressions of the executioners hurling stones are reminiscent of the equally vindictive faces to be found in the Winchester Psalter [365].

The same atelier was responsible for glass now in the main west window illustrating the life of St Julian, who was said to have evangelized Le Mans and to have been its first bishop.

The types of face and foliage in the nine of the eighteen scenes that are authentic demonstrate close knowledge of the west windows of Chartres.[114] The figures of two scenes in another window in the west front are in a much looser and more linear, but still Romanesque, style. The colours and forms of decoration are related to Angevin glass of the last quarter of the century, and the work is ascribed to the period around 1190.[115] The window shows St Paul appearing to St Ambrose in a dream [389]; St Ambrose, guided by this vision, recovering the remains of St Gervase and St Protase (whose relics were held by the cathedral); and scenes from the lives of St Valeria and St Vitalis, the supposed parents of Gervase and Protase. In another window, reassembled in the twentieth century and also now in the west front, are two episodes from the martyrdom of Gervase and Protase, and a third in which they accomplish a miracle with the assistance of the Virgin. These panels are in a totally different style from the other glass; they are ascribed to the 1160s,[116] but the agility of the figures and the suppleness of the draperies suggest a later date.

The cathedral of Poitiers,[117] too, suffered Huguenot bombardment in the sixteenth century, and ensuing restoration of its glass created an unusual problem by obscuring in the famous Crucifixion window in the chevet [390] a vital inscription identifying the donors – a royal couple shown, together with their children, offering (in a nineteenth-century interpolation[118]) this very window to Christ. The view of the abbé Auber is now generally accepted that the couple were Henry II and Eleanor of Aquitaine,[119] married in the cathedral in 1152, which would place the probable date

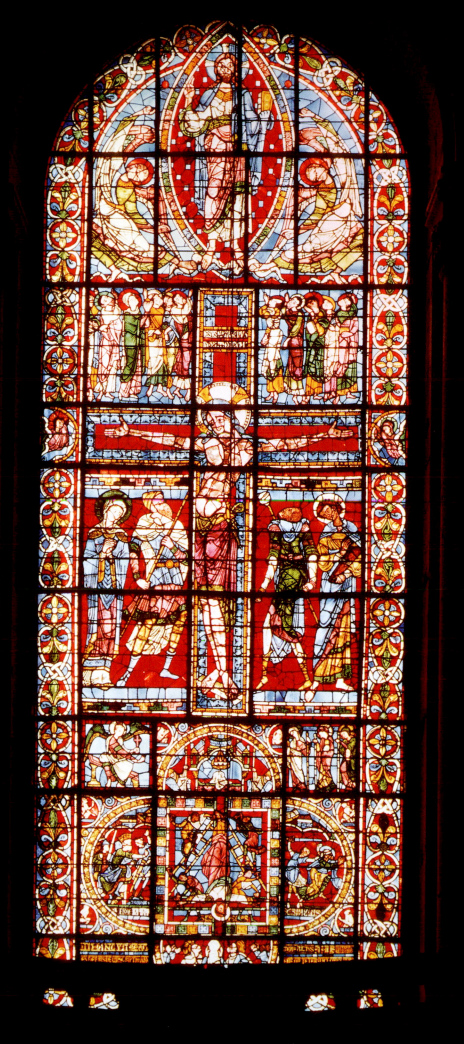

of the glass between 1165 and 1170. The Crucifixion window is both one of the biggest – it is over nine metres high – and one of the finest to survive from twelfth-century France. On either side of Christ on the Cross are Longinus and Stephaton with lance and sponge, and the Virgin and St John stand by. Above, the victorious Christ in a mandorla is carried aloft by two angels, their graceful bodies curving in a triumphal flourish, and below them, but above the arms of the Cross, the smaller-scale Virgin and apostles look upwards and point to Christ's Ascension. In a kind of visual footnote, in allusion to the Resurrection, the Holy Women are shown being addressed by the angel at the empty sepulchre, accompanied by scenes of the judgement and martyrdom of St Peter and St Paul.[120] The predominant colours of the glass are cool blues and warm reds, with gentler greens, yellows, and purples as background accompaniments; the Cross itself is 'infilled' with red to remind us of the blood of the sacrifice. Despite the difference of his colour harmonies, the Poitiers artist has been much influenced by the Ascension window of Le Mans, particularly in the high-waisted figures, some characteristics of faces and draperies, and the half-pirouetting movement of one of the apostles.

This dancing movement is to be seen again at Poitiers in the two heavily restored lateral windows. Of the one on the left commemorating the martyrdom of St Lawrence, to whom a chapel was dedicated (no doubt because the cathedral owned a relic of him), only a few panels are authentic, and seven are entirely modern.[121] Modern too are no less than fourteen panels of the right-hand window. This takes up a minor theme of the great Crucifixion window, the martyrdom of St Peter (the church's patron saint), illustrating in medallions and half-medallions the events that led up to his death. One or two episodes from the life of St Paul are also shown, and so – most unusually – is the fall of Simon the Magician. The original panels of this window are those of the central column (except the top medallion) and the two lateral half-medallions of the bottom register, though even these are restored.[122]

Impressive as the glass of Poitiers is, the only influence from it so far detected is in the forms of ornamentation for a rather humdrum Christ in Majesty, surrounded by symbols of the evangelists, of the last quarter of the century in the central bay of the apse of Notre-Dame at Gargilesse (Indre).[123]

THE LOIRE

The earliest stained glass to survive in the Loire region is in the abbey of La Trinité at Vendôme, on a tributary to the north. The Virgin and Child[124] there is roughly contemporary with the Le Mans Ascension and bears some relation to it in style, though the distortions necessitated by the length and narrowness of the window space have given it an abstraction extreme even for Romanesque art. This solemn hieratic image is surrounded by a mandorla clearly influenced by metalwork, for it looks like an engraved and gem-studded gold frame.

The cathedral of Angers[125] has the richest collection of twelfth-century glass in the region – so shuffled and reshuffled by the hand of time, however, that not one of the windows seems to be in its original place, and even the scenes within them are out of order. The five twelfth-century windows on the north side of the nave (the Virgin in Majesty is of the

early thirteenth) are associated with a known gift from Hugh de Semblançay, a canon of the cathedral. The St Mary, St Vincent, and St Catherine windows (all restored) look backward to Poitiers in the richness and warmth of their colouring and the decorative vocabulary of their borders, but forward to the thirteenth century in the sophisticated ordering of the various medallion and half-medallion scenes. The extended (if now confused) sequence concerned with the Virgin's death – her entombment, Assumption, and coronation in heaven – also seems to anticipate the next century, when the cult of the Virgin was at its height. This window is close in style to the St Vincent window. The St Catherine glass is different, and more conservative: here the halfpirouetting feet and the linear 'damp-folds' are reminiscent of the Ascension and the Last Judgement at Le Mans [387]. This window must be the earliest of the three, though they can all be dated c.1180. Relics of St Catherine and St Vincent were given to the cathedral by Bishop Raoul de Beaumont (1178–98) in the last quarter of the century, and this may have prompted the installation of the windows.

The fourth window (with a probably alien border) is attributed to c.1155.[126] It illustrates the childhood of Christ in five principal registers, the lowest two consisting of heterogeneous elements, the other three focusing – though not in this order – on the Annunciation, the Nativity (in which, unusually, the Virgin wears a crown), and the Adoration of the Magi. The colour harmonies here point towards Vendôme, the slender and curving figures to Le Mans. The condition of the fifth window, with scenes from the life of St Andrew, is too poor to permit comment.

Characteristics of the Angers windows recur in other churches dotted along the Loire – for example at Charentilly and Les Essards. Amazingly enough, they even crop up in the central light of the east window of an English church[127] – at Rivenhall, in Essex – for which the glass, originally at Saint-Martin de Chenu to the north-west of Tours, was purchased in 1839. Ascribed to c.1170–80, it shows (reading downwards) Christ in Majesty with angels, the Virgin and Child with angels, the Annunciation, and possibly the entombment of the Virgin. Two haloed figures of archbishops in the lateral lights are from the same French source. The quality of the glass is more admirable than its condition.

Two sets of glass must be reported from the province of Berry, bordering on the Loire. The scenes from the life of St Denis at Saint-Denisde-Jouhet (Indre)[128] are significant in iconography through dilapidated in state. On the south side of the choir in the cathedral of Bourges[129] are two panels, attributed to c.1160, of the Annunciation and the Adoration of the Magi which have some stylistic connections with western France, chiefly Le Mans, but are given individuality by richness of colour (yellow is used to simulate gold) and by a strong ornamental sense which is particularly apparent in the heavy patterning of the Virgin's drapery in the Annunciation scene. Two other, incomplete scenes of Peter and Paul and of Christ at table with Simon and the Magdalene are in a different, more tranquil style of c.1170. It is by no means certain that these two originated in Bourges; they were discovered in the nineteenth century in a glazier's workshop and were not – as far as we know – installed in the cathedral until after the Second World War.

CENTRAL AND EASTERN FRANCE

The earliest surviving stained glass of eastern France is attributed to the period between 1160 and 1175. It is thought to have been made for the choir of the Cluniac priory of Domène, some seven or eight miles from its present setting in the tiny church of Le Champ-près-Froges (Isère),[130] and despite restoration is basically in good condition. In a style characterized by linear assurance, balanced composition, and confident colour harmonies, it represents, in three scenes within medallions, the Ascension [391] and Pentecost. Domène was then within the empire, and the iconography of the Ascension scene draws accordingly on Ottonian compositions; the light colour range and the fastidious feeling for decoration, too, find their best parallels in German productions, particularly those of the Rhineland glass-painter Gerlachus, to whom we shall come later. With the glass of Clermont-Ferrand and Lyon the Le Champ glass shares an *enlevé* technique of decoration (consisting of the patterned removal of grisaille), a comparable species of ornamental palmette, similar types of heads and draperies, and also a parallel response to the Byzantinizing currents then in circulation.[131]

Closest to the glass of Le Champ-près-Froges is a Pentecost now in the chapel of St Anne at the cathedral of Clermont-Ferrand.[132] Attributed to the years between 1160 and 1170, it is the earliest of eighteen panels (the rest made towards the end of the century) originally belonging to several windows and brought together during restorations of 1913–22. They must clearly have come from the old Romanesque cathedral, for the Gothic one was not begun until 1248. As well as a Christ in Majesty, the window has scenes from the childhood of Christ and from the lives of St Peter and St Paul, and figures of St Martial, St Martin, and other saints under arcades. The iconography of one or two of the infancy scenes, especially the Nativity, shows Byzantine influence, and so do the modelling of the heads of the two apostles and the drapery folds and hair of the Christ in Majesty, which has affinities with a very fine Majesty in the Sacramentary of Clermont,[133] a local manuscript illuminated in the international style of about 1200.

Sidonius Apollinaris described simple coloured glass in the Early Christian basilica at Lyon as early as 497,[134] and some six hundred years later stained glass with figures probably filled the five windows presented between 1084 and 1106 by Archbishop Hugues de Die.[135] Today, however, the earliest surviving stained glass of Lyon is in a chapel of the cathedral formerly dedicated to St Peter. Brisac argues that it belongs to the period 1187–93, when, according to the cathedral records, the chapel was opened for services.[136] It is now in a large window in the east wall, but its history has been chequered. In the early nineteenth century it was all removed and distributed to other parts of the cathedral, and by the time it was reinstated in the mid century, not entirely in the right order, a third of the panels had gone astray and some of the rest had undergone restoration. Yet the original message of the window remains clear: it was to glorify St Peter. It is divided into five registers, with scenes in large medallions on the central vertical axis and others at the sides. In the lower four registers are scenes from the apostle's life: his attempt

391. Le Champ-près-Froges, church, west window, *Apostles witnessing the Ascension*, probably from Domène. *c.* 1160–75

to walk on the water, his raising Tabitha from the dead, his arrest and trial, and his martyrdom. In the considerably restored top register the enthroned Christ holds out to Peter the keys of the kingdom of heaven. The style is to some degree Byzantinizing and tranquil, despite a certain effusiveness of drapery folds. It is, incidentally, a silent commentary on modern pollution that the glass that remains in the cathedral is in a worse state than two original side panels that have been in the possession of the Victoria and Albert Museum since 1858. Four further twelfth-century panels placed in the nineteenth century in the rose window of the chapel are in a comparable style and must be related in date. They too are in a poor state, except for the one with the Crucifixion of St Peter.

GERMANY AND ALSACE

AUGSBURG

The earliest of all surviving stained-glass windows – like the earliest surviving fragments – come from Germany, though opinions vary concerning the precise period (usually thought to be within the eleventh century) to which they belong. They are on the south side of the nave of Augsburg Cathedral. Fischer linked them with a dedication of 1065.[137] Boeckler,[138] on the other hand, would place them as late as the third or fourth decade of the twelfth century, on the strength (as he saw it) of their stylistic relationship with the illumination of the second volume of a Passionary now in Stuttgart which we have encountered earlier[139] – and indeed some of his detailed comparisons, particularly between heads and between ornamental motifs, should be given due weight. However the stark hieraticism of the glass painting seems to indicate an earlier date, and Frenzel's attribution to the very end of the eleventh century[140] is more persuasive. Better still

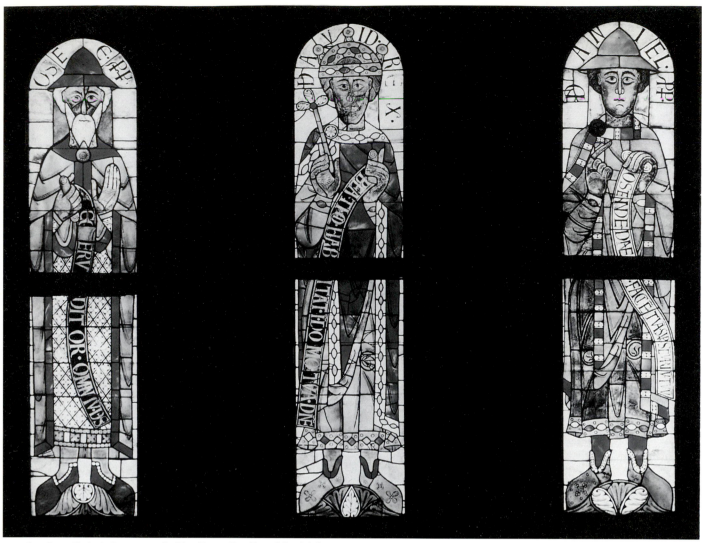

392. Augsburg Cathedral, nave south side, *Hosea, David, and Daniel.* Late eleventh/early twelfth century

might be a more cautious dating to the end of the eleventh century or the beginning of the twelfth.

The Augsburg glass has undergone many vicissitudes – from hailstorms in 1448 and 1534 and extensive damage by iconoclasts in 1537–8 to a programme of reglazing with clear glass in the years between 1655 and 1658. As a result, only four prophets remain (a fifth figure of Moses is a sixteenth-century copy) from the original set of Romanesque windows, which is thought to have featured the Virgin and Child with twelve prophets and twelve apostles. The four surviving prophets are Hosea, David, Daniel, and Jonah, each holding a scroll inscribed with a quotation from his book [392]. David's crown and drapery hem are embellished with simulated precious stones such as we shall find at Strasbourg. The texts asking God to look down upon his sanctuary and rejoicing in the blessedness of those who dwell therein probably refer to the Church in general and not to this cathedral in particular. An effect of quiet calm and uncluttered simplicity is produced by these narrow frontal figures of more than human size, shoehorned into their frames in the Ottonian manner in order to enhance their monumentality. In red, green, blue, fawn, and chocolate brown, they are set against backgrounds left largely uncoloured in order to admit more light.

STRASBOURG

Strasbourg, today in French Alsace, was in the Middle Ages Strassburg in Swabia, and (as explained in an earlier chapter) must here be treated in a German context.

Like most other Romanesque stained glass, the windows of Strasbourg Cathedral have witnessed much upheaval: they were adapted for re-use during the Gothic rebuilding; much was later lost or damaged by artillery fire; and what remained has been rearranged and quite heavily restored. Yet the researches of Zschokke[141] have given us many insights into the original programme. The main theme of the nave windows, he tells us, was the Virgin (to whom the cathedral was dedicated), accompanied by successions of prophets and apostles, martyrs and confessors. She is now, seated, in a window on the west side of the north transept beside a standing St Martin. Of the prophets, only fragments of David and Ezekiel remain (a panel with Isaiah was destroyed during the Second World War). Two of the apostles, however – Matthew (perhaps misidentified) and Bartholomew – have survived and are now in the south transept, together with heavily restored paintings of three of the martyrs of the Theban legion, Maurice, Candidus, and Victor.

As at Reims there was a sequence of French kings, so here

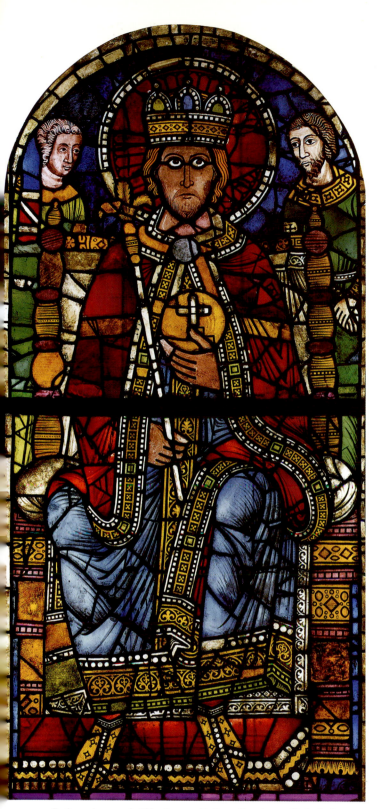

393. *Enthroned monarch (Charlemagne?)*, from Strasbourg Cathedral. *c.* 1180–1200. Strasbourg, Musée de l'Œuvre Notre-Dame

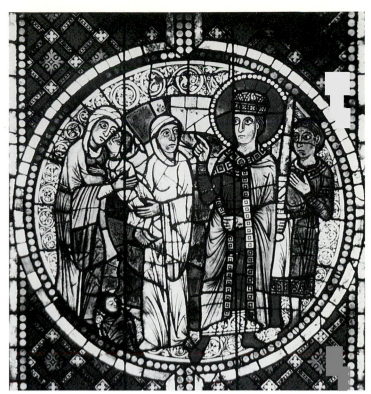

394. Strasbourg Cathedral, north transept (formerly apse), *Solomon ordering the baby to be returned to its mother*, from the Judgement of Solomon. *c.* 1180–1200

in the nave at Swabian Strasbourg there seems to have been a cycle of German kings and emperors, no doubt because the Hohenstaufen, the hereditary dukes of Swabia, rose in the twelfth century to the dignity of Holy Roman Emperors. Seven of this former gallery of nimbed kings and emperors remain and are now in the north aisle, where they were probably brought to replace destroyed Gothic windows – indeed, one or two of them might actually be described as

part Gothic and part Romanesque.[142] Only the figure of Henry I can really be said to be authentic, but sufficient detail remains in the others to give some idea of their former pearled and jewelled decoration and richness of display. All these monarchs are standing, but the ruler with two attendants on two panels which were in the south transept until 1855 (they are now in the Musée de l'Œuvre Notre-Dame[143]) is enthroned. He is lent resplendence by the gorgeous painting of his robes in red, lapis lazuli, and yellow [393], and regal decisiveness by his posture; in fact, we have here an impressive image of imperial majesty. Whether it was the majesty of Charlemagne that was intended we do not know, though the two figures hovering in the background[144] can be paralleled in portrayals of Carolingian emperors [cf. 57, 62], and Charlemagne was considered by the Chapter of Strasbourg to be the protector of their privileges; moreover, it was as a result of pressure from the greatest of the Hohenstaufen dynasty, Frederick Barbarossa, that Charlemagne was canonized in 1165.

The only survivors of the great Tree of Jesse in the central window of the Romanesque apse are the enthroned Virgin and the ornate and strikingly Byzantine angel in the north transept.[145] The apse programme also included the Judgement of Solomon in four scenes, of which three survive in the north transept [394], and a coronation of the Church by Christ which today is in one of the two south roses. The Visitation in the chapel of St John is now represented only by half-length figures of the Virgin and St Elizabeth in the museum; statuesque paintings from the same chapel of St John the Baptist and St John the Evangelist holding scrolls with scriptural quotations were originally, according to Zschokke, in two windows,[146] though today they are in one, in the north arm of the transept. Their iconography is based

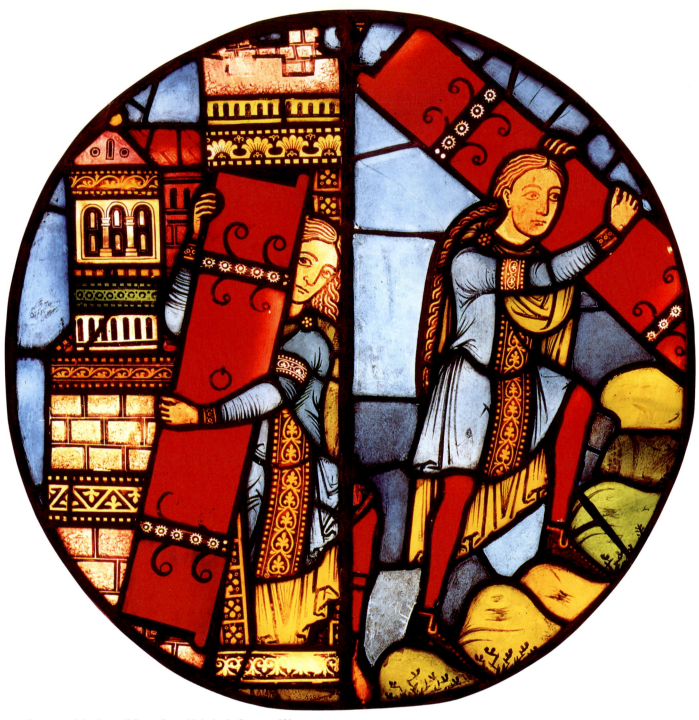

395. *Samson and the doors of Gaza*, from Alpirsbach. Late twelfth century.
Stuttgart, Württembergisches Landesmuseum

on Byzantine standing prophets, and there are Byzantine influences also in the style of John the Baptist's drapery.

The Byzantine elements may be explained by the close connection of the Hohenstaufen with southern Italy and Sicily: the emperor Henry VI became king of Sicily in 1194. Alsace's most famous manuscript, the *Hortus Deliciarum*,[147] was also Byzantine-influenced, and its very striking parallels with the glass indicate that they belonged to the same artistic milieu: the cathedral's John the Evangelist is virtually a copy of the *Hortus*'s Malachi, and there are other stylistic associations between the head of John the Baptist and the manuscript's Abraham,[148] and between the three martyrs of the Theban legion and warriors in the vellum paintings. In

the softness, ampleness, and Byzantinizing ornamentation of their garments, too, the figures in the scenes of Solomon's Judgement are very close to some in the miniatures. As it happens, the *Hortus* dilates upon Solomon's symbolism of ideal kingship, which explains the prominence given him in the stained glass of a cathedral so closely linked with the Holy Roman Emperors. The programme at Strasbourg would clearly have taken many years to carry out, and it is assigned to the period 1180–1200.[149]

From the Benedictine abbey of Alpirsbach in the Black Forest comes a particularly fine glass painting of Samson and the doors of Gaza (Judges XVI, 3) [395] whose luminous, jewelled, and highly ornamental effect is not unlike that of

the Solomon paintings just described. It is indeed thought to be a Strasbourg production; if so, it would fit in with the view that some Romanesque stained glass was made in episcopal cities or large monasteries for smaller centres unable to afford workshops of their own.[150] The painting shows Samson taking up the city gates and then carrying them up Mount Hebron, typifying according to tradition the Resurrection and the Ascension of Christ, as echoed in inscriptions held by the symbols of the evangelists Mark and John within spandrel-shaped panels which originally accompanied the roundel. The ease of style of Samson's draperies suggests a date in the later part of the twelfth century, probably in the eighties or nineties, though one scholar prefers an earlier placing.[151] The glass has since 1880 been in the Württembergisches Landesmuseum at Stuttgart, which also has four fragments of a decorative border from the same window.

Marginal links with Strasbourg can be detected at the former abbey church of St Peter and St Paul at Wissembourg,[152] some forty miles to the north, in the decoration of banded parts of the draperies and some minor points of ornamentation. The one surviving roundel, made c.1190, was at some time – presumably during rebuilding in the thirteenth century – re-sited in the north transept. It shows a Virgin and Child whose loose, square proportions relate them primarily to the illumination of a Gospel Book from Speier Cathedral.[153]

THE MIDDLE RHINE AND WESTPHALIA

Besides possessing the earliest of all stained glass, Germany has, in the middle of the Rhine region, the only stained-glass portrait of an artist from our period. Originally in the west choir of the Premonstratensian abbey at Arnstein, founded in 1139, it was purchased in the early nineteenth century for his private castle by a friend of Goethe, and passed, after later restoration, to its present home in the Landesmuseum of Münster.[154] The central window of the five in the west choir at Arnstein was filled with a Tree of Jesse, its lowest panel representing David and the recumbent Jesse, and the upper one Christ surrounded by doves typifying the seven gifts of the Holy Spirit. The Virgin must have occupied the middle panel, which is lost, and there would have been no room for any further ancestors, or for accompanying prophets, as at Saint-Denis and Chartres. The three panels that survive from the other windows illustrate Old Testament events that lend themselves to New Testament analogies, which has prompted the view that these four windows presented types and antitypes – and indeed a fragmentary inscription indicates the former existence of an Annunciation scene. According to Becksmann,[155] the surviving scene of the flowering rod of Aaron was associated with a Nativity of Christ, the Moses receiving the Tablets of the Law may have had a painting of Pentecost as its parallel, and the Moses and the burning bush could have been the type for the Annunciation.

It is in the lower part of the burning bush panel that the self-portrait of the artist is found. It is another example of the contemporary conceit, already noted in manuscript painting and sculpture[156] [318, 353–5], whereby the artist presents himself as part of his own creation, for here he is at work on his window [396]. He identifies himself as Gerlachus, and asks in an accompanying inscription (as also noted elsewhere) for the favour of the King of Kings; but whereas previous supplicants were monks, Gerlachus is seen from his dress to be a secular. The date of his glass is c.1160.[157] It is characterized by glowing colours of red, green, and yellow to simulate gold, by a linear figure style, and by backgrounds covered with ornamental floral designs. Efforts to link Gerlachus's style with manuscript paintings from the vicinity and from Helmarshausen have not been particularly successful, nor have attempts[158] to place a Crucifixion at Sainte-Ségolène, Metz, among his early work – its style is too crude, and its gestural language is different. A Crucifixion indeed made by Gerlachus was destroyed in Berlin in 1945, but black and white photographs of it are sufficient to demonstrate his ability in the Cross to simulate the graining of wood. A late development from his style is the St Bartholomew of the 1170s from Peterslahr, now in the Hessisches Landesmuseum at Darmstadt.[159]

All that remains of another Tree of Jesse, in the north transept of the collegiate church of St Patroclus at Soest,[160] north of Arnstein, are the seated Virgin and the dove of the Holy Spirit with seven rays emanating from its beak. An almost illegible inscription relating to Isaiah XI, 1 refers to Mary producing progeny from the rod [of Jesse]. The three windows of the apse were reglazed in 1829 with clear glass, and when, almost half a century later, the stained glass was reinstated, it was more often replaced than restored; as a result, very little that is authentically Romanesque remains. The south window, showing six scenes from Christ's life from the Nativity to the Mount of Olives, is relatively modern, though the Crucifixion scene in the north window is genuine, and so too are the Resurrection and some fragments of the Ascension in the middle window. Also authentic are some fragments stored in the church, and Volbach described four original panels that are now lost.[161] It has been tentatively suggested that these membra disiecta came from scenes of Moses and the burning bush, of the Magi, of the soldiers being ordered to slay the Innocents, and of the Flight into Egypt. Other remnants showing events connected with St Patroclus have prompted the conjecture that the south window dealt with the martyrdom of the church's patron.

The Crucifixion scene in the north window demonstrates that stained glass was as capable as embroidery and painting of illustrating theological subtleties. In a compartment below the main scene, the Israelite spies bear on a stave the bunch of grapes they have taken from the Promised Land (Numbers XIII, 23), and there were originally in the two side compartments[162] angels holding scrolls with the text from Isaiah LXIII, 1: 'Who is this that cometh from Edom, with dyed garments from Bozrah?' The quotation would have continued with a reference to one who has 'trodden the winepress alone' wearing apparel that was stained red, and the particular combination of words and scenes in the window was prompted by Rupert of Deutz's view[163] that Isaiah was here predicting the Passion of Christ, who trod the winepress of death so that the good could be redeemed and separated from the bad, just as the wine is separated from the grape.[164]

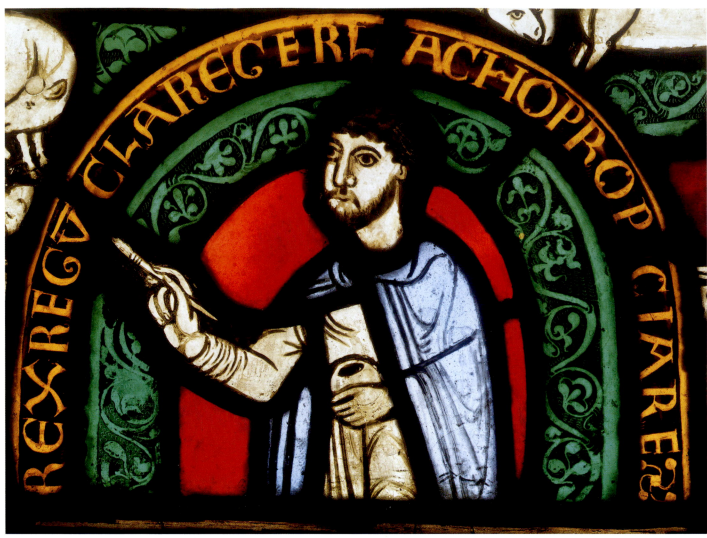

396. Gerlachus: *Self-portrait*, from Arnstein. *c.* 1160. Münster,
Landesmuseum

The winepress again featured in the idea that Christ was
crushed on the Cross, when his spirit was forced from his
body. As Rupert attributes these words to angels, it was
accordingly by angels that the words of Isaiah were held in
the window. The Israelites carrying the bunch of grapes
continue the imagery of the winepress, for the wooden stave
was thought to symbolize the Cross, and the bunch of grapes
the Redeemer himself. In the Crucifixion scene, Christ is
flanked by personifications of the Church and the Synagogue,
as well as by the Virgin and St John, and the theme of the
whole composition is reinforced by the chalice held to Christ's
side by the Church to catch the blood of his sacrifice.

Of the two artists who worked on the apse windows of St
Patroclus[165] (the fragment of the Tree of Jesse in the transept
is by a third), one was clearly chiefly concerned with line and
planes, the other with bold Romanesque forms. The inclining
heads and sweeping draperies of some of the figures have
been rightly compared to those of an antependium of *c.*1165–
80 from the church of St Walpurgis in Soest, now in the
Münster Museum, but even more significant are the
associations that have been noted[166] with the Helmarshausen

style of illumination. The treatment of figures and heads, the
compositions, and the setting of inscriptions, as well as the
representation of armour and the use of foliated backgrounds,
are so close as to suggest that the stained glass was actually
made at Helmarshausen – and it might here be recalled that
in his treatise, Theophilus, the distinguished Helmarshausen
artist, showed himself extremely knowledgeable about the
techniques of stained glass. Fragments recovered from under
the floor of the sacristy of the Westphalian church of Weslarn
have also been claimed for the workshop that produced the
St Patroclus windows.[167] The glass at Soest has been
associated with a consecration of 1166, and it is almost
certainly contemporary with a painting of Christ in Majesty
on the semi-dome of the apse that was destroyed during the
Second World War.

The evidence from St Patroclus again suggests that stained
glass might have been made at one centre for despatch to
another, and some slight support for this view is to be found
in the letters of Berengar, abbot of Tegernsee from 1003 to
1012, which allude to some kind of glass which Bange[168]
believed to be stained glass. Berengar was explaining to 'the

'we are sending you so little because we have been hampered by scarcity and ... are much afflicted by famine'. He goes on to make moving reference to the company of the starving and dying who daily arrive at his monastery from all directions. Unfortunately, no glass from Tegernsee is known to have survived.

SWITZERLAND AND AUSTRIA

Regrettably, hardly any Romanesque stained glass survives from Switzerland or Austria. In Switzerland, all that remains of the twelfth-century glass in the choir of the chapel of St James at Flums (canton of St Gallen) is a Virgin and Child, assigned to the 1170s and now in the National Museum at Zürich.[171] The insipid face of the Virgin is modern, but she sits squarely in a firm Romanesque posture and holds for the Child to see a red disc which may represent the Host, the symbol of his future sacrifice, as the dove of the Holy Spirit descends from above. The unpretentious but satisfying style is related to the illumination of the Swiss monasteries of most worthy lady, the abbess R.'[169] that she had not yet received the glass she had requested because it was not yet ready. 'We are now carrying the work forward each day,' he says, 'and once we finish it we will despatch it to you by our envoys immediately after the feast of St Andrew [30 November]'. Another letter, to Bishop Gottschalk of Freising,[170] is even more interesting, for it shows how much glass Tegernsee could produce for others even under the most adverse of circumstances. 'We are preparing only two hundred panes of glass,' Berengar writes, which could be collected in the third week after Easter; he adds apologetically,

Engelberg and Rheinau, and is part of the current flowing from the reform movement at Hirsau that led to the efflorescence of Swabian art. The close coloured hatching (admittedly much restored) on the Virgin's lower garment and on her single exposed sleeve also reminds us of the illumination of north-eastern France, for example of Saint-Amand.

In Austria, all that remains is a panel of Mary Magdalene ascribed to the 1160s and now in the Diocesan Museum of Klagenfurt.[172] Only half the size of the Swiss Madonna and Child, it yet has a certain monumentality, the Magdalene standing tall as she clasps her pot of unguent in one hand and a censer in the other. Refinement of workmanship and harmony of colour shine through the later restoration. The panel is stylistically associated with the illumination of the profusely illustrated Antiphonary from St Peter's, Salzburg [301], and it may have come from the church of St Mary Magdalene at Weitensfeld, a daughter church of Gurk Cathedral, where Abbot Henry of St Peter's was made bishop in 1167, though claims have also been put forward for the now destroyed parish church of St Mary Magdalene in Gurk itself.

ENGLAND

YORK AND THE NORTH OF ENGLAND

Fragments of plain and coloured window glass excavated at Jarrow and Monkwearmouth have been dated to a period before c.867, when Scandinavian raiders destroyed both monasteries, and it has been claimed that some of the Jarrow pieces can be pieced together to form a human figure to be dated between 685 and 800.[173] The earliest English plain glass windows of which we have mention were made for the original York Minster, i.e. before 642,[174] but the earliest surviving stained glass there is of a much later date: the twelfth century. It takes the form of panels[175] from the choir built by Archbishop Roger of Pont l'Évêque (1154–81), re-used in the clerestory windows of the Gothic nave when the choir was reconstructed in the fourteenth century. Their one surviving Old Testament scene, now in the Five Sisters window, links Daniel in the lions' den with an apocryphal account of Habakkuk bringing him food, and the same scenes are associated in the paintings of Canterbury,[176] where Archbishop Roger had previously served. The four remaining New Testament scenes show the miraculous draught of fishes, the three Marys at the Tomb, the Supper at Emmaus, and perhaps Christ and the disciples. The evidence that they formed part of a typological programme for the east end of Roger's choir[177] is too meagre to be worth pursuing.

A former Tree of Jesse window is suggested by the single panel in the north nave aisle of a king, in robes of dark green and brownish-purple against a blue ground, sitting in a tree and holding two of its branches; a former Last Judgement window is indicated by nine surviving panels, including one of St Peter and St Paul at the gates of heaven, and six showing the torments of hell. Of eight further panels in predominating shades of dark green, purple, and blue, seven illustrate episodes from the lives of St Benedict, St Martin, and St

397. York Minster, south nave aisle, *A miracle of St Nicholas*. 1170s

Nicholas [397], no doubt because the minster owned some of their relics, and the eighth has a seated figure of a bishop claimed to be St Richarius.

It can be gathered from the remaining panel that the York Tree of Jesse resembled the Saint-Denis one in the placing of figures and distribution of foliage, and surviving parts of the richly decorated borders go some way to confirming such a connection, though they are reminiscent also of Le Mans.[178] However, the English tradition predominates, as is plain if we compare the king in the Jesse Tree with another (Sigismund) in an English metal-engraving of about 1175–85;[179] the comparison is even more telling if it is made with a nineteenth-century drawing of the York figure made before it lost some of its details.[180] The decorative effect of the scene of one of St Nicholas's miracles [397] has also been persuasively related to illustrations of a late-twelfth-century Psalter from the north of England,[181] and the impressive head of the carter in the same scene has a peculiarly English flavour that we shall encounter again in the glass of Canterbury. These much worn and much restored York panels are attributed to the 1170s, and it is unfortunate that they can only provide glimpses of the full effect of Roger's stained glass.

The twelfth-century panel of an angel[182] in All Saints' at Dalbury, Derbyshire, is of humdrum quality, particularly when compared with an exceptionally good panel in the church of St Agatha at Easby near Richmond, North Yorkshire[183] [398]. It must have belonged to a Crucifixion scene, for the gently coloured figure turns towards the right in a posture adopted by St John in, for example, the Arenberg Gospels.[184] This St John may be dated to the third quarter of the twelfth century. It is today, in a mutilated state, high up in the three-light east window of the parish church and associated with a figure of the Virgin wringing her hands which must have been part of the same Crucifixion scene. The missing head has been replaced by a mid-fifteenth-century one, and other late medieval glass has been used to fill in the central lower part of the drapery.

No other Romanesque glass of English production has so far come to light in the northern province,[185] though we know from written sources that Hugh du Puiset, Roger of Pont l'Évêque's contemporary at Durham, 'increased the number of nobly painted glass windows around the altars' of his cathedral.[186] We know, too, that Kirkham Priory in Yorkshire had coloured glass windows in the second quarter of the twelfth century, for when the priory passed into the hands of the Cistercians of Rievaulx, the departing Augustinian clerks removed them for re-use in a new church that was being built in the vicinity.[187] They were replaced by clear glass, which was of course insisted on by Cistercians everywhere to comply with their own Rule. However, they discovered that the leads could be shaped into simple but pleasing patterns whose bold harmonies could endow their interiors with interest and composure, and the patterns are sufficiently similar over the West to suggest that pattern books were available.[188]

It is clear, then, that survivals of Romanesque glass in the north of the country are slight, and to gain a fuller impression of the skills of glass painting in England it is to Canterbury that we must turn, where we shall see, too, something of the transition of stained glass from Romanesque to Gothic.

CANTERBURY

The Norman cathedral at Canterbury that replaced the Anglo-Saxon building destroyed by fire in 1067 was finally consecrated in 1130. According to William of Malmesbury, it was beyond compare in England for the light of its glazed windows.[189] These may have been adorned with paintings, and we know from lucky survivals that stained-glass figures of four ancestors of Christ were inserted later in the 1150s.[190] This cathedral was in its turn burnt down in 1174, but there is no need to speculate about the stained-glass windows of its successor, for almost half of them – though by no means all *in situ* – remain to this day, having survived the iconoclasm of the Puritans and the ministrations of nineteenth- and twentieth-century restorers sometimes all too ready to replace the medieval glass with glass of their own.

398. Easby, church of St Agatha, east window, *St John*. Third quarter of the twelfth century

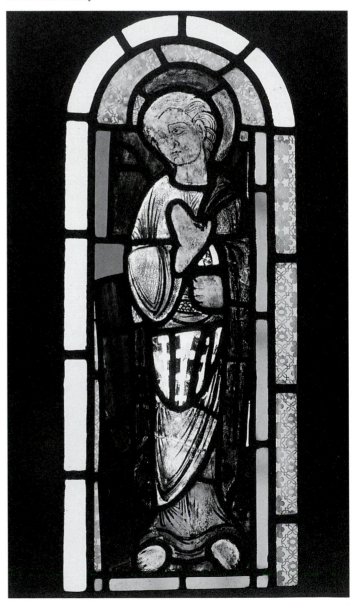

Like all stained glass, the Canterbury windows present problems of dating. We do however have two firm points of anchorage. In his detailed account of the early years of the rebuilding,[191] the Christ Church monk Gervase tells us that work began in 1175, and that the new choir was completed in 1180 and immediately put to use. The glazing of this part of the cathedral may therefore be assigned to the intervening years. Then, the newly built cathedral was consecrated in 1220 to commemorate the fiftieth anniversary of the martyrdom of St Thomas Becket, so that we know that the entire programme must by then have been complete. As a result of the community's quarrel with King John in 1207 over the election of Stephen Langton as archbishop, the majority of the monks spent the next six years in exile in France, so no work was presumably carried out on the windows during that time. This intermission aside, glazing went on for a total of forty-five years, naturally involving a succession of glass-painters. Their work has been definitively studied by Madeline Caviness,[192] whose researches underlie the account that follows.

The new cathedral at Canterbury had more than a hundred windows, and was unrivalled in the West in the extent of its stained glass. The main themes were three, two focusing on Christ and the scriptures, and the third on the lives of saints. The first two centred upon Christ's role as the culmination and fulfilment of Old Testament history, beginning with an extensive group of parallels between events in Christ's life and their prefigurations in the Old Testament. We know from Bede that the English had typological pictures on display as early as the seventh century,[193] and now, in the last quarter of the twelfth, they raised them to heights of sophistication unparalleled in the West. This typological bent is given full rein in the *Pictor in Carmine*,[194] a tract specifically written for wall painters to choose from among its six hundred and fifty types. Most of them were highly ingenious, and the work begins with no less than eighteen Old Testament parallels for the *Colloquium Gabrielis et Virginis de incarnacione verbi* (i.e., the Annunciation).[195] If only more late-twelfth-century English wall paintings had survived, it would have been fascinating to chart the *Pictor*'s effect. As it is, we can glean something from written sources: for example, verses in a twelfth-century manuscript record the existence of forty typological scenes painted on the walls of the chapter house of Worcester Cathedral,[196] and another source mentions a long sequence of twelfth-century paintings, some thematically related to the *Pictor in Carmine*, on the choir stalls of Peterborough Abbey.[197]

Eighty paintings in the Canterbury glass drew their subject matter from the *Pictor*, or from a remarkably similar source.[198] They had been in twelve major windows at ground level in the choir, the eastern transepts, and the presbytery.[199] The survivors are now gathered together in two windows on the north side of the choir, and others are known from an account in a fourteenth-century guide for pilgrims.[200] The programme started with the Annunciation, continued with events from Christ's early life, including some of the miracles and scenes from the public teaching, and culminated in his Passion and Resurrection. As Caviness has shown, the central window of the corona (the round chapel at the east end, behind the Trinity Chapel) was a thirteenth typological window, displaying the Crucifixion, the Resurrection and Ascension, the Descent of the Holy Spirit, and Christ's final appearance in Majesty.[201] Many of the parallels were straightforward, for example the association in the third window of the baptism of Christ with Noah and the Ark and the Crossing of the Red Sea, and of his temptations with the temptation of Adam and Eve. Other allusions were more recherché, demonstrating the resourcefulness, indeed the obsessiveness, with which theologians combed the Old Testament for foreshadowings of the New. In scenes still *in situ* in the second window, for example, the Adoration of the Magi is juxtaposed with the arrival of the Queen of Sheba at the court of King Solomon, and the warning given to the Magi with the sacrifice of Jeroboam. Some of the combinations are not so narrowly typological; they treat aspects of Christ's teaching and events from his life as prefigurations of later history, coupling, for example, the parable of the sower sowing on thorny ground with representations of the emperors Maurice and Julian the Apostate, who was converted but later renounced his Christian faith, and coupling also the scene of the Magi before Herod with Christ leading the Gentiles, which is explained by a verse inscription that associates the star leading the Magi away from Herod and towards Bethlehem with the power of Christianity to free the Gentiles from the grip of Satan. As it happens, these two scenes were also juxtaposed on the Peterborough choir stalls.[202]

The Canterbury glass also set out to chart Christ's lineage, and at considerable length; the original eighty-six ancestors probably constituted the longest series known to the history of art.[203] They were not the bust 'portraits' of Sigena, but large standing or seated figures, two to a window, and some of them were iconographically influenced by the Anglo-Saxon Hexateuch from Canterbury.[204] They led one at clerestory height through choir, eastern transepts, presbytery, and Trinity Chapel, beginning on the north side of the choir with the Creator and Adam, and apparently finishing on the south side with the Virgin and Christ. Forty-three of the figures survive, many of them now set in the west and south windows of the south-west transept. In the corona, Christ's genealogy was treated in a more shorthand manner in a Tree of Jesse window of which two panels remain.

The third aim of the glass was to celebrate saints who had a special connection with the cathedral or city. We know from a seventeenth-century reference that St Augustine, who led the first Roman missionaries to Canterbury, was represented in one window,[205] and there is some evidence that the saints concerned were commemorated in the transept chapels dedicated to St Gregory the Great, St Stephen, and St Martin.[206] Moreover seven scenes survive at triforium level in the north choir aisle from a series of small windows on the lives of two Anglo-Saxon archbishops of Canterbury, St Dunstan and St Aelphege.[207] However, Thomas Becket now, of course, outshone all other saints in the Canterbury firmament, and his cult was to make the city a major goal of pilgrimage throughout the rest of the Middle Ages. We have seen that pains were taken to consecrate the new cathedral on the fiftieth anniversary of his martyrdom, and on that occasion his relics were translated in great state to a rich shrine in the Trinity Chapel, by which time twelve windows at ground level were already glowing with over two hundred

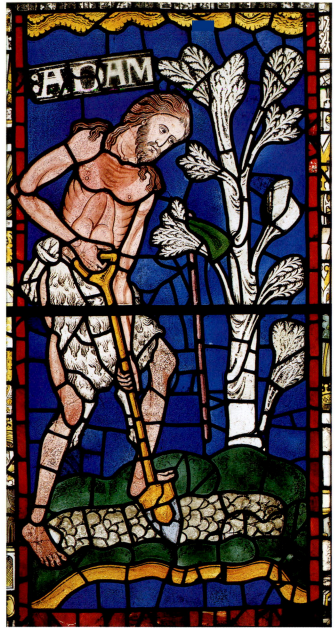

399. Canterbury Cathedral, west window, *Adam*, from the cycle of ancestors of Christ. *c.* 1175–80

400. Canterbury Cathedral, south-west transept, *Methuselah*, from the cycle of ancestors of Christ. *c.* 1175–80

scenes from his life and miracles.[208] Nearly a hundred of the miracle scenes remain today, and it has been shown that they were based on accounts of the miracles at his tomb compiled by two monks of Christ Church.[209]

Naturally enough, the forty-five years that it took to complete the glazing programme saw considerable stylistic developments, and the last windows, for the Trinity Chapel, are far removed from those of the early period between 1175 and 1180[210] when the monks were without a choir. Their unhappy eviction from the old choir was compared by their chronicler, Gervase, to the expulsion of Adam from Paradise,[211] and interestingly enough, one of the most impressive glass paintings to survive from this period shows the banished Adam digging the soil [399]. It is by the dominant master of the time, known in recognition of his fine portrayal of the patriarch [400] as the Methuselah Master.

Six of the ancestors that survive from the choir are his: monumental without being massive, they were designed to command attention from clerestory height, from where they radiate inner repose. One or two of their iconographies recall Anglo-Saxon art: both the Enoch being raised to heaven and the Noah in conversation with God are reminiscent of the corresponding scenes in Canterbury's Anglo-Saxon Hexateuch.[212] On the north side of the choir the Methuselah Master contributed to the typological windows, painting scenes from Christ's infancy. His figures here are much reduced in scale, though they retain clarity of definition and give further evidence of the mastery with which he could handle groups: the destruction of Sodom[213] is an object lesson in balanced composition in which the fine sculptural figure of Lot's wife is both a dramatic focus and also serves to separate her fleeing family from the burning city.

401. Canterbury Cathedral, north choir aisle, *The Miraculous Draught of Fishes*, from the cycle of typological scenes. *c.* 1180–90

The artists who followed in the Methuselah Master's wake moved away from the imposing grandeur of his style. In the years leading up to the commencement of the monks' exile in 1207, they glazed the eastern transepts, the presbytery, the corona, and part of the Trinity Chapel. There were quite a few painters concerned, practising various styles.[214] The continuator of the genealogical programme designed a long series of ancestors originally in the eastern transepts and presbytery, reducing the monumentality of the earlier work by placing architectural canopies over his figures' heads. The painter of some of the surviving panels of the typological windows on the other hand had a positive flair for narrative painting and a meticulous sense of detail: the netted fish in the scene of the miraculous draught are rendered with extraordinary fastidiousness [401]. The lucidity of design and admirable feeling for swinging rhythms of another painter of

typological scenes can be judged from the medallion of the sower on stony ground from his six panels of the parable of the sower. Aspects of his style, and even some specific motifs,[215] recall features of the Paris Psalter, the copy of the Eadwine and Utrecht Psalters that was discussed in the last chapter [343]. The same artist participated in the scenes from the lives of St Dunstan and St Aelphege (of which the two best preserved show the Vikings laying siege to Canterbury and taking the captured Aelphege on board ship). He is also credited with some of the surviving figures in the north oculus (the rose window in the north wall of the eastern transept), which shows Moses and the Synagogue surrounded by four virtues and the four major prophets [402]. The corresponding window on the south side may have had a complementary scene of Christ, Ecclesia, and the four evangelists. The fourth artist, who painted the prophets of the north oculus, went on

to work on the Tree of Jesse in the corona, which may be dated to the 1190s or to the opening years of the new century (as may the corona's typological Redemption window). Two panels of Josiah and the Virgin survive from the Jesse glass. They are in the traditions of Saint-Denis, Chartres, and York, and the majestic, impassive figures hold out their arms to grasp the branches which frame them like a mandorla.

By this time, the Becket scenes of the Trinity Chapel ambulatory were under way, though all that remains of the series on his life is a medallion now in the Fogg Museum. The miracle scenes that survive are dominated by the work of the Petronella Master, so called because two of his best compositions concern the cure of an epileptic nun named Petronella of Polesworth. He made one complete window for the Trinity Chapel, part of another, and two of the clerestory ancestors. His figures are pliant and lissom, his medallions have tendril backgrounds, and he is attentive to such ornamental effects as the marbling of Becket's tomb. In fact, his decorative sense and his close detailing are almost those of a miniature painter.

Caviness thinks the Petronella Master may have been French,[216] and indeed during the final period of glazing from 1213 to 1220, when the monks were back from their exile in

Saint-Omer, no doubt imbued to some extent with French tastes and French visual ideas, the associations with France become quite noticeable: in fact, a specific relationship can be charted between the stained glass of the cathedrals of Canterbury and of Sens.[217] Links were of course forged at the very beginning of the new building operations, for it was an architect from Sens, William, who planned the new choir and supervised its construction until 1178.[218] Then, during the period of exile, some of the Canterbury glass-painters apparently participated in the work on four of the ambulatory windows of the choir at Sens, of which one was devoted to Becket's life and martyrdom. They incorporate ornamental motifs used earlier at Canterbury, which also probably provided the iconographic inspiration both for the Becket window and for the window of the Good Samaritan, a parable originally also illustrated in the ninth typological window at Christ Church. But Sens was a giver as well as a receiver, and compositional formulae and motifs developed there reappear in the Trinity Chapel windows made after the monks' return to Canterbury. Indeed, the artist credited with the majority of the late windows at Canterbury is believed to have worked at Sens, and his sympathies with France are obvious. He is known as the Fitz-Eisulf Master from his painting of the effects of a plague in the house of a knight named Jordan Fitz-Eisulf. His easy, unconstrained style is apparent in the scene showing the funeral cortège of Jordan's son's nurse [403], and his talent for realistic detail is evident

402. Canterbury Cathedral, north oculus, *The prophet Ezekiel. c.* 1180–90

403. Canterbury Cathedral, Trinity Chapel, *Funeral cortège*, from the Becket cycle. 1213/20

in the painting of a physician holding to the light the urine sample of a leper, the better to examine it.[219] His flair for dramatic narration emerges in the panels that tell the story of the mad Matilda of Cologne,[220] whose frenzies subsided before the tomb of the martyr into a submissive calm. But despite his French associations, the Fitz-Eisulf Master was not completely out of touch with Canterbury art of the pre-exile period. He had originally helped in the work on the corona Redemption window,[221] and his figure style suggests that he may have been taught by the master of the parable of the sower.[222]

In general, the differences between the pre-exile and post-exile styles at Canterbury are obvious, and between the earliest and the latest glass they are quite fundamental. Whereas the Methuselah Master had followed the Romanesque pursuit of eternal verities, painting figures that were measured, remote, and authoritative, the art of the thirteenth century is warmer and altogether more gentle, with figures belonging to our own familiar world and not to some spiritual epic of the distant past. This is of course partly because, unlike the Methuselah Master, who was picturing the far-off world of the Old Testament, the later artists were painting events that had taken place at Canterbury within living memory, for Becket's miracles after all had been performed after his death. But there is more to it than this, for when Romanesque artists painted contemporary events or persons, they did so in a Romanesque style – compare the Bayeux Tapestry [10–12], for example, or the 'portraits' of contemporaries such as Desiderius of Montecassino [154] and Eadwine of Canterbury [359]. In fact the primary reason for the change of style was a shift in artistic sensibility. A major change of taste had swept over the West during the forty-five years of work on the glazing and had taken Canterbury along with it, so that the abstractions of Romanesque in its stained glass gave way accordingly to the intimacies of Gothic. In England, France, and Germany – in fact over most of the West – painting was in a state of transition to be briefly surveyed in our final chapter.

Transitional

To say it once more, Romanesque is an art of the abstract, regarding the accidental appearances of everyday life as ephemeral and inconsequential compared to the enduring reality of the spirit. In the fervent rejection of this world in favour of the ultimate and abiding, its aesthetic is fundamentally religious, and even monastic: it is indeed no accident that the history of the pictorial arts traced in this volume coincides for the most part with the great monastic era of the Western Church. Renewed by St Benedict of Aniane in the early ninth century and reinvigorated by movements of reform from Cluny, Gorze, Cîteaux, La Grande Chartreuse, and Glastonbury in the tenth and eleventh, Benedictinism was a major influence on Europe until around 1150. This was a period which saw the emergence of monk-teachers and monk-philosophers of the calibre of Hugh of Saint-Victor and Otto of Freising, it was a time when many of the great art patrons were either abbots or bishops with monastic sympathies, it was an era when the majority of manuscript painters were themselves monks. The monasteries were then the cultural strongholds of the West, imposing their own tastes on it.

But from 1150 onwards events were tolling the passing of this long age. 1151 marked the death of Suger, the abbot of Saint-Denis whose political influence gave him the title of father of the French monarchy. In 1153 died St Bernard, the abbot of Clairvaux whose ecclesiastical authority was an inspiration for the Second Crusade and whose spiritual authority gave him the right to be called the last of the Church Fathers. The great Cistercian was survived for only three years by Peter the Venerable, the last outstanding abbot of the powerful house of Cluny, and within a few more years the 'Bernard of the North', the saintly and gentle Ailred of Rievaulx, joined the departed. The years were witnessing the demise of great monks and of a whole age; the Benedictine centuries were beginning to draw to a close, and the future lay with the universities and the friars. Though monasteries continued to patronize art, the ascendancy in Western taste was moving away from the cloisters.

As if uneasily conscious of this momentous change, the art of Europe is occasionally touched in the later twelfth century by a sudden if ephemeral flamboyance. In northern France, the illustrations of the Bible of Saint-André-au-Bois,[1] near Saint-Omer [201], have a wild eccentricity of line which gives to the figures an impression of wilful irresponsibility. In Germany – especially in Swabia – a dramatic element perhaps deriving from Ottonian or Byzantine sources becomes quite histrionic. Having entered into manuscripts from Salzburg and touched the paintings of the last English copy in the tradition of the Utrecht Psalter, after the turn of the century it infuses the passionately turbulent paintings of Weingarten.[2]

The Romanesque idiom was by no means dead – indeed, it continued to pervade German styles in the early part of the thirteenth century – but it had already passed its creative zenith by the last decades of the twelfth. In the more progressive areas – particularly in France and England – the general trend is already clear. There, as the West begins to feel the ground swell of Gothic, a gradual relaxing of Romanesque intensity and power is perceptible. Indeed, one of the excitements of art at the end of our period is to watch the confrontation of the two aesthetics, which can at times lead to confusion but at others to exhilaration.

In central France, this encounter is evident in the Souvigny Bible,[3] one of the most important of the twelfth century [226]. Its figure style is still Romanesque, but the tension is being relaxed: the artists are beginning to be interested in the human form in its own right instead of taking it as a departure point for abstractions. In northern France, the splendid illustrations of the third Life of St Amand,[4] completed at Saint-Amand between 1169 and 1171 [404], are particularly instructive in this respect; in comparison with the pictures

404. Saint-Amand: *Illustration from the third Life of St Amand*, MS. 500, folio 51. *c.* 1169–71. Valenciennes, Bibliothèque Municipale

405. Anchin: *Tree of Jesse*, from Hrabanus Maurus's *De laudibus sanctae crucis*, MS. 340, folio 11. Late twelfth century. Douai, Bibliothèque Municipale

of the second life[5] [197], a manuscript of the mid century that represents the Romanesque development at its peak, the decisiveness is clearly beginning to melt. The draperies are no longer rendered in tight, abstract shapes and rhythms but fall more loosely. The figures are more suave and less inflexible. The faces exchange spiritual intensity for the more human expressions of puzzlement or surprise. One is aware of flesh and warmth. The Romanesque ethos is still at work, but the approach is much more human and less conceptual. In the illumination of a Hrabanus Maurus[6] from Anchin, perhaps of the 1160s or 1170s, a similar slackening of the Romanesque tenseness is evident, and the Tree of Jesse of another Hrabanus manuscript[7] from the same house [405] begins to exhibit an increasing interest in ornate detail for its own sake. The figures are becoming more decorative, and the inconsequential is introduced for decorative effect, as in the patterned strips of background panelling behind the prophets to left and right of the Tree. This almost deliberate breaking up of Romanesque intensity by the application of contrived decoration appears again in the last volume of the Capuchin Bible,[8] where the scrolls held by the figures run like playful streamers across the initials. In England, as elsewhere, a new delicacy and daintiness enter, for example, into the Beatus initial of the Westminster Psalter.[9] The power and impact of Romanesque are giving way to something more human and more forbearing; painting is losing its spiritual mission and becoming more indulgent – in a word, it is pointing to the Gothic future.

In the transitional period of the final decades of the twelfth century and the early years of the thirteenth, the traditional aesthetic of Romanesque encounters the nascent Gothic. During this time of conflicting tidal flows, artists, like anchored vessels, are drawn in differing directions: some still ride on the Romanesque tide, though it is almost spent; others veer away from it to anticipate the incoming Gothic. There is confrontation but not yet resolution, and it is this that makes the closing years of our period a time of complexity and turmoil.

Abbreviations

AA. SS.
Acta Sanctorum, ed. J. Bollandus *et al.* (Antwerp, 1643 etc.)

Alexander
J. J. G. Alexander, *Insular Manuscripts Sixth to the Ninth Century* (*A Survey of Manuscripts Illuminated in the British Isles*, ed. J. J. G. Alexander, I) (London, 1978)

Cahn
Walter Cahn, *Romanesque Bible Illumination* (Cornell, 1982)

D. and T.
Paul Deschamps and Marc Thibout, *La Peinture murale en France: Le haut moyen âge et l'époque romane* (Paris, 1951)

Demus (1970)
Otto Demus, *Romanesque Mural Painting* (London, 1970)

Dodwell (1954)
C. R. Dodwell, *The Canterbury School of Illumination* (Cambridge, 1954)

Dodwell (1982)
C. R. Dodwell, *Anglo-Saxon Art: A New Perspective* (Manchester, 1982)

E.R.A.
English Romanesque Art 1066–1200, catalogue of an exhibition held at the Hayward Gallery, London, April–July 1984, ed. George Zarnecki, Janet Holt, and Tristram Holland

Grodecki (1976)
Louis Grodecki, *Les Vitraux de Saint-Denis: Étude sur le vitrail au XII^e siècle*, 1 (*Corpus Vitrearum Medii Aevi, France, Studies*, 1) (Paris, 1976)

Grodecki (1977)
Louis Grodecki, *Le Vitrail roman* (Paris, 1977)

Kauffmann
C. M. Kauffmann, *Romanesque Manuscripts 1066–1190* (*A Survey of Manuscripts Illuminated in the British Isles*, ed. J. J. G. Alexander, III) (London, 1975)

L-B D
Otto Lehmann-Brockhaus, *Schriftquellen zur Kunstgeschichte des 11. und 12. Jahrhunderts für Deutschland, Lothringen und Italien*, 2 vols. (Berlin, 1938)

L-B E
Otto Lehmann-Brockhaus, *Lateinische Schriftquellen zur Kunst in England, Wales und Schottland vom Jahre 901 bis zum Jahre 1307*. 5 vols. (Munich, 1955–60)

MSS. à P.
Les Manuscrits à peintures en France du VII^e au XII^e siècle, catalogue of an exhibition held at the Bibliothèque Nationale, ed. Jean Porcher, 2nd ed. (Paris, 1954)

Mon. Germ. Hist. Poet. Lat.
Monumenta Germaniae Historica, Poetae Latini Aevi Carolini, ed. E. Duemmler *et al.* (Berlin, 1881 etc.)

Mon. Germ. Hist. SS.
Monumenta Germaniae Historica, Scriptores in folio, ed. G. H. Pertz *et al.* (Hannover, 1826 etc.)

Mortet
Victor Mortet, *Recueil de textes relatifs à l'histoire de l'architecture et à la condition des architectes en France au moyen âge*. 2 vols. (Paris, 1911–29)

Ornamenta Ecclesiae
Ornamenta Ecclesiae: Kunst und Künstler der Romanik, catalogue of an exhibition held at the Schnütgen-Museum, Cologne, ed. Anton Legner. 3 vols. (Cologne, 1985)

Pat. Lat.
Patrologiae Cursus Completus, Series Latina, ed. J. P. Migne (Paris, 1844 etc.)

Schlosser (1892)
Julius von Schlosser, *Schriftquellen zur Geschichte der karolingischen Kunst* (Vienna, 1892)

Schlosser (1896)
Julius von Schlosser, *Quellenbuch zur Kunstgeschichte des abendländischen Mittelalters* (Vienna, 1896)

Suger ed. Panofsky
Abbot Suger on the Abbey Church of St Denis and Its Treasures, ed. Erwin Panofsky (Princeton, 1946); 2nd ed., with the same pagination of Suger's text, by Gerda Panofsky-Soergel (Princeton, 1979)

Temple
E. Temple, *Anglo-Saxon Manuscripts 900–1066* (*A Survey of Manuscripts Illuminated in the British Isles*, ed. J. J. G. Alexander, II) (London, 1976)

Theophilus ed. Dodwell
Theophilus De Diversis Artibus, ed. C. R. Dodwell (London, 1961), reissued with same pagination under new title, *Theophilus: The Various Arts* (Oxford, 1986)

Wormald
Francis Wormald, *English Drawings of the Tenth and Eleventh Centuries* (London, 1952)

Notes

CHAPTER 1

For Muslim art, a companion volume in *The Pelican History of Art* should be consulted: Richard Ettinghausen and Oleg Grabar, *The Art and Architecture of Islam: 650–1250* (London, 1987).

1. Vivien Noakes, *Edward Lear* (London, 1968), p. 93.
2. Dodwell (1982), p. 150.
3. Guillaume de Poitiers, *Histoire de Guillaume le Conquérant*, ed. Raymonde Foreville (Paris, 1952), pp. 224 and 256.
4. Suger ed. Panofsky, p. 64.
5. Lines 123–5.
6. Lines 97–8.
7. Snorri Sturluson, *Heimskringla*, part 2, translated and edited by Samuel Laing and Peter Foote (London, 1961), pp. 284–5.
8. *Constantini Porphyrogeniti Imperatoris De Cerimoniis Aulae Byzantinae Libri Duo*, ed. J. J. Reiske, I (Bonn, 1829), pp. 570 ff. I am grateful to Dr Robin Cormack for drawing this source to my attention.
9. See H. Schnitzler, 'Das Kuppelmosaik der Aachener Pfalzkapelle', *Aachener Kunstblätter*, XXIX (1964), pp. 17–44.
10. See Peter Bloch, 'Das Apsismosaik von Germigny-des-Prés – Karl der Grosse und der alte Bund', *Karolingische Kunst*, ed. Wolfgang Braunfels and Hermann Schnitzler (Düsseldorf, 1965), pp. 234–61. See also A. Grabar, 'Les Mosaïques de Germigny-des-Prés', *Cahiers Archéologiques*, VII (1954), pp. 171–83.
11. Walter Oakeshott, *The Mosaics of Rome* (London, 1967), pp. 200–1.
12. *Ibid.*, p. 202 (with illustrations).
13. Guglielmo Matthiae, *Mosaici medioevali delle chiese di Roma* (Rome, 1967), pp. 229 and 269 note 8.
14. Oakeshott, *op. cit.*, pp. 204 ff.; Matthiae, *op. cit.*, pp. 233–4.
15. Oakeshott, *op. cit.*, pp. 212–13; Matthiae, *op. cit.*, p. 234.
16. It is thought that Pascal's mother may have been a Greek. See, on the Zeno chapel, B. Brenk, 'Zum Bildprogramm der Zenokapelle in Rom', *Archivo Español de Arqueología*, XLV–XLVII (1972–4), pp. 213–21.
17. Oakeshott, *op. cit.*, pp. 203–4; Matthiae, *op. cit.*, pp. 235 ff.
18. Matthiae, *op. cit.*, pp. 131 f.
19. Oakeshott, *op. cit.*, p. 196.
20. Cf. *op. cit.*, pp. 254–5, 265, 267.
21. Theophilus ed. Dodwell, p. 46.
22. Mortet, I, p. 39.
23. L-B D, 222.
24. *Ornamenta Ecclesiae*, II, p. 234.
25. Suger ed. Panofsky, p. 46.
26. Ernst Kitzinger, *The Mosaics of Monreale* (Palermo, 1960), p. 49.
27. Otto Demus, *The Mosaics of Norman Sicily* (London, 1950), pp. 446–8.
28. Otto Demus, *The Mosaics of San Marco in Venice*, 4 vols. (Chicago, 1984), I, p. 139.
29. *Ibid.*, p. 293.
30. See R. W. Scheller, *A Survey of Medieval Model Books* (Haarlem, 1963), pp. 73–7, and O. Homburger, 'Das Freiburger Einzelblatt – Der Rest eines Musterbuches der Stauferzeit?', *Studien zur Kunst des Oberrheins: Festschrift für Werner Noack* (Constance, 1959), pp. 16 ff.
31. Demus, *op. cit.* (Note 27), p. 445.
32. On a single sheet folded and bound as a bi-folium – Vat. lat. 1976. See D. J. A. Ross, 'A Late Twelfth-century Artist's Pattern-sheet', *Journal of the Warburg and Courtauld Institutes*, XXV (1962), pp. 119–28.
33. Einsiedeln, Stiftsbibliothek MS. 112.
34. H. R. Hahnloser, *Villard de Honnecourt* (Vienna, 1935).
35. *Liber Pontificalis*, ed. L. Duchesne, II (Paris, 1892), p. 147.
36. L-B D, 2865.
37. L-B D, 2724.
38. Schlosser (1892), no. 217.
39. L-B D, 2684.
40. L-B D, 2723.
41. L-B E, 6015.
42. L-B D, 2687.
43. Ernst Kitzinger, 'The Byzantine Contribution to Western Art in the Twelfth and Thirteenth Centuries', *The Art of Byzantium and the Medieval West: Selected Studies by Ernst Kitzinger*, ed. W. Eugene Kleinbauer (Bloomington and London, 1976), p. 365.
44. L-B D, 2096.
45. L-B D, 2853.
46. Dodwell (1982), p. 154.
47. Quoted by T. S. R. Boase, *English Art 1100–1216* (Oxford, 1953), p. 97.
48. Kitzinger, *op. cit.*, p. 366.
49. L-B D, 2857.
50. L-B D, 2866.
51. See É. Bertaux, *L'Art dans l'Italie méridionale* (Paris, 1903), pp. 403–7, and Thomas J. Preston, *The Bronze Doors of the Abbey of Monte Cassino and of St Paul's Rome* (Princeton, 1915).
52. See *Liber Pontificalis*, ed. L. Duchesne, 3 vols. (Paris, 1884–1957).
53. *Ibid.*, II, cap. 98 and 100 (pp. 1–34 and 52–63).
54. It is recorded in *S. Geraldi comitis . . . vita* in *Pat. Lat.*, CXXXIII, col. 658. See also F. L. Ganshof, 'Note sur un passage de la vie de Saint Géraud d'Aurillac', *Mélanges offerts à M. Nicolas Iorga* (Paris, 1933), pp. 295–307.
55. *Aelfrici abbatis Colloquia*, p. 88, in *Early Scholastic Colloquies*, ed. W. H. Stevenson (Oxford, 1929).
56. Dodwell (1982), p. 152.

CHAPTER 2

1. Helen Waddell, *Mediaeval Latin Lyrics* (London, 1943), p. 145.
2. Although, as the reader will know, *tapestry* has a technical meaning, I use the word here to mean any kind of decorative hanging; medieval writers themselves often referred to embroidered hangings as 'tapestries'.
3. F. J. E. Raby, *A History of Secular Latin Poetry in the Middle Ages*, 2 vols. (Oxford, 1934), I, p. 273.
4. *Le Roman de Tristan* by Thomas, ed. J. Bédier (Paris, 1902), I, p. 89.
5. Ed. Paul Meyer (Paris, 1884), p. 61.
6. Schlosser (1892), no. 120.
7. L-B D, 2317.
8. Dodwell (1982), p. 132.
9. C. H. Talbot, *The Life of Christina of Markyate* (Oxford, 1959), p. 43.
10. Dodwell (1982), pp. 141–2.
11. *Ibid.*, p. 132.
12. Talbot, *op. cit.*, p. 53.
13. L-B D, 1806.
14. Dodwell (1982), p. 134 ff.
15. *Ibid.*, pp. 136–7.
16. See Sofie Krafft, *Pictorial Weavings from the Viking Age. Drawings and Patterns of Textiles from the Oseberg Finds* (Oslo, 1956).
17. See A. Andersson, *The Art of Scandinavia*, II (London, 1970), pp. 392–3.
18. The bibliography for the Bayeux Tapestry is now quite extensive, but the most worthwhile general book remains *The Bayeux Tapestry*, ed. Frank Stenton (London, 1957). A more recent book with admirable plates is *The Bayeux Tapestry* by David M. Wilson (London, 1985).
19. See below, pp. 100–102.
20. Vivian B. Mann, 'Architectural Conventions on the Bayeux Tapestry', *Marsyas*, XVII (1974–5), pp. 59–65.
21. Stenton, *op. cit.* See the contribution by Francis Wormald, p. 32 and figures 14–17.
22. Drögereit argues for close affinities between the Tapestry and the account by William of Poitiers, with associations also with William of Jumièges and Guy of Amiens, plus a small Anglo-Saxon ingredient: see R. Drögereit, 'Bemerkungen zum Bayeux-Teppich', *Mitteilungen des Instituts für Österreichische Geschichtsforschung*, LXX (1962), pp. 257–93. (His dating of the Tapestry should not be taken seriously.) Brooks and Walker (see Note 28) argue for an association with the accounts of Poitiers and Jumièges, though they are not entirely sure that the designer actually knew the writings of the Normans (p. 5). They also see (pp. 12–13) some connections with the *Vita Aedwardi* which was probably written by a Flemish monk of Saint-Omer (see Frank Barlow's edition, pp. xli ff.) initially to honour Queen Edith.
23. C. R. Dodwell, 'The Bayeux Tapestry and the French Secular Epic', *Burlington Magazine*, CVIII (1966), pp. 549–60.
24. L. Herrmann published his analysis of all the fables in the border in his *Les Fables antiques de la broderie de Bayeux* (Bruxelles-Berchem, 1964), and most of his interpretations are convincing. Apart from those we mention in the text, the fables that he numbers XXII–XXIV, XXVIII, XXX, and XXXIII are to do with treachery. They are the fables of the poor man and the snake, of the two cocks and the hawk, of the sheep, the dog and the wolf, of the fowler, of the sick lion and the fox, and of the donkey and the wolf.
25. Cf. Wilson, *op. cit.*, p. 203.
26. Michael Alexander's translation, *The Earliest English Poems* (Berkeley and Los Angeles, 1970), p. 180.
27. As we shall also see later in the text, despite the oath scene, the whole ethos of the Tapestry is quite neutral in religious terms. Harold is the only character seen going to church, and the intense religious overtones of the Norman chronicles are absent: such incidents as the parading of relics in Normandy to persuade God to give a good wind to the invasion fleet, the bringing out of the relics related to the alleged oath before battle, and the saying of Mass by the Normans, are simply omitted, as is the chroniclers' unctuous harping on William's piety. In the poem, on the other hand, Byrhtnoth refers to God before the battle and, when he is fatally struck down, he thanks God for his full life and prays for his soul's deliverance from Hell. Again, whereas success in the Tapestry is basically read in material terms as the conquest of a country, in the poem it is read in terms of a strength of character that rises above defeat. Yet again, whereas the Tapestry indicates what is soon to pass, the poem makes clear that this foreknowledge is not available.

28. N. P. Brooks and H. E. Walker, 'The Authority and Interpretation of the Bayeux Tapestry', *Proceedings of the Battle Conference on Anglo-Norman Studies*, I (1978), p. 8.

29. W. Urry, *Canterbury under the Angevin Kings* (London, 1967), p. 51.

30. Wilson (*op. cit.*, p. 212) attempts to move it to Winchester for no compelling reason.

31. *Les Œuvres poétiques de Baudri de Bourgueil*, ed. Phyllis Abrahams (Paris, 1926), pp. 202–11.

32. J. Guiffrey, 'Inventaire des tapisseries du roi Charles VI vendues par les Anglais en 1422', *Bibliothèque de l'École des Chartes*, XLVIII (1887), p. 93 (no. 170) and note 7. I owe this reference to the kindness of Dr Selby Whittingham.

33. *Giraldi Cambrensis Opera*, vol. 8, ed. George F. Warner, Rolls Series (London, 1891), pp. 322–3, and L-B E, 5553.

34. L-B D, 3058.

35. Mortet, I, p. 82.

36. *Ibid.*, pp. 139–40.

37. L-B D, 2643.

38. Mortet, I, p. 319.

39. É. B D, 2697.

40. É. Bertaux, *L'Art dans l'Italie méridionale* (Paris, 1903), p. 70.

41. L-B D, 2820.

42. Mortet, I, p. 94.

43. *Ibid.*, p. 22.

44. L-B D, 2714.

45. *Ibid.*, 2606.

46. *Ibid.*, 2603.

47. *Ibid.*, 2627.

48. *Ibid.*

49. *Ibid.*, 2605.

50. *Ibid.*

51. *Ibid.*

52. *Ibid.*, 2597: '... Udalscalcus pannum Gerardusque ministrat/Cum Beretha frater pictoris acusque laborem.'

53. A necessary reservation in sources where *fecit* often means *fecit fieri*.

54. L-B D, 2595.

55. Cf. *ibid.*, 2575–2602.

56. *Ibid.*, 2575.

57. In the first, above long explanatory verses, a personification of the Old Testament declared that 'The letter kills', and of the Synagogue that 'The Lord has abandoned me'. The second presented saints and personifications with appropriate inscriptions, such as Virginity declaring 'I am the flower of the field', and the New Testament, holding a sceptre, commenting that 'The Spirit quickens'.

58. Besides the Cross itself it was embroidered with figures, among them Christ ('I will draw all things unto myself'; cf. John XII, 32), Faith ('Without faith it is impossible to please God'; cf. Hebrews XI, 6), and Hope declaring that we are all saved by hope (cf. Romans VIII, 24).

59. Another Lenten hanging began with a panel devoted to the Virgin, and continued with six more bearing persons or personifications each with a comment or a moral statement: 'Things that are true achieve a crown but things that are false are exalted only for an hour' was characterized by the figures of John the Baptist, Truth, and two angels.

60. L-B D, 2600.

61. One of Henry's hangings pictured the parables of the servants keeping watch and of the divine Bridegroom, besides saints and personifications of Innocence, the Soul, the Sabbath, Confession, etc., all with their own inscriptions. There were twelve lines of explicatory verse as well. Another associated the parable of the workers in the vineyard (Matthew XX, 1–16) with the ages of mankind. This connection – which had an earlier parallel in Mosan painting in the initial I to Genesis in the Stavelot Bible (British Library MSS. Add. 28106–7; see W. Dynes, *The Illuminations of the Stavelot Bible* (New York and London, 1978), pp. 94 ff., and cf. below, p. 405) – derives from the Commentary on Matthew by Origen, the influential third-century Alexandrian theologian, who saw the first hour in the vineyard as representing the age from Adam to Noah, the third age from Noah to Abraham, the sixth the age from Abraham to Moses, the ninth the age from Moses to the calling of the Nations, and the eleventh the ensuing age to the end of the world. This hanging, too, bore personifications – Predestination, Endurance, Justice, and so on – with appended comments and verses. Another tapestry allegorized the Church, Priesthood, and Kingship, and represented St Peter issuing the famous papal statement about the two swords, spiritual and temporal, with Old Testament figures and comments embroidered below. A line of verse down the side recorded that Henry gave this work to the saints in their praise (L-B D, 2602).

62. See P. de Palol, 'Une Broderie catalane d'époque romane ...', *Cahiers archéologiques*, VIII (1956), pp. 175–214, and IX (1957), pp. 219–51.

63. *Ibid.*, VIII, p. 203.

64. *Ibid.*, pp. 194 ff.

65. Betty Kurth, *Die deutschen Bildteppiche des Mittelalters* (Vienna, 1926), I,

66. *Ibid.*, pp. 43–4.

67. London, Lambeth Palace Library MS. 3 folio 6. For this manuscript, see below, p. 347.

68. Kurth, *op. cit.*, pp. 46–7.

69. In the Dombibliothek, Cologne; see below, p. 416.

70. As Kurth points out, *op. cit.*, p. 52 (Paris, Bibliothèque Nationale MS. lat. 1 folio 329 verso, and Rome, San Paolo Bible folio 259 verso). The Grandval Bible (London, British Library MS. Add. 10546, folio 352 verso) uses the same scheme, but has standing rather than seated figures at the four corners of the page.

71. Kurth, *op. cit.*, p. 52.

72. Julius Lessing, *Wandteppiche und Decken des Mittelalters in Deutschland* (Berlin, no date), p. 5.

73. *Ibid.*, p. 6.

74. For an analysis, see Kurth, *op. cit.*, pp. 58–60.

75. Lessing, *op. cit.*, p. 7.

76. Quoted *ibid.*, p. 5, and by Kurth, *op. cit.*, p. 53.

77. C. S. Lewis, *The Allegory of Love* (Oxford, 1969), p. 79.

78. *Iohannis Scotti annotationes in Marcianum*, ed. Cora E. Lutz (Cambridge, Mass., 1939), p. 3.

79. *Mon. Germ. Hist. SS.*, II, p. 123, quoted by G. Nuchelmans, 'Philologia et son mariage avec Mercure jusqu'à la fin du XIIᵉ siècle', *Latomus*, XVI (1957), p. 98.

80. Ruth Grönwoldt, 'Kaisergewänder und Paramente', *Die Zeit der Staufer*, Band I, Württembergisches Landesmuseum Stuttgart, Katalog der Ausstellung Stuttgart 1977 (Stuttgart, 1977), p. 643.

81. It is found, for example, in the earliest known recension of the tale of *Ami et Amile*, written in Latin verse between 1090 and 1100 by Radulfus Tortarius, a monk of Fleury. Its best known occurrence is in various versions of the *Tristan* legend (cf. that of Eilhart von Oberge, lines 4586 ff.), where its appearance has mystified editors. See the article by Bernard Heller, 'L'Épée symbole et gardienne de chasteté', *Romania*, XXXVI (1907), pp. 36–49.

82. See below, p. 201.

83. Book II, viii. This is a seventeenth-century translation used by H. F. Stewart in *Boethius The Theological Tractates* [and] *The Consolation of Philosophy*, ed. H. F. Stewart and E. K. Rand (London and New York, 1918), p. 223.

84. I owe this comment on dress to Dr Jennifer Harris.

85. Grönwoldt, *op. cit.*, cat. no. 797, and Renate Kroos, *Niedersächsische Bildstickereien des Mittelalters* (Berlin, 1970), pp. 26–8, 113–14.

86. Kroos, *op. cit.*, pp. 28–9.

87. Hermann Schnitzler, *Rheinische Schatzkammer*, II: *Die Romanik* (Düsseldorf, 1959), p. 42, and *Rhein und Maas: Kunst und Kultur 800–1400* (catalogue, Schnütgen Museum, Cologne, 1972), I, p. 167.

88. In the catalogue of the *Rhein und Maas* exhibition, *op. cit.*, Note 87.

89. Grönwoldt, *op. cit.*, cat. no. 796.

90. Schnitzler, *op. cit.*

91. Grönwoldt, *op. cit.*, cat. nos. 802, 803.

92. *Ibid.*, p. 637.

93. See below, p. 439.

94. Mortet, I, p. 82.

95. L-B D, 2710.

96. Dodwell (1982), p. 227.

97. L-B D, 2611.

98. L-B D, 2610.

99. M. Schuette and S. Müller-Christensen, *The Art of Embroidery* (London, 1964), pp. xvii, 302, figures 81–4.

100. *Ibid.*, pp. xvii, 302, figures 78–80.

101. Dodwell (1982), pp. 57–8.

102. *Ibid.*, p. 185.

103. L-B E, 3923.

104. The following information about it I take from the catalogue of the exhibition on *Opus Anglicanum: English Medieval Embroidery* held in the Victoria and Albert Museum in 1963 – no. 13.

105. Grönwoldt, *op. cit.*, cat. no. 793.

106. See Wilhelm Mrazek in Peter von Baldass *et al.*, *Romanische Kunst in Österreich* (Vienna, 1962), pp. 106 f.

107. Éva Kovács, 'Casula Sancti Stephani Regis', *Acta Historiae Artium*, V (1958), pp. 181–221.

108. *Ibid.*, pp. 195–6.

109. Dodwell (1982), p. 181.

110. Schlosser (1896), p. 182.

111. Dodwell (1982), p. 182.

112. L-B D, 2643.

113. See above, p. 24.

114. Dodwell (1982), p. 57.

115. *Ibid.*, p. 182.

116. L-B D, 2843.

117. Schlosser (1892), no. 618.

118. *Ibid.*, no. 528.

119. L-B D, 2652.

120. For these vestments, see the contributions by Plenderleith, Hohler, and Freyhan to *The Relics of Saint Cuthbert*, ed. C. F. Battiscombe (Oxford, 1956), pp. 375–432.

121. *Ibid.*, pp. 409–32 (by Freyhan), and especially pp. 415–23.

122. *Ibid.*, p. 422.

123. See above, p. 9.

124. Dodwell (1982), p. 152.

125. *Ibid.*, p. 183.

126. *Ibid.*, p. 182.

127. By Mildred Budny and Dominic Tweddle, 'The Maaseik Embroideries', *Anglo-Saxon England*, ed. Peter Clemoes *et al.*, XIII (1984), pp. 65–96; Mildred Budny, 'The Anglo-Saxon Embroideries at Maaseik: Their Historical and Art-Historical Context', *Mededelingen van de Koninklijke Academie voor Wetenschappen, Letteren en Schone Kunsten van België*, XLV (1984), pp. 57–133; and Mildred Budny and Dominic Tweddle, 'The Early Medieval Textiles at Maaseik, Belgium', *Antiquaries Journal*, LXV (1985), pp. 353–89.

128. Budny and Tweddle, *op. cit.* (*Anglo-Saxon England*, XIII), pp. 79 ff.

129. *Ibid.*, p. 86.

130. *Ibid.*, pp. 87–8.

131. L-B D, 2969 b.

132. Dodwell (1982), p. 179.

133. *Ibid.*

134. *Ibid.*, p. 180.

135. *Ibid.*

136. L-B D, 2732.

137. *Ibid.*, 2659.

138. *Ibid.*, 2697.

139. *Mon. Germ. Hist. Poet. Lat.*, II, p. 395.

140. Schlosser (1892), no. 91.

141. Dodwell (1982), p. 179.

142. *Ibid.*

143. L-B E, 6565.

144. Dodwell (1982), pp. 175 and 179.

145. *Ibid.*, p. 179.

146. See for this Sigmund von Pölnitz, *Die Bamberger Kaisermäntel* (Weissenhorn, 1973), pp. 32–8.

147. Éva Kovács, 'Casula Sancti Stephani Regis', *Acta Historiae Artium*, V (1958), p. 193.

148. Von Pölnitz, *op. cit.*, pp. 24–30.

149. *Ibid.*, pp. 20–2.

150. Published in its entirety in *Gallia Christiana*, XVI (Paris, 1865), *Instrumenta*, col. 23, and also available in Mortet, I, p. 87. It was issued by Léger, archbishop of Vienne from 1030 to 1070.

151. This emerges from a close reading of the document – it invokes, for example, the patron saint of the cathedral, St Maurice, and its first five signatories are a provost, a dean, and three archdeacons. Mortet himself is quite clear about this.

152. A. W. Haddan and W. Stubbs, *Councils and Ecclesiastical Documents relating to Great Britain and Ireland* (Oxford, 1871), pp. 368–9.

153. Schlosser (1892), 1080, 1081.

154. *Ibid.*, 1092.

155. L-B E, 6029.

156. *Ibid.* For Christina, see below, pp. 328–32.

157. L-B D, 2997.

158. L-B D, 2999.

159. Schlosser (1892), 1090.

160. Dodwell (1982), p. 70.

161. *Ibid.*

162. Schlosser (1892), 1091.

163. L-B D, 2998.

164. Schlosser (1892), 1089.

165. *Ibid.*, 1088.

166. Dodwell (1982), p. 70.

167. L-B D, 2710.

168. Schlosser (1892), 1090.

169. L-B E, 1542.

170. *Ibid.*

171. L-B E, 6444.

172. L-B D, 2998.

173. L-B D, 2637.

174. L-B E, 6458.

175. Dodwell (1982), p. 72.

176. *Ibid.*, p. 75.

177. *Ibid.*, pp. 45 and 256 note 9.

178. *Ibid.*, pp. 45, 65, 256 note 8, and especially 264 note 148.

179. See 'Hugonis Falcandi in suam historiam de regno Siciliae praefatio . . .' in Muratori's *Rerum Italicarum Scriptores* (Milan, 1725), VII, cols. 256–7; or *Epistola Hugonis Falcandi ad Petrum Panormitanae ecclesiae thesaurarium . . .*, ed. G. B. Siragusa (Rome, 1897), pp. 178–83; or L-B D, 2326.

180. See, for what follows, Grönwoldt, *op. cit.* (Note 80), cat. nos. 781, 785, 775, 776.

181. Dodwell (1982), pp. 70–2.

182. *Domesday Book* (general editor John Morris), VI, *Wiltshire*, ed. C. and F. Thorn (Chichester, 1979), 67/86.

183. Dodwell (1982), p. 327, note 100.

184. *Domesday Book* (as above), IV, *Hampshire*, ed. J. Munby (Chichester, 1982), 2/7.

185. *Ibid.*, 6/16.

186. See *Vita Aedwardi Regis*, ed. Frank Barlow (London, 1962), pp. 124–5, and L-B E, 5196.

187. Pipe Rolls 29 Henry II (p. 161). I am indebted for this information to Appendix I of the Ph.D. thesis submitted to the University of Manchester in 1977 by Dr Jennifer Harris: *The Developments of Romanesque Byzantine Elements in French and English Dress, 1050–1180*.

188. *Ibid.*, 12 Henry II (p. 130).

189. Dodwell (1982), p. 70.

CHAPTER 3

1. The case for Theodulf's authorship of the *Libri Carolini* is persuasively argued by Ann Freeman, 'Theodulf of Orleans and the *Libri Carolini*', *Speculum*, XXXII (1957), pp. 663–705, and by Paul J. Meyvaert, 'The Authorship of the *Libri Carolini*: Observations prompted by a recent book', *Revue Bénédictine*, LXXXIX (1979), pp. 29–57. The earlier view proposed by Bastgen (see next Note, and articles of his in *Neues Archiv der Gesellschaft für ältere deutsche Geschichtskunde*, XXXVI (1911), pp. 631–66, and XXXVII (1912), pp. 15–51 and 455–533) favoured Alcuin as the author.

2. Ed. Hubertus Bastgen, *Mon. Germ. Hist. Legum Sectio III Concilia Tomi II Supplementum*.

3. Cf. Bastgen, *op. cit.* (1912), p. 459.

4. *Ibid.*, pp. 20–1.

5. *Ibid.*, pp. 473–4.

6. Preface.

7. I, 2 (p. 14).

8. Cf. I, 19 (p. 44): '[imagines] quas quilibet pictor condit mundanae tantum artis experientia perdocente'; II, 27 (p. 88); 'hae pingantur a pictore humanae artis eruditione'.

9. III, 16 (p. 138).

10. III, 23 (p. 150).

11. Dodwell (1982), pp. 90–1.

12. Epistle 13 in *Pat. Lat.*, LXXVII, col. 1128.

13. Schlosser (1896), pp. 23–5.

14. *Pat. Lat.*, CVI, cols. 310–11.

15. *Pat. Lat.*, CIV, col. 218.

16. Otto Pächt, C. R. Dodwell, and Francis Wormald, *The St Albans Psalter* (London, 1960), pp. 137–8.

17. For a discussion of this, see Otto Demus, *The Mosaics of San Marco in Venice* (Chicago, 1984), I, pp. 56–7.

18. L-B E, 5074.

19. This is Coulton's translation of part of St Bernard's famous letter to William, abbot of Saint-Thierry. See G. G. Coulton, *Life in the Middle Ages* (Cambridge, 1967), IV, pp. 169–74. There are useful comments on the saint's letter in Meyer Schapiro, 'On the Aesthetic Attitude in Romanesque Art', *idem*, *Romanesque Art* (London, 1977), pp. 6–10. The statement by James R. Johnson (see 'The Tree of Jesse Window of Chartres: *Laudes Regiae*', *Speculum*, XXXVI (1961), pp. 15–16) that St Bernard did allow for the portrayal of saints in the preface to his *Life of St Malachy* (*Pat. Lat.*, CLXXXII, col. 1073) is not justified by Bernard's Latin and results from the use of an English translation in which the phrase 'illustres Sanctorum describere vitas', referring to the description of saints' lives *in writing*, is rendered 'to *portray* the illustrious lives of saints'.

20. Mortet, I, p. 166.

21. Bartholomaeus Anglicus, *Liber de proprietatibus Rerum*, lib. VII, cap. IIII (Argentine 1505 edition, i verso).

22. *Chronicon Gaufredi coenobitae . . .*, in P. Labbe, *Nova Bibliotheca Manuscriptorum*, II (Paris, 1657), p. 328.

23. L-B D, 3061.

24. L-B E, 5874.

25. L-B E, 5841.

26. Quoted by H. Oidtmann, *Die Rheinischen Glasmalereien vom 12 bis zum 16 Jahrhundert*, I (Düsseldorf, 1912), p. 30.

27. *Dialogi de miraculis sancti Benedicti auctore Desiderio abbate Casinensi*, ed. G. Schwartz and A. Hofmeister, liber II, c. 6, p. 1130 in *Mon. Germ. Hist. SS.*, XXX (Pars II).

28. *Chronica monasterii Casinensis*, liber IV, c. 129, in *Mon. Germ. Hist. SS.*, VII, p. 843.

29. *Pauli Bernriedensis de rebus gestis Gregorii septimi pontif. maximi liber singularis*, cc. XXX–XXXI, in *Rerum Italicarum Scriptores*, ed. L. A. Muratori, vol. III (Milan, 1723), col. 322.

30. *Vita S. Anskarii* (in *Acta Sanctorum*, Feb. (1), col. 409) as excerpted by Schlosser (1892), no. 950.

31. *Giraldi Cambrensis Expugnatio Hibernica*, lib. 2, cap. 30, in *Giraldi Cambrensis Opera*, V, ed. James F. Dimock, Rolls Series (London, 1867), pp. 369–71.

32. *Libellus de vita et miraculis S. Godrici heremitae de Finchale, auct. Reginaldo monacho Dunelmensi*, ed. J. Stevenson, Surtees Society, XX (London, 1847), p. 447; L-B E, 5562.

33. *Ibid.*, p. 335; L-B E, 1726.

34. Translation by Michael Alexander, *The Earliest English Poems* (London, 1966), p. 106.

35. Private communication to the author, which continues, 'But I have never been able to find a true match.'

36. See p. 232 of his *De Basilica et Patriarchio Lateranensi* as quoted by Eugène Müntz in 'The Lost Mosaics of Rome, IV to IX Century (1)', *American Journal of Archaeology*, 11 (1886), p. 306.

37. See Walter Oakeshott, *The Mosaics of Rome* (London, 1967), pp. 70 and 72.

38. Peter Clemoes, 'Cynewulf's Image of the Ascension', *England before the Conquest: Studies in primary sources presented to Dorothy Whitelock*, ed. Peter Clemoes and Kathleen Hughes (Cambridge, 1971), p. 304.

39. *Ibid.*, p. 300.

40. Edited with an introduction by M. R. James, *Archaeologia*, XCIV (1951), pp. 141–66.

41. L-B E, 2228.

42. In my edition of Theophilus, I translated *pallia* as brocades, but I now think that silks is a more accurate rendering.

43. Theophilus ed. Dodwell, pp. 62–3.

44. L-B E, 5859.

45. E.g. L-B D, 2830, L-B E, 3483 and 4758.

46. Mortet, I, p. 147.

47. L-B E, 1541.

48. L-B D, 2552.

49. One is reminded of the way that a quatrefoil motif is incorporated into the top surface of the portable altar of Stavelot of *c.* 1160.

50. L-B D, 2604.

51. *Ibid.*, 2613.

52. L-B E, 6446.

53. *Ibid.*, 5866.

54. *Ibid.*, 5940.

55. See below, p. 88.

56. See, for example, L-B D, 2540, L-B E, 1392 and 3878.

57. Schlosser (1892), 899.

58. *Les Œuvres poétiques de Baudri de Bourgueil*, ed. Phyllis Abrahams (Paris, 1926), p. 15.

59. Dodwell (1982), p. 34.

60. L-B E, 1390.

61. L-B D, 1676.

62. *Ibid.*, 2608.

63. The *Casus Petrishusensis monasterii* (lib. I, cap. 22) tell us that Bishop Gebehard I of Constance received lapis lazuli as a gift from the patriarch of Grado (described in the text as *Venetiorum episcopus*) and used it in the decoration of the monastic church of Petershausen, founded in 983.

64. Schlosser (1896), p. 234.

65. *Willelmi Malmesbiriensis monachi de gestis regum Anglorum libri quinque*, ed. W. Stubbs, Rolls Series (London, 1889), II, pp. 384–5. Also L-B E, 6694.

66. See the quotation on p. 35 above.

67. Schlosser (1896), p. 93.

68. *Ibid.*, p. 40.

69. *Ibid.*, p. 235.

70. Dodwell (1982), pp. 92–3.

71. *Ibid.*, p. 93.

72. L-B D, 2271.

73. Suger ed. Panofsky, p. 23.

74. L-B D, 1270.

75. *Pauli Historia Langobardorum*, IV, 21–2, in *Mon. Germ. Hist. Scriptores Rerum Langobardorum ...*, p. 124.

76. 'The queen also constructed a palace for herself in this place [at Monza], and therein she had paintings executed that portrayed some aspects of the history of the Lombards. These paintings clearly display the way in which the Lombards of that time cut their hair, and the manner and style of their dress. They did in fact shave the back of the neck bare up as far as the skull, while letting the hair hang down the face to the cheek, dividing it with a parting on the forehead. As for their clothes, they were loose and for the most part made of linen, such as the Anglo-Saxons are in the habit of wearing, being adorned with fairly broad borders woven in a variety of colours. Their shoes were open almost up to the end of the toe, and were kept on with criss-cross thongs. Later, they began to wear trousers, over which they would put woollen leggings when they were riding. This custom, however, they took from the Romans.'

77. L-B E, 5874.

78. L-B E, 5497.

79. Lines 2592–4.

80. Lines 5564–76.

81. *Op. cit.* (Note 58), pp. 212 ff.

82. Marie de France, *Lais*, ed. A. Ewert (Oxford, 1944), p. 9, lines 233–45.

83. See Otto Demus, *The Mosaics of Norman Sicily* (London, 1950), pp. 178 ff.

84. See Demus (1970), p. 312 and plate 99.

85. See Dodwell's edition (with translation), pp. 1–16.

86. *Memorials of St Edmund's Abbey*, II, ed. Thomas Arnold, Rolls Series (London, 1892), p. 292; L-B E, 541.

87. *Mon. Germ. Hist. Poet. Lat.*, I, p. 115.

88. Suger ed. Panofsky, p. 72.

89. *Mon. Germ. Hist. Poet. Lat.*, IV, 2, p. 1108.

90. Quoted by R. E. Swartwout, *The Monastic Craftsman* (Cambridge, 1932), p. 36.

91. L-B E, 5230.

92. *De Bestiis et aliis rebus* (*Pat. Lat.*, CLXXVII, col. 46).

93. Pierre Riché, *Daily Life in the World of Charlemagne* (Liverpool, 1978), p. 40.

94. Dom David Knowles, *The Monastic Order in England* (Cambridge, 1949), p. 425.

95. Suger ed. Panofsky, pp. 42 and 72. Both sets of craftsmen were brought in from different regions, which would hardly be likely if they were monks. The stained-glass workers are specifically referred to as *magistri* (p. 72) which, at this time, would very strongly suggest that they were secular.

96. See below, pp. 519–21.

97. See below, pp. 579–80.

98. L-B D, 1602.

99. *Ibid.* (note 1).

100. L-B D, 3029.

101. Dodwell (1982), pp. 65–6.

102. L-B E, 2143.

103. Mortet, I, pp. 279–80.

104. *Ibid.*, p. 26.

105. *Ibid.*, pp. 307–8. Saint-Ruf had originated in 1038 in a desire of four canons of Avignon Cathedral to live under a stricter discipline. At first, the relations between the seculars of Avignon and the regulars of Saint-Ruf were very cordial, but they later deteriorated. The date of this dispute is uncertain. Mortet assigns it to the late eleventh or early twelfth century, Paul Achard to a period before 1088 ('Notes sur quelques anciens artistes d'Avignon', *Archives de l'Art Français*, VII (1856), pp. 177–92), but both suggestions are conjectural.

106. Ed. Edmond-René Labande (Paris, 1981), pp. 264–6.

107. Mortet, I, p. 93.

108. F. J. E. Raby, *A History of Secular Latin Poetry in the Middle Ages*, 2 vols. (Oxford, 1934), II, pp. 26–30.

109. Dodwell (1982), pp. 92–3.

110. They were Roger (nos. 27 and 379), William (no. 120), Henry (no. 133), and Richard (no. 382). See *Winchester in the Early Middle Ages*, ed. Martin Biddle (Oxford, 1976), pp. 72 and 97, 80, 81 and 97.

111. *Ibid.*, p. 516.

112. They were Alberic, Fulco, William, Osmund, and Jacob. See William Urry, *Canterbury under the Angevin Kings* (London, 1967), pp. 222, 282, 323, and 426.

113. H. M. Colvin *et al.*, *The History of the King's Works*, I (London, 1963), p. 87 note 1.

114. *Ibid.*

115. We may also ask ourselves what was the function of Herlewin 'who painted the doors and windows of the King's house of Windsor' under Henry II (*ibid.*).

116. Printed in Mortet, I, pp. 264–5.

117. His name was Bertold, and we have already met him; see L-B D, 1602. The chronicler does not specifically refer to stained glass (nor would we expect him to), but it seems more than likely when we read that Bertold provided noble paintings for the church and then illuminated it with very beautiful windows and adorned it.

118. *Gesta Abbatum Monasterii S. Albani*, ed. H. T. Riley, 3 vols., Rolls Series (London, 1867–9), I, p. 63.

119. Mortet, I, p. 289.

120. Suger ed. Panofsky, p. 76.

121. Dodwell (1982), p. 78.

122. L-B D, 3017.

123. L-B E, 5180, 5203, 5244.

124. L-B D, 3019.

125. He brought back books and silks as well. See Dodwell (1982), pp. 84 ff., 129, 151.

126. See K. Weitzmann, 'Icon Painting in the Crusader Kingdom', *Dumbarton Oaks Papers*, XX (1966), pp. 52–3, plate 1.

127. Theophilus ed. Dodwell, p. 4.

128. See below, pp. 276–7.

129. See below, pp. 372–3.

130. See below, p. 261.

131. See below, p. 261.

132. L-B D, 1774.

133. Louis Grodecki, 'A Stained Glass *Atelier* of the Thirteenth Century: a study of windows in the cathedrals of Bourges, Chartres and Poitiers', *Journal of the Warburg and Courtauld Institutes*, XI (1948), pp. 87–111.

134. Schlosser (1892), no. 870.

135. *Ekkehardi IV Casus S. Galli*, cap. 3, in *Mon. Germ. Hist. SS.*, II, p. 97.

136. Quoted by Paul Deschamps and Marc Thibout, *La Peinture murale en France* (Paris, 1951), p. 21.

137. *Vita Balderici ep. Leodensis*, *Mon. Germ. Hist. SS.*, IV, p. 730.

138. *Ibid.*, p. 729.

139. Suger ed. Panofsky, p. 42 and p. 72.

140. Schlosser (1892), no. 1122.

141. L-B D, 3033.

142. Paul Rolland, *La Peinture murale à Tournai* (Brussels, 1946), pp. 12, 35.

143. Mortet, II, no. LXXX.

144. L. Bourgain, *La Chaire française au 12ᵉ siècle* (Paris, 1879), p. 278.

145. Theophilus ed. Dodwell, p. 20.

146. L-B E, 1967.

147. See *Les Trésors des églises de France*, catalogue of an exhibition in the Musée des Arts Décoratifs (Paris, 1965), no. 336, with bibliography, and plates 100–1.

148. Schlosser (1892), no. 539.

149. L-B D, 2965.

150. L-B D, 2728.

151. Munich, Bayerische Staatsbibliothek Clm. 13031 folio 1.

152. *The Ecclesiastical History of Orderic Vitalis*, ed. Marjorie Chibnall, II (Oxford, 1969), p. 51.

153. L-B D, 3002.

154. *Ibid.*, 3004.

155. Dodwell (1982), pp. 53–5.

156. See below, p. 247.

157. Frankfurt am Main, Stadt- und Universitätsbibliothek MS. Barth. 42 folio 110 verso. See *Ornamenta Ecclesiae*, I, pp. 244–5.

158. Bremen, Stadtbibliothek MS. b.21, Book of Pericopes of Henry III, folio 124 verso.

159. See below, p. 313.

160. Vienna, Österreichische Nationalbibliothek MS. 507.

161. See below, p. 313.

162. See below, pp. 180–1.

163. Carl Nordenfalk, 'A Travelling Milanese Artist in France at the Beginning of the Eleventh Century', *Arte del primo millennio: Atti del IIº Convegno per lo studio dell'arte dell'alto Medio Evo* (Turin, 1953), pp. 374–80.

164. See below, p. 352.

165. The Simon Master; see Rodney M. Thomson, *Manuscripts from St Albans Abbey 1066–1235*, 2 vols. (Woodbridge, 1982), I, p. 56.

166. See below, pp. 114–17.

167. Quoted by R. E. Swartwout, *op. cit.* (Note 90), p. 36.

168. See Jean Porcher, *French Miniatures from Illuminated Manuscripts* (London, 1960), p. 30.

169. See below, p. 372.

170. See below, p. 386.

171. The evidence is, in fact, not particularly convincing; see Swartwout, *op. cit.*, pp. 34–6, and J. M. Clark, *The Abbey of St Gall* (Cambridge, 1926), pp. 160–4.

172. See below, p. 205.

173. Dodwell (1982), pp. 53–5.

174. See, for England, J. J. G. Alexander, 'Scribes as Artists ... in Twelfth-Century English Manuscripts', *Medieval Scribes, Manuscripts and Libraries. Essays presented to N. R. Ker*, ed. M. B. Parkes and A. G. Watson (London, 1978), pp. 87–116, and, more generally, A. Legner, 'Illustres Manus', *Ornamenta Ecclesiae*, I, pp. 187–230.

175. Dodwell (1982), p. 53.

176. *Ibid.*, p. 55.

177. L-B D, 567.

178. *Thangmari Vita S. Bernwardi Episcopi*, p. 758, in *Mon. Germ. Hist. SS.*, IV.

179. C. R. Dodwell, 'The Meaning of *Sculptor* in the Romanesque Period', *Romanesque and Gothic Essays for George Zarnecki*, 2 vols. (Bury St Edmunds, 1987), I, p. 57.

180. *Ibid.*

181. L-B D, 3011.

182. Dodwell, *op. cit.* (Note 179), p. 57.

183. *Ibid.*

184. L-B D, 3014.

185. Dodwell, *op. cit.*, p. 57. The fact that the verb used of him on two occasions (L-B E, 495 and 501) is '*insculpere*' (my italics) makes it clear that attention was being drawn to his work as an engraver.

186. *Ibid.*, p. 60.

187. *Ibid.*, pp. 60–1.

188. An Albericus is named as *aurifaber* in Rental B (nos. 23, 25, 26) and as *pictor* in Rental A (8); see William Urry, *op. cit.* (Note 112), pp. 227–8 and 222.

189. *Willelmi Malmesbiriensis monachi gesta pontificum Anglorum*, ed. N. E. S. A. Hamilton, Rolls Series (London, 1870), pp. 103 and 96.

190. See especially the Anglo-Saxon herbal in the British Library (MS. Cotton Vitellius C.III) which is discussed below (p. 179). It is said to be copied from a Mediterranean manuscript, but the model, whatever it was, must have been very accurate indeed in terms of its illustrations.

191. L-B D, 2632.

192. *Sermones inediti b. Aelredi abbatis Rievallensis*, ed. C. H. Talbot (Rome, 1952), pp. 107–8.

CHAPTER 4

1. *Bibliotheca Rerum Germanicarum*, ed. P. Jaffé, IV, *Monumenta Carolina* (Berlin, 1867), p. 507.

2. For Merovingian illumination, see E. Heinrich Zimmermann, *Vorkarolingische Miniaturen*, 4 vols. (Berlin, 1916).

3. See Schlosser (1892), and Franz Friedrich Leitschuh, *Geschichte der karolingischen Malerei* (Berlin, 1894).

4. See, for example, *Capitulare Aquense* of about 807 in *Pat. Lat.*, XCVII, col. 310.

5. Schlosser (1896), introduction, pp. ix ff., points out that the *titulus* is, in fact, a literary form deriving from the epigram and going back to the late Antique period.

6. Schlosser (1892), no. 924.

7. *Ibid.*, no. 925.

8. *Ibid.*, no. 936.

9. *Ibid.*, no. 931.

10. *Ibid.*, no. 974.

11. *Ibid.*, no. 1023.

12. *Ibid.*, no. 1007.

13. See Roger Hinks, *Carolingian Art* (London, 1935), pp. 101–2.

14. Edward S. King, 'The Carolingian Frescoes of the Abbey of Saint Germain d'Auxerre', *Art Bulletin*, XI (1929), pp. 359–75.

15. *Ibid.*, p. 375.

16. J. Zemp and R. Durrer, 'Das Kloster St Johann zu Münster in Graubünden', *Mitt. der Schweiz. Ges. für Erhaltung hist. Kunstdenkmäler*, N.F. V–VII (1906–11); L. Birchler, 'Zur karolingischen Architektur und Malerei in Münster-Müstair', *Akten zum III. Internationalen Kongress für Frühmittelalterforschung* (Lausanne, 1954), pp. 167 ff.; G. de Francovich, 'Il Ciclo pittorico della chiesa di S. Giovanni a Münster (Müstair) nei Grigioni', *Arte Lombarda*, II (1956), pp. 28 ff.; *idem*, 'Problemi della pittura e della scultura preromanica', *Centro italiano di Studi sull'Alto Medioevo, Spoleto*, II (1955), pp. 435 ff.

17. De Francovich, *op. cit.* (1955), pp. 452 ff.; J. Garber, 'Die karolingische St Benediktkirche in Mals', *Zeitschrift des Ferdinandeums*, LIX (1915) pp. 3–61; E. W. Anthony, *Romanesque Frescoes* (Princeton, 1951), pp. 122–4.

18. André Grabar and Carl Nordenfalk, *Early Medieval Painting* (Lausanne, 1957), p. 58.

19. Anthony, *op. cit.*, pp. 117 f.

20. Friedrich Behn, *Die karolingische Klosterkirche von Lorsch an der Bergstrasse* (Berlin and Leipzig, 1934); Anthony, *op. cit.*, pp. 119 f.

21. H. Eichler, 'Peintures murales carolingiennes à Saint-Maximin de Trèves', *Cahiers archéologiques*, VI (1952), pp. 83 ff.; Grabar and Nordenfalk, *op. cit.*, pp. 73 ff.

22. *Mon. Germ. Hist. Epistolarum*, IV: *Epistolae Karolini Aevi*, II, ed. Duemmler (Berlin, 1895), p. 141.

23. F. J. E. Raby, *A History of Secular Latin Poetry in the Middle Ages*, I (Oxford, 1934), p. 201.

24. *Ibid.*, p. 203.

25. *Mon. Germ. Hist. Poet. Lat.*, I, pp. 493 ff. The reference to the bowl is on pp. 498–9.

26. See above, p. 32.

27. III, 23 (ed. Bastgen, *Mon. Germ. Hist. Legum Sectio III Concilia Tomi II Supplementum*, pp. 150 ff.).

28. Utrecht University Library MS. 32; see below, pp. 64–6.

29. A. M. Amelli, *Miniature sacre e profane dell'anno 1023* (Montecassino, 1896); F. Saxl, 'Illustrated Encyclopaedias', *Lectures* (London, 1957), I, pp. 234 ff., and II, plates 155–65, 167, 173; Erwin Panofsky, 'Hercules Agricola: A Further Complication in the Problem of the Illustrated Hrabanus Manuscripts', *Essays in the History of Art presented to Rudolf Wittkower*, ed. Douglas Fraser and others (London, 1967), II, pp. 20 ff. See also below, p. 169.

30. Rome, Vatican Library MS. Vat. lat. 3868; Leslie Webber Jones and C. R. Morey, *The Miniatures of the Manuscripts of Terence* (Princeton, 1931), pp. 27 ff. and relevant plates, and also Wilhelm Koehler and Florentine Mütherich, *Die karolingischen Miniaturen*, IV, *Die Hofschule Kaiser Lothars* (Berlin, 1971), pp. 74–7.

31. H. Stern, *Le Calendrier de 354*, Institut français d'archéologie de Beyrouth, Bibliothèque archéologique et historique, LV (Paris, 1953).

32. British Library MS. Harley 647; Saxl, *op. cit.*, I, pp. 101 ff., and II, plates 54, 57–60, and Koehler and Mütherich, *op. cit.*, pp. 77–9, 101–7.

33. Leiden University Library Cod. Voss. lat. Q.79; G. Thiele, *Antike Himmelsbilder* (Berlin, 1898), pp. 76 ff.

34. Cf. Heinrich Fichtenau, *The Carolingian Empire* (Oxford, 1957), pp. 47 ff.

35. Ed. K. A. Eckhardt (Weimar, 1953), pp. 82 ff.

36. E. Kantorowicz, *Laudes Regiae* (Berkeley, 1946), pp. 56 f.

37. *Ibid.*

38. Fichtenau, *op. cit.*, pp. 71–2; and see H. Lilienfein, *Die Anschauungen von Staat und Kirche im Reich der Karolinger*, Heidelberger Abhandlungen zur mittleren und neueren Geschichte, I (1902), pp. 28 ff.

39. See below, pp. 71–4.

40. See Otfrid in the preface *Ad Ludovicum* of his vernacular version of the Gospels, and the comments of D. H. Green in *The Millstätter Exodus* (Cambridge, 1966), p. 204. And see, more generally, F. J. E. Raby, *A History of Christian-Latin Poetry from the Beginnings to the Close of the Middle Ages* (Oxford, 1953), for example, p. 155.

41. Peter Bloch, 'Das Apsismosaik von Germigny-des-Prés: Karl der Grosse und der alte Bund', *Karolingische Kunst*, ed. Wolfgang Braunfels and Hermann Schnitzler, vol. III of *Karl der Grosse*, ed. Braunfels (Düsseldorf, 1965), p. 259.

42. *Ibid.*, p. 260, with bibliography.

43. See below, pp. 60, 67, 71–4.

44. Schlosser (1892), no. 390.

45. Peter Bloch, *op. cit.*, pp. 234–61; André Grabar, 'Les Mosaïques de Germigny-des-Prés', *Cahiers Archéologiques*, VII (1954), pp. 171–83.

46. I, 20 (ed. Bastgen, *op. cit.* (Note 27), pp. 46–8).

47. Paul J. Meyvaert, 'The Authorship of the *Libri Carolini*: Observations prompted by a recent book', *Revue Bénédictine*, LXXXIX (1979), p. 56. The link between mosaic and text was first established by Ann Freeman, 'Theodulf of Orleans and the *Libri Carolini*', *Speculum*, XXXII (1957), pp. 699–701.

48. I, 15 (ed. Bastgen, p. 35): 'Arca namque foederis secundum quosdam Dominum et Salvatorem nostrum, in quo solo foedus pacis apud Patrem habemus, designat.'

49. Bloch, *op. cit.*, pp. 256, 261.

50. See Wilhelm Koehler, *Die karolingischen Miniaturen*, II, *Die Hofschule Karls des Grossen*, 2 vols. (Berlin, 1958); Florentine Mütherich, 'Die Buchmalerei am Hofe Karls des Grossen', *Karolingische Kunst*, *op. cit.* (Note 41), pp. 9–53.

51. See K. Menzel, P. Corssen, H. Janitschek, A. Schnütgen, F. Hettner, and K. Lamprecht, *Die Trierer Ada-Handschrift* (Leipzig, 1889); Albert Boeckler, 'Die Evangelistenbilder der Adagruppe', *Münchner Jahrbuch der bildenden Kunst*, 3. Folge, III/IV (1952–3), pp. 121–44; *idem*, 'Formgeschichtliche Studien zur Adagruppe', *Bayerische Akademie der Wissenschaften Phil.-Hist. Klasse, Abhandlungen*, Neue Folge, Heft XLII (Munich, 1956).

52. Koehler, *op. cit.* (Note 50), p. 34.

53. Apart from those listed in the text, there is the Dagulf Psalter made between 784 and 795 for presentation to Pope Hadrian I and now Vienna, Nationalbibliothek cod. 1861 (see *Karl der Grosse*, the catalogue of the 1965 Aachen exhibition, Aachen, 1965, no. 413, with bibliography); and the Abbeville Gospels, now Abbeville, Bibliothèque Municipale MS. 4 (1) (see *ibid.*, no. 414, with bibliography). It has been suggested that an incomplete Gospel Book at Munich (Universitätsbibliothek cod. 29) may be from this school – see Mütherich, *op. cit.*, pp. 25 f. For the fragment of a Gospel Lectionary which is stuck on folio 132 verso of British Library MS. Cotton Claudius B.V, see Wilhelm Koehler, 'An Illustrated Evangelistary of the Ada School and its Model', *Journal of the Warburg and Courtauld Institutes*, XV (1952), pp. 48–66.

54. Paris, Bibliothèque Nationale MS. nouv. acq. lat. 1203.

55. Paris, Bibliothèque de l'Arsenal MS. 599. See *Karl der Grosse*, *op. cit.* (Note 53), no. 412, with bibliography.

56. Stadtbibliothek cod. 22; *Karl der Grosse*, no. 416, with bibliography.

57. British Library MS. Harley 2788.

58. Paris, Bibliothèque Nationale MS. lat. 8850; *Karl der Grosse*, no. 417, with bibliography.

59. Alba Julia, Biblioteca Batthyáneum.

60. Vatican Library, cod. Pal. lat. 50; *Karl der Grosse*, no. 418, with bibliography. See also the facsimile *Lorsch Gospels* with introduction by Wolfgang Braunfels (New York, 1967).

61. Mütherich, *op. cit.* (Note 50), pp. 15 ff.

62. *Ibid.*, p. 15, and Zimmermann, *op. cit.* (Note 2), Taf. 288.

63. Mütherich, *op. cit.*, p. 25; Boeckler, *op. cit.* (Note 51, 1952–3), p. 126.

64. Robert M. Walker, 'Illustrations to the Priscillian Prologues in the Gospel Manuscripts of the Carolingian Ada School', *Art Bulletin*, XXX (1948), pp. 1–10.

65. Paris, Bibliothèque Nationale MS. nouv. acq. lat. 1203.

66. See Paul A. Underwood, 'The Fountain of Life in Manuscripts of the Gospels', *Dumbarton Oaks Papers*, V (1950), pp. 43–138.

67. *Ibid.*, p. 46. It appears once in the Godescalc Lectionary (Paris, Bibliothèque Nationale MS. nouv. acq. lat. 1203) and twice in the Soissons Gospels (Paris, Bibliothèque Nationale MS. lat. 8850). It is also found in the Gospels of St Emmeram (Munich, Staatsbibliothek Clm. 14000), which belongs to the Court School of Charles the Bald and copies from the lastnamed manuscript.

68. Koehler, *Hofschule*, pp. 9, 22–8, and plates 1–12; Mütherich, *op. cit.*, pp. 31 ff.

69. Elizabeth Rosenbaum, 'The Evangelist Portraits of the Ada School and their Models', *Art Bulletin*, XXXVIII (1956), pp. 82 ff.

70. Koehler, *op. cit.*, pp. 49–55, plates 33–41; Mütherich, *op. cit.*, pp. 34 f.

71. Rosenbaum, *op. cit.*, pp. 85–6.

72. *Ibid.*

73. Koehler, *op. cit.*, pp. 34–41, plates 20–30 and 94–8; Mütherich, *op. cit.*, p. 36.

74. See Boeckler, *op. cit.* (1952–3) (Note 51).

75. Koehler, *op. cit.*, pp. 56–69, plates 42–66; Mütherich, *op. cit.*, p. 35.

76. Koehler, *op. cit.*, pp. 70–82, plates 67–93; Mütherich, *op. cit.*, pp. 35 f.

77. Koehler, *op. cit.*, pp. 88–100, plates 99–116; Mütherich, *op. cit.*, p. 36.

78. See Wilhelm Koehler, *Die karolingischen Miniaturen*, III, *Die Gruppe des Wiener Krönungs-Evangeliars*, 2 vols. (Berlin, 1960); Mütherich, *op. cit.*, pp. 45 ff.

79. Vienna, Weltliche Schatzkammer der Hofburg.

80. In the treasury of Aachen Cathedral.

81. Biblioteca Civica Queriniana cod. E.II.9.

82. Bibliothèque Royale cod. 18723.

83. Madrid, Biblioteca Nacional cod. 3307.

84. Koehler, *op. cit.*, pp. 25 ff.; Mütherich, *op. cit.*, p. 47.

85. H. Swarzenski, 'The Xanten Purple Leaf and the Carolingian Renaissance', *Art Bulletin*, XXII (1940), pp. 7–24, especially pp. 22–3.

86. Koehler, *op. cit.*, pp. 49 ff.

87. See the second part of Wilhelm Koehler, *op. cit.* (Note 78), which is entitled *Metzer Handschriften* (Berlin, 1960).

88. Paris, Bibliothèque Nationale MS. lat. 9383.

89. Paris, Bibliothèque Nationale MS. lat. 9388.

90. Paris, Bibliothèque Nationale MS. lat. 9428.

91. Koehler and Mütherich, *op. cit.* (Note 30).

92. British Library Add. MS. 37768.

93. Padua, Biblioteca Capitolare MS. D.47.

94. Berlin, Staatsbibliothek theol. fol. 260.

95. Rome, Vatican Library MS. Urb. lat. 3, and Berlin, Staatsbibliothek theol. lat. fol. 3.

96. Wilhelm Koehler and Florentine Mütherich, *Die karolingischen Miniaturen*, V, *Die Hofschule Karls des Kahlen* (Berlin, 1982).

97. *Ibid.*, pp. 70–1.

98. They are listed *ibid.*, pp. 9–10.

99. Munich, Bayerische Staatsbibliothek Clm. 14000.

100. In Munich, Schatzkammer der Residenz.

101. Paris, Bibliothèque Nationale MS. lat. 1152.

102. The Darmstadt Gospels – Hessische Landesbibliothek cod. 746.

103. Koehler and Mütherich, *op. cit.* (Note 96), p. 33.

104. Peter Lasko, *Ars Sacra* (Harmondsworth, 1972), pp. 63–4. As Lasko points out on p. 36, the great Crucifixion panel, now embellishing a Gospel Book from Bamberg, may have originally belonged to this *Codex Aureus*.

105. Paris, Bibliothèque Nationale MS. lat. 1152.

106. Bibliothèque Nationale MS. lat. 323.

107. In Munich, Schatzkammer der Residenz.

108. Koehler and Mütherich, *op. cit.* (Note 96), p. 76.

109. Munich, Bayerische Staatsbibliothek Clm. 14000; see *ibid.*, pp. 12 ff. and 175 ff.

110. See *Notitia Dignitatum*, ed. Otto Seeck (Berlin, 1876).

111. Paris, Bibliothèque Nationale MS. lat. 1141.

112. A. M. Friend, 'Two Manuscripts of the School of St Denis', *Speculum*, I (1926), p. 69.

113. In the Schatzkammer der Residenz, Munich.

114. Koehler and Mütherich, *op. cit.* (Note 96), pp. 75 ff.

115. Paris, Bibliothèque Nationale MS. lat. 1152; *ibid.*, pp. 132 ff.

116. Paris, Bibliothèque de l'Arsenal MS. 1171.

117. Paris, Bibliothèque Nationale MSS. lat. 323 and 324; *ibid.*, pp. 41 ff.

118. Paris, Bibliothèque Nationale MSS. lat. 1152 and 323.

119. Utrecht, University Library MS. 32. See the recent facsimile edition, *Utrecht-Psalter, Codices Selecti*, LXXV (Graz, 1984).

120. See below, p. 66.

121. Folio 17, Psalm 30 (31).

122. Folio 64, Psalm 108 (109).

123. Gertrude R. Benson and Dimitri Tselos, 'New Light on the Origin of the Utrecht Psalter', *Art Bulletin*, XIII (1931), pp. 53–79.

124. Pierre Battifol, 'Librairies byzantines à Rome', *École française de Rome. Mélanges d'archéologie et d'histoire*, VIII (1888), p. 297.

125. G. P. Bognetti, G. Chierici, and A. de Capitani d'Arzago, *S. Maria di Castelseprio* (Milan, 1948); K. Weitzmann, *The Fresco Cycle of S. Maria di Castelseprio* (Princeton, 1951); E. Kitzinger, 'The Hellenistic Heritage in Byzantine Art', *Dumbarton Oaks Papers*, XVII (1963), p. 108.

126. Bibliothèque Municipale MS. 1; Amédée Boinet, *La Miniature carolingienne* (Paris, 1913), plates LXVI–LXIX; Benson and Tselos, *op. cit.*, figures 4–11; Francis Wormald, *The Utrecht Psalter* (Utrecht, 1953), plate 10; A. Goldschmidt, 'Der Utrechtpsalter', *Repertorium für Kunstwissenschaft*, XV (1892), pp. 156 ff.

127. Facsimile ed. C. von Steiger and O. Homburger (Basel, 1964); O. Homburger, *Die illustrierten Handschriften der Burgerbibliothek Bern* (Bern, 1962), pp. 101 ff.

128. Paris, Bibliothèque Nationale MS. lat. 7899.

129. Universitätsbibliothek MS. B.113 folios 5 and 5 verso.

130. Oxford, Bodleian Library MS. Douce 59.

131. Treasury of Saint-Étienne-de-Troyes.

132. Joachim E. Gaehde, 'The Bible of San Paolo fuori le mura in Rome: its date and its relation to Charles the Bald', *Gesta*, V (1966), p. 9.

133. Herbert Schade, 'Studien zu der karolingischen Bilderbibel aus St Paul vor den Mauern in Rom (2. Teil)', *Wallraf-Richartz-Jahrbuch*, XXII (1960), pp. 20–1.

134. Joachim E. Gaehde, 'The Pictorial Sources of the Illustrations to the Books of Kings, Proverbs, Judith and Maccabees in the Carolingian Bible of San Paolo fuori le Mura in Rome', *Frühmittelalterliche Studien*, IX (1975), pp. 387–9.

135. *Ibid.*, pp. 386–9, and *idem*, 'Carolingian Interpretations of an Early Christian Picture Cycle to the Octateuch in the Bible of San Paolo fuori le Mura in Rome', *Frühmittelalterliche Studien*, VIII (1974), pp. 361–2, 379–82.

136. *Idem, op. cit.* (Note 134), p. 372.

137. Herbert Schade, 'Studien zu der karolingischen Bilderbibel aus St Paul vor den Mauern in Rom', *Wallraf-Richartz-Jahrbuch*, XXI (1959), pp. 34–6.

138. Schade, *op. cit.* (Note 137), pp. 20–4.

139. Reims, Bibliothèque Municipale MS. 7; see Boinet, *op. cit.*, plates LXXV–LXXVII; *MSS. à P.*, no. 43, with bibliography.

140. Paris, Bibliothèque Nationale MS. lat. 17968; see Boinet, *op. cit.*, plates LXXIII–LXXIV; *MSS. à P.*, no. 44, with bibliography.

141. Paris, Bibliothèque Nationale MS. lat. 265; see Boinet, *op. cit.*, plates LXXI–LXXII; *MSS. à P.*, no. 45, with bibliography.

142. The Framegaud Gospels, named after its scribe, Paris, Bibliothèque Nationale MS. lat 17969 (see A. Boutemy, *Scriptorium*, II (1948), p. 289, and *MSS. à P.*, no. 50, with bibliography); the Pierpont Morgan Gospels, New York, Pierpont Morgan Library MS. 640 (*MSS. à P.*, no. 47, with bibliography); the Saint-Frambourg de Senlis Gospels, Paris, Bibliothèque Sainte-Geneviève MS. 1190 (*ibid.*, no. 48); and the Morienval Gospels, Noyon Cathedral Treasury (*ibid.*, no. 49).

143. Wilhelm Koehler, *Die karolingischen Miniaturen*, I, *Die Schule von Tours*, 3 vols. (Berlin, 1930–3).

144. Quoted by Heinrich Fichtenau, *The Carolingian Empire* (Oxford, 1957), pp. 94–5.

145. Koehler, *op. cit.*, I (1), pp. 14–28.

146. *Ibid.*, chapter I and p. 434.

147. *Ibid.*, pp. 81–2.

148. St Gallen, Stiftsbibliothek cod. 75.

149. Stuttgart, Württembergische Landesbibliothek cod. HB.II.40.

150. British Library, MS. Add. 11848.

151. Koehler, *op. cit.*, I (2), pp. 239–40.

152. Bamberg, Staatsbibliothek MS. bibl. 1.

153. British Library, MS. Add. 10546.

154. Paris, Bibliothèque Nationale MS. lat. 1.

155. Koehler, *op. cit.*, I (2), pp. 110, 193–212.

156. Alfred A. Schmid, *Die Bibel von Moutier-Grandval*, ed. J. Duft *et al.* (Bern, 1971), p. 185.

157. See Herbert L. Kessler's revision of Koehler's views in his *The Illustrated Bibles from Tours* (Princeton, 1977).

158. Schmid, *op. cit.*, pp. 180–4.

159. Koehler, *op. cit.*, I (2), figure 15b.

160. *Ibid.*, pp. 29–65, for an analysis of their work.

161. Staatsbibliothek theol. lat. fol. 733; *ibid.*, pp. 67–71.

162. Paris, Bibliothèque Nationale MS. lat. 9385; *ibid.*, pp. 86–93.

163. Paris, Bibliothèque Nationale MS. lat. 266; *ibid.*, pp. 71–85, and, on the date of the manuscript, I (1), pp. 69–71.

164. Koehler, *op. cit.*, I (2), pp. 94–108.

165. *Ibid.*, pp. 106–7.

166. Nancy, Cathedral Treasury.

167. Bamberg, Staatsbibliothek MS. bibl. 1.

168. Autun, Bibliothèque Municipale MS. 19 bis.

169. See Charles Niver, *A Study of Certain of the More Important Manuscripts of the Franco-Saxon School* (Harvard University thesis, 1941); A. Boutemy, 'Le Style franco-saxon, style de Saint-Amand', *Scriptorium*, III (1949), pp. 260 ff.

170. Paris, Bibliothèque Nationale MS. lat. 2.

171. Arras, Bibliothèque Municipale MS. 233.

172. Paris, Bibliothèque Nationale MS. lat. 257.

173. Paris, Bibliothèque Nationale MS. lat. 9386; see B. Davezac, 'L'Évangéliaire de Chartres B.N. Lat. 9386. Contribution à l'étude de la peinture monastique carolingienne', *Cahiers archéologiques*, XXVII (1978), pp. 39–60.

174. Cambrai, Bibliothèque Municipale MS. 327.

175. In Gannat, church of Sainte-Croix.

176. Paris, Bibliothèque de l'Arsenal MS. 592.

177. Jean Porcher, 'La Peinture provinciale', *Karolingische Kunst*, ed. W. Braunfels and H. Schnitzler (Düsseldorf, 1965), pp. 59 ff.

178. Amiens, Bibliothèque Municipale MS. 18.

179. Stuttgart, Württembergische Landesbibliothek bibl. fol. 23.

180. For this manuscript, see *Der Stuttgarter Bilderpsalter*, I (facsimile, Stuttgart, 1965) and II (*Untersuchungen*, Stuttgart, 1968).

181. Florentine Mütherich, 'Die Initialen', *ibid.*, pp. 43–9.

182. *Idem*, 'Die Stellung der Bilder in der frühmittelalterlichen Psalterillustration', *ibid.*, pp. 151 ff.

183. This point is made by Carl Nordenfalk in his review article on the Stuttgart edition of the Psalter in *Zeitschrift für Kunstgeschichte*, XXXII (1968), p. 161.

184. Mütherich, *op. cit.* (Note 182), pp. 160 ff.

185. *Ibid.*, pp. 175 ff.

186. Cambridge, Corpus Christi College MS. 286.

187. Mütherich, *op. cit.* (Note 182), p. 165.

188. For objections to this, see *ibid.*, p. 196.

189. 'Historia Abbatum auctore Baeda', in *Venerabilis Baedae Opera Historica*, ed. Carolus Plummer (Oxford, 1896), I, p. 369.

190. Stadtbibliothek MS. 31.

191. Bibliothèque Municipale MS. 386.

192. Bibliothèque Municipale MS. 99.

193. Bibliothèque Nationale MS. nouv. acq. lat. 1132.

194. R. Laufner and P. K. Klein, *Trierer Apokalypse* (Kommentarband) (Graz, 1975), pp. 34–6.

195. *Ibid.*, pp. 68–9.

196. *Ibid.*, p. 37.

197. *Ibid.*, pp. 114–15.

198. *Ibid.*, p. 102.

199. *Ibid.*, pp. 97–9.

200. Franz von Juraschek, *Die Apokalypse von Valenciennes* (Linz, 1954).

201. *Ibid.*, pp. 14 ff.

202. See Alexander, no. 63, for a comment upon this.

203. Von Juraschek, *op. cit.*, pp. 18–22.

204. As stated on folio 39 verso.

205. Munich, Bayerische Staatsbibliothek Clm. 28561.

206. The attribution is by Bernhard Bischoff in a personal communication to Peter Klein; see Laufner and Klein, *op. cit.*, p. 104, note 325.

207. On p. 235 of Bernhard Bischoff's *Karl der Grosse Das Geistige Leben* (Düsseldorf, 1965), being vol. II of *Karl der Grosse*, ed. W. Braunfels.

208. Museum Plantin-Moretus MS. M.17.4; see Alexander, no. 65, for bibliography.

209. W. Koehler, 'Die Denkmäler der karolingischen Kunst in Belgien', *Belgische Kunstdenkmäler*, ed. P. Clemen (Munich, 1923), I, pp. 7 ff., especially p. 10.

210. See Dodwell (1982), p. 96.

211. Valenciennes, Bibliothèque Municipale MS. 412.

212. Bibliothek der Rijksuniversiteit, cod. Burm. Q.3.

213. G. Swarzenski, *Die Salzburger Malerei von den ersten Anfängen bis zur Blütezeit des romanischen Stils*, 2 vols. (Leipzig, 1908–13), II, pp. 1 ff.

214. Vienna, Nationalbibliothek cod. 1224.

215. Bibliothèque de la Faculté de Médecine MS. 409.

216. Kremsmünster, Stiftsbibliothek Clm. 1. See Willibrord Neumüller and Kurt Holter, *Der Codex Millenarius* (Linz, 1959), *passim*; D. H. Wright, 'The Codex Millenarius and its Model', *Münchner Jahrbuch der bildenden Kunst*, 3. Folge, XV (1964), pp. 37–54.

217. Vienna, Nationalbibliothek cod. 387.

218. See Adolf Merton, *Die Buchmalerei in St Gallen*, 2nd ed. (Leipzig, 1923).

219. *Ibid.*, chapter II.

220. St Gallen, Stiftsbibliothek cod. 23; Franz Landsberger, *Der St Galler Folchart-Psalter* (St Gallen, 1912).

221. Merton, *op. cit.*, chapter III.

222. St Gallen, Stiftsbibliothek cod. 22.

223. St Gallen, Stiftsbibliothek cod. 53; Landsberger, *op. cit.*, pp. 32 f.

224. Leiden, Bibliothek der Rijksuniversiteit cod. Perizoni F.17.

225. Bern, Burgerbibliothek cod. 264.

CHAPTER 5

1. *Cogadh Gaedhel re Gallaibh, The War of the Gaedhil with the Gaill . . .*, ed. J. H. Todd, Rolls Series (London, 1867), pp. 138–9.

2. Dublin, Trinity College MS. A.1.6. This famous and controversial manuscript has attracted a large body of writing which is well surveyed in Alexander, no. 52. Two works must, however, feature in any bibliography: E. H. Alton and P. Meyer's *Evangeliorum Quattuor Codex Cenannensis*, 3 vols. (Bern, 1951), and Françoise Henry's *The Book of Kells* (London, 1974).

3. T. J. Brown, 'Northumbria and the Book of Kells', *Anglo-Saxon England*, I (1972), pp. 219–46.

4. F. C. Burkitt, 'Kells, Durrow and Lindisfarne', *Antiquity*, IX (1935), p. 37.

5. A. M. Friend, 'The Canon Tables of the Book of Kells', *Medieval Studies in Memory of A. Kingsley Porter*, ed. W. R. W. Koehler (Cambridge, Mass., 1939), II, pp. 611–41, especially p. 639, and also Henry, *op. cit.*, pp. 150 and 218, and *idem*, *Irish Art during the Viking Invasions* (London, 1967), pp. 69–70.

6. 'The Book of Kells and Iona', *The Art Bulletin*, LXXI (1989), pp. 6–19.

7. Meyvaert tentatively links its production to 'the solemn translation of Columba's relics to a splendid new shrine' around the middle of the eighth century (*op. cit.*, p. 13), and Henry to the second centenary of the death of St Columba in 797 (*op. cit.*, Note 2, p. 221).

8. See Ernst Kitzinger, 'The Coffin-Reliquary', *The Relics of Saint Cuthbert*, ed. C. F. Battiscombe (Oxford, 1956), pp. 202–307, especially pp. 263–4.

9. Henry, *Kells*, pp. 188–9. The manuscript is the St Augustine Gospels, probably then at Canterbury and now Cambridge, Corpus Christi College MS. 286.

10. Henry, *Kells*, p. 190, and *Irish Art . . .*, p. 81.

11. L-B E, 5940. I do not share the view of some scholars that Gerald was describing the Book of Kells. For one thing, he was at Kildare not Kells when he saw the manuscript (he associated it with St Brigid). For another, he himself says (see the quotation in the text) that the manuscript he was looking at had nearly as many illuminations as pages, and no one would suppose that the Book of Kells was as lavishly illuminated as that.

12. *Adamnani Vita S. Columbae*, ed. J. T. Fowler (Oxford, 1920), I, c. 48, and III, c. 23.

13. Helen Waddell, *The Wandering Scholars* (1943), p. 31.

14. Henry, *Irish Art . . .*, pp. 64 ff., and *Kells*, pp. 215–16.

15. British Library Cotton MS. Nero D.IV.

16. Cambridge, University Library MS. Ii.6.32; Alexander, no. 72.

17. Dublin, Trinity College MS. A.4.20; Alexander, no. 75.

18. Leningrad, Public Library Cod. Q.v.XIV.I; Alexander, no. 42.

19. Cambridge, University Library MS. Ll.1.10; Alexander, no. 66.

20. Biblioteca Nazionale Cod. O.IV.20; Alexander, no. 61, and Henry, *Irish Art . . .*, pp. 95–9.

21. Stiftsbibliothek Cod. 51; Alexander, no. 44.

22. Rome, Vatican, Biblioteca Apostolica MS. Barberini Lat. 570.

23. Henry, *Irish Art . . .*, p. 97.

24. See Alexander, nos. 57, 58.

25. Dublin, Trinity College MS. A.4.6; Alexander, no. 59.

26. Dublin, Trinity College MS. A.1.15; Alexander, no. 45, with bibliography.

27. Dublin, Trinity College MS. A.4.23; Alexander, no. 48.

28. Oxford, Bodleian Library MS. Auct. D.2.19; Alexander, no. 54.

29. Dublin, Trinity College MS. 52; see Alexander, no. 53, with bibliography, and Henry, *Irish Art . . .*, pp. 100 f.

30. Henry, *Irish Art . . .*, pp. 100–1.

31. Leiden, Universiteitsbibliotheek MS. B.P.L.67, and St Gallen, Stiftsbibliothek Cod. 904; see Alexander, nos. 63 and 68, and Henry, *Irish Art . . .*,

pp. 101–2.

32. London, Lambeth Palace Library MS. 1370; see Alexander, no. 70, and Henry, *Irish Art . . .*, pp. 102–5.

33. British Library Cotton MS. Vitellius F.XI, and Cambridge, St John's College MS. C.9; see Alexander, nos. 73 and 74, and Henry, *Irish Art . . .*, pp. 105 ff.

34. Durham, Cathedral Library MS. B.II.30; see Alexander, no. 17.

35. British Library Harley MS. 1023; see Alexander, no. 76, and F. Henry, *Irish Art in the Romanesque Period* (London, 1970), p. 63.

36. British Library Harley MS. 1802; see Alexander, no. 77, and Henry, *op. cit.* (Note 35), pp. 64–6.

37. Killiney, Library of the Franciscan House of Celtic Studies MS. A.2; Henry, *op. cit.* (Note 35), pp. 56–60.

38. British Library Add. MS. 36929; *ibid.*, pp. 72–3, and Alexander, no. 78.

39. Henry, *Irish Art during the Viking Invasions*, p. 70.

40. *Ibid.*, p. 101.

41. Alexander, p. 81.

42. Alexander, p. 82.

43. Alexander, p. 90; Henry, *Irish Art in the Romanesque Period*, p. 72.

44. Alexander, p. 85.

45. Alexander, p. 77.

46. British Library Egerton MS. 3323; see Henry, *Irish Art in the Romanesque Period*, p. 51.

47. British Library Harley MS. 1802; see *ibid.*, p. 65, and Alexander, no. 77.

48. L. Gougaud, 'Les Scribes monastiques d'Irlande au travail', *Revue d'histoire ecclésiastique*, XXVII (1931), p. 294.

49. *Ibid.*, p. 295.

50. *Ibid.*

51. Rome, Vatican Library MS. Pal. lat. 830; Henry, *Irish Art in the Romanesque Period*, pp. 54–5.

52. See below, p. 269.

53. See below, pp. 208–11.

CHAPTER 6

1. Letter 16, *Mon. Germ. Hist. Epist. Karol. Aevi*, II, pp. 42–3.

2. Stockholm, Royal Library MS. A.135; see *English Historical Documents*, I, ed. Dorothy Whitelock (London, 1979), no. 98.

3. *King Alfred's West-Saxon Version of Gregory's Pastoral Care*, ed. Henry Sweet (London, 1871), p. 4.

4. *Asser's Life of King Alfred*, ed. W. H. Stevenson (Oxford, 1904), p. 20.

5. Dodwell (1982), p. 32.

6. Oxford, Bodleian Library MS. Hatton 20; Temple, no. 1.

7. Used by William of Malmesbury in his *De Gestis Regum Anglorum*; see the edition by William Stubbs in the Rolls Series (London, 1887), I, p. 150.

8. Dodwell (1982), p. 244 note 88.

9. Oxford, St John's College MS. 194; Temple, no. 12, and Wormald, no. 52.

10. Cambridge, Trinity College MS. B.16.3; Temple, no. 14.

11. Folio 1 verso.

12. Cambridge, Corpus Christi College MS. 183; Temple, no. 6.

13. British Library MS. Cotton Galba A.XVIII and Oxford, Bodleian Library MS. Rawl. B.484 folio 85; Temple, no. 5, and J. J. G. Alexander, *Norman Illumination at Mont St Michel 966–1100* (Oxford, 1970), pp. 133, 150, 160, 207.

14. Wormald in L. Grodecki, F. Mütherich, J. Taralon, and F. Wormald, *Le Siècle de l'an mil* (Paris, 1973), pp. 231–2.

15. Robert Deshman, 'Anglo-Saxon Art after Alfred', *Art Bulletin*, LVI (1974), pp. 176–200.

16. Dom David Knowles, *The Monastic Order in England . . . 943–1216* (Cambridge, 1950), pp. 697–701. The information in my next paragraph is taken from *ibid.*, pp. 49–52.

17. British Library MS. Cotton Vespasian A.VIII folios 2 verso–33 verso; Temple, no. 16, and Francis Wormald, 'Late Anglo-Saxon Art', *Studies in Western Art: Acts of the Twentieth International Congress of the History of Art*, I: *Romanesque and Gothic Art*, ed. M. Meiss (Princeton, 1963), pp. 19–26.

18. R. Freyhan, 'The Place of the Stole and Maniples in Anglo-Saxon Art of the Tenth Century', *The Relics of St Cuthbert*, ed. C. F. Battiscombe (Oxford, 1956), pp. 426–7.

19. Wormald, *op. cit.* (Note 17), p. 25.

20. Richard Gem and Pamela Tudor-Craig, 'A "Winchester School" Wall-Painting in Nether Wallop, Hampshire', *Anglo-Saxon England*, IX (1981), pp. 115–36.

21. M. Biddle, 'Excavations at Winchester 1966: fifth interim report', *The Antiquaries Journal*, XLVII (1967), p. 277.

22. See Dodwell (1982), p. 48 and p. 258 note 36.

23. Oxford, Bodleian Library MS. Auct. F.4.32 folio 1; Temple, no. 11; Wormald, no. 46; and R. W. Hunt, *St Dunstan's Classbook from Glastonbury*,

Umbrae Codicum Occidentalium, IV (Amsterdam, 1961).

24. M. T. D'Alverny, 'Le Symbolisme de la Sagesse et le Christ de Saint Dunstan', *Bodleian Library Record*, V (1956), pp. 232–44.

25. Hunt, *op. cit.*, p. xv.

26. *Ibid.*, pp. vi–vii.

27. John Beckwith, *Ivory Carvings in Early Medieval England* (London, 1972), p. 30.

28. Francis Wormald, *English Drawings of the Tenth and Eleventh Centuries* (London, 1952), hereafter referred to as Wormald.

29. Oxford, St John's College MS. 28; Temple, no. 13, and Wormald, no. 51.

30. Paris, Bibliothèque Nationale MS. lat. 943; Temple, no. 35, and Wormald, no. 54.

31. Lambeth Palace Library MS. 200(II); Temple, no. 39, and Wormald, no. 43.

32. Cambridge, Trinity College MS. O.3.7 folio 1; Temple, no. 20, and Wormald, no. 17.

33. Oxford, Bodleian Library MS. Bodley 579; Temple, no. 17, and Wormald, no. 49. The Sphere of Apuleius is discussed by Adelheid Heimann in 'Three Illustrations from the Bury St Edmunds Psalter and their Prototypes', *Journal of the Warburg and Courtauld Institutes*, XXIX (1966), pp. 39–59.

34. New York, Pierpont Morgan Library MS. 869; Temple, no. 56.

35. Folio 4 verso; see Note 30.

36. Adelheid Heimann suggests that the Eadwine and Paris Psalter copies were made from a lost recension, but see below, pp. 504–5, for my own rejection of her views. Her article, 'The Last Copy of the Utrecht Psalter', appears in *The Year 1200: A Symposium*, by François Avril and others (Metropolitan Museum of Art, New York, 1975), pp. 313–29.

37. British Library MS. Harley 603; Temple, no. 64; Wormald, no. 34; Dodwell (1954), pp. 1–3, 27 f.; and S. Dufrenne, 'Les Copies anglaises du Psautier d'Utrecht', *Scriptorium*, XVIII (1964), pp. 185–97.

38. British Library MS. Cotton Julius A.VI; Temple, no. 62, and Wormald, no. 30.

39. Besançon, Bibliothèque Municipale MS. 14 folio 58 verso; Temple, no. 76, and Wormald, no. 1.

40. Vatican, Biblioteca Apostolica MS. Reg. lat. 12; Temple, no. 84 and bibliography.

41. Rainer Kahsnitz, *Der Werdener Psalter in Berlin* (Düsseldorf, 1979), p. 220. I owe the reference to the kindness of Professor Jonathan Alexander.

42. British Library MS. Harley 2904; Temple, no. 41, and Wormald, no. 36.

43. F. Wormald, 'The Survival of Anglo-Saxon Illumination after the Norman Conquest', *Proceedings of the British Academy*, XXX (1944), p. 130.

44. Corpus Christi College MS. 23; Temple, no. 48, and Wormald, no. 4.

45. British Library MS. Stowe 944; Temple, no. 78, and Wormald, no. 42.

46. Dodwell (1982), p. 52.

47. Dodwell (1954), pp. 3, 27–8.

48. British Library MS. Arundel 60; Temple, no. 103, and Wormald, no. 25.

49. British Library MS. Cotton Tiberius C.VI; Temple, no. 98, Wormald, no. 32, and Francis Wormald, 'An English Eleventh-Century Psalter with Pictures', *Walpole Society*, XXXVIII (1962), pp. 1–13.

50. See R. Stettiner, *Die illustrierten Prudentius-Handschriften*, 2 vols. (Berlin, 1895–1905), and H. Woodruff, 'The Illustrated Manuscripts of Prudentius', *Art Studies*, VII (1929), pp. 33–79.

51. See Note 44.

52. For the claims of Malmesbury, see Peter J. Lucas, 'MS. Junius 11 and Malmesbury', *Scriptorium*, XXXIV (1980), p. 215.

53. Oxford, Bodleian Library MS. Junius 11; Temple, no. 58; Wormald, no. 50; and Charles W. Kennedy, *The Caedmon Poems* (London, 1916).

54. See Lucas, *op. cit.*, pp. 214 ff., for the claims of Malmesbury.

55. T. H. Ohlgren, 'The Illustrations of the *Caedmonian Genesis*', *Medievalia et Humanistica*, N.S. III (1972), pp. 192–212.

56. C. R. Dodwell and Peter Clemoes, *The Old English Illustrated Hexateuch* (Copenhagen, 1974), pp. 58–9.

57. British Library MS. Arundel 155 folio 133; Temple, no. 66, and Wormald, no. 26.

58. Dodwell and Clemoes, *op. cit.*, p. 59.

59. British Library Add. MS. 49598; Temple, no. 23; G. F. Warner and H. A. Wilson, *The Benedictional of St Aethelwold* (Oxford, 1910); and Francis Wormald, *The Benedictional of St Ethelwold* (London, 1959).

60. Wormald, *Benedictional*, p. 11.

61. O. Homburger, *Die Anfänge der Malschule von Winchester im X. Jahrhundert* (Leipzig, 1912). See also his 'L'Art carolingien de Metz et l'école de Winchester', *Essais en l'honneur de Jean Porcher*, ed. O. Pächt (1963), pp. 36–7, 41–3.

62. Wormald, *Benedictional*, p. 14.

63. A. Boutemy, 'L'Enluminure anglaise de l'époque saxonne (Xe–XIe siècles) et la Flandre française', *Bulletin de la Société nationale des Antiquaires de France*

(1956), p. 44.

64. Wormald, *Benedictional*, p. 13.

65. Paris, Bibliothèque Nationale MS. lat. 987; Temple, no. 25, and Wormald, *Benedictional*, pp. 9, 10.

66. Rouen, Bibliothèque Municipale MS. 369 (Y7); Temple, no. 24, and Wormald, *Benedictional*, p. 9.

67. Rouen, Bibliothèque Municipale MS. 274 (Y6); Temple, no. 72.

68. Dodwell (1982), p. 202.

69. *Ibid.*

70. *Ibid.*

71. Cambridge, Trinity College MS. B.10.4; Temple, no. 65.

72. Dodwell (1954), pp. 11 ff.

73. York Minster, Chapter Library MS. Add. 1; Temple, no. 61.

74. British Library Add. MS. 34890; Temple, no. 68.

75. See T. A. M. Bishop, *English Caroline Minuscule* (Oxford, 1971), p. 22. He lists eleven manuscripts in which, in his view, Eadui's hand is to be found.

76. Kestner Museum W.M.XXIa.36; Temple, no. 67.

77. A. Boutemy, 'Two Obituaries of Christ Church, Canterbury', *English Historical Review*, L (1935), p. 297.

78. Reims, Bibliothèque Municipale MS. 9; William M. Hinkle, 'The Gift of an Anglo-Saxon Gospel Book to the Abbey of Saint-Remi, Reims', *Journal of the British Archaeological Association*, XXXIII (1970), pp. 21–35.

79. See Temple, p. 50, and Bruce-Mitford, as quoted in Note 81.

80. Kongelige Bibliotek MS. G.K.S.10 2°; Temple, no. 47.

81. Bruce-Mitford, however, takes the view that the Copenhagen artist did not draw on the Lindisfarne Gospels but that the artists of both manuscripts were using a common Early Christian source which he believes was produced in sixth-century Italy. See R. L. S. Bruce-Mitford, 'The Evangelist Portraits: Discussion', *Codex Lindisfarnensis*, ed. T. D. Kendrick *et al.* (Olten and Lausanne, 1960), pp. 158 ff., especially p. 173.

82. On rare occasions, such as in Cambridge, Corpus Christi College MS. 411, London, College of Arms MS. Arundel 22, and the Grimbald Gospels, the Franco-Saxon influences are more straightforward. See F. Wormald, *op. cit.* (Note 17), and *idem*, 'Continental Influence on English Medieval Illumination', *Fourth International Congress of Bibliophiles* (London, 1967).

83. See Dodwell (1954), plates 8a, 8e, 10b.

84. British Library MS. Harley 2904 folio 4.

85. Temple, pp. 51–2.

86. Cambridge, Pembroke College MS. 302; Temple, no. 96.

87. British Library MS. Cotton Caligula A.XIV; Temple, no. 97.

88. Dodwell (1982), p. 244 note 88.

89. British Library MS. Cotton Tiberius B.V(I); Temple, no. 87, and P. McGurk *et al.*, *An Eleventh-Century Anglo-Saxon Illustrated Miscellany* (Copenhagen, 1983).

90. *Raleigh's Discovery of Guiana*, ed. W. H. D. Rouse (London, 1905), p. 82.

91. British Library MS. Cotton Vitellius A.XV; Temple, no. 52.

92. See Note 38.

93. See above, p. 48.

94. British Library MS. Cotton Vitellius C.III; Temple, no. 63.

95. See Charles Singer, 'Early English Magic and Medicine', *Proceedings of the British Academy*, IX (1919–20), pp. 341–74, especially p. 367.

96. Dodwell (1982), p. 23.

97. *Ibid.*, p. 98 and note 75.

98. Oxford, Bodleian Library MS. lat. lit. F.5; Temple, no. 91.

99. New York, Pierpont Morgan Library MSS. 708 and 709, Montecassino, Archivio della Badia MS. BB.437, 439; Temple, nos. 94, 93, and 95.

100. New York, Pierpont Morgan Library MS. 709 folio 1 verso.

101. An unpublished note in the catalogue of the Pierpont Morgan Library puts it after 1051. I hope in a future publication to show that it is a good deal later.

102. British Library MS. Harley 2506; Temple, no. 42.

103. Orléans, Bibliothèque Municipale MS. 175; Temple, no. 43.

104. Paris, Bibliothèque Nationale MS. lat. 6401; Temple, no. 32.

105. Boulogne, Bibliothèque Municipale MS. 20; Temple, pp. 23, 100.

106. Boulogne, Bibliothèque Municipale MS. 11; Temple, no. 44.

107. A. Boutemy, 'Un Monument capital de l'enluminure anglo-saxonne: le manuscrit 11 de Boulogne-sur-mer', *Cahiers de civilisation médiévale*, I (1958), pp. 179–80.

108. New York, Pierpont Morgan Library MS. 827; see Temple, no. 45, and bibliography there, especially H. Swarzenski, 'The Anhalt Morgan Gospels', *Art Bulletin*, XXXI (1949), pp. 77–83.

109. M. Schapiro, 'The Image of the Disappearing Christ', *Gazette des Beaux-Arts*, XXIII (1943), pp. 135 ff.

110. There can, of course, be no absolute certainty in this, as Wormald points out ('Continental Influence ...', *op. cit.*, Note 82). His association of pictures like these with Psalter Prefaces is of considerable interest. 'There is,' he writes (p. 10), 'printed among Alcuin's works, but probably incorrectly, a preface to

the Psalms in which the virtues of the Psalter are enumerated. In it the following sentence is found: "Therefore in the psalms you will find, if you examine them intently and can reach to a full spiritual understanding of them, the Incarnation, the Passion, Resurrection and Ascension of the Divine Word and also the judgement to come as well as the prophecy of the general resurrection" [*Pat. Lat.*, 101, col. 465]. If this sentence is borne in mind the prefatory pictures in the medieval psalter . . . appear . . . as an illustrated preface to the psalter capable of immense variety.'

111. God is represented with the architect's dividers in such manuscripts as British Library MS. Royal I.E.VII (folio 1 verso), MS. Cotton Tiberius C.VI (folio 7 verso), and Hannover, Kestner Museum WM.XXIᵃ.36 (folios 9 verso–10). Dr A. Heimann draws attention to this in 'Three Illustrations from the Bury St Edmunds Psalter . . .', *Journal of the Warburg and Courtauld Institutes*, XXIX (1966), pp. 39–59, and refers it to a passage in Byrhtferth.

112. Dimitri Tselos, 'English Manuscript Illustration and the Utrecht Psalter', *Art Bulletin*, XLI (1959), p. 140.

113. See E. H. Kantorowicz, 'The Baptism of the Apostles', *Dumbarton Oaks Papers*, IX/X (1955–6), pp. 205–51; Temple, p. 116.

114. George Zarnecki, *Studies in Romanesque Sculpture* (London, 1979), V 12.

115. British Library MS. Cotton Titus D.XXVII folio 75 verso; see Ernst H. Kantorowicz, 'The Quinity of Winchester', *Art Bulletin*, XXIX (1947), pp. 73–85.

116. Wormald, *op. cit.* (Note 17), pp. 22–3.

117. British Library MS. Add. 34890 folio 114 verso.

118. British Library MS. Cotton Claudius B.IV; Temple, no. 86. For a facsimile with scholarly introductions, see C. R. Dodwell and Peter Clemoes, *op. cit.* (Note 56).

119. *Ibid.*, p. 58.

120. Dodwell (1982), p. 56.

121. Dodwell and Clemoes, *op. cit.*, pp. 58–64.

122. Paris, Bibliothèque Nationale MS. lat. 8824. See Robert M. Harris, 'An Illustration in an Anglo-Saxon Psalter in Paris', *Journal of the Warburg and Courtauld Institutes*, XXVI (1963), pp. 255–63.

123. Ruth Mellinkoff, 'The Round, Cap-shaped Hats depicted on Jews in B. M. Cotton Claudius B iv', *Anglo-Saxon England*, ed. Peter Clemoes, II (1973), pp. 155–65.

124. Dodwell and Clemoes, *op. cit.*, p. 73. See also on this theme R. Mellinkoff, *The Horned Moses in Medieval Art and Thought* (Berkeley, Los Angeles, London, 1970).

125. M. Schapiro, 'Cain's jaw-bone that did the first murder', *Art Bulletin*, XXIV (1942), especially p. 206.

126. Dodwell and Clemoes, *op. cit.*, pp. 71 ff.

127. W. Urry, *Canterbury under the Angevin Kings* (London, 1967), p. 205.

128. Rouen, Bibliothèque Municipale MS. A.27 folio 2 verso.

129. I am here expressing personal views.

130. British Library MS. Cotton Vespasian A.VIII folio 2 verso.

131. British Library MS. Stowe 944 folio 6.

132. British Library MS. Add. 24199 folio 21 verso; and see Dodwell (1982), p. 175.

133. British Library MS. Cotton Tiberius C.VI folio 10 verso, and *ibid.*, p. 27.

134. *Ibid.*, p. 217.

135. *Ibid.*, p. 216 and note 1.

136. *Ibid.*, p. 202.

137. *S. Anselmi Cantuariensis Archiepiscopi Opera Omnia*, ed. F. S. Schmitt, III (Edinburgh, 1946), p. 113.

138. Dodwell (1982), p. 232 and note 143.

139. *Ibid.*, p. 217.

140. Oxford, University College MS. 165.

141. M. Baker, 'Medieval Illustrations of Bede's *Life of St Cuthbert*' (with an appendix by D. H. Farmer), *Journal of the Warburg and Courtauld Institutes*, XLI (1978), pp. 16–49.

142. Cambridge, Corpus Christi College MS. 391 folio 24 verso; Wormald, no. 11.

143. Paris, Bibliothèque Nationale MS. lat. 14782, and Oxford, Wadham College MS. A.10.22. See Kauffmann, nos. 2 and 5, *E.R.A.*, no. 9, and J. J. G. Alexander, 'A Little-known Gospel Book of the Later 11th Century from Exeter', *Burlington Magazine*, CVIII (1966), pp. 6–16.

144. Cambridge, Corpus Christi College MS. 389 folio 1 verso; Dodwell (1954), plate 16c.

145. British Library Arundel MS. 60 folio 52 verso; Dodwell (1954), pp. 118–19, Kauffmann, no. 1, and *E.R.A.*, no. 7.

146. British Library MS. Cotton Caligula A.XV, folios 122 verso and 123; Temple, no. 106, and Wormald, no. 27.

147. Oxford, Bodleian Library MS. Bodley 130; Kauffmann, no. 11.

148. Dodwell (1954), pp. 9 ff.

149. Established chiefly by T. A. M. Bishop in a series of articles; see also Note 75.

CHAPTER 7

1. See, for example, *Vita Gebehardi*, p. 36 (*Mon. Germ. Hist. SS.*, XI).

2. See, for example, the description of the abbacy of Immo at St Gallen, *Casuum S. Galli Continuatio II*, pp. 149–50 (*Mon. Germ. Hist. SS.*, II).

3. See below, pp. 134, 135, 141.

4. For Ottonian views of empire, see the relevant sections of P. E. Schramm, *Kaiser, Rom und Renovatio* (Leipzig and Berlin, 1929), Robert Folz, *L'Idée d'Empire en Occident du Vᵉ au XIVᵉ siècle* (Paris, 1953), and Walter Ullmann, *The Growth of Papal Government in the Middle Ages* (London, 1955).

5. See below, pp. 165–6.

6. See R. Deshman, 'Otto III and the Warmund Sacramentary . . .', *Zeitschrift für Kunstgeschichte*, XXXIV (1971), pp. 1–20.

7. See the reproduction in Percy Ernst Schramm and Florentine Mütherich, *Denkmale der deutschen Könige und Kaiser* (Munich, 1962), no. 111 (p. 329).

8. Staatsbibliothek cod. lat. 4456 folio 11. See Adolph Goldschmidt, *Die Deutsche Buchmalerei* (Florence and Munich, 1928), II, plate 72.

9. Uppsala University Library, Uppsala (Goslar) Gospels, folio 3 verso.

10. Page 31. See Goldschmidt, *op. cit.*, plate 1.

11. Ernst H. Kantorowicz, *The King's Two Bodies. A Study in Mediaeval Political Theology* (Princeton, 1957), chapter III.

12. Robert Deshman, 'Benedictus Monarcha et Monachus', *Frühmittelalterliche Studien*, XXII (1988), pp. 204–40.

13. Kurt Weitzmann, 'Various Aspects of Byzantine Influence on the Latin Countries from the Sixth to the Twelfth Century', *Dumbarton Oaks Papers*, XX (1966), pp. 14–15.

14. These are the views of Hanns Swarzenski. Compare *Notitia Dignitatum*, ed. Otto Seeck (Berlin, 1876), illustration of provinces with tributes on p. 9.

15. Quoted by Ullmann, *op. cit.*, p. 250.

16. See above, p. 27.

17. See *Chronicon abbatum monast. Tegernseensis* c. 6, in B. Pez, *Thesaurus anecdotorum novissimus*, III (Augsburg, 1721), Pars III, col. 512, and *Pat. Lat.*, CXLII, col. 721.

18. *Casus Monasterii Petrishusensis*, p. 632 (*Mon. Germ. Hist. SS.*, XX).

19. *Purchardi Carmen De Gestis Witigowonis Abbatis*, p. 629 (*Mon. Germ. Hist. SS.*, IV).

20. L-B D, 563, 565.

21. *Vita S Gerardi Ep. Tullensis* (*AA.SS. Aprilis Tomus III*), p. 208.

22. L-B D, 222.

23. *Ibid.*, 273.

24. *Ibid.*, 501.

25. *Ibid.*, 654.

26. *Ibid.*, 717.

27. *Ibid.*, 852 and 2573.

28. *Ibid.*, 1600.

29. *Mon. Germ. Hist. SS.*, IV, p. 729.

30. L-B D, 3014 and 1420.

31. *Ibid.*, 3053.

32. *Ibid.*, 338.

33. *Ibid.*, 1712.

34. *Ibid.*, 273.

35. *Thangmari Vita Bernwardi ep.*, p. 761 (*Mon. Germ. Hist. SS.*, IV).

36. L-B D, 338.

37. *Vita Gebehardi*, p. 586 (*Mon. Germ. Hist. SS.*, X).

38. *Casuum S. Galli Continuatio II*, pp. 150–1 (*Mon. Germ. Hist. SS.*, II).

39. As Note 19.

40. L-B D, 2573.

41. Dodwell (1982), pp. 79–80, 92–3.

42. Otto Lehmann-Brockhaus, *Die Kunst des X. Jahrhunderts im Lichte der Schriftquellen*, Sammlung Heitz Akademische Abhandlungen zur Kulturgeschichte, III. Reihe Band 6 (Strassburg, 1935), pp. 45–51.

43. N. Wibiral, 'Beiträge zur Ikonographie der frühromanischen Fresken im ehem. Westchor der Stiftskirche von Lambach', *Würzburger Diözesangeschichtsblätter*, XXV (1963), pp. 63 ff., and 'Die Wandmalereien des XI. Jahrhunderts im ehemaligen Westchor der Klosterkirche von Lambach', *Oberösterreich* (1967) (3); Demus (1970), pp. 624–7.

44. Anton Schmitt, *Die Fuldaer Wandmalerei des frühen Mittelalters* (Fulda, 1949).

45. For a general survey, see J. Sauer, 'Die Monumentalmalerei der Reichenau', *Die Kultur der Abtei Reichenau*, II, ed. K. Beyerle (Munich, 1925), pp. 902–55. See also Demus (1970), pp. 599–600.

46. Sauer, *op. cit.*, figure 9.

47. *Ibid.*, pp. 906–23, and F. X. Kraus, *Die Wandgemälde in der S. Georgskirche zu Oberzell auf der Reichenau* (Freiburg im Breisgau, 1884). For a more recent study, see Kurt Martin, *Die ottonischen Wandbilder der St Georgskirche Reichenau-Oberzell*, 2nd ed. (Sigmaringen, 1975).

48. Sauer, *op. cit.*, p. 914.

49. Rome, Vatican, cod. Vat. grec. 1613. See *Il menologio di Basilio II*, II, *Codices e Vaticanis selecti*, VIII (Turin, 1907), plates 59, 78, 97, 308, etc.

50. Rome, Vatican, cod. Reg. grec. 1. See Hugo Buchthal, *The Miniatures of the Paris Psalter* (London, 1938), figures 27, 42, and 43.

51. Demus (1970), p. 600.

52. *Ibid.*, p. 601.

53. *Ibid.*, p. 600.

54. *Ibid.*

55. *Mon. Germ. Hist. Poet. Lat.*, IV (2), p. 1108.

56. The painters were paid, so they could not have been monks, and the Petershausen chronicle pillories them as thieves. See *Casus Monasterii Petrishusensis* (*Mon. Germ. Hist. SS.*, XX), p. 633.

57. See above, pp. 39–40.

58. See above, p. 40.

59. See above, p. 39.

60. Demus (1970), p. 291.

61. H. V. Sauerland and A. Haseloff, *Der Psalter Erzbischof Egberts von Trier Codex Gertrudianus in Cividale* (Trier, 1901), p. 160.

62. The view that Reichenau was the principal centre of Ottonian illumination was first stated in its completeness by Haseloff in his contribution to Sauerland and Haseloff, *op. cit.*, and is most clearly and cogently expressed by Albert Boeckler in his article 'Die Reichenauer Buchmalerei', in K. Beyerle (ed.), *op. cit.* (Note 45), pp. 956–98. Comprehensive claims for Reichenau are made in a Munich dissertation by Walter Gernsheim, *Die Buchmalerei der Reichenau* (1934). Many of the manuscripts concerned were first grouped together by Wilhelm Vöge, *Eine deutsche Malerschule um die Wende des ersten Jahrtausends, Westdeutsche Zeitschrift für Geschichte und Kunst*, Ergänzungsheft VII (Trier, 1891). Vöge, however, did not attribute them to Reichenau: he originally assigned them to Cologne, though he later changed his mind and opted for Trier (see *Repertorium für Kunstwissenschaft*, XIX (1896), pp. 131 ff.).

63. C. R. Dodwell and D. H. Turner, *Reichenau Reconsidered, A Reassessment of the Place of Reichenau in Ottonian Art, Warburg Institute Surveys*, II (London, 1965).

64. For which see below, p. 134.

65. See below, p. 146.

66. See below, pp. 208 and 357. Sawalo does mention his own monastery of Saint-Amand when he gives his 'signature' there – see below, p. 205 – but he worked for more than one house.

67. Adolph Goldschmidt, *Die deutsche Buchmalerei*, II (Florence and Munich, 1928), p. 3.

68. Dodwell and Turner, *op. cit.*, plate 1.

69. Boeckler, *op. cit.* (Note 62), pp. 958–69.

70. Darmstadt, Hessische Landesbibliothek cod. 1948.

71. Dodwell and Turner, *op. cit.*, pp. 10 and 36–7.

72. Adolf Schmidt, *Die Miniaturen des Gerokodex* (Leipzig, 1924), plate XIII.

73. See above, p. 52.

74. Schmidt, *op. cit.*, plates XIII and XI.

75. Sauerland and Haseloff, *op. cit.*, pp. 128 f., and plate 62, 1–4.

76. Heidelberg University Library MS. Sal. IX.b. Described with illustrations by A. von Oechelhaeuser, *Die Miniaturen der Universitäts-Bibliothek zu Heidelberg*, I (Heidelberg, 1887), pp. 4–55 and plates 1–9.

77. Oechelhaeuser, *op. cit.*, plate 2.

78. Dodwell and Turner, *op. cit.*, pp. 12, 50.

79. Solothurn, Küsterei des Kollegiatstiftes MS. U.1; Peter Bloch, *Das Hornbacher Sakramentar und seine Stellung innerhalb der frühen Reichenauer Buchmalerei, Basler Studien zur Kunstgeschichte*, XV (1956).

80. *Ibid.*, Tafeln 1–4.

81. Kassius Hallinger, *Gorze-Kluny: Studien zu den monastischen Lebensformen und Gegensätzen im Hochmittelalter*, I (Rome, 1950), pp. 95–128.

82. Dodwell and Turner, *op. cit.*, pp. 17 f.

83. *Ibid.*, pp. 18 and 94 note 177.

84. *Ibid.*, p. 30.

85. C. Brower, *Antiquitates et Annales Trevirenses* (Leodii, 1670), I, p. 481.

86. *Ibid.*, p. 492.

87. *Lettres de Gerbert*, ed. J. Havet (Paris, 1889), nos. 104, 106, 126.

88. Cividale, Museo Archeologico cod. sacr. N.6; Sauerland and Haseloff, *op. cit.* (Note 61).

89. Described with full discussion by Sauerland, *ibid.*, pp. 15–36.

90. Sauerland (*ibid.*, p. 35) believes that the 'psalterium magnum auro conscriptum' mentioned by the Zwiefalten chronicle as being among Salome's gifts (cf. *Mon. Germ. Hist. SS.*, X, p. 104) refers to the Egbert Psalter. But one should perhaps be cautious of making this identification, as the chronicle actually indicates that this Psalter was one of a number of gifts that had to remain behind in Poland because of lack of sufficient transport facilities – see above, p. 39. It is possible, of course, that it was despatched at a slightly later date.

91. It is worth recording that, after describing the gifts made to Zwiefalten by Salome and her two sisters, the Zwiefalten chronicle observes that many of these gifts had to be sold to keep the community in food and clothing and to finance building work (cf. *Mon. Germ. Hist. SS.*, X, p. 104).

92. See Hermann Schnitzler, *Rheinische Schatzkammer*, I (Düsseldorf, 1957), pp. 24–5, with bibliography.

93. Koblenz, Staatsarchiv cod. 701.

94. In 970 Egbert accompanied Otto I to Italy and remained there for the best part of three years, visiting a number of centres and apparently acquiring a variety of notable relics: cf. *Mon. Germ. Hist. SS.*, VIII, p. 170. In 983 he participated in the Council of Verona.

95. Havet, *op. cit.*, no. 13.

96. For the illumination of southern England, see above, pp. 154 ff. And, for a Trier cleric at Wilton, see above, p. 74.

97. Dodwell and Turner, *op. cit.*, pp. 16 and 70 ff.

98. *Ekkehardi IV Casus S. Galli*, p. 126 (*Mon. Germ. Hist. SS.*, II).

99. *Ibid.*, pp. 127 ff., and Hallinger, *op. cit.*, pp. 187–99.

100. *Ekkehardi IV* (*op. cit.*), p. 132.

101. *Ibid.*, p. 147.

102. Paris, Bibliothèque Nationale MS. lat. 10514; Sauerland and Haseloff, *op. cit.*, pp. 81 ff. and plates 53–6.

103. E. Gaspard, 'L'Abbaye et chapitre de Poussay', *Mémoires de la Société d'archéologie lorraine*, 2ᵉ série, XIII (1871), p. 122.

104. See Adolph Goldschmidt, *Die deutsche Buchmalerei*, II (Florence and Munich, 1928), Tafel 22, and P. Lauer, *Les Enluminures romanes des manuscrits de la Bibliothèque Nationale* (Paris, 1927), plate LXVI.

105. C. R. Morey, *Early Christian Art* (Princeton, 1953), figure 177.

106. *Ibid.*, figure 186.

107. Albert Boeckler, 'Bildvorlagen der Reichenau', *Zeitschrift für Kunstgeschichte*, XII (1949), pp. 13 ff., figures 1–6.

108. We are chiefly indebted to Haseloff and Nordenfalk for identifications of the Gregory Master's work. See Sauerland and Haseloff, *op. cit.*, pp. 77 ff., and Carl Nordenfalk, 'Der Meister des Registrum Gregorii', *Münchner Jahrbuch der bildenden Kunst*, 3. Folge, I (1950), pp. 61–77. A convenient list of manuscripts attributed wholly or partly to the Gregory Master is given in Hubert Schiel, *Codex Egberti der Stadtbibliothek Trier* (Basel, 1960), pp. 81 ff.

109. Sauerland and Haseloff, *op. cit.*, pp. 77 ff.

110. Nordenfalk, *op. cit.*, p. 62.

111. Prague, Museum of Czech Literature cod. D.F.III,3.

112. Nordenfalk, *op. cit.*, figures 3 and 4. Compare the Carolingian Cleves Gospels: A. Boinet, *La Miniature carolingienne* (Paris, 1913), plate LXXA.

113. Nordenfalk, *op. cit.*, p. 66.

114. Paris, Bibliothèque Nationale MS. lat. 8851; Lauer, *op. cit.* (Note 104), plates LXXI–LXXIII; Sauerland and Haseloff, *op. cit.*, p. 75; Nordenfalk, *op. cit.*, figure 9.

115. Nordenfalk, *op. cit.*, p. 66.

116. Nordenfalk, *op. cit.*, pp. 73 ff.

117. Chantilly, Musée Condé, and Trier, Stadtbibliothek.

118. W. F. Volbach, *Early Christian Art* (London, 1961), plate 95.

119. Trier, Stadtbibliothek cod. 24. See the facsimile edition with introduction by Hubert Schiel quoted in Note 108.

120. Walter Gernsheim, *op. cit.*, pp. 32–3. For a cogent summary of various views of the artists, see Schiel, *op. cit.*, pp. 71 ff.

121. Rome, Vatican, cod. Vat. lat. 3225.

122. Compare Egbert Codex folio 15 verso and J. de Wit, *Die Miniaturen des Vergilius Vaticanus* (Amsterdam, 1959), plate 16(1).

123. *Ibid.*, plate 14(1).

124. Berlin, Staatsbibliothek cod. theol. lat. fol. 485.

125. Albert Boeckler, 'Ikonographische Studien zu den Wunderszenen in der ottonischen Malerei der Reichenau', *Bayerische Akademie der Wissenschaften Phil.-Hist. Klasse, Abhandlungen*, Neue Folge, Heft LII (Munich, 1961), figures 4–7, 13–16, 36–7, 39–45, 78–82; Hugo Buchthal, 'Byzantium and Reichenau', *Byzantine Art, an European Art: Lectures*, Council of Europe (Athens, 1966), pp. 47 ff.

126. Cambridge, Corpus Christi College MS. 286.

127. Folio 52 verso.

128. Folio 84 verso.

129. Folio 101.

130. Folios 3 verso–6.

131. Boeckler, *op. cit.* (Note 107), pp. 22–3, figures 18–21.

132. Boeckler, *op. cit.* (Note 62), pp. 982–98.

133. Staatsbibliothek Clm. 4453. For the first, see Stephan Beissel, *Die Bilder der Handschrift des Kaisers Otto im Münster zu Aachen* (Aachen, 1886). For the second, see G. Leidinger, *Miniaturen aus Handschriften der Kgl. Hof- und Staatsbibliothek in München*, Heft I, *Das sogenannte Evangeliarium Kaiser Ottos III* (Munich, 1912).

134. Munich, Staatsbibliothek Clm. 4452.

135. Bamberg, Staatsbibliothek cod. bibl. 22 and 76; Hans Fischer, *Mittelalterliche Miniaturen aus der Staatlichen Bibliothek Bamberg* (Bamberg, 1926).

136. Cod. bibl. 140; Heinrich Wölfflin, *Die Bamberger Apokalypse* (Munich, 1918).

137. Beissel, *op. cit.*, plate II.

138. Dodwell and Turner, *op. cit.*, p. 28.

139. *Ibid.*, p. 29.

140. Peter Metz, *The Golden Gospels of Echternach* (London, 1957), pp. 41 and 59.

141. Munich, Staatsbibliothek Clm. 4452, and Bamberg, Staatsbibliothek cod. bibl. 140, and probably also Munich, Staatsbibliotek Clm. 4454 were made for him to present to his foundation at Bamberg. See Vöge, *op. cit.* (Note 62), p. 8 note 1.

142. K. B. Powell, 'Observations on a Number of Liuthar Manuscripts', *Journal of the Warburg and Courtauld Institutes*, XXXIV (1971), pp. 1–11.

143. Bamberg, Staatsbibliothek cod. bibl. 22 and 76.

144. Munich, Staatsbibliothek cod. lat. 4453 and 4452.

145. W. Weisbach, 'Les Images des évangélistes dans "L'Évangéliaire d'Othon III" ...', *Gazette des Beaux-Arts*, 6ᵉ période, XXI (1939), p. 148. See also Konrad Hoffmann, 'Die Evangelistenbilder des Münchener Otto-Evangeliars ...', *Zeitschrift des deutschen Vereins für Kunstwissenschaft*, XX (1966), especially pp. 23–30 and 36–7.

146. Bamberg, Staatsbibliothek cod. bibl. 76 folio 10 verso.

147. L-B D, 1712.

148. Metz, *op. cit.* (Note 140).

149. Albert Boeckler, *Das Goldene Evangelienbuch Heinrichs III* (Berlin, 1933), pp. 72–3, and Carl Nordenfalk, 'Neue Dokumente zur Datierung des Echternacher Evangeliars in Gotha', *Zeitschrift für Kunstgeschichte*, I (1932), p. 153.

150. Boeckler, *op. cit.* (Note 149), pp. 59–60.

151. *Ibid.*, pp. 54 ff.

152. Boeckler, *op. cit.* (Note 149), Philipp Schweinfurth, 'Das Goldene Evangelienbuch Heinrichs III und Byzanz', *Zeitschrift für Kunstgeschichte*, X (1942), pp. 42–66, and, for a view that the Byzantine contribution to the manuscript was contemporary and not of a later period, Kurt Weitzmann, 'Various Aspects of Byzantine Influence on the Latin Countries from the Sixth to the Twelfth Century', *Dumbarton Oaks Papers*, XX (1966), p. 4.

153. Schweinfurth, *op. cit.*, pp. 49–52.

154. Boeckler, *op. cit.* (Note 149), pp. 59–61.

155. *Ibid.*, pp. 65–6.

156. Uppsala University Library MS. C.93. See the facsimile edition *Codex Caesareus Upsaliensis: An Echternach Gospel-Book of the Eleventh Century*, ed. Carl Nordenfalk (Stockholm, 1971).

157. Paris, Bibliothèque Nationale MS. nouv. acq. lat. 2196.

158. On the Cologne illuminated manuscripts, see Peter Bloch and Hermann Schnitzler, *Die Ottonische Kölner Malerschule*, 2 vols. (Düsseldorf, 1967–70). References will be to vol. II.

159. Darmstadt, Hessische Landesbibliothek cod. 1640.

160. Biblioteka Narodowa MS. BOZ.8.

161. Universitätsbibliothek cod. 360a.

162. Paris, Bibliothèque Nationale MS. lat. 817.

163. Manchester, John Rylands University Library MS. 98.

164. Stuttgart, Württembergische Landesbibliothek bibl. fol. 21.

165. Bloch and Schnitzler, *op. cit.*, pp. 125 f.

166. *Ibid.*, pp. 126 ff.

167. *Ibid.*, pp. 45 ff.

168. *Ibid.*, pp. 64 ff.

169. Dombibliothek Col. Metr. 12.

170. Staatsbibliothek MS. Bibl. 94.

171. Bloch and Schnitzler, *op. cit.*, p. 127.

172. *Ibid.*, p. 132.

173. *Ibid.* These Gospel Books are the manuscripts of what Bloch and Schnitzler call 'die reiche Gruppe' – Cologne, Erzbischöfliches Priesterseminar MS. 1a, New York, Pierpont Morgan Library MS. 651, Bamberg, Staatsbibliothek MS. Bibl. 94.

174. Namur, Bibliothèque du Grand Séminaire M.43(13); Bloch and Schnitzler, *op. cit.*, p. 40.

175. Paris, Bibliothèque Nationale MS. lat. 817.

176. Biblioteca Ambrosiana C.53 Sup.

177. Bloch and Schnitzler, *op. cit.*, pp. 93 ff.

178. *Ibid.*, p. 93.

179. Darmstadt, Hessische Landesbibliothek cod. 1640.

180. Cf. Bloch and Schnitzler, *op. cit.*, p. 99.

181. Paris, Bibliothèque Nationale MS. lat. 139.

182. Rome, Vatican Library cod. Reg. gr. 1.

183. Bloch and Schnitzler, *op. cit.*, pp. 108–9.

184. *Ibid.*, p. 109.

185. *Ibid.*, p. 107.

186. See above, p. 158.

187. See above, p. 157.

188. Berlin, Staatliche Museen, Kupferstichkabinett cod. 78A3.

189. Bloch and Schnitzler, *op. cit.*, p. 30.

190. Harley MS. 2820.

191. *Annales et Notae S Emmerammi Ratisbonenses*, p. 567, note 1 (*Mon. Germ. Hist. SS.*, XVII).

192. *Arnoldus de S Emmerammo*, Lib. II, p. 568 (*Mon. Germ. Hist. SS.*, IV).

193. Cf. above, p. 27.

194. Bamberg, Staatsbibliothek MS. lit. 142; Georg Swarzenski, *Die Regensburger Buchmalerei des X. und XI. Jahrhunderts* (Leipzig, 1901), pp. 46–55 and plates II–III; *Regensburger Buchmalerei von frühkarolingischer Zeit bis zum Ausgang des Mittelalters: Ausstellung der Bayerischen Staatsbibliothek München und der Museen der Stadt Regensburg*, catalogue (Munich, 1987), no. 14.

195. Munich, Bayerische Staatsbibliothek Clm. 14000.

196. Swarzenski, *op. cit.*, p. 30.

197. *Ibid.*, plate I (1).

198. Munich, Bayerische Staatsbibliothek Clm. 4456; *ibid.*, pp. 63–87 and plates IV–IX; *Regensburger Buchmalerei ...*, no. 16.

199. Munich, Bayerische Staatsbibliothek Clm. 13601; Swarzenski, *op. cit.*, pp. 88–122 and plates XII–XVIII; *Regensburger Buchmalerei ...*, no. 17.

200. The stole is a familiar symbol in literary sources for everlasting life (cf. *Mon. Germ. Hist. SS.*, XV, p. 33, and *Analecta Bollandiana*, LVI (1938), p. 45), though it may also simply represent Christ's role as high priest.

201. For the development of scholarship at Regensburg and its relationship to art, see Bernhard Bischoff, 'Literarisches und künstlerisches Leben in St Emmeram während des frühen und hohen Mittelalters', *Studien und Mitteilungen zur Geschichte des Benediktiner-Ordens*, LI (1933), pp. 102–42. Professor Bischoff identifies the mind behind the theological thought of the Uta Codex as that of the scholar Hartwic.

202. *In Joannis evang. tractatus*, XXIV, 2, *Pat. Lat.*, XXXV, col. 1593; quoted by Meyer Schapiro, 'On the Aesthetic Attitude in Romanesque Art', *Art and Thought*, ed. K. Bharatha Iyer (London, 1947), p. 150.

203. Rome, Vatican Library MS. Ottob. lat. 74; Swarzenski, *op. cit.*, pp. 123–32 and plates XIX–XXI; *Regensburger Buchmalerei ...*, no. 18.

204. The point is made by Florentine Mütherich, *ibid.*, p. 28.

205. Berlin, Staatsbibliothek Preussischer Kulturbesitz MS. theol. lat. qu. 199; *ibid.*, no. 21.

206. Paris, Bibliothèque Nationale MS. lat. 1231; *ibid.*, no. 25.

207. Malibu, J. Paul Getty Museum, MS. Ludwig VII,1; *ibid.*, no. 22.

208. Cracow, Cathedral Chapter Library MS. 208; Swarzenski, *op. cit.*, pp. 178–89 and plates XXIII–XXV; *Regensburger Buchmalerei ...*, no. 26.

209. Hallinger, *op. cit.*, p. 137.

210. Georg Swarzenski, *Die Salzburger Malerei von den ersten Anfängen bis zur Blütezeit des romanischen Stils*, II (Leipzig, 1913), p. 24.

211. Bayerische Staatsbibliothek Clm. 15904 and Clm. 8272; *ibid.*, I, plates X–XIII, and II, pp. 24–30.

212. MS. 781 (formerly Stiftsbibliothek St Peter MS. A.X.6); *ibid.*, I, plates XI–XIX, and II, pp. 30–41; Otto Mazal, *Buchkunst der Romanik* (Graz, 1978), p. 206.

213. Folio 181 verso; Swarzenski, *op. cit.*, I, plate XVII (56).

214. Folio 211 verso; *ibid.*, plate XIX (61).

215. Munich, Bayerische Staatsbibliothek Clm. 15713; Swarzenski, *op. cit.* (Note 194), pp. 135–55 and plates XXII–XXVII; Paul Buberl, 'Über einige Werke der Salzburger Buchmalerei des XI. Jahrhunderts', *Kunstgeschichtliches Jahrbuch der K.K. Zentral-Kommission für Erforschung und Erhaltung der Kunst- und historischen Denkmale*, I (1907), pp. 53 ff.; Mazal, *op. cit.*, pp. 206–7.

216. Swarzenski, *op. cit.* (Note 194), plate XXII (56).

217. Folio 14; *ibid.*, plate XXV (64).

218. Folio 37 verso; *ibid.*, plate XXVII (71).

219. New York, Pierpont Morgan Library MS. 780; *ibid.*, pp. 156–67 and plates XXVIII–XXXII; Buberl, *op. cit.*, pp. 29 ff.; Mazal, *op. cit.*, pp. 207–8.

220. Swarzenski, *op. cit.* (Note 194), plate XXIX (77).

221. *Ibid.*, plate XXIII (57).

222. Folio 64 verso; *ibid.*, plate XXXII (90).

223. Mazal, *op. cit.*, p. 208.

224. Stiftsbibliothek cod. 511; Buberl, *op. cit.*, pp. 30 ff. and plate VI; Swarzenski, *op. cit.* (Note 210), pp. 50–3.

225. *Vita Gebehardi et successorum eius*, p. 36 (*Mon. Germ. Hist. SS.*, XI).

226. Universitätsbibliothek cod. 805; Buberl, *op. cit.*, pp. 44 ff. and plate VII; Swarzenski, *op. cit.* (Note 210), pp. 53–5.

227. Mazal, *op. cit.*, p. 208. It was formerly thought that the manuscript came from Gurk.

228. See E. Heinrich Zimmermann, 'Die Fuldaer Buchmalerei in karolingischer und ottonischer Zeit', *Kunstgeschichtliches Jahrbuch der K.K. Zentral-Kommission für Erforschung und Erhaltung der Kunst- und historischen Denkmale*, IV (1910), pp. 1–104.

229. Berlin, Staatsbibliothek cod. theol. lat. fol. 192, front flyleaf.

230. Berlin, Staatsbibliothek cod. theol. lat. fol. 1; Albert Boeckler, *Der Codex Wittekindeus* (Leipzig, 1938).

231. *Ibid.*, pp. 12 ff.

232. Paris, Bibliothèque Nationale MS. lat. 8850.

233. British Library MS. Harley 2788.

234. Erlangen, Universitätsbibliothek cod. 9.

235. Göttingen, Universitätsbibliothek cod. theol. fol. 231.

236. Boeckler, *op. cit.*, pp. 19 f.

237. Bamberg, Staatsbibliothek cod. lit. I; Zimmermann, *op. cit.*, pp. 21 ff. and figures 14–16.

238. Vatican, cod. Vat. lat. 3548; *ibid.*, pp. 29 ff., plate IV and figure 18.

239. See Stephan Beissel, *Des hl. Bernward Evangelienbuch im Dome zu Hildesheim* (Hildesheim, 1891), and Francis J. Tschan, *Saint Bernward of Hildesheim*, II–III (Notre Dame, Indiana, 1951–2).

240. *Thangmari Vita Bernwardi Episcopi*, p. 758 (*Mon. Germ. Hist. SS.*, IV).

241. Hildesheim, Domschatz Nr. 19; Tschan, *op. cit.*, III, plate 45.

242. Hildesheim, Domschatz Nr. 33; *ibid.*, plates 18, 21, 25, 29, 33.

243. Hildesheim, Domschatz Nr. 18; *ibid.*, plates 54–78.

244. See Paul Lehmann, 'Corveyer Studien', *Abhandlungen d. Bayer. Akadem. d. Wissensch. Phil.-Hist. Kl.*, XXX, p. 5; A. Boeckler, *Abendländische Miniaturen* (Berlin and Leipzig, 1930), pp. 51–2.

245. Pierpont Morgan Library MS. 755 and a Gospel Book in the New York Public Library.

246. Landesbibliothek cod. theol. fol. 60.

247. Herzog-August-Bibliothek Heinemann 2187.

248. Pommersfelden, Gräflich-Schönborn'sche Schlossbibliothek Cod. 2940; André Grabar and Carl Nordenfalk, *Early Medieval Painting* (Lausanne, 1957), pp. 209–10.

249. MS. 7.

250. See E. F. Bange, *Eine bayerische Malerschule des XI. und XII. Jahrhunderts* (Munich, 1923).

251. K. M. Swoboda, 'Zu den romanischen Wandmalereien in Maria Wörth in Kärnten', *Österr. Zeitschrift für Kunst und Denkmalpflege*, XIX (1965), pp. 3 ff.

CHAPTER 8

1. Guglielmo Matthiae, *Mosaici medioevali delle chiese di Roma*, 2 vols. (Rome, 1967), I, pp. 277–8 with bibliography; Raimond van Marle, *La Peinture romaine au moyen-âge* (Strasbourg, 1921), p. 120; *idem, The Development of the Italian Schools of Painting*, I (The Hague, 1923), p. 152, figure 67; Walter Oakeshott, *The Mosaics of Rome* (London, 1967), p. 198, plate 138.

2. Ernst Kitzinger, 'The First Mosaic Decoration of Salerno Cathedral', *Jahrbuch der Österreichischen Byzantinistik*, XXI (1972), pp. 149–62.

3. *Ibid.*, p. 154.

4. Matthiae, *op. cit.*, I, pp. 283 ff., and II, figures 230 ff.; Oakeshott, *op. cit.*, pp. 247–50; E. W. Anthony, *A History of Mosaics* (Boston, 1935), pp. 209 f.

5. Oakeshott, *op. cit.*, p. 248.

6. J. Wilpert (*Die römischen Mosaiken und Malereien der kirchlichen Bauten vom IV. bis zum XIII. Jahrhundert*, 4 vols. (Freiburg i/B., 1917), II, pp. 516 ff.) thinks the theme was largely copied from an original mosaic of the fourth century.

7. Anthony, *op. cit.*, pp. 212 f.

8. See Ernst Kitzinger, 'A Virgin's Face: Antiquarianism in Twelfth-Century Art', *Art Bulletin*, LXII (1980), pp. 6–19.

9. *Ibid.*, p. 13.

10. Van Marle, *op. cit.* (1921), pp. 158–9; Matthiae, *op. cit.*, I, pp. 323–5.

11. Anthony, *op. cit.*, plate LXV.

12. Oakeshott, *op. cit.*, p. 252.

13. See *ibid.*, p. 255.

14. Anthony, *op. cit.*, p. 81.

15. *Ibid.*, pp. 279–80 note 90 (where the Latin is given).

16. Demus (1970), pp. 298–9; Guglielmo Matthiae, *Pittura romana del medioevo*, 2 vols. (Rome, 1965–6), II, pp. 35 ff., plates 16–21; Edgar Waterman Anthony, *Romanesque Frescoes* (Princeton, 1951), pp. 69 ff. with bibliography, and figures 63–6; P. Toesca, *Storia dell'arte italiana*, I (2) (Turin, 1927), p. 925; É. Bertaux, *L'Art dans l'Italie méridionale* (Paris, 1904), p. 301; G. J. Hoogewerff, 'Gli Affreschi nella chiesa di Sant'Elia', *Dedalo*, VIII (1927–8), pp. 331–43.

17. Van Marle, *op. cit.* (1921), pp. 127 ff.; *idem, op. cit.* (1923), pp. 152 ff.; Anthony, *op. cit.* (Note 16), p. 69; Matthiae, *op. cit.* (Note 16), I, pp. 242 ff., figures 168, 170, 171.

18. C. R. Morey, *Lost Mosaics and Frescoes of Rome of the Mediaeval Period* (Princeton, 1915), plate I, chapter I.

19. Anthony, *op. cit.* (Note 4), plate V.

20. Anthony, *op. cit.* (Note 16), pp. 69 f.

21. *Ibid.*, p. 71; Demus (1970), pp. 303–4.

22. Matthiae, *op. cit.* (Note 1), I, p. 332.

23. H. Toubert, 'Le Renouveau paléochrétien à Rome au début du XIIᵉ siècle', *Cahiers archéologiques*, XX (1970), pp. 99, 112.

24. *Eraclius De Coloribus et Artibus Romanorum*, lines 6–10 of the introduction to Book I; see Mrs Mary P. Merrifield, *Original Treatises on the Arts of Painting* (London, 1849, republished London, 1967), I, p. 183.

25. Toesca, *op. cit.* (Note 16), I (2), p. 921.

26. J. Gay, *L'Italie méridionale et l'empire byzantin* (Paris, 1904), pp. 376–85.

27. Bertaux, *op. cit.*, pp. 115 ff.; C. Diehl, *L'Art byzantin dans l'Italie méridionale* (Paris, 1894); G. Gabrieli, *Inventario topografico e bibliografico delle cripte*

eremitiche basiliane di Puglia (Rome, 1936); A. Medea, *Gli Affreschi delle cripte eremitiche pugliesi*, 2 vols. (Rome, 1939).

28. Bertaux, *op. cit.*, p. 143, figure 56.

29. *Ibid.*, p. 138.

30. *Ibid.*

31. Richard Hodges, 'Excavations at San Vincenzo al Volturno: a regional and international centre from *c.* A.D. 400–1100', *San Vincenzo al Volturno. The Archaeology, Art and Territory of an Early Medieval Monastery*, ed. Richard Hodges and John Mitchell (Oxford, 1985), pp. 27–9.

32. Bertaux, *op. cit.*, pp. 107 ff., and John Mitchell, 'The Painted Decoration of the Early Medieval Monastery', Hodges and Mitchell, eds., *op. cit.*, p. 166.

33. Hodges, *op. cit.*, p. 2.

34. Mitchell, *op. cit.*, p. 125.

35. *Ibid.*, pp. 143 ff.

36. See Bertaux, *op. cit.*, pp. 90 ff.; Toesca, *op. cit.* (Note 16), pp. 408 ff.; *idem*, 'Reliquie d'arte della Badia di S. Vincenzo al Volturno', *Bull. dell'Istituto storico italiano*, XXV (1904), pp. 1 ff.; C. Brandi, 'Gli Affreschi della cripta di S. Lorenzo a S. Vincenzo al Volturno', *Boll. dell'Istituto centrale del Restauro*, XXXI–XXXII (1957), pp. 93–6; Anthony, *op. cit.* (Note 16), pp. 86 ff., figures 113–22; Hans Belting, *Studien zur beneventanischen Malerei* (Wiesbaden, 1968), pp. 24 ff.

37. Anthony, *op. cit.* (Note 16), figure 117.

38. *Ibid.*, figure 120.

39. Belting, *op. cit.*, pp. 34–6.

40. *Ibid.*, p. 32 note 25 and pp. 218–19.

41. Van Marle, *op. cit.* (1923), pp. 126 f.

42. Bertaux, *op. cit.*, p. 99.

43. Compare, for example, J. Ebersolt, *La Miniature byzantine* (Paris, 1926), plates XIII and XV.

44. See the personifications of cities in the Joshua Roll – Vatican Library, cod. Pal. gr. 431.

45. Bertaux, *op. cit.*, pp. 244 ff.

46. Janine Wettstein, *Sant'Angelo in Formis et la peinture médiévale en Campanie* (Geneva, 1960), pp. 82 ff.; Belting, *op. cit.*, pp. 42 ff.

47. Berlin, Staatsbibliothek MS. Phillipps 1676; cf. Belting, *op. cit.*, p. 214.

48. *Ibid.*, pp. 228–9.

49. Schlosser (1896), pp. 23 ff.

50. See Hans Belting, *Die Basilica dei SS. Martiri in Cimitile und ihr frühmittelalterlicher Freskenzyklus* (Wiesbaden, 1962), pp. 89 ff. and 153 ff.

51. The decoration is attributed to the period of Leo's episcopacy by Belting, *op. cit.* (Note 50). He subsequently suggested that there are some stylistic grounds for dating the programme twenty or thirty years later (*op. cit.* (Note 36), pp. 97–8), but it seems inherently more likely that the painting was carried out concurrently with Leo's restorations to the church. The highly specific message of the scene of Christ's command to St Peter would have ceased to be relevant following Leo's death (the exact date of which is not known).

52. Belting, *op. cit.* (Note 50), p. 125.

53. *Ibid.*, pp. 127–9 and 159.

54. Both have the same press-mark – Rome, Biblioteca Casanatense MS. 724.BI.13; see Avery, *op. cit.* (Note 57), plates CIV–CXVII.

55. Vatican Library, cod. Vat. gr. 1613.

56. Vatican Library, cod. Vat. lat. 9820; Avery, *op. cit.*, plates CXXXV–CXLVI.

57. See Myrtilla Avery, *The Exultet Rolls of South Italy* (Princeton, 1936).

58. L-B D, 2857.

59. E.g. Avery, *op. cit.*, plates X, CXLV, CLII; see also Bertaux, *op. cit.*, p. 232.

60. Peter Baldass, 'Die Miniaturen Zweier Exultet-Rollen', *Scriptorium*, VIII (1954), p. 217.

61. Bari Cathedral Archives I; Avery, *op. cit.*, plates IV–XI.

62. *Ibid.*, plates XII–XVI.

63. London, British Library Add. MS. 30337 (Avery, *op. cit.*, plates XLIII–LI); Rome, Vatican Library cod. Vat. lat. 3784 (*ibid.*, plates CXXX–CXXXIV); Rome, Vatican Library cod. Barb. lat. 592 (*ibid.*, plates CXLVII–CLIII). For a possible fourth, see Janine Wettstein, 'Un Rouleau campanien du XIᵉ siècle conservé au Musée San Matteo à Pise', *Scriptorium*, XV (1961), pp. 234–9.

64. British Library Add. MS. 30337; Avery, *op. cit.*, plates XLIII–LI; J. P. Gilson, *An Exultet Roll Illuminated in the XIth Century at the Abbey of Monte Cassino reproduced from Add. MS. 30337* (London, 1929).

65. See Herbert Bloch, 'Monte Cassino, Byzantium, and the West in the Earlier Middle Ages', *Dumbarton Oaks Papers*, III (1946), pp. 165–224, reprinted,

with some revision and expansion, in the same author's *Monte Cassino in the Middle Ages*, I (Rome, 1986), pp. 3–112.

66. Rome, Vatican Library MS. Ottob. lat. 74; see above, p. 152.
67. Bloch, *op. cit.* (1946), pp. 182 ff.
68. Quoted Bertaux, *op. cit.*, pp. 159–60.
69. *Ibid.*, p. 158.
70. Quoted Bloch, *op. cit.* (1946), p. 195.
71. *Chronica monast. Casinensis*, lib. III, c. 27; also L-B D, no. 2278.
72. The same bombardment destroyed an area of pavement that had survived in the sacristy. See Bloch, *op. cit.* (1986), pp. 44–7.
73. Wettstein, *op. cit.* (Note 46), p. 51.
74. See Wettstein, *op. cit.*; Ottavio Morisani, *Gli Affreschi di S. Angelo in Formis* (Naples, 1962).
75. Demus (1970), pp. 297–8; Ottavio Morisani, *Bisanzio e la pittura cassinese* (Palermo, 1955), pp. 23 ff.; Peter Anker and Knut Berg, 'The Narthex of Sant'Angelo in Formis', *Acta Archaeologica*, XXIX (1958), pp. 95–110.
76. Demus (1970), p. 298.
77. *Ibid.*, p. 82.
78. *Ibid.*, pp. 294–7; also Morisani, *op. cit.* (Note 75).
79. Demus (1970), p. 295.
80. Morisani, *op. cit.* (Note 75), plates 1 and 2.
81. *Ibid.*, plates 17 and 35.
82. Bertaux, *op. cit.*, p. 256.
83. C. R. Morey, *Mediaeval Art* (New York, 1942), p. 133.
84. *Pat. Lat.*, CLXXII, col. 586.
85. Bloch, *op. cit.* (1946), p. 196.
86. Bertaux, *op. cit.*, pp. 267 ff. and chapter VII; Wettstein, *op. cit.*, pp. 93 ff.
87. Quoted Bloch, *op. cit.* (1946), p. 206.
88. Montecassino MS. 99; G. Ladner, 'Die italienische Malerei im 11. Jahrhundert', *Jahrbuch der kunsthistorischen Sammlungen in Wien*, V (1931), p. 40.
89. Montecassino MS. 175.
90. Montecassino MS. 269.
91. Montecassino MS. 148.
92. Bertaux, *op. cit.*, p. 195.
93. *Chronica monasterii Casinensis*, lib. II, c. 53 (*Mon. Germ. Hist. SS.*, VII, p. 662).
94. Montecassino MS. 73.
95. Montecassino MS. 132; see Chapter 4, Note 29 for bibliography.
96. Vatican Library, cod. Ottob. lat. 74.
97. Quoted Bloch, *op. cit.* (1946), p. 178.
98. *Ibid.*
99. *Ibid.*, p. 207.
100. *Ibid.*, p. 199.
101. See Peter Baldass, 'Disegni della scuola cassinese del tempo di Desiderio', *Bollettino d'Arte*, XXXVII (1952), pp. 102 ff.
102. Montecassino MS. 98; bibliography as for MS. 99 (Note 104).
103. Vatican Library, cod. Vat. lat. 1202; D. M. Inguanez and M. Avery, *Miniature cassinesi del secolo XI illustranti la vita di S. Benedetto* (Montecassino, 1934); Bertaux, *op. cit.*, pp. 206 ff.; Baldass, *op. cit.*, p. 111; Ladner, *op. cit.*, pp. 47 ff.; Bloch, *op. cit.*, pp. 201 ff.; Wettstein, *op. cit.*, pp. 65 f., 117 f., and 122 ff.
104. Montecassino MS. 99; Bertaux, *op. cit.*, pp. 201 and 204 ff.; Ladner, *op. cit.*, pp. 38 ff.; Baldass, *op. cit.*, pp. 102 ff.; Bloch, *op. cit.* (1946), pp. 201 ff.; Wettstein, *op. cit.*, pp. 116–17 and 121–2.
105. Vatican Library, cod. Vat. lat. 1203.
106. Add. MS. 40731.
107. L-B D, 2857.
108. On p. 5.
109. On p. 3.
110. Naples, Biblioteca Nazionale MS. VIII.c.4; Ladner, *op. cit.*, pp. 50 ff.
111. Matthiae, *op. cit.* (Note 16), I, pp. 219–20.
112. John Osborne, *Early Mediaeval Wall-Paintings in the Lower Church of San Clemente* (New York and London, 1984); Matthiae, *op. cit.*, I, pp. 221 ff.
113. Florence, Biblioteca Medicea Laurenziana MS. Plut. I. 56.
114. Vatican Library, cod. Vat. gr. 749; E. B. Garrison, *Studies in the History of Mediaeval Italian Painting*, 4 vols. (Florence, 1953–62), IV, p. 192.
115. Osborne, *op. cit.*, pp. 41–3.
116. *Ibid.*, pp. 54 ff.
117. Matthiae, *op. cit.*, I, pp. 225 ff.
118. *Ibid.*, pp. 242–3.
119. *Ibid.*, p. 246.
120. *Ibid.*, p. 241.
121. *Ibid.*
122. Matthiae, *op. cit.*, II, pp. 12–13.
123. *Ibid.*, p. 16.
124. Demus (1970), pp. 299–300; Ladner, *op. cit.*, pp. 61 ff.
125. F. Bologna, *Early Italian Painting* (London, 1963), p. 31, and Demus (1970), p. 83.

126. See Bertaux, *op. cit.*, pp. 208 ff.
127. Garrison, *op. cit.*, III, pp. 117–18.
128. Cesena, Biblioteca Piana MS. 3.210; see Garrison, *op. cit.*, II, pp. 179–80, and *Mostra storica nazionale della miniatura*, Catalogo (1954), no. 107.
129. Matthiae, *op. cit.*, II, p. 24.
130. Osborne, *op. cit.*, pp. 12 ff.
131. Matthiae, *op. cit.*, II, p. 30.
132. Garrison, *op. cit.*, II, pp. 180 ff.; Matthiae, *op. cit.*, II, pp. 45 ff. and plates 42–6; Demus (1970), pp. 300–1.
133. Reproduced Garrison, *op. cit.*, II, figures 197, 199, 201, 203.
134. Van Marle, *op. cit.* (Note 1) (1921), pp. 129–30, and (1923), pp. 154–7; Toesca, *op. cit.* (Note 16), pp. 925, 1024; Ladner, *op. cit.*, pp. 69 ff.; Matthiae, *op. cit.*, II, pp. 35 ff., plates 16–25; Demus (1970), pp. 298–9.
135. IOH[ANNES ET] STEFANUS FRATRES PICTO[RES] ROMANI ET NICOLAUS NEPUS IOHANNIS. The claim that they were monks was first made by G. J. Hoogewerff, 'Gli Affreschi nella chiesa di Sant'Elia presso Nepi', *Dedalo*, VIII (1927–8), p. 340.
136. Toesca, *op. cit.*, p. 924; Anthony, *op. cit.*, pp. 75 f.; Garrison, *op. cit.*, III, p. 12; Matthiae, *op. cit.*, II, pp. 21 ff., where they are dated to the end of the eleventh century; Demus (1970), p. 301.
137. Matthiae, *op. cit.*, II, p. 21.
138. *Ibid.*, pp. 43–4.
139. Matthiae, *op. cit.*, II, pp. 40 ff.; Demus (1970), p. 301.
140. Matthiae, *op. cit.*, II, p. 41; Demus (1970), p. 301.
141. Matthiae, *op. cit.*, II, pp. 63–4.
142. *Ibid.*, pp. 93 ff.; Demus (1970), p. 301.
143. Matthiae, *op. cit.*, II, pp. 30 ff.; Demus (1970), pp. 301–2.
144. Matthiae, *op. cit.*, II, p. 31.
145. Garrison, *op. cit.*, II, p. 25.
146. Oxford, Bodleian Library Add. MS. D.104; *ibid.*, II, p. 81, III, p. 17.
147. Vatican Library, cod. Pal. lat. 3, 4, 5; Garrison, *op. cit.*, I, pp. 10 f., II, pp. 131 ff.; Cahn, 135.
148. Florence, Biblioteca Medicea-Laurenziana MS. Plut. 16.21; Garrison, *op. cit.*, IV, pp. 185 ff.
149. Bamberg, Staatsbibliothek bibl. 41; *ibid.*, III, p. 286 (with bibliography), IV, pp. 179–85.
150. *Ibid.*, IV, p. 189.
151. Florence, Biblioteca Nazionale F.N.II.I.412; *ibid.*, pp. 194 ff.
152. *Ibid.*, figure 150.
153. See David M. Wilson, *Anglo-Saxon Art* (London, 1984), figures 121 and 122.
154. Garrison, *op. cit.*, IV, figures 145 and 146.
155. Munich, Staatsbibliothek cod. lat. 13001; P. Toesca, *La Pittura e la miniatura nella Lombardia* (Milan, 1912), p. 78, note 1; G. Swarzenski, *Die Regensburger Buchmalerei* (Leipzig, 1901), pp. 175–6; Garrison, *op. cit.*, II, pp. 139 ff.; Cahn, 129.
156. See below, pp. 200–201.
157. Pietro Toesca, 'Miniature romane dei secoli XI e XII', *Rivista del R. Istituto d'Archeologia e Storia dell'Arte*, I (1929), pp. 73 ff.; Toesca, *op. cit.* (Note 16), pp. 928, 930, 1052–5; Cahn, pp. 284–9.
158. Garrison, *op. cit.*, I, p. 41 ff.
159. *Ibid.*, p. 46.
160. In his *Studies*.
161. Florence, Biblioteca Medicea-Laurenziana MS. Plut. 17.27; *ibid.*, III, pp. 17 ff.
162. Vatican Library cod. Barb. lat. 587; *ibid.*; Cahn, 132.
163. Garrison and Berg, both quoted with discussion by Cahn.
164. Mantua, Biblioteca Civica MS. C.III.20; Toesca, *op. cit.* (Note 155), p. 75.
165. Madrid, Biblioteca Nacional cod. 193; Garrison, *op. cit.*, IV, p. 152.
166. Vatican Library, cod. Vat. lat. 12958; *ibid.*, pp. 118 ff.; Cahn, 134.
167. Vatican Library, cod. Vat. lat. 6074; Garrison, *op. cit.*, IV, pp. 138 ff.
168. Vatican Library, cod. Vat. lat. 10405; *ibid.*, pp. 141 ff.; Toesca, *op. cit.* (Note 155), pp. 78–9; Cahn, 133.
169. Garrison, *op. cit.*, IV, pp. 142–6 and figure 111.
170. *Ibid.*, pp. 141 ff.
171. Rome, Biblioteca Angelica cod. 1273; Garrison, *op. cit.*, III, p. 212; Cahn, 137.
172. Perugia, Biblioteca Comunale MS. L.59; Toesca, *op. cit.* (Note 16), pp. 928, 1055; Garrison, *op. cit.*, IV, pp. 148 ff.; Cahn, 131.
173. Garrison, *op. cit.*, IV, pp. 201 ff.
174. Garrison, *op. cit.*, II, p. 5 ff., III, pp. 189 ff.; also *idem, Italian Romanesque Panel Painting* (Florence, 1949), no. 279.
175. Garrison, *Studies*, II, p. 190; W. F. Volbach, 'Il Cristo di Sutri e la venerazione del SS. Salvatore nel Lazio', *Atti della Pontificia Accademia Romana di Archeologia, Rendiconti*, XVII (1941), p. 119.
176. Garrison, *Studies*, II, p. 5.
177. Matthiae, *op. cit.*, II, p. 60.
178. *Ibid.*, pp. 60–61.

179. *Ibid.*, p. 61.

180. Florence, Biblioteca Medicea-Laurenziana MS. Edili 125/6; P. D'Ancona, *La Miniatura fiorentina* (Florence, 1914), pp. 9 ff., plates III–V; Toesca, *op. cit.* (Note 157), figures 20–4; *idem, op. cit.* (Note 16), p. 1057; Garrison, *op. cit.*, I, pp. 164–6, II, pp. 170 and 228–33; Cahn, 121.

181. This is the view of Garrison, *op. cit.*, II, pp. 230–2.

182. New York, Pierpont Morgan Library MS. 492.

183. See Robert H. Rough, *The Reformist Illuminations in the Gospels of Matilda, Countess of Tuscany: A Study in the Art of the Age of Gregory VII* (The Hague, 1973), pp. 22–3, 27, 32–3, 34–6.

184. *Ibid.*, pp. 14 and 29.

185. *Pat. Lat.*, CXLIX, col. 478.

186. Certosa di Calci cod. 1; Cahn, 118; K. Berg, *Studies in Tuscan Twelfth-Century Illumination* (Oslo etc., 1968), pp. 151–7 and 224–7.

187. Berg, *op. cit.*, p. 155.

188. Paris, Bibliothèque Nationale MS. lat. 2508; Garrison, *op. cit.*, IV, pp. 61 and 64–6 and figure 22.

189. *Ibid.*, I, figures 1 and 33–42, II, pp. 49–51, III, figures 1–2 and pp. 82–3, IV, pp. 60, 71–2.

190. Madrid, Biblioteca Nacional MS. Vitr. 15–1; *ibid.*, I, figures 34–5, 38, and pp. 110–11; Cahn, 125.

191. In the Archivio Capitolare; Garrison, *op. cit.*, I, figures 1, 36, 39, II, pp. 50–1, IV, p. 60 and figures 13–15.

192. Laurenziana Conv. Soppr. 630; *ibid.*, II, pp. 199–202, IV, p. 60.

193. Museo Diocesano cod. 2546; *ibid.*, I, figure 33 and p. 112, IV, figure 9 and p. 59; Cahn, 139.

194. Garrison, *op. cit.*, I, pp. 188 and 190.

195. Lucca, Biblioteca Capitolare cod. C; *ibid.*, pp. 115 ff.

196. *Ibid.*, p. 116.

197. Garrison, *Italian Romanesque Panel Painting* (Florence, 1949), section XXIX, with bibliography.

198. G. M. Richter, 'The Crucifix of Guilielmus at Sarzana', *Burlington Magazine*, LI (1927), pp. 162 ff.; E. Sandberg-Vavalà, 'Quattro Croci romaniche a Sarzana e a Lucca', *Dedalo*, IX (1928–9), pp. 65 ff., 129 ff.; E. B. Garrison, 'A Lucchese Passionary related to the Sarzana Crucifix', *Art Bulletin*, XXXV (1953), pp. 109 ff.

199. See Toesca, *op. cit.* (Note 155); G. A. Dell'Acqua, 'Affreschi inediti del medioevo lombardo', *Bollettino d'arte*, XL (1955), pp. 289 ff.; Ferdinando Bologna, *Early Italian Painting* (London, 1964), *passim*.

200. See Anthony, *op. cit.*, p. 99; G. de Francovich, 'Problemi della pittura e della scultura preromanica', *Settimane di studio del Centro italiano di studi sull'alto medioevo*, II (1955), pp. 421 ff.; P. Toesca, *Aosta* (Rome, 1911), pp. 88–9; A. Grabar, 'Fresques d'Aoste et l'étude des peintures romanes', *La Critica d'Arte*, VIII (1949–50), pp. 261–73; Demus (1970), pp. 291–2.

201. Anthony, *op. cit.*, pp. 98 f.; Toesca, *op. cit.* (Note 16), p. 947, and *idem, op. cit.* (Note 155), pp. 42 ff.; G. Ansaldi, *Gli Affreschi della basilica di S. Vincenzo a Galliano* (Milan, 1949); Demus (1970), p. 291.

202. Toesca, *op. cit.* (Note 155), pp. 100 ff.; Anthony, *op. cit.*, pp. 101 f.; Demus (1970), pp. 292–4.

203. Demus (1970), p. 292.

204. See Edoardo Arslan, *La Pittura e la scultura veronese dal secolo VIII al secolo XIII* (Milan, 1943), chapters II, III, and V.

205. *Ibid.*, p. 27.

206. *Ibid.*, pp. 34 ff.

207. *Ibid.*, pp. 51 ff.

208. *Ibid.*, p. 54.

209. *Ibid.*, pp. 56 ff.

210. *Ibid.*, pp. 62 ff.

211. *Ibid.*, figure 77.

212. *Ibid.*, pp. 125 ff.

213. *Ibid.*, p. 127 and p. 130 note 40.

214. Otto Demus, *The Mosaics of San Marco in Venice*, 4 vols. (Chicago and London, 1984). All references are to volume I.

215. *Ibid.*, chapter 3.

216. *Ibid.*, pp. 43 ff.

217. *Ibid.*, pp. 84 ff.

218. *Ibid.*, pp. 94 ff.

219. *Ibid.*, pp. 109 ff.

220. *Ibid.*, pp. 54 ff.

221. *Ibid.*, pp. 127 ff.

222. *Ibid.*, pp. 148 ff.

223. *Ibid.*, pp. 160 ff.

224. *Ibid.*, pp. 171 ff.

225. *Ibid.*, p. 172.

226. *Ibid.*, pp. 196 ff.

227. *Ibid.*, pp. 219 ff.

228. Demus (1970), p. 292.

229. *Ibid.*, pp. 306–8 with bibliography.

230. *Ibid.*, p. 308.

231. *Hugonis Falcandi ... praefatio ad Petrum Panormitanae ecclesiae thesaurarium*, in L. A. Muratori, *Rerum Italicarum Scriptores*, VII (Milan, 1725), col. 256.

232. Otto Demus, *The Mosaics of Norman Sicily* (London, 1950), pp. 54–5.

233. *Ibid.*, p. 128.

234. *Ibid.*, pp. 94–8.

235. *Ibid.*, p. 16.

236. *Ibid.*, p. 57.

237. *Ibid.*, p. 453.

238. *Ibid.*, p. 452.

239. *Ibid.*, p. 411.

240. *Ibid.*

241. Hugo Buchthal, 'A School of Miniature Painting in Norman Sicily', *Late Classical and Mediaeval Studies in Honor of Albert Mathias Friend Jr*, ed. Kurt Weitzmann (Princeton, 1955), pp. 312–39, and 'The Beginnings of Manuscript Illumination in Norman Sicily', *Papers of the British School at Rome*, XXIV (1956), pp. 78–85.

242. Biblioteca Nacional MS. 52; see Buchthal, *op. cit.* (1955), pp. 315 ff.

243. Florence, Riccardiana Library MS. 227, and Malta, Cathedral Treasure of Città Nobile; *ibid.*, p. 319 f.

244. Biblioteca Nacional MSS. 6, 9, 10, and 14; *ibid.*, pp. 322 ff.

245. Madrid, Biblioteca Nacional MSS. 31–47; *ibid.*, pp. 320 f.

CHAPTER 9

1. *Gerberti Epistolae*, nos. 169, 173, 175, in *Pat. Lat.*, 139, cols. 246, 248–9.

2. Bibliothèque Municipale MS. 50 folio 1; J. J. G. Alexander, *Norman Illumination at Mont St Michel 966–1100* (Oxford, 1970), plate 17b.

3. Avranches, Bibliothèque Municipale MS. 72 folio 97; *ibid.*, plate 22.

4. See *ibid.*, pp. 121–5.

5. Avranches, Bibliothèque Municipale MS. 76, folio A verso, top left.

6. Paris, Bibliothèque Nationale MS. lat. 272.

7. Rouen, Bibliothèque Municipale MS. A.337 (506). One of many manuscripts brought to our attention by François Avril; see his *Bibliothèque Municipale de Rouen: Manuscrits normands XI–XIIième siècles* (Rouen, 1975), pp. 12–13.

8. Rouen, Bibliothèque Municipale MS. Y.6 (274).

9. Rouen, Bibliothèque Municipale MS. Y.7 (369).

10. Dodwell (1954), p. 14.

11. New York, Pierpont Morgan Library MS. 641; Alexander, *op. cit.*, pp. 127 ff., analyses it in depth.

12. Alexander, *op. cit.*, pp. 132–3.

13. *Ibid.*, p. 140; cf. plate 34a for a black and white reproduction of the initial.

14. Avranches, Bibliothèque Municipale MS. 103 folio 4 verso; *ibid.*, pp. 173 ff. and plate 47.

15. Bordeaux, Bibliothèque Municipale MS. 1.

16. Dodwell (1954), chapter 1.

17. Alexander, *op. cit.*, *passim*.

18. Rouen, Bibliothèque Municipale MS. A.85 (467).

19. MS. Add. 11850.

20. Dodwell (1954), plate 72b; Hanns Swarzenski, 'Der Stil der Bibel Carilefs von Durham', in *Form und Inhalt – Otto Schmitt zum 60. Geburtstag* (Stuttgart, 1951), pp. 89–95.

21. Durham Cathedral Library MS. A.II.4.

22. *Symeonis Monachi Opera Omnia*, ed. T. Arnold, I, Rolls Series (London, 1882), p. 128.

23. See C. H. Turner, 'The Earliest List of Durham Manuscripts', *Journal of Theological Studies*, XIX (1917–18), pp. 121–32.

24. R. A. B. Mynors suggests twenty-two altogether – see his *Durham Cathedral Manuscripts* (Oxford, 1939), pp. 32 ff. Not all of these came from across the Channel.

25. Durham Cathedral Library MSS. B.II.13 and 14.

26. Dodwell (1954), pp. 115–16.

27. Durham Cathedral Library MS. A.II.4; *ibid.*

28. T. D. Kendrick, *Late Saxon and Viking Art* (London, 1949), p. 133.

29. Guillaume de Poitiers, *Histoire de Guillaume le Conquérant*, ed. Raymonde Foreville (Paris, 1952), p. 244.

30. Dodwell (1982), p. 226.

31. *Ibid.*

32. Dodwell (1954), pp. 117–18.

33. *Ibid.*, plate 72a and d.

34. See Arthur Watson, *The Early Iconography of the Tree of Jesse* (London, 1934).

35. Folio 102.

36. Oxford, Bodleian MS. Bodley 717 folio 287 verso; see Otto Pächt, 'Hugo Pictor', *Bodleian Library Record*, III (1950), pp. 96–103.

37. *Ibid.*, plate Va. The manuscript is Paris, Bibliothèque Nationale MS. lat. 13765.

38. Cf. Myrtilla Avery, *The Exultet Rolls of South Italy* (Princeton, 1936), plate CXLVII.

39. British Library MS. Add. 17739.

40. Rouen, Bibliothèque Municipale MS. Y.109 (1408) folio 32.

41. Rouen, Bibliothèque Municipale MS. A.6 (8).

42. Rouen, Bibliothèque Municipale MS. A.21 (32); see Dodwell (1954), p. 10, note 2, and plate 8b.

43. Avranches, Bibliothèque Municipale MS. 210.

44. For a brief survey of his work, see A. Boutemy, 'Un Grand Enlumineur du Xᵉ siècle, l'abbé Odbert de Saint-Bertin', *Annales de la Fédération Archéologique et Historique de Belgique: Congrès d'Anvers, 27–31 juillet 1947* (Antwerp, 1950), pp. 247–54, and also *Illumination at Saint-Bertin and Saint-Omer under the Abbacy of Odbert*, a thesis submitted to the University of London for the Ph.D. degree in 1968 by Claire Kelleher.

45. Apart from Boulogne-sur-Mer, Bibliothèque Municipale MS. 20, the following MSS. contain inscriptions recording that the manuscript was made at Odbert's request: Boulogne, MS. 102, Saint-Omer, Bibliothèque Municipale MSS. 168, 342 bis, and 765.

46. André Wilmart recognizes twenty-one MSS. of the Odbert atelier in his 'Les Livres de l'abbé Odbert', *Bulletin Historique de la Société des Antiquaires de la Morinie*, XIV (1922–9), pp. 169–88. Others have added further manuscripts to the group.

47. Boulogne-sur-Mer, Bibliothèque Municipale MS. 20. The inscription on folio 1 verso reads: ME COMPSIT HERIVEUS ET ODBERTUS [in red] DECORAVIT EXCERPSIT DODOLINUS. There are two other references in this long poem to 'pater Odbertus', whose name is honoured by red letters.

48. MS. 188.

49. Burgerbibliothek MS. 88; G. Thiele, *Antike Himmelsbilder* (Berlin, 1898), pp. 83–4.

50. Leiden, University Library MS. Voss. lat. Q.79.

51. Philip Grierson, 'The Relations between England and Flanders before the Norman Conquest', *Transactions of the Royal Historical Society*, 4th series, XXIII (1941), pp. 71–112.

52. *Ibid.*, pp. 84 f. and 89 f.

53. Wissant; *ibid.*, p. 80.

54. *Ibid.*, p. 94 note 1.

55. Boulogne, Bibliothèque Municipale MS. 20; V. Leroquais, *Les Psautiers manuscrits latins des bibliothèques publiques de France*, 3 vols. (Mâcon, 1940–1), I, pp. 94–101; III, plates XV–XXI.

56. Compare the praying monk on folio 30 with St Pachomius in British Museum MS. Arundel 155 (Wormald, *op. cit.* (next Note), plate 24a), and also the figure of Victory on folio 29 verso with the Canterbury drawing of Christ (Wormald, *op. cit.*, plate 17a).

57. Rome, Vatican Reg. lat. 12; see above, p. 158, and Francis Wormald, *English Drawings of the Tenth and Eleventh Centuries* (London, 1952), plates 26–8.

58. Bibliothèque Municipale MS. 11.

59. André Boutemy, 'Un Monument capital de l'enluminure anglo-saxonne: le manuscrit 11 de Boulogne-sur-Mer', *Cahiers de Civilisation Médiévale*, I (1958), p. 181.

60. See e.g. the Fulda Sacramentary (Göttingen, Universitätsbibliothek MS. theol. 231).

61. Bibliothèque Municipale MS. 56 folio 35.

62. MS. 333.

63. Cambridge, Corpus Christi College MS. 183; see above, p. 95. It is also revived in England in Lambeth MS. 200 (see T. D. Kendrick, *Late Saxon and Viking Art*, London, 1949, p. 39), but only in relationship with an initial.

64. Boulogne, Bibliothèque Municipale MS. 20.

65. Folio 2.

66. Paris, Bibliothèque Nationale MS. lat. 9428; see above, p. 60.

67. Amiens, Bibliothèque Municipale MS. 18; see above, pp. 76–9.

68. See above, p. 79.

69. Compare the inhabited scrollwork of two Odbert manuscripts – the Morgan Gospels and Saint-Omer, Bibliothèque Municipale MS. 56 – with that of a Saint-Vaast manuscript, Boulogne, Bibliothèque Municipale MS. 12 (folio 15).

70. New York, Pierpont Morgan Library MS. 827; see Hanns Swarzenski, 'The Anhalt Morgan Gospels', *Art Bulletin*, XXXI (1949), pp. 77–83.

71. Above, p. 116.

72. Folio 66 verso.

73. Arras, Bibliothèque Municipale MS. 559; described with illustrations by André Boutemy, 'Une Bible enluminée de Saint-Vaast à Arras', *Scriptorium*, IV (1950), pp. 67–81.

74. A similar combination of Franco-Saxon and Anglo-Saxon elements is found in a contemporary Saint-Vaast Gospel Book now in Boulogne (MS. 9) which was apparently planned as a companion volume to the Bible. The artist of this Gospel Book may himself have participated in the illumination of the Bible. See S. Schulten, 'Die Buchmalerei des 11. Jahrhunderts im Kloster St

Vaast in Arras', *Münchner Jahrbuch der bildenden Kunst*, VII (1956), pp. 57–61.

75. Boutemy, *op. cit.* (Note 73), plate 2.

76. British Library Add. MS. 24199.

77. P. H. Brieger, 'Bible Illustration and Gregorian Reform', *Studies in Church History*, II (1965), pp. 154–64.

78. *Ibid.*, p. 163; cf. *Pat. Lat.*, 189, col. 741.

79. Saint-Quentin Chapter Library.

80. Saint-Omer, Bibliothèque Municipale MS. 698.

81. Bibliothèque Municipale MS. 24.

82. Valenciennes, Bibliothèque Municipale MSS. 39 and 41, and Paris, Bibliothèque Nationale MS. lat. 1991. Valenciennes MS. 41, which is the final volume of the three, is of smaller format and has very little decoration.

83. Valenciennes, Bibliothèque Municipale MS. 502; Hanns Swarzenski, in *Monuments of Romanesque Art* (London, 1954), figures 178–9; Jean Porcher, *French Miniatures from Illuminated Manuscripts* (London, 1960), figure 35; also Francis Wormald, 'Some Illustrated Manuscripts of the Lives of Saints', *Bulletin of the John Rylands Library*, XXXV (1952), pp. 256 ff.

84. Valenciennes, Bibliothèque Municipale MS. 169 folio 2.

85. Valenciennes, Bibliothèque Municipale MSS. 9–11. The original two volumes were in fact divided into four at an unknown date, but the third part has been lost.

86. Cahn, 116; A. Boutemy, 'Les Enlumineurs de l'abbaye de Saint-Amand', *Revue belge d'archéologie et d'histoire de l'art*, XII (1942), pp. 135–41, 145.

87. Valenciennes, Bibliothèque Municipale MSS. 39 and 41 and Paris, Bibliothèque Nationale MS. lat. 1991; *ibid*.

88. Boutemy, *op. cit.* (Note 86), p. 138.

89. See below, p. 354.

90. Valenciennes, Bibliothèque Municipale MS. 108 folio 58 verso.

91. See below, p. 352.

92. N. Garborini, *Der Miniator Sawalo . . .* (Cologne, 1978), shows (pp. 67–8) that the figure style in the fifth volume of the Sawalo Bible (the illumination of which, apart from the opening full-page initial to Matthew's Gospel, is not by Sawalo) was related to that of the Saint-Amand Crucifixion and, in reference to other manuscripts of Saint-Amand, says that the Byzantinisms in them were introduced from English sources.

93. Garborini, *op. cit.*, pp. 25, 27–9.

94. *Ibid.*, pp. 29–34.

95. *Ibid.*, pp. 34–5.

96. See on him Garborini, *op. cit.*, and A. Boutemy, 'Quelques Aspects de l'œuvre de Sawalon . . .', *Revue belge d'archéologie et d'histoire de l'art*, IX (1939), pp. 299–316.

97. Valenciennes, Bibliothèque Municipale MSS. 1–5; *MSS. à P.*, 163; Cahn, 115.

98. Garborini, *op. cit.*, pp. 69–70.

99. Paris, Bibliothèque Nationale MS. lat. 1699; *MSS. à P.*, 165.

100. Garborini, *op. cit.*, pp. 76–7.

101. Valenciennes, Bibliothèque Municipale MS. 186; *MSS. à P.*, 164.

102. Garborini, *op. cit.*, pp. 83–4.

103. *Ibid.*, pp. 88–91.

104. *Ibid.*, p. 92.

105. *Ibid.*, pp. 120 ff. They are Douai, Bibliothèque Municipale MSS. 94, 258, 277, 360, 362 I and II, 364.

106. *Ibid.*, pp. 56–7.

107. *Ibid.*, p. 73.

108. *Ibid.*, pp. 72–3.

109. *Ibid.*, pp. 74–5; A. Boutemy, 'Relations artistiques entre les abbayes d'Anchin et de Saint-Amand au milieu du XIIᵉ siècle', *Bull. de la Société Nationale des Antiquaires de France* (1954–5), pp. 75–8, and 'Enluminures d'Anchin . . .', *Scriptorium*, XI (1957), pp. 234–48.

110. See below, pp. 408–10.

111. A. Boutemy, 'L'Illustration de la Vie de Saint Amand', *Revue belge d'archéologie et d'histoire de l'art*, X (1940), pp. 231–49.

112. Valenciennes, Bibliothèque Municipale MS. 501; *MSS. à P.*, 168; Porcher, *op. cit.*, pp. 38–9. Porcher wrongly views this manuscript as being the third Life of St Amand.

113. Garborini, *op. cit.*, pp. 82–3.

114. Valenciennes, Bibliothèque Municipale MS. 500; *MSS. à P.*, 167; Porcher, *op. cit.*, p. 37. Believed by Porcher to be the second Life.

115. Garborini, *op. cit.*, pp. 104–5.

116. *Ibid.*, p. 105.

117. See below, pp. 408–10.

118. Valenciennes, Bibliothèque Municipale MSS. 9–11; Cahn, 116.

119. Boulogne, Bibliothèque Municipale MS. 14; *MSS. à P.*, 123.

120. Boulogne, Bibliothèque Municipale MS. 46 folio 1 verso; *MSS. à P.*, 124.

121. Paris, Bibliothèque Nationale MSS. lat. 12004, 11580, 12270; *MSS. à P.*, 137–9.

122. To Nevelo at Corbie (Paris, Bibliothèque Nationale MS. lat. 17767), Alardus and Guntfredus at Saint-Vaast (Arras, Bibliothèque Municipale MS. 548 and Boulogne, Bibliothèque Municipale MS. 9), and Siger at Anchin (Douai, Bibliothèque Municipale MS. 372, vol. II); *MSS. à P.*, 134, 143, 145, 156.

123. The manuscript is lost, but see A. Boutemy, 'Enluminures d'Anchin au temps de l'abbé Gossuin', *Scriptorium*, XI (1957), plate 18d, p. 237.

124. Paris, Bibliothèque Nationale MS. lat. 11575; *MSS. à P.*, 140.

125. Douai, Bibliothèque Municipale MS. 340; *MSS. à P.*, 153.

126. Douai, Bibliothèque Municipale MS. 315, vol. II; *MSS. à P.*, 152.

127. Valenciennes, Bibliothèque Municipale MS. 186 folio 2 verso; *MSS. à P.*, 164.

128. Valenciennes, Bibliothèque Municipale MS. 197 folio 3; *MSS. à P.*, 166.

129. See below, p. 271.

130. Paris, Bibliothèque Nationale MS. lat. 2287; *MSS. à P.*, 169; Porcher, *op. cit.*, p. 37 and plate XXXIII.

131. Douai, Bibliothèque Municipale MS. 250 folio 2; *MSS. à P.*, 148; Porcher, *op. cit.*, p. 37 and frontispiece.

132. Paris, Bibliothèque Nationale MS. lat. 2288; *MSS. à P.*, 149.

133. We can add as another example Valenciennes, Bibliothèque Municipale MS. 512 folio 4 verso; *MSS. à P.*, 162; Dodwell (1954), plate 32b.

134. Douai, Bibliothèque Municipale MS. 315 vol. II, folio 1; *MSS. à P.*, 152; Dodwell (1954), plate 32c.

135. See below, p. 324.

136. Saint-Omer, Bibliothèque Municipale MS. 12; *MSS. à P.*, 129.

137. Porcher, *op. cit.*, p. 35.

138. Cambrai, Bibliothèque Municipale MS. 559; *MSS. à P.*, 178.

139. Boulogne, Bibliothèque Municipale MS. 2; *MSS. à P.*, 183; Cahn, 56; Dodwell (1954), p. 107; A. Boutemy, 'La "Bible" de Saint-André-au-Bois', *Scriptorium*, V (1951), pp. 222–37.

140. Dodwell (1954), p. 107, plate 65 a–d.

141. MSS. 8–10; *MSS. à P.*, 334; Cahn, 99; Dodwell (1954), pp. 109–11; A. Boinet, 'Les Manuscrits à peintures de la Bibliothèque Sainte-Geneviève', *Bulletin de la Société française de Reproductions de Manuscrits à Peintures*, V (1921), pp. 21–9.

142. Robert Branner, 'The Manerius Signatures', *Art Bulletin*, L (1968), p. 183.

143. Printed in *New Palaeographical Society*, 1st series (1903–12), comments on plates 116–18.

144. William Urry, *Canterbury under the Angevin Kings* (London, 1967), p. 174.

145. Boinet, *op. cit.*, p. 29; Paris, Bibliothèque Nationale MS. lat. 8823.

146. *Ibid.*, pp. 28–9; Paris, Bibliothèque Nationale MSS. lat. 11534–5.

147. Dodwell (1954), pp. 104–9.

148. *Ibid.*, pp. 108–9.

149. C. F. R. de Hamel, *Glossed Books of the Bible and the Origins of the Paris Book Trade* (1984), pp. 38–54.

150. Dodwell (1954), p. 107.

151. De Hamel, *op. cit.*, pp. 47–8.

152. See above, p. 127.

153. Yvonne Deslandres, 'Les Manuscrits décorés au XIᵉ siècle à Saint-Germain-des-Prés par Ingelard', *Scriptorium*, IX (1955), pp. 3–16, and Charles Niver, 'Notes upon an Eleventh-century Psalter', *Speculum*, III (1928), pp. 398–401.

154. Paris, Bibliothèque Nationale MS. lat. 11550 folio 6; *MSS. à P.*, 246; Porcher, *op. cit.*, p. 15 and plate III.

155. Paris, Bibliothèque Nationale MSS. lat. 11749–11752.

156. Paris, Bibliothèque Nationale MS. lat. 12610.

157. Paris, Bibliothèque Nationale MS. lat. 11685.

158. Paris, Bibliothèque Nationale MS. lat. 12117.

159. Paris, Bibliothèque Nationale MSS. lat. 12197 and 12584.

160. Paris, Bibliothèque Nationale MS. lat. 103; Deslandres, *op. cit.*, p. 14.

161. Paris, Bibliothèque Nationale MS. lat. 9436.

162. Schulten, *op. cit.* (Note 74), pp. 66–70.

163. Paris, Bibliothèque Nationale MSS. lat. 14395–6 and Bibliothèque Mazarine MS. 47; Cahn, 94.

164. *Ibid.*

165. See above, p. 33.

166. The date of the ban is discussed on p. 186 of the chapter on 'L'Enluminure cistercienne primitive' in Jean-Baptiste Auberger, *L'Unanimité cistercienne primitive: mythe ou réalité?* (*Cîteaux: Studia et Documenta*, III) (Cîteaux, 1986).

167. See Dodwell (1954), p. 109, and, for Morimondo, J. Leclercq, 'Les Peintures de la Bible de Morimondo', *Scriptorium*, X (1956), pp. 22–6.

168. St Bernard himself is reputed to have been the owner of a Bible (Troyes, Bibliothèque Municipale MS. 548) whose painted initials include gold embellishment and figural illustrations, and it is thought that this can only have come to him as a gift. See Walter Cahn, 'The *Rule* and the Book: Cistercian Book Illumination in Burgundy and Champagne', *Monasticism and the Arts*, ed.

Timothy Gregory Verdon (Syracuse University Press, 1984), p. 161.

169. A number have been published in C. Oursel, *La Miniature du XIIᵉ siècle à l'abbaye de Cîteaux* (Dijon, 1926), which will be quoted as Oursel. Some are reproduced in colour in *idem, Miniatures cisterciennes* (Mâcon, 1960). Yolanta Zaluska's thesis on Cistercian manuscripts, which was submitted to the Sorbonne, awaits publication.

170. As stated in a famous colophon to vol. II of the Bible of Stephen Harding (Dijon, Bibliothèque Municipale MS. 13) printed in *Pat. Lat.*, CLXVI, cols. 1373–6.

171. Dijon, Bibliothèque Municipale MSS. 12–15; Cahn, 66.

172. As the note at the end of the second volume informs us. The illumination of the third and fourth volumes is in a different style, and these volumes are to be dated a few years later.

173. Oursel, p. 23.

174. Dijon, Bibliothèque Municipale MSS. 30 and 130; *ibid.*, plates I and LI, and descriptions. See also Auberger, *op. cit.*, pp. 187 f.

175. Oursel, plates XXXVIII–XLIV.

176. Especially British Library MS. Cotton Claudius E.V and Cambridge, St John's College MS. A.8.

177. Dijon, Bibliothèque Municipale MS. 170 folio 6 verso.

178. Otto Pächt, C. R. Dodwell, and Francis Wormald, *The St Albans Psalter* (London, 1960), plate 41.

179. See below, p. 328.

180. Dijon, Bibliothèque Municipale MS. 14.

181. Dijon, Bibliothèque Municipale MSS. 641 and 642.

182. Cambridge, Pembroke College MS. 120; see below, pp. 335–6.

183. Oursel, p. 29, and Auberger, *op. cit.*, pp. 193–5.

184. Dijon, Bibliothèque Municipale MS. 173 folio 41; Oursel, plate XXV.

185. Dijon, Bibliothèque Municipale MS. 170 folio 59; *ibid.*

186. Dijon, Bibliothèque Municipale MS. 170 folio 75 verso; *ibid.*, plate XXVI.

187. Dijon, Bibliothèque Municipale MS. 173 folio 148; *ibid.*

188. Dijon, Bibliothèque Municipale MS. 170 folio 32; *ibid.*

189. Dijon, Bibliothèque Municipale MS. 173 folio 92 verso; *ibid.*, plate XXV.

190. MS. 173 folio 174.

191. His foppishness is such that, in an earlier book, I described him as a woman.

192. Dodwell (1982), p. 223.

193. See above, pp. 119–20.

194. See A. Watson, *The Early Iconography of the Tree of Jesse* (London, 1934).

195. R. I. Moore, *The Birth of Popular Heresy* (London, 1975), p. 92. Their belief was that Christ was a spiritual being with simulated flesh.

196. Walter Cahn, 'A Defense of the Trinity in the Cîteaux Bible', *Marsyas*, XI (1962–4), pp. 58–62.

197. Dijon, Bibliothèque Municipale MS. 641 folio 40 verso.

198. Dijon, Bibliothèque Municipale MS. 129 folio 4 verso.

199. Cahn, p. 270.

200. Dijon, Bibliothèque Municipale MS. 2; Cahn, 65; *MSS. à P.*, 287.

201. *MSS. à P.*, 287.

202. *Ibid.*

203. See Joan Evans, *Cluniac Art of the Romanesque Period* (Cambridge, 1950).

204. *Chronicum Cluniacense*, in M. Marrier, *Bibliotheca Cluniacensis* (Paris, 1614), col. 1645.

205. *Dialogus inter Cluniacensem et Cisterciensem monachum*, in E. Martène and U. Durand, *Thesaurus Novus Anecdotorum*, V (Paris, 1717), col. 1584.

206. He was Peter Damian who is quoted with other Information by M. D. Knowles in *Cistercians and Cluniacs* (Oxford, 1955), pp. 6–7.

207. Gérard Cames, 'Recherches sur l'enluminure romane de Cluny', *Cahiers de Civilisation Médiévale*, VII (1964), pp. 152 ff.

208. Cleveland, Museum of Art no. 68.190; Cahn, 64; W. D. Wixom, 'A Manuscript Painting from Cluny', *Bulletin of the Cleveland Museum of Art*, LVI (1969), pp. 131–5.

209. Parma, Biblioteca Palatina MS. 1650; Meyer Schapiro, *The Parma Ildefonsus: a Romanesque Illuminated Manuscript from Cluny and Related Works* (New York, 1964).

210. L. C. Pratesi, 'Il "Parma Ildefonsus", Cluny e la pittura catalana', *Arte Lombarda*, N.S. LII (1979), pp. 21–30.

211. Schapiro, *op. cit.*, pp. 26 ff.

212. *Ibid.*, p. 20.

213. *Ibid.*, figure 23 and colour plate II.

214. E. Margaret Thompson, *The Carthusian Order in England* (London, 1930), p. 15.

215. *Ibid.*, p. 13.

216. Quoted *ibid.*

217. *Ibid.*, p. 17.

218. *Ibid.*

219. *Ibid.*

220. Grenoble, Bibliothèque Municipale MSS. 16–18; Cahn, 71; *MSS. à P.*, 338.

221. Grenoble, Bibliothèque Municipale MSS. 12–15; Cahn, 70; *MSS. à P.*, 339.

222. Paris, Bibliothèque Nationale MS. lat. 5058; *MSS. à P.*, 313.

223. Leiden, Bibliotheek der Rijksuniversiteit Cod. Perizoni F.17, folio 46.

224. Brussels, Bibliothèque Royale MS. 10066–77 folio 135 verso.

225. Porcher gives it to Moissac in his exhibition catalogue (*MSS. à P.*, 313) and to the vicinity of Saint-Sernin in his book (*op. cit.* (Note 83), p. 28).

226. Avranches, Bibliothèque Municipale MS. 210 folio 19 verso; *MSS. à P.*, 195 and plate XXI.

227. Poitiers, Bibliothèque Municipale MS. 250; *MSS. à P.*, 222.

228. Paris, Bibliothèque Nationale MS. nouv. acq. lat. 1390; *MSS. à P.*, 221.

229. *Ibid.*

230. Amiens, Bibliothèque Municipale MS. Lescalopier 2; *MSS. à P.*, 220.

231. Angers, Bibliothèque Municipale MSS. 3–4; Cahn, 50; *MSS. à P.*, 219.

232. See Mortet, I, p. 264, no. LXXXVII.

233. *MSS. à P.*, p. 48.

234. One school of thought believes it to be Carolingian, another considers it to have been deliberately archaized to look as if it is Carolingian.

235. D. Gaborit-Chopin, *La Décoration des manuscrits à Saint-Martial de Limoges et en Limousin du IXᵉ au XIIᵉ siècle* (Paris and Geneva, 1969), p. 15.

236. Paris, Bibliothèque Nationale MS. lat. 260; Julien Cain *et al.*, *L'Art roman à Saint-Martial de Limoges, Catalogue de l'exposition* (Limoges, 1950), no. 1.

237. Paris, Bibliothèque Nationale MS. lat. 5; Cahn, 83; *MSS. à P.*, 319.

238. *L'Art religieux du XIIᵉ siècle en France* (Paris, 1924), pp. 18–20.

239. Gaborit-Chopin, *op. cit.*, pp. 44 ff.

240. Porcher, *op. cit.*, p. 26 (figure 25).

241. Cahn, p. 275.

242. Gaborit-Chopin, *op. cit.*, p. 44; Paris, Bibliothèque Nationale MS. lat. 1897.

243. *Ibid.*, pp. 55–6.

244. *Ibid.*, pp. 63–8; Paris, Bibliothèque Nationale MS. lat. 5301.

245. Paris, Bibliothèque Nationale MS. lat. 1120.

246. Paris, Bibliothèque Nationale MS. lat. 5240.

247. Gaborit-Chopin, *op. cit.*, p. 63.

248. Paris, Bibliothèque Nationale MS. lat. 8; Cahn, 85; *MSS. à P.*, 325.

249. Gaborit-Chopin, *op. cit.*, pp. 97–8. The Lectionary and the Gregorius are both in Paris – Bibliothèque des Beaux-Arts MS. lat. 11 and Bibliothèque Nationale MS. lat. 2799.

250. Paris, Bibliothèque Nationale MS. lat 5296A.

251. Gaborit-Chopin, *op. cit.*, pp. 95, 121–2.

252. Paris, Bibliothèque Nationale MS. lat. 5243; *ibid.*, pp. 122–4.

253. Paris, Bibliothèque Nationale MS. lat. 9438.

254. Dublin, Chester Beatty Collection MS. 18.

255. Paris, Bibliothèque Mazarine MSS. 1 and 2 (Cahn, 81), and Saint-Yrieix, Hôtel de Ville MS. 1 (Cahn, 108).

256. For all this, see Gaborit-Chopin, *op. cit.*, pp. 127 ff.

257. *Ibid.*, p. 137.

258. *Ibid.*, p. 18.

259. See Danielle Gaborit-Chopin, 'Les Dessins d'Adémar de Chabannes', *Bulletin archéologique du Comité des travaux historiques et scientifiques*, N.S. III (1967), pp. 163–224.

260. Bibliotheek der Rijksuniversiteit MS. Voss. lat. 8° 15; Gaborit-Chopin, *op. cit.* (Note 259), pp. 168 ff.; Cain, *op. cit.* (Note 236), p. 50 and nos. 26–9; and M. W. Evans, *Medieval Drawings* (London, 1969), plates 86–7.

261. I accept the date suggested by Porcher (*MSS. à P.*, 305).

262. Paris, Bibliothèque Nationale MS. lat. 1118; *MSS. à P.*, 305.

263. Gaborit-Chopin's arguments for this (*op. cit.* (Note 235), p. 82) are convincing.

264. Paris, Bibliothèque Nationale MS. lat. 8878. See Émile A. Van Moé, *L'Apocalypse de Saint-Sever ...* (Paris, 1942) for reproductions and descriptions of some of the illustrations, and for a full facsimile, *El 'Beato' de Saint-Sever*, ed. Xavier Barral i Altet *et al.* (Madrid, 1984).

265. H. A. Sanders, *Beati in Apocalypsin Libri Duodecim* (Rome, 1930), p. xv.

266. John Williams, 'Le Beatus de Saint-Sever: état des questions', *Saint-Sever: Millénaire de l'abbaye* (Colloque international 25, 26 et 27 Mai 1985), Comité d'études sur l'histoire et l'art de la Gascogne (Mont-de-Marsan, 1986), pp. 260–1.

267. F. Avril, 'Quelques Considérations sur l'exécution matérielle des enluminures de l'Apocalypse de Saint-Sever', *Actas del Simposio para el estudio de los códices del 'Comentario al Apocalipsis' de Beato de Liébana*, I** (Madrid, 1980), pp. 263–71.

268. J. Vezin, 'Observations paléographiques sur l'Apocalypse de Saint-Sever', *Saint-Sever, op. cit.* (Note 266), pp. 265–74.

269. *Op. cit.* (Note 238), pp. 4 ff.

270. N. Mézoughi, 'Le Tympan de Moissac ...', *Les Cahiers de Saint-Michel de Cuxa*, IX (1978), p. 179, quoting Grodecki.

271. *Idem*, 'Notes sur le Beatus de Saint-Sever', *ibid.*, X (1979), pp. 131–7.

272. Mézoughi, *op. cit.* (Note 270), p. 178.

273. M. Mentré, 'Le Beatus de Saint-Sever et l'enluminure limousine', *Actes du 102ᵉ Congrès National des Sociétés savantes tenu à Limoges en Avril 1977, Section d'archéologie et d'histoire de l'art*, pp. 99–127.

274. In this connection, Meyer Schapiro draws specific attention to the portrayal of Daniel in the lions' den when compared to the same scene in the Gerona Apocalypse (*Words and Pictures ...*, Paris, 1973, p. 42), and, compared to the Spanish Beatuses (which are of course quite unrealistic), there is a distinct infusion of 'realism' in many other scenes.

275. Paris, Bibliothèque Nationale MS. lat. 1118; *MSS. à P.*, 305.

276. Bibliothèque Municipale MS. 1; A. Boinet, 'Notice sur un Évangéliaire de la Bibliothèque de Perpignan', *Congrès archéologique de France LXXIIIᵉ Session* (1907), pp. 534–51.

277. *Ibid.*

278. Moulins, Bibliothèque Municipale MS. 1; Cahn, 76; *MSS. à P.*, 331.

279. Cahn, p. 273.

280. Bibliothèque Municipale MS. 1; Cahn, 63; *MSS. à P.*, 329.

281. Bourges, Bibliothèque Municipale MS. 3; Cahn, 58; *MSS. à P.*, 332.

282. Paris, Bibliothèque Nationale MS. lat. 58; Cahn, p. 273.

283. See M. Labrousse, 'Étude ... des initiales historiées de la "Bible de Souvigny"', *Cahiers de Civilisation Médiévale*, VIII (1965), pp. 397–412.

284. *MSS. à P.*, 331.

285. Suger ed. Panofsky, p. 42.

286. D. and T., p. 46.

287. *Ibid.*, pp. 36–8; Demus (1970), pp. 415–16.

288. D. and T., p. 34.

289. *Ibid.*, pp. 56–60; Demus (1970), p. 416.

290. D. and T., pp. 47–8.

291. *Ibid.*, p. 49.

292. *Ibid.*, p. 49.

293. *Ibid.*, pp. 49–52; Demus (1970), p. 416.

294. See Fernand Mercier, *Les Primitifs français, la peinture clunysienne* (Paris, 1931); Joan Evans, *Cluniac Art of the Romanesque Period* (Cambridge, 1950), pp. 26 f.; Edgar Waterman Anthony, *Romanesque Frescoes* (Princeton, 1951), pp. 135 f.; Demus (1970), pp. 416–17.

295. Demus (1970), p. 292.

296. D. and T., pp. 140–1; Demus (1970), p. 417.

297. Demus (1970), p. 418.

298. *Ibid.*

299. D. and T., pp. 60–2.

300. G. Gaillard, *Les Fresques de Saint-Savin* (Paris, 1944); P. Deschamps, 'Les Peintures de l'église de Saint-Savin', *Congrès Archéologique de France, CIXᵉ Session* (1952), pp. 437–9; Élisa Maillard, *L'Église de Saint-Savin-sur-Gartempe* (Paris, 1926); Henri Focillon, *Peintures romanes des églises de France* (Paris, 1950), plates 1–39; Demus (1970), pp. 420–3.

301. By Grabar, as quoted by Demus (1970), p. 102.

302. Poitiers, Bibliothèque Municipale MS. 250; see above, p. 334.

303. By I. Yoshikawa – see his *L'Apocalypse de Saint-Savin* (Paris, 1939).

304. George Henderson, 'The Sources of the Genesis Cycle at Saint-Savin-sur-Gartempe', *Journal of the British Archaeological Association*, 3rd series, XXVI (1963), pp. 11–26, especially pp. 18–21.

305. D. and T., pp. 69–71; Demus (1970), p. 419.

306. D. and T., pp. 86–8; Demus (1970), p. 423; Marc Thibout, 'Découverte de peintures murales dans l'église Saint-Jean-Baptiste de Château-Gontier', *Bulletin Monumental*, CI (1942), pp. 5–40.

307. D. Bogner, 'Die Fresken von Saint-Martin und von Saint-Julien in Tours und ihre Stellung in der romanischen Malerei des Loiregebietes', *Wiener Jahrbuch für Kunstgeschichte*, XXX/XXXI (1977–8), pp. 22–3.

308. A. Grabar, 'Fresques romanes copiées sur les miniatures du Pentateuque de Tours', *Cahiers archéologiques*, IX (1957), pp. 329–41; see also A. S. Cahn, 'A Note: the Missing Model of the Saint-Julien de Tours Frescoes ...', *ibid.*, XVI (1966), pp. 203–7.

309. See below, p. 251.

310. Grabar, *op. cit.*, p. 332.

311. D. Bogner, *op. cit.*, pp. 12–14.

312. D. and T., pp. 100–2; Demus (1970), p. 424.

313. D. and T., pp. 38–45; Demus (1970), p. 424.

314. D. and T., pp. 88–9; Demus (1970), p. 425.

315. Mortet, I, p. 94.

316. D. and T., pp. 88–9.

317. Demus (1970), p. 425.

318. Don Denny, 'A Romanesque Fresco in Auxerre Cathedral', *Gesta*, XXV (1986), pp. 197–202.

319. D. and T., pp. 102–4; Demus (1970), pp. 424–5.

320. D. and T., pp. 115–17; Demus (1970), p. 425.

321. D. and T., pp. 118–20; Demus (1970), p. 426.

322. By Robert Gérard, *Sur un prieuré bénédictin de la route des pèlerinages – Saint-Gilles de Montoire* (Paris, 1935), pp. 51–2.

323. D. and T., pp. 131–2; Demus (1970), p. 427.

324. D. and T., pp. 113–15; Demus (1970), p. 427.

325. Louis Bréhier, 'Peintures romanes d'Auvergne', *Gazette des Beaux-Arts*, LXIX (2) (1927), p. 136.

326. Demus (1970), p. 427.

327. Voichita Munteanu, *The Cycle of Frescoes of the Chapel of Le Liget* (New York and London, 1978).

328. *Ibid.*, pp. 37–9, 48, chapter IV.

329. *Ibid.*, pp. 71–83.

330. *Ibid.*, pp. 159–64.

331. *Ibid.*, figures 118 and 119.

332. Demus (1970), p. 428.

333. D. and T., pp. 126–30; Demus (1970), pp. 428–9.

334. Demus (1970), p. 429.

335. *Ibid.*, pp. 429–30.

336. See below, p. 379.

337. As next Note, pp. 261 f.

338. Nâsir-i-Khosrau, quoted in Hugues Vincent and F.-M. Abel, *Jérusalem Nouvelle* (Hugues Vincent, *Jérusalem: Recherches de topographie, d'archéologie et d'histoire*, II) (Paris, 1914), p. 252.

339. *Ibid.*, pp. 253, 261–2.

340. W. Harvey *et al.*, *The Church of the Nativity at Bethlehem* (London, 1910), p. 26.

341. Quoted in full, *ibid.*, p. 43.

342. *Ibid.*, p. 26.

343. By Brother Felix Fabri, quoted *ibid.*, pp. 67–8.

344. *Ibid.*, pp. 34 and 43.

345. John Phocas, soldier turned monk; quoted in full in Harvey, *op. cit.*, pp. 65–6.

346. T. S. R. Boase, 'The Arts in the Latin Kingdom of Jerusalem', *Journal of the Warburg Institute*, II (1938–9), p. 13.

347. Hugo Buchthal, *Miniature Painting in the Latin Kingdom of Jerusalem* (Oxford, 1957).

348. *Ibid.*, pp. 12, 13, 15, 34.

349. British Library MS. Egerton 1139, for which see *ibid.*, pp. 1 ff.

350. *Ibid.*, pp. 2 ff.

351. *Ibid.*, p. 14.

352. Paris, Bibliothèque Nationale MS. lat. 276 and Rome, Biblioteca Vaticana MS. Vat. lat. 5974.

353. Buchthal, *op. cit.*, pp. 25 ff.

354. For them, see Kurt Weitzmann, 'Crusader Icons on Mount Sinai', *Actes du XIIᵉ Congrès international d'études byzantines*, III (Belgrade, 1964), pp. 409–13, and idem, 'Icon Painting in the Crusader Kingdom', *Dumbarton Oaks Papers*, XX (1966), pp. 51–83.

CHAPTER 10

1. See P. B. Gams, *Die Kirchengeschichte von Spanien* (Regensburg, 1874), II (2), pp. 321 ff., and F. Meyrick, *The Church in Spain* (London, 1892), chapter XXI.

2. *Pat. Lat.*, LXXX, col. 147.

3. *Heterii et Sancti Beati ad Elipandum Epistola* (*Pat. Lat.*, XCVI, col. 901).

4. *Ibid.*, cols. 893–1030.

5. They are surveyed by Wilhelm Neuss, *Die Apokalypse des Hl. Johannes in der altspanischen und altchristlichen Bibel-illustration*, 2 vols. (Münster, 1931). One or two of the manuscripts have been given new press-marks since Neuss's day: the new ones, and a concordance with the symbols used by Neuss, can be found on pp. 102–27 of the exhibition catalogue *Los Beatos* (*Europalia 85 España*, Chapelle de Nassau, Bibliothèque royale Albert Iᵉʳ, 1985). See also *Actas del Simposio para el estudio de los códices del 'Comentario al Apocalipsis' de Beato de Liébana*, 3 vols. (Madrid, 1978–80), vols. 2–3.

6. See G. G. King, 'Divagations on the Beatus', *Art Studies*, VIII (1) (1930), p. 25, note 3, for documents in the Beatus at Burgo de Osma.

7. King, *op. cit.*, pp. 9–10, 52–3.

8. Henry A. Sanders, *Beati in Apocalipsin Libri Duodecim* (*Papers and Monographs of the American Academy in Rome*, VII) (Rome, 1930), p. 2.

9. *Pat. Lat.*, XCVI, col. 907.

10. *Ibid.*, cols. 924, 933.

11. *Ibid.*, cols. 977 ff.: 'De Christo et eius Corpore quod est ecclesia et de diabolo et eius corpore quod est Antichristus.'

12. Neuss, *op. cit.*, I, pp. 73–80, II, figures 209–18.

13. *Ibid.*, I, pp. 119–25, II, figures 14–29.

14. *Pat. Lat.*, XCVI, col. 911.

15. C. O. Nordström, 'Text and Myth in some Beatus Miniatures', *Cahiers Archéologiques*, XXV (1976), pp. 7 ff.

16. Neuss, *op. cit.*, I, pp. 125 ff.

17. In the Gerona MS. of 975 (Gerona, Archivo de la Catedral MS. 7) and in the Turin MS. of the late eleventh or early twelfth century (Turin, Biblioteca Nazionale MS. I.II.1); see Neuss, *op. cit.*, I, p. 126, II, figure 28.

18. In the eleventh-century Saint-Sever MS. (Paris, Bibliothèque Nationale MS. lat. 8878); see Neuss, *op. cit.*, I, p. 126, II, figure 30.

19. As, among others, in the Gerona MS., the Saint-Sever MS., and the twelfth-century Rylands MS. (Manchester, John Rylands University Library MS. 8); see Neuss, *op. cit.*, I, p. 126, II, figure 29.

20. In the Gerona and Turin MSS.; see Neuss, *op. cit.*, I, p. 127.

21. *Ibid.*, I, pp. 116–19, II, figures 6–13.

22. Madrid, Biblioteca Nacional MS. Vit. 14–2; see Umberto Eco, *Beato di Liébana. Miniature del Beato de Fernando I y Sancha (Codice B. N. Madrid Vit. 14–2)* (Parma, 1973).

23. In two tenth-century MSS. – the Gerona Beatus and the Urgel Beatus (Archivo de la Catedral MS. 4) – in the Saint-Sever MS., and in the Turin and Rylands MSS.; see Neuss, *op. cit.*, I, pp. 133–4, II, figure 222.

24. Neuss, *op. cit.*, I, pp. 133–4.

25. Sanders (ed.), *op. cit.*, pp. 255–63.

26. See St Augustine (*Pat. Lat.*, XLI, cols. 472–6) and St Hilary (*ibid.*, IX, col. 874).

27. Neuss, *op. cit.*, I, pp. 71–3, II, figures 90–5.

28. *In Libros Veteris ac Novi Testamenti Prooemia, Pat. Lat.*, LXXXIII, col. 169.

29. On the Daniel illustrations, see Neuss, *op. cit.*, I, pp. 222–36, II, figures 196–208.

30. Gams, *op. cit.* (Note 1), II (2), p. 323, and Meyrick, *op. cit.* (Note 1), pp. 270, 274.

31. Nordström, *op. cit.*, pp. 30 and 36.

32. Neuss, *op. cit.*, I, pp. 113–14, II, figure 1; Pedro de Palol and Max Hirmer, *Early Medieval Art in Spain* (London, 1967), plate VIII.

33. Neuss, *op. cit.*, I, p. 113.

34. Rafael Altamira, 'Spain 1031–1248', *Cambridge Medieval History*, VI (Cambridge, 1929), chapter XII, p. 421.

35. C. U. Clark, 'Collectanea Hispanica', *Transactions of the Connecticut Academy of Arts and Sciences*, XXIV (1920), pp. 66 f.

36. Neuss, *op. cit.*, I, p. 40. Compare the end of the colophon with that in Berlin, Staatsbibliothek MS. Phillipps 1662, folio 241, a manuscript given to Saint-Vincent at Metz by Bishop Dietrich.

37. New York, Pierpont Morgan Library MS. 644. The date recorded in the colophon was read by Neuss (*op. cit.*, I, pp. 12 f.) as 922, but the wording in which it is given is difficult to interpret, and has anyway been partially obscured by an erasure. Stylistic and paleographical criteria suggest that the manuscript was produced in the 950s. See Peter K. Klein, *Der ältere Beatus-Kodex Vitr. 14–1 der Biblioteca Nacional zu Madrid* (Hildesheim and New York, 1976), pp. 280 ff.

38. Neuss, *op. cit.*, I, p. 12.

39. Cod. 1097B of the Archivo Histórico Nacional of Madrid; see Neuss, *op. cit.*, I, p. 19.

40. Valladolid, Biblioteca de la Universidad MS. 433; see Neuss, *op. cit.*, I, pp. 16–18.

41. *Sancti Beati a Liebana in Apocalipsin Codex Gerundensis*, I, ed. Titus Burckhardt (Olten and Lausanne, 1962), pp. 49 and 69–71.

42. MS. 1 of the cathedral library of Burgo de Osma; see Neuss, *op. cit.*, I, p. 37.

43. British Library Add. MS. 11695; see Neuss, *op. cit.*, I, pp. 39–40.

44. C. U. Clark, *op. cit.* (Note 35), p. 60, no. 696; Toledo, Biblioteca Capitular MS. 14, 23.

45. *Ibid.*, p. 54, no. 669; Paris, Bibliothèque Nationale MS. nouv. acq. lat. 2170.

46. Valladolid, Biblioteca de la Universidad MS. 433; Neuss, *op. cit.*, I, p. 17.

47. Cod. 1097B of the Archivo Histórico Nacional of Madrid; Neuss, *op. cit.*, I, p. 19.

48. See above, p. 40.

49. New York, Pierpont Morgan Library MS. 644; see Neuss, *op. cit.*, I, p. 12.

50. For a comprehensive survey of Mozarabic art, see Mireille Mentré, *La Peinture mozarabe* (Paris, 1984), and for a study of the Mozarabic aspect of the Beatus manuscripts, with excellent colour reproductions, Henri Stierlin, *Los Beatos de Liébana y el arte mozárabe* (Madrid, 1983).

51. M. C. Ross, *Arts of the Migration Period in the Walters Art Gallery* (Baltimore, 1961), pp. 100–1.

52. New York, Pierpont Morgan Library MS. 644.

53. Helmut Schlunk, 'Observaciones en torno al problema de la miniatura

visigoda', *Archivo Español de Arte*, XVIII (1945), pp. 241–65, figures 13–15, 25.

54. For example the Gerona Beatus (Archivo de la Catedral MS. 7) and the Valladolid one (Biblioteca de la Universidad MS. 433). A facsimile of the Gerona Beatus has been published under the editorship of T. Burckhardt, *Sancti Beati a Liebana in Apocalypsin Codex Gerundensis* (Olten and Lausanne, 1962).

55. See, for example, the Beatuses of Urgel (Archivo de la Catedral MS. 4) and of Valladolid (Biblioteca de la Universidad MS. 433).

56. Schlunk, *op. cit.*, figure 19.

57. Neuss, *op. cit.*, II, figures 47, 78.

58. E. H. Zimmermann, *Vorkarolingische Miniaturen* (Berlin, 1916), III, 170.

59. Blas Taracena, 'Arte Romano', *Ars Hispaniae*, II (Madrid, 1947), plate II opposite p. 220.

60. Schlunk, *op. cit.*, figure 9.

61. Zimmermann, *op. cit.*, III, 222.

62. *Ibid.*, 248.

63. *Ibid.*, IV, 269.

64. Neuss, *op. cit.*, II, figure 47.

65. Zimmermann, *op. cit.*, IV, 255.

66. *Ibid.*, III, 195.

67. Neuss, *op. cit.*, II, figures 48, 66, 71, 86, 110, 127, 143, 170, 188.

68. For the interlace initials, see Jacques Guilmain, 'Observations on some Early Interlace Initials ... in Mozarabic Manuscripts', *Scriptorium*, XV (1961), pp. 23–35; *idem*, 'Zoomorphic Decoration ...', *Speculum*, XXXV (1960), pp. 17–38; *idem*, 'Interlace Decoration and the Influence of the North ...', *Art Bulletin*, XLII (1960), pp. 211–18.

69. André Grabar and Carl Nordenfalk, *Early Medieval Painting* (Lausanne, 1957), p. 165.

70. Cf. Neuss, *op. cit.*, I, 238–41 and 243–4, and Schlunk, *op. cit.*, pp. 245–6.

71. See L-B D, 266, 2826, 2830, 2832. In England, Abbot Henry of Glastonbury (1126–71) – i.e. Henry of Blois – presented his church with a tapestry of Saracenic workmanship – see L-B E, 1868.

72. Theophilus ed. Dodwell, p. 4.

73. L-B D, 2941.

74. Walter W. S. Cook, 'The Stucco Altar-Frontals of Catalonia', *Art Studies*, II (1924), p. 74.

75. *Ibid.*

76. Quoted by F. Meyrick, *op. cit.* (Note 1), pp. 262–3.

77. Cook, *op. cit.*, p. 75.

78. *Ibid.*

79. C. U. Clark, *op. cit.*, p. 45, no. 614 (Madrid, Biblioteca Nacional MS. Tolet. 2,1 (Vit. 4)).

80. *Ibid.*, p. 49, no. 641 (Montecassino, MS. 19).

81. *Ibid.*, pp. 33 and 34, nos. 524, 531, 536 (Escorial, MSS. &.I.14, R.II.18, T.II.24)).

82. *Ibid.*, p. 44, no. 610 (Madrid, Biblioteca Nacional MS. Gg 132).

83. Cook, *op. cit.*, p. 75, note 5.

84. Clark, *op. cit.*, p. 32, no. 520 (Escorial, MS. d.I.2).

85. *Ibid.*, p. 63, no. 709 (in Urgel, Chapter Library).

86. King, *op. cit.* (Note 6), p. 35 and plate I.

87. Burckhardt, *op. cit.* (Note 54), preface.

88. John Williams, 'The *Moralia in Job* of 945: Some Iconographic Sources', *Archivo Español de Arqueología*, XLV-VII (1972–4), p. 234.

89. Cook, *op. cit.*, p. 76.

90. *Ibid.*, p. 71, note 5.

91. *Ibid.*

92. *Ibid.*, p. 71.

93. *Ibid.*, p. 77.

94. Theophilus ed. Dodwell, p. 4.

95. British Library Add. MS. 11695; see Neuss, *op. cit.*, II, figure 56.

96. King, *op. cit.*, plate IV.

97. New York, Pierpont Morgan Library MS. 644.

98. Madrid, Biblioteca Nacional MS. Vit. 14–2.

99. Madrid, Archivo Histórico Nacional Cod. 1097B.

100. Madrid, Museo Arqueológico Nacional MS. 2, and New York, Pierpont Morgan Library MS. 429.

101. Clark, *op. cit.* (Note 35), pp. 192 ff., plates 43–5; Wilhelm Neuss, *Die Katalanische Bibelillustration um die Wende des ersten Jahrtausends und die altspanische Buchmalerei* (Bonn and Leipzig, 1922), pp. 72 ff.

102. Cod. 6.

103. Real Colegiata de San Isidoro cod. 2.

104. Folio 514.

105. A Cassiodorus on the Psalms completed in 953 in the same library; Clark, *op. cit.*, pp. 36 (no. 552) and 192.

106. John W. Williams, 'A Castilian Tradition of Bible Illustration', *Journal of the Warburg and Courtauld Institutes*, XXVIII (1965), p. 68.

107. *Ibid.*, p. 69.

108. *Ibid.*, pp. 66 ff.

109. *Ibid.*, p. 74.

110. Neuss, *Apokalypse*, I, p. 224.

111. Paris, Bibliothèque Nationale MS. nouv. acq. lat. 2334.

112. Burckhardt, *op. cit.* (Note 54), I, p. 59.

113. Williams, *op. cit.* (Note 106), p. 73.

114. *Ibid.*, pp. 71–2.

115. The information which follows on Count Oliba and Abbot Oliba is derived from Joseph Pijoan's article, 'Oliba de Ripoll (971–1046)', in *Art Studies*, VI (1928), pp. 81–101.

116. Cod. Vat. lat. 5729; see Neuss, *Bibelillustration*, pp. 16 ff.

117. *Ibid.*, pp. 21 ff.

118. British Library, Cotton MS. Claudius B.IV; see above, pp. 185–7.

119. Paris, Bibliothèque Nationale MS. lat. 6; see Peter K. Klein, 'Date et scriptorium de la Bible de Roda ...', *Les Cahiers de Saint-Michel de Cuxa*, III (1972), pp. 91–102.

120. Barcelona, Archivo de la Corona de Aragón MS. Riv. 52; Klein, *op. cit.*, p. 95.

121. Peter K. Klein, 'Der Apokalypse-Zyklus der Roda-Bibel ...', *Archivo Español de Arqueología*, XLV-VII (1972–4), pp. 267–333.

122. *Ibid.*, pp. 296–7.

123. Burgos, Biblioteca Provincial MS. 846; Cahn, 141.

124. J. Y. Luaces, 'Las Miniaturas de la Biblia de Burgos', *Archivo Español de Arte*, XLII (1969), pp. 185–203.

125. Coimbra, Biblioteca-Geral da Universidade MS. 31432; Cahn, 142.

126. Colegiata de San Isidoro cod. I.3; Cahn, 143.

127. See below, p. 344.

128. The decoration of the mosque of the Umayyads at Damascus is, in fact, comparable; see C. Diehl, *La Peinture byzantine* (Paris, 1933), plate XVIII.

129. See Helmut Schlunk, 'Las Pinturas de Santullano. Avance al estudio de la pintura mural asturiana de los siglos IX y X', *Archivo Español de Arqueología*, XXV (1952), pp. 15–37; *idem* and Magín Berenguer, *La Pintura mural asturiana de los siglos IX y X* (Madrid, 1957), pp. 14 ff.

130. Schlunk, 'Las Pinturas', p. 22 and figure 5.

131. Walter William Spencer Cook and José Gudiol Ricart, *Pintura y imaginería románicas (Ars Hispaniae, VI)* (Madrid, 1950), p. 21.

132. Such as those of the Barcelona *Moralia in Job* – Barcelona Cathedral MS. 102.

133. Cook and Gudiol Ricart, *op. cit.*, p. 22 and figure 6.

134. *Ibid.*, pp. 22 ff., figures 3–5.

135. Neuss, *Apokalypse*, II, figure 193.

136. In the Early Christian mausoleum at Centcellas near Tarragona; see Grabar and Nordenfalk, *op. cit.* (Note 69), p. 62.

137. Cook and Gudiol Ricart, *op. cit.*, figure 2.

138. Charles L. Kuhn, 'Notes on Some Spanish Frescoes', *Art Studies*, VI (1928), figures 1 and 2, opposite p. 123.

139. Cook and Gudiol Ricart, *op. cit.*, pp. 25 f., figures 7 and 8.

140. *Ibid.*, p. 26.

141. See above, p. 246.

142. It appears, for example, at Saint-Martin de Fenollar and San Pedro de Sorpe, and may also be found on altar frontals from Vich and Llusá.

143. As, for example, in the frescoes of Santa María de Mur, Saint-Martin de Fenollar, San Martín del Brull, San Salvador de Poliñá, and Santa María de Barbará.

144. As in San Clemente, Rome. See, on the iconography, Charles L. Kuhn, *Romanesque Mural Painting of Catalonia* (Cambridge, Mass., 1930), p. 77.

145. See above, p. 245.

146. As at San Miguel d'Engolasters.

147. See also San Pedro del Burgal.

148. See Kuhn, *op. cit.* (Note 144), pp. 89–90.

149. *Ibid.*, p. 29.

150. *Ibid.*, p. 17.

151. Demus (1970), p. 478.

152. *Ibid.*, p. 476.

153. Marcel Durliat, *L'Art roman en Espagne* (Paris, 1962), p. 47.

154. See, as one example, Cook and Gudiol Ricart, *op. cit.*, pp. 57–8.

155. *Ibid.*, p. 65.

156. Now in the Art Museum at Worcester, Mass.

157. See P. Duval, *La Pensée alchimique et le conte du Graal* (Paris, 1979), p. 169.

158. I owe the suggestion to Timothy Graham.

159. Durliat, *op. cit.*, p. 47; Demus (1970), p. 478.

160. W. W. S. Cook, *La Pintura mural románica en Cataluña* (Madrid, 1956), pp. 25–6; Cook and Gudiol Ricart, *op. cit.*, p. 48; Demus (1970), p. 478.

161. *Le Guide du pèlerin de Saint-Jacques de Compostelle*, ed. Jeanne Vielliard (Mâcon, 1950).

162. See Cook, *op. cit.*, pp. 13–14; Cook and Gudiol Ricart, *op. cit.*, pp. 17,

32–43; Palol and Hirmer, *op. cit.* (Note 32), pp. 176–8; Demus (1970), p. 479.

163. Demus (1970), p. 480.

164. Cook, *op. cit.*, pp. 24–5; Cook and Gudiol Ricart, *op. cit.*, p. 48; Demus (1970), p. 478.

165. Cook, *op. cit.*, pp. 14–15; Cook and Gudiol Ricart, *op. cit.*, pp. 43–8; Demus (1970), pp. 478–9.

166. Cook and Gudiol Ricart, *loc. cit.*, especially p. 47.

167. Cook and Gudiol Ricart, *op. cit.*, p. 43. Demus (p. 57) considers that he went from Aragon to Catalonia.

168. Cook and Gudiol Ricart, *op. cit.*, pp. 149–54; Durliat, *op. cit.*, pp. 48 and 79; Demus (1970), pp. 480–1.

169. Cook and Gudiol Ricart, *op. cit.*, pp. 139–49; Durliat, *op. cit.*, p. 79; Demus (1970), pp. 481–2.

170. Diehl, *op. cit.* (Note 128), plate XXV.

171. Otto Demus, *The Mosaics of Norman Sicily* (London, 1950), plate 116.

172. El Marqués de Lozoya, 'Pinturas románicas en la parroquia de San Justo de Segovia', *Archivo Español de Arte*, XXXVIII (1965), pp. 81–5.

173. Cook and Gudiol Ricart, *op. cit.*, pp. 154–60; Demus (1970), pp. 484–5.

174. See J. Williams, 'San Isidoro in León: Evidence for a New History', *Art Bulletin*, LV (1973), pp. 171–84. It has generally been assumed that the construction of the Panteón was contemporary with the rebuilding of the church, though it has also been argued that it was not built until after Ferdinand's death, under the patronage of his daughter Urraca.

175. See Williams, *op. cit.*, and Janine Wettstein, *La Fresque romane*, II (Geneva, 1978), pp. 121–2.

176. See above, p. 220.

177. The view of Jean Ainaud, as quoted by Durliat, *op. cit.*, p. 48.

178. Cook, *op. cit.*, pp. 30–1; Cook and Gudiol Ricart, *op. cit.*, p. 88; Demus (1970), p. 482.

179. B. Al-Hamdani, 'The Genesis Scenes in the Romanesque Frescoes of Bagüés', *Cahiers archéologiques*, XXIII (1974), pp. 169–94.

180. Wettstein, *op. cit.*, pp. 99–108.

181. Cook, *op. cit.*, pp. 30–1; Cook and Gudiol Ricart, *op. cit.*, pp. 88–91; Demus (1970), p. 482.

182. *Ibid.*; *ibid.*; *ibid.*

183. Cook and Gudiol Ricart, *op. cit.*, p. 91; Demus (1970), p. 482.

184. Cook, *op. cit.*, pp. 18–19; Cook and Gudiol Ricart, *op. cit.*, p. 53; Demus (1970), p. 482.

185. Cook, *op. cit.*, pp. 29–30; Cook and Gudiol Ricart, *op. cit.*, pp. 80, 87; Demus (1970), p. 482.

186. Cook, *op. cit.*, pp. 23–4; Cook and Gudiol Ricart, *op. cit.*, p. 69; Demus (1970), p. 482.

187. The richest churches and sanctuaries of Spain did of course possess altar frontals made of precious metals, as we know from written records. These were melted down in the sixteenth, seventeenth, and eighteenth centuries, and none remains today. Cf. Walter W. S. Cook, 'The Stucco Altar-Frontals of Catalonia', *Art Studies*, II (1924), pp. 41–2.

188. Cook and Gudiol Ricart, *op. cit.*, pp. 190–3.

189. However, as we shall see, the Seo de Urgel and Hix frontals are assigned by some scholars to the late eleventh/early twelfth century.

190. Cook and Gudiol Ricart, *op. cit.*, p. 193.

191. *L'Art roman: exposition*, catalogue (Barcelona and Santiago de Compostella, 1961), p. 33 for both frontals.

192. Cook and Gudiol Ricart, *op. cit.*, pp. 193–4.

193. *Ibid.*, p. 194.

194. *Ibid.*

195. *Ibid.*

196. *Ibid.*, p. 203.

197. *Ibid.*, pp. 203–4.

198. *Ibid.*, pp. 204–9.

199. C. R. Post, *A History of Spanish Painting*, I (Cambridge, Mass., 1930), pp. 238–40.

200. Cook and Gudiol Ricart, *op. cit.*, p. 204, where it is attributed to Ripoll.

201. *Ibid.*, where they are attributed to Ripoll. Édouard Junyent, *Catalogne romane*, II (Éditions Zodiaque, 1961), p. 246, attributes them to Vich.

202. Said by Cook and Gudiol Ricart (*op. cit.*, p. 210) to be from a hermitage near Torelló, and in the catalogue of *L'Art roman* (pp. 187–8) to be from the monastery of Santa Margarita in Vilaseca in the parish of San Martín Sescorts (Barcelona).

203. Cook and Gudiol Ricart, *op. cit.*, p. 210.

204. *Ibid.*

205. *Ibid.*, p. 215.

206. Cook, *op. cit.*, p. 32; Cook and Gudiol Ricart, *op. cit.*, pp. 91–2; Demus (1970), pp. 482–3.

207. Whose accounts may be found in the *Materials for the History of Thomas Becket*, ed. J. C. Robertson, Rolls Series (London, 1875–85). For Grim's description of the martyrdom in his *Vita S. Thomae*, see vol. II, pp. 436–8; for

Herbert of Bosham's account, vol. III, p. 498.

208. Herbert says (*loc. cit.*) that he has mentioned Grim's name in order that his memory may be blessed ('cujus memoria ut in benedictione sit'), which implies that Grim was dead at the time of writing. Herbert's *Vita* was written some time after 18 August 1186 and before 1190.

209. Cook and Gudiol Ricart, *op. cit.*, p. 215.

210. *Ibid.*, pp. 173–4; Demus (1970), p. 487.

CHAPTER 11

1. MS. 1; Cahn, 48. The colophon is on the last folio.

2. British Library MSS. Add. 28106 and 28107; Cahn, 47.

3. Folio 228 of the first volume and folio 240 of the second.

4. Brussels, Bibliothèque Royale MS. II.1179.

5. See C. Gaspar and F. Lyna, *Les Principaux Manuscrits à peintures de la Bibliothèque Royale de Belgique* (Paris, 1937), pp. 66–9; Suzanne Collon-Gevaert and others, *Art roman dans la vallée de la Meuse aux XI^e et XII^e siècles* (Brussels, 1962), p. 156.

6. For which see Wayne Dynes, *The Illuminations of the Stavelot Bible* (New York and London, 1978).

7. K. H. Usener, 'Les Débuts du style roman dans l'art mosan', *L'Art mosan*, ed. P. Francastel (Paris, 1953), pp. 103–12.

8. Dynes, *op. cit.*, p. 73.

9. *Ibid.*, pp. 94 ff.

10. *Ibid.*, pp. 210 ff.

11. *Ibid.*, pp. 213–14.

12. See below, p. 273.

13. A. Boutemy, 'La Miniature', in E. de Moreau, *Histoire de l'Église en Belgique*, II (Brussels, 1945), p. 321.

14. British Library MS. Add. 28107 folio 136.

15. Hanns Swarzenski, *Monuments of Romanesque Art* (London, 1954), plates 110–13 and p. 58, with bibliography.

16. See Marcel Laurent, 'Art rhénan, art mosan et art byzantin: la Bible de Stavelot', *Byzantion*, VI (1931), pp. 89–90, 93.

17. Swarzenski, *op. cit.*, p. 30.

18. See K. H. Usener, 'Das Breviar Clm. 23261 der bayerischen Staatsbibliothek und die Anfänge der romanischen Buchmalerei in Lüttich', *Münchner Jahrbuch der bildenden Kunst*, III. Folge, Band 1 (1950), pp. 78–92.

19. *Ibid.*, pp. 82–3.

20. *Ibid.*, p. 85.

21. Munich, Bayerische Staatsbibliothek Clm. 13067; Cahn, p. 263.

22. Brussels, Bibliothèque Royale MS. II.1639, and Namur, Musée Archéologique, Fonds de la Ville, no. 4; Cahn, 39.

23. Liège, Bibliothèque de l'Université MSS. 224–5; Cahn, no. 44.

24. Brussels, Bibliothèque Royale MSS. 9916–17; Boutemy, *op. cit.*, pp. 354–5.

25. Harley MS. 1585 p. 14.

26. Liège, Bibliothèque de l'Université MS. 363C.

27. British Library Add. MSS. 17737–8; Cahn, 46.

28. These dates are disputed by Gretel Chapman in 'The Bible of Floreffe: Redating of a Romanesque Manuscript', *Gesta*, X/2 (1971), pp. 49–62, but see the ripostes by Herbert Köllner, 'Zur Datierung der Bibel von Floreffe ...', *Rhein und Maas: Kunst und Kultur 800–1400* (Schnütgen-Museum, Cologne, 1973), II, pp. 361–76, and by Elisabeth Klemm, *Ein romanischer Miniaturenzyklus aus dem Maasgebiet* (Vienna, 1973), pp. 88–9.

29. Peter Lasko, *Ars Sacra* (Pelican History of Art) (Harmondsworth, 1972), plate 205.

30. Brussels, Bibliothèque Royale MS. 10527; Cahn, p. 265.

31. Köllner, *op. cit.*, p. 372.

32. Brussels, Bibliothèque Royale MS. II.2524; Cahn, 42.

33. Cologne, Dombibliothek MS. 157.

34. Berlin, Staatliche Museen, Kupferstichkabinett MS. 78A6; discussed by Klemm, *op. cit.*, and see *Ornamenta Ecclesiae*, B 76.

35. Klemm, *op. cit.*, pp. 67–71.

36. Swarzenski, *op. cit.*, plate 113.

37. MS. 2613.

38. MS. 413.

39. Brussels, Bibliothèque Royale MSS. 9107–10; Cahn, 43.

40. British Library Add. MSS. 14788–90; Cahn, 45.

41. Bibliothèque Royale MS. II.2525; Cahn, 40.

42. Quoted by Cahn, p. 263; *Mon. Germ. Hist. SS.*, XIV, p. 311.

43. For Odo and the information on him given here, see A. Boutemy, 'Odon d'Orléans et les origines de la bibliothèque de l'abbaye de Saint-Martin de Tournai', *Mélanges dédiés à la mémoire de Félix Grat* (Paris, 1949), II, pp. 179–222.

44. Heriman in his *Liber de restauratione monasterii S. Martini Tornacensis* (*Mon. Germ. Hist. SS.*, XIV, p. 313) as quoted by Boutemy.

45. *The Ecclesiastical History of Orderic Vitalis*, ed. Marjorie Chibnall, II

(Oxford, 1969), pp. 49–51 (Chibnall's translation).

46. Boutemy, *op. cit.* (Note 43), pp. 212–13. He makes comparisons between this Bible and the Alardus Bible from Saint-Amand in Valenciennes, Bibliothèque Municipale MSS. 9–11.

47. A. Boutemy, 'Les Enlumineurs de l'abbaye de Saint-Amand', *Revue belge d'archéologie et d'histoire de l'art*, XII (1942), p. 166, and *idem*, 'Les Miniatures de la *Vita Anselmi* de Saint-Martin de Tournai et leurs origines', *ibid.*, XIII (1943), p. 118. He compares the St Gregory of Paris, Bibliothèque Nationale MS. lat 2288 with the St Augustine of Douai, Bibliothèque Municipale MS. 250.

48. Boutemy, *op. cit.* (1943), p. 119, comparing folio 44 verso of a Tournai manuscript in a private collection with folio 5 verso of Valenciennes, Bibliothèque Municipale MS. 501.

49. As Boutemy argues in *op. cit.* (1942), pp. 163–5. The manuscript is Metz, Bibliothèque Municipale Fonds Salis, MS. 37.

50. See Paul Rolland, *La Peinture murale à Tournai* (Brussels, 1946), and Demus (1970), pp. 608–9.

51. Brussels, Bibliothèque Royale MS. 1287.

52. Compare Saint-Omer, Bibliothèque Municipale MS. 1.

53. British Library Add. MS. 15219 folio 11 verso.

54. Identified by Demus (1970), p. 609.

55. *Ibid.*

56. *Ibid.*, pp. 604–6, and Albert Verbeek, *Schwarzrheindorf: Die Doppelkirche und ihre Wandgemälde* (Düsseldorf, 1953).

57. Verbeek, *op. cit.*, pp. liii–liv.

58. *Ibid.*, pp. lv ff.

59. *Ibid.*, pp. lvii–lviii.

60. Demus (1970), pp. 607–8.

61. *Ibid.*, p. 608.

62. A. Reichensperger, 'Die Deckengemälde in dem Kapitelsaale der Abtei zu Brauweiler bei Köln', *Jahrbücher des Vereins von Alterthumsfreunden im Rheinlande*, XI (1847), pp. 85 ff.

63. Munich, Staatsbibliothek Clm. 14055; Hermann Schnitzler, *Rheinische Schatzkammer: Die Romanik* (Düsseldorf, 1959), no. 20.

64. Cologne, Dombibliothek Dom MS. 59; *ibid.*, no. 23; *Ornamenta Ecclesiae*, A 20.

65. Albert Boeckler, 'Beiträge zur romanischen Kölner Buchmalerei', *Mittelalterliche Handschriften: Festgabe zum 60. Geburtstage von Hermann Degering* (Leipzig, 1926), p. 17.

66. Leipzig, Stadtbibliothek cod. CLXV; *ibid.*, pp. 22–4; Schnitzler, *op. cit.*, no. 21.

67. British Library Harley MS. 2889; Boeckler, *op. cit.* (Note 65), pp. 22–4; D. H. Turner, 'The Siegburg Lectionary', *Scriptorium*, XVI (1962), pp. 16–27.

68. Cologne, Stadtarchiv cod. 312a; Boeckler, *op. cit.*, p. 18; Schnitzler, *op. cit.*, no. 22.

69. Boeckler, *op. cit.*, p. 18.

70. Landesmuseum cod. 508; *ibid.*, pp. 16 ff.

71. Hessische Landesbibliothek cod. 530; *ibid.*; Schnitzler, *op. cit.*, no. 35.

72. Schnitzler, *op. cit.*, p. 43.

73. Boeckler, *op. cit.*, p. 17.

74. See Hanns Swarzenski, *Monuments of Romanesque Art* (London, 1954), p. 57, caption to figure 241, where the old number of MS. 508 is given. Others, it should be added, merely see great similarities between the two Majesties, e.g. Boeckler, *op. cit.*, pp. 16–17, and Elisabeth Verres-Schipperges, 'Studien zu zwei romanischen Handschriften aus der Abtei Gladbach', *München-Gladbach: aus Geschichte und Kultur einer rheinischen Stadt* (München-Gladbach, 1950), p. 464.

75. Cologne, Dombibliothek bibl. fol. 207; Boeckler, *op. cit.*, p. 24.

76. Bibliothèque Nationale MS. lat. 15675; Schnitzler, *op. cit.*, p. 29.

77. Cologne, Stadtarchiv; Boeckler, *op. cit.*, pp. 17–18.

78. Bibliothèque Nationale MS. lat. 17325; Schnitzler, *op. cit.*, no. 24.

79. Rheinisches Museum Inv. no. 15328. Nos. 15326–7 have been cut from the same manuscript (Trier, Dombibliothek MS. 132).

80. Kestner Museum Inv. 3984; *Ornamenta Ecclesiae*, A 19.

81. For Hildegard see *Wisse die Wege*, ed. Maura Böckeler (Berlin, 1928) (2nd ed. with colour plates but without descriptions, Salzburg, 1954); L. Baillet, 'Les Miniatures du "Scivias" de Sainte Hildegarde', *Fondation Eugène Piot: Monuments et mémoires publiés par l'académie des inscriptions et belles-lettres*, XIX (Paris, 1911), pp. 49–149; Charles Singer, 'The Scientific Views and Visions of Saint Hildegard (1098–1180)', *Studies in the History and Method of Science*, ed. Charles Singer (Oxford, 1917), pp. 1–55; *Hildegardis Scivias*, ed. Adelgundis Führkötter collaborante Angela Carlevaris (*Corpus Christianorum Continuatio Mediaevalis* XLIIIA) (Turnholti, 1978); and J. B. Pitra, *Analecta Sacra*, VIII: *Sanctae Hildegardis Opera Spicilegio Solesmensi Parata* (Monte Cassino, 1882).

82. Pitra, *op. cit.*, p. 332.

83. Formerly Wiesbaden, Hessische Landesbibliothek MS. 1.

84. Gräflich-Schönborn'sche Schlossbibliothek cod. 333–4; Cahn, 19.

85. London, British Library Harley MSS. 2803–4; Cahn, 9; Aliza Cohen-Mushlin, *The Making of a Manuscript: The Worms Bible of 1148* (Wiesbaden, 1983).

86. *Ibid.*, pp. 166 ff. and especially pp. 191–3.

87. *Ibid.*, p. 14.

88. *Ibid.*, p. 109. He takes over as the sole scribe-artist from folio 233 verso, which means that in the manuscript's present state, the last forty-one folios are entirely his work. However, it should be noted that the second volume is mutilated, and lacks the last chapters of Acts, the Catholic Epistles, and the Book of Revelation.

89. Vol. I, fol. 288 verso.

90. Cohen-Mushlin, *op. cit.*, p. 209.

91. British Library Harley MSS. 2798–9; Cahn, 8.

92. H. Köllner, 'Ein Annalenfragment und die Datierung der Arnsteiner Bibel in London', *Scriptorium*, XXVI (1972), pp. 34 ff.

93. Cahn, p. 253.

94. British Library Harley MSS. 2800–2.

95. British Library Harley MS. 3045.

96. See Dodwell (1982), p. 193. Such quotations are found in countries other than England.

97. Suger ed. Panofsky, pp. 54 and 60, 46, 62, 56 ff.

98. 'Materiam superabat opus' (*Metamorphoses* II, 5).

99. Theophilus ed. Dodwell, p. 4. Theophilus clearly knew nothing of England or Spain, but he indicates the artistic specializations of other major countries.

100. Franz Jansen, *Die Helmarshausener Buchmalerei zur Zeit Heinrichs des Löwen* (Hildesheim, 1933), pp. 10–11.

101. *Ibid.*, pp. 21 ff.

102. Malibu, J. Paul Getty Museum MS. Ludwig II, 3. See A. von Euw and J. M. Plotzek, *Die Handschriften der Sammlung Ludwig*, I (Cologne, 1979), pp. 153–8.

103. Jansen, *op. cit.*, p. 24.

104. Uppsala, University Library MS. C.83, and Copenhagen, Kongelige Bibliotek MS. Thott. quart. 21; *ibid.*, pp. 25 ff.

105. *Ibid.*, pp. 31–2.

106. Lasko, *op. cit.* (Note 29), p. 160.

107. Münster, Staatsarchiv MS. I.133; Jansen, *op. cit.*, pp. 33 ff.

108. Cathedral Chapter Library MS. 2; *ibid.*, pp. 46 ff.

109. MS. 73. See Adolph Goldschmidt, 'A German Psalter of the Twelfth Century written in Helmarshausen', *Journal of the Walters Art Gallery*, I (1938), pp. 19–23.

110. *Ibid.*, p. 22.

111. Ekkehard Krüger, *Die Schreib- und Malwerkstatt der Abtei Helmarshausen bis in die Zeit Heinrichs des Löwen* (Darmstadt and Marburg, 1972), p. 289.

112. British Library MS. Lansdowne 381.

113. Wolfenbüttel, Herzog August Bibliothek cod. Guelph 105 Noviss. 2°. See Jansen, *op. cit.*, pp. 61–95; Christopher de Hamel, *The Gospels of Henry the Lion* (Sotheby's, 1983); Horst Fuhrmann and Florentine Mütherich, *Das Evangeliar Heinrichs des Löwen und das mittelalterliche Herrscherbild* (Munich, 1986); and Frank Neidhart Steigerwald, *Das Evangeliar Heinrichs des Löwen* (Offenbach/M and Braunschweig, 1985).

114. Steigerwald, *op. cit.*, p. 11.

115. *Ibid.*, p. 35.

116. De Hamel, *op. cit.*, p. 20.

117. Steigerwald, *op. cit.*, p. 18.

118. Kassel, Landesbibliothek MS. theol. fol. 59; Jansen, *op. cit.*, pp. 109 ff.

119. Dombibliothek MS. 142; *ibid.*, pp. 118 ff.

120. Wolfenbüttel, Herzog August-Bibliothek MS. Helmst. 65; *ibid.*, pp. 128 ff.

121. Halberstadt, Dombibliothek cod. 1–2; Cahn, 4.

122. *Ibid.*, p. 252.

123. Cod. 1–3; Cahn, 13.

124. Cahn, p. 182.

125. Demus (1970), pp. 602–4, and Ruth Ehmke, *Der Freskenzyklus in Idensen* (Bremen and Horn, 1958).

126. Quoted Ehmke, *op. cit.*, p. 4.

127. First remarked by V. C. Habicht in 'Die neuentdeckten Fresken in Idensen', *Belvedere*, X (1931), pp. 149 ff.

128. Ehmke, *op. cit.*, pp. 28–9.

129. *Ibid.*, pp. 31–3.

130. *Ibid.*, pp. 56–8.

131. *Ibid.*, pp. 73–5.

132. *Ibid.*, p. 65.

133. See Johannes Sommer, *Das Deckenbild der Michaeliskirche zu Hildesheim* (Hildesheim, 1966); Demus (1970), pp. 614–15.

134. L-B D, 1112.

135. See Erwin Poeschel, *Die romanischen Deckengemälde von Zillis* (Erlenbach-Zürich, 1941); Peter Wiesmann, 'Zur Formensprache der Deckenbilder von Zillis', *Zeitschrift für schweizerische Archäologie und Kunstgeschichte*, XI (1950), pp. 17–21; Ernst Murbach, *Zillis. Die romanische*

Bilderdecke der Kirche St Martin (Zürich and Freiburg im Breisgau, 1967); and Susanne Brugger-Koch, *Die romanische Bilderdecke von Sankt Martin, Zillis (Graubünden), Stil und Ikonographie* (Muttenz, 1981).

136. I refer to the famous St Augustine Gospels at Corpus Christi College, Cambridge, MS. 286.

137. Murbach, *op. cit.*, pp. 23, 29.

138. R. Frauenfelder, '153 Fische', *Schaffhauser Nachrichten* (22 April 1967).

139. Murbach, *op. cit.*, p. 37.

140. See Beat Brenk, *Die romanische Wandmalerei in der Schweiz* (Bern, 1963), p. 25.

141. As suggested by Poeschel, *op. cit.*, p. 61.

142. Brenk, *op. cit.*, pp. 28 ff.

143. *Ibid.*, pp. 30–2.

144. *Ibid.*, p. 49.

145. *Ibid.*, pp. 42–4.

146. Demus (1970), p. 308.

147. *Ibid.*

148. Brenk, *op. cit.*, pp. 16 ff.

149. *Ibid.*, pp. 62–4.

150. *Ibid.*, pp. 69 ff.

151. *Ibid.*, pp. 136 ff.

152. *Ibid.*, pp. 143 ff.

153. *Ibid.*, pp. 149–50.

154. *Ibid.*, p. 148.

155. Wolfgang Hafner, 'Die Maler- und Schreiberschule von Engelberg', *Stultifera Navis*, XI (1954), pp. 13–20.

156. Engelberg, Stiftsbibliothek MSS. 3–5; Cahn, 2.

157. Hafner, *op. cit.*, p. 19 and figure 6 with caption.

158. Engelberg, Stiftsbibliothek MS. 14; *ibid.*, pp. 19–20.

159. Einsiedeln, Stiftsbibliothek MSS. 151 and 176.

160. Einsiedeln, Stiftsbibliothek MS. 1 (8); Cahn, 1.

161. Cahn, p. 251.

162. Einsiedeln, Stiftsbibliothek MS. 112.

163. Karl Löffler, *Schwäbische Buchmalerei in romanischer Zeit* (Augsburg, 1928), pp. 16 ff.

164. Stuttgart, Württembergische Landesbibliothek bibl. fol. 57, 56, 58 in their correct order. All further manuscript references in the following six notes are to the same library. For Boeckler's consideration of the Martyrology, see his *Das Stuttgarter Passionale* (Augsburg, 1923).

165. Cod. hist. 4° N 147; Löffler, *op. cit.*, pp. 5 ff.

166. Brev. 128; *ibid.*, pp. 35 ff.

167. Cod. hist. fol. 415; *ibid.*, pp. 40 ff.

168. *Ibid.*, pp. 58 ff.

169. *Ibid.*, p. 47.

170. Cod. hist. fol. 418; *ibid.*, pp. 65–7.

171. See R. Kahn, 'Hochromanische Handschriften aus Kloster Weingarten ...', *Städel Jahrbuch*, I (1921), pp. 60 ff., and A. Boeckler, 'Unerkannte Weingartner Bildhandschriften', *Adolf Goldschmidt zu seinem siebzigsten Geburtstag* (Berlin, 1935), pp. 35–9.

172. Fulda, Hessische Landesbibliothek Cod. Aa 6 and Aa 35, and Manchester, John Rylands University Library MS. 108. The Bible is now divided between three libraries: British Library Add. MS. 14791, New York, Pierpont Morgan Library MS. 11, and Fulda, Hessische Landesbibliothek Cod. Aa 16; see Cahn, 10.

173. Now Städel Museum, Frankfurt am Main, Inv. no. 622.

174. Fulda, Hessische Landesbibliothek Cod. Aa 35.

175. Bound into Stuttgart, Württembergische Landesbibliothek Cod. H.B.XIV.6.

176. Fulda, Hessische Landesbibliothek Cod. D 11.

177. Rosalie Green, Michael Evans, Christine Bischoff, and Michael Curschmann, *Hortus Deliciarum* (London and Leiden, 1979).

178. Quoted *ibid.*, p. 17.

179. British Library MS. Add. 42497; R. B. Green, 'The Flabellum of Hohenbourg', *Art Bulletin*, XXXIII (1951), pp. 153–5.

180. Green *et al.*, *op. cit.*, plates 167–8.

181. *Ibid.*, p. 31.

182. *Ibid.*, pp. 150, 210, 224.

183. *Ibid.*, p. 31.

184. Gérard Cames, *Byzance et la peinture romane de Germanie* (Paris, 1966).

185. O. Demus, *The Mosaics of Norman Sicily* (London, 1950), p. 447.

186. *Ibid.*, pp. 446–8.

187. Green *et al.*, *op. cit.*, p. 32.

188. *Ibid.*, pp. 137, 138, 140, 142, 162, 166, 167, 179.

189. K. Weitzmann, *Studies in Classical and Byzantine Manuscript Illumination* (Chicago, 1971), p. 304.

190. R. B. Green, 'The Adam and Eve Cycle in the *Hortus Deliciarum*', *Late Classical and Mediaeval Studies in Honor of Albert Mathias Friend, Jr*, ed. Kurt Weitzmann (Princeton, 1955), pp. 340–7.

191. Green *et al.*, *op. cit.*, pp. 33–4.

192. See folio 221 and p. 202.

193. Karlsruhe, Badische Landesbibliothek Cod. St Peter perg. 7; see Ellen J. Beer, *Das Evangelistar aus St Peter* (Vollfaksimile-Ausgabe) (Basel, 1961).

194. *Ibid.*, pp. 36–7.

195. Demus (1970), p. 601.

196. L-B D, 2684.

197. St Florian, Stiftsbibliothek Cod. XI.1; Cahn, 21; Georg Swarzenski, *Die Salzburger Malerei* (Leipzig, 1913), pp. 63 f.

198. Michaelbeuern, Stiftsbibliothek Cod. perg. 1; Cahn, 14; G. Swarzenski, *op. cit.*, pp. 67 ff.

199. Vienna, Österreichische Nationalbibliothek Cod. S.N.2701–2; Cahn, 26; G. Swarzenski, *op. cit.*, pp. 72 ff.; K. M. Swoboda, *Neue Aufgaben der Kunstgeschichte* (Brünn/Brno, 1935), pp. 47 ff.

200. Ilona Berkovits, *Illuminated Manuscripts in Hungary* (Shannon, 1969), p. 18.

201. See H. Swarzenski, 'Two Unnoticed Leaves from the Admont Bible', *Scriptorium*, X (1956), pp. 94–6.

202. Swoboda, *op. cit.*, p. 59.

203. *Ibid.*, pp. 52–4.

204. Munich, Bayerische Staatsbibliothek Clm. 15903.

205. Vienna, Österreichische Nationalbibliothek Cod. S.N. 2700.

206. Peter von Baldass *et al.*, *Romanische Kunst in Österreich* (Vienna, Hannover, Bern, 1962), pp. 66–7.

207. Munich, Bayerische Staatsbibliothek Clm. 8271.

208. G. Swarzenski, *op. cit.*, pp. 93 ff.

209. Munich, Bayerische Staatsbibliothek Clm. 15812 folio 1 verso.

210. Salzburg, Stiftsbibliothek St Peter Cod. A.IX.7, p. 128.

211. Salzburg, Stiftsbibliothek St Peter Cod. A. XII.18, 19, 20, vol. 1 folio 6.

212. Österreichische Nationalbibliothek Cod. 953.

452. 213. G. Swarzenski, *op. cit.*, pp. 97 ff.; Otto Mazal, *Buchkunst der Romanik* (Graz, 1978), pp. 217–18.

214. Österreichische Nationalbibliothek cod. 1244. The verses are on folio 2, and are printed by G. Swarzenski, *op. cit.*, p. 163.

215. Munich, Bayerische Staatsbibliothek Clm. 8272; see above, p. 236.

216. Vienna, Österreichische Nationalbibliothek cod. 444.

217. Folio 2 verso; G. Swarzenski, *op. cit.*, Abb. 255.

218. Vienna, Österreichische Nationalbibliothek cod. 723; cf. Mazal, *op. cit.*, p. 218.

219. Munich, Bayerische Staatsbibliothek Clm. 15902.

220. Erich Winkler, *Die Buchmalerei in Niederösterreich von 1150–1250* (Vienna, 1923), p. 10.

221. *Ibid.*, pp. 5 ff.

222. Heiligenkreuz, Stiftsbibliothek cod. 24 folio 63 verso; *ibid.*, p. 6 and figure 10a.

223. Zwettl, Stiftsbibliothek MSS. 8–10; *ibid.*, pp. 14–15.

224. Klosterneuburg, Stiftsbibliothek MS. 685.

225. Where it still is – Cod. III/208.

226. Baldass *et al.*, *op. cit.*, p. 68.

227. Munich, Bayerische Staatsbibliothek Clm. 16002.

228. Paul Buberl, *Die romanischen Wandmalereien im Kloster Nonnberg in Salzburg und ihre Beziehungen zur Salzburger Buchmalerei und zur Byzantinischen Kunst (Sonderabdruck aus dem Kunstgeschichtlichen Jahrbuch der K.K. Zentral-Kommission für Kunst- und historische Denkmale 1909)* (Vienna, 1910), pp. 50–1.

229. Demus (1970), p. 628.

230. See Buberl, *op. cit.*, Walter Frodl, 'Die romanischen Wandgemälde in der Stiftskirche am Nonnberg in Salzburg ...', *Österreichische Zeitschrift für Kunst und Denkmalpflege*, X (1956), pp. 90–101 (chiefly on the condition and restoration of the paintings), and Demus (1970), p. 628.

231. Demus (1970), pp. 629–30.

232. Baldass *et al.*, *op. cit.*, p. 60.

233. E. Weiss, 'Der Freskenzyklus der Johanneskapelle in Pürgg', *Wiener Jahrbuch für Kunstgeschichte*, XXII (1969), p. 17.

234. *Ibid.*, p. 42.

235. *Ibid.*, pp. 40–1.

236. See below, p. 347 and Chapter 12, Note 206.

237. See his contribution to Vladimir Milojčić *et al.*, *Bericht über die Ausgrabungen und Bauuntersuchungen in der Abtei Frauenwörth auf der Fraueninsel im Chiemsee 1961–4* (Munich, 1966), pp. 273–4.

238. Munich, Bayerische Staatsbibliothek Clm. 16002.

239. See Demus (1970), p. 612.

240. See *Liber de miraculis sanctae Dei genitricis Mariae*, ed. T. F. Crane (Ithaca and London, 1925), p. 58.

241. Demus (1970), p. 610; Hubert Schrade, *Die romanische Malerei* (Cologne, 1963), pp. 190 ff.; Heidrun Stein, *Die romanischen Wandmalereien in der Klosterkirche Prüfening* (Regensburg, 1987).

242. When the paintings came to light at the end of the nineteenth century,

it was found that, where they adjoined, the paintings of the crossing pillars in part overlay those of the main choir, indicating composition at a later date; see Stein, *op. cit.*, p. 147.

243. *Ibid.*, pp. 49 ff., 66 f.

244. Schrade, *op. cit.*, p. 192 dissents from the general view and believes the ruler to be Lothar of Supplinburg (d. 1137).

245. Stein, *op. cit.*, pp. 69 ff.

246. *Ibid.*, pp. 110 ff., and L-B D, 2602; see also above, Chapter 2, Note 61.

247. Stein, *op. cit.*, p. 126, and cf. p. 12.

248. Demus (1970), pp. 611–12, and also his 'Regensburg, Sizilien und Venedig: zur Frage des byzantinischen Einflusses in der romanischen Wandmalerei', *Jahrbuch der Österreichischen byzantinischen Gesellschaft*, II (1952), pp. 95–104.

249. Ernst Kitzinger, 'Norman Sicily as a Source of Influence on Western Art in the Twelfth Century', *Byzantine Art, an European Art: Lectures* (Council of Europe) (Athens, 1966), pp. 123–4.

250. *Ibid.*

251. J. A. Endres, 'Die Wandgemälde der Allerheiligenkapelle zu Regensburg', *Zeitschrift für christliche Kunst*, XXV (1912), cols. 43–52.

252. Erlangen, Universitätsbibliothek Cod. 1 perg.; see G. Swarzenski, *op. cit.* (Note 197), pp. 129 ff.; Hans Fischer, *Die lateinischen Pergamenthandschriften der Universitätsbibliothek Erlangen* (Erlangen, 1928), pp. 1 ff.; Eberhard Lutze, *Die Bilderhandschriften der Universitätsbibliothek Erlangen* (Erlangen, 1936), pp. 122 ff.; and Cahn, 3.

253. G. Swarzenski, *op. cit.*, pp. 138 ff.

254. Lutze, *op. cit.*, p. 122.

255. See Cahn, pp. 195–8, etc., from which I draw the examples.

256. On folio 1 verso; see Fischer, *op. cit.*, p. 3.

257. See above, p. 180.

258. R. E. Swartwout, *The Monastic Craftsman* (Cambridge, 1932), p. 109.

259. Albert Boeckler, *Die Regensburg-Prüfeninger Buchmalerei des XII. und XIII. Jahrhunderts* (Munich, 1924), pp. 76–7.

260. Boeckler, *op. cit.*, p. 64, says 'Sie ist nichts weniger als ein Abklatsch oder eine Filiation der Salzburger Malerei.'

261. Munich, Bayerische Staatsbibliothek Clm. 14399; see Boeckler, *op. cit.*, pp. 29–33, and *Regensburger Buchmalerei von frühkarolingischer Zeit bis zum Ausgang des Mittelalters: Ausstellung der bayerischen Staatsbibliothek München und der Museen der Stadt Regensburg* (Munich, 1987), no. 36.

262. Boeckler, *op. cit.*, p. 31.

263. Munich, Bayerische Staatsbibliothek Clm. 13031; *ibid.*, pp. 15–18.

264. Munich, Bayerische Staatsbibliothek Clm. 13004; *ibid.*, p. 17.

265. Munich, Bayerische Staatsbibliothek Clm. 13074; *ibid.*, pp. 49–54, and *Regensburger Buchmalerei* (Note 261), no. 39.

266. Boeckler, *op. cit.*, p. 49.

267. Munich, Bayerische Staatsbibliothek Clm. 13002 folio 7 verso; *ibid.*, pp. 20–2, and *Regensburger Buchmalerei ...*, no. 34.

268. Munich, Bayerische Staatsbibliothek Clm. 13031 folio 1; *Ornamenta Ecclesiae*, B 39.

269. Munich, Bayerische Staatsbibliothek Clm. 13002.

270. The manuscript in which the copies appear is Munich, Bayerische Staatsbibliothek Clm. 17403; see *Ornamenta Ecclesiae*, B 106.

271. Munich, Bayerische Staatsbibliothek Clm. 14159; Boeckler, *op. cit.*, pp. 33–46, and *Regensburger Buchmalerei ...*, no. 38.

272. Bamberg, Staatsbibliothek MS. Patr. 5 (B.II.5) folio 1 verso.

273. See Albert Boeckler, 'Zur böhmischen Buchkunst des 12. Jahrhunderts', *Konsthistorisk Tidskrift*, XXII (1953), pp. 61–74.

274. *Ibid.*, pp. 72–4.

275. Prague, University Library MS. XIV.A.13/1; no. 99 of the exhibition catalogue *L'Art ancien en Tchécoslovaquie* (Musée des Arts Décoratifs, Paris, 1957). See also the facsimile edition, *Codex Vyšehradensis* (*Editio cimelia Bohemica*, XIII) (Prague, 1970).

276. Prague, Cathedral Chapter Library MS. A.XXI/1; no. 100 of the exhibition catalogue.

277. Stockholm, Royal Library MS. Theol. A.144.

278. Leipzig, Stadtbibliothek MS. CLXV, and New York, Pierpont Morgan Library MS. 563; Boeckler, *op. cit.* (Note 273), pp. 70–1.

279. See Boeckler, *op. cit.* pp. 61 ff.

280. *Ibid.*, pp. 64–5.

281. Prague, Cathedral Chapter Library MS. A.VII; no. 101 of the exhibition catalogue.

282. Boeckler, *op. cit.*, p. 71.

283. Exhibition catalogue no. 101.

284. Jiří Mašín, *Romanesque Mural Painting in Bohemia and Moravia* (Prague, 1954), pp. 9–11.

285. *Ibid.*, p. 11.

286. *Ibid.*, pp. 11–12.

287. See above, pp. 134–5.

288. See Florentine Mütherich, 'Epistola Mathildis Sueviae. Zu einer verschollenen Handschrift aus dem 11. Jahrhundert', *Studien zur Buchmalerei und Goldschmiedekunst des Mittelalters. Festschrift für Karl Hermann Usener zum 60. Geburtstag*, ed. Frieda Dettweiler *et al.* (Marburg, 1967), pp. 137–42.

289. Staatsbibliothek Class. 79.

290. Another German manuscript to reach Poland was the Gospels of Henry IV or V made at Regensburg some time between 1099 and 1111 (see above, pp. 152–3). Now in the library of Cracow Cathedral, its precise route to Poland is unknown, though it is thought that it arrived there as early as the twelfth century, as a result of the kinship that existed between the Salian house and the Polish ruling family. See *Regensburger Buchmalerei ...*, *op. cit.* (Note 261), p. 38.

291. Cathedral Library MS. 1a. See Michał Walicki, *Sztuka Polska przedromańska i romańska do schylku XIII wieku* (vol. 1 of *Dziej Sztuki Polskiej*), in two volumes paginated consecutively (Warsaw, 1971), pp. 256, 692.

292. Czartoryski Collection MS. 1207; see Walicki, *op. cit.*, pp. 256, 745.

293. From St Wacław's Cathedral, Cracow-Wawel; now Cracow, Jagiellonian Library MS. 2057. See Walicki, *op. cit.*, pp. 259, 714–15.

294. Formerly Płock, Seminary Library MS. 2; Walicki, *op. cit.*, pp. 260–61, 745–6.

295. Quoted *ibid.*, p. 746.

296. Formerly Płock, Seminary Library MS. 40; Walicki, *op. cit.*, pp. 262, 746.

297. Formerly Warsaw, National Library MS. Lat. F. vel. I. 32; Walicki, *op. cit.*, pp. 261–2, 682–3.

298. Chantilly, Musée Condé MS. 1632 folio 3. See *Art roman dans la vallée de la Meuse aux XIᵉ et XIIᵉ siècles*, ed. Suzanne Collon-Gevaert *et al.* (Brussels, 1962), p. 231 for excellent reproduction.

299. Walicki, *op. cit.*, pp. 230, 732, reconstruction on p. 231.

300. R. Dabrowski, 'Odrycie romańskie polichromii w Tumie pod łeczyca', *Ochrona Zabytków*, V (1952), no. 4, pp. 240–52.

301. See above, p. 284.

302. Aron Andersson, *The Art of Scandinavia*, II (London, 1970), pp. 269 f.

303. *Ibid.*, p. 242.

304. F. Beckett, *Danmarks Kunst* (Copenhagen, 1924), pp. 273 ff.; P. Nørlund and E. Lind, *Danmarks romanske Kalkmalerier* (Copenhagen, 1944), pp. 244 ff.; E. W. Anthony, *Romanesque Frescoes* (Princeton, 1951), p. 201.

305. Andersson, *op. cit.*, pp. 243 f.

306. O. Rydbeck, *Medeltida Kalkma lningar i Ska nes kyrkor* (Lund, 1904) figures 10 and 36; Anthony, *op. cit.*, figure 493, p. 202.

307. J. Roosval, *Swedish Art* (Princeton, 1932), pp. 35 f.; Nørlund and Lind, *op. cit.*, figure 69; Anthony, *op. cit.*, p. 202.

308. Andersson, *op. cit.*, pp. 276, 278.

309. Roosval, *op. cit.*, pp. 36 f. and plate 14b; Andersson, *op. cit.*, p. 276.

310. Anthony, *op. cit.*, p. 201; Andersson, *op. cit.*, pp. 276 ff.

311. See Beckett, *op. cit.*, figures 358, 359, 361.

312. Andersson, *op. cit.*, p. 243.

313. *Ibid.*, pp. 243 f.; Ulla Haastrup, 'Die romanischen Wandmalereien in Ra sted', *Hafnia Copenhagen Papers in the History of Art* (Copenhagen, 1972), pp. 69–138.

314. Andersson, *op. cit.*, pp. 245 ff.

315. *Ibid.*, pp. 266 f.

316. See above, p. 305.

317. Rydbeck, *op. cit.*, pp. 16 ff., 23 ff., figures 4, 20, 21, 32–4; Anthony, *op. cit.*, p. 203.

CHAPTER 12

1. Dodwell (1954), plates 11c, 7f, 15a, 14c, 18b.

2. *Ibid.*, plate 36a.

3. *Ibid.*, plates 13b, 18a,b,c, 25a.

4. *Ibid.*, plate 36d.

5. *Ibid.*, pp. 75 ff.

6. *Ibid.*, pp. 61 ff.

7. *Ibid.*, pp. 69 ff.

8. *Ibid.*, pp. 72 ff.

9. *Ibid.*, chapter II. The pioneer work here is F. Wormald, 'The Survival of Anglo-Saxon Illumination after the Norman Conquest', *Proceedings of the British Academy*, XXX (1944), pp. 127–45.

10. British Library Arundel MS. 91; *E.R.A.*, no. 14. See also British Library Cotton MS. Vitellius C.XII (Kauffmann, no. 18).

11. Kauffmann, figure 48.

12. Durham Cathedral Library MS. Hunter 100 folio 44; R. A. B. Mynors, *Durham Cathedral Manuscripts* (Oxford, 1939), plate 37.

13. British Library MS. Cotton Titus D.XVI; Kauffmann, no. 30; *E.R.A.*, no. 16; Thomson, *op. cit.* (Note 38), no. 19. It is bound in with three other volumes.

14. See below, pp. 329, 332–3. Pächt thinks it was actually produced in the

atelier of the Alexis Master after 1120 (O. Pächt, C. R. Dodwell, and F. Wormald, *The St Albans Psalter* (London, 1960), p. 168).

15. Florence, Biblioteca Medicea-Laurenziana MS. Plut. XII.17; Kauffmann, no. 19.

16. L-B E, 730.

17. L-B E, 800.

18. See above, p. 99.

19. E. W. Tristram, *English Medieval Wall Painting* (Oxford, 1944), pp. 27–8, 128–33, and Audrey Baker, 'Lewes Priory and the Early Group of Wall-Paintings in Sussex', *Walpole Society*, XXXI (1942–3), pp. 42–4. The most important study is the excellent article by David Park, 'The "Lewes Group" of Wall Paintings in Sussex', *Anglo-Norman Studies*, ed. R. Allen Brown, VI (1983), pp. 205–7, 210–12, 217–21, 230.

20. Baker, *op. cit.*

21. Park, *op. cit.*, pp. 217–19.

22. Tristram, *op. cit.*, pp. 28–9, 113–15, and Park, *op. cit., passim.*

23. Park, *op. cit.*, p. 209.

24. *Ibid.*, pp. 210–11.

25. *Ibid.*, pp. 211–12.

26. See on this David Park, 'The Romanesque Wall Paintings of All Saints' Church, Witley, Surrey', *Surrey Archaeological Collections*, LXXIV (1983), pp. 157–67.

27. *Ibid.*, p. 165.

28. K. F. N. Flynn, 'The Mural Painting in the Church of Saints Peter and Paul, Chaldon, Surrey', *Surrey Archaeological Collections*, LXXII (1980), pp. 127–56.

29. Tristram, *op. cit.*, pp. 51–4, 115–19.

30. David Park, 'Romanesque Wall Paintings at Ickleton', *Romanesque and Gothic Essays for George Zarnecki*, ed. Neil Stratford (Woodbridge, 1987), pp. 159–69.

31. *Ibid.*, p. 166.

32. Tristram, *op. cit.*, pp. 42–4, 134–6.

33. Ed. H. T. Riley; it is volume 1 that interests us here (Rolls Series, London, 1867).

34. Though the view of Brian Golding is that the compiler, Matthew Paris, was deliberately editing his sources in terms of *exempla*; see 'Wealth and Artistic Patronage at Twelfth-Century St Albans', *Art and Patronage in the English Romanesque*, ed. Sarah Macready and F. H. Thompson (London, 1986), p. 107.

35. Riley, *op. cit.*, p. 58.

36. *Ibid.*, pp. 70 and 76.

37. *Ibid.*, pp. 76 and 94.

38. For a survey of these, see Rodney M. Thomson, *Manuscripts from St Albans Abbey 1066–1235*, 2 vols. (Woodbridge, 1982).

39. *Gesta Abbatum . . ., op. cit.* (Note 33), p. 73.

40. *Ibid.*, p. 93.

41. Now at St Godehard's, Hildesheim. See O. Pächt, C. R. Dodwell, and F. Wormald, *The St Albans Psalter* (London, 1960), which will be referred to as Pächt, Dodwell, Wormald; Kauffmann, no. 29; *E.R.A.*, nos. 17 and 17a.

42. See C. H. Talbot, *The Life of Christina of Markyate* (Oxford, 1959), a text admirably recovered by Talbot from a much damaged manuscript.

43. *Ibid.*, pp. 13 and 15. She had not yet come back to Markyate in January 1123 – see p. 118.

44. *Ibid.*, p. 138.

45. Page 285.

46. This is not the view of Pächt, but it was that of A. Goldschmidt, *Der Albanipsalter in Hildesheim* (Berlin, 1895).

47. Page 57.

48. Dr C. J. Holdsworth drew attention to the connections between these pictures and the *Life* in 'Christina of Markyate', *Medieval Women*, ed. D. Baker (*Studies in Church History, Subsidia*, 1, 1978), pp. 185–204.

49. Talbot, *op. cit.*, p. 7.

50. *Ibid.*, p. 186.

51. *Ibid.*, p. 182.

52. *Ibid.*, pp. 182–4.

53. *Ibid.*, pp. 186–8.

54. Pächt, Dodwell, Wormald, pp. 54–7.

55. *Ibid.*, pp. 117–19.

56. *Ibid.*, p. 116.

57. *Ibid.*, pp. 99, 119 ff.

58. *Ibid.*, pp. 71 ff.

59. *Ibid.*, pp. 122 ff.

60. *Ibid.*, pp. 184 ff.

61. Page 315; see *ibid.*, pp. 250–1.

62. *Ibid.*, pp. 181–4.

63. *Ibid.*, pp. 279–80. Others hold different views: Holdsworth (*op. cit.*, p. 195) places it between 1140 and 1146, and Talbot (*op. cit.*, p. 26) after 1155.

64. Talbot, *op. cit.*, pp. 144–6.

65. *Ibid.*, p. 98.

66. The decorative initial on folio 1 of Princeton, University Library MS. Garret 73 is very close in style to that representing Christina in the St Albans Psalter, and is said by Thomson to be perhaps by the same hand. He claims that it is to be dated between 1120 and 1140 (*op. cit.* (Note 38), I, pp. 23, 116; II, figure 120). He also claims (and I certainly disagree), on the basis of the script (I, p. 35), that the Christina picture belongs to the period 1140 to 1160.

67. I would not disagree with Talbot, who says (p. 15) *c.* 1131.

68. Thomson, *op. cit.*, I, p. 26, says it is by the hand that wrote a St Albans Josephus (British Library MS. Royal 13.D.VI–VII).

69. Verdun, Bibliothèque Municipale MS. 70; Kauffmann, no. 31; *E.R.A.*, no. 19; O. Pächt, 'The Illustrations of St Anselm's Prayers and Meditations', *Journal of the Warburg and Courtauld Institutes*, XIX (1956), pp. 74 f.; Thomson, *op. cit.*, I, pp. 25–6, 40–1.

70. Hereford Cathedral Library MS. O.1.VIII; Kauffmann, no. 33; *E.R.A.*, no. 18; Thomson, *op. cit.*, I, pp. 25–6.

71. New York, Pierpont Morgan Library MS. 736; Kauffmann, no. 34; *E.R.A.*, no. 20; Thomson, *op. cit.*, I, pp. 25–6; Pächt, Dodwell, Wormald, pp. 141 f.; Elizabeth Parker McLachlan, *The Scriptorium of Bury St Edmunds in the Twelfth Century* (New York and London, 1986), chapter III.

72. R. M. Thomson, 'Early Romanesque Book Illustration in England; the Dates of the Pierpont Morgan *Vitae S. Edmundi* and the Bury Bible', *Viator*, II (1971), pp. 211–25.

73. McLachlan, *op. cit.*, pp. 84–5.

74. Thomson, *op. cit.* (1982) (Note 38), I, p. 26.

75. B. Abou-El-Haj, 'Bury St Edmund's Abbey between 1070 and 1124 . . .', *Art History*, VI (1983), pp. 1–29.

76. I am anticipated in this observation by Dr T. A. Heslop, whose article on 'Dunstanus Archiepiscopus' throws new light on the picture concerned: see *The Burlington Magazine*, CXXVI (1984), pp. 195–204 and plate 2.

77. The manuscript has been damaged by fire, and the reference to 'crux' is an emendation by Talbot that is difficult to resist.

78. Talbot, *op. cit.*, p. 186.

79. *Ibid.*, p. 128.

80. Compare the crown worn by David in the imperial crown in the Vienna Schatzkammer and also the crown-cover from the grave of Henry IV at Speier Cathedral, plates 67 and 166 of P. E. Schramm and F. Mütherich, *Denkmale der deutschen Könige und Kaiser* (Munich, 1962).

81. Munich Clm. 4456 folio 11; Pächt, Dodwell, Wormald, pp. 118–19.

82. Thomson, *op. cit.* (1982), I, p. 26.

83. McLachlan, *op. cit.*, pp. 76 f., has some useful comments on the question of texts.

84. Pächt in Pächt, Dodwell, Wormald, pp. 172 ff.

85. Thomson, *op. cit.* (1982), I, p. 24.

86. British Library MS. Lansdowne 383; Kauffmann, no. 48, with bibliography; *E.R.A.*, no. 25.

87. Hereford Cathedral Library MS. O.5.XI; M. A. Farley and F. Wormald, 'Three Related English Romanesque Manuscripts', *Art Bulletin*, XXII (1940), pp. 157–61; Kauffmann, no. 51; *E.R.A.*, no. 26.

88. Oxford, Bodleian Library MS. Auct. F.6.5; Kauffmann, no. 49; *E.R.A.*, no. 31.

89. Walter Oakeshott, *The Two Winchester Bibles* (Oxford, 1981), p. 99.

90. *The Heads of Religious Houses England and Wales*, ed. David Knowles *et al.* (Cambridge, 1972), p. 219.

91. B. Garfield, quoted by Kauffmann, p. 83.

92. In Cambridge, Pembroke College MS. 120; Kauffmann, no. 35; *E.R.A.*, no. 21; Elizabeth Parker, 'A Twelfth Century Cycle of New Testament Drawings from Bury St Edmunds Abbey', *Proceedings of the Suffolk Institute of Archaeology*, XXXI (1969), pp. 263–302; McLachlan, *op. cit.*, chapter IV.

93. McLachlan, *op. cit.*, p. 125.

94. G. D. S. Henderson, 'Narrative Illustration and Theological Exposition in Medieval Art', *Studies in Church History*, XVII (1981), pp. 26 ff., especially note 20.

95. See Parker, *op. cit.* (Note 92). 'It is very possible', she says (p. 294), '. . . that the cycle was a Ministry and Passion cycle . . . for the adornment of a Gospel-book or lectionary.' See also McLachlan (her married name), *op. cit.*, p. 137.

96. McLachlan believes that the drawings and the text are separated by twenty years (*op. cit.*, p. 135).

97. C. M. Kauffmann points to stylistic connections between the drawings and the work of the Bury scriptorium: see his *Romanesque Manuscripts*, p. 75, and his 'The Bury Bible', *Journal of the Warburg and Courtauld Institutes*, XXIX (1966), pp. 65–6.

98. McLachlan, *op. cit.*, pp. 121 and 123.

99. L-B E, 6020.

100. Xenia Muratova, 'Bestiaries: an Aspect of Medieval Patronage', in Macready and Thompson, eds., *op. cit.* (Note 34), p. 118.

101. L-B E, 4765.

102. L-B E, 512.

103. As against this, one later manuscript (Oxford, Bodleian Library Bodley MS. 225) has an inscription saying that it was redeemed by a sacrist (McLachlan, *op. cit.*, p. 22).

104. *Ibid.*, p. 123.

105. Parker, *op. cit.*, p. 271 and plate XLII.

106. McLachlan, *op. cit.*, p. 134.

107. Parker, *op. cit.*, pp. 277–91.

108. McLachlan, *op. cit.*, p. 134.

109. H. T. Riley, ed., *op. cit.* (Note 33), I, p. 79.

110. The abbey of Bec; L-B E, 6043.

111. McLachlan, *op. cit.*, p. 131.

112. *Ibid.*, p. 130.

113. In the Bayeux Tapestry and in British Library MS. Cotton Titus D.XVI.

114. Parker, *op. cit.*, pp. 268–9; McLachlan, *op. cit.*, p. 129.

115. British Library MS. Add. 37472(1), New York, Pierpont Morgan Library M.521 and M.724, Victoria and Albert Museum MS. 661; see Kauffmann, no. 66, and the study by M. R. James, 'Four Leaves of an English Psalter', *Walpole Society*, XXV (1936–7), pp. 1–23.

116. See below, p. 352.

117. L-B E, 4762.

118. See above, pp. 11–14 and 120.

119. See above, p. 11, for the three references.

120. *Rationale Divinorum Officiorum*, Book I, chapter iii, par. 22; cf. the edition of J. M. Neale and B. Webb, *The Symbolism of Churches and Church Ornaments* (Leeds, 1843), p. 68.

121. Demus (1970), p. 626.

122. See above, p. 142.

123. For the Hexateuch, see above, pp. 185–7, and also my comments in C. R. Dodwell and Peter Clemoes, *The Old English Illustrated Hexateuch* (*Early English Manuscripts in Facsimile*, XVIII) (Copenhagen, 1974), pp. 65–73.

124. See above, p. 118.

125. See above, p. 150.

126. See above, pp. 328–9, 332.

127. See T. A. Heslop, 'Brief in Words but Heavy in the Weight of its Mysteries', *Art History*, IX (1986), pp. 1–11.

128. See above, p. 16.

129. A Gospel Book thought to have belonged to St Augustine, the evangelist of the Anglo-Saxons – Cambridge, Corpus Christi College MS. 286.

130. Paris, Bibliothèque Nationale MS. lat. 8846. The view that the Paris and Eadwine Psalters were taken from a lost copy of the Utrecht Psalter I deal with later (p. 340).

131. Cambridge, Trinity College MS. R.17.1; see M. R. James, *The Canterbury Psalter* (London, 1935); Dodwell (1954), chapter IV; Kauffmann, no. 68; *E.R.A.*, no. 62.

132. See the last sentence of Note 130.

133. Dodwell (1954), pp. 42–4.

134. *Ibid.*, plate 28.

135. *I Henry VI*, I, i, 2–3 (see also *Julius Caesar* II, ii, 30–1).

136. Guy of Amiens in the *Carmen de Hastingae Proelio*, ed. C. Morton and H. Muntz (Oxford, 1972), pp. 10–11.

137. Dodwell (1954), p. 42.

138. British Library MS. Cotton Vespasian D.XIX, folio 69.

139. See George Zarnecki, 'The Eadwine Portrait', *Études d'art médiéval offertes à Louis Grodecki*, ed. S. McK. Crosby *et al.* (Paris, 1981), p. 94 and note 14.

140. I am most grateful to Dr F. Richard Stephenson of the Department of Physics in the University of Durham for spending much time in discussing and writing to me on the question of comets in the Middle Ages.

141. Alexandre Guy Pingré, *Cométographie, ou Traité historique et théorique des comètes*, 2 vols. (Paris, 1783–4), I, p. 394. Pingré notes that the Continental sighting of the comet is recorded in Laurence of Liège's history of the bishops and abbots of Verdun, for which see *Laurentii de Leodio Gesta Episcoporum Virdunensium et Abbatum S. Vitoni*, ed. G. Waitz (*Mon. Germ. Hist. SS.*, X) (1852), pp. 516–17. Laurence quotes verses in which the comet is associated with the departure of troops on the Second Crusade, and the Germans under Conrad left in May.

142. The 1147 comet is listed in the International Astronomical Union's *Catalogue of Cometary Orbits* – see the 5th edition, ed. Brian G. Marsden (1986), p. 8. See also Ho Peng Yoke, 'Ancient and Mediaeval Observations of Comets and Novae in Chinese Sources', *Vistas in Astronomy*, V (1962), p. 189; the Far Eastern scholar quotes sightings in both China and Japan.

143. Which was, in fact, Halley's comet, well known to us in view of its appearance in 1986.

144. *Chronica Magistri Rogeri de Houedene*, ed. W. Stubbs, Rolls Series (London, 1868), I, p. 231. In fact, Howden claims that there were two comets seen, which, Dr Stephenson tells me, is not entirely impossible but most unlikely. One possibility he suggests is that it was not two comets but an auroral display. Another possibility – if we give Howden any credence – is that the two comets

145. were, in fact, reappearances of the same one.

145. William Urry, *Canterbury under the Angevin Kings* (London, 1967), pp. 5 and 6. Urry observes that 'This hand has close affinities with that of the running commentaries in the great Psalter of Eadwine' and that 'it is very tempting to speculate whether we have here another example' of the Psalter scribe's work.

146. Canterbury, Cathedral, City and Diocesan Record Office, Charta Antiqua C.117/38.

147. See above, p. 274.

148. Margaret Gibson, 'Who Designed the Eadwine Psalter?', *Art and Patronage in the English Romanesque*, ed. S. Macready and F. H. Thompson (London, 1986), pp. 71–6, says that the commentary belongs to the decade *c.* 1150–60, but in a private communication she tells me that she is revising the views expressed in that article. I do not personally accept that this kind of evidence can give pinpoint accuracy.

149. MS. lat. 8846; see N. J. Morgan, *Early Gothic Manuscripts* (I) (London, 1982), no. 1, with bibliography.

150. It lacks its final word, *eius*, which would have started off the following folio had the work not been abandoned. The final page (folio 174 verso) is without the marginal Latin commentary and interlinear French translation added on all previous pages, and the scribe, in copying out the interlinear (as distinct from marginal) Latin commentary on his last page, got no farther than the first verse of Psalm 98.

151. Millard Meiss, 'Italian Style in Catalonia', *Journal of the Walters Art Gallery*, IV (1941), pp. 73 ff.

152. That the frames had already been marked in while the manuscript was at Canterbury is indicated by the fact that the Catalan picture to Psalm 64 on folio 109 verso has a circular format which we also find on folio 109 verso of the Eadwine Psalter and in the equivalent illustration of the Utrecht Psalter. It was in any case frequent practice for the frames for the illuminations to be entered on the pages of a manuscript before the text was written, so that the scribe knew what space was available to him.

153. The picture space for the illustration to Psalm 53 (folio 93) is divided into two registers, and the top register has a column separating its two scenes: these features accord with practices adopted in the English illustrations from Psalm 35 onwards. The main part of the upper register is taken up with a scene illustrating verse 6, 'I will freely sacrifice unto thee', and this is clearly based on an English underdrawing since the various elements are also found in the Utrecht and Eadwine Psalters: a temple on the right with a fire kindled on a stone altar in front, on one side of the altar a priest, on the other side the Psalmist, and the Hand of God above.

154. See above, p. 266.

155. The title reads 'Psalmus David cum fugeret a facie Absalom filii sui'. The manner of Absalom's death is described in the introductory Latin comments that are common to both the Eadwine and the Paris Psalters.

156. See Adelheid Heimann, 'The Last Copy of the Utrecht Psalter', in François Avril *et al.*, *The Year 1200: a Symposium* (Metropolitan Museum of Art, New York, 1975), pp. 313–38. Heimann's theory of a lost model has been reiterated by Morgan, *op. cit.*, p. 48, and by C. M. Kauffmann in the exhibition catalogue *English Romanesque Art 1066–1200* (Hayward Gallery, London, 1984), p. 126.

157. A full analysis of this is given in C. R. Dodwell, 'The Final Copy of the Utrecht Psalter and its Relationship with the Utrecht and Eadwine Psalters', *Scriptorium*, XLIV (1990), pp. 21–53.

158. See Note 157.

159. For example, the earlier cycle has scenes portraying the nativity and the naming of John the Baptist which do not appear in the Paris Psalter, while the latter shows John baptizing in the Jordan and being beheaded, incidents not portrayed on the leaves.

It should be noted that the earlier cycle now lacks its opening, the first scenes being of the birth of Moses. The cycle in the Paris Psalter, for its part, seems to be wanting its conclusion, for it ends with Christ healing the man with the withered hand when we would expect it to go on to show his Passion and Resurrection.

160. Such an increase may be seen in the illustration to Psalm 4 [344, 345], where the number of figures before the altar is doubled from three to six and the group below and to the left is substantially augmented.

161. Women changed to men: folio 22 (Psalm 13), folio 70 (Psalm 39), folio 75 (Psalm 42), folio 92 (Psalm 52). Men changed to women: folio 62 verso (Psalm 36).

162. Folio 20.

163. Folio 90 verso.

164. In the illustration to Psalm 43 (folio 76), the sword and bow before the Psalmist are depicted as broken, and this seems to indicate a response to the words of verse 6: 'for I will not trust in my bow, neither shall my sword save me'. In the illustration to Psalm 50 (folio 88 verso), whereas the Utrecht and Eadwine Psalters show us two men struggling with a single bullock before a

temple, the Paris manuscript shows the two men placing two bullocks upon an altar, and this is a more accurate reflection of the text: 'then shall they offer bullocks upon thine altar'.

165. See, for example, the temples in the illustrations to Psalms 5 and 10 (folios 10 and 19), and the fountains in the illustrations to Psalms 25 and 35 (folios 43 verso and 61). In addition, buildings are frequently added where none had appeared in the earlier manuscripts.

166. In particular, many figures are provided with headgear where they have none in the earlier manuscripts.

167. See the illustrations to Psalms 26 (folio 44 verso) and 43 (folio 76).

168. See the illustrations to Psalms 5 (folio 10), 7 (folio 12 verso), 29 (folio 49), 30 (folio 50), 38 (folio 68).

169. By Madeline Harrison Caviness, *The Early Stained Glass of Canterbury Cathedral* (Princeton, 1977), p. 65.

170. Morgan, *op. cit.*, p. 48.

171. The Dover Bible, for which see below, pp. 352, 354–5.

172. The Lincoln Bible (Lincoln Cathedral Library MS. A.1.2 and Cambridge, Trinity College MS. B.5.2) and the Rochester Bible (British Library MS. Royal 1.C.VII) are earlier, but not great Bibles in the more sumptuous sense of the word.

173. Cambridge, Corpus Christi College MS. 2; see Kauffmann, no. 56, and Cahn, no. 27, both with bibliographies; *E.R.A.*, no. 44; C. M. Kauffmann, 'The Bury Bible', *Journal of the Warburg and Courtauld Institutes*, XXIX (1966), pp. 60–81; McLachlan, *op. cit.* (Note 71), chapter v; also two articles by Rodney M. Thomson, 'Early Romanesque Book-Illustration in England; the Dates of the Pierpont Morgan *Vitae Sancti Edmundi* and the Bury Bible', *Viator*, II (1971), pp. 211–25, and 'The Date of the Bury Bible Reexamined', *ibid.*, VI (1975), pp. 51–8.

174. *Gesta Sacristarum Monasterii S. Edmundi*, in *Memorials of St Edmunds Abbey*, ed. T. Arnold, Rolls Series (London, 1890–6), II.

175. L-B E, 495.

176. For the dates, see McLachlan, *op. cit.*, p. 23 and note 1.

177. L-B E, 501.

178. R. M. Thomson, *op. cit.* (1975) (Note 173), p. 54, points out that Sacristan Hervey (who paid for the Bible) was out of office in 1136. Presumably, however, the money might have been forthcoming before the Bible was actually made.

179. Kauffmann, p. 88.

180. McLachlan, *op. cit.*, p. 250.

181. L-B E, 495. There is reference here to funds being provided for the copying out of the great Bible.

182. We cannot, however, entirely reject the possibility that this showed he had been through the schools.

183. British Library Arundel MS. 91 folio 47 verso, from St Augustine's.

184. As M. R. James, the pioneer on the subject, pointed out; see L-B E, 495.

185. See above, p. 254.

186. McLachlan, *op. cit.*, pp. 242 and 243.

187. For whom see Peter Lasko, *Ars Sacra 800–1200* (The Pelican History of Art) (Harmondsworth, 1972), pp. 169 ff.

188. See Kauffmann, *op. cit.* (1966) (Note 173), pp. 66–74.

189. Beryl Smalley, 'L'Exégèse biblique du 12e siècle', *Entretiens sur la renaissance du 12e siècle*, ed. M. de Gandillac and E. Jeauneau (Paris, 1968), pp. 278 ff., to which Kauffmann draws attention.

190. McLachlan, *op. cit.*, pp. 231–6.

191. See E. P. McLachlan, 'In the Wake of the Bury Bible ...', *Journal of the Warburg and Courtauld Institutes*, XLII (1979), pp. 216–24, and *eadem*, *op. cit.*, pp. 251–61. The manuscripts are Cambridge, Pembroke College MSS. 16, 72, 69, 64, 78, 67 and 68, and Oxford, Bodleian Library Bodley MS. 297.

192. Tristram, *op. cit.* (Note 19), pp. 21–4 and 105, and Demus (1970), p. 509.

193. Ernst Kitzinger, 'The Byzantine Contribution to Western Art of the Twelfth and Thirteenth Centuries', *The Art of Byzantium and the Medieval West: Selected Studies by Ernst Kitzinger*, ed. W. Eugene Kleinbauer (Bloomington and London, 1976), p. 369 and figures 8–9.

194. These points were made by G. Zarnecki in an unpublished paper given at a conference on Anselm at Canterbury on 4 July 1979.

195. This redating was advanced by Zarnecki in 1979 (see last Note), confirmed by Ursula Nilgen in her article 'Thomas Becket as a Patron of Arts', *Art History*, III (1980), pp. 357–74, and reinforced by Deborah Kahn in her architectural analysis 'The Structural Evidence for the Dating of the St Gabriel Chapel Wall-paintings at Christ Church Cathedral, Canterbury', *The Burlington Magazine*, CXXVI (1984), pp. 225–9.

196. Nilgen, *op. cit.*

197. *Ibid.*, p. 373 note 36.

198. Tristram, *op. cit.*, pp. 19–21, 102–5.

199. Kahn, *op. cit.*, p. 229.

200. Cambridge, St John's College MS. A.8; Kauffmann, plate 118.

201. Lambeth Palace Library MS. 3 and Maidstone Museum MS. P.5; Kauffmann, no. 70; Cahn, no. 34; *E.R.A.*, nos. 53 and 53a; Dodwell (1954), pp. 48 ff.; and C. R. Dodwell, *The Great Lambeth Bible* (London, 1959).

202. D. Denny, 'Notes on the Lambeth Bible', *Gesta*, XVI/2 (1977), pp. 51–64. Denny makes some interesting points, but, despite his comments, there can be no doubt of some Byzantine influences – or more properly Siculo-Byzantine influences – on the Lambeth Bible. What Denny fails to consider is that there were various waves of Byzantine influence on the West in the twelfth century and they could make their independent impacts on iconography in different areas. In other words, it does not follow that because a similar (or, in one or two of his comparisons, not very similar) Byzantinizing iconography appears in England and on the Continent, they must relate to each other: they may reflect separate waves of influences from Byzantine (or Siculo-Byzantine) art.

203. See Dodwell (1954), plates 48 and 49.

204. Denny, *op. cit.*

205. Kauffmann, p. 100.

206. Dodwell (1954), pp. 89 f.

207. Maidstone Museum MS. P.5.

208. See Dodwell (1954), pp. 51–2.

209. Our source associates the making of a Crucifix by Hugo both with the refurbishing that followed a disastrous fire which we learn from other records desolated parts of the abbey in 1150 or 1152 (see Note 176 above), and with Elias's tenure as sacrist. The dates of this are not certain, but he is said to have been sacrist under Abbot Ording, who ruled from 1148 to 1156. The name of Elias's successor as sacristan, Frodo, first appears in a charter which can be dated 1156–60 (see R. M. Thomson, *Viator*, II (1971), p. 222 note 68). We may therefore suppose that Hugo was still alive in the fifties.

210. Denny, *op. cit.*, pp. 51–2.

211. Thomson, *op. cit.* (Note 38), I, pp. 32–3.

212. British Library MS. Royal 13.D.VI; Dodwell (1954), p. 50, and Thomson, *op. cit.*, I, p. 99, where it is said to be of c. 1125.

213. Oxford, Bodleian Library MS. Auct. D.2.6; Kauffmann, no. 71; Otto Pächt and J. J. G. Alexander, *Illuminated Manuscripts in the Bodleian Library Oxford*, III (Oxford, 1973), no. 117; Thomson, *op. cit.*, I, p. 36, 38.

214. Pächt and Alexander, *op. cit.*, do not share this opinion.

215. See E. W. B. Nicholson, *Introduction to the Study of Some of the Oldest Latin Musical Manuscripts in the Bodleian Library, Oxford* (London, 1913), pp. lxxix–lxxx.

216. Oxford, Corpus Christi College MS. 2* folios 1 verso and 2; Kauffmann, no. 72.

217. Dodwell (1954), pp. 51 ff.

218. *Ibid.*, p. 52.

219. British Library MS. Cotton Claudius E.V, folio 44. The mask-head, however, is at the top of the initial A in the Maidstone manuscript and at the bottom of the initial V in the British Library one.

220. British Library MS. Add. 37517 folio 128 verso.

221. Formerly Metz, Bibliothèque Municipale MS. 1151.

222. In the possession of the Société Archéologique. They were related to the Gospel Book by Dom Leclercq, 'Les Manuscrits de l'abbaye de Liessies', *Scriptorium*, VI (1952), pp. 51–62. See also *E.R.A.*, no. 54; Dodwell (1954), pp. 54 ff.; Dodwell, *op. cit.* (Note 201), pp. 16 ff.; A. Boinet, 'L'Atelier de miniaturistes de Liessies au XIIe siècle', *La Bibliofilia*, L (1948), pp. 149–61.

223. As Boinet notes, *op. cit.*, p. 153.

224. Leclercq, *op. cit.*, p. 52, points this out.

225. Dodwell (1954), p. 48, pointed out that the main hand of the Eadwine Psalter was that of the Dover Bible and that the scribal doodles in each manuscript were patently by the same hand (plates 29 f and g). I also then said that the Dover Bible may be the 'Biblia Edwini' which is recorded in Eastry's catalogue of Christ Church compiled between 1284 and 1331. Zarnecki, *op. cit.* (Note 139), p. 95 and note 18, expressed doubts about this, since the Eastry catalogue does not refer to the Eadwine Bible as being a Bible in two parts, whereas the phrase 'Biblia bipartita' is applied to the previous entry in the catalogue. I myself had noted that the 'Biblia Edwini' was not described as a 'Biblia bipartita', but went on to say that, unless it be assumed that Eadwine wrote two Bibles, the 'Biblia Edwini' probably referred to the Dover Bible (p. 48). After all, cataloguers can make mistakes. I still think that the 'Biblia Edwini' is the Dover Bible, since I do not suppose that Eadwine copied out two giant Bibles as well as the most important part of the Eadwine Psalter, whose complex layout, in my view, he also supervised.

I say that he copied out the main part of the Psalter because I cannot believe that the extravagant praise for Eadwine as scribe that we find surrounding a picture of him at the end of the manuscript would have been intended for anyone but the main scribe.

However, I should add that an alternative view is to be put forward in a forthcoming publication on the Eadwine Psalter by Dr Pfaff and others, where it will be suggested that the main hand of the Psalter, which reappears in the

Bible, is not that of Eadwine himself. I am grateful to Dr T. A. Heslop, one of the contributors to the forthcoming volume, for informing me of the views of his colleagues.

226. Cambridge, Corpus Christi College MSS. 3 and 4; Kauffmann, no. 69; Cahn, no. 28; Dodwell (1954), pp. 48 ff.

227. Geneva, Biblioteca Bodmeriana MS. 127 folio 244. See Solange Michon, 'Un Moine enlumineur du XIIe siècle: Frère Rufillus de Weissenau' in *Zeitschrift für Schweizerische Archäologie und Kunstgeschichte*, XLIV (1987), pp. 1–7, who points out that Rufillus left another self-portrait of himself in another manuscript from Weissenau, now Amiens, Bibliothèque Municipale MS. Lescalopier 30, folio 29 verso.

228. See Kurt Weitzmann, *Die Byzantinische Buchmalerei des IX. und X. Jahrhunderts* (Berlin, 1935), plate LII (307 and 308).

229. T. A. Heslop, *op. cit.* (Note 127), p. 2.

230. See Dodwell (1954), plate 32.

231. *Ibid.*, p. 86 and plate 57b.

232. *Ibid.*, pp. 87–8 and plate 58b.

233. *Ibid.*, p. 88, plate 58 a, b, c.

234. *Ibid.*, plate 62.

235. *Ibid.*, pp. 84–5, plate 54.

236. *Ibid.*, p. 85, plate 55.

237. I do not comprehend why, in his joint article (see Note 241), Hohler should say (p. 99) that the Psalter, when it was copied, 'was Eadwine's personal property' as a secular and had 'nothing to do with a Benedictine community'. The prayer for Eadwine on folio 262 speaks of him in monastic terms as the servant, serving God and singing the Psalter 'in Thy sight'. It is unquestionably a monastic prayer and is very similar, as Dr C. H. Talbot has pointed out to me, to a prayer at the end of a Bridgettine Breviary (ed. A. Jefferies Collins, Henry Bradshaw Society, XCVI (1969), p. 151):

Omnipotens et misericors deus domine ihesu christe *clemenciam tuam suppliciter deprecor ut me famulam tuam … fideliter tibi servire concedas et perseveranciam assiduam in tuo sancto servicio amore et timore usque ad huius vite consummacionem nobis largiri digneris ut hii psalmi quos in conspectu tuo dixi ad remedium et consolacionem anime mee … ad vitam proficiant sempiternam …*

Hohler's view that the Utrecht Psalter belonged not to a monastery but to a succession of archbishops also seems to me to be curious. Bishops and archbishops (as we know from the will of Theodred, for example) left their possessions to friends and institutions according to their fancy, yet we know that the Utrecht Psalter remained at Canterbury after 1000 and certainly up to the later part of the twelfth century.

238. See above, p. 206.

239. See above, p. 205.

240. Folio 65 verso; Dodwell (1954), plate 33b.

241. George Zarnecki, 'The Eadwine Portrait' (with additional notes by Christopher Hohler), *Études d'art médiéval offertes à Louis Grodecki*, ed. S. McK. Crosby *et al.* (Paris, 1981), pp. 94–100.

242. Copenhagen, Kongelige Bibliotek MS. Thott 143 2°; Kauffmann, no. 96; *E.R.A.*, no. 76.

243. Oxford, Bodleian Library MS. Gough Liturg. 2; Kauffmann, no. 97 and p. 119.

244. Glasgow, University Library MS. Hunter U.3.2; *ibid.*, no. 95 and p. 119; *E.R.A.*, no. 75.

245. Two artists worked on the full-page illustrations and four on the initials. See M. Mackeprang, V. Madsen, and C. S. Petersen, *Greek and Latin Illuminated Manuscripts in Danish Collections* (Copenhagen, 1921), pp. 32 ff. The so-called Simon Master contributed to the initials, as to a number of manuscripts made for other centres. None of his other manuscripts can be dated with any accuracy and, though most of them are given such dates as *c.* 1170–80, or *c.* 1170–90, by Rodney M. Thomson (*op. cit.* (Note 38), I, nos. 92 ff.), one (no. 105) he dates *c.* 1150–70, and another (no. 96 'probably by the Simon Master') to *c.* 1150–60.

246. One view is that this has less significance in the northern province than in the southern one, but it is not one I give too much weight to, considering how rapidly his cult spread even in Sicily.

247. Kauffmann, p. 119.

248. The help given me by the Sub-Librarian of Trinity College Library, Mr Trevor Kaye, when I was working on the Eadwine Psalter was quite remarkable and I would like to express my gratitude to him here. Dr Dominique Markey was then working on the French text of the manuscript, and her article in *Scriptorium*, XXXVII (1983), on 'Le Dernier Cahier du Psautier d'Eadwine' (pp. 245–58) gives an important analysis of the codicology of the manuscript.

249. British Library Cotton MS. Galba A.XVIII.

250. Oxford, Bodleian Library MS. Bodley 579.

251. Cambridge, Corpus Christi College MS. 411.

252. Same collection, MS. 391.

253. British Library Arundel MS. 60.

254. Paris, Bibliothèque Nationale MS. lat. 987.

255. British Library MS. Add. 37517.

256. This we know from Dr Sydney Cockerell (in a letter to me dated 1 October 1982), who disbound the manuscript in 1972 in the course of repair work, and from the fact that there is damage (now repaired) common to the lower inside corner of both folio 283 and its conjoint folio 278. Today's tight binding within heavy oak boards would make it virtually impossible to insert Eadwine's 'portrait' on folio 283, but originally there was probably another guard leaf (or leaves) after it and – more importantly – a different binding. The present one, probably of the sixteenth or seventeenth century, must be smaller in area than its predecessor, for the leaves of the Psalter have had to be trimmed to fit it. This is particularly clear in the folio carrying the Eadwine picture, but this cropping to the detriment of pictures or script can be seen in a number of other folios, for example, folios 5 verso, 10, and 180 (pictures) and folios 12 verso, 211, and 270 (script).

Dr T. A. Heslop kindly informs me that the binding has been dated *c.* 1600 and attributed to London by Mirjam Foot and Nicholas Pickwoad.

Concerning the guard leaf, Mr Trevor Kaye has pointed out to me that there is a stub immediately following the Eadwine leaf. This is an extension of the first folio of the gathering, folio 277, which is itself now a single, and this stub may well have been an original folio 284. Mr Kaye suggests to me that this lost folio could have been used for the smaller plan, which I come to later. See further Note 258, below.

257. See R. Willis, 'The Conventual Buildings of the Monastery of Christ Church in Canterbury', *Archaeologia Cantiana*, VII (1868), pp. 3–5, 158–73, and Appendix 3, and M. R. James, *op. cit.* (Note 131), pp. 53 ff., with earlier bibliography. For the record, I might add that, when Dr Cockerell repaired the manuscript in 1972, the last leaf (the smaller plan) was simply stuck to the folding leaf (the larger plan) at the bottom, and it is now glued on to a stub which he inserted himself (private communication from Mr Trevor Kaye to myself in 1982).

258. This opinion Dr Cockerell was kind enough to give me in a private communication of 29 September 1987. I should add that the view that the plans are on leaves that were inserted into the manuscript was put forward by Willis and has been generally accepted since his time. However, Dr T. A. Heslop informs me that his researches have led him to conclude that the pages on which the plans appear were in fact blank flyleaves that were already part of the manuscript. Dr Heslop's views will be published shortly in the forthcoming volume on the Eadwine Psalter to which he is a contributor.

259. Zarnecki, *op. cit.*, p. 96.

260. See above, pp. 40, 134, 135, 139, 169, 352.

261. The manuscript, made under Abbot Gossuin (1131/3–65), is now lost, but the page in question is reproduced as plate 18d in André Boutemy's article, 'Enluminures d'Anchin au temps de l'abbé Gossuin', *Scriptorium*, XI (1957), pp. 234–48, and as figure 233 of A. Michel's *Histoire de l'Art*, II (1) (Paris, 1906). We have referred to this manuscript in an earlier chapter.

262. Boulogne, Bibliothèque Municipale MS. 46 folio 1 verso; Hanns Swarzenski, *Monuments of Romanesque Art* (London, 1954), figure 289.

263. E. R. Curtius, *European Literature and the Latin Middle Ages* (New York, 1953), p. 485.

264. *Pat. Lat.*, 209, col. 572.

265. T. S. R. Boase, *English Art 1100–1216* (Oxford, 1953), p. 170.

266. *Florentii Wigorniensis monachi Chronicon ex Chronicis*, ed. B. Thorpe, II (1849), pp. 133–4.

267. Wormald (see next Note) points out some personal intrusions of Henry of Blois into the Calendar (p. 107) and says (p. 108), 'What we have then is a calendar made for use at Winchester by the bishop, Henry de Blois.' Henry remains the most likely candidate despite the comments of Haney (see next Note), p. 135, note 15.

268. British Library MS. Cotton Nero C.IV; Francis Wormald, *The Winchester Psalter* (London, 1973); Kauffmann, no. 78; *E.R.A.*, no. 61; Kristine Haney, *The Winchester Psalter: an Iconographic Study* (Leicester, 1986).

269. The provenance is discussed by Wormald, *op. cit.*, and Haney, *op. cit.*, and also by K. E. Haney in 'The Provenance of the Psalter of Henry of Blois', *Manuscripta*, XXIV (1980), pp. 40–4.

270. Haney, *op. cit.* (Note 268), p. 66.

271. See above, p. 120.

272. London, British Library Stowe MS. 944 folio 7.

273. Wormald, *op. cit.*, p. 69.

274. Haney, *op. cit.* (Note 268), pp. 30–4.

275. Boase, *op. cit.*, p. 174.

276. Haney, *op. cit.*, pp. 36–7.

277. Wormald, *op. cit.*, pp. 14–28 and 69. Maria Witzling more or less agrees in her 'The Winchester Psalter: a re-ordering of its prefatory miniatures according to the scriptural sequence', *Gesta*, XXIII (1984), pp. 17–25.

278. Haney, *op. cit.*, pp. 53 ff.

279. Now folios 29 and 30. See Wormald, *op. cit.*, pp. 87 ff.

280. George Zarnecki, *Later English Romanesque Sculpture 1140–1210*

281. McLachlan, *op. cit.* (Note 71), p. 229, draws attention to differing expressions on faces in the Bury Bible, but these do not have the dramatic intensity of the expressions here.

282. See Leslie Webber Jones and C.R. Morey, *The Miniatures of the Manuscripts of Terence*, 2 vols. (Princeton, 1931).

283. See above, pp. 46–7.

284. Paris, Bibliothèque Nationale MS. lat. 7899; Jones and Morey, *op. cit.*, pp. 53 ff.

285. Paris, Bibliothèque Nationale MS. lat. 7900; *ibid.*, pp. 94 ff.

286. Oxford, Bodleian MS. Auct. F.2.13; *ibid.*, pp. 68 ff.; Kauffmann, no. 73; *E.R.A.*, no. 56.

287. This happens to be the only display of masks that was made for, or has survived in, this particular illustrated copy of Terence.

288. Le Mans, Bibliothèque Municipale MS. 263; *MSS. à P.*, no. 231; *E.R.A.*, no. 57; Wormald, *op. cit.* (Note 268), pp. 83–4; Oakeshott, *op. cit.* (Note 89), p. 103; Thomson, *op. cit.* (Note 38), I, p. 135 note 76.

289. See Yves Bonnefoy, *Peintures murales de la France gothique* (Paris, 1954), pp. 8–9 and plates 1–5.

290. British Library MS. Add. 46487; Kauffmann, no. 60; *E.R.A.*, no. 46.

291. MS. Auct. E. inf. 1–2; Kauffmann, no. 82; Cahn, no. 35; *E.R.A.*, nos. 63 and 63A; and Oakeshott, *op. cit.* (Note 89), especially chapter V.

292. Thomson, *op. cit.* (Note 38), I, pp. 33–5.

293. Oakeshott, *op. cit.* (Note 89), chapter V.

294. *Ibid.*, pp. 66, 104.

295. Le Mans, Bibliothèque Municipale MS. 263, a *de luxe* manuscript of the mid twelfth century with a poor text. Oakeshott considered the artist to be the Entangled Figures Master ('Some New Initials by the Entangled Figures Master', *The Burlington Magazine*, CXXVI (1984), pp. 230–2), but Thomson disagrees (*op. cit.*, I, p. 135).

296. By Boase, *op. cit.*, p. 179.

297. Oakeshott, *op. cit.*, p. 99 ff.

298. Oxford, Bodleian Library MS. Auct. D.2.4; Oakeshott, *op. cit.*, pp. 131–2.

299. *The Heads of Religious Houses England and Wales 940–1216*, ed. David Knowles *et al.* (Cambridge, 1972), p. 149.

300. A convenient summary of the well-known story is given in Oakeshott, *op. cit.*, pp. 33–4; see also L-B E, 4828–9.

301. Oakeshott, *op. cit.*, pp. 33–4.

302. See Kauffmann, no. 83; Cahn, no. 38; *E.R.A.*, nos. 64, 64a, 64b, 65; Oakeshott, *op. cit.*, especially chapter IV.

303. Oakeshott, *op. cit.*, p. 3.

304. *Ibid.*, pp. 13–14.

305. The Bible of Bishop Hugh du Puiset, now Durham, Cathedral Library MS. A.II.1; see Kauffmann, no. 98.

306. McLachlan, *op. cit.* (Note 71), p. 198 note 2, points out that along the edge of folio 54 of the Bury Bible, where a frontispiece to Leviticus has been removed, there are remains of instructions to the miniaturist.

307. Oakeshott, *op. cit.*, p. 13.

308. *Ibid.*, pp. 43 ff.

309. Walter Oakeshott, *Sigena: Romanesque Paintings in Spain and the Winchester Bible Artists* (London, 1972), p. 82.

310. Oakeshott, *op. cit.* (Note 89), pp. 53 ff.

311. *Ibid.*, p. 53.

312. Jones and Morey, *op. cit.* (Note 282), p. 70, remark that our artist was 'probably the headmaster of the scriptorium' that produced the Terence.

313. Oakeshott, *op. cit.* (Note 89), pp. 65 ff.

314. *Ibid.*, pp. 75 ff.

315. *Ibid.*, p. 21.

316. British Library Royal MS. 2.A.XXII folio 14 verso; Oakeshott, *op. cit.* (Note 309), p. 98.

317. Oakeshott, *op. cit.* (Note 89), pp. 71 ff.

318. *Ibid.*, pp. 75 ff.

319. *Ibid.*, p. 113, and Oakeshott, *op. cit.* (Note 309), p. 84.

320. Oakeshott, *op. cit.* (Note 89), p. 39.

321. *Ibid.*, p. 68.

322. *Ibid.*, pp. 45–7.

323. Neil Ker, as quoted by Oakeshott, *op. cit.* (Note 309), p. 142.

324. David Park, 'The Wall Paintings of the Holy Sepulchre Chapel', *Medieval Art and Architecture at Winchester Cathedral*, vol. VI of *The British Archaeological Association Conference Transactions for the Year 1980* (1983), p. 50.

325. *Ibid.*, pp. 39–41.

326. *Ibid.*

327. *Ibid.*, p. 52.

328. The sources are: Mariano de Pano, 'Acta de apertura y reconocimiento de los sepulcros reales del monasterio de Sijena', *Boletín de la Real Academia de la Historia*, XI (1887), pp. 462–9, and Ricardo del Arco, 'El Real Monasterio de Sigena', *Boletín de la Sociedad Española de Excursiones*, XXIX (1921), pp. 26–63.

Useful biographical details about Doña Sancha are to be found in *Historia de España: Gran Historia General de los Pueblos Hispanos*, II: *La Alta Edad Media (Siglos V al XII)*, 2nd ed. (Barcelona, 1958).

329. J. A. de Funes, *Coronica de la ilustrissima milicia, y sagrada religion de San Iuan Bautista de Ierusalem* (Valencia, 1626), p. 65.

330. The date is indicated by the title of J. del Val's book, *Resumen historico de Nuestra Señora del Coro, del monasterio de Señoras comendadoras de San Juan de Sijena, que aparecio en aquel sitio junto al rio Alcanadre el año de 1182*, which was published in Zaragoza in 1740, though I have not been able to track down a copy.

331. A charter, dated March 1182 by modern reckoning, in which King Alfonso gives the town of Tortosa to the Templars, bears Sancha's signature. See J. Caruana's article, 'Itinerario de Alfonso II de Aragón', *Estudios de Edad Media de la Corona de Aragón*, VII (1962), pp. 73–298; the charter is cited on pp. 207–8.

332. De Funes, *op. cit.*, p. 65.

333. Del Arco, *op. cit.*, p. 54.

334. See *Ars Hispaniae*, VI: *Pintura e imaginería románicas*, by W. W. S. Cook and José Gudiol Ricart (Madrid, 1950), figure 369. Del Arco says that the seated Virgin was shown with the Christ Child on her knee. He was blessing with one hand and had an open book, inscribed with the words 'Ego sum lux mundi', in the other. She was offering him a flower. The flower had gone when the photograph was taken, but the Virgin's hand clearly originally held something. It cannot be seen from the photograph whether the open book was inscribed.

335. The charter of confirmation to Sigena issued by the Grand Master of the Hospitallers at Acre in 1207 mentions 'a number of up to thirteen or more' as being an expedient number for the community (J. Delaville le Roulx, *Cartulaire Général de l'Ordre des Hospitaliers de S. Jean de Jérusalem* (Paris, 1894), II, p. 76 no. 1272).

336. Marco Antonio Varón, *Historia del Real Monasterio de Sixena*, I (Pamplona, 1773), pp. 50 and 51. The date of the reception of the nuns on 23 April is supported by Augustín Ubieto, *El Real Monasterio de Sigena (1188–1300)* (Valencia, 1966), p. 22, by Julio P. Arribas Salaberri, *Historia de Sijena* (Lérida, 1975), p. 24, and by Juan-Manuel Palacios Sánchez, *El Real Monasterio de Sijena* (Zaragoza, 1980), p. 14.

337. Ubieto, *op. cit.*, p. 22, and Salaberri, *op. cit.*, p. 24.

338. Published by Le Roulx (*op. cit.*, I, no. 859), see pp. 535 and 538. The full text of Ricardo's Rule was accompanied by a letter of authorization from the Hospitallers which is dated October 1188. The Rule was actually read out at the reception of the first nuns on 23 April, but del Arco (p. 29) believes that this was only a substantial part, or digest, of it.

339. Del Arco, *op. cit.*, p. 28.

340. The pioneer work on the Sigena murals is Otto Pächt, 'A Cycle of English Frescoes in Spain', *Burlington Magazine*, CIII (1961), pp. 166–75, where conclusive proof is given of their Englishness. A fuller book-length study by Oakeshott is quoted in Note 309.

341. *Radulphi de Diceto Decani Lundoniensis Opera Historica*, ed. W. Stubbs, I, Rolls Series (London, 1876), p. 414.

342. *Materials for the History of Thomas Becket*, ed. J. C. Robertson, VI, Rolls Series (London, 1882), p. 457.

343. Henry's mother, Matilda, was Sancha's great-grandmother through her first marriage to the Emperor Henry V; and Henry's son-in-law, Alfonso VIII of Castile, was the son of Sancha's half-brother King Sancho.

344. W. Stubbs, ed., *op. cit.* (Note 341), p. 353.

345. *Gesta Regis Henrici Secundi*, ed. W. Stubbs, I, Rolls Series (London, 1867), p. 303.

346. In his remarkable pioneering study (*op. cit.* (Note 340), pp. 169–70), Pächt proposed that the painting of the barnacle goose in the murals itself offered proof of a connection with the English court, but unfortunately this cannot be sustained. He thought that it had been stimulated by the description of the barnacle goose in a work dedicated to Henry II, begun in 1185 and completed by the spring of 1188: the *Topographia Hibernica* of Henry's court chaplain, Gerald of Wales (Distinctio I, c. xv; *Giraldi Cambrensis Opera*, V, ed. J. F. Dymock, Rolls Series (London, 1867), p. 47). Pächt's belief that Gerald was the first to write of the bird is justified in the case of the one described by Gerald, but not of the one represented at Sigena, for medieval lore distinguished two species of barnacle goose. Gerald's was a type thought to be miraculously generated from dead wood that had been steeped in sea water. A gum then formed on the wood, developed a protective shell, and gradually took on the shape of a bird. Finally feathers developed, and the bird either dropped off into the water or took straight to the air. Gerald's report, quickly incorporated into works on natural history, was however contradicted towards the middle of the thirteenth century by no less a person than the Emperor Frederick II (*Friderici Romanorum Imperatoris Secundi De arte venandi cum avibus*, ed. C. A. Willemsen (Leipzig, 1942), I, p. 55), who pointed out from his own observation that the creature in question was no bird but a type of shellfish that clings to rotting ship's timbers. However this may be, the barnacle goose at Sigena was of a

second type which might be called a tree goose, for it was said to be generated from the trunk or branches of a tree that grew by the sea. The Sigena birds, shown hanging from the leaves of a tree, have a much longer pedigree than Gerald's type, for birds generated from trees are mentioned in a letter, probably written in 1067, from Peter Damian to Abbot Desiderius of Montecassino (*Pierre Damien, Lettre sur la toute-puissance divine*, ed. André Cantin (Paris, 1972), p. 456). Pächt took the Sigena geese as a proof that the artists were Englishmen on the grounds that the murals were more or less contemporary with the *Topographia Hibernica*, so that none but Englishmen would have been aware of Gerald's description at that time. This argument of course loses its validity in face of the fact that the painting is not based upon Gerald's text, but the English nationality of the artists is nevertheless established on stylistic and iconographic grounds that link Sigena unassailably with the Winchester Bible.

It is interesting, incidentally, that works incorporating Gerald's description of the barnacle goose are actually illustrated by pictures of the other family of barnacle geese, those generated in trees, as we see in British Library MS. Harley 4751 and Bodleian Library MS. Bodley 764 (both Bestiaries), and even in a copy of Gerald's own text, British Library MS. Royal 13.B.VIII. The implication seems to be that pictures of the earlier fable were known and simply borrowed to illustrate the later legend.

347. 'Hugonis Falcandi in suam historiam de regno Siciliae praefatio . . .', in vol. VII of Muratori's *Rerum Italicarum Scriptores* (Milan, 1725) and reprinted by G.B. Siragusa as *Epistola ad Petrum Panormitanae ecclesiae thesaurarium* (Rome, 1897).

348. Oakeshott, *op. cit.* (Note 309), pp. 96–8.

349. *Ibid.*, pp. 137 ff.

350. *Ibid.*, pp. 107–11.

351. *Ibid.*, pp. 104–5.

352. *Ibid.*, pp. 98–9 and p. 143 note 25, where the view expressed by Pächt is quoted that the Morgan Master may actually have designed the mosaic figures of this group.

353. *Ibid.*, p. 104.

CHAPTER 13

1. See above, p. 247.

2. See L-B E, 2373.

3. Carlo Cecchelli, 'Vetri da finestra del S. Vitale di Ravenna', *Felix Ravenna*, XXXV (1930), pp. 14 ff. The two figures whom Christ was blessing have disappeared.

4. J. Lafond, *Le Vitrail* (Librairie Arthème Fayard, 1978), pp. 19–21.

5. Mrs Mary P. Merrifield, *Original Treatises on the Arts of Painting*, 2 vols. (but with continuing pagination), republished New York, 1967, from 1849 edition, p. lxxxii.

6. It would appear from the discovery of fragments of stained glass during excavations at the Zeyrek Camii (formerly the church of the Pantocrator), Istanbul, that the Byzantines may also have been producing stained-glass windows in the twelfth century (see Arthur H.S. Megaw, 'Notes on Recent Work of the Byzantine Institute in Istanbul', *Dumbarton Oaks Papers*, XVII (1963), pp. 333–71, especially pp. 349–64). However, the claim that it was the Byzantine example that stimulated the production of stained glass in the West in the twelfth century (*ibid.*, pp. 363–4) is overstated, and overlooks the documentary evidence indicating a longstanding tradition of stained glass in the West.

7. See Theophilus ed. Dodwell, p. 24.

8. Lafond, *op. cit.*, p. 37.

9. *Richeri Historiae*, lib. III, c. 23, in *Mon. Germ. Hist. SS.*, III, p. 613. The statement in some modern works (e.g. Grodecki (1977), p. 43) that these windows were in the abbey church of Saint-Remi is incorrect.

10. Lafond, *op. cit.*, pp. 37–8.

11. Grodecki (1977), p. 43.

12 Book II, ed. Dodwell, pp. 36 ff.

13. É. Mâle, 'La Peinture sur verre en France', in A. Michel, *Histoire de l'Art*, I (2) (Paris, 1905), p. 785.

14. Merrifield, *op. cit.*, p. 197.

15. Ed. Dodwell, pp. 57–8.

16. Though not, Grodecki points out, using Theophilus's recommended technique, which does not first appear in surviving glass until the thirteenth century at Regensburg. It would seem that Theophilus's technique of fusion was not a permanent one. See Louis Grodecki, 'Le Chapitre XXVIII de la *Schedula* du moine Théophile: technique et esthétique du vitrail roman', *Académie des Inscriptions et Belles-Lettres, Comptes rendus des séances de l'année 1976* (Paris, 1976), pp. 346–9.

17. *Eneide*, lines 9468–73.

18. *Parzival*, book XII, lines 198–203.

19. Ed. Dodwell, p. 4.

20. Suger ed. Panofsky, p. 76.

21. Ed. Dodwell, p. 44.

22. Suger ed. Panofsky, pp. 52 and 76.

23. *Ibid.*, p. 76.

24. Schlosser (1892), no. 153.

25. See below, p. 569.

26. Rüdiger Becksmann, 'Glasmalerei', *Die Zeit der Staufer*, I, exhibition catalogue, Württembergisches Landesmuseum (Stuttgart, 1977), p. 276.

27. Rüdiger Becksmann and Stephan Waetzoldt, *Vitrea Dedicata: Das Stifterbild in der deutschen Glasmalerei des Mittelalters* (Berlin, 1975), p. 68.

28. Madeline H. Caviness, 'Romanesque "belles verrières" in Canterbury?' *Romanesque and Gothic Essays for George Zarnecki*, 2 vols. (Woodbridge, 1987), I, p. 38.

29. H. M. Colvin *et al.*, *The History of the King's Works*, I (London, 1963), p. 87.

30. *Segreti per Colori*, VII, 214–16, ed. Merrifield, *op. cit.*, p. 493.

31. G. G. Coulton, *Five Centuries of Religion*, II (Cambridge, 1927), p. 20.

32. Schlosser (1896), p. 108.

33. See above, pp. 159–60.

34. Schlosser (1892), no. 713. The quotation is from the *Vita Boniti Episcopi Arverni*, which is printed in full in *Mon. Germ. Hist. SS. Rerum Merovingicarum*, VI, ed. B. Krusch and W. Levison (Hannover and Leipzig, 1913), pp. 110–39. It was commissioned to celebrate the translation of the relics of St Bonitus, which took place some time (probably soon) after 711, and it seems reasonable from comments in the account to date the *Vita* before 725.

35. Schlosser (1892), no. 240.

36. Theophilus ed. Dodwell, p. 37.

37. Louis Grodecki, *The Stained Glass of French Churches* (London, 1948), p. 6.

38. Friedrich Gerke, 'Das Lorscher Glasfenster', *Beiträge zur Kunst des Mittelalters: Vorträge der Ersten Deutschen Kunsthistorikertagung auf Schloss Brühl 1948* (Berlin, 1950), pp. 186–92.

39. Herbert Rode, 'Eine Ornamentscherbe aus der Kölner Domgrabung und Erwägungen zu den Glasfenstern des alten Doms', *Die Kunstdenkmäler des Rheinlandes*, Beiheft 20, ed. Günther Borchers (Düsseldorf, 1974), pp. 15–33.

40. Rüdiger Becksmann, 'Das Schwarzacher Köpfchen. Ein Ottonischer Glasmalereifund', *Kunstchronik*, XXIII (1970), pp. 3–9.

41. *Ibid.*, p. 6.

42. V. Beyer, *Les Vitraux des musées de Strasbourg* (Strasbourg, 1966), no. 1, pp. 11–12.

43. Musée des Arts Décoratifs, *Vitraux de France du XI^e au XVI^e siècle*, exhibition catalogue (Paris, 1953), pp. 37–8.

44. Quoted in Lafond, *op. cit.*, p. 112.

45. Theophilus ed. Dodwell, p. 4.

46. For which see Grodecki's detailed analysis in Grodecki (1976).

47. See Panofsky's edition, given in list of abbreviations for books often cited.

48. Suger ed. Panofsky, p. 100. In the second edition of 1979, the first edition's reading *sacratissimarum vitrearum* is corrected to *clarissimarum vitrearum*.

49. For their present whereabouts see Grodecki (1976), pp. 65 ff.

50. See David O'Connor and Peter Gibson, 'The Chapel Windows at Raby Castle, County Durham', *The Journal of Stained Glass*, XVIII (2) (1986–7), pp. 125–8.

51. For Abelard's own account of this see his *Historia Calamitatum* in *The Letters of Abelard and Heloise*, ed. Betty Radice (Harmondsworth, 1974), pp. 85–6.

52. Grodecki (1976), pp. 98–102.

53. See Jane Hayward, 'Stained Glass at Saint-Denis', in *The Royal Abbey of Saint-Denis in the Time of Abbot Suger (1122–1151)*, ed. S. McK. Crosby *et al.*, exhibition catalogue, Metropolitan Museum of Art (New York, 1981), p. 86.

54. Konrad Hoffmann, 'Sugers "Anagogisches Fenster" in St Denis', *Wallraf-Richartz Jahrbuch*, XXX (1968), pp. 58–9.

55. Suger ed. Panofsky, pp. 74–6.

56. Grodecki (1976), p. 105.

57. Suger ed. Panofsky, p. 72.

58. Grodecki (1976), p. 64.

59. Michael Cothren, 'A Re-Evaluation of the Iconography and Design of the Infancy Window from the Abbey of Saint-Denis', *Gesta*, XVII/1 (1978), p. 74. Hayward, however, expresses some doubts about the authenticity of the panel (*op. cit.*, pp. 78–81).

60. Suger ed. Panofsky, p. 31.

61. Grodecki (1976), pp. 115–21.

62. *Radiance and Reflection: Medieval Art from the Raymond Pitcairn Collection*, exhibition catalogue, Metropolitan Museum of Art (New York, 1982), p. 92.

63. B. de Montfaucon, *Les Monumens de la Monarchie Française* (Paris, 1729–33), I, plates L–LIV, following p. 390.

64. *Descriptio qualiter Karolus Magnus clavum et coronam Domini a Constantinopoli Aquisgrani detulerit qualiterque Karolus Calvus hec ad Sanctum Dionysium retulerit*; see Grodecki (1976), p. 118.

65. Grodecki (1976), p. 18.

66. *Radiance and Reflection*, *op. cit.* (Note 62), pp. 93 ff.

67. Grodecki (1976), p. 114.

68. In the Dépôt des Monuments Historiques; *ibid.*, pp. 106-7.

69. Suger ed. Panofsky, p. 80. The word *pallia* usually means rich silks.

70. *Ibid.*, pp. 72-4.

71. Grodecki (1977), p. 98.

72. *Ibid.*

73. Jane Hayward, *op. cit.* (Note 53), pp. 65-7.

74. Sec Y. Delaporte and E. Houvet, *Les Vitraux de la cathédrale de Chartres* ..., 4 vols. (Chartres, 1926), and Grodecki (1977), pp. 103-12, 279-81.

75. Grodecki (1977), pp. 106 ff.

76. Luke III, 5.

77. Chantal Bouchon *et al.*, 'La "Belle-Verrière" de Chartres', *Revue de l'art*, XLVI (1979), pp. 18-19.

78. *Gallia Christiana*, VIII (Paris, 1744), col. 1226, quoted by Paul Popesco, 'Les Panneaux de vitrail du XIIᵉ siècle de l'église Saint-Pierre de Chartres, ancienne abbatiale', *Revue de l'Art*, X (1970), p. 48 and note 15.

79. Grodecki (1977), pp. 114-16, 286.

80. See L. Grodecki, 'Les Vitraux du XIIᵉ siècle de Saint-Germer-de-Fly', *Miscellanea pro Arte* (Festschrift for Hermann Schnitzler) (Düsseldorf, 1965), p. 157.

81. *Ibid.*, p. 155.

82. British Library MS. Arundel 60 folio 52 verso.

83. See the four articles by L. Grodecki: 'Les Vitraux de la cathédrale de Châlons-sur-Marne', *Bulletin de la Société Nationale des Antiquaires de France* (1950-1), pp. 196-203, quoted as Grodecki (1950-1); 'A propos des vitraux de Châlons-sur-Marne: deux points d'iconographie mosane', *L'Art mosan: journées d'études, Paris, février 1952*, ed. P. Francastel (Paris, 1953), pp. 161-70, quoted as Grodecki (1953); 'La Restauration des vitraux du XIIᵉ siècle provenant de la cathédrale de Châlons-sur-Marne', *Mémoires de la Société d'Agriculture, Commerce, Sciences et Arts du Département de la Marne*, 2nd ser., XXVIII (1953-4), pp. 323-52, quoted as Grodecki (1953-4); and 'Les Vitraux de Châlons-sur-Marne et l'art mosan', *Relations artistiques entre la France et les autres pays depuis le haut Moyen Âge jusqu'à la fin du XIXᵉ siècle* (*Actes du XIXᵉ Congrès international d'histoire de l'art*) (Paris, 1959), pp. 183-90, quoted as Grodecki (1959).

84. See Grodecki (1953), p. 169.

85. Folio 84.

86. See Grodecki (1959), p. 186.

87. See Grodecki (1953-4).

88. Grodecki (1950-1), p. 201.

89. Grodecki (1959), p. 188.

90. *Ibid.*, pp. 189-90.

91. Hans Reinhardt, 'Le Vitrail de la découverte des reliques de saint Étienne à la cathédrale de Châlons-sur-Marne', *Mémoires de la Société d'Agriculture, Commerce, Sciences et Arts du Département de la Marne*, XCI (1976), pp. 135-42.

92. Grodecki (1977), pp. 129-30, 286.

93. See above, p. 374.

94. L-B D, 1774.

95. Hincmar's address at the coronation of Charles the Bald as king of Lotharingia in 869, in *Pat. Lat.*, CXXV, col. 806.

96. Louis Grodecki, 'Les plus anciens vitraux de Saint-Remi de Reims', *Beiträge zur Kunst des Mittelalters: Festschrift für Hans Wentzel zum 60. Geburtstag* (Berlin, 1975), p. 76.

97. Grodecki (1977), p. 134.

98. See above, p. 383.

99. Anne Prache, 'Le Vitrail de la Crucifixion de Saint-Remi de Reims', *Études d'art médiéval offertes à Louis Grodecki*, ed. S. McK. Crosby *et al.* (Paris, 1981), pp. 145, 148.

100. See the three articles by Louis Grodecki: 'Les Vitraux de la fin du XIIᵉ ou du début du XIIIᵉ siècle à la cathédrale de Troyes', *Bulletin de la Société Nationale des Antiquaires de France* (1961), pp. 57-8; 'Problèmes de la peinture en Champagne pendant la seconde moitié du douzième siècle', *Studies in Western Art. Acts of the Twentieth International Congress of the History of Art*, I: *Romanesque and Gothic Art*, ed. M. Meiss (Princeton, 1963), pp. 129-41; 'Nouvelles découvertes sur les vitraux de la cathédrale de Troyes', *Intuition und Kunstwissenschaft: Festschrift für Hanns Swarzenski zum 70. Geburtstag*, ed. Peter Bloch *et al.* (Berlin, 1973), pp. 191-203.

101. See Grodecki, *op. cit.* (Note 100) (1961), and Charles T. Little, 'Membra Disjecta: More Early Stained Glass from Troyes Cathedral', *Gesta*, XX (1981), pp. 119-27.

102. See Little, *op. cit.* p. 119.

103. *Radiance and Reflection*, *op. cit.* (Note 62), pp. 106-7.

104. Paris, Bibliothèque Nationale MSS. lat. 16743-6. The two relevant volumes are 1 and 3.

105. Troyes, Bibliothèque Municipale MS. 92.

106. See above, p. 273, and Grodecki, *op. cit.* (Note 100) (1963), pp. 136-7.

107. *Ibid.*, p. 139.

108. Grodecki (1977), p. 68. For the glass, see *ibid.*, pp. 57-70, 283-4, and

idem, 'Les Vitraux de la cathédrale du Mans', *Congrès Archéologique de France*, CXIX (1961), pp. 59 ff.

109. Grodecki (1977), p. 283.

110. See above, pp. 235-6.

111. For these styles, see above, pp. 329 and 347.

112. Grodecki (1977), pp. 58-60.

113. By Grodecki (1977), p. 284.

114. *Ibid.*, p. 66.

115. *Ibid.*, p. 284.

116. *Ibid.*, p. 283.

117. See *ibid.*, pp. 70-6, 286-7, and L. Grodecki, 'Les Vitraux de la cathédrale de Poitiers', *Congrès Archéologique de France*, CIX (1952), pp. 138-63.

118. Grodecki, *op. cit.* (Note 117), p. 146.

119. See R. Crozet, 'Le Vitrail de la Crucifixion à la cathédrale de Poitiers', *Gazette des Beaux-Arts*, 6ᵉ période, XI(1) (1934), pp. 219-23.

120. For the meaning of the programme, see R. Grinnell, 'Iconography and Philosophy in the Crucifixion Window at Poitiers', *Art Bulletin*, XXVIII (1946), pp. 171-96, especially pp. 194-5.

121. Grodecki, *op. cit.* (Note 117), pp. 148-9.

122. *Ibid.*, pp. 146-7.

123. Louis Grodecki, 'Le Vitrail roman de Gargilesse (Indre)', *Mélanges offerts à René Crozet ... à l'occasion de son soixante-dixième anniversaire*, ed. P. Gallais and Y.-J. Riou (Poitiers, 1966), pp. 953-7.

124. Grodecki (1977), pp. 78-9, 295.

125. See J. Hayward and L. Grodecki, 'Les Vitraux de la cathédrale d'Angers', *Bulletin Monumental*, CXXIV (1966), pp. 7-67, and Grodecki (1977), pp. 80-6, 276-7.

126. Grodecki (1977), p. 276.

127. *Ibid.*, pp. 86, 281, and F. Perrot and A. Granboulan, 'The French ... Glass at Rivenhall, Essex', *The Journal of Stained Glass*, XVIII(1) (1983-4), pp. 1-3.

128. Grodecki (1977), p. 88.

129. *Ibid.*, pp. 88-90, 277-8.

130. Catherine Brisac, 'La Verrière du Champ-près-Froges (Isère)', *L'Information d'histoire de l'art*, XVII (1972), pp. 158-62.

131. Louis Grodecki, 'Un Groupe de vitraux français du XIIᵉ siècle', *Festschrift für Hans R. Hahnloser zum 60. Geburtstag*, ed. Ellen J. Beer *et al.* (Basel, 1961), pp. 289-98.

132. Grodecki (1977), pp. 190-4, 281-2, and *Radiance and Reflection*, *op. cit.* (Note 62), pp. 121 ff.

133. Clermont-Ferrand, Bibliothèque Municipale MS. 63; see Grodecki (1977), pp. 191 and 193.

134. Catherine Brisac, 'La Peinture sur verre à Lyon', *Dossiers de l'Archéologie*, XXVI (1978): *Découvrir et sauver les vitraux*, p. 38.

135. *Ibid.*

136. *Ibid.*, p. 39.

137. J. L. Fischer, *Handbuch der Glasmalerei* (Leipzig, 1937), p. 18.

138. A. Boeckler, 'Die romanischen Fenster des Augsburger Domes und die Stilwende vom 11. zum 12. Jahrhundert', *Zeitschrift des Deutschen Vereins für Kunstwissenschaft*, X (1943), pp. 168 ff.

139. Stuttgart, Württembergische Landesbibliothek bibl. fol. 56-8; see above, p. 439.

140. Gottfried Frenzel, 'Glasmalerei in Schwaben', *Suevia Sacra: Frühe Kunst in Schwaben, Ausstellung im Rathaus vom 30 Juni-16 Sept. 1973* (Augsburg, 1973), p. 53.

141. F. Zschokke, *Die romanischen Glasgemälde des Strassburger Münsters* (Basel, 1942). See also the recent study by Victor Beyer, Christiane Wild-Block, and Fridtjof Zschokke, *Les Vitraux de la cathédrale Notre-Dame de Strasbourg*, C.V.M.A. France, IX-1 (Paris, 1986), which does not substantially modify Zschokke's earlier conclusions.

142. Zschokke, *op. cit.*, pp. 66-70.

143. F. Zschokke, 'Un Vitrail de la cathédrale romane de Strasbourg retrouvé en 1933', *Archives Alsaciennes d'Histoire de l'Art*, XIV (1935), pp. 159-64.

144. Rüdiger Becksmann (*op. cit.* (Note 26), p. 285), for reasons that I do not comprehend, says that they are Roland and Olivier.

145. Zschokke no longer believes the figure of an archangel, now in the crypt, to have belonged to the Tree of Jesse window; see Beyer *et al.*, *op. cit.*, p. 31.

146. Zschokke, *op. cit.* (Note 141), p. 29.

147. See above, pp. 294-6.

148. Zschokke, *op. cit.* (Note 141), pp. 57-8.

149. Grodecki (1977), p. 292.

150. Cf. Becksmann, *op. cit.*, p. 277.

151. *Ibid.*, p. 284.

152. Simone Schultz-Foyard, 'Un Vitrail roman alsacien: la Vierge de Wissembourg', *L'Information d'histoire de l'art*, XV (1970), pp. 16-21; Grodecki (1977), pp. 180-4, 295.

153. Karlsruhe, Landesbibliothek cod. Bruchsal 1; Grodecki (1977), p. 182.

154. See Hans Wentzel, *Meisterwerke der Glasmalerei* (Berlin, 1954), pp. 19–22, Grodecki (1977), pp. 151–60, 268–9, and Becksmann, *op. cit.*, catalogue no. 400.

155. Becksmann, *op. cit.*, p. 278.

156. See above, pp. 352, 354.

157. Grodecki (1977), pp. 268–9.

158. Made in an unpublished paper by Paul Frankl, quoted *ibid.*, pp. 156 and 263.

159. Wentzel, *op. cit.*, p. 21 and plate 23.

160. Hans Wentzel, 'Zur Bestandsaufnahme der romanischen Chorfenster von St Patroklus in Soest', *Westfalen*, XXXVII (1959), pp. 92–103, and Ulf-Dietrich Korn, *Die romanische Farbverglasung von St Patrokli in Soest* (*Westfalen*, 17. Sonderheft) (Münster Westfalen, 1967).

161. W. F. Volbach, 'Vier Scheiben aus dem Patroklidom in Soest', *Der Sammler*, XII (1922), Heft 4, pp. 49–50.

162. Today they show groups of bystanders.

163. Korn, *op. cit.*, pp. 32–3. For Rupert's comments, see *Pat. Lat.*, CLXVII, cols. 1356 ff.

164. The symbolism recurs on folio 241 of the *Hortus Deliciarum*.

165. Korn, *op. cit.*, pp. 50–4.

166. *Ibid.*, pp. 64–70.

167. Ulf-Dietrich Korn, 'Glasmalereifunde in der ev. Pfarrkirche zu Weslarn', *Westfalen*, LV (1977), p. 503.

168. E. F. Bange, *Eine bayerische Malerschule des XI. und XII. Jahrhunderts* (Munich, 1923), p. 7.

169. *Die Tegernseer Briefsammlung (Froumund)*, ed. Karl Strecker (*Mon. Germ. Hist. Epistolae Selectae*, III) (Berlin, 1925), no. 75, p. 84; L-B D, 3041.

170. *Ibid.*, no. 81, p. 88, and L-B D, 3043.

171. E. J. Beer, *Die Glasmalereien der Schweiz vom 12. bis zum Beginn des 14. Jahrhunderts* (Basel, 1956), pp. 17–22.

172. Becksmann, *op. cit.* (Note 26), cat. no. 420.

173. Rosemary Cramp, 'Window Glass from the Monastic Site of Jarrow: Problems of Interpretation', *Journal of Glass Studies*, XVII (1975), pp. 92–3. For the Monkwearmouth fragments see the same author's 'Decorated Window-Glass and Millefiori from Monkwearmouth', *The Antiquaries Journal*, L (1970), pp. 327–35.

174. Dodwell (1982), p. 63.

175. They are well surveyed by David E. O'Connor and Jeremy Haselock in 'The Stained and Painted Glass', *A History of York Minster*, ed. G. E. Aylmer and Reginald Cant (Oxford, 1977), pp. 319 ff. See also the stained glass section of *E.R.A.*, pp. 135 ff.; W. R. Lethaby, 'Archbishop Roger's Cathedral at York and its Stained Glass', *Archaeological Journal*, XXII (1915), pp. 37–48; and N. H. J. Westlake, *A History of Design in Painted Glass*, 3 vols. (London, 1881–94), I, chapter IX.

176. See Dodwell (1954), plate 53a.

177. Cf. Lethaby, *op. cit.*, pp. 42–5, and O'Connor and Haselock, *op. cit.*, pp. 320–1.

178. O'Connor and Haselock, *op. cit.*, p. 324. Westlake first noticed the connections with Saint-Denis.

179. M. Caviness, 'The Canterbury Jesse Window', *The Year 1200: A Symposium*, Metropolitan Museum of Art (New York, 1975), p. 384, note 27.

180. Westlake, *op. cit.*, p. 42.

181. *E.R.A.*, p. 136.

182. Published by Sarah Crewe, *Stained Glass in England 1180–1540* (London, 1987), plate 5.

183. David O'Connor very generously drew my attention to the glass, which is his discovery. He intends, with Keith Barley, to publish and discuss it in a future issue of *The Journal of Stained Glass*.

184. See above, p. 100.

185. However, according to Lafond, one figure and some decorative elements now in the south rose of Lincoln Cathedral may be twelfth-century. See Jean Lafond, 'The Stained Glass Decoration of Lincoln Cathedral in the Thirteenth Century', *Archaeological Journal*, CIII (1946), p. 150.

186. L-B E, 1408.

187. L-B E, 2228.

188. Helen Jackson Zakin, *French Cistercian Grisaille Glass* (University Microfilms International, Michigan and London, 1982), p. 200.

189. L-B E, 730.

190. Caviness, *op. cit.* (Note 28).

191. *Tractatus de combustione et reparatione Cantuariensis ecclesiae*, in *Gervasii Cantuariensis Opera Historica*, I, ed. W. Stubbs, Rolls Series (London, 1879), pp. 3–29.

192. *The Early Stained Glass of Canterbury Cathedral* (Princeton, 1977), quoted as Caviness (1977), and *The Windows of Christ Church Cathedral Canterbury*, C.V.M.A. Great Britain II (British Academy, 1981), quoted as Caviness (1981).

193. Dodwell (1982), pp. 84–6.

194. M. R. James, 'Pictor in Carmine', *Archaeologia*, XCIV (1951), pp. 141–66. The probable Englishness of the tract is discussed on p. 35.

195. *Ibid.*, p. 151.

196. E. W. Tristram, *English Medieval Wall Painting: the Twelfth Century* (Oxford, 1944), p. 155.

197. *Ibid.*, p. 140, and M. R. James, 'On the Paintings formerly in the Choir at Peterborough', *Proceedings of the Cambridge Antiquarian Society*, IX (1897), pp. 178–94.

198. See James, *op. cit.* (Note 194), pp. 148–50.

199. See Caviness (1977), pp. 115 ff., and 168–74 for reconstruction.

200. M. R. James, *The Verses Formerly Inscribed on Twelve Windows in the Choir of Canterbury Cathedral*, Cambridge Antiquarian Society Octavo Publications, XXXVIII (Cambridge, 1901).

201. Caviness (1977), pp. 104–5, 116.

202. James, *op. cit.* (Note 197), p. 189.

203. Caviness (1981), p. 10.

204. The influences are considered by Caviness (1977), pp. 112 ff. For the Hexateuch, see above, pp. 185–7.

205. Caviness (1977), p. 141.

206. *Ibid.*, p. 140.

207. *Ibid.*, pp. 140, 144 ff.

208. *Ibid.*, pp. 146 ff.

209. *Ibid.*, p. 147.

210. *Ibid.*, pp. 49 ff.

211. Gervase, *op. cit.* (Note 191), p. 24: 'Eiectus est autem conventus per incendium de choro sicut Adam de paradyso ...'.

212. Caviness (1977), p. 112.

213. *Ibid.*, colour plate I.

214. *Ibid.*, pp. 58 ff.

215. Listed *ibid.*, p. 65.

216. *Ibid.*, p. 79.

217. See *ibid.*, pp. 84 ff., for a very full discussion of this relationship.

218. Gervase, *op. cit.* (Note 191), pp. 19 ff.; L-B E, 815.

219. Caviness (1977), plate 190.

220. *Ibid.*, plates 209–11.

221. *Ibid.*, p. 77.

222. *Ibid.*, pp. 77, 93–4.

CHAPTER 14

1. Boulogne, Bibliothèque Municipale MS. 2; A. Boutemy, 'La "Bible" de Saint-André-au-Bois', *Scriptorium*, V (1951), pp. 222–37; cf. p. 317 above.

2. See New York, Pierpont Morgan Library MS. 710, and H. Swarzenski, *The Berthold Missal* (New York, 1943).

3. Moulins, Bibliothèque Municipale MS. 1; cf. p. 344 above.

4. Valenciennes, Bibliothèque Municipale MS. 500; cf. p. 313 above.

5. Valenciennes, Bibliothèque Municipale MS. 501.

6. Douai, Bibliothèque Municipale MS. 339.

7. Douai, Bibliothèque Municipale MS. 340.

8. Paris, Bibliothèque Nationale MS. lat. 16746.

9. London, British Library MS. Royal 2.A.XXII, folio 15; see N. J. Morgan, *Early Gothic Manuscripts [I] 1190–1250* (London, 1982), no. 2 and plate 10.

Select Bibliography

A. DOCUMENTARY SOURCE MATERIALS

BASTGEN, Hubertus (ed.). *Libri Carolini sive Caroli Magni Capitulare de Imaginibus* (*Monumenta Germaniae Historica Legum Sectio III, Concilia, Tomi I Supplementum*). Hannover and Leipzig, 1924.

DAVIS-WEYER, Caecilia. *Early Medieval Art 300–1150.* Toronto and London, 1986.

DODWELL, C. R. (ed.). *Theophilus De Diversis Artibus.* London, 1961. Reissued as *Theophilus The Various Arts.* Oxford, 1986.

LEHMANN-BROCKHAUS, Otto. *Schriftquellen zur Kunstgeschichte des 11. und 12 Jahrhunderts für Deutschland Lothringen und Italien.* 2 vols. Berlin, 1938.

LEHMANN-BROCKHAUS, Otto. *Lateinische Schriftquellen zur Kunst in England Wales und Schottland vom Jahre 901 bis zum Jahre 1307.* 5 vols. Munich, 1955-60.

MORTET, Victor. *Recueil de textes relatifs à l'histoire de l'architecture et à la condition des architectes en France au Moyen Âge.* 2 vols. Paris, 1911–29.

PANOFSKY, Erwin. *Abbot Suger on the Abbey Church of St Denis and its Art Treasures.* Princeton, 1946; second ed., Princeton, 1979.

SCHLOSSER, Julius von. *Schriftquellen zur Geschichte der karolingischen Kunst.* Vienna, 1892.

SCHLOSSER, Julius von. *Quellenbuch zur Kunstgeschichte des abendländischen Mittelalters.* Vienna, 1896.

B. STUDIES

GENERAL

ANTHONY, E. W. *A History of Mosaics.* Boston, 1935.

ANTHONY, E. W. *Romanesque Frescoes.* Princeton, 1951.

BECKWITH, John. *Early Medieval Art.* London, 1964.

BOECKLER, Albert. *Abendländische Miniaturen.* Berlin and Leipzig, 1930.

CAHN, Walter. *Romanesque Bible Illumination.* Cornell U. P., 1982.

CALKINS, Robert G. *Illuminated Books of the Middle Ages.* Cornell U.P., 1983.

DEMUS, Otto. *Romanesque Mural Painting,* with photographs by Max Hirmer. London, 1970.

EVANS, M. W. *Medieval Drawings.* London, 1969.

GEIJER, Agnes. *A History of Textile Art.* London, 1979.

GRABAR, André, and NORDENFALK, Carl. *Early Medieval Painting.* Lausanne, 1957.

GRABAR, André, and NORDENFALK, Carl. *Romanesque Painting.* Lausanne, 1958.

GRODECKI, Louis. *Le Vitrail roman.* Paris, 1977.

KITZINGER, Ernst. *The Art of Byzantium and the Medieval West: Selected Studies by Ernst Kitzinger,* ed. W. Eugene Kleinbauer. Bloomington and London, 1976.

LAFOND, Jean. *Le Vitrail.* Paris, 1978.

MAZAL, Otto. *Buchkunst der Romanik.* Graz, 1978.

MICHEL, André. *Histoire de l'art,* 1.2. Paris, 1905.

MOREY, C. R. *Mediaeval Art.* New York, 1942.

PÄCHT, Otto. *Book Illumination in the Middle Ages.* London and Oxford, 1986.

SCHUETTE, Marie, and MÜLLER-CHRISTENSEN, Sigrid. *The Art of Embroidery.* London, 1964.

SWARZENSKI, Hanns. *Monuments of Romanesque Art.* London, 1954.

WEITZMANN, Kurt. 'Various Aspects of Byzantine Influence on the Latin Countries from the Sixth to the Twelfth Century', *Dumbarton Oaks Papers,* XX (1966), pp. 3–24.

WETTSTEIN, Janine. *La Fresque romane.* 2 vols. Geneva and Paris, 1971–8.

CAROLINGIAN

BOINET, Amédée. *La Miniature carolingienne.* Paris, 1913.

BRAUNFELS, Wolfgang. *Die Welt der Karolinger und ihre Kunst.* Munich, 1968.

BRAUNFELS, Wolfgang, and SCHNITZLER, Hermann (eds.). *Karolingische Kunst* (*Karl der Grosse,* ed. W. Braunfels, III). Düsseldorf, 1965.

DUFT, J., *et al.* (eds.). *Die Bibel von Moutier-Grandval.* Berlin, 1971.

EGGENBERGER, Christoph. *Psalterium Aureum Sancti Galli: Mittelalterliche Psalterillustration im Kloster St Gallen.* Sigmaringen, 1987.

FILLITZ, Hermann (ed.). *Das Mittelalter,* I (*Propyläen Kunstgeschichte,* V). Berlin, 1969.

GRABAR, André. 'Les Mosaïques de Germigny-des-Prés', *Cahiers Archéologiques,* VII (1954), pp. 171–83.

HUBERT, J., PORCHER, J., and VOLBACH, W. F. *L'Empire carolingien.* Paris, 1968.

Karl der Grosse. Exhibition catalogue. Aachen, 1965.

KESSLER, Herbert L. *The Illustrated Bibles from Tours.* Princeton, 1977.

KOEHLER, Wilhelm. *Die karolingischen Miniaturen,* in five parts:
 I. *Die Schule von Tours.* 3 vols. Berlin, 1930–3.
 II. *Die Hofschule Karls des Grossen.* 2 vols. Berlin, 1958.
 III. *Die Gruppe des Wiener Krönungs-Evangeliars; Metzer Handschriften.* 2 vols. Berlin, 1960.
 IV. (with Florentine Mütherich). *Die Hofschule Kaiser Lothars.* 2 vols. Berlin, 1971.
 V. (with Florentine Mütherich). *Die Hofschule Karls des Kahlen.* 2 vols. Berlin, 1982.

LAUFNER, R., and KLEIN, P. K. *Trierer Apokalypse.* Facsimile and commentary. 2 vols. Graz, 1975.

MÜTHERICH, Florentine, and GAEHDE, Joachim E. *Karolingische Buchmalerei.* Munich, 1976.

Der Stuttgarter Bilderpsalter. Facsimile and commentary. 2 vols. Stuttgart, 1965-8.

Utrecht-Psalter. Facsimile and commentary. 2 vols. Graz, 1984.

OTTONIAN

BLOCH, Peter, and SCHNITZLER, Hermann. *Die Ottonische Kölner Malerschule.* 2 vols. Düsseldorf, 1967–70.

BOECKLER, Albert. 'Die Reichenauer Buchmalerei', *Die Kultur der Abtei Reichenau,* ed. K. Beyerle, II (Munich, 1925), pp. 956–98.

BOECKLER, Albert. *Das goldene Evangelienbuch Heinrichs III.* Berlin, 1933.

BUBERL, Paul. 'Über einige Werke der Salzburger Buchmalerei des XI. Jahrhunderts', *Kunstgeschichtliches Jahrbuch der K. K. Zentral-Kommission für Erforschung und Erhaltung der Kunst- und historischen Denkmale,* I (1903), pp. 29–60.

Codex Egberti. Teilfaksimile-Ausgabe des MS. 24 der Stadtbibliothek Trier. Wiesbaden, 1983.

DESHMAN, Robert. '*Christus rex et magi reges:* Kingship and Christology in Ottonian and Anglo-Saxon Art', *Frühmittelalterliche Studien,* X (1976), pp. 367–405.

DODWELL, C. R., and TURNER, D. H. *Reichenau Reconsidered, A Reassessment of the Place of Reichenau in Ottonian Art* (*Warburg Institute Surveys,* II). London, 1965.

Das Evangeliar Ottos III. Clm. 4453 der Bayerischen Staatsbibliothek München. Facsimile and commentary. 2 vols. Frankfurt am Main, 1978.

GERNSHEIM, Walter. *Die Buchmalerei der Reichenau.* Munich University dissertation, 1934.

HOFFMANN, Hartmut. *Buchkunst und Königtum im ottonischen und frühsalischen Reich* (*Schriften der Monumenta Germaniae Historica,* XXX). Stuttgart, 1986.

HOFFMANN, Konrad. 'Die Evangelistenbilder des Münchener Otto-Evangeliars', *Zeitschrift des deutschen Vereins für Kunstwissenschaft,* XX (1966), pp. 17–46.

HOFFMANN, Konrad. 'Das Herrscherbild im "Evangeliar Ottos III." (clm. 4453)', *Frühmittelalterliche Studien,* VII (1973), pp. 324–41.

JANTZEN, H. *Ottonische Kunst.* Munich, 1947.

KAHSNITZ, R., *et al. Das Goldene Evangelienbuch von Echternach: Eine Prunkhandschrift des 11. Jahrhunderts.* Frankfurt am Main, 1982.

KELLER, Hagen. 'Herrscherbild und Herrschaftslegitimation. Zur Deutung der ottonischen Denkmäler', *Frühmittelalterliche Studien,* XIX (1985), pp. 290–311.

MARTIN, Kurt. *Die ottonischen Wandbilder der St Georgskirche Reichenau-Oberzell.* 2nd ed. Sigmaringen, 1975.

METZ, Peter. *The Golden Gospels of Echternach.* London, 1957.

MÜTHERICH, Florentine. 'Malerei', *Die Zeit der Ottonen und Salier,* pp. 85–225. Munich, 1973.

NORDENFALK, Carl. 'Der Meister des Registrum Gregorii', *Münchner Jahrbuch der bildenden Kunst,* 3. Folge, I (1950), pp. 61–77.

NORDENFALK, Carl. 'The Chronology of the Registrum Master', *Kunsthistorische Forschungen: O. Pächt zu seinem 70. Geburtstag,* ed. A. Rosenauer and G. Weber, pp. 62–76. Salzburg, 1972.

NORDENFALK, Carl. *Codex Caesareus Upsaliensis. An Echternach Gospel-Book of the Eleventh Century.* Stockholm, 1971.

SAUERLAND, H. V., and HASELOFF, A. *Der Psalter Erzbischof Egberts von Trier Codex Gertrudianus in Cividale.* Trier, 1901.

SCHIEL, Hubert. *Codex Egberti der Stadtbibliothek Trier.* Basel, 1960.

SCHRAMM, P. E. *Die deutschen Kaiser und Könige in Bildern ihrer Zeit 751–1190.* Neuauflage unter Mitarbeit von P. Berghaus, N. Gussone, und F. Mütherich, ed. F. Mütherich. Munich, 1983.

SWARZENSKI, Georg. *Die Regensburger Buchmalerei des X. und XI. Jahrhunderts.* Leipzig, 1901.

VÖGE, Wilhelm. *Eine deutsche Malerschule um die Wende des ersten Jahrtausends* (*Westdeutsche Zeitschrift für Geschichte und Kunst,* Ergänzungsheft VII). Trier, 1891.

WIBIRAL, N. 'Die Wandmalereien des XI. Jahrhunderts im ehemaligen Westchor der Klosterkirche von Lambach', *Oberösterreich 1967* (3).

INDIVIDUAL COUNTRIES

Austria

BALDASS, Peter von, BUCHOWIECKI, Walther, and MRAZEK, Wilhelm. *Romanische Kunst in Österreich*. Vienna, Hannover, and Bern, 1962.

BUBERL, Paul. *Die romanischen Wandmalereien im Kloster Nonnberg in Salzburg und ihre Beziehungen zur Salzburger Buchmalerei und zur byzantinischen Kunst (Sonderabdruck aus dem Kunstgeschichtlichen Jahrbuch der K.K. Zentral-Kommission für Erforschung und Erhaltung der Kunst- und historischen Denkmale 1909)*. Vienna, 1910.

SWARZENKSI, Georg. *Die Salzburger Malerei von den ersten Anfängen bis zur Blütezeit des romanischen Stils*. 2 vols. Leipzig, 1908–13.

SWOBODA, K. M. 'Die Bilder der Admonter Bibel des 12. Jahrhunderts', *idem, Neue Aufgaben der Kunstgeschichte*, pp. 47–63. Brünn etc., n.d.

WEISS, E. 'Der Freskenzyklus der Johanneskapelle in Pürgg', *Wiener Jahrbuch für Kunstgeschichte*, XXII (1969), pp. 7–42.

WINKLER, Erich. *Die Buchmalerei in Niederösterreich von 1150–1250*. Vienna, 1923.

Bohemia

L'Art ancien en Tchécoslovaquie. Exhibition catalogue, Musée des Arts Décoratifs. Paris, 1957.

BOECKLER, Albert. 'Zur böhmischen Buchkunst des 12. Jahrhunderts', *Konsthistorisk Tidskrift*, XXII (1953), pp. 61–74.

MAŠÍN, Jiří. *Romanesque Mural Painting in Bohemia and Moravia*. Prague, 1954.

England

ALEXANDER, J. J. G. *Insular Manuscripts Sixth to the Ninth Century (A Survey of Manuscripts Illuminated in the British Isles*, ed. J. J. G. Alexander, I). London, 1978.

BOASE, T. S. R. *English Art 1100–1216*. Oxford, 1953.

BROOKS, N. P., and WALKER, H. E. 'The Authority and Interpretation of the Bayeux Tapestry', *Proceedings of the Battle Conference on Anglo-Norman Studies*, I (1978), pp. 1–34.

BUDNY, Mildred. 'The Anglo-Saxon Embroideries at Maaseik: their historical and art-historical context', *Mededelingen van de Koninklijke Academie voor Wetenschappen, Letteren en Schone Kunsten van België*, XLV (1984), pp. 57–133.

CAVINESS, Madeline H. *The Early Stained Glass of Canterbury Cathedral*. Princeton, 1977.

D'ALVERNY, M. T. 'Le Symbolisme de la Sagesse et le Christ de Saint Dunstan', *Bodleian Library Record*, V (1956), pp. 232–44.

DESHMAN, Robert. 'Anglo-Saxon Art after Alfred', *Art Bulletin*, LV (1974), pp. 176–200.

DODWELL, C. R. *The Canterbury School of Illumination*. Cambridge, 1954.

DODWELL, C. R. *Anglo-Saxon Art: A New Perspective*. Manchester, 1982.

DODWELL, C. R., and CLEMOES, Peter. *The Old English Illustrated Hexateuch (Early English Manuscripts in Facsimile*, XVIII). Copenhagen, 1974.

English Romanesque Art 1066–1200. Exhibition catalogue, Hayward Gallery. London, 1984.

HANEY, K. E. *The Winchester Psalter: An Iconographic Study*. Leicester, 1986.

HUNT, R. W. *St Dunstan's Classbook from Glastonbury (Umbrae Codicum Occidentalium*, IV). Amsterdam, 1961.

JAMES, M. R. *The Canterbury Psalter*. London, 1935.

JAMES, M. R. 'Four Leaves of an English Psalter', *Walpole Society*, XXV (1936–7), pp. 1–23.

KAUFFMANN, C. M. 'The Bury Bible', *Journal of the Warburg and Courtauld Institutes*, XXIX (1966), pp. 60–81.

KAUFFMANN, C. M. *Romanesque Manuscripts 1066–1190 (A Survey of Manuscripts Illuminated in the British Isles*, ed. J. J. G. Alexander, III). London, 1975.

KENDRICK, T. D. *Late Saxon and Viking Art*. London, 1949.

McGURK, P., et al. *An Eleventh-Century Anglo-Saxon Illustrated Miscellany*. Copenhagen, 1983.

McLACHLAN, Elizabeth Parker. *The Scriptorium of Bury St Edmunds in the Twelfth Century*. New York and London, 1986.

MACREADY, Sarah, and THOMPSON, F. H. (eds.). *Art and Patronage in the English Romanesque*. London, 1986.

MILLAR, E. G. *English Illuminated Manuscripts from the Xth to the XIIIth Century*. Paris and Brussels, 1926.

MORGAN, N. J. *Early Gothic Manuscripts (I) (A Survey of Manuscripts Illuminated in the British Isles*, ed. J. J. G. Alexander, IV). London, 1982.

OAKESHOTT, Walter. *Sigena: Romanesque Paintings in Spain and the Winchester Bible Artists*. London, 1972.

OAKESHOTT, Walter. *The Two Winchester Bibles*. Oxford, 1981.

O'CONNOR, David E., and HASELOCK, Jeremy. 'The Stained and Painted Glass', *A History of York Minster*, ed. G. E. Aylmer and Reginald Cant, pp. 313–93. Oxford, 1977.

Opus Anglicanum: English Medieval Embroidery. Exhibition catalogue, Victoria and Albert Museum. London, 1963.

PÄCHT, Otto. 'A Cycle of English Frescoes in Spain', *Burlington Magazine*, CIII (1961), pp. 166–75.

PÄCHT, Otto. *The Rise of Pictorial Narrative in Twelfth-Century England*. Oxford, 1962.

PÄCHT, Otto, DODWELL, C. R., and WORMALD, Francis. *The St Albans Psalter*. London, 1960.

PARK, David. 'The "Lewes Group" of Wall Paintings in Sussex', *Anglo-Norman Studies*, VI (1983), pp. 201–37.

RICKERT, Margaret. *Painting in Britain: The Middle Ages (The Pelican History of Art)*. 2nd ed. Harmondsworth, 1965.

STENTON, F. M. (ed.). *The Bayeux Tapestry*. London, 1957.

TEMPLE, Elzbieta. *Anglo-Saxon Manuscripts 900–1066 (A Survey of Manuscripts Illuminated in the British Isles*, ed. J. J. G. Alexander, II). London, 1976.

THOMSON, Rodney M. *Manuscripts from St Albans Abbey 1066–1235*. 2 vols. Woodbridge, 1982.

TRISTRAM, E. W. *English Medieval Wall Painting: The Twelfth Century*. Oxford, 1944.

WILSON, David M. *The Bayeux Tapestry*. London, 1985.

WORMALD, Francis. 'The Survival of Anglo-Saxon Illumination after the Norman Conquest', *Proceedings of the British Academy*, XXX (1944), pp. 127–45.

WORMALD, Francis. *English Drawings of the Tenth and Eleventh Centuries*. London, 1952.

WORMALD, Francis. *The Benedictional of St Ethelwold*. London, 1959.

WORMALD, Francis. 'Continental Influence on English Medieval Illumination', *Fourth International Congress of Bibliophiles*, pp. 4–16. London, 1967.

WORMALD, Francis. *The Winchester Psalter*. London, 1973.

Flanders, the Low Countries

BOUTEMY, André. 'L'Illustration de la vie de Saint Amand', *Revue belge d'archéologie et d'histoire de l'art*, X (1940), pp. 231–49.

BOUTEMY, André. 'Les Enlumineurs de l'abbaye de Saint-Amand', *Revue belge d'archéologie et d'histoire de l'art*, XII (1942), pp. 131–67.

BOUTEMY, André. 'La Miniature', in E. de Moreau, *Histoire de l'Église en Belgique*, II. 2nd ed. Brussels, 1945.

BOUTEMY, André. 'Odon d'Orléans et les origines de la bibliothèque de l'abbaye de Saint-Martin de Tournai', *Mélanges dédiés à la mémoire de Félix Grat*, II, pp. 179–222. Paris, 1949.

BOUTEMY, André. 'Relations artistiques entre les abbayes d'Anchin et de Saint-Amand au milieu du XIIe siècle', *Bulletin de la Société nationale des Antiquaires de France* (1954–5), pp. 75–8.

BOUTEMY, André. 'Enluminures d'Anchin au temps de l'abbé Gossuin', *Scriptorium*, XI (1957), pp. 234–48.

COLLON-GEVAERT, Suzanne, et al. *Art roman dans la vallée de la Meuse aux XIe et XIIe siècles*. Brussels, 1962.

DEUCHLER, Florens. *Der Ingeborgpsalter*. Berlin, 1967.

DYNES, Wayne. *The Illuminations of the Stavelot Bible*. New York and London, 1978.

GARBORINI, Norbert. *Der Miniator Sawalo*. Cologne, 1978.

KLEMM, Elisabeth. *Ein romanischer Miniaturenzyklus aus dem Maasgebiet*. Vienna, 1973.

Rhein und Maas: Kunst und Kultur 800–1400. Exhibition catalogue, Schnütgen-Museum. 2 vols. Cologne, 1973.

ROLLAND, Paul. *La Peinture murale à Tournai*. Brussels, 1946.

France

ALEXANDER, J. J. G. *Norman Illumination at Mont St Michel 966–1100*. Oxford, 1970.

BOUTEMY, André. 'Un grand enlumineur du Xe siècle, l'abbé Odbert de Saint-Bertin', *Annales de la Fédération archéologique et historique de Belgique: Congrès d'Anvers, 27–31 juillet 1947*, pp. 247–54. Antwerp, 1950.

CAMES, Gérard. 'Recherches sur l'enluminure romane de Cluny', *Bulletin of the Cleveland Museum of Art*, LVI (1969), pp. 131–5.

DE HAMEL, C. F. R. *Glossed Books of the Bible and the Origins of the Paris Book Trade*. Woodbridge, 1984.

DELAPORTE, Y., and HOUVET, E. *Les Vitraux de la cathédrale de Chartres*. 4 vols. Chartres, 1926.

DESCHAMPS, Paul, and THIBOUT, Marc. *La Peinture murale en France: le haut Moyen Âge et l'époque romane*. Paris, 1951.

EVANS, Joan. *Cluniac Art of the Romanesque Period*. Cambridge, 1950.

FOCILLON, Henri. *Peintures romanes des églises de France*. Paris, 1950.

GABORIT-CHOPIN, D. *La Décoration des manuscrits à Saint-Martial de Limoges et en Limousin du IXe au XIIe siècle*. Paris and Geneva, 1969.

GAILLARD, G. *Les Fresques de Saint-Savin*. Paris, 1944.

GRODECKI, Louis. *The Stained Glass of French Churches*. London, 1948.

GRODECKI, Louis. *Les Vitraux de Saint-Denis: Étude sur le vitrail au XIIe siècle*, I (C.V.M.A. France: *Studies*, I). Paris, 1976.

HAYWARD, Jane. 'Stained Glass at Saint-Denis', *The Royal Abbey of Saint-Denis in the Time of Abbot Suger (1122–1151)*, ed. S. McK. Crosby *et al.*, pp. 61–99. Exhibition catalogue, Metropolitan Museum of Art. New York, 1981.

HENDERSON, George. 'The Sources of the Genesis Cycle at Saint-Savin-sur-Gartempe', *Journal of the British Archaeological Association*, 3rd series, XXVI (1963), pp. 11–26.

HOFFMANN, Konrad. 'Sugers "Anagogisches Fenster" in St Denis', *Wallraf-Richartz-Jahrbuch*, XXX (1968), pp. 57–88.

MÂLE, Émile. *L'Art religieux du XIIe siècle en France*. Paris, 1940.

MUNTEANU, Voichita. *The Cycle of Frescoes of the Chapel of Le Liget*. New York and London, 1978.

MURAL I ALTET, Xavier, *et al.* *El 'Beato' de Saint-Sever*. Madrid, 1984.

OURSEL, Charles. *La Miniature du XIIe siècle à l'abbaye de Cîteaux*. Dijon, 1926.

OURSEL, Charles. *Miniatures cisterciennes*. Mâcon, 1960.

PORCHER, Jean (ed.). *Les Manuscrits à peintures en France du VIIe au XIIe siècle*. Exhibition catalogue. Paris, 1954.

PORCHER, Jean. *French Miniatures from Illuminated Manuscripts*. London, 1960.

Radiance and Reflection: Medieval Art from the Raymond Pitcairn Collection. Exhibition catalogue, including stained glass panels from Saint-Denis and elsewhere, Metropolitan Museum of Art. New York, 1982.

SCHAPIRO, Meyer. *The Parma Ildefonsus: A Romanesque Illuminated Manuscript from Cluny and Related Works*. New York, 1964.

SCHULTEN, S. 'Die Buchmalerei des 11. Jahrhunderts im Kloster St Vaast in Arras', *Münchner Jahrbuch der bildenden Kunst*, VII (1956), pp. 49–90.

VAN MOÉ, Émile A. *L'Apocalypse de Saint-Sever*. Paris, 1942.

WILLIAMS, John. 'Le Beatus de Saint-Sever: état des questions', *Saint-Sever: Millénaire de l'Abbaye (Colloque international 25, 26 et 27 mai 1985)*, pp. 251–63 (Comité d'études sur l'histoire et l'art de la Gascogne). Mont-de-Marsan, 1986.

Germany

BAILLET, L. 'Les Miniatures du "Scivias" de Sainte Hildegarde', *Fondation Eugène Piot: Monuments et mémoires publiés par l'Académie des Inscriptions et Belles-Lettres*, XIX, pp. 49–149. Paris, 1911.

BANGE, E. F. *Eine bayerische Malerschule des XI. und XII. Jahrhunderts*. Munich, 1923.

BEER, Ellen J. *Das Evangelistar aus St Peter*. Facsimile with introduction. Basel, 1961.

BOECKLER, Albert. *Das Stuttgarter Passionale*. Augsburg, 1923.

BOECKLER, Albert. *Die Regensburg-Prüfeninger Buchmalerei des XII. und XIII. Jahrhunderts*. Munich, 1924.

DE HAMEL, Christopher. *The Gospels of Henry the Lion*. London, 1983.

GOLDSCHMIDT, Adolph. *German Illumination*. 2 vols. Florence and Paris, 1928.

GREEN, R.B., EVANS, Michael, BISCHOFF, Christine, and CURSCHMANN, Michael. *Hortus Deliciarum*. 2 vols. London and Leiden, 1979.

JANSEN, Franz. *Die Helmarshausener Buchmalerei zur Zeit Heinrichs des Löwen*. Hildesheim, 1933.

KORN, Ulf-Dietrich. *Die romanische Farbverglasung von St Patrokli in Soest* (*Westfalen*, 17. Sonderheft). Münster Westfalen, 1967.

KOVÁCS, Éva. 'Casula Sancti Stephani Regis', *Acta Historiae Artium*, V (1958), pp. 181–221.

KROOS, Renate. *Niedersächsische Bildstickereien des Mittelalters*. Berlin, 1970.

KRÜGER, Ekkehard. *Die Schreib- und Malwerkstatt der Abtei Helmarshausen bis in die Zeit Heinrichs des Löwen*. 3 vols. Darmstadt and Marburg, 1972.

KURTH, Betty. *Die deutschen Bildteppiche des Mittelalters*. 3 vols. Vienna, 1926.

LESSING, Julius. *Wandteppiche und Decken des Mittelalters in Deutschland*. Berlin, n.d.

LÖFFLER, Karl. *Schwäbische Buchmalerei in romanischer Zeit*. Augsburg, 1928.

Ornamenta Ecclesiae Kunst und Künstler der Romanik. Exhibition catalogue, Schnütgen-Museum. 3 vols. Cologne, 1985.

PÖLNITZ, Sigmund von. *Die Bamberger Kaisermäntel*. Weissenhorn, 1973.

Regensburger Buchmalerei von frühkarolingischer Zeit bis zum Ausgang des Mittelalters. Exhibition catalogue, Bayerische Staatsbibliothek. Munich, 1987.

SCHNITZLER, Hermann. *Rheinische Schatzkammer*. 2 vols. Düsseldorf, 1957–9.

SCHRAMM, Percy Ernst, and MÜTHERICH, Florentine. *Denkmale der deutschen Könige und Kaiser*. Munich, 1962.

SINGER, Charles. 'The Scientific Views and Visions of Saint Hildegard (1098–1180)', *Studies in the History and Method of Science*, ed. Charles Singer, pp. 1–55. Oxford, 1917.

STEIGERWALD, Frank Neidhart. *Das Evangeliar Heinrichs des Löwen*. Offenbach am Main and Brunswick, 1985.

STEIN, Heidrun. *Die romanischen Wandmalereien in der Klosterkirche Prüfening*. Regensburg, 1987.

Suevia Sacra: Frühe Kunst in Schwaben. Exhibition catalogue. Augsburg, 1973.

VERBEEK, Albert. *Schwarzrheindorf: Die Doppelkirche und ihre Wandgemälde*. Düsseldorf, 1953.

Die Zeit der Staufer. Exhibition catalogue, Württembergisches Landesmuseum.

5 vols. Stuttgart, 1977.

ZSCHOKKE, Fridtjof. *Die romanischen Glasgemälde des Strassburger Münsters*. Basel, 1942.

Ireland

ALTON, E.H., and MEYER, P. *Evangeliorum Quattuor Codex Cenannensis*. 3 vols. Bern, 1951.

FOX, Peter (ed.). *The Book of Kells*. Facsimile and commentary. 2 vols. Lucerne, 1990.

GOUGAUD, L. 'Les Scribes monastiques d'Irlande au travail', *Revue d'Histoire ecclésiastique*, XXVII (1931), pp. 293–306.

HENRY, Françoise. *Irish Art During the Viking Invasions*. London, 1967.

HENRY, Françoise. *Irish Art in the Romanesque Period*. London, 1970.

HENRY, Françoise. *The Book of Kells*. London, 1974.

Italy

AVERY, Myrtilla. *The Exultet Rolls of South Italy*. Princeton, 1936.

BELTING, Hans. *Studien zur beneventanischen Malerei*. Wiesbaden, 1968.

BERG, Knut. *Studies in Tuscan Twelfth-Century Illumination*. Oslo, 1968.

BERTAUX, Émile. *L'Art dans l'Italie méridionale*. Paris, 1904.

BLOCH, Herbert. 'Monte Cassino, Byzantium, and the West in the Earlier Middle Ages', *Dumbarton Oaks Papers*, III (1946), pp. 165–224.

BLOCH, Herbert. *Monte Cassino in the Middle Ages*. 3 vols. Rome, 1986.

BOLOGNA, F. *Early Italian Painting*. London, 1963.

BUCHTHAL, Hugo. 'A School of Miniature Painting in Norman Sicily', *Late Classical and Mediaeval Studies in Honor of Albert Matthias Friend Jr*, ed. Kurt Weitzmann, pp. 312–39. Princeton, 1955.

BUCHTHAL, Hugo. 'The Beginnings of Manuscript Illumination in Norman Sicily', *Papers of the British School at Rome*, XXIV (1956), pp. 78–85.

DEMUS, Otto. *The Mosaics of Norman Sicily*. London, 1950.

DEMUS, Otto. *The Mosaics of San Marco in Venice*. 4 vols. Chicago and London, 1984.

GARRISON, E.B. *Italian Romanesque Panel Painting*. Florence, 1949.

GARRISON, E.B. *Studies in the History of Mediaeval Italian Painting*. 4 vols. Florence, 1953–62.

HODGES, Richard, and MITCHELL, John (eds.). *San Vincenzo al Volturno. The Archaeology, Art and Territory of an Early Medieval Monastery* (B.A.R. International Series, 252). Oxford, 1985.

KITZINGER, Ernst. 'The First Mosaic Decoration of Salerno Cathedral', *Jahrbuch der Österreichischen Byzantinistik*, XXI (1972), pp. 149–62.

KITZINGER, Ernst. 'A Virgin's Face: antiquarianism in twelfth-century art', *Art Bulletin*, LXII (1980), pp. 6–19.

LADNER, G. 'Die italienische Malerei im 11. Jahrhundert', *Jahrbuch der kunsthistorischen Sammlungen in Wien*, V (1931), pp. 33–160.

MARLE, Raimond van. *The Development of the Italian Schools of Painting*, I. The Hague, 1923.

MATTHIAE, Guglielmo. *Pittura romana del medioevo*. 2 vols. Rome, 1965–6.

MATTHIAE, Guglielmo. *Mosaici medioevali delle chiese di Roma*. 2 vols. Rome, 1967.

MORISANI, Ottavio. *Gli Affreschi di S. Angelo in Formis*. Naples, 1962.

OAKESHOTT, Walter. *The Mosaics of Rome*. London, 1967.

OSBORNE, John. *Early Mediaeval Wall-Paintings in the Lower Church of San Clemente*. New York and London, 1984.

TOESCA, Pietro. *La Pittura e la miniatura nella Lombardia*. Milan, 1912.

TOESCA, Pietro. *Storia dell'arte italiana*, I. Turin, 1927.

TOUBERT, H. 'Le Renouveau paléochrétien à Rome au début du XIIe siècle', *Cahiers Archéologiques*, XX (1970), pp. 99–154.

WEITZMANN, Kurt. *The Fresco Cycle of S. Maria di Castelseprio*. Princeton, 1951.

WETTSTEIN, Janine. *Sant'Angelo in Formis et la peinture médiévale en Campanie*. Geneva, 1960.

WILPERT, J. *Die römischen Mosaiken und Malereien der kirchlichen Bauten vom IV. bis zum XIII. Jahrhundert*. 4 vols. Freiburg im Breisgau, 1917.

The Latin Kingdom of Jerusalem

BOASE, T.S.R. 'The Arts in the Latin Kingdom of Jerusalem', *Journal of the Warburg Institute*, II (1938–9), pp. 1–21.

BUCHTHAL, Hugo. *Miniature Painting in the Latin Kingdom of Jerusalem*. Oxford, 1957.

WEITZMANN, Kurt. 'Icon Painting in the Crusader Kingdom', *Dumbarton Oaks Papers*, XX (1966), pp. 51–83.

Poland

MÜTHERICH, Florentine. 'Epistola Mathildis Sueviae. Zu einer verschollenen Handschrift aus dem 11. Jahrhundert', *Studien zur Buchmalerei und Goldschmiedekunst des Mittelalters: Festschrift für K.H. Usener zum 60. Geburtstag*, ed. F. Dettweiler *et al.*, pp. 137–42. Marburg, 1967.

WALICKI, Michał. *Sztuka Polska przedromańska i romańska do schyłku XIII wieku* (*Dziej Sztuki Polskiej*, I). Warsaw, 1971.

Scandinavia

ANKER, Peter, and ANDERSSON, Aron. *The Art of Scandinavia*. 2 vols. London, 1968.

BECKETT, F. *Danmarks Kunst.* Copenhagen, 1924.

NØRLUND, P., and LIND, E. *Danmarks romanske Kalkmalerier*. Copenhagen, 1944.

ROOSVAL, J. *Swedish Art*. Princeton, 1932.

RYDBECK, O. *Medeltida Kalkma lningar i Ska nes kyrkor*. Lund, 1904.

Spain

Actas del simposio para el estudio de los códices del 'Comentario al Apocalipsis' de Beato de Liébana. 3 vols. Madrid, 1980.

L'Art roman: exposition. Exhibition catalogue. Barcelona and Santiago de Compostella, 1961.

Los Beatos. Exhibition catalogue, Europalia 85 España, Chapelle de Nassau, Bibliothèque Royale Albert Ier. Brussels, 1985.

BURCKHARDT, Titus (ed.). *Sancti Beati a Liebana in Apocalypsin Codex Gerundensis*. Facsimile and commentary. 2 vols. Olten and Lausanne, 1962.

COOK, W. W. S. *La Pintura románica en Cataluña*. Madrid, 1956.

COOK, W. W. S., and GUDIOL RICART, J. *Pintura y imaginería románicas (Ars Hispaniae, VI)*. Madrid, 1950.

DURLIAT, Marcel. *L'Art roman en Espagne*. Paris, 1962.

ECO, Umberto (ed.). *Beato di Liébana. Miniature del Beato de Fernando I y Sancha (Codice B. N. Madrid Vit. 14–2)*. Parma, 1973.

JUNYENT, Édouard. *Catalogne romane*. 2 vols. Éditions Zodiaque, 1961.

KLEIN, Peter K. 'Date et scriptorium de la Bible de Roda', *Les Cahiers de Saint-Michel de Cuxa*, III (1972), pp. 91–102.

KLEIN, Peter K. 'Der Apokalypse-Zyklus der Roda-Bibel', *Archivo Español de Arqueología*, XLV–XLVII (1972–4), pp. 267–333.

KUHN, Charles L. *Romanesque Mural Painting of Catalonia*. Cambridge, Mass., 1930.

MENTRÉ, Mireille. *La Peinture mozarabe*. Paris, 1984.

NEUSS, Wilhelm. *Die katalanische Bibelillustration um die Wende des ersten Jahrtausends und die altspanische Buchmalerei*. Bonn and Leipzig, 1922.

NEUSS, Wilhelm. *Die Apokalypse des hl. Johannes in der altspanischen und altchristlichen Bibel-illustration*. 2 vols. Münster, 1931.

PALOL, Pedro de, and HIRMER, Max. *Early Medieval Art in Spain*. London, 1967.

POST, C. R. *A History of Spanish Painting*, I. Cambridge, Mass., 1930.

SCHLUNK, Helmut, and BERENGUER, Magin. *La Pintura mural asturiana de los siglos IX y X*. Madrid, 1957.

STIERLIN, Henri. *Los Beatos de Liébana y el arte mozárabe*. Madrid, 1983.

WILLIAMS, John W. 'A Castilian Tradition of Bible Illustration', *Journal of the Warburg and Courtauld Institutes*, XXVIII (1965), pp. 66–85.

WILLIAMS, John W. 'San Isidoro in León: evidence for a new history', *Art Bulletin*, LV (1973), pp. 171–84.

Switzerland

BEER, Ellen J. *Die Glasmalereien der Schweiz vom 12. bis zum Beginn des 14. Jahrhunderts*. Basel, 1956.

BRENK, Beat. *Die romanische Wandmalerei in der Schweiz*. Bern, 1963.

HAFNER, Wolfgang. 'Die Maler- und Schreiberschule von Engelberg', *Stultifera Navis*, XI (1954), pp. 13–20.

MURBACH, Ernst. *Zillis. Die romanische Bilderdecke der Kirche St Martin*. Zürich and Freiburg im Breisgau, 1967.

Index of iconography and of named artists and scribes

General index

Photographic Acknowledgements

Photographic material has been supplied by and reproduced by courtesy of the owners, unless otherwise indicated below.

Aachen, Ann Münchow, 44, 129
Augsburg, Studio Müller, 392
Barcelona, Fisa I.G., 242
Bari, Fotogramma, 152
Barnard Castle, Eddie Ryle-Hodges, 354
Basel, Peter Heman, 290, 291
Bayeux, Ville de, 10, 11, 12
Boulogne, Castelet, 379
Brussels, A.C.L., 274
Cambridge, James Austin, 32, 151, 332, 333
Cambridge, Master and Fellows of Corpus Christi College, 76, 89, 346, 347, 353, 356, 357, 358
Cambridge, Master and Fellows of Pembroke College, 340
Cambridge, Master and Fellows of Trinity College, 75, 82, 95, 342, 344, 359
Cambridge, Syndics of the University Library, 327
Casarsa, Elio Ciol, 123
Le Champ-près-Froges, Mairie, 391
Cocomello, Octavio, 159
Cologne, Rheinisches Bildarchiv, 275, 276, 281
Copenhagen, Nationalmuseet, 325
Creech St Michael, George H. Hall, 79, 308
Czechoslovak Embassy, 321
Dijon, R. Remy, 211
Dodwell, C.R., 183, 185, 189, 190, 191, 192, 193, 194, 197, 198, 201, 204, 206, 207, 210, 212, 217, 254, 255, 257, 258, 261, 262, 264, 404, 405

Durham, The Dean and Chapter, 24
Ecublens, André Held, 263
Florence, Alinari, 175
Florence, Index/Padicini, 158, 164
Florence, Scala, 1, 2, 3, 147, 148, 155, 160, 161, 170, 174
Florence, Soprintendenza alle Gallerie, 169
Halle, Institut für Denkmalpflege, 15, 16, 17
Halliday, Sonia, 399, 410, 403
London, His Grace the Archbishop of Canterbury and the Trustees of Lambeth Palace Library, 72, 350, 351
London, Courtauld Institute, 171, 253, 346, 349, 358
London, A.F. Kersting, 331
London, Warburg Institute, 118, 122, 334, 335, 337, 371, 372, 374
Madrid, Biblioteca Nacional, 246
Madrid, Mas, 14, 135, 249, 250, 259, 265, 266, 376, 377
Madrid, Patrimonio Nacional, 134
Madrid, Servicio Nacional de Microfilm, 243
Marburg, 20, 30, 59, 65, 116, 117, 119, 121, 140, 287, 289, 292, 312
Marly, La Boîte à Images, 195
Michigan-Princeton-Alexandria Expedition to Mount Sinai, 240
Munich, Bayerische Verwaltung der staatl. Schlösser, Gärten und Seen, 310
Munich, Hirmer, 4, 8, 13, 115, 309
Orléans, Augustin Thierry, 184
Paris, A.P., 229, 230, 233, 234, 236, 237, 380, 384, 389
Paris, Bibliothèque Nationale, 38, 64, 186, 208, 209, 213, 293, 294, 295, 352
Paris, Caisse Nationale des Monuments

Historiques et des Sites (SPADEM), 36, 227, 383
Paris, Giraudon, 126, 378, 381, 382, 387, 393
Paris, Lauros-Giraudon, 390
Paris, Ministère de la Culture, 388
Paris, Studio Ethel, 202
Parma, Tosti, 215
Philippot, J. (SPADEM), 385
Prague, Castle Archive, 319, 320
Quedlinburg, Foto-Studio, 18, 19
Rome, Anderson, 156
Rome, Biblioteca Hertziana, 154, 163
Rome, G.F.N., 149, 150, 167, 168
Rome, Archivio Fotografico Gall. Mus. Vaticani, 162
Roubier, Jean, 235
Rouen, Ville de, 94
Saint-Omer, J.P. Demolin, 200
Salzburg, Adolf Hahnl, 303
Salzburg, Reinhard Rinnerthaler, 306
Stockholm, Antikvarisk-Topografiska Arkivet, 326
Strasbourg, Association pour le développement de l'inventaire des monuments et des richesses artistiques de l'Alsace, 394
Valenciennes, Ets. Gérard, 196
Vienna, Kunsthistoriches Museum, 43
Vienna, Österreichische Nationalbibliothek, 296, 297, 307
Warsaw, Tomasz Prazmowski, 323
Washington, DC, Photographic Archives, National Gallery of Art, 172, 173
Weimar, Klaus G. Beyer, 288
Wiesbaden, Dr Reichert Verlag, 28
York, Dean and Chapter (photo: David O'Connor), 397